*ARTS AND CULTURE

AN INTRODUCTION TO THE HUMANITIES

Combined Edition

*ARTS AND CULTURE

AN INTRODUCTION TO THE HUMANITIES

Revised First Edition

JANETTA REBOLD BENTON PACE UNIVERSITY, NY

ROBERT DIYANNI
THE COLLEGE BOARD

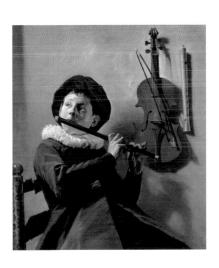

Library of Congress Cataloging-in-Publication Data

Benton, Janetta Rebold

Arts and culture: an introduction to the humanities/ Janetta Rebold Benton, Robert DiYanni. -- Combined ed.

p. cm.

Includes bibliographical references and index.

ISBN 0-13-863192-1

1. Arts--History. I. DiYanni, Robert. II. Title.

NX440.B46 1998

700--dc21

97-17901

CIP

For our children: Alexander, Ethan, Meredith, and Leland; Karen and Michael.

Editorial Director: Charlyce Jones Owen

Publisher: Bud Therien

Director of Manufacturing and Production: Barbara Kittle

Production editor: Joe Scordato

Editor-in-chief of development: Susanna Lesan

Marketing manager: Chris Ruel Creative director: Leslie Osher

Interior design: Joseph Rattan Design

Manufacturing manager: Nick Sklitsis

Manufacturing buyer: Sherry Lewis

Editorial assistant: Wendy Yurash

Cover art: Leyster, Judith (c. 1600-1660). Boy Playing the Flute, oil on canvas, 73 × 62 cm. © Erich Lessing/Art Resource, NY. National Museum, Stockholm, Sweden.

This book was set in 10/12 Janson and was printed and bound by RR Donnelley & Sons, Inc. The cover was printed by The Lehigh Press, Inc.

© 2002 by Pearson Education, Inc. Upper Saddle River, NJ 07458

All rights reserved. No part of this book may be reproduced, in any form or by any means, without permission in writing from the publisher.

Printed in the United States of America 10 9 8 7 6 4 3 2

ISBN 0-13-097509-5

Pearson Education Ltd.

Pearson Education Australia Pty. Ltd.

Pearson Education Singapore, Pte. Ltd.

Pearson Education North Asia Ltd.

Pearson Education Canada, Ltd.

Pearson Educación de Mexico, S.A. de C.V.

Pearson Education-Tokyo, Japan

Pearson Education Malaysia, Pte. Ltd.

Pearson Education, Upper Saddle River, New Jersey

Contents Overview

- 2. Ancient Egypt
- Aegean Culture and the Rise of Ancient Greece
- 5. ♦ The Roman World
- 6. \(\) Judaism and the Rise of Christianity

- 10. ← The Civilizations of the Americas

- 13. ← The Renaissance and Mannerism in Italy
- 15. ← The Baroque Age
- 16. ← The Eighteenth Century
- 17. ← Romanticism and Realism
- 18. ← The Belle Époque
- 20. ← Russian Civilization
- 22.

 Modern Africa and Latin America
- 23. ← The Age of Affluence
- 24. ← The Diversity of Contemporary Life

Contents

PREFACE XV

Introduction 1

- ← THE HUMANITIES AND THE ARTS 1
- ← ART AND ARTISTS OVER TIME 1
- ← THE ROLE OF THE ARTIST 2
- ← ART AND RITUAL 2
- ← CRITICAL THINKING AND EVALUATION OF THE ARTS 2
- ← FORM AND CONTENT DISTINCTIONS 3

STARTER KIT 4

COMMONALITIES 4 STYLE 4 FUNCTIONS AND GENRES 4

← THE VISUAL ARTS 4

FORMAL ANALYSIS 5

COMPONENTS OF THE VISUAL ARTS 6 ARCHITECTURE 7

← Literature 8

SPEECH, WRITING, AND LITERATURE 8 LITERACY AND LITERATURE 8 FORMS OF LITERATURE 8

♦ MUSIC 9

SOCIAL AND RITUAL ROLES 9
INSTRUMENTS 10
MUSICAL QUALITIES AND STRUCTURE 10
LISTENING TO MUSIC 11

♦ HISTORY AND PHILOSOPHY 11

HISTORY 11 RELIGION AND PHILOSOPHY 11

CHAPTER 1

The Dawn of Culture 12

← THE EARLIEST CULTURES 14

THE PALEOLITHIC PERIOD 14

Wall Paintings 14 Sculpture 15

THE NEOLITHIC PERIOD 16

Wall Paintings 17 Architecture 18

♦ MESOPOTAMIA: THE CRADLE OF CIVILIZATION 19

SUMER 19

Architecture 20 Sculpture 21 Literature 23

Box Cross Currents / Sumerian Myth and the Bible 24

AKKAD 24 BABYLON 25 Sculpture 25 ASSYRIA 26

Sculpture 26

Box Connections / The Fundamentals of Civilization 27

NEBUCHADNEZZAR'S BABYLON 28

PERSIA 30

Sculpture 30 Architecture 30 Relief Sculpture 31 Religion 31

Box Then & Now / Beer 31

CHAPTER 2

Ancient Egypt 32

♦ THE CIVILIZATION OF THE NILE 34

HIEROGLYPHICS 35 RELIGIOUS BELIEFS 36 The Afterlife 36

Box Then & Now / The Nile 37

← THE OLD KINGDOM 37

ARCHITECTURE 37

Mastabas 38 The Stepped Pyramid of Zoser 38 The Great Pyramids 39

SCULPTURE 40

The Great Sphinx 40 The Statue of Chefren 41 Mycerinus and Khamerernebty 41 Ka-Aper 42

RELIEF SCULPTURE AND PAINTING 43
Ti Watching a Hippopotamus Hunt 43

♦ THE MIDDLE KINGDOM 43

ARCHITECTURE 44 SCULPTURE 44

← THE NEW KINGDOM 45

ARCHITECTURE 45

Temple of Queen Hatshepsut 45 Temple of Amen-Mut-Khonsu 46 Family Homes 47

SCULPTURE 52

Temple of Ramesses II 48

RELIEF SCULPTURE AND PAINTING 48
Nobleman Hunting in the Marshes 49

Box Connections / Dance and Music in Ancient Egypt 50

AKHENATEN AND TUTANKHAMEN 50
Akhenaten, Nefertiti, and Their Children Worshiping
the Sun 51 Queen Nefertiti 51 Queen Tiy 56
Tomb of Tutankhamen 52

LITERATURE: LYRIC POETRY 53

Box Cross Currents / Ancient Egypt in the European Imagination 54

CHAPTER 3

Aegean Culture and the Rise of Ancient Greece 56

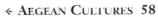

CYCLADIC CULTURE 58

MINOAN CULTURE 59

The Palace of Minos 60 The Myth of the Minotaur 62 The Toreador Fresco 62 Ceramic Ware 63 The Snake Goddess 64

Box Then & Now / The Snake Goddess 64

MYCENAEAN CULTURE 64

The Palace at Mycenae 65 The Warrior Vase 67

♦ THE RISE OF ANCIENT GREECE 67

THE PANTHEON OF GREEK GODS 67 Apollo and Daphne 68 Athena and Arachne 68 Perseus 68 Herakles 69 Dionysos 69

Box Cross Currents / Hesiod's Theogony and Mesopotamian Creation Myths 69

THE GEOMETRIC PERIOD 70

Pottery 70 Sculpture 71 Homer's Iliad and Odyssey 72

THE ORIENTALIZING PERIOD 73 Pottery 74

THE ARCHAIC PERIOD 74

Black-Figure Vases 75 Red-Figure Vases 76

Box Connections / Landscape and Architecture 77

> The Greek Temple 77 The Temple of Hera I at Paestum 78 The Temple of Aphaia at Aegina 78 Sculpture 79 Philosophy 81 Sappho and the Lyric Poem 81

CHAPTER 4

Classical and Hellenistic Greece 82

← CLASSICAL GREECE 84

FROM ARCHAIC TO CLASSICAL 84

Political Reform 84 The Persian Threat 85

THE GOLDEN AGE OF ATHENS 86

ARCHITECTURE AND ARCHITECTURAL

SCULPTURE ON THE ACROPOLIS 87

The Greek Orders 87 The Propylaia 88 The Parthenon 89 Parthenon Sculpture 90

The Erechtheion 93 The Temple of Athena Nike 93

SCULPTURE 93

The Kritios Boy 94 Polykleitos 94 Praxiteles 95

Lysippos 96

Box Then & Now / The Olympiad 96

VASE PAINTING 97

White-Ground Ceramics 97

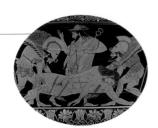

THE EMERGENCE OF DRAMA 98 Aeschylus 98

Box Connections / Aristotle and Greek Theater 100 Sophocles 100 Euripides 101 Aristophanes 101

PHILOSOPHY 101

Socrates 101 Plato 102 Aristotle 103

MUSIC AND GREEK SOCIETY 1040 The Musical Modes 105

← HELLENISTIC GREECE 105

ARCHITECTURE 107

The Temple of the Olympian Zeus 107 Pergamon's Altar of Zeus 107

Box Cross Currents / The Hellenization of India 109

SCULPTURE 109

The Battle of the Gods and the Giants 109 The Nike of Samothrace 110 Laocoön and His Sons 110

PHILOSOPHY 111

Stoicism 111 Epicureanism 111 Skepticism 111

CHAPTER 5

The Roman World 112

THE GREEK LEGACY AND THE ROMAN IDEAL 114

& ETRUSCAN CIVILIZATION 114

TEMPLES 115 TOMBS 115

SCULPTURE 117

← REPUBLICAN ROME 118

THE REPUBLIC 118

Box Cross Currents / The Roman Pantheon 120

THE ART OF REPUBLICAN ROME 120

Architecture 121 Aqueducts 122 Sculpture 122

LITERATURE 124

Lucretius 124 Catullus 124

Roman Drama: Plautus and Terence 124

← THE EMPIRE 124

DAILY LIFE IN IMPERIAL ROME 127

THE ARCHITECTURE OF THE EMPIRE 128

The Roman Forum 128 The Colosseum 129

The Pantheon 130 Baths 131

SCULPTURE 131

Augustus of Primaporta 131 The Ara Pacis 132 The Column of Trajan 133 The Equestrian Statue of Marcus Aurelius 134

Box Connections / The Ara Pacis and the Politics

of Family Life 134

Portrait Bust of Caracalla 135 Head of Constantine 135 The Arch of Constantine 136

PAINTING 137

First Style 137 Second Style 138 Third Style

139Fourth Style 140

PHILOSOPHY 140

Stoicism 140

Box Then & Now / Graffiti 141

LITERATURE 142

Virgil 142 Horace 142 Ovid 142 Petronius 143

CHAPTER 6

Judaism and the Rise of Christianity 144

HISTORY AND RELIGION 146

Creation 146 Patriarchs 146 Prophets 148 Kings 148 Return from Exile 148

THE BIBLE AS LITERATURE 148

History and Fiction 149 Biblical Poetry 150

Box Then & Now / The Bible 150

← EARLY CHRISTIANITY 151

JESUS AND HIS MESSAGE 151

EARLY CHRISTIAN HISTORY 152

EARLY CHRISTIAN ART 153

Architecture 153 Sculpture 154 Painting 158

THE NEW TESTAMENT AS LITERATURE 159
Gospels 160 Epistles 161 Revelation 161

Box Cross Currents / Christianity and the Eastern Cults 160

EARLY CHRISTIAN MUSIC 161 PHILOSOPHY: AUGUSTINE AND THE NEOPLATONIC INHERITANCE 162

Box Connections: Gnosticism and Christianity 162

CHAPTER 7

Byzantine and Islamic Civilizations 164

♦ BYZANTINE CIVILIZATION 166

THE GOLDEN AGE OF CONSTANTINOPLE 166 BYZANTINE ART 168

San Vitale, Ravenna 168

Box Cross Currents / The Silk Trade 169

Hagia Sophia 171 St. Mark's, Venice 173 Madonna and Child Enthroned 175

Box Then & Now / Jerusalem 176

♦ ISLAMIC CIVILIZATION 177

RELIGION 177

Muhammad 177 The Quran 177 Basic Tenets and the Five Pillars of Islam 178 Islamic Mysticism: The Sufis 179

PHILOSOPHY 180

Avicenna and Averroes 180

ISLAMIC ART AND ARCHITECTURE 181

The Mosque 181 The Alhambra Palace 183 Ceramics and Miniature Painting 184

LITERATURE 184

Arabic and Persian Poetry 184 Poetry of Islamic Spain 185 Arabic Prose: The Thousand and One Nights 186

MUSIC 186

Box Connections / Sufism, Dancing, and Music 186

CHAPTER 8

Indian Civilization 188

♦ THE VEDIC PERIOD 190

HINDUISM 190

Hindu Gods 191 Karma 191

Hindu Class Structure 191

LITERATURE: THE HINDU CLASSICS 191

The Vedas 191 The Upanishads 192

The Ramayana 192 The Mahabharata 192

← THE MAURYA PERIOD 193

Box Connections / The Logic of Jainism 193

BUDDHISM 193

Buddhism versus Hinduism 194

The Four Noble Truths and the Eight-Fold Path 194

MAURYA ART 195

The Sarnath Capital 195 The Great Stupa at Sanchi 196

← THE GUPTA ERA 197

GUPTA ART 197

THE JATAKA AND THE PANCATANTRA 198

♦ THE HINDU DYNASTIES 199

THE HINDU TEMPLE 199

Box Then & Now / Muslim India 200

SCULPTURE 200

HINDU LYRIC POETRY 200

MUSIC 201

Box Cross Currents / Ravi Shankar and Philip Glass 201

CHAPTER 9

Early Chinese and Japanese Civilizations 202

← CHINA BEFORE 1279 204

THE SHANG AND ZHOU DYNASTIES 204
Shang and Zhou Bronzes 204 Confucianism 204
Taoism 206 Yin and Yang 207 Lyric Poetry 207
Music 207

EMPIRE: THE QIN AND HAN DYNASTIES 207

THE SIX DYNASTIES 209

THE TANG DYNASTY 209

Li Bai and Du Fu 209

Box Connections / The Seven Sages of the Bamboo Grove 210

THE SONG DYNASTY 210
Painting 210

Box Cross Currents / Marco Polo's Hangzhou 212

← Japan before the Fifteenth Century 212

RELIGION 212

Buddhism and Shinto 212

ASUKA AND NARA PERIODS 213

Art and Architecture 213

THE HEIAN PERIOD 213

The Tale of Genji 213 Heian Handscrolls 214

THE KAMAKURA PERIOD 215

Zen Buddhism 215

Box Then & Now / Zen 216

THE ASHIKAGA PERIOD 216

The Tea Ceremony 217

The Civilizations of the Americas 218

← MESOAMERICA 220

THE OLMECS 220 TEOTIHUACÁN 220

MAYAN CULTURE 222

The Mayan Universe 222 Tikal 222 The Jaguar Kings of Palenque 223

Box Then & Now / The Maya 224

THE TOLTECS AND AZTECS 224

← THE CULTURES OF PERU 225

THE MOCHE 226 THE INCA 227

Box Connections / The Mystery of the Nazca Lines 229

♦ NORTH AMERICA 229

THE NORTHWEST COAST 229
THE SOUTHWEST 230
THE MOUNDBUILDERS 230

THE BUFFALO HUNTERS 321

Box Cross Currents / Conquest and Disease 231

CHAPTER 11

The Early Middle Ages and the Romanesque 232

← EARLY MEDIEVAL CULTURE 234

THE MERGING OF CHRISTIAN

AND CELTO-GERMANIC TRADITIONS 234
The Animal Style 234 Christian Gospel Books 235
The Beowulf Epic and the Christian Poem 236

Literature: The Song of Roland 238

MONASTICISM 238

The Rule of St. Benedict and Cluniac Reform 238

Box Connections / The Mystery Plays and the Guilds 240

The Monastery 240 Manuscript Illumination 241 Music: Gregorian Chant 243

♦ ROMANESQUE CULTURE 243

THE FEUDAL MONARCHS 244

The Capetians 244 The Norman Conquest 244 Magna Carta 245 The Crusades 246

ROMANESQUE ARCHITECTURE 246

Pilgrimages and the Church 246 Saint-Sernin, Toulouse 246 Sainte-Madeleine, Vézelay 248 Cathedral Group, Pisa 249

Box Cross Currents / The Pisa Griffin 9

SCULPTURE 249

The Vézeley Mission of the Apostles 250 The Autun Last Judgment 251

DECORATIVE ARTS 251

Reliquaries and Enamel Work 251

THE CHIVALRIC TRADITION IN LITERATURE 252

The Troubadours 252 Chrétien de Troyes 253

Box Then & Now / Chant 253

MUSIC 253

Hildegard of Bingen 253

CHAPTER 12

The Gothic and Late Middle Ages 254

← THE GOTHIC ERA 256

PARIS IN THE LATER MIDDLE AGES 256

Box Then & Now / The Louvre 257

GOTHIC ARCHITECTURE 257

Royal Abbey, Saint-Denis 259 Notre-Dame, Paris 259 Notre-Dame, Chartres 260

Box Connections / Numerology at Chartres 262

Notre-Dame, Amiens 263 Sainte-Chapelle, Paris 265 Saint-Maclou, Rouen 265

GOTHIC ARCHITECTURE OUTSIDE FRANCE 266
Salisbury Cathedral 266 Westminster Abbey, London 266
Florence Cathedral 268 Milan Cathedral 269

SCULPTURE 269

Notre-Dame, Chartres 269 Notre-Dame, Reims 270 Notre-Dame-de-Paris 270 Gargoyles 271

PAINTING AND DECORATIVE ARTS 272

Manuscript Illumination 272 Stained Glass 272

Tapestry 274

Box Cross Currents / Muslim Spain 274

SCHOLASTICISM 275

The Growth of the University 276 The Synthesis of

St. Thomas Aquinas 276 Duns Scotus and William of Ockham 276 Francis of Assisi 277

LITERATURE 277

Dante's Divine Comedy 277

MUSIC 279

The Notre-Dame School 279

NATURALISM IN ART 281

The Pisanos 281 Duccio and Giotto 281

REALISM IN LITERATURE 284

Boccaccio's Decameron 284 Chaucer's Canterbury Tales 285 Christine de Pizan 286

SECULAR SONG 287

Guillaume de Machaut 287 English Song 287

CHAPTER 13

The Renaissance and Mannerism in Italy 228

← THE EARLY RENAISSANCE 290

THE MEDICI'S FLORENCE 290 Cosimo de' Medici 291 Lorenzo the Magnificent 292 THE HUMANIST SPIRIT 292

Box Cross Currents / Montezuma's Tenochtitlan 293

THE PLATONIC ACADEMY OF PHILOSOPHY 293 Marsilio Ficino 293 Pico della Mirandola 294

SCULPTURE 294

Lorenzo Ghiberti 294 Donatello 295

ARCHITECTURE 298

Filippo Brunelleschi 298 Leon Battista Alberti 298 Michelozzo di Bartolommeo 300

PAINTING 301

Masaccio 301 Piero della Francesca 303 Fra Angelico 304 Sandro Botticelli 305

EARLY RENAISSANCE MUSIC 308

Guillaume Dufay 308 Motets 308 Word Painting 308

Box Connections / Mathematical Proportions: Brunelleschi and Dufay 309

LITERATURE 309

Petrarch 309 The Petrarchan Sonnet 310

← THE HIGH RENAISSANCE 310

FRA SAVONAROLA AND THE FLORENTINES 310 PAINTING 310

Leonardo da Vinci 310

THE REINVENTION OF ROME 314

Pope Sixtus IV 314 The New Vatican 314

PAINTING 315

Raphael 315 Michelangelo 316

THE NEW ST. PETER'S BASILICA 321

Donato Bramante 321 Michelangelo's St. Peter's 322

VENICE PAINTING 323

Venetian Oil Painting 323 Giorgione and Titian 324 Tintoretto 325

MUSIC 325

Josquin des Près 325 Palestrina 326

LITERATURE 326

Baldassare Castiglione 326 Niccolò Machiavelli 327

← Mannerism 328

PAINTING 328

Michelangelo 328 Parmigianino 330 Bronzino 330 El Greco 331

SCULPTURE 332

Benvenuto Cellini 332 The Autobiography of Benvenuto Cellini 332

ARCHITECTURE 333

Box Then and Now / The Venice Ghetto 333

CHAPTER 14

The Renaissance in the North 334

← THE EARLY RENAISSANCE IN THE NORTH 336

> GHENT AND BRUGES 336 FLEMISH OIL PAINTING 336 Robert Campin 336 Jan van Eyck 338 Hieronymus Bosch 341

♦ THE HIGH RENAISSANCE IN THE NORTH 343

THE HABSBURG PATRONAGE 343 ICONOCLASM 344 ERASMUS AND NORTHERN HUMANISM 345

Box Then & Now / Iconoclasm and the Attack on the Arts 346

MARTIN LUTHER AND THE REFORMATION 346 JOHN CALVIN AND THE INSTITUTES OF THE CHRISTIAN RELIGION 348

Cross Currents / Dürer Describes Box Mexican Treasures 349

THE AGE OF DISCOVERY 349

Renaissance Explorers 349 Nicolas Copernicus 349 The New Scientists 350

PAINTING AND PRINTMAKING 351

Albrecht Dürer 351 Hans Holbein the Younger 353 Pieter Bruegel the Elder 354

ARCHITECTURE 355

Château of Chambord 356 Hardwick Hall 356

SECULAR MUSIC 357

English Madrigals 357 Thomas Weelkes 357 Thomas Morley 358

LITERATURE 358

Michel de Montaigne 358 William Shakespeare 359

Connections / Shakespeare and Music: Music and Character Revelation / Musical Imagery / Composers and Instruments 361

CHAPTER 15

The Baroque Age 362

← THE BAROQUE IN ITALY 364

THE COUNTER-

REFORMATION IN ROME 364

The Oratorians 365

The Fesuits 365

SCULPTURE AND ARCHITECTURE IN ROME 365 St. Peter's Basilica 365 Gianlorenzo Bernini 366

Francesco Borromini 369

PAINTING IN ITALY 370

Caravaggio 370 Artemisia Gentileschi 372 Annibale Carracci 372 Fra Andrea Pozzo 373

MUSIC IN ITALY 374

Claudio Monteverdi and Early Opera 374

Antonio Vivaldi and the Concerto Grosso 374

← THE BAROQUE OUTSIDE ITALY 375

PAINTING IN BOURGEOIS HOLLAND 375 Pieter de Hooch 375 Frans Hals 376

Connections / Vermeer and the Origins of Photography 377

Rembrandt van Rijn 377 Fudith Leyster 377

Jan Vermeer 379

PAINTING IN THE ROYAL COLLECTIONS 380 Peter Paul Rubens 380 Anthony van Dyck 382 Diego Velázquez 384 Claude Lorrain and Nicolas Poussin 386 The French Academy 387

ARCHITECTURE 388

The Louvre 388 The Palace of Versailles 389 St. Paul's Cathedral 389

BAROOUE MUSIC OUTSIDE ITALY 391

Handel and the Oratorio 391 Johann Sebastian Bach 392

Cross Currents / The Baroque in Mexico 393

THE SCIENCE OF OBSERVATION 393

Anton van Leeuwenhoek 393 Johannes Kepler 394 Galileo Galilei 394

PHILOSOPHY 394

René Descartes 394 Thomas Hobbes 395 John Locke 396 LITERATURE 396

Molière and the Baroque Stage 396

Then & Now / The Telescope 397

John Donne 397 Anne Bradstreet 398 John Milton 398 Miguel de Cervantes 399

CHAPTER 16

The Eighteenth Century 400

← ENLIGHTENMENT AND **REVOLUTION 402**

THE ENLIGHTENMENT 403

The Philosophes 403 Rational Humanism 403 THE INDUSTRIAL REVOLUTION 404

The Birth of the Factory 404 Adam Smith 404 THE SCIENTIFIC REVOLUTION 405

← THE ROCOCO 407

THE FRENCH ROCOCO 407

The New Hôtels 407 Jean-Antoine Watteau 407 François Boucher 408 Jean-Honoré Fragonard 410 Marie-Louise-Elisabeth Vigée-Lebrun 410

Box Connections / Diderot as Art Critic 411

ENGLISH PAINTING 411

William Hogarth 411 Sir Joshua Reynolds 412 Thomas Gainsborough 413

LITERATURE 414

Samuel Johnson's "Club" 414 Alexander Pope 414 Jonathan Swift 414

VOLTAIRE'S PHILOSOPHY OF CYNICISM 415

← THE FRENCH REVOLUTION 416

THE NATIONAL ASSEMBLY 417

Then & Now / The Rights of Women 418 THE DEMISE OF THE MONARCHY 418 NAPOLEON BONAPARTE 419

♦ NEOCLASSICISM 419

PAINTING 420

Angelica Kauffmann 421 Benjamin West 422 John Singleton Copley 423

SCULPTURE 424

Jean-Antoine Houdon 424 The Statue of George Washington 424

ARCHITECTURE 425

Chiswick House 425 La Madeleine 425 Monticello 426

LITERATURE 427

The Novel 427 Jane Austen 427

CLASSICAL MUSIC 428

The Symphony 428 Franz Joseph Haydn 428 Wolfgang Amadeus Mozart 429

← Toward Romanticism 430

BEETHOVEN: FROM CLASSICAL TO ROMANTIC 430

Box Connections / Turkish Military Music and Viennese Composers 431

The Three Periods of Beethoven's Music 431 Symphony No. 5 in C Minor, Opus 67 431 GARDENS 432

CHAPTER 17

Romanticism and Realism 434

← ROMANTICISM 436

PAINTING 437

Francisco Goya 437 Théodore Géricault 439 Eugène Delacroix 441 Jean-Auguste-Dominique Ingres 442

Cross Currents / Delacroix and the Orientalist Sensibility 443

John Constable 443 J.M.W. Turner 444 Thomas Cole 445 Frederic Edwin Church 446

Box Then & Now / America's National Parks 447

SCULPTURE 447

GOTHIC REVIVAL ARCHITECTURE 448

PHILOSOPHY 449

Jean-Jacques Rousseau and the Concept of Self 449 Ralph Waldo Emerson and Transcendentalism 449 Henry David Thoreau 449

LITERATURE 450

William Blake 450 William Wordsworth and Samuel Taylor Coleridge 451 John Keats 451 Lord Byron 452 Emily Brontë 452 Johann Wolfgang von Goethe 452 Walt Whitman 453 Emily Dickinson 453

MUSIC 454

Program Music 454 Hector Berlioz 455 Franz Schubert and Johannes Brahms 455 Chopin and the Piano 455

Box Connections / Goethe and Schubert: Poetry and Song 456

> Giuseppe Verdi and Grand Opera 456 Richard Wagner 457

♦ REALISM 458

THE JULY MONARCHY 458

Delacroix's Liberty Leading the People 458

Honoré Daumier 460

KARL MARX AND FRIEDRICH ENGELS 460 THE PAINTERS OF MODERN LIFE 461 Rosa Bonheur 461 Gustave Courbet 462 Édouard Manet 463

THE RISE OF PHOTOGRAPHY 465

The Daguerreotype 465 Mathew B. Brady 466

Eadweard Muybridge 466

AMERICAN PAINTING 466

Winslow Homer 466 Thomas Eakins 468
ARCHITECTURE AND SCULPTURE 469

The Crystal Palace 469 The Statue of Liberty 469

Box Then & Now / Charles Darwin and the Kritzky Moth 470

LITERATURE 470

Honoré de Balzac 470 Charles Baudelaire 470 Gustave Flaubert 471 Émile Zola 471 Realist Writing 472

THE NEW SCIENCES: PASTEUR AND DARWIN 472

CHAPTER 18

The Belle Époque 474

♦ IMPRESSIONISM 476

HAUSSMANN'S PARIS 476 PAINTING 478 Claude Monet 480

Auguste Renoir 408 Berthe Morisot 480 Edgar Degas 481

Box Cross Currents / Japanese Prints and Western Painters 482

Mary Cassatt 482 James Abbott McNeill Whistler 483 LITERATURE 483

The Symbolists 483

Box Connections / Debussy and Mallarmé: Impressionist and Symbolist 484

Naturalism 484 MUSIC 485 Debussy's Musical Impressionism 485

← The Fin de Siècle 485

NEW SCIENCE AND NEW TECHNOLOGIES 486
The Theory of Relativity 487 The Atom 487
PHILOSOPHY AT THE TURN OF THE CENTURY 487
Friedrich Nietzsche 487 Sigmund Freud 487
POST-IMPRESSIONIST PAINTING 487
Paul Cézanne 487 Georges Seurat 489
Vincent van Gogh 490

Box Then & Now / Pointillism and Television 491

Paul Gauguin 491

NEW DIRECTIONS IN SCULPTURE AND

ARCHITECTURE 491

Auguste Rodin 491 American Architecture 492 Art Nouveau 493

← THE AVANT-GARDE 494

FAUVISM 495

Henri Matisse 495

CUBISM 497

Pablo Picasso 497 Georges Braque 499

FUTURISM 500

Gino Severini 501

GERMAN EXPRESSIONISM 501

Emil Nolde 501 Vassily Kandinsky 501

MUSIC 503

Igor Stravinsky 503 The Rite of Spring 503

CHAPTER 19

Chinese and Japanese Civilizations 504

CHINESE CULTURE AFTER THE THIRTEENTH CENTURY 506

LANDSCAPE PAINTING 506 Shen Zhou 506 Qiu Ying 507 ARCHITECTURE: CITY PLANNING 508

Box Then and Now / Hong Kong 510

LITERATURE 510

Traditional Poetry 510 Cao Xuequin's Dream of the Red Chamber 510 Modern Chinese Poetry 511 USIC 511

Chinese Theater Music 511 Beijing Opera 511

THE SHINTO REVIVAL 512 LANDSCAPE PAINTING 512 WOODBLOCK PRINTS 513

Utamaro Kitagawa 513 Hokusai Katsushika 514

ARCHITECTURE 514

The Temple of the Golden Pavilion (Kinkakuji) 514 Himeji Castle 515

THE JAPANESE GARDEN 515

LITERATURE 516

Saikaku Ihara 516

Box Cross Currents / East Meets West:

Takemitsu Toru 517

The Haiku 517 Basho 517 Matsuo 517

Modern Fiction 517

Box Connections / Bunraku: Japanese

Puppet Theater 518

THEATER 518

Noh 518 Kabuki 518

CONTEMPORARY MUSIC 519

Oe Hikari 519

CHAPTER 20

Russian Civilization 520

♦ Russia Before the Revolution 522

THE EASTERN ORTHODOX

CHURCH 522

Religious Icons 522 Virgin of Vladimir 523

ST. PETERSBURG 523

ARCHITECTURE 524

The Kremlin 524 The Cathedral of St. Basil 525

LITERATURE AND DRAMA 526

Fyodor Dostoyevsky 526 Leo Tolstoy 526

Anton Chekhov 527

MUSIC 527

Modest Mussorgsky 527 Peter Tchaikovsky 527

Box Cross Currents / The Ballets Russes 528

← THE REVOLUTION AND AFTER 528

REVOLUTIONARY ART 529

Kazimir Malevich 529 El Lissitzky 529

FILM 530

KHRUSHCHEV'S RUSSIA 531

Box Connections / Art as Politics 532

THE LITERATURE OF DISSENT 532

THE MUSIC OF DISSENT 533

CHAPTER 21

The Age of Anxiety 534

← THE GREAT WAR AND
AFTER 536

WORLD WAR I 536

THE DADA MOVEMENT 537

Marcel Duchamp 538 Kurt Schwitters 538

Piet Mondrian 539

THE SURREALISTS 540

Joan Miró 541 Salvador Dalí 542

ABSTRACTION IN SCULPTURE 542

Constantin Brancusi 542

Box Connections / Graham and Noguchi: The Sculpture of Dance 543

Henry Moore 543 Alexander Calder 544

Isamu Noguchi 545

AMERICAN MODERNISM 545

Alfred Stieglitz 545 Georgia O'Keeffe 546

Charles Demuth 547

MODERNIST LITERATURE 547

Ezra Pound and T.S. Eliot 547 James Joyce 548

Virginia Woolf 548 Ernest Hemingway 548

Box Then & Now / Robin Hood at the Movies 549

MODERN MUSIC 549

Arnold Schoenberg 550

REPRESSION AND DEPRESSION: THE THIRTIES 550

FASCISM IN EUROPE 550

Benito Mussolini 550 Adolf Hitler 551

Francisco Franco 552

FRANKLIN DELANO ROOSEVELT AND THE

NEW DEAL 553

PHOTOGRAPHY AND THE FSA 554

Dorothea Lange 554 Walker Evans 554

Margaret Bourke-White 555

REGIONALISM IN AMERICAN PAINTING 555

Edward Hopper 555 Thomas Hart Benton 556

Facob Lawrence 556

SOUTHERN REGIONALIST WRITING 557

William Faulkner 557 Flannery O'Connor 558

THE AMERICAN SOUND 558

Box Cross Currents / Diego Rivera and the Detroit Murals 559

Aaron Copland 559 George Gershwin 560

THE JAZZ AGE 560

Scott Joplin 560 Louis Armstrong 560 Duke Ellington 560

CHAPTER 22

Modern Africa and Latin America 562

♦ MODERN AFRICA 564

SCULPTURE 564

Pre-Colonial Sculpture in Benin 565

Colonial Sculpture 566

Box Connections / The Mask as Dance 567

Post-Colonial Sculpture 567

MUSIC 567

LITERATURE 568

Chinua Achebe 568 Wole Soyinka 568

Box Then & Now / Twins 569

MODERN LATIN AMERICA 569

PAINTING 569

Colonial Art 569 The Mexican Mural Movement 570 Frida Kahlo 571 Wilfredo Lam 572

Fernando Botero 572

MUSIC 572

LITERATURE 572

Jorge Luis Borges 573 Gabriel García Márquez 573 Isabel Allende 573

Box Cross Currents / Bach in Brazil 573

CHAPTER 23

The Age of Affluence 574

WORLD WAR II AND AFTER 576

> COLD WAR AND ECONOMIC RECOVERY 577

THE PHILOSOPHY OF EXISTENTIALISM 579

Jean-Paul Sartre 579 Simone de Beauvoir 580

ABSTRACTION IN AMERICAN ART 580

Jackson Pollock 581 Willem de Kooning 581

Mark Rothko 582 Willem de Kooning 581

Box Connections / Abstract Expressionism in Japan 583

Helen Frankenthaler 583
CONTEMPORARY ARCHITECTURE 584
Walter Gropius 584 Ludwig Mies van der
Robe 585 Le Corbusier 585 Frank Lloyd Wright 586
MODERN DRAMA 588

POP CULTURE 589

Box Then & Now / McDonald's 590

ARTISTS OF THE EVERYDAY 591
Robert Rauschenberg 591 Louise Nevelson 591
Andy Warhol 592 Roy Lichtenstein 593
Claes Oldenburg 593 The Happening 594
MINIMAL AND CONCEPTUAL ART 594

Box Connections / Rauschenberg, Cage, and Cunningham 595

Donald Judd 595 Sol LeWitt 595
Christo and Jeanne-Claude 596
THE ARCHITECTURE OF THE STRIP 597
Frank Gebry 597
LITERATURE: THE BEATS 598
Jack Kerouac 598 Allen Ginsberg 598
THE POPULARIZATION OF CLASSICAL MUSIC 598
The Boston Pops 598 Leonard Bernstein 598

CHAPTER 24

The Diversity of Contemporary Life 600

DIVERSITY IN THE UNITED STATES 602

Judy Chicago 603 Eleanor Antin 604 Cindy Sherman 604 Susan Rothenberg 604 Betye Saar 605 Jean-Michel Basquiat 605 Judith F. Baca 606 Lisa Fifield 607 Jaune Quick-to-See Smith 608 Maya Lin and the Vietnam Veterans' Memorial 608 THE DIVERSITY OF AMERICAN VOICES 609

THE DIVERSITY OF AMERICAN VOICES 609 Adrienne Rich 609

Box Cross Currents / The Cybernetic Sculpture of Wen-Ying Tsai 610

Maxine Hong Kingston 610 Toni Morrison 610 Sandra Cisneros 611 Judith Ortiz Cofer 611 Oscar Hijuelos 611 N. Scott Momaday 611 Leslie Marmon Silko 611

Box Then & Now / Navigating the Web 612

THE GLOBAL VILLAGE 612

MAGICIANS OF THE EARTH 612 THE EXAMPLE OF AUSTRALIAN ABORIGINAL PAINTING 612

GLOSSARY 616

PICTURE CREDITS AND FURTHER INFORMATION 626

LITERATURE CREDITS 627

INDEX 628

Preface

Arts and Culture provides an introduction to the world's major civilizations—to their artistic achievements, their history, and their cultures. Through an integrated approach to the humanities, Arts and Culture offers an opportunity to view works of art, listen to music, and read literature, in historical and cultural contexts.

The most accomplished works of painting, sculpture, and architecture, of music, literature, and philosophy are studied for what they reveal about human life. They open doors to the past, especially to the values and belief systems from which those artworks sprang. They also tell us about human attitudes and feelings, about ideas and ideals that continue to have value today.

Works of art from different cultures reveal common human experiences of birth and death, love and loss, pleasure and pain, hope and frustration, elation and despair. Study of the humanities—history, literature, philosophy, religion, and the arts—also reveals what others value and believe, inviting each of us to consider our personal, social, and cultural values in relation to those of others.

In studying the humanities, our attention is focused on works of art in the broadest sense, works that reflect and embody the central values and beliefs of particular cultures and specific historical moments. The following questions deserve consideration:

- 1. What kind of artwork is it? To what artistic category does it belong? What is its type? These questions lead to considerations of genre. A painting, for example, might be a portrait or a landscape, a religious icon or an abstract design. A musical work might be a song or a symphony, a chamber instrumental work, such as a string quartet, or a religious cantata.
- 2. Why was the artwork made? What was its function, purpose, or use? Who was responsible for producing it? Who paid for or commissioned it? These questions lead to considerations of context. Many works of art were commissioned by religious institutions and wealthy patrons. Many paintings and sculptures were commissioned by the Church and were intended to be both didactic and decorative. Many eighteenth and nineteenth century string quartets and piano trios were written for performance at the home of the patrons who paid composers to write them.
- 3. What does the work express or convey? What does it reveal about its creator? What does it reveal about its historical and social context? These questions lead to considerations of meaning. Some paintings and

sculptures are intended to record actual events or to encourage (or discourage) particular types of behaviour. A lyric poem written in ancient China or India may express feelings of sadness or longing, elation at seeing the beloved, grief over the death of a friend. Such poetic lyrics, whatever their age, language and country of origin, reveal not only the writer's feelings, but also cultural attitudes and social values.

4. How was the artwork made or constructed? This question leads to considerations of technique. Paintings made during the Middle Ages in Europe were likely to be done in egg tempera on a wooden panel. A painting from Renaissance Europe may be a fresco painted on the interior wall of a church or other building. A painting may also have been done in oil on canvas for framing and hanging in a private home. Or to take an example on a much larger scale, an Islamic mosque, a Catholic cathedral, a Greek or Japanese temple—all are constructed according to specified plans, their interior spaces designed to serve particular religious purposes.

Architectural structures such as these were also made of many types of materials and built using the technologies and tools available at the time of their construction. Developments in technology continually liberated the artistic imagination of painters, sculptors, architects, and composers, who were able to create, for example, new musical tones with the extension of the sonic range of instruments and with the invention of instruments such as the piano.

- 5. What are the parts or elements of a work of art? How are these parts related to create a unified artwork? These questions lead to considerations of formal analysis, understanding the ways the artwork coheres as a whole. Painters, sculptors, and architects work with line, form, color, composition, texture, and other aesthetic elements. In the same way, a Gregorian chant, like a Blues song or a German Lied or artsong, reveals a particular structural pattern or organizational design. So does an Elizabethan sonnet, a Japanese haiku, an Arabic qasida, and a Greek epic. Analysis of the form of artworks leads to an appreciation of their artistic integrity and their meaning.
- 6. What social, cultural, and moral values does the work express, reflect, or embody? Works of art bear the social, moral, and cultural values of their creators. They also reflect the times and circumstances of their creation—cven when the individual artist, composer, or writer worked against the cultural ethos of the times. We

study works of art to understand the human values they embody for artworks give us insight into human experience. Unlike scientific works or creations—whether formulas, such as Newton's formula for gravitational attraction or Einstein's E=mc²—which are predictive and practical, works of art produce a creative discovery or enlightenment in viewers and readers. They appeal to the human capacity for feeling and thought through the imagination. In contrast to science, which seeks to explain what exists, art seeks to create something new—but something that bears a distinct relationship to what exists.

Balancing the social, cultural, and historical realities that works of art reflect are their uniquely personal visions of experience. Works of art are experiments in living. Through them readers and viewers can experience other imaginative perspectives, share other visions of human life. Works of art provide an imaginative extension of life's possibilities for those who remain open to their unique forms of creative expression.

MAKING CONNECTIONS

A study of the humanities involves more than an examination of the artistic monuments of civilizations past and present. More importantly, it involves a consideration of how forms of human achievement in many times and places echo and reinforce, alter and modify each other. An important aspect of humanities study involves seeing connections among the arts of a given culture and discovering relationships between the arts of different cultures.

Three forms of connection are of particular importance: (1) *interdisciplinary connections* among artworks of an individual culture;

- (2) cross currents among artworks of different cultures;
- (3) transhistorical links between past and present, then and now.

These forms of connection invite readers and viewers to locate relationships among various humanities disciplines and to identify links between and among the achievements of diverse cultures. Discovering such connections can be intellectually stimulating and emotionally stirring since the forms of human experience reflected and embodied in the works of art of many cultures resonate with common human concerns. These artworks address and answer social questions about who we are, philosophical questions about why we exist at all, and religious questions concerning what awaits us after death. These and numerous other perennial questions and the varying perspectives taken on them have been central to every culture, and find expression in their arts. Consider the following examples.

Interdisciplinary CONNECTIONS

One type of interdisciplinary connection appears in the ways the music and architecture of Renaissance Florence were influenced by mathematical proportion and ancient notions of "harmony." Mathematics played a crucial role in all the arts of the Renaissance. Architects were guided in the design of their buildings by mathematical ratios and proportions; composers likewise wrote music that reflected mathematical ratios in both its melody and harmony.

Other kinds of interdisciplinary connections are evident in the collaboration of artists, choreographers, and composers in creating producing and ballets, such as those performed by the Ballets Russes in the early twentieth century. Still other interdisciplinary connections appear in literature and music in the poems of Johan Wolfgang von Goethe that Franz Schubert set to music.

Cultural CROSS CURRENTS

Cultural cross currents reflect the ways artistic ideals, literary movements, and historical events influence the arts of other cultures. Turkish military music, for example, found its way into the symphonies and piano compositions of Viennese composers, such as Mozart and Beethoven. Japanese woodblock prints influenced the art of the Impressionist painter Claude Monet and the Post-Impressionist painter Vincent van Gogh. And the dynamic cybernetic sculpture of contemporary artist Wen-Ying Tsai weds western technology with ancient Chinese aesthetic principles.

Transhistorical Connections—THEN & NOW

Arts and Culture also considers connections between the past and present. A series of THEN & NOW boxes offers discussions of a wide range of subjects that form various types of historical bridges. Discussions range from such subjects as cities, ghettos, and legal codes to movies and monuments, revealing parallels and links between the old and the new in art and architecture, literature and music, philosophy and film.

BALANCING THE WORK AND ITS WORLD

Study of the humanities provides a balance between appreciating masterful individual works of art in themselves and understanding their social and historical contexts. Arts and Culture highlights the individual artistic qualities of numerous works—paintings, sculptures, architectural monuments, buildings, and other visual images, such as photographs; poems, plays, novels, and essays; songs, symphonies, and other musical compositions; philosophical and religious systems of belief—always in light of the cultural worlds in which they were created. Each work's significance is discussed in conjunction with the social attitudes and cultural values it embodies, without losing sight of its individual expression and artistic achievement.

This balancing act appears throughout the book, though it sometimes leans more in one direction than the other. In discussing ancient Chinese and Japanese sculpture and architecture, for example, explanations of the Buddhist religious ideals they reflect are accompanied by considerations of their artistic forms. In discussing Renaissance literature the focus sometimes shifts between the artistic individuality of the works examined—as with Shakespeare's *Hamlet*—and particular cultural values the works embody.

The cultural traditions included in *Arts and Culture* reflect a broad rather than a narrow understanding of the term "culture," a humanistic approach to culture rather than an anthropological or sociological study. The idea of culture presented in this book reflects the complex of distinctive attainments, beliefs, and traditions of a civilization. This sense of culture is embodied in works of art and in historical forces that reveal the social, intellectual and artistic aspects of the civilizations that produced them.

Two important questions underlie the choice of works included in *Arts and Culture*: (1) What makes a work a masterpiece of its type? (2) What qualities of a work of art enable it to be appreciated over time? These questions imply that some works of art are better, more perfect embodiments of their genre, or type, than others. The implication is also that masterpieces are worthy of more attention, more studied effort, more reflective consideration than other "lesser" works.

One of the most interesting of all questions in the humanities concerns the way in which particular works become cultural icons, enabling them to represent the cultures out of which they arose. How does the Parthenon represent Greek cultural and artistic ideals? How did Beethoven's Symphony No. 5 come to stand for the very idea of a symphony? Why does the Eiffel Tower symbolize France?

Certain works richly embody the spirit of a particular culture and yet can simulaneously transcend that culture to reflect broader universal values. It is a stunning paradox that those works that do come to speak beyond the confines of the times and places that produced them are often rooted in the local and the particular. The short stories in James Joyce's book *Dubliners*, for example, describe the lives of middle-class Irish people as they lived in early twentieth-century Dublin. Yet Joyce's stories speak to people beyond Dublin, and even beyond Europe, across time and cultures to a set of shared human concerns.

Arts and Culture includes a wide-ranging representation of the world's civilizations. In addition to Western culture, the civilizations of Africa, China, India, Japan, Latin America, and Mesoamerica are examined, along with a special chapter devoted exclusively to Russian civilization. Significant attention is accorded the contributions of women, from the eleventh-century writings of the Japanese Murasaki Shikibu, the twelfth-century

music of Germany's Hildegard of Bingen, and the fourteenth-century writings of the Italian Christine de Pizan, to the Rococo art of the French Marie-Louise-Elisabeth Vigée-Le Brun, the Romantic music of Clara Schumann, and the numerous women writers, painters, architects, sculptors, and photographers of the nineteenth and twentieth centuries, European and American.

The final chapter of *Arts and Culture* brings together a broad spectrum of styles, voices, and perspectives, which, though focusing on contemporary multicultural America, reflects trends and influences from around the globe. A number of current issues in the arts are raised, including what constitutes worthwhile contemporary art, which works will endure, and how technology has globalized the arts today. The numerous and varied contributions of artists and writers include works by Native-American painters such as Lisa Fifield and Jaune Quick-to-See Smith, Latina/Latino writers such as Sandra Cisneros and Oscar Hijuelos, and Australian Aborigine artists.

Throughout the book as a whole, the authors have tried to present the arts and cultures of the world to suggest their richness, variety, and humanity. Readers of Arts and Culture can find in these pages the background necessary to understand not only the artistic achievements of many civilizations but also the representation of human experience in all its complexity. In a time of rapid social change when the world's cultures are becoming increasingly globalized, it has become necessary to understand the values of human beings around the world. The common humanity we share has been recorded, inscribed, and celebrated in arts and achievements of all cultures. Our survival and our happiness as human beings about to enter a new millennium warrants nothing less than understanding our human heritage as revealed in the art and cultural achievements that Arts and Culture brings together.

 Λ complete package of supplementary material accompanies ${\it Arts}$ and ${\it Culture}.$

- Student Study Guide—designed to make students' lives easier. It is carefully coordinated with the text and is thoughtfully presented to help students work their way through unfamiliar material.
- Music Compact Disk—a collection of music that contains important works discussed in the text.
- Instructors' Manual—provides chapter summaries, further topics for discussion, other activities, and a test bank. These are all carefully organized to make preparation, classroom instruction, and student testing smoother and more effective.
- Faculty Slide Set—for qualified adoptions an accompanying set of slides is available free to instructors. Contact

your local Prentice Hall representative for information on ordering this supplement.

 Prentice Hall Custom Test—this computerized text item file allows you to create your own personalized exams using your own computer. Available for DOS, Windows, and Macintosh.

And finally a comprehensive website (http://www.prenhall.com/benton) has been developed to integrate many of the study guide features with many of the existing links to the arts currently found on the Internet.

Art and Humanities on the World Wide Web is a comprehensive website designed to augment Arts and Culture. The website is designed for professors and students teaching and studying the humanities. By utilizing the technology of "hypertext," the web allows users access to a vast array of historical, cultural, and general interest sites organized around and correlated to chapters and content found in the text.

NEW-Prentice Hall Humanities CD-ROM presents fourteen segments that bring to life basic terms and ideas from two-dimensional and three-dimensional visual art, architecture, music, theatre, dance and literature. These two- to seven-minute video and audio presentations, connected by narrative, demonstrate how paintings and drawings achieve deep space, how sculpture is carved and modeled, how modern dance and ballet turn motion into art, how a theatre director works, and how a theatre building is used in production. In addition, a tour of an orchestra demonstrates the basic musical instrument groups, a series of vignettes brings various musical forms to life, and the concept of rhythm in dance and music is explored. A tour of the Parthenon illustrates classical architecture, Romanesque and Gothic styles emerge in examinations of medieval churches, and Frank Lloyd Wright's Taliesin West highlights modern style.

ACKNOWLEDGMENTS

Arts and Culture represents the cooperative efforts of many people. The book originated with a suggestion ten years ago by Tony English, then of Macmillan Publishing. Work on the project began with Tony and his Macmillan colleagues and continued with Prentice Hall when Macmillan was acquired by Simon & Schuster in 1993.

At Prentice Hall we have had the good fortune to work with Bud Therien, Publisher, who oversaw the book's development in every respect, and Clare Payton, Development Editor, whose guidance and critical eye shaped the book. Important contributions were made by Bud and Clare and by their colleagues Susanna Lesan, Editor-in-Chief of Development; Charlyce Jones Owen, Editorial Director; Sheryl Adams, Marketing Manager;

Leslie Osher, Creative Director; Joe Scordato, Production Liaison; and Gianna Caradonna, Editorial Assistant. These and other Prentice Hall staff, including the President of the Humanities and Social Sciences division, Phil Miller, offered wise counsel and made numerous helpful suggestions. The intelligence and enthusiasm Phil and his colleagues brought to their work have helped make *Arts and Culture* the book it is.

We have been fortunate as well that Calmann & King Ltd effectively handled the book's production. We have enjoyed working with Robert Shore, Editor, who not only supervised the production of *Arts and Culture*, but who also assumed responsibility for the development of Vol. I midway through the process.

Also deserving of particular mention are Sylvia Moore for her contribution to the introductory materials and Jenny Moss for her hard work on the timelines and glossary, Ailsa Heritage and Andrea Fairbrass for their imaginative work on the maps, and Simon Cowell and Pamela Ellis for their copyediting and proofreading skills.

We owe a special debt of gratitude to Henry Sayre, without whom we simply could not have completed *Arts and Culture* on schedule. Professor Sayre helped us shape the drafts of our chapters, melding our styles and recommending organizational changes that have resulted, we believe, in an integrated and compelling overview of the humanities. His engaging contributions to the historical narrative that informs the book have been of inestimable value to the project.

From readers of various drafts of Arts and Culture we received thoughtful criticism along with helpful suggestions for improvement. We would like to thank the following reviewers for their insight and advice: Martha G. Anderson, Alfred University; William Cloonan, Florida State University; Roger Crum, University of Dayton; Jane Anderson Jones, Manatee Community College; Kimberley Jones, Seminole Community College; Elizabeth Jordan, University of California, San Diego; Leslie Lambert, Sante Fe Community College; Virginia Pond, Catonsville Community College; Sylvia White, Florida Community College at Jacksonville; and Judith B. Wise, Clark State Community College.

We would also like to thank each other for offering mutual support, encouragement, advice, and help throughout a long and sometimes arduous process of writing, revising, and editing. Our families, too deserve our thanks, for without their patience and understanding we could not have completed our work with equanimity and good humor. In particular, the encouragement and loving support of our spouses, Elliot Benton and Mary DiYanni, enabled us to do our work on *Arts and Culture* with a minimum of anxiety and a maximum of pleasure.

I-ntroduction

Arts and Culture is an introduction to the humanities and the arts, from the earliest times to the present day. The goal of the book is to familiarize readers with a fundamental body of art, history, and ideas that are a basis for understanding both Western and non-Western cultures. In demonstrating the interrelationships, obvious or subtle, between the creators of art and the historical and social forces at work in a given culture at any particular time, the text seeks to foster an understanding of the creative process and the uses of the arts.

One challenge for the reader lies in appreciating the sheer array of human creativity on display across a wide spectrum of arts and cultures. Though *Arts and Culture* focuses on Western civilization, from its ancient roots to the present, it does not limit itself to the West. Rather, Western European culture is presented within a multicultural global framework, represented by chapters on non-European cultures and cross-cultural features within the Western chapters.

An additional challenge for the reader is to become familiar with the vocabularies and concepts of the arts and humanities. An understanding of a wide range of artistic terms and concepts is necessary to appreciate artistic achievements. It is also essential for being able to discuss the arts knowledgeably and for the expansion of personal taste.

THE HUMANITIES AND THE ARTS

The humanities are those areas of thought and creation whose subject is human experience. They include history, philosophy, religion, and the arts. Broadly speaking, the arts are artificial objects or experiences created by human beings. Although the term "artificial" often has a negative connotation, when used to mean "phony" or "fake," it is used here in its original sense, meaning "not from nature," that is, something made by humans. The word "art" comes from the same root. The role of the human creator, therefore, is central to any study of the arts since, ultimately, the arts and humanities are a record of human experience and concerns. The arts convey information—a lyric poem can describe a summer's day, for example—yet this is not their primary function. More importantly, the arts give form to what is imagined, express human subjective beliefs and emotions, create beauty, celebrate sensual pleasure, and entertain their audiences.

The arts include visual art and architecture, drama, music, and literature, and photography and film. Seeing the arts within their historical and social context

is necessary for understanding their development. For example, the figure of the biblical giant-killer, David, was popular during the Renaissance in the Italian city-state of Florence. Michelangelo's *David* was commissioned by the Florentine city officials (fig. 0.1; see also fig. 13.32). Florence had recently fought off an attempt at annexation by the much larger city-state of Milan. Thus, the biblical David slaying the giant, Goliath, became a symbol of Florentine cleverness and courage in defense of independence. It is a theme particular to its time and place, yet one that has been used throughout history to express the success of the "little" person against powerful exploiters.

ART AND ARTISTS OVER TIME

We study what survives, which is not necessarily all that once existed. Not all arts survive the passage of time. Art can be divided into the durable and the ephemeral, or short-lived. Surviving objects tend to be large (the

Figure 0.1 Michelangelo, *David* (detail), 1501–04, marble, height 13'5" (4.09 m), Galleria dell'Accademia, Florence.

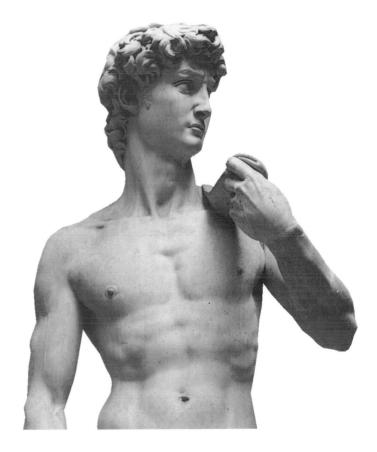

Pyramids) or hidden (the contents of tombs). Until human beings created the means of capturing moving images and sounds, the ephemeral arts such as music and dance could be described but not reexperienced. Therefore, some of the oldest arts—music and dance of the ancient world, for example—are lost. With the development of writing, humans began the long process of liberating themselves from the tyranny of time. They began to communicate across space and time, leaving a record of their lives. In our own century, we have seen our recording abilities explode from sound recording and silent movies at the turn of the century into the digitized world of the CD-ROM and the Internet today. The result has been an unprecedented expansion in the humanities.

THE ROLE OF THE ARTIST

The functions of the artist and the artwork have varied widely during the past five thousand years. To understand these functions it may be necessary to set aside some modern assumptions about art and artists. In our time, the artist is seen as an independent worker, dedicated to the expression of a unique subjective experience. Often the artist's role is that of the outsider, a critical or rebellious figure. He or she is a specialist who has usually undergone advanced training in a university department of art or theater, or a school with a particular focus, such as a music conservatory. In our societies, works of art are presented in specialized settings: theaters, concert halls, performance spaces, galleries, and museums. There is usually a sharp division between the artist and her or his audience of non-artists. We also associate works of art with money: art auctions in which paintings sell for millions of dollars, ticket sales to the ballet, or fundraising for the local symphony.

In other societies and in parts of our own society, now and in the past, the arts are closer to the lives of ordinary people. For the majority of their history, artists have expressed the dominant beliefs of a culture, rather than rebelling against them. In place of our emphasis on the development of a personal or original style, artists were trained to conform to the conventions of their art form. Nor have artists always been specialists; in some societies and periods, all members of a society participated in art. The modern Western economic mode, which treats art as a commodity for sale, is not universal. In societies such as that of the Navajo, the concept of selling or creating a salable version of a sand painting would be completely incomprehensible. Selling Navajo sand paintings created as part of a ritual would profane a sacred experience.

Artists' identities are rarely known before the Renaissance, with the exception of the period of Classical Greece, when artists were highly regarded for their individual talents and styles. Among artists who were known, there were fewer women than men. In the twentieth century, many female artists in all the disciplines have been recognized. Their absence in prior centuries does not indicate lack of talent, but reflects lack of opportunity. The necessary social, educational, and economic conditions to create art rarely existed for women in the past.

Artists of color have also been recognized in the West only recently. The reasons for this absence range from the simple—there were few Asians in America and Europe prior to the middle of the nineteenth century—to the complexities surrounding the African diaspora. The art of indigenous peoples, while far older than that of the West, did not share the same expressive methods or aims as Western art. Until recently, such art was ignored or dismissed in Western society by the dominant cultural gatekeepers.

ART AND RITUAL

Throughout much of the history of the Western humanities, the arts have had a public function as religious or social ritual in which beauty and representation were secondary. The ritual function of art survives in the liturgical music, dance, and art of all cultures. Socially, the arts often serve to reinforce, demonstrate, or celebrate the dominant values of a society. In our own time, the arts may reflect the preferences of a large group of people—popular music and action movies, for example—or a small but influential elite—the audience for opera, or avant-garde theater, for instance.

Critical Thinking and Evaluation of the **A**rts

Because of their manifold functions, the arts are understood through the use of different human faculties. We know them by our senses. We can apply our intellects to analyze and describe what we see and experience. We also respond to the arts subjectively, through nonrational means such as intuition, subjective interpretation, and emotional response. Our understanding of the arts depends in part on our knowledge of the historical and social context surrounding a work. For instance, for whom was a particular work intended—a private or a public audience? What was or is its setting—public, private, accessible, or hidden? How is the work related to the economic workings of its time: for example, was it commissioned by a ruler, a religious organization, a group of guildspeople, a corporation? Was it created by

nuns or monks, by peasants, or by specially trained craftspersons? Each of these considerations expands our understanding of a given work, even when we cannot know all the answers.

The branch of philosophy devoted to thinking about the arts is called "aesthetics." Aesthetic knowledge is both intuitive and intellectual; that is, we can grasp a work of art on an emotional level while at the same time analyzing it. There is no single, unquestionable body of aesthetic knowledge, although philosophers have tried to create universal systems. Each culture has its own aesthetic preferences. In addition, different disciplines and different styles within a culture reflect different aesthetic values. Today, for example, rap music coexists with country, jazz, classical, and other types of music.

Each of us is, at one time or another, a critic of the arts. For example, deciding what movie to attend, what book to read, or what recording to purchase are all critical acts, based on personal taste and judgment. Criticism in the arts takes this natural human trait and refines it.

FORM AND CONTENT DISTINCTIONS

When discussing works of art, it is useful to distinguish between the form of the artwork and its content. The form of a work of art is its structural or organizing principle—the shape of its content. A work's content is what it is about—its subject matter. At its most basic, formal analysis provides a description of the apparent properties of an artwork. Artists use these properties to engineer our perception and response. In music, for example, a formal analysis would discuss the melody, the harmony, and the structure. In visual art, comparable elements would be line, color, and composition. The goal of formal analysis is to understand how an artwork's form expresses its content.

Contextual approaches to the arts seek to situate artworks within the circumstances of their creation. Historians of the arts conduct research aimed at recreating the context of a given work. Armed with this information, the historian interprets the work in light of that context. Knowing, for example, that Guernica (fig. 0.2; see also fig. 21.20), Pablo Picasso's anti-war painting, depicts an aerial bombing of a small village of unarmed civilians in the Spanish Civil War, drives its brutal images of pain and death home to viewers. Picasso chose black, white, and grey for this painting because he learned of the attack through the black and white photojournalism of the newspapers. Knowing the reason for this choice, which may otherwise have seemed arbitrary to modern viewers of the work, adds to the meaning of the image. Picasso's choice of black and white also intensifies the horrors he depicts.

Figure 0.2 Pablo Picasso, *Guernica*, 1937, oil on canvas, $11'5\frac{1}{2}'' \times 25'5\frac{1}{2}''$ (3.49 × 7.75 m), Centro de Arte Reina Sofia, Madrid.

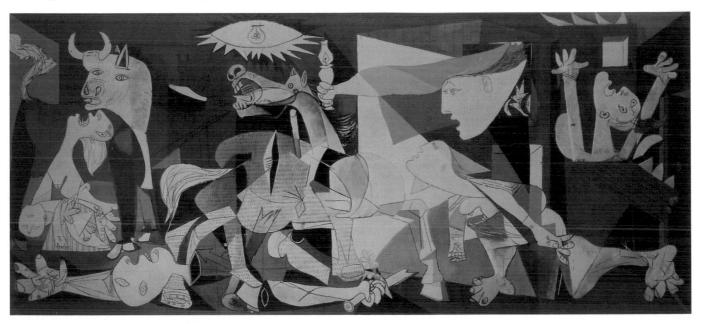

Starter Kit

This Starter Kit provides you with a brief reference guide to key terms and concepts for studying the humanities. The following section will give you a basis for analyzing, understanding, and describing art forms.

Commonalities. We refer to the different branches of humanities—art and architecture, music, literature, philosophy, history—as the **disciplines**. The humanistic disciplines and the arts have many key terms in common. However, each discipline has defining characteristics, a distinct vocabulary, and its own conventions, so that the same word may mean different things in different disciplines.

Every work of art has two core components: form and content. **Form** refers to the arrangement, pattern, or structure of a work, how a work is presented to our senses. **Content** is what a work is about, its meaning or substance. The form might be an Impressionist painting; the content might be the beauty of nature in a particular place. To comprehend how the form expresses the content is one of the keys to understanding a work of art.

The term **artist** is used for the producer of artworks in any discipline. All artworks have a **composition**, the arrangement of its constituent parts. **Technique** refers to the process or method that produced the art. The **medium** is the physical material that makes up the work, such as oil paint on canvas. **Crafts** refers to the technical skill of the artist, which is apparent in the execution of the work.

Style. We use the term style to mean several different things. Most simply, style refers to the manner in which something is done. Many elements form a style. Artists working at the same time and place are often trained in the same style. In a text, historical styles are usually capitalized, as in Classical Greek art, referring to the arts of that particular time and place, which shared distinct characteristics. If used with lowercase letters, such as classical style, the term refers to works which, although not from Classical Greece, are similar in character to Classical Greek art, or to Roman art, which was largely derived from Greek forms.

Conventions are accepted practices, such as the use of a frontal eye in a profile face, found in the art of the ancient Egyptians, or the use of the sonnet form by Shakespeare and his contemporaries.

Functions and Genres. In general, the functions of the arts can be divided into religious and secular art. Religious or liturgical art, music, or drama is used as part of the ritual of a given religion. Art that is not religious art is termed secular art. Secular art is primarily used for entertainment purposes, but among other functions has been its use in the service of pol-

itical or propaganda ends, as films were used in Nazi Germany.

Each discipline has subsets, called **genres**. In music, for example, we have the symphony, a large, complex work for orchestra, in contrast to a quartet, written for only four instruments. In literature we might contrast the novel, with its extended narrative and complexities of character, with the compression of a short story. From the seventeenth to the nineteenth centuries, certain subjects were assigned higher or lower rank by the academies that controlled the arts in most European countries. Portrait painting, for example, was considered lower than history painting. That practice has been abandoned; today the genres are usually accorded equal respect and valued for their distinctive qualities.

THE VISUAL ARTS

The visual arts are first experienced by sight, yet they often evoke other senses such as touch or smell. Because human beings are such visual creatures, our world is saturated with visual art, in advertising, on objects from CD covers to billboards, on TV and the Internet. The visual arts occur in many varieties of two-dimensional and three-dimensional forms, from painting, printmaking, and photography, to sculpture and architecture.

As is the case with other arts, the origins of the visual arts are now lost. However, their development represents a milestone in human civilization. Drawing, the representation of three-dimensional forms (real or imagined) on a two-dimensional surface, is an inherent human ability, and failure to draw by a certain stage in a child's growth is a sign of serious trouble. Attaining the ability to draw is an important cognitive development in both babies and human history. The creation and manipulation of images was and is a first step toward mastery of the physical world itself.

The visual arts serve a variety of purposes, using different methods. **Representation** is an ancient function of visual art, in which a likeness of an object or life form is produced. There are many different conventions of representation, which have to be learned by artist and viewer alike. One important convention is **perspective**, which gives the illusion of depth and distance. Systems of perspective were perfected by artists and theorists of the Renaissance period. In **abstract** art, the artist may extract some element from the actual appearance of an object and use it for its expressive or symbolic properties. For example, an artist may use red and orange tones on a canvas to suggest a brilliant poppy. **Nonobjective** art is entirely free from representation; a nonobjective sculpture may be a group of geometric shapes welded

Visual Arts

Line: A mark on a surface. Lines may be continuous or broken. They are used to create patterns and textures, to imply three dimensions, and to direct visual movement.

Shape: An area with identifiable boundaries. Shapes may be **organic**, based on natural forms and thus rounded or irregular, or they may be **geometric**, based on measured forms.

Mass: The solid parts of a three-dimensional object. An area of space devoid of mass is called **negative space**; while **positive space** is an area occupied by mass.

Form: The shape and structure of something. In discussions of art, form refers to visual aspects such as line, shape, color, texture, and composition.

Color: The sensation produced by various wavelengths of light. Also called **hue**. Red, blue, and yellow are the **primary colors**, which cannot be made from mixing other colors. **Secondary colors** (orange, green, and purple) are hues produced by mixing two primary colors.

Value: The lightness or darkness of an area of color, or as measured between black and white. The lighter, the higher in value it is; the darker, the lower in value.

Texture: The appearance or feel of a surface, basically smooth or rough. Texture may be actual, as the surface of a polished steel sculpture, or implied, as in a painting of human flesh or the fur of an animal.

Composition: The arrangement of the formal components of a work, most frequently used to describe the organization of elements in a drawing or painting.

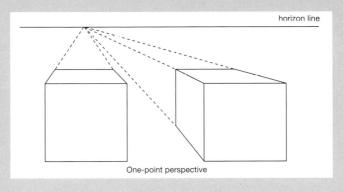

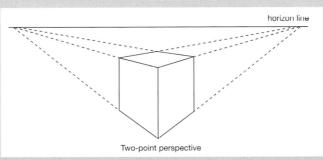

Perspective: A system of portraying three-dimensional space on a two-dimensional surface. In **one-point** linear perspective, lines recede toward a single **vanishing point** on the horizon line. In **two-point** perspective there are two vanishing points. **Atmospheric** or **aerial** perspective uses properties of light and air, in which objects become less distinct and cooler in color as they recede into distance.

together. Abstract and nonobjective art, arising in the twentieth century, are more concerned with the elements on the **picture plane** (the paper or canvas) rather than depth of **pictorial space**. Visual art also often has a purely decorative or ornamental purpose, used to create visual pleasure or to add visual interest to a functional item, as in wallpaper, fabric, or furniture design.

Formal Analysis. To analyze a work of visual art formally, its visual elements are considered without reference to the content, whereas moving to more sophisticated levels involves the content as well. At its simplest, the content is what is represented, the subject matter, whether a person, an orange, or a flag. However, the image may not stop with the representation; there may be a symbolic element. It is useful to distinguish between signs and symbols. Signs convey visual information economically by means of images or words. Symbols are images that have resonance, or additional meaning. Works of visual art may use both signs and symbols.

Artists use symbolic systems, part of the visual language of their time. Like all languages, these must be learned. Sometimes artists create their own symbols.

The **iconography** of a work of art, that is, the meaning assigned to the symbols, is often religious in nature. For example, different representations of Jesus derive from incidents in his life. To understand the deeper levels of the work, it is necessary to understand the language of the iconography. The use of personal iconography by an artist is a relatively recent development of the past few centuries.

The following analysis of *The Scream* by Edvard Munch (fig. 0.3) will serve as an example of this process. Viewed formally, the major visual elements used by Munch in this painting are line and color. There are two kinds of lines: the geometric lines that form the sharply receding bridge contrast with the swirling organic lines of the main figure and the landscape, sea, and sky. There is little or no modelling or shading. The colors contrast bright red and yellow with rich blue, offset by neutral

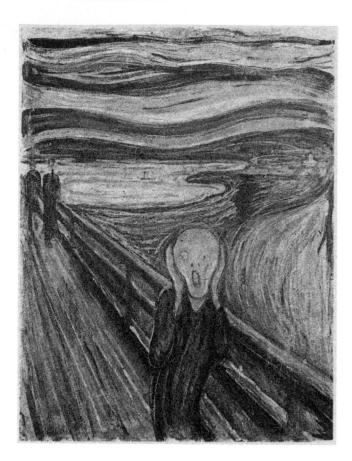

Figure 0.3 Edvard Munch, *The Scream*, 1893, tempera and casein on cardboard, 36×29 " (91.3 \times 73.7 cm), Nasjonalgalleriet, Oslo.

tones. *The Scream* is a painting executed on cardboard with rapid, loose brushstrokes. The composition is dynamic; the artist has used exaggerated diagonals to suggest a dramatic perspective for the bridge. The figure at the front is the focal point. The craft is secondary to the expressive purpose of the work.

It should be obvious that in *The Scream* more is going on than the preceding analysis indicates. Three people are on a bridge at sunset. Two are walking away; one stands transfixed with his hands over his ears. The expression on his face functions as a sign to convey shock or horror. To understand the significance of his expression, we turn to the historical context and the artist's life. Munch, a Norwegian artist who worked in the late nineteenth and early twentieth centuries, was one of the artists who rejected conventions and created personal symbolic systems, based largely on his experience. The Scream is usually interpreted as representing a screaming person. This is not correct. As we know from the artist's diary, the work refers to the "scream of nature." The image captured is a powerful evocation of a sensitive man overwhelmed by nature's power, which his companions cannot sense. The swirling lines suggest the impact of screaming nature on this person. The blood-red sky

resonates as a symbol of savage nature oblivious to the puny humans below.

Components of the Visual Arts. The basic elements used to construct a work of visual art are line, shape, mass—a shape in three dimensions—color and value, real or implied texture, and composition, the arrangement of all the elements. While many drawings are executed in black mediums, such as pencil and charcoal, on a white ground, color is a vital ingredient of art, especially important in conveying information as well as emotion to the viewer. Color affects us both physically and psychologically and has significance to us both in our personal lives and in our cultural traditions.

There can be no color without light. In the seventeenth century, Sir Isaac Newton observed that sunlight passing through a glass prism broke up, or refracted the light into rainbow colors. Our perception of color depends upon reflected light rays of various wavelengths. Theorists have arranged colors on a color wheel (fig. 0.4) that is well-known to students of painting and even young schoolchildren. On it are the primary colors—red, yellow, and blue—and secondary colors—orange, green, and purple. Some wheels show tertiary colors such as yellow-green and red-purple. The primary colors cannot be created by mixing other colors, but secondary and tertiary colors are made, respectively. by mixing two primaries, or primaries and secondaries, together. Complementary colors are placed opposite each other on the wheel, so that red is opposite from green, orange from blue, and yellow from purple. Many artists have studied and worked with the optical effects

Figure 0.4 Color wheel.

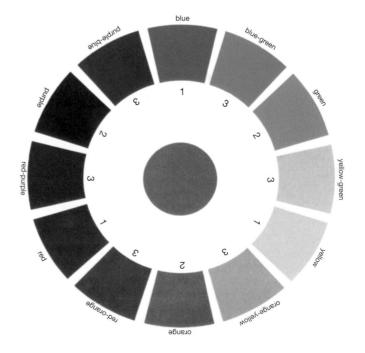

A*rchitecture

Architect: One who designs and supervises the construction of buildings. Ideally, the architect is part builder with a sound knowledge of engineering principles, materials, structural systems, and other such practical necessities, as well as part artist who works with form, space, scale, light, and other aesthetic properties.

Scale: The relative size of one thing compared to another. The relationship of a building to another element, often the height of a human being.

Site: The location of an object or building. Care must be taken to choose a solid, attractive, and appropriate building site.

Structural System: The engineering principles used to create a structure. Two basic kinds of structural system are the **shell** system, where one or more building materials such as stone or brick provide both support and covering, and the **skeleton and skin** system, as in modern skyscrapers with steel skeletons and glass skin.

Column: a supporting pillar consisting of a base, a cylindrical shaft, and a decorative capital at the top. Three Classical orders, established in ancient Greece, are the **Doric, Ionic,** or **Corinthian,** identified by the capital.

Post and Lintel: A basic structural system dating from ancient times that uses paired vertical elements (posts) to support a horizontal element (lintel).

Arch, dome, and vault: An arch consists of a series of wedged-shaped stones, called voussoirs, locked in place by a keystone at the top center. In principle, an arch rotated 180 degrees creates a dome. A series of arches forms a barrel or tunnel vault. When two such vaults are constructed so that they intersect at right angles, a cross or groin vault is created. Roman and Romanesque masons used semi-circular arches, whereas Gothic masons built with pointed arches to create vaults that were reinforced with ribs, permitting large openings in the walls. The true arch, dome, and vault are dynamic systems—the lateral thrust that they exert must be buttressed externally to prevent collapse.

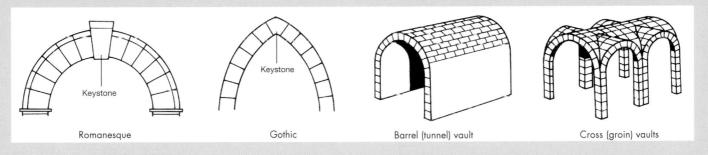

of color, especially the French Impressionist Claude Monet and the Post-Impressionist Georges Seurat.

Architecture. Architecture is a branch of the visual arts that combines practical function and artistic expression. The function served by a building usually determines its form. In addition to the purely useful purpose of providing shelter, architecture answers prevailing social needs. The use of architects to design and erect public and religious structures has given rise to many innovative forms throughout history. Architecture reflects the society in which it is built as it controls the actions of those who use it. Structural systems depend upon the available building materials, technological advancements, the intended function of the building, and aesthetics of the culture. The relationship between a building and its site, or location, is integral to architecture. The Greek Parthenon (fig. 0.5), for example, crowns a hill overlooking Athens. The elevated location indicates its importance, and the pathway one must ascend to reach the Parthenon is part of the experience.

Figure 0.5 Ictinus and Callicrates, Parthenon, Acropolis, Athens, 448–432 B.C.

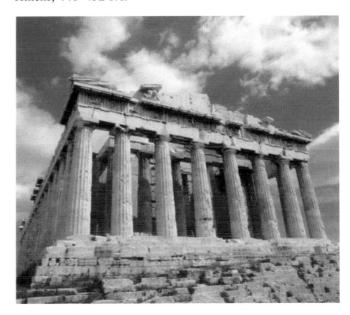

LITERATURE

Speech, Writing, and Literature. Literature differs from the visual arts since it is not built from physical elements, such as paint and stone; nor is it composed of sound as is music, but from words, the basic elements of language. Paint and sound have no intrinsic meaning; words do. Speech depends on meaningful units of sound—words, which are the building blocks of communication in language. Literature presupposes language, with its multitudes of meaning (content), its grammar (rules for construction), and its syntax, the arrangement of words.

Language, essentially communicative, has many functions. We use language to make emotional contact with others: for example, a parent using baby talk to a child too young to understand the meaning of words. Through language we convey information to each other, as in the classroom, where a dialogue between teacher and student is part of the educational process. All literature is language, but not all language is literature. Distinguishing between literature and other forms of language is sometimes difficult, but refinement in language and careful structuring or ordering typically characterizes literature.

Literature, in the broadest sense, is widely apparent in everyday life. Popular songs, magazine essays, greeting card verse, hymns and prayers are all forms of literature. One meaning of the word *literature*, in fact, is what is written. Generally, however, the term "literature" is reserved for those works that exhibit "the best that has been thought and said," works that represent a culture's highest literary achievements.

Literacy and Literature.

The Development of Literature Literature predates literacy. Ancient literature was oral—spoken—rather than written. To make it easier to remember and recite, much of this was in the form of song or poetry. The invention of writing enabled people to communicate across space and time. It was with this invention that recorded history was born. The earliest writings of the ancient world are businesslike records of laws, prayers, and commerce—informative but not expressive. When mechanical methods of printing were developed, literacy spread. Today, universal literacy is a goal in all civilized countries.

The Functions of Literature Literature serves a variety of social functions. One of its most ancient functions is as **religious literature**, the prayers and mythology of a given culture. The myths of the Greeks and Romans have exerted a powerful influence on Western culture; their origins lie deep in the history of Egypt and Mesopotamia. **Epic literature**, such as the Greek poet Homer's *The Iliad* and *The Odyssey*, or the sagas from Norway and

Iceland, combine history and imagination. Immense bodies of literature such as these were passed down by oral tradition. Literature distinct from liturgical or epic forms was invented by the ancient Greeks. Their literary forms included history, philosophy, drama, and poetry. Novels and short stories were a later development. The novel in its modern form was named for tales popular in Italy in the late thirteenth century, though the novel is generally identified with prose narratives that developed in the eighteenth century in Europe.

Since literature is a communicative act, it is important to consider the audience and setting. Silent reading is a recent development, alien to the oral roots of literature. Most literature through the ages was meant to be recited, sung, or read aloud in groups ranging from general public gatherings to the intimate setting of the private home. Authors today may give readings from their work in libraries, bookstores, and educational institutions.

Forms of Literature. Literature can be divided into fiction and nonfiction, poetry and prose.

Poetry is distinguished by its concentrated and precise language, "the best words in the best order," as one poet defined it. **Diction** is the poet's selection of words, and **syntax** the ordering of those words in sentences. Other poetic elements include images—details that evoke sense perception—along with metaphor and other forms of comparison With its roots in song, poetry of many eras and places exhibits rhyme and other types of sound play as well as rhythm and meter, the measured pattern of accent in poetic lines. Drama, plays intended for performance, are somtimes written in verse, rhymed or unrhymed, as, for example, in **blank verse**.

Prose Language that is not poetry is prose. Not all prose is literature; some, such as journalism or technical writing, is purely descriptive or informative, as some visual art is purely representational. Literature can be fiction or nonfiction, or a combination of both. Fiction is a work of the imagination. Fictional forms can be long and complex, as in a novel or play, or short and concise, as in a novella or short story. Nonfiction, which deals with actual events or persons, includes expressions of opinion, such as political essays. Functions of nonfiction include explanation, persuasion, commentary, exposition, or any blend of these. Sometimes philosophic essays and works of history are included in the category of literature.

Fiction and drama, and much nonfiction as well, create their effects through elements such as the plot, or story line, characters, description of the setting, dialogue between the characters, and exposition, or explanation. The latter is presented in the voice of a narrator, who may represent the author using the third-person perspective, or may instead be a character expressing a first-person point of view.

I:iterature

Fiction: Literature that is imaginative, rather than descriptive of actual events. Typical fictional forms are the short story and the novel, which has greater length and complexity.

Nonfiction: An account of actual events and people. Forms of nonfiction include essays, biography and autobiography, and journalistic writing, as for newspapers and magazines.

Narrative: The telling of a story; a structured account of events.

Narrator: The storyteller from whose **point of view** the story is told. The point of view can be **first-person** or **third-person**, and may shift within the work. The narrator can be **omniscient**, knowing everything, or limited to what she or he can know personally or be told by others.

Plot: The plan or story line. To plot a story is to conceive and arrange the action of the characters and the sequence of events. Plots typically involve **rising action**,

events that complicate the plot and move it forward to a **climax**, the moment of greatest intensity. This is followed by the **denouement**, the resolution of the plot.

Characters: The people in a literary work. The leading character is known as the **protagonist**, a word stemming from ancient Greek drama in which the protagonist was opposed by an **antagonist**.

Dialogue: Conversation between two or more characters. Drama is mainly rendered through dialogue; it is used in fiction to a lesser extent.

Setting: Where the events take place; includes location, time, and situation. In theatrical productions, a **set** is the scenery, sometimes very elaborate, constructed for a stage performance. In films the set is the sound stage or the enclosure where a scene is filmed.

Exposition: Explanatory material, which, especially in drama, often lays out the current situation as it arises from the past.

In common with visual art and music, literature has themes, or overarching ideas that are expressed by all the elements working together. The structure of a work of literature is analogous to the composition of a symphony or a painting. Writers use symbolism, much as visual artists do. A successful work of literature will likely establish a mood, hold the reader's interest through a variety of incidents or ideas with evident focus, yet possess an overall sense of unity.

Autobiography, as a separate literary and historical endeavor, began with the *Confessions* of St. Augustine (A.D. 354–430), in which he told the story of his life and the progress of his religious convictions. Autobiography is history written from a subjective point of view. The memoir, so popular in recent years, is descended from this first, spiritual autobiography.

Biography is a branch of both literature and history. The author's role is complicated because a biographer must check the facts of the subject's life, usually by interviewing both the subject and many other people. Deciding the major theme of a person's life, the relationship between that person and his or her time, and considering what is true as well as what is germane are the biographer's responsibility. Different biographers may offer quite different interpretations of a subject's life.

History is a powerful force that shapes the humanities as a whole. The writing of listory varies across cultures, and as cultures change, history itself is continu-

ously under revision. The leaders of some societies would never allow the publication of versions of history that vary from their orthodox beliefs, no matter what the facts might be. Because history is an interpretative discipline, several versions of events may coexist, with scholars arguing and defending the merits of each. This is particularly true in our multicultural and pluralist era.

MUSIC

We are surrounded by sounds at all times. The art that derives from our sense of hearing is music, order given to sounds by human intent. A temporal art, one that exists in time, music is the least material of the arts, its basic elements being sound and silence. Silence in music is analogous to a painter's, sculptor's, or architect's use of negative space: unoccupied but important, so that the intervals between the notes are necessary parts of a musical piece. Music permeates our daily lives—in the movies, on radio and television, in elevators and stores. The success of the Sony Walkman reflects our human desire to surround ourselves with music.

Until the development of sound recording, music was one of the **ephemeral** arts, like dance and live theater, which exist only for the duration of their performances. Until the late Middle Ages, music in the West was not written down, or **notated**. It was taught by ear, passed on from one generation to the next.

Social and Ritual Roles. Music has many different functions. It has been and remains a major element in

Meusic

Acoustics: The qualities of sound, often used to describe the relationship between sound and architecture, as in a concert hall.

Vibrations: Trembling or oscillating motions that produce sound. When singers or stringed instruments produce a wavering sound, causing a fluctuation in pitch, it is termed **vibrato.**

Pitch: The sound produced by vibrations. The speed of vibrations controls the pitch: slow vibrations produce low pitches; fast vibrations produce high pitches.

Tempo: The speed at which music is played or sung. This is shown on sheet music, usually in Italian terms, by **tempo marks** that indicate the desired speed. A device called a **metronome** can indicate tempo with precision.

Timbre: The characteristic sound or tonal quality of an instrument or voice. Also termed **color**, it can refer to the combination produced by more than one instrument's timbres, as **orchestral color**.

Tone: A sound of specific pitch and quality, the basic building material of music. Its properties are pitch, timbre, duration, and intensity.

Note: The written symbol for a tone, shown as **whole notes**, **half notes**, etc. These indicate the time a note is held, with a corresponding **rest** sign. **Notation** is the use of a set of symbols to record music in written form.

Melody: The succession of notes or pitches played or sung. Music with a single melodic line is called **monophony**, while music with more than one melodic line is **polyphony**.

Texture: In music, this refers to the number of different melodic lines; the greater the number, the thicker the texture.

Harmony: The combination of notes sung or played at one time, or **chords**; applies to homophonic music. **Consonance** refers to the sound of notes that are agreeable together; **dissonance** to the sound of notes that are discordant.

religious ritual. It is also used frequently in collective labor; the regular rhythm that characterizes work songs keeps the pace steady and makes the work more fun. For example, aerobics classes and workout tapes depend on music to motivate exercisers and help them keep the pace. On the other hand, parents use lullabies to lull their babies to sleep.

Since the late Middle Ages, Western music has developed many conventional types. These genres vary with the audience, the instruments, and the musical structures. Liturgical music was designed for churches, used sacred texts, and took advantage of church acoustics. The soaring vaults of Gothic cathedrals were perfect for the music of the Middle Ages. Music known as **chant** or **plainsong** is simply the human voice singing a religious text without instrumental accompaniment. When the voice is unaccompanied, it is known as **a cappella**. When the sound is made by specialized devices, called **instruments**, the music is termed **instrumental**.

Secular, that is nonreligious, music brought about other forms. Chamber music, instrumental music that was originally played in palaces for royalty and nobility, calls for more intimate spaces, a small ensemble of players, and small audiences. Orchestral music is the most public and complex form, involving a full orchestra and a concert hall, where the acoustics, or quality of sound, is very important. Popular music, often shortened to pop, appeals to a wide audience. It includes rock, folk, country, rap, and other types of music. Jazz is an improvisational form that arose in the United States from blues and ragtime. Musical theater, as the name

implies, is a combination of drama and music. Its songs often enter the pop repertoire as **show tunes**. **Opera**, a narrative in which both dialogue and exposition is sung, combines music with literature and drama.

Instruments. Musical instruments, which vary widely across cultures, can nevertheless be grouped in families. Probably most ancient are the percussion instruments, which make noise as they are struck. Drums, blocks, cymbals, and tambourines are percussion instruments. Stringed instruments, deriving from the hunting bow, have strings stretched between two points; sounds are produced when they are plucked, strummed, bowed, or struck. Woodwinds are hollow instruments that were originally made of wood, such as the flute, recorder, and panpipes. Reed instruments, such as the oboe, are woodwinds that use a mouthpiece created from a compressed reed. Brasses are metal horns like the tuba, trumpet, and cornet. In addition to their musical function, brasses were long used by the military to communicate over distances in battle or in camp. Using a prearranged trumpet call, the commander could sound "retreat" or "charge."

Musical Qualities and Structure. Musical structure ranges from a simple tune or rhythm to the intricacy of a symphony or an opera. The tone, or sound of a specific quality, is the basis of all music, using varieties of high or low pitches and timbres with varying intensity and tempos. Music appeals to our emotions through tempo, musical color or timbre, and harmonic structure. We associate different emotions

with different timbres. The harp, for example, evokes gentleness or calm, whereas brasses evoke more stirring emotions.

Musical structure can be simple, such as Ravel's *Bolero*, which uses the repetition of a single melody with increased tempo and volume to build to a climax. Increases in tempo generate excitement, literally increasing the listener's heart rate and breathing speed. These qualities were used to good advantage in Blake Edwards's film *10*. Composers of movie music manipulate our emotions expertly, heightening the appeal of the action.

The comparatively uncomplicated pop songs we sing are based on melodies, a succession of notes, with accompanying words. We are also familiar with the 32-bar structure of most pop and rock music, in which **verses** alternate with repeated **choruses**. To appreciate and enjoy more complex music, some understanding of structure is important. The simple song "Row, Row, Row Your Boat," familiar to many of us from childhood, is a **round** or **canon**; the same melody is sung by each voice, but voices enter one after the other, creating overlapping notes, or **chords**. More elaborate forms stemming from such simple structures are found in **classical** music, beginning with European music of the eighteenth and nineteenth centuries.

Harmonic structure is a complex topic. Western music is written in keys, a system of notes based on one central note, such as the key of C Major. The different keys have their own emotional connotations. A minor key is often associated with sadness, a major key seems happier or more forceful. Notes that seem to fit together are consonant, while clashing notes are dissonant. Generally, consonance seems peaceful or happy to most people, while dissonance may be unsettling.

Listening to Music. Music is a temporal art, designed to be listened to from beginning to end without interruption. We use music as a background so much it is sometimes difficult to learn to really listen to it. If you are listening to recorded music, reduce your distractions by turning off the television or lowering the lights. At a performance, concentrate on the performers or look at a particular spot while you absorb the music. Read program notes carefully to find out all you can about the piece and the composer. Analyze your reactions to the music, keeping in mind all you have learned about the forms, the instruments, and the musical structure.

HISTORY AND PHILOSOPHY

History, the recording and explanation of events, and philosophy, the search for truth, have both influenced the arts. These subjects have themselves evolved as humanistic disciplines. **Aesthetics**, the branch of philosophy concerned with the functions, practice, and

appreciation of the arts, along with their role in society, is an important part of this book and of cultural studies in general.

History. Unlike expressive literature, or fiction, history is an inquiry into and report upon real events and people. Its origins lie in the epic literature of the ancients with its creation myths. Such literature contains much that we now consider historical: stories of wars, reigns, natural disasters. However, until the Greek historian Herodotus, traveling in the Mediterranean lands of the sixth century B.C., turned his questioning and skeptical eye on the received beliefs and tales of peoples he met, history was inseparable from religious faith and folk memory. Historians have since developed methods of inquiry, questioning the likelihood of stories and delving into the motives of their informants. They learned to consider nonhistorical accounts and records as checks on the official versions of events. They began, in Byzantium, to consider the psychological motives of the people they chronicled. The artistry of their presentation became a part of the discipline.

Religion and Philosophy. Religion has played a crucial role in the development of the arts, which provide images, sounds, and words for use in worship, prayers, and religious stories. Theology, the theory of religious belief, prescribes religious practices, moral beliefs, and rules for social behavior. The dominant religion in a culture often controls the art, either directly by training artists and commissioning art, or indirectly. The medieval Catholic belief in the efficacy of relics to heal or give aid, for example, led to the practice of pilgrimage, and from that to the creation of great cathedrals. As religious orders acquired holy relics, they housed them in shrines within the churches. Problems arose when the many pilgrims who came to be healed and blessed disrupted services. Romanesque architects then developed the ambulatory, or walkway, that allowed pilgrims to see the relics without interrupting worshipers at a scrvice, thereby altering religious architecture. Different religions hold different aesthetic beliefs. Nudity was acceptable in the temple statues of Classical Greece and Hindu India. Islam prohibits any figurative images in places of worship, and some Native Americans believe a permanent house of worship is itself inappropriate.

In Western culture, philosophy and religion are intertwined. Like religion, philosophy is concerned with the basic truths and principles of the universe. Both are also concerned with human perception and understanding of these truths, and with the development of moral and cthical principles for living. However, their means differ. Philosophy is based on logic; religion on faith. Like so many other humanistic inventions and advances, philosophy, along with its specialized branch of aesthetics, originated in ancient Greece.

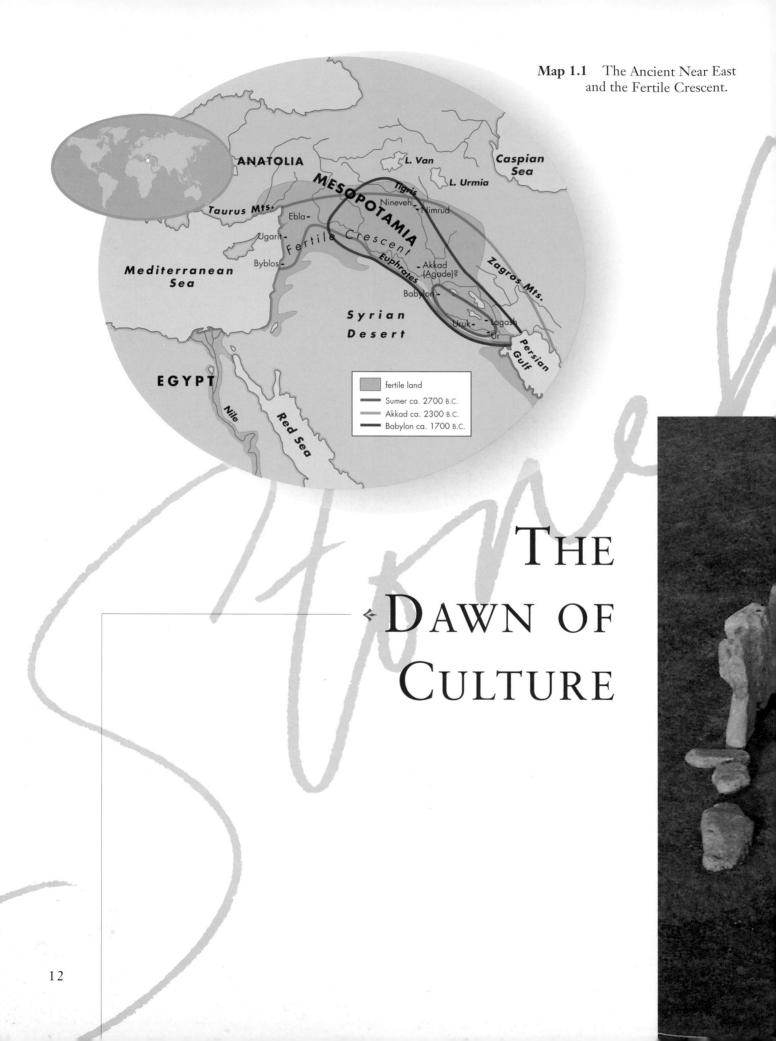

C H A P T E R 1

- The Earliest Cultures
- * Mesopotamia: The Cradle of Civilization

Stonehenge, Salisbury Plain, Wiltshire, England, ca. 2000 B.C.

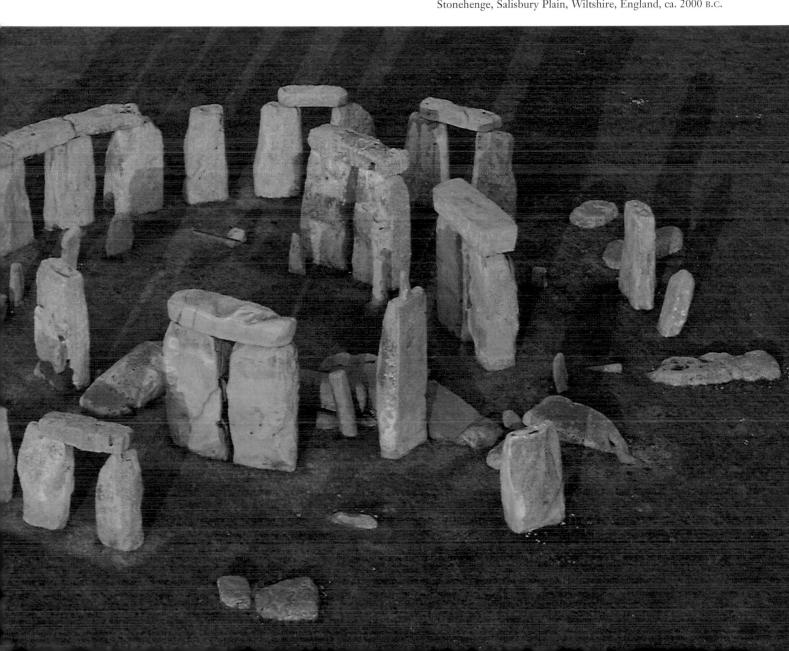

THE EARLIEST CULTURES

A **culture** is a way of living built up by a group of people and transmitted from one generation to the next. It is, in other words, the basis of communal life. A culture expresses itself in the arts, writings, manners, and intellectual pursuits of the community, and it embodies the community's values. The ability of a culture to express itself well, especially in writing, and to organize itself thoroughly, as a social, economic, and political entity, distinguishes it as a **civilization**.

Just when the earliest cultures took form, and then subsequently transformed themselves into civilizations, is a matter of some conjecture among anthropologists, scientists who study humankind's institutions and beliefs from the earliest times. The first historical evidence of a culture coming into being can be found in the artifacts of the earliest *homo sapiens*, or "the one who knows." About 37,000 years ago, the hominid species *homo sapiens*, which had come into being about 200,000 B.C., probably in Africa, began to assert itself in the forests and plains of what is today known as Europe, gradually supplanting the Neanderthal *homo erectus* who had roamed the same areas for the previous hundred thousand years.

Both homo sapiens and homo erectus were tool makers, as even our earliest ancestors seem to have been. Kenyapithecus (the "Kenya ape"), for instance, which lived in the Olduvai Gorge in east-central Africa between nineteen and fourteen million years ago, made crude stone weapons or tools. Homo sapiens and the Neanderthals both cooked with fire, wore skins as clothing, and used tools as a matter of course. They evidently buried their dead in ritual ceremonies, which provide the earliest indications of religious beliefs and practices. These activities suggest the transmission of knowledge and patterns of social behavior from one generation to the next. But between 35,000 and 10,000 B.C.—the last part of the period known as the Paleolithic, or Old Stone Age, when homo sapiens became more and more dominant and the Neanderthal line died out-the first objects that can be considered works of art began to appear, objects that seem to express the values and beliefs of the Paleolithic people. The Paleolithic period thus represents the very earliest cultural era.

THE PALEOLITHIC PERIOD

The Paleolithic period corresponds to the geological Pleistocene era, or Ice Age. Periodically, glaciers moved south over the European and Asian continents, forcing the inhabitants of the areas to move south, around the Mediterranean and into Africa. These people lived nomadic lives, following animal herds (bison, mammoths, reindeer, and wild horses were abundant), on which they depended for food.

Wall Paintings. Long before the creation of writing, Paleolithic people began to draw and paint the animals they hunted, and what is known of Paleolithic life derives largely from paintings found in caves, particularly in the Franco-Cantabrian area of southern France and northern Spain. Many of these paintings have been discovered in relatively recent times. A cave at Lascaux, in the Dordogne region of southern France, was found by accident in 1940 by children looking for a lost dog. The entrance to the Cosquer cave near Marseilles was found under water by a diver in 1991. A cave near Vallon-Pont-d'Arc, in the Ardèche region of southern France, was found in 1994 when three explorers felt a draft coming from the ground. This cave contains wall paintings, probably made about 20,000 B.C., that provide an extraordinary inventory of the animals hunted for food and clothing in this area—woolly rhinos, bears, mammoths, and oxen are frequently depicted, but also portrayed are a hyena, a panther, and owls. The images vary in size from two to twelve feet.

The most famous prehistoric wall paintings are those in the cave at Lascaux, France (fig. 1.1), which were created between ca. 15,000 and 10,000 B.C. On the cave walls there are paintings of bison, mammoths, reindeer, boars, wolves, and horses. These images were created by people whose lives were dependent upon the animals for food. Some are shown upside down, perhaps indicating a method of killing animals in which the animals would be driven off a precipice and so fall to their deaths. A grid-like structure recurs several times in these paintings and may represent a trap.

The Lascaux paintings are extremely naturalistic and demonstrate prehistoric artists' keen observation and ability to record an image remembered after the model was no longer before the eyes. Many of the animals gracefully jump, run, and romp, conveying a remarkable sense of animation. Painting is done in blacks, browns, reds, and yellows, with most of the pigments used of mineral oxides, with deeper black from burned bones.

Questions about the meaning and purpose of these paintings will never be fully answered: only speculation is possible. The paintings at Vallon-Pont-d'Arc and Lascaux, for instance, are located deep within the caves and are often very hard to reach. There is no evidence of human habitation where the paintings are located instead, people seem to have lived at or near the entrances to the caves, where natural light was available. How and why, then, were these paintings created? It is thought that the artists worked by the light of oil lamps. The location of the works has given rise to the so-called "mother earth" theory of the paintings' creation. By painting these animals in the "womb" of mother earth, the creators may have hoped that more animals would actually be born. Associated with this theory is the possibility that the superimposing, or layering, of animals was intended to show them mating.

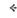

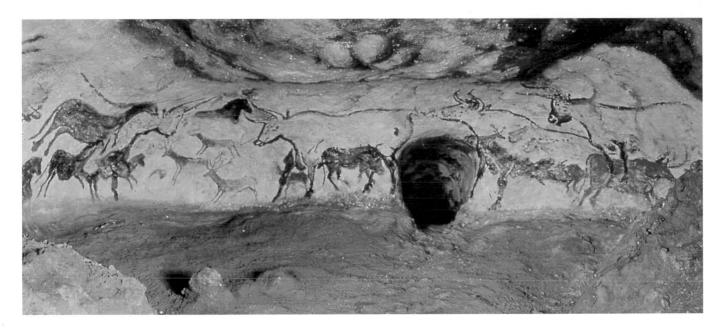

Figure 1.1 Overview of the Hall of the Bulls, ca. 15,000–10,000 B.C., cave painting, Lascaux, Dordogne, France. Prehistoric artists depicted with notable realism the animals on which they depended for food. With very few exceptions, the animals represented in such paintings are identifiable.

In neither Vallon-Pont-d'Arc nor Lascaux is there evidence of an overall planned composition. Most of the animals appear randomly placed; some are shown in isolation, while others interact. Some, as noted, are superimposed on others, and scale is inconsistent. The absence of evidence of a controlling scheme suggests that the important part for the artists may have been less the finished product than the process of painting the animal, reinforcing the theory that by creating the animal in paint, the animal might be created in reality. Thus these depictions of animals may have been created for the benefit of hunters who used images to facilitate their capture.

The theory that rituals were performed in the caves to gain control over these animals is strongly supported not only by the painting of spears on the animals, but also by actual spearheads found driven into some of the painted animals who were shown to bleed as a result of their injuries. Thus, in order to ensure a successful hunt, the animal may have been killed in effigy before the hunt. Further, hand prints are found on some of the animals, suggesting the desire to have human control over, or the ability to obtain, the animals.

Sculpture. Whether painting or sculpture was developed first by prehistoric people is among the unanswered questions in the history of art. Only a fraction of the sculpture made in prehistoric times of durable materials such as ivory, bone, horn, stone, and clay is known today, and any sculpture made of a perishable material, such as wood, is lost. The many Paleolithic sculptures

found in the debris on cave floors are small—easily transported mobile art, necessitated by a nomadic life style.

As in painting, the most frequently depicted subjects are highly naturalistic memory images of animals. An excellent example is offered by two bison (fig. 1.2) at Le Tuc d'Audoubert, in the Ariège region of France, carved

Figure 1.2 Two bison, ca. 13,000 B.C., clay relief on cave wall, length 25" and 24" (63.5 and 61 cm), Le Tuc d'Audoubert, Ariège, France. Although presumably created from memory, prehistoric depictions of animals show far greater realism than depictions of humans.

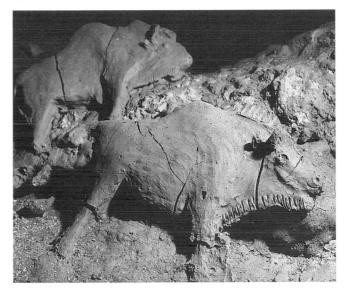

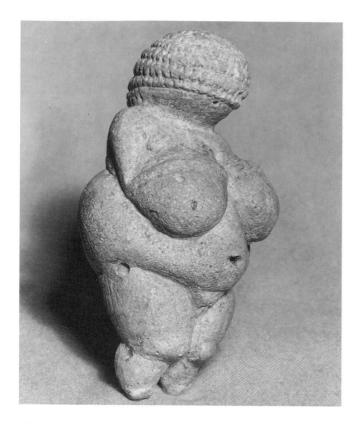

Figure 1.3 Woman of Willendorf, found at Willendorf, Austria, ca. 25,000–20,000 B.C., limestone, height $4\frac{3}{8}''$ (11 cm), Naturhistorisches Museum, Vienna. The so-called *Venus of Willendorf* is the most famous (but not the most physically distorted) of several extant female figurines thought to be associated with prehistoric beliefs about human fertility, or, alternatively, fat as a sign of physical beauty in an era when food was scarce.

and modeled in about 13,000 B.C. from the clay of the cave, taking advantage of the wall's natural contours.

Depictions of the human figure are rare in Paleolithic sculpture, and the few known are mostly female figures. Curiously, although animals are portrayed with great realism and fidelity to nature, the same is not true of representations of humans. In spite of the greater possibility of working from a live model, depictions of humans tend to be highly abstracted. This is true of the most famous example of prehistoric sculpture, the so-called *Woman* (or *Venus*) of *Willendorf* (fig. 1.3), a stone figure small enough to be held in a hand, dated to about 25,000–20,000 B.C., and named for the place where it was found in western Austria near the Danube River.

The Woman of Willendorf is elementary, direct, and emphatic, able to convey expressive force in spite of its tiny scale. Highly stylized, it is voluminous and rounded. The possibility that the Woman of Willendorf was intended to be a portrait of a specific recognizable individual must be ruled out, because the helmet/hair covers most of the head. The greatly enlarged breasts and abdomen—which suggest pregnancy—indicate the work's possible connection to human fertility. In fact, prior to the Neolithic period, almost no other human types are known. Perhaps such figures were a type of idol and were intended to promote human fertility, much as the cave paintings of animals might have been intended to "create" animals for the hunters.

THE NEOLITHIC PERIOD

What impact the Ice Age itself had on the availability of game is difficult to say, but by about 10,000 B.C., during

Timeline 1.1 Prehistoric culture.

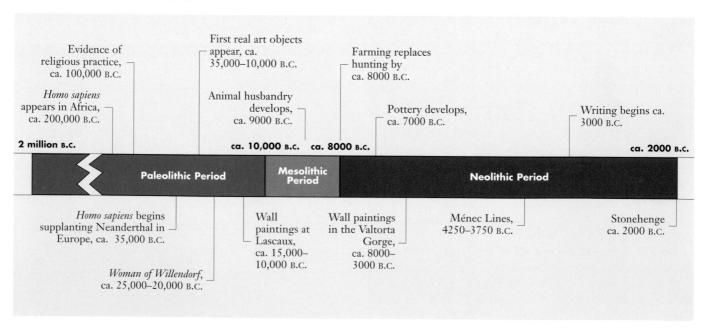

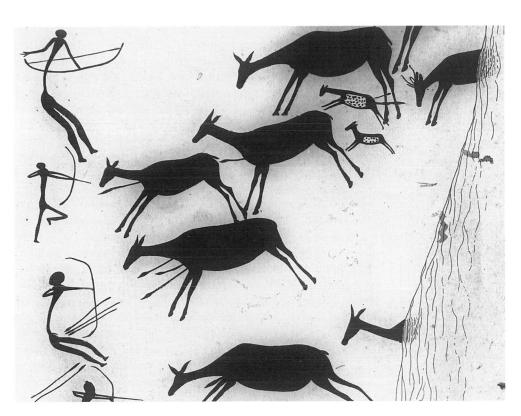

Figure 1.4 Herd crossing river, hunters with bows and arrows, ca. 8000–3000 B.C., rock painting, Valtorta Gorge, Levant, Spain. Because humans are prominently depicted, are shown using weapons, and because this scene has a definite composition, the Valtorta Gorge paintings are believed to date later than those at Lascaux.

a short period known as the **Mesolithic**, or Middle Stone Age, the glaciers that almost covered Europe began to recede northward and dense forests began to grow. Reindeer and woolly rhinos were supplanted by elk and deer, dogs were domesticated, the wheel invented, and the arts of weaving and ceramics developed. By 8000 B.C., an even more important transition had begun to take place: around the world, in the Near East, in South and Central America, and in Southeast Asia, human beings ceased to hunt and began instead to farm, plowing and planting seeds, growing crops, and domesticating animals, using them not only as a reliable source of food and clothing but also as beasts of burden, inaugurating what is known as the Neolithic period, or New Stone Age. Thus, possibly the most important transformation in the history of human civilization took place. Hunters and gatherers became herders and farmers, and more permanent societies began to develop.

Wall Paintings. Such advances were slower to arrive in Europe. In the Valtorta Gorge (fig. 1.4) on the southeast coast of Spain, paintings that date from sometime after 8000 B.C. and possibly as late as 3000 B.C. suggest that hunting remained the chief preoccupation of these peoples well into the Neolithic period. But changes

and advances are evident. Unlike the paintings of the Franco-Cantabrian area that are located deep in caves, the Valtorta Gorge paintings are on the smooth limestone walls in rock shelters and beneath cliff overhangs. The subjects portrayed differ significantly also, for here the human figure is given prominence, with humans shown hunting animals, fighting, and dancing together, as a group or community.

A degree of narrative is evident in the Valtorta wall paintings as the hunters, running from the left, attack the herd crossing a stream from the right. The composition is organized with a definite flow to the chase, a sense of action and movement conveyed by the lively postures of the figures—indeed, this appears to be a record of an actual event. A superb document of early hunting techniques, the scene shows hunters using the bow and arrow, a weapon not seen in Franco-Cantabrian art.

The paintings of the Valtorta Gorge differ from those of the Franco-Cantabrian area in additional ways. They are generally smaller in scale, and the figures are painted in solid colors—black or, more often, red. The human figures are abbreviated, abstracted, stylized, and shown in silhouette. The distinctive figure type has a small circular head, no neck, an elongated triangular torso tapering to a pinched waist, and exceptionally large legs,

perhaps indicative of the importance of running quickly in the hunt. Direct and simple, these figures convey a remarkable sense of vitality and movement.

Architecture. In the Neolithic period, as cultivation of the land supplanted hunting as the chief means of obtaining food, people became increasingly tied to a single site, and permanent structures began to be built. Food storage pits have been found, indicating that, at least at times, the supply of food was more than adequate, allowing people the freedom to begin to develop social structures and specialized skills. There is evidence that people settled in communities and towns, building homes and even communal structures. Stated in the simplest terms, settled habitation plus specialization results in the earliest evidence of what may be called civilization.

Prehistoric architecture survives only from the Neolithic period, and very little survives at all. Structures made of wood, other plant material, or mud brick decayed and disappeared long ago. **Megalithic** (huge stone) arrangements and structures appear toward the close of the Neolithic period. Among them are menhirs and cromlechs. A **menhir** is a single stone or **monolith** ("mono" means one; "lith" means stone) set vertically into the ground. Menhirs were often placed at or near a burial place. A field of 1,009 menhirs known as the Ménec Lines, dated to 4250–3750 B.C., is located near Carnac, in Brittany, France. Placed on end, the tallest rising twelve feet, the stones are arranged in several rows

Figure 1.5 Stonehenge, Salisbury Plain, Wiltshire, England, completed ca. 2000 B.C., bluestone and sarsen, height of stones of outer circle 20′ (6.09 m). This enigmatic remnant of prehistoric architecture is believed to have been a monumental clock, laid out so the stones relate to the position of the sun at the summer and winter solstices.

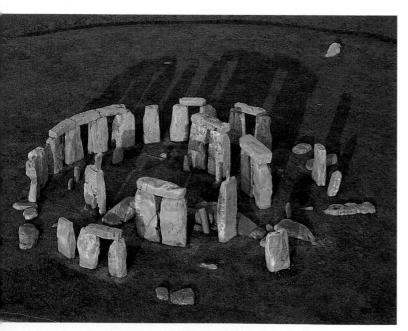

three-quarters of a mile long. Some of the stones are unshaped, others taper toward the top, and others are carved with geometric designs. The largest menhir known is the Great Menhir, near Locmariaquer, in Brittany. It has fallen and is now broken into several pieces, but originally stood sixty-four feet high and is estimated to weigh approximately 347 tons. The purpose of the menhirs remains a subject of debate.

The most famous example of prehistoric architecture is surely the **cromlech**, or circle of stones having a religious purpose, known as Stonehenge (fig. 1.5), located on the Salisbury plain in Wiltshire, England, and completed ca. 2000 B.C. A henge is a circle of stones or posts. Stonehenge is not the only prehistoric cromlech to have survived, but it is the most impressive and best preserved. The outer trench is approximately 150 feet in diameter, and the individual stones approximately twenty feet high. There is a definite entrance way, as well as four mounds evenly placed on the outer trench, and a central stone referred to as the altar stone. The huge upright stones form an outer circle and two inner circles or U shapes. Some of the stones are shaped into rectangles, and some also have patterns cut into them. Stonehenge is constructed using the post and lintel system—in its simplest form, two vertical posts support a horizontal lintel. At Stonehenge, the vertical posts have dowel pins carved into their uppermost end, which fit into circular depressions carved on the underside of the lintels at both ends, thereby locking the posts and lintels together.

Two main types of stone, bluestone and sarsen, were used to create this architectural marvel. Yet the closest site where bluestone is found is Wales. To transport stone from Wales to Wiltshire presumably required tremendous weights of stone to be moved over land, water, and then land again, by being rolled on logs and floated on rafts. Sarsen is more readily available on the Marlborough Downs, twenty miles north of Stonehenge.

What can the purpose or function of so monumental an undertaking have been? The answer seems to be connected with several "correspondences." If you stand in the center of Stonehenge and look to the so-called heelstone, you see that the top aligns with the horizon. The sun rises directly over the heelstone at the summer solstice—the longest day of the year. On each of the four mounds were other stones at horizon level—the one to the southwest is at the point of the setting sun at the winter solstice, the shortest day of the year. Stonehenge, therefore, seems to be an enormous sun clock or calendar, based upon the rising and setting sun at the summer and winter solstices. But could these simply be coincidences? That is, with enough stones in enough places, is it not probable that something is going to align with, to coincide with, something else? To resolve this question, the "coincidences" were weighed against probability by a computer; the results established that the placement of the stones must have been intentional.

Mesopotamia: The Cradle of Civilization

Even before Stonehenge was built in England, two far more advanced civilizations were developing in the Near East: that of Mesopotamia and that of Egypt (discussed in Chapter 2). Mesopotamian civilization developed in the valley between the Tigris and Euphrates Rivers: Mesopotamia is a Greek word meaning literally "the land between two rivers." Consisting of the eastern part of what is known as the Fertile Crescent, which extends northward along the eastern coast of the Mediterranean through what is today Israel and Lebanon, eastward into present-day Syria and Iraq, and south down the Tigris and Euphrates valleys to the Persian Gulf, Mesopotamia was the most fertile and arable land in the Near East, and perhaps, at the dawn of the Neolithic Age, the most fertile in the world. It was here, at any rate, that around 9000 B.C. agriculture—literally, the *cultura*, or cultivation, of the land, ager—was first fully developed.

By about 3000 B.C., two further developments had taken place that had a decisive influence on the course of civilization. Sometime after 6000 B.C. people learned to mine and use copper; by 3000 B.C., they had discovered that by combining tin with copper they could produce a much stronger alloy, bronze, which allowed tremendous innovations in the production of weapons, tools, and jewelry. This marked the beginning of the Bronze Age.

The second development marks the move from prehistory into the first historical period—that is, a period for which written records exist. By about 3000 B.C., the people of ancient Mesopotamia were using written language, known today largely from clay tablets that were first unearthed in the mid-nineteenth century. Chiefly the province of the upper class and priests, this writing was accomplished in wedge-shaped cuneiform characters (from the Latin cuneus, meaning "wedge") made with a stylus that was itself wedge-shaped and that was pressed into wet clay tablets. The original purpose of this writing seems to have been to keep agricultural records. Among the oldest examples of cuneiform writing, for instance, is a tablet from a temple complex at Uruk that lists sacks of grains and heads of cattle. Cuneiform writing began as a pictographic system. In its earliest form, the symbol for "cow" was an abstract "picture" of a cow's head:

But the pictographs were quickly abstracted even further, presumably in no small part because it was difficult to draw a curve with a reed stylus in wet clay. Between 2500

and 1800 B.C., the sign for "cow" was first turned ninety degrees sideways and then converted into a series of quickly imprinted wedges:

By combining pictograms, more complex ideas—or ideograms—and even abstract ideas could be represented. A bird next to an egg meant "fertility." Two crossed lines meant "hatred" or "enmity," and parallel lines signified "friendship":

A significant aid to our understanding the cuneiform vocabulary of Mesopotamian culture are groups of "sign lists" compiled by scribes as an aid to teaching the script to students. Sometime around 2000 B.C., another important development occurred, when pictograms began to represent not only objects but sounds—the birth of phonetic writing.

Assisted by these technical advances, three successive civilizations—those of Sumer, Akkad, and Babylon—blossomed in Mesopotamia over the following 1500 years.

SUMER

The Sumerians, who lived at the southern end of the Tigris and Euphrates Rivers, founded the Mesopotamian civilization between 3500 and 3000 B.C., contemporary with the beginning of Egyptian civilization. Sumerian culture reached its zenith by approximately 2800–2700 B.C. It was at this time that Sumer's most famous king, GILGAMESH [GIL-gah-mesh] (ca. 2700 B.C.), ruled Uruk, one of the many independent city-states that grew up in Mesopotamia.

Little or no unity ever developed among these city-states, and no concentration of wealth or population resulted. Instead, each Sumerian city-state had its own local god and its own local ruler. The kings were not thought of as gods—rather, the god was considered the owner of the city-state. Life seems to have been ruled by religion, with the king as intermediary between the god and the people. In each city-state, the buildings were clustered around the temple of the city's god. Religion focused on seasonal fertility. Agricultural mythology included the Bull of Heaven, whose fiery breath could burn crops, and Imdugud, a lion-headed eagle whose wings covered the heavens in dark clouds, a good

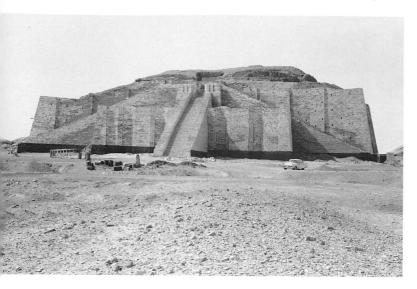

Figure 1.6 Ziggurat of King Urnammu (Nanna), Ur (El Muqeiyar), Iraq, ca. 2500–2050 B.C., sun-baked mud brick. The Sumerians built their temples atop ziggurats—rectangular mountains constructed of mud brick, with battered (sloping) walls.

creature who brought rain and ended droughts brought on by the Bull of Heaven.

Like most early religions, Sumerian and later Mesopotamian religions were **polytheistic**—that is, there were many gods and goddesses, who often competed with one another for the attention of the worshipers. The gods were human in form, and possessed human personalities and foibles—that is, they were **anthropomorphic**. The four chief gods were Anu, the heaven god; Ninhursag, the mother goddess; Enlil, the god of air; and Enki, the god of water. As human as the behavior of these gods might be, they were nonetheless clearly superior to humans, particularly by their immortality. The cuneiform sign for god is a star, which also means "on high," or "elevated," as well as "in the heavens."

Architecture. Sumerian domestic architecture seems to have consisted largely of houses that were square or rectangular in plan and built of clay brick. Archaeologists have not been able to work out the precise layouts of Mesopotamian cities, but it seems certain that at the heart of the settlement would have been the temple. Sumerian temples were built on raised platforms known as **ziggurats**, an example of which is the Ziggurat of King Urnammu at Ur, in Iraq (fig. 1.6), constructed ca. 2500-2050 B.C. of sun-baked mud brick and, consequently, now greatly disintegrated. The lowest level is fifty feet high. The walls are battered, that is, sloping, making them stronger than vertical walls because they are self-supporting. The walls are constructed with weeper holes to allow water that collects in the masonry to run out through these small regularly placed openings. The ziggurat at Ur demonstrates the use of specific orientation in architecture, for the angles point north, south, east, and west.

Timeline 1.2 Mesopotamian culture up to the rise of the Persian Empire.

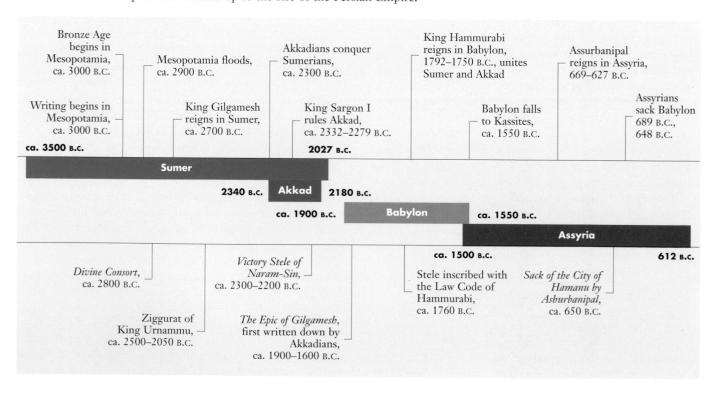

The actual temple was atop the ziggurat. Within the temple, a statue of the god stood in the sanctuary, a long room running the entire length of the temple. The lower levels of the ziggurat were covered with dirt and planted with trees, thus creating the effect of a mountain with a temple on top. This practice is explained by the belief that the gods lived on the mountain tops, so ziggurats brought worhipers closer to heaven.

Sculpture. Since little stone was available naturally in Sumeria, limestone, gypsum, and marble were imported. Consequently, all Sumerian statues are small. Although Sumerian sculpture includes occasional secular subjects, most examples appear to be religious or commemorative in purpose, and to have been made for temples. The human figure is represented in a distinctive manner unique to Sumerian sculpture. The style is one of formal simplification, geometric and symmetrical. The figure type is squat in proportions, with broad hips and heavy legs.

The so-called *Divine Consort* (fig. 1.7), carved ca. 2800 B.C., is the head from a cult statue from Uruk (modern Warka). The huge eyes and single continuous eyebrows of such figures were originally inlaid with colored material. Some have their ears pierced for small gold earrings. The most expressive feature of Sumerian figures is surely the size of the wide open cycs, giving them a look of rapt devotion. They appear to be transfixed—as if they are witnessing an astounding occurrence. In fact, cunciform texts reveal that the worshiper must fix upon the god with an attentive gaze.

Figure 1.7 Female head, known as the *Divine Consort*, from Uruk (Warka), ca. 2800 B.C., alabaster, height ca. 8" (20.3 cm), Iraq Museum, Baghdad. This alabaster face was meant to be attached to a wooden background and probably wore a wig of gold.

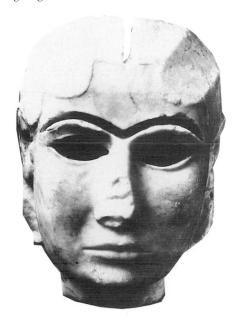

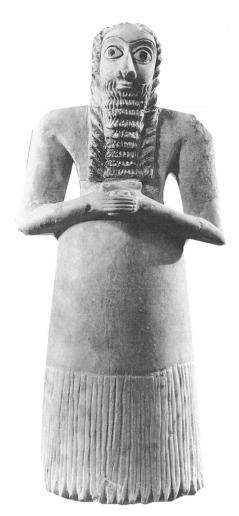

Figure 1.8 Standing man, formerly thought to represent Abu, the god of vegetation, from Tell Asmar, ca. 2600 B.C., white gypsum, insets of black limestone and white shell, height ca. $11\frac{3}{4}''$ (29.8 cm), Metropolitan Museum of Art, New York. Sumerian statues are easily recognized by their large eyes, single eyebrow, and seemingly astonished facial expression.

A statue formerly thought to represent Abu (Abu means "father" in Arabic languages), the god of vegetation (fig. 1.8), comes from a group of similar statues dated ca. 2600 B.C., carved of white gypsum, with black limestone and white shell insets, found in the Abu temple at Tell Asmar. Some of these statues may represent gods. Others may represent worshipers. Curiously, it appears that Sumerian people might have a statue carved to represent themselves and do their worshiping for them—in their place, as a stand-in. An inscription on one such statue translates, "It offers prayers." Another inscription says, "Statue, say unto my king (god) …"

The figures from the Abu temple stand erect (seated figures are rare in Sumerian art), with their hands clasped, some holding small vessels for pouring libations. Some figures are made with the head and hands of marble or other stone, and the rest of the figure of wood.

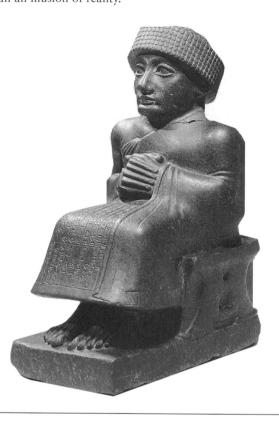

Their costumes consist of a skirt, perhaps made of animal skins, and they may be bearded. Otherwise, they are simple and unadorned.

Also known by name is Gudea of Lagash (Telloh) (fig. 1.9), carved ca. 2144-2124 B.C. of diorite, a hard stone that allows a fine finish. Gudea, ruler of Lagash, had statues of himself placed in shrines—about twenty statues of him remain, all small in scale. There is some variety to the Gudea statues, but he is always shown to be serene and forceful. Gudea's unusual attire crosses the chest and falls over one arm, and the simplified heavy skirt does not reveal the form beneath. The same squat proportions are used as with other Sumerian figures. Gudea may stand, sit, appear to worship, or offer a plan for a temple to his god, but the rigid figures do not bend, twist, or move. His hands are likely to be firmly clasped. the tension of the arms shown by the bulging muscles. The carefully rendered muscles of the arms contrast with the conventionalized face, which is fleshy and rounded. with huge eyes and one continuous evebrow—heavy evebrows were a racial trait. The contrast of textures of the smooth skin, eyebrows, and headdress is emphasized.

Although little or no Sumerian painting remains, decorative objects have survived. A noteworthy example is an inlaid standard (fig. 1.10), from Ur, dated ca. 2700–2600 B.C. The figures on this double-sided panel are made of shell or mother-of-pearl inlaid in bitumen, with the background formed from pieces of the blue stone, lapis lazuli, and additional bits of red limestone. The standard, on which scenes of war are portrayed, is

Figure 1.10 Inlaid Standard, from the "royal cemetery" at Ur, ca. 2700–2600 B.C., double-sided panel, shell or mother-of-pearl, lapis lazuli, and red limestone, inlaid in bitumen, ca. $8\times19''$ (20.3 \times 48.3 cm), British Museum, London. Much like today's comic strips, a series of scenes are arranged in chronological sequence to tell a tale—in this case, that of a successful battle, the victory feast, and the taking of war spoils.

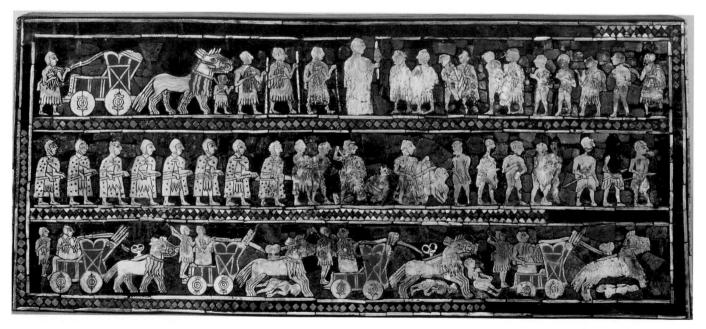

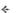

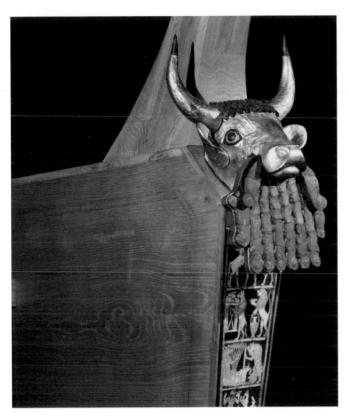

Figure 1.11 Lyre from the tomb of Queen Puabi, Ur, ca. 2600 B.C., wood with gold-leaf bull's head, inlaid gold, lapis lazuli, and shell, height ca. 12" (30.5 cm), University Museum, Philadelphia. Akin to large-scale jewelry, this lyre represents the splendid sculpture in gold and other precious materials created in ancient Sumeria.

commemorative, with events arranged in horizontal rows. On one side, on the top row, the king steps out of his chariot to inspect his captives. The king is shown to be taller than anyone else—his head breaks through the border. On the two lower rows are scenes of battle, with fighters wearing metal helmets, cloaks, fleece kilts, and riding in four-wheeled chariots. On the other side, on the top row, the victory feast is shown. The king and his officers sit in chairs and drink. The king is, again, largest. On the two lower rows, booty taken in battle is paraded in front of them, including cows and animals of unidentifiable species.

That the crudeness of Sumcrian stone sculpture is due to lack of stone on which to practice rather than to lack of skill is supported by the splendid work of Sumerian jewelers and goldsmiths. A superbly crafted wooden lyre, a stringed musical instrument similar to a harp (fig. 1.11), made ca. 2600 B.C., comes from the tomb of Queen Puabi at Ur and was ornamented with a bull's head made of gold leaf, the hair and beard of lapis lazuli. Below the head, on the sound box of the lyre, is a panel (fig. 1.12) made of wood, gold, lapis lazuli, and shell, inlaid to form a variety of images. Among these images are a man,

animals acting like people, including one who plays a harp, and monstrous combinations of humans and animals. All figures, or portions thereof, appear in one of two ways: either directly from the front or in profile, simultaneously diminishing any sensation of dimension and enhancing the decorative quality of the whole. Although seemingly amusing, and certainly engaging, these creatures played an important part in Sumerian mythology. The animals depicted here are the traditional guardians of the gateway through which newly dead Sumerians must pass, and this fantastic scene may well portray the afterlife.

The oldest known major literary work Literature. in the world is The Epic of Gilgamesh, the earliest elements of which date from about 2500 B.C., when Gilgamesh reigned in the Euphrates city-state of Uruk. Legends about Gilgamesh were told but not recorded until hundreds of years after his death. Before about 2000 B.C., these stories were recorded on cuneiform tablets. From around 1900-1600 B.C. onward, the Gilgamesh stories were written down by the Akkadians, a people who spoke an early Semitic language related to both Hebrew and Arabic. Under the powerful military leadership of the Akkadians, who conquered the city-states of Sumer and adopted their culture, the epic work was organized into a coherent whole. The earliest known version of the epic was discovered in the seventh century B.C. in the library of the Assyrian king Assurbanipal (669–627 B.C.).

Figure 1.12 Panel from the lyre shown in fig. 1.11.

Cross Currents

SUMERIAN MYTH AND THE BIBLE

There are strong parallels between Sumerian mythology and the stories in the biblical book of Genesis. There are, for instance, surviving Sumerian texts that parallel the story of Noah and the flood, including an episode in The Epic of Gilgamesh-a huge flood did indeed inundate Mesopotamia about 2900 B.C. In another Sumerian myth, the story of Enki and Ninhursag, which is some three hundred verses long, Enki, the great Sumerian god of water, creates a garden paradise in Dilmun by bringing water up from the earth. In Genesis 2:6, a similar event occurs: "But there went up a mist from the earth, and watered the whole face of the ground." Ninhursag, the mother-goddess of the Sumerians, causes eight plants to sprout in this proto-Garden of Eden, and Enki, wanting to taste the plants, has another lesser god pick them. Ninhursag is furious and pronounces

the curse of death upon Enki. This is a moment in the story that anticipates the biblical God's fury at Adam and Eve for eating the apple that Satan has tempted them with and their expulsion from the garden into a fallen world in which they must confront their mortality. Unlike Adam and Eve, however, Enki is eventually restored to immortality by Ninhursag, but the parallels between the two stories are striking.

Also close in spirit to the biblical Creation story is the *Poem of the Supersage*, an Akkadian text written down about 1700 B.C. Like most Akkadian texts, it is probably based on Sumerian legend. The story begins in a divine society where the gods, in order to satisfy their material needs, had to work. Some gods, the leaders, called Anunnaki, were pure consumers, but the rest were laborers. These last, called Igigu, finally revolted, creating the prospect of famine among the Anunnaki. It was Enki who resolved the crisis by proposing that the gods create

a substitute labor force out of the clay of the earth, whose destiny it would be to work and whose life would have a limited duration. Thus, as in Genesis, humankind is created out of clay, must labor, and is mortal.

The earliest parts of the Bible date from about 1000 B.C. Most of the Sumerian texts date from 2000 B.C. or earlier. How these stories survived is a matter of speculation, though it is worth pointing out that the biblical Abraham was born in Ur, perhaps around 1700 B.C. It is therefore entirely possible that it was he who brought this lore with him to Palestine. Even more to the point, the language of the Akkadians, who conquered the Sumerians in about 2300 B.C., was also used throughout Palestine during the second millennium B.C., and there is little doubt that Palestinian scholars were well acquainted with Akkadian stories and texts, most of which are retellings, in one form or another, of Sumerian prototypes.

Like other ancient epics such as those of Homer (see Chapter 3), *The Epic of Gilgamesh* includes elements of folklore, legend, and myth that accrued over time. The work is compiled of originally separate stories concerning Gilgamesh; Enkidu, a primeval human figure; Utnapishtim [OOT-nah-PISH-tim], a Babylonian counterpart of Noah; and a number of other figures.

The epic begins with a kind of prologue that emphasizes Gilgamesh's wisdom as a ruler and his importance to recorded history. The prologue also characterizes him as a semi-divine figure, who, though not immortal, is courageous, strong, and beautiful. He is also described as an arrogant and oppressive ruler. When his people cry out for help to their gods for assistance, the god Anu creates Enkidu, a primitive combination of man and wild animal, a figure related to those depicted on the lyre from the tomb of Queen Puabi in Ur.

The story of the mutually positive influences Gilgamesh and Enkidu exert upon each other, of their developing friendship, and their heroic adventures occupies the bulk of the epic. An additional segment concerning Gilgamesh in the Underworld forms a kind of epilogue. In their first adventure, Gilgamesh and Enkidu confront and kill the giant Humbaba. When the goddess Ishtar proposes that Gilgamesh become her lover, he refuses, which precipitates the goddess sending the

Bull of Heaven to destroy the city of Uruk by famine.

The second adventure of Gilgamesh and Enkidu involves the slaying of the destructive Bull, the punishment for which is Enkidu's death through illness. After losing his companion, Gilgamesh journeys to visit Utnapishtim, the only human ever granted immortality, but fails to learn the secret of everlasting life, though he does return home having gleaned much else from the wisdom of Utnapishtim. With this knowledge he rules as a wise king. Gilgamesh's adventures are occasions for writers to explore questions that will be raised again in later epics. What is the relationship between human beings and their deities? How are human beings linked with the world of nature and animals? What are the obligations of friendship, family, and public duty? How should one live in the face of mortality?

AKKAD

Under the leadership of King SARGON I, who ruled ca. 2332–2279 B.C., and his grandson and successor NARAM-SIN [NA-ram-sin], the Semitic people of Akkad conquered all of the city-states of Sumer. Subsequently, the governors of these cities were "slaves" to the king of Akkad, and he himself was a god to them.

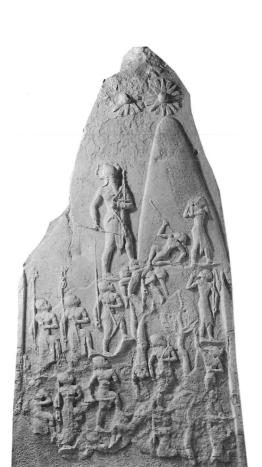

Figure 1.13 Victory Stele of Naram-Sin, ca. 2300–2200 B.C., limestone, height 6' 6" (1.98 m), Musée du Louvre, Paris. This stone slab carved in relief served as a public monument to commemorate the military accomplishments of Naram-Sin. In this, it deserves comparison to the palette of the Egyptian pharaoh Narmer (see fig. 2.1).

The actual site of the city of Akkad has never been discovered, though it is thought to be near present-day Baghdad. As a result, little in the way of Akkadian art remains, and we know the culture largely through its language, which, by 2300 B.C., was spoken, as noted above, throughout the Near East.

The most celebrated example of Akkadian art is the *Victory Stele of Naram-Sin* (fig. 1.13), ca. 2300–2200 B.C. A **stele** is a vertical slab of stone that serves as a marker. The *Victory Stele of Naram-Sin*, which is six and a half feet high, is carved on one side only. At the top of the scene is a set of stars—the sign for Naram-Sin's protecting gods—and below, Naram-Sin and his army victoriously climb a mountain, as if to place themselves in closer proximity to the gods, the defeated lying slaughtered or begging for mercy at their feet. Naram-Sin himself, taller than the rest, as is always the case in Akkadian depictions of royalty, wearing the horned helmet used to identify the gods, and, standing at the very top of the battle, on the bodies of two victims, strides confidently to his place as the leader of all Mesopotamia.

BABYLON

However powerful Sargon I and Naram-Sin might have been, the Akkad kingdom lasted under two hundred years. For the next three hundred years, until about 1900 B.C., Mesopotamia was subject to constant division and conflict among its various city-states. Then a tribe of nomads, originally known as the Amorites, invaded the region from the Arab peninsula and established a royal city in Babylon. In 1792 B.C., when HAMMURABI [ham-ooh-RAH-bee] (r. 1792–1750), the first great king of Babylon, took power, the Sumerian and Akkadian city-states were unified as a single kingdom under his rule.

Sculpture. One of Hammurabi's great accomplishments was to codify the laws of the region. The stele inscribed with the Law Code of Hammurabi (fig. 1.14),

Figure 1.14 Stele inscribed with the Law Code of Hammurabi, ca. 1760 B.C., basalt, height of stele ca. 7' (2.13 m), height of relief ca. 28" (71.1 cm), Musée du Louvre, Paris. The significance of this legal document was made clear to the Babylonian people by the relief at the top of the stele that depicts the sun god Shamash giving these laws directly to Hammurabi, king of Babylon.

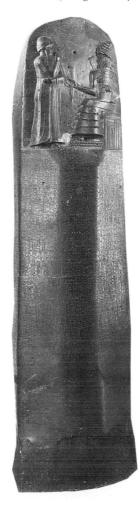

carved of basalt ca. 1760 B.C., which stands seven feet high, is both a work of art and a historic legal document. Hammurabi's law code is the earliest known written body of laws. The code consists of 282 laws arranged in six chapters: 1. Personal property; 2. Land; 3. Trade and commerce (this chapter seems strikingly modern, for it includes fixing of prices, contracts, rates of interest, promissory notes, and credit); 4. Family; 5. Maltreatment; and 6. Labor (including the fixing of wages). The death penalty is often mentioned—this is an eye-for-aneye, tooth-for-a-tooth approach to law.

The relief at the top of the Law Code of Hammurabi shows Shamash, the sun god who controlled plant life and weather, dispelled evil spirits of disease, and personified righteousness and justice—the appropriate god for a law code. (Shamash is also represented in the *Stele of Naram-Sin* as one of the stars overlooking the scene.) Hammurabi appears to converse with Shamash, from whom he receives the laws. The difference in importance between the two figures is made clear, the king standing while Shamash is shown larger, elevated, and enthroned.

ASSYRIA

Babylon fell to the nomadic Kassite people in about 1550 B.C. This was followed by a period of relative cultural decline, before the last great ancient Mesopotamian civilization was developed by the Assyrians. The Assyrian culture began in the middle of the second millennium B.C., achieved significant power around 900 B.C., and lasted until 612 B.C. when Nineveh and Syria fell. The instability of life in ancient Assyria is reflected in the emphasis on fortifications and military subjects in art. The Assyrians took much from Sumerian and Babylonian art, such as building their temples on ziggurats at Nimrud (Calah). The Assyrians, however, had greater resources than the Sumerians, in terms of population, money, and materials.

Sculpture. Stone, in particular, was far more abundant in the northern region of the Tigris and Euphrates valleys where the Assyrians originated, permitting them to produce large-scale sculpture. Between the ninth and seventh centuries B.C., stone guardian monsters were placed at gateways and defined an Assyrian style; several examples survive, including those from the palace of ASHURNASIRPAL II [ash-er-na-SEER-pal] (r. 883-859 B.C.) at Nimrud (fig. 1.15). The headdress is peculiar to Mesopotamian deities and is similar to that worm by Shamash on the Babylonian stele with the Law Code of Hammurabi. With the body of a lion, wings of a bird, and head of a human, such guardian figures were perhaps intended to combine human intelligence with animal strength. Perhaps they were intended to be frightening as well or to impress people with the king's power.

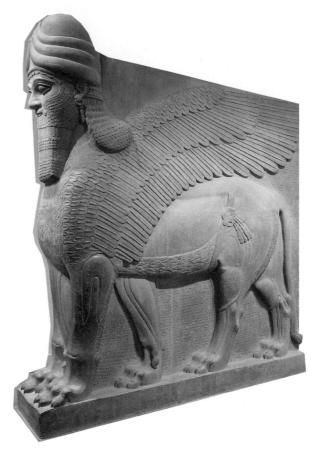

Figure 1.15 Human-Headed Winged Lion, from the northwest palace of Ashurnasirpal II at Nimrud (Calah), ca. 883-859 B.C., limestone, height $10'2\frac{1}{2}''$ (3.11 m), length $9'1\frac{1}{2}''$ (2.78 m), Metropolitan Museum of Art, New York. Part human and part animal, the five-legged Assyrian gate monsters are among a vast population of early imaginary composite creatures. Later artists, in various cultures, created generations of descendants with a remarkable range of implausible physiognomies.

Alternatively, they have been said to represent the Assyrian god Nergal, whose emblem is a winged lion.

Seen from the front, only the two front legs of these creatures are visible. Seen from the side, four legs are visible and the creature appears to be walking. To make this monster appear correct both from the front and the side, the sculptor has generously given him five legs!

Other than gateway guardians, Assyrian sculpture consists mostly of reliefs—figures cut from a flat, two-dimensional background. Statues in the round—sculptures that are freestanding and made to be seen from all sides—are extremely rare. Assyrian reliefs were part of the architecture; the carved panels were set into the walls of the palaces. These reliefs show little interest in religious subjects, depicting instead scenes that provide historical documents of actual events often arranged chronologically. The subjects, which are usually royal activities that glorify the king, provide records of ancient armor, weapons, chariots, harnesses, and other accoutrements of war. Little information about ordinary life is

Connections

THE FUNDAMENTALS OF CIVILIZATION

Civilization requires many different components to function. The study of early cultures indicates what some of these things are: technology, or tools and special technical skills that give rise to trade; laws, for the regulation of society; governmental structures; cities, or permanent settlements; and writing, through which culture is transmitted.

One Sumerian text outlines the knowledge necessary to live as civilized people. An extraordinary tale, narrated by Berossos, a Babylonian scholar who, around 300 B.C., recorded in Greek the history and traditions of his country, it recalls a time when the people of Chaldea, on the Persian Gulf, in Lower

Mcsopotamia, "lived an irreligious life, similar to that of animals":

In the first year an extraordinary monster appeared ... on the shore of the Red Sea, and its name was Oannes. Its entire body was that of a fish, and underneath his head was a second one, as well as feet similar to those of a man—an image that is still remembered and that is still depicted up to today. This being lived among the people without eating anything and taught them writing, science, and technology of all types, the foundation of cities, the building of temples, jurisprudence, and geometry. He also revealed to them [how to cultivate] grains and how to harvest fruits. In short, he revealed to them all that constitutes civilized life. He did it so

well that ever since one has found nothing exceptional in it. When the sun set, the monster Oannes plunged back into the sea to pass the night in the water, because he was amphibious. Later similar creatures appeared ...

The story is not meant to be interpreted literally. Like many of the adventures in *The Epic of Gilgamesh*, it is a **myth**, a story involving legendary heroes, gods, and creatures that explains important cultural practices or beliefs. However "true" or otherwise the story may be, the lesson is clear: No one thing guarantees civilization. It is the combination of science, technology, agriculture, mathematics, law, literature, architecture, and the arts that constitutes civilized life.

included, and women are rarely shown in these scenes of warfare and hunting.

One such relief, the depiction of *Ashurnasirpal II Killing Lions* (fig. 1.16), carved ca. 850 B.C., from Nimrud, portrays a militaristic subject commonly used to glorify the king. In fact, this event was more a ceremony than an actual lion hunt, since soldiers lined up to form a square,

and the lion was released from a cage into the square. The artist has not tried to duplicate observed reality. Three horses are shown, but each receives only two legs. Although figures overlap, there is no sense of space, no setting, and everything takes place on the same ground line. The result is more a decorative surface than a realistic three-dimensional depiction.

Figure 1.16 Ashurnasirpal II Killing Lions, from the palace of Ashurnasirpal II at Nimrud (Calah), Iraq, ca. 850 B.C., limestone relief, 3'3" × 8'4" (0.99 × 2.54 m), British Museum, London. This precisely carved relief records a ceremony used to emphasize the power of the Assyrian king—he is shown overcoming a lion, long regarded as "king of beasts."

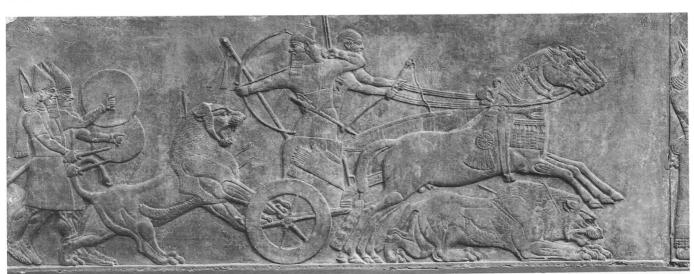

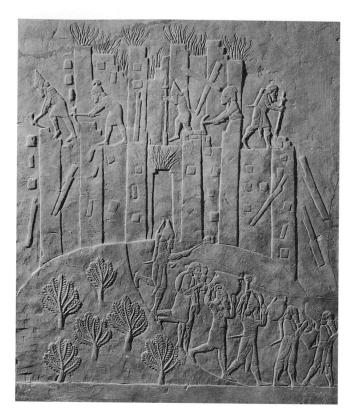

Figure 1.17 Sack of the City of Hamanu by Ashurbanipal, from the palace of Ashurbanipal at Nineveh (Kuyunjik), Iraq, ca. 650 B.C., limestone relief, $36 \times 24\frac{1}{2}$ " (92.7 × 62.2 cm), British Museum, London. Assyrian emphasis on narration and documentation permitted disregard for relative scale and spatial logic. Realistic representation of a military campaign in stone relief first appears on the Column of Trajan (see figs. 5.20 and 5.21) in the second century A.D.

The limestone relief depicting the Sack of the City of Hamanu by Ashurbanipal (fig. 1.17), from the palace of ASHURBANIPAL [ash-er-BAN-ee-pul] (r. 669-ca. 627 B.C.) at Nineveh, was carved two hundred years after the Nimrud relief, in approximately 650 B.C. Assyrian artists were the first to attempt large-scale narrative sculpture depicting specific events. The carving shown in figure 1.17 is one of a series of historical reliefs that records the defeat of the Elamites by Ashurbanipal. Here, the story of the Assyrian sack of Hamanu is clearly told. Buildings are burned; Ashurbanipal's soldiers tear down buildings with pickaxes; pieces of the structures fall through the air. Soldiers carry contraband down the hill. The little scene below shows soldiers at the campfire, eating and drinking, while one stands guard. This matter-of-fact record was no doubt intended to glorify Ashurbanipal's military achievements and to intimidate enemies wanting to challenge his authority. It should be added that the Assyrians had a real reputation for ferocity; which they earned, in part, by their practice of impaling the heads of their enemies on spikes.

NEBUCHADNEZZAR'S BABYLON

In the New Testament of the Bible, in describing Rome the author of the book of Revelation invokes the name of the great sixth-century B.C. Mesopotamian city of Babylon with at best mixed emotions: "What city is like unto this great city ... that great city that was clothed in fine linen and purple and scarlet and decked with gold and precious stones and pearls! ... Babylon, the Great, the Mother of Harlots and of the Abominations of the Earth." The biblical prophet tells us as much about his own Judeo-Christian morality as he does about Babylon's decadence, but of Babylon's great wealth and position in the sixth century B.C. there can be no doubt.

The Assyrians undertook a major rebuilding of the original city that Hammurabi had built a thousand years earlier, after sacking and destroying it in 689 B.C. Only forty years later in 648 B.C., its population had once again become sufficiently irritating to the Assyrian kings to cause Ashurbanipal to attack it again, killing all those who opposed him. "I fed their corpses to the dogs, pigs, *zibu*-birds, vultures, the birds of the sky and the fish of the ocean," Ashurbanipal bragged.

Figure 1.18 Reconstruction drawing of Babylon in the sixth century B.C., Oriental Institute of the University of Chicago. In this contemporary rendering of ancient Babylon, a procession enters the Ishtar Gate. Above and to the right are the Hanging Gardens; in the distance, the Ziggurat of Marduk can be seen.

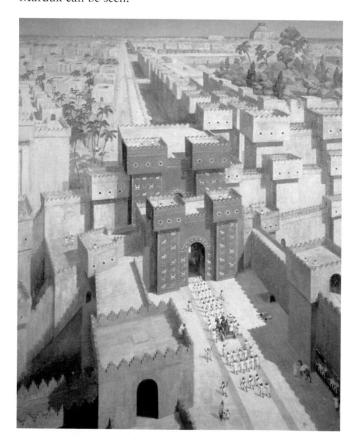

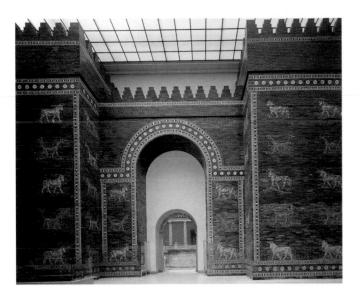

Figure 1.19 Ishtar Gate, from Babylon, ca. 575 B.C., glazed brick, Staatliche Museen zu Berlin, Preussischer Kulturbesitz, Vorderasiatisches Museum, Berlin. The appeal of animals as architectural ornament to the Babylonians is evident on this gate to Nebuchadnezzar's sacred precinct.

After the death of Ashurbanipal, when Assyrian dominance in the region collapsed, the city again rose to prominence. Referred to by scholars as Neo-Babylon, to distinguish it from the Babylon of Hammurabi, and sometimes called Chaldea as well, it was rebuilt by the architects of NEBUCHADNEZZAR II [ney-book-ad-NEZ-zahr] (r. 604-562 B.C.) to become the greatest city in the Near East (fig. 1.18). It was graced by its famous Hanging Gardens, one of the so-called "Seven Wonders of the World." Rising high above the flat plain of the vallev floor, was its Marduk ziggurat—sometimes believed to be the biblical Tower of Babel, since Bab-il was an early form of the city's name. The Greek historian Herodotus, who traveled widely in the region in the fifth century B.C., described the city in some detail in his Histories:

Babylon lies in a wide plain, a vast city in the form of a square with sides nearly fourteen miles long and a circuit of some fifty-six miles, and in addition to its enormous size it surpasses in splendor any city of the known world. It is surrounded by a broad deep moat full of water, and within the moat there is a wall fifty cubits wide and two hundred high ... The temple [of Marduk] is a square building, two furlongs each way, with bronze gates, and was still in existence in my time; it has a solid central tower, one furlong square, with a second erected on top of it and then a third, and so on up to eight. All eight towers can be climbed by a spiral way running round the outside, and about half-way up there are seats for those who make the ascent to rest on. On the summit of the topmost tower stands a great temple with a fine large couch in it, richly covered, and a golden table beside it ... In the temple of Babylon there is a second shrine lower down, in which is a great sitting figure of Bel, all of gold on a golden throne, supported on a base of gold, with a golden table standing beside it. I was told by the Chaldeans that, to make all this, more than twenty-two tons of gold were used.

The richness of the city is embodied in the most remarkable of its surviving parts, the Ishtar Gate (fig. 1.19), built ca. 575 B.C. by Nebuchadnezzar himself and today housed in the Berlin State Museums. Ishtar is the Sumerian goddess of love and war. Her gate is ornamented with bulls, lions, and dragons-all emblematic of her power-arranged in tiers, on a blue background, in brown, yellow, and white. The gate rose over the Processional Way, known in Babylonian as Aibur-shabu, the place "the enemy shall never pass." Leading up to the gate was a broad paved road lined with high walls that were decorated with the figures of 120 lions, symbols of Ishtar. The animals on both the Ishtar Gate and the wall of the Processional Way are made in relief of glazed (painted and fired) brick, the technique for making them probably invented in Mesopotamia during Nebuchadnezzar's reign. The glaze made the mud bricks waterproof, which accounts for their survival.

PERSIA

In 539 B.C., the King of Persia, CYRUS II [SI-rus] (r. 559–530 B.C.), entered Babylon without significant resistance and took over the city, forbidding looting and appointing a Persian governor. Cyrus offered peace and friendship to the Babylonians, and he allowed them to continue worshiping their own gods. In fact, legend quickly had it that as he advanced on the city, the Babylonian god Marduk was at his side.

The Persians originated from Elam, in modern-day western Iran. Although some sites date back to around 5000 B.C., the Persians had begun to rise to power by the sixth century B.C. and by 480 B.C. their empire extended from the Indus River in the east to the Danube in the north. Moreover, in the same period that Cyrus overran Mesopotamia, the other great Near Eastern civilization, Egypt, lost its independence to the Persians (see Chapter 2). Persian art is found across this large geographical area.

Sculpture. The earliest extant Persian art consists of portable objects characteristic of nomadic peoples. Objects buried with the dead have survived—weapons, decorative items including jewelry, containers such as jugs, bowls, and cups, and other objects. Their style is referred to as an "animal style" because the objects are characterized by the decorative use of animal motifs. Small forms are used in ornamental jewel-like concentration. Popular motifs derive from the ibex (wild goat), serpent, bird, bull, and sheep, while the human figure plays a minor role.

A later example of this animal style, and a high point in technical accomplishment, is the winged ibex (fig. 1.20), a wild mountain goat made of silver, partly gilded, and intended to serve as a handle to a vase, dating from the fourth century B.C. This ibex has been magically graced with wings. Striking a lively pose, it seems also to have been given life. Despite its supernatural characteristics, the care with which it has been crafted underscores the Persian fascination with, and love of, animals. In fact, the Persians built gardens and "paradises"—enclosed sanctuaries where birds and animals were protected.

Architecture. Because the ancient Persian religion centered on fire altars in the open air, no religious architecture was needed. However, huge palaces with many rooms, halls, and courts were constructed. The visitor to the palace at Persepolis (fig. 1.21), built 518–

Figure 1.20 Vase handle in the form of a winged ibex, from Persia, fourth century B.C., silver, partly gilded, height ca. $10\frac{1}{2}''$ (26.7 cm), Musée du Louvre, Paris. The skill of Persian metalsmiths is clearly evident in this exquisitely crafted wild moutain goat. Embellished by the addition of wings, two of Nature's creatures have been combined to create a new species.

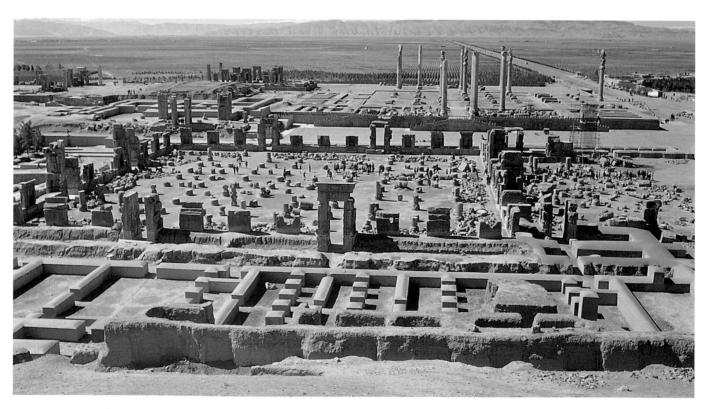

Figure 1.21 Palace of Darius and Xerxes, Persepolis, Iran, 518–ca. 460 B.C., overview. Constructed on a raised platform and impressive in its enormous scale, the palace includes large rooms filled with forests of columns. The plan—axial, formal, and repetitious—appears to have been laid out on a grid.

Then & Now

BEER

The beer people drink today is an alcoholic beverage made by fermenting grains and usually incorporating hops, but the process of making it was discovered nearly 8000 years ago, around 6000 B.C., in Sumeria. The Sumerians made beer out of bappir, or half-baked, crusty loaves of bread, which they crumbled into water, fermented, and then filtered through a basket. Surviving records indicate that as much as fifty per cent of each grain harvest went into the production of beer and that in Ur, around 3000 B.C., needy persons were allotted one gallon of beer each day as part of a general social welfare program.

Literally hundreds of surviving cuneiform tablets contain recipes for beer, including kassi (a black beer), kassag (fine black beer), and kassagsaan (the finest premium beer). There were wheat beers, white beers, and red beers as well. One surviving tablet, which is rather reminiscent of modern advertising slogans, reads "Drink Ebla-the beer with the heart of a lion." Kings were buried with elaborate straws made of gold and lapis lazuli, designed for sipping beer. There was even a goddess, Ninkasi-"she who fills the mouth"who looked over the production and distribution of the drink. "I feel wonderful, drinking beer," wrote one poet, about 3000 B.C., "in a blissful mood with joy in my heart and a happy liver." But the Law Code of Hammurabi specifically banned the selling of beer for money. It could be bartered only for barley: "If a beer seller do not receive barley as the price for beer, but if she receive money or make the beer a measure smaller than the barley measure received, they shall throw her into the water."

Today there are over six hundred breweries making beer in the United States alone, each with its own unique process, producing perhaps ten times that many beers, each with its own unique flavor and color. The tradition, clearly, is as long and venerable as civilization itself.

ca. 460 B.C. by DARIUS [DAR-ee-uss] (521–486 B.C.) and XERXES I (485–465 B.C.) who were the successors of Cyrus, is met by huge guardian monsters at the entrance towers of the Porch of Xerxes, reminiscent of the Assyrian guardian monsters. The palace of Persepolis is also similar to Assyrian palaces in being set on a raised platform. At Persepolis the palace stands on a rock-cut terrace, 545 by 330 yards, approached by a broad stairway of 106 shallow steps. Beyond were the main courtyards and the Throne Hall of Xerxes, known as the Hall of One Hundred Columns. This room was a forest of pillars, filled by ten rows of ten columns, each column rising forty feet. This was a new style for Mesopotamia, based on the use of tall columns.

Relief Sculpture. The palace at Persepolis was decorated with stone reliefs, including that of *Tribute Bearers Bringing Offerings* (fig. 1.22), flanking the stairway and carved ca. 490 B.C. Such ceremonial sculpture is concentrated almost exclusively along the staircases, giving a decorative emphasis to the main approaches. Three to six figures are used to represent each of twenty-three different nations of the empire. The repetition of stylized figures—in attendance, as servants, and in processions—may be said to become monotonous. These figures are stiff, if not frozen; representations of animals in Persian art have greater life and personality than representations of humans.

Religion. Perhaps the most lasting innovation made by Persian culture was in religion. The prophet Zoroaster, or Zarathustra, who lived around 600 B.C., rejected the polytheism of earlier Mesopotamian cultures and instead developed a **dualistic religion**, in which the uni-

verse is divided between two forces, one good and one evil. According to Zoroaster, Ahuramazda, the god of light, was caught up in an eternal struggle with Ahriman, the god of darkness. As noted earlier, the Christian Bible may have been influenced in some of its stories by *The Epic of Gilgamesh*. Similarly, there are some ideas in Zoroastrianism that may have influenced later religions, such as the idea of a "Prince of Darkness" (Satan) and a Last Judgment.

Figure 1.22 Tribute Bearers Bringing Offerings, ca. 490 B.C., limestone relief, height 8'4" (2.54 m), flanking stairway, Palace of Darius and Xerxes, Persepolis, Iran. The message conveyed by these stiff, formal, and generous giftbearing figures, passed by the visitor when entering the palace, is hardly subtle.

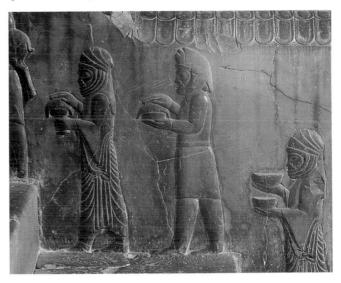

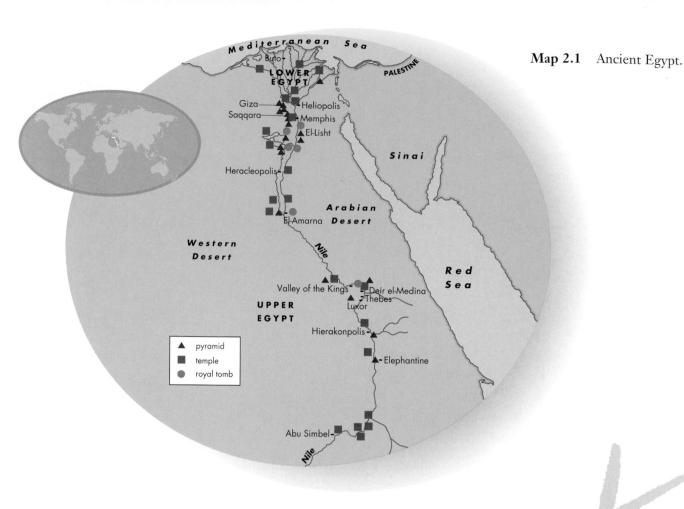

Ancient -- * Egypt

The Civilization of the Nile

Like its Mesopotamian counterpart (see Chapter 1), ancient Egyptian civilization developed slowly from about 5000 B.C. to approximately 3100 B.C. with no united or central government. There were in essence two independent Egypts: Upper Egypt and Lower Egypt ("Lower" Egypt actually lies north of "Upper" Egypt). Upper Egypt was a narrow strip of land on either side of the Nile River, extending seven hundred miles from the first cataract, or waterfall, in the south to the Nile Delta. Lower Egypt was situated in the northern lands of the fertile Nile Delta where the river branches out and runs into the Mediterranean. Then, around 3100 B.C., the two Egypts were united by the king of Upper Egypt, NARMER, also known as MENES [ME-neez], and it is with this event that Egyptian history is usually said to begin. The event is celebrated in one of the earliest surviving Egyptian stone sculptures, the so-called Palette of Narmer (fig. 2.1).

The decoration on the palette—which also served a practical function, since the central depression on the front was used for grinding malachite to produce face paint for ritual purposes—memorialized Narmer's victory over Lower Egypt. The composition is organized into registers or rows according to a register system. Each row thus contains a different idea or a separate event, and almost every figure stands on a groundline. There is no setting as such, and as in Sumerian art, Narmer is made larger than everyone else to indicate his importance. The human figure is represented in a unique, Egyptian style. Each part of the body is seen from its most characteristic angle. Thus, heads are in profile, though the eye is depicted frontally. The shoulders are also seen as if from the front, and the waist twisted so that the hips, legs, and feet are seen once again in profile. One foot is generally placed before the other on the groundline. What is particularly remarkable is that these conventions for showing the human figure persisted, especially in depictions of royalty, well into the fourth century B.C.

At the top of the front side of the *Palette of Narmer* are two images of Hathor, the cow-headed goddess who protects the city of the dead. Between the cow-heads is a hieroglyphic representation of Narmer's name (this is explained in the section on hieroglyphics below). On the top row, the King wears the crown of Lower Egypt; on the back of the palette he wears the crown of Upper Egypt. Narmer carries a club and whip, and is followed by a figure holding his sandals and a vase. In front of him is a row of standard bearers. The King is inspecting two rows of decapitated enemies—their heads are between their ankles. These are placed one above the other on the palette, as Egyptian artists indicated distance by showing things that were supposed to be further away above

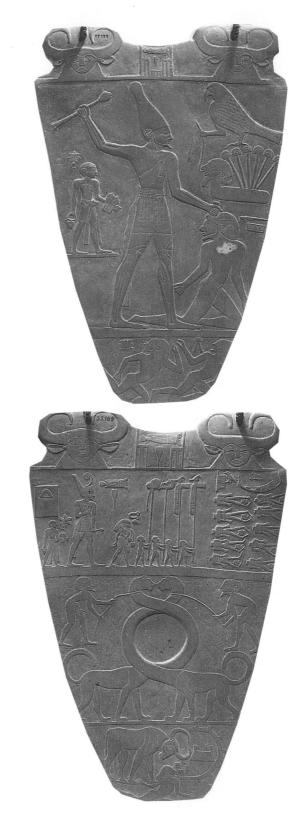

Figure 2.1 Palette of Narmer, front and back, ca. 3100 B.C., First Dynasty, slate, from Hierakonpolis, height 25" (63.5 cm), Egyptian Museum, Cairo. This celebrated work is simultaneously a functional palette, an exquisite relief carving, and an historical document of the uniting of Lower and Upper Egypt by Narmer, the first pharaoh of the first Egyptian dynasty.

things that were supposed to be closer to the viewer. In the center register, two feline animals with elongated necks, each held on a leash by an attendant, circle the depression used for grinding. Their intertwining probably refers to the unification of the lower and upper parts of the country. On the bottom register, a bull, whose strength probably refers to the strength of Narmer himself, menaces a fallen victim.

On the back, the King himself wears a ceremonial bull's tail. He has taken off his sandals, indicating that he is on holy ground and is about to slay an enemy as a symbol of victory. The hawk or falcon, symbol of the god Horus and of the local god of Upper Egypt, also refers to the successful war. Six papyrus buds (papyrus is a symbol of Lower Egypt) symbolize the number of Narmer's captives—six thousand. The small rectangle is the symbol for a fortified town or citadel.

Historians have traditionally viewed Narmer's victory as the beginning of Egyptian history. The Egyptian priest and historian Manetho of Sebennytos in ca. 300 B.C. was the first to divide three thousand years of Egyptian history into dynasties, or periods of ruling houses. Although subsequent historians have discovered that many of Manetho's facts were incorrect, his divisions—into about thirty dynasties, beginning with Narmer-are still in use. We know very little of the first two dynasties, but beginning with the third, the Egyptian dynasties are grouped into several major periods distinguished by their stability and achievement: the Old Kingdom (2686–2181 B.C., consisting of dynasties 3–6), the Middle Kingdom (2040-1786 B.C., consisting of dynasties 11-14), and the New Kingdom, or Empire (1552-1069 B.C., consisting of dynasties 18-20). Socalled "Intermediate" periods of relative instability intervened between each of the "Kingdoms," and the last, "New" Kingdom was followed by a Late Period that concludes around 525 B.C. when Egypt finally lost its independence and was absorbed into the Persian Empire.

Despite times of relative disruption, life was unusually secure in ancient Egypt. The fertility of the Nile Valley, which swept huge amounts of fertile top soil each summer into the Valley from far upstream in the African lake region and the Ethiopian plateau, supported the establishment of a permanent agricultural society. Moreover, the surrounding deserts largely eliminated the fear of invasion. The king, later called "pharaoh," which means "great house," was the absolute ruler and was considered divine. Beneath him was a large class of priests and government bureaucrats. The permanence and stability of life and the highly centralized organization of ancient Egyptian society is reflected in the monumental and essentially permanent architecture of the pyramids. In fact, with few exceptions the art of Egypt remained remarkably consistent in style over three millennia. The unquestioning acceptance of convention is a major characteristic of ancient Egyptian culture. As a result, a sense of order and continuity pervades the history of ancient Egyptian life and art.

HIEROGLYPHICS

The Egyptians had developed a calendar, used irrigation systems, discovered the use of basic metals, and started using hieroglyphics, their writing system, all before 3000 B.C. For centuries scholars thought that the "glyphs" or characters used in hieroglyphics all represented complete ideas rather than individual units of sound. Indeed, until 1822 the actual meaning of the

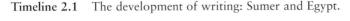

Figure 2.2 Rosetta Stone, 196 B.C., basalt, British Museum, London. The same information is inscribed in three languages: 1. Greek; 2. demotic script, a simplified form of hieroglyphic (the common language of Egypt); and 3. hieroglyphic, a pictographic script. By comparing the languages, hieroglyphics were finally translated in the early nineteenth century.

hieroglyphics was unknown. In that year, however, a Frenchman, Jean François Champollion, deciphered the Rosetta Stone (fig. 2.2). This was a large fragment of basalt that had been found during Napoleon's military campaign in Egypt near the town of Rosetta in the Nile Delta. The stone was inscribed with three languages: Greek, a common (demotic) Egyptian dialect, and Egyptian hieroglyphics. Knowledge of Greek had never been lost, and though the Greek on the stone was imperfect, Champollion was able to read it. When it became apparent that all three languages on the Rosetta Stone expressed almost the same thing—a decree in honor of Ptolemy V (196 B.C.), Champollion was able to establish that the corresponding Egyptian symbols were meant, as in Sumerian, to be read not just symbolically but phonetically as well. Thus, while a pictograph of a fish did indeed represent a "fish," combined with other pictographs it represented the sound of the word "fish," which is pronounced "nar." For instance, the name of the king of a united Egypt, Narmer, consists of the sign for a fish, "nar," and the sign for a chisel, which is pronounced "mer."

RELIGIOUS BELIEFS

Ancient Egyptian religion was polytheistic, involving belief in a profusion of gods. Among the most important gods in Egypt were the cosmic forces, including the sun, earth, sky, air, and water. The Nile was also worshiped as a deity, not surprisingly given its importance to Egyptian life. These forces and aspects of nature were depicted in various forms, often as animals, humans, or as hybrids. For example, the sun was sometimes pictured as a falcon, other times as a falcon-headed man wearing a sun-disk as a crown. Archaeologists and anthropologists have suggested that the human-animal hybrids might be "transitional" deities linking the earlier, more primitive animal cults with the later more "humanized" concept of the divine. Whatever the case may be, animals had enduring significance for the ancient Egyptians, who believed, like the Persians, that the divine was manifest in them. The animal attributes of the gods were often a shorthand for their qualities. For example, Hathor, who was the goddess of joy and love-attributes which the Egyptians viewed the cow as possessing—was depicted as a cow.

Among the most important of the Egyptian gods was Osiris, originally a local god of Lower Egypt, whose worship eventually spread throughout the country. The legend of Osiris's death at the hands of his brother Set, and the search for the corpse by Isis, Osiris's wife, plays an important part in Egyptian mythology, and is connected with Egyptian belief in the afterlife. According to the myth, after Isis discovered her husband's dead body in Phoenicia, she brought it back to Egypt and buried it there. Set came upon the buried body and, enraged, tore the dead Osiris limb from limb, scattering the pieces throughout the country. Again Isis found her dead husband's body parts and buried each where it lay.

The son of Isis and Osiris avenged his father's death by engaging Set in battle and defeating him. However, when Set was brought to Isis, instead of killing him, she set him free. According to some versions of the myth, Osiris was restored to life and became king of the underworld. This myth of Osiris's resurrection later became an important element of the cult of Isis, the most important mother goddess in Egyptian religion, and a significant influence on Egyptian belief in life after death. Egyptian religion shared this belief in an afterlife with Christianity, especially the Christian belief in the resurrection of Jesus.

The Afterlife. Much of Egyptian life appears to have been oriented toward preparing for the hereafter. The Old Kingdom Egyptians believed that the body of the deceased must be preserved if the ka, the indestructible essence or vital principle of each person, roughly equivalent to the Christian concept of a soul, were to live on. This is why the Egyptians embalmed and bound their dead. This process of mummification was a complex procedure that involved emptying the bodily cavities of their

Then & Now

THE NILE

Egypt," the Greek historian Herodotus wrote, "is a gift of the Nile." In ancient Egypt, the Nile flooded every summer, from July to October. The floods began when the rain in the central Sudan raised the level of the White Nile, one of its tributaries, followed by the summer monsoon in the Ethiopian highlands raising the level of the Blue Nile, another of its tributaries. By August, these waters reached Egypt proper, flooding the entire basin except for the highest ground, where villages and temples were built, and depositing a deep layer of silt over the fields.

If rainfall came short of expectations, the next season's crops could be dramatically affected; and, sometimes just as disastrous, if rainfall was excessive, villages and farms had to be evacuated. To combat this, gauges, or "Nilometers," were placed upstream on

the Nile, and river levels could be compared with records kept over the centuries, so that those downstream might know what to expect each August. In fact, annual taxes were levied according to the height of the river in any particular year.

In 1899, in order to gain greater control over the Nile and help local agriculture, the British financed a dam project on the Nile at Aswan, 550 miles upstream from Cairo. At Aswan, the Nile pours rapidly through steep cliffs and gorges, and it seemed a perfect spot for a dam. When the dam was finished in 1902, it regulated the flow of the river and allowed for an extra ten to fifteen percent of land to be farmed.

Originally 98 feet high, the dam was raised to 138 feet in 1933. By then a giant lake, 140 miles long, stretched behind it, submerging Nubian villages and a large number of monuments for part of the year, most famously the

Temple of Isis. In the 1950s, President Nasser proposed another dam, the Aswan High Dam. The endangered Temples of Isis and Hathor were removed to higher ground for safety.

Designed to provide Egypt with predictable and sufficient water resources, as well as providing for the country's electrical needs, the Aswan High Dam has had foreseeable negative impacts as well as beneficial ones. Even the early British dam had stopped the natural flow of silt down the Nile, forcing farmers to rely on chemical fertilizers instead. But worst, perhaps, is the fact that Lake Nasser, behind the Aswan High Dam, has changed rainfall patterns in the region and significantly raised the level of the underground water table far downstream, threatening even the temples of Luxor 133 miles to the north. The Nile today never floods, but this victory has had its costs.

organs, refilling them with spices and Arabic gums, and then wrapping the body in layers of bandages. This took seventy days to complete, after which the mummified body was ready for the hereafter, where it would rejoin its ka. To be doubly sure of the survival of the ka, a likeness of the dead person was made in a hard stone, intended to serve as a backup, should anything happen to the mummy. One Egyptian word for sculptor translates literally as "he who keeps alive." Members of the noble class were mummified and accompanied by their personal likeness; common people were merely buried in holes, though Egyptian religion does appear to have offered them the hope of life in an afterworld, too. The belief in the necessity of housing the dead in a tomb that would endure forever, for the benefit of the ka of the deceased, gave rise to Egypt's monumental conception of architecture, exemplified most spectacularly in the pyramids.

THE OLD KINGDOM

The Old Kingdom (2686–2181 B.C.) was a time of political and social stability in Egypt, a stability reflected in its grandest achievements, the great pyramids. While tradition long held that slaves built these giant funerary monuments to the kings, it now seems clear that an entire class of artisans, sculptors, and builders were responsible for them. That a culture could organize such mammoth

undertakings and accomplish them with what appears to be the willing cooperation of its people emphasizes the unity of the society as a whole.

ARCHITECTURE

The ancient Egyptian architecture extant today is made of stone. Stone, of many kinds, was abundantly available, and this availability must in part explain the giant proportions of these surviving buildings. Limestone and sandstone were easily quarried in nearby locations along the Nile cliffs. Harder stones such as granite, basalt, and quartzite, were obtained from more remote regions.

Although Egypt lacked timber, other plant materials could be employed instead. For instance, lotus and papyrus reeds, bundled together and matted with clay, were used as building materials. Mud brick, made by mixing mud from the Nile River with straw, shaping the resulting substance into bricks, and then allowing them to dry in the sun, was also used. Mud-brick buildings are cool in the summer, warm in the winter, and, as Egypt has little rainfall, lasted quite well. Homes of peasants were made in this way. The pharaoh's home was also made of mud brick, but was larger, lime-washed, and painted.

Ancient Egyptian architecture is based, like prehistoric Stonehenge (see Chapter 1), on the post and lintel system. Buildings constructed using this system are

simple and stable, and subject only to the forces of gravity. The flat roofs produced by this method of construction are suitable for the dry Egyptian climate—a pitched roof is not needed to allow water to run off. The Egyptian builders used no cement, relying instead on the weight of the huge stones to keep the structure together.

Mastabas. The earliest burial places of the Old Kingdom Egyptian nobility were mastabas, flat-topped, one-story rectangular buildings with slanted walls. Faced with brick or stone, the mastabas were oriented very specifically, with the four sides facing north, south, east, and west. Surviving mastabas vary in length from 15 to 170 feet, and vary in height from 10 to 30 feet. The interiors have different layouts, but all include the following: (1) A chapel or offering room, used to make offerings to the spirit of the dead person (there are two doors to this room, one real, the other false—to be used by the spirit to collect what was offered); (2) The serdab or cellar, a tiny secret room in the center of the mastaba, containing a statue of the dead person (the ka statue) and treasure; and (3) A shaft running from the mastaba down through

the earth, and into the actual burial chamber located perhaps over a hundred feet below ground level. The plan of the mastaba is believed to be an adaptation of a house plan, which seems logical since the tomb was regarded as the house of the soul.

The Stepped Pyramid of Zoser. The stepped pyramid of King Zoser [ZHO-suh] (Third Dynasty, ca. 2600 B.C.), built on the west bank of the Nile at Saggara (fig. 2.3), makes clear how the true pyramid developed from the mastaba, as well as suggesting a possible influence from the Sumerian ziggurat (see fig. 1.6). The stepped pyramid is essentially a stack of mastabas; if the steps were filled in, the pure pyramidal form would be achieved. The stepped pyramid was built by IMHOTEP [EE-moh-tep], King Zoser's architect. Imhotep is the first artist/architect in history whose name has been recorded for posterity (his name appears on Zoser's ka statue in the serdab of the pyramid). Imhotep was also an astronomer, writer, sage, priest, and, above all, a physician who came to be deified as the god of medicine and science.

Figure 2.3 Imhotep, Stepped Pyramid of Zoser, Saqqara, ca. 2600 B.C., Third Dynasty. This stepped pyramid was transitional between the rectangular mastabas (here seemingly placed one on top of another) and the true pyramidal form.

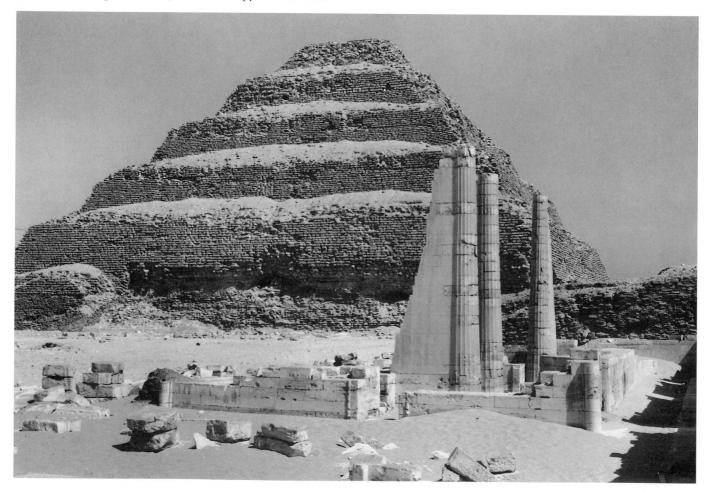

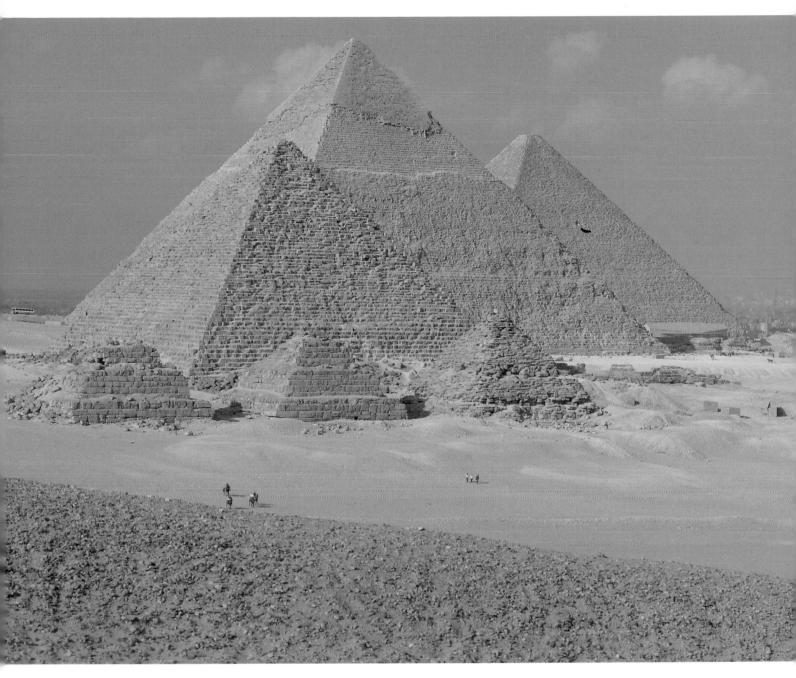

Figure 2.4 Great Pyramids, Giza, built for the Old Kingdom pharaohs Cheops, ca. 2530 B.C., Chefren, ca. 2500 B.C., and Mycerinus, ca. 2470 B.C., Fourth Dynasty, limestone and granite, height of pyramid of Cheops ca. 450′ (137.16 m). The permanence of the pyramids, built to last forever, was related to the Egyptian concept of an afterlife and the mummification of their dead.

The six levels of this stepped pyramid rise over two hundred feet high, making it the oldest sizable stone structure in the world. It was once surrounded by courts and buildings, the whole complex enclosed by a wall over thirty feet high. Zoser's *ka* statue was oriented to peer out toward an adjacent funerary temple through two peepholes in the *serdab*, so that, in the afterlife, he could continue to observe the rituals in his honor.

The Great Pyramids. The first true pyramids—the Great Pyramids at Giza (fig. 2.4) on the west bank of the Nile—were built in the Fourth Dynasty of the Old Kingdom. The three pyramids were built by the pharaohs CHEOPS [KEE-ops], ca. 2530 B.C.; CHEF-REN [KEF-run], ca. 2500 B.C.; and MYCERINUS [MIK-ur-EE-nus], ca. 2470 B.C. Because the pharaoh was considered divine and would consequently return to the

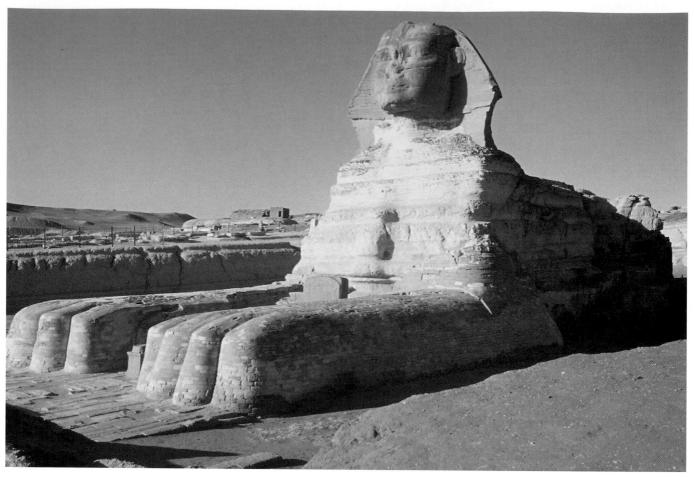

Figure 2.5 Great Sphinx, Giza, ca. 2500 B.C., Fourth Dynasty, sandstone, height 65′ (19.81 m). Although similar to the Assyrian guardian monsters in combining a human head and an animal body (see fig. 1.15), here the facial features are those of the pharaoh, and the monumental dimensions are intended to impress the viewer with his power.

gods when he died, the pyramids were designed to soar to heaven. Inscribed on the walls of later pyramids are descriptions of kings climbing the sides of the pyramids to join the sun god Ra, and the triangular shape may itself symbolize the falling rays of the sun.

The Great Pyramids are extraordinary accomplishments of engineering. Satisfying the Egyptian craving for permanence, the pyramid is one of the most stable geometric forms. The Great Pyramids are built of solid limestone masonry. The blocks were cut with metal tools in the eastern Nile cliffs, marked by the stone masons with red ink to indicate their eventual location, floated across the river during the seasonal floods, and then dragged up temporary ramps and moved into their final position. The largest and oldest pyramid, that of Cheops, covers thirteen acres and is made up of approximately 2,300,000 blocks, each averaging $2\frac{1}{2}$ tons in weight. Counting the polished, pearly-white limestone encasement that has now almost entirely disappeared but once rose some 30 feet above the present apex, the pyramid was 450 feet high.

With characteristic Egyptian mathematical precision, the three Great Pyramids are aligned, their corners oriented north, south, east, and west. The proportions of the base width to the height of the pyramids are eleven to seven, a proportion that modern research has shown is inherently pleasing to many people. Inside the pyramids have systems of corridors that lead to the burial chamber, where the mummified body of the pharaoh was placed, along with the rich possessions that were to accompany him to the afterlife.

SCULPTURE

The Great Sphinx. Most extant Egyptian sculpture is religious or political in purpose, and either reflects the characteristic Egyptian desire for immortality and belief in an afterlife or demonstrates the pharaoh's power and divinity. The Great Sphinx (fig. 2.5), which guards the pyramid of Chefren at Giza, is a majestic and monumental symbol of the king's strength created by combining a human head (probably an idealized portrait of Chefren

himself, the face of which is now damaged) with the body of a lion. The Great Sphinx is 65 feet high, the scale indicative not only of the power of the pharaoh, but also of the Egyptian love of enormous proportions. The sphinx reappears in Classical Greek mythology, in particular in the story of Oedipus (see Chapter 4).

Statue of Chefren. Egyptian sculptural style is based on a handful of basic forms. With few exceptions, the human figure is shown in a very limited number of poses: sitting on a block, standing with one foot forward, sitting cross-legged on the floor (a less common pose), or kneeling on both knees (quite rare). Further, each of these poses is shown in a specific way and according to certain conventions. These standard poses were established in the Old Kingdom and continued largely unchanged through the three millennia of ancient Egyptian culture. To be original and innovative was not a goal for ancient Egyptian artists.

The seated statue of Chefren (fig. 2.6), builder of the second pyramid at Giza, was carved of diorite around 2500 B.C., during the Fourth Dynasty. It is a good example of a figure seated on a block. The pharaoh is idealized, his individual characteristics minimized, and his features carved in general terms to suggest power and immortality. He is shown to be a majestic, serene ruler.

Chefren wears a simple kilt and a linen headdress. The hawk or falcon, with wings protecting his head, is a symbol of the god Horus or Ra. This indicates that Chefren is the divine son of the god and is under this god's protection. Chefren probably held a scepter, symbol of divine royalty, in his right hand. He wears a false ceremonial beard, which derives from the idea of a pastoral chieftain carrying a crook and a goat-beard from his flock. The earliest kings are shown dressed in this way, which continued to be the ceremonial royal attire.

The carving technique used by ancient Egyptian sculptors can be deduced from unfinished statues. The front and side profiles were drawn on the block of stone. The sculptor cut along these outlines until they intersected. The angles were rounded off, the forms modeled, and the details carved. The result is a solid piece. Given this method of carving, understandably, all Egyptian statues are essentially symmetrical and **frontal** (they are carved to be viewed from one side only), with a rigid verticality to the body, no bending, no twisting, and little sense of animation.

Mycerinus and Khamerernebty. The double statue of the royal couple Mycerinus and his wife, Queen Khamerernebty (fig. 2.7), carved of slate, ca. 2470 B.C., demonstrates the conventions of representing the standing figure. This is believed to have been the first double statue of its kind made; it set a fashion for showing the pharaoh embraced by, or supported by, the queen. The Queen's revealing dress clings to her contours. The King, in addition to a wrapped linen skirt,

wears a ceremonial false beard and headdress, both symbols of rank.

Certain features seen here are characteristic of all Egyptian standing figures: the frontality, the erect stance with the left foot forward and the arms rigidly against the body, and the sense of vigor and dignity. In spite of both having a foot forward, these stiff figures do not appear to be walking, for weight is equally distributed on both feet. This is not a natural stance; people normally stand with their weight equally on both feet, placed side by side, or, more frequently, stand with their weight supported on one foot.

Because such sculpture was funerary in purpose and was placed in the tomb as a precaution against having no home for the *ka* if the mummy were destroyed, permanence was of great importance—the web of stone

Figure 2.6 Chefren, from Giza, ca. 2500 B.C., Fourth Dynasty, diorite, height $5'6\frac{8}{8}''$ (1.68 m), Egyptian Museum, Cairo. This ka statue portrait of Chefren gives a sense of what the face of the Great Sphinx must have looked like. His firmly anchored, seated pose is traditional in Egyptian sculpture.

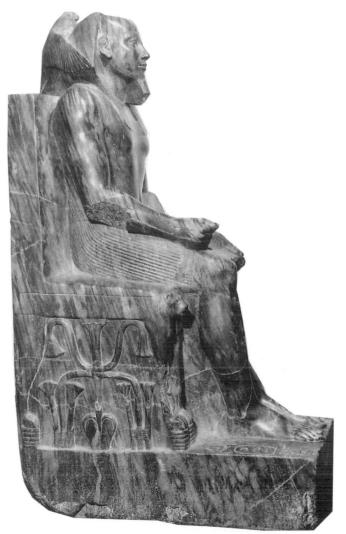

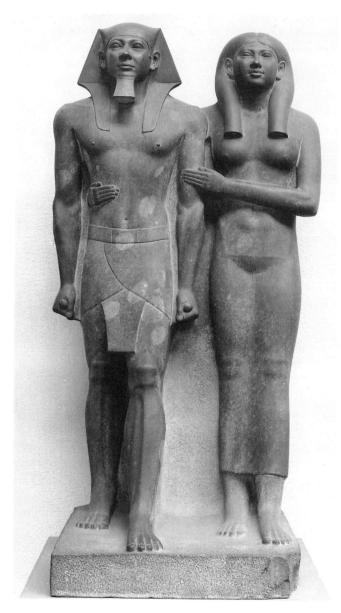

Figure 2.7 Mycerinus and Khamerernebty, from Giza, ca. 2470 B.C., slate, height $4'6\frac{1}{2}''$ (1.38 m), Museum of Fine Arts, Boston. In another common pose the figure stands, one leg forward, yet rigidly erect, weight equally distributed on both feet, and therefore seemingly immobile.

between the Queen and King is intended to prevent breakage. (This statue was actually buried with Mycerinus in his pyramid at Giza.)

Ka-Aper. In Egyptian sculpture, class distinctions are generally made in visual terms by costume and also by physical type. The nobility are idealized and shown in their physical prime. Those of lower social status, however, were evidently permitted to be depicted by artists as aged, physically imperfect, and individualized.

This is demonstrated by the figure of Ka-Aper (also called Sheikh el-Beled) (fig. 2.8), carved ca. 2500 B.C., in

the Fifth Dynasty. It is made of wood. The degree of freedom evident in the pose is the result of working in this material rather than stone and of joining the arms to the torso at the shoulder. The eyes, inset with rock crystal, give a look of bright-eyed vivacity. The figure of Ka-Aper was originally covered with stucco and linen, painted, and also wore a wig. Unlike the sculptures of pharaohs and nobles, he has been individualized and given a fleshy face and full lips. His protruding abdomen shows that he is no longer in his physical prime. Such liberty was afforded to the artist only because Ka-Aper was not of the noble class. The statue was buried in the tomb of Ka-Aper's master: he would continue to serve the king in the spirit world as he had done in life.

Figure 2.8 Ka-Aper (Sheikh el-Beled), from a tomb at Saqqara, ca. 2500 B.C., Fifth Dynasty, wood, height ca. 3'7" (1.09 m), Egyptian Museum, Cairo. Sculpture such as this reveals that the Egyptians were capable of highly realistic representational accuracy, but valued more stylized forms of representation, especially in their depiction of royalty.

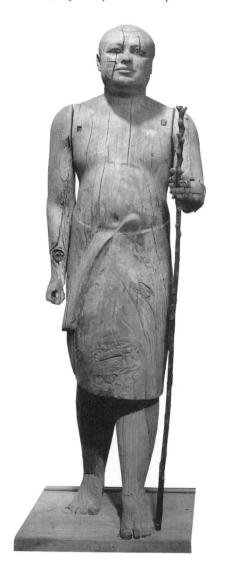

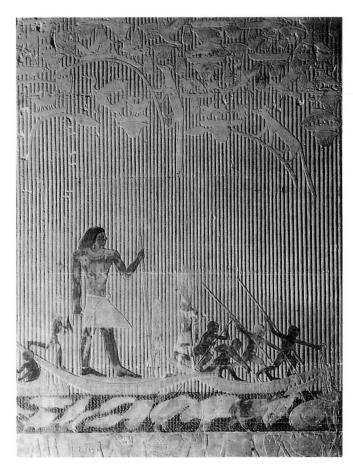

Figure 2.9 Ti Watching a Hippopotamus Hunt, ca. 2500–2400 B.C., Fifth Dynasty, painted linestone wall relief, height ca. 3'9" (1.14 m), Tomb of Ti, Saqqara. Standard conventions of mixed perspective in ancient Egyptian art include depiction of the eye from the front though the head is shown in profile, and the shoulders from the front, though the legs are shown from the side.

RELIEF SCULPTURE AND PAINTING

Relief sculpture and painting were closely linked in ancient Egyptian art, and reliefs were often painted. Clarity in storytelling seems to have been more important to the artist than naturalistic representation. The style, which includes few non-essentials, is condensed and abbreviated. Figures are shown predominantly from the side, although the eye and shoulders are shown from the front. Clearly, these non-anatomical figures are not drawn directly from models but are instead memory images of a composite view of the human body, each part of the body shown from its most characteristic point of view. Egyptian art does not portray what the eye sees, but what the mind knows is there.

Ti Watching a Hippopotamus Hunt. An engaging depiction known as *Ti Watching a Hippopotamus Hunt* (fig. 2.9) was painted on the wall of Ti's tomb in Saqqara, dated ca. 2500–2400 B.C. in the Fifth Dynasty. Ti does

not actually participate in the killing; instead, he stands on a small boat and directs his servants, who hold harpoons. As is traditional, Ti is distinguished from his social inferiors by being made bigger, and his pose combines both frontal and profile views. The water of the Nile River is shown as wavy lines, with fish, hippopotami, and a crocodile shown in profile. The ribbed background represents the papyrus plants along the banks of the Nile. At the top of the painting, where Egyptian artists often put background detail, there are buds and flowers, and birds of various kinds, some of which are being stalked by foxes.

A tomb painting such as this was meant to be seen only by the ka of the deceased—in this case the ka of Ti, whose position was that of "Curator of Monuments." His own final monument, like those of other high-ranking Egyptians, was painted with murals showing him in the afterlife. However, because the afterlife was believed to be a more blissful continuation of real life, it may be assumed that such tomb paintings documented daily life in ancient Egypt—at least in its more pleasant aspects.

To make such a tomb painting, which is actually a painted low relief, the composition was planned with the aid of guidelines. A grid of squares was used to assure symmetry and proper proportion. The figures were sketched and then the background cut away, leaving the design in low relief. If the stone was rough, a thin layer of plaster was applied. The pigments were probably mixed with a gum binder, and were applied with brushes made of reeds. In contrast to paintings familiar from later Western traditions, there is no illusion of light and shadow, and little if any modeling or gradation of tone is used to create an illusion of depth.

THE MIDDLE KINGDOM

After the collapse of the Old Kingdom, a period of political and social turmoil ensued—the first of the so-called "Intermediate" periods of Egyptian history. For over 150 years no single dynasty could reunite the country as Narmer had done a thousand years earlier. Finally, in about 2040 B.C., a prince by the name of Mentuhotep II, from Thebes, managed to subdue both upper and lower parts, inaugurating the Middle Kingdom. The subsequent government was far less centralized than that of the Old Kingdom, with only affairs of national import being left to the king, while much more authority was given to regional governors. Under these new conditions, the country prospered as never before. Large-scale waterworks were undertaken to irrigate higher ground in the Nile basin, and farming yields, which were already higher than anywhere else in the world, increased dramatically.

ARCHITECTURE

During the Middle Kingdom, most building was done in mud brick and, consequently, much of it has now disappeared. A few traces of pyramids remain—they appear to have been similar to those of the Old Kingdom but smaller, and a number of rock-cut tombs, burial places hollowed out of the faces of cliffs, survive. These are to be found at Beni Hasan, located 125 miles up the river from Giza, and were built ca. 2100–1800 B.C., during the Eleventh Dynasty.

The basic plan of these tombs is believed to be similar to that of an Egyptian home of the time. Each tomb consists of a vestibule or portico, a hall with pillars, a private sacred chamber, and a small room at the rear to contain a statue of the dead person. The interior has certain elements that appear to be stone versions of structures originally made of other materials. Thus, although the columns are of stone, the form is that of a bundle of reeds tied together. The ceiling is painted with a diapered and checkered pattern that looks much like the woven matting used to cover houses. The walls are also often painted, though there is a change from Old Kingdom styles discernible here. Instead of military exploits, the paintings now feature depictions of domestic and farm life.

SCULPTURE

During the Middle Kingdom, the traditional types of Egyptian figurative representation were perpetuated—figures sit on a block, stand with one foot forward, or sit cross-legged on the ground. In this conservative society, rigid rules, conventions, and traditions were valued more than innovation. Perhaps the most notable change found during the Middle Kingdom is that the facial expressions no longer have the calm assurance seen in the Old Kingdom; instead, faces look concerned, worried, and

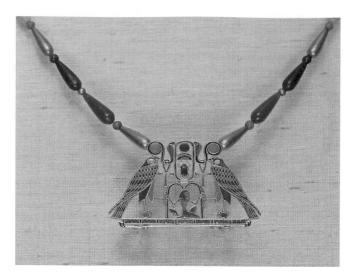

Figure 2.10 Pectoral of Senwosret II, from the tomb of Princess Sithathoryunet, el-Lahun, ca. 1895–1878 B.C., Twelfth Dynasty, gold and semi-precious stones, length $3\frac{1}{4}$ " (8.2 cm), Metropolitan Museum of Art, New York. The scarab beetle that forms part of Senwosret's name is also a symbol of Ra, as well as the idea of rebirth associated with him.

introspective. Perhaps this was in response to the more troubled and uncertain times in which they lived.

One new trend is that Middle Kingdom artists seem to have been particularly adept at making small, highly crafted objects in gold and semi-precious stones. One of the most beautiful is a chest ornament, or pectoral, found at el-Lahun (fig. 2.10). Discovered in the tomb of King Senwosret II's daughter, the pectoral consists of two falcons, which represent Horus, and, above them, two coiled cobras. Between them, in an oval loop, is the hieroglyph for the king's name, consisting of a red sun

Timeline 2.2 Control of ancient Egypt, ca. 3100–1552 B.C.

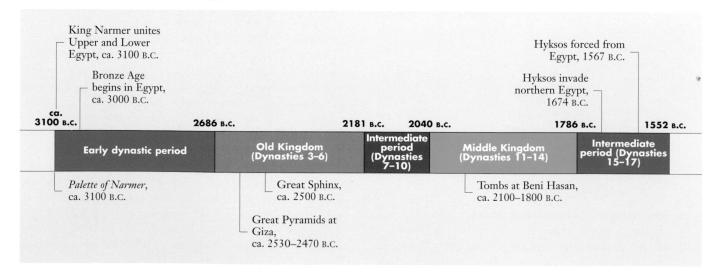

disk, made of carnelian, and below that a scarab beetle. Below this is a male figure helping the falcons support the double arch of palms, a hieroglyph meaning "millions of years." The entire pectoral image may be read, in fact, as a single message. "May Ra grant eternal life to Senwosret II."

THE NEW KINGDOM

After the Middle Kingdom collapsed and a second Intermediate period had begun, an eastern Mediterranean tribe called the Hyksos invaded northern Egypt in 1674 B.C., bringing with them bronze weapons and horse-drawn chariots. For over two hundred years, Egypt was again divided. But beginning in 1552 B.C., the old order was reestablished, perhaps by means of the new technology that the Hyksos tribes had introduced to their unwilling hosts. Certainly, it was through contact with the Hyksos that Egypt entered the Bronze Age. The New Kingdom or Empire that resulted was the most brilliant period in Egyptian history. It was a Theban king, AHMOSE I [AR-mohz], who first pushed back the Hyksos into Palestine, conquering foreign peoples along the way and bringing into being the first Egyptian empire. During the reign of THUTMOSE III [thoot-MOS-uh], (r. 1479-1425 B.C.), the first Egyptian king to be called "pharaoh," Egypt controlled not only the entire Nile basin but the entire eastern Mediterranean coast as far as present-day Syria. The great empire only fell into decline after about 1200 B.C., when it came under the successive influence of Assyria and Libya, and finally lost its independence to Persia in about 525 B.C.

ARCHITECTURE

The New Kingdom established its capital at Thebes, and a great amount of building was done there as well as up and down the length of the Nile. Much art was produced in an exuberant display of wealth and sophistication. Burial was still carried out with great care during the New Kingdom, but the futility of pyramids as places of safe preservation was now fully recognized and accepted. Pyramids, monumental advertisements of the treasures contained within, were irresistibly attractive to robbers and looters—the pyramids were not, after all, very difficult to find. Consequently, nobility and royalty were now buried in chambers hollowed deep into the cliffs on the west bank of the Nile River in the Valley of the Kings at Thebes. Here, rock-cut tombs are approached by corridors up to 500 feet long hollowed straight into the hillside. The entrances were carefully hidden, and rocks were arranged over the entrances to look as if they had fallen there. Many clever tricks and precautions were used by the ancient Egyptians to protect their tombs. In one case, their success lasted until 1922, when the shaft

tomb of Tutankhamen (sometimes referred to popularly today as King Tut) was found nearly intact. All other known tombs were looted in antiquity.

Temple of Queen Hatshepsut. The Old Kingdom has been called the period of the pyramids; the New Kingdom is the time of the temples. The concern for concealment brought about the end of monumental memorial architecture. A mortuary temple of the queen or king would now be built far from the actual tomb. The funerary Temple of Queen Hatshepsut (fig. 2.11), for instance, was built against a cliff at Deir el-Bahari, Thebes, ca. 1480 B.C., early in the Eighteenth Dynasty, by the architect SENMUT [SEN-mut].

In a culture dominated by male kings, HATSHEP-SUT [hat-SHEP-sut] (r. 1478–1458 B.C.) is a figure of some significance. At the death of her husband, Thutmose II, she became regent of Thutmose III, her son-in-law. For the next twenty years, Thutmose III,

Figure 2.11 Senmut, Funerary Temple of Queen Hatshepsut, Deir el-Bahari, Thebes, ca. 1480 B.C., early Eighteenth Dynasty. In the New Kingdom, the body of the queen or pharaoh was buried in a different location from the mortuary temple. That of Queen Hatshepsut was built with terraces, ramps, sculptures, and hanging gardens.

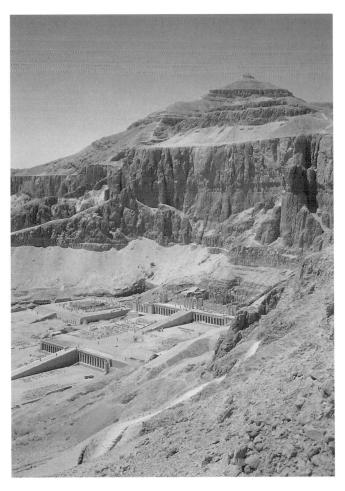

who would later conquer so much of the Mediterranean, was at best something like her prime minister, carrying out her will. The size and magnificence of her temple reflect her political importance.

The huge temple is constructed of repeated elements—colonnaded terraces with columnar porticoes (covered walkways), halls, and private chambers. The three terraces are connected by ramps to the cliff, and chambers are cut into the cliff. These chambers are chapels to the god Amen; to the cow-headed goddess Hathor, who protects the city of the dead; to Anubis, the god of embalming, who protects the dead; and to the Queen herself.

Like all Egyptian buildings, the Temple of Hatshepsut was roofed with stone. As a result, the rooms

are dense forests of statues and square or sixteen-sided support columns—the distance between these supports had to be small enough to span with a stone lintel. Sculpture was used lavishly; there were perhaps two hundred statues in Hatshepsut's funerary temple. The walls were covered with brightly painted low relief. The terraces, now bare, were once filled with gardens.

Temple of Amen-Mut-Khonsu. In the New Kingdom, many temples dedicated to the gods were built, and the priesthood remained powerful. The Temple of Amen-Mut-Khonsu (the god Amen, and his wife Mut, the goddess of heaven, were the parents of Khonsu) at Luxor (figs. 2.12 and 2.13) is one of the largest Egyptian temples. It was built over a long time

Figure 2.12 Temple of Amen-Mut-Khonsu, Luxor, major construction under Amenhotep III, ca. 1390 B.C., and Ramesses II, ca. 1260 B.C. Like all ancient Egyptian temples, this is constructed on the post and lintel system. Columns and capitals look like plant stalks and buds—perishable forms have been made permanent in stone.

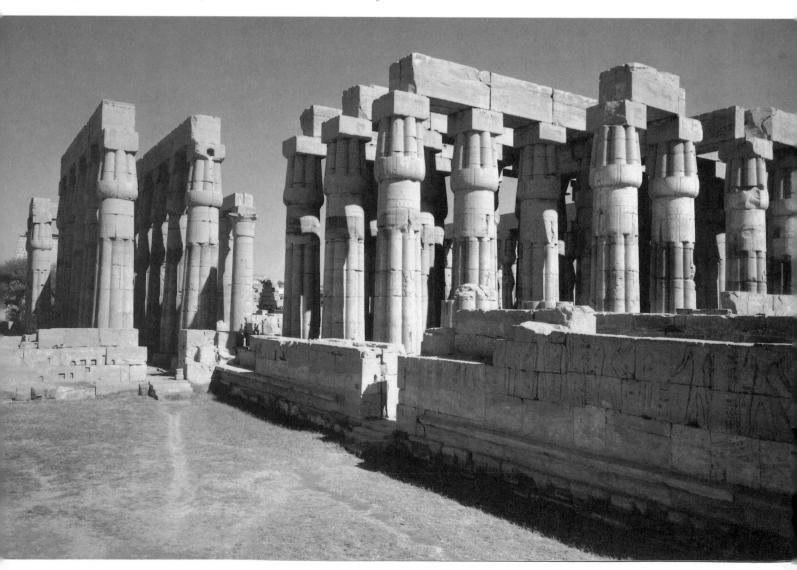

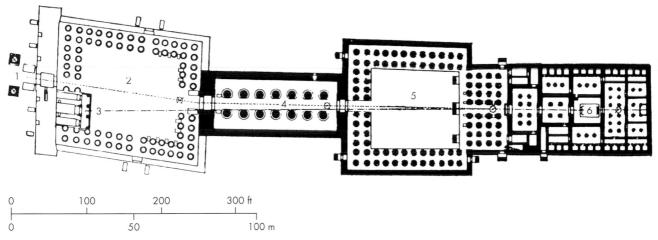

Temple of Amen-Mut-Khonsu, Luxor, plan. (1) entrance, (2) first court, (3) earlier sanctuaries, (4) great hall, (5) second court, and (6) sanctuaries of Amon, Mut, and Khonsu.

period, with major construction under Amenhotep III (r. 1390–1352 B.C.), and under Ramesses II (r. ca. 1279– 1212 B.C.). The temple, which was considered the home of the god, was based on house plans, but made larger and more permanent. The entire temple complex, like many other Egyptian temple complexes, is organized around a longitudinal axis and is essentially symmetrical.

The complex at Luxor consists of a pylon (massive gateway), a forecourt, a hall with pillars, a court, and the actual temple, which is a square room with four columns surrounded by halls, chapels, storerooms, and other rooms. The entire structure was once enclosed by high walls. It was the interior, however, that was most important.

The columns of the temple at Luxor are used for both structure and decorative expression. They are carved in the form of many lotus and papyrus reeds bound together. The effect of the series of bulging convexities is the opposite of the concavities of a fluted Greek column (see Chapter 4). The Egyptian column capitals are bellshaped, similar to an opening flower bud. Leaves might have been painted on—all Egyptian columns are believed originally to have been painted. In addition, papyrus, lotus, and palm leaves were carved on the walls. This choice of decorative subject may be connected with vegetable fertility and the annual resurgence of life in the Nile Valley brought by the sun and river. Archaeologists have established that there was an annual celebration in which bundles of flowers were hung from the posts of the priests' houses.

Much of what is known today about Family Homes. the ancient Egyptians derives from the study of royal tombs; consequently, knowledge of Egyptian life is largely limited to the uppermost levels of society. But at a few sites the homes of everyday people have been unearthed,

and much can be learnt about the lifestyle of average Egyptians from these excavations.

One such site is Deir el-Medina (fig. 2.14), a village that first came into being in the Eighteenth Dynasty as the permanent residence of the tomb builders and artisans who worked across the Nile at Luxor. The city existed for nearly four centuries, through the Twentieth Dynasty, and grew to contain about seventy homes within its walls and fifty outside. The interior layout of each of the houses is relatively uniform. The entrance room, which opened onto the street, was the household chapel, with niches for offerings and an image of the god Bes, a family deity associated with childbirth. Behind this was the main room, with a high roof supported by one or

Site of Deir el-Medina. The main street of the Figure 2.14 original town can be readily seen bisecting the village.

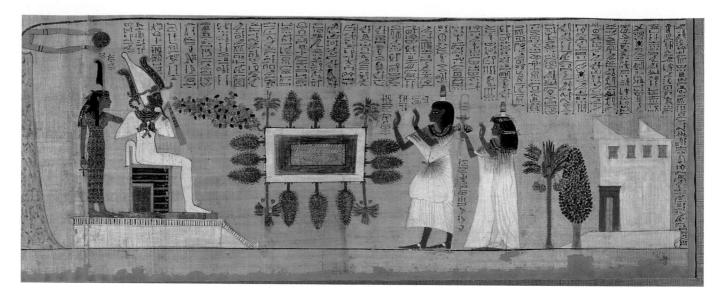

Figure 2.15 House and Garden of the Scribe Nakte, from Nakte's Book of the Dead, Eighteenth Dynasty, British Museum, London. In the New Kingdom, papyrus scrolls that would assist the dead in successfully passing their last test before Osiris prior to enjoying the afterlife were often placed among the wrappings of mummified bodies. Called Books of the Dead, these scrolls were often beautifully decorated.

more columns. A raised platform on one wall served as both an eating area and bed. Beneath this was a cellar. One or two smaller rooms for sleeping or storage led off the main room. At the back of the house was a walled garden, which also served as the kitchen, with an oven in one corner and, nearby, a grain silo and grinding equipment. A staircase led from this courtyard to the roof of the house, where the cool evening breezes of the Nile could be enjoyed. Furniture might have included stools, tables, wooden beds, and lamps made of pottery, containing oil and a wick.

More lavish homes, with large gardens and pools, were built by Egyptians of higher standing. A painting of the home and garden of the royal scribe Nakte (fig. 2.15), from the Eighteenth Dynasty, shows him with his wife, standing before their home, giving praise to the king and queen. Their garden pool is surrounded by trees, including a grape arbor. The house is whitewashed to reflect the heat better. High up on the wall are windows into the main room, and on the roof are two triangular vents designed to catch the evening breezes. The house is elevated on a platform to protect its mud brick from moisture and flood.

SCULPTURE

Temple of Ramesses II. The perpetuation of Old Kingdom types into the New Kingdom is demonstrated at the Temple of Ramesses II at Abu Simbel (fig. 2.16), built ca. 1260 B.C., during the Nineteenth Dynasty. The facade and inner rooms are cut into the sandstone on the

west bank of the Nile. In theory, the temple was built in honor of the sun; there is a statue of the sun god in a niche in the center of the facade. At the top of this facade is a row of dog-headed apes, sacred to the worship of the rising sun. Reliefs and hieroglyphs on the facade also have to do with the pharaoh Ramesses II's respect for the sun god. But all this is overshadowed by the four enormous statues of Ramesses II, each 65 feet high. (The much smaller figures around and between the legs of these statues are members of his family.)

Despite their giant scale, however, these four statues look very much like the statue of Chefren carved more than 1300 years earlier during the Old Kingdom (see fig. 2.6). The pose, physical type, and attire are the same. When they are compared closely, differences between sculpture of the Old, Middle, and New Kingdoms do become apparent: Old Kingdom sculpture is relatively realistic; New Kingdom sculpture is more elegant. But, in view of the enormous timespan, the differences are minor. Once again Egyptian art is seen to be characterized by remarkable uniformity. Art was, for the most part, created by adhering to and perpetuating established forms.

RELIEF SCULPTURE AND PAINTING

As in the Old and Middle Kingdoms, New Kingdom temples and tombs were decorated with reliefs and paintings. There were some innovations, however. For instance, greater freedom of pose, wider variety of movement, more complex figure groupings, and a more

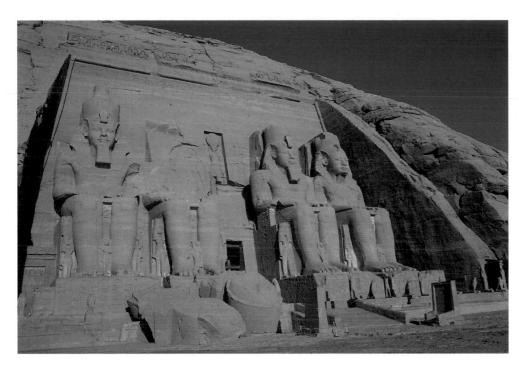

Figure 2.16 Four Seated Figures of Ramesses II, ca. 1260 B.C., Nineteenth Dynasty, Temple of Ramesses II, Abu Simbel, facade. So completely governed by tradition and convention was Egyptian art and culture that, more than 1300 years after Chefren was carved, these figures of Ramesses II demonstrate that the seated figure continued to be depicted in almost exactly the same way.

flowing line are seen in the New Kingdom than in the Old Kingdom. But the basic conventions endure, such as the profile head with frontal eye, the impossible poses, and the arrangement of figures in zones of the register system.

Nobleman Hunting in the Marshes. Nobleman Hunting in the Marshes (fig. 2.17), painted around 1400 B.C., in the Eighteenth Dynasty, from a tomb at Thebes, illustrates this new freedom, as well as the perpetuation of long-established tradition in New Kingdom painting. Active and agile, the nobleman holds three birds in one hand and a wand in the other. Equally impressive is the acrobatic accomplishment of the cat sitting on the bending lotus stems, for she catches one bird with her teeth, another with her claws, and a third with her tail. One bird is catching a butterfly. All people, birds, animals, and fish are shown in profile. The birds neatly form a series of overlapping profiles.

Nobleman Hunting in the Marshes deserves comparison with Ti Watching a Hippopotamus Hunt (see fig. 2.9), painted a thousand years earlier in the Fifth Dynasty. The similarities are striking. Both men are long-haired and wear white skirts. Both of their boats are on rather than in the water. The water is thus not shown realistically but functions as a groundline and is rendered as a series of zigzag lines. In both, people are drawn with the heads and legs seen from the sides, but eyes and chest

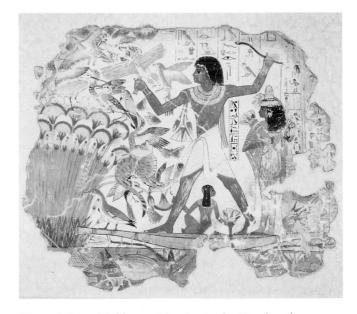

Figure 2.17 Nobleman Hunting in the Marshes, from a tomb at Thebes, ca. 1400 B.C., Eighteenth Dynasty, wall painting on dry plaster, British Museum, London. Created a millennium after the painting of *Ti Watching a Hippopotamus Hunt*, the painting *Nobleman Hunting in the Marshes* demonstrates the remarkable consistency of ancient Egyptian style. Emphasis continued to be placed on the clarity with which information is conveyed rather than on realistic representation.

Connections

DANCE AND MUSIC IN ANCIENT EGYPT

What we know of music and dance in ancient Egypt depends upon two very different kinds of evidence: the visual record of dancers and musicians that we find in surviving reliefs and paintings; and, more problematic, present musical and dance forms that appear to have survived since ancient times. Of the first, we have, for instance, a detail of a wall painting from the tomb of Nebamun at Thebes, dating from about 1400 B.C. (fig. 2.18). It shows four seated women, three of whom are watching and apparently clapping along with music played on a double oboe by the fourth. Two nude figures dance to the music. So relaxed is the scene that most of the conventions of

traditional Egyptian representation have been abandoned.

In addition to the double oboe seen here, Egyptian music made especial use of harps, lutes, and lyres. Surviving paintings often show a blind man playing the harp, but lutes and lyres were apparently played predominantly by women. Single oboes, flutes, and clarinets were also popular, and trumpets were used in military and religious ceremonies. Religious festivals appear to have been primarily musical occasions, and participants routinely danced throughout the celebration.

Many modern Egyptians, as well as scholars, believe that contemporary belly dancing derives from dances such as that seen in the wall painting on the tomb at Nebamun. The belly dance, called the baladi, probably originated in Egypt as part of both fertility and funeral rituals. Like the contemporary belly dance, the original dances may well have been designed to create a sense of physical and emotional rhapsody, and probably utilized many of the same musical effects, particularly everincreasing rhythmic pace and provocative physical movement.

Figure 2.18 Musicians and Dancers, detail of a wall painting from the tomb of Nebamun, Thebes, ca. 1400 B.C., fragment, $11\frac{3}{4} \times 27\frac{1}{4}$ " (29.9 × 69.2 cm), British Museum, London. The two central figures, the one playing the reeds and the seated figure next to her, are remarkable in the way that they face the viewer, a point of view rarely seen in Egyptian painting.

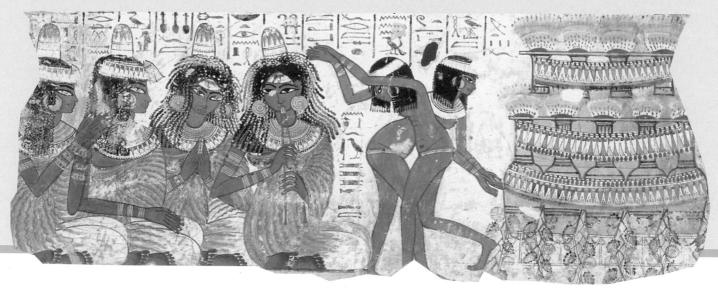

from the front. The continued use of relative size to indicate importance is shown by the small figure between the nobleman's legs; she cannot be interpreted as being in the distant background, for she grasps his shin.

AKHENATEN AND TUTANKHAMEN

The sole significant challenge—and it proved only a temporary deviation—to Egypt's consistency of attitude and approach to representation and design came in the Eighteenth Dynasty under Amenhotep IV [am-EN-oh-TEP] (r. 1352–1336 B.C.). He closed the Amen temples, displaced the sun god Amen-Ra, officially dispensed with the pantheon of other Egyptian gods, and replaced them all with a monotheistic system, worshiping the single god Aten, the sun disk. In this, his innovations seem to have anticipated the ideas of the later Hebrew and Christian religions. He moved the capital from Thebes to a new city far to the north that he called Akhetaten, "the horizon of Aten," modern-day Tell el-Amarna. He then changed his name as well, to Akhenaten [AK-uhn-AHtan], which means "He who is effective on behalf of Aten." Just as significantly he transformed the art of Egypt, liberating it from convention. Akhenaten has been described as a mystic, a dreamer, a religious fanatic and pacifist, who was not sufficiently materialistic to be a ruler. Egypt, set in thousands of years of tradition, did not easily accept his revolutionary ideas. In particular,

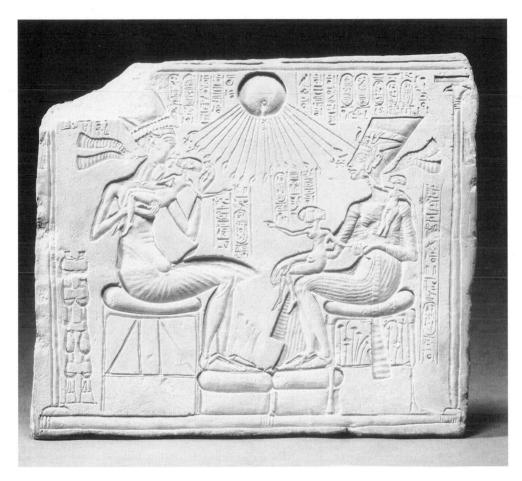

Akhenaten, Nefertiti, and Their Children Worshiping the Sun, ca. 1348–1336 B.C., Eighteenth Dynasty, painted limestone relief, $12\frac{1}{4} \times 15\frac{1}{4}$ (31.1 × 38.7 cm), Staatliche Museen zu Berlin, Preussischer Kulturbesitz, Ägyptisches Museum. The only significant break in the continuity of Egyptian life were the changes—political, religious, and artistic—instituted by the pharaoh Akhenaten in the Eighteenth Dynasty.

these posed a serious challenge to the influence of the priests. When Akhenaten died, Egypt thus returned to a polytheistic faith, the capital returned to Thebes, and artists began to return to the old conventions.

Nefertiti, and Their Children Akbenaten, Worshiping the Sun. This painted limestone relief (fig. 2.19), dated 1348-1336 B.C., represents an extraordinary change from traditional Egyptian art. Akhenaten and his Queen, Nefertiti, play with their three daughters, who are shown as miniature adults. Akhenaten even kisses one of his children, a rare display of affection in Egyptian art. These people are shown in easy poses. More notable, however, are their physical distortions long necks and skulls, protruding abdomens, and large hips, presumably shown to create a likeness. Although royalty, Akhenaten and his family are not idealized, perfect physical types. This departs from the rigidity and formality of earlier Egyptian art. Royalty is now depicted in domestic situations, casually, intimately. Rather than stressing dignity, this art is playful and informal.

All depictions of Akhenaten show this peculiarly exaggerated physique, distorted to the point of caricature. But as all depictions show the same distortion, it cannot have been totally due to the artists' creativity. In fact, if the bones that archaeologists believe to be his actually are his, Akhenaten may have suffered from a rare medical condition that results in the elongated skull, broad hips, and slouching posture with which he was routinely portrayed.

Queen Nefertiti. Akhenaten's wife, the beautiful Queen Nefertiti (fig. 2.20), was recorded in a lifesize portrait in 1348-1336 B.C., carved of limestone and painted, the eyes inlaid with rock crystal. Discovered in 1912 in the studio of Thutmosis, Akhenaten's chief sculptor, this individualized portrait is characteristic of the more informal, relaxed style of Akhenaten's reign. The carving of this charming portrait is sensitive and refined, and its beauty is probably not exaggerated. Surviving texts refer to the Queen as "Fair of Face," "Great of Love," and "Endowed with Favors."

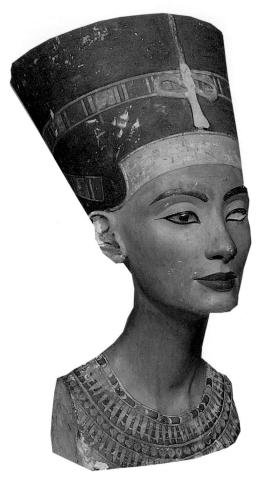

Figure 2.20 Queen Nefertiti, ca. 1348–1336 B.C., Eighteenth Dynasty, painted limestone, rock crystal eyes, height 20" (50.8 cm), Staatliche Museen zu Berlin, Preussischer Kulturbesitz, Ägyptisches Museum. Although ideals of beauty have changed greatly throughout time, the appeal of Nefertiti, elegant wife of Akhenaten, endures.

Queen Tiy. Nefertiti contrasts dramatically with Akhenaten's mother, Queen TIY [TIE], whose likeness is known from a miniature portrait head (fig. 2.21). Probably the work of Yuti, her personal sculptor who had his studio within the precincts of the royal palace, her powerful and determined expression is in keeping with the realism favored by her son. Queen Tiy was, in fact, a powerful political force, who as chief wife of Akhenaten's father, Amenhotep III, exerted considerable influence throughout the Eighteenth Dynasty.

Tomb of Tutankhamen. Akhenaten's successor was TUTANKHAMEN [too-tan-KAH-moon] (r. ca. 1336–1327 B.C.), at the end of the Eighteenth Dynasty. Tutankhamen was married to one of the daughters of Akhenaten and Nefertiti. However, as king, Tutankhamen disavowed his parents-in-law and returned to the worship of Amen, reestablishing the capital at Thebes. But Tutankhamen's fame today derives from the discovery of his tomb, nearly intact and containing an extraordinary treasure, in the early 1920s by the British archaeologist Howard Carter. Tutankhamen's tomb, which was uncovered in the Valley of the Kings near Thebes, consisted of a corridor-like shaft leading to four decorated rooms.

From this tomb comes the inner coffin of Tutankhamen's sarcophagus (fig. 2.22), made of polished gold about a quarter of an inch thick, inlaid with enamel and semi-precious stones, $72\frac{7}{8}$ inches long, and weighing 250 pounds. This alone makes clear why tombs were sacked. Tutankhamen was probably between eighteen and twenty years old when he died from a blow to the head. Despite the brevity of his reign, this minor ruler was buried in a sarcophagus that contained three coffins, one inside another, the outer two of wood covered with gold sheets, and the innermost one made of solid gold.

Timeline 2.3 Control of ancient Egypt, 1552–525 B.C.

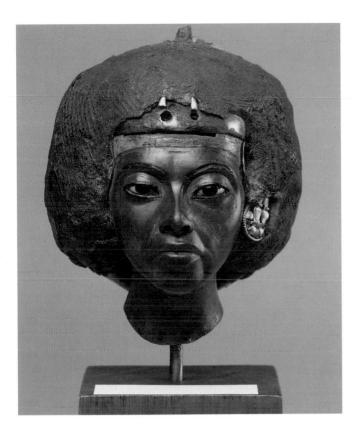

Figure 2.21 Queen Tiy, from Kom Medinet Ghurab, ca. 1390–1352 B.C., Eighteenth Dynasty, boxwood, ebony, glass, gold, lapis lazuli, cloth, clay, and wax, height $3\frac{3}{4}''$ (9.4 cm), Staatliche Museen zu Berlin, Preussischer Kulturbesitz, Ägyptisches Museum. The realistic depiction of royalty characteristic of the reign of Akhenaten is evidenced by this portrayal of his politically powerful mother, Queen Tiy.

LITERATURE: LYRIC POETRY

The literature of the ancient Egyptians is not as readily available as their art and architecture. Less literature has survived, and most of what remains exists only in scattered fragments. The oldest Egyptian poems, dating from ca. 2650–2050 B.C., are religious. Most are incantations and invocations to the gods to aid the departed Egyptian kings. But one of the most important Egyptian religious poems is the pharaoh Akhenaten's "Hymn to the Sun." In this poem, Akhenaten presents himself as the son of Aten, and then describes the sun's rising:

Earth-dawning mounts the horizon, glows in the sun-disk as day:
You drive away darkness, offer your arrows of shining, and the Two Lands [Upper and Lower Egypt] are lively with morningsong.

Sun's children awaken and stand, for you, golden light, have upraised the sleepers; Bathed are their bodies, who dress in clean linen,

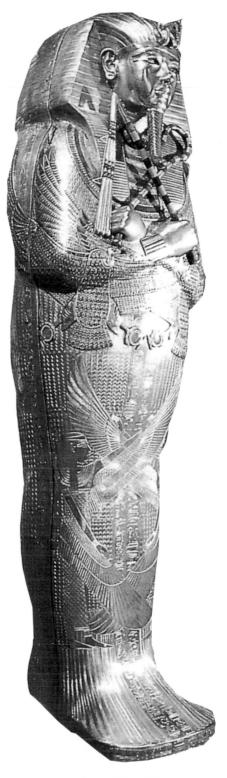

Figure 2.22 Inner coffin of Tutankhamen's sarcophagus, ca. 1336–1327 B.C., polished gold, inlaid with enamel and semi-precious stones, height $6'\frac{7}{8}''$ (1.85 m), weight 250 lbs., Egyptian Museum, Cairo. Akhenaten's successor, popularly known today as King Tut, was a minor ruler who died young. Yet the splendor of his burial indicates the care lavished upon the burial of royalty, as well as the reason why tombs were plundered by grave robbers.

Cross Currents

ANCIENT EGYPT IN THE EUROPEAN IMAGINATION

Of the "Seven Wonders of the World" first listed by Greek authors in the second century B.C., only the pyramids at Giza survive. Perhaps because of this, they have come to symbolize in Western consciousness what is perhaps the closest thing to eternity on earth.

As a twelfth-century Arab historian put it: "All things fear time, but time fears the pyramids." When Napoleon Bonaparte attacked Egypt in 1798, in order to cut off England's lifeline to India, he inspired his troops on the day of one of the most famous battles in history, the Battle of the Pyramids, with the words: "Soldiers, forty centuries look down upon you."

Figure 2.23 Hubert Robert, *The Pyramid*, 1760, oil on wood, $4' \times 4'2\frac{1}{4''}$ (1.22 × 1.28 m), Smith College Museum of Art, Northampton, Massachusetts. Robert's work was painted amidst a general revival in France of monumental Egyptian architecture, particularly of funerary monuments, many of which were proposed in competitions organized by the French government, but none of which was ever built.

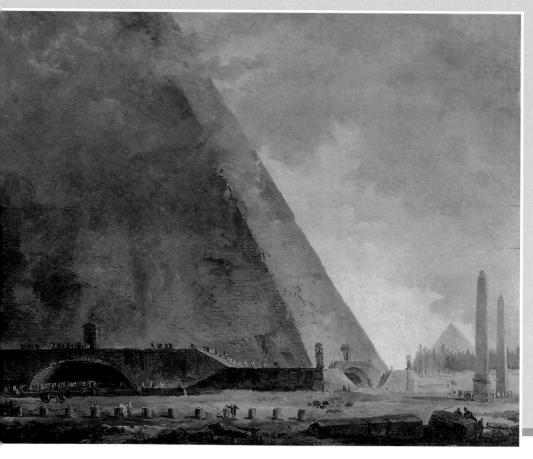

The Frenchman Hubert Robert's 1760 painting The Pyramid (fig. 2.23) captures another of its aspects: not only was it eternal, it was colossal. Robert's painting overstates its scale: the figures that approach it are minuscule and the pyramid itself disappears off the canvas into the clouds and airy mists, like a Himalayan peak, as if the painting cannot contain it. But Robert does capture something of its emotional power. Unable to perceive its bounds, we realize we are in the presence of something that approaches, imaginatively at least, the infinite—what eighteenth-century writers would call the "sublime."

The sublime is both spiritual—an earthly manifestation of God—and terrifying, because it makes our own being seem so insignificant and ephemeral. Probably no writer in the nineteenth century summed up the ability of Egyptian art to so move us better than the English poet Percy Bysshe Shelley, whose poem "Ozymandias" is based on a statue in the mortuary temple of Ramesses II:

I met a traveler from an antique land,
Who said: Two vast and trunkless legs of stone
Stand in the desert ... Near them, on the sand,
Half sunk, a shattered visage lies, whose frown,
And wrinkled lip, and sneer of cold command,
Tell that its sculptor well those passions read
Which yet survive, stamped on these lifeless
things

The hand that mocked them, and the heart that fed,

And on the pedestal these words appear:
"My name is Ozymandias, king of kings:
Look on my works, ye Mighty, and despair!"
Nothing beside remains. Round the decay
Of that colossal wreck, boundless and bard
The lone and level sands stretch far away.

their arms held high to praise your Return. Across the face of the earth they go to their crafts and professions.

Other ancient Egyptian poems of interest include "The Song of the Harper" (ca. 1160 B.C.) and a series

of lyrics composed between ca. 2000 and 1000 B.C., especially the love poems written during the late Rameside period (ca. 1300–1100 B.C.). The harper's song differs from Egyptian religious poetry in emphasizing the joys and pleasures of life. The spirit of the poem anticipates later Roman poetry that emphasizes the enjoyment

of life's pleasures in an attitude of carpe diem (seize the day).

All who come into being as flesh pass on, and have since God walked the earth; and young blood mounts to their places.

The busy fluttering souls and bright transfigured spirits who people the world below and those who shine in the stars with Orion, They built their mansions, they built their tombs—and all men rest in the grave.

So, seize the day! hold holiday!

Be unwearied, unceasing, alive,
you and your own true love;

Let not your heart be troubled during your sojourn on
earth,
but seize the day as it passes!

As with later Greek and Roman love poctry, and the nearly equally ancient love poetry of the Hebrews (the biblical Song of Songs), ancient Egyptian love poems display a wide range of mood and feeling. Written on limestone as well as on papyrus, these ancient love poems reflect attitudes that appear strikingly modern.

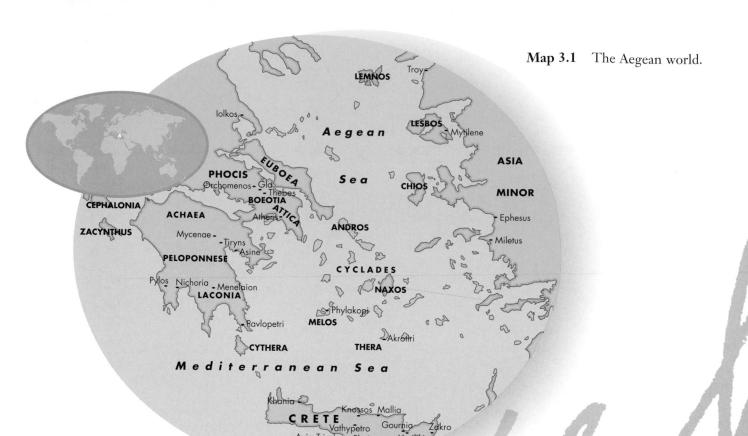

AEGEAN CULTURE AND THE RISE OF ANCIENT GREECE

CHAPTER 3

- ← Aegean Cultures
- ← The Rise of Ancient Greece

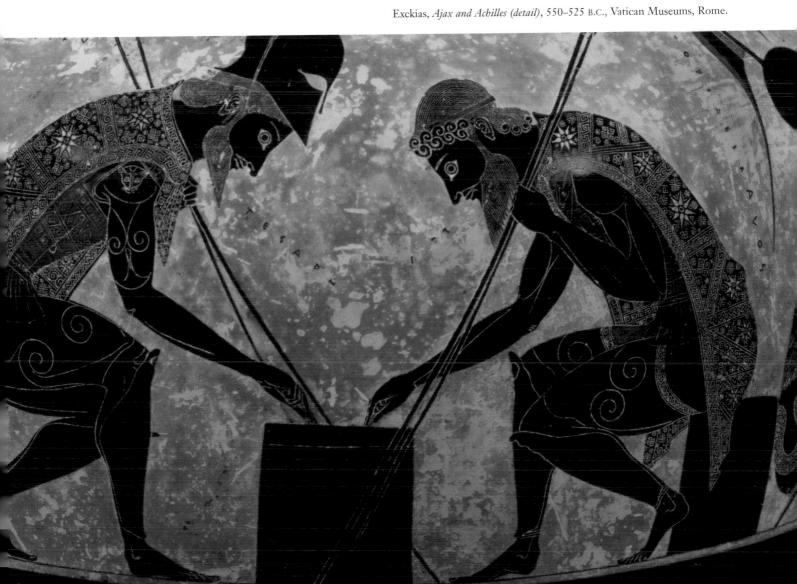

AEGEAN CULTURES

We now know that between approximately 3000 and 1100 B.C., prior to the rise of the Greek city-states, a number of cultures flourished along the coasts of the eastern Mediterranean and on the islands in the Aegean Sea. However, until about 1870, the existence of these cultures-Troy in Anatolia, Mycenae on mainland Greece, and Knossos on Crete-was considered more likely than not the creation of one poet's imagination. For the principal evidence for these great early cultures was to be found in Homer's Greek epics, The Iliad and The Odyssey. But when the archaeologist HEINRICH SCHLIEMANN [SHLEE-man] (1822-1890) first uncovered Helen's Troy and, subsequently, Agamemnon's Mycenae, and then, in 1899, when SIR ARTHUR EVANS (1851-1941) uncovered the labyrinth of Knossos on Crete, it became clear that the world of Homer's Iliad and Odyssey had really existed. More important still, it seemed that the stories and myths from

Figure 3.1 Statuette of a woman, third millennium B.C. marble, height $24\frac{3}{4}$ " (62.9 cm), Metropolitan Museum of Art, New York. This flattened physique forms a striking contrast to the bulbous body of the prehistoric *Woman of Willendorf* (see fig. 1.3). Yet this Cycladic figure, and others like it, are also thought to have been connected with early beliefs about human fertility.

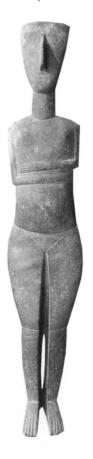

these Bronze Age civilizations were, at some deep and important level, the basis of later Greek traditions and beliefs. Three civilizations rose to dominance in quick succession in this early Aegean period: the Cycladic culture on the Cyclades islands, the Minoan culture centered on the island of Crete, and the Mycenaean or Helladic culture on the Greek mainland.

Early Aegean culture was dominated by one important geographical factor, the Aegean Sea itself, which was dotted with over a thousand islands and could be sailed with confidence long before the development of sophisticated navigational equipment. What appears to have been a rich maritime culture developed. The Minoans certainly traded with mainland Greece, especially with the city of Mycenae. There is also evidence of commerce with Egypt. Surviving tablets found at Knossos on Crete are written in two different scripts known as Linear A and Linear B. The first of these remains undeciphered, although there are indications that it may have originated in Phoenicia, present-day Lebanon. Such linguistic influence again suggests trade contacts. The second script, Linear B, which has been dated to before 1460 B.C., was deciphered in 1952 by an English scholar, who discovered it to be an early version of Greek. It has also been found on similar tablets across Greece and at Mycenae itself. Two important conclusions can be drawn from this. In the first place, Mycenaeans must have occupied Crete by 1460 B.C. Second, and more important, is the suggestion that by around this date the Aegean cultures shared a common, Greek language.

CYCLADIC CULTURE

The most ancient of the Aegean civilizations developed in the Cyclades in the second half of the third millennium B.C. (2500-2000 B.C.). It continued to thrive, probably under the influence of the Minoan civilization in Crete, to the south, until the middle of the second millennium B.C. It has been suggested that the "lost" island of Atlantis may have been the Cycladic island of Thera, the majority of which disappeared into the sea in 1623 B.C. when the five-thousand-foot volcano situated on it erupted. Evidence of the eruption has recently been found in tree rings as far away as Ireland and California, as well as deep in the ice core of Greenland. On one of the remaining sections of the original island, at a site named Akrotiri, excavations that were initiated in 1967 have revealed a rich and apparently highly inventive civilization buried under fifteen feet of ash.

Until this site was explored, however, the majority of known artifacts from the Cyclades were statuettes found in tombs. Many of these figures were carved of marble in Cycladic workshops during the third and second millennia B.C. They range in size from a few inches to lifesize. The marble statuette of a nude female with her arms crossed over her body (fig. 3.1) is characteristic of most

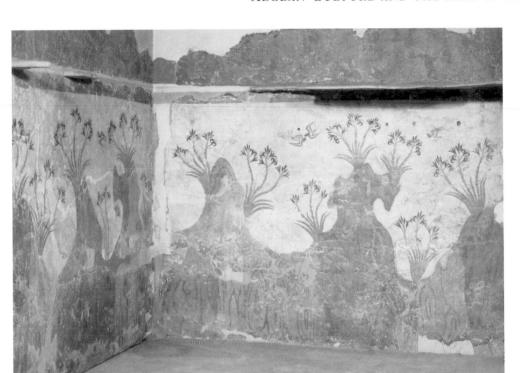

Figure 3.2 Landscape, wall painting with areas of modern reconstruction, from Akrotiri, Thera, Cyclades, before 1630–1500 B.C., National Archaeological Museum, Athens. Recently discovered at Akrotiri on Thera, these murals show an affection for nature—though the subjects are by no means copied literally. Rather, nature's forms have been translated by the painters into a colorful, rhythmic decoration. The result is quite unlike anything else known from antiquity.

extant examples of Cycladic art. The only indication of attire or jewelry are lines incised at the neck. Although the legs are together and straight, the figure was not made to stand up. These Cycladic figures are presumed in general to represent the Mother Goddess, bringer of fertility and the major deity in the ancient Aegean. Since they were often buried with people, they are also presumed to have had a part in the funeral ritual.

The non-naturalistic anatomy of the carving is characteristically Cycladic. An angular torso is flattened and two-dimensional, while a cylindrical neck supports an oval head, flattened on top, with receding forehead. The eyes would probably have been painted on, and lips and ears may have been carved in relief. But the most notable facial feature is the particularly prominent nose. The proportions of the Cycladic figures vary somewhat—some are rounder, others more angular, the shoulders and hips broader or narrower. The pose, however, is unvarying. The refined geometric simplicity of these statuettes appears almost modern. A sort of minimalist approach to the body is evidenced by these extremely simple, yet extremely sophisticated, figures.

A number of wall paintings recently discovered at Akrotiri on Thera include a landscape unlike any other known to have survived from antiquity (fig. 3.2).

Swallows fly above a landscape consisting of a series of jagged peaks, with giant plumes of red lilies erupting from their tops and sides. It is thought that the art of wall painting was probably brought to the Cyclades from Crete soon after 1700 B.C., but nothing like this work is known in Minoan culture.

MINOAN CULTURE

According to later Greek myth, the Minoan civilization on the island of Crete was created by an offspring of Zeus, the chief deity in the Greek pantheon of the gods. Zeus's main characteristics include his ability to change his physical form and his attraction to mortal women. On one occasion, Zeus is said to have fallen in love with Europa, a Phoenician princess. He therefore transformed himself into a beautiful white bull and approached Europa who, entranced by the creature, climbed onto its back. In a scene depicted by the Venetian painter Titian in the sixteenth-century painting The Rape of Europa (see fig. 15.23), Zeus immediately flew up into the sky with his prey. According to the myth, the product of their union was King Minos, the founder of the civilization on Crete. It was after this king that the archaeologist Sir Arthur Evans later named

Minoan civilization. Evan's archaeological work established that life had flourished on the island between around 2800 B.C. and 1400 B.C., a period that Evans subdivided into three main phases—Early Minoan, Middle Minoan, and Late Minoan. It was with the beginning of the Middle Minoan phase, ca. 2000 B.C., that the civilization appeared to have developed significantly, at which time a series of large urban centers grew up on the island at Knossos, Phaistos, Mallia, and Zakro.

The Minoans were sailors and traders. Crete, which is the largest of the Aegean islands, nearly 150 miles in length, was provided with natural protection by the sea; life was secure on this idyllic island. Consequently military subjects are rarely found in Minoan painting and sculpture, and Minoan architecture is not fortified. Moreover, the extant Minoan architecture is largely domestic and secular, for although religion appears to have played an important cultural role, temples do not seem to have been a part of it. The most significant architectural remains are generally referred to as palaces, although they appear to have served a wide variety of functions beyond simply housing the ruling families.

The Palace of Minos. The major surviving Minoan architectural monument is the so-called Palace of Minos at Knossos (fig. 3.3), built between 1700 and 1300 B.C. The palace was continually modified—parts were added, demolished, and reconstructed, until the arrangement seemed to be without a plan. It was also enormous, once covering six acres and including 1300 rooms. Built around a central courtyard and several smaller courtyards, the palace is a seemingly arbitrary accumulation of rooms linked together by corridors, highly irregular and confused in layout (fig. 3.4). The Greeks later referred to

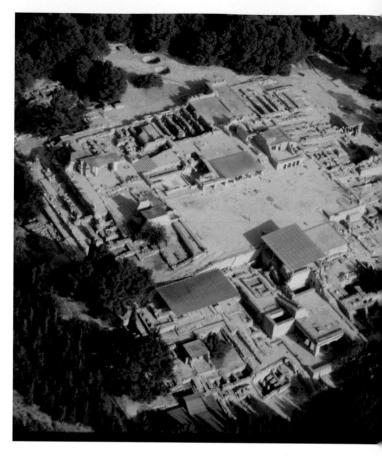

Figure 3.3 Palace of Minos, Knossos, Crete, ca. 1700–1300 B.C. Built on a site that receives cool sea breezes even in mid-summer, the palace is decorated with delicate and colorful wall-paintings that feature aquatic motifs.

Timeline 3.1 Cycladic and Minoan cultures.

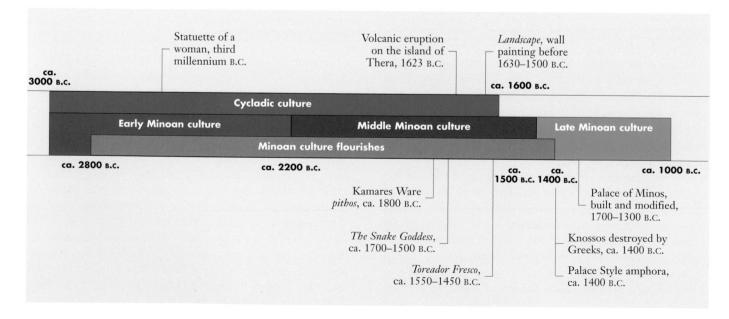

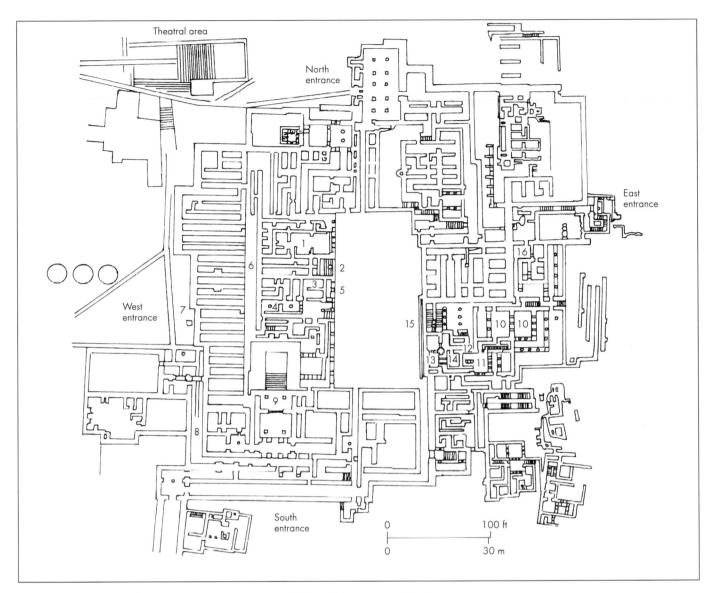

Figure 3.4 Palace of Minos, Knossos, Crete, ca. 1700–1300 B.C., plan: (1) throne room; (2) staircase; (3) temple repositories; (4) pillar crypt; (5) main shrine; (6) corridor access to magazines; (7) altars; (8) corridor of the processions; (9) staircase; (10) Hall of the Double Axes; (11) Queen's Hall; (12) bathroom; (13) lavatory; (14) storeroom; (15) Great Staircase; (16) lapidary's workshop.

it as the "Labyrinth," meaning literally the House of the Double Axes (from the Greek *labyrs*, "double ax"). Over time, however, the word *labyrinth* has taken on the meaning of "maze."

Open and airy, the palace was constructed with many porticoes, staircases, airshafts, and lightwells (uncovered vertical shafts in buildings allowing light into the lower stories), and built on several levels and in several stories—up to five stories in some areas. But the room ceilings were low and, consequently, the palace never rose very high. The wall surfaces were stuccoed and covered with frescoes.

The Minoans built with an unusual and distinctive type of column. The Minoan column is referred to as an

"inverted" column because, unlike the later Greek column, it tapers downward, the diameter being smaller at the bottom than at the top. The columns were made of wood rather than stone and were painted bright red. They stood on simple stone bases and were topped by bulging cushion-shaped capitals (fig. 3.5). Replicas now line the Great Staircase of the palace at Knossos. This impressive staircase once served as a lightwell and gave access to all five stories of the palace.

The basement of the palace was the storage area for food, supplies, and valuables. Some of the earthenware storage vases remain in place. These huge **pithoi** (singular, **pithos**) were used to store oil, grain, dried fish, beans, and olives. The palace was a self-sufficient unit

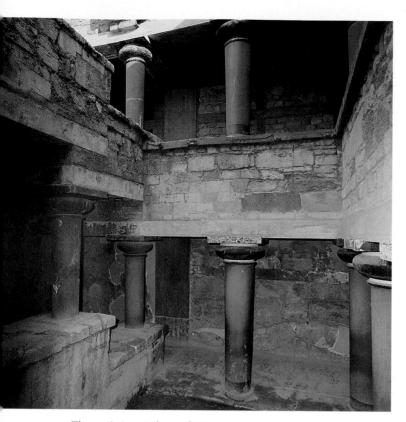

Figure 3.5 Palace of Minos, Knossos, Crete, ca. 1700–1300 B.C., staircase in east wing with "inverted" columns. Structurally as sound as the usual column shape that tapers to the top (compare the columns on the ancient Greek Parthenon, fig. 4.5), this "inverted" shape, which tapers toward the bottom, is a characteristic of Minoan architecture.

that included oil and wine presses as well as grain mills. Highly valued items, such as those made of gold and other precious materials, were stored beneath the floor of the basement. These objects were placed in carefully cut holes lined with stone slabs.

Because of today's tendency to judge other cultures on the basis of their plumbing and level of sanitation, it may also be worth mentioning that the palace had fine bathrooms with decorated terra cotta bathtubs, as well as good plumbing and an effective sewage system.

The Myth of the Minotaur. The story of the labyrinth or maze at Knossos has an honored place in later Greek mythology. According to legend, Minos's queen, Pasiphae, was seduced by a bull belonging to Poseidon, the god of the sea. The fruit of their union was the Minotaur, part man, part bull, whom Minos consigned to the maze designed by his chief artist and architect, Daedalus. The Minotaur had a huge appetite for human flesh, and to satisfy him King Minos ordered the neighboring subject city of Athens to pay a yearly tribute of seven young men and seven young women for sacrifice to the Minotaur. The Athenians were understandably

upset at the order, and so Theseus, the son of the Athenian king Aegeus, offered to accompany the fourteen to Crete, where he vowed to kill the Minotaur. As was the custom, the group set out for the island in a ship with black sails. If Theseus was successful, he vowed to his father to return flying white sails instead.

Upon his arrival in Crete, Theseus quickly won the affection of the Minoan princess Ariadne. She provided him with a sword with which to kill the Minotaur and a ball of thread to mark his path so that he would then be able to find his way out of the labyrinth. Theseus succeeded in his mission and sailed back to Athens with the relieved would-be victims. However, he forgot to replace his black sails with white ones. His father Aegeus, seeing the black sails, cast himself into the sea in despair (and by this act apparently gave the Aegean Sea its name). With the death of his father, Theseus became king of Athens himself.

The Minotaur is a characteristically Minoan mythical creature. The bull is known to have been a sacred animal on Crete, important in ceremonial and religious activities. The frequent depictions of bulls in Minoan art may be assumed to have had a religious and/or ritualistic significance. Bull's horns, some large, some small, carved of stone, were erected at the Palace of Minos. They are referred to as "horns of consecration" and are believed by archaeologists to be religious symbols, denoting sacred spots and objects.

The Toreador Fresco. The Minoans made lavish use of wall paintings. The most famous example features the sacred bull. This is the *Toreador Fresco* (fig. 3.6), which was painted around 1550–1450 B.C. in the Palace of

Figure 3.6 Toreador Fresco, from the Palace of Minos at Knossos, Crete, ca. 1550–1450 B.C., wall painting, height with border ca. $24\frac{1}{2}$ " (62.2 cm), Archaeological Museum, Herakleion (Iraklion), Crete. The importance of the bull in Minoan culture is evidenced by this display of bull-vaulting. In spite of extensive restoration, the delicacy and lively animation typical of Minoan wall painting remains evident.

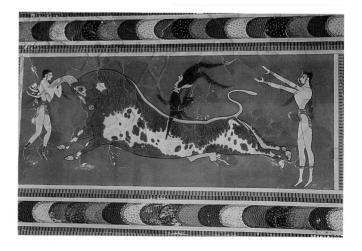

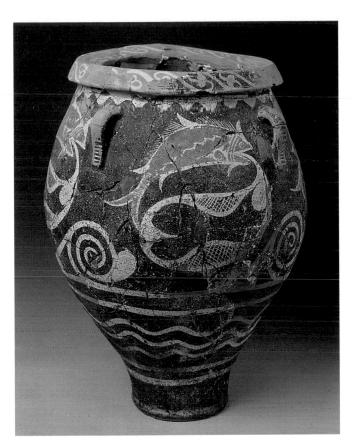

Figure 3.7 Kamares Ware spouted three-handled *pithos*, with fish, from Phaistos, Crete, ca. 1800 B.C. terra cotta, height $19\frac{7}{8}$ " (50 cm), Archaeological Museum, Herakleion (Iraklion), Crete. Kamares Ware, identified by its color, was often decorated with aquatic motifs—in accord with the artists' island home.

Minos at Knossos. The dark areas are original; the rest is restoration. The activity depicted here is bull-vaulting, in which a person jumps over a running bull's back. As the painting illustrates, when the bull charges, the jumper must "take the bull by the horns," so to speak, vault onto its back, and hope to land standing up like the figure on the far right of this painting. Despite the fact that there are other representations of this activity, the purpose of bull-vaulting remains unclear. It may have been a means of sacrificing people or it may have been an early form of bullfighting. Whether this was a ritual or a sport remains uncertain. It has even been questioned if the acrobatic feat depicted is actually possible, but no one has come forward with an offer to prove it one way or the other.

Ceramic Ware. Painting, in several distinctive styles, was also done on Minoan ceramic objects. The most important styles of Minoan ceramic painting are known as Kamares Ware and the Palace Style. A spouted, three-handled pithos (fig. 3.7), decorated with fish and made ca. 1800 B.C., is an example of Kamares Ware,

which is distinguished by its color: a dark purplish-brown background is painted with chalk-white and touches of orange-red. Dynamic and decorative swirls, spirals, and S-shapes are typical motifs on Kamares Ware ceramics. The forms flow—wave patterns were popular with the sea-faring Minoans, as were other marine and plant torms. Kamares Ware pieces are heavy, with thick walls and asymmetrical shapes.

The Palace Style, which dates from approximately 1600 to 1300 B.C., is represented by a three-handled amphora, with naturalistic lilies and papyrus (fig. 3.8), made ca. 1400 B.C. from Knossos. Like Kamares Ware, the Palace Style is characterized by graceful forms that derive from nature. But unlike Kamares Ware decoration, the forms do not flow over the surface of the vase. Instead, the plants seem to grow up the side of the vase. Palace Style decoration is more delicate than that of

Figure 3.8 Palace Style three-handled amphora, with lilies and papyrus, from Knossos, Crete, ca. 1400 B.C., terra cotta, Archaeological Museum, Herakleion (Iraklion), Crete. In Palace Style, as in Kamares Ware, forms of nature are used as inspiration for decorations. However, rather than swirling over the surface, in Palace Style the decoration appears to grow up the vase.

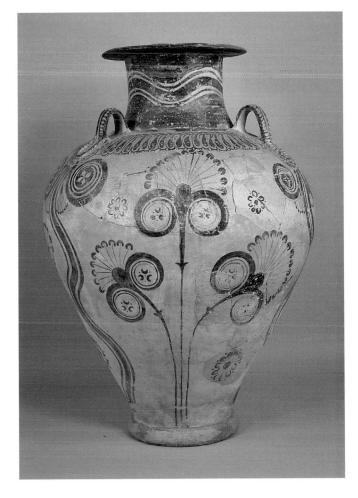

Then & Now

THE SNAKE GODDESS

The efforts of the Feminist movement in the United States and Europe in the late 1960s and early 1970s gave rise not only to a vast array of social and political reforms but to revisions of historical interpretation as well. Most art history texts before the early 1970s, reflecting the social balance within the society that produced them, paid little or no attention to art by women. and most works of art were viewed from a particularly male perspective. Attempting to redress the balance, Feminist historians became especially interested in the art of Aegean civilizations because it seemed that artifacts such as the Minoan Snake Goddess (see fig. 3.9) were the products of a matriarchal culture in which women, rather than men, played the dominant

Key to this theory is a 1976 book by Merlin Stone entitled *When God Was* a *Woman*. "It was quite apparent", Stone wrote, describing her research into Aegean culture, "that the myths and legends that grew from, and were propagated by, a religion in which the deity was female, and revered as wise, valiant, powerful and just, provided very different images from those which are offered by the male-oriented religions of today." If it was a male, King Minos, for example, who exercised governmental authority, it was perhaps the female goddess who exercised spiritual and moral authority in Crete.

Recent scholarship suggests that the "demonization" of woman in Western thought dates from after the invasion of the Aegean basin by warlike tribes from the north who brought with them strong patriarchal traditions. This demonization is reflected in the Greek transformation of the Minoan Snake Goddess into the mythic figure of the Medusa, whose hair is a nest of vipers and whose gaze turns men into stone, as well as in the Christian story of Eve's seduction by the Devil, who, significantly, takes the form of a snake, bringing about humankind's expulsion from Paradise.

Figure 3.9 Snake Goddess, ca. 1700–1500 B.C., faience, height $11\frac{5}{8}$ " (29.5 cm), Archaeological Museum, Herakleion (Iraklion), Crete. Minoan religion focused on female deities. In Minoan art, both women and men were depicted with unusually tiny waists and long flowing hair.

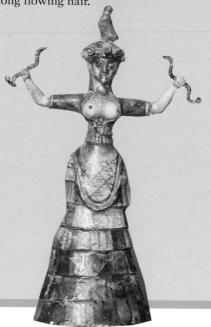

Kamares Ware. The color, too, is different, for Palace Style decoration is painted with dark colors on a light background.

The Snake Goddess. Although the Minoans produced no large-scale sculpture in the round, they did create small-scale figures. The best-known example of Minoan sculpture is the Snake Goddess, or Snake Priestess, a statuette made of faience, a lustrous glazed ceramic, ca. 1700-1500 B.C. (fig. 3.9). The physical type of the statuette, with its rounded limbs and body and pinched waist, is typically Minoan. The sculptor gives great emphasis to the elaborately detailed costume. The chief deities of the Minoan religion were female-mother or fertility goddesses. The goddess portrayed here holds a snake in each hand. In many religions snakes were associated with earth deities and with male fertility. Snakes were believed to be in direct contact with the gods of the lower world, and were therefore supposed to be able to cure disease and restore life. The snakes, combined with the goddess's frankly female form and bared breasts, suggest fertility.

MYCENAEAN CULTURE

Beginning about 3000 B.C. Greek-speaking peoples began to invade the Greek mainland from the north, inaugurating the Mycenaean or Helladic Age (Hellas is the Greek word for "Greece"). After about 1500 B.C., when Minoan culture began to decline, these mainland peoples started to have increasing influence throughout the region. As opposed to the islanders, who relied on the sea for protection and whose palaces were, as a result, open and airy, the mainland Greeks built strong fortresses and, under continual threat of invasion from the north, were evidently much more concerned with things military. Most of these strongholds—such as Mycenae and Tiryns—were in southern Greece, the Peloponnese, although there were also settlements in the north, in particular at Athens in Attica. Among these, Mycenae was the most powerful and richest center; as a result, the entire culture takes its name from this city.

In Homer's *Iliad*, the Trojan War begins when the King of Mycenae, Agamemnon, leads the Greeks against the city of Troy. In legend, the battle was said to have

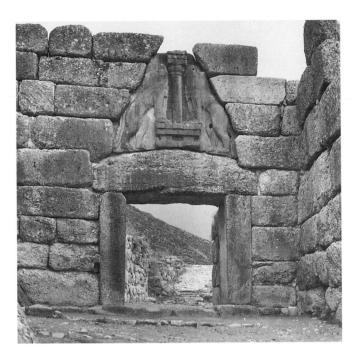

Figure 3.10 Lion Gate, entrance to Mycenae, Greece, ca. 1300–1200 B.C., limestone, height of relief ca. 9'6" (2.89 m). The lion, the animal most frequently depicted throughout the history of art, was often used as a guardian figure.

been precipitated when the Trojan prince Paris abducted Helen, the wife of Agamemnon's brother, his reward for choosing Aphrodite over Athena and Hera as the most beautiful of the goddesses. Homer's story seems to have had a basis in history, although it is more plausible that

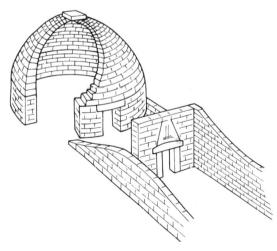

Figure 3.11 Treasury of Atreus, Mycenae, Greece, ca. 1300–1200 B.C., drawing showing the method of construction. Unlike the true dome, a dynamic structure made of wedge-shaped voussoirs, the corbeled dome is a static structure subject only to the forces of gravity. The diameter of each successive circle of stones is slightly diminished, until the central opening can be covered by a single capstone.

the Greeks were prompted in their aggression by their predilection for plunder, the principal target in this case being the palace of the Trojan king Priam. The Mycenaeans also conquered other territories in the Mediterranean area, including Cyprus, Rhodes, and Crete, assimilating many aspects of the defeated people's art, especially that of the Minoan civilization.

The Palace at Mycenae. The main gateway to the fortified hilltop city of Mycenae was the famous Lion Gate (fig. 3.10), built ca. 1300–1200 B.C. The Lion Gate is constructed of huge stones, with the horizontal lintel above the doorway estimated to weigh twenty tons. Above the lintel is a relieving triangle, an opening that serves to relieve the weight on the lintel. The relieving triangle is filled by a relatively thin slab of limestone on which lions are carved in relief. Symmetrical rampant guardian lions, muscular and powerful, flank a Minoan column—an "inverted" column that tapers downward and has a cushion-like capital. This relief is the oldest piece of monumental sculpture in Europe.

The Lion Gate leads to, among other structures extant at Mycenae, the so-called Treasury of Atreus (figs. 3.11 and 3.12), built ca. 1300–1200 B.C. Atreus was the

Figure 3.12 Treasury of Atreus, Mycenae, Greece, ca. 1300–1200 B.C., stone, height of vault ca. 43′ (13.11 m), diameter 47′6″ (14.48 m). The final step in the construction of a corbclcd dome was to cut off all projecting edges and smooth the stone surface into a continuous curve.

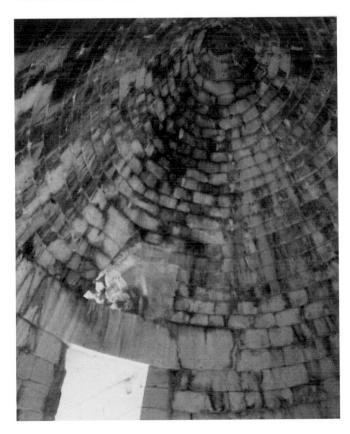

Timeline 3.2 Mycenaean culture.

father of Agamemnon. The building was given its name by the archaeologist Heinrich Schliemann, who had a fanatical interest in Homer's heroes. It is, however, a little misleading, since it was neither a treasury nor was it associated with Atreus. It was actually a tomb.

The dromos, or entrance way, was cut into the hillside, and the walls were lined with ashlar masonry, in which each stone is carefully cut with right-angle corners. At the end of the dromos, the doorway to the tomb is surmounted by a lintel and a relieving triangle. Originally the doorway facade was elaborately decorated with carved reliefs of various colored stones, and the doorway was flanked by slender columns carved with ornamental relief, the columns tapering downward in the Minoan manner. The tomb itself is a tholos (plural, tholoi), the term for any round building, in this case a domed circular tomb shaped like a beehive about fortyfive feet high. The technical name for this kind of structure is a corbeled dome. Such a building is constructed by first digging a circular pit in the earth. Courses of ashlar masonry are then laid in a circle around the circumference of this space, each successive course slightly overhanging the one below, gradually diminishing the diameter of the circle, until a single stone, the "capstone," covers the small remaining opening. The projecting corners of the masonry blocks are then cut off and smoothed to create a continuous curving surface.

The Treasury of Atreus is the most famous of the nine tholoi at Mycenae. All were presumably used for royal burials. They seem each to have served a royal person and the person's immediate family. The interior of the Treasury of Atreus was once decorated with bronze plaques and rosettes. Now nothing remains inside except the nails and nail holes used to hold them in place, since all the Mycenaean tholoi were pillaged in antiquity.

Also just inside the Lion Gate at Mycenae is Royal Grave Circle A (there is also a second—Grave Circle B), dated 1600–1500 B.C., which was excavated by Schliemann in 1876. Schliemann found that this double circle of stone slabs enclosed six shaft graves. In these graves

Schliemann found golden treasure. Many of the bodies buried here had been literally laden with gold. Two children were found wrapped in sheets of gold. Among the objects unearthed here were a magnificent gold diadem embossed with geometric patterns, small individual ornaments of gold plate sewn or stuck onto the clothing, a **rhyton** (drinking vessel) in the shape of a lion's head, gold cups, bronze dagger blades inlaid with gold, silver, and copper, a gold breast plate, and gold masks (fig. 3.13), some of which were found placed over the faces of the dead. These last were made of thin sheet gold and were hammered into shape over a wooden core.

Figure 3.13 Gold mask, from tomb V of Grave Circle A, Mycenae, Greece, ca. 1550–1500 B.C., gold, height ca. 12" (30.5 cm), National Archeological Museum, Athens. The rich burials of Mycenaean nobility included a variety of sheet gold objects. Homer described Mycenae as "rich in gold."

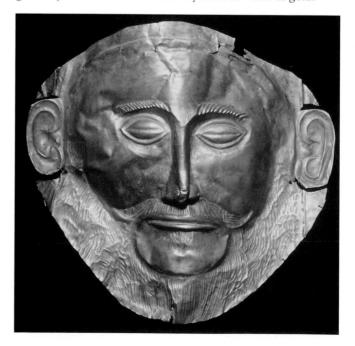

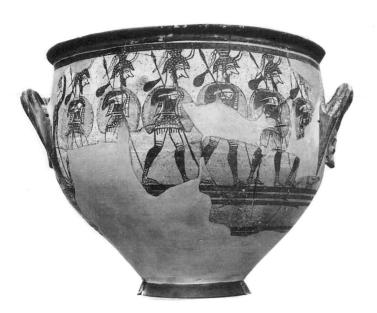

Figure 3.14 Warrior Vase, from Mycenae, Greece, ca. 1200 B.C., terra cotta, height ca. 16" (40.6 cm), National Archaeological Museum, Athens. Differing from the characteristic flora-and-fauna decoration of the Minoans, whose safety was insured by their island location, the war motifs of this vase reflect the more military aspect of Mycenaean life. Although not realistically drawn, the decoration of the Warrior Vase provides a document of early defensive arms and armor.

The objects found in the excavations of Grave Circle Λ make it easy to understand why Homer referred to the city of Mycenae as *polychrysos*—"rich in gold." These are the graves of the nobility—the Mycenaean ruling system was one of family dynasties—but they are not the graves of Atreus and Agamemnon, even though the mask illustrated here is often referred to as the "Mask of Agamemnon." In fact, the mask predates any possible Mycenaean invasion of Troy by nearly three hundred years (the Trojan War is now dated to ca. 1250 B.C.).

The Warrior Vase. Probably no surviving artifact better embodies the warlike character of the Mycenaeans than the famed Warrior Vase (fig. 3.14), made ca. 1200 B.C. Unlike the art of the earlier Cycladic and Minoan cultures, Mycenaean works tend to be concerned with war and death. Between bands of decoration, soldiers march, seemingly in single file. At the far left, a woman raises her arm to bid farewell to the troops. The execution of the painting is careless and the figures are clumsy caricatures. The vase itself is crudely constructed. The base is significantly smaller than the opening, making the shape unstable and impractical. The Warrior Vase dates from the end of the Mycenaean civilization and, in its unrefined execution and decoration, can be seen to portend the destruction of social order in Mycenae. Around 1100 B.C. the Aegean civilization died out, and the so-called "Dark Age" began, a period in which writing seems to have disappeared, and art-making ground to a halt. Faced with Dorian invaders from the north, whose weapons were made of iron instead of bronze—perhaps the very invaders the soldiers depicted on the Warrior Vase are marching to meet—Mycenaean civilization collapsed.

THE RISE OF ANCIENT GREECE

Mycenaean civilization, and with it the Bronze Age in the Aegean, came to an abrupt end around 1100 B.C. During the following century, many of the achievements of the previous millennia appear to have been forgotten. Not until around 1000 B.C. did the Greeks of the mainland begin to forge a new civilization that would culminate in the fifth century B.C. in the achievements of Classical Athens. The history of Greece in the intervening centuries is usually subdivided into several phases: the Geometric period, ca. 1000-700 B.C.: the Orientalizing period, a period of Greek colonization and contact with the East, ca. 700-600 B.C.; and the Archaic period, ca. 600-480 B.C. It was owing to the achievements of these five hundred years that Greek culture was able to flourish so spectacularly after 480 B.C. and that the artistic, cultural, and political foundations of modern Western civilization were laid.

THE PANTHEON OF GREEK GODS

According to Greek mythology, before the world was created, before the division into earth, water, and sky, there was Chaos. From this Chaos there emerged a god named Ouranos [YOOR-ah-noss], representing the heavens, and a goddess named Gaea [JEE-ah], representing the earth. Their union produced a race of giants called the Titans. One of these, Kronos [KROH-nos], overthrew his father, Ouranos, and married his sister Rhea [REE-ah]. Their offspring were the Olympian gods. However, there was a prophecy that Kronos himself would be overthrown by one of his own children, and so to forestall this he decided to eat all his own progeny. Only Zeus [ZOOSS] survived, saved by Rhea. When Zeus ultimately and inevitably revolted against his father, Kronos regurgitated all the other children—Demeter [du-MEE-ter], the goddess of agriculture and fertility; Hera [HEAR-ah], goddess of marriage and stability; Hades [HAY-deez], god of the underworld; Poseidon [pu-SIGH-dun], god of the sea; and Hestia [HESS-ti-ah], goddess of the hearth and home. Zeus married Hera, and they in turn produced a second order of gods and goddesses: Apollo [a-POLLoh], who as god of the sun and light represents intellectual beauty; Dionysos, god of wine and revelry; Aphrodite [ah-fro-DI-tee], goddess of love, who represents physical beauty; Ares [AIR-ease], god of war; and Artemis [ARtum-iss], goddess of the moon and the hunt. Athena

[a-THEE-nuh], goddess of wisdom, and of the arts and crafts, and patron goddess of Athens, sprang full-grown from the brow of Zeus himself—a pure idea.

It was Prometheus, a Titan, who first took earth, mixed it with water, and fashioned human beings out of the resulting mud, forming them in the image of the gods. His brother fashioned the animals, bestowing on them the various gifts of courage, strength, swiftness, and wisdom, together with the claws, shells, and wings that distinguish them from one another. The first woman was Pandora, a joint creation of all the gods. According to one version of the story, each of the gods gave her something—Aphrodite gave her beauty, Hermes the gift of persuasion, Apollo musical skill. Zeus presented her to Prometheus's brother, and she brought with her a box containing all her marriage presents. When she opened the box, all the blessings escaped—except hope!

Unlike the gods of the ancient Hebrews and of India, those of ancient Greece could not be counted on for help. Traditionally inhabiting the top of Mount Olympus, in northeastern Greece, the Greek pantheon, the family headed by Zeus, supervises human society. Unlike the Christian system, there is no god who represents complete good or complete evil. Zeus is a patriarch, a father, in some sense a model for the tyrant of the Greek polis, but frequently an adulterous husband. His wife, Hera, is often jealous with good cause. Their marital relationship reflects the weakness of human relationships, and their monumental jealousies and rages were reflected not only in the devastating wars that disrupted Greek life but also in the petty animosities that spoilt civic harmony. Mirroring human frailty, the ancient Greek gods represented irrational forces that were both violent and unpredictable. The ancient Greek attitude toward their gods embodied their skeptical view of human nature, and many of the more famous Greek myths reflect this. However, unlike Christianity and Judaism, Greek culture never developed a single unified account of these myths, which exist instead in many varying forms.

Apollo and Daphne. One day Eros (Cupid), the son of Aphrodite and Hephaistos, the blacksmith god who made the gods' armor as well as Zeus's thunderbolts, was playing with his bow. Apollo, renowned for his own prowess as an archer, saw the boy and chided him: "What have you to do with warlike weapons, you saucy boy? Leave them for hands worthy of them." Eros answered back: "Your arrows may strike all things else, Apollo, but mine shall strike you." With these words, he took a golden-tipped arrow, meant to excite love, and shot Apollo through the heart with it. Then he took a second arrow, this one tipped with lead and designed to thwart love, and shot the nymph Daphne with it. Apollo was immediately enthralled by the nymph, but she was repelled by her suitor.

Apollo pursued Daphne relentlessly. But whenever he found her, she fled. The pursuit turned into an outright chase, and as Apollo gained on her, her strength fading, she pleaded with her father, Peneus, the river god, for help: "Open the earth to enclose me, or change my form, which has brought this danger on me." The moment she spoke these words, all her limbs began to stiffen, her breast was covered by bark, her feet stuck fast in the ground, and her hair was transformed into leaves. Apollo stood amazed. He realized he had lost his love forever. "Since you cannot be my wife," he exclaimed, "you will be my tree. As eternal youth is mine, you too will always be green, and your leaf shall never decay." Daphne, now a laurel tree, bowed her head with gratitude.

Athena and Arachne. Apollo was only one of many figures in Greek mythology to bring suffering on himself through his pride, or **hubris**, as the Greeks called it. The mortal Arachne was famous for her skill in weaving and embroidery, so skilled that the nymphs would come out of the woods to watch her, and those who saw her works believed that Athena, in her role as goddess of the arts and crafts, must have taught her everything she knew. But Arachne was insulted at the idea: "Let Athena try her skill with mine," she said, "and if I am beaten, I will accept the penalty." Athena heard the challenge, and assuming a disguise she spoke to Arachne: "Challenge your fellow mortals as you wish," she warned, "but I advise you not to compete with a goddess. In fact, I suggest you ask Athena's forgiveness. She is generous, and she will forgive you." But Arachne would not take back her challenge.

And so Athena revealed herself, and the contest was engaged. Athena wove a scene in which the twelve most prominent gods were depicted, and in the four corners were illustrations of incidents in which presumptuous mortals had dared to contend with the gods. Arachne filled her weaving with subjects exhibiting the failings of the gods—Zeus's seduction of Leda when he assumed the form of a swan, his rape of Europa in the form of a bull, and his seduction of Danaë as a shower of gold.

Athena could not help but admire Arachne's skill, but neither could she accept the insult to the gods implied in her work. She struck Arachne on the forehead, causing her to feel extraordinary guilt and shame, and Arachne went and hanged herself. But Athena pitied the girl when she saw her hanging body: "You and your descendants, Arachne, shall so hang for all future times." And sprinkling Arachne with magic juices, she transformed her into a spider, hanging from the web it had woven.

Perseus. Perseus was the son of Zeus and Danaë, the seduction of whom Arachne had condemned in the tapestry she wove in her contest with Athena. Like so many of the demi-gods in Greek legend, born of the union of god and human, and thus endowed with powers

Cross Currents

Hesiod's Theogony and Mesopotamian Creation Myths

In his *Theogony*, Hesiod [HEH-see-ud] (ca. seventh century B.C.) presents a poetic account of the origins of the Greek gods. The *Theogony* identifies Gaia as the original divine being. Gaia is both the physical earth and a giant human-like deity who produces her own mate, Ouranos, the sky. This primal couple then spawns the first beings, the Titans, whom Ouranos tries to eliminate by stuffing them back into the recesses of their mother. One of these children, the Titan Kronos, slays his

father and replaces him as Gaia's consort.

Like his father Ouranos, Kronos disposes of his offspring. However, one child, Zeus, is saved by Gaia and grows in safety until he can liberate the other devoured children, battle with the Titans, and displace his father as the chief male deity.

The Greek account of the origin of the gods is indebted to various Mesopotamian creation accounts. From Mesopotamia, Greece derived the idea of projecting a magnified version of human power onto the divine realm. Greece also borrowed the idea of the universe as a city governed by a succession of rulers, each displaced by the next in a power struggle. Moreover, with its lists of succeeding gods, Hesiod's *Theogony* echoes Mesopotamian lists of kings, which are traced back genealogically to the gods. Both Mesopotamian and ancient Greek poetry account for the order and hierarchy of the universe.

Like Homer's epics, Hesiod's works had a profound effect on succeeding generations of Greek culture. Hesiod's poems were considered repositories of wisdom and technical knowledge about a host of matters, including farming and war. The works of both Homer and Hesiod went on to form the foundation of classical Athenian education in the fifth century B.C.

greater than mere mortals, Perseus took on many legendary challenges. The first of these was the destruction of the monster Medusa, who had once been a beautiful maiden with gorgeous long hair before she dared to vie in beauty with Athena. In revenge Athena had transformed her hair into hissing serpents, and all that beheld Medusa in this state turned to stone. Taking care to approach her in her sleep, and looking at her only in a reflection in his brightly polished shield, Perseus cut off her head and set off to present it to Athena.

He soon arrived at the edge of the world, where he encountered Atlas, a Titan giant whose gardens bore fruit of gold. Atlas knew a prophecy that foretold that a son of Zeus would one day come to steal his golden apples, and so he attempted to throw Perseus out of his gardens. Offended, Perseus showed Atlas Medusa's head and Atlas was promptly turned to stone, whereupon he increased in bulk until he became a mountain and all the stars in heaven rested upon his shoulders.

Herakles. Known to most contemporary readers by his Roman name, Hercules, Herakles was the son of Zeus and the mortal Alcmena. Hera, always hostile to her husband Zeus's mortal offspring, declared war on the demi-god Herakles at his birth, arranging for him a series of difficult and dangerous tasks, known as his "Twelve Labors."

First, Herakles had to fight a terrible lion in the valley of Nemea. Neither club nor arrows could subdue the lion and Herakles finally had to strangle it with his own hands. Next he was ordered to slaughter the Hydra, a creature with nine heads, the middle one of which was immortal. As Herakles struck off each head with his club, two new ones grew in its place. Finally, he burned away

the Hydra's heads, and buried the ninth, immortal one under a huge rock.

Yet another labor was the cleaning of the stables of King Augeas's three thousand oxen, which had not been washed for thirty years. Herakles managed this task by diverting the rivers Alpheus and Peneus through them, cleansing the stables in a single day.

But Herakles' most difficult labor was retrieving the golden apples of Hesperides. Atlas, Hesperides' father, was best qualified to get them back, but he had been condemned to bear the weight of the heavens on his shoulders and so could not move. Hence Herakles took Atlas's place, relieving him of his heavy burden while he found the apples. Atlas was successful and returned to give them to Herakles and, somewhat reluctantly, reassumed his position beneath the weight of the sky.

Dionysos. Yet another god was Dionysos, son of Zeus and Semele. Ever jealous, Hera planted in Semele's head doubts about the paternity of her child and suggested that she ask her disguised lover Zeus to grant her a favor to prove who he was. Without bothering to ask what the favor might be, Zeus agreed, only to discover that Semele wanted to see him, not in disguise, but in all his heavenly splendor. Zeus had to comply, and when Semele saw him, her mortal being could not endure his dazzling radiance, and she was reduced to ashes.

Consequently, Zeus had to find someone to raise Dionysos, and so gave him to a group of nymphs. As a youth, Dionysos discovered grapes and perfected the means for extracting their juice and converting it to wine. But Hera, always inclined to punish Zeus's progeny, struck him mad and sent him out into the world as a perpetual wanderer. Everywhere he went, he

introduced the culture of the vine, but with it he brought madness and disorder. Eventually he returned to his native Thebes, where the king, Pentheus, had him arrested. While preparations were being made for his execution, Dionysos escaped with Pentheus's mother and aunts to the nearby mountains, where they began to celebrate his freedom in a wild orgy. In a rage, Pentheus followed them, but his mother, perhaps blinded by Dionysos, mistook him for a wild boar, and, with the help of her sisters, tore her own son to pieces. The worship of Dionysos was thus established in Greece, a wild and ecstatic celebration that temporarily overpowered even the authority of the king.

For the Greeks, Dionysos, thus associated with wine and orgisatic celebration, came to represent irrational forces, including the destructive power of the emotions. Poets frequently used the figure of Dionysos to represent the irrational and violent part of human existence, while Apollo was used to represent order and control.

THE GEOMETRIC PERIOD

The Geometric period (ca. 1000–700 B.C.) is sometimes referred to as the Heroic Age, since it was during this time that Homer created his poetic epics, the *Iliad* and *Odyssey*, centered on the figures of the great heroes Achilles and Odysseus. The other arts are less well preserved for us now. There is very little trace of archi-

tecture and not much sculpture. Most of the evidence for the visual art of the period is derived from pottery.

Cultural development in this period appears to have been slow. After the destruction of the Mycenaean empire, mainland Greece lacked a political center. When communities began to emerge, as at Athens in Attica and at Sparta in Laconia, they took the form of independent city-states, **poleis** (singular, **polis**).

The development of the Greek polis, which provided the focus for political, artistic, and religious activities in the region, is central to the later Western ideal of democracy. However, in this early period, each polis was ruled by a council of aristocrats. It is also important to note that the polis, with its tradition of fierce independence, meant that even at its artistic and cultural height in the fifth century B.C., Greece remained politically fragmented and always on the verge of violent self-destruction. Athens and Sparta, for instance, remained hostile neighbors. Their temporary alliance in the early fifth century B.C. managed to beat off Persian invaders, but Greek civilization was delivered a fatal blow later in the same century by the Peloponnesian War between these same two city-states.

Pottery. There was undoubtedly some cultural continuity between Mycenaean Greece and the civilization that re-emerged after 1000 B.C. However, the distinctive style of art that appears around the latter date was probably influenced by the Dorian invaders. Known as the

Timeline 3.3 Ancient Greek culture.

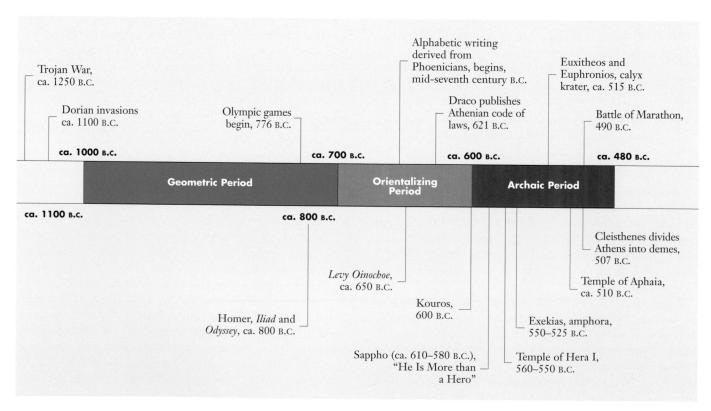

Geometric style and characterized by geometric forms, it soon dominated the art of the Greek mainland. Human and animal figures on pottery from the period are depicted in terms of simplified geometric forms, in a style reminiscent of the early sculptural forms of the Cyclades. This Geometric style in pottery was to flourish in Attica and, in particular, in its most important city, Athens.

The Geometric style is distinguished by decoration in bands covering the entire surface, and by literally geometric forms of ornament—meanders (maze patterns), checkers, zigzags, and lozenges. Whereas on Aegean pottery the decoration flows over the surface of the vessel, on Geometric pottery the painted decoration is adapted to the zones or divisions of the vase. In many ways, the Geometric system may be compared to the Egyptian register system in the horizontal divisions of the surface into defined and separated areas (see fig. 2.1). Geometric ceramics show a concern with proportion and thoughtful composition and placement of the decorative elements.

An example of the Geometric style is an eighth-century B.C. terra cotta **krater**, a large vase with a wide mouth (fig. 3.15). It comes from the Dipylon Cemetery (di means "two"; a pylon is a massive gateway; a dipylon is a massive double gate) in Athens. The center of the ceramics industry in Athens was here at the cemetery. Indeed, the area was also called the *Kerameikos*, the origin of our word "ceramics." Large vases, up to six feet high, were buried halfway into the ground on shaft graves as markers. Such vases have holes in the bottom or have no bottom at all. Poured in the top as offerings to the deceased, liquids would seep down into the body below.

The subject depicted on this vase is a common one: mourners lamenting for the deceased, who is shown lying on a funeral bed or bier. Funerary processions are pictured going from the home of the deceased to the cemetery, while mourners tear their hair. Other Dipylon vases include depictions of funeral processions, horse-drawn chariots, animals to be eaten at the funeral banquet, and funeral games. (It was customary to have games at funerals in honor of the deceased.) Significant to the future course of vase painting is the fact that the work here is beginning to develop narrative elements. Greek potters increasingly turned away from purely geometric decoration, giving over a greater percentage of the surface to larger and more representational figures designed to tell a tale.

However, for the moment everything is shown in strict silhouette, simplified for clarity. Figures are flat, with triangular torsos and pinched waists; humans and horses have essentially the same physique. Everything is highly stylized and simplified to a series of geometric planes. Thus, the legs on the funeral bier look like the legs on the people. More abstracted than

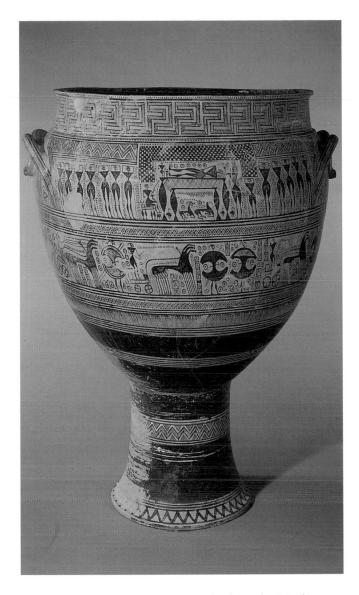

Figure 3.15 Krater, Geometric style, from the Dipylon Cemetery, Athens, ca. 750 B.C., terra cotta, height 3'4½" (1.03 m), Mctropolitan Museum of Art, New York. Geometric style vases are, as the term indicates, decorated with precisely drawn, simple geometric forms. Each of the several shapes of Greek vases has a name and was used for a specific purpose; this very large krater was used as a burial marker.

realistic, this is an abbreviated or shorthand style of representation.

Sculpture. Prior to the mid-seventh century B.C., Greek sculptors restricted their work to small-scale pieces in wood, clay, ivory, and bronze (bronze casting of sculpture seems to have started in Greece in the ninth century B.C.). All work in perishable materials has been lost, but there are a few extant ivory pieces and many fine bronzes.

The surviving examples, found in tombs and sanctuaries, are statuettes of humans and animals. Bronze cows

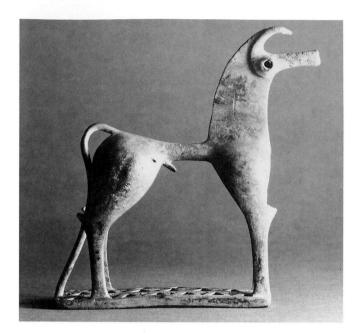

Figure 3.16 Horse, second half of the eighth century B.C., bronze, height ca. $6\frac{3}{8}$ " (16 cm), Staatliche Museum, Berlin. In the Geometric Period, forms of nature were simplified and made literally geometric, torsos of horses and humans (as on the Geometric vase in fig. 3.15) turned into triangles.

and rams were used as votive offerings to the gods in place of actual sacrificial animals. Because horses were associated with certain goddesses and gods, they received special attention and may have been used as votive offerings to the deities. The example shown here (fig. 3.16) dates to the second half of the eighth century B.C. This late Geometric horse is simplified, abstracted, and highly sophisticated. With its contrast between flat and rounded areas, and its crisp and sharp rendering of forms, it is clearly the work of a skilled artist. Rather than being a unique or isolated example, this horse is representative of a physical type found in sculpture and in painting—the horse looks like the horses on contemporary Geometric vases. The pinched waist is, moreover, common to both horses and humans in Geometric art, be it in sculpture or in painting.

Homer's Iliad and Odyssey. Greek poetry in written form begins with the two most famous epics in Western literature, The Iliad and The Odyssey. Tradition credits the authorship of these poems to Homer, about whom nothing is known with certainty except his name. Early Greeks believed Homer to have been blind, and many scholars think he lived in Ionia, in Asia Minor, but none of this is sure. Both The Iliad and The Odyssey were first put in writing during the seventh century B.C., although they are based on a long oral tradition predating their written versions by hundreds of years. Despite their long genesis, each epic bears the stylistic imprint and imaginative vision of a single resourceful poet.

Both The Iliad and The Odyssey reflect their social context, a warring aristocratic society in which honor, courage, heroism, and cunning are the prime human virtues. The gods and goddesses of the Greek pantheon figure prominently in the Homeric epics. Each of the poems centers on a single heroic figure. The Iliad describes the wrath of Achilles and its consequences for himself and his comrades. The Odyssey tells the story of Odysseus, who, after long years spent wandering, returns to reclaim what is his own from a group of Greek princes who have more or less laid siege to his wife and home. Homer's *Iliad* and *Odyssey* have been enormously influential in the history of Western poetry. The Roman poet Virgil's Aeneid (see Chapter 5) and John Milton's Paradise Lost (see Chapter 14) both imitate Homer's epics in their different ways, to cite only two famous examples.

The Iliad describes a short period toward the end of the Trojan War (ca. 1250 B.C.), the ten-year siege that a band of ancient Greek military adventurers laid against the city of Troy. The work focuses on the anger and exploits of its hero, Achilles, renowned as the greatest of all soldiers. The epic begins with a quarrel between Achilles and the Greek king and military commander, Agamemnon, over the beautiful Trojan woman, Briseis. Agamemnon had taken Briseis as his royal right, even though Achilles believed he had earned her as his share of the battle spoils. Achilles expresses his disgust with Agamemnon by withdrawing sulkily and refusing to do battle with the enemy. Without Achilles' help, the Greeks are repeatedly defeated by the Trojans. Achilles returns to battle only after his friend Patroclus is killed. He kills Hector, the son of the Trojan king Priam, and abuses his corpse out of frustration and guilt at having let his friend Patroclus die through his anger. The source of the quarrel, the reason for Achilles's return to battle, and the military exploits Homer describes in vivid detail all reflect the warrior world The Iliad celebrates. Though the gods are present throughout to comment on the action, at the center of Homer's world are his human actors. The poet is concerned with human responsibility and motivation, and for these reasons his work stands at the very beginning of the Western literary tradition.

Although *The Iliad* glorifies great deeds performed on the battlefield, the poem also conveys a sense of war's terrible consequences. Homer vividly describes battles, with armies arrayed against one another in deadly combat. He describes with equal drama the conflicting loyalties of heroes on both sides as they take leave of their wives and families to kill one another in defense of honor and in pursuit of military glory. These heroic values are honored consistently throughout the epic, though *The Iliad's* world-view is occasionally tempered by scenes that portray other less military virtues. For, example, kindheartedness and forgiveness are exemplified in the scenes between the Trojan warrior Hector and his family, and in the scene describing Achilles' meeting with the old

Perhaps the most famous adventure story in Western literature, Homer's *Odyssey* contains a number of memorable episodes. Two of the most famous concern dangerous escapes. In one episode, Odysseus is captured by the giant one-eyed Cyclops. Odysseus gets the Cyclops drunk, blinds him with a stake, and escapes from the monster's cave by clinging to the belly of a sheep so that the Cyclops cannot feel him. In a second adventure, Odysseus and his men have to sail through the dangerous seas inhabited by the Sirens, whose enchanting singing causes sailors to crash their boats on the rocky shores of their island. To avoid this fate, Odysseus plugs his men's ears with wax and then has them tie him to the mast of their ship.

These and other exotic events make The Odyssey different in spirit from The Iliad. Other differences concern The Odyssey's hero, Odysseus, who after a twenty-year absence from home, returns to his wife, Penelope, and his son, Telemachos. While Achilles's strength in The Iliad is purely physical, Odysseus also has mental fortitude. Odysseus's cunning and wit enable him to escape numerous dangerous predicaments, and he also pursues self-knowledge. Odysseus seems much more modern than Achilles, and his journeys toward understanding and toward "home" and all that that means take place in a world that is much closer to our own than is the more primitive world of The Iliad. Moreover, where the focus of The Iliad is narrowly trained on the military world, the vision of The Odyssey is much wider. Its values are those of home and hearth, of patience and fidelity, of filial piety, of the wisdom gained through suffering. The range and depth of its depiction of women far surpasses The Iliad's image of women as the mere property of men. In addition to the clever and faithful Penelope, The Odyssey's female characters include the intelligent and beautiful princess Nausicaa; the dangerously seductive witch Circe; the goddess Calypso, who offers Odysseus immortality; Athena, who serves as Odysseus's guide and protector; and Odysseus's nurse, Euryclea. Moreover, when Odysseus visits the Land of the Dead, he sees not only his mother, Anticleia, who had died in his absence, but other famous women of heroic times.

Odysseus's journey home is interrupted by his oneyear stay with Circe and by the eight years he remains on Calypso's island. In total, he is absent from Penelope and home for twenty years, ten for the long siege of Troy and ten for his voyage. This long delay is due partly to Odysseus's unalterable fate and partly to his temperament. Warring within him are two contrary impulses: a wish to return to the peaceful kingdom of Ithaca, where he reigns as prince, and a desire to experience adventure and test himself against dangerous challenges. This split is echoed by the clash between Odysseus's temptation to forget his identity as husband, father, and king in his adventures, and his responsibility to resume these less exotic and more stable roles.

The Odyssey makes reference at a number of points to characters and events of The Iliad, most notably to the death of Achilles. In an important scene near the middle of The Odyssey, Homer has his hero descend to the underworld, where he meets the spirit of Achilles. Odysseus also encounters the shade of Agamemnon, whose murder by his wife serves as a warning of the fate that could befall a man who has been away too long. Homer uses the tragic story of the house of Atreus in thematic counterpoint to the duties and responsibilities of husband, wife, and son that The Odyssey endorses.

In essence, Homer's epics were to ancient Greece what Scripture was to the ancient Hebrews. The Homeric poems became the basis of all education and a reflection of the entire culture's values. The human characters in *The Iliad* and *The Odyssey* served as models of conduct—of heroism and pride, of cunning and loyalty—for later generations. The Homeric gods, however, were less models of ideal behavior than influences on human events. Homer gives them a secondary importance, choosing instead to emphasize men and women living out mysterious destinies. Moreover, Homer reveals the gods as subject to the same implacable fate as humans. Although they are honored and worshiped by the characters, the gods are also portrayed as worthy of blame as well as praise, of laughter as well as fear.

THE ORIENTALIZING PERIOD

In the Orientalizing period, ca. 700–600 B.C., the Greek city-states began to foster trade links, particularly across the Aegean Sea, and many built up large merchant fleets. In part, this development was the result of two factors: power and wealth remained the preserve of a small hereditary aristocracy, and the population was increasing rapidly. For this reason, the Greeks began to look overseas. Not only did they trade abroad, they also colonized. Cities were established as far east as the Black Sea, and the first settlements were made to the west in *Magna Graecia*, the Latin name for Great Greece, in southern Italy and Sicily.

The impact on the arts of this expanding commerce and colonization was immense. For the first time in three hundred years, Greece made contact with the civilizations of the Near East, in particular Egypt, Persia, and Phoenicia, and began to import objects as well as ideas. It is from the mid-seventh century B.C. that the earliest Greek stone sculptures of the human figure date, and it seems certain that the Greek sculptors were inspired by the example of the Egyptians. It is also around this time that Greece began to be unified linguistically through the introduction of a new alphabet, seemingly derived from that of the Phoenicians. The enormous impact of Near Eastern or Oriental culture on Greek art and life

has led to the period being known as the "Orientalizing" period.

Pottery. Between 700 and 600 B.C. the style of Greek pottery was influenced by trade with the Near East, Asia Minor, and Egypt. An example is the seventh-century Levy Oinochoe (fig. 3.17) (an oinochoe, from the Greek word meaning "to pour out wine," is a wine jug with a pinched lip). Although the design appears to be stenciled, in fact the outlines and details are incised. In a departure from the Geometric style, the figures begin to be given much more importance. Also many Oriental motifs appear—lotuses, palmettes, rosettes—all apparently derived from Egyptian art. Winged animals similar to those found in Mesopotamia (see fig. 1.15) and sphinxes from Egypt (see fig. 2.5) appear as well.

By 600 B.C. this Orientalizing process had taken especially strong hold in Corinth, a port city with close ties to the cultures of the East. From 600 to 550 B.C. Corinth was the biggest vase-producing city in Greece. The color of Corinthian ware is distinctive: purplish-brown, reddish-brown, red, and black are painted on a lighter background. The origin of a vase may be determined by the color of the clay from which it was made. For

Figure 3.17 Levy Oinochoe, Orientalizing style, east Greek, ca. 650 B.C., terra cotta, height $15\frac{1}{2}$ " (39.4 cm), Musée du Louvre, Paris. The importance of figures in vase painting was gradually increased. Contact with the East resulted in the use of Oriental motifs.

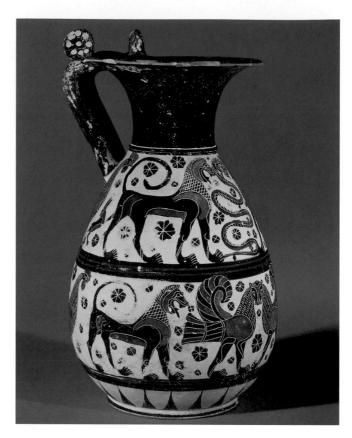

Figure 3.18 Pitcher (olpe), from Corinth, ca. 600 B.C., terra cotta, height $11\frac{1}{2}$ " (29.2 cm), British Museum, London. Corinthian ware was made in the city of Corinth, where the clay is beige in color, differing from the orange clay found in Athens. Corinth and Athens competed in the production of vases.

instance, the clay of Corinth is beige, while that of Athens is orange.

An example of Corinthian ware is the **olpe**, or pitcher, dating from about 600 B.C. (fig. 3.18). Animals are popular motifs on Corinthian ware. Some are real animals, such as goats, panthers, lions, stags, bulls, and birds; other creatures are imaginary, such as sirens and sphinxes. Here, arranged in strict symmetry, one head is attached to two bodies, creating a monster with combined parts, something also found in the "animal" style of Mesopotamia.

THE ARCHAIC PERIOD

The Archaic period, ca. 600–480 B.C., was a time of rapid change and development in ancient Greece. The political organization of the city-states began to undergo significant alteration as the old aristocratic rulers were displaced by the vigorous new class of wealthy traders, who had profited from expanding Greek commerce and colonization overseas. Individual rulers replaced the old council of aristocrats. These powerful individuals had the

title of tyrants. (The word "tyrant," however, only later came to have its modern negative connotation, for tyrants often enjoyed the broad support of the people.) These political reforms were only the first in a long and critical series that led to the establishment of what we now call the first democracy (see Chapter 4).

In other respects, the Archaic period saw the emergence of the artistic forms and skills that reached their peak in the fifth century B.C. and that have dominated the artistic history of Western civilization ever since. Central to this is the depiction of the human figure. Leaving behind the abstract decorations of the Geometric period, Greek artists took as their most important task the study of the human form and sought to depict it with everincreasing naturalism. In many ways, this choice has determined the course of Western art, which, until the beginning of the twentieth century, centered on the human figure and its accurate portrayal. Sixth-century B.C. sculptors produced large-scale freestanding figures, and also began creating relief sculpture for temples. The first great architectural works were created in this period, and pottery, now dominated by Athens, showed remarkable developments.

Black-Figure Vases. One of the two most important types of Greek vase painting is the black-figure style. First developed in Corinth, the black-figure style spread from there to Athens, where it was refined in the second half of the seventh century B.C., reaching its peak between 600 and 500 B.C. In the black-figure style, painting is done with a black glaze on a natural red clay background. In essence, the artist works with silhouetted forms, drawing the outlines and then filling in the color. Once this color has been applied, details are created by scraping through the black glaze to reveal the red clay beneath. Since the artist must exert considerable pressure to make these details, the resulting lines do not flow readily. The technique thus tends to produce a decorative two-dimensional effect.

Many different black-figure workshops were active, and the distinct styles of individual artists are discernible. In fact, several black-figure artists are known by name. EXEKIAS [egg-ZEEK-yas] (active last half of the sixth century B.C.) is considered the master of the black-figure style. He was both painter and potter—two vases are signed "Exekias decorated and made me"—whereas, in other cases, different names are given for the potter and the painter. Exekias is renowned for his exquisite detailing—finely formed folds of fabric, precisely painted patterns, exquisite outlines. Many vases painted by Exekias survive.

An **amphora**—a two-handled vessel named for the Greek word meaning "to carry on both sides"—by Exekias and dated 550–525 B.C. (fig. 3.19) is a mature example of the black-figure style. It depicts Achilles and Ajax. Homer's epic *The Iliad* tells of the great warrior

Ajax and the even greater Achilles, the military heroes of the Greeks, playing checkers in their camp at Troy. Achilles eventually wins the game, but their concentration on the competition causes them not to hear Athena blowing her trumpet to call them to fight against the Trojans. This subject became popular in painting and even in sculpture after the sixth century B.C.

The figures stand on a baseline, suggesting some concept of a three-dimensional space. The composition is a perfect balance of verticals, horizontals, and diagonals. The figures, which are labeled on the vase, conform to the shape of the vase, bending with the bulge. The warriors wear their armor plus elaborate ornamental cloaks, which are used to embellish the surface decoration. Exekias paints perfect profile portraits of the protagonists, yet the eye is seen from the front in the Egyptian

Figure 3.19 Exekias, *Ajax and Achilles*, amphora, blackfigure style, 550-525 B.C., terra cotta, height $26\frac{3}{8}"$ (67 cm), Vatican Museums, Rome. Narrative became progressively more popular on vases, the subjects often taken from mythology. Exekias, master of the black-figure style, is especially noted for his carefully composed scenes.

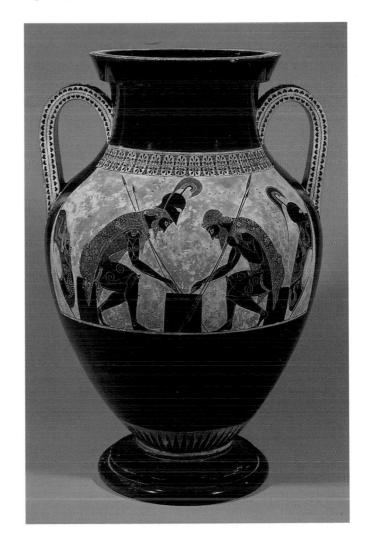

Figure 3.20 Signed by Nikias as potter, Pan-Athenaic amphora, black-figure style, ca. 560-555 B.C., terra cotta, height $24\frac{1}{3}$ " (61.7 cm), Metropolitan Museum of Art, New York. A special type of vase, routinely painted in blackfigure even after the introduction of red-figure, Pan-Athenaic amphoras were given as prizes—the specific competition for which the vase was awarded is shown on the other side of the vase.

manner. Not until around 470 B.C. would artists depict the eye in profile.

Narratives dominate vase decoration over the next centuries, the subjects frequently derived from mythology as well as daily life. A special type of vase that recorded a specific aspect of ancient Greek life was an amphora representing the Pan-Athenaic Games, which were held every summer in Athens in honor of Athena. Almost always done in the black-figure technique, the type is represented here by an example (fig. 3.20) signed by NIKIAS [NEEK-i-as] (active mid-sixth century B.C.) and made ca. 560-555 B.C. Amphoras were given as prizes or awards at the games, and filled with wine, olive

oil, or water. The Greeks held various types of competitions, ranging from foot races and wrestling to chariot and horse races. The scenes on Pan-Athenaic amphoras are always much the same. The rooster on the column is a symbol of the competition. The inscription says "from the games at Athens" or "one of the prizes from Athens." Depicted on the vase is Athena, patron goddess of Athens, armed with shield and spear. On the other side the activity for which the vase was awarded is shown.

Red-Figure Vases. Around 530 B.C., under pressure from the Persians, a flood of Ionian Greek refugees came to Greece from Asia Minor, introducing Oriental and Ionic influences to mainland art. At the same time, redfigure vase painting started in Athens. As this style took hold, the black-figure style gradually disappeared. Redfigure finally replaced black-figure around 500 B.C. Only Pan-Athenaic amphoras continued to be made in the black-figure style.

The red-figure technique is essentially an inversion of the black-figure technique. In the red-figure technique the background around the figures is painted black. Details within the contours of the figures are then painted with a brush on the reddish clay. Variety of color is achieved by diluting the black, and a range from dark brown to yellowish is possible. In the red-figure

Figure 3.21 Euxitheos and Euphronios, Death of Sarpedon, calyx krater, red-figure style, ca. 515 B.C., terra cotta, height 18" (45.7 cm), Metropolitan Museum of Art, New York. Although in the black-figure technique details must be scraped through the black glaze, in red-figure details are painted on with a tiny brush. Therefore, details are achieved more easily, and greater fluidity of line is possible.

Connections

LANDSCAPE AND ARCHITECTURE

According to Vincent Scully, an architectural historian, the great Greek temples can best be understood by exploring their relation to the landscape around them. Characteristically, the Greek landscape is formed by mountains of moderate size, which surround very clearly defined areas of valley and plain, and by islands, clearly demarcated land surfaces surrounded by flat blue sea. Unlike the deserts of Asia Minor and northern Africa or the Alps of Central Europe, the Greek landscape is

of a scale and clarity that can be contained, so to speak, by the human eye.

With this in mind, Scully notes that each of the Minoan palaces possesses the same relation to the landscape: the palace is set in an enclosed valley on a north-south axis; there is, nearby, a gently mounded or conical hill; beyond this, on the same axis, is a higher, double-peaked or cleft mountain.

The two temples of Hera at Paestum have an analogous relation to the landscape. Hera is not only the wife of Zeus, and thus the goddess of marriage and domestic stability, but also the earth mother. The temples at Pacstum were built side by side, on the same axis, oriented toward a conical notched mountain to the east. Standing beside them, at their western end, the direction from which the viewer would naturally approach them, the perspective created by their sides points toward the mountain itself. "Once seen together," Scully writes, "both land-scape and temple will seem forever incomplete without the other. Each ennobles its opposite, and their relationship brings the universe of nature and man into a new stable order."

technique, the details no longer need to be scraped into the surface as they had been in black-figure, and this facilitates the drawing of details. It is easier to paint details with a brush than to incise them.

The red-figure style put Athens in the forefront of the vase-producing industry. Athenian red-figure vases were exported, as black-figure vases had been. In the last quarter of the fifth century B.C., Athenian vase painting was at its peak of production, and the city was to maintain its monopoly on the vase industry for about two hundred years. In fact, the other vase-producing sites (Corinth, Sikyon, Sparta, the islands, the Ionian east) stopped producing vases or greatly diminished their industry.

Signed by EUXITHEOS [yoog-SITH-ios] as potter and EUPHRONIOS [yoo-FRO-nios] as painter is a calyx krater (fig. 3.21), dating from about 515 B.C., on which is depicted the Death of Sarpedon from the story of the Trojan War. As Homer tells it in The Iliad, Sarpedon, the son of Zeus and Europa, was a Trojan leader. He was killed by Patroclus at Troy when attacking the Greek camp, after which there ensued a battle over his body. In this scene, Sarpedon is lifted by Sleep and Death in the presence of Hermes and two Trojans. Sleep and Death are twin brothers. It is a scene of mourning—a favorite Greek subject from the Geometric period onward. Sleep and Death bring Sarpedon back to his home. Hermes is included in the scene because he is the messenger of the gods, but also because he is the guide of the dead in Hades; he conducts the souls of the dead to Hades. All the names of the figures are inscribed, sometimes written right to left.

In this active and emotional scene, the narrative element is highly developed, as is the refined style.

Sarpedon is shown from the front, with the anatomy realistically rendered. Details of the muscles, tendons, and beards are finely depicted. The scene is drawn within a rectangle, and the figures move along a baseline in typical red-figure style. Within this rectangle, the composition accommodates the shape of the vase. Decorative bands provide a border, above and below. Red-figure vases of the later Classical period show a decreased interest in the heavy borders, which become less prominent or are absent.

The Greek Temple. The monumental structures erected by ancient Greek architects have proved to be of immense importance historically, influencing much of Western architecture. Even today, the principles and "vocabulary" of the ancient Greeks continue to be an extremely significant source of inspiration for architects. Despite their continuing importance, however, the study of ancient Greek architecture is hampered by selective survival. Buildings constructed of impermanent materials-wood, for instance-no longer exist, whereas many structures built of stone still survive. The functions of these buildings also tend to be limited to public use—the history of ancient Greek architecture is largely the history of the Greek temple, although there are extant treasuries, porticoes, massive gateways, theaters, and monuments as well. Virtually nothing remains of domestic architecture, for there is no evidence of the architecture in which most of the people passed most of their lives.

The typical Greek temple consists of three basic parts: the **platform**, **colonnade**, and **entablature** (fig. 3.22). The platform is made up of the **crepidoma** or **crepis**,

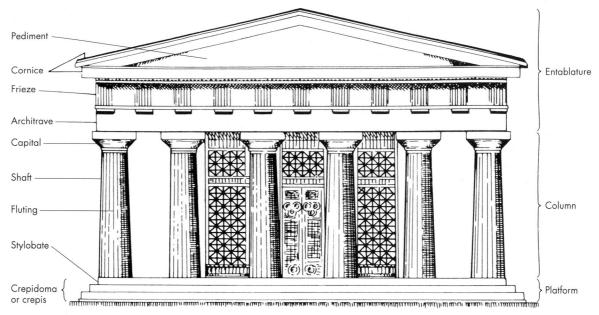

Figure 3.22 The basic elements of a typical Greek temple facade.

the three visible steps of the platform, of which the stylobate, or base for the columns, is the top step. The columns which make up the peristyle, or colonnade surrounding all four side of the temple, consist of a shaft, which tapers upward, differing from the Minoan column, which tapers downward. The columns are fluted, or carved with a series of parallel vertical ridges, and are topped by the capital. The entablature consists of the architrave immediately above the capitals and, in many temples, a frieze or band of ornamental carving. Rising above the entablature on each end of the temple and enclosed by a cornice is a triangular pediment.

The Temple of Hera I at Paestum. The earliest style of Greek temples is known as the Doric, after the tribes that invaded Mycenae from the north after about 1100 B.C. The Doric style is simple, severe, powerful in appearance, with little decorative embellishment. Some of the purest examples of the Doric style can be found in the lower third of Italy and in Sicily, regions that were considered part of Greece as early as the seventh century B.C. At Paestum in southern Italy the Greeks built three temples, side by side, the earliest of which is extremely important in the study of the development of the Doric order.

Dated 560–550 B.C., the Temple of Hera I (fig. 3.23), so called to distinguish it from the later Temple of Hera built at the same site, was constructed of local limestone. Its closely spaced columns support a high and heavy entablature that makes them appear squat. Thick heavy columns taper noticeably to the top, with an abrupt transition from shaft to capital, which projects widely beyond the shaft. Little **entasis**—a subtle convex bulge in the

middle of a column shaft—is seen in these early columns. The entire effect, while monumental, appears disproportionate and awkward.

The Temple of Aphaia at Aegina. Soon after, back on the Greek mainland, the Doric temple achieved remarkable beauty in the Temple of Aphaia at Aegina

Figure 3.23 Temple of Hera I, Paestum, Italy, 560–550 B.C., limestone. The sixth century B.C. was a time of architectural experimentation. Although the proportions used here are not harmonious, the two temples built later at Paestum have thinner columns and less overhang to the capitals.

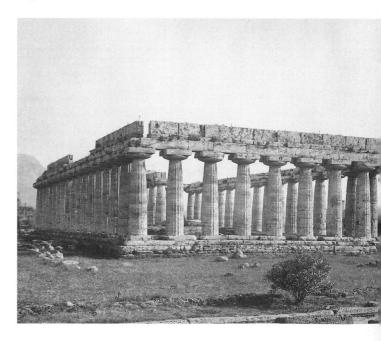

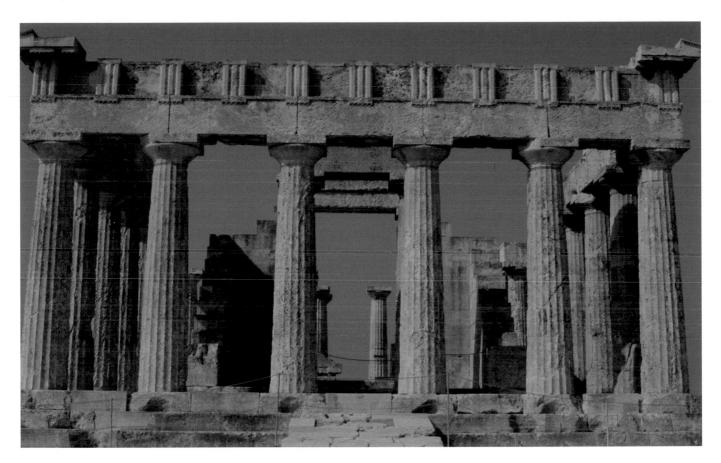

Figure 3.24 Temple of Aphaia at Aegina, view from the southeast, ca. 510 B.C. The columns and capital of the Aeginian temple appear more graceful than those of the Temple of Hera at Paestum, thus indicating a later date of construction.

(fig. 3.24). This is accomplished by widening the spaces between the columns, making them proportionately taller in relation to the entablature, and, particularly, by narrowing the individual columns themselves. The sense of proper proportion achieved in the process became a fundamental characteristic of Greek art and architecture. Both the Temple of Hera I at Paestum and the Temple of Aphaia at Aegina utilize a 1:2 mathematical ratio. That is, at Paestum, there are nine columns on the ends and eighteen on the sides of the temple, while the Aegina temple has six columns on the ends and twelve on the sides. Soon, however, this proportion was modified. In what is now referred to as a regular temple, the number of columns along the sides was designed to be double the number of columns on the ends plus one. Examples of regular temples are the six-by-thirteen Temple of Athena at Paestum, and the Parthenon in Athens, which is an eight-by-seventeen temple. The desire to refine and perfect in a quest for order and harmony is seen in the continual experimentation that preoccupied the Greeks as they strived to arrive at an ideal type. The goal was to improve upon what already existed, rather than to innovate radically.

Sculpture. The history of ancient Greek sculpture is dominated by images of the human figure, particularly the **kouros** (plural, **kouroi**) [COO-ross; COO-roy] (fig. 3.25), a lifesize representation of a nude male youth, seen standing with one foot forward and arms to his sides, and the **kore** (plural, **korai**) [CO-ray], the female equivalent, but clothed.

Strictly speaking, the first large-scale sculptures of the human figure date from the Orientalizing period, although the form developed so rapidly in the Archaic period that we will concentrate on sixth-century B.C. examples. The early Near Eastern influence appears to have been decisive. The characteristic pose of the kouros is believed to have derived from Egyptian sculpture. The marble kouros (fig. 3.25), carved ca. 600 B.C., shares many of its features with Egyptian figures (see fig. 2.7): the rigid frontality, erect stance, and pose with left foot forward. However, the Greek figure is nude and has been carved to be freestanding. There are thus no webs of stone between the arms and body and between the legs, and no supporting back pillars.

The kouros reproduced here was also originally painted—all sculpture was colored with reds, yellows,

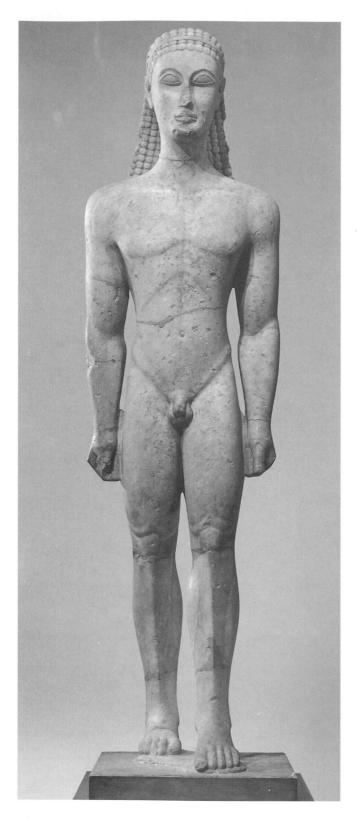

Figure 3.25 Kouros, ca. 600 B.C., marble, height 6'4" (1.93m), Metropolitan Museum of Art, New York. A Greek kouros is a statue of a standing nude male. Details of the anatomy form a decorative surface pattern. The pose, with one foot forward yet the weight of the body equally distributed on both feet, comes from Egypt.

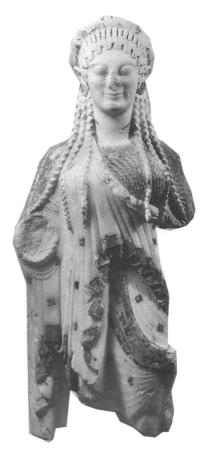

Figure 3.26 Kore, wearing an Ionic chiton, ca. 520 B.C., marble, height $22\frac{1}{8}$ " (56.3 cm), Acropolis Museum, Athens. The decorative chiton, made of soft, thin fabric, clings to the body. The Archaic smile is still evident here.

blues, and greens. Some pieces still retain some of their original color. Touches of red pigment remain on this kouros's hair and elsewhere.

Early kouros figures are highly stylized and characteristically have an enigmatic expression, which is often referred to as an "Archaic smile." The eyes are abnormally large, and the hair forms a decorative bead-like pattern. The anatomy is arranged for design rather than in strict imitation of nature; thus the abdominal muscles and knee-caps become surface decoration. The figures are not portraits of individuals; there is no evidence that they were done from models.

Over time kouros and kore figures become less stylized and more naturalistic and the poses more relaxed. They remain slender, but the waist gradually expands. Proportions of the various body parts become more natural and are no longer indicated by lines on the surface but rather by the sculpting of the material itself. It is possible to assign approximate dates to examples on the basis of these changes.

The changes that were gradually taking place are demonstrated by a late Archaic kore (fig. 3.26), carved ca. 520 B.C. Made of Island marble, this particular kore

was elaborately painted. Figures like this with one hand extended may represent a goddess or donor.

Exquisitely sculpted, this delicate and dainty figure appears soft and sensual. The face still has an "Archaic smile," but the eyes are smaller than they were before, and the slanting eyes, hairstyle, and decorative treatment of the costume suggest an Eastern origin for this figure in the Ionian islands—perhaps the island of Chios.

The figure is dressed in a chiton, a belted single-piece garment for women with buttoned sleeves, which was imported to Athens from castern Ionia just before the middle of the sixth century B.C. The sculptor gives much attention to this costume. The fabric is thin and clings to the body, the folds and draping are complex, the cut of the garment asymmetrical, and the hemlines are emphasized with colored bands. The cloak, worn over the chiton, ties on one shoulder, creating diagonal patterns and curved lines. The simplicity of earlier sculpture has given way to more sophisticated subtle modeling, even as Greek culture was becoming more sophisticated itself.

Philosophy. Perhaps nothing distinguishes the rise of ancient Greece as a civilization more than its love of pure thought. The Greeks were the first to practice "philosophy," literally the "love of wisdom," in a systematic way, categorizing the various aspects of the world and their relation to it in terms that were based not on faith or emotion but on logic and reasoning.

Before the ascendancy of Socrates and his pupil Plato in the late fifth century B.C. and after, Greek thinkers hotly debated the nature of the world and their place in it. There were the **materialists**, who explained the world in terms of the four elements—fire, earth, air, and water. HERAKLEITOS [hair-ah-KLY-tus] (ca. 535–475 B.C.) defined the world as being in a state of constant flux: Nothing is, he claimed, rather all is in a constant state of becoming. One can never step in the same river twice, he said, since the water will necessarily have flowed on downstream the second time, and even if one were to follow the water, the bank would have changed. Thus, every day is different, enmeshed in the flow of time.

Another group of thinkers, the **atomists**, led by DEMOCRITUS [dih-MAH-crih-tus] (ca. 460 B.C.), conceived of the world as being made up of two basic elements, atoms—small, invisible particles that cannot be divided into smaller units—and the void, the empty space

between atoms. Atomism survived in a changed form in the later philosophy of the Epicureans (see Chapter 4) and had a dramatic influence on the thinking of the scientists who evolved modern atomic theory and quantum mechanics.

But perhaps the most important of these Presocratic thinkers was PYTHAGORAS [pih-THAY-guh-rus] (582–507 B.C.). For him, "number" was at the heart of all things. Today he is most often remembered for his theorem in geometry—in right-angle triangles, the square of the hypotenuse is equal to the sum of the square of the other two sides. These triangles are unified by number. Pythagoras extended this principle to music. He discovered that a string of a certain length, when plucked, made a certain sound; cut in half, it played the same note, only an octave higher. Mathematical ratios, he reasoned, determined musical sound relationships. The entire natural world, including the movement of the planets, depended upon these same ratios, he believed. There was, underlying all things, a "harmony of the spheres."

Sappho and the Lyric Poem. As with epic poetry, there was an oral tradition of lyric poetry long before the first verse was written down. Unlike epic, which was chanted, lyric poetry was originally sung, accompanied by the lyre, the stringed instrument from which the name "lyric" derives. Also unlike epic, which flourished in Ionia, lyric flourished on the island of Lesbos, especially in the sixth century B.C. with the lyric poetry of Sappho [SAFF-oh] (ca. 610–580 B.C.). Where epic provides a somewhat distant and communal perspective on human experience, lyric offers a personal voice, an intimate expression of subjective feeling and sensation.

Sappho's fame as a poet was acclaimed by Plato, who described her as "the tenth Muse." The Early Christian Church, however, did not appreciate the sensuality of the poems, nor their lesbian subject matter. Much of Sappho's work was destroyed during the Middle Ages, with manuscripts of her poetry consigned to fires during the fourth century A.D. in Constantinople and during the eleventh century in Rome. Only a few poems remain in their entirety along with a series of fragments of others.

Little is known of Sappho's life, except that she was married and had a daughter, Cleis. Even from what little survives of Sappho's work, readers can appreciate the intensity of emotion they express and the direct and graceful way they celebrate female experience.

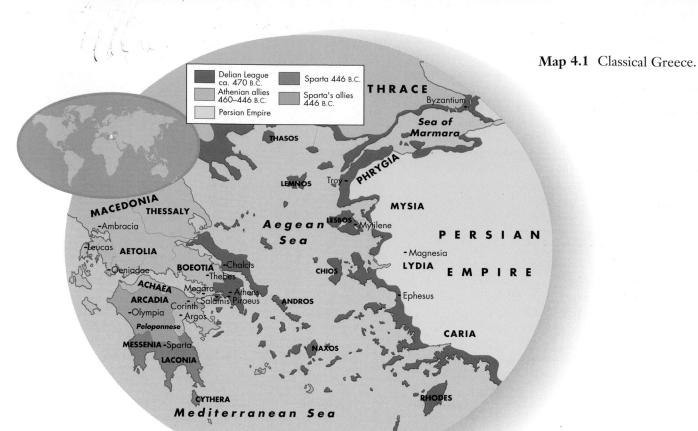

CLASSICAL *AND HELLENISTIC GREECE

> "spirit of the age." Ancient Greece: Ostring for what is beautiful (Righteus/victure) 1. History of Anthers/ government / Zerst Geist @ Humanism: Glorifing the human spirit body and 2) Temples Eredom. 3) Philosophy 4.) Impact on World History CHAPTER 4 04/04/03 Philosophy = love of wisdom asking questions

O socrates - socratic method asking questions Classical Greece - utopia > Perfect Place (nepublic) 3 Plato Hellenistic Greece 3 Aristutle lilethics > wrong/right? 1) Battle of Marathon 12) Scientific me and 4) Alexander the Great plan of marathon Spread Greek Culture castward, Egypt, and North 2) Battle of thermophyia Pass Destroyed = Persians pestray athens Oathers Lestroyed (2) Persion threat - Arch - style lasts to the very Day!
-liberty, and freedom & Highest virtues in Acropalis Temple athens 1) Parthenon anthens math } Evold , Phylagorus (AZ+B)=cZ 2) Erechtheim entrance 3) Propylia Mnesikles, Erechtheion, Acropolis, Athens, 437 or 421-406/405 B.C. Athena Nike 4) temple

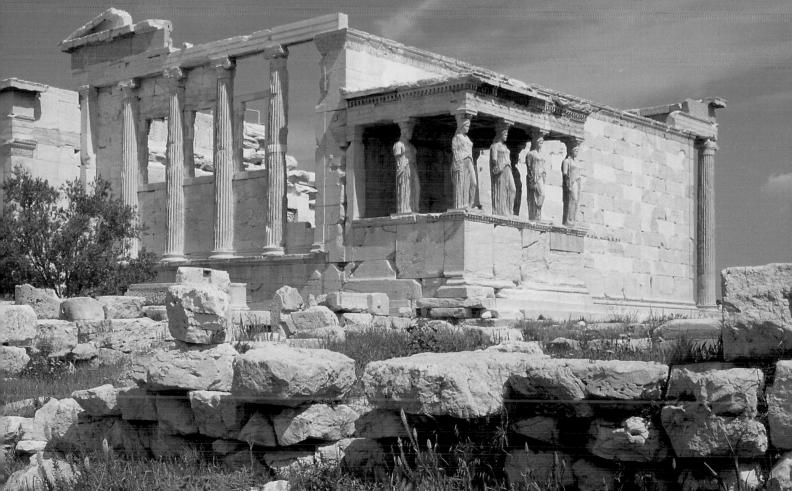

CLASSICAL GREECE

In the decade between 490 and 480 B.C., something remarkable happened in Greece, and in Athens in particular, that resulted in one of the most culturally productive eras in the history of humankind. Before 490 B.C., as was explored in the last chapter, the Greeks had developed a highly sophisticated culture, but it pales by comparison to developments in the so-called Athenian Golden Age, a period of unsurpassed cultural achievement that can be said to begin with the Athenian defeat of the Persians in 479 B.C. and end nearly eighty years later, in 404 B.C., when Athens fell to Sparta. But the cultural achievement of the era was by no means exhausted with Athens's fall. This Golden Age had sparked a Classical period in Greece—"classical" because it forms the very basis of Western tradition down to this day that would extend nearly another century until the death of Alexander the Great in 323 B.C. Even then, as the political power of Greece waned, its cultural preeminence carried on, through a Hellenistic period (from the verb "to Hellenize," or spread the influence of Greek culture), in which the basic tenets of Greek thought were perpetuated by the three dynasties that emerged after Alexander's death—the Ptolemies in Egypt, the Seleucids in Syria and Mesopotamia, and the Antigonids in Macedon—despite the competition for political dominance among them. Only after Rome captured Corinth in 146 B.C., making Greece into a province of the Roman Empire, did Greek culture begin to be absorbed into the new "Romanized" world. Even then the Hellenistic period was not truly at an end, continuing in Egypt until the death of Queen Cleopatra in 30 B.C.

Classical Greek civilization, especially that of Golden Age Athens, was crucial to the development of Western civilization as we know it today. The Greeks of antiquity developed a rich and vibrant culture, whose achievements consisted of preeminent masterpieces of pottery, sculpture and architecture, poetry and drama. Their achievements also included expertise in the practical arts of commerce and seafaring; metalwork, coining, and engraving; medicine and athletics; and philosophy, education, and government. The philosopher Protagoras [proh-TA-go-rus] (ca. 485-415 B.C.) wrote that "People are the measure of all things," a phrase that heralded the enterprise first undertaken in Classical Greece but which has been so central to Western culture ever since. Classical Greece was the first civilization to so thoroughly explore the human condition, recognizing the realities and constraints of human life, yet constantly striving to realize ideals. The Greeks invented democracy and left it as a legacy for Western Europe to emulate two millennia after the decline of Athens. Their ideal of political freedom also served as the basis for the pursuit of other ideals such as justice, truth, and beauty. Political freedom was part of the culture's belief in individual expression. The Greek system of *paideia*, or learning, was grounded in respect for individual thought, and emphasized logic, dialectic, debate, and elegance of expression. As in athletics, competition was encouraged in the arts, and the victor was celebrated as a kind of hero. The annual competition among dramatists led to the creation of Sophocles' plays, including *Oedipus the King*. Above all, against the background of warring mainland Greece in the fifth century B.C., the Greeks provided the Western world with a sense of the value, balance, and harmony in all things—in art, architecture, philosophy, literature, politics, and daily life.

FROM ARCHAIC TO CLASSICAL

Political Reform. Many things contributed to the astonishing rise of Athens as the cultural center of the world in the fifth century B.C. Chief among them is the century of political reform that preceded the Golden Age. As early as 621 B.C., the benevolent tyrant DRACO [DRAY-koh] published what is thought to be the first comprehensive code of laws in Athens. This offered a single standard of justice to all Athenians. Aristocratic judges could no longer automatically favor the landed aristocracy in their rulings, making up the law as they went along. Instead they were required to apply Draco's code uniformly to the growing commercial class and even to poor farmers.

Just as important to this process of change was SOLON [SOH-lon] (ca. 640-558 B.C.), who brought great reforms to the civil administration of Athens. He divided the citizens into four classes, all of whom had the right to take part in the debates in the political Assembly. Though Solon limited the highest offices to members of the nobility, he did allow the lower classes to sit on juries, and jury duty became a civic responsibility. He ended debt-slavery (the practice of paying off a debt by becoming the creditor's slave), employed large numbers of artisans, and promoted trade, particularly trade in pottery. PISISTRATOS [pi-SIS-truh-tus] (ca. 605-527 B.C.) went even further, redistributing the large estates of the nobility to the landless farmers, who, as a result of their improved economic status, suddenly found themselves able to vote. Like Solon, Pisistratos also championed the arts, commissioning the first editions of The Iliad and The Odyssey for students and scholars.

Shortly prior to 508 B.C. CLEISTHENES [KLICE-thuh-nees] (d. 508 B.C.) divided Athens into **demes** (neighborhoods), representing what he had labeled the ten "tribes" of Athens. Each "tribe" was allotted fifty seats on a Council of Five Hundred. The fifty representatives for each neighborhood were selected at random from a list of nominees on the theory that anyone nominated was capable of exercising judgment about affairs of state. The Council elected ten generals yearly to run the

city, and at the head of them was a commander-in-chief, also elected yearly. Thus, out of the demes of Athens developed the first democracy.

The Persian Threat. This democracy was put to the test beginning in 490 B.C. when the same Darius who built the palace at Persepolis in Persia (see fig. 1.21) invaded the Greek mainland. On the plain of Marathon, north of Athens, Darius's mighty army was confronted by a mcrc ten thousand Greeks, led by General MILTI-ADES [mil-TIE-uh-dees]. In a surprise dawn attack, Miltiades' troops crushed the Persians, killing an estimated six thousand, while the Greeks suffered only minimal losses themselves. Victory was announced to the waiting citizens of Athens by the messenger PHIDIPPIDES [fi-DIP-ih-dees], who ran twenty-six miles with the news—the original "marathon" run.

To the Athenians, the Battle of Marathon symbolized the triumph of civilization over barbarian hordes, of wit and intelligence over brute strength, and of democracy over tyranny. But the Persian giant was not yet tamed, and the Athenian general THEMISTOCLES [thih-MIS-tu-klees] knew this. A rebellion in Egypt and the death of Darius in 486 B.C., following which his son Xerxes ascended the throne, preoccupied the Persians temporarily. But all the while Themistocles was preparing for what he believed to be the inevitable return of the Persian army. And come Xerxes did, in 480 B.C., with an army so large that reports had it drinking rivers dry.

It is to HERODOTUS [heh-ROD-ut-us] (484–420 B.C.), the first writer to devote himself solely to history

and who is therefore known as the Father of History, that we are indebted for much of our knowledge of the Persian Wars. He estimated the Persian army at five million men, surely an exaggeration, but certainly the Persians far outnumbered the Greeks. Themistocles knew that such an army could not be defeated on land. More conservative Athenian leaders, remembering the great victory at Marathon, thought otherwise. Athens was evacuated, and a small force of three hundred Spartans led by LEONIDES [lee-ON-ih-dees] went north to Thermopylai [thur-MOP-uh-lye], a narrow pass between the sea and the mountains, where they held off the Persian advance for days. Betrayed by a local guide, who showed Xerxes a path around the pass, the Spartans were finally surrounded, but continued fighting until all were dead. With Athens now deserted, it was destroyed by the Persians, and Themistocles retreated to the island of Salamis [SAL-ah-miss]. This was a trick, however, for when the Persians boldly sailed after him, they were unable to maneuver in the narrow bay, and the Persian fleet was entirely destroyed. The playwright Aeschylus, who fought both at Marathon and at Salamis, later celebrated the victory in verse:

Crushed hulls lay upturned on the sea, so thick You could not see the water, choked with wrecks And slaughtered men; while all the shores and reefs Were strewn with corpses...

Within a year, the Persian land forces were also driven from the mainland, and Greece was free.

Timeline 4.1 Classical Greece.

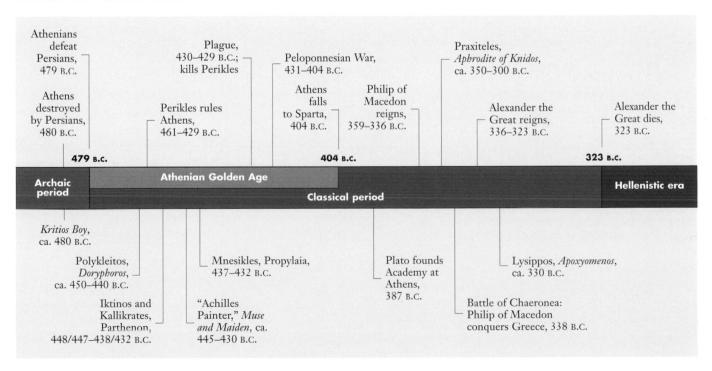

THE GOLDEN AGE OF ATHENS

Over the centuries Athens had grown and prospered, a city within strong stone walls, protected by a vast citadel on an **acropolis** (literally, the high point of the city, from *akros*, meaning "top," and *polis*, "city"). There, temples were erected, law courts and shrines were built, and a forum for the Pan-Athenaic Games was constructed. The Persians destroyed all this and more in 480 B.C. The whole of Athens had to be rebuilt.

The first order of business was the city's walls, and the entire population was put to work restoring them. When the walls were completed, the Athenians turned their attention to the **agora**, or market place, in which shop-keepers and craftspeople made, displayed, and sold their wares. Here, at the foot of the Acropolis, they built a council chamber, a court house, several long **stoas**, or roofed colonnades, to house shops, and a smaller royal stoa in which the "Laws of Solon" were carved on stone and could be viewed by all citizens.

No attempt was made to rebuild the temples on the Acropolis. Their foundations were left bare as a reminder of the Persian aggression. But by mid-century, the restoration of the site seemed a matter of civic responsibility, an act of homage to Athena who had helped the Greeks defeat the Persians, and it was taken on by the great Athenian leader PERIKLES [PAIR-ih-klees] (ca. 500-429 B.C.). Perikles was first elected general-in-chief in 461 B.C., and, except for two years when he was voted out of office, remained in command until his death in 429 B.C. Under the artistic and administrative supervision of PHIDIAS [FI-dee-us], the best artists and artisans were hired, over 22,000 tons of marble were transported from quarries ten miles away, and vast numbers of workers were employed in a construction project that lasted until the end of the century. The Acropolis embodied, for Perikles, the Athenians' "love of beauty," as he put it in an oration delivered in 430 B.C. at a state funeral for Athenian citizens who had died in battle. Its

Figure 4.1 General view of the Acropolis. Even in relative ruin, the Athenian Acropolis remains a breathtaking sight, and a poignant reminder of past accomplishments.

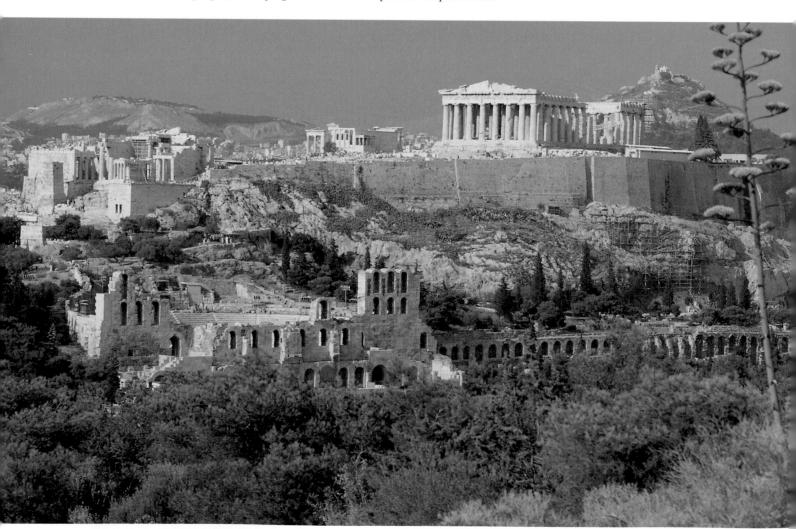

Figure 4.2 Diagram of the Doric (a), Ionic (b), and Corinthian (c) orders. The three orders of Greek architecture were developed in antiquity and continue to be used even today.

buildings were "things of the mind," he said, embodiments of the greatness of Athens itself (fig. 4.1). And it is true that when work on the citadel was completed, the Acropolis at Athens was, with the possible exception of the Egyptian pyramids, probably the most impressive visual spectacle in the world.

The achievements of the sculptors and architects on the Acropolis represent the high point of Classical Greece in the visual arts, although at the same time dramatists, philosophers, and historians were laying the foundations for their subjects for the next two millennia. However, all of this was done against a background of social and political uncertainty. It is often said that the Greeks' characteristic pursuit of balance and order in their art was a reaction to the extreme disorder of the world around them. Two major disasters struck Athens in the late fifth century B.C. The first, a devastating plague, occurred in 430-429 B.C., its most important victim being Perikles himself. The Greek historian THU-CYDIDES [thyou-SID-id-ease] (ca. 460-ca. 400 B.C.) described how the "bodies of the dying were heaped upon one another" as "half-dead creatures" were "staggering about in the streets or flocking around the fountains in their desire for water." A year earlier, the longstanding Spartan resentment of Athenian power had erupted in the Peloponnesian War, which ended with Athens's defeat at the hands of the Spartans in 404 B.C. Although the glory of Athenian civilization was effectively over, its magnificent cultural achievements in the fields of art and architecture, literature and politics, would forever influence the future of Western civilization.

ARCHITECTURE AND ARCHITECTURAL SCULPTURE ON THE ACROPOLIS

The Greek Orders. The ancient Greeks developed the three orders or arrangements of architecture—the Doric order, the Ionic order, and the Corinthian order (fig. 4.2). The column capital is the easiest way to determine whether the order is Doric, Ionic, or Corinthian.

As noted in Chapter 3, the **Doric** is the oldest and simplest of the three orders and was the order most frequently employed by the ancient Greek architects. By the Golden Age it had been perfected. Its capital is characterized by the square block of the **abacus** and the cushion-shaped **echinus**, usually cut from the same piece of stone. There is no base beneath the Doric column, whereas there is a base at the foot of the Ionic and Corinthian columns. The Doric **frieze** consists of alternating **triglyphs**, so called because they have three sections, and **metopes**, square or rectangular areas that may be decorated.

The **Ionic** order is characterized by the scroll/volute capital—graceful and swirling. The Ionic was Eastern in

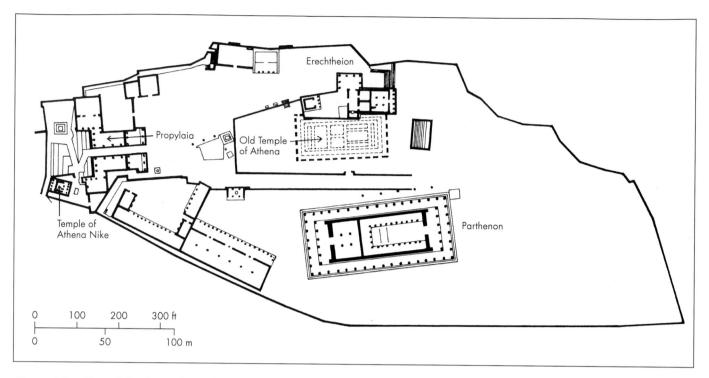

Figure 4.3 Plan of the Acropolis, Athens, after the mid-fifth century B.C. Shown here are the Propylaia, Parthenon, Erechtheion, and Temple of Athena Nike.

origin and was especially popular in Asia Minor and the Greek islands. The **entablature** has a frieze of continous decoration.

The **Corinthian** order, a development of the Hellenistic age, is characterized by the large curling acanthus

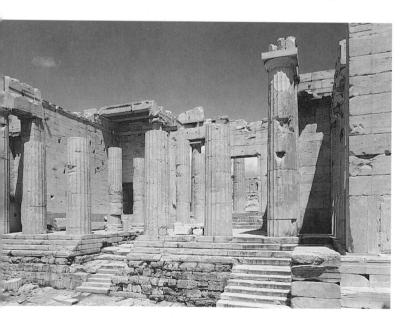

Figure 4.4 Mnesikles, Propylaia, Acropolis, Athens, 437–432 B.C., marble, seen from the west. To gain access to the Acropolis ("high city"), the visitor ascended the many stairs of the Propylaia ("front gates").

leaves that ornament the capital. The Corinthian is the most ornamental and delicate of the three orders. It was the order least used by the Greeks but most favored later by the Romans.

Both figuratively and literally, Classical Greek architecture reached its high point on the Acropolis (fig. 4.3). Here the Doric and Ionic orders came together in a stunning exhibition of architectural beauty and refinement. The four main buildings on the Acropolis are the Propylaia, the Parthenon, the Erechtheion, and the Temple of Athena Nike, all of which were built under the supervision of Phidias in the second half of the fifth century B.C.

The Propylaia. The visitor to the Acropolis must enter through the Propylaia [PROP-uh-LIE-yuh] (fig. 4.4), the front gates, constructed at the only natural access point to the Acropolis. Construction of the Propylaia was begun in 437 B.C., but due to the outbreak of the Peloponnesian War in 431 B.C., it was never finished. The architect was MNESIKLES [mee-NES-ihklees]. On the north side of the Propylaia was a pinakotheke or picture gallery. The visitor passed through a porch with six Doric columns, into a hall, from which the wings of the Propylaia extended. Ascending several levels, passing between columns, the visitor emerged on the east side, exiting through another porch with six columns. The central set of columns is wider than the others-useful for processions of people and sacrificial animals.

The Parthenon. The Parthenon [PAR-theeh-none] (fig. 4.5) is the only Acropolis building that was actually finished—construction of the rest was halted by the Peloponnesian War. The Parthenon is considered the ultimate example of ancient Greek architecture, the paradigm of perfection. Dated by inscriptions to between 448/447 and 438 or 432 B.C., it is the perfect example of the Classical Doric temple and is dedicated to the goddess Athena. Located at the highest point on the Λcropolis, the Parthenon is the largest building there and is also the largest Doric building on the Greek mainland. The architects were IKTINOS [ik-TIE-nus] and KAL-LIKRATES [ka-LIK-kra-tees]. Phidias took on the task of its sculptural decoration, and he made a gold and ivory cult image of Athena Parthenos, dedicated in 437 B.C.

The Parthenon has all the features that characterize a Classical Doric temple (fig. 4.6). The **cella**, the enclosed part of the temple, contained the cult statue of Athena Parthenos. The **pronaos** is the front porch or vestibule supported by columns (*pro* means "in front of," and *naos* means "temple"). The **opisthodomos** is the back porch, with columns. The Parthenon is surrounded by a **peristyle**, or colonnade.

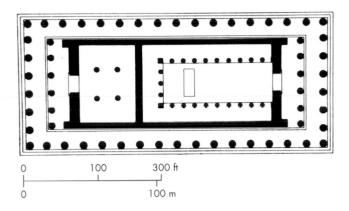

Figure 4.6 Plan of the Parthenon. Because of the ratio between the number of columns on the width to those on the length, the Parthenon is referred to as a regular temple. The length (here seventeen columns) is twice plus one the width (eight columns).

Perhaps nothing better explains the overwhelming beauty of the Parthenon, still apparent even in its ruined condition today, than the perfection of its proportions. The facade is based on the so-called **Golden Section**:

Figure 4.5 Iktinos and Kallikrates, Parthenon, Acropolis, Athens, 448–432 B.C., marble, seen from the northwest. The epitome of Classical Greek architecture, the Parthenon is a regular Doric temple. All major lines actually curve slightly. Such refinements are now believed to have been intended to add to the beauty of the building rather than to correct for optical distortion.

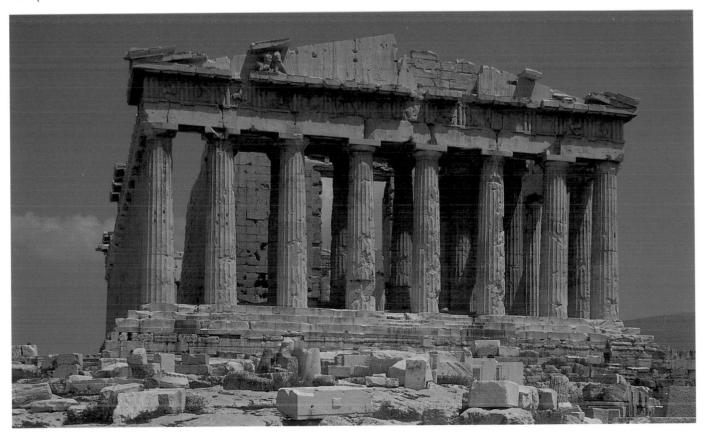

the width of the building is 1.618 times the height, a ratio of approximately 8:5. Plato regarded this ratio as the key to understanding the cosmos. That Athena's temple, the Parthenon, should be constructed according to this proportion is hardly accidental. As the goddess of wisdom, Athena represents the ultimate wisdom of the cosmos itself.

In addition to the beauty of its proportions, the Parthenon possesses all of the "refinements"—the deviations from absolute regularity and rigidity—used by ancient Greek architects. Despite appearances, there are no straight lines to the Parthenon. The steps and the entablature both form convex curves. Each block of marble is a rectangular prism with precisely cut right-angle corners (referred to as **ashlar** masonry), but when the courses were laid, the blocks were positioned so as to be faceted in relation to one another. The columns have **entasis**, the slight bulge in the column shaft, and they taper to the top—that is, their diameter is less at the top than at the bottom. The columns at the corners are placed closer together than elsewhere.

Why were these refinements introduced? The columns lean inward. They would meet if they were extended, creating a pyramidal form, the most stable of geometric forms. They are fluted, we know, because, seen from a distance, they would appear as flat slabs rather than rounded columns without the pattern of light and shade created by the fluting. But why make the platform and entablature convex? It has been suggested that this was done to adjust the visual perspective, to correct optical distortion, the argument being that the human eye perceives parallel lines as coming together in the middle. However, if the refinements were intended to correct optical distortion, the argument must follow that they should go unperceived by our eyes. However, the visitor to the Parthenon finds the refinements readily visible.

Perhaps a more accurate explanation for the refinements is that they are intended to add beauty to the building. Curved lines are more appealing, satisfying, comfortable to our eyes than are rigidly straight ones. Nature creates no straight lines—only people produce perfectly straight lines and right angles. The columns, ultimately taking their form from tree trunks, are larger at the bottom than the top. And the trunks of certain types of trees do bulge along their length, as is reflected in the entasis of the stone columns.

Like the Propylaia, the Parthenon combines Doric and Ionic elements. Although the peristyle is Doric, the frieze around the top of the cella wall is an Ionic element. In addition, there were four Ionic columns inside the cella.

Parthenon Sculpture. The sculptural decoration of the Parthenon was done under the direct supervision of Phidias. Phidias himself created the now lost chryselephantine (gold and ivory over a wooden core) statue of the Athena Parthenos (Virgin Athena), which was housed in the cella of the Parthenon proper, and a giant bronze, also now lost, an Athena Promachus (Athena the Defender), which stood just inside the Propylaia, and which was so tall the sailors arriving at the Athenian port of Piraeus ten miles distant claimed to see the sun reflected off her helmet. It remains unclear just how much of the other Acropolis sculpture Phidias was personally responsible for, but it is generally consistent in style and is referred to as "Phidian."

There are three categories of surviving Parthenon sculpture: ninety-two squarish metopes on the entablature, carved in high relief—most of those that survive have as their subject the mythological battle between the Lapiths and centaurs (fig. 4.7); the frieze on the upper wall of the cella, carved in low relief; and the huge free-standing figures that filled the east and west pediments, carved in the round.

The west pediment depicts the competition between Athena and Poseidon for the land of Attica. The east pediment depicts the birth of Athena from the head of Zeus. The figures are badly damaged, but nonetheless demonstrate the magnificent Classical balance struck between idealism and naturalism. The way the sculptor suggests the folds of the drapery is at once highly naturalistic and governed by a sense of perfect proportion (fig. 4.8).

Figure 4.7 Lapith and centaur, metope, Parthenon, ca. 440 B.C., marble, height 4'5" (1.34 m), British Museum, London. The struggle of the Lapiths with the centaurs served the Greeks as a metaphor for the conflict between the civilized and the barbaric.

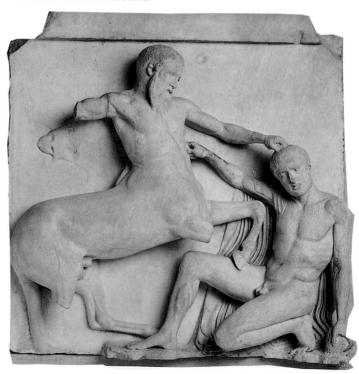

91

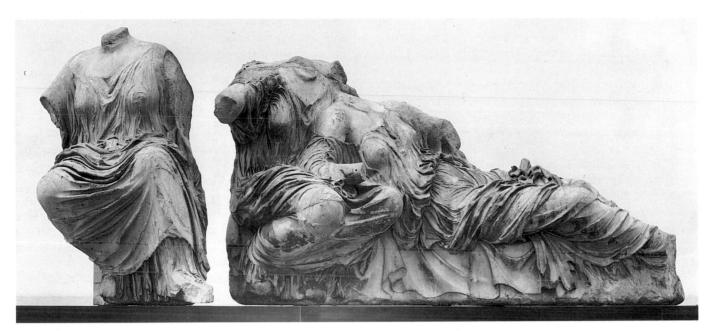

Figure 4.8 Three seated goddesses, east pediment, Parthenon, 438–432 B.C., marble. Far from their stiff ancestors, the movements of these casual figures seem to flow easily. The drapery is contrived to reveal the body and appears almost "wet."

The frieze (fig. 4.9) was carved ca. 440 B.C. of marble. The background of the frieze was painted and so were details of the horses' bridles and reins. Other accessories were made of bronze and riveted on. Until recently, the frieze's subject was widely believed to be a procession of people at the Pan-Athenaic festival held every four years

in honor of Athena. At this festival, the people of Athens walked in a long procession up the Acropolis to the Parthenon. Art historians have thus seen the frieze in the following terms: People are shown to come in chariots, on horseback, and on foot. Some move quickly, others more slowly. Some make music on flutes and kitharas.

Figure 4.9 Procession of Women, relief, from the Parthenon, Acropolis, Athens, ca. 440 B.C., marble, height of relief frieze 3'6" (1.07 m), Musée du Louvre, Paris. The aesthetic principle of unity and variety is demonstrated here: the figures have enough in common to appear unified, yet sufficient variety to avoid monotony. The physical type favored in the Classical Period was strong and young, idealized rather than individualized.

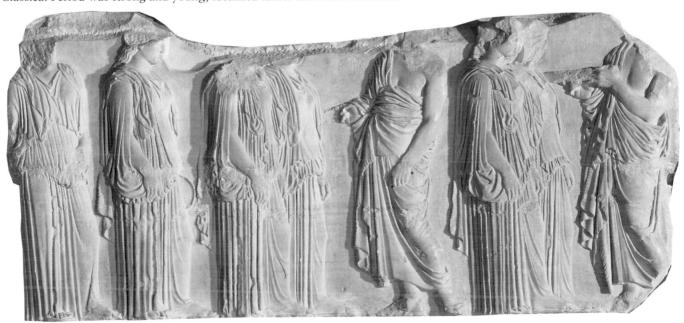

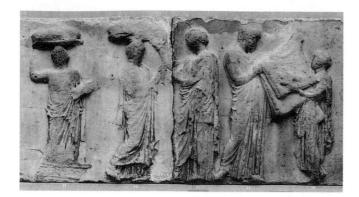

Figure 4.10 Erechtheus, Praxithea, and Their Daughters (?), relief, from the Parthenon, Acropolis, Athens, ca. 440 B.C., height of relief frieze 3'6" (1.07 m), British Museum, London. This section of the frieze originally stood immediately over the doorway giving access to the interior of the temple and to the statue of Athena. It probably depicts Erechtheus, dressed as a priest for the event, bestowing a funerary dress on his daughter, who is half disrobed. Behind him is Praxithea, who watches as her two older daughters bring her their funerary garments.

Animals for sacrifice are also included in the procession. However, this interpretation of the subject matter as a "documentary" record of a contemporary festival, though long accepted, is problematic, since on all other Greek temples the decoration is concerned exclusively with mythological subjects; ordinary people in scenes from contemporary Greek life are not depicted anywhere else.

A recent reinterpretation suggests that the Parthenon frieze may not after all be the first representation of a non-mythological subject in Greek art, but is instead a version of one of the foundation myths of Athens, that of Erechtheus and his daughters. Such an interpretation would certainly bring the decoration of the Parthenon into line with that of other Greek temples.

According to the 250 surviving lines of a lost play by Euripides, the Erechtheus, the story runs as follows: Athens was threatened by Eumolpos, the son of Poseidon, who was still angry at having lost the city's patronage to Athena—the battle for Athens between Athena and Poseidon is depicted on the west pediment. The oracle at Delphi tells King Erechtheus that he must sacrifice one of his three daughters to save Athens from destruction at Eumolpos's hands. But the daughters have long before made a pact that if one of them dies the others will die as well. Praxithea, Erechtheus's wife, knows this, but when she is told that a daughter must be sacrificed, she responds by choosing the common good over her own children. Erechtheus sacrifices his daughter, and the other two die, as does Erechtheus himself, swallowed up in a chasm made by Poseidon. But Athena triumphs over Eumolpos. In lines from Euripides' play rediscovered in 1962, Athena appears to Praxithea, and consoles her:

And first I shall tell you about the girl whom your husband sacrificed for this land: bury her where she breathed out her pitiful life, and these sisters in the same tomb of the land, on account of their nobility ... To my fellow townsmen I say not to forget them in time but with annual sacrifices and bull-slaying slaughters to honor them, celebrating them with holy maiden-dances.

In light of this story, the section of the east frieze that stood directly over the door to the temple may be seen to show the royal family preparing their youngest daughter

Figure 4.11 Mnesikles, Erechtheion, Acropolis, Athens, 437 or 421–406/405 B.C., marble. The most complex of the Acropolis buildings, the highly irregular plan of the Erechtheion covers several areas sacred to the early history of Athens. On the Porch of the Maidens, female figures (caryatids) perform the structural role of columns.

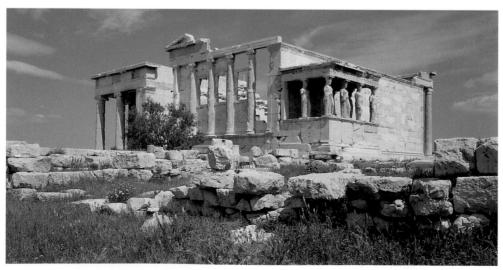

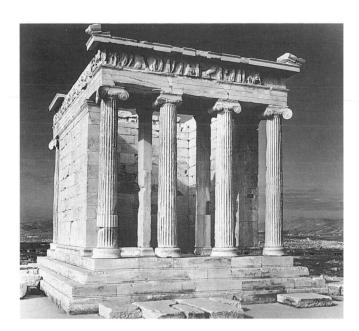

Figure 4.12 Probably Kallikrates or Mnesikles, Temple of Athena Nike, Acropolis, Athens, 427–424 B.C., marble. Dedicated to Nike, the winged goddess of victory, this tiny Ionic temple was largely dismantled and has now been reconstructed.

for sacrifice (fig. 4.10). Dressed as a priest for the occasion, Erechtheus hands his half-dressed youngest daughter her funereal garb. Behind him Praxithea watches as their other two daughters carry funerary garments. The Parthenon itself may rest over the tombs of the three virgin daughters of Erechtheus. "Parthenoi" can be translated "place of the virgins," and thus the procession depicted on the frieze might not be a commemoration of Athena but of Erechtheus and his daughters, who gave their lives that Athens might be saved.

The Erechtheion. The most architecturally complex building on the Acropolis, the Erechtheion [er-EK-thee-on] (fig. 4.11), was begun either in 437 B.C., the same year the Propylaia was begun, or in 421 B.C., after the death of Perikles. Work continued until 406/405 B.C., but the building was never finished. The architect may have been Mnesikles, the architect of the Propylaia.

The Erechtheion is unique and extremely irregular in plan. This is not due to the fact that the building was never finished. Nor is it due to the fact that it is constructed on uneven ground—the three main rooms are on three different levels; there is a nine-foot difference between the southeast side and the northwest side. Rather, the irregularities seem to derive from functional necessity, since the Erechtheion was designed to contain several sacred sites connected with the early history of Athens.

An olive tree here relates to the legend that Athena competed with Poseidon for patronage of Athens and won. Athens was therefore named after Athena and the goddess gave her city an olive tree. The Erechtheion certainly contained Athena's statue. The Athenians also appear to have sought to placate the defeated Poseidon, since part of the building was also dedicated to him.

In the southwest corner of the building is the Kekropium, the grave of Kekrops, the legendary founder and first ruler of Athens, who was said to be half-man and half-snake, and who judged the contest between Athena and Poseidon. Finally, the room across the west of the building is called the "Salt Sca of Erechtheus." Reputed to be a reservoir connected to the sea by an underground passageway, it is dedicated to Erechtheus, the early Athenian king under whose reign Demeter taught the Athenians the art of agriculture.

The most famous part of the Erechtheion is the Porch of the Maidens on the south side. Here there are six caryatids—female figures used as architectural supports. (Male figures that function in the same way are called atlantes.) The functional use of sculpture in architecture is a rarity in ancient Greece. However, these statues blend beautifully with the building: the figures' hair is carved so that the curls flow into the capitals. They stand in the contrapposto pose (see p. 110), the supporting leg hidden by the drapery of their dresses. This drapery falls in folds that simulate the fluting of a column, emphasizing their architectural role. Each figure has one arm down by her side; the other, now broken off, was extended. The figures form an obvious group, yet each of the six is slightly different—an example of the Greek aesthetic principle of "unity and variety." This porch was famous in antiquity and was used as the model for a multitude of buildings then and later.

The Temple of Athena Nike. The Temple of Athena Nike (fig. 4.12), dated between 427 and 424 B.C., was probably built from a plan by either Kallikrates or Mnesikles. In 449 B.C. a decree was issued stating that Kallikrates was to build a temple to Nike—which he may be presumed to have done, though the temple was not started until many years later.

Made in the Ionic style, it is a miniature temple with four Ionic columns on the front and four on the back. The continuous sculpted frieze on the entablature is also an Ionic feature. Between 410 and 407 B.C. a surrounding wall covered with low-relief sculpted panels depicting Athena as she prepared for her victory celebration was added—*Nike* is the Greek for "victory." The wall no longer survives, but some of its panels do.

SCULPTURE

The caryatids decorating the Porch of the Maidens on the Erechtheion, the friezes on the Parthenon, and the wall around the Temple of Athena Nike all make clear the centrality of sculpture to the architectural project on

Figure 4.13 Kritios Boy, ca. 480 B.C., marble, height 3'10" (1.17 m), Acropolis Museum, Athens. This work is transitional between the Archaic and Classical periods. The rigid frontality of the Archaic era is broken by the gentle turn of the head and the slight movement in the torso.

the Acropolis. The chief subject of this sculpture, characteristically enough, is the human figure. Just as the design of the temples was determined by carefully conceived orders as well as mathematically precise notions of proper proportion and scale, the human figure was portrayed according to an equally formalized set of ideal standards. However, certain important developments are visible between Classical Greece and the mid-fourth century B.C., as sculptors first concentrated on idealized heroic figures and then passed to more realistic, emotionally charged portrayals.

The Kritios Boy. The first signs of this growing sense of an ideal human form can be seen in the kouros known as the Kritios Boy (fig. 4.13), which we know was damaged in the Persian sack of Athens in 480 B.C., and must, therefore, date to just before that year. The body of the figure was discovered in 1865 in the debris on the Acropolis, southeast of the Parthenon; in 1888 the head was found a bit further east. The sculpture is called the "Kritios Boy" because it was executed in a style associated with that of the sculptor KRITIOS [CRIT-i-os] of Athens, whose work is otherwise known only from Roman copies. The Kritios Boy differs from earlier kouroi significantly in terms of pose. The spine forms a gentle S-curve; one hip is raised slightly in apparent response to the displacement of weight onto one leg. This is the *con*trapposto (counterpoise) pose, introduced by the ancient Greeks at the beginning of the transition to the Classical period. The head is turned slightly to the side, the pose is relaxed and natural. The body is carved with accurate anatomical detail, and the Archaic smile has gone. A new sense of movement appears, in large part a result of his weight falling on a single leg. Although the arms are broken off, they were not placed rigidly at the sides as in earlier figures. Instead, the left arm was further back than the right arm. The sculpting of the Kritios Boy indicates a growing anatomical understanding of bone, muscles, tendons, fat, flesh, and skin, and the way in which they work together.

Polykleitos. The sense of naturalness and perfection hinted at in the Kritios Boy is fully realized in the Doryphoros (Spear-Bearer) (fig. 4.14). This was originally made in bronze, ca. 450-440 B.C., by POLYKLEITOS [pohl-ee-KLYE-tus], but now survives only in a marble Roman copy. At about the same time as he was working on The Spear-Bearer, Polykleitos developed a set of written rules for sculpting the ideal human form. These were formulated in a treatise called The Canon (the Greek word kanon means "measure" or "rule"), which, like the original Spear-Bearer, no longer survives. But by careful study of copies of Polykleitos's work, the basics of The Canon can be discerned. All parts of the body were considered. The height of the head was used as the unit of measurement for determining the overall height of the body—The Spear-Bearer is eight heads tall. This statue

Figure 4.14 Doryphoros (Spear-Bearer), Roman marble copy of a Greek original of ca. 450–440 B.C. by Polykleitos, height 6'6" (1.98 m), Museo Archeologico Nazionale, Naples. In the Classical Period the relaxed and natural contrapposto (counterpoise) pose, with the weight on one leg, hips and shoulders no longer parallel, and spine in a gentle S-curve, became the norm.

was viewed in antiquity as the definitive word on perfect proportions and was copied many times.

The Spear-Bearer stands in a fully developed contrapposto pose. Because only one leg is weight-bearing, the two sides are not identical. The pelvis and shoulders are tilted in opposite directions. The spine forms a gentle S-shape. The pose is natural, relaxed, and perfectly balanced. With complete understanding of the human body, Polykleitos recorded everything—down to the veins in the backs of the hands.

Praxiteles. The sculptor PRAXITELES [prac-SIT-el-ease] is known especially for Aphrodite (Venus) figures, represented by the *Aphrodite of Knidos* (fig. 4.15), another Roman copy after an original of ca. 350–300 B.C. Aphrodite is the goddess of love, born from the sea. In the sixth and fifth centuries B.C., male nudes were commonplace, as we have seen, but the female nude was a rarity. However, due to the influence of Praxiteles, whose work was considered wonderful in ancient times, the

Figure 4.15 Aphrodite of Knidos, Roman marble copy of a Greek original of ca. 350–300 B.C. by Praxiteles, height 6'8" (2.03 m), Museo Pio Clementino, Musei Vaticani, Rome. The female nude became a popular subject in the Hellenistic Period. An illusion of warm soft flesh is created from cold hard stone.

Then & Now

THE OLYMPIAD

The ancient Greeks had a prescription for good living that is still popular today: "mens sana in corpore sano," as the Romans translated it, "A sound mind in a sound body." The Greeks celebrated the human body and physical accomplishment as no other culture had before, particularly in sporting contests. These events were an important part of the Pan-Athenaic festival in Athens, but the most enduring of all sporting contests was the Olympiad, begun in 776 B.C. at Olympia on the Greek Peloponnese. These Olympic Games were held every four years until A.D. 394, when the Roman Emperor Theodosius abolished all non-Christian events in the Empire.

From the outset, the short foot race, or *stade*, was the most important event. Held in honor of Zeus, the course was six hundred feet in length (the length of the *stadium* at Olympia), about equivalent to a modern-day two-hundred meter race. Legend has it that at the first Olympics, Herakles paced off the length himself by placing one foot in front of the other six hundred times.

The first thirteen Olympic Games consisted solely of this race, but soon the *diaulos* was added, consisting of two lengths of the stadium (or about one time around a modern track), as well as the *dolichos*, a long-distance race consisting of either twenty or twenty-four lengths of the stadium, perhaps a mile and a half. An athlete who won all three races was known as a *triastes*, or "tripler." The greatest tripler of them all was Leonidas of Rhodes, who won all three events in four successive Olympiads between 164 and 152 B.C.

Over the years, other events were added, including, in 708 B.C., the pentathlon, consisting of five events-discus, long-jump, javelin, running, and wrestling-all contested in the course of a single afternoon. Only two measurements of the early long-jumps survive, from the mid-fifth century B.C., both of which are over sixteen meters in length. Since the current world longjump record is just under nine meters, it is probable that the Greek long-jump was a multiple jump event, comparable to the modern triple-jump (the modern record of which is just over seventeen meters). By the mid-fifth century B.C.

the Games had become a five-day event and had been expanded to include a chariot race and even sculpture exhibitions.

Centuries after their suppression by Theodosius, the Olympic Games were reinitiated in Athens in 1896. At this first modern Olympiad, the organizers celebrated the return of the games by introducing a new running event, the "marathon," to celebrate Phidippides's legendary run in 490 B.C. from the plain of Marathon to Athens with news of the stunning Greek defeat of the Persians.

Today the Olympic Games have become more than just an athletic contest. They are big business. The United States Olympic Committee has an annual operating budget of \$388 million for funding the training and preparation of US athletes. They are also usually a major economic boon to the community that hosts the Games. When Atlanta hosted the 1996 Summer Games, for instance, 73,000 hotel rooms were filled within a ninetyminute radius of the Olympic Center, pumping over \$5.1 billion into the local economy.

female nude became a major subject for late Classical and Hellenistic artists. His subject here is the modest Aphrodite—she covers herself—yet sensuality is not suppressed in the slightest. She stands in a slight S-curve, weight on one foot, turning her head, in a relaxed and easy pose.

Lysippos. Sculpture continued to flourish in the late Classical period between the end of the Peloponnesian War in 404 B.C. and the death of Alexander the Great in 323 B.C. The sculptor LYSIPPOS [lee-SI-pus] was active by 370 B.C. and still working ca. 310 B.C., a longevity that earned him the name "Lysippos the old man." During these many years, Lysippos is said to have produced two thousand works of art, but he is known today only through a few Roman copies. From 328 to 325 B.C. Lysippos held the position of court sculptor to Alexander the Great.

We know Lysippos's *Apoxyomenos (The Scraper)* (fig. 4.16) from a Roman marble copy of the bronze original of ca. 330 B.C. that was found in the Trastevere section of Rome. In this sculpture, an athlete is shown using a

strigil, or scraper, to clean the dirt and sweat off his body after exercising on the *palaestra*—the school where young men learned to wrestle and box under the guidance of a master. The figure's pose is relaxed and spontaneous; it looks as if he has just shifted or is just about to shift his weight from one leg to the other. Moreover, he is not only moving from left to right but is also advancing out toward the viewer as he stretches his arms forward. Lysippos makes his subject move in three dimensions.

The Scraper is a slender figure with a small head. The body is rounded, with long, loose, lithe legs. The proportions are different from those of Polykleitos's Spear-Bearer of 450–440 B.C. (see fig. 4.14). Indeed, Lysippos, working about a century later, created a new canon of ideal proportions for the human body. According to the Roman historian Pliny, the height ratio of head to overall figure size in Lysippos's sculpture was 1:9, whereas Polykleitos's was 1:8. This new physique was to gain favor and dominate through the end of the Hellenistic era.

The expressive face of *The Scraper*, sensitively rendered, appears somewhat nervous as he glances to the

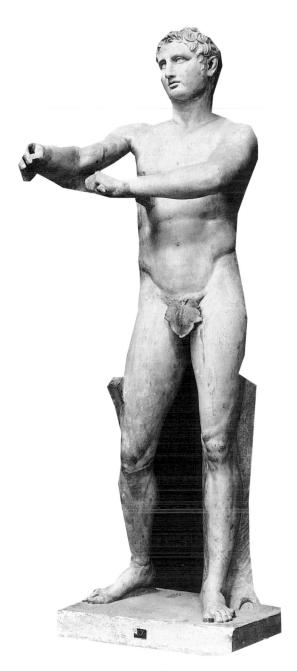

Figure 4.16 Apoxyomenos (The Scraper), Roman copy after the original bronze of ca. 330 B.C. by Lysippos, marble, height 6'9" (2.06 m), Gabinetto dell'Apoxymenos, Museo Pio Clementino, Musei Vaticani, Rome. A little more than a century after the Spear Bearer, the ideal male nude has slenderer proportions and moves freely in space. No longer to be seen solely from the front, The Scraper is of interest from all sides.

side. This individualized face may be a portrait of the noted wrestler Cheilon of Patrai, who died in 322 B.C., of whom Lysippos is known to have made a statue after his death. This is another important development after the idealized figures and faces of the Classical period. Anonymity has been abandoned, and a new interest in individualization has arrived (see also fig. 4.19).

VASE PAINTING

White-Ground Ceramics. In the first half of the fifth century B.C., a new technique was introduced into Greek ceramic production. In this white-ground technique, the vase is made of the same reddish Attic clay that was used for earlier black- and red-figure pottery. However, here a white slip is painted over the surface of the vase. The figures are not then filled in, as they were in the black-figure technique, nor is the background filled in, as in the red-figure technique. Instead, the central picture and surrounding decorative patterns are painted on with a fine brush. The style is characterized by free and spontaneous lines. The white-ground technique presents the painter with no more technical problems than working on the equivalent of a white piece of paper—except that the surface of the vase curves.

The white-ground technique is associated in particular with lekythoi (singular, lekythos), small cylindrical oil jugs with a single handle, used as funerary monuments

"Achilles Painter," Muse and Maiden, Figure 4.17 lekythos, white-ground style, ca. 445-430 B.C., terra cotta, height 16' (40.7 cm), Staatliche Antikensammlungen, Munich. One of the great advantages of working in the white-ground technique is that technical restrictions are reduced to a minimum. Neither the figures (as in the blackfigure style) nor the background (as in the red-figure style) need to be filled in.

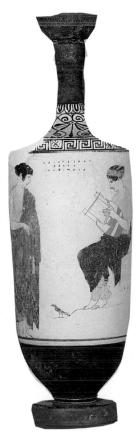

and offerings. They were favored in particular by fifth-century B.C. Athenians. A lekythos (fig. 4.17) by the ACHILLES PAINTER, painted ca. 445–430 B.C. in a mature Classical style, shows a muse and maiden on Mount Helikon playing a kithara, a stringed musical instrument. Mount Helikon is the mountain of the muses; the word "Helikon" is written below her seat. Muses, goddesses of the arts, excelled in song. The scene offers a comforting view of the afterlife in Elysium, Homer's beautiful blissful land at the end of the earth, where there is no pain, only happiness and constant good weather.

THE EMERGENCE OF DRAMA

Aeschylus. Greek drama developed from choral celebrations honoring Dionysos, the Greek god of wine and fertility. These celebrations included dancing as part of the religious ritual. Legend has it that the poet Thespis introduced a speaker who was separate from the chorus but who engaged in dialogue with the chorus. From this dialogue drama emerged. A second actor was then added to this first speaker and the chorus by AESCHYLUS [ESS-kuh-luss] (ca. 524–456 B.C.), who is today acknowledged as the "creator of tragedy."

Figure 4.18 Polykleitos the Younger, theater, Epidauros, ca. 350 B.C., later modified. Ancient Greek theaters were built into a hillside that provided support for the tiers of seats. Ancient Roman theaters, in contrast, were built freestanding.

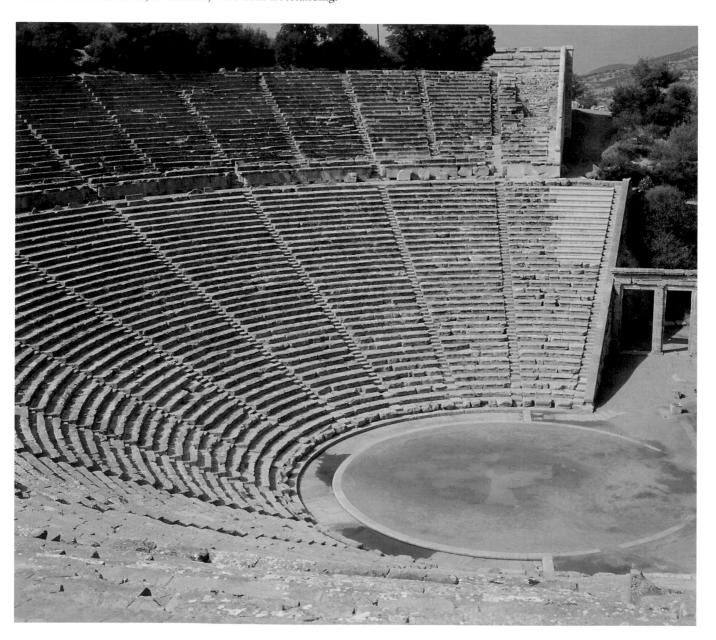

Greek plays were performed in huge outdoor amphitheaters capable of seating upward of fifteen thousand people. The theater at Epidauros, for example, accommodated sixteen thousand (fig. 4.18). The audience sat in tiers of seats built into the slope of the hillside. The hills echoed the sound of the actors' voices, which were projected through large masks that further amplified them. The actors also wore elevated shoes, which restricted their movements on the stage. The shoes and masks made subtle nuances of gesture and expression impossible in this very early form of theater. The playwright's language, therefore, had to compensate for these limitations. However, the performances themselves must nonetheless have been quite spectacular. The words appear to have been mostly sung to music, and music accompanied the dances performed by the

Ancient Greek plays were performed on an elevated platform. Behind the acting area was a building (*skene*) that functioned as both dressing room and scenic background. Below the stage was the orchestra, or dancing place for the chorus. Standing between the actors and the audience, the chorus had an important part in the drama, often representing the communal perspective. One of the chorus's principal functions was to mark the divisions between the scenes of a play, by dancing and chanting poetry. These lyrical choral interludes sometimes tragically comment on the action and interpret it, while providing the author's perspective on the mythic sources of the plays.

chorus.

Aeschylus is the earliest dramatist whose works have survived. Seven of his nineteen plays are still extant. His plays, like those of his successors Sophocles and Euripides, were all written for the twice-annual festivals for Dionysos held at Athens. Each dramatist had to submit three tragedies and a lighthearted "satyr" play for performance together at the festival. The work for which Aeschylus is best known—the trilogy called the Oresteia [oar-es-TIE-uh], after the central character, Orestes [oar-ES-tees]—won first prize in the festival at Athens of 458 B.C. The first play in the trilogy, Agamemnon, dramatizes the story of the murder of the Greek king, Agamemnon, who upon returning from the Trojan War is slain by his wife, Clytemnestra [clie-tem-NES-tra], and her lover Aegisthus [aye-GISS-this]. The second play, The Libation Bearers, describes the return of Agamemnon and Clytemnestra's son, Orestes, who kills his mother and her lover to avenge the death of his father. The concluding play, The Fumenides [you-MENih-dees], describes the pursuit of Orestes by the Furies for his act of vengeance and Orestes' ultimate exoneration in an Athenian court of law.

Taken together, the three plays dramatize the growth of Greek civilization—the movement from a Homeric tribal society system, in which vengeance was the rule and individuals felt obligated to exact private vengeance, to a modern society ruled by law. The third play of the trilogy describes the establishment in Athens, under the jurisdiction of the goddess Athena, the city's patron, of a court of law to decide Orestes' case. Athena herself must render the verdict as the jury of citizens is unable to decide Orestes' guilt or innocence. Symbolically, with the establishment of the court of law in the last part of

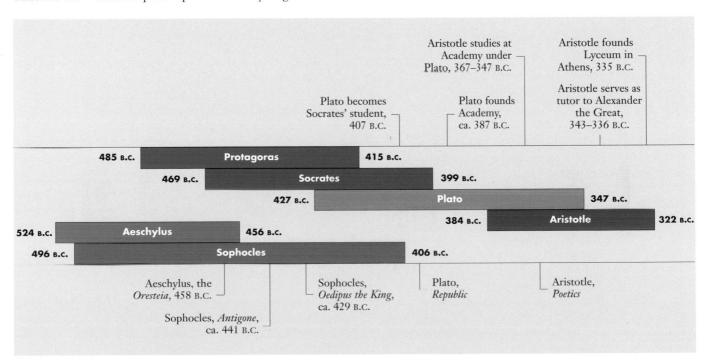

Connections

Aristotle and Greek Theater

Of his many achievements, Aristotle's work as the first Western literary theorist has been among his most influential. Aristotle's literary ideas are developed in his *Poetics*, a treatise on the nature of literature, focusing particularly on Sophocles' *Oedipus the King. The Poetics* offers a provocative and enduring set of ideas about the literary experience. Aristotle, in fact, is concerned in *The Poetics* not only with literature but with art in general.

An important idea derived from The Poetics concerns Aristotle's notion of "catharsis." Aristotle explains catharsis as a purging of the passions of pity and fear aroused in an audience during the tragic action of a play. Aristotle considers this catharsis the goal or end of tragedy. Aristotle's reasoning reverses conventional wisdom, suggesting that an audience's experience of pity and fear at, for example, Oedipus's tragic fate, would provide pleasure and not pain. The reason is that the emotions built up during the course of the tragic dramatic action are "purged" by the end of the performance. In Aristotle's view, the purging includes both physical purging through the excitement

generated and released, and a spiritual purgation analogous to the release or cleansing of the soul for religious purposes. Such purging thus contributes to the health of the society beyond the theater.

The bulk of Aristotle's *Poetics* focuses on drama, especially tragedy. Aristotle is concerned primarily with the "art" of tragedy, which he analyzes under six headings: plot, character, thought, rhythm, song, and spectacle. Aristotle's interest in tragic plots concerns how they are constructed to create particular effects leading to catharsis involving the purging of pity and fear. The action of a play is seen not in terms of isolated scenes or events but as the working out of its "motive" or "spring of action."

In Sophocles's *Oedipus the King*, for example, this motive is Oedipus's desire and attempt to find the slayer of King Laius. Like any successful tragic dramatist, Sophocles created in *Oedipus* a complete action with a beginning, middle, and end. The beginning identifies the main character's central purpose; the middle describes his passionate following through on his intention; the end reveals his perception of his tragic mistake or error. This perception on the part of the tragic hero is his

recognition or *anagnorisis*, which follows the ironic reversal of his fortunes, and which leads to the pathos of his suffering inevitably to follow. Throughout *The Poetics* Aristotle refers repeatedly to Sophocles's *Oedipus* as the consummate example of tragic drama.

Aristotle also places a high premium on the literary artist's use of language, particularly metaphor. For Aristotle, mastery of metaphor is the identifying mark of a poetic genius. He writes that "the greatest thing by far is to have a command of metaphor ... it is the mark of genius." Sophocles' use of imagery of light and darkness to represent knowledge and ignorance, and his metaphors of healing and disease to signify life and death, qualify him for Aristotle's highest praise.

Aristotle's insights into literary language and dramatic structure have remained influential for more than two thousand years. Throughout the Renaissance, and well into the eighteenth and nineteenth centuries, Aristotle was recognized as having set the standards for literary appreciation. At the end of the second millennium, nearly 2500 years after Aristotle wrote *The Poetics*, literary historians and critics continue to employ Aristotle's categories and terminology.

the trilogy, the old order passes and a new order emerges. Communal justice rather than the pursuit of individual vengeance comes to regulate civil society.

Sophocles. Of the Greek tragic dramatists, SOPHO-CLES [SAH-fuh-clees] (496–406 B.C.) is perhaps the most widely read and performed today. Unlike those of his forebear Aeschylus, Sophocles' plays focus on individual human, rather than broad civil and religious, concerns. His most famous plays—Oedipus the King and Antigone—center on private crises and portray characters under extreme duress. Antigone, which takes place in Thebes, a city prostrated by war, turns on the difficult decisions that Antigone, Oedipus's daughter, and King Creon, his brother-in-law, must make. In Oedipus the King, which is set against a background of a plague-stricken city, Sophocles examines the behavior of Oedipus, who has been destined before birth to murder his father and marry his mother.

Athenian audiences watching performances of *Oedipus the King* would have been familiar with Oedipus's story from sources such as Homer's *Odyssey*. Oedipus's parents, King Laius and Queen Jocasta of Thebes, had been foretold of their son's terrible fate and therefore left him as a baby in the wilderness to die. This plan went awry when the child was taken by a shepherd to Corinth, where he was adopted by a childless couple, King Polybus and Queen Merope. Upon hearing an oracle pronounce his fate, and believing Polybus and Merope to be his natural parents, Oedipus then left Corinth to get far away from the King and Queen. Ironically, however, en route to his true birthplace, Thebes, Oedipus kills an old man who gets in his way. This old man, Oedipus only much later discovers, was his true father, Laius.

Sophocles' version of the story, *Oedipus the King*, begins at the point when Thebes has been suffering a series of catastrophes, the most terrible of which is a devastating plague. Oedipus had previously saved Thebes

from the Sphinx, a winged creature with the body of a lion and the head of a woman. The Sphinx had terrorized the city by devouring anyone who crossed its path and was unable to answer its riddle correctly-"What goes on four legs in the morning, two legs in the afternoon, and three legs in the evening?" Oedipus solved the riddle by answering "Man." After slaying the Sphinx, Oedipus was given the kingship of Thebes and the hand of its recently widowed queen, Jocasta, in reward. Unknown to Oedipus, but known to the Athenian audience, was the fact that Jocasta was his mother and that her recently slain husband, Laius, had been killed by Oedipus himself. All this and more Oedipus soon discovers as he comes to self-knowledge.

Sophocles' Oedipus the King is one of the greatest tragedies in theatrical history—one of the definitions of tragedy is the representation of the downfall of a great hero. It also provides one of the best examples of dramatic irony, where speeches have different meanings for the audience and the speaker: the audience know much more than the speaker. Thematically, the play raises questions about fate and human responsibility, particularly the extent to which Oedipus is responsible for his own tragic destiny. Sophocles portrays his tragic protagonists heroically. These tragic heroes suffer the consequences of their actions nobly and with grandeur.

Euripides. One of the greatest and most disturbing of Greek tragic dramatists is EURIPIDES [you-RIP id ease] (ca. 480-406 B.C.). As Aristotle put it, where Sophocles depicts people as they ought to be, Euripides depicts them as they really are. His plays were written under the shadow of the Peloponnesian War, and they spare no one, showing humankind at its worst. While ostensibly about the enslavement of the female survivors of Troy, The Trojan Women, first staged in 415 B.C., is a barely disguised indictment of the women of Melos after the Athenian defeat of that city. In The Bacchae, Euripides depicts a civilization gone mad, as followers of Dionysos kill the king of Thebes under the drunken belief that he is a wild animal. Dionysos's followers, perhaps in part a portrait of the Athenian people, are unwilling to think for themselves and hence liable to be led blindly into the most senseless of acts.

Aristophanes. All was not tragedy on the Greek stage, however. Comedy was very popular, and the master of the medium was ARISTOPHANES [air-ihs-TOFfan-nees] (ca. 445–388 B.C.). His plays satirized contemporary politics and political personalities, poking fun at Greek society and ridiculing the rich in particular. Aristophanes even took on Socrates, depicting him as a hopeless dreamer. In Lysistruta, produced in 411 B.C. in the midst of the same Peloponnesian War that so outraged Euripides, Aristophanes' title character persuades her fellow Athenian women to withhold sexual favors from their husbands until peace is declared. They carry out their plans with merriment, teasing their husbands and even occupying the Acropolis. The women win the day, judging their husbands' priorities acutely, and at the end of the play Spartans and Athenians are reconciled and dance together in joy.

PHILOSOPHY

Of all the legacies of Greece, its philosophical tradition is one of the most enduring. The Greeks believed that what distinguished human beings was their intellectual capacity, their ability to reason, and thus the philosopher held a special place in their society. It was the philosopher's business to query the nature of human existence. Is there a difference between appearance and reality? What is our relation to the divine, and how can we recognize it? What ethical principles should guide us? What happens when the individual will finds itself at odds with the will of the state, the polis? What is the nature of love? What does it mean to be free? All of these questions were posed and answered, and then posed again, as they have been ever since the Greeks first pondered them.

Socrates. SOCRATES [SOC-ra-tees] (469–399 B.C.), the most famous of Western philosophers, is known primarily through the exposition of his ideas in Plato's dialogues. In the earliest of Plato's writings, Socrates

Figure 4.19 Portrait bust of Socrates, Roman copy of an original bronze of ca. 350 B.C. by Lysippos, marble, lifesize, Museo Nazionale Romano, Rome. At his trial in 399 B.C. for impropriety toward the gods and corruption of the young, Socrates cheerfully admitted to causing unrest and insisted that it was his duty to seek the truth.

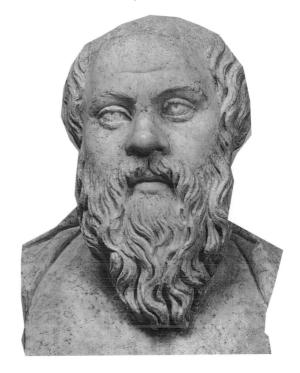

(fig. 4.19) appears as a figure whose supreme goal is to pursue knowledge and truth. Best known for his method of questioning others' beliefs and eliciting their assumptions in a form of dialectical inquiry, known as the "Socratic method," Socrates is recognized as a model of intellectual honesty and heroic equanimity in the face of death. He was executed in 399 B.C. after being put on trial for impiety and corruption of the young. The authorities appear to have offered Socrates the chance to escape, but the philosopher refused.

Socrates arrived on the philosophical scene in Golden Age Athens at a time when previous philosophy had concerned matters of cosmology. Presocratic philosophers had speculated that the world was composed of one or another substance, and that everything in existence was ultimately derivable from this original material. For THALES [THAY-lees] (fl. 585 B.C.) everything derived from and could be explained in terms of water. For Democritus it was matter; for Pythagoras number. For still others, such as ANAXAGORAS [a-nax-AG-or-us] (ca. 500–428 B.C.) the first principle was *Nous* or Mind, whereas for Herakleitos it was *Logos*, by which he meant divine intelligence or rational principle represented by fire.

Socrates would have none of this. His interest instead was in ethics, how we live in the world. Known as the "Father of Ethics," Socrates was concerned with pursuing wisdom so as to know the good, the true, and the beautiful. His pursuit of right living was governed by reason, and central to this was the need to "Know thyself," as his famous maxim stated. Socrates urged a vigilant self-examination and encouraged a critical questioning of one's own and other's ideas and assumptions. Only through such efforts, Socrates believed, could one arrive at true understanding of the Good, which was necessary for the moral life and happiness.

Socrates developed his pursuit of knowledge and emphasis on virtue when the Sophists, who used philosophy for practical and opportunistic ends, held sway. Although Sophist philosophers such as Protagoras shared Socrates' emphasis on the immediate concerns of life in the world, their aims and practices differed sharply from his. Instead of the pursuit of an absolute standard of truth, the Sophists believed that all moral and ethical standards were matters of convention and that no such thing as absolute truth existed. Knowledge, the Sophists believed, was relative, based on individual experience, and hence could be reduced to opinion. Unlike Socrates' relentless and single-minded pursuit of truth, the Sophists would argue both sides of an issue with equal persuasiveness. Rhetoric's negative connotations, as in "mere rhetoric," and the use of the word "sophistry" to mean specious reasoning derive from the practices of the Greek Sophists.

Socrates typifies the Greek philosophical ideal developed in the writings of his pupil, Plato, who advanced and extended a number of key Socratic ideas. For

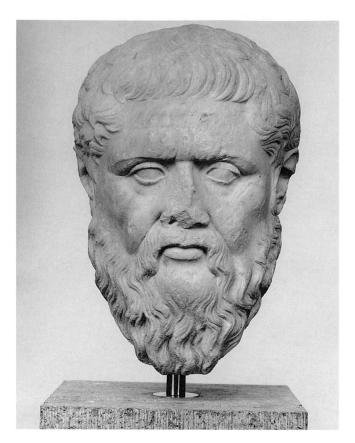

Figure 4.20 Portrait bust of Plato, 350–340 B.C., Roman copy of an original bronze of ca. 427–347 B.C. by Silanion (?), marble, Glyptothek, Munich. Though his real name was Arsitocles, Plato went by his nickname, which means "the broad one," a physical trait evident even in this portrait bust.

Socrates, the life of the mind was paramount, as evidenced by his maxim "The unexamined life is not worth living." Self-knowledge is crucial in determining how to master passion and appetite through reason. Living a virtuous life directed by a reasoned pursuit of moral perfection leads to happiness.

With this emphasis on the spiritual, the intellectual, and the moral, Socrates provided Western thought with a new philosophical direction. By living according to his principles, by making philosophy a life-long process, Socrates also provided a model and ideal of one who loves wisdom, the literal meaning, in Greek, of the word "philosopher."

Plato. PLATO [PLAY-toh] (427–347 B.C.) and Socrates are frequently spoken of in the same breath because so many of Plato's dialogues present Socrates as a character and speaker. As a result, it is not always easy to determine where Socrates' thinking leaves off and Plato's begins. It is perhaps best to consider Plato's idealist philosophy as extending key elements of Socratic thought. In dialogues such as *The Symposium* and *The Republic*,

Plato (fig. 4.20) developed the Socratic perspective implicit in his mentor's life and teaching.

Plato's paradigm, or model, for reality was mathematics, for Plato believed that in mathematical truth, which exists beyond time and space, perfection could be found. Plato argued, for instance, that it was the idea of a circle, rather than any actual example of one in nature or in a drawing, that was true and perfect. Any example of a circle only approximated the perfect idea of circularity, which existed in a special realm that transcended all particular manifestations. This realm Plato identified as the realm of Perfect Forms or Ideas. Virtues such as courage and kindness similarly transcended their everyday exemplary manifestations.

Most important, however, was Plato's postulation of ideal Goodness, Truth, and Beauty, which he argued were all One, in the realm of Ideal Forms. For if Plato's argument were true, then all actions could be measured against an ideal, and that ideal standard could be used as a goal toward which human beings might strive. This was obviously a significant departure from the relativism of the Sophists. One consequence of this idea was that, according to Plato, human beings should be less concerned with the material world of impermanence and change and more concerned with unchanging spiritual "realities." Thus, the highest spiritual principle of reason should be used to control the lower human aspects of energy and desire.

Both of these ideas are advanced in what is perhaps Plato's best-known work, The Republic. A complex and ambitious book, The Republic is concerned primarily with the concept of justice, especially with how to achieve a just society. In establishing his argument, Plato proposes the division of society into three strands or layers, each of which reflects one of the three aspects of the soul. Plato argues that people whose primary impulse is toward satisfying their physical desires are not capable of making proper judgments in accordance with reason, and that they should therefore occupy the lowest positions in society, those of servitude. Above these workers are the soldiers, whose primary force is that of energy or spiritedness. The soldiers and the workers in Plato's ideal republic work together harmoniously at their allotted tasks under the directorship of the highest social groups, the philosophers, whose decisions in governing the republic are guided by reason.

In The Republic, Plato explains his idea about the differences among levels of knowledge or understanding by means of two analogies. One, the analogy of the Divided Line, presents a way to distinguish between lower and higher orders of knowledge. A vertical line is divided into four segments, with the upper two representing the intellectual world and the lower two the visible world. The lowest part of the line represents shadows and reflections (explained below in the Allegory of the Cave); the one above it represents material and natural things. The two lower earthbound parts of the line are complemented by the upper segments, which represent reasoning about the world and its objects (the lower segment of the upper line), and philosophical principles arrived at without reference to objects (abstract thought, the uppermost portion of the line).

Plato supplements this visual analogy about the nature of knowledge with his famous Allegory of the Cave. In this, he illustrates his distinction between true knowledge of reality and the illusion of appearances. He describes a cave in which the only light visible to human beings chained to a wall is that reflected from a fire behind and above them. When objects are reflected as shadows on the wall, the cave inhabitants take these shadows for reality. Only the one freed from the cave can see that what he had previously considered real are simply shadowy reflections of their actual counterparts. Instead of being a prisoner of illusion like those still chained in the cave, the escapee has a true knowledge of reality.

For Plato, such a revelation reflects the difference between ignorance and knowledge of truth, the difference between the world of material objects and the realm of Ideal Essences, the true forms of those things. This division between the higher spiritual forms and the lower material world is echoed by other dualisms in Plato's philosophy. Foremost among the divisions are those between the philosopher and the common people, the perfect and the imperfect, and the spiritual life and the physical life.

Aristotle. Born in Stageira, in Thrace, ARISTO-TLE [air-iss-TOT-ul] (384-322 B.C.) studied in Plato's school, the Academy, in Athens. He remained there for twenty years until Plato's death in 347 B.C., when he left to establish his own school, first in Assos and later in Lesbos. Aristotle's most famous pupil was Alexander the Great, whom the philosopher served as private tutor from 343 until 336 B.C., when Alexander succeeded to the Macedonian throne.

In 335 B.C. Aristotle returned to Athens to establish his own school at the Lyceum, where lectures and discussions took place under a covered walkway. Lecturers moved about among their audiences, thereby acquiring the designation "Peripatetics" (walkers). Like Socrates, Aristotle was charged with impiety and condemned by the Athenian tribunal of judges. Upon leaving Athens before a sentence of death could be carried out, Aristotle is reputed to have remarked that he would not allow Athens to commit a second crime against philosophy.

Aristotle's logic provides a framework for scientific and philosophical thinking that is still in use now. The hasis of Aristotle's logic is an analysis of argument. Its central feature is the syllogism. In syllogistic reasoning, one proposition or statement follows from another by necessity, when the premises are true. In such a case the syllogism is considered valid, as in the following example: All philosophers are mortal. Aristotle is a philosopher. Aristotle was mortal.

In the next example, the syllogism is invalid even though the conclusion is true, because one of the propositions the first—is untrue:

All philosophers are men. Aristotle was a philosopher. Aristotle was a man.

Aristotle's logic also includes an analysis of the basic categories used to describe the natural world. According to Aristotle, things possess substance (their primary reality) and incidental qualities. A dog, for example, possesses something—this is its substance—that distinguishes it from other animals, making it a dog and not a cat or a horse. At the same time, the dog may be large and brown with long shaggy hair—these are incidental qualities and secondary compared to the dog's substantial reality. Another dog, which is small and white with short fine hair, nonetheless possesses the same substance as the first larger darker dog.

Aristotle disagreed with his teacher Plato on a number of important issues. For Aristotle, an object's matter and form are inseparable. Even though we can think of the "whiteness" of a dog and its "dogness," those concepts do not have independent existence outside of the things they embody. Unlike Plato, who posited an Ideal realm of Forms, where the perfect idea of a dog exists independent of actual physical examples of dogs in the world, for Aristotle the idea of a dog can only exist in relation to an actual canine quadruped. Aristotle held that this dependence of the form of an object on its physical matter is in effect for all things. Thus, for Aristotle, the existence of any universal concept is dependent upon empirical reality in the form of a particular physical thing. By insisting on the necessary link between form and matter, Aristotle stood Plato's thought on its head and brought Platonic ideas down to earth.

Similarly, Aristotle emphasized the way the substance of a thing becomes itself in a *process* of growth and development. With his early study of biology as an influence, Aristotle's philosophical thinking takes account of development and process in ways that Plato's more mathematically influenced philosophy does not. For example, Aristotle describes the *potential* of a seed to become a flower or a fruit, of an embryo to become a living human or animal. The oak is potentially existent in the acorn, from which it grows and toward which its growth is a natural and inevitable cause of its being.

Aristotle's philosophy is grounded in the notion of teleology, which views the end or goal of an object or being as more important than its starting point or beginning. His teleological mind explains the way all material things are designed to achieve their purpose and attain their end. This end or goal of each thing is the fulfillment of the potential it embodies from the beginning of its existence.

Aristotle arrives at a conviction about the nature of God from logic rather than from ethics or religious faith. In his *Physics* Aristotle argues that everything is in motion toward fulfilling or realizing its potential. Since everything is in motion, there must be something that provided the primary impulse (the prime mover) toward motion and that itself is not in motion. For to be in motion is to be in a potential state, and the prime mover must be in a state of completeness and thus not in motion. The prime mover must be immaterial as well as unchanging.

Finally, Aristotle differed from his Greek predecessors significantly in his approach to ethics. Ethics, for Aristotle, were a matter of contingency. For Aristotle, that is, there were no absolutely unchanging ethical norms to guide right behavior and determine right conduct. Instead, there were only approximations based on the principle of the mean between extremes. Courage, thus, exists as a balance between cowardice and rash behavior, and temperance as a balance between deprivation and overindulgence. Virtue consists of negotiating between dangerous extremes, the balance point changing according to circumstances.

Aristotle's approach to ethics is grounded in the realities and contingencies of the empirical world. Aristotle consistently emphasized the tangible, the physical materiality of concrete everyday experience. In the process of formulating his more empirically based philosophy, Aristotle thus provided a necessary realistic counterpoint to the idealism espoused by his teacher and predecessor, Plato. Together their complementary philosophies have spurred theological and philosophical speculation for more than two thousand years. If, as one modern philosopher put it, "All philosophy is but a footnote to Plato," Aristotle's has been the richest, most complex, and most influential "footnote" of all.

MUSIC AND GREEK SOCIETY

Music is mentioned in ancient Greece as early as Homer's *Iliad*, which includes a reference to Achilles playing a lyre in his tent. It was not uncommon for a warrior to soothe his spirits with the charms of music, much as in ancient Israel David played the harp to assuage the anxieties of King Saul.

An integral part of Greek life, music was associated with festivals and banquets, religion and social ritual, including marriages, funerals, and harvest rites. It was associated with Greek drama, for which a special place, the orchestra, was set aside for dancers. Music was an essential part of the Homeric epics, which were chanted to the accompaniment of the lyre. In addition, music formed a significant part of the Olympic athletic

contests. At the festivals, the ancient Greeks held contests for musicians equal to those of the athletes, awarding prizes and honors of similar measure.

Music, for the ancient Greeks, was not an isolated art. The basic elements of Greek music derived from mathematics, which served as the foundation of ancient Greek philosophy and astronomy. Music, thus, became associated with these other Hellenic achievements, largely through ideas about number, especially numerical relationships expressed as ratios. The most important of the early Greek theorists of music was Pythagoras (ca. 582–507 B.C.).

For Pythagoras, numbers provided the key to understanding the universe. He believed that music and arithmetic functioned as a single unit, with the system of musical sounds governed by mathematical laws. Pythagoras argued that since music embodies number in ratios and proportions, music exemplifies the harmony of the universe.

Music was so important to the ancient Greeks that all philosophers, including Plato and Aristotle, made a point of discussing it. Plato, for example, believed that music could influence human emotion and character. He argued that only music that encouraged bravery and emotional stability should be taught to the young. Aristotle also believed in the importance of music for building character. Like Plato, Aristotle wrote about music's power to affect the development of the inner person, particularly music's power to affect the soul. Other ancient philosophers commented on music's ethical influence. Like Plato and Aristotle, they associated certain musical modes with virtue and vice, spiritual development and spiritual danger.

The Musical Modes. Greek music was primarily a music of melody, with little concern for harmony. For the ancient Greeks, musical scales, or modes upon which melodies were based, had particular ethical effects associated with them. Each mode used a particular sequence of intervals that established its modality. The Greek system, still in use today, divides the octave into twelve equal-sounding smaller intervals, each called a half-step. In a musical mode or scale, there are eight tones with seven intervals between them, five of which are half-steps and two whole steps. The position of the whole and half steps in the scale or mode affects the specific character or quality of the scale or mode. Some scales or modes sound "happy" or "bright" while others sound "mournful" or "dark."

Each of the Greek musical modes was considered to have a specific ethical effect on hearers, thus resulting in the various strictures placed upon them by Plato and Aristotle. The best of the modes, the one most conducive to virtue, was thought to be the Dorian mode, which, for Aristotle, represented the golden mean of music, comparable to the golden mean of his ethics.

While ancient Greek instruments, such as the lyre, can be recognized from their depiction in painting and sculpture, the melodies played on them are virtually extinct. The scraps of melody inscribed on papyrus or incised in stone do not provide much help in understanding what ancient Greek music sounded like. The best available examples of ancient Greek musical manuscripts date from the second century B.C. and are tributes to the god Apollo.

Hellenistic Greece

After the fall of Athens in 404 B.C., first Sparta and then Thebes controlled the Greek mainland, but neither proved very effective. And then, in 359 B.C., Macedonia, a minor Greek state on the northern end of the Aegean, beyond Mount Olympus, began to assert itself when Philip II became ruler. In 338 B.C. Macedonia defeated the Greeks decisively at Chaeronea. Ambassadors were dispatched to Athens and Thebes with terms for peace. Among the ambassadors to Athens was Philip's eighteen-year-old son, Alexander—ALEXANDER THE GREAT (356–323 B.C.), as he would come to be known (fig. 4.21). Raised to rule, he had been schooled by Aristotle to be "a leader to the Greeks and a despot to the barbarians, to

Figure 4.21 Portrait bust of Alexander the Great, Roman copy of a Greek original of ca. 330 B.C., marble, Dresden Museum, Germany. Although a womanizer, an excessive drinker, and perhaps a megalomaniac, Alexander was nevertheless a great general who astonished the world with his stunning succession of military triumphs, which gave the word "empire" a new meaning.

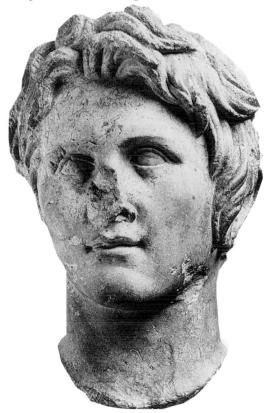

look after the former as after friends and relatives, and to deal with the latter as with beasts or plants." Alexander took his tutor's words to heart, and as a result came to enjoy the enthusiastic support of almost all Greek intellectuals. When Philip II was assassinated in 336 B.C.—possibly at Alexander's behest, since Philip had divorced his mother and removed his son from substantive roles in the government—Alexander took control.

On his accession, he crushed a rebellion in Thebes, destroying the city and selling the entire population into slavery. He then set out to expand the Macedonian empire and control the world. By 334 B.C. he had defeated the Persians. Soon he ruled all the territory west of the Euphrates. Next he conquered Egypt, where in 332 B.C. he founded the great port city of Alexandria in the Nile Delta. Marching back into Mesopotamia, he entered Babylon, and made a sacrifice to the local god, Marduk. Then he marched on Persepolis and burned it, seizing its royal treasure. Convinced that India was small, and that beyond it lay Ocean, as he called it, by which route he could return to Europe by sea, he set out to conquer present-day Pakistan. However, his troops were exhausted and met unexpected resistance in the form of war elephants; Alexander was thus forced to sail down the Indus River to the Indian Ocean. Along this route he founded present-day Karachiat the time named Alexandria after himself. Returning finally to Babylon, in 323 B.C., Alexander caught a fever and died.

The Hellenistic era begins with Alexander's death at the age of thirty-three. Alexander had brought about a mingling of Eastern and Western cultures through his policies and conquests. He encouraged for instance, marriages between his soldiers and Middle Eastern women by providing large wedding gifts and by marrying two Persian women himself. But culturally the Greek army had a greater impact on the Middle East than the Middle East had on them. In fact, the term "Hellenistic," first used in 1833 by the historian Johann Gustav Droysen, was coined to describe the impact of Greece on the Middle East-its "Hellenization"-after Alexander's death. The generals Alexander had installed as governors of the different territories in his empire set themselves up as kings. Political, artistic, social, and economic dominance shifted from the mainland of Greece to the new Hellenistic kingdoms such as those of the Seleucids in Syria and the Ptolemies in Egypt. The cities of Pergamon in Turkey and Alexandria in Egypt in particular were great centers of learning. The massive library at Alexandria contained over 700,000 papyri and scrolls, and Pergamon's library rivaled it. As if inspired by the dramatic successes of Alexander himself, the art such Hellenistic cities spawned was itself highly dramatic. Where Classical Greek art was concerned with balance and order and idealized its subjects, Hellenistic art focused on the individual, in all the individual's unidealized particularity, and on emotional states. Even the dominant philosophies of the day reflect this tendency.

Map 4.2 Alexander's empire.

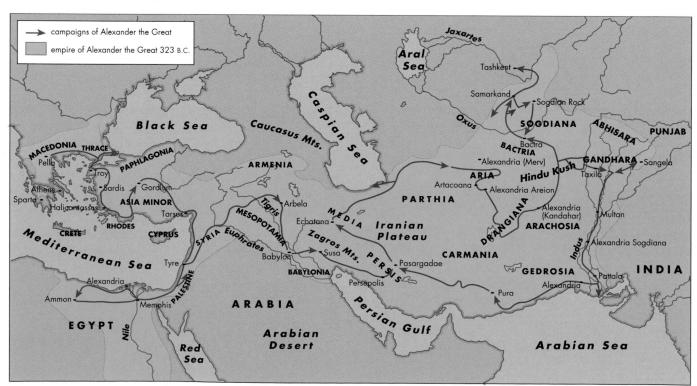

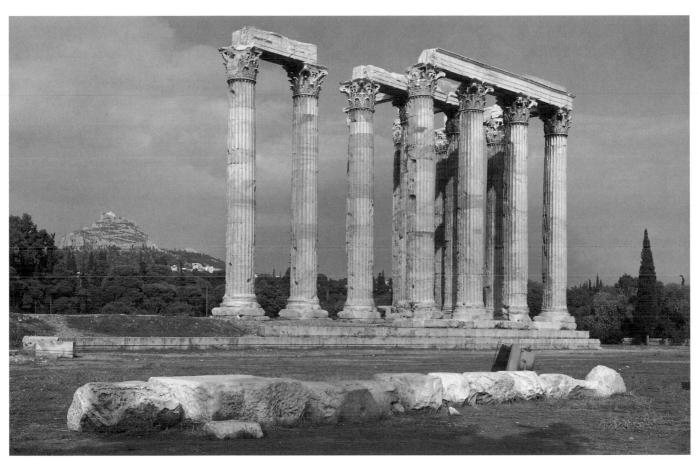

Figure 4.22 Temple of the Olympian Zeus, Athens, second century B.C.-second century A.D. This once enormous temple was the first large-scale use of the Corinthian order on the exterior of a building. The Romans would favor the ornate Corinthian order.

More important for the future of Western thought were the acts of preservation and dispersion performed by Hellenistic scholars as they collected, edited, analyzed, and interpreted the philosophical works of the past. This work of humanistic scholarship included preserving not only the works of ancient Greek philosophy and literature, especially those of Plato and Homer, for example, but the Greek translation of the Hebrew Bible as well. Moreover, the emergence of humanistic scholarship was accompanied by educational institutions established for its continued development. In the spectacular libraries at Alexandria and Pergamon, and in Athens, which was home to a great academy of its own, Greek intellectual achievements endured.

ARCHITECTURE

The Temple of the Olympian Zeus. The popularity of the Corinthian order in the Hellenistic era is demonstrated by the Temple of the Olympian Zeus in Athens (fig. 4.22). This temple was originally built in the Doric order in the sixth century B.C., but was reconstructed in

Hellenistic times, beginning in the second century B.C., with work continuing into the second century A.D. in Roman times under the Emperor Hadrian. The Corinthian capital was given greater prominence here than it ever was in Classical Greek architecture. This extraordinary structure once was an eight-by-twenty temple, the columns in the peristyle formed with double rows of twenty columns on the sides and three rows of eight columns on the ends. Today, although little remains of this monumental undertaking, there is enough to make it obvious that the Corinthian order is the most ornamental and the most luxurious of the three orders.

Pergamon's Altar of Zeus. Perhaps nothing better embodies the extravagant Hellenistic attitude to architecture and the visual arts in general than the Upper City of Pergamon in Asia Minor, built by KING ATTALOS [ah-TAL-us] (241–197 B.C.) and almost finished by EUMENES II [you-MEN-ease] (197–159 B.C.). This Hellenistic city was grand in vision, designed on a large scale and embellished with a profusion of ornament. Essentially a large complex of architecture and sculpture built in the slope of a hill, Pergamon appears as if nature

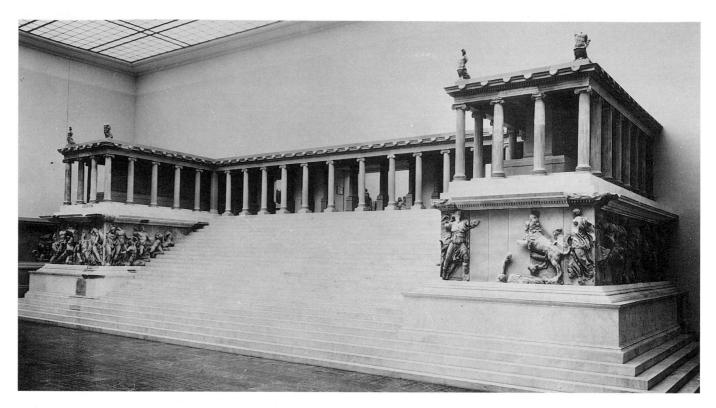

Figure 4.23 Altar of Zeus, from Pergamon, Turkey, west front, restored, built ca. 180–160 B.C., under Eumenes II, base 100' square (30.5 sq. m), Staatliche Museen, Berlin. The subject depicted on the frieze on the Pergamon altar is highly emotional, its rendering charged with the dramatic action and expression characteristic of Hellenistic art.

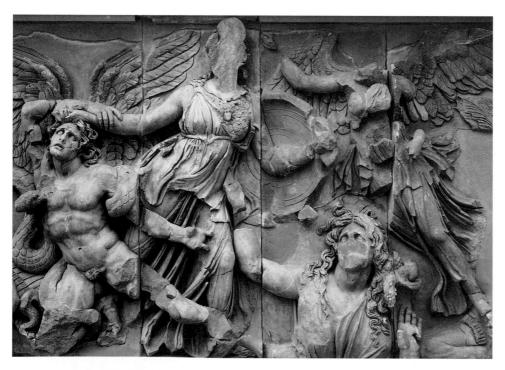

Figure 4.24 Battle of the Gods and the Giants, Altar of Zeus, Pergamon, ca. 180–160 B.C., height 7'6" (2.34 m), Staatliche Museen, Berlin. Here Athena has grabbed the hair of a winged monster who writhes in agony. His mother, identifiable by her "monstrous" curled locks, rises to help him.

Cross Currents

THE HELLENIZATION OF INDIA

By 326 B.C. Alexander the Great's forces had pushed as far east as the Punjab in northwest India. It was there that they confronted, for the first time, war elephants, two hundred strong. Though Alexander's troops defeated the Indian troops, it was rumored that the army of the Ganges, further east, was equipped with five thousand such beasts, and thus the Greek troops refused to go on. But the connection

between the Greek world and India had been established.

Remnants of Alexander's forces settled in Bactria, between the Oxus River and the Hindu Kush mountains. Excavations at the Bactrian Greek city of Al Khanum have revealed Corinthian capitals and fragments of statues of various gods and goddesses. Coins with images of Herakles, Apollo, and Zeus were produced. There were portraits of the Bactrian kings on the other sides: Euthydemus, Demetrius,

and Menander. However, it was not always Greek ideas that triumphed over Indian cultural traditions. Around 150 B.C. King Menander was converted to Buddhism by the monk Nagasena. The monk's conversation with the King is preserved as *The Questions of Melinda*, Melinda being the Indian version of Menander's name.

At Gandhara, on the north end of the Indus River, across the Khyber Pass from Bactria, Greek influence was especially strong. Though Gandharan art is mostly Buddhist in content, it has a Hellenistic style. In Taxila, a temple resembling the Parthenon in structure was constructed between 50 B.C. and A.D. 65. There is even evidence that the Homeric legend of the Trojan horse was known here (fig. 4.25).

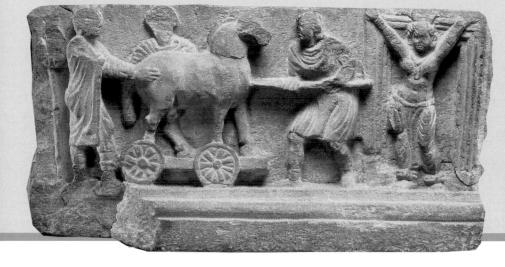

Figure 4.25 Trojan horse frieze, Gandhara, second to third century a.d. Though the style shows local influences, the subject matter here is most definitely Greek as the Trojan prophetess Cassandra and the priest Laocoön (see fig. 4.28) attempt to block the entry of the Greek gift-horse into Troy.

has been sculpted into several terraces occupied by splendid structures. The whole is indicative of a changed attitude toward the relationship between environment and architecture. Where Classical Greek architectural planning favored balance and order, the Hellen-istic period shows a new assertiveness. Periklean res-traint is a thing of the past.

The upper city included the celebrated Altar of Zeus (fig. 4.23), built 180–160 B.C. under Eumenes II, a demonstration of the dramatic theatricality and large scale favored in the Hellenistic era. In 278 B.C. the Gauls came sweeping into Asia Minor, to be conquered by Attalos I of Pergamon in 241 B.C. This monument was erected to commemorate the victory over the Gauls. The Altar of Zeus occupied a terrace all on its own on the hill at Pergamon.

SCULPTURE

The Battle of the Gods and the Giants. The Altar of Zeus at Pergamon was much celebrated in antiquity, although in the Early Christian era it was dubbed

"Satan's Seat." On the sides of the podium of the altar was the relief frieze of the Battle of the Gods and the Giants (fig. 4.24), four hundred feet in length. The relief carving is very deep; the figures are almost carved in the round. The giants—the Titans of Greek mythology are huge in size and terrible in appearance, with large snakes in place of legs. Legend had it that these giants of divine origin could be killed only if simultaneously slain by a god and a mortal. When the Titans revolted against the gods, attacking Zeus and Athena with rocks and flaming trees, Zeus and Athena responded with thunderbolts. Herakles, a mortal, aided them in killing the various giants in a variety of painful but picturesque ways the giant Ephialtes, for instance, received an arrow in his left eye from the quiver of Apollo as an arrow landed in his right eye from the bow of Herakles.

Known as **gigantomachy**, the subject of the revolt of the giants against the gods was popular with Hellenistic artists. On the Altar of Zeus its treatment can be interpreted symbolically. Here the gods' triumph over the giants symbolizes the victories of Attalos I—art and politics working together for propagandistic ends. The style

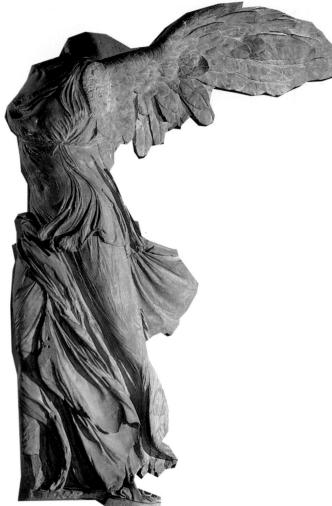

Figure 4.26 Nike of Samothrace, ca. 200–190 B.C., marble, height 8' (2.44 m), Musée du Louvre, Paris. Stonc scemingly brought to life, this dynamic figure of Victory moves through space, the drapery blown against her body by her rapid movement.

of this work—its action, violence, display of emotion, and windblown drapery—also defines the Hellenistic age in the arts.

The Nike of Samothrace. The splendid Hellenistic Nike of Samothrace (fig. 4.26), also known as the Winged Victory, is one of the artistic treasures of the ancient world. It is related to the figures in the Pergamon frieze in the great sweeping gesture of the body, in the suggestion of movement through space, and in the treatment of the drapery. The date of the Nike is debated, but it was probably created between 200 and 190 B.C. The torso of this statue of the goddess of victory was discovered in 1863 on the island of Samothrace in the Sanctuary of the Great Gods. In 1950, further excavations uncovered the right hand and other smaller body parts. The statue was originally placed on the prow of a stone ship located in a

niche cut into the mountainside above the Sanctuary of the Great Gods. The head was turned to face the sea. The composition was designed to give the impression that the goddess had just descended to the prow of the ship, her garments still responding to her movement through space. Theatrical and emotional, the statue is dynamic: the wind blows her drapery back as she appears to move forward. Far from static, the figure interacts with, and becomes part of, the surrounding space.

Laocoön and His Sons. An expenditure of still greater energy, induced by agony, is seen in the Laocoön group (fig. 4.27), sculpted by Hagesandros, Athanodoros, and Polydoros of Rhodes according to ancient sources. The date of this statue is debated, the possibilities ranging from 150 B.C. to the first century A.D. Whatever the case, it was only rediscovered in 1506 in Rome.

The subject of the sculpture is taken from Homer's *Iliad*. Laocoön was a priest of Apollo of Troy. He and his

Figure 4.27 Laocoön and His Sons, perhaps a Roman marble copy after a Greek original by Hagesandros, Athanodoros, and Polydoros of Rhodes, variously dated between the second century B.C. and the first century A.D., height 7' (2.10 m), Museo Pio Clementino, Musei Vaticani, Rome. In the Hellenistic Period, drama replaced the emotional restraint of the Classical Period. Laocoön and his sons, attacked by serpents, make obvious their torment through straining poses and agonized facial expressions.

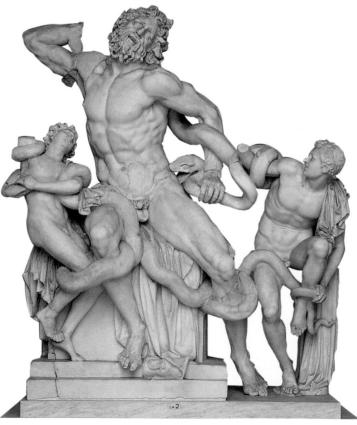

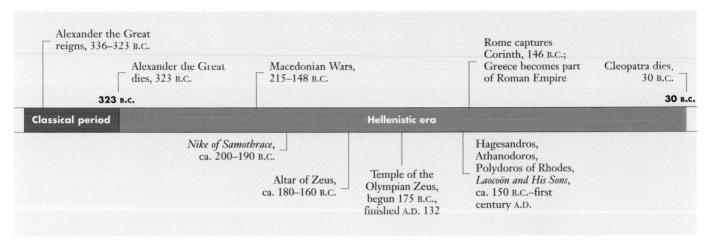

sons were strangled by snakes sent from the sea by Apollo when Laocoön tried to warn the Trojans against accepting the wooden horse, seemingly left as a gift to them by the retreating Greeks. In the sculpture the figures writhe violently, but all in one plane, like a relief. Laocoön and his two sons try to move apart, but are bound together by the serpent's coils, creating an extraordinary dynamism. With their wild hair and pained expressions, these figures are far removed from Classical restraint; here, in all its full-blown glory, is the theatricality, passion, and drama of the Hellenistic age.

PHILOSOPHY

The English words "stoic," "skeptic," and "epicurean" derive from schools of Greek philosophy—Stoicism, Skepticism, and Epicureanism. Although none of these philosophical systems has had the long-term impact of Platonism or Aristotelianism, Stoicism and Epicureanism dominated Greek philosophy during the Hellenistic period. In addition, all three philosophies were embraced by the Romans, with Stoicism also later finding a home in Christian philosophy.

Stoicism. Stoicism was less concerned with formulating a systematic philosophy than with providing an approach to everyday living. According to the Stoic view, an intelligent spiritual force resembling reason, the Logos, pervades the universe. Human beings can achieve happiness only by bringing their wills into harmony with this pervasive universal reason. The individual must accept whatever fortune brings; all the individual can do is exercise control over her or his own will. Characteristic Stoic virtues are serenity, self-discipline, and courage in the face of suffering and affliction.

Epicureanism. Epicureanism is frequently thought of as a philosophy of self-indulgence and pleasure-seeking. Its primary practical impulse, however, is to escape fear and pain. The founder, EPICURUS [ep-ee-

CURE-us] (341–271 B.C.), taught that fear, especially the fear of death and punishment after death, is responsible for human misery. As an antidote to what he considered religious and mythological superstition, Epicurus argued that the gods lack interest in the affairs of human beings, and that death utterly extinguishes pain. Thus, according to Epicurus, human beings have nothing to fear from it.

A materialist, Epicurus believed that the soul, like the body, was a physical substance, composed of tiny particles in motion. As such, for Epicurus the only path to knowledge was through physical sensation; consequently, the way to achieve happiness was to enhance physical pleasure and to limit physical pain.

Skepticism. The English word "skeptic" derives from the Greek skeptikos, which means "inquirer." Skepticism is not necessarily a negative perspective; rather it requires an attitude of questioning. Two early and important exponents of Skepticism were SEXTUS EMPIRICUS [em-PIR-i-cuss], who lived in the midsecond century B.C., and his intellectual ancestor, PYRRHO [PIE-roh] (ca. 360–270 B.C.). As with Stoicism and Epicureanism, Skepticism was less a philosophical system than a perspective on experience anchored in practical advice about how to live an unperturbed life.

What distinguishes Skepticism from Stoicism and Epicureanism is its emphasis upon achieving this state of unperturbed equilibrium through suspending judgment about nearly everything. The reason for this suspension of judgment is that one cannot know anything with certainty, because all evidence is inconclusive in itself. The conflict between opposing assertions can only be settled by an appeal to an additional criterion. But since the criterion can be similarly called into question, there is nothing upon which finally to base knowledge. Thus, peace of mind can only be achieved by abandoning the search for knowledge and accepting uncertainty.

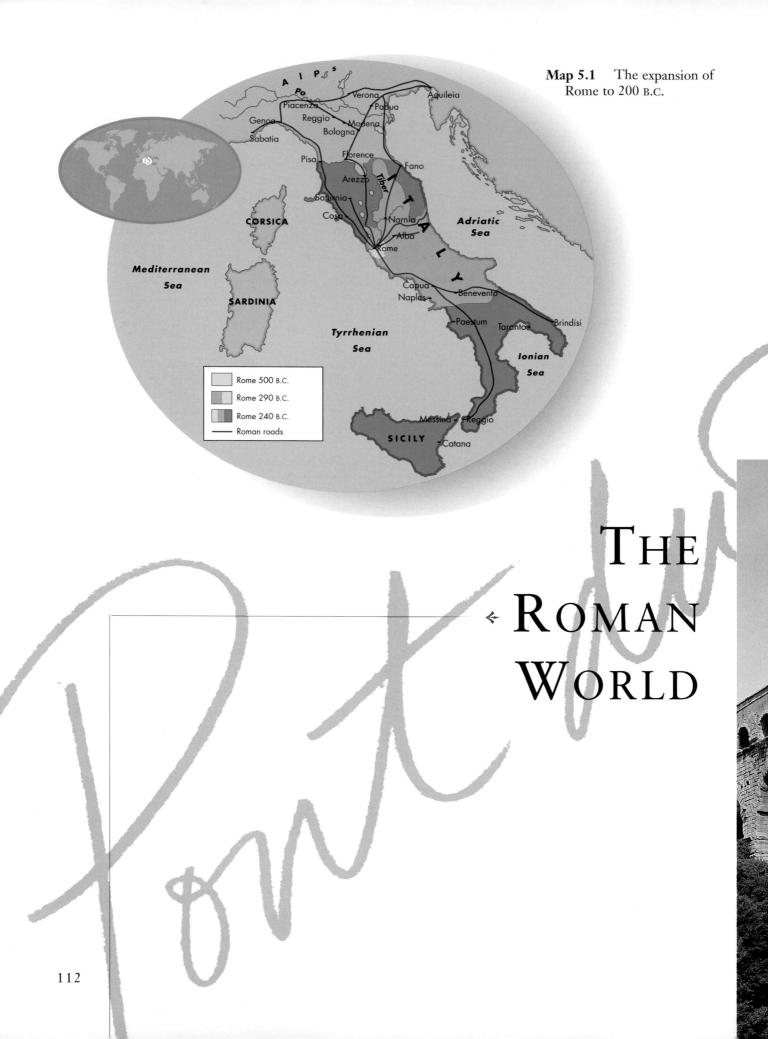

CHAPTER 5

- Etruscan Civilization
- Republican Rome
- The Empire

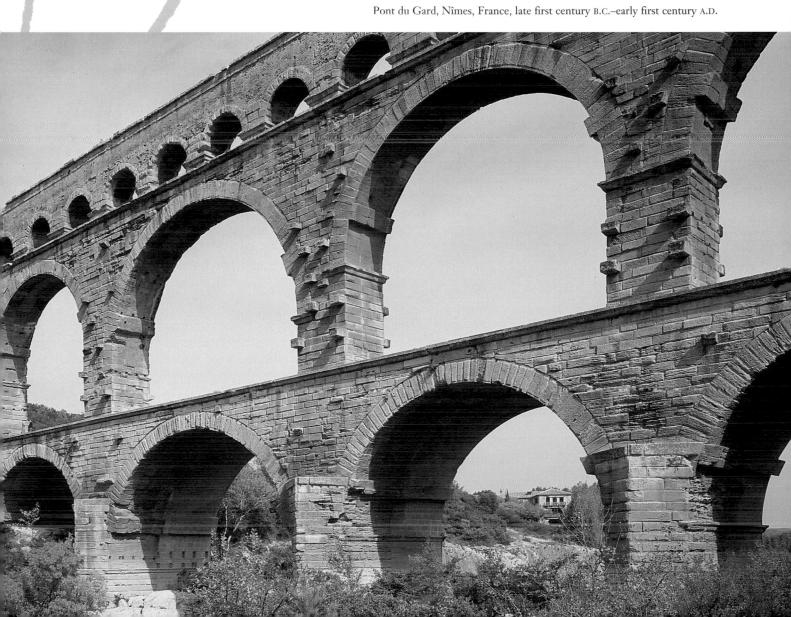

THE GREEK LEGACY AND THE ROMAN IDEAL

In many ways, Rome inherited its culture—its art, its literature, its philosophical and religious life—from Greece. The Italian peninsula was occupied by the Greeks by the seventh century B.C., which ensured the influence of Greek ways upon the developing Italian culture. However, it was the later Roman determination to control and rule the entire Western world that consolidated the Hellenization of the West and much of the Eastern world. Even more effectively than Alexander the Great, the Romans spread Greek art and literature as far as Britain in the north, Africa in the south, India in the east, and Spain in the west. Apart from disseminating Greek culture, Roman civilization produced remarkable achievements of its own, in the fields of politics, law, and engineering.

If the Romans held Greek art and literature in the highest esteem, they were not so impressed with the Greeks themselves. They found in certain aspects of the Greek love of music and poetry, their fascination with the human body, and their love of drama (as opposed to "real life") signs of weakness. The Roman satirist Juvenal, writing at the end of the first century A.D., expressed a low opinion of the Greek character: "These people are extremely clever at flattery; they praise the conversational skills of the biggest dimwit and physical beauty of an ugly friend ... Greece is a nation of actors. Laugh, and they will laugh with you. Cry, and they cry too, although they feel no grief." Insincerity was, indeed, an entirely unRoman trait.

The Romans feared that the fate of Athens might be their own. Accordingly, they studied Greek history intently so that they might learn from it and avoid a similar decline. What they recognized in Greek culture was its lack of practical know-how. It is therefore no accident that it is for their genius for organization and problemsolving that the Western world is most indebted to the Romans. The Romans were superb engineers. The road system that they put in place across Europe is, in part, still in use today. The Romans built bridges and aqueducts that crossed rivers and valleys and carried fresh water to houses and public baths. Roman town architecture was eminently practical too. Great amphitheaters like the Colosseum in Rome were designed to accommodate vast crowds and to let them enter and exit more quickly and efficiently than today's sports fans can at similarly sized stadiums.

Romans' love of the efficient and practical is also seen in their political structure. The Romans invented the field of civil law—the branch of law that deals with property rights—which became the foundation for legal systems in many Western countries. The Romans were also responsible for the idea of "natural law," which emerged from the philosophy of Stoicism. Natural law, which

postulated a set of rights beyond those described in civil (or property) law, became the basis for the inherently "inalienable rights" promised to all people by the framers of the American Declaration of Independence many centuries later (see Chapter 17). The Romans believed in the possibility of a society composed of "ideal" citizens, who respected others and possessed a deep sense of equity and fairness. This idea of civility in social behavior and civilized conduct and discourse in public life is perhaps Rome's greatest legacy (although it should be remembered that Rome had slaves and women had few rights); except perhaps for its language, Latin. Many major European languages—Italian, Spanish, French—in some degree descend from Latin. Though Germanic in root, English contains many Latin loan-words. All of these languages consequently bear within them the influence of Roman culture and ideals and all, of course, use the Roman alphabet.

ETRUSCAN CIVILIZATION

+

While the Greeks were settling in southern Italy and Sicily, another people—the Etruscans—inhabited the central Italian mainland. Relatively little is known about the Etruscans. Their alphabet is derived from Greek, but their language seems unique, insofar as can be judged from the small amount of undeciphered literature and the few inscriptions on works of art that survive. Herodotus, the fifth-century B.C. Greek historian, said that the Etruscans came to Italy from Lydia (Turkey) in Asia Minor around 800 B.C. Etruscan civilization proper dates from about 700 B.C. and was at its peak in the seventh and sixth centuries B.C.—the same time as the Archaic period in Greece.

While Etruscan civilization was at its height, the future imperial capital of Rome remained little more than a cluster of mud huts inhabited by shepherds and farmers known as Latins. Why Rome would eventually be transformed into the most powerful city in the world is difficult to say, except that, positioned on the south bank of the Tiber River in central Italy, it was midway between the Etruscan settlements to the north and the Greek colonies in the south of the peninsula. Rome thus lay on the trade route between the two civilizations. The Etruscans were influenced by the Greeks and came to know them literally "through" Rome. They sent skillfully manufactured bronze household utensils down the Tiber through Rome and on to the Greeks in the south in return for Greek vases, many of which have been found in Etruscan tombs. Greek heroes and deities were incorporated into the Etruscan pantheon, and their temples reflected Greek influence. In turn, the Etruscans exerted an important civilizing influence over the Latins in Rome.

Figure 5.1 Reconstruction of an Etruscan temple according to Vitruvius, Istituto di Etruscologia e Antichità Italiche, University of Rome. To a great extent, the Etruscan temple form was a modification of the Greek. Different from the Greek, however, are the high flight of stairs on one side only, deeper porch, and wider cella.

TEMPLES

Only the stone foundations of Etruscan temples have survived. Fortunately, the ancient Roman author and architect VITRUVIUS [vi-TROO-vee-us] (fl. first century A.D.) provided a description of an Etruscan temple, on the basis of which it has been possible to create a reconstruction (fig. 5.1).

The Etruscan temple was similar to the Greek temple in its rectangular plan, raised podium, and peaked roof. Some temples were built with columns of the **Tuscan order**, which is the Doric order modified by the addition of a base. Nonetheless, the Etruscan temple differs from the Greek temple (see fig. 4.6) in several significant ways. For instance, the Etruscan temple has steps on only the south side, whereas the Greek temple has steps on all four sides. The Etruscan temple has a deep front porch, occupying much more of the platform than is occupied by the porch of a Greek temple. And the cella (enclosed part) of the Etruscan temple is divided into three rooms, further differing from the Greek temple plan.

TOMBS

Although Etruscan temples have disappeared, a significant number of tombs remain. Etruscan tombs were rich with weapons, gold work, and vases. As a result, like their Egyptian and Mycenaean counterparts, they were the targets of grave robbers. Scientific excavation of Etruscan tombs began only in the mid-nineteenth century.

The tombs are of two types: corbeled domes covered with mounds of earth, and rock-cut chambers with rectangular rooms. The most famous and most impressive of the rock-cut tombs at the ancient site of Cerveteri is the so-called Tomb of the Reliefs (fig. 5.2), of the third century B.C. The tomb is made of **tufa**, a type of stone

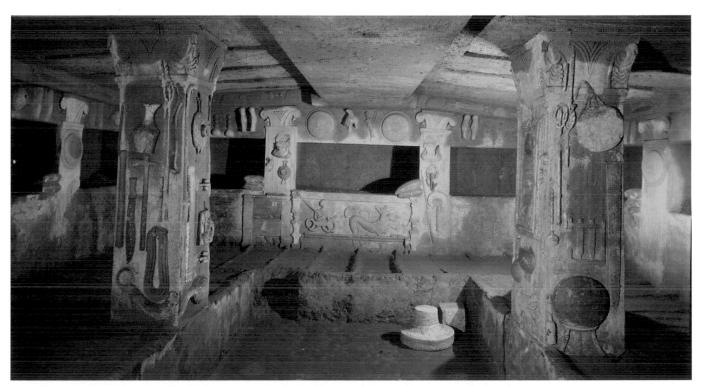

Figure 5.2 Tomb of the Reliefs, Cerveteri, third century B.C., interior. This exceptional tomb is believed to duplicate an actual Etruscan home in stone, even including pillows and pets. An entire family was buried here.

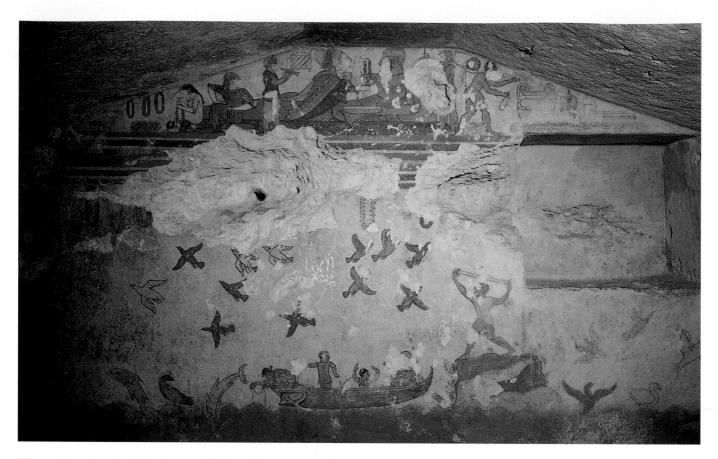

Figure 5.3 Tomb of Hunting and Fishing, Tarquinia, wall painting, ca. 520 B.C. This and other tomb paintings record the good life when Etruria prospered in the sixth century B.C. Later, as the economic situation declined, the outlook on the afterlife was less optimistic.

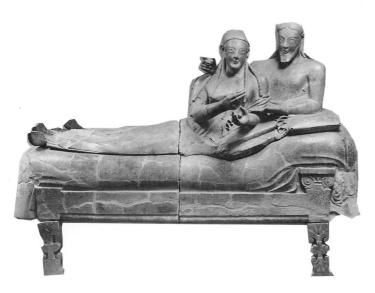

Figure 5.4 Wife and Husband Sarcophagus, from Cerveteri, ca. 520 B.C., terra cotta, length 6'7" (2.01 m), Museo Nazionale di Villa Giulia, Rome. The deceased couple is shown as if alive, healthy, and enjoying themselves. The rounded forms are readily achieved in malleable terra cotta, unlike hard stone.

that is soft when cut, but hardens when exposed to the air, and tends to remain quite white. Such tombs were used for entire families. This one has places for over forty bodies. The interior of the Tomb of the Reliefs was designed to look like a home and provides a wonderful document of Etruscan life. The beds even have stone pillows! Roof beams are carved, and on the walls are depictions of weapons, armor, household items, and busts of the dead. The column capitals are similar to an early Ionic type that was brought to Greece from Asia Minor, which supports Herodotus's theory that the Etruscans originated in Lydia.

Other tombs were painted with scenes from everyday life. Particularly fine examples have been found at Tarquinia, where the subjects include scenes of hunting and fishing, banquets, musicians, dancers, athletic competitions, and religious ceremonies. The paintings in the Tomb of Hunting and Fishing (fig. 5.3), of ca. 520 B.C., in which fish jump out of the water in front of a man who attempts to catch them, and birds fly around a man who attempts to shoot one with a sling shot, convey a sense of energy and even humor.

This wall painting is presumably a view of the afterlife. Its optimism is also seen in Etruscan sculpture. An early example is offered by a wife and husband sarcophagus, from Cerveteri (fig. 5.4), ca. 520 B.C. The sarcophagus, modeled in clay and once brightly painted, is shaped like a couch, with the deceased couple shown to recline on top; women and men were social equals. Like contemporary Greek statues, the pair have Archaic smiles (see Chapter 3). They are shown as if alive, comfortable, healthy, and happy, though they do not seem to be individualized portraits.

SCULPTURE

The Etruscans were celebrated in antiquity for their ability to work in metal. Their homeland of Tuscany (which is named for the Etruscans) is rich in copper and iron and provided ample raw materials. From 600 B.C. onward, the Etruscans produced many bronze statuettes and utensils, some of which they exported. The most famous Etruscan bronze sculpture is the so-called *Capitoline She-Wolf* (fig. 5.5), of ca. 500 B.C. The two suckling babes were added only in the Renaissance. However, the shewolf is authentic and has the energy and vitality characteristic of Etruscan art. A beautiful decorative surface is achieved by contrasting the crisp, curving patterns of the neck fur with the wolf's sleek, smooth body.

Although the work of an Etruscan artist, the statue has become the symbol of Rome. Its name, the *Capitoline She-Wolf*, derives from its long association with Rome's Capitoline Hill. Either this statue or another sculpture of a shc-wolf was dedicated on the Capitoline Hill in 296 B.C., becoming in effect Rome's political mascot. The subject of the statue is connected with one of the myths

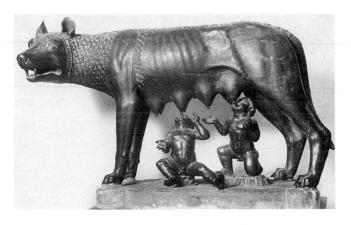

Figure 5.5 Capitoline She-Wolf, ca. 500 B.C., bronze, height $33\frac{1}{2}$ " (85.1 cm), Museo Capitolino, Rome. The Etruscans were famed in antiquity for their fine metalwork. With the twin infants, added in the Renaissance, this Etruscan bronze has become the symbol of Rome.

about the foundation of Rome. According to legend, the twin founders of the city, Romulus and Remus, were abandoned as children in the Tiber by a wicked uncle. By good fortune, they were washed up on the river bank, where they were discovered by a she-wolf, who suckled them. Subsequently raised by a shepherd, Romulus and Remus decided, in 753 B.C., to build a city on the Palatine Hill, above the spot along the river bank where the wolf rescued them. The auspicious founding of the city was marred by Romulus's murder of his brother during a quarrel, but Romulus went on to become Rome's first king, ruling for forty years.

Timeline 5.1 Control of Rome.

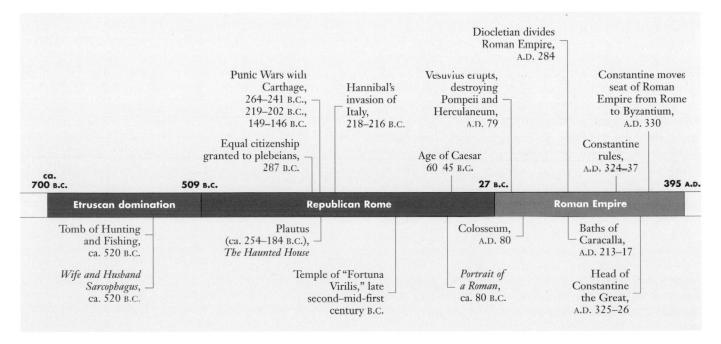

REPUBLICAN ROME

> -

Beginning with Romulus, Rome was ruled first by a succession of kings and then, in 509 B.C., constituted itself a republic, which lasted until 27 B.C. Romulus himself is said to have established the traditional Roman distinction between the **patricians**, the land-owning aristocrats who served as priests and magistrates, lawyers and judges, and the **plebeians**, the poorer class who tilled the land, herded livestock, and worked for wages as craftspeople, tradespeople, and laborers.

At first, the plebeians depended upon the patricians for support. According to one ancient historian, each plebeian in Romulus's Rome could choose for himself any patrician as a patron, initiating the system known as **patronage**. "It was the duty of the patricians to explain the laws to their clients, to bring suits on their behalf if they were wronged or injured, and to defend them against prosecutors."

The essentially paternalistic relationship of patrician to plebeian reflects the family's central role in Roman society. At the head of the family was the *pater*, the father, and it was his duty to protect not only his wife and children, but also his clients, those who had submitted to his patronage. In return for the *pater*'s protection, his family and his clients were obligated to give him their total obedience and to defer to him in all things—an attitude the Romans referred to as *pietas*. The patrician males led the state as they led the family, contributing to the state's well-being in return for the people's gratitude and veneration. So fundamental was this attitude that by imperial times, the Roman emperor was referred to as the *pater patriae*, "the father of the fatherland."

THE REPUBLIC

Actual historical records documenting the development of Rome do not begin until 509 B.C., with the dedication of the Temple of Jupiter on the Capitoline Hill, but in the two centuries following Romulus's rule, the fundamentals of Rome's political, religious, and military customs were put in place. In truth, the development of Rome seems to have owed much to the Etruscans, who occupied it between 616 and 509 B.C. Prior to 616 B.C., Rome appears to have been very modest indeed. It was under the Etruscan kings that the boundaries of the city were gradually expanded from the Palatine to include all seven hills of Rome. The forum—the central political and social meeting place in the city—was established in the valley between the Palatine and Capitoline Hills, and a canal was dug to drain it. But apparently chafing at Etruscan rule, in 509 B.C. the Romans expelled King Tarquinius Superbus ("the Proud"), and decided to rule themselves without a king.

From 509 until 27 B.C., Rome was a republic based on the patrician/plebeian model in which every male citizen enjoyed the privilege of voting on matters of legislation as well as in elections of government officials. But from the outset, the republic was plagued by conflict between the patricians and the plebeians. There was obvious political inequality. The Senate, the political assembly responsible for formulating new law, was almost exclusively patrician. Thus, the plebeians formed their own legislative assembly, the Consilium Plebis, electing their own officers, called tribunes, to protect them from the patrician magistrates. Initially, patricians were not subject to legislation passed by the plebeian assembly—the plebiscite. Finally, in 287 B.C., however, the plebiscite became binding legislation on all citizens, whether plebeian or patrician, and something resembling equal citizenship was established for all.

At about the same time, Rome began a series of military campaigns that would, eventually, result in its control of the largest and most powerful empire ever created. By the middle of the third century B.C., Rome had established dominion over the Italian peninsula by creating municipalities and colonies in every region, offering land to plebeians willing to move. Beginning in 264 B.C., the city inaugurated a series of campaigns against Carthage, a Phoenician state in North Africa that controlled the wealthy island of Sicily, as well as the islands of Sardinia and Corsica. The Punic Wars ensued (from the Latin *poeni*, meaning "Phoenician"). When they ended, in 146 B.C., Carthage had been razed, and Rome had established an overseas empire, with control over the islands of Sicily, Corsica, and Sardinia.

As Rome moved in on the Hellenistic world, beginning in 146 B.C. with the invasion of Macedonia and Greece, both the dangers and rewards of military expansionism became increasingly apparent. The Carthaginian general Hannibal, who in 218 B.C. invaded Italy from the north, marching with his elephants over the Alps and laying the Italian farm country to waste as he burned everything in his path, had already revealed the real human cost of military conflict. But there were also vast monetary gains to be made from conquest-commercial opportunities in trading, shipping, business, banking, and agriculture that many Romans could not ignore. The Roman army had to adapt to meet the new challenge. It had traditionally been made up of citizen property owners, one of whose obligations was to defend the state. But citizens absent for long periods on military campaigns often returned to find their property taken over by others. Thus, in about 107 B.C., a general named Gaius Marius began to enroll men in the army who did not meet the property or citizenship qualification. These men saw military service as a career, and a professional army was soon in place. Each soldier served for twenty years and, when not involved in combat, was occupied by the construction of roads, bridges, and aqueducts. At the end of their service, they were given land in the province where they had served, as well as Roman citizenship.

The financial opportunities afforded by imperial conquest stimulated the growth of a new "class" of Roman citizen. Born into families that could pursue senatorial status, these men instead chose careers in business and finance. They called themselves *equites* ("equestrians"), probably because they served in the cavalry in the military—only the wealthy could afford horses—and they embraced a commercial world that their patrician brothers (sometimes quite literally their brothers) found crass and demeaning. By the first century B.C., these *equites* were openly in conflict with the Senate, pressing for greater and greater rights for both themselves and the plebeians. In an effort to quell rebellion, the Senate granted citizenship and equal status to all free men living on the Italian peninsula.

However, civil war between the senators and the equites erupted anyway. The general Lucius Cornelius SULLA [SOO-lah] ruled as dictator from 82 to 79 B.C., murdering thousands of his opponents and introducing a new constitution, which placed power firmly in the hands of the Senate. But all he finally succeeded in doing was exacerbating the situation. When the general Gnaeus Pompeius Magnus—Pompey the Great—returned to Rome in 62 B.C. after successful campaigns in the east, the Senate refused to ratify his settlements with the eastern provinces and, worse perhaps, refused to provide land allotments for his veterans. Pompey was outraged. In 60 B.C. he joined forces with both Marcus Licinius CRASSUS [CRASS-us], with whom he had suppressed the slave revolt of Spartacus in 71 B.C., and Gaius JULIUS CAESAR [SEE-zar] (fig. 5.6) to form the socalled First Triumvirate, an official alliance that used vast sums of money and the threat of civil war to dominate the Roman state. To cement the agreement, Pompey married Caesar's daughter, Julia, a year later.

But it was a tumultuous alliance. Realizing that military prowess was an absolute necessity if he were to continue in power, Caesar set off for Gaul (present-day France), which he quickly subdued. It was perhaps inevitable that Caesar could not long remain in happy alliance with Pompey and Crassus. When his daughter

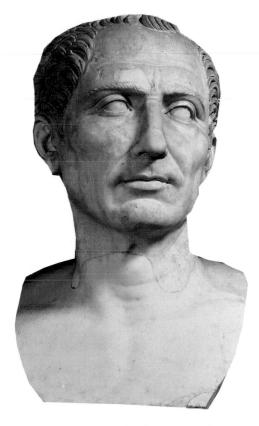

Figure 5.6 Portrait bust of Julius Caesar, first century B.C., marble, height 38" (96.5 cm), Museo Archeologico Nazionale, Naples. Like all Roman portrait sculpture of the time, the bust is stunningly realistic. Every anomaly of the facial terrain has been observed and recorded.

Julia died in 54 B.C., Caesar broke with Pompey, who in turn allied himself with the Senate. In 49 B.C., with Gaul under his control, Caesar decided to return home, it was feared with the intention of assuming absolute power for himself—in effect, becoming emperor. The Senate reminded him of a longstanding tradition that he should leave his army behind, but on January 10 Caesar led his army across the Rubicon River into Italy, and civil war began again. Pompey fled to Greece, where Caesar defeated him a year later. Pompey escaped

Timeline 5.2 Conquests of the Roman republic.

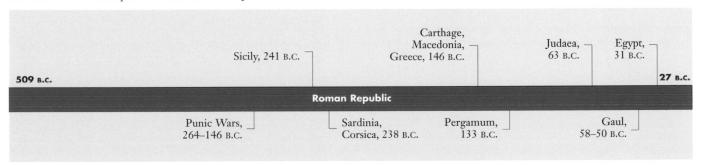

Cross Currents

THE ROMAN PANTHEON

The major gods of the Romans were essentially the same as those of the Greeks. In adopting the Greek gods, the Romans demonstrated in yet another way how the great military conquerors were themselves conquered by Greek culture. The accompanying chart identifies the deities of Rome with their Greek counterparts and their corresponding roles and responsibilities:

GREEK	ROMAN	ROLE/FUNCTION
Zeus	Jupiter/Jove	chief god/sky
Hera	Juno	wife of Zeus/Jove
Eros	Cupid	god of love
Dionysos	Bacchus	god of wine/revelry

Demeter	Ceres	earth goddess/grain
Persephone	Proserpina	queen of the underworld
Aphrodite	Venus	goddess of love and beauty
Ares	Mars	god of war
Apollo	Apollo	god of sun, music, and the arts
Artemis	Diana	goddess of the hunt
Hermes	Mercury	messenger of the gods
Poseidon	Neptune	god of the sea
Hades	Pluto	god of the underworld
Athena	Minerva	goddess of wis- dom
Hephaistos	Vulcan	god of metal- work

There were, nonetheless, some important differences in the way the Romans viewed their gods. The Roman pantheon reflected the culture's political rather than spiritual values, and Roman gods tended to be less embodiments of various human virtues and foibles and more personifications of abstract ideas—love, war, and fortune, for instance.

The Romans also had a vast array of other, local gods. Every place, tree, stream, meadow, and wood had its own spirit. Unlike the gods of Greek origin, anthropomorphic, or human, characteristics were rarely attributed to these spirits. However, it was essential for, say, a farmer to keep on good terms with the spirit of his fields. Since so much depended upon annual water flow, the sources of rivers were especially venerated spots and were often decorated with numerous shrines.

once more, this time to Egypt, where he was murdered, and Caesar became dictator, not only of Rome, but of an empire that included Italy, Spain, Greece, Syria, Egypt, and North Africa. In 45 B.C., on the Ides of March—March 15—Caesar was stabbed twenty-three times by a group of some sixty senators on the floor of the Roman Senate at the base of a statue honoring the memory of Pompey. The people were outraged, the aristocracy disgraced, and Caesar martyred.

Caesar had been aware of the plot against him, and he had provided well for his adopted grand-nephew and heir, OCTAVIAN, not only monetarily—Caesar's military exploits had left him with a massive fortune—but politically. Octavian was only eighteen years of age, but he responded to his great-uncle's tutelage by acting quickly in the quagmire of the Roman political arena. He defeated his rival MARK ANTONY, Caesar's former supporter, in two successive encounters, and then adroitly formed a Second Triumvirate with Antony and LEPIDUS, an alliance so powerful that it quelled all dissent. Together Octavian and Antony went to war in the east, defeating Cassius and Brutus, two of Caesar's murderers, at the battle of Philippi in Macedonia.

The Triumvirate divided up the Roman world between them. Lepidus controlled Africa, Antony the eastern provinces, and Octavian the western provinces, including Rome itself. However, perhaps because Octavian kept Rome for himself, the other two rulers

soon plotted against him. When Lepidus challenged the young Octavian for power, Octavian managed to convince Lepidus's troops to desert their leader and join him instead. Lepidus retired, and Octavian doubled the size of his army. Meanwhile Mark Antony had pursued other republicans to Egypt and, after defeating them, formed an alliance with Cleopatra, Queen of Egypt, with whom he plotted Octavian's overthrow. When Octavian defeated Antony's army at Actium in 31 B.C., Antony and Cleopatra committed suicide. Octavian was now the sole power in Rome, the pater patriae, "father of the fatherland," and renamed himself Augustus, "the revered one." The constitutional government of the republic, which Julius Caesar had himself effectively ended when he took complete control after his return from Gaul, was finally and definitively overturned. And Octavian, now Caesar Augustus, was effectively emperor of the entire Roman world.

THE ART OF REPUBLICAN ROME

Roman troops conquered vast territories, bringing many different peoples under their domination. In turn, these peoples exerted an influence on Roman culture. In particular, Roman art was influenced by Greek art. The Romans conquered the Greeks militarily and politically, but the Greeks conquered the Romans artistically and culturally. As the first-century B.C. poet Horace put it, "Graecia capta ferum victorem cepit" ("Captive Greece

conquered her wild conqueror"). Roman writers rarely make reference to Roman artists. Instead, they write about the Greek masters—Polykleitos, Phidias, Praxiteles, Lysippos. Roman authors refer to the Greeks as the "ancients"; Greek art already had the authority of antiquity for the Romans. The Romans not only imported Greek vases, marbles, and bronzes, but Greek artists as well, many of whom they then put to work copying Greek originals.

Yet Roman art is not solely a continuation, perpetuation, or amplification of Greek art. The Romans were very different from the Greeks, and their art is accordingly different in emphasis and focus. The Romans were impressed with great size—the size of their empire, of their buildings, of their sculptures. Above all, the Romans were a practical people. Their architecture shows them to have been superb engineers. Their sculpture and painting is realistic, with an emphasis on particulars—specific people, places, and times—a trend that continued until the second century A.D., when Christianity began to foster a more abstract and mystical direction.

Architecture. The Romans adopted the Greek orders—the Doric, Ionic, and Corinthian—but made modifications. Directly influenced by the Tuscan order of Etruscan architecture, the Romans made Doric columns taller and slimmer and gave them a base. The acanthus leaves of the Corinthian order were combined with the volutes of the Ionic order to create the composite order. The Romans used the orders with greater freedom than the Greeks, often taking elements from each for use on a single building. The Romans used the Corinthian order most, the Doric least—the opposite of the Greeks. Unlike Greek architects, Roman architects often used engaged columns (columns that are attached to the wall) on the inside and outside of buildings.

Much Roman building, like Greek building, was done with ashlar masonry, using carefully cut stone blocks laid in horizontal courses. But the Romans introduced new building materials and methods that were to have a lasting influence. In the late second century B.C. they developed a type of wall made by setting small broken stones in cement. Walls thus constructed were very strong and could be faced with different types of patterned stonework. This new construction method, as opposed to ashlar masonry, opened new directions in architecture, including construction using concrete, which consists of cement mixed with small pieces of stone. Concrete is strong, can be cast into any shape, and is far less costly than stone construction. The Romans did not invent concrete, but they did develop its potentials.

Roman rectangular temples have the same basic elements as Greek temples: cella, columns, the orders,

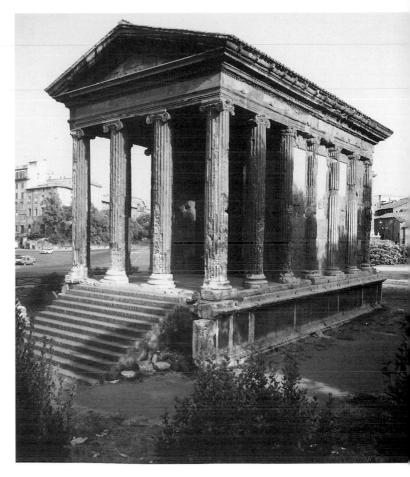

Figure 5.7 Temple of "Fortuna Virilis," Rome, late second to mid-first century B.C. The rectangular Roman temple form is essentially a combination of the Greek and Etruscan temple forms—compare to the Greek Parthenon (see fig. 4.5) and the Etruscan temple (see fig. 5.1).

entablature. This is seen in the Ionic Temple of "Fortuna Virilis," located in the Forum Boarium in Rome (fig. 5.7). This was built between the end of the second century and the middle of the first century B.C. and was probably dedicated to Portunus, the Roman god of harbors and rivers. Italo-Etruscan elements include the raised platform or podium, the entry on one end only by ascending a flight of stairs, a front porch that takes up about one-third of the whole podium area, and a cella as wide as the podium. As a result of the increased width of the cella, unlike the Greek temple, the Roman temple does not have a true peristyle and therefore cannot be described as peripteral—that is, it is not surrounded by a row of freestanding columns. Instead, it is pseudoperipteral, since the columns are engaged to the walls of the cella.

The Romans, unlike the Greeks, favored circular temples. A representative example is the Temple of Vesta in Rome (fig. 5.8), built ca. 80 B.C. Vesta was the goddess of the hearth and of fire. The temple is simple

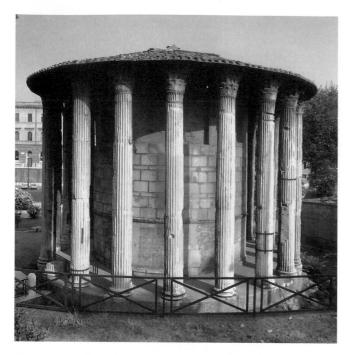

Figure 5.8 Temple of Vesta, ca. 80 B.C., Rome. In addition to perpetuating the Greek and Etruscan rectangular temple, the Romans made significant use of the circular temple. Among the orders, Greeks used the simple Doric most, whereas the Romans preferred the ornate Corinthian order, seen here.

in plan and small in scale. Circular Roman temples were made of concrete and faced with brick or stone. The Corinthian columns here are tall and slender. The entablature is much reduced and the roof rests almost directly on the columns.

Aqueducts. A dramatic demonstration of Roman engineering is provided by the network of aqueducts the Romans constructed throughout their territories. An aqueduct is a "water tube," a device that uses gravity to move water from mountain springs to cities in the valleys below. Some of the aqueducts built by the Romans were many miles long, crossing valleys, spanning rivers, going over mountains and even passing underground. In Rome itself, beginning in 144 B.C., a system of aqueducts was built to bring water to all seven of the city's hills, paid for by spoils from the victory in Carthage.

The most famous and best-preserved of the ancient Roman aqueducts is known as the Pont du Gard (bridge over the Gard River) at Nîmes, in southern France (fig. 5.9), built between the first century B.C. and the first century A.D. The Pont du Gard is based on a series of arches, each arch being buttressed by the arches on either side of it. The water channel is at the very top and is lined with cement. Flat stone slabs were placed over the top to keep out leaves and debris.

Sculpture. The ancient Romans made extensive use of sculpture—on both the inside and outside of public and private buildings, on columns, arches, tombs, and elsewhere.

The Romans imported and copied Greek statues, and modeled their own sculpture on that of the Greeks. Roman sculpture reflects the earlier traditions so strongly that it has even been questioned if there was a truly Roman style. But the Romans did introduce something new—realistic portraiture. While the Greeks made statues of deities and idealized heroes, Roman sculpture focused on individual people, particularly political figures.

The Roman custom of erecting commemorative portrait statues in public places dates back to the end of the period of kings and was very popular through the republican and early imperial periods. Eventually, there were so many that in the second century A.D. the Roman Senate tried to limit the number being put up.

The inclination of artists in the republican era to represent the figure without idealizing it is embodied in the *Portrait of a Roman* (fig. 5.10). The high level of realism evident here may have been assisted by the custom of making deathmasks, called *imagines* by the Romans. Shortly after death, a wax mask would be modeled on the

Figure 5.9 Pont du Gard, Nîmes, France, late first century B.C.—early first century A.D., height 180′ (54.9 m), current length approx. 900′ (275 m). Between 8,000 and 12,000 gallons of water were delivered to Nîmes per day through this aqueduct, which extended for thirty-one miles.

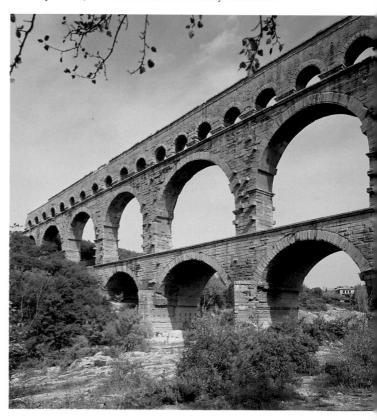

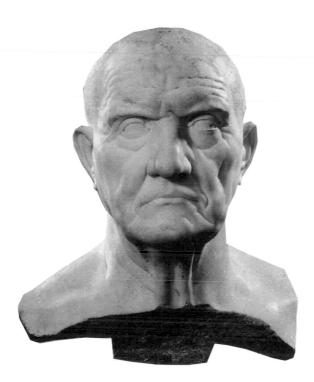

Figure 5.10 Portrait of a Roman, from the Palazzo Torlonia, Rome, ca. 80 B.C., marble, lifesize, Mctropolitan Museum of Art, New York. This bust, remarkably realistic with its sunken cheeks and furrowed brow, documents every detail of personal appearance.

face of the deceased and was then sometimes transferred to stone. This greatly helped sculptors in portraying people as they actually looked. Republican-period portraits are often brutally realistic. Every nook, cranny, and crevice is revealed, each irregularity, asymmetry, and anomaly recorded.

Republican-period portraiture seems to reflect the virtues lauded in the literature of this time: seriousness, honesty, and a straightforward approach to life. The character type most admired seems to have been stern and of unbending will and rigid moral virtue.

A Roman Patrician with Busts of His Ancestors (fig. 5.11), from the late first century B.C., also makes clear the great emphasis placed upon lineage by the ancient Romans. Masks of the ancestors of the deceased were carried or worn in funeral processions, and portrait busts and imagines of ancestors were generally displayed in homes. This man wears the toga, a garment fashionable in the republican era and documented in sculpture. The Etruscan and the republican Roman toga were made with less material than the later imperial-style toga. This earlier type was cut flat in a semi-circular shape, with no seams. Another garment of the republican era is the pallium, a rectangular piece of fabric. Statues can be dated based upon the type of toga or pallium worn and the way in which it is wrapped around the body.

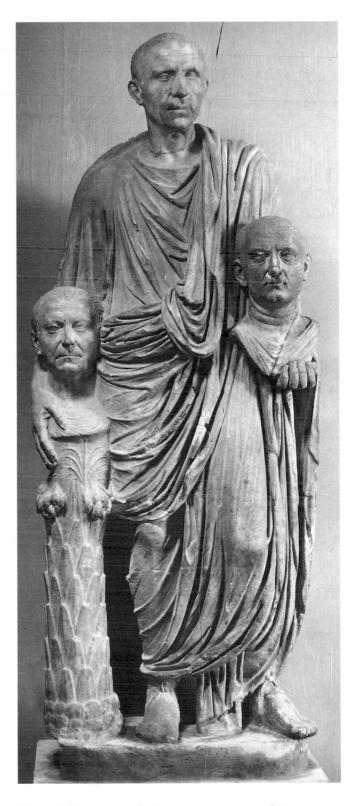

Figure 5.11 A Roman Patrician with Busts of His Ancestors, late first century B.C., marble, lifesize, Museo Capitolino, Rome. The great importance attached to family and lineage by the ancient Romans, exemplified here in this austere sculpture, is one of the motivating forces in the development of highly realistic portraiture during the republican era.

LITERATURE

Like their counterparts in the visual arts, Roman writers owe an immense debt to their Greek predecessors. Although the efforts of Roman writers cannot be dismissed as mere slavish copies of Greek models, it is true that Roman writers never really matched the achievements of their illustrious forebears. For the most part, Roman poets used Greek genres, although satire appears to have been an authentic Roman invention. Roman playwrights sometimes adapted Greek plays, with varying degrees of ingenuity.

Lucretius. The greatest work of the Latin poet LUCRETIUS [loo-KREE-shus] (ca. 99–ca. 55 B.C.), the long didactic poem, De Rerum Natura (Of the Nature of Things), is indebted to two Greek philosophers, Democritus and Epicurus. From Democritus, Lucretius borrowed the philosophy of atomism, which explains the universe as being composed entirely of tiny particles, or atoms. From Epicurus, Lucretius took the idea that the goal of life is to avoid pain and increase pleasure. Lucretius's poem attempts to clear the mind of superstition and ready it for reasoned discussion of the nature of things.

Catullus. Like the Greek lyric poet Sappho, CAT-ULLUS [ka-TUL-us] (84–54 B.C.) wrote passionate love poems, one of which is, in fact, a translation into Latin of one of Sappho's most celebrated lyrics, "Seizure."

Reflecting daily life in first-century B.C. Rome, many of Catullus's poems are written in a racy colloquial style. Catullus also wrote twenty-five poems about his love affair with Lesbia. These demonstrate his range and show him at his passionate best. Catullus can also be moving in expressing grief, as his lament for the death of his brother demonstrates.

Roman Drama: Plautus and Terence. While Greek theater excelled in the grandeur of tragedy, the theatrical glory of Rome is its comedy. The two most important Roman comic dramatists are PLAUTUS [PLOW-tus] (ca. 254–184 B.C.) and TERENCE (195–159 B.C.). Terence's plays were aimed at an aristocratic audience, by whom he was subsidized, while Plautus wrote for the common people. Not surprisingly, Plautus is the more robust and ribald of the two. Although the plays of both dramatists are humorous, Terence's wit is more cerebral than Plautus's, which more often elicits a belly laugh. Despite these differences, the works of both playwrights are adaptations of Greek comedy.

Terence offers subtlety of plot for Plautus's farce; he provides character development and interplay for Plautus's stock figures; and he presents economical dialogue in place of Plautus's colorful word-play. Terence more obviously exhibits tolerance for his characters and appreciation for their mixed motives and muddled but often good intentions. He is more sympathetic toward

the elderly, particularly the old fathers that Plautus ridicules. Terence is also more interested in women than Plautus, generally making them more complex and interesting characters.

Plautus's chief characters, those who run the dramatic engine of his plots, are typically slaves and parasites who turn the tables on their masters. With a notable lack of respect for authority, Plautus's characters flout social regulations, especially by undermining figures of authority. These include masters, fathers, and husbands. In Plautine comedy, slaves outwit their masters, sons fool their fathers, wives dupe their husbands.

The subversive dimension of Plautus's drama can be seen in the way filial loyalty is treated in The Haunted House (Mostellaria). In the absence of his wealthy merchant father, Philolocles holds wild parties in the family home, and spends money profligately, egged on by the family slave Tranio. When the father returns unexpectedly, Tranio masterminds a series of outlandish schemes to avoid punishment for his actions. These include telling the returning father that his house is haunted and that he therefore should not enter. Tranio keeps up the deceit by involving the actors in ever more desperate ploys of quick-thinking outrageousness. In The Haunted House Plautus presents the opposite of the ideal relations that Romans believed should obtain between servant and master, and between father and son. The slave's shenanigans and the son's disobedient behavior disrupt the normative ideals of the culture, occasioning hilarity in the

But Plautus's subversion of Roman cultural values goes even further. It also includes blaspheming the Roman gods, which results in a questioning of the moral foundation of Roman society. Yet this irreverence and disrespect, the consistent undermining of moral values and religious principles, occurs only on stage. When the play is over, the Roman audience go back to being who they were in real life—noble, civil, obedient, law-abiding citizens of a restrictive Roman society.

THE EMPIRE

When Octavian, CAESAR AUGUSTUS (63 B.C.–14 A.D.), as he was soon known, assumed power in 27 B.C., he claimed to have restored the republic. In reality, however, he had complete authority over not only the Senate but over all of Roman life. By A.D. 12 he had been given the title *Pontifex Maximus*, or "High Priest," and when he died, two years later, the Senate ordered that he be venerated henceforth as a god. He was an emperor in all but name. Together with his wife Livia, who was herself an administrator of great skill, he created the conditions for a period of peace and stability in the empire that lasted for two hundred years. Known as the *Pax Romana*, the "Roman Peace," it was made possible in large part by

125

Augustus's sensitivity to the people that Rome had conquered. Augustus dispatched governors to all the provinces with armies to maintain law and order. But these armies, freed of the need to conduct wars, turned instead to building great public works—aqueducts, theaters, libraries, marketplaces, and roads. Trade was greatly facilitated, and economic prosperity spread throughout the empire. Rome, however, remained at the heart of this trade network. Addressing his words to the great capital in the second century A.D., Aelius Aristides, a Greek rhetorician, put it this way:

Large continents lie all around the Mediterranean, and from them, to you, Rome, flow constant supplies of goods. Everything is shipped to you, from every land and from every sea—the products of each season, of each country, of each river and lake. If anyone wants to see all these items, he must either travel the whole world to behold them, or live in this city.

After nearly a century of political turmoil, Augustus's rule ushered in a new Golden Age. The art and literature of the Augustan period are regarded as the pinnacle of Roman cultural accomplishment.

The empire was so strong by the end of Augustus's reign that even a series of debauched and decadent emperors, such as CALIGULA [cal-IG-you-lah] (A.D. 12-

41), who ruled for only four years before he was assassinated and who was probably insane, and NERO [NEAR-oh] (37–68 A.D.), whose fourteen-year reign ended when the Senate displaced him, could not destroy it. When fire devastated Rome in A.D. 64, burning the monumental center of the city, Nero blamed the Christians for the blaze, probably to divert public opinion from laying blame on his administration. Nonetheless, he seized the opportunity to rebuild the city on the grandest of scales, including erecting the Colossus, a giant statue of himself as the sun-god.

There were also some very able emperors. After the fall of Nero, the FLAVIAN [FLAY-vee-an] dynasty, consisting of three emperors, restored imperial finances. More successful still were the so-called "Five Good Emperors"—NERVA [NER-vah] (A.D. 96–98), TRA-JAN [TRA-jan] (A.D. 98–117), HADRIAN [HAY-dree-an] (A.D. 117–138), ANTONINUS PIUS [PIE-us] (A.D. 138–161), and MARCUS AURELIUS [OW-REE-lee-us] (A.D. 161–180). Between them, these five ruled for eighty-four consecutive years, during which Rome flour-ished as never before. By A.D. 180 the Roman empire had grown to enormous proportions, extending from Spain in the west to the Persian Gulf in the Middle East, and from Britain and the Rhine River in the north to Egypt

Map 5.2 The Roman Empire at its greatest extent, ca. A.D. 180.

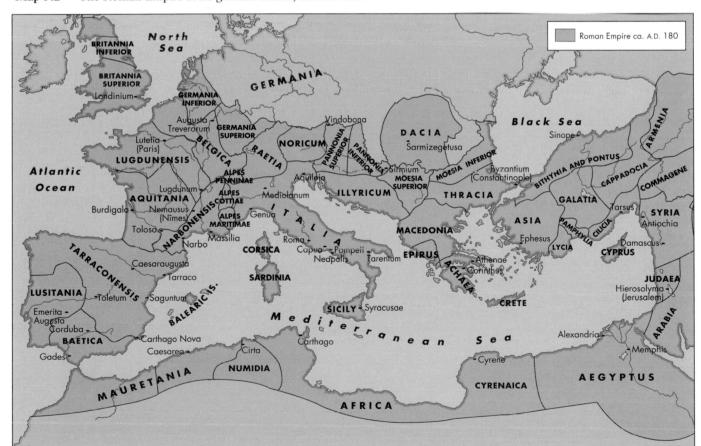

Timeline 5.3 The Pax Romana.

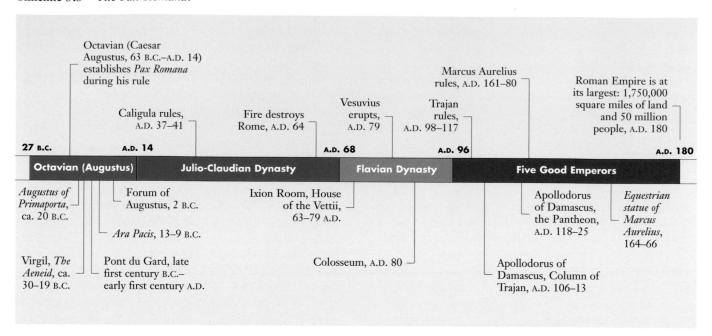

and the Sahara Desert in the south. It encompassed some 1,750,000 square miles and about fifty million people. Rather than chafing at Roman rule, some peoples of the empire longed to become citizens themselves. To satisfy this desire, citizenship was extended in A.D. 212 to all free people within the empire's vast borders.

However, beginning with the rule of Marcus Aurelius's son COMMODUS [coh-MODE-us] (r. A.D. 180–192), the empire started to flounder. Commodus was a tyrant whose murder inaugurated a series of civil wars. Of the twenty-six emperors to rule between A.D. 235 and 284, twenty-five were murdered. The Senate was powerless. The army acted only when it was bribed. Plague ravaged Rome—between A.D. 251 and 266 many thousands of Romans died from it. And, perhaps most ominously, the empire's borders began to be seriously threatened by barbarian hordes.

In A.D. 284, DIOCLETIAN [DI-oh-CLEE-shun] briefly restored order by dividing the empire into four portions—the tetrarchy—and assumed personal control of Asia Minor, Syria, and Egypt. His counterpart in the West was MAXIMIAN [mac-SIM-ee-an]. Each was designated "Augustus," and each appointed an heir, who held the title of Caesar and ruled lesser territories in order to gain experience. Diocletian's Caesar governed the Balkans, while Maximian's ruled Gaul. Spain, and Britain. At his headquarters in Nicomedia, Diocletian assumed the status of an Eastern king. He wore robes of blue and gold, symbolizing the sky and the sun. To affect an aura of heavenly inspiration, he sprinkled his hair with gold dust, and he sheathed himself in jewels. At all public appearances, he carried a giant golden staff, topped by a golden orb upon which a golden Roman eagle perched with a sapphire in its beak. All present sank to the floor in obeisance until he was seated in his throne.

After the abdication of Diocletian and Maximian in A.D. 305, the tetrarchy briefly continued until CON-STANTINE [CON-stan-tine] seized control of the entire empire in A.D. 324, ruling until his death in A.D. 337. In A.D. 330, Constantine moved the seat of government from Rome to the port city of Byzantium, which he renamed Constantinople after himself—humility was not part of the job description of the Roman emperor (today the city is known as Istanbul and is in Turkey). Rome's long ascendancy as the cultural center of the Western world was at an end (see Chapter 7).

One invaluable source for our knowledge of the Roman empire was provided by a natural disaster. In A.D. 79, the volcano Vesuvius, located about 150 miles south of Rome near the bay of Naples, erupted, engulfing a number of small Roman towns, including the fashionable suburban residences of Herculaneum and Pompeii. Most inhabitants escaped—but with only their lives. Everything else was left in place, food literally still on the tables. Vesuvius buried Herculaneum in hot mud and lava that hardened like stone thirty-five to eighty feet deep. Pompeii was covered in twenty to thirty feet of pumice stone and ash. Excavation was begun at both sites in the mid-eighteenth century—a process that has been far easier at Pompeii, but which today is still not complete at either site and which has provided a great deal of information on first-century A.D. life in the Roman empire. Our knowledge of Roman painting, for instance, would be immeasurably poorer without the evidence of these towns.

At the time Augustus assumed power, the city of Rome had about one million residents, making it the largest city of antiquity. Of these inhabitants, approximately ninety percent were of foreign extraction. Indeed, people from all Rome's colonies came to the city seeking Roman citizenship, which many were granted. Others were brought to Rome as slaves. Slaves in Rome performed not only the menial and back-breaking labor, but also served as bookkeepers, secretaries, and clerks. Many of these slaves lived far more comfortably than those who were technically free.

Ancient Rome was notable for the extent and ingenuity of its water system. Eight giant aqueducts brought water streaming into the heart of the city, filling its hundreds of public fountains and supplying water for the kitchens, bathrooms, and private fountains of the wealthy. Water was not privately available to all, however. The financially less well-off, who lived in crowded and poorly constructed apartment blocks called insulae, fetched their water from public fountains in buckets. Inhabitants of these apartments also suffered from inadequate sewer facilities. Occupants of the upper floors of the apartment buildings typically dumped the contents of their chamber pots from the windows of the upper stories rather than carrying them down many flights of stairs for disposal in a pit or cesspool. Commenting on the Romans' habit of dumping all sorts of things from their residences, the satirist JUVENAL [JOO-ven-all] (ca. A.D. 60–140) wrote "You can suffer as many deaths as there are open windows to pass under. So offer up a prayer that people will be content with just emptying out their slop bowls."

Even with these inconveniences, Roman efficiency ensured that the streets were kept clean. An underground drainage system carried away waste and rain water; municipal street crews kept city streets clean and in good repair. In the best public toilets, which were cleaned regularly and flushed with rapidly flowing water, there were even marble seats, which were warmed in winter.

Following the devastating fire in A.D. 64, much of Rome had to be rebuilt. Streets, however, remained narrow, as they were before the fire. Many of them were also twisting, irregular, and illogically organized, which to this day makes driving in Rome dangerous and finding an address there an adventure. Juvenal also had some unflattering things to say about Rome's overcrowded and narrow streets, in which citizens could find themselves "hit by poles and elbows, buffeted by beams and barrels, and their toes trodden on by a soldier's hobnailed boot." It was also a city, in Juvenal's phrase in his Third Satire, where "the curses of drivers caught in traffic jams will rob even a deaf man of sleep."

The rich were not subject to such conditions. As Juvenal says, "Sleep comes only to the wealthy." Roman senators and their families would rise early in their peaceful villas, surrounded by walls painted with architectural and landscape views, as well as still-life images of animals and flowers, and walk upon marble and mosaic floors. Ornaments decorated shelves and window-sills, including images of Greek art and statues and busts of important ancestors.

The family took its main meal at home in the evening in the *triclinium*, a name derived from the three couches or benches upon which the diners reclined. Supporting themselves on their left elbows, they ate with their right hands, either spooning or fingering food to their mouths. Meals could last as long as three hours, sometimes even longer. Between the seven or more courses, wealthier citizens entertained their guests with acrobats, storytellers, musicians, and dancers. The food served might include oysters, snails, lobsters, capons, suckling pigs, veal, pheasant, asparagus, mushrooms, fruit, and cake. Wine flowed copiously.

Following dinner the guests might sit down to talk, drink more wine, and play games, or they might go out to one of Rome's many public baths, where they could congregate and gossip, wrestle, and play games. In addition to hot and cold pools, the baths had reading rooms, libraries, exhibition rooms, and promenades, even occasionally beauty parlors.

For entertainment there was also the Circus, the largest of which in Rome was the Circus Maximus. Here chariot races were held, with as many as a dozen chariots competing, drawn by anywhere from two to ten horses. The Circus Maximus was also a venue for daredevil riders and performers of other stunts and feats of skill. It could accommodate up to 15,000 spectators.

Great crowds would also fill the Roman Colosseum. Unlike in the Circus, here women were not permitted to sit next to men. Instead, they were exiled to the top story of the great amphitheater, where they shared an enclosed gallery with the poor. In the story beneath sat slaves and foreigners, with the bottom two of the four stories reserved for male citizens, who sat in marble seats. The main attraction for the crowds at the Colosseum was gladiatorial combat. These often fatal battles were punctuated with comic interludes of clownish displays. Other entertainment was provided by the slaying of thousands of animals, some exotic and imported specifically for this purpose, as well as the slaughtering of Christians, who might be fed to lions, burned alive, or killed with arrows or swords.

The civilization of ancient Rome, then, was marked by different characteristics. On the one hand, there was the splendor of its marble buildings and its astonishing feats of organization and engineering; on the other, there were the crude entertainments of its Circuses and the cruelty of its Colosseum displays.

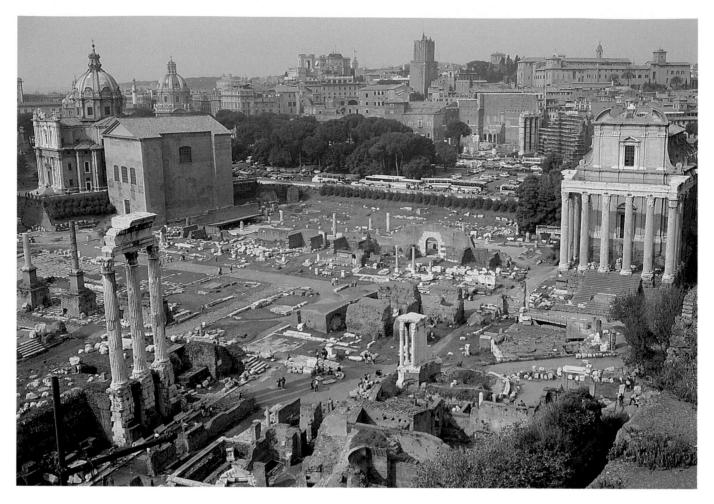

Figure 5.12 Roman Forum, Rome. A forum, a public area with markets, meeting places, and temples, was roughly the Roman equivalent of the Greek agora. The area of the Forum in Rome was expanded over many years.

THE ARCHITECTURE OF THE EMPIRE

Before Augustus took power, Sulla, Pompey, and Caesar had all inaugurated impressive building plans designed to celebrate their military exploits and victories. On the Capitoline Hill, Sulla had erected a giant temple of Jupiter Maximus in 83 B.C., importing its marble columns from the unfinished Temple of Zeus in Athens. Pompey completed Rome's first permanent stone theater in 55 B.C. Between it and the nearby temples, he created a vast enclosed green space of trees, fountains, and statues—the first public park. Caesar went even further, developing a new plan for the entire city, which included a large Forum Iulium, with colonnades, shops, and arcades, a new Senate House, and a basilica.

Augustus perpetuated this tradition. An active builder, he once claimed to have restored eighty-two temples in a single year. Suetonius's *Lives of the Caesars* says that Augustus boasted, "I found Rome a city of brick, and left it a city of marble," though he did so largely by putting a marble veneer over the brick.

The Roman Forum. One of Augustus's most ambitious projects was his forum, dedicated in 2 B.C. Augustus, a skilled manipulator of public opinion, gave political significance to this forum by dedicating its temple to Mars the Avenger. It was intended to serve as a reminder of the revenge he had taken on the murderers of his uncle, Julius Caesar, and the temple, with eight columns across its front, was one of the largest in the city, rivaling the Athenian Parthenon in size. The Forum of Augustus is actually one of many for athat are traditionally referred to collectively in the singular as "the Forum." The Roman Forum consists of nineteen fora—those of Julius Caesar, Augustus, Trajan, Nerva, a forum of peace, and so on-all abutting one another (fig. 5.12). The original use of the Forum was similar to that of the Greek agora. The Forum was the center of city life, serving as a public area where assemblies were held, justice was administered, and markets were located, with shops an important part of the Roman Forum. There were also a number of temples, such as two dedicated to Vesta, the Temple of Saturn, the Temple of Castor and Pollux, and the Temple of Antoninus Pius and Faustina. Symmetry and order reigned within each forum, but the different fora combined were chaotic. The Romans, more cosmopolitan and materialistic than the ancient Greeks, built on a larger scale, using a greater variety of building materials, and paid less attention to minute details. The Roman predilection was for combining diverse elements in order to achieve a grand overall effect.

The Colosseum. Another form of public architecture was the theater. The celebrated Flavian Colosseum in Rome (fig. 5.13), so called because of its association with a colossal statue of the emperor Nero, was dedicated in A.D. 80, having taken up to ten years to build. The Colosseum is an amphitheater, a type of building developed by the Romans. The word "theater" refers to the semi-circular form. The prefix "amphi" means "both"; an amphitheater is a theater at both ends, and is therefore circular or oval in plan. The seating area of the Colosseum accommodated over fifty thousand people, each of whom had a clear view of the arena. To protect the audience from the brilliant Roman sunshine, an awning could be stretched over part of the Colosseum.

The supporting structure of the Colosseum is made of concrete, but the exterior was covered with a stone facing of **travertine** (a form of limestone) and tufa. Holes can now be seen in the stone where people have dug to

get at the bronze clamps that held the facing in place. These stones hide the supporting structure. This is fundamentally different from the Greek approach to architecture, where the structure was not hidden but, rather, emphasized.

The exterior of the Colosseum is given definition by the entablatures that separate the stories and by the engaged columns that separate the arches. The three architectural orders are combined. The lowest level features the Tuscan variation on the Doric order; the second level is Ionic; and the third level is Corinthian. These columns are engaged (attached to the wall) and have no structural function. Anti-Greek in their use of the Greek orders, the Colosseum's columns cease to function as structural members. On the Colosseum, their only purpose is as surface decoration.

The practical Roman designers combined concrete structure with one of the other great architectural developments of the period—the arch principle. Arches are rare in Greek architecture; the Romans seem to have got the idea from the Etruscans. The visitor to the Colosseum can enter or exit through any of eighty arches around the Colosseum at street level. Each of these arches is buttressed by its neighbors and buttresses its neighbors in turn, as on the Pont du Gard. The interior is constructed with vaulted corridors and many staircases to permit free movement to a large number of people.

Figure 5.13 Colosseum, Rome, dedicated A.D. 80. The freestanding amphitheater, developed by the Romans, was made possible by the use of concrete and the arch principle. Compare this to the Greek theater of Epidauros where support for the seats is provided by the hillside (see fig. 4.18).

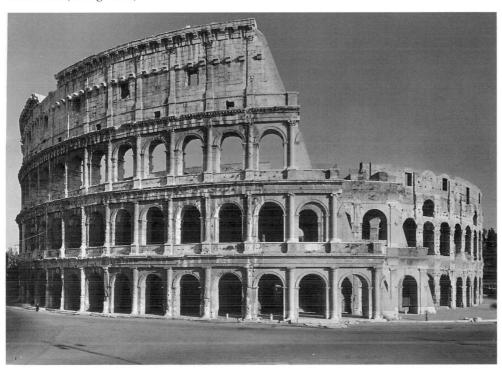

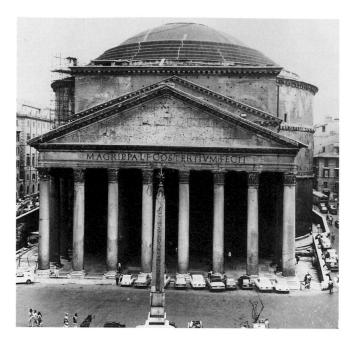

Figure 5.14 Apollodorus of Damascus, Pantheon, Rome, A.D. 118–25, exterior. A superb display of Roman engineering skill, the Pantheon includes a variety of ingenious devices to deal with the lateral thrust exerted by the dome. The paradigm of circular temples, the Pantheon would prove to be the model for many buildings in the following centuries.

A tremendous number of amphitheaters were built throughout the empire because it was official policy that the state should provide "entertainment" for the public. This entertainment fell into several categories of bloody combat: human versus human; human versus animal; animal versus animal; and naval battles—the Colosseum could be flooded to accommodate warships. The quality of this "entertainment" soon turned into a political issue, but the displays nonetheless became progressively more extravagant.

The Pantheon. Built between A.D. 118 and 125 in the reign of Emperor Hadrian and designed by the architect Apollodorus of Damascus, the magnificent Roman Pantheon (fig. 5.14) is a large circular temple dedicated to "all the gods" (the literal meaning of the word pantheon). Originally, steps led up to the entrance, but over the centuries the level of the street has been raised. Once there was also more to the porch; otherwise the Pantheon is very well preserved. In contrast to the Greek emphasis on the exterior of temples, the most important part of the Pantheon is the interior. One might almost fail to notice the enormous dome that crowns this building from the outside. Inside, however, the dome becomes the focus of attention and, because no columns are needed to support it, creates a feeling of vast spaciousness (fig. 5.15). The Pantheon was considered the most harmonious interior of antiquity.

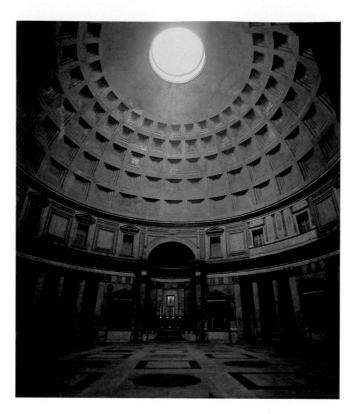

Figure 5.15 Apollodorus of Damascus, Pantheon, Rome, A.D. 118–25, interior. A domed ceiling offers the advantage of an open interior space, uninterrupted by the supports required in the post and lintel system. The sole source of light inside the Pantheon is the circular oculus in the center of the ceiling.

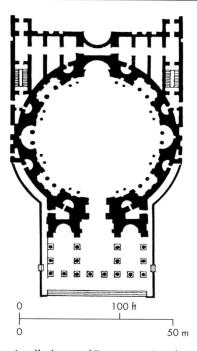

Figure 5.16 Apollodorus of Damascus, Pantheon, Rome, A.D. 118–25, plan. The enormous weight of the concrete dome is supported on a circular base with eight massive piers.

The dome is another of the great innovations of Roman architecture. A series of arches forms a **vault**. An arch rotated 180 degrees forms a **dome**.

The Pantheon's dome is raised on a high base, making the height and diameter of the dome the same—144 feet. The Pantheon was the largest dome until the twentieth century. The dome is made of concrete, the weight of which is concentrated on eight pillars distributed around its circumference (fig. 5.16). The **oculus**, the "eye" or opening in the center of the ceiling, is thirty feet across and is the sole source of light in the building. The squarish indentations in the dome, called **coffers**, were once plated with gold and each had a bronze rosette fastened in the center. The effect, with the brilliant sunlight of Rome coming from the central oculus above, must have been dazzling.

Baths. The Baths of Caracalla in Rome (fig. 5.17), built A.D. 213–17), were once a massive structure, but are now largely ruined. The emperor Caracalla [ca-RA-calah] (r. A.D. 211–217) based his baths on those built by his predecessors Titus and Trajan, but made his bigger than either of theirs. In general, it may be said that, just as emperors competed for the admiration of the people by financing ever more extravagant entertainments at the Colosseum, Roman buildings kept getting bigger as successive emperors tried to outdo the projects of their predecessors. Set in a walled park, the Baths of Caracalla

form a large complex measuring over three hundred yards square. The entire plan is symmetrical, and includes three bathing halls with baths at different temperatures: the *frigidarium*—the cold bath; the *tepidarium*—the tepid bath; and the *caldarium*—the hot bath. A central heating system, a *hypocaust*, heated the floors and walls. The floors were supported by stone posts, and a fire was built beneath the floor. There were also many smaller side rooms, dressing rooms, exercise rooms, a *palaestra*—an open area for wrestling and games—lounges, and even a library. The baths were, in many ways, the center of Roman social life. A large portion of one's day could be spent here; business, reputable and otherwise, was conducted at the baths.

SCULPTURE

With Augustus's rise to power in 27 B.C., sculpture changed its style. Depictions of realistically rendered aging Republicans were jettisoned in favor of more idealized versions of youth, and an increased taste for things Greek. This change in taste was in part the result of Augustus's efforts to import Greek craftspeople and artists. In the new Augustan style, Greek idealism was combined with Roman realism.

Augustus of Primaporta. The statue the Augustus of Prima-porta (fig. 5.18), of ca. 20 B.C., is a slightly over-

Figure 5.17 Baths of Caracalla, Rome, A.D. 213–17, aerial overview. The bath was an important part of the ancient Roman way of life. The baths of Emperor Caracalla, enormous in scale, had all possible conveniences for the mind and body, including a library and exercise areas.

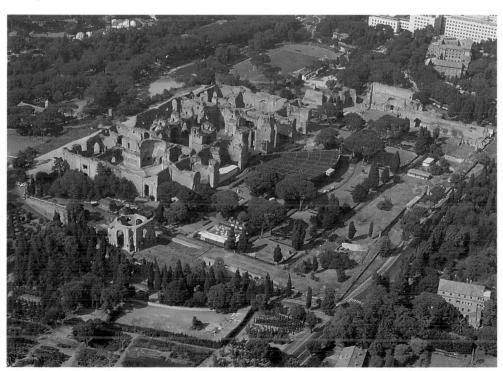

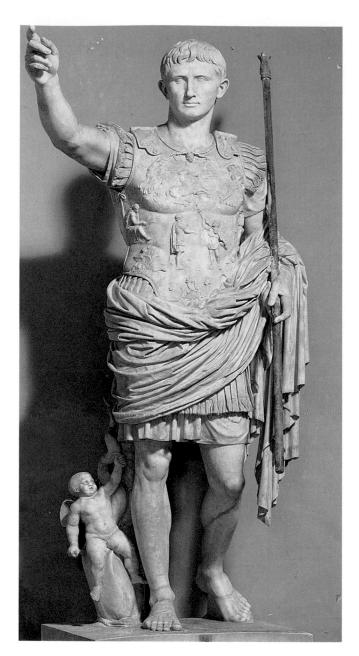

Figure 5.18 Augustus of Primaporta, ca. 20 B.C., marble, height 6'8" (2.03 m), Braccio Nuovo, Musei Vaticani, Rome. Although this statue does record the appearance of Emperor Augustus, under his reign harsh Roman republican realism was somewhat softened by Greek idealism.

lifesize marble figure that was intended to glorify the Emperor and Roman peace under his rule. The statue is on the whole very well preserved, and many traces of pigment remain—the statue was originally painted. The face of the statue is recognizably that of Augustus; the same features are seen on other portraits of the Emperor, although here they are somewhat idealized. Augustus is shown to be heroic, aloof, self-contained. The prototype for this portrait is the *Doryphoros* (*Spear-Bearer*) of Polykleitos (see fig. 4.14); indeed, Augustus probably

held a spear in his left hand originally, but it has since been restored as a scepter. There is perhaps even a concession to traditional Greek nudity in showing the Emperor barefoot. The grand gesture with one arm extended—as if addressing his troops—was a common pose. The cupid riding on a dolphin beside Augustus's right leg is an allusion to Aeneas's mother, Venus, in Virgil's heroic poem, *The Aeneid* (see. p. 188), and suggests Augustus's own supposed divine heritage. The relief on Augustus's cuirass (breastplate) is symbolic and refers to the *Pax Romana*, the peace and harmony that prevailed under his reign.

The Ara Pacis. At times the distinction between architecture and sculpture is blurred in buildings that are totally covered with relief sculpture, as in the Ara Pacis (Altar of Peace), built 13–9 B.C. by Augustus. Whether it is sculpture or architecture, however, it is undoubtedly the greatest artistic work of the Augustan age. Augustus billed himself as the "Prince of Peace" and this altar is a beautiful example of political propaganda.

The *Ara Pacis* is a small rectangular building. Among the extensive reliefs that adorn its sides is an imperial procession including Augustus and Livia (fig. 5.19). In their wake follow the imperial household, including children, priests with caps, and dignitaries. These figures move along both of the long walls of the altar, converging toward the entrance. The degree of naturalism achieved in this marble relief is striking. The depictions of people are varied—some stand still, others talk with their neighbors, or form groups, or look off in different directions; figures are seen from the front, from the side, and in three-quarter views. Drapery is skilfully rendered so that fabric falls naturalistically, yet also forms a pleasing rhythmic pattern of loops and curves across the whole relief.

Figure 5.19 Ara Pacis, relief of procession of figures, 13–9 B.C., height ca. 5'3" (1.6 m). Augustus, now older, is depicted with his wife, Livia. Unlike the timeless, generalized, idealized Greek relief from the Parthenon (see fig. 4.9), the Roman relief shows specific people at a specific event.

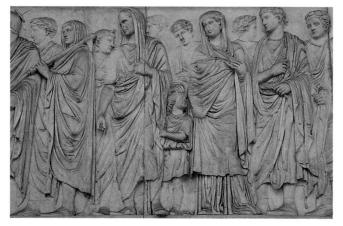

An illusion of spatial recession has been created in stone relief. Figures in the front are a little larger than figures in the back, and are carved in higher relief. The different levels of relief create an illusion of space, so that any area left blank no longer looks like a solid wall but rather reads as actual space into and from which figures

Figure 5.20 Apollodorus of Damascus, Column of Trajan, Rome, A.D. 106–13, marble, height with base 125′ (38.1 m). In spite of the obvious difficulty the viewer encounters in following a story told in a relief that spirals around a column rising high above, this was not the only such commemorative column erected by the Romans.

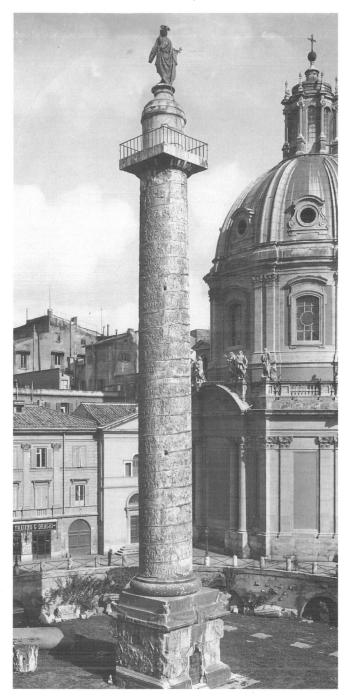

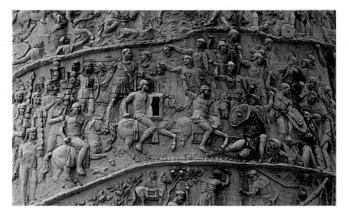

Figure 5.21 Apollodorus of Damascus, Column of Trajan, Rome, A.D. 106–13, relief, detail of fig. 5.20. The long band of reliefs records Trajan's victories over the Dacians with documentary accuracy. Details of setting, armor, weapons, and even military tactics are included.

recede and emerge. A particularly clever illusionistic touch is the positioning of toes so that they protrude over the ledge on which the figures stand. It is as if the figures are genuinely three-dimensional and capable of stepping out of their space and into ours, adding to the immediacy of the work and to the illusion of reality that it creates.

The Column of Trajan. Columns, usually erected to celebrate a military victory, are another distinctively Roman architectural form. The emperor Trajan (r. Λ.D. 98–117) used art to show himself as an ideal leader, as the embodiment of valor and virtue. To this end, in Λ.D. 106–113 he erected the Column of Trajan (fig. 5.20) in the Forum of Trajan in Rome. The creator of the Pantheon, the Greek architect Apollodorus of Damascus, designed the column; the carving, however, was done by Romans. Upon his death, Trajan's sarcophagus was placed in the base, although barbarian invaders later took the sarcophagus for its gold and scattered the Emperor's ashes.

On top of the column there was originally an eagle. When Trajan died, his successor, Hadrian, replaced the eagle with a statue of Trajan. In 1587, Pope Sixtus removed the statue, melted it down, and recast the bronze into a statue of St. Peter, which now tops the column. The base is made of huge blocks with a square stairway inside, while a circular stairway consisting of 182 steps winds around the interior of the actual column. The surface of the column is covered with a continuous band of relief 656 feet long that makes twenty-three turns as it spirals upward like a twisting tapestry. As the column becomes narrower toward the top, the height of the relief band increases, presumably to make the upper relief easier to see from the ground. The relief consists of about 150 scenes and 2,500 figures.

The reliefs (fig. 5.21), reading from the bottom to the top, document an actual event—the military campaign of

Connections

THE ARA PACIS AND THE POLITICS OF FAMILY LIFE

Three generations of Augustus's family appear in the section of the Ara Pacis illustrated in figure 5.19. On the left, his head covered by his robe, is Marcus Agrippa. At the time of the carving he was married to Augustus's daughter Julia and was next in line to be emperor after Augustus, but he died in A.D. 12, two years before Augustus himself. Next to him in the relief is his eldest son, Gaius Caesar, who clings to Agrippa's robe. Augustus was particularly fond of Gaius and his younger brother Lucius. The two boys often traveled with the Emperor, and he took on important aspects of their education, teaching them to swim, to read, and to imitate his own handwriting. The proud grandmother, Augustus's wife Livia, stands beside Marcus Agrippa and Gaius Caesar. Behind her is her own son Tiberius, who would in

fact succeed Augustus as emperor. Behind Tiberius is Antonia, Augustus's niece and the wife of Tiberius's brother Drusus, at whom she is looking. Antonia holds the hand of her and Drusus's son, Germanicus. Drusus's nephew Gnaeus clings to his uncle's robe.

In the period before the Ara Pacis, there are very few examples of depictions of children in Roman public sculpture, a fact that raises an important question: What moved Augustus to include children so conspicuously in this monument? By the time Augustus took control of Rome, slaves and freed slaves threatened to outnumber Roman citizens in Rome itself, and they clearly outnumbered the Roman nobility. Augustus took this seriously and saw it as the result of a crisis in Roman family life. Adultery and divorce had become commonplace. Furthermore, the cost of maintaining a family was increasing. Consequently Roman families were becoming smaller and smaller.

Augustus introduced a series of measures to combat this decline in the traditional Roman family. He criminalized adultery and passed a number of laws designed to promote marriage as an institution and encourage larger families. Men between the ages of twentyfive and sixty and women between the ages of twenty and fifty were required to marry. A divorced woman was required to remarry within six months, a widow within a year. A childless woman, married or not, was required to pay large taxes on her property. A childless man was denied any inheritance. And the nobility were granted political advantages in line with the size of their families.

The *Ara Pacis* can be seen as part of Augustus's general program to revitalize the institution of marriage in Roman life. His own family, so prominently displayed in the frieze, was intended to serve as a model for all Roman families.

A.D. 101–03 to subdue the forces of Decebalus, prince of Dacia, present-day Romania. This was the first of Rome's wars against the Dacians. In the second, in A.D. 105–07, Trajan completely destroyed his enemy.

The story begins with a bridge of boats—a pontoon—and the crossing of the Danube River. A giant river-god looks on in approval. Just above, the Romans construct their military headquarters in Dacia. Higher on the column, the relief celebrates Trajan's ruthlessness in war. The Emperor ordered that no prisoners be taken, and the relief shows the beheading of several Dacians. At times horrifyingly frank, the Column of Trajan is a monument to realism and an invaluable document of ancient Roman politics, military tactics, and military life. As a reminder of the empire's might in war, it is also a great work of Roman propaganda.

The Equestrian Statue of Marcus Aurelius. The over-lifesize equestrian statue of Emperor Marcus Aurelius (fig. 5.22), of A.D. 164–66, became a favorite type of commemorative sculpture. This statue has survived to the present only because it was long mistaken for a portrait of Constantine, the first Christian emperor, and was thus spared the fate of being melted down as so many other "pagan" Roman bronzes were (for instance, the statue of Trajan on top of his column—see above). A philosopher-emperor, gentle and wise, who held Stoic

Figure 5.22 Equestrian Statue of Marcus Aurelius, A.D. 164–66, gilded bronze, height 11'6" (3.51 m), Piazza del Campidoglio, Rome. This image became a model for future representations of military leaders.

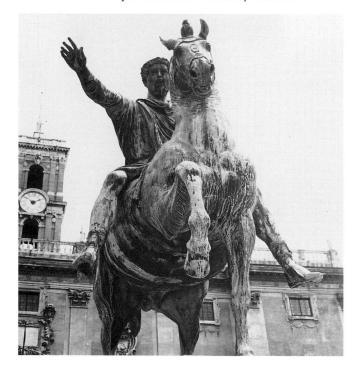

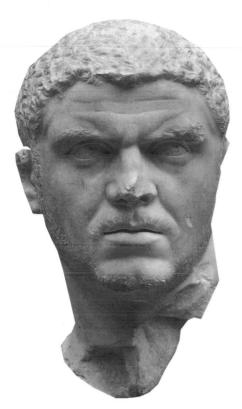

Figure 5.23 Caracalla, ca. A.D. 215, marble, lifesize, Metropolitan Museum of Art, New York. This bust records Emperor Caracalla's physical appearance, but goes beyond the superficial representation of the subject's facial terrain to reveal his personality—which was described as often angry.

beliefs, Marcus Aurelius is garbed in the traditional robes of the republican philosophers. He subdues his enemies without weapons or armor—originally, a barbarian lay beneath the horse's upraised hoof—and in victory brings with him the promise of peace.

Portrait Bust of Caracalla. A time of political revolution and social change, the third century in Rome was marked by continual strife at home and abroad and by a rapid turnover of rulers. The violence of the era is embodied in the portrait bust of Caracalla (fig. 5.23). The Emperor's real name was Antoninus, but he was nicknamed Caracalla after the *caracallus*, a floor-length coat, because he gave clothing to the people. In fact, his *Constitutio Antoniniana* gave everyone living in the Roman empire something that proved more lasting—civil rights.

But however generous he may have been, in the sculpture Caracalla seems to have been portrayed as the most brutal of despots. How has the sculptor accompished this? Emphasis is on the eyes: The pupils are carved out and the irises are engraved. Caracalla gazes into the distance, but he seems to focus on a definite point. His forehead is furrowed, his brow contracted, as if in anxiety. The truth behind the portrait

is that Caracalla was so intent on power and authority that he had murdered his brother Geta to gain the emperorship.

Many copies of the bust survive—Caracalla must have approved of this image himself. It is as if brutality has become the very sign of power and authority. And the portrait set a style for the third century which emphasizes such animated and broken silhouettes. The skillful carving, creating a vivid contrast between flesh and hair, is descriptive rather than decorative.

Head of Constantine. The eyes of this head of Constantine the Great (fig. 5.24), the first Christian emperor, who ruled 306–37, gaze out into the distance like Caracalla's, but Constantine no longer seems to focus on anything in particular. Instead, in keeping with

Figure 5.24 Constantine the Great, head from a huge statue, A.D. 325–26, marble, height 8'5" (2.58 m), Palazzo dei Conservatori, Rome. This image of Constantine, the first Christian emperor, impresses through enormous scale rather than photographic realism. With the spread of Christianity came a turn away from the factual and toward the spiritual.

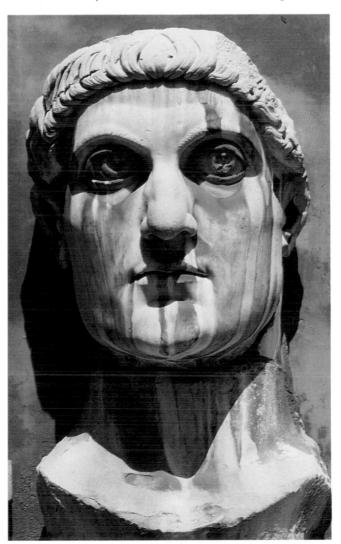

the spirituality of the times, he appears to be in a kind of trance. The head itself is over eight feet high, and was originally part of an enormous thirty-foot-high seated sculpture of the emperor, of which only a few marble fragments survive, among them a giant hand that points heavenward. Placed behind the altar of the Basilica Nova in Rome, it dominated the interior space. Constantine is both mystical and majestic. He is shown to be calm, capable, and composed by an image that is self-glorifying and self-exalting.

The Arch of Constantine. Constantine had come to power after defeating the emperor Maxentius at the Milvian Bridge, an entrance to Rome. The night before the battle, legend has it, Constantine saw a flaming cross in the sky, and heard these words, "In hoc signo, vinces" ("In this sign you will conquer"). The next day, he had painted on the shields and armor of all his men the Greek chi and rho, the first two letters of Jesus Christ's name (chi and rho were also a Roman abbreviation for "auspicious"). Constantine was victorious and became emperor,

and in A.D. 313 issued the Edict of Milan, granting freedom to all Christians and all other groups to practice their religions.

To celebrate Constantine's victory over Maxentius, the Senate erected a giant triple arch next to the Colosseum in Rome (fig. 5.25). Such triumphal arches, like columns, were characteristically Roman and were erected to commemorate military successes. Much of the decoration was taken from second-century A.D. monuments, and the figures changed to look like Constantine (fig. 5.26). The medallions decorating the arch were carved A.D. 128-38 during the time of Hadrian. In the medallion showing Emperor Hadrian hunting a boar, a variety of levels of relief create a sense of depth. Horses move on diagonals. Figures twist, turn, and bend in space. By way of contrast, the frieze below, carved in the early fourth century, had Constantine in the center, but he was later replaced by a figure of Jesus, and now the head is gone. A complete disregard of the Classical tradition is evident here. No attempt is made to create threedimensional space—there are no diagonals, there is no

Figure 5.25 Arch of Constantine, A.D. 312–15, Rome. The simple type of ancient Roman triumphal arch has a single opening; the more complex type like the Arch of Constantine has three openings. Typically Roman is the non-structural use of columns as surface decoration.

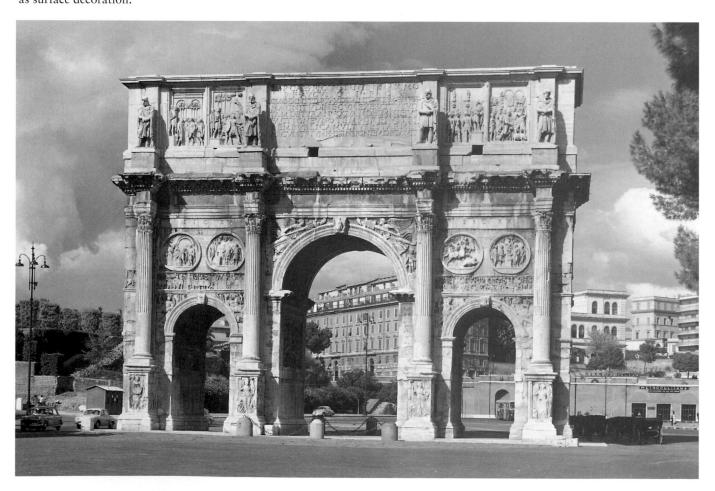

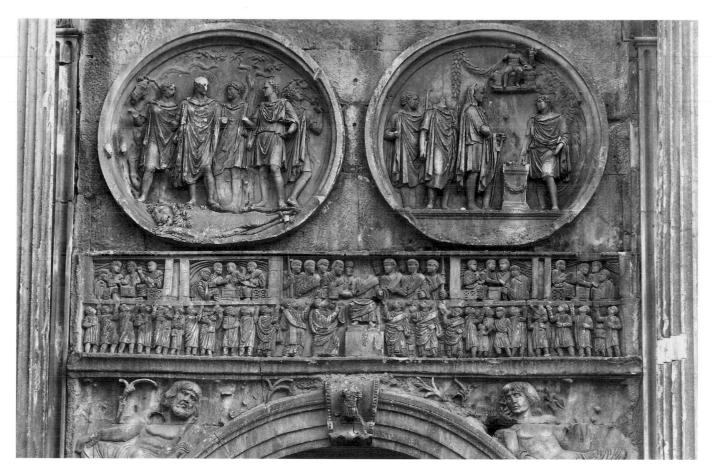

Figure 5.26 Arch of Constantine, north side, medallions carved A.D. 128–38, frieze carved early fourth century A.D., Rome. The contrast between the naturalism of the medallions and the simplified distortions and absence of interest in spatial illusionism in the frieze reveals major changes in Roman art.

foreshortening, all the carving is done to the same depth. The figures are not united in a common action. Instead, each figure is iso-lated. Rather than being depicted in the *contrapposto* pose, each figure has the weight equally distributed on both fcct. Figures are indicated as being behind others by rows of heads above. The proportions of the figures are stocky and doll-like, very different from Classical Greek proportions.

PAINTING

Only a fraction of the paintings produced by ancient Roman artists remain. The small-scale portable paintings on ivory, stone, and wood are now almost entirely gone, though it is known that such paintings sold for high prices. Roman painting is generally assumed to derive largely from Greek painting, much as Roman architecture and sculpture were largely dependent on Greek models. Unfortunately, the extent of this dependence in painting cannot be very precisely determined. This is because, with a few minor exceptions, the only Greek painting to survive is on vases, while almost the only

Roman painting to survive is found on walls in the form of **murals**.

The walls of private homes were usually painted. These paintings are almost exclusively decorative in intent. The best extant examples of ancient Roman wall painting were preserved in Herculaneum and Pompeii by the eruption of the volcano Vesuvius. A few examples that date from after A.D. 79 have survived in Rome, Ostia, and the provinces.

Ancient Roman wall painting was classified into four styles by the German historian August Mau in 1882. Although Mau's system continues to be used today, not all art historians are in agreement as to the dates at which one style ends and the next begins.

First Style. The First Style may be said to start in the second century B.C. and continue until 80 B.C. It is referred to as the "incrustation" or "masonry" style, since the paintings of this period are attempts to imitate the appearance of colored marble slabs. The wall surface in this example from the Casa di Sallustio at Pompeii (fig. 5.27), of the mid-second century B.C., is divided into

Figure 5.27 Casa di Sallustio, Pompeii, second century B.C. The first of the four styles of ancient Roman wall painting (a system of classification developed not by the ancient Romans but by a nineteenth-century historian) is readily recognizable. Also known as the "incrustation" style, the First Style consists of painted imitations of marble slabs.

squares and rectangles, which are painted to look like costly marble wall-facing. There are no figures and no attempt to give the illusion of three-dimensional space—the only illusion is that of costly building materials.

Second Style. The Second Style begins about 80 B.C. and lasts until 30 or 20 B.C. and is often referred to as the "architectonic," the "architectural," or the "illusionistic" style. In this period actual architectural structures, which were themselves colored, were copied in paint. An example of the Second Style is in the Villa of the Mysteries, outside Pompeii (fig. 5.28), which dates to the mid-first century B.C. One room here is especially famous, partly for the puzzle it presents. Many theories have been suggested to explain the activities depicted on the four walls of this room. The subject may have to do with a bridal initiation into the mystery cult of Dionysos.

The figures are solid and substantial, and almost all female. They move in a shallow space with green floors and red walls, which are divided up into sections. A novel feature in this room is that the figures act and react across the corners of the room, animating and activating the space of the room.

A more characteristic example of the Second Style is the *cubiculum* (fig. 5.29) from the Villa at Boscoreale, a mile north of Pompeii, built shortly after the mid-first century B.C. The bedroom of a wealthy Roman by the name of Publius Fannius Synistor, this room was at the northwest corner of a colonnaded court of the house. It

was buried by the eruption of Mount Vesuvius in A.D. 79 and was only redisovered in the late nineteenth century.

The walls of the room are painted with illusionistic architecture that creates a free prospect into space. The painter has extended the space of the room. The solid wall is obliterated. It has been suggested that this was inspired by stage painting—there are theater masks at the top. Vitruvius refers to the use of stage scenery as house decoration. Or perhaps this reflects actual contemporary architecture. Might this be a portrayal of an ideal villa? Could this be a visual retreat—the idea of escaping from daily cares into this fantastic architectural realm?

The wall is treated as if it were a window to an imaginary outdoor vista. Perspective is used, but it is not scientific or consistent. It is not possible to make a logical groundplan of this cityscape. What do the buildings stand on? Yet the light falls as if from the actual window in the back wall. The use of highlights and shadows is determined on the basis of the way the light would actually fall from this window and cast shadows.

Both the First and Second Styles evidence the Roman delight in fooling the viewer's eyes. Such realism was admired in antiquity. In his *Natural History*, Pliny says a certain painted decoration was praised "because some crows, deceived by a painted representation of roof-tiles, tried to alight on them." With different textures, with

Figure 5.28 Scenes of Dionysiac mystery cult, Villa of the Mysteries, outside Pompeii, ca. 50 B.C. Although the exact subject depicted in this room remains unclear, it seems to be connected with the cult of Dionysos, god of wine. Clever use is made of space, for the figures interact with one another on adjoining walls across the corners of the room.

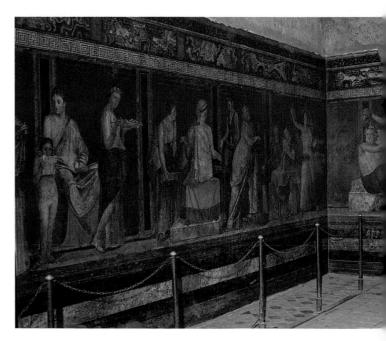

marble columns that appear round, with painted colonnades on a projecting base, a fairly convincing illusion of three dimensions is created on a two-dimensional surface. The Boscoreale *cubiculum* is intended to trick the eye on a grand scale. The murals may be indicative of the villa owner's desire to amuse, to entertain, and, espe-

Third Style. The Third Style dates from the late first century B.C. to the mid-first century A.D. The Third Style is variously known as the "ornamental/ ornamented" style, the "capricious" style, the "ornate" style, the "candelabra" style, or the "classic" style. There

cially, to impress his guests.

is a new concern with decorative detail here. The abrupt shift evident in the Third Style coincides with the reign of Augustus. It is a revolutionary style, reacting against the preceding one, rather than building upon it.

The Third Style places an emphasis on the wall surface rather than on illusions of depth (fig. 5.30). Walls are now often almost monochromatic, the range of colors restricted to red, black, or white. These large areas of monochrome seem to acknowledge the wall's two-dimensionality. Landscapes are no longer spread over the wall to create spatial illusions. Instead, landscapes are treated as framed pictures on the wall, as vignettes, like mirages, not located in depth behind the wall surface

Figure 5.29 Villa at Boscoreale, *cubiculum*, overview, first century B.C., Metropolitan Museum of Art, New York. In this example of the Second Style, also known as the "architectonic" style, an entire bedroom is painted with illusionistic architecture and distant cityscapes.

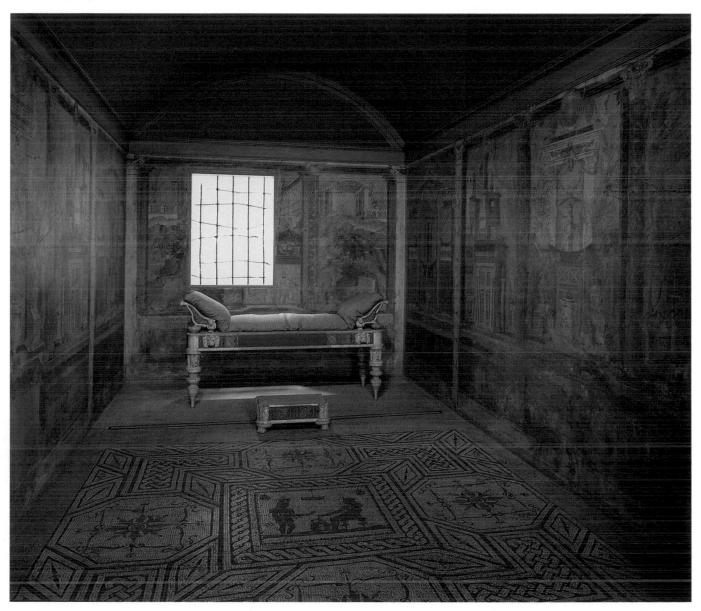

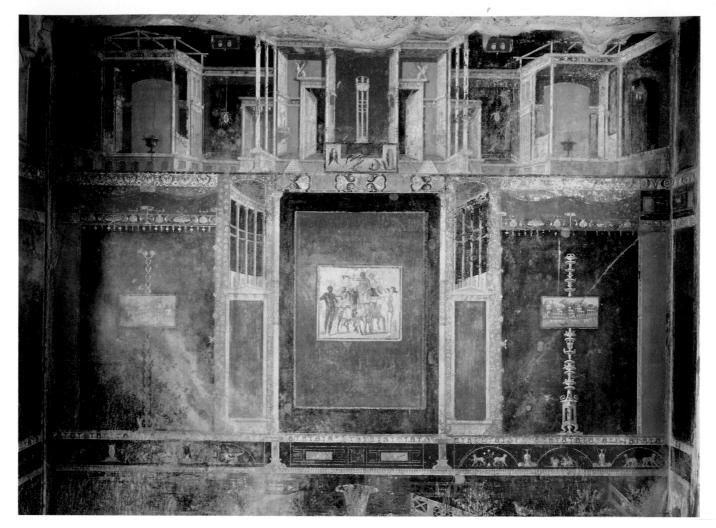

House of M. Lucretius Fronto, Pompeii, mid-first century A.D. In the Third Style, also known as the "ornamental" style, there is a return to a flatter effect with large areas of solid color and landscapes treated as framed pictures hanging on the wall.

but floating on the surface. These landscapes serve as settings for mythological stories. The surrounding flat fields of colors are painted with elaborate details of architecture, plant forms, and figures, delicate and decorative. The massive columns and architectural framework of the Second Style have given way to spindly non-structural columns.

Fourth Style. The Fourth, and final, Style largely dates from the mid-first century A.D. or from the earthquake in A.D. 62 until the eruption of the volcano Vesuvius in A.D. 79, although there are extant examples that postdate the eruption of Vesuvius, in Rome, Ostia, and the provinces. The Fourth Style is the most elaborate of all and is known as the "composite," "fantasy," or "intricate" style. The technique is freer, sketchier, more impressionistic than the First, Second, or Third Styles. There is greater use of still life and landscape.

The Ixion Room of the House of the Vettii in Pompeii (fig. 5.31), painted A.D. 63-79, is typical of the Fourth Style. Within the Fourth Style are returns to "false" earlier styles. This example combines the simulated marble inlay of the First Style on the lower wall, the illusionistic architecture of the Second Style on the upper wall, and the framed vignette floating on a flat area of solid color of the Third Style. A completely painted fantasy is achieved. Figures and architecture are combined. What more could possibly be added to this playful and decorative ornament?

PHILOSOPHY

Stoicism. Like so much else in the artistic and philosophical traditions of Greece, Stoicism migrated to Rome (see Chapter 4). From the second century B.C. through the period of the Roman empire, Stoicism was

Then & Now

GRAFFITI

The urge to write on walls is apparently as old as civilization itself. Before the invention of writing, for instance, prehistoric people outlined their hands on cave walls, as if to say, "I was here." In contemporary society, our national parks and monuments are plagued by this apparently basic human need to announce our presence, as generation after generation have inscribed their names and dates of visit on canyon walls and giant redwoods. One of the earliest records of the Spanish conquest of the American Southwest is preserved on Inscription Rock at El Morro National Monument in New Mexico. It reads, "Passed by here the Adelantado Don Juan de Oñate, from the discovery of the Sea of the South, the 16th April of 1605." It is the first of a long legacy of such inscriptions, culminating in the graffiti that today "decorates" so much of the local landscape—the so-called "tags," or names, of graffiti "writers" that vie for prominence on many walls of urban America.

The Romans, it seems, were themselves great practitioners of the "art" of graffiti. In Pompeii alone over 3,500 graffiti have been found. Among them is the normal fare: "Successus was here"; "Publius Comicius Restitutus stood here with his brother"; "We are here, two dear friends, comrades forever. If you want to know our names, they

are Gaius and Aulus"; and "Gaius Julius Primigenius was here. Why are you late?" But the Romans were also adept at the kind of graffiti we normally associate today with "bathroom humor": One wit apparently paraphrases Julius Caesar's famous boast "I came, I saw, I conquered," transforming it into "I came here, I screwed, I returned home." There are as well many graffiti of the "Marcus loves Spendusa" and "Serena hates Isidore" variety. But one writer sums up the feelings of future generations of graffiti readers: "I am amazed, O wall, that you have not collapsed and fallen, since you must bear the tedious stupidities of so many scrawlers."

Figure 5.31 Ixion Room, House of the Vettii, Pompeii, A.D. 63–79. The Fourth Style, also known as the "composite" style, combines aspects of the earlier styles: imitation marble incrustation; illustionistic architecture; and areas of flat color with small framed scenes.

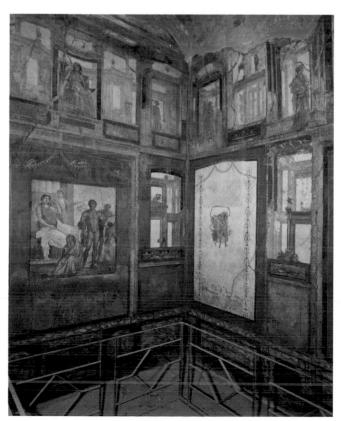

the dominant Roman philosophy. The great Roman orator Marcus Tullius CICERO [SIS-ur-oh] (106–43 B.C.) and the dramatist and statesman Lucius Annaeus SENECA [SEN-uh-cuh] (ca. 4 B.C.–A.D. 65) commented on it, but Stoicism's two best-known adherents and practitioners were EPICTETUS [eh-pic-TEE-tus] (ca. A.D. 60–110), a Greek slave and secretary in the imperial administration, and Epictetus's student MARCUS AURELIUS, who reigned as emperor some years after Nero.

Like the Greek philosophers who came after Aristotle, Epictetus was a practical philosopher. His interest lay less in elaborating a metaphysical system than in providing guidance for living a life of virtue and equanimity. Epictetus exemplified the Stoic ideal in his own life, living simply and avoiding the temptations and distractions of the world as much as possible. He urged his followers in his *Discourses* to control what elements of their lives they could and to avoid worrying about those they could not. Epictetus accepted, for example, that he could not change the fact that he was a slave. What he could control, however, was his attitude toward his situation. It was this attitude, according to Epictetus, that determined one's moral worth, not one's external circumstances.

Unlike Epictetus, Marcus Aurelius was born into a wealthy Roman family. He succeeded his uncle, Antoninus Pius, to the imperial throne in A.D. 161. This was a time of great difficulty for Rome, which had suffered a devastating plague as well as incursions into its territories by barbarians. As emperor, Marcus Aurelius spent nearly half his life on military campaigns. It was

during his military duties that he composed his *Meditations*, a series of reflections on the proper conduct of life.

The Meditations are more attentive to religious questions than Epictetus's Discourses. Like his Greek Stoic predecessors, Marcus Aurelius described the divine less in terms of a personal god in the Judaeo-Christian tradition and more as an indwelling spirit of rationality. Marcus Aurelius considered the entire universe to be governed by reason, and accepted the world as being fundamentally good. It is the ethical dimension of The Meditations, however, that has determined their popularity and influence. In preaching a doctrine of acceptance, Marcus Aurelius recommended that a person not return evil for evil, but rather ignore the evil that others did to one, since what happened to an individual's person and possessions was insignificant. According to Marcus Aurelius, only the soul, the inner self, counted.

LITERATURE

Poetry in the Roman empire flourished as never before under the rule of Augustus. Augustus himself appears to have been a significant patron of the literary arts and he encouraged writers to glorify the themes of his reign—peace and the imperial destiny of Rome.

Virgil. Latin poets celebrated Roman culture while emulating the cultural achievements of their Greek predecessors. The poet who best harmonized these two cultural and literary strains was Publius Vergilius Maro, known simply as VIRGIL [VER-jil] (70–19 B.C.), whose poem *The Aeneid* [ee-NEE-id] rivals the Homeric epics in literary splendor and cultural significance.

Virgil was almost certainly commissioned by the Emperor himself to write his great epic. There is much in the poem that is Augustan in theme.

The Aeneid is a heroic account of the events that led to the founding of the city of Rome and the Roman empire, especially the misfortunes and deprivations that accompany heroic deeds. The poem concerns the Trojan prince Aeneas [ee-NEE-as] who flees his home as it is being destroyed at the end of the Trojan War and sails away to found a new city in Italy—the successor to the great Trojan civilization.

I sing of warfare and a man at war.°
From the sea-coast of Troy in early days
He came to Italy by destiny.
To our Lavinian° western shore,
A fugitive, this captain, buffeted
Cruelly on land as on the sea
By blows from powers of the air—behind them
Baleful Juno° in her sleepless rage.
And cruel losses were his lot in war.
Till he could found a city and bring home
His gods to Latium, land of the Latin race.
The Alban° lords, and the high walls of Rome.

Tell me the causes now. O Muse, how galled In her divine pride, and how sore at heart From her old wound, the queen of gods compelled

A man apart, devoted to his mission— To undergo so many perilous days And enter on so many trials.

Clearly Aeneas's new city is the forerunner of Rome, and the person of Aeneas in the poem is obviously in some degree intended to honor Augustus himself—the links between Augustus and Aeneas were alluded to by other artists (see p. 178).

It is probable that Augustus felt that his great empire should have a literary work to rival Homer. Like Homer's Iliad, Virgil's epic depicts the horrors and the glories of war. Like Homer's Odyssey, Virgil's poem describes its hero's adventures, both dangerous and amorous. In spite of Virgil's debt to Greek epic, however, The Aeneid is a thoroughly Roman poem. It is saturated in Roman traditions and marked at every turn by its respect for family and country. This can perhaps best be characterized by the term pietas, or piety. Pietas involves a devotion to duty, especially love and honor of one's family and country in the context of devotion to the gods. As he sails from Troy to Italy, Aeneas is shipwrecked in North Africa at Carthage, where he falls in love with Queen Dido. However, Aeneas is forced to leave the Queen when a messenger from the gods appears to remind him of his duty and destiny.

Horace. Among the other poetic genres important in Roman literature were the ode and the satire. The most important writer of odes—lyric poems on particular subjects made up of lines of varying lengths—was Quintus Horatius Flaccus, known simply as HORACE (65-8 B.C.). Of humble origins, Horace was freed from economic worry when he was befriended by Virgil, who helped him secure the support of Maecenas, a wealthy patron of the arts. Like Virgil, Horace was also encouraged to write poetry by Augustus. Horace's odes espouse a philosophy of moderation, which derives from earlier Greek culture. Horace's influence on English poetry was perhaps greatest from the sixteenth to eighteenth centuries, with one of his most famous poems, "Ars Poetica" ("The Art of Poetry"), being especially valued as a guide to poetic practice during the Renaissance and the eighteenth century.

Ovid. Augustan Rome's successor to Catullus, OVID [O-vid] (43–17 B.C.), wrote witty and ironic poems. The titles of Ovid's books reveal his persistent interest in the erotic—the Amores (Loves) and the Ars Amatoria (The Art of Love). His most famous work, the Metamorphoses [meh-tah-MOR-foh-sees], is based on a series of stories about transformation, many derived from Greek mythology. These are often related with an erotic twist. Ovid's poetry combines skillful narrative

with elegance and grace. In addition, Ovid is generally recognized as a subtle analyst of the human heart. Though ironic, Ovid's poetry is not cruel or sarcastic; rather, Ovid seems almost compassionate toward the characters whose experiences he describes.

Petronius. First-century A.D. Rome was a place saturated in material rather than spiritual values. The Roman emperor Nero set the tone with elaborate banquets, orgiastic feastings, and bloody entertainments. During Nero's reign, the satirist PETRONIUS [peh-TROHN-ee-us] provided a sharply realistic picture of the manners, luxuries, and vices of the age. Satire aims to bring about moral reform through making contemporary vices or habits appear ridiculous. The Satyricon [sah-TIR-ih-con], which is usually attributed to Petronius, depicts the pragmatic materialism of first-century

A.D. Rome. Although only fragments of the work survive, the *Satyricon* nonetheless vividly conveys early Rome's veneration of material wealth and infatuation with physical pleasure.

In the longest extant section of the work, "Dinner with Trimalchio," an aristocratic narrator describes a meal he and his friends share with the slave-turned-millionaire, Trimalchio. The dinner conversation reflects the temper of early Roman civilization in the characters' selfishness, their anti-intellectualism, and their obsession with cheating one another. The satire is enhanced by means of numerous echoes of the Greek heroic traditions with references to Homer's *Iliad* and *Odyssey*. The ironic references reflect the Roman characters' distance from the heroic ideal as they live only for themselves and only for the moment. Already the ideal-ism of Augustan Rome seems very distant.

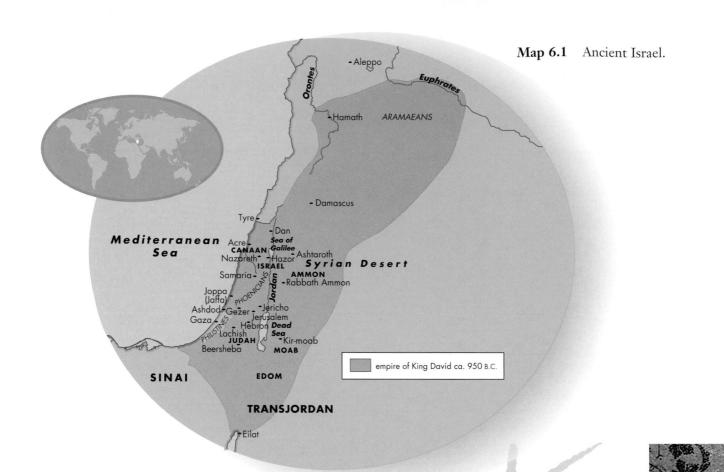

JUDAISM AND * THE RISE OF CHRISTIANITY

and the second second

CHAPTER 6

- < Judaism
- Early Christianity

Judaism

The Greeks and the Romans had dominated the ancient world politically and socially, but there was a different tradition that, while not as significant artistically or politically, came to be the other main influence on Western civilization. The founders of this tradition were a tribe who called themselves the "Children of Israel," the Israelites, or Hebrews (from *Habiru*, meaning "nomad" or "outcast"). Later they became known as Jews, a name derived from their place of habitation, the area around Jerusalem known as Judaea.

While the Greco-Roman tradition was bound up with the rational and the practical, and was dedicated to the arts, the Hebrew tradition was associated more with the spiritual and the mystical and was founded on faith. The Jews produced a "religion of the book" which evolved into the Old Testament portion of the Bible, providing not only the spiritual, but also the moral foundation of Western culture. Judaism itself was a religion that sought no converts—the Hebrew scriptures represented God's will and words to his "Chosen People." It emphasized a special national destiny, privilege, and responsibility. Christianity, which grew out of Judaism, did seek converts, and was from its earliest days in the first century A.D. a missionary religion, seeking to attract as many followers as possible. It spread the word of God through evangelists, from the Greek euangelos, meaning "bearer of good news"—eu means "good" and angelos "messenger." It was because of this missionary zeal on the part of the Early Christians that the Greco-Roman and biblical traditions were finally united. In A.D. 313 the Roman emperor Constantine granted toleration to Christians, then on his deathbed in 337 he received Christian baptism and Christianity became the official state religion.

The nomadic Hebrew people were forced out of their home in the Mesopotamian basin about 2000 B.C. by the warlike Akkadians and the threat posed by the ascendancy of the Babylonians. Led by the patriarch Abraham, the Hebrews settled in Canaan, the hilly country between the Jordan River and the eastern Mediterranean coast. Canaan became their homeland and was, the Hebrews believed, promised to them by their god. Monotheistic (meaning the belief in only one God), as opposed to the polytheistic religions of Greece, Rome, and other Near Eastern peoples, the Hebrew religion had but one God—Yahweh, a name so sacred that even today the pious never speak or write it.

In contrast, other Near Eastern tribes worshiped the various powers of nature as independent and multiple divine beings. The Babylonians, for instance, paid homage to, among others, a storm-god and a rain-god. Where the gods of Egypt and Mesopotamia were considered immanent, or present in nature, the Hebrew god

was believed to be transcendent, apart from nature, which he also controlled. Thus, the sun, which the Egyptians worshiped as a god, was for the Hebrews subject to the power of their God, who had created it. Moreover, they considered the divine figures of other religions subordinate to the God of Israel.

Unlike the gods of the Greeks and Romans, Yahweh did not engage in amorous play with other gods or with human beings. He would only punish mortals with just cause and for a reason that ultimately benefited the human race. He was represented as a righteous God, whose justice was tempered with mercy, and who wished his Chosen People to live righteous and honorable lives in accordance with his commandments. As the biblical story of Noah and the Ark demonstrates, the Hebrew God had the power to destroy humankind, yet he also had the capacity for mercy.

HISTORY AND RELIGION

The history and religion of the Hebrews are essentially one and the same, and that history and religion are recorded in the Bible. The Hebrew Bible, which consists only of that part of the Christian Bible known as the Old Testament, can be read as the history of the Hebrews' relationship with their God. For the Israelites, God's power was made manifest in particular historical events, such as the very creation of the world and its destruction in the great flood.

Creation. The Hebrews believed that God created the world in a perfect state. The Bible describes both the world and the human beings that originally populated it as "good." The reason why it is no longer the paradisc originally created, however, results directly from humankind's disobedience, as illustrated in Genesis by the story of Adam and Eve in the Garden of Eden and their eating of the forbidden fruit. Adam and Eve's act inaugurates a pattern of exile from divinity that is repeated in other biblical stories, and which foretells the wanderings of the patriarchs.

Patriarchs. The early patriarchs of ancient Israel were unusual men who believed they were favored by God and consequently led lives that honored God. The first of the patriarchs was Abraham, whose name has come to signify the ancient Judaic faith in God. When God called Abraham out of the land of Ur in ancient Sumeria to Canaan, Abraham's response was an immediate and total acceptance of God's will.

To Abraham and his descendants God made the solemn promise of the **covenant**. An agreement between God and his people, it was passed down to the patriarchs who followed Abraham—to his son Isaac and his grandson Jacob, or Israel. In the covenant, God agrees to be the Hebrew deity if the Hebrews agree, in turn, to be his

people and to follow his will. With each of the Hebrew patriarchs, God renews the following covenant originally made with Noah after the flood:

I am God Almighty; be fruitful and multiply; a nation and a company of nations shall come from you, and kings shall spring from you. The land which I gave to Abraham and Isaac I will give to you, and I will give the land to your descendants after you. (Gen. 35:11–12)

This covenant is referred to many times in the first five books of the Bible, which are called the Law, or the Torah (Hebrew for "instruction" or "teaching").

Perhaps the most important renewal of the covenant took place seven hundred years after the time of Abraham, in about 1250 B.C., when the Hebrews had been living in Egypt for many years. Why they had left Canaan for Egypt in about 1600 B.C. we do not know, but they prospered there until the Egyptians enslaved them. In outright defiance of the pharaoh, the patriarch Moses led his people out of Egypt (the exodus) and into the Sinai desert, which lies on the peninsula between Egypt and Canaan. There, on the top of a mountain, God is said to have given Moses the Ten Commandments, also known as the Decalogue.

- 1. You shall have no other gods before me.
- 2. You shall not make for yourself a graven image, or any likeness of any thing that is in heaven above, or that is on the earth beneath, or that is in the water under the earth.

- 3. You shall not take the name of the Lord your God in
- 4. Observe the sabbath day, to keep it holy, as the Lord your God commanded you.
- 5. Honor your father and your mother.
- 6. You shall not kill.
- 7. Neither shall you commit adultery.
- 8. Neither shall you steal.
- 9. Neither shall you bear false witness against your
- 10. Neither shall you covet your neighbor's wife, or anything that is your neighbor's.

The Hebrews carried the Ten Commandments with them, carved into stone tablets kept in a sacred chest called the Ark of the Covenant (fig. 6.1). Other sacred objects were also kept in the Ark such as the menorahs (seven-branched candelabra), which had been described by God to Moses, and which originally lit the Ark in its portable tabernacle. The Ten Commandments are the essence of the religious law of the ancient Judaeo-Christian world. As a set of guiding principles, they are the first word in moral rectitude, not the last. They require repeated interpretation, elaboration, and evaluation. Their influence has been enormous. Beginning with the six hundred and more laws recorded in the book of Leviticus, and continuing with the exploration of morality in the time of Jesus, the Commandments have long provided a basis for moral reflection and analysis.

Figure 6.1 Menorahs and Ark of the Covenant, wall painting in a Jewish catacomb, third century A.D., $3'11'' \times 5'9''$ (1.19 × 1.8 m), Villa Torlonia, Rome. The form of the menoral probably derives from the Tree of Life, an ancient Mesopotamian symbol.

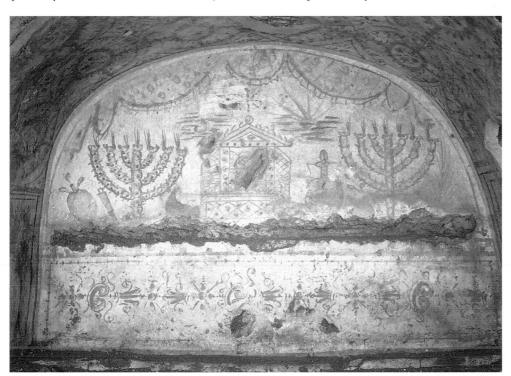

For the ancient Hebrews, divine acts like the conferring of the Ten Commandments were acknowledgements of their status as God's Chosen People. After Moses's death, however, the Hebrews wandered for forty years "in the wilderness" of the Sinai, until they were delivered to the Promised Land, the land of "milk and honey," by the patriarch Joshua, who led them across the Jordan River and into Canaan once again. Over the next two hundred years, they gradually gained control of the entire region, calling themselves Israelites, after the patriarch Jacob, who had named himself Israel.

Prophets. Despite the imperative of God's covenant, the ancient Hebrews believed that human beings were ultimately responsible for their own actions and for doing whatever was necessary to improve their lot. When something was wrong in the social order, the onus was on believers to correct it. This would become the central message of the biblical prophets from the eighth through the sixth century B.C.

The Israelite prophets spoke for God. They were not "prophetic" in the sense that they foretold the future. Instead they functioned as mouthpieces, preaching what they had been instructed by God in visions or through ecstasy. They taught people the importance of living according to the Ten Commandments. In many cases, the prophets operated as voices of conscience, confronting the Israelite kings with their wrongdoings. The best known and most important of the biblical prophets were Isaiah, Jeremiah, and Ezekiel, although there were another twelve whose books are still included in the Old Testament.

Isaiah called for social justice and for an end to war. It is a mark of the enduring influence of the language and moral code of the Israelites that a verse from the biblical book of Isaiah adorns the United Nations building in New York City: "And they shall beat their swords into ploughshares, and their spears into pruning hooks; nation shall not lift up sword against nation, neither shall they learn war any more" (Isa. 2:4).

Kings. The process by which the descendants of the twelve sons of Jacob (Israel) became the twelve tribes of Israel winds through a long and bloody series of military campaigns, as described in the books of Joshua, Judges, and Samuel. By 1000 B.C., the kingdom of Israel was at last established, with SAUL (r. ca. 1040-1000 B.C.) as its first king. The first book of Samuel describes Saul's kingship and the arrival of David, who saves the Israelites from their enemy, the Philistines, by slaying the giant Goliath with a stone from a slingshot.

DAVID (r. ca. 1000–961 B.C.) was Israel's greatest king. His reign lasted about forty years and was a time of military success, a period that included the capture of Jerusalem, which David made the capital of his kingdom. David's rule did not prevent him from composing poetry and music, including some of the biblical Psalms.

Perhaps the most interesting aspect of David, however, is his imperfection, for the Bible depicts him as a person who was both a sinner and a penitent. His transgressions include having one of his soldiers, Uriah, dispatched to the front line where he would undoubtedly be killed, so that David could marry his widow, Bathsheba. Yet, David was also to suffer the death of his son Absalom, who mounted a military rebellion against him. These episodes are among the most powerful in all of ancient literature, and, one might argue, among the most realistic. The books of Samuel reveal political intrigues and complex familial dynamics with great subtlety and literary artistry.

The last important Israelite king was David's son, SOLOMON [SOL-oh-mun] (r. ca. 961–922 B.C.). Famous for his wisdom, Solomon is also associated with the Temple he had built in Jerusalem, where the Ark of the Covenant was kept, signifying God's presence. Like his father, Solomon was a poet. He is the reputed author of the biblical Song of Songs, a sensual love poem that has been read by later critics as a metaphor for the love between God and his people.

Following the death of Solomon, the kingdom of Israel was split in two. The Northern Kingdom retained the name Israel while the Southern Kingdom was called Judah. The Northern Kingdom fell to the Assyrians in 722 B.C.; the Southern Kingdom was overrun in 587 B.C. by the Babylonians under the command of Nebuchadnezzar [ne-BYUK-ad-NEZ-ah], who destroyed Solomon's magnificent temple. The Southern Kingdom Hebrews were carried off into exile, which inaugurated a period known as the Babylonian Captivity.

Return from Exile. The Hebrews remained in exile for over sixty years. On their return to their homeland around 539 B.C., they rebuilt their Temple, which was destroyed again by the Romans in A.D. 70. The intervening period was one of almost continuous foreign occupation. However, the Roman destruction of the Temple and of Jerusalem in A.D. 70 marked the end of Jewish power in the region until the middle of the twentieth century.

THE BIBLE AS LITERATURE

The Hebrew Bible (from the Greek name for the city of Byblos, the major exporter of papyrus, the material used for making books in the ancient world) consists of the canon of books accepted and officially sanctioned by Judaism. These include three major groupings: the Law, the Prophets, and the Writings. The Law comprises the first five books: Genesis, Exodus, Leviticus, Numbers, and Deuteronomy. (Authorship of these books is ascribed to Moses.) The Prophets include those mentioned above and, in addition, the books of Joel, Obadiah, Jonah, Micah, Nahum, Habakkuk, Zephaniah, Haggai, Zechariah, and Malachi, as well as six historical books: Joshua, Judges, Samuel (two books), and Kings (two

books). The remaining books are categorized as the Writings, and include the narrative books of Ruth, Esther, and Daniel; the poetic books of Psalms and the Song of Songs; and the wisdom books of Proverbs, Job, and Ecclesiastes. Also part of the Writings are Chronicles, Lamentations, Ezra, and Nehemiah.

A number of biblical books can be cited for their outstanding literary accomplishment. The stories of David in the book of Samuel, and those of Daniel and of Jonah, the poetry of the Song of Songs and the Psalms, the wisdom of Ecclesiastes—all warrant claims as significant literary achievements, regardless of their status as holy scripture. Two books of the Hebrew Bible, however, tower above the rest: Genesis and Job—Genesis for its fascinating narratives, and Job for its sublime philosophical poetry. Both Genesis and Job, moreover, reflect the important cultural ideals of ancient Israel.

History and Fiction. The narratives in the book of Genesis can be read in different ways. They may be treated as being literally true. However, if they are looked at from a more literary perspective, they may be divided into two broad categories: prehistoric myths and historicized fiction. The stories of the Creation and the Fall, of the Great Flood and the Tower of Babel, are mythic narratives designed to explain such things as the origin of the universe and its creatures, the reason human beings suffer pain and death, and the emergence of the world's languages. These etiological stories, or stories

about the origins and causes of things, occupy the first eleven chapters of Genesis. Among them is an explanation of why rainbows appear in the sky (they function as a sign of Yahweh's covenant), and why snakes crawl on their bellies (the reptilian curse for tempting Adam and Eve to eat the forbidden fruit).

The second category of narrative—historicized fiction—includes the stories of the patriarchs Abraham, Isaac, and Jacob. Certain elements of these stories are ancient, having been passed down through oral tradition, and having only achieved written form around the twelfth to the tenth centuries B.C. The patriarchal stories as written have the character of history, to the extent that they are presented as detailed accounts of deeds performed by particular individuals. However, they differ from later biblical narratives, such as the books of Samuel. The later, more historical writing of the period of the kings has been termed "fictionalized history" to distinguish it from the historicized fiction of the Genesis patriarchal narratives.

The stories about David in the book of Samuel use fictional literary techniques and take imaginative liberties with the historical facts upon which they are based. The earlier patriarchal stories describe perhaps fictitious characters and situations in their enterprise to convey important theological ideas and to account for historical realities, such as how the Hebrews found themselves in Egypt (which is explained in the stories about Joseph and his brothers [Gen. 37–50]).

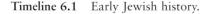

Then & Now

THE BIBLE

The books of the Hebrew Bible were composed over a period of nearly three thousand years, from approximately 3000 B.C., when the earliest Genesis materials appear orally, until near the beginning of the first century A.D., when the books of Ezra and Nehemiah were written. The original manuscripts of the biblical books have not survived. The earliest extant passages are those found in caves Qumran-the "Dead Sea Scrolls"which include parchment scrolls of the prophetic book of Isaiah (fig. 6.2).

Originally written in Hebrew, with brief sections in Aramaic, a Near Eastern Semitic language, the presentday Bible in English has been influenced by a series of different translations: Greek (the Septuagint); Latin (the Vulgate-translated by St. Ierome); and Renaissance English, initially translated by John Wycliffe and William Tyndale. The most important early English translation, however, was that undertaken by a committee established by King James I. Known as the "King James translation" or the "Authorized Version" or "AV," this rendering has exerted a profound influence on English and American literature for nearly four hundred

During the 1940s and 1950s, the King James translation was updated and corrected, taking account of archaeological discoveries made in the late nineteenth and early twentieth centuries, and reflecting developments in historical and linguistic scholarship. The resulting Revised Standard Version (RSV) was revised once more and published as the New Revised Standard Version (NSRV) in the 1990s.

Figure 6.2 The Dead Sea Isaiah Scroll (detail), first century B.C.–first century A.D. The Scrolls are copies of the Hebrew Bible made by a radical Jewish sect that disavowed the leadership of Jerusalem. The Scroll contains all sixty-six chapters of the Bible's longest book.

The contract of the contract o

Biblical Poetry. The biblical poetic tradition goes back more than three thousand years. As with other ancient civilizations, such as those in Greece, Hebraic poetry was bound up with the religious, social, and military life of the Hebrews. War victories were celebrated in verse, as were various other achievements, such as the liberation of the Hebrew slaves from their Egyptian masters. Indeed, the two oldest recorded Hebrew poems are celebrations of great accomplishments. The Bible's oldest poem, the Song of Deborah (Judges 5:1–31) describes how its heroine, Jael, saves the Hebrew people by killing the Canaanite military leader Sisera. Better known is the "Song of the Sea," which celebrates the destruction of

the Egyptian pharaoh's army, along with his chariots and horsemen, in the Red Sea.

The most consistent important concern of ancient Hebrew poetry, however, is religious faith. This can be clearly identified in the poetry of the Psalms, the prophecies of Isaiah, and the wisdom of Job. Complementing these morally oriented and religiously grounded poetic works are other biblical poems in a more secular and less ostensibly religious vein (although they, too, have been interpreted allegorically as being religious). The most beautiful and famous of these are the Song of Songs, (also known as the Song of Solomon) and the book of Ecclesiastes.

EARLY CHRISTIANITY

With its belief that a Messiah would come into the world to save humankind, thereby fulfilling God's promises, Judaism was crucial in the emergence of Christianity and to the formulation of many of the new religion's central tenets. Many apocalyptic Hebrew writings, including chapters 7–10 of the book of Daniel, predicted the coming of such a Savior. John the Baptist further prepared the way for Jesus's ministry by preaching that a Messiah was at hand. Those who believed Jesus when he preached that the Kingdom of God was imminent, and who saw that Kingdom as represented in Jesus, became the first Christians.

Just as Jews believe that they are God's Chosen People and Muslims that their holy book, the Quran, is the word of God, Christians believe that Jesus is God and Savior. Moreover, they maintain that by accepting Iesus as their Savior, they will share eternal life with him in heaven when they die. One of the most important elements of their faith is the belief that Jesus rose from the dead after being crucified by the Romans. Their faith gave rise to a revisionary interpretation of the Messianic prophecy, which converted a prior hope for an earthly king into a belief in a divine and spiritual king, whose coming to earth signaled new hope in human redemption. Jesus's kingdom would be a kingdom of the next world, the afterlife, to which the redeemed Christian soul would be taken after death.

IESUS AND HIS MESSAGE

It is important to remember that Jesus was Jewish. His followers, who identified him as the Christ-which means "Messiah" or "Anointed One"-were the first Christians. Jesus was born in Judaea, a land under the political control of the Romans, during the reign of the emperor Augustus.

The public ministry of Jesus began when he was thirty years old, with the performance of his first miracle, the changing of water into wine, at the marriage feast of Cana, a small village north of Nazareth, where Jesus was born. This first miracle is recorded in the New Testament Gospel of John, where it is presented less as an astounding feat than as a sign identifying the presence of God in Jesus. Other miracles followed, including healing the blind and the lame, curing paralytics, and even raising the dead. This aspect of Jesus's mission is the one that draws most attention, as the miracles are typically read as manifestations of his divine power. However, emphasis is placed not only on Jesus's healing miracles, but also on his natural miracles, such as his calming of a storm on the sea of Galilee, his walking on water, and his feeding of thousands of people with only a few fishes and loaves of bread.

Yet, it is Jesus's teaching, rather than his miracles, that is central to Christian beliefs and values. Jesus preached the promise of hope and salvation. He preached that those who believed in him, and in the heavenly Father who had sent him into the world, would have eternal life. He delivered his message in simple and direct language that common people could understand: Believe in him

The spread of Christianity by A.D. 600. Map 6.2

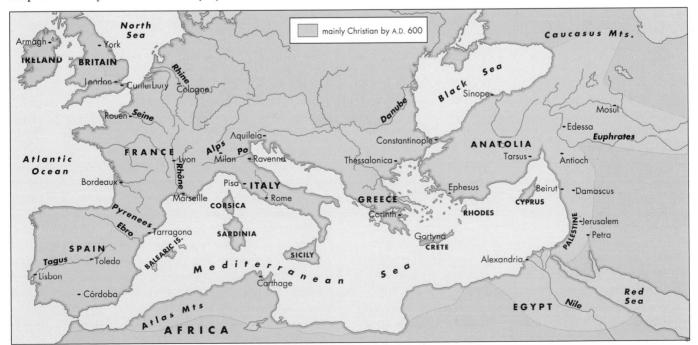

Timeline 6.2 Early Christian history.

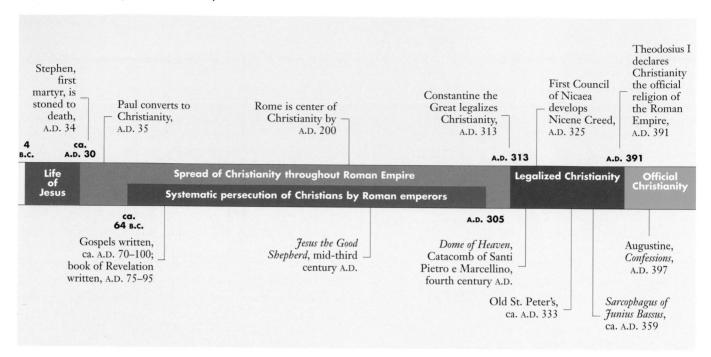

and be saved; beware of false prophets; don't get lost in the intricacies of religious ritual observance; stick to the essentials of faith in God, love of humanity, and hope for the future. He explained this relatively straightforward doctrine through stories, or **parables**, such as that of the Good Samaritan. Parables illustrate an essential Christian principle: in the case of the Good Samaritan, that believing Christians should love their "neighbors"—and that their neighbors included all human beings.

Jesus's increasing popularity, which derived both from the power of his preaching and from the fame of his miracles, angered the Jewish religious authorities of the time. It was the Roman authorities, however, who held the real power in Jesus's day in Galilee, where Jesus did most of his preaching, and it was Pontius Pilate, the procurator of Judaea, who was ultimately responsible for Jesus's crucifixion and death.

Although Jesus did not himself claim to be the son of God, others claimed that exalted status for him. This, in fact, was the crime against the state that led to Jesus's execution, because only the emperor was considered divine. Any mortal suspected of harboring such august notions of self was in violation of the law, the punishment for which was death.

Jesus preached not only the hope of life after death and the need to love one's neighbor as oneself, but also the need to love God with all one's mind, heart, and soul. His preaching was meant to encourage, yet also challenge. He challenged the rich to give up their material possessions; he challenged the poor to be content with their lot; he challenged believers to come and follow him, to live their lives in simplicity while going about spreading his message and performing good deeds.

Jesus's teaching can be reduced to two essential commandments: to love God above all, and to love others as one loves oneself. In addition to preaching faith and love, Jesus also articulated ethical ideals and proposed standards of moral behavior. Most of them are summed up in the Sermon on the Mount, the fullest version of which is contained in the Gospel of Matthew.

EARLY CHRISTIAN HISTORY

After the death of Jesus, Christianity spread throughout the Mediterranean due to the efforts of martyrs such as Stephen and Sebastian and missionaries such as Paul. Stephen, the first Christian martyr, was stoned to death in A.D. 34 for preaching blasphemy against the Jewish God, while Sebastian was tied to a tree and shot full of arrows for refusing to acknowledge the Roman gods. According to one legend, he survived this only to be beaten to death. Paul was perhaps the most important of the first-century Christians in spreading the new religion. Born Saul, he was at first strongly opposed to Christianity until he underwent conversion near Damascus in A.D. 35 (the so-called "Damascene conversion"). From then until his execution ca. A.D. 62, he proselytized tirelessly for Christianity, formulating doctrine, writing to other Christian communities, and traveling at least as far west as Rome.

The next centuries were a period of slow growth for Christianity and of continual persecution at the hands of the Romans. For instance, in A.D. 64 Nero blamed the Christians for a fire that burned down the imperial capital, though it seems likely that he himself was responsible for it. Two hundred years later, the emperor Decius expelled the Christians from Rome. Such persecution was unusual in the Roman Empire, where other sects and religions were usually tolerated. The problem for the Roman authorities appears to have been the Christians' refusal to worship the Roman gods alongside their own God. The first great turning point came in A.D. 313, when the emperor Constantine issued the Edict of Milan, which granted Christianity toleration as a religion. Constantine convened the first of a series of councils concerned with various matters of faith, such as the trinitarian nature of the godhead. The First Council of Nicaea developed the Nicene Creed, the conventional statement of Christian belief. After Constantine's death, Julian briefly attempted to restore paganism, but in A.D. 391 Theodosius I officially declared Christianity the Roman state religion, banning all pagan cults.

EARLY CHRISTIAN ART

There is no such thing as a coherent or consistent "Early Christian style" of art. In fact, Christianity was at first averse to art because art served the worship of idols. However, Christians recognized that art could be appropriated to help many illiterate followers with visual representations of the Bible's teachings—when, that is, art itself was no longer the object of worship but a means to worship, it became an important instrument of theology.

Figure 6.3 Old St. Peter's, Rome, begun ca. A.D. 333, reconstruction drawing. Based on the Roman basilica, which would house, in the apse, a statue of the emperor, the new Christian church placed a cathedra or "throne of the bishop" in the emperor's place—hence the origin of the word "cathedral."

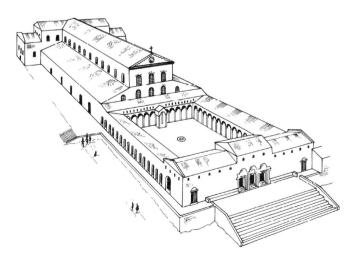

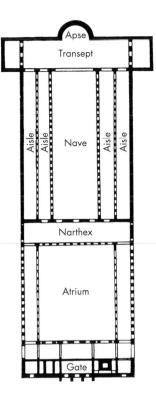

Figure 6.4 Old St. Peter's, Rome, begun ca. A.D. 333, plan. The type of church established here, known as the Early Christian basilica, would be the basis for all churches built with a longitudinal axis - the Latin-cross plan.

Architecture. When Christianity became an official state religion, the need for churches arose. The type of church built is known as the Early Christian basilica and, by the fourth century, was well established. Old St. Peter's in Rome (fig. 6.3), the quintessential example, located over the tomb of St. Peter, was erected by Constantine. It was destroyed in the fifteenth century to make way for the present St. Peter's (see Chapter 13).

When entering an Early Christian basilica like Old St. Peter's (fig. 6.4), the visitor first came into the atrium, a rectangular forecourt, open in the center to the sky, surrounded on all four sides by columnar arcades. The atrium was the area for people not yet baptized. Next, the visitor passed through the narthex, an entrance hall or vestibule. Having now reached the actual church, the visitor entered the nave, a large rectangular space needed for the masses of people, and flanked on both sides by one or two aisles, separated from the nave by colonnades. At the end of the nave was the transept. Finally, the building ended with the apse, a semi-circular space at the back of the church. The altar was in front of the apse, so that the visitor had to walk from one end of the church to the other to reach it.

The reconstruction drawing of the exterior (see fig. 6.3) shows the nave with clerestory windows, that is, a

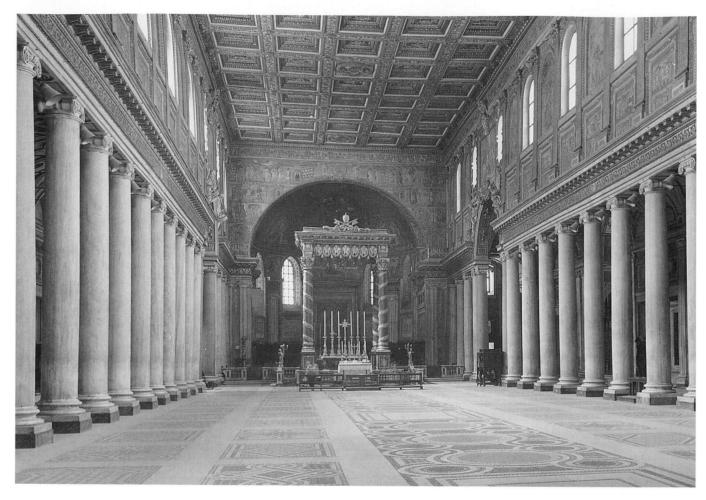

Figure 6.5 Santa Maria Maggiore, Rome, ca. A.D. 430, later modified, view of nave looking toward altar. An advantage of the longitudinal axis of the Early Christian basilica is that, upon entering, the visitor's eyes are automatically directed toward the altar. But a disadvantage of its post and lintel construction is the limited open space, and fire was a constant threat to a building in which candles burned below a wooden ceiling.

row of windows on a section of wall that rises above the part of the roof over the side aisle. Because the nave roof was of lightweight wood, it was easy to support, windows could be made in the walls, and a light interior achieved. The disadvantage of wood was the danger of fire.

A surviving example of an Early Christian basilica, but one that has now been expanded and modified, is Santa Maria Maggiore in Rome (fig. 6.5), originally built ca. A.D. 430. Early Christian basilicas had drab exteriors—the outside of the building was not the part intended to be admired. But the interiors, as demonstrated by Santa Maria Maggiore, were very elaborate, with patterned marble floors, marble columns, and mosaics of colored stone, glass, and gold on the walls and ceilings.

In addition to the basilica plan with its longitudinal axis, as used in Old St. Peter's and Santa Maria Maggiore, round or polygonal buildings with domed roofs were also built in the Early Christian era. The finest example is Santa Costanza in Rome (figs. 6.6 and fig. 6.7), built

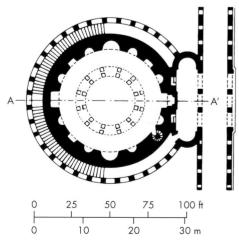

Figure 6.6 Santa Costanza, Rome, ca. A.D. 350, plan. A central plan (circular or polygonal) building, when roofed with a dome, as here, offers an uninterrupted interior space.

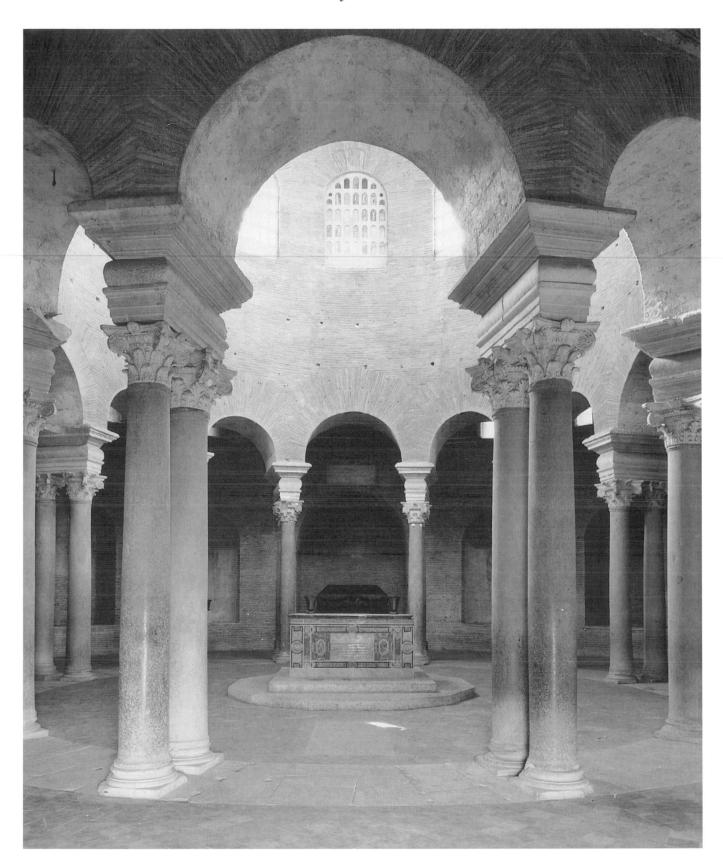

Figure 6.7 Santa Costanza, Rome, ca. A.D. 350, interior. The basic scheme of Santa Costanza would later be used by Byzantine architects, and would also serve as the model for the baptisteries that were connected to Christian churches.

Figure 6.8 Wine-Making Scene, ca. A.D. 350, mosaic, ambulatory vault of Santa Costanza, Rome. Demonstrating the Christian adaptation of pagan subjects, the vine here represents the words of Jesus, "I am the true vine." The grapes came to symbolize the eucharistic wine and, therefore, the blood of Jesus.

ca. A.D. 350. This was a mausoleum constructed for the emperor Constantine's daughter Constantia, and was once part of a larger church.

The exterior, made of unadorned brick, is plain and simple, but the interior is ornate, with rich materials, textures, colors, and designs. Light comes in through the clerestory windows. The surrounding circular aisle or **ambulatory** is covered with a barrel vault, which is ornamented with mosaics (fig. 6.8).

These mosaics consist of a vine pattern with small scenes along the sides. Laborers are shown picking grapes and putting them into carts, transporting the grapes to a press, where three men crush them underfoot. This subject, common on tavern floor mosaics, may seem out of place here. But because wine plays an important part in the Christian liturgy, it was possible to adopt and adapt a pagan subject to Christian needs.

Sculpture. In the Early Christian era, due to Christianity's disdain for idol worship, sculpture was always secondary to painting and mosaic. One of the rare examples of Early Christian figure sculpture is the statue of Jesus the Good Shepherd (fig. 6.9), which dates from the mid-third century A.D., and depicts Jesus carrying a sheep across his shoulders. The subject was common in catacomb painting (see fig. 6.12). There are several versions of this statue, this being one of the earliest and the best. Jesus is portrayed in the Classical tradition. The pose is free, natural, and relaxed, with the weight on one foot

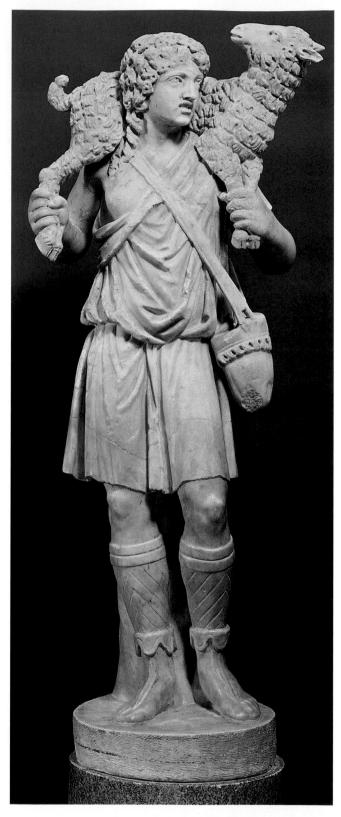

Figure 6.9 *Jesus the Good Shepherd*, mid-third century A.D., marble, height 39" (99 cm), Vatican Museums, Rome. Large-scale sculptures such as this are extremely rare in Early Christian art. The lamb represents Jesus's followers, whom he guards and guides.

and the head turned to the side, the *contrapposto* stance similar to that of the ancient Greek *Spear-Bearer* (see fig. 4.14). The idealized head has the youthful Jesus gazing into the distance.

For the most part, sculptors turned to small-scale relief work on stone **sarcophagi** (coffins) and ivory panels. Marble sarcophagi, the fronts and occasionally the lids of which were carved with small figures in high relief, are among the earliest works of Christian sculptors, with examples dating from the early third century A.D. onward. The *Sarcophagus of Junius Bassus*, a prefect of Rome (a high position similar to that of a governor or administrator), is among the most notable of these (fig. 6.10). Bassus converted to Christianity shortly before his death in 359. The front of his sarcophagus is divided by

two tiers of columns into ten neat and orderly areas. The subjects depicted in these panels are drawn from the Old and New Testaments of the Bible. The upper row, left to right, shows the sacrifice of Isaac; St. Peter taken prisoner; Jesus enthroned with Saints Peter and Paul; and, in two separate sections, Jesus before Pontius Pilate. The lower row, left to right, shows the misery of Job; Adam and Eve after eating from the Tree of Knowledge; Jesus entering Jerusalem; Daniel in the lions' den; and St. Paul being led to his death. The proportions of the figures are far from Classical and reflect the late Roman change in relief style, as also seen in the fourth-century reliefs on the Arch of Constantine in Rome (see fig. 5.26). Large heads are supported on boneless doll-like bodies with muscleless arms and legs. Background setting is almost

Figure 6.10 Sarcophagus of Junius Bassus, ca. A.D. 359, marble, $3'10\frac{1}{2}'' \times 8'$ (1.18 \times 2.44 m), Museo Petriano, St. Peter's, Rome. Early Christian sculpture consists primarily of reliefs carved on sarcophagi and small ivory plaques. Greater importance was attached to the recognition of the subjects than to realistic representation of the human body.

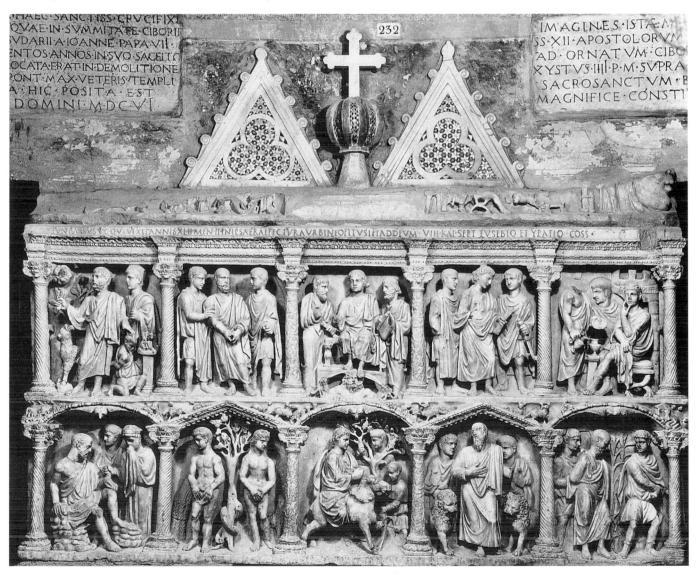

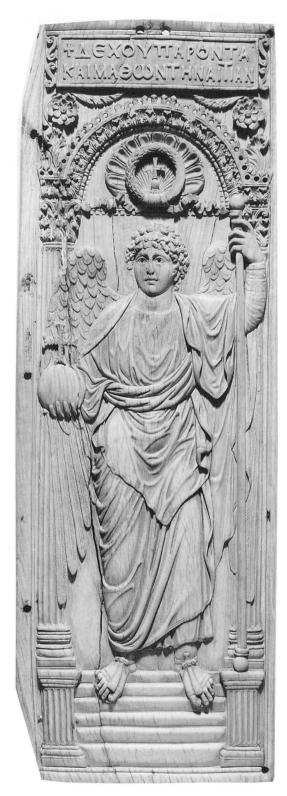

Figure 6.11 Archangel Michael, leaf of a diptych, early sixth century A.D., ivory relief, $17 \times 5\frac{1}{2}$ " (43.2 × 14 cm), British Museum, London. Although the carving is technically exquisite, there is little evidence of interest in a realistic spatial relation between figure and setting. Michael's precarious position suggests that he will soon need to make use of his wings to keep his balance.

entirely eliminated in these crowded scenes, action or drama kept to a minimum, and the figures, even when the story suggests they should be animated, are passive and calm. However, these little vignettes are not intended to provide the viewer with a highly detailed narrative. They are only required to bring to mind a story that the viewer is expected to know already.

A representative example of an Early Christian ivory is that of the Archangel Michael (fig. 6.11), made in the early sixth century, one leaf of a diptych—a pair of hinged panels. Here pagan Greek forms have been appropriated for Christian purposes. Michael derives from the winged victory figures of Classical art (see fig. 4.27) and his drapery is rendered in the "wet" style of fifth-century B.C. Greek sculpture. The figure, if seen in isolation, would be convincing. However, the treatment of space around it is not. In spite of the architectural setting, there is no sense of depth. Michael's feet dangle over three steps. His hands are shown to be in front of the columns, yet the column bases are in front of the stairs, which implies that Michael is placed at a precarious angle. Without understanding the basic spatial concept of Greek art, the Christian artist has carefully copied the superficial forms.

Painting. The earliest Christian art was found in the **catacombs**—the underground cemeteries of the Christians in and around Rome. The catacombs were practically underground towns of sepulchers and funeral chapels, miles of subterranean passageways cut into the rock.

A painted ceiling in the Catacomb of Santi Pietro e Marcellino in Rome (fig. 6.12), from the fourth century, is an especially well-preserved example. The walls of catacombs were decorated with frescoes, paintings made quickly on freshly applied wet lime plaster. The subjects depicted were generally related to the soul's future life. Especially common was the subject of Tesus the Good Shepherd, seen also in sculpture (see fig. 6.9). Filling the center of the ceiling, the painting embodies the idea that the Christian people make up Jesus's flock and, as the Good Shepherd, Jesus watches over and cares for them. The arrangement painted here represents the dome of heaven, with the decoration positioned to form a cross. The story of Jonah is shown in the surrounding semi-circles. Jonah is thrown overboard into the mouth of the waiting whale (the curly serpent-dog makes clear that whales were not known from first-hand experience in fourth-century Rome). Jonah emerges from the whale and then relaxes in safety under the vines. The figures that stand between the semi-circles have assumed a common early prayer pose—the orans (from the Latin word for "praying"), with hands raised to heaven.

Popular Old Testament subjects for catacomb paintings were Noah and the Ark, Moses, Jonah and the whale, Daniel in the lions' den, and the story of Susanna.

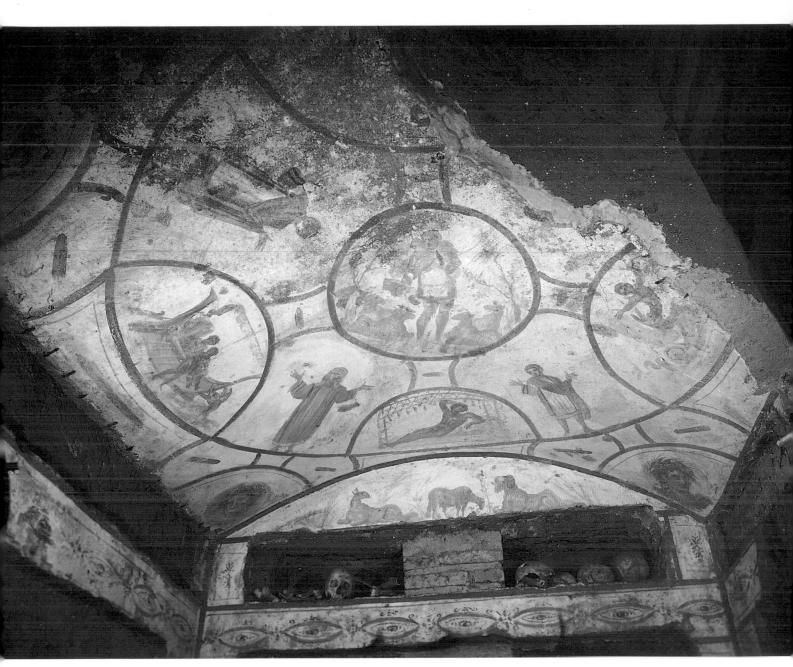

Figure 6.12 Dome of Heaven, painted ceiling in the catacomb of Santi Pietro e Marcellino, Rome, fourth century A.D. Catacombs, the underground burial areas of the Early Christians, were painted with symbolic subjects. Jesus was repeatedly shown as the Good Shepherd with his flock of followers.

Popular New Testament themes were taken from the life of Jesus, especially the miracles, such as the healing of the paralytic and the resurrection of Lazarus. The subjects selected from the scriptures illustrate how God is merciful and will intervene to save the faithful. The rewards of constant prayer are emphasized. Depictions of Jesus's passion (his suffering at the end of his life) are entirely omitted; the earliest known representations of the passion are fifth-century carvings. The catacomb paintings do not treat the subject of Jesus's death and

resurrection, which was a popular subject in the Renaissance (see Chapters 13 and 14).

THE NEW TESTAMENT AS LITERATURE

The New Testament is for Christianity what the Hebrew scriptures are for Judaism and the Quran is for Islam: the repository of revealed religious truth. The New Testament, which was written in Greek, records and interprets the acts and words of the Christian Savior,

Cross Currents

CHRISTIANITY AND THE EASTERN CULTS

 $T_{
m o}$ the Romans, who had tolerated Judaism, Christianity appeared at first to be another cult from the East, of the kind that had long been attracting converts in the republic. A Bacchus cult, for instance, had acquired a popular following by the second century B.C. God of wine, Bacchus promised his followers salvation and immortality, in the manner of the grapevine itself, which appears to die each autumn, only to be reborn in the spring. His followers engaged in Bacchanalia, high-spirited rites which soon gained the reputation of being little more than drunken orgies, and although the Senate restricted its activities in a law of 186 B.C., the cult of Bacchus persisted for many centuries.

By the time of Christianity's arrival, two other cults had enjoyed success similar to that of Bacchus-the cult of Isis and the cult of Mithras. The worship of Isis originated in Egypt. Each year, when she saw Egypt's arid and barren landscape, she would cry in compassion for the Egyptian people, her tears causing the Nile to flood, thus bringing life back to the earth. As in the Bacchus cult, this rebirth of the land promised human immortality. The cult of Mithras was of particular appeal to the military. Mithras was sent to earth to kill a divine bull, and from the bull's blood all living things sprang. The cult had seven stages of initiation, one of which was a baptism, but because it was a mystery cult, open only to people initiated into its rites, we know very little about it. Mithras, we do know, was a god of truth and light, associated with

the sun, and his birthday was celebrated on December 25, just after the winter solstice, when the sun is "reborn" for another year.

Elements from all of these cult religions survive in Christianity—in its ritual use of wine, in its emphasis on an Isis-like compassion, and in its celebration of Jesus's birth on December 25. It is possible, moreover, that Christianity borrowed some of their traits to attract converts. All of these so-called cults, Christianity chief among them, promised redemption and salvation. While the Bacchus cult had no explicit moral dimension, both the Isis and Mithras cults, like Christianity, had ethical codes that guided the individual's behavior. Such guidance was absent in the state religion, the chief deity of which, Jove/Zeus, was monstrously immoral.

Jesus Christ. The New Testament contains four distinct types of writing: the gospels, or accounts of Jesus's life and ministry, the epistles, or letters to the early Christian churches; the Acts of the Apostles, a history of the spread of Christianity during the thirty years after Jesus's death and resurrection; and Revelation, or the Apocalypse, the last biblical book, which is concerned with the end of the world.

Gospels. Written from about forty to two hundred years after the death of Jesus, the New Testament is far closer in time of composition to the events it describes than is the Old Testament to the events it describes. Three of the four gospels contain much common material, and present a similar overview of Jesus's life and ministry. These three "synoptic" gospels (or gospels to be "viewed together") are those of Matthew, Mark, and Luke. The fourth and final gospel, ascribed to John, provides more analysis and interpretation of Jesus's life than the other three. John's, one might argue, is the most metaphorical of the gospels, and the one least concerned with Jesus's miracles and his attempts to reform first-century Judaism.

The gospels were, apart from Paul's letters, the earliest books of the New Testament. None, however, is an actual eyewitness account of Jesus's life and work. An early source may have been composed during Jesus's lifetime. This source, which is not included in the Bible, is referred to by scholars as "Q" (for the German word

Quelle, which means source). This Q gospel was written, perhaps, by one of the twelve apostles, and may have been drawn upon by the later gospel writers.

Of the surviving gospels, the Gospel of Mark is the earliest, composed around A.D. 70. It portrays Jesus as a miracle worker as well as a dynamic and vibrant social reformer. The Gospel of Mark is action-centered, moving quickly from one event to the next, describing Jesus's life, ministry, passion, and death.

The Gospel of Matthew, written ten to twenty years after that of Mark, which probably along with Q provided its source, emphasizes Jesus as the Messiah referred to in Old Testament prophecies, the one who would complete the Jewish community's destiny. Matthew cites the Hebrew scriptures more than fifty times to show how Jesus could be seen as the fulfillment of the Old Testament prophecies,

Luke is the most literary and artistic of the gospel writers. His gospel displays an unusual stylistic elegance that distinguishes it from the immediacy of Mark and the allusiveness of Matthew. Luke's gospel is the only one that describes Jesus's birth in a manger in Bethlehem. Luke's gospel also focuses more on women—from Mary the mother of Jesus, to Mary Magdalene, the sinner Jesus forgives, to the adulterous woman with whom Jesus converses as he disbands a mob about to stone her to death.

The Gospel of John differs radically from the three synoptic gospels, even as those three gospels differ from one another in focus, emphasis, and degree of literary sophistication. John's is the most theological of the gospels, the one most attuned to the religious and philosophical implications of Jesus's work and words. John's gospel begins, for example, with an idea inherited from Greek thought. Jesus is the *Logos*, the divine word that came into the world as a light into darkness. He is represented not only as one who speaks words of salvation to those ignorant of spiritual realities, but also as a physical embodiment of the meaning of his message. He is an emblem of the living light that dispels the darkness of ignorance, fear, superstition, and disbelief.

Another image that pervades John's gospel is that of water. John describes Jesus as the living water who quenches the spiritual thirst of those unable to find satisfaction in their lives. This image is closely tied to Jesus's emphasis on being reborn into the kingdom of heaven through the agency of baptism in water and a spiritual and metaphorical baptism of the spirit.

Epistles. The New Testament contains twenty-one epistles addressed to Early Christian communities. Fourteen of these letters are traditionally ascribed to the apostle Paul. The titles of the Pauline epistles are derived from their recipients: Romans, Corinthians, Ephesians, and so on. They were written as a means of explaining points of doctrine, clarifying misunderstandings, and as a way of exhorting Christians in various communities to remain committed to their faith in Jesus. The importance of Paul to the spread of Christianity in the first century A.D. and his influence in formulating Christian doctrine can hardly be exaggerated. Along with his travels to preach Jesus's message, Paul's epistles served as part of his missionary vocation, giving impetus to the spread of Christianity throughout the Greco-Roman world.

Paul preached and wrote on a wide range of subjects relating to the lives of the Early Christians. He urged them to believe in the risen Jesus as the Savior who redeemed them from sin and death. He also exhorted them to live holy and chaste lives, ignoring the demands of the flesh, so that they could join Jesus at the final resurrection, when the bodies of all those believers who had died would be joined with their souls and taken up into heaven.

Two of the most important and influential Christian doctrines expounded in Paul's epistles are the Incarnation and the Atonement, or Redemption. The Incarnation refers to the birth of God in human form as Jesus. As the second person of the Holy Trinity (the union of the Father, Son, and the Holy Ghost in a single godhead) and equal to the Father and the Holy Spirit, Jesus is a divine being. In taking on human form, becoming a man in the flesh and living and dying like any mortal, Jesus revealed his love for humankind.

Paul argued that Jesus became human so that he could suffer and die for the sins of humankind. The theological explanation of this, referred to as the Atonement, involves a number of Christian concepts, including sin and salvation. Essentially, Jesus's sacrifice of himself on the cross atones or compensates for human beings' sins against God, because as a human, he can act as substitute for the actual sinners, and as a divine being, his sacrifice is acceptable to God the Father. Only a human could perform the sacrifice, since it is humans who have sinned; only a divine being could provide acceptable compensation, since divinity was sinned against.

The theological analysis contained in the Pauline epistles is intricate and complex. In developing theories to explain various Christian beliefs, such as the resurrection of the body and the immortality of the soul, Paul relies both on Greek philosophical ideas and on the Old Testament, which he interprets in light of the new teaching. Paul's ideas have influenced Christian teaching for nearly two thousand years, and are reflected in many works of Western literature, including Chaucer's *Canterbury Tales*, Dante's *Divine Comedy*, Shakespeare's plays, and Milton's *Paradise Lost*.

Revelation. Also known as "The Apocalypse," the Greek word for "unveiling," Revelation presents a visionary account of the Last Judgment and the end of the world. Written sometime near the end of the first century A.D., ca. 75–95, this final book of the Bible presents a symbolic vision of the future. The symbols used include the seven scals, the seven lamps, the Great Beast, the seven bowls, and the woman, child, and dragon. The actual meaning of this symbolism is complex and controversial, and has spawned numerous conflicting interpretations through the centuries.

EARLY CHRISTIAN MUSIC

The music of the Early Christian Church had its roots in Jewish worship. Jewish religious rites were accompanied by chanting of sacred texts, with an instrumental doubling on the harp or lyre. Essentially, two different kinds of singing developed in Christian services: **responsorial** and **antiphonal**. In Christian services, the congregation sang simple responses to trained cantors and choirs, which sang the more complex parts. In singing a psalm, for example, the cantor or choir would sing the verses and the congregation the standard response of "Amen" or "Alleluia."

This responsorial type of chanting was comple-mented by antiphonal singing, in which either a cantor and the congregation or different parts of the congregation alternated in singing verses of the psalm. In some cases the congregation would be divided into parts, usually positioned on opposite sides of the church, to enhance the effectiveness of this alternation of the chant.

Early Christianity, unlike Judaism, prohibited instrumental accompaniment of any kind, which was

Connections

GNOSTICISM AND CHRISTIANITY

Alternative, suppressed forms of quasi-Christian belief existed alongside orthodox Christianity in the Early Church. One influential form of Early Christianity was Gnosticism, central to which was a belief that redemption could be achieved through possessing special secret knowledge. Gnostics believed that they had access to secret wisdom (gnosis is the Greek word for "knowledge"). This special knowledge was restricted to small groups of Gnostic adherents who pursued lives

of asceticism and who observed strict dietary practices, refraining from sensual indulgence and removing themselves from temptation.

Gnosticism was a dualist philosophy which, like Zoroastrianism and Manicheism, divided the world into good and evil. The evil part, which was material rather than spiritual, was created by a demonic spirit. It was this demonic spirit that was said to be responsible for the fall of humanity. Second-century A.D. Gnostics believed that humankind predates the fall and that, before that event, all human

beings contained a spark of divinity within them.

Gnosticism shocked the followers of early orthodox Christianity, who were dismayed by Gnostic beliefs in reincarnation and equality for women. Gnosticism nonetheless managed to establish itself as an alternative form of Christianity. Suppressed Gnostic texts co-existed with the canonical Christian scriptures, the Gospel of Thomas, dating from the second century A.D., being perhaps the best known and most widely disseminated.

considered pagan. Up until the fourth century, Early Christian **liturgical music** (music used in religious ritual) was based exclusively on sacred texts. Starting in the fifth century, some nonscriptural hymns supplemented these scripture-based chants.

Musical practice differed somewhat in churches that followed the Byzantine liturgy rather than that of St. Ambrose. The Western liturgy of Ambrose made accommodations for active musical participation by the congregation. This required that the music be kept relatively simple, with a single note sung to each syllable. In contrast, Byzantine liturgical music was more complex, with many notes sung to a syllable in a more florid style. These sixth-century Byzantine liturgical musical practices were modified, however, by the seventh-century reforms toward less complex chant melodies.

PHILOSOPHY: AUGUSTINE AND THE NEOPLATONIC INHERITANCE

The spread of Christianity during the early centuries was accompanied by a need to explain and systematize Christian thought. The single most important expounder of Christian doctrine was AUGUSTINE (A.D. 354–430) from Hippo (near present-day Algeria), in northern Africa. Augustine's early life was influenced by Manicheism, a dualistic faith that divides the universe into forces of light and darkness, good and evil. However, it was only when Augustine discovered the philosophy of Plotinus, a third-century Greek Neoplatonist, that he really became aware of Christianity.

Augustine achieved a synthesis of the Platonic philosophical tradition and the Judaeo-Christian emphasis on divine revelation. For Augustine, human beings can only know true ideas when they are illuminated in the soul by God. Augustine dismissed knowledge derived from sense experience as unreliable. Such empirical knowledge was considered suspect due to humanity's fall from grace. To Plato's emphasis on pure ideas—now spiritualized by God's inner light—Augustine added a source of equal importance: divinely revealed truth as recorded in sacred scripture and interpreted by Church tradition.

In his early adulthood, Augustine had lived a life of self-indulgence and debauchery. His Confessions describe his dissatisfaction with this way of life, his search for spiritual fulfillment, and, finally, his conversion to Christianity. It functions both as an autobiography and as an allegory of the journey of a soul toward salvation. In recounting his life, Augustine proposes a process of scriptural interpretation that was to become influential for hundreds of years. According to Augustine's theory, the Old Testament prefigures or anticipates the New Testament, with Old Testament characters and events serving as "types" or prefigurations of those in the New Testament. Jesus, for example, is the second Adam. Adam's sin is redeemed by Jesus. New Testament redemption in Jesus from the bondage of sin is prefigured in the deliverance of the Israelites from their captivity in Egypt. Mary is the second Eve, the spiritual mother of humankind, as Eve was its biological mother. Augustine himself serves as a type for the lost soul who finds salvation in an acceptance of Christian revelation.

As the first Western autobiography, Augustine's *Confessions* was enormously influential. Throughout the Middle Ages the book was read, copied, and imitated. The book's image of the spiritual journey influenced medieval poems of pilgrimage, such as William Langland's *Piers Ploughman* and Dante's *Divine Comedy*. As well as providing a framework for these and other forms of spiritual autobiography, the *Confessions* paved the way for the Renaissance rediscovery of the self.

In addition to his Confessions, Augustine wrote On Christian Doctrine, which analyzes and explains the central tenets of Christian teaching, and the City of God, in which he explores the relationship between faith and reason, and the cause of history as a movement toward the clash of two opposite visions of life, represented by two contrasting cities, the city of God and the city of the

One of Augustine's central philosophical ideas is that evil does not possess reality in the same sense that good does. According to Augustine, evil is a deficiency in good rather than something that exists in its own right. God did not create evil; rather, evil entered the world through incorrect choices made by human beings, as when Adam chose to disobey God's injunction not to eat the forbidden fruit (Genesis 1). Regardless of the source of sin, however, Augustine follows St. Paul in explaining how Christ redeemed humanity, and how life is a spiritual pilgrimage toward God, in whom human beings find their salvation and their eternal rest.

Like Paul, whose epistles he echoes frequently, Augustine distrusted the fleshly body, which he held accountable for humankind's fall from grace. Augustine, in fact, described the original sin as "concupiscence," or lust, to which he had himself succumbed during his early adulthood. This distrust of the physical body and his subordination of it to the faculties of the spiritual soul were to affect Church teaching for many centuries.

Another influential Augustinian idea was that of humankind's inability to obtain salvation on its own.

Augustine argued that only God could freely grant this grace. A thousand years later, Martin Luther would argue that people's good works were valueless, and that faith alone could fulfill Christians. Moreover, Augustine argued that since God was omniscient, existing beyond time in the realm of eternity, he comprehends everything in an eternal present. He thus knows who will be saved and who will be damned. This idea of God's foreknowledge would develop later into Calvin's theory of predestination (see Chapter 14).

According to Augustine, since human beings were unable to save themselves, their only hope for salvation lay in accepting God's truth as revealed in sacred scripture, including the New Testament. Furthermore, since human beings were prone to error, misunderstanding, and sin due to the corruption they inherited from Adam and Eve's original sin, they were not in a position to understand the complexities of divine revelation on their own. For that, they needed the authoritative teaching of the Church.

Augustine wrote voluminously in support of Church authority and unity in matters of doctrine. He made vigorous attacks on the doctrines that circulated around the Church in the early centuries. He also defended Christianity against charges that the new religion was responsible for the decline of Roman civilization. Instead, Augustine saw the fall of Rome as part of God's providential plan for the progressive development of human history toward its fulfillment in the Parousiathe return of Jesus to earth at the end of the world.

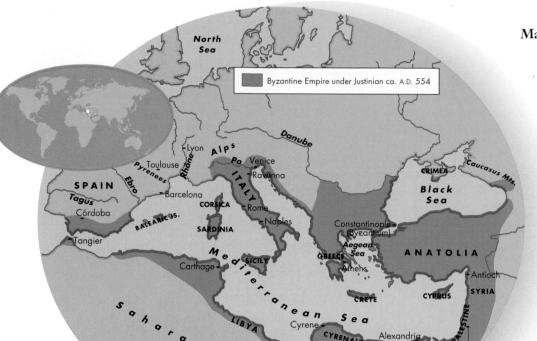

Map 7.1 The Byzantine Empire under Justinian.

BYZANTINE AND ISLAMIC CIVILIZATIONS

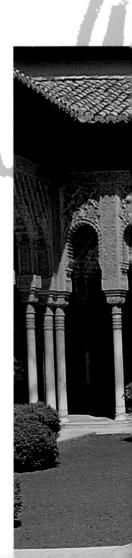

C H A P T E R 7

- Byzantine Civilization
- Islamic Civilization

Court of the Lions, Alhambra Palace, Granada, Spain, 1354-91.

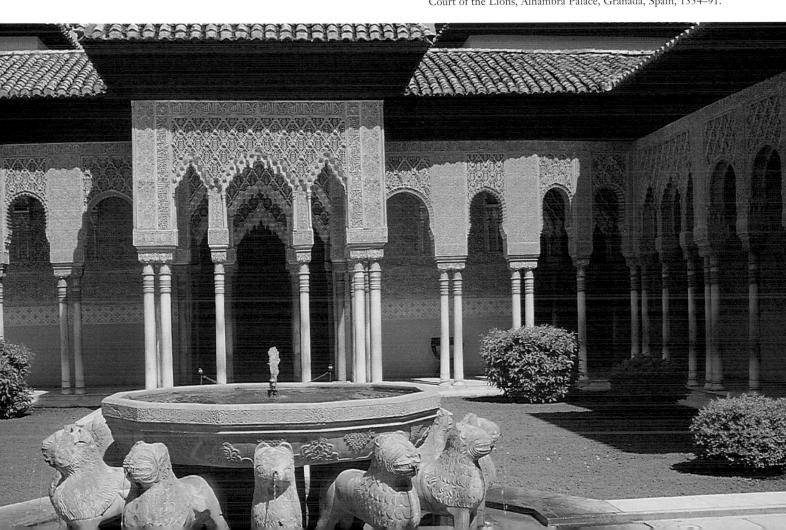

BYZANTINE CIVILIZATION

In A.D. 330, with the Roman Empire in severe economic and political decline, the emperor Constantine established the trading city of Byzantium as his new Eastern capital, renaming it Constantinople in the process.

From this time on, power and influence increasingly deserted Rome, which became a favorite target for invading barbarian hordes from the north. Rome suffered a further indignity when, in A.D. 402, the emperor Honorius moved the capital of the Western empire to Ravenna, a seaport south of Venice on the Adriatic coast of Italy. Then, in 410, a barbarian tribe from Germany, the Visigoths, laid siege to the former capital and, when the Senate refused to pay the invaders tribute, Rome was sacked for the first time in eight hundred years. Another group, the Vandals, sacked the city again in 455.

Meanwhile, the Western empire was crumbling. Successive waves of Saxons, Angles, and Jutes attacked and occupied Britain, while Burgundians wrested large parts of France from the Romans, and the Vandals came to control North Africa and Spain. The last Western emperor died in Rome in 476 when the Goths seized the city and established their own king, ODOACER [ohdoh-AH-sur], there. By the end of the fifth century, Roman power in the West had disintegrated, and the empire had been replaced by a patchwork of barbarian kingdoms.

In the east, however, imperial life flourished in the capital of Constantinople. There, a new and influential Christian civilization took root, usually known as BYZANTIUM [bi-ZAN-tee-um] after Constantinople's original name. (The city has changed name again in the twentieth century and is now called Istanbul.) Christian Byzantium continued to thrive for hundreds of years, although after the seventh century it had to compete increasingly with the rising civilization of Islam for control of the Mediterranean basin. Finally, in the fifteenth century, Constantinople itself was occupied by Muslim forces.

Of the early Byzantine emperors, JUSTINIAN [jus-TIN-ee-an] (r. 527–565) exerted the greatest cultural and political influence. His armies defeated Germanic tribes in Italy, Spain, and North Africa, reuniting the Mediterranean in a semblance of the original empire. Perhaps most important, however, was his undertaking of a massive rebuilding program in Constantinople itself, necessitated by the rebellion of 532, which had virtually destroyed the city. It was Justinian's wife and empress, THEODORA [THEE-oh-DOOR-ah], who in a famous speech to her husband persuaded him not to abandon Constantinople: "If you wish to save yourself, O Emperor, that is easy. For we have much money, there is the sea, here are the boats. But think whether after you have

been saved you may not come to feel that you would have preferred to die." Theodora became one of the most powerful people of her day, controlling public policy, and was the first of three women to rule alone in the course of Byzantine history. Together, Justinian and Theodora sought to restore the grandeur of the empire and of their capital, Constantinople.

THE GOLDEN AGE OF CONSTANTINOPLE

Constantinople lies on the straits of Bosphorus, at the confluence of the Black Sea and the Sea of Marmara. The city has one of the finest harbors in the world, controlling the land route from Europe to Asia and the waterways that lead to the ports on the Black Sea, the Aegean, and the Mediterranean. Fortified by great walls on three sides and the straits on the other, it withstood attacks for more than a thousand years, until the Turks captured it in 1453, after which it became a Muslim city.

Life in Constantinople at the time of the emperor Justinian was rich in pleasures. The well-to-do enjoyed a high standard of living with a level of hygiene and health unknown in Europe at the time. Entertainments included chariot races at the amphitheater and theatrical productions that were notorious for their indecency. The empress Theodora had been an actress before marrying Justinian and had gained a somewhat unsavory reputation as a result. This, however, was only one aspect of the city. Constantinople was also a place of elegance and splendor, with one of the most magnificent religious buildings ever constructed, the Church of the Holy Wisdom, or Hagia Sophia, built by Justinian and Theodora after the revolt in 532. The great domed structure stands as testimony to their ambitions (fig. 7.1).

Well into the ninth and tenth centuries Constantinople remained the largest, richest, and most sophisticated city in the world. The immense city walls with their 37 gates and 486 towers—not to mention Constantinople's hundreds of churches and chapels and the monumental Hagia Sophia, which was used as a lighthouse by ships twenty miles out at sea—gave the impression of indomitable power.

The wealth of Constantinople was legendary. The city produced manuscripts and jewelry of every description, as well as rich fabrics in cotton, linen, and silk, embroidered with gold. Valuable metals, ivory, and precious stones were abundant, as were spices, including ginger and cloves, pepper, and saffron. So too were medicinal drugs and ingredients for dyeing fabric.

As the world's richest and largest market, Constantinople was tightly controlled; its customs duties were high and restrictive. Demand for its goods was maintained by limiting their supply and by keeping prices high. Although commerce with cities throughout Western Europe developed, only Venice was given privileged trading status.

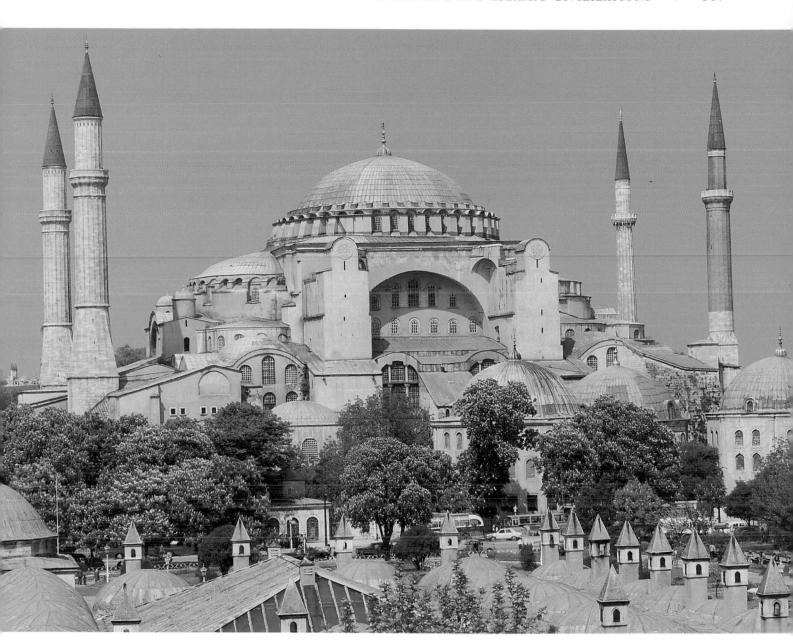

Figure 7.1 Anthemius of Tralles and Isidorus of Miletus, Hagia Sophia, Istanbul, 532–37. The towers surrounding Hagia Sophia are a later, Muslim addition. They are, in fact, minarets, from which the Muslim faithful are called to worship.

By virtue of its easy access to land and sea trade routes, Constantinople was well situated to transport goods between East and West. Yet despite this abundant mercantile exchange, there was still a certain mutual mistrust, bred of a lack of understanding and of important differences between Constantinople and the West.

Most important of all, there were deep-rooted differences between the Christian Churches of the West and East, which, because of the splitting of the Roman empire in the fourth century, developed distinct traditions. Latin was the language of the Roman Church, Greek that of the Byzantine Church. In Rome, the

Church was ruled by local bishops, who, in the absence of an imperial ruler, elected a pope as their head. In Constantinople, the Church was controlled by a patriarch who was often appointed, and even more often disposed of, by the emperor. In the West, priests were encouraged to be celibate and in 1139 celibacy became compulsory; in the East, priests could and often did marry. These differences were exacerbated when the Eastern patriarch refused to submit to the authority of the Roman pope in 1054, precipitating a final and permanent **schism**, or split, between the Eastern and Western Churches.

These differences are seen in miniature in the Western Church's response to the iconoclastic controversy in the Byzantine empire. The word **iconoclasm** derives from the Greek for "image-breaking," and twice, in the years 726–87 and 813–42, zealots who believed that the Bible forbade the worship of "graven images" systematically destroyed **icons** (sacred images) throughout the Byzantine empire. By way of contrast, the leaders of the Western Churches, the popes, had a far more tolerant view of images, believing that they served a valuable educational function.

Constantinople finally fell to the Turks in 1453, and Hagia Sophia was converted into an Islamic mosque. But the city's power had been diminishing since the end of the twelfth century. With the ascendancy of Turkish rule, Greek Byzantine scholars were dispersed throughout Europe, many taking refuge in Italy, where they contributed to the resurgence of interest in the preservation of ancient Greek culture throughout Western Europe—a development that was fundamental in bringing about the Renaissance (see Chapter 13).

BYZANTINE ART

So generously did Justinian patronize the arts that his reign is referred to as the First Golden Age of Byzantine art, with Constantinople as its artistic capital. However, because of the iconoclastic practices of later ages, much of the art created during this First Golden Age survives only outside Constantinople, in particular in the city of

Ravenna and in the monastery of St. Catherine built by Justinian at Mount Sinai.

Moreover, the influence of Byzantine artistic practices was particularly long-lasting, as the examples that follow attest. This continuing influence was the result of two factors. First, until the fifteenth century, Constantinople remained the cultural heart of the Eastern Christian world. Second, Eastern Christianity proved very conservative, and so there was little pressure for artistic change once conventions for, say, mosaic scenes and icon painting had been established.

San Vitale, Ravenna. The architecture and mosaics of the church of San Vitale in Ravenna (fig. 7.2), dated 526–47, are especially important accomplishments of the First Golden Age. Though begun by Bishop Maximian in 526, San Vitale bears the imprint of the influence of Constantinople and Justinian. It is octagonal in plan, a shape favored in Constantinople. Light is admitted to the interior by windows on the lower levels. However, this light is filtered through the aisles, which are two stories high, before reaching the nave. The only direct light, and therefore the strongest and most dramatic, enters the nave from the the third-story clerestory above.

Like the circular church of Santa Costanza in Rome (see fig. 6.6) the polygonal San Vitale has no longitudinal axis and is therefore referred to as having a central plan. Unlike the Early Christian churches of the basilica type that have a longitudinal axis (see figs. 6.3–6.5), such structures have no need of rows of columns to hold up

Timeline 7.1 The Byzantine empire.

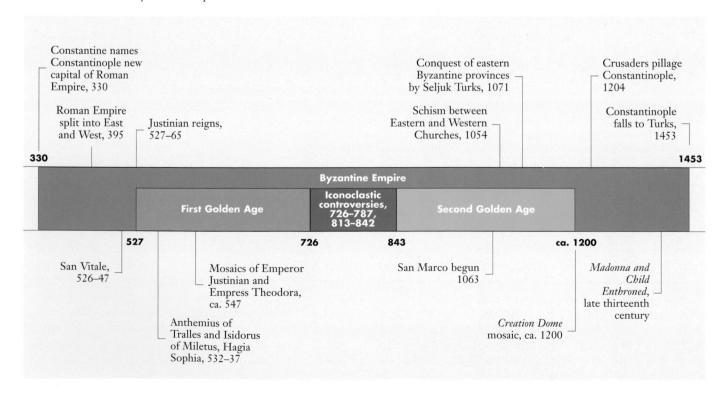

Cross Currents

THE SILK TRADE

As early as the first century B.C., silk from China began to reach Rome, where it was received with astonishment and admiration. Here was the lightest and most beautiful cloth ever seen, but the secrets of its production remained closely guarded by the Chinese.

The trade route that linked China to the West, and most importantly to Rome, was called the "Silk Road." Less a direct land route than a shifting network of caravan trails between remote kingdoms and trading posts, the Silk Road traversed China from the Han capital of Xian north and west across the Taklamakan Desert and on to the oasis city of Kashgar. From there, caravans carrying Chinese silk proceeded across the mountain passes of northern India, and on into the ancient Persian

cities of Samarkand and Bukhara. Eventually the land route would come to an end at Constantinople, or at the Mediterranean ports of Antioch or Tyre, after which ships would complete the journey to Rome.

Although silk was the primary commodity traded with the West, eastern merchants also loaded camels with ceramics, fur, and lacquered goods. In exchange, they received gold, wool, ivory, amber, and glass from the West. It was Chinese silk, however, that captured the imagination of Rome, so much so that the Romans, who had learned about the Chinese from the Greeks, called the material *serica*, from the Greek word for the Chinese, *Seres*. For the Romans, China was synonymous with silk.

Until the sixth century A.D., silk was regularly supplied to the Romans by the Persians, who monopolized the silk trade and charged high prices. It was the Byzantine emperor Justinian who eventually broke this monopoly in the sixth century. According to the historian Procopius (died A.D. 562), "certain monks from India, knowing with what zeal the emperor Justinian endeavored to prevent the Romans from buying silk from the Persians (who were his enemy), came to visit the emperor and promised him that they would undertake the manufacture of silk." These monks explained to Justinian that silk was made by silkworms fed on mulberry leaves; Justinian promised them "great favors" if they would smuggle the requisite worms and mulberry trees back to Constantinople and begin to cultivate them there for him. This they did, and Justinian initiated a flourishing silk trade that was to become one of the chief sources of his vast wealth.

Figure 7.2 San Vitale, Ravenna, 526–47. A central-planned building is either circular, like Santa Costanza (see fig. 6.6), or polygonal, like San Vitale. An advantage of the central dome is the large space covered, while a potential disadvantage is that the visitor's eyes tend to be attracted up into the dome rather than toward the altar.

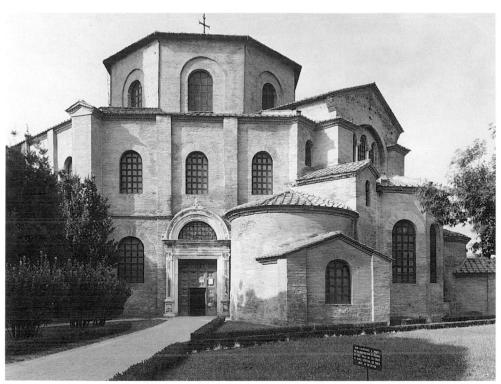

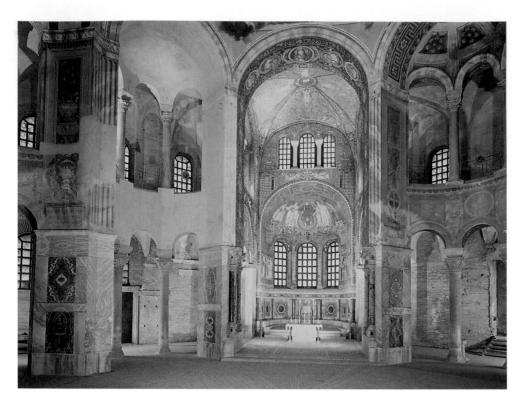

Figure 7.3 San Vitale, Ravenna, 526–47, interior. This view only begins to indicate the complexity of San Vitale's interior space. As the worshiper moves through it, the play of light on the mosaics changes continually.

their roofs and are capped with domes, which are supported by the walls instead. The result is that the interior feels light and spacious. However, two focal points compete for the visitor's attention. Whereas in a church with a longitudinal axis, on entering the worshiper is naturally directed toward the altar, the center of the ritual, this is less obviously the case at San Vitale, where the worshiper's eyes are also drawn up to the dome.

In striking contrast to its drab exterior, the interior of San Vitale (fig. 7.3) is opulent in its ornament, made colorful by mosaics that cover all the upper portions (the angels on clouds are later additions), by thin slabs of marble veneer, and by marble columns with carved and painted capitals (fig. 7.4). Seemingly immaterial, the lacy delicacy of the surface decoration belies the underlying strength of the structure.

Flanking the altar at San Vitale and drawing the worshiper's gaze down from the dome are the celebrated mosaics of the emperor Justinian and the empress Theodora (fig. 7.5) of ca. 547. Justinian and Theodora, each accompanied by attendants, are shown as good Christian rulers to be ever in attendance at the religious service. The figures are not necessarily intended to be recognizable portraits of specific individuals. Instead, everyone looks much alike, with big dark eyes, curved eyebrows, long noses, and small mouths—the characteristic Byzantine facial type. Their drapery gives no

Figure 7.4 San Vitale, Ravenna, 526–47, capital. The surfaces of the capital and impost block above are carved to appear lace-like, which belies the strength of the underlying structure.

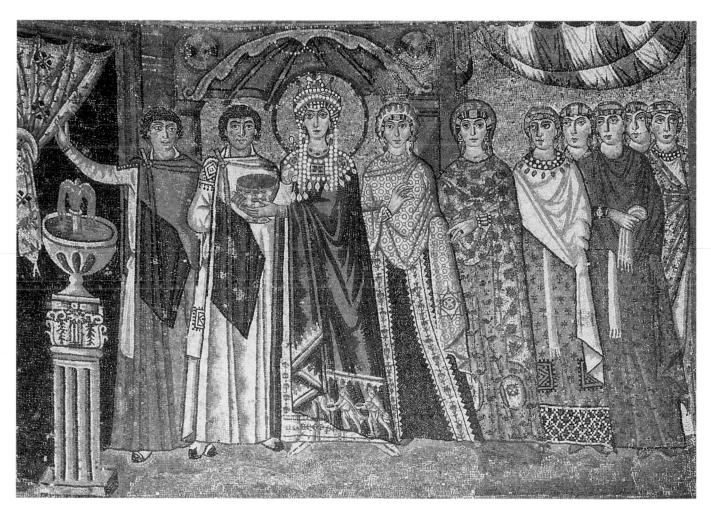

Figure 7.5 Theodora and Her Attendants, ca. 547, mosaic, San Vitale, Ravenna. The typical Byzantine face is shown to have large eyes, a long nose, and a tiny mouth. The body is characteristically slender and weightless—or so one might hope, since the figures appear to step on one another's feet.

suggestion of a body beneath; the only indication that these people have legs is the appearance of feet below the hem of their garments. Their elongated bodies seem insubstantial, ethereal and immaterial, motionless, their gestures frozen.

The flat frontal figures form a rhythmic pattern across the surface of the mosaic. Three-quarter views, which suggest a degree of movement and dimension, are avoided. The Byzantine lack of concern for realistic or even consistent representation of space is illustrated by the doorway on the left, the top and bottom of which are seen from two different vantage points. The ancient Roman interest in specific details is gone. Yet, whatever this architectural decoration may lose in realism, it gains in splendor. Realism is not the goal here. Glittering mosaic is an ideal medium with which to enhance the image of divine power promoted by the Byzantine emperor and empress, while simultaneously increasing the splendor of San Vitale.

Hagia Sophia. Hagia Sophia, the Church of the Holy Wisdom in Constantinople (see fig. 7.1), was built for Justinian and Theodora between 532 and 537 by the architects Anthemius of Tralles and Isidorus of Miletus. There is little exterior decoration (the four minarets, or towers, are later Turkish additions). Seen from the outside, Hagia Sophia appears to be a very solid structure, building up by waves to the huge central dome.

The plan (fig. 7.7) shows the arrangement around the central dome, with half-domes on opposite sides, which are in turn flanked by smaller half-domes. Thus, Hagia Sophia, although domed, is not a pure central-plan church like San Vitale, because a longitudinal axis is created by the oval nave. Hagia Sophia's ingenious plan has a single focus of attention as well as a great open space, combining the advantages of the longitudinal basilica plan with those of the domed central plan.

Unlike the dome of the Roman Pantheon (see fig. 5.14), which rests on a circular base, the dome of Hagia

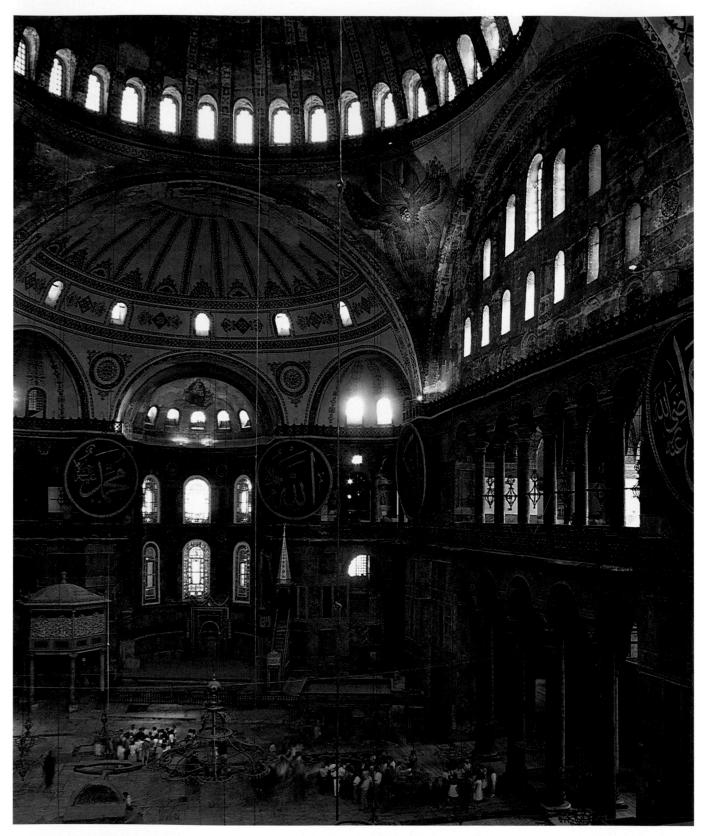

Figure 7.6 Anthemius of Tralles and Isidorus of Miletus, Hagia Sophia, Istanbul, 532–37, interior. Triangular pendentives provide the transition between the circular dome and the square base on which it rests. The closely spaced windows at the base of the dome create a ring of light that makes the dome appear to float.

Figure 7.7 Anthemius of Tralles and Isidorus of Miletus, Hagia Sophia, Istanbul, 532–37, plan. Hagia Sophia demonstrates that the advantages of the longitudinal axis of the basilica plan can be combined with those of the dome of the central plan. Here the central dome is buttressed by half-domes, which are buttressed in turn by smaller half-domes.

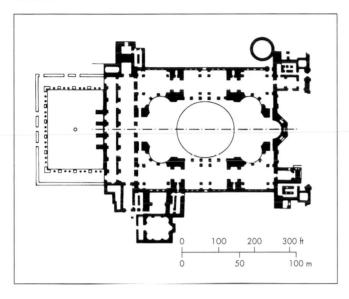

Sophia is supported by a square base formed by four huge piers. Transition from circle to square is achieved by the architects through their use of four **pendentives**, pieces of triangular supporting masonry. In effect, the dome rests on a larger dome from which segments have been removed. Hagia Sophia is one of the earliest examples of a dome on pendentives.

The interior (fig. 7.6) is an extremely lofty, light-filled, unobstructed space. From the inside, the dome seems to billow or to float—as if it were suspended from above rather than supported from below. Because the dome is made of lightweight tiles, it was possible for the architects to puncture the base of the dome with a band of forty windows. The light that streams through these windows is used as an artistic element, for it is reflected in the mosaics and the marbles. A richly polychrome scheme is created by the red and green porphyry columns, the polished marble slabs on the lower walls, and the mosaics on the upper walls. Like San Vitale, the elaborate surface decoration conceals the strength of the underlying structure.

St. Mark's, Venice. The First Golden Age of Byzantine art ended with the "iconoclastic controversy." Yet when in 843 the iconophiles—the lovers of artistic

Figure 7.8 St. Mark's, Venice, begun 1063. A dramatic silhouette is created by the five domes. St. Mark's Greek-cross plan, with four equal arms, differs from the Latin-cross plan with one dominant axis, represented by Old St. Peter's (see fig. 6.4).

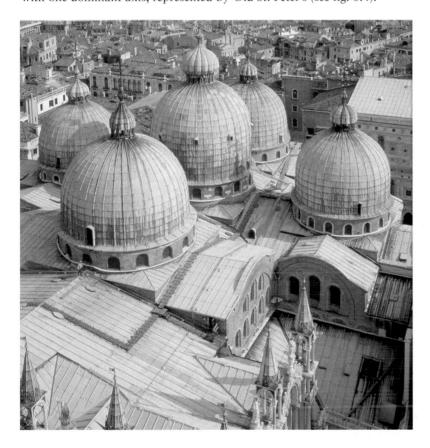

images—triumphed over the iconoclasts, a Second Golden Age of Byzantine art began, lasting until the beginning of the thirteenth century. The biggest and most elaborate church of the Second Golden Age is St. Mark's in Venice, begun in 1063. Its location on one side of a large **piazza** (open public area) is particularly impressive. The original facade has since been modified.

The plan is a **Greek cross**—that is, a cross with four arms of equal length. There is a dome over the center, plus a dome over each arm (fig. 7.8). All five domes are covered with wood and gilt copper, making them very striking and giving St. Mark's a distinctive silhouette.

The interior of St. Mark's (fig. 7.10) offers the visitor an experience in ultimate splendor. The vast space is quite dark, originally illuminated only by windows in the bases of the domes and the flickering light of countless candles. Yet all the surfaces glitter, for they are covered with mosaics, many of which are made with gold tesserae.

Among the celebrated mosaics of St. Mark's, the most famous is the Creation Dome in the narthex, made about 1200. The story of Genesis is told in a series of scenes arranged in three concentric circles. The narrative begins in the innermost circle with the creation of heaven and earth. The story of Adam and Eve occupies part of the second circle and the outermost circle (fig. 7.9). In the scene shown here, God is pictured creating Eve from Adam's rib. Among the other memorable scenes is that in which God is shown giving Adam his soul, usually represented by a tiny winged figure entering Adam's mouth.

These mosaic figures hardly appear to have been taken from live models. Instead, the figures—doll-like

Figure 7.9 God Creates Eve, detail of the Creation Dome, ca. 1200, mosaic, narthex of St. Mark's, Venice. Engaging narrative is more important than realism in these mosaics. The intended audience was assumed to be familiar with the biblical stories told here, which, therefore, could be depicted in summary rather than in detail.

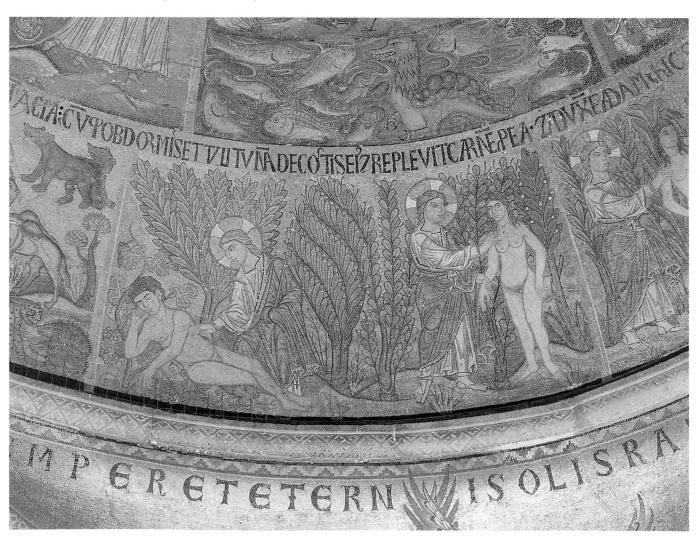

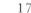

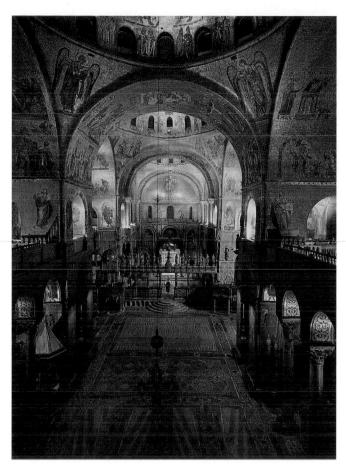

St. Mark's, Venice, begun 1063. Glittering gold mosaics covering the walls and vaults successfully transport the visitor from the crowded streets of the island-city of Venice to an extraordinary otherworldly environment.

and stocky with big heads—are intended to express the superhuman nature of the subject portrayed. The setting is symbolic only and represented in the simplest manner possible to convey the ideas. To elucidate the narrative, aids, such as bands of lettering and symbols, are employed. Emphasis is on design, decoration, and on the didactic message.

Madonna and Child Enthroned. Characteristic of this Byzantine style is the Madonna and Child Enthroned (fig. 7.11), a late thirteenth-century egg tempera painting on a wooden panel. Egg tempera (pigment mixed with egg yolk) was the standard medium used to paint on wood throughout the Middle Ages.

Madonna and Child Enthroned represents a type repeated over and over according to strict rules. It is an icon, a painted image of a religious figure or religious scene used in worship. The figures typically face out directly to the front, encouraging the viewer's spiritual engagement. In this Madonna and Child Enthroned, Mary's typically Byzantine face has a somewhat wistful or melancholy expression. She is gentle and graceful,

her bodily proportions elongated. Jesus's proportions are those of a tiny adult. Moreover, he acts as an adult, holding the scroll of law in one hand and blessing with the other.

Mary is traditionally shown wearing garments of red and blue-both primary colors. Jesus wears orange and green, two secondary colors. Byzantine drapery is

Figure 7.11 Madonna and Child Enthroned, egg tempera on panel, $32\frac{1}{8}'' \times 19\frac{3}{8}''$ (81.6 × 49.2 cm), late thirteenth century, National Gallery of Art, Washington, D.C. An icon such as this is meant to bring certain religious concepts to the viewer's mind. Because the image must be readily recognizable to be effective, it is quite standardized artistic innovation was not the goal.

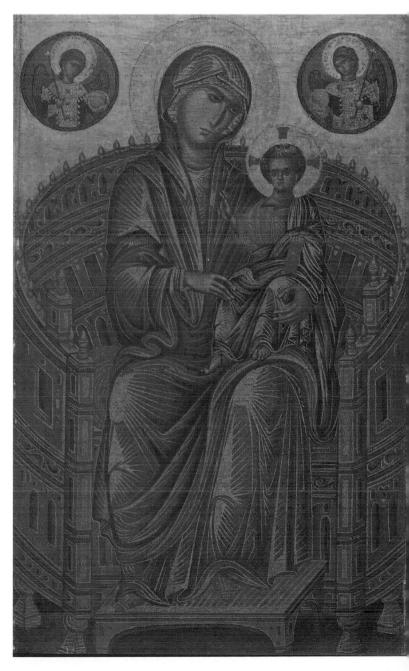

Then & Now

JERUSALEM

The possession of the city of Jerusalem has historically been contested by three major world faiths: Judaism, Christianity, and Islam. The city's history is one of warring religious factions, all claiming its holy ground for themselves. Today, within a space of five hundred yards, sometimes in peaceful coexistence, sometimes not, lie the western wall of ancient Israel's Temple of Solomon, the rock marking the place of Jesus's tomb, and the Muslim shrine designating the site where Muhammad is believed to have ascended to heaven.

Archaeological evidence indicates that Jerusalem began in the Bronze Age as a mere nine-acre settlement at the edge of the Judaean desert. The Hebrew king David made Jerusalem the capital of the unified country of ancient Israel during the early tenth century B.C. He extended the city limits, building towers and battlements throughout. The city's most glorious years, however, occurred during the reign of King Solomon, David's successor. Solomon built a magnificent temple to house the holy Ark of the Covenant. To this temple he attached an equally magnificent palace, while also extending the city walls and further enlarging its defenses.

Numerous times in its history, Jerusalem has been captured or destroyed. Alexander the Great took the city without resistance in 332 B.C. In 250 B.C. Ptolemy the Great destroyed the city walls. In 168 B.C. the Syrian king Antiochus Epiphanes enslaved Jerusalem's inhabitants. The Roman leader Pompey captured the city in the first century B.C., and the Roman general Titus crushed a rebellion a century later, leveling the city in the process. A thousand years later, the Crusaders conquered the city, taking it from the Muslims, and leaving it little more than a military outpost, dispersing those citizens who were spared from death.

During the era of the Jewish king Herod in the first century A.D., the rebuilding of Solomon's Temple, which had been destroyed by the Babylonians under King Nebuchadnezzar in 587 B.C., took place amidst the most unusual circumstances. To preserve the sanctity of the temple grounds, the king trained a thousand priests as carpenters and stonemasons, whose work did not interrupt religious worship. Herod also constructed temples to Greek and Roman gods and personally presided over the Olympic Games.

Muslims, Jews, and Christians all lay claim to the Temple Mount, the site of Solomon's Temple. For Muslims, the Temple Mount and the magnificent mosque constructed upon it, the Dome of the Rock (fig. 7.12), are second only to Mecca and Medina as holy sites. For Jews and Christians, this was the site of

the patriarch Abraham's aborted sacrifice of his son Isaac. For members of all three faiths, Solomon's Temple was the site of Jesus's debate with the rabbis and a place where he preached.

The city of Jerusalem is constructed out of the history and cultures of many peoples. Roman vaults are coupled with Christian convents; an Arab arch cannot be separated from a Jewish wall. This complex mix of religions and cultures makes Jerusalem a truly multicultural city, whose bedrock is a faith in God, albeit a God called by various names, and conceived under a variety of identities.

Figure 7.12 Dome of the Rock, Jerusalem, late 680s–692.

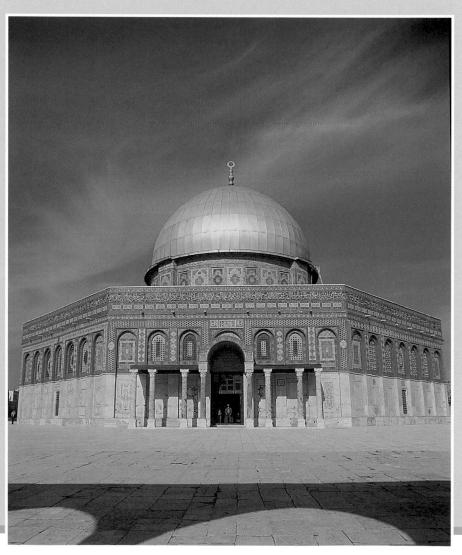

characterized by elaborate and unrealistic folds, seemingly having a life of their own, independent of the body beneath. The hard ornamental highlights contrast with the soft skin of the figures.

These figures, barely of our species, do not inhabit our earthly realm. Compression of space is emphasized by the flat decorative designs. The throne, which has been compared to the Colosseum in Rome, is drawn in such a way that the interior and exterior do not correspond. Similarly, the footstool does not obey the rules of **linear perspective**, which require objects to diminish in scale as they recede into space.

Floating in this golden realm are two half-angels. Each carries a staff, a symbol of Jesus's passion, and an orb or globe with a cross, which signifies Jesus's domination over the world. These are examples of **iconography**, the language of symbols, which was especially useful in an era when few people were literate. It was intended that the audience would be able to recognize the subject immediately. Consistency in the use of symbols, therefore, was important. The quest for innovation, for the novel, for things unique, has no place in Byzantine religious art.

ISLAMIC CIVILIZATION

Islam is the youngest of the world's major religions. It was first proclaimed by MUHAMMAD (ca. 570–632) in the town of Mecca, in Arabia, in about the year 610. The followers of Islam, Muslims, consider their faith to be the third and final revelation of God's truth—the first and second manifestations being Judaism and Christianity. Muslims view their religion as a continuation and fulfillment of Judaism and Christianity, and thus accept the sanctity of significant portions of Hebrew and Christian scripture. All three religions believe in a single God and are, thus, monotheistic. In Islam, God is called "Allah."

The rapid expansion of Islam throughout the Mediterranean was the result of three factors—the human appeal of the religion, the overpopulation of the Arabian peninsula where it originated, and a fundamental unwillingness on the part of the nomadic population of Arabia to submit to the authority of the caliphs, the religious leaders who assumed the mantle of Muhammad's representatives on earth after his death. These last two factors led, by 750, to the spread of Islam eastward to the Indus River and the frontiers of China, and westward across North Africa into Spain. In 725, Muslim forces had pushed as far north as Tours in France, from where, seven years later, French troops forced them back into Spain. Muslim rulers remained in Spain until the end of the fifteenth century. They left behind, in France and Europe as a whole, not so much their religion but magnificent architecture, particularly in Spain, and another of their cultural inventions—the institution of courtly love, including both its poetry and the instruments the poet used to sing to his mistress, such as the lute, tambourine, and guitar (all Arabic words) (see Chapter 11).

In the East, the spread of Islam underwent no such reversal. In 1453 the great Byzantine capital of Constantinople fell to the Muslim Ottomans from Turkey and Justinian's great Christian church, Hagia Sophia, was converted into a mosque.

RELIGION

Muhammad. Muhammad is revered as a prophet. Muslims consider him the "seal," or final culmination, of the prophetic tradition that extends from the biblical patriarch Abraham through Moses and on to Jesus, whom Muslims also revere as a prophet but do not consider a divinity. The word Muslim literally means "one who surrenders"; Islam means "submission to God." In the first place, Muslims surrender themselves to the prophet Muhammad and through him to Allah, by obeying Muhammad's instructions for living.

A merchant by profession, Muhammad received, at about the age of forty, what he described as a call to become God's messenger and prophet. According to Islamic tradition, Muhammad heard a voice enjoining him to "recite," to which he responded, "What shall I recite?" The answer came to him in the form of a series of revelations from Allah that lasted more than twenty years, beginning at Mecca and continuing in Medina, a city north of Mecca, to which Muhammad fled in 622 because of hostility to his religious message and where he died ten years later. Muhammad's flight to Medina is known as the *Hijrah* or *Hegira*, and marks the beginning of the Muslim calendar (A.D. 622 = 1 for Muslims).

Upon Muhammad's death, a succession of caliphs took his place, which led to a division among the Islamic faithful. In 656, those who favored choosing only a member of Muhammad's family as caliph, rallied around ALI [AH-lee], Muhammad's cousin. They called themselves Shi'ites [SHE-ites]. But when Ali was chosen caliph, civil war broke out, Ali was murdered, and the UMAYYAD [OO-MY-ad] dynasty, who bore no family relation with Muhammad, took control. The ninety-year Umayyad rule was marked by prosperity, but Shi'ite resentment remained. In 750, led by the great-grandson of a cousin of Muhammad, Abu-l Abbas, the Shi'ites overthrew the Umayyad caliphs, and the capital of Islam was moved east to Baghdad, where the ABASSID [a-BAA-sid] dynasty ruled until 1258.

The Quran. Despite this political strife, Islam remained strong. At the center of the religion is the Quran (or Koran), the scripture of Islam. The word Quran means "recitation" and reflects the Muslim belief

that the book is a recitation of God's words to Muhammad. Muhammad, who was illiterate, memorized the messages he received and dictated them to various scribes. Unlike the Hebrew scriptures, which were composed over a period of more than twelve hundred years and which for a long time remained in many different versions, the text of the Quran was definitively established after Muhammad's death by the third caliph, Uthman, around 650.

Slightly shorter than the New Testament, the Quran is divided into 114 **Surahs** or chapters, which become shorter as the Quran progresses. The first Surah contains 287 **ayas**, or verses, while the last contains only three. Each Surah begins with the words, "In the name of Allah, the Beneficent, the Merciful."

The words of the Quran are the first Muslims hear when they are born and the last many hear before death. The Quran forms the core of Muslim education and serves as a textbook for the study of Arabic. Moreover, verses from it are inscribed on the walls of Muslim homes as decoration and as a reminder of their faith.

An additional important source of Islamic teaching, the **hadith** ("narrative" or "report"), consists of the sayings of Muhammad and anecdotes about him, which were initially passed on orally, but in the ninth century were collected and written down by scholars. Six canonical collections of hadith are used to determine points of Islamic theology and doctrine.

Basic Tenets and the Five Pillars of Islam. The basic tenets of Islam concern the nature of God, creation, humankind, and the afterlife. According to Islam, God is one, immaterial, invisible, and omnipotent. This single God dominates the entire universe with his power and his mercy. He is also the creator of the universe, which, because it is his creation, is also beautiful and good. For the Muslims, the natural world reflects God's presence and is a way of being at one with Him.

The supreme creation of Allah, however, is humankind. As in the Judaeo-Christian scriptures, human beings, made in the image of God, are viewed as the culmination of creation. Women and men possess distinct, individual souls, which are immortal, and can live eternally with God—provided individuals live their earthly lives according to Islamic teaching.

To achieve heaven, Muslims must accept belief in Allah as the supreme being and the only God. They must also practice their religion by fulfilling the obligations characterized as the "five pillars" of Islam. These are:

Map 7.2 The expansion of Islam to ca. A.D. 850.

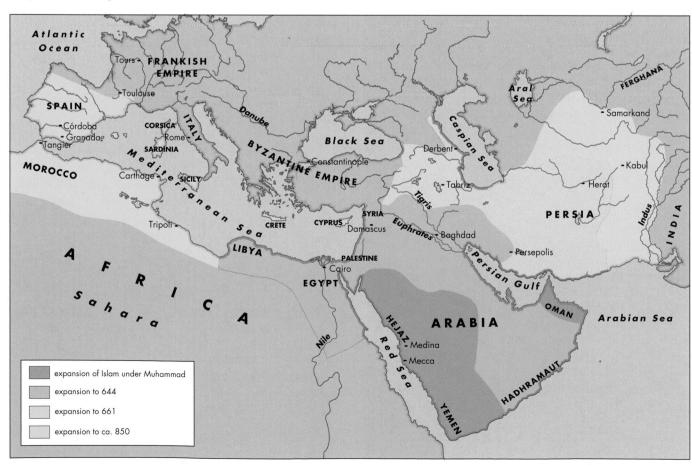

Timeline 7.2 Islamic civilization.

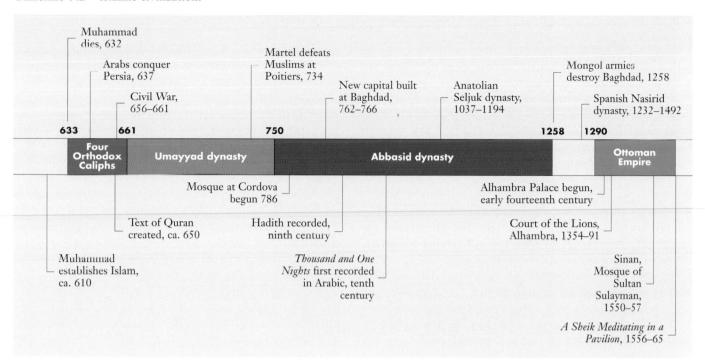

repetition of the creed, daily prayer, almsgiving, fasting during Ramadan, and pilgrimage to Mecca.

The Islamic creed (shahadah) consists of a single sentence: La ilaha illa Allah; Muhammad rasul Allah ("There is no God but Allah; Muhammad is the messenger of Allah"). All Muslims must say this creed slowly, thoughtfully, and with conviction at least once during their lives, though many practicing Muslims recite it several times each day.

Daily prayer (*salat*) is recited five times: at dawn, midday, mid-afternoon, sunset, and nightfall. In Muslim communities, *muezzins* call the faithful to prayer from mosque towers. Whether the people pray where they are or go to the mosque, they must cleanse themselves of impurities before praying. During prayer, Muslims face Mecca and perform a series of ritual gestures that includes bowing and prostration.

Charity or almsgiving (*zakat*) is the third pillar of Islam. In addition to *ad hoc* giving to the poor, Islam instructs its followers to contribute one-fortieth of their income and assets to the needy. Originally a form of tax, today the *zakat* is a respected form of holy offering.

The fourth pillar is the fast (sawm) during the holy month of Ramadan, the ninth month of the Muslim lunar calendar. Depending on the moon's cycles, Ramadan may last twenty-nine or thirty days, and shifts from year to year, spanning all the seasons over a thirty-three-year period. The fast includes abstaining from food, drink, medicine, tobacco, and sexual intercourse from sunrise to sundown. Moreover, during the month of fasting, Muslims are expected to recite the entire

Quran at least once. Ramadan is considered the Islamic holy month because it was during Ramadan that Muhammad received his initial call as a prophet and during Ramadan that he made his historic flight from Mecca to Medina ten years later.

The final pillar of Islam is the pilgrimage (*hajj*) to Mecca, which all healthy adult Muslims are expected to complete at least once. The goal of pilgrimage is to heighten devotion through veneration of Islam's sacred shrines, the most notable being the *Kaaba* ("Cube"), the sacred black stone enshrined at the place where Abraham and his son Ishmael, the ancestors of all Muslims, were directed by God to build a sanctuary.

Islamic Mysticism: The Sufis. Like all other major religions, Islam has its mystics. Because it developed in Byzantium, where there was a strong Jewish and Christian mystical tradition, and also in India, which had its own ascetic tradition, Islam was influenced to find its own mystical path. This path was followed most powerfully by the Sufis. The word sufi means "woolen" and refers to the coarse woolen clothing the Sufis wear as a sign of their rejection of worldly comforts.

Although the Sufis trace their lineage back to the seventh century, it is more likely that the movement began in earnest in the ninth century, when there was an increase in materialism; the Sufis' choice of austerity was a direct response to this. During the twelfth century, the Sufis organized themselves into monastic orders, much like the monks of medieval Christendom. A convert to a Sufi order was called a *fakir* ("poor man") or *dervish*

("beggar"), terms intended to indicate the monk's experience of poverty and begging. Although the monastic practices of the Sufis varied, they generally included strict discipline along with abstinence, poverty, and sometimes celibacy.

The legacy of the Sufis also includes their attention to the spirit rather than the letter of Islamic religious law. Their goal was to get to the spiritual heart of every aspect of Islamic religious life, from the simplest prayers to the most elaborate ritual.

One of the more notable features of Sufism in early Islam is that it recognized women as fully equal to men. A woman, for example, could become a Sufi leader or *shaykh* (feminine *shaykha*). Among the most prominent of *shaykhas* was RABIA AL-ADAWIYYA [RAA-be-ah] (d. 801), who preached an intensely devotional love of God with a corresponding withdrawal from the ordinary world. Her emphasis on worshiping God out of pure love, rather than for either temporal or eternal reward, served as both inspiration and a model for other Sufis.

Prominent among Sufi ideas is the soul's yearning and perpetual search for God, since God is the ultimate source of all life. This notion is expressed in the poetry of the thirteenth-century Persian mystic JALALODDIN RUMI [ROO-me] (1207–1273), whose poems often feature a lover seeking his beloved as a metaphor for the soul's seeking of God.

PHILOSOPHY

Avicenna and Averroes. If the Quran expresses Islamic theology and the Sufis the mystical element of

Figure 7.13 Mosque, Cordova, begun 786, exterior. This mosque, a masterpiece of Islamic architecture, was started by Abd-al Rahman I. It is an example of the work of the Umayyad dynasty in Spain.

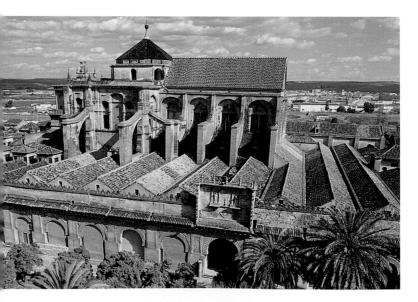

Islamic thought, Islam's philosophical bent is best figured by AVICENNA [ah-vee-SEN-ah] (980–1037) and AVERROES [a-VER-o-ease] (1126–1198).

Better known as a doctor than as a philosopher, Avicenna articulated the beliefs of Islam in terms drawn from Aristotle and Plato, wedding two divergent Greek philosophical traditions as well as linking Greek philosophy with Islamic beliefs. Following Aristotle, Avicenna argued that God was the creator, or Prime Cause, of all that exists, a necessary being whose existence and essence were one and the same.

The second major voice of Islamic philosophy was raised not in Arabia but in Spain by Averroes, another physician-philosopher. Like Avicenna, Averroes attempted to build a bridge between the philosophy of Aristotle and the more Neoplatonically based theology of Islamic thinkers.

By following Aristotle's lead in paying renewed attention to the natural world, Averroes paved the way for Thomas Aquinas (see Chapter 12) to develop his scholastic philosophical system, which was also indebted to Aristotle and which, like the philosophy of Averroes, privileged reason above faith. Both Aquinas and Averroes, for example, argue that the existence of God can be proved by reason without the aid of revelation.

Averroes and Avicenna helped preserve the Western intellectual tradition through their reverence for education, books, and philosophy. The libraries acquired by Islamic rulers and philosophers continued the philosophic tradition that began in the West with the Greeks and found renewed expression in the religious thought of the Middle Ages and scientific spirit of later centuries.

Figure 7.14 Mosque, Cordova, begun 786, plan. Although the original structure was enlarged four times, the traditional plan continued to be organized and precise, as if laid out on a grid. The mosque includes a court, prayer hall, and arcades.

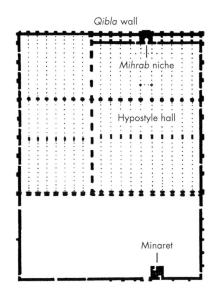

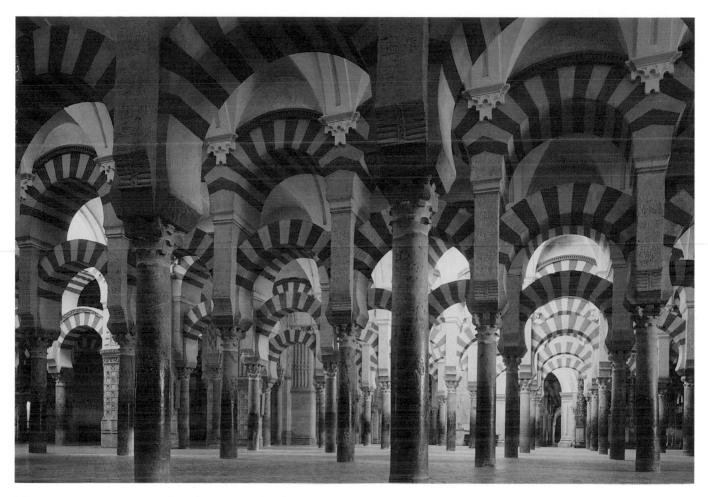

Figure 7.15 Mosque, Cordova, begun 786, interior. Decoration in plaster and marble creates an effect of delicacy and lightness, of the material made immaterial. Walls have not one plane but many, and the layers of space overlap, becoming mesh-like.

ISLAMIC ART AND ARCHITECTURE

Islamic art is not the art of one particular group of people, nor that of one country. Rather, it is the art associated with the life of one person, Muhammad, and the teachings of one book, the Quran. It is, therefore, a fusion of many different cultures, the most influential of which are Turkish, Persian, and, particularly and originally, Arabic.

The Mosque. There is little evidence of art in Arabia before Islam, and, at first, Islam did not encourage art. Islam opposes idol worship—Muhammad had all pagan idols destroyed. Furthermore, a Muslim could pray anywhere without the need of religious architecture. Nonetheless, in the late seventh century, Muslim rulers started to build palaces and mosques—the buildings in which Muslims assemble for religious purposes. In an attempt to compete with Byzantium, the caliphs built with materials and on a scale to rival Christian churches. Typically, a mosque is rectangular in plan, with an open court, and a fountain in the center used for

purification. Covered walkways, with flat roofs supported on columns and arches, lead to the side, on which is located the **mihrab**, a small niche indicating the side facing Mecca. All mosques are oriented toward Mecca, Muhammad's place of birth, and it is the direction in which Muslims turn when praying. **Minarets** are towers beside mosques from which the faithful are called to prayer by the **muezzin**, the person who ascends a spiral staircase to a platform at the top.

Construction of the mosque at Cordova in Spain (fig. 7.13) was started in 786. The plan (fig. 7.14) is simple, making it easy to enlarge the mosque by adding more aisles, as happened on several occasions. The interior (fig. 7.15) contains hundreds of columns. A visitor must follow the aisles through this forest to reach the mihrab side. There are two tiers of arches, which create a light and airy interior, an impression enhanced by the contrasting stripes of the **voussoirs**—the wedge-shaped stones that make up the arches. The individual arches are the characteristically Muslim horseshoe shape. The result is a fluid, almost mystical space.

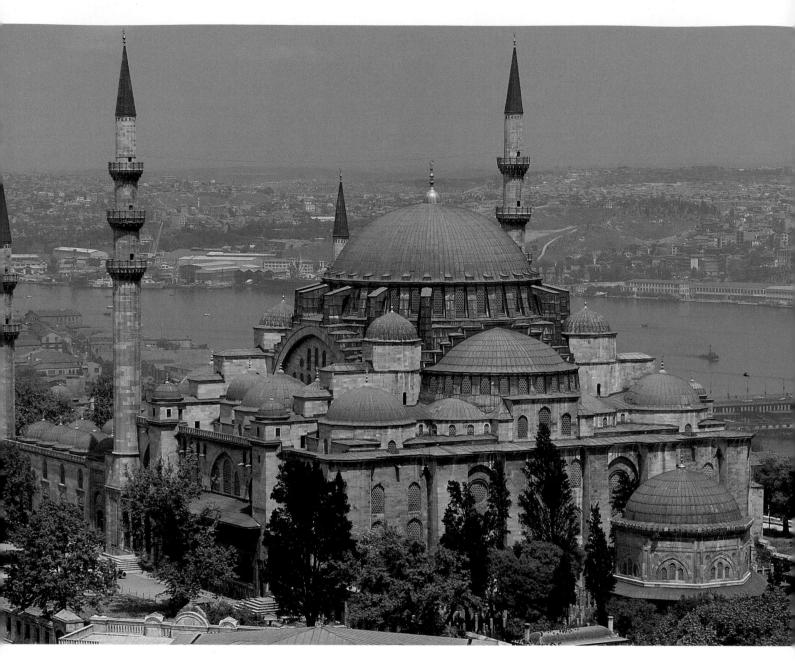

Figure 7.16 Sinan, Mosque of Sultan Sulayman, Istanbul, 1550–57, exterior. Like Hagia Sophia, built in the same city by the Christian Byzantines a millennium earlier, this Islamic mosque consists of a large central dome with abutting half-domes and smaller semi-domes.

The Mosque of Sultan Sulayman (Suleiman) (fig. 7.16), built 1550–57, is the main mosque of Constantinople, an enormous complex including tombs, hospitals, and facilities for traveling merchants and which symbolizes the city's importance as the center of Western Islamic civilization. The architect of the mosque was SINAN [SIGH-nan], the greatest master of his day. The mosque appears to build up in waves, as does Hagia Sophia which was built a thousand years earlier in the same city: the Muslims were clearly attempting to rival the Byzantines. The very tall minarets give emphasis to

the vertical; those at Hagia Sophia are later Muslim additions. The similarity between the buildings continues with the domes: like Hagia Sophia, the mosque has a large dome, two big half-domes, and several smaller ones. The surface decoration of the facade is so light and lacy that it makes the building appear delicate and fragile. The courtyard is constructed with columns and arches but, rather than a flat roof, there is a series of domes—the same roofing system employed in the mosque itself, creating a sense of unity between inside and out.

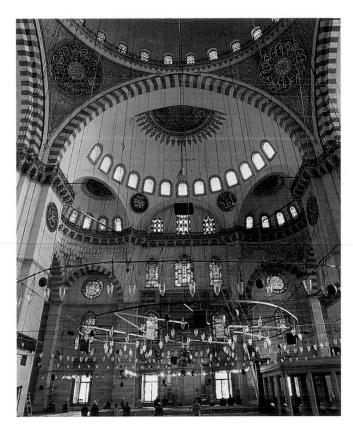

Figure 7.17 Sinan, Mosque of Sultan Sulayman, Istanbul, 1550–57, interior. The interior of this Islamic mosque, with a ring of windows at the base of the dome, is worthy of comparison with the interiors of the Byzantine churches of Hagia Sophia and St. Mark's.

The interior of the mosque (fig. 7.17) has a ring of windows at the base of the dome, which makes the dome appear weightless and floating, and a large number of windows in the walls, turning them into airy screens. The shimmering tile decoration has the effect of separating the surface from its underlying structural function. Ornamental patterns and inscriptions can be found everywhere. The tiles are often floral and polychromatic; the ceramic artist and architect worked together to create an effect whereby visitors feel surrounded by gardens of luxurious flowers.

The Alhambra Palace. The Alhambra Palace in Granada, Spain, is one of the finest examples of Islamic architecture. A palace fortress, the Alhambra is the most remarkable legacy of the Nasirid dynasty, which ruled southern Spain from 1232 until the united armies of Catholic Spain under the leadership of Ferdinand and Isabella chased the last Muslim rulers out of the country in 1492.

The Alhambra is built on top of a hill overlooking the city of Granada, providing spectacular views and a cool respite from the heat of southern Spain. Surrounded by gardens built in terraces, the palace is irregular in plan,

with several courts and a number of towers added by successive rulers.

Here, architectural function is obscured. Walls become lace-like webs. Surfaces are decorated with intricate patterns that disguise and seem to dissolve material substance. The solidity of stone is eclipsed as domes filled with designs seem to become floating lace canopies. The dissolution of matter is a fundamental principle of Islamic art. This ephemeral style is unlike any other in the history of art.

Decoration is made of tile and stucco, which is either modeled in low relief or is built up in layers which are then cut away to create the effect of stalactites. Surfaces are covered with a seemingly infinite variety of complex geometric patterns. Decoration is exquisite, achieving the height of sophistication, refinement, and richness. Ornament is profuse, yet the whole is controlled by a predilection for symmetry and repeated rhythms. Much use is made of calligraphic designs, including decorative Cufic writing, floral patterns, and purely abstract linear elements. Arabic calligraphy—fine handwriting pervades Islamic art, appearing not only in manuscripts, but also on buildings, textiles, pottery, and elsewhere. The popularity of calligraphy is in part a result of traditional Muslim iconoclasm. Because the figurative arts were discouraged, artists elaborated the abstract beauty of handwriting.

Figure 7.18 Court of the Lions, Alhambra Palace, Granada, 1354–91. Rather than stressing the supporting structure, emphasis is on the decorative surfaces, the slender columns, and the extreme sophistication with which all surfaces are ornamented.

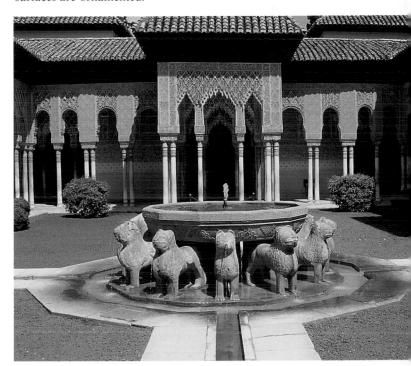

The Court of the Lions (fig. 7.18), built 1354–91 by Mohammed V, is probably the most famous part of the Alhambra. It is named for the stone lions that form the base of a fountain in the middle of the court; such freestanding figurative sculpture is extremely rare in Islamic art. The Court of the Lions is considered the quintessence of the Moorish style. Slender columns surround the courtyard, arranged singly or in pairs, and support a series of arches of fantastic shapes.

Ceramics and Miniature Painting. Islamic pictorial arts were curtailed by Muhammad's opposition to idolatry. The Quran's view that statues are the work of the devil largely eliminated sculpture. The lions in the Court of the Lions at the Alhambra Palace are rare examples, and, moreover, they serve a functional purpose, acting as supports for the water basin of the fountain. Although the Quran does not mention painting or any other medium, the argument against the portrayal of human figures or animals—or, indeed, anything living—is that only God can create life and the artist must not try to imitate God. Thus, mosques contain no figurative representations. Nonetheless, Islamic art does include some images of living things, but they are not large-scale, nor made for display. Instead, such images are usually restricted to small-scale or functional objects, such as textiles and vessels (fig. 7.19). Otherwise, geometric and plant designs were preferred.

Figure 7.19 Bowl, from Iran, twelfth or thirteenth century, ceramic, diameter $8\frac{1}{2}$ " (21.7 cm), Khalili Collection, London. The figurative design showing a couple in a garden was popular in the period. The decorative bands of script that are around the rim of the plate repeat two words, "Glory" and "Piety."

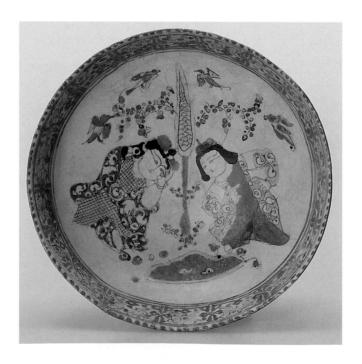

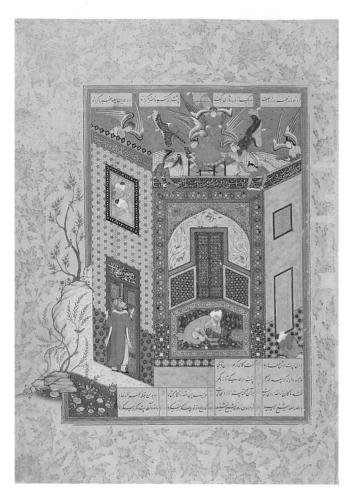

Figure 7.20 A Sheik Meditating in a Pavilion, illustrating the poem Haft Aurang (The Seven Thrones), by Jami, 1556-65, $13\frac{1}{2} \times 9\frac{1}{8}$ " (34.3 × 23.9 cm), Freer Gallery of Art, Smithsonian Institution, Washington, D.C.

Despite this ban on figurative images, a rich tradition of figurative miniature painting extends from the thirteenth to the late seventeenth century, depicting the hadith, or traditional legends appended to the Quran, as well as the poetry of religious mystics. For example, *A Sheik Meditating in a Pavilion* (fig. 7.20) illustrates a scene from the poem *Haft Aurang (The Seven Thrones)*, written by the Persian poet JAMI [JAR-me] (1414–1492).

LITERATURE

Arabic and Persian Poetry. Like English poetry, Arabic poetry began appearing in written form around 700. Arab lexicographers and philologists began collecting and recording poems that had survived orally in various Arab tribal traditions. These poems had long been chanted by *rawi*, professional reciters, who kept the verse alive.

One of the oldest forms of Arabic poetry is the *qasidah*, a highly formalized ode. The *qasidah* has three parts: (1) a visit to an abandoned encampment to find the beloved, whose departure the poet laments; (2) the poet's journey to find her, replete with descriptions of flowers and animals, especially his camel, which he eulogizes; and (3) a eulogy on a neighbor or tribe that often includes a tribute to the poet's own ancestry. The *qasidah* ranges from 30 to 120 lines in length, each line ending with the same rhyme. Central to any *qasidah* is the image, or rather a series of juxtaposed images, that vividly expresses what the poet has observed.

When Arabs invaded and conquered Persia in A.D. 637, they brought with them Islam and their Arabic script, which the Persians adopted in place of their complicated ideograms. Many Arabic words passed into Persian and some literary forms underwent modification. With the adoption of the Arabic script came an explosion of Persian poetry, including work by the early Persian poet FIRDAWSI [fear-DOW-See] (late tenthearly eleventh century). Like other Persian poets of his time and later, Firdawsi wrote in both Arabic and Persian, translating poems readily from one language to the other. The first major Persian poet and one of the greatest, Firdawsi wrote the epic *Shah-namah* (*Book of Kings*), a work of sixty thousand couplets (fig. 7.21).

One consequence of translating Persian poems into Arabic was the introduction into Arabic poetry of the quatrain (ruba'i, plural ruba'iyat), a Persian form of four lines with rhyming pattern of AABA. The ruba'i is familiar to readers of English through Edward Fitzgerald's translation of The Ruba'iyat of Omar Khayyam. The influence of the two poetic traditions, however, was reciprocal, and the Arabic qasidah was taken into Persian. The exchange of forms also includes the ghazal, a short Arabic love lyric of five to fifteen couplets believed to be of Persian origin.

Persian poetry is almost always lyrical, and its most frequent subject is love. Common features include the distraught lover, who, anguished over imagined slights, is completely at the mercy of a haughty and indifferent beloved. Some scholars have suggested that the relationship of sorrowful lover to paramour is a metaphor for the relationship between the believer and God. In fact, there is a school of Persian poetry, influenced by the mystical ideas of Sufism, that uses many of the same images as love poetry. The ambiguity of subject found in some Persian love poetry can also be found in the biblical Song of Songs. In addition, the technique of using the language of physical love to describe the love of divinity is analogous to that of certain Western poets, such as John Donne and Emily Dickinson. Persian writers, moreover, have a long history of using mysticism and symbolism to veil meaning in politically perilous times.

A further characteristic of Persian poetry is its celebration of spring, a time of renewal and hope. Seasonal

Figure 7.21 Page from a copy of the *Shah-namah* (*Book of Kings*), by Firdawsi, 1562–83, watercolor and gold on paper, $18\frac{1}{2} \times 13''$ (43.0 × 33.0 cm), Museum of Fine Arts, Boston. Until recent times, every Muslim text began with the phrase "In the name of Allah." Called the *bismillah*, the phrase opens the Quran. Here it is at the top right hand corner (Arabic texts read right to left). To write the *bismillah* as beautifully as possible is the highest form of Islamic art.

celebration has a prominence in Persian poetry for a number of reasons. One reason has to do with the climate and topography of Persia, an area that is largely desert, in which the blossoming of flowers in the spring is an especially welcome sight. Another is that, since Persians celebrate their solar New Year on March 21, the first day of spring, the season is associated with gift-giving and a renewal of hope. In addition, Persian poets often celebrate the transience of the flowers of spring as emblems of the transience of earthly joy.

Poetry of Islamic Spain. One of the legacies of the invasion of Spain by the Umayyad Muslims in 711 is a splendid profusion of Arabic Andalusian poems. Many of the most distinctive of the Andalusian poems (Arabic

Connections

SUFISM, DANCING, AND MUSIC

Sufism attempted to achieve direct contact with God through mystical trance. One method of achieving trance and thus connection with the divine was through dance, especially the spinning circular form of dance that became associated with the "whirling dervishes." Dance provided the Sufi with an outlet for emotion and an opportunity to achieve ecstasy through psychic illumination in trance.

The music that accompanied such dancing would probably have been primarily percussive, for example, a drum beat, that pounded out a steady rhythm, or would perhaps have included wooden flutes, tambourines, or even a stringed instrument, such as an *ud*, or Arabic lute.

The beautiful painting reproduced here (fig. 7.22) appears in a Turkish manuscript dating from the sixteenth century. The dancers in the center raise their hands in ecstatic celebration, while the figures in the foreground may have succumbed to dizziness. Music and dancing were disapproved of by some Muslims, but they were none-theless practiced by many Sufi orders, for whom the dance may be seen as representing the soul's movement toward God.

Figure 7.22 Turkish miniature of dervishes dancing, from a copy of the *Sessions of the Lovers*, sixteenth century, illuminated manuscript, ca. $9 \times 6''$ (25.0 \times 15.0 cm), Bodleian Library, Oxford.

poetry written in Spain) date from the eleventh century, when Andalusian poetry acquired a distinctiveness that set it apart from its Middle Eastern Arabic counterpart. Arabic Andalusian poetry tends toward lyric simplicity and directness, emphasizing the beauty of nature. Many of the poems are highly metaphoric. The most distinctive form, the *muwashshah*, includes Spanish colloquialisms mixed in with Arabic verse, and can be read as an analogy of the way in which the two cultures became interwoven.

Andalusian poems are Spanish versions of Arabic poems that were collected in the 1243 codex (manuscript volume) of Ibn Sa'id. A Spanish scholar of Arabic acquired the codex in Cairo in 1928, and proceeded to translate and publish a selection of the poems as *Poemas Arabigoandaluces* two years later. So great has been its popularity that many modern Spanish-speaking poets have acknowledged its influence on their work. The translator Cola Franzen suggests that in the manner of "wooing a woman, the Arabs courted, cosseted, adored, and adorned Spain with orchards, gardens, fountains and pools, cities and palaces, and century after century sang her praises in unforgettable verse ... The courtship lasted almost eight hundred years; the suitor was rejected in the end, and we are left with the love letters."

Arabic Prose: The Thousand and One Nights. One of the most famous of all Arabic works of literature is The Thousand and One Nights, better known in the West as The Arabian Nights. Of Indo-Persian origin, the stories

recounted in *The Thousand and One Nights* were introduced into written Arabic some time during the tenth century, and were subsequently embellished, polished, and expanded. Different as their ethnic origins may be—Persian, Indian, Arabic—the stories of *The Thousand and One Nights* became assimilated to reflect the cultural and artistic history of the Arabic Islamic tradition.

The stories cast a romantic glow of Eastern enchantment, and, while they do not chronicle the adventures of a single hero as do medieval narratives such as the *Song of Roland* or the *Divine Comedy*, they are linked by the device of a single narrator, Shahrazad, the wife of the Persian king Shahrayar, who is entertained night after night by her storytelling, which prolongs her life and cures his hatred of women. The stories are remarkable for their blending of the marvelous with the everyday.

With their exotic settings and rich aura of fantasy, the tales of *The Thousand and One Nights* captured the imagination of European readers. Although they did not reach the West until after Chaucer and Boccaccio had written their comic masterpieces, Chaucer's "Squire's Tale" from *The Canterbury Tales* and some of the tales from Boccaccio's *Decameron* were of Arabian origin.

MUSIC

During the period of the four orthodox caliphs, or representatives of Muhammad, who reigned from the prophet's death in 632 until 661, music was classed as one

of the *malahi*, or forbidden pleasures. Associated with frivolity, sensuality, and luxury, it was deemed to be at odds with the religious values of Islam. With the advent of the Umayyad dynasty (661–750), however, music began to find a favorable audience throughout the Islamic world. The Umayyads held a lively court in Damascus, one that encouraged the development of the arts and sciences.

Persian music had an influence on Arabic music, and vice versa. Moreover, in the same way that Islam influenced poetry in southern Spain, so the Cordovan Islamic community supported the development of a new and distinctive musical style in Andalusian Spain. Music, especially Arabic music, flourished most, however, during the Abbasid dynasty (750–1258), the period immediately following the reign of the Umayyads. During the reign of the Abbasids, music became an obligatory accomplishment for every educated person, much as it did later at the courts of Renaissance Europe. Yet with the collapse of the Abbasid dynasty and the destruction of Baghdad

by the Mongol armies in 1258, music declined during a period of general intellectual and cultural stagnation.

Medieval Arabic music was influenced to a significant degree by ancient Greek musical theory, which reached Near Eastern scholars in the ninth century when the works of Ptolemy, Pythagoras, and other Greek theorists were translated into Arabic. One Arabic theorist in particular who was influenced by Greek musical theory was AL-KINDI [al-KIN-dee] (790-874), who, like his Greek precursors, was interested in the effects of music on people's feelings and behavior.

Although much Islamic music was court music, which served either as vocal entertainment or as an accompaniment for dancing by professional dancers in palaces and private residences, religion also made use of music. Music was, and still is, used in calling Muslims to prayer, in chanting verses of the Quran, in hymns for special occasions and holy days, and in the *dhikr*, in which music accompanies the solemn repetition of the name of God.

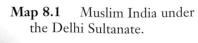

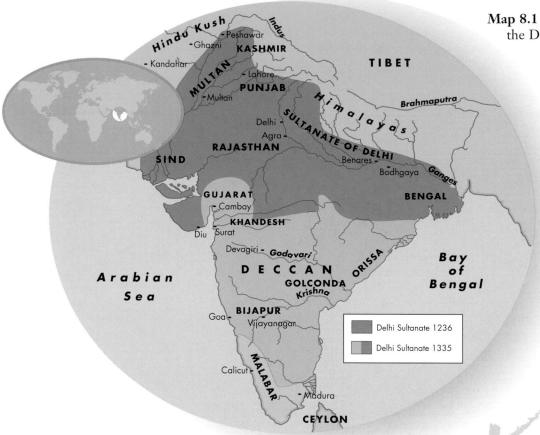

Indian * Civilization

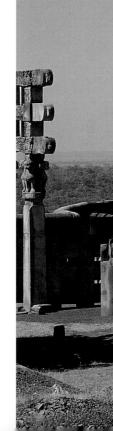

C H A P T E R

- ← The Vedic Period
- + The Maurya Period
- † The Gupta Era
- ← The Hindu Dynasties

Great Stupa, Sanchi, third century B.C.-early first century A.D.

India, as we know it today, is a distinct subcontinent bordered on the north by the Himalayan mountains, on the east by the Bay of Bengal, and on the west by the Arabian Sea. The only land routes into or out of the country are the northwestern passes through the Hindu Kush, the mountains separating India from Iran, and eastward past the mouth of the Ganges River, through Burma into China.

But despite its relative geographic isolation, India has long been the center of trade between East and West, on both land and sea. In his *Geography*, the ancient author Ptolemy records the visits of Western traders to stations on the Silk Road in the second century A.D. Between the fifth and ninth centuries A.D. the Chinese regularly traveled along Indian trade routes. In addition, maritime trade routes up and down the Indian coast connected China to the West long after Mongol hordes had laid waste the Silk Road itself in the thirteenth century.

The Vedic period, named after the oldest surviving sacred Indian writings, the *Vedas*, extends from about 1500 B.C. to just before 300 B.C. and represents a time of cultural assimilation that proved critical to India's subsequent development.

Sometime around 1500 B.C., Aryan tribes from the west settled in northern India. In many ways they were much less advanced—technologically and intellectually—than the native Indian population, the Dasas, or "slaves." The Aryans were nomadic, whereas the Dasas had built two great cities—Mohenjo-Daro and Harrapa—on the Indus River a thousand years before. However, the Aryans brought with them early forms of a language—Sanskrit—and of a religion—Hinduism—that would evolve to become very important to Indian cultural life.

It would take over a thousand years for the Aryans and Dasas to become fully integrated. During this period, in response to the growing complexity and social rigidity of Hinduism, various alternative religions emerged—most notably Buddhism and Jainism, both of which challenged the Hindu hereditary class structure.

HINDUISM

The origins of Hinduism are unknown, although they are believed to date to around the sixth century B.C., perhaps even as early as 1500 B.C. The word *Hindu* derives from the Sanskrit name for the Indus River, *Sindhu*. Like the Ganges, another important Indian river, the Indus was used for religious ceremonies, especially for rites of purification.

Figure 8.1 Vishnu Narayana on the Cosmic Waters, relief panel in the Vishnu Temple at Deogarh, Uttar Pradesh, India, ca. 530 B.C. In this scene, Vishnu lies on the waters of the cosmos at the very beginning of creation. He sleeps on the serpent of infinity. The goddess Lakshmi holds his foot as he dreams the universe into existence, by thinking "May I become Many."

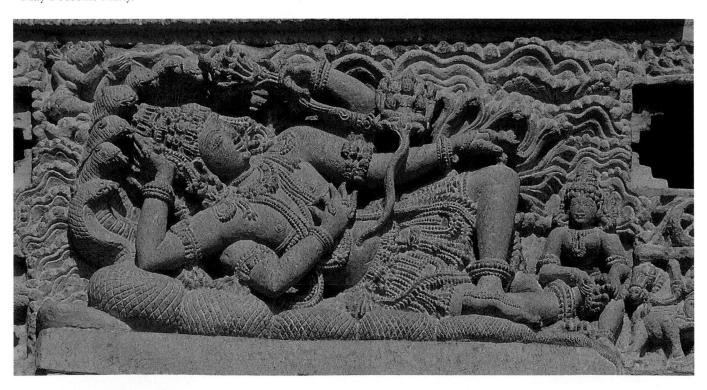

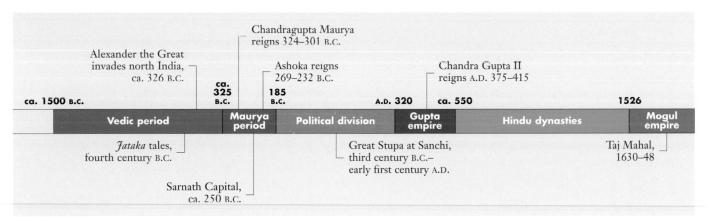

Hindu Gods. At the center of Hindu religious thought is the idea of BRAHMAN [BRAH-man], the indivisible essence of all spiritual reality, the divine source of all being. In ancient Hinduism (sometimes called Brahmanism), Brahman is a god who represents creation, preservation, and destruction. In later Hinduism, Brahman's three functions are divided among three gods: BRAHMA [BRAH-mah], the creator (as distinct from Brahman, the ubiquitous spirit of the universe); VISHNU [VISH-noo], the preserver (fig. 8.1); and SHIVA [SHE-vah], the destroyer.

The most popular of the three gods is Vishnu, the preserver. Vishnu is the god of benevolence, forgiveness, and love. He enjoys games and pranks. His consort, or companion, is LAKSHMI [LACK-shmee], with whom he is often depicted. Because of his great love for humankind, Vishnu is said to have appeared on earth many times in various forms, including that of a man. Among his avatars, or appearances in earthly form, is his incarnation as KRISHNA [KRISH-nah], a charioteer who advises the warrior Arjuna about his military responsibilities. Krishna is also believed by some Hindus to have been reincarnated as Gautama, or the Buddha.

Shiva, the destroyer, is the god of disease and death. He is also the god of dance. His most frequent consort is KALI [KAH-lee], a goddess of destruction, even more terrible than Shiva. Kali is often depicted with a necklace of human skulls. Since, for Hindus, death is a prelude to rebirth, Shiva and Kali are also gods of sexuality and reproduction. Devout Hindus profess their faith in one or more of these and other gods, and worship at temples built to honor them.

Karma. The idea of karma is central to Hindu thought. *Karma* (which means "action") involves a kind of moral cause-and-effect, in which people's actions affect their moral development. Each act individuals perform turns them more and more into a particular kind of being: for example, a sage, a warrior, or a thief. People's

spirits are reincarnated and have many successive existences. The law of karma suggests that the present condition of a person's life has been determined by actions in previous existences.

Hindu Class Structure. The social structure of ancient Indian society derives from and reflects these religious concepts and beliefs, and is based on the division of society into four distinct classes or castes.

At the top of the social order, the Brahmins serve as Hindu society's priests, leaders, seers, and religious authorities. Next in rank are the Kshatriyas, who in ancient times were Hindu society's kings and aristocratic warriors, but more recently have been its administrators, politicians, and civil authorities. Beneath the Kshatriyas are the Vaishyas, the society's entrepreneurs, in ancient times merchants and traders, in more recent times its professionals, such as doctors, lawyers, and teachers. The Shudras are Hindu society's laborers, its servant class. Outcastes, who fall outside the four main castes, are considered "untouchable" and are therefore avoided by members of other castes. Outcastes are either non-Aryan by birth or were originally members of the other castes but violated caste laws, such as those regarding work or marriage.

This hierarchical model of society was later challenged by certain communities which were based on different religious ideals, such as the Jains and the Buddhists. The caste system, however, has continued to be the governing principle of Indian society for two thousand years.

LITERATURE: THE HINDU CLASSICS

The Vedas. The earliest Indian literature was composed by the Aryans, the nomads who migrated to India around 1500 B.C. Composed between 1500 and 1000 B.C. in Sanskrit, this consists of a set of hymns known as *The Vedas*, which praise the Hindu gods. All later works ultimately derive from these Vedic songs, and most are a

commentary on them. Transmitted orally at first, *The Vedas* would be chanted during religious rituals, accompanied by various instruments.

The Upanishads. The Upanishads, an anthology of philosophical poems and discourses, were later added to The Vedas, the most ancient form of Hindu scripture. The Upanishads, though not as popular with ordinary people as the hymns and prayers of The Vedas, have been influential in Indian philosophy. They contain discussion and teachings that, while at odds with the polytheism of Vedic myth and legend, explain key Hindu ideas such as maya (illusion) and karma (action).

Based on the central tenet that there is one true spiritual reality in the universe (Brahman), *The Upanishads* explain how all existence is a tissue of false appearances—maya—that conceal this fundamental spiritual reality. According to *The Upanishads*, human beings do not realize that what appears real to the senses is entirely illusory, and that what counts eternally is the spiritual essence of life, of which they are a part.

The Upanishads typically illustrate the idea of maya and ignorance with a story about a tiger. The tiger had been orphaned as a cub and raised among goats. Believing itself to be a goat, the cub ate grass and made goat noises. One day, another tiger came upon it and took the confused tiger to a pool in which his tiger-image was reflected. It was then that the cub realized his true nature. In the same way, human beings need to realize their true nature, the divinity that resides within all.

The Ramayana. The oldest of Hindu epics, The Ramayana (The Way of Rama) by VALMIKI [val-MIH-kee] (sixth century B.C.), is also the most popular work of Indian literature, and arguably among the most influential literary works in the world. The story of Prince Rama and his queen, Sita, has its narrative origins in Indian folk traditions that go back to as early as the seventh century B.C. The Ramayana itself is dated approximately 550 B.C., when Valmiki, much like Homer in ancient Greece, gathered the various strands of the story into a cohesive work of literature organized in seven kanda, or books.

Blending historical sagas, myths, legends, and moral tales with religious and social teaching, *The Ramayana* has long been the single most important repository of Indian social, moral, and ethical values. Rama is believed by devout Hindus to be one of the two most important avatars or incarnations of the god Vishnu, who assumed human form to save humankind. Reading or witnessing a performance of episodes from *The Ramayana* is thus considered a religious exercise, as is repeating the name of Rama.

The Ramayana stands, moreover, as an enduring monument and a living guide to political, social, and family life in Vedic India. The behavior of its hero, Prince Rama, serves as a model for the behavior of the ideal son, brother, husband, warrior, and king. Rama's respect for his father and love for his wife, along with his regal bearing and self-control, represent the paradigm for Indian males to emulate. Rama's behavior is also closely linked to the religious values embodied in the epic. His wife Sita loves, honors, and serves her husband with absolute fidelity. In being governed by *dharma* (the "teachings") rather than self-interest, Rama and Sita stand as models for Hindu life.

The story of *The Ramayana* is complex and intricate. One of its central motifs concerns Rama's disinheritance, which is instigated by the jealous queen, Rama's stepmother Kaikeyi, who wants her own son, Bharatha, to become king instead of Rama. The king, Rama's father, reluctantly has his son exiled, but thereafter soon dies, desolate over Rama's departure. With his wife, Sita, and his brother, Lakshmana, Rama lives in the wilderness of central India. There they encounter the fierce king of the demons, Ravana, a god whom no one can harm except a mortal being. It was only in the form of Rama, therefore, that Vishnu could destroy Ravana. He accomplishes his goal with the help of Rama's family and friends, many of whom are gods living in the form of monkeys. In the process, however, Sita dies. Like Rama, who goes on to rule as a wise and compassionate king, Sita is portrayed in the epic as the embodiment of ideal conduct.

The Mahabharata. The second great Indian epic is The Mahabharata, which was composed over a period of more than eight hundred years, between 400 B.C. to A.D. 400. Unlike The Ramayana, which focuses on the adventures of one central hero, The Mahabharata chronicles the story of a pair of rival warring families, the Pandavas and the Kauravas. The warlike world of The Mahabharata is more akin to that of The Iliad, while the adventurefilled quest of The Ramayana has more of the character of Homer's other great epic, The Odyssey. With its hundred thousand verses, The Mahabharata is four times the length of The Ramayana, and more than eight times that of The Iliad and The Odyssey combined. What The Mahabharata lacks in unity and focus, however, it makes up for in multi-plicity of incident, breadth of social panorama, and philosophical discursiveness.

Forming part of the sixth book of *The Mahabharata* is the *Bhagavad Gita*, the section most familiar to Western readers. It is also the epic's most important source of spiritual teaching. Written early in the first century B.C., the *Bhagavad Gita* centers on the moral conflict experienced by Arjuna, a warrior who struggles with his duty to kill his kinsmen during the war between the Pandavas and Kauravas, a great battle that ends in the destruction of both armies.

When Arjuna sees his relatives ready to do battle against one another, he puts down his weapons and refuses to fight. His charioteer, Krishna, an avatar of the god Vishnu, explains that it is Arjuna's duty to fight: even

Connections

THE LOGIC OF JAINISM

ainism, which arose at the same time as Buddhism, was also a reaction to Hinduism, particularly the caste system and the claims of the Brahmins to social superiority. Its founder was MAHAVI-RA [ma-ha-VEE-rah] (599-527 B.C.), which means "Great Man." His early life resembles that of Sakyamuni, the founder of Buddhism. Born a prince, who, as legend has it, was attended by five nurses, "a wet-nurse, a nurse to bathe him, one to dress him, one to play with him, and one to carry him," Mahavira was raised in the lap of luxury. But as he grew older, he tired of this life, and at the age of thirty joined a band of monks who practiced an ascetic existence. But even the monks had too indulgent a lifestyle for his taste, and so Mahavira set out on his own, wandering the Indian countryside entirely naked, maintaining that salvation is possible only through severe deprivation of the pleasures of life and the practice of *ahimsa*, not causing harm to any living thing.

Jainism has gained a wide following in India, and today the Jains number about two million, with an especially large community in Bombay, where MAHATMA GANDHI [GAHN-dee] (1869–1948), the great twentieth-century pacifist leader, was influenced by its tenets. Jainism stresses the

importance of asceticism, meditation, and ahimsa. But one of the most distinctive features of the Jain philosophy is a special sensitivity to the relativity of all things. A favorite Jain parable is the story of the six blind men, each of whom puts his hands on a different part of an elephant and describes what he feels in totally different terms-it is like a fan, a wall, a snake, a rope, and so on. In Jainist thought, each description is satisfactory given each person's limited knowledge of the whole of the elephant. In one sense, an elephant is like a snake, but only in a very limited way. By extension, all knowledge is, from one point of view, true, and, from another, false.

though the Hindu religion generally prohibits killing, the sanction is lifted for members of Arjuna's warrior class, the Kshatriyas. He also tells Arjuna that fighting can break the karmic cycle of **samsara**, the endless cycle of birth, death, and reincarnation to which mortal beings are subject, and move him toward spiritual liberation. Arjuna learns that the spirit in which an act is performed counts more than the act itself. Since Arjuna is not fighting to achieve any particular goal but only to fulfill his duty, his behavior is irreproachable.

THE MAURYA PERIOD

In ancient India, each region was politically autonomous. These regions were governed by small dynasties which remained relatively immune from outside influences and challenges. From time to time, however, the governments of individual regions would join together in loose federations to create empires. One of the earliest and most important of these was the empire of the Maurya, which emerged in response to a power vacuum created by Alexander the Great's conquest of northern India around 326 B.C.

CHANDRAGUPTA MAURYA [MOW-ya], effectively the first emperor of India, reigned 324–301 B.C. His empire extended from the Ganges River to the Indus and into the northern mountains. After Chandragupta's death, and following the reign of his son Bindusara, came the most important of Mauryan emperors, ASHOKA [a-SHOW-ka], who assumed the throne in 269 B.C. Lasting nearly forty years (269–232 B.C.), Ashoka's reign marked a critical turning point in Indian history—the emergence

of Buddhism as a political force in India. Regretting the terrible destruction his armies had wrought in a victorious battle with the armies of a neighboring region, Ashoka embraced Buddhism, which had begun to displace the more worldly Hinduism three centuries earlier.

The connection between political power and religious idealism continued throughout Ashoka's life and for half a century after his death. The emperor sent missionaries, including his daughter and son, throughout India to spread the Buddhist faith. He also had sites marked that were of religious and historical significance to Buddhists, and a shrine to house the possessions and remains of the Buddha.

BUDDHISM

Buddhism begins with a man, SIDDHARTHA GAUTAMA SAKYA (ca. 563–483 B.C.), also known as Sakyamuni, meaning "the sage or silent one of the Sakya." At his birth, it was prophesied that Sakyamuni would be either a king or a world redeemer. He was raised in a princely household, and so as a young man was sheltered from pain and suffering. Legend has it that he was suddenly transformed when, on a journey, he became acquainted with age by passing an old man, with disease by seeing a sick person, with death by seeing a corpse, and with want by encountering a group of monks with their begging bowls. Shaken by his discovery that life is subject to age and death, he determined to find a realm where human beings are immune from these facts of physical existence.

So he set off on a journey. He studied for six years with Hindu masters. He joined a band of ascetics and

practiced austerity and self-discipline. When he realized that asceticism would not bring him enlightenment, he sat under a fig tree to meditate, determined not to rise until he experienced the wisdom of enlightenment.

After meditating for forty-nine days and nights, Sakyamuni experienced a mental epiphany, an awakening involving rapture, bliss, and enlightenment. While in this state, he was subjected to a number of temptations. Among these was the temptation to be satisfied that he had attained this state of rapture himself but to assume that no one else could understand his experience. But he resisted and set off to become a wandering preacher, whose goal was to help other people achieve the same state of enlightenment. After forty-five years of preaching and dedicating himself to others, the Buddha (a word derived from the name of the tree under which he first achieved enlightenment—the Bo tree, short for Bodhi, meaning "wisdom" or "enlightenment") died at the age of eighty.

Buddhism versus Hinduism. Unlike Hinduism, which developed over many centuries, Buddhism seemed to arise overnight, even if it took many centuries for a political leader to adopt it. The Buddha challenged Hindu religious practice in a number of ways. He argued that the caste of Brahmins was granted too much power and given too many privileges. The forms of ritual had become, he believed, devoid of meaning, and were debased by being linked with commercial transactions. Hindu philosophical thought had become excessively intricate and arcane, and consequently increasingly disconnected from everyday spiritual life. Religious mystery had degenerated into mystification and magic.

Superstition and divination had replaced miracle and true mysticism. Perhaps worst of all, too many people, in the Buddha's view, had come to believe that their actions did not matter, that whatever they believed they would be caught up in samsara, the endless cycle of rebirth, from which escape was impossible.

The Buddha responded to this by providing an alternative religious practice in which each individual had to find her or his own way to enlightenment. So devoid of the notion of higher authority is Buddhism that it is a religion without a god. There is only enlightenment. Furthermore, ritual is an irrelevant diversion from the real work of achieving enlightenment. The Buddha argued that it need not take hundreds of lifetimes or thousands of reincarnations to break out of the round of existence. A determined individual could achieve enlightenment in a single lifetime and so attain **nirvana**, that is, liberation from the limitations of existence and rebirth in the cycle of samsara.

As a result of these new objectives, Buddhism developed few of the characteristics of traditional religions. As already stated, it was a religion without a god and without the concept of immortality. It posited no creation or last judgment. It presented no revelation from a god. Instead, it emphasized the here and now.

The Four Noble Truths and the Eight-Fold Path. The Eight-Fold Path can be seen as a course of spiritual treatment for the diseased human condition. Buddhist thought is based on an analysis of the human condition that is founded on four axioms or truths. These basic principles have come to be known as the Four Noble Truths:

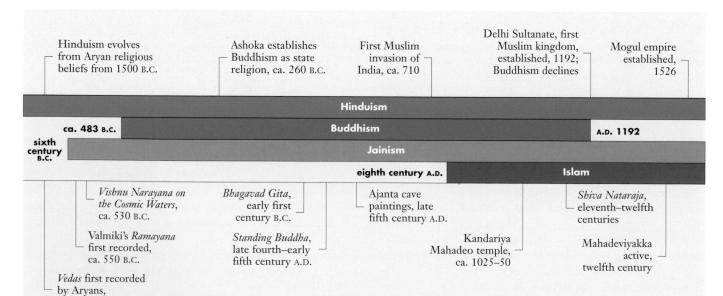

Timeline 8.2 Culture and religion in India.

1500-1000 B.C.

- 1. Life consists of suffering, impermanence, imperfection, incompleteness.
- 2. The cause of life's suffering is selfishness.
- 3. Suffering and selfishness can be brought to an end.
- 4. The answer to life's problems of suffering is the Eight-Fold Path.

The Eight-Fold Path itself consists of knowledge of these Four Noble Truths, the first step on the path, followed by seven other steps: right aspiration toward the goal of enlightenment; right speech that is honest and charitable; right conduct—no drinking, killing, lying, or lust; right living according to the goals of Buddhism; right effort; right thinking with an emphasis on self-awareness; and the right use of meditation to achieve enlightenment.

MAURYA ART

The earliest significant body of Indian art extant today dates from the Maurya period, chiefly from the reign of the emperor Ashoka. Much of this work was created to celebrate Ashoka's conversion to Buddhism. Ashoka ordered the construction of numerous **stupas**, or memorial buildings, that enshrined relics of the Buddha, marking sites sacred to his memory. Many of the eighty thousand or more stupas erected during Ashoka's reign were dedicated to the Buddha and his miracles. Later, stupas were used for burial of the remains of sacred monks.

The Sarnath Capital. Ashoka also had a large number of stone columns built to memorialize significant events in the Buddha's life. Carved into many of these, as well as into rocks and caves, were political edicts that promoted various aspects of the Buddhist creed. The stone pillars usually had capitals, often carved in the form of an animal, usually a lion. One of the most magnificent of these is a beautifully preserved lion capital (fig. 8.2) from a pillar at Sarnath that dates from about 250 B.C.

The Sarnath capital consists of three elements. On top of a fluted bell are four royal animals and four wheels carved in relief. Above these are four lions carved back to back all the way round the capital. The stylization of the lions' facial features and claws, along with the decorative handling of their manes and upper torsos, is similar to that of the lion sculptures at Persepolis, a city destroyed by Alexander the Great before his invasion of northern India. As was described in Chapter 4, Alexander's forces made an enduring cultural impression on the region. It is highly likely that either Persian sculptors or Persiantrained Greek sculptors created this capital, which marks a dramatic growth in the style, complexity, and beauty of Indian sculpture.

The seven-foot sculpture was originally surmounted by a large stone wheel on the lions' shoulders. This capital (now used as the emblem of the modern Republic of

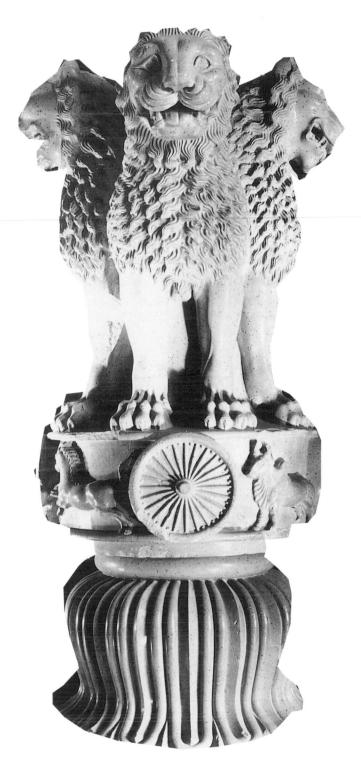

Figure 8.2 Lion capital of a pillar erected by Ashoka at Sarnath, Mauryan, ca. 250 B.C., Chunar sandstone, height 7' (2.15 m), Archaeological Museum, Sarnath. This lion capital reveres the lion as king of the animal world while honoring the Buddha as king or lion among religious teachers.

Figure 8.3 Great Stupa, Sanchi, from the east, third century B.C.-early first century A.D. For the increasing numbers of Buddhist faithful, the stupa became a central symbol of religious faith.

India) is highly symbolic. Hailing from a period during which Buddhist art avoided representing the Buddha directly, the Sarnath lion capital suggests his presence in other ways. Most importantly, since Sarnath is recognized as the site where the Buddha first preached about *dharma*, the wheel signifies the wheel of the law of *dharma*. The lion itself was perceived as the most powerful and magnificent of animals, and thus suggests that the Buddha is a lion among religious leaders. The four animals sculpted on the plinth—the elephant, horse, bull, and lion—represent the four parts of the world to which the Buddha's law of *dharma* was to extend.

The Great Stupa at Sanchi. Many of the stupas erected by Ashoka were enlarged by subsequent dynasties in the second and first centuries B.C. For instance, at Sanchi in central India, Ashoka had built a stupa sixty feet in diameter and twenty-five feet high. The Andhras, who ruled in the region toward the end of the first century B.C., doubled its size (fig. 8.3). They replaced Ashoka's wooden railings with new stone ones nine feet high. A sixteen-foot-high passage encircling the stupa was also added. At the very top of the stupa three umbrellas represent the three "jewels" of Buddhism: the Buddha, the law, and the community of monks.

Surrounding these umbrellas is a square railing that reflects the ancient tradition of putting a fence around a sacred tree.

However, the architectural glories of the Sanchi stupa are four carved stone gates, each of which is more than thirty feet high (fig. 8.4). Begun during the first century B.C., but only completed during the first century A.D., the gates are adorned with symbols associated with the Buddha, including the wheel of the law, folktales from his life, and his animal incarnations. Additional figures include elephants, peacocks, and *yakshis*, or protective female earth spirits.

The Sanchi stupa symbolizes the world, its four gates representing the four corners of the universe. Its umbrella points toward the sky, linking heaven with earth and a life of bliss with that of pain and suffering below. Entering the eastern gate of the stupa, a visitor would move clockwise in a circle around it on a path especially constructed for that purpose. Even though the stupa, one might argue, is more a work of sculpture than of architecture, like Hindu temples it invites worshipers to enter into a spiritual state of mind.

Figure 8.4 Gate of the Great Stupa, Sanchi, inner facade of the north gate, stone, height 34′ (10.35 m), third century B.C.—early first century A.D. Depicted on the columns and cross beams of this large stone gate are events in the life of the Buddha and stories from the *Jataka* tales.

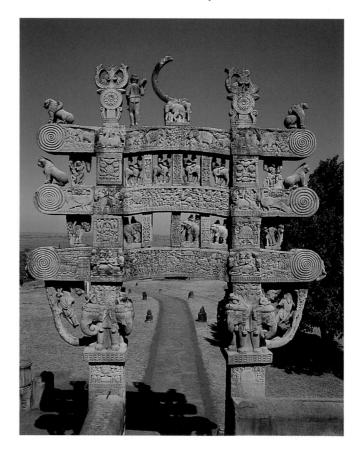

At the beginning of the Christian era in Europe, events were also occurring in India that would have a tremendous influence on the country's cultural and religious future. Buddhism was undergoing important changes; in the new form of the religion, the goal was no longer to reach nirvana for oneself, but instead the attainment of buddhahood for everyone in the universe. As a result, a category of princely beings known as **bodhisattvas**, "those whose essence is wisdom," developed. These are great beings, who will achieve buddhahood, but who have stayed behind in the world to help others attain the same state. Popular mainly in northern India, this new Mahayana form of Buddhism spread rapidly to China, Japan, and Korea, along the trade routes that ran through India's mountain passes.

Of the ancient Indian empires that developed in this period, the most important was that of the Gupta, which lasted from the fourth to the sixth century A.D. During the reign of the Guptas, India flourished culturally and commercially. Significant scientific discoveries were made; important developments occurred in literature, music, sculpture, and painting. It was during the reign of CHANDRA GUPTA II (A.D. 375–415), for example, that the cave paintings at Ajanta were undertaken. In terms of Indian cultural achievements the Gupta era is comparable to Periklean Athens, Han China, and Augustan Rome.

The Gupta empire eventually collapsed under repeated onslaughts by the Huns, who had previously invaded and conquered the Roman world. Regional autonomy was reestablished as the empire became increasingly fractured. From early in the eighth century Islamic influences began to appear in India, culminating five hundred years later, when northern India and the Ganges area fell directly under Turkish Islamic control. Buddhism was eclipsed to a large extent, and as Hinduism gradually reasserted itself, it became mixed with Muslim influences.

GUPTA ART

Gupta art has become associated with the deeply spiritual figure of the Buddha, standing with equanimity, eyes seemingly closed in concentration. Whether standing or seated, Buddhas sculpted in the Gupta Buddhist style appear calm, their worldly cares replaced by an inner tranquillity that suggests other-worldliness. Their hands are placed in prescribed positions, called **mudras**, that are highly symbolic. The *Standing Buddha* (fig. 8.5) reaches forward with his right hand (now missing) in the *abhaya* mudra, a sign of reassurance, blessing, and protection. His left hand drops to his side in the *varada*

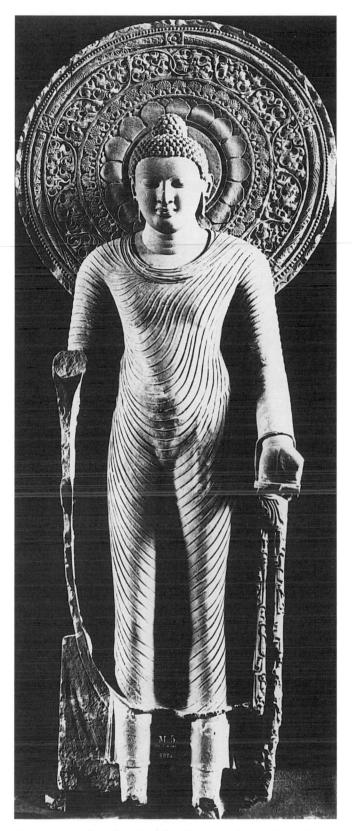

Figure 8.5 Standing Buddha, from Mathura, Gupta, late fourth–early fifth century A.D., red sandstone, height $7'\frac{3}{8}''$ (2.17 m), National Museum, New Delhi. The elegance of this standing figure, especially its calm serenity, characterizes the Gupta Buddhist style of sculpture.

mudra, signifying charity and the fulfillment of all wishes. The *Seated Buddha*'s hands form the *dharma-chakra* mudra (fig. 8.6), a sign of teaching in which the hands make a circle with the thumb and forefinger, a reference to the wheel of *dharma*. The mudra most familiar to Westerners is the *dhyana* mudra, in which the hands rest on the buddha's lap, palms facing upward. A gesture of meditation and harmony, it symbolizes the path to enlightenment.

Something of this serenity appears in the cave paintings from Ajanta. The paintings describe the various lives and incarnations of the Buddha as narrated in the *Jataka* tales. One depicting the Bodhisattva Padmapani shows him holding a blue lotus and standing in the classic *trib-banga* sculptural pose (fig. 8.7), in which the figure leans precariously to the side, with his weight on one leg. The scene shows the serene bodhisattva oblivious to the activity around him.

THE JATAKA AND THE PANCATANTRA

Ancient Indian literature contains many folktales and animal stories. One of the most important collections of early stories is the Jataka, which means "the story of a

Figure 8.6 Seated Buddha, Sarnath, Gupta, fifth century A.D., sandstone, height 5'3" (1.60 m), Archaeological Museum, Sarnath. Seated on a throne in the meditation posture, this Buddha's hands are positioned in the sign of the dharmachakra mudra, a teaching gesture that sets the wheel of the Buddhist law in motion.

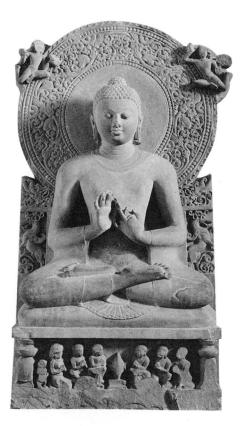

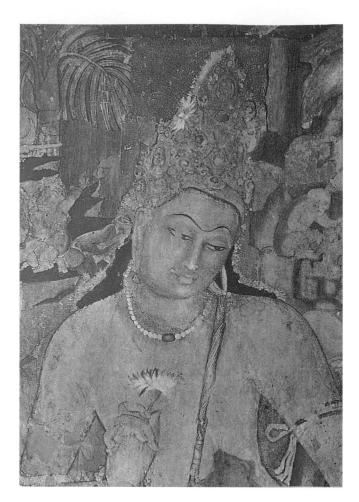

Figure 8.7 Bodhisattva Padmapani, wall painting, Ajanta caves, Gupta, late fifth century A.D. Oblivious to the figures that surround him, this bodhisattva is encircled in an otherworldly light, created by the burnishing of the painting's outer coating with a smooth stone.

birth," consisting of 547 tales that describe the lives the Buddha passed through before achieving enlightenment. The *Pancatantra* is a group of didactic stories, designed with the practical aim of providing advice about getting on in the world.

One of the most famous tales of the fourth-century B.C. *Jataka* describes a hare who sacrifices itself to feed a hungry brahmin. The tale's action reveals the hare to be a bodhisattva in the form of an animal. Like another *Jataka* hero, a monkey who gives up his life for others, the hare displays the perfection of spiritual being in a completely selfless act.

This is quite different from the spirit and flavor of the *Pancatantra*, in which the behavior of its animal heroes is more self-serving and pragmatic. The title, *Pancatantra*, which means "the five strategies," suggests the book's pragmatic inclination. Composed during the second or third century A.D., the stories are linked so that one story is joined to another in a continuous chain. This is similar

Then & Now

MUSLIM INDIA

Islam arrived in India as carly as the eighth century, but it was not until the twelfth century that it began to have a powerful impact on the subcontinent. In 1192, the Afghan king Muhammad of Ghur, invading from the north by land, defeated the Hindus. To celebrate his victory he erected the giant Quwwat ul-Islam ("Might of Islam") mosque on the site of Delhi's largest Hindu temple, incorporating columns pillaged from other local Hindu shrines. The resulting structure is a curious amalgamation of two cultures—an Islamic mosque with Hindu decoration.

After initial fighting, a spirit of peaceful coexistence lasted for several centuries. But no two religions could be more different than Hinduism and Islam. Hinduism is sufficiently loose in its religious structure to allow great divergences in spiritual beliefs and practices, while Islam controls almost every aspect of daily life. But where Hinduism is intellectually liberal and Islam conservative, the opposite is true socially. The social restrictions of Hinduism's caste system, in contrast to the possi-bilities of social

mobility and equality offered by Islam, may have led many Indians to adopt the Islamic faith. Especially around Delhi and Agra, where the Muslim rulers held sway, Islam took firm hold and was responsible for the creation of some of the greatest monuments of Indian culture.

Possibly the most famous building in

Figure 8.8 Taj Mahal, Agra, 1630–48. This mausoleum was built by Shah Jahan for his wife, Mumtaz Mahal. The white marble domes seem to reach heavenward, while being reflected in the long pool of water.

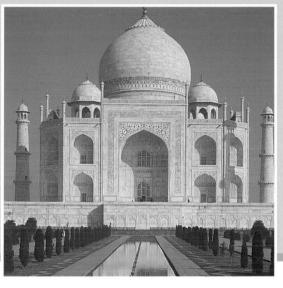

India is the Taj Mahal (fig. 8.8), in Agra, built 1630-48 by the Muslim Shah Jahan as a mausoleum for his wite. Mumtaz Mahal. Its white marble walls are deeply cut with arched recesses that catch shadows, creating a three-dimensional facade. The building appears to be weightless, the dome floating like a balloon. Decoration includes floral relief carving and gray stone inlay. The landscape setting continues the formal concern with symmetry, as the building is reflected in a long pool flanked by rows of small trees and shrubs. The Taj Mahal is celebrated for its exquisite refinement and elegance.

By the twentieth century, relations between India's Hindus and Muslims had reached crisis point, and in 1947, after a violent and bloody partition, the independent Muslim state of Pakistan was born, consisting of two separate areas: West Pakistan, with its capital at Islamabad near the Khyber Pass on the Indus River, and East Pakistan (which seceded from the union in 1971 to become Bangladesh), with its capital at Dacca. The fifty million Muslims who were left in India became an official minority with the right to parliamentary representation in India.

to the connected stories of *The Thousand and One Nights* (see Chapter 7), which may have been influenced by the *Pancatantra*. The authors of the *Jataka* and the *Pancatantra* provide fast-moving action, witty dialogue, and memorable counsel in stories that entertain as they instruct, be that in Buddhist spirituality or in more worldly wisdom.

THE HINDU DYNASTIES

Although Buddhism flourished during the Gupta era, the Gupta monarchs themselves were increasingly attracted to Hinduism. Temples and sculptures of Hindu gods began to appear, and they continued to proliferate well into the fifteenth and sixteenth centuries, when Muslim kings from Persia took control of most of the subcontinent. Particularly in the south, where the warring Hindu

dynasties of the Pallavas and the Cholas vied for power, a long period of great artistic production was set in motion, marked both by decorated temples, rich in stone sculpture, and by the rise of bronze as a favored medium for sculpture.

THE HINDU TEMPLE

The structure and design of the Hindu temple were established in the series of ancient texts called **shastras**. The shastras function as guides to many different activities, not just temple-building, and include advice on cooking, warfare, lovemaking, poetry, and music. The guides to architecture, especially those concerning temple architecture, do not always concur in every detail with actual temple construction.

Temples in the south are better preserved than northern temples, since the Muslim incursion into India was

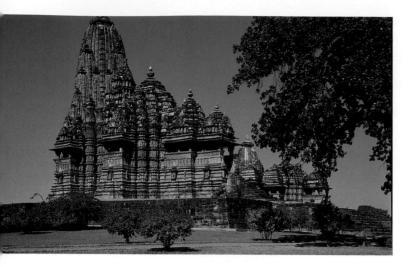

Figure 8.9 Kandariya Mahadeo temple, Khajuraho, Chandella, ca. 1025–50. This temple's tower soars more than a hundred feet into the air, its eighty-four subordinate towers providing a visual display of majestic grandeur.

most destructive in the north. One of the most magnificent of medieval Hindu temples and one in an exceptional state of preservation is the Kandariya Mahadeo temple at Khajuraho, dating from the eleventh century (fig. 8.9). As with many temples of that period, it forms part of a cluster of temples in the area.

The Kandariya Mahadeo temple is situated on a high masonry platform with richly decorated walls. Intricate dome-like roofs rise like successive mountain peaks in a crescendo of grandeur. Equally compelling is the vibrancy and richness of their surface ornamentation. Niches and screens, pillars and openings, pavilions and courtyards enhance the splendor of the edifice. Adorning the temple is a wealth of sculpture that depicts historical and mythological subjects.

SCULPTURE

Bronze was the medium most favored by the southern Indian Chola dynasties from the tenth to the twelfth century. Chola sculptors employed the *cire perdue* or lost-wax process. In this technique, a model of the subject is first made in wax, which is easy to mold. The wax model is then encased in clay and heated; the wax melts but the clay does not. Holes are made in the clay surround before it is heated, however, to permit the wax to run out. The hollow clay case is then filled with molten bronze. When the bronze has cooled and hardened, the clay is broken away, leaving a finished bronze cast.

The Shiva Nataraja (Lord of the Dance) (fig. 8.10) is perhaps the most famous of Hindu icons. Numerous examples of this icon exist—strict rules governing its

production have resulted in a remarkable consistency across individual instances—and it continues to be produced in southern India to this day. The icon depicts the dancing Shiva as creator and destroyer of the universe, symbolized by the ring around him. The dancing Shiva crushes the dwarf of ignorance, promising relief from life's illusoriness, and also reassurance and blessing in the *abhaya* mudra of his front right hand. This dance is said to herald the last night of the world, when all the stars fall from the sky and the universe is reduced to ashes. But the dance promises the renewal of creation.

HINDU LYRIC POETRY

The poetry of the twelfth-century mystic MAHA-DEVIYAKKA [ma-ha-de-VEE-ha-ka], the foremost Indian woman poet before the modern era, represents the quintessential medieval genre of **bhakti** or devotional religious poetry. Bhakti poetry was part of a larger movement in which the poets were recognized as saints and celebrated as models of religious devotion.

Bhakti devotional poetry is rooted in deeply felt emotion. As with the devotional poetry of other cultures, it draws on imagery from everyday experience in an attempt to convey a sense of earthly longing for the divine.

Figure 8.10 Shiva Nataraja (Lord of the Dance), Chola, eleventh-twelfth centuries, bronze, height $32\frac{1}{2}$ " (82 cm), Von der Heydt Collection, Museum Rietherg, Zurich. The most famous of Hindu icons, the dancing Shiva is both the creator and destroyer of the universe.

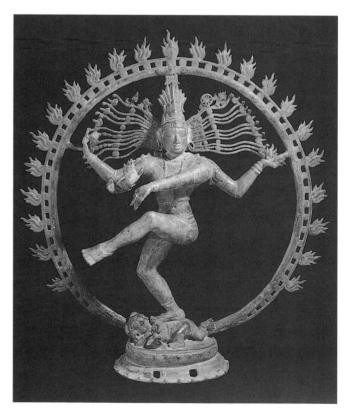

Cross Currents

RAVI SHANKAR AND PHILIP GLASS

Born in Baltimore in 1937, American composer PHILIP GLASS was trained at the Julliard School of Music in New York. He was frustrated with the state of contemporary music until, in the 1960s, he was hired to work on the soundtrack for a now-forgotten "alternative" film entitled Chappaqua. His job was to take the improvised Indian ragas of Indian musician RAVI SHANKAR [SHANkah] (b. 1920) (fig 8.11) and transcribe them into Western musical notation, so that Western musicians could perform them on the soundtrack. Glass was parti-cularly impressed with the background drone chord of the raga. He thought it was made up of units of two and three notes that formed long chains of modular rhythmic patterns. He was in fact wrong in terms of musicology, but it led him, as misreadings so often can, to invent his own distinct musical

style. He traveled to India many times and gradually developed an almost hypnotic rhythmic style of his own. The music he began to compose consisted of the rhythmic units he had heard in Shankar's work, with simple and apparently arbitrarily chosen notes or pitches strung together in cyclical groups. The repetitiveness of the musical form suggests the drone chord of the raga.

The culmination of the Indian connection in Glass's music was his opera Satyagraha, first performed in Rotterdam, Holland, in 1980. The work consists of several stories from the life of the young Mahatma Gandhi, the great pacificist and political and spiritual leader who led the campaign to free India from British rule. The work's title, Satyagraha, means "holding fast to the truth" and refers to Gandhi's nonviolent method of non-cooperation and civil disobedience. Slow and meditative in its rhythm, the music evokes the image of Gandhi sitting in

protest, as he fasted and meditated, in full confidence that India would eventually triumph.

Figure 8.11 Ravi Shankar playing the sitar, *Life* magazine, 1958. The sitar is a lute-shaped instrument with an extended neck and movable frets that enable performers to produce a wide range of scale tones.

MUSIC

Indian music is essentially melodic. Harmony is present only as a backdrop, in the form of the continuous sounding of a single tone, while the complex melody is elaborated over the top. Indian music is rarely written out formally as a score. This independence from notation offers performers great interpretive latitude, allowing them to improvise creatively and develop the mood of the pieces they play. The music is typically performed by a soloist, who plays or sings the melody; a drummer, who supplies the rhythm; and a third player, who provides the drone chord, which is a single three-note chord that is sounded continuously throughout the piece, usually on the lute-like *tambura*.

Although also serving a purpose as entertainment, Indian music is rich in religious associations. Hindu deities, for example, are frequently evoked in classical dance and songs. Moreover, it is not uncommon for musicians to consider their performance as an act of religious devotion.

The most important instrument in the performance of Indian music is the human voice. With its great flexibility and expressiveness, the voice provides a model for other instruments. As in the Western classical tradition, singers of Indian music are trained to be able to

perform an extensive range of vocal intricacies, often involving many more tones than in Western music.

The **sitar** is a lute-shaped instrument with an extended neck (fig. 8.11). Its movable frets enable performers to produce an enormous number of tones. The standard sitar has five melody strings, two drone strings, and a dozen or more "sympathetic" strings beneath them. These lower strings are not struck with the fingers or a plectrum as are the others. Instead, they vibrate in "sympathy" with those actually played, lending the music an enriched shimmering sound.

The sitar is the chief instrument used in playing ragas, musical compositions based on one of the eight primary rasas—moods or flavors—of Indian aesthetics: love, courage, hatred, anger, mirth, terror, pity, and surprise. A raga, then, is a piece of music that conveys a distinct impression (the word *raga* means "passion" or "feeling").

A standard raga form will include an improvised prelude or introductory section called an **alap**, played in a free tempo. This is followed by a formally composed musical section for a solo instrument with a percussion accompaniment. The final section is an improvisation on the composed music with many returns of the theme, in a form loosely comparable to the **rondo** (or returning theme) of Western music.

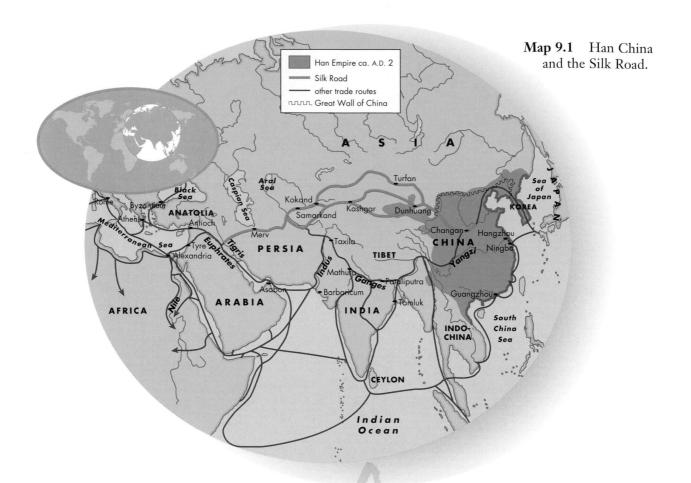

EARLY CHINESE *AND JAPANESE CIVILIZATIONS

CHAPTER 9

- China before 1279
- Japan before the Fifteenth Century

Zhu Jan, Seeking the Tao in the Autumn Mountains (detail), ca. 970, Collection of National Palace Museum, Taipei, Taiwan.

CHINA BEFORE 1279

THE SHANG AND ZHOU DYNASTIES

China is the world's oldest civilization, tracing its roots back as far as the fifth millennium B.C., although the earliest of the Chinese eras for which archaeological evidence has been found is that of the Shang dynasty, dating from ca. 1760 B.C. The Shang dynasty itself was long believed to be only legend and myth, until its existence was verified through twentieth-century excavations. These excavations have yielded not only ancient artifacts but also the oldest examples of Chinese writing. This written language has remained virtually unchanged for centuries, uniting a country about the size of the USA where the spoken form of the language varies so much that it cannot be understood from region to region.

The ancient Shang people inhabited the central Yellow River Valley area of China and developed the most advanced technology of the Chinese Bronze Age. The ruler of the Shang state had a quasi-divine status, which was honored by the people in ritual ceremonies and through serving the ruler in war. The talents of Shang craftworkers were also deployed in honoring their god-king rulers.

Although the oldest Shang city at Cheng Chow dates from the sixteenth century B.C., it is the later city site of

Figure 9.1 Fang ding, Tomb 1004, Houjiazhang, Anyang, Henan, Shang dynasty, bronze, twelfth century B.C., British Museum, London. The ornate design on this square vessel was typical for Shang bronze artifacts. The emphasis on animal motifs suggests the importance of hunting.

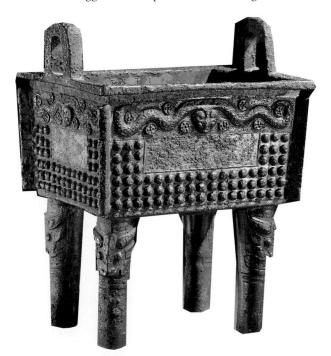

Anyang (ca. 1384–1111 B.C.) that has yielded the majority of Shang artifacts. At Anyang, archaeologists have found rich burial sites, but no city walls or dwellings, leading them to believe that Anyang may have been a royal burial site for another city.

The Shang kings ruled until about 1100 B.C., when the Zhou people came from the northwest and conquered them. The Zhou dynasty (1100-221 B.C.) introduced organized agriculture, which replaced the Shang emphasis on hunting. The Zhou established a feudal society—in which land was granted to someone by the king or an overlord in return for support in war and loyalty-with the Zhou king ruling as a "Tian" or "Son of Heaven." The principles of societal relationships that the Zhou formulated were to influence later Chinese civilization, and they can be found in such Chinese classics as the Book of Odes and the Book of Ritual. Yet while the Zhou modified the social and religious practices of the Shang, they adopted other aspects of Shang culture, in particular the Shang use of bronze casting and their decorative techniques.

Shang and Zhou Bronzes. Although jade and glazed pottery artifacts dating from the Shang dynasty have been found, by far the most numerous and important Shang artifacts are made of bronze. The fang ding (fig. 9.1) was used for storing food and wine for social and religious ceremonial functions. The emphasis on animal motifs, which is typical of the intricate ornamental design found in Shang bronze artifacts, suggests the importance of hunting in Shang culture. Yet the strange creatures depicted here evoke a sense of mystery and fear associated with the supernatural, and thus may be of religious significance as well.

Such bronze objects remained of great importance throughout the Zhou period that followed. One indication of the great wealth of the Zhou rulers is the monumental carillon, consisting of sixty-five bronze bells, discovered in the tomb of Marquis Yi of Zheng (fig. 9.2). The bells, which are believed to have been used to communicate with the supernatural, produce two quite distinct tones when struck near the center and at the rim.

Confucianism. Toward the middle of the Zhou dynasty, the two great philosophical and religious traditions indigenous to China took hold—Confucianism and Taoism. Like Buddhism (see Chapter 8), which would later have its own impact on China, Confucianism is based on the teachings of one man. CONFUCIUS [con-FYOU-shus] (551–479 B.C.) was the son of aristocratic parents who had lost their wealth during the decline of feudalism in China. Confucius's father died before he was born, and he was raised by his mother in poverty. He received an education from the village tutor, studying poetry, history, music, hunting, fishing, and archery—the traditional educational disciplines of the time. After a

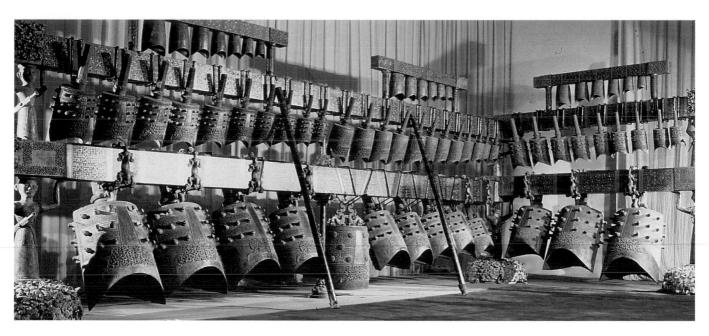

Figure 9.2 Bronze bells, Zhou dynasty, 433 B.C., frame height 9' (2.74 m), length 25' (7.62 m), Hubei Provincial Museum, Wuhan. These ancient ceremonial bells, which were believed to have been used to communicate with the supernatural, produce two distinct tones when struck near the center and at the rim.

brief stint as a government official, Confucius embarked on a career as a teacher. He wandered from place to place, offering his services as an advisor on human conduct and on government. After many years as a successful and famous teacher, Confucius spent the last part of his life quietly teaching at home.

After his death, Confucius's sayings, along with those of his followers, were collected together during the fifth century in a volume called *The Analects*. Drawing on cultural values anchored in ancient Chinese tradition, these eminently practical sayings focus on this world rather than the next. Although Confucius deeply respected the Chinese cultural heritage, valuing its best aspects, he adapted ancient traditions to the circumstances of his own time. Confucius lived in a period of political chaos and moral confusion; perhaps for that reason he emphasized the importance of the traditional values of self-control, propriety, and filial piety to a productive and good society. It was through such virtues that Confucius believed that anarchy could be overcome and social cohesion restored.

Confucius's point of departure was the individual rather than society. He believed that if each individual could be virtuous, then the family would live in harmony. Similarly, if each family lived according to certain moral principles, the village would be harmonious. Village harmony, in turn, would lead to a country focused on moral values, coupled with an aesthetic sensibility that would allow life to be lived to its fullest creative potential.

Four qualities in particular—*li*, *jen*, *te*, and *wen*—were valued in Confucian teaching. Li equates to propriety, ceremony, and civility, and requires the development of proper attitudes and a due respect for established forms of conduct. At its heart are the four basic social rules of human relationships: courtesy, politeness, good manners, and respect, especially a reverence for age. These are supplemented by a fifth rule or concept, that of yi or duty, a sense of the obligation one has to others. These five key rules strongly underpin the centrality of the family in Chinese life. Children's duty to their parents is the root from which moral and social virtues grow. In talking to an older person, for example, the younger person responds only after the elder has spoken. The younger person also listens with due deference, and does not interrupt or contradict.

Jen refers to the ideal relationship that should exist between people. Based on respect for oneself, jen extends this self-respect to others and manifests itself in acts of charity and courtesy. Jen and li together make for a superior human being according to the Confucian ideal.

Te refers to virtue. Originally it referred to the quality of greatness that enabled an individual to subdue enemies, inspire respect, and influence others. However, in Confucian teaching it came to signify a different kind of power—the power of moral example rather than that of physical strength or might. A strong leader who guides by example exhibits te. So do the forces of nature, as the following saying from *The Analects* illustrates:

Asked by the ruler whether the lawless should be executed, Confucius answered: "What need is there of the death penalty in government? If you showed a sincere desire to be good, your people would likewise be good. The virtue of the prince is like the wind; the virtue of the people is like grass. It is the nature of grass to bend when the wind blows upon it."

The final characteristic of Confucian tradition, wen, refers to the arts of peace, that is, to music, poetry, art, and other cultural activities. Confucius considered the arts a form of moral education. He saw music as especially conducive to order and harmony, and he believed that the greatest painting and poetry functioned in the same way as an excellent leader, insofar as they provided a model of excellence.

Ultimately, Confucius was an empiricist, justifying the value of his moral prescriptions by an appeal to experience. His teachings were designed to help his followers live a better life in the present rather than to achieve an eternal reward after death. Morality, moreover, depended on context. There was no inflexible "thou shalt not." Instead, any moral decision was guided by the circumstances of a particular problem.

Taoism. Like Confucianism, Taoism [DOW-ism] is principally concerned with morality and ethical behavior insofar as they benefit people in the present world. Thus it is often considered a philosophy rather than a religion. Its founder was LAOZI [LOW-ZEE] (b. 604 B.C.), whose name means "the Old Boy" or "the Old Master." Little is known about Laozi, though a number of legends exist to explain how he came to write the *Taodejing (The Way and Its Power)*, which summarizes Taoist teaching.

In the most popular of these legends, Laozi, having retired from court life, was journeying out of China when a guard at a mountain pass recognized him and insisted that he write down the sum of his wisdom before leaving the country.

The **Tao** (or Dao) is the ultimate reality behind existence, a transcendent and eternal spiritual essence. Mysterious and mystical, it is finally incomprehensible and ineffable. As the *Taodejing* states: "The Tao which can be conceived is not the real Tao ... Those who know don't say, and those who say don't know."

At the same time, however, the Tao is immanent—that is, it exists in nature, manifesting its ordering principle in the cycle of the seasons, in the flowing of rivers, in the singing of birds. In this second sense, the Tao is the governing order of life represented by the rhythm and force of nature.

Taoism is a way of ordering one's life. It is a set of principles by which to control one's life, so as to achieve peace and harmony with the rest of creation. Like Confucianism, Taoism values *te*, or power. In Taoism, however, the *te* of a thing is its power in the sense of its essential virtue, its identity, and integrity. So the characteristic nature of each thing is its *te*. The *te* of a person is her or his integrity or genuineness—one's authentic self at its best. One expresses *te* through meekness and humility. Instead of competition, *te* proposes cooperation; instead of insistent willfulness, patient attentiveness.

Along with te, Taoists encourage wu-wei, a kind of creative calm. Wu-wei involves relaxing the conscious mind. Like the Buddhist and Hindu ascetic ideals, wu-wei seeks the denial of the personal and the dissolution of the

Timeline 9.1 Early Chinese culture.

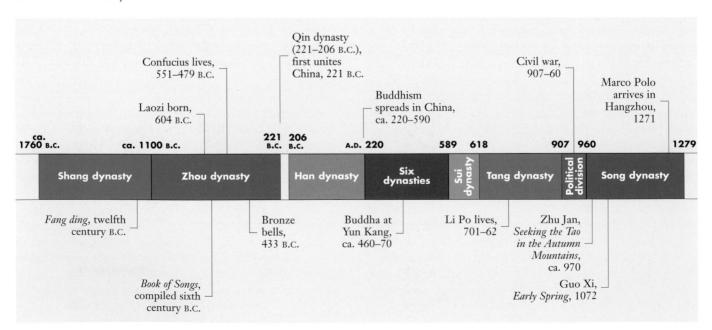

Figure 9.3 The yin/yang symbol. Yin and yang represent the complementary negative and positive principles of the universe.

conscious individual self. Taoism illustrates the concept of *wu-wei* with examples from nature, especially water. Supple yet strong, water adapts itself to its surroundings, flowing over or filling what it encounters.

The Taoist ideal of *p'u*, which literally means "unpainted wood," stresses simplicity. The Taoist prefers unvarnished wood, and thus Taoist architecture employs wood in its natural state, leaving gilt and lacquer to the Confucians, along with ceremonialism and the intricate forms and formulae of civilized life. Taoist painting uses only simple lines, suggesting much in little. Human figures in such paintings are kept small in relation to the vastness of nature.

Yin and Yang. One of the best known of all Chinese images is that of the yin and yang (fig. 9.3). **Yin and yang** represent contrasting but complementary principles that sum up life's basic opposing elements—pain and pleasure, good and evil, light and dark, male and female, and so on. Instead of seeing these contrasting elements as contradictory, the Chinese emphasize the way in which they complement one another.

Illustrating the philosophical ideal of harmonious integration, the two forms, yin and yang, coexist peacefully within a larger circle. Each form provides the border for its opposite, partly defining it. In the very center of each form, there is the defining aspect of the complementary form: the dark teardrop contains a spot of white; the white teardrop includes a small dark circle. The one cannot exist without the other.

Yin is the negative form, associated with earth, darkness, and passivity. Conversely, the yang form is positive and associated with heaven, light, and the constructive impulse. Yin and yang represent the perpetual interplay and mutual relation of all things.

Lyric Poetry. Unlike most national literatures, which typically have their origins in prose tales, epic poetry, or other narrative forms, the earliest known Chinese literature is lyric poetry. Lyrics are usually written to be set to music and are personal in nature. Educated Chinese were expected not only to understand and appreciate poetry, but also to compose it.

The Book of Songs, which contains material passed down orally from as far back as the tenth century B.C.,

was first written down in the sixth century B.C. in Confucius's time. It is one of the five ancient Confucian classics; some scholars have suggested that Confucius himself edited the collection. The poems are variously concerned with love and war, lamentation and celebration, and reflect the perspectives of all strata of ancient Zhou society, from peasants to kings.

As is suggested by its title, *The Book of Songs* contains poems that were meant to be accompanied by music. More than half of the 305 poems are classified as folk songs; the remainder were either written for performance at court or as part of a ritual. The individualism and occasional rebelliousness of the speakers in the poems sometimes make them seem at odds with the Confucian ideal. However, the depth of feeling they express and the richness of the experience they draw on have ensured that *The Book of Songs* remains not only popular but also essential reading for educated Chinese to the present day.

Music. During the time of Confucius and Laozi, music was categorized according to its social functions. Particular types of music played on certain instruments in specified tonalities were designated for use in accompanying the chanting of poetry, the worship of ancestors, as well as at court banquets, country feasts, archery contests, military parades, and the like. Confucius, like Plato, believed that music should be used to educate. Music was to display the qualities of moderation and harmony, mirroring the emphasis that Confucius placed on those virtues in social and political life. Certain dangerous aspects of music were to be avoided, such as its ability to induce excited states of emotion.

EMPIRE: THE QIN AND HAN DYNASTIES

Both Confucianism and Taoism developed in response to the political instability of the Zhou dynasty, which began to be undermined by invasions from the west in 771 B.C. Political fragmentation continued until the QIN [CHIN—the origin of the name China] dynasty (221–206 B.C.) unified the country for the first time.

Although the Qin dynasty's rule was brief, it introduced many measures to ensure that the empire could be ruled efficiently and would remain unified, which indeed it has down to the present day. The Qin rulers established a central bureaucracy, divided the country into administrative units, and standardized the writing system, as well as the currency, weights, and measures. All citizens were made subject to Qin laws, and everyone had to pay taxes to the Qin emperor.

The Qin initiated major building projects—networks of roads and canals that would link the different parts of the empire. It was also the Qin who created most of the fourteen-hundred-mile-long Great Wall as a defense for their empire against invaders. The Great Wall was made

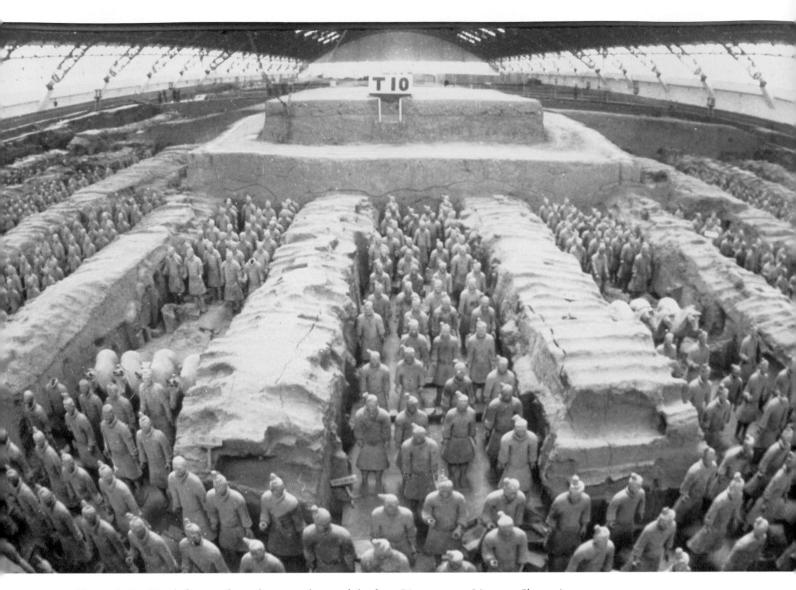

Figure 9.4 Tomb figures, from the mausoleum of the first Qin emperor, Lintong, Shaanxi. Qin dynasty, ca. 210 B.C., earthenware, lifesize. This army of terra cotta figures, found buried in the mausoleum of the first Qin emperor, was meant to serve him in the afterlife.

by joining together the border walls of the formerly independent regions.

There was a downside to this great imperial ambition, however. In order to maintain control, the Qin suppressed free speech, persecuting scholars and destroying classical literary and philosophical texts, which were only preserved by the ingenuity of those who memorized and later reconstructed them. Confucianism was temporarily supplanted with a new philosophical system called Legalism created by Qin intellectuals. Reflecting a belief in the absolute power of the emperor, Qin rule proved so harsh that rebellions soon broke out and the dynasty was overthrown after only fifteen years in power.

Some idea of the aspirations of grandeur of the Qin dynasty can be gained from viewing the tomb of the first

Qin emperor, SHINHUANGDI [SHIN-HU-AN-TI] (221–206 B.C.) (fig. 9.4). Excavators working in Shaanxi province inadvertently uncovered thousands of lifesize earthenware figures, which had been buried in the emperor's tomb to accompany and serve him in the afterlife. The emperor's burial ground was richly stocked with furniture, as well as with wooden chariots, and even contained a model of the Qin universe, with representations of rivers and constellations of stars and planets.

With the advent of the Han dynasty (206 B.C.–A.D. 220), Chinese culture found its most characteristic and defining forms. Han emperors restored Confucianism to favor, making it the state philosophy, established a national academy to train civil servants, and reinvigorated

classical scholarship and learning by honoring scholars and employing them in the national bureaucracy.

It was under the Han dynasty that the Silk Road trade route was established. It was along the Silk Road that goods traveled from China to India, and on to Greece and finally Rome. It was also by this route that religious missionaries from the West brought Christianity to India and Persia, and Buddhism spread from India into China, where it soon flourished.

THE SIX DYNASTIES

Intrigue and rebellion led to political and social disunity during the period of the "Six Dynasties" (A.D. 220–589), which followed the Han dynasty. Warring factions fought for control of the country, with six successive dynasties gaining power for a brief time. From this period of political turmoil there survives a series of monumental stone sculptures cut into caves at Yun Kang (Yungang, Shaanxi). The most colossal of these is a forty-five-foot-high image of the Buddha (fig. 9.5), made around A.D. 460–470. The statue is carved directly into the rock cave, in the manner of Indian monumental sculpture, from which this Buddhist figure clearly derives (compare fig. 8.6). This earliest of Buddhist styles of sculpture in China has been termed "archaic," and, as in

ancient Greece (see fig. 3.26), the figures characteristically wear what has been called on an "archaic smile."

THE TANG DYNASTY

At the end of the Six Dynasties period, the Sui rulers (A.D. 589–618) reunited China. The Sui, the last of the six dynasties, were quickly overcome, however, by the Tang dynasty, who went on to reestablish China as a world power during nearly three hundred years of prosperity and cultural enrichment (A.D. 618–907).

The Tang emperors restored the Silk Road, which had fallen into disuse during the Six Dynasties period, forging trade and cultural links with other countries, especially Persia, India, and Japan. During the Tang dynastic period, literature and the other arts were held in high esteem, with civil servants and gentry required to master the Confucian classics and to compose poetry of their own.

Li Bai and Du Fu. Much early Chinese poetry was composed according to ancient folk-song models. These poems were called **shih**. Two of the great practitioners of shih were LI BAI previously known as LEE PO (701–762) and DU FU [DOO FOO] (712–770). Both poets have long been associated with Confucianism and

Figure 9.5 Colossal Buddha, cave 20, Yungang, Shaanxi, A.D. 460–70, stone, height 45′ (13.72 m). Like the less monumental sculptures of ancient Greek civilization (see fig. 3.26), this archaic figure possesses a similar smiling expression.

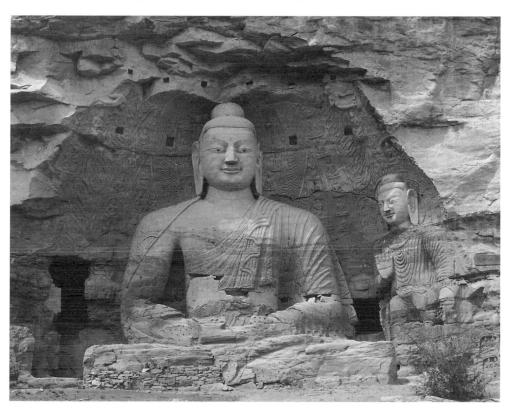

Connections

THE SEVEN SAGES OF THE BAMBOO GROVE

Early in the Six Dynasties period, seven Taoist poet-philosophers, seeking relief from the formalities of Confucianism, began to hold meetings in a bamboo grove. There, these "Seven Sages" gathered to consider the spiritual side of their life, write and discuss poetry, play musical instruments, play chess, contemplate nature, and, perhaps above all, drink wine. The latter, they felt, released the spirit from all constraint. As one famous saying of the Sages had it:

Brief indeed is a man's life! So, let's sing over our wine.

Ruan Ji was said to have given up a high official post in order to live near a brewery. In one of his famous poems, entitled "Singing from My Heart," he remembers his seriousness as a youth and comments that now "I mock myself for my past gloom." Liu Ling, another Sage, wrote the "Hymn to the Virtue of Wine" and is notorious for having tricked his teetotalling wife by telling her that he too had decided to give up alcohol and having her prepare a feast

for the gods, and then drinking all the wine intended for the gods himself.

The Seven Sages inaugurated a tradition that would last for many centuries in China and still finds an echo today in the West in a film such as Dead Poets' Society. During the Tang dynasty, the poet Li Bai took his followers on a similar retreat to a garden of peach and plum trees on a moonlit spring night. There, they too drank wine and, having liberated themselves from the constraints of their everyday lives, composed their poems. Both the gathering of the Seven Sages in the bamboo grove and Li Bai's conclave in the orchard would be a subject for painters for generations to come (fig 9.6).

Figure 9.6 Liang Kai, *The Poet Li Bai Walking and Chanting a Poem*, Southern Song dynasty, ca. 1200, hanging scroll, ink on paper, $31\frac{3}{4} \times 11\frac{7}{8}$ " (80.6 × 30.2 cm), Tokyo National Museum, Japan. This depiction of Li Bai juxtaposes the quick brushstrokes used to describe the robe with the precise and detailed work on his face, suggesting a tension between the freedom of the poet's spirit and the intensity of his intelligence.

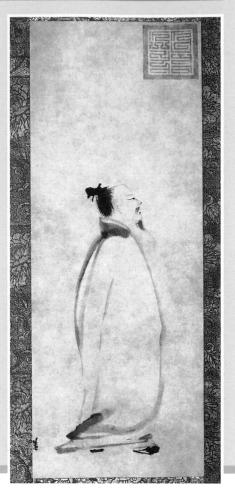

Taoism. Du Fu is often described as a Confucian poet. Du Fu's poems stress the importance of love of family and of harmonious social relationships. They also celebrate the Con-fucian ideals of self-discipline and serenity.

The poems of Li Bai (or Li Po, as he is sometimes known) are written in a more open style and take greater liberties with the formal poetic conventions of the time than the poems of Du Fu. Li Bai (fig. 9.6) has been described as a poetic individualist and a precursor of the Western Romantic poets (see Chapter 18). His verse has been profoundly influential in China and also in Japan, where he is known as Rihaku. Through the translations of Ezra Pound and the Sinologist Arthur Waley, he has also had a strong impact on modern American poetry.

THE SONG DYNASTY

When the Tang dynasty came to an end in 907, China was thrown into a half-century of civil war. The empire was reunified in 960 under the Song rulers, who inaugurated a period of great technological advancement. During the Song dynasty (960–1279), China saw within

its borders the invention of the navigational compass, paper currency, gunpowder, and printing, well before Gutenberg's invention of movable type in fifteenth-century Germany. The rule of the Song emperors created two conditions necessary for artistic development: first, an abundance of leisure time, which allowed for intellectual pursuits, including a reformulation of Confucian ideals; second, the availability of patronage, which helped bring about a resurgence in the art of painting and, with it, elaborations of art theory.

Painting. The art of painting flourished during the Song period. Seeking the Tao in the Autumn Mountains (fig. 9.7), by ZHU JAN [JOO JAN] (fl. ca. 960–980), is, as its title suggests, representative of the Taoist artistic tradition. Huge mountains evoke a sense of the remote and the eternal. Rising dramatically and powerfully in the center of the painting, they suggest the modest position of humanity in the grand scale of the natural world.

Neo-Confucianism, which developed during the Song dynasty, unified Taoism and Buddhism into a single system of thought. *Early Spring* (fig. 9.8), by GUO XI

Zhu Jan, Seeking the Tao in the Autumn Figure 9.7 Mountains, ca. 970, ink on silk, $61\frac{1}{2} \times 30\frac{3}{4}$ " (156.2 × 78.1) cm), Collection of National Palace Museum, Taipei, Taiwan. Long sweeping brushstrokes complemented by carefully placed dots of dark ink accentuate the mountain's highlights as they guide the viewer's gaze upward.

[GOO-OH SEE] (after 1000-ca. 1090), embodies the Confucian ideal of *li*, which is at the heart of nature. As in Zhu Jan's painting, the human presence in this landscape passes almost unnoticed, so vast is the scale of the central mountain. Small figures can be identified in the lower foreground on both the left and right, and in the middle distance on the right a village is tucked between the hills. The mountain, representing Nature, is a powerful symbol of eternity that dwarfs human existence.

A court painter during the reign of Emperor Shenzong (r. 1068-85), Guo Xi was given the task of painting all the murals in the Forbidden City, the imperial compound in Beijing that foreigners were prohibited from entering. His ideas about painting were recorded by his son Guo Si in a book entitled The Lofty Message of the Forests and Streams. According to Guo Si, the central peak in Early Spring symbolizes the Emperor himself, its tall pines the gentlemanly ideals of the court. Here Guo Xi has painted the ideal Confucian and Buddhist world; the Emperor, like the Buddha surrounded by his bodhisattvas, gathers all around him, just as in Early Spring the mountain, the trees and hills suggest the proper order and rhythm of the universe.

Guo Xi, Early Spring, 1072, Northern Song Figure 9.8 dynasty, hanging scroll, ink and slight color on silk, length 5' (1.52 m), National Palace Museum, Taipei, Taiwan. Everything has its appropriate place in the Chinese universe, and thus we gaze up at the central mountain here, which represents the Emperor, and down into a deep gorge, where at the bottom right a human figure rows a boat, underscoring the insignificance of the individual in the face of both nature and, symbolically, the emperor.

Gross Currents

MARCO POLO'S HANGZHOU

Little was known about China and the Far East in the West before the nineteenth century. One of the most important sources was the account written by the Venetian traveler MARCO POLO (ca. 1254–1324). His description of the Song capital, Hangzhou, is particularly vivid.

Hangzhou, formerly called Kinsai, or the "City of Heaven," might also have been known as the "City of Bridges," since twelve thousand wood and stone bridges cross its wide waterways. Described by Polo, who arrived in the city in 1271, as, "without doubt the finest and most splendid city in the world," the Hangzhou of the Song dynasty was an important commercial center as well as the imperial capital of China. Its population—of more than a million people—was then the largest in the world. Thirty-foot-high crenelated walls, studded with towers, protected

the city against enemy attack. Guards stationed strategically at the bridges to repulse invaders also served as time-keepers, striking a gong and drum to mark the passing of the hours.

Polo's descriptions evoked life in Hangzhou for his Western audiences. On the city's streets, porters carried goods suspended from long poles in baskets and jars. On its canals, boats and ships of many sizes transported food and building materials. Its markets, open three days a week in the city's squares, were crammed with food and spices, books and flowers, cloth and gemstones, in addition to a huge variety of meats and game. Dress, as in the West, was a mark of social and financial status for both women and men. The rank of mandarins (government officials) was indicated by robes and headgear. On special occasions, these mandarins wore silk robes embroidered with flowers, animals, and symbols. Their belt buckles were made of jade or

rhinoceros horn, and their caps were adorned with buttons, again signaling the officials' importance.

Among the places people congregated, according to Polo, were parks and lakes, especially the great West Lake, which was often filled with boats, barges, and floating teahouses, from which passengers could view the numerous palaces, temples, pagodas, and pavilions that dotted the surrounding landscape. On land, the wealthy congregated in clubs and centers to read poems, see plays, sing, and dance, as well as practice calligraphy and painting. It was especially important for young men with the ambition to become scholar officials to become well versed in the Chinese classics in preparation for the civil service examinations. Young women were also expected to take lessons, with classes in music, dancing, spinning, embroidery, and social etiquette preparing them for the good marriages they hoped to contract.

Japan before the Fifteenth Century

Until some time during the first centuries A.D., Japan remained politically fragmented, split into more than a hundred independent warring states. Then some regions began to form tribal confederacies. These were typically ruled by an aristocratic warrior clan. Around A.D. 300 one of these clans, the YAMATO [ya-MAH-toh], emerged as a dominant force throughout the country.

Yamato rule, which begins the KOFUN period, was indebted in many respects to the Chinese model. Chinese political administration, Chinese religion and philosophy, and the Chinese system of writing soon became ingrained in Japan. At first, this influence came through Korea, with which both Japan and China maintained close relations. Then, from around A.D. 625 to A.D. 825, Japan had direct contact with China, largely through the Japanese students and political ambassadors who traveled between the two countries.

RELIGION

Buddhism and Shinto. Of the religious influences Japan inherited from China, the strongest was that of

Buddhism, which China had itself imported from India. But whereas China stressed the philosophical elements of Buddhism, Japan stressed its religious aspects. This difference in cultural style is especially evident in the way Japan modified and adapted the Chinese form of Ch'an, later developing what became known as Zen (see p. 307).

Japan, however, already had its own religious practices, designated as **Shinto** to distinguish them from the imported forms of Buddhism. Shinto later developed from a kind of nature worship into a state religion of patriotic appreciation of the Japanese land. Shinto requires a commemoration of Japanese heroes and significant events from the nation's history. Shinto can also include aspects of animism, nature worship, and ancestor worship, and Shinto rituals may be carried out in private homes as well as in Shinto temples.

To some extent, the development of Shinto was a reaction against Chinese religious and cultural influence. In addition, in the seventh and eighth centuries, the Japanese collected their native myths in the *Kojiki*, "Chronicles of Ancient Events." In explaining the origin of Japanese culture, the *Kojiki* describe the creation of the Japanese islands by two *kami*, or gods, Izanagi and his consort Izanami. All other gods descend from these two, of whom the most important is Ameterasu, the sun goddess, said to be the ancestor of the Japanese emperors.

ASUKA AND NARA PERIODS

Art and Architecture. The earliest Japanese sculpture and architecture, that of the Asuka period, A.D. 552-646, is closely identified with Buddhism. One of the best-preserved and most important Japanese temples is Horvu-ii, the oldest wooden temple in the world (ca. 670) (fig. 9.9). Horyu-ji's architectural design reveals how Buddhist-inspired Chinese architecture influenced early Japanese temple-building.

Among the many treasures housed in the buildings of Horyu-ji is a sculpture known as the Shaka Triad (fig. 9.10). This is, as its title suggests, a triple image of the Buddha, whose Japanese name is Shakyamuni. The oversized figures, especially the Buddha sitting in the center, and the decorative motifs, reveal the sculptor TORI BUSSHYI's [BOOSH-vi] awareness of the Chinese sculptural tradition.

From the late seventh century on, Japanese rulers were true monarchs, no longer merely aristocratic warlords. Around the same time, Nara became Japan's first true capital. Although the rulers of ancient Japan are often referred to as emperors, these rulers are best thought of as sovereigns. The distinction is important as it signals a shift from the military authority of the earlier warlords to a genuine pursuit of political and cultural cohesion.

Horyu-ji compound, with pagoda and Golden Figure 9.9 Hall, Nara, Japan, ca. A.D. 670, aerial view. Visitors entering this temple compound move through the first building and then must take a turn to the right or the left rather than moving in a straight line from one building to the next. This favoring of lateral over linear movement is a characteristic of Japanese artistic style.

Tori Busshyi, Shaka Triad, Asuka period, A.D. 623, bronze, height 5'9" (1.76 m), Horyu-ji, Nara, Asuka period, A.D. 623. The Buddha, flanked by attendants, sits in regal stiffness on a simple throne against a decorative background medallion that testifies to his importance.

THE HEIAN PERIOD

In 794, the Japanese capital was moved to Heian, which in the process became one of the most densely populated cities in the world. The Heian period was a period of rich productivity and peace. At this time, the Japanese sovereign had the support of aristocratic families. Court culture during the Heian era became extremely refined and elegant, and the arts flourished. Among the great works produced was the world's first major work of prose fiction, The Tale of Genji.

The Tale of Genji. One of the most enduring and influential works of Japanese literature is The Tale of Genji (Genji monogatari, ca. 1021), a sprawling narrative of court life, spanning many generations and featuring a host of characters. Considered the first important novel in world literature, The Tale of Genji, was written by MURASAKI SHIKIBU [moo-rah-SAH-key] (ca. 976ca. 1026), a member of the lower echelons of medieval Japanese aristocracy. Her work is highly regarded for its psychological subtlety and its rich portrayal of character.

The Heian era was a time of cultural sophistication, during which Japanese painters and poets broke away from the Chinese aesthetic influence of previous periods. To some extent, the novel romanticizes courtly life as the author experienced it, though without idealizing the characters so much that they lose their credibility. According to an eighteenth-century Japanese scholar, Matoori Noringa, the greatness of The Tale of Genji lies in the way it conveys the sorrow of human existence as reflected in the behavior of its hero, Genji. Though he violates the religious injunctions of Confucianism and Buddhism, Genji nonetheless "combines in himself all good things." Like the author who created him, Genji exhibits great sensitivity to the people who cross his path, especially the many women who share his love.

Heian Handscrolls. The art of the Heian period sees a movement away from religious subjects to more secular concerns. The art also shows the development of a more distinctively indigenous Japanese style. Japanese landscape painting, for example, departed from Chinese depictions of majestic mountains, replacing them with representations of paddy fields and cherry blossoms. In general, Japanese landscapes of this period are more

intricate than Chinese landscape paintings, evoking the sense of transience and poignant sadness frequently found in Japanese poetry.

One of the most distinctive of secular Japanese painting styles is exhibited in the painting of narrative handscrolls, or *emaki-mano*, associated with court life, and usually attributed to the artist TAKAYOSHI [ta-ka-YOH-shi]. Some of the most celebrated handscrolls are linked with *The Tale of Genji* (fig. 9.11). The oldest illustrations of this work date from ca. 1120, and survive only in fragments, along with short pieces of the handwritten text.

The highly decorative *Genji* illustrations emphasize the placement of figures, their costumes, and the use of color. The artist breaks up the composition by using screens, walls, and the kind of sliding panels found in the traditional Japanese home. Figures are shown at an angle, with the viewpoint from above. Women are depicted in broadly draped garments that hide their figures, leaving only their heads and hands visible. They are engaged in calm activity, one combing another's hair, while others read and look at picture scrolls. The overall effect is to convey a sense of court life quietly, with little dramatic action.

Map 9.2 Japan before the fifteenth century.

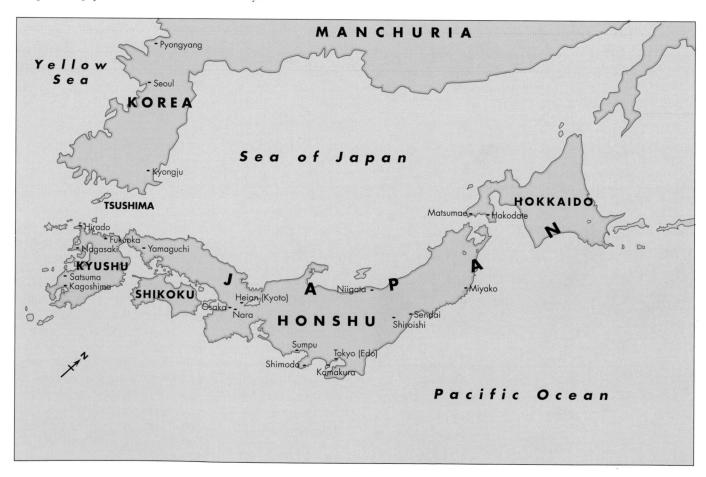

Figure 9.11 Attributed to Takayoshi, illustration to the Azumaya chapter of *The Tale of Genji*, late Heian period, twelfth century, handscroll, ink and color on paper, height $8\frac{1}{2}''$ (21.6 cm), Tokugawa Art Museum, Nagoya. This handscroll illustrates a scene from the world's oldest novel. Unlike Buddhist didactic illustrations, *Genji* illustrations were aimed at an aristocratic audience and reveal a nostalgia for the passing of an era of elegance, peace, and artistic prosperity.

THE KAMAKURA PERIOD

During the Heian era, rulers began to see their power diminish at the hands of the samurai, highly regarded and honored regional warriors in the service of the governing nobility. These warriors were at the disposal of warring families competing for the throne, and they were instrumental in the ascendancy of many rulers. The period is known as the Kamakura period because the capital was now moved to Kamakura. In a tradition inaugurated by MINAMOTO YORITOMO [MI-na-MO-to] (1147–1199), these warriors began to give themselves the title of shogun (general-in-chief) of the samurai. They continued to pay lip service to the official sovereign, but increasingly it was the shogun who exercised authority, a tradition that lasted in various forms until 1868 when imperial rule was properly restored. The shogun and his samurai prided themselves on their self-reliance, and they were particularly attracted to Zen, a form of Buddhism that promoted self-sufficiency.

Zen Buddhism. By the ninth century, Buddhism and Shinto had converged, to a certain extent, with the boundaries between the two religions becoming blurred. Shinto kami and Buddhist deities, for example, gradually became conflated. Buddhist priests used Shinto temples for meditation and worship; Shinto temples assumed elements of the Buddhist architectural style. Buddhism, however, began to assume prominence, temporarily

eclipsing Shintoism. Buddhism itself then underwent a transformation, as the Japanese converted the Chinese form of Buddhism they had inherited into their own uniquely Japanese form of Zen.

Nothing dominates Japanese cultural life after the rise of the shogunate more than Zen. Though it grew out of Indian and Chinese Buddhism, today Zen is often considered a distinctly Japanese religion, one that has influenced almost every aspect of Japanese cultural life, from civil ceremony and social etiquette, to flower arranging, the tea ceremony, painting, swordsmanship, haiku writing, and landscape architecture.

Zen has been defined as "the art of seeing into the nature of one's own being." It is less a religion or a philosophy than a way of life, an attitude, an active stance toward everyday experience. Like the Buddhism from which it sprang, Zen has no scripture, enforces no creed, requires no ritual ceremonies, has developed no theology. Nor is Zen concerned with the afterlife—with heaven or hell—or with the immortality of the soul. Its focus instead is on the world. When a Zen master was asked about life after death, he replied: "Leave that to Buddha, it is no business of ours."

When another Zen master was questioned as to how one could escape the reality of cold and heat, the pangs of hunger and the parching of thirst, he answered: "In winter you shiver, in summer you sweat. When you are hungry eat, and drink when you are thirsty." The point is

Then & Now

ZEN

Zen Buddhism was popularized in the United States through the writings of Teitaro Suzuki, especially his *Essays on Zen Buddhism*. These were first published in 1927 and then reprinted several times in the 1950s and 1960s as first the Beat generation and then the "hippies" discovered the philosophy. Suzuki was especially influential among artists, most notably the Abstract Expressionist painter Willem de Kooning and the composer John Cage, who studied with Suzuki in the 1940s (see Chapter 23).

So prominent and reverend a figure was Suzuki in the West that Christian Humphries, who was for many years president of the Buddhist Society in London, wrote in the preface to Suzuki's collected works, "To those unable to sit at the feet of the Master,

his writings must be a substitute." But Suzuki was hardly a master. Raised a Zen Buddhist, he traveled to the USA in 1893 as interpreter for Soyen Shaku, a genuine Zen master, who was to introduce Zen to the World's Parliament of Religions in Chicago. A Chicago publisher soon enticed Suzuki to return to the United States to work as a translator. He became the first, and for many years remained probably the only, Zen Buddhist living in the USA.

Suzuki himself never claimed to be anything other than a lay authority on Zen, but he was taken by almost everyone to be a master. Whatever the case, Suzuki's version of Zen was very different from traditional Japanese Zen. Suzuki promised the possibility of "sudden" satori, or enlightenment. It should be said that of the three main Zen sects, only one is interested in satori—the one

in which Suzuki was raised-and even for that sect it is only a starting point on the road to the negation of personality. But for Suzuki, satori was key. "Satori finds," he claimed, "a meaning hitherto hidden in our daily concrete particular experiences." This was an idea that American artists, well versed in the writings of Emerson and Thoreau, found compelling. The "Zen-man" was the consummate artist. As Suzuki himself put it in Zen and Japanese Culture, "While the artists have to resort to the canvas and brush or mechanical instruments to express themselves. Zen has no need of things external ... The Zenman is an artist [who] transforms his own life into a work of creation!" Suzuki's "Zen-man" is hardly the personality deprived of all sense of self, the product of Zen meditation. It is, rather, a distinctively American phenomenon.

that one does not try to escape physical reality. In Zen, one accepts it for what it is. Life is to be lived, not transcended, and Zen informs everything in one's life, from getting dressed and eating, to reading, working, and relaxing. Life is to be lived simply, directly, and attentively, even appreciatively. There is no mystery about it.

One aspect of Zen particularly attractive to Westerners is **satori**, the achievement of enlightenment. This is enlightenment of the kind taught by the Buddha, symbolized by a third eye, which opens not on a hidden world but on the world seen by the other two eyes. The third eye sees things as they really are, sees what is ever present

but is yet to be discovered or noticed. Satori, then, is less an attainment of a special state of bliss or mystic ecstasy, than a realization or state of awareness. With enlightenment comes a transformation of the world from one that contains contradictions and oppositions to one that reflects unity, consistency, and harmony.

THE ASHIKAGA PERIOD

The Kamakura period ended in civil war in 1333, and insurrections of one kind or another continued to plague Japan almost continuously until 1573, when a central government was formed. During this era, known as the

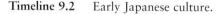

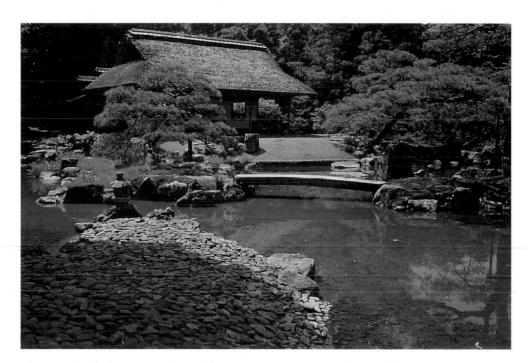

Figure 9.12 Shokintei (Pavilion of the Pine Lute), Katsura Palace gardens, near Kyoto, early 1660s. Named after the sound of wind in the pines that surround it, the pavilion is larger than many tea huts, but its setting is almost ideal.

Ashikaga period, Japan was ruled by shoguns and their samurai warriors, and as a result Zen practice dominated Japanese life.

Tea Ceremony. One of the major cultural institutions founded on Zen thinking is the *cha-no-yu*, or the "tea ceremony," which developed during the Ashikaga period and survives to this day. According to Rikyu, one of its founders, "The tea ceremony is nothing more than boiling water, making tea, and drinking it." But it is a much more elaborate ceremony than Rikyu lets on, one that the Portuguese Jesuit priest Joao Rodrigues (1562–1633) described after thirty years of life in Japan as a ritual designed "to produce courtesy, politeness, modesty, moderation, calmness, peace of body and soul, without pride or arrogance, fleeing from all ostentation, pomp, external grandeur and magnificence."

The tea ceremony began in the 1470s when the Ashikaga ruler Yoshimasa retreated from the conflicts

that dominated urban life to collect Chinese paintings and ceramics at his villa on the island of Higashiyama. The monk Murata Juko suggested to him that by drinking tea in a small hut like that illustrated here, in the Katsura Palace gardens (fig. 9.12), with only a few companions, he could experience wabi, "lonely seclusion." Wabi is a heightened sense of awareness, in which the practitioner experiences, for instance, "the cold winter wind on his skin."

In the tea ceremony proper, the kettle, the simple pottery tea cups made in local Japanese kilns, even the bamboo tea scoop were objects to be contemplated and appreciated for their humble practicality. The tea hut was decorated with a hanging scroll of painting or perhaps a flower arrangement appropriate for the time of year, and the hut itself was placed in a carefully designed garden. The self-conscious simplicity, even starkness, of the tea ceremony has continued to influence Japanese design and taste to this day.

THE — CIVILIZATIONS OF THE AMERICAS

CHAPTER 10

- Mesoamerica
- ← The Cultures of Peru
- * North America

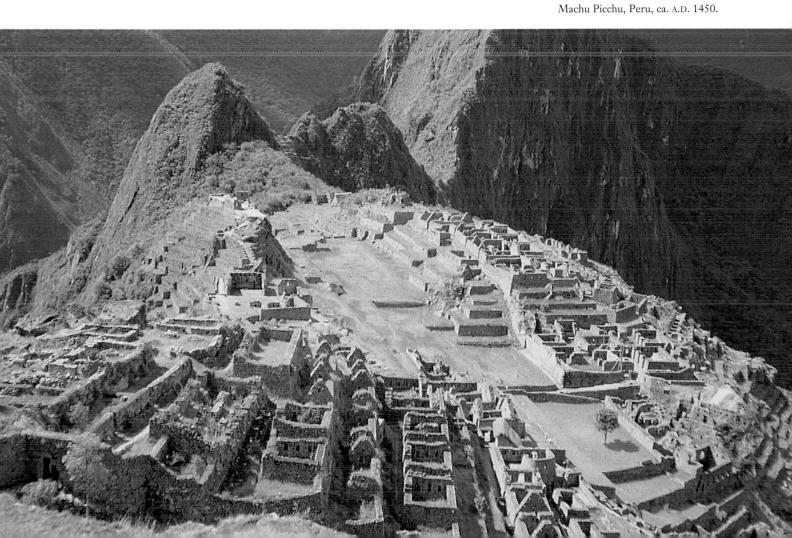

Sometime between 30,000 and 12,000 years ago, at the height of the Ice Age, tribal hunters began to migrate from Asia into the Americas across a land bridge that extended for perhaps a thousand miles south of the presentday Bering Straits. This giant plain was rich in grass and animal life, and the tribes were naturally drawn on further across it, and then on southward, in pursuit of game. By 11,000 B.C., they had reached the tip of South America and the Atlantic coast of North America.

As the ice melted and the oceans rose at the close of the Ice Age, the tribes in the Americas were cut off from Asia and Europe. This isolation lasted until October 12, 1492, when Christopher Columbus landed on San Salvador in the Bahamas. Thinking he was on the east coast of Asia, near India, Columbus called the people who met him "Indios," Indians. While these Native Americans seemed simple and uncivilized to Columbus, they were in fact the descendants of ancient and often quite magnificent civilizations, some of which dated back to the first millennium B.C.

MESOAMERICA

Mesoamerica extends from central Mexico to Honduras, and includes Belize and Guatemala. The ancient Mesoamerican cultures include those of the Olmecs (1300-600 B.C.), the Maya (250 B.C.-A.D. 1000), the Zapotecs (400-800), and the Toltecs (900-1200), precursors of the Aztecs (1350-1521), along with the civilization of Teotihuacán (100–800). The Mesoamericans spoke many languages. Among these was the Nahua family of languages, which includes thes language of the Aztecs and the Maya, dialects of which survive to this day in southern Mexico and Guatemala. The diverse early Mesoamerican civilizations shared other cultural features. including hieroglyphic writing, an applied knowledge of astronomy, and a form of monarchical government intimately linked with religious ideas and practices.

THE OLMECS

The earliest Mesoamerican art dates from about 1300 B.C., when the Olmecs inhabited the southern coast of the Gulf of Mexico, especially the area between Veracruz and Tabasco. There is some question whether the Olmecs were a distinct people and culture or whether the term "Olmec," which derives from a word for rubber, refers to an artistic style that prevailed throughout ancient Central America.

Whoever they were, the Olmecs were outstanding stone carvers. The most remarkable carvings that have survived to the present day are a series of sixteen colossal stone heads up to twelve feet high (fig. 10.1). Eight of these heads were found in San Lorenzo, Veracruz, where they were placed facing outward on the circumference

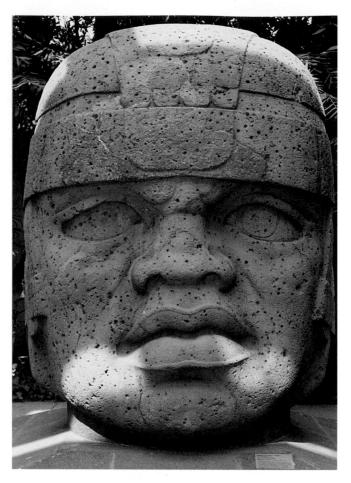

Figure 10.1 Colossal Head, from La Venta, Mexico, Olmec culture, ca. 900-500 B.C., basalt, height 7'5" (2.26 m), La Venta Park, Villahermosa, Tabasco, Mexico. This example of a giant carved stone head represents the height of sculptural achievement among the ancient Olmecs.

of a ceremonial area. They are carved of basalt. Since the nearest basalt quarry is fifty miles away in the Tuxtla Mountains, the enormous stones from which the heads were carved had, apparently, to be dragged down from the mountains, loaded onto rafts, floated down to the Gulf of Mexico, then up river to San Lorenzo, and finally dragged up and positioned on the ceremonial plateau.

Believed to be portraits of Olmec rulers, the heads share similar facial features, including flattened noses, thick lips, and puffy cheeks. They all are capped with headgear similar to old-style American football helmets. This is believed to have served as protection in war and in a type of ceremonial ball game played throughout Mesoamerica. Among other discoveries at San Lorenzo are stone figurines of ball players and a ball court.

TEOTIHUACÁN

Among the most splendid of all Mesoamerican sites must be the ancient city of Teotihuacán [te-oh-te-wu-KAN], which means "where one becomes a god." Teotihuacán (fig. 10.2) grew to dominance after 300 B.C. By the time it reached the height of its political and cultural influence, between ca. A.D. 350–650, its population numbered between 100,000 and 200,000, making it one of the largest cities on earth at the time.

The people of Teotihuacán were great pyramid-builders. The city is laid out in a grid pattern with a giant avenue (the Avenue of the Dead) at its center. This central artery links two great pyramids, the Pyramids of the Moon and of the Sun, which are the focal points of six hundred smaller pyramids, five hundred workshop areas, nearly two thousand apartment compounds, numerous plazas, and a giant market area. Built in about A.D. 150 over a natural cave (but only rediscovered in 1971), the Pyramid of the Sun is oriented to mark the passage of the sun from east to west and the rising of the stellar constellation the Pleiades on the days of the equinox. Thus it links the underworld to the heavens, the forces of life and death.

Along the Avenue of the Dead are a series of zigguratlike structures with numerous steps leading to an elevated platform, which originally supported a temple. After the Pyramids of the Sun and the Moon, the most important structure in Teotihuacán was the Temple of Quetzalcoatl, the god of priestly wisdom. This temple contains elaborate relief carvings, which include the heads of feathered serpents and fire serpents.

The overall design and layout of Teotihuacán suggests its role as an astronomical and ritualistic center. The relation of the Pyramid of the Sun to the others suggests the order of the universe, a cosmological order that influenced all aspects of life, including political organization, social behavior, and religious ritual. Even time was represented. Each of the two staircases of the Pyramid of the Sun, for example, contains 182 steps, which, when the platform at the apex is added, together total 365. This spatial representation of the solar calendar is echocd in the Temple of Quetzalcoatl, which has 364 serpent fangs.

By about 700, Teotihuacán's influence had waned, and the city was sacked and burned in about 750. We can only speculate about what finally led to its demise, but an ecological explanation is possible. The surrounding countryside had been pillaged to provide lime for the mortar used to build Teotihuacán. As the city's population grew, adequate provision of food became a problem.

Figure 10.2 Teotihuacán, Mexico, Teotihuacán culture, A.D. 350–650. The city of Tcotihuacán covered an area of nine miles square and contained between 100,000 and 200,000 people, an enormous scale and population for a culture of its time.

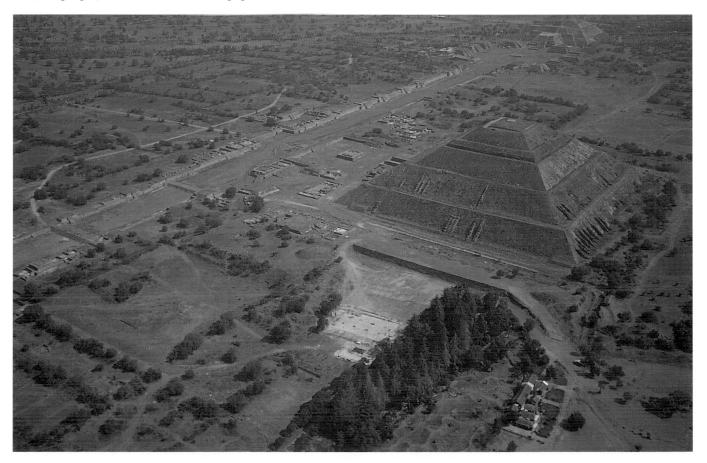

Coupled with the effects of drought, the environmental catastrophe wreaked upon the countryside probably made it impossible to maintain a stable civilization.

MAYAN CULTURE

The ancient Maya inhabited the Yucatán peninsula, which extends into Belize and Guatemala, parts of the Mexican states of Chiapas and Tabasco, and the western part of Honduras and El Salvador. The culture appears to have lasted from about 250 B.C. to A.D. 1000. Although the Maya possessed their own form of hieroglyphic writing, they shared with other Mesoamerican peoples the use of books made of fig-bark paper or deerskin that unfolded into screens. The ancient Maya are set apart from their ancient Mesoamerican neighbors, however, in their arithmetical and astronomical knowledge, which rivaled that of the ancient Babylonians. The Maya possessed a profound understanding of the regularity and continuity of the heavenly bodies, which they saw as a metaphor for the ruler's consistent safeguarding of his people.

The Mayan Universe. For the Maya, the universe consisted of three layers—the Upperworld of the heavens, the Middleworld of human civilization, and the Underworld below—linked by a great tree, the Wacah Chan, which grew from the center of the Middleworld and from which the cardinal directions flowed. Each direction possessed its own symbolic significance and was represented by its own color, bird, and gods. East was the principal direction, since the sun rose there, and its color was red. North was the direction of the dead, and its color was white. The king was the personification of the Wacah Chan. When he stood at the top of a pyramid in ritual activity, he was seen to link the three layers of the

universe in his own person. During such rituals, the king would let his own blood in order to give sustenance to the spiritual world. While ritual bloodletting seems to many people to be a barbaric or at least an exotic practice, it should be remembered that Christians symbolically drink the blood of Jesus when they celebrate Holy Communion—the role of blood in Mayan ritual is similar.

To the Maya, time was not linear, as we conceive it, but cyclical. They used two calendars. The first was a 365-day farming calendar which consisted of eighteen "months" of twenty days each and one short month of just five days. The second was a sacred calendar of 260 days which probably relates to the average length of human gestation from the first missed menstrual flow to birth (which is actually 266 days). It is clear that this second calendar possesses a close connection to Mayan bloodletting rituals. The Mayans combined the two calendars to create a long cycle of fifty-two years, or 18,980 days (a particular day in one calendar will fall on the same day in the other calendar every fifty-two years), at the end of which time repeated itself.

Tikal. Among the most important sites of classic Mayan culture is that of Tikal [te-KAL], in present-day Guatemala. There, one of the great "ancestors" of Mayan civilization, Yax Moch Xoc (r. A.D. 219–238), ruled over a city which contained in an area of just over six square miles six giant temple-pyramids used for the celebration of religious rituals of the kind described above.

The meticulously ordered layout of Teotihuacán is not characteristic of Mayan cities. Tikal and other Mayan urban centers seem instead to have grown by accretion, undergoing rebuilding and modification over centuries. Most striking among the remains of Tikal's buildings are

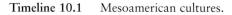

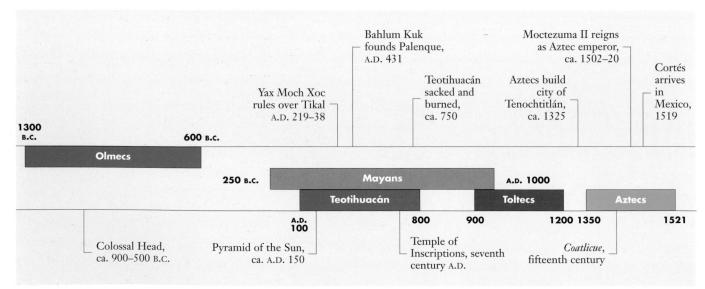

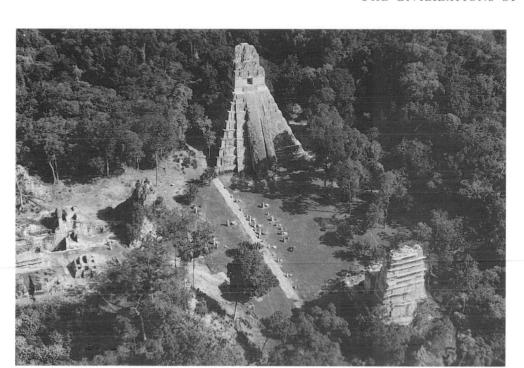

Figure 10.3 Tikal, Guatemala, Maya culture, ca. A.D. 700. Since Maya rituals were conducted in the open air, temple architecture atop pyramids emphasized external features.

six enormous temple-pyramids (fig. 10.3). Two of these are unusually steep, rising to a height of nearly 230 fect, and face each other across a large grassy square. Each is topped by an extension that resembles the comb of a rooster, called a "roof comb," and gives the impression of an elevated throne on an enormously high dais.

War dominated Tikal life. For two hundred years after A.D. 300, Tikal exercised power over the southeastern region of Mesoamerica. Its patron and protector was the Jaguar God, whose strength and hunting ability were likened to the power of the king himself and the warlike ferocity of the Tikal people. Like the king, the jaguar can adapt to every environment, hunting with equal facility on land, in water, and even in the Upperworld of the trees. That it hunts at night, with eyesight that penetrates the darkness, suggests its magical powers.

The Jaguar Kings of Palenque. The Jaguar God is common to all Mesoamerican cultures, from the Olmecs to the Aztecs. At Palenque, the Mayan kings called themselves Bahlum, "Jaguar," and their history is recorded on the Temple of Inscriptions (fig. 10.4). According to kinglists carved in the temple's corridors, the first king was Bahlum Kuk ("Jaguar Quetzal"), who founded the city on March 11, A.D. 431.

These king-lists, which record a dynasty of some twelve kings, were commissioned by two rulers, Pacal ("Shield") and his oldest son Chan Bahlum ("Snake Jaguar"). Pacal ruled for sixty-seven years, beginning in 615, and the Temple of Inscriptions was erected as his

tomb. In 1952, the Mexican archaeologist Alberto Ruz discovered a hidden staircase at the heart of the temple, and at its bottom Pacal's body, adorned with a jade collar and green headband, lying in a red-painted stone sarcophagus. The outside of the sarcophagus is decorated

Figure 10.4 Temple of Inscriptions, Palenque, Mexico, Maya culture, seventh century A.D. Rising in nine steps, like the temples at Tikal, the temple is inscribed with the history of the Palenque kings and rests over the grave of Pacal, one of its greatest leaders.

Then & Now

THE MAYA

Like Pacal himself, Palenque and the other Mayan states would eventually fall. Some time in the ninth century, the Maya abandoned their cities and returned to the countryside to farm, where their descendants work the fields to this day. Scattered across the southern Mexican state of Chiapas and throughout Guatemala, the contemporary Mayans speak twenty different dialects of their original language and engage in distinctly different cultural practices, sometimes in villages separated by no more than ten or twelve miles. In Chiapas, for instance, the Mayan inhabitants of the village of Zinacantán characteristically dress in bright red and purple and celebrate fiestas with loud bands and fireworks, while in nearby Chamula the men wear white or black wool serapes, carry large, intimidating sticks, and practice a stern, mystical brand of Catholicism that blends Mayan interest in the spirit world of animals with a part-Christian, part-Mayan sense of self-sacrifice.

Many traditional Mayan practices survive in contemporary culture. Not only do the beautiful embroidery and weaving of the contemporary Mayans contain references to ancient Mayan hieroglyphics, but Mayan women still associate giving birth with the ancient 260-day calendar. In fact, children born on particular days are still esteemed by contemporary Mayans as "daykeepers," persons able to receive messages from the external world, both natural and supernatural, through their bodies. These daykeepers describe a sensation in their bodies as if air were rapidly moving over it in a flickering manner, similar to sheet lightning moving over a lake at night. The daykeepers learn to interpret these tremblings and will eventually become the head "motherfathers" or priest-shamans of their respective families.

Blood also continues to play a significant role in contemporary Mayan culture. Throughout Guatemala and Chiapas, blood is still considered to be an animate object, capable of speaking. Shamans can receive messages from a patient's blood by "pulsing," or touching a patient's body at various pressure points. An ancient poem, which continues to be recited among contemporary Mayan peoples who no longer practice the ritual, describes the dance of the bowman, who sharpens his arrows and dances around the victims in preparation for their sacrifice. The song recalls and memorializes the staging of the sacrificial action, and testifies to the importance of memory as an aspect of Mayan culture.

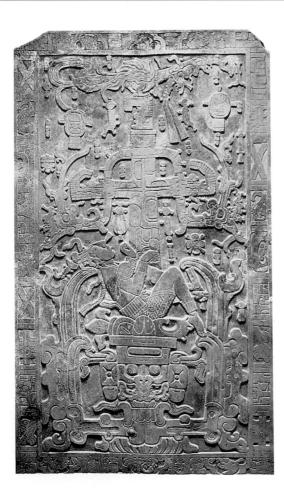

with a magnificent stone relief carving (fig. 10.5), which depicts Pacal's fall down the Wacah Chan, the great tree at the center of the world. Pacal lands at the bottom on an altarlike image that represents the setting sun.

THE TOLTECS AND AZTECS

Among the best known of the Mesoamerican civilizations is that of the Aztecs (or Mexica, as they referred to themselves). This civilization flourished relatively late, after approximately 1350, and continued until it was overcome by the Spaniards in 1521.

The greatest Aztec families claimed descent from the Toltecs, who were said to have invented the calendar and who were the mightiest of warriors. The Toltecs came to power in Tula in Hidalgo Province around A.D. 900 after Teotihuacán's power had diminished. In the twelfth century the militaristic Toltecs came to a violent end, when Tula was burned and its inhabitants scattered. Among the escaping tribes were the Mexica, who wandered into the Valley of Mexico around 1325 and built a village on the shores of Lake Texcoco. There they dug canals, draining high areas of the lake and converting

Figure 10.5 Sarcophagus lid, tomb of Pacal, Temple of Inscriptions, Palenque, Mexico, Maya culture, ca. A.D. 683, limestone, ca. $12'6'' \times 7'$ (3.80 \times 2.14 m). The lid represents Pacal's fall in death from the sacred tree of the Maya, whose roots are in the earth and whose branches are in the heavens.

them into fertile fields, and also built the magnificent city of Tenochtitlán. By 1440, when MONTEZUMA ILHUICAMINA [mon-tay-ZOO-mah] (r. 1440–1486) assumed power, they considered themselves masters of the entire world.

Perhaps the most frequently cited aspect of Aztec culture is human sacrifice, which was linked with religious ritual. As in Mayan culture, the shedding of human blood was seen as necessary for the continuance of the earth's fertility. The sun, moon, earth, and vegetation gods required human blood for their sustenance and the continuance of human life. During the reign of Moctezuma Ilhuicamina's successor, AHUITZOTL (r. 1486–1501), no fewer than twenty thousand captives were sacrificed in the city.

The central activity of the Aztec state was war, with the primary goal being to secure enough captives for sacrifice. Young men were prepared for war from their birth. A newborn male was greeted with war cries by his midwife, who took him from the mother and dedicated him to the Sun and to battle. His umbilical cord was buried by a veteran warrior in a place of battle. Following soon upon birth was the naming ceremony, during which the baby boy's hand was closed around a tiny bow, arrows, and shield. Shortly after this ceremony, priests fitted the child with the decorative lip-plug worn by Aztec warriors.

At puberty most commoner (i.e. non-royal) boys, with the exception of those destined to become priests, were placed under the jurisdiction of the youth house, which was associated with a local warrior house. Although young boys were trained for war, they were also taught various horticultural, mercantile, hunting, and fishing skills. Nonetheless, the way a young man secured prestige and fame was in war rather than in the pursuit of a vocation, with success measured in the number of enemy captured alive for later ritual killing on ceremonial occasions.

For Aztec men, dying in battle was considered a great honor, as is made evident in the following Nahuatl song:

There is nothing like death in war, nothing like the flowery death so precious to Him who gives life: far off I see it: my heart yearns for it!

Aztec art typically reflects the fierceness of the culture. A colossal statue of Coatlicue, the "Serpent Skirt," (fig. 10.6), goddess of the earth, shows a face with two serpent heads set on a thick powerful body. The serpents may represent blood jetting from the heads of ritually sacrificed women. Coatlicue's necklace is made up of human hearts and hands, with a human skull dangling at its base. Her skirt, which consists of writhing snakes, suggests sexual activity and its aftermath, birth.

Coatlicue is said to embody the Aztecs' belief in the creative principle, an attitude reflected in their love of

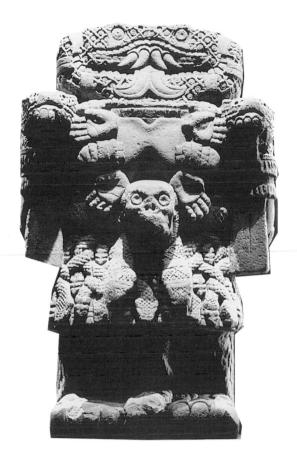

Coarlicue, Aztec, fifteenth century, stone, height 8'6" (2.65 m), Museo Nacional de Antropologia, Mexico City. With her two rattlesnake heads and her skirt of serpents, along with large serpent fangs and necklace of human body parts, this Aztec deity induces awe in some, amazement in others who stand in her presence.

poetry. For the Aztecs, poetic speech, chanted or sung, was a creative force, one that not only conveyed their vision of the world but simultaneously enacted it. This power of the poetic spoken word was further displayed in the Aztec emphasis on systematic memorizing of poems and songs to preserve Aztec cultural traditions. Poetry was called "flower-song." In Aztec painted scrolls, poetry is represented as a flowered scroll emanating from an open mouth. This use of images—of flower and song together—was characteristic of Nahuatl metaphor, standing for poetry specifically, and more generally for the symbolic dimension of art.

THE CULTURES OF PERU

Peru is a land of dramatic geographical contrasts. Along the Pacific coast is one of the driest deserts in the world, where the rivers that descend out of the Andes mountains to the east form strips of oases. The Andes themselves are mammoth mountains, steep and high. Beyond them, to the east, lies the jungle, the tropical rainforest of the Amazon basin. These various terrains were home to a series of cultures, in particular the Moche and the Inca, before the arrival of Spanish colonists.

THE MOCHE

Among the early cultures to develop in Peru was that of the Moche, who controlled the area along the Peruvian north coast from A.D. 200 to 700. They lived around great huacas, pyramids made of sun-dried bricks, that rose high above the river floodplains. The largest was Huaca del Sol, the Pyramid of the Sun (fig. 10.7), which is 135 feet high—about two-thirds the height of the Pyramid of the Sun at Teotihuacán. Its truncated summit, however, is much vaster than Teotihuacán's. At least two-thirds of the pyramid was destroyed in the seventeenth century when Spanish colonists, searching for gold, diverted the Moche River into it and used the river's fast current to erode the mound. The colonists did indeed discover many gold artifacts buried with the dead in the sides of the structure. Unfortunately, they melted these artifacts down for bullion. What they left, however, is a record of the pyramid's construction. The sliced-away mound reveals at least eight stages of construction, and we can extrapolate to conclude that around 143 million bricks, made in rectangular molds from river silt, were used to build it.

The Moche were gifted metalsmiths, and they employed the same lost-wax technique used by the Romans. They adorned their copper sculptures with gold

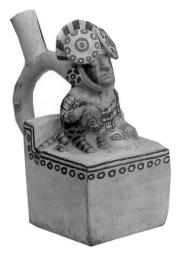

Figure 10.8 Moche Lord with a Feline, Moche culture, Moche valley, Peru, ca. 100 B.C.–A.D. 500, painted ceramic, height $7\frac{1}{2}$ " (19 cm), Art Institute of Chicago. Vessels such as this one were buried in large quantities with people of high rank.

by binding liquid gold to the copper surface at temperatures reaching as high as 1472°F (800°C). Further decorated with turquoise and shells, the results were often astonishingly beautiful. But the Moche were, above all, the most gifted ceramic artists in the Americas. In addition to working with potter's wheels, they also produced clay objects from molds, allowing them to reproduce the same objects again and again. Their most distinctive designs are found on bottles with stirrup-shaped spouts

Figure 10.7 Huaca del Sol (Pyramid of the Sun), Moche culture, Moche valley, Peru, ca. A.D. 500, height 135' (41.1 m). Destroyed by Spanish colonizers seeking gold, this giant pyramid was built of more than 143 million sun-dried bricks.

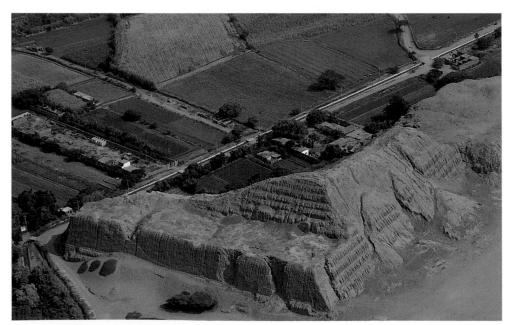

that curve out from the body of the vessel. Bottles might be decorated with images of anything from the king or high official—as illustrated here (fig. 10.8), in ceremonial headdress and stroking a jaguar cub—to strange partanimal/part-human deities, and to everyday scenes such as a design for a typical Moche house. Warriors do battle on some of the vessels, prisoners are decapitated and dismembered on others, while on another famous example, a ruler in a giant feather headdress looks on as a line of naked prisoners passes before him.

Around 800, Moche society vanished. Evidence suggests that some time between 650 and 700 a great earthquake rattled the Andes, causing massive landslides, filling the rivers with debris, and blocking the normal channels to the ocean. As the sand washed ashore, huge dunes were formed, and the coastal plain was suddenly subject to vast, blinding sandstorms. It seems clear as well that El Niño, the warm current that slides up and down the Pacific coast of the Americas, changed the climate, destroying the fisheries and bringing torrential floods to the normally dry desert plain. It was all apparently too much, and the Moche disappeared.

THE INCA

Roughly contemporaneous with the rise of the Aztecs in Tenochtitlán was the emergence of the Inca civilization in Peru around 1300. The Incas inhabited the central Andes in what is today primarily Bolivia and Peru. They became a dominant military force around 1500, and appear also to have developed an organizational capacity to rival the engineering genius of the Romans. The Inca capital was at Cuzco, a city of 100,000 inhabitants at its height, built on a broad open valley between the Andes mountains north of Lake Titicaca. They called their empire Tawantinsuyu, "Land of Four Quarters," and, in fact, four highways emanated from Cuzco's central plaza, dividing the kingdom into quadrants. The 19,000 miles of roads and tracks that extended throughout their empire provide some indication of their engineering skill. The Incas understood the need for a functional communications system in a territory as large as theirs. Along these roadways, official runners could carry messages as far as 125-50 miles per day. And along them as well llamas carried goods and products for trade.

Map 10.2 The Inca empire, ca. 1525.

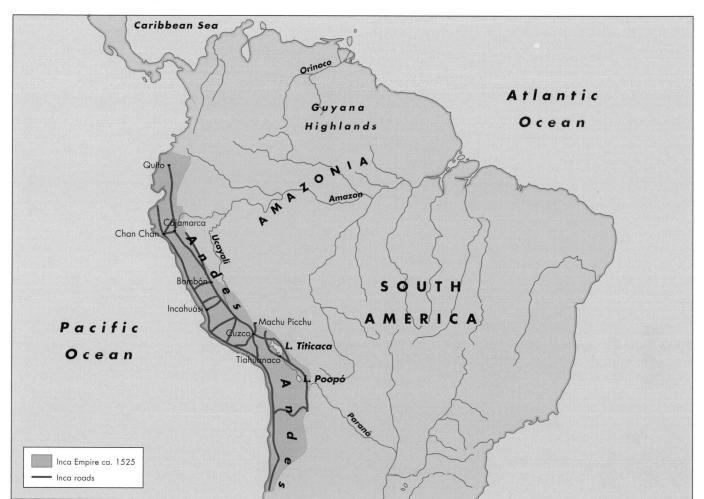

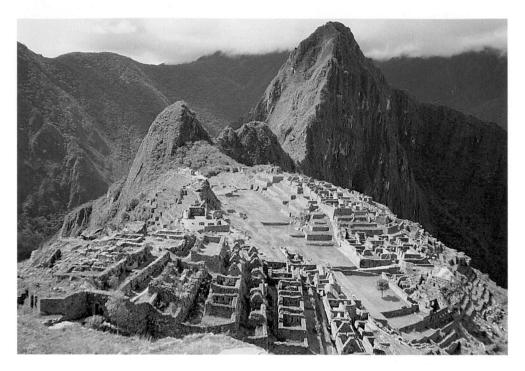

Figure 10.9 Machu Picchu, Inca culture, Peru, ca. 1450. This beautiful mountain habitation escaped destruction when the Spaniards overwhelmed the Inca civilization in 1532, partly because of its remote location high in the Andes mountains, and partly because it was not a large city like the Inca capital of Cuzco.

One of the most impressive of all Inca accomplishments is the fortified town of Machu Picchu (fig. 10.9), built around 1450. Located high in the Andes mountains, Machu Picchu was built perhaps as a refuge for Inca monarchs, perhaps as a place of religious retreat. Terraced fields adorn the slopes of the mountain that rises from the valley thousands of feet below. The stones for the walls and buildings were hoisted without benefit of carts or any wheeled contrivance, as the wheel was not used in either the Andes or Mesoamerica before the arrival of the Spaniards. Tools used for fitting the stones together snugly were primitive—mostly stone hammers, since neither the Andean nor Mesoamerican civilizations had developed metal implements at this time.

Machu Picchu was abandoned shortly after the arrival of Francisco Pizarro and the Spanish Conquistadores. The Spaniards destroyed Inca civilization with technologically advanced weapons by enlisting the allied assistance of Inca enemies, and through the agency of contagious diseases, especially smallpox. Just a dozen years after Montezuma and the Aztecs had been defeated by the Spanish under Hernán Cortés, the Andean Inca civilization suffered an equally ignoble demise. Machu Picchu, however, was overlooked by the Spaniards, perhaps in part because it was a small village of five hundred inhabitants. This oversight means that to this day it remains one of the architectural wonders of the world.

Timeline 10.2 Peruvian cultures.

Connections

THE MYSTERY OF THE NAZCA LINES

Perhaps no phenomenon better underscores the intimate connection between art, archaeology, and science than the mystery of the famous Nazca lines. These are giant drawings made on the plains of the south Peruvian coast where the earth is covered by a topsoil of fine sand and pebbles that, when dug away, reveals white alluvium. A culture that traded with the Moche to the north and thrived from 100 B.C. to A.D. 700, the Nazca dug away this top soil to create a web of lines, some running straight for as long as five miles, others forming complex geometric designs in the shape, for instance, of a monkey with a coiled tail or, as illustrated here, a hummingbird (fig. 10.10).

Ever since the German-born mathematician and astronomer Maria Reiche became obsessed by the lines in 1932, they have been the center of controversy. Reiche singlehandedly surveyed all of the lines over the course of her career and concluded that the straight lines point to celestial activity on the horizon and that the animals represent ancient constellations. In 1963, Nazca

was visited by Gerald Hawkins of Boston University, whose computer calculations of Stonchenge had helped reveal its astronomical relations, but he was unable to link many of the lines to the configuration of the heavens in the Nazca period. In the early 1970s, Erich von Däniken theorized that the lines were guidance patterns for alien spacecraft, a proposal that soon gained a wide and vocal following.

More recently, archaeologists have proposed that these **geogylphs**, as they are called, are actually depictions of giant gods whose job it is to guarantee both the availability of water and the fertility of the Nazca valleys. This theory is supported by the fact that in several sites, the straight lines point, not at aspects on the horizon, but directly at natural springs and water sources.

Figure 10.10 Earth drawing of a hummingbird, Nazca Plain, southwest Peru, Nazca culture, ca. 200 B.C.—A.D. 200, length ca. 450′ (138 m), wingspan ca. 200′ (60.5 m). Aerial photographs and satellite images have revealed not only figurative designs such as this one, but over 800 miles of straight lines.

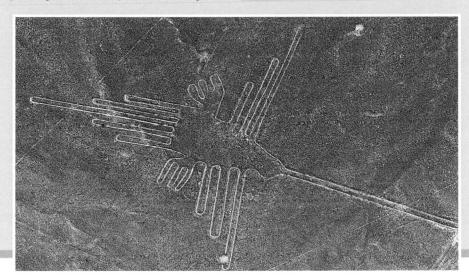

NORTH AMERICA

> -

The Native American populations in North America were far less densely concentrated than those in Mesoand South America. The peoples of the region lived primarily nomadic lives, hunting and fishing, until around 1200 B.C., when the production of maize spread from Mexico into the southwest region of the present-day U. S., inaugurating agricultural production in the north thousands of years after its introduction in the south. The climate was not conducive to raising corn, and the practice was slow to take hold. As a result, the organized and complex civilizations that have usually accompanied agricultural development were also slow to form. Indeed, down to the time of the European colonization of the end of the fifteenth century, many native peoples continued to live as they had since the time of the extinction of the vast herds of mammoth and other species that inhabited the continent at the end of the Ice Age, ca. 6000 B.C.

THE NORTHWEST COAST

One of the oldest cultures of the north developed along the northwest coast of the continent, in present-day Oregon, Washington State, British Columbia, and Alaska. Reaching back to approximately 3500 B.C., when the world's oceans had more or less stabilized at their current levels, rich fishing grounds developed in the region, with vast quantities of salmon and steelhead migrating inland up the rivers annually to spawn. One of the richest habitats on earth in natural resources, the northwest was home to over 300 edible animal species.

Here the native peoples—among them the Tlingit, the Haida, and the Kwakiutl—gathered wild berries and nuts, fished the streams and inlets, and hunted game. In the winters, they came together in plank houses, made with wood from the abundant forests, and engaged in a rich ceremonial life. By 450 B.C., they had become expert woodworkers, not only building their winter homes out of timber and rough-sawn planks, but also carving out canoes and making elaborate decorative sculpture. The

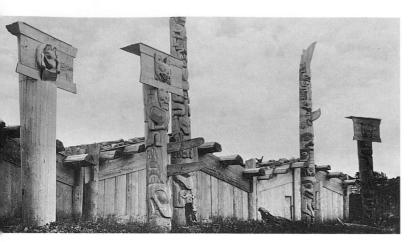

Figure 10.11 Haida mortuary poles and house frontal poles at Skedans Village, British Columbia, 1878, National Archives, Canada. Totem poles honored dead clans leaders and stood in front of homes serving a spiritual function.

most famous form of this decorative sculpture is the socalled totem pole (fig. 10.11). These mortuary poles, erected to memorialize dead chiefs, consist of animal and spirit emblems or totems stacked one upon the other.

The kinship ties of the extended family tribe were celebrated at elaborate ceremonies called **potlatches**, hosted by the chief. Guests arrived in ceremonial dress, formal speeches of welcome followed, and gifts were distributed. Then dancing would follow long into the night. The potlatch was intended to confirm the chief's authority and insure the loyalty of his tribal group.

THE SOUTHWEST

The native populations of the desert southwest faced severe difficulties in adapting to conditions following the end of the Ice Age. Like the Moche in Peru who lived in similar desert conditions, tribes gathered around rivers, streams, and springs that brought precious water from the mountains. However, water in the North American desert was far less abundant than in the South American river oases. Nonetheless, the inhabitants of the region, called the Anasazi (meaning "ancient ones"), slowly learned to recognize good moisture-bearing soil, to plant on north- and east-facing slopes protected from the direct sunlight of late day, and to take advantage of the natural irrigation of floodplains.

Small farming communities developed in the canyons and on the mesas of the region. In the thirty-two square miles of Chaco Canyon, in the northeastern region of present-day Arizona, thirteen separate towns, centered around circular underground ceremonial rooms called **kivas**, had begun to take shape by A.D. 700. In the kiva, the community celebrated its connection to the earth, from which all things were said to emanate and to which all things return—not just humans, but, importantly,

water as well. Connected to other sites in the area by a network of wide straight roads, the largest of these towns was Pueblo Benito, which was constructed between 900 and 1250. Shaped like a massive letter "D," its outer perimeter was 1300 feet long. At the center of the "D" was a giant plaza, built on top of the two largest kivas (there are thirty other kivas at Pueblo Benito).

Perhaps the most famous Anasazi site is Mesa Verde (fig. 10.12) in southwestern Colorado, near the Four Corners where Colorado, Utah, Arizona, and New Mexico all meet. Discovered in 1888 by two cowboys, Richard Wetherill and Richard Morgan, searching for stray cattle, Mesa Verde consists of a series of cliff dwellings built into the cavelike overhangs of the small canyons and arroyos that descend from the mesa top. While as many as 30,000 people lived in the Montezuma Valley below, probably no more than 2,500 people ever lived on the mesa itself. On the mesa these inhabitants developed an elaborate irrigation system consisting of a series of small ditches which filled a mesatop reservoir capable of holding nearly half a million gallons of water.

In about 1150, severe drought struck the Four Corners region, and the Anasazi at both Chaco and Mesa Verde abandoned their communities. They migrated into the Rio Grande Valley of New Mexico, where they were absorbed into the later native societies of the southwest, particularly the Hopi and the Zuni.

THE MOUNDBUILDERS

Throughout the Mississippi and Ohio River basins, beginning in about 1000 B.C. with the arrival of maize from Mesoamerica, small farming villages began building monumental earthworks in which to bury their dead.

Figure 10.12 Mesa Verde, Spruce Tree House, Anasazi culture, A.D. 1200–1300. In front on the right are three round kiva, which were once roofed, the roofs forming a common. The Anasazi farmed on the mesatop above.

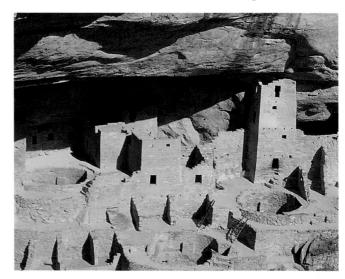

Cross Currents

CONQUEST AND DISEASE

The end of the great buffalo herds was not the only devastation the conquering Europeans brought with them. In 1519, in Veracruz, Mexico, one of the invading Spanish soldiers came ashore with smallpox. The Native Americans had no natural immunity. Of the approximately eleven million people living in Mexico before the arrival of the Spaniards, only 6.4 million remained by 1540. By 1607, perhaps two million indigenous people remained. When the Spanish arrived in California in 1679, the population was approximately 310,000. By 1900, there were only 20,000 Native Americans in the region. Along the eastern seaboard of the

United States, through the Ohio Valley and the Midwest, entire populations were exterminated by disease. In the matter of a month or two, an entire village might lose ninety percent of its people.

The destruction of Native American peoples, and with them their traditions and cultures, is movingly stated by the Wanapum prophet Smohalla, whose people died *en masse* not long after the 1844 arrival of Marcus Whitman to establish a mission in the Walla Walla Valley of Washington State:

The whites have caused us great suffering. Dr. Whitman many years ago made a journey to the east to get a bottle of poison for us. He was gone about a year, and after he came back, strong and terrible diseases broke out among us. The Indians killed Dr. Whitman, but it was too late. He had uncorked his bottle and all the air was poisoned. Before there was little sickness among us, but since then many of us have died. I have had children and grandchildren, but they are all dead ... We are now so few and weak that we can offer no resistance, and their preachers have persuaded them to let a few of us live, so as to claim credit with the Great Spirit for being generous and humane.

By far the largest of these was at Cahokia, in present-day Fast St. Louis, Illinois, where as many as 30,000 people lived between A.D. 1050 and 1250. The so-called Monk's Mound rises in four stages to a height of nearly one hundred feet and extends over sixteen acres.

The moundbuilders had begun by burying their dead in low ridges overlooking river valleys. The sites were apparently sacred, and as more and more burials were added, the mounds became increasingly large, especially as large burial chambers started to be constructed, at about the time of Jesus, to contain important tribal leaders. Sheets of mica, copper ornaments, and carved stone pipes were buried with these chiefs and shamans, and the mounds became increasingly elaborate. One of

Figure 10.13 Great Serpent Mound, Adams County, Ohio, Adena culture, 600 B.C.-A.D. 200, length ca. 1254′ (382.5 m). Though the Great Serpent Mound is perhaps the most spectacular example, there are between three and five hundred such mounds in the Ohio Valley alone.

the most famous is the Great Serpent Mound (fig. 10.13). Overlooking a small stream, it rises from its coiled tail as if to strike a giant oval form which its mouth has already encircled. What it symbolizes is as mysterious as the forms of the Nazca lines in Peru.

THE BUFFALO HUNTERS

It remains unclear what led to the extinction of the great game species at the end of the Ice Age—perhaps a combination of over-hunting and climatic change. But one large pre-extinction mammal continued to thrive—the bison, commonly known as the buffalo. The species survived because it learned to eat the grasses that soon spread across the Great Plains of North America, where it roamed. Hunting it became the chief occupation of the peoples who inhabited the region.

Archaeological evidence suggests that as much as 8500 years ago a group of Native Americans who lived southeast of Kit Carson, Colorado, stampeded an entire herd of buffalo off a cliff. The fall killed about 152 of the animals, and they were butchered where they lay for their hides and meat. The practice of stampeding continued, essentially unchanged, down to the time of the Spanish conquest, when horses were reintroduced to the Americas—the native variety had grown extinct by A.D. 600—and with the horse, the rifle.

But perhaps the most devastating change as far as the buffalo were concerned was the coming of the Europeans themselves. Between 1830 and 1870, the buffalo population in the West dropped from around thirty to eight million. Between 1872 and 1874, hunters killed an estimated 4,374,000 buffalo on the Great Plains.

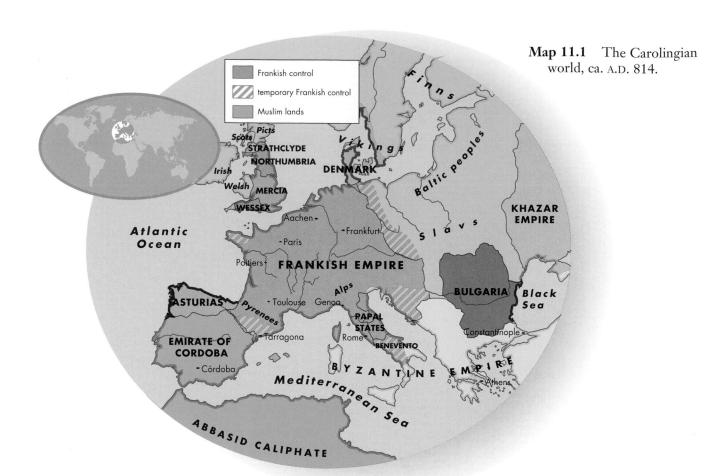

THE EARLY MIDDLE AGES AND THE ROMANESQUE

C H A P T E R 11

- ← Early Medieval Culture
- ← Romanesque Culture

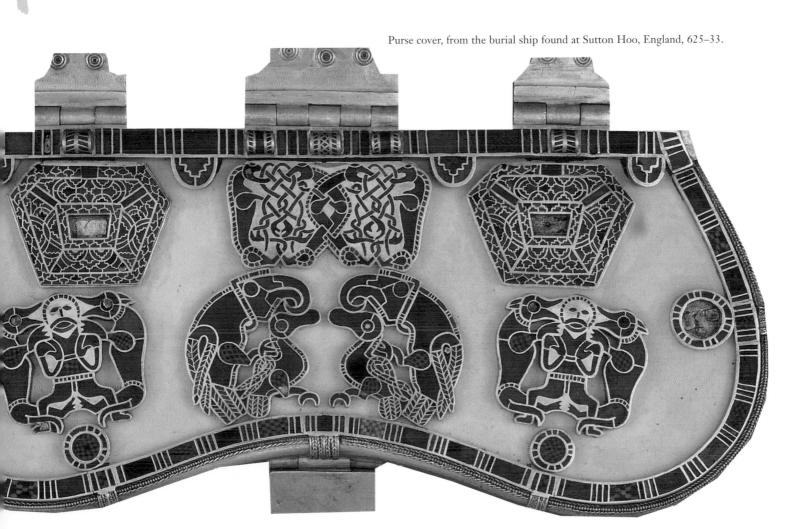

EARLY MEDIEVAL CULTURE

While Byzantine culture flourished in the Eastern Mediterranean, in the West, especially north of Italy, the fall of Rome led to a fragmentation in European political, social, and artistic culture. Spanning from Constantine's move from Rome to Constantinople in A.D. 330 and the emergence in the fifteenth century of the powerful Italian city-states such as Florence, Venice, and Milan, this medieval period has often been considered one of relative cultural poverty, culminating in the great catastrophe of the "Black Death," the epidemic of bubonic plague that spread across Europe after 1348.

This perspective is misleading. The period referred to as the "Dark Ages" stretched only from the sixth to the eighth century, and was followed by the rise of some remarkable cultures. The Early Middle Ages are recognized as a period of tremendous cultural accomplishment in their own right. Certainly, the fifteenth-century flowering of Western civilization that we call the Renaissance or "rebirth" was only possible because of what took place in the thousand years that preceded it. The beginning of this period was marked by the collision of two very different cultural forces—the Christian Church, which gradually spread northward from Rome, and the Germanic tribes and other barbarian groups, who controlled civic and social life in northern Europe. It was their mutual cultural assimilation that would come to shape early medieval life.

THE MERGING OF CHRISTIAN AND CELTO-GERMANIC TRADITIONS

In the first half of the fifth century A.D., Anglo-Saxons invaded Britain from northeastern Europe as part of the vast migration of Germanic tribes into the former territories of the Roman Empire. The Anglo-Saxons were actually three different tribes, the Angles, the Saxons, and the Jutes, who, though distinct, shared the same ancestors, traditions, and language. In Britain, they quickly suppressed the indigenous Christian inhabitants, the Celts. By 550, under the influence of the Anglo-Saxon invaders, Christianity had disappeared from all but the most remote corners of Britain, and the culture of the country had become distinctly Germanic. However, a reversal began in 597, when St. Augustine was sent to Britain as a missionary by Pope Gregory. At the same time missionaries from Ireland arrived in the northern part of the country and began to preach the Christian message there. King Ethelbert of Kent was converted to the Roman faith, and within seventy-five years Britain was once again predominantly Christian. Its language remained Anglo-Saxon—Old English, as it is called today-yet this language soon started to be increasingly "Latinized," especially after the Norman Conquest in

1066, to become the English we know today. In the same way, the culture itself started to blend the visual and literary ideals of Christianity and the heroic Germanic tradition. However, there is little trace of Christianity in some of the earliest artifacts from this period.

The Animal Style. Some of the finest examples of the art of these Germanic tribes are the exquisite objects discovered in the rich burial ship of an East Anglian king, dated between 625 and 633, at Sutton Hoo in Suffolk, England. As part of the king's funeral rite, the ship was lifted out of the water, dragged some distance inland, and then buried. Excavation of the site was carried out in 1939. Among the artifacts discovered was a purse cover (fig. 11.1) made of gold, garnet, and enamel (the background has been restored), with a clasp made of enamel on gold. This is decorated in what is called the "animal style." The ornamental patterns consist of distorted creatures, their bodies twisted and stretched. Some are made up of parts from different animals. Interlaced with these bestial forms are purely abstract patterns. But this is by no means wild, undisciplined design. On the contrary, the symmetrical compositions are meticulously compiled of smaller units that are, in themselves, symmetrical. The unifying aesthetic suggests a preference for vigorous, ornamental patterns. The swirling lines and animal interlace seen here are the two basic forms that later appear in Irish Anglo-Saxon manuscript illumination.

Evidence for this "animal style" is found outside Britain too. A burial ship uncovered at Oseberg, in southern Norway, dating from about 825, contained two wooden animal heads (fig. 11.2). The shapes of these heads are quite naturalistic, but the treatment of their surfaces is not. They are covered with organic and

Figure 11.1 Purse cover, from the burial ship found at Sutton Hoo, England, 625–33, gold, garnets, and enamel (background restored), length 8" (20.3 cm), British Museum, London. This and other exquisite objects show how inappropriate it is to call the era during which they were created the "Dark Ages." Working with the highest technical skill, artists created symmetrical patterns from animal shapes.

Figure 11.2 Animal head, from the burial ship found at Oseberg, Norway, ca. 825, wood, height of head ca. 5" (12.7 cm), University Museum of National Antiquities, Oslo. Intricate interlacing patterns cover the surface of this animal head. Attached to the prow of a ship, this and other similar animal heads that have survived may explain the origin of certain tales about sea monsters.

abstract shapes, which are combined in a style that is at once disciplined yet free. Animal heads such as these were used on the prows of ships, perhaps giving rise to the tales of "sea monsters," of which the Loch Ness monster is a modern survivor.

Christian Gospel Books. The animal-style artifacts from the Sutton Hoo and Oseberg finds are among the few examples of art to have survived from these early years. Evidence of other art forms has almost entirely vanished. Paintings were executed on the walls and ceilings of churches, but little now remains. In fact, the only paintings that survive in good condition from the early medieval era are in illuminated manuscripts produced in monasteries in northern England and Ireland after the mid-seventh century. Illuminated manuscripts are books written by hand on parchment (animal skin; the finest quality is called vellum) and elaborately decorated with paintings. Each separate page is referred to as a

folio. Early examples are usually copies of the four Christian gospels of Matthew, Mark, Luke, and John. In terms of decoration, these show the Christian assimilation of the Anglo-Saxon animal style.

A **cross page**, also referred to as a **carpet page**, in the *Lindisfarne Gospels*, ca. 700 (fig. 11.3), is entirely covered with a symmetrical geometric pattern filled with curvilinear shapes made up of "animal interlace"—birds and animals so elongated and intertwined that they look like ribbons. The page is decorated much as a piece of precious jewelry might be.

The *Book of Kells*, the finest gospel book of the Early Middle Ages still in existence, was written and decorated by Irish monks, probably around 800, but the exact date and place of origin are uncertain. The first known document mentioning the *Book of Kells* records its theft in 1006; the *Book of Kells* was already at that date referred to as "the chief relic of the Western world." Such a book was not intended for daily devotional use. Rather,

Figure 11.3 Cross page from the *Lindisfarne Gospels*, ca. 700, manuscript illumination, $13\frac{1}{2}'' \times 9\frac{1}{4}''$ (34.3 × 23.5 cm), British Library, London. This dense, intricate work is created by interlacing ribbon-like animals, organized by an underlying cross pattern. The care lavished on the decoration of a manuscript was intended to indicate the importance accorded the words of the text.

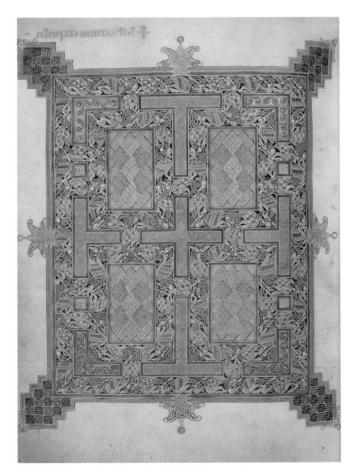

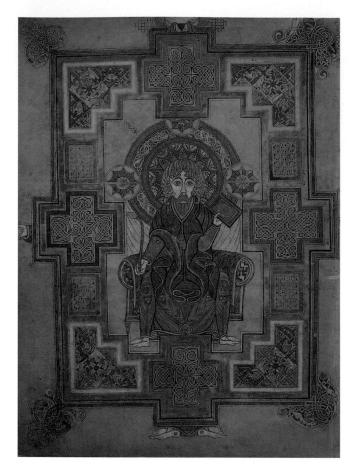

Figure 11.4 St. John, ornamental page from the Book of Kells, ca. 800 (?), manuscript illumination, $13 \times 9\frac{1}{2}$ " (33 × 24.1 cm), Trinity College Library, Dublin. The human body, treated as no more three-dimensional than the surface on which it is painted, becomes part of a flat design. The past Classical tradition of realism and pictorial illusionism is not identifiable here. Do not overlook the "footnotes" at the "foot of the page."

it was created as a work of art, presumably to be used only on very special occasions.

The Book of Kells contains the texts of the four gospels in Latin. As is clear from the ornamental page depicting St. John (fig. 11.4), in the illustration work perfection is sought on the smallest scale humanly possible. Curiously, the fine technical execution is accompanied by an extremely inaccurate representation of the human body. John is seen from the front yet appears flat, no more three-dimensional than the page on which he is painted. The human figure is treated as a pattern of lines. The curvilinear drapery falls in impossible folds, forming a two-dimensional decorative design that gives little hint of a solid body beneath. This Celtic style of manuscript illumination, like its Byzantine counterpart (see Chapter 7), takes us far from nature and the Classical tradition's allegiance to portraying the visible world.

The Beowulf Epic and the Christian Poem. Little secular literature survives from this earliest period of the Middle Ages. The greatest of the Anglo-Saxon Germanic epics is Beowulf. It was probably composed in the first half of the eighth century, though the only version of it that survives dates from the tenth century, and that version was itself badly damaged in 1731 in a London fire. Much of the poem has been lost, which only adds to the difficulty of deciphering the Old English text.

Beowulf is an almost completely Germanic tale. Set in Denmark, its action ideally exemplifies the values of a warrior society. As a good king Beowulf is referred to as "ring-giver," or "dispenser of treasure," and his duty is to take care of his loyal thanes or noblemen. Yet the act of giving has a spiritual side as well—out of generosity, unity and brotherhood emerge. This spiritual bonding, called comitatus, is balanced by the omnipresent threat of death. In fact, Beowulf is a poem permeated by a strong sense of doom, as its main narrative indicates. As a youth, Beowulf wins the admiration of his peers by killing the monster Grendel, which has been attacking the hall of the Danish king. Having killed Grendel, Beowulf must next avenge Grendel's mother's killing of a number of Beowulf's companions in revenge for her son's death. He tracks her down to a swamp, where he storms into her cave and kills her with a weapon forged by the giants of old. However, his victory over Grendel and his mother is tempered by the fact that his own men are dead, and, in the poem's final episode, after he has become king, Beowulf is himself slain when he goes to fight a mighty dragon that is terrorizing his people. However great a hero's courage, Fate (wyrd) can always intervene to destroy him, and sooner or later will.

There are hints of a Christian perspective in *Beowulf*, though these are very submerged. In the poem, *wyrd* can also be read as God's will, and Beowulf's heroic duty to rid the land of Grendel and his mother as ridding the world of the devil's influence. Indeed, Grendel is described as a descendant of Cain. But Jesus is never mentioned, and Beowulf's funeral, in a burial ship like that found at Sutton Hoo, is entirely pagan. The immortality that is his reward is the pagan form of immortality—the celebration of his memory in the poem itself.

In contrast to *Beowulf*, the short *Caedmon's Hymn*, the oldest extant Old English poem, composed between 658 and 680, employs the language of Anglo-Saxon heroic verse in an explicitly Christian context. Like a heroic king, God is referred to as the *Weard*, or Guardian, of his kingdom. The legend of the poem's composition is recounted by the historian-monk the VENERABLE BEDE [BEED] (ca. 673–735) in his *Ecclesiastical History of the English People*, completed in 731. An illiterate cowherd named Caedmon heard a voice in a dream that called out, "Caedmon, sing me something." "I don't know how to sing," he replied. "All the same," the voice insisted, "you must sing for me." "What must I sing?"

Caedmon asked. "Sing about the Creation," was the reply. And thus Caedmon sang. The first four lines of his hymn appear below in both Old and modern English:

heofronrices Weard Nu sculon herigan Now we must praise heaven-kingdom's Guardian Meotodes meahte and his modgethanc the Measurer's might and his mind-plans, worc Wuldor-Fæder swa he wundra gehwæs the work of the Glorywhen he of every wonder Father ece Drihten onstealde. or eternal Lord, the beginning established.

After this visitation, Caedmon retired to the monastery of Whitby, ruled by the abbess HILDA (614–680), where he is said to have written other works.

CHARLEMAGNE AND THE CAROLINGIAN ERA

Perhaps the greatest example of the convergence of Christian and Germanic cultures is found in the rule of Charles the Great or CHARLEMAGNE [SHAR-lumain] (742–814), king of the Franks. His rule is generally reckoned to have inaugurated a period of cultural reawakening in Western Europe. This period is known as the Carolingian era after his own Latin name, Carolus Magnus.

A vastly capable warrior, Charlemagne fought the Muslims in Spain and conquered the Saxons in a war that lasted some thirty years, seizing their home territory below Denmark and forcibly converting them to Christianity. By the end of his life he ruled all of present-day France, northern Spain as far south as Barcelona, most of northern Italy except for the Papal States, and,

to the east, Bohemia, much of Austria, and parts of Hungary and Croatia. As a reward for converting the peoples he conquered to Christianity, Charlemagne was crowned emperor of the West by Pope Leo III in Rome on Christmas Day of the year 800—the official beginning of a new "Holy" Roman Empire with a Christian emperor. Often credited with the major achievements of the so-called Carolingian Renaissance, Charlemagne saw himself very much as a successor to the great Roman emperors and therefore encouraged a revival of classical learning and arts. His court at Aachen was a focal point for these interests.

Feudal Society. Charlemagne's government was essentially an early version of feudalism, a legal and social system that developed in Western Europe in the eighth century. Under feudalism a lord would offer protection and land to his vassals, or servants, in return for an oath of fealty, or loyalty, and military support. Charlemagne's primary officials were his household staff—his chamberlain, his count of the stable (that is, his "constable"), and so on. Like Beowulf, Charlemagne depended upon the comitatus of those under his command. However, Charlemagne ruled an enormous empire, which he could not hope to control effectively without a wider network of support. He therefore divided his territory into approximately three hundred counties, each governed by a count who was given authority to rule over it. Such a land grant was called a feudum, a fief, from which the term "feudal" derives. A fieldom was hereditary, that is, passed on at the death of the vassal to his heir.

Architecture. To match his imperial ambitions, Charlemagne had created for himself a new capital, at Aachen in Germany. Here he built a sumptuous palace and a magnificent royal chapel (fig. 11.5), designed by

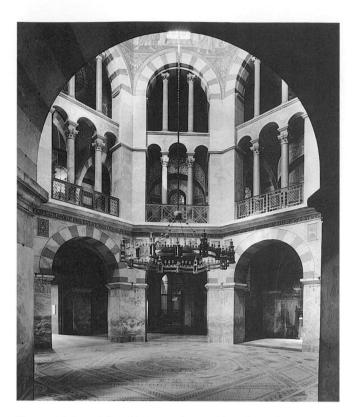

Figure 11.5 Odo of Metz, Palatine Chapel, Aachen, Germany, A.D. 792–805. Charlemagne was determined to make his chapel worthy of his piety, and so had materials brought from Rome and Ravenna to enrich it.

ODO OF METZ [OH-doh]. Apart from this chapel, little Carolingian architecture has survived. Nonetheless, it is clear that Carolingian builders developed ideas that influenced later medieval styles. An important example of this is provided by the church of Saint-Riquier in Abbeville, France (fig. 11.6), consecrated in 799, the greatest basilica church of its time. Although Saint-Riquier has been destroyed, its appearance is known from a 1612 engraving of an eleventh-century manuscript illumination. The Early Christian basilica plan was modified to accommodate the changing needs of the people and of the Church in the Carolingian era. Innovations found at Saint-Riquier that were to have future importance are: (1) a westwork (a monumental entryway) with two circular staircases; (2) a vaulted narthex that projects beyond the aisles, forming a second transept; (3) two towers, one over the crossing of the nave and west transept, one over the crossing of the nave and east transept; and (4) the addition of a square choir (where the monks sang the Divine Office) between the apse and nave. Its multiple towers formed what was to become the typical church silhouette of medieval Western Europe.

Literature: The Song of Roland. One of the most famous of all early medieval French literary works is the

Song of Roland, a chanson de geste, or "song of deeds," which dates from the mid-eleventh century in Brittany. It consists of more than four thousand lines, which are given their regularity and shape by the use of assonance, or the repetition of vowel and consonantal sounds, rather than by pure rhyme. The poem tells the story of the Christian army of Charlemagne doing battle against the Muslim Saracens. The poem is based on a historical incident from the year 778, when Charlemagne, returning home from a war in northern Spain, was attacked as he crossed the Pyrenees. The poet transforms the factual details into a heroic poem in which near miraculous feats are performed by the Christian soldiers led by Charlemagne's nephew Roland, one of his twelve Paladins, or princes. Roland is made the focus of the poem's action, while Charlemagne remains a significant background figure.

Roland is betrayed by one of his military colleagues, Ganelon, who informs the Saracen enemy leader of Roland's route through Roncesvalles, where his army is consequently ambushed by 400,000 Saracens. The poem recounts the valorous deeds of Roland and his men. Roland's dying act is to sound his hunting horn several times to warn Charlemagne of the enemy's presence. Upon finding Roland and his army dead, and discovering Ganelon's treachery, Charlemagne has the traitor executed and goes on to defeat the Saracens.

The poem is noted for its clarity and for the elegance of its language, the simplicity of its narrative, and the masterful precision of its detail. Of considerable importance is the feudal code of honor that serves as a foundation for, and standard against which to measure, the actions of its major characters. Celebrating loyalty over treachery, courage over cowardice, good judgment over foolishness, the *Song of Roland* exemplifies the values of French feudal society. Like the heroes of the Greek and Roman epics whose actions reflect the ideals of their societies, Roland embodies the ideals of medieval chivalry. He is at once a valiant warrior, an obedient and faithful servant of his king, and a warm and affectionate friend, whose behavior is governed by a Christian sense of moral rectitude.

MONASTICISM

The Rule of St. Benedict and Cluniac Reform. Monasticism, a term derived from the Greek word monos, meaning "alone," had been an integral part of Christian life since the third century. During the Middle Ages, monasticism developed rapidly, resulting in an increasing number of monasteries and influential religious orders of monks and nuns. However, the observance of rules was anything but strict, and the lifestyle enjoyed in many monasteries was often quite relaxed. The earliest monastic guidelines were those provided by ST. BENE-DICT (480–543), who established a monastery at Monte

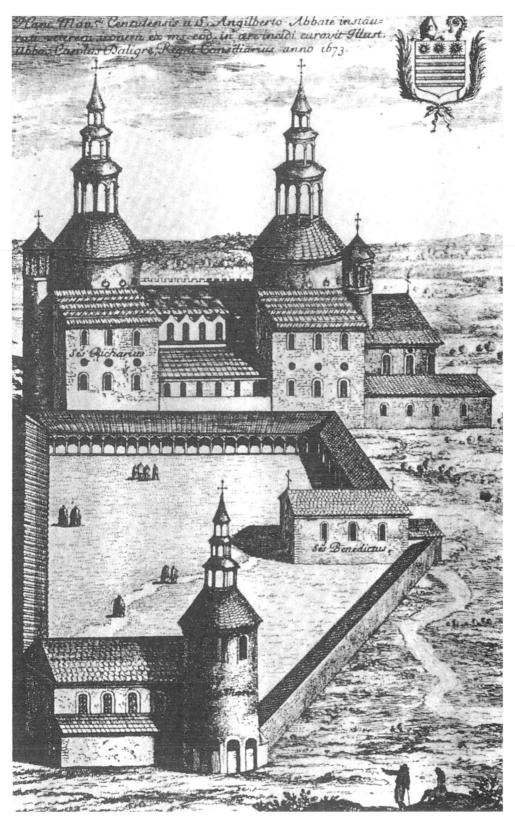

Figure 11.6 Church of Saint-Riquier, Abbeville, consecrated 799, now destroyed, engraving made in 1612 from an eleventh-century manuscript illumination, Bibliothèque Nationale, Paris. Although this church no longer exists, certain features here became standard in church architecture: a massive entryway, two transepts, multiple towers with staircases, and a choir.

Connections

THE MYSTERY PLAYS AND THE GUILDS

Between the years 1000 and 1300, the population of Europe nearly doubled (to roughly seventy million), and urban areas began to grow as people gathered together in the interest of trade and commerce. The populations of these newly developing towns, which tended to form around old Roman settlements, along trade routes, and near the castles of great landowners, were, at least to a degree, free of feudal control, a fact that made them also free of organized government.

One of the chief means of establishing order in the growing towns and cities was the guild system. **Guilds** were associations of artisans and craftspeople (and soon merchants and bankers too) that regulated the quality of work produced in their own trade and the prices that an individual shopkeeper or tradesperson could charge. The guilds also controlled the training of apprentices and craftspeople, set

wages, supervised contracts, and approved new businesses. They built guild halls around the central square of the town, usually in front of the church. They also provided insurance and burial services for their members.

The guilds actively participated in the presentation of the so-called mystery plays—an early English corruption of the Latin word ministerium, or "occupation," referring to the guildsa form of liturgical drama that began to develop in the ninth century. The mystery plays were dramatizations of narratives in the Old and New Testaments, usually composed in cycles containing as many as forty-eight individual plays. Typically, they would begin with the Creation, then recount the Fall of Adam and Eve, the Flood and Noah's Ark, David and Goliath, and so on, through the Old Testament to the Nativity, the events of Jesus's life, the Crucifixion, and the Last Judgment.

Each guild was responsible for an individual play, which was sometimes connected with its own trade. The

shipwrights' guild might present the story of Noah's Ark, for instance, and the bankers the story of Jesus and the moneylenders. These dramas were performed in the open air at different places around the town. In some towns, each guild would have its own wagon that served as a stage, and the wagons would proceed from one location to another, with the actors performing at each stop, so that the audience could see the whole cycle without moving. In other towns, the plays were probably acted out on a single stage or platform in the main city square.

The mystery plays were performed every summer, either at Whitsuntide, the week following the seventh Sunday after Easter, or at Corpus Christi, a week later. They served as both entertainment and education for their largely illiterate audience. They also functioned as festive celebrations which brought together every aspect of medieval life—social, political, economic, and religious—for the entire community.

Cassino, south of Rome, and created the Benedictine order. Charlemagne believed deeply in the Benedictine guidelines, and brought the Benedictine monk ALCUIN of York [AL-coo-in] (ca. 735–804) to his kingdom in order to impose them on the Frankish monasteries. In fact, the earliest surviving copy of the Rule of St. Benedict is one Charlemagne himself had made in 814, which is kept at St. Gall in Switzerland. Dividing their day into organized periods of prayer, work, and study, the Benedictines had a life that was summed up in the motto: "Pray and work." Their lives were based on four vows: they were to possess nothing (poverty); live in one place their entire life (stability); follow the abbot's direction (obedience); and remain unmarried (chastity).

In addition to these vows, the monks at the monastery in Cluny, France, decided to undertake reforms. Bishops had, up until then, lived like local feudal lords, often buying and selling Church offices to the highest bidder. The Cluniacs removed themselves from the feudal structure, answering only to the pope in Rome. They soon spread beyond their original monastery to establish similar monastic houses throughout Europe. In addition, they influenced the founding and development of other religious orders such as the Cistercians, established at Cîteaux in 1098, its most famous member being ST.

BERNARD OF CLAIRVAUX [clare-VOH] (1090–1153). The Cistercians were a far more ascetic order than the Benedictines. For example, they simplified their religious services, stripping them of elaborate ceremony and complex ritual, as well as removing much religious art from their surroundings. The Cistercians also fasted and prayed longer and more frequently than the Benedictines.

The Monastery. The original plan for an ideal Carolingian monastery that was never built (fig. 11.7) is kept in the library of the Benedictine monastery of St. Gall, Switzerland. The plan, with Latin inscriptions explaining the function of each part, is drawn in red ink on parchment. In 816–17 a council had met near Aachen and decided upon a basic monastery plan, which it sent off to the abbot of St. Gall. It was intended to serve as a model, though each monastery was to adapt it to its specific needs.

Although no monastery exactly like this was ever built, the plan gives a good idea of what a medieval monastery was like. The monastery was intended to be self-contained and self-sufficient. Everything necessary for living is provided within this plan. The largest building is the church. Suited to the needs of monks rather than to those of a congregation, there is an apse and an altar at

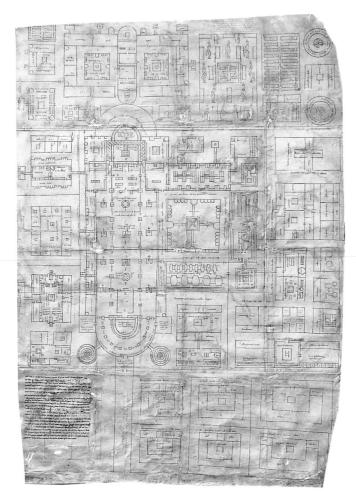

Figure 11.7 Plan for a monastery, ca. 817-820, red ink on parchment, $2'4'' \times 3'8\frac{1}{8}''$ (71.1 × 112.1 cm), Stiftsbibliothek, St. Gall, Switzerland. This plan for a prototype monastery was intended to be adopted and adapted to the specific needs of each monastic community—no monastery was ever built that precisely matched its layout. However, the drawing illustrates the basic ideal, which was that the monastery should be self-sufficient, providing for all the monks' needs.

both ends, several entrances along the sides, and partitions dividing the nave. To the south of the church is the cloister, which is a standard part of the medieval monastery. The cloister is a square or rectangular space, open to the sky, usually with a source of water such as a fountain or well in the center, surrounded on all four sides by covered walkways. In the cloister garden, or garth, the monks might read, study, meditate, talk, and have contact with nature within the confines of the cloistered life. Also on the south side are the **refectory**, where meals were taken, the dormitory, baths, latrines, and various workshops. To the west are places where animals could be kept. To the north are the guest house, school (monasteries played an important part in the revival of learning, for it was here that education was available), and abbot's house. To the east are the physician's quarters (with bloodletting mentioned on the plan), and the

infirmary, a short distance from the cemetery. The plan shows several kitchens, located throughout the monastery. Countering today's assumptions about the austerity of medieval monastic life, it is worth noting that the plan includes more than one building for servants. However, little if any heating was part of the plan, and winters must have been extremely difficult to endure.

Manuscript Illumination. Much of the work carried out by the monks consisted of revising, copying, and illustrating liturgical books. Alcuin of York, for instance, published both a sacramentary, a book of prayers and rites for the administration of the sacraments, and a book of Old and New Testament passages in Latin for reading during mass. Medieval manuscripts were more often than not lavishly bound—it was felt that the cover enclosing the words of God should be as splendid as possible. Among the most sumptuous of all book covers ever created is that of the Lindau Gospels (fig. 11.8), made in about 870, out of gold, pearls, and semi-precious stones. In the Middle Ages, gemstones were not cut in facets, as they are today. Instead, they were smoothed and rounded

Figure 11.8 Cover of the *Lindau Gospels*, gold, pearls, and semi-precious stones, ca. 870, $13\frac{3}{4} \times 10\frac{3}{8}$ " (34.9 × 26.4 cm), Pierpont Morgan Library, New York. This lavish and carefully handcrafted book cover can be contrasted with today's mass-produced paperback books. The stones are treated as cabochons—smoothed and polished rather than cut in facets as is now customary.

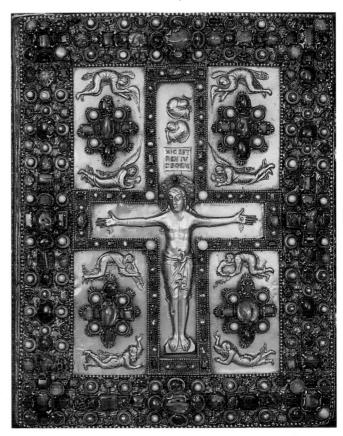

into what are known as **cabochons**, like the ones on the *Lindau Gospels* cover. The cabochons are not set into the gold, but raised up on little feet, some by almost an inch, so that light can pass right through them, enhancing their brilliance. A rich variety of colors, shapes, and patterns is created by the cross, the heavily jeweled border, and the four jeweled medallions between the arms of the cross. Jesus is not depicted here as suffering. His body, rather than hanging from the cross, appears weightless. He simply appears to be standing. It seems as if he is speaking, in triumph over death. Between the arms of the cross, each of the eight tiny figures is in a different pose, according to the space available. They are all done in **repoussé** (hammered out from the back), against a plain background.

Due to the classical revival encouraged by Charlemagne, the human figure once again became important

Figure 11.9 St. John, from the Gospel Book of Charlemagne (Coronation Gospels), ca. 800–810, manuscript illumination, $12\frac{3}{4} \times 9\frac{7}{8}$ " (32.4 × 25.1 cm), Schatzkammer, Kunsthistorisches Museum, Vienna. Emperor Charlemagne encouraged a revival of the antique—in part for political purposes. The impact of the antique is evident in this depiction of St. John, which is more realistic than that in the Book of Kells (see fig. 11.4).

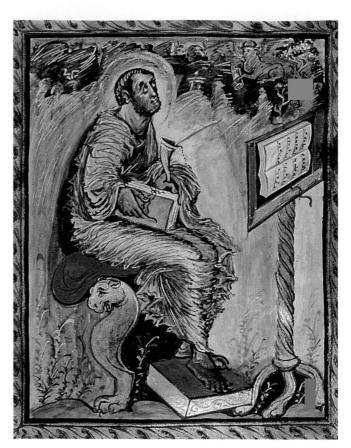

Figure 11.10 St. Luke, from the Gospel Book of Archbishop Ebbo, 816–35, manuscript illumination, $10\frac{1}{4} \times 8\frac{3}{4}$ " (26 × 22.2 cm), Bibliothèque Municipale, Épernay. The style here is animated, if not agitated. Each of the four evangelists is identified by a symbol, Luke's being the winged ox. Iconography, the language of symbols, was especially useful in an era when most people were illiterate.

in the visual arts. This can be seen in the many manuscripts of the gospels and other sacred texts produced by Carolingian scribes and illuminators working in monastic and royal workshops. An image of St. John (fig. 11.9) is included in the Gospel Book of Charlemagne, also known as the Coronation Gospels, dated ca. 800-810. The manuscript is said to have been found in Charlemagne's tomb at his court in Aachen. St. John is portrayed in the Roman tradition—the style is similar to wall paintings found at Pompeii and Herculaneum (see figs. 5.27-5.30). A frame has been painted onto the vellum folio, creating the impression that the viewer is looking through a window to see John outside. The legs of John's footstool overlap the frame, as if the frame were genuinely three-dimensional. The proportions of John's body are accurate and he wears a garment much like a Roman toga.

The representation of St. Luke (fig. 11.10) in the Gospel Book of Archbishop Ebbo, dated 816–35, differs from its restrained classical prototypes in its suggestion of

movement and emotion. The drapery swirls around the figure, as if blown by a very strong wind into flame-like, nervous ripples. Even the landscape is oddly animated, for the hills seem to sweep upward. Everything appears to be moving in this energetic and dynamic style. Luke is shown in the process of writing his gospel. He holds an ink horn and is writing with a quill pen, although his writing stand is strikingly unstable.

Music: Gregorian Chant. Music, which in the Middle Ages was largely linked to religion, was a particular passion of Charlemagne's, who brought monks to his kingdom from Rome to standardize ecclesiastical music. In church services for the laity (non-clergy) and in worship in the monasteries, the predominant form of music was plainchant, in which Latin liturgical texts were sung to a single melody line (monophony) without harmonic instrumental accompaniment.

The monks from Rome brought with them a particular tradition of Church music. This was Gregorian chant, which took its name from Pope GREGORY THE GREAT (540-604), who by legend is connected with the development of this form of music. A distinctly Frankish chant remained popular in Charlemagne's time too. During the centuries that followed, many new types of chant were composed, some of which were elaborated with tropes or turns in which other texts or melodies were introduced. Chants became more complex as the development of **polyphony** took place, in which two or more voice lines are sung simultaneously.

The basic chants have a serene, otherworldly quality with their flexible rhythms and melodic lines that typically move in tandem within a narrow range of pitch. Part of this quality comes from the use of church modes rather than major-minor scales. It also derives from the lack of harmonic accompaniment, as well as from the large resonating space of the cathedrals or monastery churches in which chants are frequently sung. The freefloating rhythms of the chant, with a lack of a steady beat or pattern of rhythmic accents, contribute to its solemnity, so much so that chant is sometimes described as "prayer on pitch."

During the reign of Charlemagne, Gregorian chants, which had formerly been passed down orally, were codified and written down in a rudimentary form of musical notation that used small curved strokes called neumes to indicate the up and down movement of the chant melody. In the eleventh century, an Italian monk, GUIDO D'AREZZO [da-RET-zoh] (ca. 997–1050), created a musical graph, or set of lines, on which to mark the various chanted musical pitches. Guido's graph used colored lines to make the representation of the musical pitches easy to read. It took two more centuries for the musical staff to develop, and until the sixteenth and seventeenth centuries before notes were written in the rounded forms common today.

Romanesque Culture

After Charlemagne's death in 814, the personal bonds that held the Holy Roman Empire together soon dissolved. After two further centuries of political fragmentation, however, around the year 1000, a few powerful feudal families began to extend their influence, conquering weaker feudal rulers and cementing their gains by intermarriage. These families soon developed into fullfledged monarchies. Two in particular—in France and in England—rose to real and lasting prominence. In 800, Charlemagne had allowed himself to be crowned emperor by the pope, thereby in some degree acknowledging

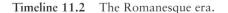

the Church's superior power. At first, neither of the emerging dynasties in England or France could contemplate open conflict with the authority of the papacy in Rome. However, as the secular power of these monarchs grew, the influence of the Church was increasingly threatened.

THE FEUDAL MONARCHS

The Capetians. When HUGH CAPET [CA-pay] (ca. 938–996) ascended to the French throne, he established a dynasty of kings that would rule for nearly 350 years. Hugh already controlled his own fiefdom, the Île de France (roughly the area between Paris on the Seine down to Orléans on the Loire); in part because of this personal power, he was accepted by all the feudal lords of France as their king in 987. Throughout the subsequent CAPETIAN [ca-PEA-shun] era, the dukes of Normandy, technically vassals of the Capetian throne but at least initially more powerful, quarreled with their king. Nevertheless, the Capetian monarchs gradually consolidated power around themselves, and Paris became the political and intellectual center of Europe.

The Norman Conquest. The dukes of Normandy, however, had other plans. Though servants to the Capetian kings in France, they claimed England for

themselves and ruled as kings in their own right. The story of their conquest of England is recounted in the Bayeux Tapestry, dated ca. 1066–82. Probably made by English women soon after the Norman victory, it is actually a giant embroidery, measuring approximately 231 feet in length and $19\frac{1}{2}$ inches high, in which the design is sewn in wool threads onto a linen fabric background.

The story begins in 1064, when the heirless king of England, EDWARD THE CONFESSOR (r. 1042-1066), sent Harold of Wessex to tell WILLIAM, duke of Normandy (ca. 1027–1087), that he had been chosen as heir to the English throne (fig. 11.11). However, when Edward died, on January 6, 1066, Harold had himself crowned king of England, justifying his action by saying that Edward had changed his mind on his deathbed and made Harold his heir. Understandably, William was angered. On October 14, 1066, at Hastings in southern England, King Harold of England and Duke William of Normandy, who had crossed the English Channel with his army, engaged in battle. Harold's death, which the Bayeux Tapestry portrays as the result of an arrow penetrating his eye, permitted William to be crowned king of England, in Westminster Abbey, on Christmas Day, 1066. William became the first Norman king of England, and was known thereafter as William the Conqueror.

William divided England up into fiefs for his Norman barons, ruling as a feudal monarch. He also gave the

Figure 11.11 King Edward Sends Harold of Wessex to Normandy, detail of the Bayeux Tapestry, ca. 1066-82, wool embroidery on linen, height approx. $19\frac{1}{2}''$ (49.5 cm), total length ca. 231' (70.41 m), Centre Guillaume le Conquérant, Bayeux, France. The entire story of the invasion of England by William of Normandy, thereafter known as William the Conqueror, is told on this so-called tapestry. A wonderful document of military tactics and weaponry, the various parts of the work show the soldiers in battle, preparing for combat, traveling, and eating.

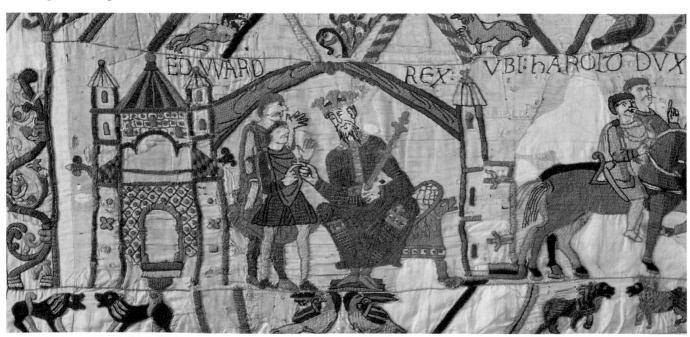

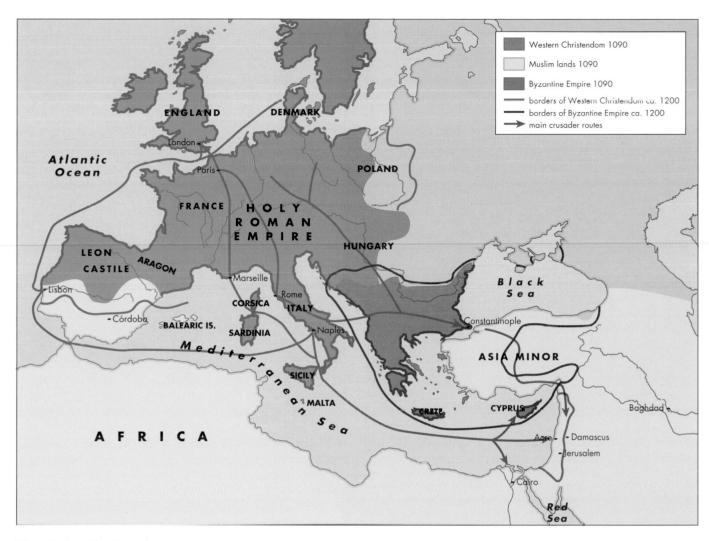

Map 11.2 The Crusades.

Church a quarter of the land, in an attempt to win its loyalty. Finally, he maintained Anglo-Saxon custom and law, thereby trying to gain the respect of the common people. Nonetheless, Norman culture proved very influential in England. For instance, the Latin-influenced French language spoken by the Norman invaders gradually began to mix with the native Anglo-Saxon, and the English language as we know it today started to emerge.

Magna Carta. Relations between the rulers of England and France remained difficult. King LOUIS VII of France (r. 1137–1180) had married ELEANOR OF AQUITAINE (ca. 1122–1204), Aquitaine being the great duchy that consists of most of southwestern France. But when she failed to provide a male heir, he annulled the marriage, and she promptly married HENRY II of England (r. 1154–1189), thus making the English king lord of more than half of France.

The Capetians balked at this, and Louis's successor, Philip II, or PHILIP AUGUSTUS (r. 1180–1223),

plotted with John, Henry II's younger son, to overthrow John's older brother, RICHARD "THE LION-HEARTED," who had assumed the English throne in 1189. Richard was often absent from England, either on crusade in the Holy Land or fighting with Philip Augustus. Both endeavors were financially crippling. Heavy taxes were consequently levied on the English barons, and many possessions were confiscated. Thus, when his brother John finally acceded to the English throne in 1199, the crown was bankrupt. Philip Augustus succeeded in expelling the English from France north of the Loire River, and, outraged at the expense of John's continued campaign against France, the English barons drew up a list of demands that John was forced to sign on June 15, 1215. Called the Magna Carta, or "Great Charter," it stated, among other things, that no taxation should be levied "except by the common consent of the realm." Similarly, it laid down that "No freeman shall be arrested or imprisoned, or dispossessed or outlawed or banished or in any way molested; nor will we set forth

against him, nor send against him, unless by the lawful judgment of his peers and by the law of the land." These provisions for the first time set a limit on the power of the ruler. The Magna Carta is often seen as a crucial political document that paved the way for constitutional monarchy and the development of democracy in Western Europe.

The Crusades. The crusades were a series of military expeditions organized in Western Europe with the principal aim of recovering the Holy Land in Palestine, especially Jerusalem, from its Muslim occupiers. The First Crusade was launched by Pope Urban in 1095. Two years later, a hundred thousand soldiers from all over Europe arrived in Constantinople. They came for all manner of reasons, both spiritual and mercenary.

Jerusalem fell to the first crusaders on July 15, 1099, but by the middle of the next century, Muslim authority had begun to reassert itself. In 1189, forces led by Richard the Lionhearted, the Holy Roman Emperor Frederick Barbarossa, and Philip Augustus of France reached the outskirts of Jerusalem, and probably would have won the city back had their mutual animosity not shattered their chances.

Politically and religiously, the crusades were a failure. However, for nearly a century, they succeeded in giving the feudal nobility something to do other than attack one another. As unstable as France and England were politically during this time, they benefited immeasurably from

Figure 11.12 Saint-Sernin, Toulouse, begun ca. 1070 or 1077, aerial view from the southwest. The exterior of the building reflects the interior. Each section of space is clearly defined and neatly separated, unlike the flowing spaces that will characterize Gothic architecture.

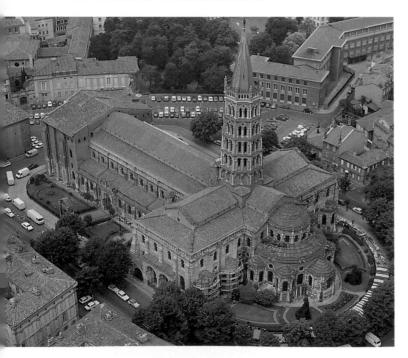

the absence of so many warriors. More importantly, trade between Asia and Europe was greatly stimulated as a result of the conflicts, and with it intellectual commerce as well, as the ideals of ancient Greece became more current once again in the European imagination.

ROMANESQUE ARCHITECTURE

Pilgrimages and the Church. Part of the inspiration for the crusades to retake Jerusalem was provided by the medieval practice of pilgrimage. The chief purpose of a pilgrimage was to worship relics of the saints (objects connected with sacred figures), especially relics that were claimed to have miraculous powers. Pilgrim-ages were a social phenomenon of medieval life. They were obviously an important expression of religious faith, but they also represented a social opportunity: pilgrims could meet different kinds of people and were a kind of early tourist.

The medieval pilgrim's goal was likely to be the church of Santiago de Compostela (St. James of Compostela) in northwestern Spain, if not Rome or Jerusalem. Santiago de Compostela began to attract pilgrims in the ninth century, when it was claimed that it housed the tomb of St. James. A Romanesque cathedral was built on the site of the tomb in 1078–1211. For the many people who traveled great distances along the pilgrim routes, facilities were available at abbeys, priories, monasteries, and hospices. Some of these were built specifically for pilgrims, at intervals of twenty or so miles, not a difficult distance to cover in a day, even then. People slept in big open halls, and there were special chapels for religious services. Charities were set up to aid the sick and the destitute, and to take care of the dead.

Churches visited in this way by medieval pilgrims are referred to as "pilgrimage churches." There were originally five great pilgrimage churches. Two are now gone: Saint-Martin in Tours and Saint-Martial in Limoges. Three remain: Sainte-Foy in Conques, Saint-Sernin in Toulouse, and the ultimate goal of the pilgrim, Santiago de Compostela. All have the same basic plan and certain similarities of construction. Their style is called Romanesque, and indeed the architecture relies on the basic Roman elements of the basilica plan (see fig. 6.4), employing rounded arches, vaulted ceilings, piers and columns for support, and thick, sturdy walls. However, the style is not called Romanesque for this reason but because it was associated with the Romance languages. All pilgrimage churches had large naves with flanking aisles, a transept, choir, ambulatory, and radiating chapels on the east end.

Saint-Sernin, Toulouse. Among the most important buildings constructed in the eleventh century is Saint-Sernin in Toulouse (fig. 11.12), the best known of the great pilgrimage churches. Saint-Sernin was started ca. 1070 or 1077 but never finished. The west facade, which underwent restoration in 1855, has been gener-

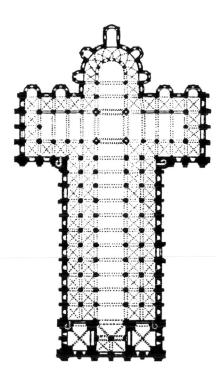

Figure 11.13 Saint-Sernin, Toulouse, begun ca. 1070 or 1077, plan. This Latin-cross plan with ambulatory and radiating chapels is typical of churches located along the pilgrimage route leading to Santiago de Compostela. In the many chapels, pilgrims venerated relics, especially if a relic was believed to be miracle-working.

ously described as an "awkward bulk." The builders' original intent (and the Romanesque norm) was to have two facade towers, but they were never completed. The apse end was completed by about 1098, with many different roof levels that reflect the interior plan. Each chapel is seen as a separate bulge from the outside; above the ambulatory, the apse protrudes; and the levels build up to the crossing tower. Each space is separate, as is typical of Romanesque architecture.

Saint-Sernin, like the other four great pilgrimage churches, has a Latin-cross plan (fig. 11.13)—a cruciform plan with one long arm—as opposed to the Greek-cross plan, which has four arms of equal length. The proportions of Saint-Sernin are mathematically determined: the aisles are composed of a series of square **bays** that serve as the basic unit. The nave and transept bays are twice as large. The crossing tower is four times the basic unit, as are the bases of the intended facade towers. Certain ancient Greek temples had similar numerical ratios between their different parts.

The nave of Saint-Sernin (fig. 11.14) is typically Romanesque, with thick walls, closely spaced piers, engaged columns on the walls, and a stone vault. The **barrel vault** (also called a **tunnel vault**) covering the nave is a structural system which offers several advantages. Here, the acoustics are superb, with voices rever-

berating through the vaulted space. The threat of fire is reduced—a constant danger in the Middle Ages, especially to structures with wooden ceilings. The large interior is open, free of the intrusive posts necessary to the post and lintel system. Yet the barrel vault also has its disadvantages. An extension of the arch principle, it exerts a constant lateral thrust that must be buttressed. This is accomplished largely by the great thickness of the walls, which means that any opening in the supporting walls weakens the system. Consequently the windows in

Figure 11.14 Saint-Sernin, Toulouse, begun ca. 1070 or 1077, nave looking toward altar. Romanesque masons experimented with various vaulting methods, using most frequently the barrel (tunnel)vault based upon the semicircular arch. Advantages of this stone vault, compared to the wooden ceiling of the Early Christian basilica, include superb acoustics and minimized risk of fire; disadvantages include lack of direct light into the nave.

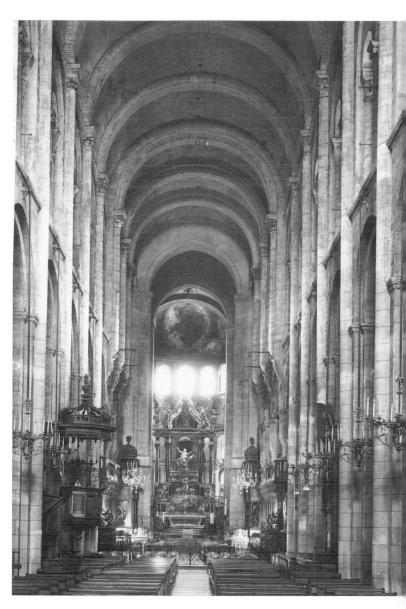

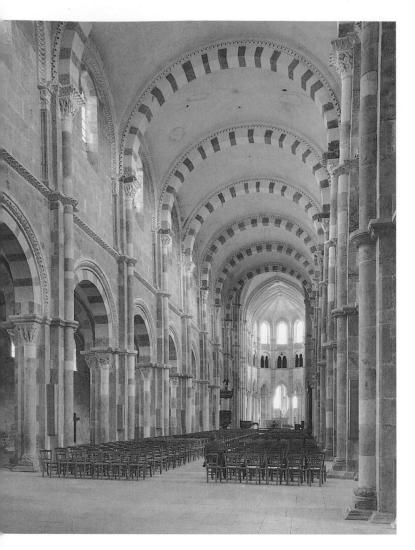

Figure 11.15 Sainte-Madeleine, Vézelay, nave looking toward altar, 1120–32. A solution to the problem of obtaining direct light in the nave is the use of cross (groin) vaults, which provide a space for windows on the nave walls.

Romanesque churches are few and small, and the interiors often very dark.

Sainte-Madeleine, Vézelay. Another pilgrimage church, Sainte-Madeleine in Vézelay, occupies a spectacular site at the top of the crooked streets of this tiny town, the start of one of the roads leading to Santiago de Compostela. A Carolingian church was originally erected on this site and consecrated in 878. Vézelay's real rise began in the early eleventh century, however, when it was claimed that the town possessed the bones of Mary Magdalene. The Romanesque church of Sainte-Madeleine was built between 1096 and 1132. At its peak, Vézelay had eight hundred monks and lay brothers living in its monastery. Unfortunately, most of the monastery was torn down during the French Revolution—only the church and part of the cloister remain.

The nave (fig. 11.15), built between 1120 and 1132, is

very light for a Romanesque church. It is also very harmonious. Simple mathematics determines the proportions of the interior, which is two hundred feet long, sixty feet high, and forty feet wide. The alternating light and dark voussoirs (wedge-shaped blocks of stone that make up the arches) are inconsistent in size, resulting in irregular stripes. The supports are massive. Romanesque supports tend to vary: a simple pier or column may be elaborated by the addition of engaged columns. Sometimes the supports alternate—as is often the case in later Romanesque buildings. The nave elevation is two stories high, as at both Saint-Sernin and Santiago de Compostela. At Vézelay, however, the upper level is a clerestory with a row of windows. This is made possible because the nave bays are covered by cross vaults (also called groin vaults)-two tunnel (barrel) vaults intersecting at right angles, which automatically create a flat space on the wall where a window can be constructed. Vézelay's interior therefore offers a solution to the problem of obtaining direct light in the nave. However, despite the theoretical success of the structure, the reality is that it was neither well built nor adequately buttressed. Problems developed and the walls began to lean. Flying buttresses were added in the Gothic era and then rebuilt in the nineteenth century. The walls now lean outward by about twenty inches.

Cathedral Group, Pisa. Of all the Romanesque cathedrals constructed outside the pilgrimage routes, perhaps one of the most striking is that in Pisa, Italy. The "Cathedral Group" in Pisa (fig. 11.16) consists of the cathedral, begun in 1063; the baptistery, begun in 1153;

Figure 11.16 Cathedral group, Pisa: baptistery, begun 1153; cathedral, begun 1063; campanile, begun 1174. In addition to marble incrustation, the architecture of Romanesque Pisa is characterized by tiers of arcades.

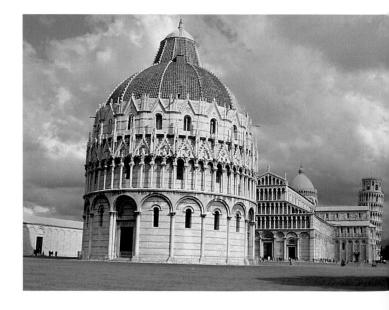

Cross Currents

THE PISA GRIFFIN

 $F_{
m rom~1100~until~1828,~a~three-and-a-}$ half-foot-high Islamic bronze griffin (fig. 11.17) (a mythological creature, halfeagle, half lion) sat on top of the cathedral in Pisa. This griffin may have originally been a fountain spout, but how it came to Pisa is unknown. Scholars have suggested that its provenance might be Persia, in the east, or perhaps Spain, in the west. But what-ever its origins, placed on top of the cathedral which was itself built to celebrate Pisa's 1063 victory over Muslim forces in the western Mediterranean, it soon came to symbolize the city's place at the very center of Mediterranean trade.

The griffin is decorated with incised feathers on its wings, and the carving of its back suggests silk drapery, linking it with Asia. A favorite symbol of both the Assyrians and Persians, the griffin was said to guard the gold of India, and the Greeks believed that these creatures watched over the gold of the Scythians. For Muslims, the eagle-like qualities of the beast signified vigilance, and its lion-like qualities courage. By the time it was placed on Pisa cathcdral, Christians had appropriated the beast

Figure 11.17 Griffin, from the Islamic Mediterranean, eleventh century, bronze, height $3'6_8^{1''}$ (1.07 m), Museo dell'Opera del Duomo, Pisa. With the body of a lion, symbolizing courage, and the wings, head, and claws of an eagle, symbolizing vigilance, this griffin stood atop Pisa cathedral until it was moved to the cathedral museum in 1828.

to their own iconological ends, where it came to signify the dual nature of Christ, his divinity (the eagle) and his humanity (the lion).

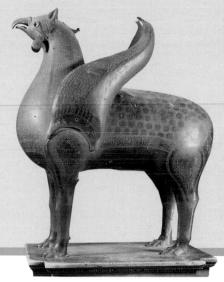

and the **campanile** (the bell tower), of 1174, the famous "Leaning Tower of Pisa." All three buildings are covered in white marble, inlaid with dark green marble, a technique used by the ancient Romans.

The baptistery is circular and domed. The first two floors are Romanesque, with marble panels and arcades. The pointy gables are fourteenth-century Gothic. The architect of the cathedral was Buscheto, though the facade was designed by Rainaldo. The marble arcades are a Pisan hallmark. Blind arcades create a lacy effect, with colorful light and shade patterns. The five stories of arcades on the facade match the interior: the bottom corresponds to the nave arcade; the first open arcade reflects the galleries; the second open arcade the roof of the galleries; the third the clerestory; and the last the roof. Simple mathematical ratios determine the dimensions: the blind arcade is one-third the height of the facade, whereas each open arcade is one-sixth the height.

Pisa's most famous monument is undoubtedly the "Leaning Tower." The bell tower is usually a separate building in Italy; in other countries there are normally two bell towers on the facade of a Romanesque church. The designer of the campanile was Bonanno Pisano, who was also known as a sculptor, a fact reflected in the sculptural effect of the eight stories of arcades. The campanile leans because the foundations were poorly laid and offer uneven resistance. Most Italian towers of the Middle Ages leaned, but rarely to this degree. Pisa's campanile began to settle unevenly even while being built. The tower is 179 feet tall and is now approximately sixteen

feet out of plumb. Any further tilting has been stopped by a modern foundation. Although said not to pose any threat to safety today, no "Keep off the Grass" sign is needed on the side of the tower's potential descent.

SCULPTURE

Romanesque sculpture offers an enormous quantity of information. As Victor Hugo put it, "In the Middle Ages human genius had no important thought which it did not engrave in stone." The vast majority of people living in Western Europe during the Middle Ages were illiterate—a portion of the clergy included. Sermons were therefore, literally, carved in stone, with sculptors creating the equivalent of picture books for those who could not read. This was accomplished in a very expressive non-naturalistic style. The lack of realism certainly does not signify a lack of skill.

Romanesque architectural sculpture is concentrated on church portals, especially on **tympana** (the **tympanum** is the semi-circular section above the doorway, with a horizontal lintel at the bottom, supported by a central **trumeau** or post), and column capitals. This kind of sculpture was once painted with bright colors.

The typical Romanesque tympanum has a figure of Jesus in the center, in majesty. He is surrounded by a mandorla, a glory of light in the shape of a pointed oval. Outside the mandorla, the subjects of different tympana vary. For example, in France at Conques and Autun it is the Last Judgment, and at Moissac it is the Apocalypse.

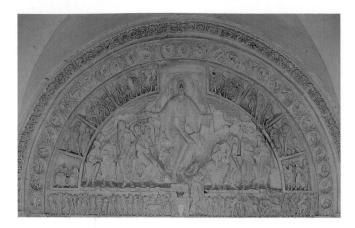

Figure 11.18 Mission of the Apostles, tympanum, Sainte-Madeleine, Vézelay, 1120–32. The relief sculpture is both decorative and didactic. The message is that Jesus's ideas, which travel from his fingertips to apostles' head, are to be conveyed to all parts of the world at all times of the year.

The Vézelay Mission of the Apostles. An extraordinary tympanum can be found in the narthex of the church of Sainte-Madeleine in Vézelay (fig. 11.18), carved 1120–32. The subject depicted here is the Mission of the Apostles, presented as an allegory of the congrega-

tion's own mission to continually spread the Christian message to all the peoples of the earth. Yet how is the story told visually? Romanesque narration is simple and direct. To show Jesus's thoughts passing into the minds of the apostles, rays emanate from Jesus's hands as he touches the head of each of them. To show that the message must be spread at all times, the second archivolt (or arch above the tympanum) depicts the signs of the zodiac and the labors of the months. The task of showing all the peoples of the earth was perhaps the most difficult for the sculptor. The innermost archivolt and lintel depict the various types of people believed to inhabit the distant regions of the earth. Shown there, as described in fanciful travelers' tales of the time, are people with dog-heads, who communicate by barking—the Cynocephali—and a pig-snouted tribe. Such figures continue on the lintel where the different races approach Peter and Paul. Last are the Panotii, whose ears are so large that they can be used to envelope the body like a blanket if it is cold, or to fly away if in danger. The diminutive stature of the pygmies is indicated by their use of ladders to mount their horses. Vézelay's tympanum provides the modern visitor with a revealing insight into the twelfth-century view of the world, which was based largely upon ancient literary sources, rather than upon contemporary accounts of actual travel and contact with other peoples.

Figure 11.19 Gislebertus, *Last Judgment*, tympanum, cathedral Saint-Lazare, Autun, ca. 1120–35. Medieval Christians were told, as depicted here, that on the day of judgment one's soul literally "hung in the balance." On the left, the Saved ascend to heaven; on the right, the Damned are consigned to the tortures of hell.

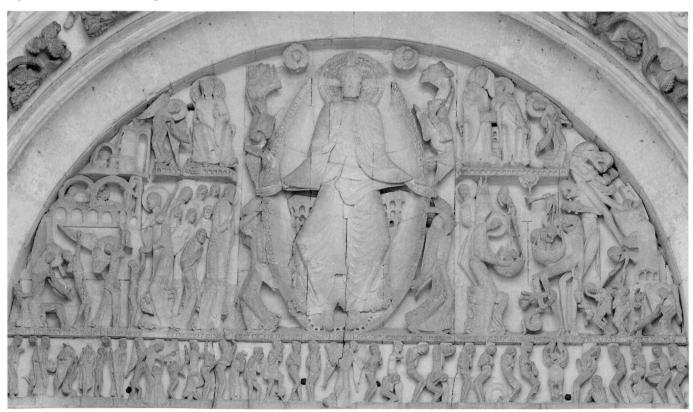

The style in which this tympanum is carved seems to accept distortion as the norm, for even the central figures in the scene appear to be barely human. Jesus's elongated body becomes a flattened frame of bent pipes to hold drapery. The apostles vary in size according to the space available. They appear nervous, even frantic. The space in which they exist is not our space; their movements are not realistically portrayed. Much as in manuscript illumination, the drapery consists of finely drawn parallel pleats, with zigzag edges, the hems turned up into fluttering folds. Romanesque figures have been described as "the dream of God on the eve of creation, a terrible first-draft of his plan."

Yet the Vézelay tympanum should not be judged according to a realistic standard; its importance lies in its effectiveness as a symbolic and didactic illustration of Church dogma. Characterized by an exquisite abstract design, this visionary work is populated by figures intended as representations of spiritual characters rather than as illusions of reality.

The Autun Last Judgment. Closely related in time and style to the sculpture at Vézelay is that at nearby Autun Cathedral. The monumental tympanum on the west facade, carved between 1120 and 1135, is signed "Gislebertus hoc fecit" (Gislebertus made it)—an extremely rare example of a signature in medieval art. As in other Romanesque tympana, there is a huge figure of Jesus in the center, surrounded by a mandorla. Flanking Jesus are scenes arranged in different sections.

The tympanum at Autun portrays the *Last Judgment* (fig. 11.19), a very popular subject in Romanesque art, intended to give an image of what awaits the viewer on Judgment Day. The expressive power and impact serve a didactic purpose; people are emphatically, dramatically, reminded to behave themselves while on earth, with the consequences for those who behave badly clearly shown.

In medieval depictions of the Last Judgment the soul literally hung in the balance between heaven and hell. On the right side of Autun's tympanum the Weighing of the Souls is represented literally. On the left, an angel tugs at the basket. On the right, a devil actually hangs from the balance bar. Thus, angel and devil both cheat! The angel wins this particular soul; other saved souls already cling to the angel. Another angel conducts the saved souls to heaven. But what about the damned? Down on the lintel, these unfortunate souls can be seen rising fearfully from the grave. The wicked cringe in agony. A serpent gnaws at the breasts of Unchastity. Intemperance scrapes an empty dish. The claws of the devil close on the head of a sinner. The image is intended to scare people who might otherwise go astray.

DECORATIVE ARTS

Reliquaries and Enamels. One important aspect of participating in a pilgrimage was the possibility of vener-

Figure 11.20 Reliquary coffer, enamel, French, Limoges, twelfth century. Elaborate coffers such as this were used to house precious relics: for instance, pieces of Jesus's cross or, perhaps, a piece of silk worn by the Virgin Mary. Such relics were thought to be endowed with magical powers.

ating relics that could be found in the churches along the route. The relics were objects connected with sacred figures such as Jesus, the Virgin Mary, or saints, and were believed to have special powers. They might be something the venerated owned, something with which they had contact, or part of their body—including bodily fluids. These relics attracted pilgrims—and their donations—helping to insure a church's prosperity and the town's wealth through tourism. Throughout the Middle Ages, trafficking in stolen and suspect relics was a major enterprise. The great spiritual and commercial value of relics explains why the most precious materials were used to make **reliquaries**, the containers for the relics.

An example is the reliquary coffer shown in figure 11.20, which was made in Limoges in the twelfth century. One of the most important Christian relics was the wooden cross on which Jesus was crucified; many reliquaries were therefore created to house pieces of the cross. The legend of the True Cross tells that the actual cross on which Jesus was crucified was found by the emperor Constantine's mother, Helena, and that most of it was kept in the Church of the Holy Sepulcher in Jerusalem, though part was also kept in Rome. In 614, the Persians conquered Jerusalem and stole the cross. In 630, it was retrieved for Jerusalem by the Byzantine emperor Heraclius, who then took it to Constantinople to protect it from the Arabs. Today, there are over 1100 reliquaries said to contain portions of the True Cross in existence.

The two major areas in Western Europe where enamel work was manufactured are the French city of

Figure 11.21 Nicholas of Verdun, *Birth of Jesus*, plaque from the *Klosterneuburg Abbey Altarpiece*, 1181, enamel on gold, height $5\frac{1}{2}$ " (14 cm), Klosterneuburg Abbey, Austria. By the late twelfth century the Gothic was superseding the Romanesque, with increased interest in recording the visible world. The drapery reveals the form beneath—unlike the flat folds unrelated to the body found in earlier Romanesque art.

Limoges, where this coffer was made, and the Mosan area, today part of Belgium. An example of Mosan work is NICHOLAS OF VERDUN's masterpiece, the altarpiece at Klosterneuburg Abbey, near Vienna. This is the most significant piece of enamel work from the twelfth century still in existence. The original altarpiece had forty-five plaques, each depicting a different scene, the figures engraved and gilded on separate enamel plaques. The Birth of Tesus (fig. 11.21) shows the infant on an altar, a reference to his future sacrifice. He is wrapped in swaddling clothes, as babies customarily were in the Middle Ages. The ox and the ass are traditional inclusions, derived from Isaiah, intended to indicate that even these humble animals recognized Jesus's divinity. In the work of Nicholas of Verdun there is a sense of a threedimensional body beneath the drapery. The fabric appears to cling, almost as if it were wet—a return to the classical manner of depicting the relationship between the figure and the fabric that covers it. This drapery is not used as a device to create abstract linear patterns, as was characteristic in most of the work of the Romanesque era. After the mid-twelfth century there was a change in artistic representation, indicative of a growing interest in the human figure, in nature, and in the world in general. The art of Nicholas of Verdun is located at this turning point, and is moving out of the Romanesque era and into the Gothic.

THE CHIVALRIC TRADITION IN LITERATURE

With their men off fighting in the crusades, medieval women began to play an increasingly powerful role in everyday life. Many women ran their family estates in their husbands' absence, and, though they had little official or legal status, they promoted a chivalric ideal in which their own position was elevated and the feudal code of stern courage and valiant warfare was displaced in favor of more genteel and refined patterns of behavior.

The Troubadours. Among the most influential proponents of this new chivalric code were the troubadours, poet-musicians who were active in the area of Provence in southern France. Writing in Occitan, the language of southern France at that time, they wrote words to sing to original melodies (as opposed to church composers, who used chant melodies handed down from the past). Troubadours were especially active in aristocratic circles, and sometimes had kings and queens as their patrons. Members of the court themselves composed works too.

The poems these minstrels sang and performed ranged widely in subject from love and morality to war and politics. However, by the middle of the twelfth century, these songs, which were often addressed to court ladies, had taken love, and particularly adulterous passion, as their central theme. Though the works celebrated the chivalric virtues, especially honor, nobility, and commitment to ideals, they were also fully cognizant of the tension between those ideals and the reality of secular love.

Such values were promoted especially by Eleanor of Aquitaine, her daughter Marie of Champagne, and her grand-daughter Blanche of Castille. Eleanor was herself the grand-daughter of one of the first such poets, Duke William IX of Aquitaine, and together with Marie she established a "Court of Love" in Poitiers in 1170. The court was governed by a code of etiquette, which was given written form in *The Art of Courtly Love* (1170–74) by Andreas Cappelanus. Marie commissioned Cappelanus to write and she clearly intended the book to be an accurate portrayal of life in Eleanor's court.

In fact, the court of love was first developed by Eleanor in England before she left Henry II to live with her daughter in Poitiers. Among the poets who wrote for her in England, evidence suggests, was MARIE DE FRANCE (twelfth century), the first woman to write verse in French. Marie de France is best known for her *lais* (lays), narratives of moderate length, which typically involve one or more miraculous or marvelous incidents and adventures concerning romantic love. A number of her *lais* concern the stories of Arthurian legend, including that of Sir Launfal. Marie's treatment of the

Then & Now

CHANT

For most of its history, chant was the official music of the Catholic Church, just as Latin was its official language. With the Vatican reforms of 1965, however, both the Church's official language and its official music were changed.

The earliest chants were transmitted orally before they were first written down in the ninth century. One explanation for the consistency of these early melodies is that they were the responsibility of a single individual—St.

Gregory, who was often depicted with a dove (symbol of divine inspiration) on his shoulder.

Chant suffered a first challenge to its authority as the dominant liturgical musical form in the Reformation of the sixteenth century. Then it was supplanted in Protestant worship by hymns and cantatas such as those composed by J.S. Bach (see Chapters 14 and 15). In the 1960s, chant gave way, even in Catholic worship, to alternative forms of music, including melodies and hymn tunes in popular styles, such as gospel and folk music.

At the end of the twentieth century, however, chant has had a surprising resurgence, less as a form of Catholic liturgy than as a reflection of popular musical taste. In the mid-1990s the CDs *Chant* and *Chant II* exhibited crossover power by heading both the popular and classical music charts. Sung by Spanish monks from the Benedictine abbey of Solesmes, *Chant* inaugurated and reflected a renewed interest in spirituality. The mystical otherworldly character of this ancient music has brought a bit of the Middle Ages into the contemporary world.

action is less heroic than it is romantic, the characters less noble than human, the plot less concerned with grave matters of history and state than with the intimate affairs and feelings of a few people.

One of Eleanor's most gifted troubadour poets was BERNART DE VENTADORN [VEN-tuh-DOR] (d. 1195). The following stanza, from a poem apparently addressed to Eleanor herself, gives the modern reader some idea of the freedom of expression the troubadour poet was given:

Evil she is if she doesn't call me
To come where she undresses alone
So that I can wait her bidding
Beside the bed, along the edge,
Where I can pull off her close-fitting shoes
Down on my knees, my head bent down:
If only she'll offer me her foot.

There is no direct reference to sexual consummation, though it is implied. Of course, adultery was strictly for-bidden by the chivalric code, and though the passions expressed here are strong, they are carefully controlled. Even if in actual court life nobles succumbed to temptation, in poetry at least the notion of *courtoisie*, "courtesy," was always upheld. In the end, much of the pleasure of the poetry of courtly love is derived from the clever word play. The poetry celebrates, in its purest form, the ennobling power of friendship between man and woman.

Chrétien de Troyes. An especially popular literary form depicting the chivalric relations between knights and their ladies was the romance, a long narrative form taking its subject matter generally from stories surrounding King Arthur and his Knights of the Round Table. Among the very first writers to popularize the romance was CHRÉTIEN DE TROYES [CRE-tee-EN] (ca. 1148–ca. 1190), whose account of the legend of Lancelot and his adulterous affair with King Arthur's wife

Guinevere became a particular favorite. Called "the perfect romance," his *Chevalier de la Charette* expresses the doctrines of courtly love in their most refined form. Identifying Lancelot with Jesus, Chrétien goes so far as to equate Lancelot's noble suffering with Jesus's passion.

MUSIC

Hildegard of Bingen. Only relatively few women, those of the nobility, could enjoy the pleasures of the court of love. Most women worked the fields, at the sides of their husbands, and had the possibility of inheriting the land. Alternatively, women could become nuns and live in convents.

The head of one such convent was HILDEGARD OF BINGEN (1098–1179). Born to noble parents, Hildegard had a mystical vision at the age of five, and when she was eight was put into the care of a small community of nuns attached to the Benedictine monastery outside Bingen, near Frankfurt, Germany. She became a playwright and poet, and composed a cycle of seventy-seven songs in plainchant. She also wrote a book on medicine, and a book of visionary writings.

Hildegard of Bingen's music was written for performance by the nuns of her convent. Her major work, *The Symphony of the Harmony of Celestial Revelations*, which occupied her for much of her creative life, contains some of her finest work. One of her most beautiful compositions, *O Ecclesia*, celebrates St. Ursula who, according to legend, was martyred with eleven thousand virgins at Cologne. Like Hildegard, Ursula had led a company of women and had devoted her life to God. The music for three sopranos is accompanied by an instrumental drone, which serves as a sustained bass over which the voices weave their flowing and undulating chant-like melody.

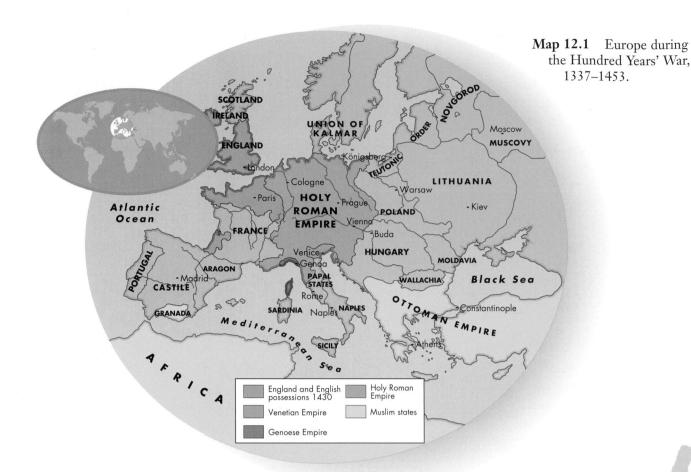

THE GOTHIC * AND LATE MIDDLE AGES

CHAPTER 12

- + The Gothic Era
- * Toward the Renaissance

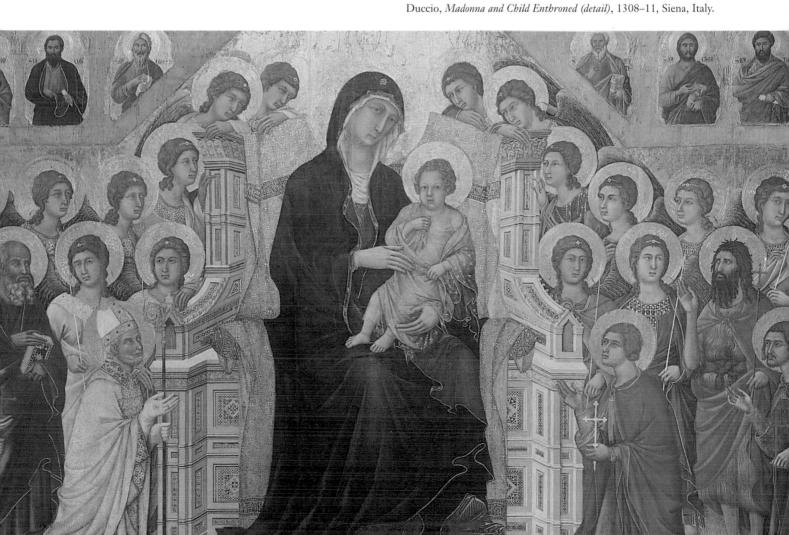

THE GOTHIC ERA

PARIS IN THE LATER MIDDLE AGES

No city dominated the later Middle Ages more than Paris. Home to a revival in learning at the newly founded university, Paris was also the seat of the French government, overseen by King LOUIS IX (later St. Louis) (r. 1226-1270). The monarchy had not enjoyed such power and respect since the time of Charlemagne. Louis made a determined effort to be a king to all his people, sending royal commissioners into the countryside to monitor the administration of local government and to ensure justice for all. He outlawed private warfare and abolished serfdom, and granted his subjects the right to appeal to higher courts. Furthermore, he became something of a peacekeeper among the other European powers, and was in most matters more influential than the pope. In short, he became associated with fairness and justice, and France consolidated itself as a nation around him, with Paris as its focal point. Soon all roads led to Paris, as they had once led to Rome.

Louis IX continued a remarkable building program in Paris. Construction of the cathedral of Notre-Dame had begun in 1163. Under Louis IX, work progressed, with Paris's approximately 120 guilds all contributing labor and money. The cathedral was, in this sense, not only the center of spiritual life, but also a very real focus for the community. In addition, Louis IX commissioned the magnificent Sainte-Chapelle, the royal chapel, also on the Île-de-la-Cité, the island in the middle of the Seine River that had been the city center since Roman times. The chapel was built to house an important relic, Jesus's Crown of Thorns; the Sainte-Chapelle was, in effect, its monumental reliquary.

The relative security and productivity of Louis IX's reign, however, could not long be sustained. In addition to the cost of the building program in Paris, France suffered the crippling expense of fighting what would become known as the Hundred Years' War, which actually began in 1337 and ended in 1453. Ostensibly a fight over the succession to the French throne—none of Louis IX's successor Philip IV's three sons produced a male heir—it was instigated by Edward III of England (r. 1327–77), who claimed that, as the nephew of the last Capetian king, he was the rightful ruler of France. As the French kings increased taxes to support what was generally a losing battle, and then suffered humiliating defeats at Crécy in 1346 and again at Poitiers in 1356, the general population rebelled.

The English had captured King John II, known as John the Good (r. 1350–64) at Poitiers, and perhaps sensing the weakness of Charles, John's adolescent son, who acted as regent for his father during his captivity in England, the merchant provost Étienne Marcel revolted

against the crown. On February 22, 1358, he led a mob into Charles's apartments, slaughtering the regent's counsellors before his eyes. Charles, however, did not surrender, and eventually Marcel was murdered and the revolt crushed.

When Charles came to the throne as CHARLES V (r. 1364–1380), he could not bring himself to live any longer in the buildings where he had witnessed the bloody revolt. Transforming the old palace into his Parliament, or Palace of Justice, as it is known today, he moved across the river onto the right bank, turning old fortifications built by Philip Augustus against the threat of English invasion into the royal residence—the Louvre. In Les Très Riches Heures (fig. 12.1), an illuminated

Figure 12.1 Limbourg brothers, October, from Les Très Riches Heures of the Duke of Berry, French, 1413–16, manuscript illumination, $11\frac{1}{2} \times 8\frac{1}{4}$ " (29.2 × 21 cm), Musée Condé, Château of Chantilly, France. This illustration depicts the Louvre as it appeared in the time of Charles V in a highly realistic manner, containing the first representations of shadows since classical antiquity.

Then & Now

THE LOUVRE

The Louvre today is one of the most famous museums in the world. It is also the largest royal palace in the world, a building that has undergone more redevelopment through the ages than any other building in Europe. The first building on the site was a fortress, erected in 1200 by Philip Augustus, with a keep, the symbol of royal power, surrounded by a moat. Remnants of the moat and keep still exist, and can be viewed on the bottom floor of the museum.

It was Charles V who first used the building as a royal residence, but over the years its galleries and arcades have also served as a prison, an arsenal, a mint, a granary, a county seat, a publishing house, a ministry, the Institute for Advanced Studies, a telegraph station, a shopping arcade, a tavern, and a hotel for visiting heads of state. The expansive and open plan of the Louvre today, with its two great arms extending from the original building west to the Tuileries gardens, is the result of later additions. In the latter part of the sixteenth century, Henry IV added the Grand Galleries, initially conceived as a covered walkway connecting the palace to the garden, and where the Dauphin

would later exercise his camel, riding it up and down their length. In the seventeenth century, Louis XIV closed off the east end, forming the Cour Carrée.

The result of all these various additions and alterations is a building that represents almost every architectural style in the history of the West. A Romanesque fortress forms its basis, and outward from it spread two Gothic and two Renaissance wings. Baroque and Rococo ornamentation can be found throughout, and the closed-off

end is Neoclassical. In this spirit of heterogeneity and plurality, architect I.M. Pei designed a glass pyramid (fig. 12.2) to serve as the museum's new entrance in 1988. Set above a network of underground rooms and walkways, Pei's pyramid is 61 feet high and 108 feet wide at the base, and constructed of 105 tons of glass. Beside it are flat triangular pools that reflect the walls of the surrounding palace, bringing the ancient and the modern into harmony.

Figure 12.2 I.M. Pei, Glass Pyramid, addition to the Louvre, Paris, France, 1988. Pei's pyramid was highly controversial at the time of its construction, as Parisians claimed it did not "fit" architecturally into this most eclectic of architectural spaces.

manuscript commissioned by the Duke of Berry and created by the Limbourg brothers in 1413-16, Charles's new palace at the Louvre, with its towers, ramparts, and crenelated walls, is seen in open country just west of the university from a point on the left bank of the Seine. In his new residence Charles installed a library of 973 books, then the largest in France, on cypress-wood shelves (cypress being poisonous to insects). His collection included the texts of Ovid and Livy, works of magic, scripture, bestiaries, and astronomies, and was to eventually form the foundation of the Bibliothèque Nationale, today France's great national library. Charles also erected new walls around the city to the north, anchored to the east by the newly erected Bastille. Within these walls, the population of Paris numbered approximately 150,000, an extremely large city considering that only a few years earlier nearly half its inhabitants had been wiped out by the plague.

GOTHIC ARCHITECTURE

The term **Gothic** refers to the style of visual arts and culture that first developed, beginning about 1140, in the Île de France, and which reached its zenith in the thirteenth century. From the mid-thirteenth through the mid-fourteenth century, Paris was an important source of artistic inspiration for the rest of France, Germany, and England, while Italy remained quite separate aesthetically. By the middle of the sixteenth century, the Gothic style was at an end in France, although aspects of it continued to influence artists in Germany and England until the seventeenth century.

What is now called "Gothic art" was originally called the "French style," and referred to architecture. Architecture, in fact, dominates the era. This is the age of the great cathedrals of northern Europe. However, it was the Renaissance Italians who gave the style its name. Preferring the classical style, the Italians thought the Gothic barbaric and identified it with the most notorious of the barbarian tribes, the Goths. Thus, the style was labeled "Gothic," with a decidedly derogatory intent.

The Gothic style developed out of the Romanesque. Romanesque buildings, such as the church of Saint-Sernin in Toulouse, are broad and massive, characterized by semi-circular arches, thick walls, and closely spaced supports that create a feeling of security. Solid and heavy, Romanesque buildings seem to be bound to the earth. In contrast, Gothic buildings rise to the heavens. Airy and delicate, they have a soaring quality, for the vertical is constantly emphasized and the walls are thin. Small Romanesque windows give way in Gothic architecture to vast windows of stained glass.

The Gothic was an era of confidence and daring, as its extraordinary architectural accomplishments testify. The tremendous height of the buildings was a reflection of religious ideals and enthusiasm, of inspiration and aspiration. The vast naves of the Gothic cathedrals create an extraordinary atmosphere of spirituality. The chants sung here reverberated from the high vaults.

The important structural innovations (fig. 12.3) that made this new style possible and characterized it included the following:

(1) Pointed arches and vaults, which exert less lateral thrust than the semi-circular Romanesque arches and vaults. The pointed ribbed vault can be constructed in a variety of floor plans and, in theory, built to any height.

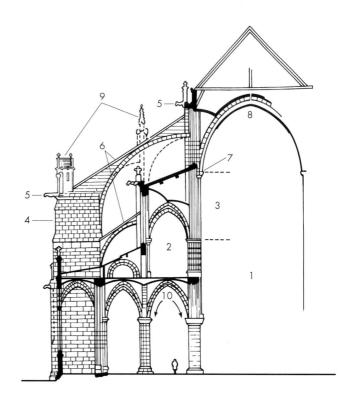

Figure 12.3 The principal features of a Gothic church include (1) the nave; (2) gallery/triforium; (3) clerestory window; (4) buttress; (5) gargoyle; (6) flying buttresses; (7) architectural rib; (8) vault; (9) pinnacles; (10) pointed arch.

Timeline 12.1 France and England during the later Middle Ages.

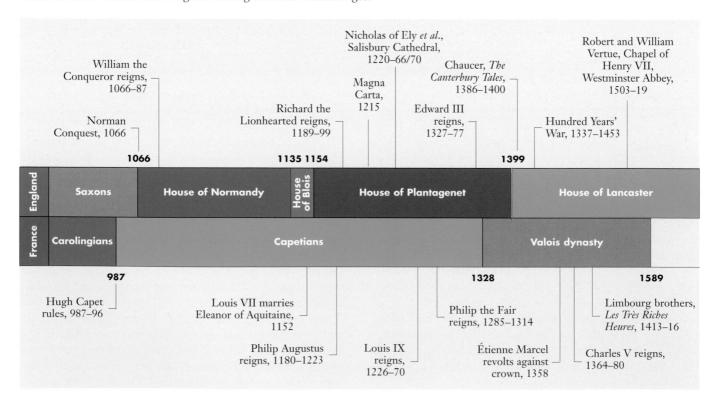

259

The Gothic system is more flexible than the Romanesque, which cannot attain comparable height and is generally restricted to simpler floor plans.

- (2) Ribs, which serve to concentrate the weight of the vault at certain points, making it possible to eliminate the wall between these points.
- (3) Flying buttresses, which were introduced in response to the problem created by the lateral thrust exerted by a true vault. The idea of a buttress, a solid mass of masonry used to reinforce a wall, was an old one. But the "flying" part, the exterior arch, was an invention of the Gothic era. Flying buttresses project outward on the exterior of the building and cannot be seen from the inside through the stained glass windows.

Royal Abbey, Saint-Denis. There is little debate as to where the Gothic style began—the royal abbey of Saint-Denis, located just north of Paris. The first church on the site was erected in 475 in honor of St. Denis, who,

Figure 12.4 Royal Abbey, Saint-Denis, France. Ambulatory, 1140–44. The eccentric and egocentric Abbot Suger initiated the Gothic style of architecture, characterized by a new lightness of proportion and sense of flowing space. The pointed Gothic arches exert less lateral thrust than the Romanesque semi-circular arches, and the ribs reinforce the vaults.

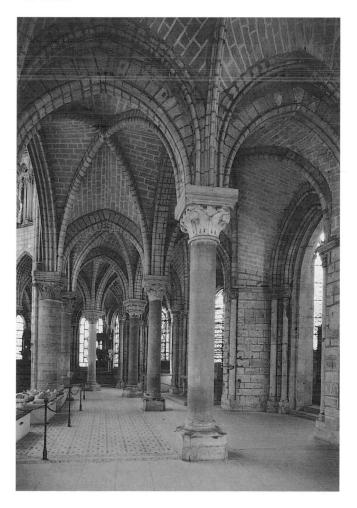

as one of the first of seven bishops sent to Paris around A.D. 250 to convert the Gauls, was rewarded for his efforts by being tortured on a hot grill and then decapitated. St. Denis is said to have picked up his head and walked north to the site where the abbey was subsequently built.

The parts of the abbey of Saint-Denis that herald the beginning of the Gothic were built under Abbot SUGER [SOO-zjay] (1081-1151) around 1140. A Benedictine monk, Suger was also a politician, and he served as advisor to successive kings of France and was even regent of the country during the Second Crusade. He regarded the Church as symbolic of the Kingdom of God on earth and was intent on making Saint-Denis as magnificent as possible. Suger rebuilt the facade, the narthex, and the east end of Saint-Denis. He commissioned a golden altar, jeweled crosses, chalices, vases, and ewers made of precious materials. This richness was in honor of God, France, and possibly also Suger. At a time when humble anonymity was the norm, Suger had himself depicted in stained glass and sculpture, and had his name included in inscriptions.

Of great historical importance as the first large and truly Gothic building, Saint-Denis served as the prototype for other Gothic structures. The facade of Saint-Denis, dated about 1137-40, was the first to synthesize monumental sculpture and architecture. Considered an artistic composition, with rhythm, clarity, and variety, its two towers, rose window (a circular window with tracery radiating from its center to form a roselike symmetrical pattern), rows of figures representing Jesus's biblical ancestors, and column figures on the jambs, all became standard features of later Gothic cathedrals. Between 1140 and 1144, when Suger was working on the east end of Saint-Denis, he removed the existing Carolingian apse and built a new choir. Today, the ambulatory and the seven chapels are all that remains of the abbey of Suger's day (fig. 12.4).

In Suger's plan, the divisions between the chapels are almost eliminated. Each chapel has two large windows. This introduction of light was a new concept of architectural space, of light, and of lightness. The space is not divided into distinct units, as it had been in Romanesque architecture. Instead, without the solid walls and massive supports that had characterized the Romanesque, Gothic space flows freely and areas merge with each other.

Notre-Dame, Paris. The celebrated cathedral of Notre-Dame-de-Paris (Our Lady of Paris) (fig. 12.5), located in the heart of Paris on the Île-de-la-Cité, is a major monument in Western architectural history. The spectacular site is the historical center of the city. Gallo-Roman ramparts once fortified it, and earlier churches had been built there as well. Bishop Maurice of Sully, founder of the cathedral, had these removed, however.

Construction of Notre-Dame started in 1163. Work began with the choir—the construction of a church or

cathedral usually commences at the choir end, the most significant area for liturgical purposes. The altar is oriented to the east, the entrance toward the west. There are few exceptions to this specific orientation of Christian churches. Notre-Dame was first finished in 1235. Yet a fundamental reconstruction began almost at once. The vaulting of the choir was redone; almost all the clerestory windows were enlarged; the flying buttresses were doubled; the transepts were rebuilt; and work was carried out on over forty chapels. All this remodeling took several decades.

The facade (fig. 12.6) dates, for the most part, from the first half of the thirteenth century. Large amounts of wall are still evident, a holdover from the Romanesque period. At Notre-Dame, a subtle equilibrium of horizontals and verticals creates a masterpiece of balance on an enormous scale. Based on a complex sequence of squares, one inside another, the entire facade is one large square, 142 feet on each side. The towers are one-half the height of the whole solid area—a simple and visually satisfying geometry.

Figure 12.5 Cathedral of Notre-Dame, Paris, France, 1163–ca. 1250, apse, flying buttresses added in the 1180s. Exterior wall buttresses have a long history; innovative are the arch-shaped "flying buttresses," used especially on large multi-storied buildings to absorb the lateral thrust exerted by the vaulting. The solid walls of Romanesque architecture were replaced by the characteristically Gothic flying buttresses.

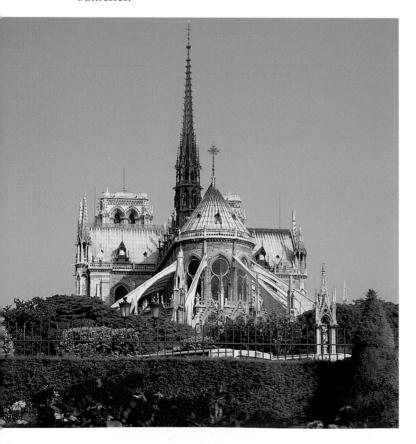

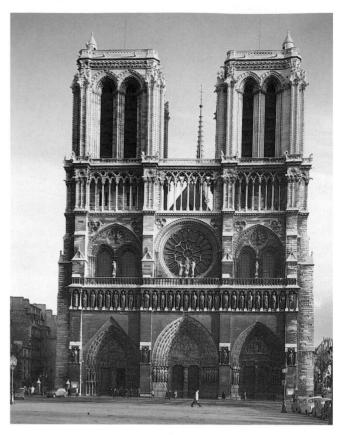

Figure 12.6 Cathedral of Notre-Dame, Paris, France, 1163–ca. 1250, west facade, mostly first half of thirteenth century. This celebrated cathedral is an example of the first phase of the Gothic, referred to as Early Gothic. In Romanesque architecture horizontals dominated; here horizontals and verticals balance; soon the verticals will dominate.

In the 1180s, flying buttresses (see fig. 12.5) were introduced at Notre-Dame to stabilize its great height—the first use of flying buttresses occurred here in Paris. The buttresses are in two parts: the outer buttress is exposed; the inner buttress is hidden under the roof of the inner aisle. From this time forward, flying buttresses would play an important structural and visual role in Gothic architecture.

Notre-Dame, Chartres. The cathedral of Notre-Dame in Chartres (fig. 12.7), a spectacular structure with splendid sculpture and sparkling stained glass, leads into the High Gothic. Earlier Gothic forms are here refined, extended, and made more vertical. The spaces between the buttresses are more open, making the building lighter and airier.

Dedicated to the Virgin Mary, Chartres cathedral was intended to be a "terrestrial palace" for her, built on the highest part of the city in order to bring it closer to heaven. Chartres cathedral possesses an important relic of Mary. Known as the *sancta camisia*, it is a piece of cloth, possibly part of a tunic or veil, said to have been worn by

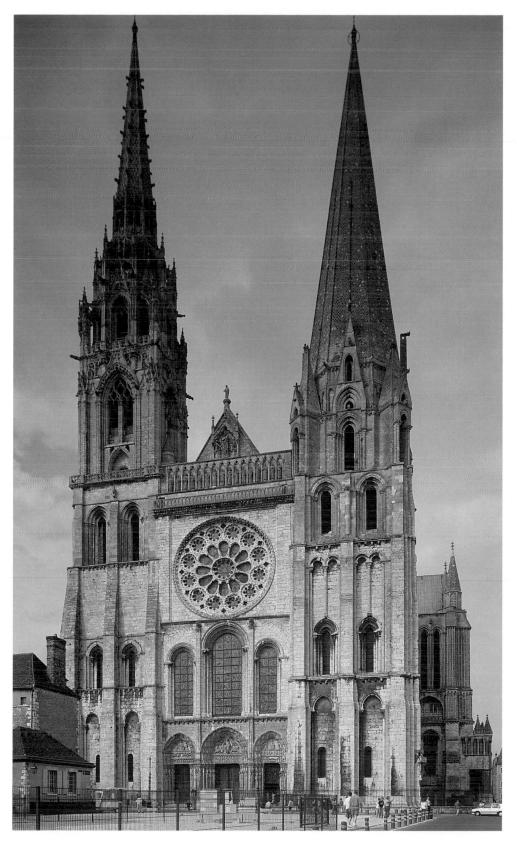

Figure 12.7 Cathedral of Notre-Dame, Chartres, rebuilding 1145–1220; north spire 1507–13. The cathedral dominates the surrounding landscape and is visible for miles around. The Gothic cathedral was routinely built on the highest site available.

Connections

NUMEROLOGY AT CHARTRES

At the cathedral school at Chartres, Plato's theory of the correspondence between visual and musical proportions and the beauty of the cosmos was carefully studied. The number three, also important in Christian theology, seems to have assumed special importance for the builders at Chartres. It symbolized the Holy Trinity and Plato's secular trinity of truth, beauty, and goodness.

The architecture of Chartres is replete with threes—on the exterior a three-step facade is matched by three corresponding internal levels, culminating in the heavenly light of the clere-story. There are three semicircular chapels in the apse, and each clerestory consists of one rose and two lancet windows. The six-petaled rose in the mosaic in the center of the nave represents the sum of one, two and three.

The number nine, associated with the Virgin Mary, is also of special importance. The cathedral, which houses a piece of her veil from the Nativity, celebrates her number. Mary is, as Dante said, "the square of the Trinity." Chartres has nine entrance portals—three times three—and in its original plan it was to have nine towers, two on the facade, two on each of the transepts, two flanking the apse, and one rising over the crossing.

Figure 12.8 Cathedral of Notre-Dame, Chartres, France, rebuilding begun 1145, vault finished by 1220, nave looking toward altar. The first architectural masterpiece of the second phase of the Gothic, known as the High Gothic, Chartres Cathedral was designed from the start to have flying buttresses. In this three-story nave elevation, large clerestory windows allow light to enter directly into the nave, the deep colors of stained glass creating an atmosphere of multi-colored light.

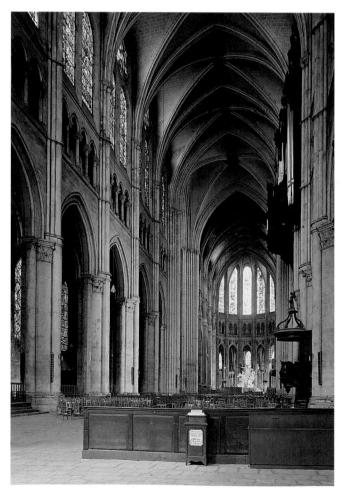

Mary when Jesus was born. Because it had this relic. Chartres was believed to be protected by the Virgin and became an extremely popular pilgrimage site. Although it was believed to have produced many miracles, the relic could not fend off fire, constant enemy of churches during the Middle Ages and the cause of the cathedral's destruction in 1020. Rebuilding began immediately, and by 1024 a new crypt was finished. Known as "Fulbert's Crypt," it was then, and still is, the largest crypt in France. A Romanesque cathedral was then constructed on the site, but in 1134 fire destroyed the town, and the building was damaged. The Royal Portals and the stained glass windows on the west facade were made 1145–55. In 1194 there was yet another fire in which the cathedral suffered great damage. Little more than Fulbert's Crypt and the Royal Portals and windows survived.

Mary's cloth, safe in the crypt, survived the fire of 1194. This was taken as a sign to build a yet more magnificent monument in her honor. The people of Chartres willingly gave money, labor, and time. All social classes participated, from the high nobility to the humble peasantry. Rough limestone was brought from five miles away in carts, an activity referred to as the "cult of the carts." By 1220, the main structure and the vaults were finished, built at great speed yet in a consistent style. In 1260, the cathedral was dedicated. Like the facade of Notre-Dame in Paris, Chartres has four buttresses, three portals, two towers, and one rose window. Yet, at Chartres, the two facade towers are strikingly dissimilar. The south spire is 344 feet high, built at the same time as the rest of the upper facade. But the north steeple of the early sixteenth century, built in a much more "Flamboyant" Gothic style, rises 377 feet. Symmetry was, obviously, not a Gothic aim. Instead, each tower was built in the style popular at the time of its construction. However, the towers are not discordant—it might even be argued that they are twice as interesting as two identical towers.

Chartres is the first masterpiece of the High Gothic, the first cathedral to be planned with flying buttresses (Notre-Dame in Paris has them, but they are later additions), and to use them for the entire cathedral. The buttresses at Chartres are designed as an integral part of the structure, for they counteract, as discussed above, the lateral thrust of the vault. They join the wall at the critical point of thrust, between the clerestory windows, where there is a minimum of stone and a maximum of glass. Using the flying buttress, it is possible, in theory, to reduce the wall to the point of creating a mere web of stone; flying buttresses also make possible the tremendous height, verticality, and open wall that characterize Gothic religious architecture.

The nave (fig. 12.8) has a sense of soaring verticality, of openness and airiness. Whereas the nave at Notre-Dame in Paris is just over 108 feet high, Chartres's is 121 feet high and 422 feet long. The three-story elevation consists of the arcade; the triforium (although there are four openings in each bay of the *tri*forium); and the clerestory. The lines lead up the wall to the clerestory windows, which are almost the same height as the openings in the nave arcade—about forty-five feet. The openings are tall and narrow, emphasizing the vertical rather than the horizontal. A vast amount of window area is permitted by the exterior buttressing. Yet this was not done to produce a brightly lit interior, as the stained glass prevents much of the natural light from entering.

Figure 12.9 Robert de Luzarches, Thomas de Cormont, and Renaud de Cormont, Cathedral of Notre-Dame, Amiens, France, 1220–70, plan. When building with pointed arches, ribbed vaulting, and flying buttresses, in theory, there is no limit to the height attainable. Soaring heavenward, the nave of Notre-Dame at Paris rises over 108 feet; at Chartres 121 feet; at Amiens 139 feet; yet Beauvais Cathedral, at 158 feet, after it collapsed and was rebuilt, demonstrated the practical limits of the structural system.

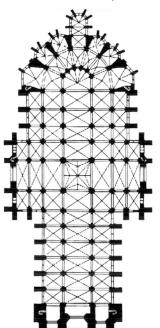

Instead, stained glass provides colored and changing light in the windows themselves and flickering light over the stone interior.

Notre-Dame, Amiens. The soaring and sophisticated cathedral of Notre-Dame in Amiens (fig. 12.9) represents the climax of the High Gothic style. Like many other French Gothic cathedrals, Amiens Cathedral dominates the city. Building began in 1220 and by 1270 the cathedral was almost finished; only the tops of the towers above the rose window date from the fourteenth and fifteenth centuries. The facade (fig. 12.10) has five parts: (1) the usual three portals on the ground floor, which are exceptionally deep; (2) the gallery; (3) the gallery of kings—twenty-two figures, each fifteen feet high, representing the Kings of Judah, each holding a rod of the Tree of Jesse; (4) the rose window, with sixteenth-century glass; and (5) above this, the fourteenth- and fifteenth-century work. The great height achieved by

Figure 12.10 Robert de Luzarches, Thomas de Cormont, and Renaud de Cormont, Cathedral of Notre-Dame, Amiens, France, begun 1220, west facade. Buildings became ever more delicate during the Gothic era, stone seemingly turned into lace. The height of a city's cathedral was a matter of civic pride—similar to the twentieth-century battle in Manhattan between the architects of the Chrysler Building and those of the Empire State Building to erect "the tallest building in the world."

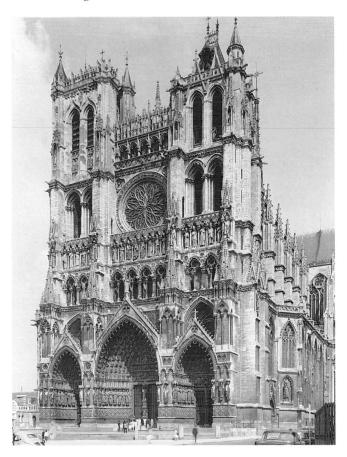

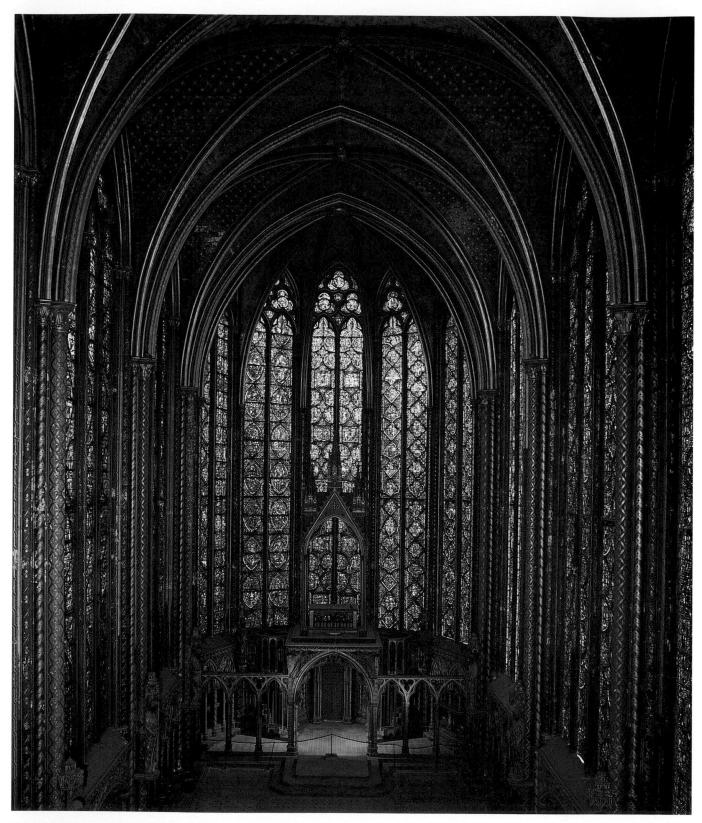

Figure 12.11 Pierre de Montreuil (?), Sainte-Chapelle, Paris, France, 1243–48, upper chapel, looking toward the apse. In this example of the third phase, the Rayonnant Gothic, the amount of masonry is reduced and the building becomes a cage of glass. Standing inside the upper chapel, when sunlight streams through the stained-glass windows, it is as if one is standing inside a sparkling multi-colored, multi-faceted jewel.

medieval masons was a matter of civic pride and a symbol of strength—what might be called "tower power." Each town tried to outdo the others in terms of height. When a conquering army took a defeated city, they destroyed its church or cathedral spire; to lop off the top of the tower was the sign of the city's submission.

Sainte-Chapelle, Paris By the middle of the thirteenth century, a new "Rayonnant" style of Gothic style had begun to emerge. The name "Rayonnant" comes from the French rayonner, which means "to shine" or "to radiate." The move to this new phase of the Gothic did not involve a change in basic architectural plan. Rather, it was the result of a changing sense of harmony, and the gradual substitution of window for wall. In this Rayonnant style, stone tracery divisions between the areas of glass in rose windows are made progressively thinner and are formed into ever more intricate patterns.

Paris under King Louis IX was the center for the Rayonnant style. Louis not only acquired a portion of the Crown of Thorns for the Sainte-Chapelle, but purchased many other relics as well, including what was believed to be a piece of Jesus's cross, iron fragments of the Holy Spear that pierced Jesus's side, the Holy Sponge, the robe, the shroud of Jesus, and a nail from the crucifixion. Later, the front part of the skull of St. John the Baptist was purchased (the back was in Amiens). Louis had these relics placed in an ornate shrine in the Sainte-Chapelle which cost at least 100,000 livres. While it is difficult to determine what this would equal in today's dollars, some sense of the expense may be had by noting that the chapel itself only cost 40,000 livres to build. Nonetheless, 100,000 livres for the shrine is somewhat eclipsed by the cost of the Crown of Thorns, for which Louis spent the enormous sum of 135,000 livres.

Perhaps the quintessential example of the Rayonnant style, the Sainte-Chapelle looks like an enormous reliquary. Rich and refined, this display of architectural virtuosity was considered a masterpiece as soon as it was built. Its reputation has remained undiminished. Its greatness is not due to great scale; when compared to other Gothic buildings, the Sainte-Chapelle is extremely small. The interior is a mere 108 feet long, and thirtyfive feet wide. Divided into a lower and an upper chapel, the lower is only a little under twenty-two feet high, and the upper only just over sixty-seven feet. The upper chapel (fig. 12.11) was dedicated to the Holy Crown of Thorns and the Holy Cross. The plan is extremely simple, consisting of only the nave of four rectangular bays and a seven-sided apse. The walls disappear. The lines soar. The windows are shafts of light. The building is a cage of glass and stone, seemingly weightless, an illusion that relies on extraordinary architectural engineering. The Sainte-Chapelle appears to defy the laws of gravity. The thin piers of stone are hardly noticed. All the space between the piers is given over to huge windows, with

more than three-quarters of the walls in this ethereal environment actually being stained glass. The piers actually project inward over three feet, but their bulk is masked by groups of nine colonettes. All other supports are placed outside, leaving the interior a continuous uninterrupted space. In 1323, Master Jean de Jandun described his experience of the chapel in the following way: "On entering, one would think oneself transported to heaven and one might with reason imagine oneself taken into one of the most beautiful mansions of paradise."

The entire scheme of the upper chapel glass relates to the relics of Jesus kept there. The central apse window shows Jesus's passion, introduced by the Old Testament stories in the nave. The cycle begins on the north side with the Book of Genesis. It concludes on the south side with the story of the relics of the passion, especially the Crown of Thorns, and their arrival in Paris. The French king is depicted alongside kings David and Solomon. It has been observed that the windows of the Sainte-Chapelle include a great number of coronation scenes—twenty plus that of Jesus. Could this be interpreted as an attempt to link the crown of France to Jesus's Crown of Thorns, the revered relic in the apse of the Sainte-Chapelle? Is a connection being made between French royalty and biblical royalty?

Saint-Maclou, *Rouen*. Saint-Maclou in Rouen (fig. 12.12), a small parish church, is the paradigm of the Flamboyant Gothic style, the final phase in the development of Gothic architecture. The church was designed in

Figure 12.12 Pierre Robin, Saint-Maclou, Rouen, France, designed 1434, west facade designed by Ambroise Havel (?) 1500–21. The finest example of the fourth and final phase of the Gothic, the Flamboyant or Late Gothic, this small building has enough decoration to equal that of a huge cathedral. The lacy stone tracery is "flamboyant"— "flamelike"—with its undulating curves.

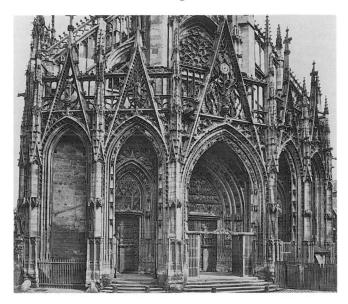

1434 by PIERRE ROBIN, although the facade was probably designed by AMBROISE HAVEL. Perhaps its most striking feature is the porch, which is faceted into three planes and thus bows outward.

The Flamboyant style is so called because of the mesh of flamelike curving stone tracery: *flamboyant* is the French for "flaming." It is a style characterized more by ornament than by structure. There is an identifiable delight in delicacy, a compulsion for complexity. Surfaces become luxurious, covered with a great profusion of lacelike ornament. The skill of the artisans who made it is apparent everywhere, as is their fantasy and, in a sense, ostentation. No large flat wall areas remain. All surfaces are broken.

Indeed, the ornament almost obscures the actual structure beneath it. Complexity is preferred over clarity. The design is exuberant, with interlacing and overlapping planes. The steeply pitched openwork gables are filled with flamelike forms, created by endless curves and countercurves, a surface tangle that is animated by light and shade as the sun moves. This new form of decoration is dynamic, as is the underlying structure that makes it possible.

GOTHIC ARCHITECTURE OUTSIDE FRANCE

Salisbury Cathedral. The French Gothic spread rapidly outside France, each country modifying it for its own needs. In England, the Early Gothic was relatively understated, but the Late Gothic reached extremes of eccentricity beyond anything found in France. Early English Gothic is represented by Salisbury Cathedral (fig. 12.13). The choir, Lady Chapel, transepts, and nave were built between 1220 and 1258 by NICHOLAS OF ELY. Work was finally completed by 1270. The building is not at all compact. The whole structure, which measures 473 by 230 feet, lacks a rounded apse, ambulatory, and radiating chapels, having instead, in typical English Gothic form, a square east end. The long nave has ten bays instead of the seven usually found in France.

The facade of Salisbury Cathedral, although begun in the same year as Amiens Cathedral, has very different proportions. Salisbury is low and wide, as if stretched horizontally, with no particular emphasis on height. The facade is wider, in fact, than the church and is treated as a screen, divided into horizontal bands with importance placed on the sculpture but little on the portals. English cathedrals are usually entered by a porch on the side of the nave or on the transept. Flying buttresses, so characteristic of French Gothic, were used only sparingly in England.

Westminster Abbey, London. After English Gothic architects had thoroughly mastered initial structural problems, they refined and enriched their forms. Vaulting became progressively more adventurous. The

ultimate example of fantastic English vaulting is in Westminster Abbey, London. The enormous interior culminates in the chapel of Henry VII (fig. 12.14). The architects were ROBERT and WILLIAM VERTUE. The tomb of Henry VII is behind a grill at the back of the altar. William Vertue replaced the axial chapel, originally built in 1220, with this one, built 1503–19. The most remarkable feature is the ceiling, a sort of fan vaulting, so called because the ribs radiate in a manner similar to those on a fan. But here the idea is carried to an extreme, to become pendant vaults hanging down in knobs. Such a structure appears to counter conventional ways of building, in a denial of both logic and gravity. Describing the chapel, one historian noted, "Its extraordinary, petrified foliage gives the impression of some

Figure 12.13 Nicholas Ely et al., Cathedral, Salisbury, England, 1220–70, west facade. Typical of early English Gothic, Salisbury is sprawling in plan, surrounded by a green lawn, and makes little use of flying buttresses—as opposed to French Gothic cathedrals, which are typically compact in plan, located in the city center, and rely on flying buttresses for structural support.

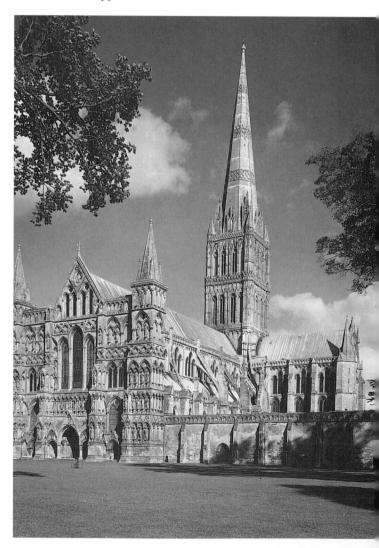

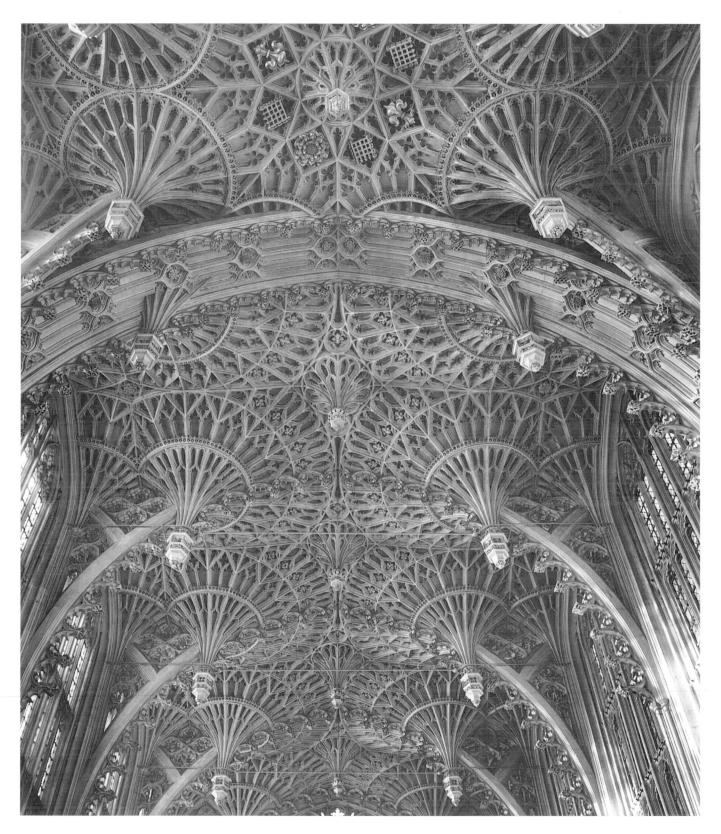

Figure 12.14 Robert and William Vertue, Chapel of Henry VII, Westminster Abbey, London, England, 1503–19, interior. The radiating ribs of fan vaulting are taken to an extreme here, becoming pendant vaults that actually hang down into the space of the chapel. The surface dissolves in this late and extreme example of English architectural eccentricity.

Figure 12.15 Arnolfo di Cambio, Francesco Talenti, Andrea Pisano, and others, Cathedral, Florence, Italy, begun 1296; redesigned 1357 and 1366, drum and dome 1420–36; campanile designed by Giotto, built ca. 1334–50. The dome of the cathedral could not be built as originally designed. It was only in the early part of the Renaissance that Filippo Brunelleschi would solve the engineering problems that had prevented its earlier construction (see Chapter 13).

fantastic, luminous grotto encrusted with stalactites." Elaborate designs cover the entire surface, an indication of the English inclination toward the architectural extreme, the eccentric, the intricate, and the opulent.

Florence Cathedral. Italy was only superficially affected by the Gothic style. Instead of the elaborate buttress systems and large windows popular in the north, Italian architects favored large wall surfaces with emphasis on the horizontal, as is evident in the major landmarks of the city of Florence—its cathedral (duomo), bell tower (campanile), and baptistery (fig. 12.15).

The single most important construction work carried out during the Gothic era in Florence was that done on the cathedral. The cathedral has an unusually complicated history. There had been an older church on the site, but in 1296 ARNOLFO DI CAMBIO began to build a new cathedral. Work started at the west (entrance) end and proceeded quickly, until Arnolfo's death in 1302, after

which work ground to a halt. In 1343, Francesco Talenti took charge. Work continued over a long period of time, with various architects involved. All of the surfaces are treated to colorful marble incrustation. Italy is wonderfully rich in marbles of many colors, a fine example of which is the Romanesque baptistery, just in front of the cathedral. The decoration is flat, differing from the French love of sculpted surfaces. The dome was not constructed until the early Renaissance.

The campanile was designed by Giotto and is referred to as "Giotto's Tower." Although the freestanding campanile is typically Italian, it is not an invention of the Italian Gothic; the campanile of Pisa, the famous "Leaning Tower," was built in the Romanesque era (see fig. 11.16). The richly ornamented Gothic campanile of Florence, with its multicolored marble incrustation and sculpture, served not only as the bell tower but also as a symbol of the sovereignty of the Florence commune.

In 1334, Giotto was appointed architect-in-chief of the building of Florence Cathedral. He received this appointment because he was the most famous Florentine artist of his day. Giotto, however, was a painter who knew little about architectural structure and ended up designing only the campanile. His original drawing of it

Figure 12.16 Cathedral, Milan, Italy, begun 1386, west facade. With its plethora of pinnacles and delicate decoration, Milan Cathedral is the most Gothic example—in the French sense—of cathedral architecture in Italy. Architects came from northern Europe to work on this northern Italian cathedral.

survives, from which it is known that he intended the tower to be topped by a spire. When Giotto died in 1337, only the first floor of the tower was finished. Work was continued by Andrea Pisano among others, and finished by Francesco Talenti in a somewhat different design around 1350–60. The interior of the tower consists of a series of rooms connected by staircases.

Milan Cathedral. The most Gothic of Italian cathedrals, in the French sense, is Milan Cathedral (fig. 12.16), conscerated in 1386 by the ruler of Milan, Gian Galeazzo Visconti, and occupying an impressive site with an enormous piazza in front. The cathedral was built with the support of all classes of Milanese society. Different guilds performed different tasks, each one trying to outdo the others in their contributions. The exterior is covered in Rayonnant ornament, the result of architects from the north coming to Milan to give advice on the cathedral's construction. The building has even been said to have an "over-abundance" of ornament. Certainly, there is an accumulation, all of which seems to compete for the visitor's attention.

Was Italy unreceptive to the Gothic? It has been suggested that there was a conscious resistance to trends in French architecture, with Italian nationalism cited as a possible explanation.

It may be, however, that the reason the French Gothic style never became very popular in Italy had less to do with national pride than with climate. The huge windows that were so desirable in the cathedrals of northern Europe would be extremely impractical in the heat of central or southern Italy, where their effect would be somewhat to cook the congregation. It seems worth noting, in support of this argument, that Milan Cathedral, the most "French" Gothic building to be found in Italy, is in the northern, cooler part of the country.

SCULPTURE

Notre-Dame, Chartres. The logical place to go to find the earliest Gothic sculpture would be Saint-Denis, but the work there has been badly damaged. Fortunately, the sculpture at Chartres Cathedral has fared better. The cathedral has three important triple portals: on the west facade and the north and south transepts, all adorned with magnificent sculpture. On the west, from the early Gothic era, are the Royal Portals (fig. 12.17), dated ca. 1145–55. All the sculpture was once richly painted and gilded; now only the beige stone remains.

Each of the three entrances of the Royal Portal is flanked by statues. These are symmetrical, ordered, and clear—Gothic compositions can typically be grasped at a glance, whereas in the Romanesque era there was a pref erence for greater complexity. These jamb figures form what is known as a "precursor portal," of a type first seen at Saint-Denis and perhaps started by Abbot Suger. The visitor passes by Old Testament figures to enter the

Figure 12.17 Column figures, ca. 1145–55, stone, flanking the Royal Portals, west facade, Chartres Cathedral, Chartres, France. Early Gothic figures perpetuate the distortion seen in Romanesque figures, but no longer have their frantic animation. Instead, these stiff elongated figures maintain the shape of the column to which they are attached, emphasizing their architectural function.

church. Those without crowns are the prophets, priests, and patriarchs of the Old Testament. They are Jesus's spiritual precursors. Those with crowns are the kings and queens of Judah. They are Jesus and Mary's physical ancestors. Medieval iconography is intentionally complex, with layered meanings, permitting multiple interpretations of these statues. Thus, in addition to being the royal ancestors of Mary and Jesus, the kings and queens of Judah are also associated with the kings and queens of France, joining together religious and secular authority. Further, the church was an earthly version of the heavenly Jerusalem, and these portals were regarded as the "gates of heaven," through which Christians had to pass to enter, making a symbolic spiritual journey through biblical history to arrive at Jesus in the present.

Such jamb figures are also called "column figures," as the shape of the figure follows that of the column. Sculpture here is very closely tied to architecture; columns have been carved to resemble the human form.

Figure 12.18 Annunciation and Visitation, ca. 1230–45, stone, west facade, Cathedral, Reims, France. Descendants of column figures, these High Gothic sculptures dominate their architectural setting and have little to do with the columns behind. Characteristic of the increased realism and idealism of the Gothic era, the proportions and movements of these figures are now normal, and they even turn toward one another as if conversing.

Unlike their agitated Romanesque counterparts, these majestic figures are calm and serene, with a noble dignity. They are immobile—there is no twisting, turning, or bending. They do not interact with one another or with the viewer. The drapery, however, still consists of many tiny linear folds that fall into perfect zigzag hems. Obscuring the form of the bodies beneath, it looks much like the fluting of a column, stressing the architectural role of these figures, which are only slightly larger than their columns. The figures are not treated as human bodies with weight, requiring something on which to stand—the feet of these immaterial beings simply dangle.

Notre-Dame, **Reims**. The High Gothic figures who act out the *Annunciation and Visitation* (fig. 12.18) on the west facade of Reims Cathedral, dated to the 1230s or early 1240s, are descendants of the column figures at Chartres. Yet at Reims, rather than standing rigidly side by side, unaware of the next figure's presence, they interact. Moreover, the columns from which they extend are less noticeable.

The Annunciation depicts the moment when the angel Gabriel tells the Virgin Mary that she will give birth to Jesus. In view of the rather extraordinary nature of the news she has just received, Mary shows surprisingly little emotional response. She is severe, standing erect, her heavy drapery falling in broad sharp folds to completely obscure her legs. But Gabriel is different. He holds his drapery so that it falls diagonally. His slender body forms

an S-curve. He moves gracefully, with a relaxed elegance. And he gives a Gothic grin! The new interest in emotion is a characteristic of the Gothic era.

The *Visitation* shows the meeting of Mary, now pregnant with Jesus, and her cousin Elizabeth, pregnant with John the Baptist. They exchange their happy news. According to the story, Elizabeth is older, and this is correctly shown by the sculptor. Both figures form an Scurve—a revival of the *contrapposto* pose of antiquity. They seem to move in space. Many small drapery folds run on diagonals and horizontals, the complex creases following the outlines of the body.

Notre-Dame-de-Paris. Medieval art includes a great many images of Mary and the infant Jesus. From the late eleventh century on, there was great popular devotion to the Virgin Mary. Many churches, cathedrals, religious orders, and brotherhoods were dedicated to Mary. Often referred to as "Our Lady" or the "Madonna" (or "My Lady"), she was portrayed as the ideal woman, the second Eve. People of all levels of society participated in the Cult of the Virgin. Images of Mary were commissioned by those who could just barely afford a humble work, and by those who were able to commission a work made in gold by the finest metalworkers and set with glittering gems. Mary's virtues were praised in literature and art, where she was repeatedly portrayed as Queen of Heaven. By the fourteenth century, Mary was often shown being crowned by Jesus and was given

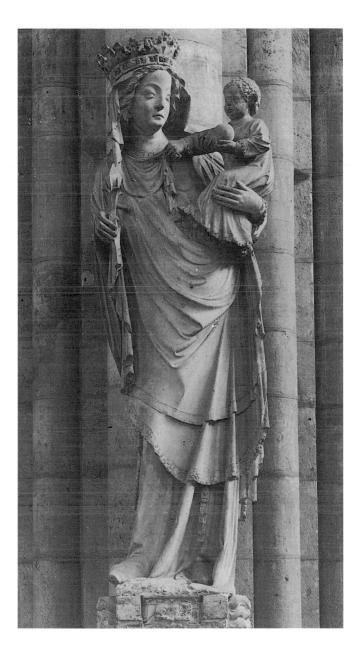

Figure 12.19 Notre-Dame-de-Paris, French, early fourteenth century, marble, in the crossing of Notre-Dame cathedral, Paris, France. Gracefully swaying in space, with Jesus on her side, this image of Mary is very different from the stiff unapproachable images of her created during of the Romanesque era. Mary is now shown as an elegant French princess.

comparable status. People appealed to Mary for help as the Madonna of Mercy.

A famous devotional image of the Virgin Mary is known as *Notre-Dame-de-Paris* (Our Lady of Paris) (fig. 12.19), a marble statue that dates from the early four-teenth century and stands in the crossing of Notre-Dame Cathedral in Paris. Graceful and elegant, Mary pulls a garment across her body, increasing the complexity of the pattern of folds, and indicating the body beneath.

Rather than tiny parallel pleats, the drapery now has broader sweeping folds. The silhouette is broken and animated. Rather than sitting rigidly as was the norm in the Romanesque era, the behavior of Jesus is now more appropriate for an infant, for he plays with his mother's clothing. Jesus has finally been portrayed with the bodily proportions of a baby, looking quite different from his portrayal as a little man in the Romanesque era.

Gargoyles. Gargoyles (fig. 12.20) are a special category of medieval sculpture. A multitude of gargoyles glower down from the roof lines of medieval buildings—and on rainy days, they spit! The true gargoyle, a characteristic feature of Romanesque and especially Gothic buildings, is a waterspout, a functional necessity turned into a decorative fantasy.

In view of where they are located—often on churches and cathedrals—gargoyles are surprisingly irreverent. The rainwater may issue from a barrel held by a gargoyle in the form of a person, but more often the figure appears to vomit, and some even defecate. Animals, such as dogs or pigs, and more exotic ones like lions or

Figure 12.20 Gargoyle, thirteenth century, stone, west facade, Cathedral of Saint-Pierre, Poitiers, France. Gargoyles, which reached their peak of popularity during the Gothic era, are glorified gutters, typically carved to look like monstrous creatures, the water usually issuing from the mouth. When carving for the gargoyles' aerial realm, sculptors seem to have been exempt from the usual iconographic restraints of medieval art.

monkeys, served as gargoyles as well as human figures. However, the majority of gargoyles are in the form of grotesque fauna, inventions of the fertile medieval imagination: howling monsters or malformed humanoids.

There is great debate over the meaning of the medieval gargoyles. Although they are common on churches and cathedrals, gargoyles do not represent usual religious subjects. It has been suggested that they represent devils and evil spirits who have been excluded from the church, or who have been made to serve the church—as waterspouts. Alternatively, the frequently monstrous physiognomy of the gargoyles may have been intended to scare evil spirits away from the church.

PAINTING AND DECORATIVE ARTS

Manuscript Illumination. Manuscript illumination reached a peak in the Gothic period. Books were written in finer lettering than ever before, and the size of the books was reduced. After the mid-thirteenth century, painting was greatly affected by stained glass: reds and blues dominate; the figures are outlined in black; the effect is ornamental and flat. A good example is Joshua Bidding the Sun to Stand Still (fig. 12.21), a folio in the Psalter of St. Louis, made ca. 1260 for King Louis IX of France. Gothic architecture, including rose windows and pinnacles, forms the background in this painting. The two-dimensional buildings contrast with the long, thin, three-dimensional modeled figures.

In the years just before and following 1400, a single style of manuscript illumination was popular throughout Europe, to the extent that it is now referred to as the "International Style." Typical of this International Style are bright contrasting colors, decorative flowing lines, elongated figures, surface patterning, a crowded quality, and opulent elegance. A prime example in northern painting is the celebrated manuscript known as Les Très Riches Heures (The Very Rich Hours) of the Duke of Berry, which dates from 1413-16 and is the work of the LIM-BOURG BROTHERS, POL, HERMAN, and JEAN. They were probably German or Flemish but worked in France for the Duke of Berry, brother of the French king Charles V, and a patron of the arts. Les Très Riches Heures is a book of hours or private prayer book. It contains a series of illuminations, one for each calendar month of the year. June includes a depiction of the Sainte-Chapelle in Paris, and October (see fig. 12.1) shows the Louvre. In both, women and men are shown working in the fields. A different level of society is portrayed in January (fig. 12.22), one of several scenes of aristocratic life. The Duke of Berry is hosting a banquet, perhaps in celebration of the New Year, or Twelfth Night, the day the magi, following the star of Bethlehem, arrived to present gifts to the infant Jesus. The Duke sits in front of a large fireplace and is emphasized by the fire screen that creates the effect of a halo around him. Above the head of the man

behind him—some think this is a portrait of Pol de Limbourg—are the words *aproche*, *aproche*, "come in, come in," signifying the Duke's hospitality. An extraordinary record detailing the many particulars of custom, costume, and consumption that characterized medieval life—note that the dogs are fed on the floor *and* on the table—it underscores a growing interest in everyday life that reflects the teachings of Aquinas and points to the Renaissance celebration of each individual being.

Stained Glass. Gothic architecture offers the fullest possibilities for stained glass, an important element in the creation of the characteristic atmosphere of Gothic buildings. The solid walls of the Romanesque period were covered with murals simultaneously decorative and didactic. In the Gothic period this dual function passes to stained-glass windows. From the exterior of the building there is little to see in a stained-glass window except the pattern of the stone tracery; stained glass is interior decoration, intended to be seen illuminated from behind by sunlight.

Figure 12.21 *Joshua Bidding the Sun to Stand Still*, from the *Psalter of St. Louis*, French, ca. 1260, manuscript illumination, $5 \times 3\frac{1}{2}$ " (13.6 \times 8.7 cm), Bibliothèque Nationale, Paris, France. Manuscript illumination reached a highpoint during the Gothic era, with the finest manuscripts produced in Paris. The elegant, animated, modeled figures are not in scale with the building they enter, and contrast with the flat patterned background, which is based upon contemporary architecture.

273

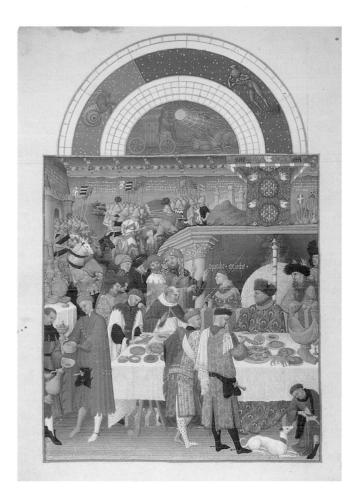

Figure 12.22 Limbourg brothers, *January*, from *Les Très Riches Heures* of the Duke of Berry, French, 1413–16, manuscript illumination, $11\frac{1}{2} \times 8\frac{1}{4}$ " (29.2 × 21 cm), Musée Condé, Château of Chantilly, France. This famous manuscript includes twelve folios, one for each month of the year, that record how the upper and the lower classes lived, providing details of costume, customs, and climate.

The colored light that floods the interior of Gothic buildings through their stained-glass windows had special religious importance in the Middle Ages. Light was believed to have mystical qualities and was perceived as an attribute of divinity in medieval philosophy. John the Evangelist saw Jesus as "the true light," and as "the light of the world who came into the darkness." St. Augustine called God "light" and distinguished between types of physical and spiritual light.

Chartres Cathedral is famous for its stained-glass windows (fig. 12.23). In addition to the twelfth-century rose window and three lancets on the west facade, there are over 150 early thirteenth-century windows. Local merchants donated forty-two windows, which include over a hundred depictions of their occupations. These windows document medieval tools, materials, and working methods. The masons, for instance, are depicted carving royal

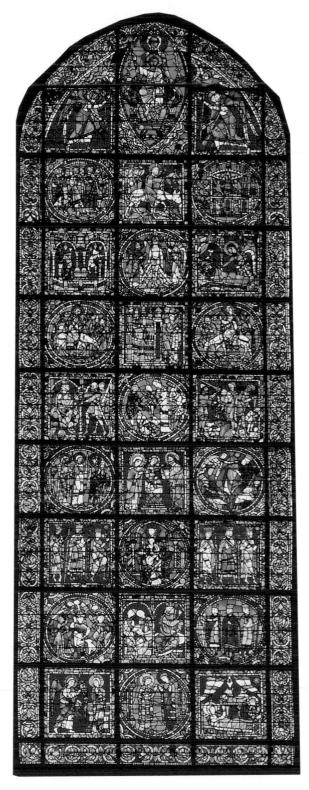

Figure 12.23 Life of Jesus, ca. 1150, stained glass, central lancet window, west facade, Chartres Cathedral, Chartres, France. Stained glass was at its peak during the Gothic era, filling the huge windows permitted by the skeletal architectural system, creating constantly changing patterns of colored light flickering over the interiors. Narratives that had been told in paintings on walls and vaults were now told in stained glass windows.

Cross Currents

MUSLIM SPAIN

The great Gothic cathedrals of northern Europe are contemporaneous with one of Spain's most beautiful Islamic buildings, the Alhambra in Granada (see fig. 7.18). Spain was the most multicultural country in Europe, a legacy of the arrival of the first Muslim conquerors in Spain in 711. Spain had been controlled since 589 by Visigoth kings, but by the turn of the eighth century most native Spaniards were no longer willing to serve in the Visigoth army, a duty that the king required of all free men. Furthermore, until 650, Jews had controlled most of the commerce in Spain, but in 694, the Visigoth kings, who had themselves become Christian, enslaved all Jews who would not accept a Christian baptism. Thus most Spaniards, Jews, and Christians alike greeted the Muslim army in 711 as liberators.

And liberators they were. Both the Jews and the Christians were tolerated as "protected" groups. They paid taxes to the Muslim lords, but they were free to practice their own religion and to

engage in business as they pleased. Thus Spain became a multicultural country like no other, with Jews, Islamic Moors, and Christians working together in a spirit of convivencia, "coexistence." The population consisted of six distinct groups: (1) Mozárabes, Christians who had adopted Muslim culture; (2) Mudéjares, Moors who were vassals of Christians; (3) Muladies, Christians who had adopted the Islamic faith; (4) Tornadizos, Moors who had turned Christian; (5) Enaciados, those who sat on the fence between both Islam and Christianity, and who pretended to be one or the other as the occasion warranted; and (6) the large Jewish community.

The cultures seemed to invigorate each other. An older Christian man, writing in 854, lamented the acceptance of Muslim ways by the Christian youth, but his protest reveals much of the culture's vitality:

Our Christian young men, with their elegant airs and fluent speech, are showy in their dress and carriage, and are famed for the learning of the Gentiles; intoxicated with Arab eloquence, they greedily handle, eagerly devour and zealously discuss the books of the Mohammadans ... They can even make poems, every line ending with the same letter, which display high flights of beauty and more skill in handling meter than the Gentiles themselves possess.

The odes of the Islamic poets that the Christian youth were imitating began with an erotic prelude, then moved through a series of conventional themes such as descriptions of camels and horses, hunting scenes, and battles, and then culminated in the praise of a valiant chieftain. The odes soon developed into independent love songs and drinking songs, and it was in fact out of this tradition that the troubadour poets sprang.

Moorish influence on medieval and Renaissance Europe extended beyond this. For instance, it was through Arab scholars that much classical learning passed back into Europe (see Chapter 7). Nonetheless, by 1492 the last traces of this happy cohabitation were erased when Ferdinand and Isabella of Aragon reclaimed Spain for Christianity and expelled the Moors and Jews.

figures and show us just how Chartres's sculptures themselves were created.

The Sainte-Chapelle in Paris is a major monument for the study of stained glass. Compare the subject from the Sainte-Chapelle, the *Presentation of Mary at the Temple* (fig. 12.24), with the treatment of the *Annunciation and Visitation* carved out of stone as part of the sculptural architecture at Reims Cathedral (see fig. 12.18). At the Sainte-Chapelle the little figures have a certain vitality and spontaneity about them. The stories are told by gestures and poses. Everything is abbreviated in a highly expressive form of narrative shorthand.

Were these windows created by several workshops, or by several "hands," working under a single master? It is likely that one guiding mind established the program, the iconography, and its sequence of presentation. However, this may not have been the same person who then designed the individual compositions.

Tapestry. Also characteristic of the Gothic era, tapestries were a form of insulation as well as decoration, for these woven wall-hangings helped to keep the cold

air out and the cold stone at one remove from the interior living space. They were also luxury items, to be coveted and collected, a significant economic investment.

To produce a tapestry, the artist first makes a smallscale color drawing. This is then copied and enlarged to the dimensions intended for the tapestry on linen or paper. This enlarged design is called the **cartoon**. Next, the weavers translate the cartoon into tapestry. A tapestry is woven on a loom, which is worked by several people sitting side by side. If a set of tapestries was to be produced, as was often the case, several looms were employed. The loom is strung with warp threads of tightly twisted wool. The number of warp threads per inch determines how fine the tapestry will be. The warp threads will be hidden by the weft threads of wool, silk, and even silver and gold. Tapestries are woven from the back; the finished image is an inversion of the artist's original design. When the design is woven, every change of color requires a change of thread; the weaving of a tapestry is a tedious and exceedingly slow process.

One of the most famous of medieval tapestries is the set known as the *Unicorn Tapestries*, made in Brussels

Figure 12.24 Presentation of Mary at the Temple, mid thirteenth century, stained glass, Sainte-Chapelle, Paris, France. The absence of realism and the decorative quality of this scene are characteristics of stained-glass windows, which are composed of many small pieces of colored glass held together by lead strips. Details of facial features, fingers, and fabric folds are painted onto the glass.

around 1500. These tapestries tell the story of the hunt, capture, and murder of the unicorn. The first and the last tapestry (fig. 12.25) are in the *mille-fleurs* ("thousand-flowers") style, which is characterized by dense backgrounds of plants. Many of these are meticulously observed and can be identified, yet at the same time they represent an unreal realm, an impossible environment in which a variety of plants from different geographic areas and climates are all in bloom simultaneously, the weavers accomplishing what Nature could not. The unicorn, an equally unrealistic figure, is both a religious symbol of Jesus and a secular symbol of a bridegroom.

The tapestries may have been made as a wedding gift. According to religious interpretation, the unicorn represents Jesus at the Resurrection, in a heavenly garden. According to secular interpretation, the unicorn represents the lover, now wearing the chaîne d'amour (chain of love) around his neck and surrounded by a fence, perhaps tamed and domesticated by obtaining his lady's affection. Red juice falls on the unicorn's white fur from the pomegranates above. Like the unicorn, the pomegranate can be read in both religious and secular terms. Taken from a religious point of view, the many seeds of the pomegranate represent the unity of the Church and hope for the resurrection. In a secular light, the crown-like finial represents royalty and the many seeds fertility. Here, as elsewhere, the iconography of medieval art is often plural in meaning, with context crucial to the interpretation.

SCHOLASTICISM

Europe was, in fact, ripe for intellectual stimulation. As the Middle Ages progressed, the attitude of the Roman Catholic Church toward secular learning and the wisdom of ancient writers began to change. Assured of its spiritual supremacy, the Church started to lower its opposition to the works of pagan writers. More often than not, the Church simply incorporated into its own teaching the learning it acquired from other cultures, including the literature and philosophy of ancient Greece and Rome, along with the Byzantine and Islamic religious and philosophical traditions. In this more open intellectual climate, forms of secular learning that derived from

Figure 12.25 The Unicorn in Captivity, from the Unicorn Tapestries, Franco-Flemish, made in Brussels, ca. 1500, wool and silk tapestry, 12'1" × 8'3" (3.68 × 2.51 m), Cloisters Collection, Metropolitan Museum of Art, New York. During the Middle Ages, people believed in the existence of the unicorn, a fabulous animal said to have a single horn in the center of its forehead. When a tapestry is made, the picture is formed as the fabric is woven from colored threads. This type of tapestry is known as millefleurs—"thousands of flowers," shown scattered over the background.

observation of the natural world rather than the written word of scripture were no longer at odds with a Christian perspective. Such natural knowledge was seen as a necessary foundation for the more advanced states of religious contemplation.

The Growth of the University. The shift in the Church's intellectual perspective was stimulated by the preservation and translation by Muslim scholars of Aristotle's writings, which passed back into Christian Europe in the twelfth and thirteenth centuries. This appreciation of Aristotle's philosophy was complemented by the rise of the universities, which were evolving into major centers of learning, with the University of Paris leading the way. Cathedral and monastery schools had been obliged, since 1179, to provide an education free of charge to all lay people who wanted to learn, and the University of Paris was the result of the expansion of the cathedral school at Notre-Dame. In turn, the University of Paris gave rise to institutions like Oxford and Cambridge in England, the former being founded by teachers and students who had left Paris, the latter created by a group disenchanted with the Oxford curriculum. Such debate about what should be studied created a climate of intellectual controversy and led to the foundation of more and more universities. Soon universities in Spain, Portugal, and Germany assumed their place among the approximately eighty institutions of higher learning that existed by the end of the Middle Ages.

The university curriculum consisted of the seven original "liberal arts": the *trivium* (grammar, logic, and rhetoric) and the *quadrivium* (arithmetic, astronomy, geometry, and music). Soon degrees were awarded in both civil and canonical law, in medicine, and in theology. And there was a further important change. Prior to the thirteenth century, medieval philosophy had centered on demonstrating the truths of religious faith through reason, but now a new focus on the empirical observation of the natural world began to elevate the importance of rational thinking even when it was divorced from the service of Christian belief. Reason became faith's equal instead of its servant. Predictably enough, with this newfound equality, tensions between faith and reason resulted.

The Synthesis of St. Thomas Aquinas. Using Aristotle's focus on the natural world to explain how God's wisdom is revealed, the Dominican friar ST. THOMAS AQUINAS [a-QWHY-ness] (1225–1274) effected a synthesis of Aristotelian philosophy and Catholic religious thought. Aquinas, like Aristotle, begins with empirical knowledge. Unlike Aristotle, however, Aquinas then moves from the physical, rational, and intelligible to the divine. Aquinas claimed that the order of nature reflected the mind of God, while being a beautiful harmonious structure in its own right. Thus, he

connected reason with faith in a way that explained how nature revealed divine wisdom.

Aquinas saw no conflict between the demands of reason and the claims of faith. Nor did he see any conflict between the requirements of belief and the inducements of independent thought. In fact, for Aquinas, the exercise of intellectual freedom exemplified an individual's autonomy, which was granted by God according to the divine plan. This freedom was essential not only for defining what makes a person human, but also for presenting the opportunity for every individual to choose or deny God by using the tools of reason.

Unlike his philosophical and theological forebears Plato and Augustine, for whom physical reality and material circumstance were not as real or important as spiritual essences or qualities, Aquinas argued, much like Ambrose, that the soul and body were inextricably interrelated. The body needs the soul to live; the soul needs the body's experience. Each complements and completes the other in a harmonious unity. According to Aquinas, spiritual knowledge and theological understanding require a grounding in the body's experience and in observation of the visible physical world.

In accomplishing this feat of integration, Aquinas showed that philosophy and theology need not be in conflict, and that in fact they could co-exist in mutually supporting ways. Nevertheless, Aquinas's approach was not convincing to all. With the introduction of rational analysis into theological speculation, and the privileging of empirical evidence and material conditions as elements of philosophical thinking, critics of Aquinas's system began to question the validity of his unification of faith and reason.

Duns Scotus and William of Ockham. Two who refused to accept Aquinas's grand synthesis were DUNS SCOTUS (1265-1308) and WILLIAM OF OCKHAM (1285-1349), both of whom were Franciscan friars. Scotus was a Scotsman who had studied at Oxford and Paris; Ockham was an Englishman, who had also studied at Oxford, and who wound up vilified and excommunicated for what were perceived as heretical views. Duns Scotus, known as "the subtle doctor," reacted against the theological views of both Aquinas and Augustine. In place of Augustine's divine illumination and Aquinas's integration of faith and reason, Scotus posited the central importance of "will," emphasizing the freedom of individuals in their actions. Scotus believed that a person's will is guided on the one hand by what is good for the individual, and on the other by what is good for all, the two being modulated according to a sense of justice.

William of Ockham went beyond Scotus by denying the existence of any correspondence between concrete individual beings or things. He eschewed the notion of universals except as mental concepts. Similarities among individual human beings, or, say, particular dogs or trees,

Figure 12.26 St. Francis of Assisi, thirteenth century, fresco, Sacro Speco, Subiaco, Italy. The earliest known portrait of St. Francis, this fresco may have been executed during his lifetime. St. Francis founded his own monastic order, the Franciscan order, in 1209, and it had already grown to be a powerful movement within the medieval Church by the time of his death in 1226. One of the most important features of the order was its imposition of poverty on its members.

exist strictly in the mind as mental abstractions, as ideas rather than as "real things." For Ockham, the issue of the universal existing beyond the physical was a matter for theology or for logic rather than a concern of philosophy. Thus he rejected Aquinas's notion that the human mind possessed a divine light that guided the intellect toward a proper understanding of reality, and he severed the link between faith and reason that Aquinas had so carefully established. With "Ockham's razor," his principle that the best explanation is the simplest and most direct, Ockham also broke away from the elaborate and subtle explanations of the scholastic philosophers or "schoolmen," whose ideas had dominated medieval philosophical thinking. In doing so, Ockham helped prepare the ground for the developments of Cartesian rationalism and Baconian empiricism (see Chapter 15).

Francis of Assisi. The intellectualism of scholars like Aquinas was also challenged by the life and teachings of Giovanni Bernadone (1181-1226), nicknamed "Francesco" by his father, who was born in the Italian town of Assisi. Captured as a youth in a battle against the neighboring town of Perugia and held in solitary confinement, FRANCIS OF ASSISI (fig. 12.26), as he came to be known, is said to have decided in prison that real freedom demanded complete poverty. On his release, he consequently gave up all worldly goods and, identifying closely with the passion of Jesus, began to lead the life of a wandering preacher. This lifestyle, which made him wholly dependent on the goodness and generosity of others for his survival, attracted many followers, who came to be known as Franciscans, and who were already a powerful monastic order of the church by the time of Francis's death in 1226.

St. Francis's belief that the average human could share in Jesus's life and example—his own body was said to bear the crucifixion marks, or *stigmata* of Jesus, so close was his identification with the passion—is not entirely incompatible with Aquinas's philosophical position. St. Francis's was a form of intimate knowing, albeit more emotional than intellectual, and his love of creation—the birds and the animals, the poor and the weak—was consistent with Aquinas's belief that the universal and the essential are rooted in the local and the particular.

LITERATURE

Dante's Divine Comedy. The most celebrated literary work of the Middle Ages is the epic poem *The Divine Comedy* by the Italian poet DANTE ALIGHIERI [DAN-tay] (1265–1321) (fig. 12.27). Born in Florence in 1265, Dante was involved in politics as well as literature. When a rival party seized power in 1302, Dante was exiled from his home city, never to return. *The Divine Comedy* was completed in Ravenna shortly before Dante's death. In the poem, Dante makes numerous

references to the politics of his day, especially to the rivalry between the Guelphs and the Ghibellines, two opposing Florentine political parties, that left him an exile from this native city.

The Divine Comedy is divided into three parts: Inferno (Hell), Purgatorio (Purgatory), and Paradiso (Heaven). These are the three different places in medieval theology to which the soul can be sent after a person's death. In the poem Dante ascends through Hell and Purgatory to Heaven, guided in the first stages by the pagan poet Virgil, who represents human reason, and at the end by his beloved, Beatrice, who represents divine revelation. Though deeply indebted to the great classical poetic tradition, The Divine Comedy is an explicitly Christian poem. Hence Virgil is not allowed into Heaven with Dante.

The entire poem contains one hundred cantos equally divided among the three sections, with the opening canto of the prologue prefacing the *Inferno*. Dante's attention to organization, especially structural symmetry, is apparent in every aspect of the work, particularly in the use of *terza rima*, a succession of three-line stanzas that rhyme ABA, BCB, CDC, and so on, in which the unrhymed line-ending in each stanza is picked up in the following stanza, where it becomes the principal rhyme. Dante employs this harmonious pattern of interlocked rhyme through the entire length of the work.

One of the most notable features of Dante's *Inferno* is the law of symbolic retribution, which suggests how a punishment should match the sin to which it has been ascribed. In depicting opportunists, for example, Dante positions them outside of Hell proper, in a kind of vestibule. Since they were unwilling to take firm positions in life, they are not completely in or out of Hell after death. And as they were swayed by winds of change and fashion, their eternal punishment is to follow a waving banner that continually changes direction.

Other punishments that seem particularly well suited to their corresponding sins include those who have committed carnal offences, who in life were swayed by sexual passion and in death are swept up in a fiercely swirling wind. Murderers are punished by being immersed in a river of boiling blood, the degree of their immersion determined by the degree of their bloodlust in life. Gluttons are punished by being made to lie in the filthy slush of a garbage dump, while the giant three-headed dog, Cerberus, tears at their flesh with claws and teeth. The souls of those who committed suicide are imprisoned in trees, whose limbs are torn and eaten by giant ugly birds, the fearful Harpies.

This law of symbolic retribution is complemented by another—that the most grievous and heinous of sinners

Figure 12.27 Domenico di Michelino, *Dante and His Poem*, 1465, fresco, Florence Cathedral, Florence, Italy. Dante stands holding his poem. To his right is the Inferno, behind him Mount Purgatory, and to his left, representing Paradise, is Florence Cathedral itself, with its newly finished dome by Brunelleschi.

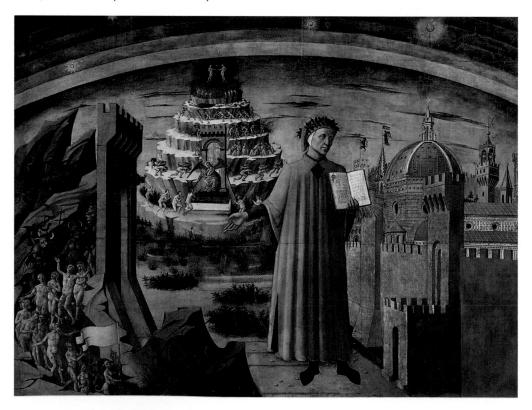

are punished more severely than those who committed less odious crimes in life. Dante's poem is an enormous synthesis of all the learning of his day—astronomy, history, natural science, philosophy—but in this differentiation between sinners it is particularly indebted to the theology of Thomas Aquinas. Dante follows Aquinas, for example, in suggesting that sins of the flesh, such as lust, are not as serious as those of malice or fraud. Thus, lust, gluttony, and anger are punished in the upper portion of Hell, where the punishments are less painful, while sins of violence and fraud are punished in the deeper recesses of the Inferno.

Since deceit and treachery are, for Dante, the most pernicious of sins, these are punished at the very bottom of hell. Dante's scheme is so carefully worked out that he even divides the betrayers into categories—betrayers of their kin, of their country, of their guests and hosts, and, finally, those who betrayed their masters. This last and worst kind of sin Dante represents by the crimes of Brutus and Cassius, who betrayed Julius Cacsar; by Judas Iscariot, the betrayer of Jesus; and, worst of all, by Satan, who betrayed God. These sinners are the furthest from God, deep in the cold dark center of Hell. Satan, a threeheaded monster, lies encased in ice, while in his three mouths he chews incessantly on the bodies of Brutus, Cassius, and Judas. Many of Dante's political enemies in Florence are discovered by the poet suffering the torments of Hell.

Just as Dante's *Inferno* reflects the type and degree of sinners' guilt, so his *Purgatorio* reflects a similar concern for justice. Dante's Purgatory is a mountain that is also an island. The mountain is arranged in tiers, with the worst sins punished at the bottom, since the sinners punished there are furthest from the Garden of Eden and from the heavens. In ascending order, the sins punished on the mountain of Purgatory are pride, envy, anger, sloth, avarice, gluttony, and lust—roughly the reverse of their positions in the *Inferno*.

Dante's *Paradiso* is based on the seven planets of medieval astronomy—the Moon, Mercury, Venus, the Sun, Mars, Jupiter, and Saturn. Just as the *Inferno* and the *Purgatorio* describe the subject's movement through hell and the purgatorial mountain, Dante's *Paradiso* also describes a journey, this one celestial, from planet to planet and beyond, to the Empyrean, the heavenly abode of God and his saints.

The influence of Dante's *Divine Comedy* can hardly be exaggerated. It was first mentioned in English by Chaucer in the fourteenth century, and in the twentieth century it has continued to influence poets such as T.S. Eliot.

MUSIC

The Notre-Dame School. One of the more elegant features of Gregorian plainchant is the way its single

melodic line molds itself to the words of the Latin text. The rounded shape of its vocal melody and the concentrated focus of its single melodic line suit it to the devotional quality of the liturgy. In the ninth and tenth centuries, however, chants began to be composed with multiple voice lines. Those with two voice lines an inter val of a fourth, fifth, or octave apart were known as parallel organum, the simplest kind of polyphonic, or multi-volced, musical practice. In parallel organum, the two melodic lines move together, note for note, parallel, and with identical rhythmic patterns. The lower, or bottom, line is the main melody, or cantus firmus, above which the second line is composed. Some time during the period from the tenth through twelfth centuries, more elaborate forms of polyphonic chant appeared, so that there might be three, four, or even five separate voice parts. Moreover, the melodies for each of the voices differed, with each of the voice lines having an independent quality that simpler forms of parallel-voiced polyphony did not.

The two most prominent chant composers of the twelfth century, LÉONIN [LAY-oh-nan] (ca. 1135ca. 1200) and PÉROTIN [PEAR-oh-tan] (ca. 1170ca. 1236), were associated with the cathedral of Notre-Dame in Paris. Though the church was not completed until the 1220s, during the 1180s an altar was consecrated and services were held. Léonin, who was active around 1175, favored a kind of chant for two voices called organum duplum, in which the lower-cantus firmus spread slowly over long held notes, while a second voice, scored higher, moved more quickly and with many more notes through the text. This top line was called the duplum and the bottom cantus firmus line the tenor. from the Latin tenere, which means "to hold." (This "tenor" has nothing to do with the later development of "tenor," referring to one of the voice ranges, as in soprano, alto, tenor, and bass.)

Working a generation later, at the turn of the thirteenth century, Pérotin was Léonin's most notable successor in composing polyphonic chants. Pérotin wrote mostly three- or four-voiced chants called respectively organum triplum and organum quadruplum. Pérotin's more complex polyphony still used the cantus firmus tenor voice, but over it were placed two or three lively voice parts, which the tenor imitated from time to time. An additional distinguishing feature of the polyphonic chants of Léonin and Pérotin was their use of measured rhythm. Unlike the free unmeasured rhythms of plainchant, the polyphonic chants of Léonin and Pérotin had a clearly defined meter with precise time values for each note. Initially, the rhythmic notations for the music were restricted to only certain patterns of notes, with the beat subdivided into threes to acknowledge the Trinity. Later, however, these rules were loosened, and polyphonic chant became even freer in structure and more richly textured.

It has been suggested that the metrical regularity of Léonin's and Pérotin's chants are especially suited to the Gothic cathedral, which by the end of the twelfth century was beginning to supplant the Romanesque, and whose construction had its own architectural rhythms. The repeating and answering patterns of polyphonic chant music have their architectural counterpart in the Gothic cathedral's repetitive patterns of arches, windows, columns, and buttresses, and its visual rhythms.

TOWARD THE RENAISSANCE

As already noted, the eruption of the Black Death in 1347–51, and again in 1388–90, devastated Europe. However, this devastation was almost matched by that wreaked by the Hundred Years' War, which not only brought political and social collapse to much of Europe, but also introduced gunpowder and heavy artillery as agents of destruction for the first time in history. Soldiers died in unprecedented numbers, and many more were crippled in ways hitherto unimaginable.

Conversely, one positive result of both the plague and the war was the rise of modern medicine. In 1390, the medical faculty at the University of Paris invited surgeons to join their ranks. Though no one correctly diagnosed the causes of the plague for centuries, hundreds of theses were published, and the medical community turned its attention away from the mostly philosophical medieval conception of the "humors"—blood, phlegm, yellow bile, and black bile, each of which was related to a specific bodily organ and believed to determine temperament—to questions of diagnosis, treatment, and cure. Perhaps most important of all, the notion of infectious disease began to take hold.

In the midst of these crises, the growing naturalism evident, for instance, in the difference between the sculpture at Chartres and that at Reims (see figs. 12.17 and 12.18), or in the illuminated manuscripts of the Limbourg brothers (see figs. 12.1 and 12.22), became more and more pronounced. In Aquinas's and St. Francis of Assisi's interest in the particulars of nature, we can detect the seeds of scientific inquiry, an urge to know the world in its every detail. Life, more and more people believed, should be an eternal quest for "truth." And the realization of visual and literary truth—the urge to depict or tell things in a manner "true to nature"—began to seem as important a quest as any other. Of

Figure 12.28 Nicola Pisano, *Nativity*, panel on pulpit, 1259-60, marble, $33\frac{1}{2}\times44\frac{1}{2}''$ (85.1 × 113 cm), Baptistery, Pisa, Italy. Important interests in antiquity and in reviving Italy's cultural past, which were to lead to the Renaissance, are already evident in the sculpture of Nicola Pisano. Ancient Roman sarcophagi reliefs provided inspiration for the classical type of figures.

Figure 12.29 Giovanni Pisano, *Nativity*, panel on pulpit, Pisa Cathedral, Pisa, Italy, 1302–10, marble, $34\frac{3}{8} \times 43''$ (87.2 × 109.2 cm). The greater naturalism of Nicola Pisano's son, Giovanni, when carving the same subject half a century later, is evidenced in his work by less crowding, a greater sense of space, and increased attention to the setting.

course, scholars were increasingly finding what seemed to them to be the "truth" in the writings of antiquity, the classical past. Thus, many reasoned that it might also be appropriate for the arts to reexamine their classical heritage.

NATURALISM IN ART

The Pisanos. Gothic sculpture in Italy differs stylistically from that of the rest of Europe. Italian sculpture is treated separately from the architecture. There is a preference for carving in marble no matter what material is used to construct the building. NICOLA PISANO [pea-SAH-noh] (ca. 1220/25 or before–1284) reintroduced a classical style, as demonstrated by the marble pulpit he made for the baptistery in Pisa, 1259-60, which consisted of a hexagonal structure supported on classical Corinthian columns. He may have studied the ancient Roman sarcophagi preserved in Pisa, for in the panel that portrays the Nativity (fig. 12.28) he has carved classical figures and faces. Included are three separate events: the Annunciation on the left; the Nativity itself in the middle; and the Adoration at the top right. Mary appears twice in the center of the composition, once with the angel Gabriel at the Annunciation, and directly below, lying prostrate at the Nativity. She is recognizably the same individual in each instance, though her expression changes. Deeply undercut, solid

and massive, the forms bulge outward from the background. The crowding of the scene is typically Gothic, but the naturalism and classicism of the figures looks forward to the Renaissance.

Nicola's son GIOVANNI PISANO (ca. 1240/45-after 1314) also carved a Nativity for Pisa, this time for the cathedral (fig. 12.29). Executed between 1302 and 1310, the style is different. The figures are slimmer than his father's, and the Mary seems more a young woman than the matronly figure in the earlier work. The drapery that clothes her is more flowing, her body almost substantial beneath its folds. The composition itself is not as crowded as Nicola's, the effect more energetic than serene. Each figure now has a logical amount of space, and the viewer seems to look down from above, thereby making the composition clearer. Giovanni includes more landscape and setting in his depiction than his father, creating a greater sense of depth, and in his sculpting uses even deeper undercutting for a greater play of light and shade.

Duccio and Giotto. Important events occurred in Italian painting at the end of the thirteenth and beginning of the fourteenth century. Two different trends emerged, associated with the rival cities of Siena and Florence. Conservative Siena, represented by the artist Duccio, clung to the medieval and Byzantine traditions, favoring abstract patterns, gold backgrounds, and

Figure 12.30 Duccio, Madonna and Child Enthroned, main panel of the Maestà Altarpiece, 1308–11, egg tempera and gold on wooden panel, $7' \times 13'$ $6\frac{1}{4}''$ (2.13 \times 4.12 m), Museo dell'Opera del Duomo, Siena, Italy. The paintings by Duccio of Siena were the final flowering of the medieval Byzantine tradition in Italy. The Maestà, which means "majesty" of the Madonna, portrays Mary as extremely elongated, enormous in size, flanked by angels and saints, as if she were a feudal queen holding court. Bright color and flowing outline are stressed rather than three-dimensionality of solid forms in space.

emphasis on line. Progressive Florence, however, represented by the artist Giotto, displayed a greater concern for depiction of the physical world and three-dimensional space and mass. This is the more naturalistic style that Europe would follow for the next several centuries.

DUCCIO [DUT-cho] (ca. 1255-before 1319) is frequently mentioned in the Sienese archives, not only for his art but also for disturbing the peace, for his many wine bills, and for having borrowed money on more than one occasion. Yet he was a great religious painter, his most famous work being the *Maestà Altarpiece*, 1308–11, on the front of which is the *Madonna and Child Enthroned* (fig. 12.30) (the Italian word *maestà* refers to the "majesty" of the Madonna). Made for the high altar of the cathedral of Siena, it was painted entirely by Duccio (the contract has survived), although the usual practice at this time was for the artist to employ assistants. When it was finished, a feast day was proclaimed in Siena.

In this rigidly symmetrical composition, Mary and the infant Jesus are enthroned, surrounded by tiers of saints

and angels. Much larger than any of the other figures, Mary is extremely elongated, ethereal, and immaterial. Her soft drapery has a flowing hemline, the linear quality emphasized by the gold edging. Outline and silhouette play a major role; the effect of shading is minor. The gentle faces are wistful and melancholic, and the angels look tenderly at Mary. The throne appears to be inlaid with multi-colored marbles, much like the architecture of the period. Yet it is not rendered with scientific perspective and does not suggest depth. Duccio represents the culmination of the old Byzantine style rather than the start of a new one.

GIOTTO [JOT-toh] (1267?–1336/7) has an extremely important place in the history of art. He is known primarily as a muralist—the small windows of Italian Gothic architecture left large areas of wall to paint. His naturalism is apparent if we compare his own *Madonna and Child Enthroned* (fig. 12.31) to Duccio's. Both were painted at about the same time. Duccio's Madonna seems like an icon, insubstantial and elongated. Giotto's Mary

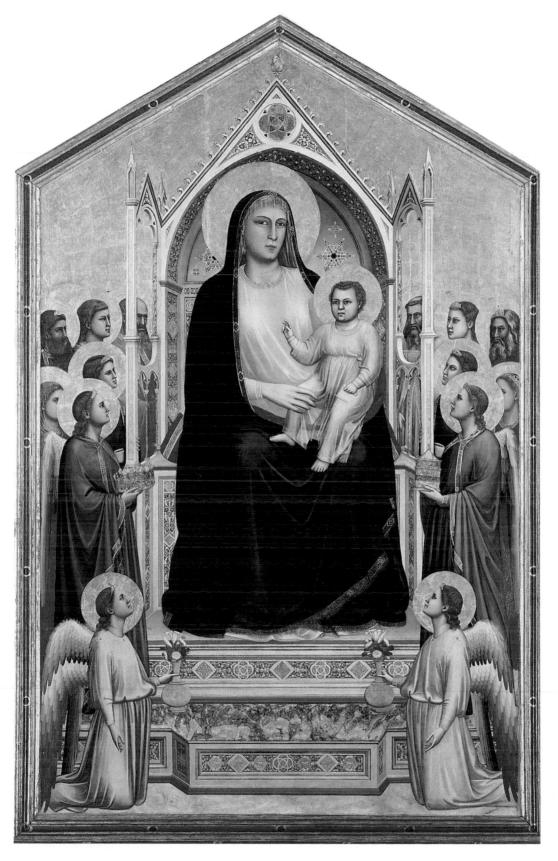

Figure 12.31 Giotto, Madonna and Child Enthroned, 1310, tempera on panel, $10'8'' \times 6'8\frac{1}{4}''$ (3.53 \times 2.05 m), Galleria degli Uffizi, Florence, Italy. In contrast to Duccio's slender Mary, Giotto's is solid and appears to sit within the space implied by her throne.

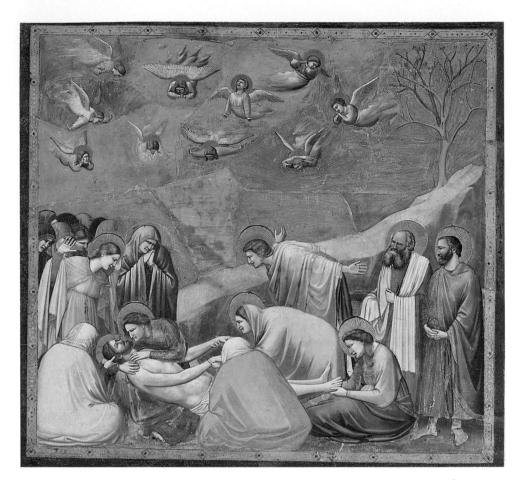

Figure 12.32 Giotto, Lamentation over the Body of Jesus, 1305–06, fresco, $6'\frac{3}{4}'' \times 6'\frac{3}{8}''$ (2.00 × 1.85 m), Arena (Scrovegni) Chapel, Padua, Italy. The profound grief of this subject is magnified by the way in which it is depicted by Giotto. The center of attention, usually in the physical center of the composition, is instead low on the left, emotionally "down," and the barren background leads the viewer's eyes down to the heads of Jesus and his mother Mary.

seems, on the other hand, to be a "real" woman. Not only does she appear to sit in actual physical space, but it is as if real bones lie beneath her skin.

Giotto's most famous work is the extensive cycle portraying the lives of Mary and Jesus in the Arena Chapel (Scrovegni Chapel) in Padua, painted 1305-06. In the scene of the Lamentation ver the Body of Fesus (fig. 12.32), the composition is used to emphasize the sadness of the subject. Position can be used to convey emotion in art just as we speak about "feeling down" or say "things are looking up." Here, atypically, the center of attention is low and off-center. Figures bend down to the dead Jesus. The diagonal of the hill leads down to the heads of Mary and Jesus, enhancing the powerful emotional impact characteristic of Gothic art. The figures form a circle around Jesus, leaving a space for one more person—the viewer, who is thereby invited to join in their grieving. Emphasis is on mass rather than line, figures are threedimensional, solid, and bulky, and an attempt has been

made to place them within the space of an actual landscape. But perhaps most important of all, the mourners appear to convey real emotion, an almost tangible sense of personal grief and loss.

REALISM IN LITERATURE

Boccaccio's Decameron. If the visual arts were becoming more and more naturalistic by the end of the fourteenth century, literature achieved something of the same effect by forsaking Latin for the spoken language, the vernacular, of the day. This is especially true of the work of GIOVANNI BOCCACCIO [bo-CAHchoh] (1313–1375). His most famous prose work, the Decameron, has similarities with Chaucer's Canterbury Tales and with Dante's Divine Comedy, upon which Boccaccio wrote a commentary. However, his interest in classical antiquity, his translations of ancient Greek texts, his Latin writings, and his search for lost Roman works

make him, with Petrarch (see Chapter 13), an influential early Italian Renaissance figure.

Boccaccio spent much of his youth in Naples, where his father was a merchant and attorney associated with the powerful Bardi Bank of Florence. Trained in banking himself, Boccaccio nonetheless preferred literature, and spent most of his adult life in Florence pursuing a literary career. The Decameron is a collection of a hundred novelle, or short stories, told by ten Florentines, who leave plague-infested Florence for the neighboring hill town of Fiesole. Written in the vernacular Tuscan of his time. Boccaccio has each of the work's ten narrators. seven women and three men, tell a tale a day, each through a cycle of ten days. Their tales, mostly comic, center on the lives and fortunes of ordinary people, who are given a voice here for the first time in Western literature. Boccaccio's sharp eye for realistic detail and his ability to present psychologically convincing characters make him a natural storyteller. His wit, frankness, and worldly cynicism are additional attractions of his style.

Chaucer's Canterbury Tales. As a well-educated medieval intellectual, the English poet GEOFFREY CHAUCER [CHAW-ser] (ca. 1342–1400) was, like Boccaccio, familiar with Latin literature, history, and philosophy. He read Ovid and Virgil in their original language, though, like Shakespeare, he did not know much, if any, Greek. Still, Chaucer was familiar with Greek myth, literature, and history through his knowledge of the Latin writers.

The most important influence on Chaucer's work, however, was not Latin but Italian. Chaucer's trip to Italy in 1372 is thought to have been the catalyst for his immersion in Italian literature, especially the works of Dante and Boccaccio. A number of Chaucer's *Canterbury*

Tales, as well as the basic narrative structure, derive from Boccaccio's *Decameron*.

Although unfinished at the time of his death in 1400, Chaucer had been working on *The Canterbury Tales*, a collection of storics told by a group of pilgrims traveling from London to Canterbury, for nearly fifteen years. Sometimes described as a medieval portrait gallery, the tales have a tremendous social breadth, including depictions of medieval figures from the highest to the lowest social classes. But *The Canterbury Tales*' distinction lies primarily in its literary art rather than its documentary sense of social history.

Chaucer had originally planned to write 120 tales (or so the Host of the tavern where the pilgrims all first gather tells us in the General Prologue), two for each of his thirty pilgrims to tell on the pilgrimage to Canterbury, and two on the return trip. However, Chaucer only completed twenty-two tales and composed fragments of two others. He also prefaced the tales with a General Prologue, which functions as a framing device for the tales, providing them with an apparent basis in fact—the pilgrimage to the shrine of St. Thomas à Becket at Canterbury. Beyond this important function, the General Prologue also introduces the characters, who later narrate their own tales. Chaucer develops the characterizations of these figures through the tales they then tell. That is, the character of the teller is further revealed by the subject of the tale and the manner in which it is told.

It would seem that Chaucer's attitude toward the various characters depicted in the General Prologue differs widely. Some, such as the Clerk and the Knight, he depicts as models, or ideals, whose behavior is to be emulated; others, such as the Monk and the Pardoner, he portrays as negative models, with their warts (both

Timeline 12.2 The Gothic era.

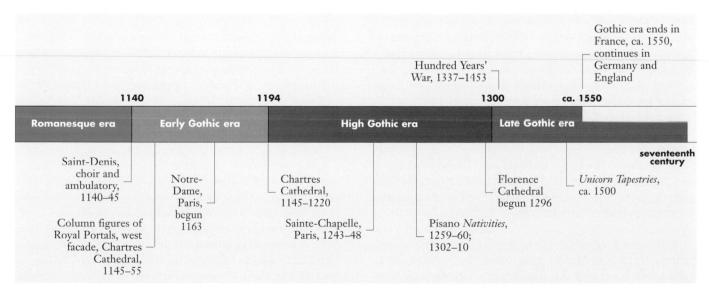

Figure 12.33 Christine de Pizan Presenting Her Poems to Isabel of Bavaria, manuscript illumination, British Library, London. The illumination shows the world of women that Christine celebrates in her writing.

literal and figurative) showing. It is through the voice of Chaucer's narrator that the ironic and satiric portraits of the other pilgrims are constructed. Yet this narrator himself is revealed by the author as being slightly naïve: at a number of points in the General Prologue he shows admiration for the Pardoner and the Monk, albeit in ways that differ from his admiration for the Clerk and the Knight. The "naïve" narrator sometimes fails to discriminate between good and evil manifestations of human behavior; he also fails to distinguish between the ideals certain of the characters are supposed to strive for and the less admirable qualities they embody—as in the cases of the Monk and the Prioress.

In such instances, Chaucer employs acute irony as an instrument of trenchant satire. His wit and observation are evident throughout the entire work, though perhaps most clearly in the General Prologue. Yet everywhere in the *Tales*, one finds a vitality that reveals a remarkable appreciation of life from its lowest and bawdiest aspects to its most elegant and spiritual manifestations.

Christine de Pizan. One of the outstanding woman writers of the later Middle Ages, Christine de Pizan [PEAzan] (1364–ca. 1431) was a scholar and court advisor, as

well as a poet and writer of prose pieces (fig. 12.33). Born in Venice, Christine de Pizan moved with her father to France, where he served as court astrologer to the French monarch Charles V. There she learned to write French and Italian as well as to read Latin, an unusual accomplishment for a woman at the time.

At the age of fifteen, she married a court notary, Eugène of Castal, who died four years later in an epidemic. As a widow with three young children, she began writing to support her family. Before long she was a recognized literary luminary, an accomplished poet and the officially sanctioned biographer of Charles V. In her numerous works of prose and poetry, she consistently argued for the wider recognition of women's status and abilities.

Among her many works are a poem about Joan of Arc; a set of letters challenging the depiction of women in the influential medieval poem *The Romance of the Rose*; a book of moral proverbs; a dream vision; a collection of a hundred brief narratives accompanied by their own commentary; a manual of instruction for knights; an admonitory essay on the art of prudence, *The Book of Feats of Arms and Chivalry*; and her best-known work, *The Book of the City of Ladies*. A universal history of women, *The Book*

of the City of Ladies includes discussion of pagan as well as Christian women, of those long deceased as well as those of her own time, and of fictional characters as well as actual people. Throughout the book, she attempts to alter the reader's perceptions of women. It is this desire to represent women from a woman's point of view that makes the writing of Christine de Pizan unique. Her book is a refutation of misogynistic images of women constructed by male writers of the past. In particular, she rebuts the images of women portrayed in Giovanni Boccaccio's De mulicribus claris (Concerning Famous Women). For example, in response to the charge that women are greedy, she states that what appears as greed in women is a prudent and sensible response to male profligacy. Since men squander, women have to protect themselves against such destructive behavior. She counterattacks by arguing that women are fundamentally generous.

Yet even as she argued for enhanced opportunities for women, Christine de Pizan profoundly echoed the ideals of Christian life as espoused in Church teaching. She supported the goals of Christian marriage, in which a moral commitment between spouses enables them to advance in grace and spirituality while fulfilling their roles as husband and wife. To a large extent, she appears to have been an idealist, one who aspired to achieve the highest values articulated in her religious tradition, while ridding it of its entrenched bias against women.

While urging women to accept their place in the hierarchy of the time, she also encouraged them to fulfill their potential—intellectually, socially, and spiritually—by developing nobility of soul, whatever their particular social status or individual circumstances. Nobility, for Christine de Pizan, was a matter of mind, heart, and spirit, rather than of birthright. She believed that through patient and persistent striving, women of her time could become "ladies," noble feminine embodiments of the highest ideals of heart and mind.

SECULAR SONG

Guillaume de Machaut. In the fourteenth century, medieval music underwent significant changes, including

the displacement of church music by secular music. Drinking songs and music that drew on the everyday began to be composed and performed as often as devotional music inspired by religious faith. In addition, a new system of musical notation had developed by the fourteenth century so that composers were now able to spell out the rhythmic values as well as the melodic pitches of notes. Other changes in musical style, such as the use of syncopation (which emphasizes notes "off" the regular beat), became so significant that theorists referred to the new music as ars nova (new art) to distinguish it from the ars antiqua (ancient or old art) of previous centuries.

One composer who wrote both sacred and secular music in the *ars nova* style was GUILLAUME DE MACHAUT [ghee-OHM duh mash-OH] (1300–1377), the foremost French composer of the time and one of France's leading poets. Like Giotto in painting, Machaut helped to usher in the Renaissance by breaking away from the older medieval style.

Though ordained a priest, Machaut spent most of his life at court. Born in the French province of Champagne, he traveled throughout Europe, and spent his later years in Reims. During his many travels, he presented carefully written and decorated copies of his music and poems to court patrons and foreign nobility. The great care he took in making these copies has ensured their survival.

English Song. One of the most striking musical works to come out of England during the Middle Ages was the song "Sumer Is Icumen in." The song is unlike anything else that has survived from the thirteenth century in providing a foretaste of musical tendencies and techniques that were to emerge over a century and a half later, in the works of Renaissance madrigalists such as Thomas Weelkes and Thomas Morley (see Chapter 14).

The words of the text were composed in English, not Latin, and they celebrate nature rather than religion, the physical life of earth rather than the spiritual joys of heaven. The composer set the words to a lively tune, which is sung by all four voice parts in a canon, or round. Each voice enters before the others have finished so that all four sing simultaneously, though they are at different places in the music at any given time.

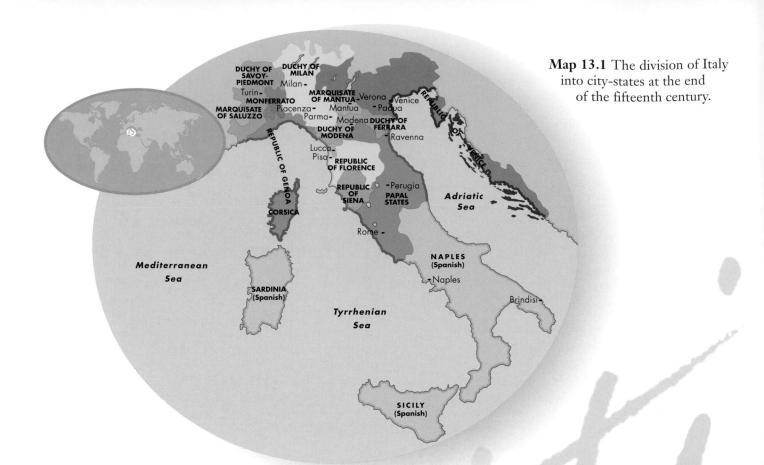

THE RENAISSANCE AND MANNERISM IN ITALY

CHAPTER 13

- ← The Early Renaissance
- ← The High Renaissance
- ← Mannerism

Sandro Botticelli, Birth of Venus, 1484–86, Galleria degli Uffizi, Florence.

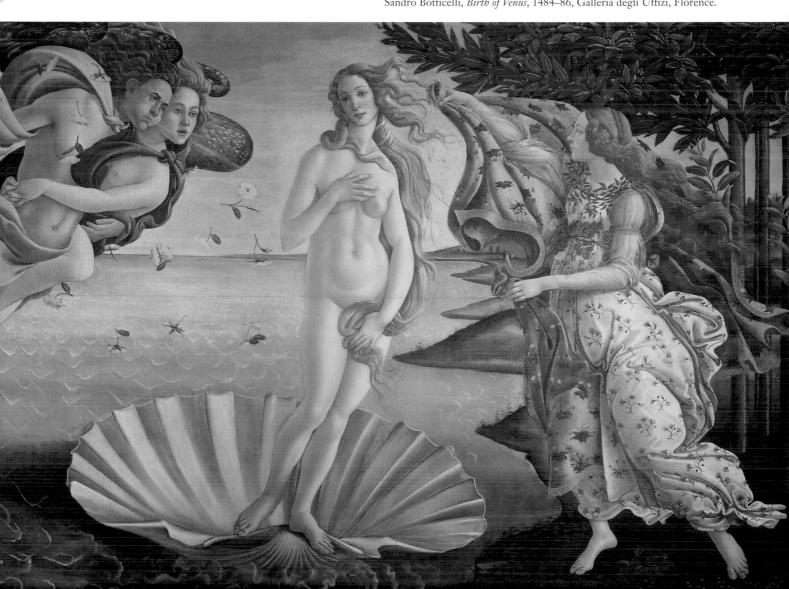

THE EARLY RENAISSANCE

In the middle of the fourteenth century, from around 1348 to 1351, Europe was ravaged by bubonic plague. Called the "Black Death," it was propagated by fleas, carried on the air by coughing and sneezing, and it killed somewhere between one-third and one-half of the population of Western Europe. In small, closed societies, such as monasteries, the infection of one person meant the death of all. The plague first incited fear, then undermined belief systems, and finally spawned widespread social unrest and turmoil. In the midst of this confusion, old ideas were challenged, and new ideas began to take hold, ideas that would lead to the sense of renewal and rebirth that we have come to call the **Renaissance**.

The term "Renaissance" is a French word literally meaning "rebirth," first employed in the nineteenth century to describe the period extending from the early fifteenth century to the middle of the next. The Italians of the time themselves believed that this period marked a radical break from the past and a reinvention in the present of the civilization and ideals of classical Greece and Rome. Today, we are aware that Italian Renaissance culture actually drew heavily on its medieval past, especially its Christian heritage; but as it followed so closely upon the plague's devastation, it is hardly surprising that Italian artists and intellectuals and their patrons believed that they had embarked on a path that would restore Italy to its place at the center of civilization, with a prestige it had not enjoyed since the fall of Rome.

This new culture would not have been possible unless the economic conditions necessary to support it were already in place. During the thirteenth and fourteenth centuries, as a result of the ongoing struggle between the popes and the European emperors, a number of city-states had grown powerful in Italy—the kingdom of Naples in the south, the Church states around Rome, and in the north, the duchy of Milan, and the republics of Venice and Florence. The last three were important trading centers, with close ties to the north. Located on the main road connecting Rome with the north, Florence had become the center of trade, and European banking had been established with credit operations available to support and spur on an increase in trade (Fig. 13.1).

Florence itself was ruled by its guilds, or arti. The seven major guilds, which were controlled by bankers, lawyers, and exporters, originally ran the civic government, but by the middle of the fourteenth century all the guilds, even the lesser guilds of middle-ranking tradesmen, had achieved some measure of political voice, and the city prided itself on its "representative" government and its status as a republic. Still, the major long-standing division between those who favored the Holy Roman Emperor (the old nobility, called the Ghibellines) and those who favored the popes (the new entrepreneurs, called the Guelphs) continued relatively unabated in Florence. Such civil strife, sometimes marked by street battles, had one inevitable result. By the fifteenth century, what the city needed most if its security were to be maintained was a leader with enough political skill, power, and wealth to stop the feuding once and for all.

THE MEDICI'S FLORENCE

It was a single family, the Medici, who led Florence to its unrivaled position as the cultural center of Renaissance Europe in the fifteenth century. The family had begun to

Figure 13.1 A map of Florence in 1490.

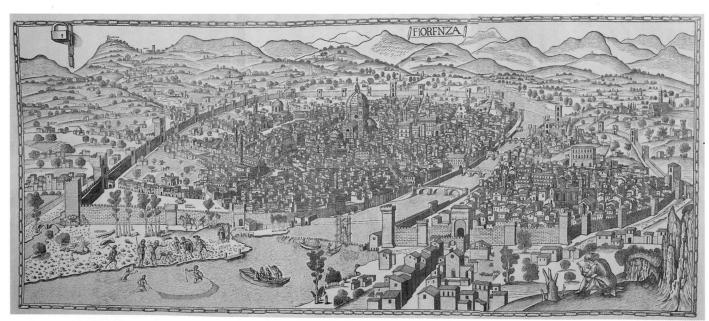

accumulate its fortune by lending money to other Florentines out of income derived from its two wool workshops. GIOVANNI DI BICCI DE' MEDICI [geo-VAHN-nee deh MED-uh-chee] (1360–1429) multiplied this fortune by setting up branch banks in major Italian cities and creating close financial allegiances with the papacy in Rome, allegiances that tended to switch the balance of power, making secular concerns more important than religious ones to the Vatican.

Cosimo de' Medici. It was his son, COSIMO [CAH-zee-moh] (1389–1464), however, who led the family to a position of unquestioned preeminence, not only in Florence but, as branches of the Medici banks opened elsewhere, in Europe as a whole. Though never the official leader of the city, Cosimo ruled, with what amounted to absolute power, from behind the scenes. By 1458, Pope Pius II described him as "master of the country ... Political questions are settled at his house. The man he chooses holds office ... He it is who decides peace and war and controls the laws ... He is King in everything but name."

Cosimo's power was based substantially on calculated acts of discretion and benevolence. "Do not appear to give advice," his father had counseled him, "but put your views forward discreetly in conversation ... never display any pride should you receive a lot of votes ... Avoid litigation and political controversy and keep out of the public eye." At the same time, Cosimo knew that if he gave a significant portion of his wealth to the city, the city would give its loyalty in return. So give Cosimo did. He built the first public library since ancient times and stocked it with ancient manuscripts and books, chiefly of Greek and Roman origin, with a special cyc toward the works of Plato and Aristotle. Though it is difficult to estimate how much money he actually spent on his

library collection in today's currency, \$25 million would not be far from the truth. At some point, virtually every major Italian artist, architect, writer, philosopher, or scholar of the day was in his employ.

In many ways, Cosimo simply solidified what was already fact—Florence had been recognized as a cultural center since the middle of the fourteenth century. Giotto's naturalistic fresco paintings signaled the beginning of the end of the highly stylized and conventional portravals of medieval art. A prominent member of Florence's Arti Maggiori, or seven "major guilds," Giotto painted the Bardi and Peruzzi chapels of Santa Croce in Florence between 1315 and 1330 and was appointed city architect and master of works for the building of Florence Cathedral in 1334 (see Chapter 12). His design of the cathedral's campanile, or bell tower, with its clear and logical structural relationships, harks back to classical principles of design. It was also in Florence, in 1274, that Dante first met his lifelong muse, Beatrice, when he was but nine years old. Dante would later reject the city as a pothole of "self-made men and fast-got gain" when he was exiled in 1302. In the *Inferno* section of his epic poem, *The Divine Comedy*, Dante depicts Florence's burgeoning mercantile culture in some of his most bitter passages. Boccaccio's great collection of stories, The Decameron, begins in a chapel of Florence's Santa Maria Novella, where one Tuesday morning after Mass in about 1348, his "seven ladies young and fair" and three men leave a city ravaged by plague to seek beauty and tranquillity in the surrounding countryside, to "hear the birds sing, and see the green hills, and the plains, and the fields covered with grain and undulating, like the sea."

Already, in these examples, we can see many of the characteristics of Renaissance art and culture: in the growing naturalism of the arts in the renewed interest in

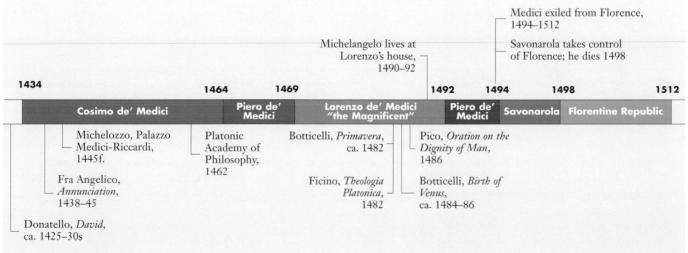

classical values (Giotto's admiration for classical principles of reason and logic), and in the rise of humanism (Dante's negative view of Florence's rampant individualism in those "self-made men," which his still medieval sensibility abhorred). The growing wealth of the city itself, together with the peace brought by Cosimo's leadership, created an atmosphere in which the arts could not only prosper but be enjoyed and appreciated, and this in turn contributed to the increasing sophistication of its citizenry. As early as 1402-03, the first historian of Florence, LEONARDO BRUNI [BREW-nee] (1374-1444), a translator of Plato, Aristotle, and Plutarch, and later a Chancellor of the Republic, praised Florence for its similarity to classical Athens; and with the ascendancy of the Medici, the citizenry truly believed that they had embarked on a new Golden Age.

Lorenzo the Magnificent. The city's dream of achieving the status of the Golden Age of Athens was fully realized, many felt, by LORENZO [LOR-ennzoh] (1449-1492), Cosimo's grandson, who assumed his place as head of the Medici at the age of twenty in 1469, inaugurating twenty-three years of great influence. Lorenzo's father, PIERO [pea-AIR-oh] (1416-1469), cursed with ill health, had ruled for only five years after Cosimo before his own death, but he had raised Lorenzo in Cosimo's image, and Lorenzo quickly established himself as a force to be reckoned with. "Lorenzo the Magnificent," he was called (Fig. 13.2) and indeed, he lived with a sense of grandeur and magnificence. He was one of the leading poets of his day, as well as an accomplished musician, playing the lute and composing numerous dances. He surrounded himself with scholars, built palaces and parks, sponsored festivals and pageants, all the while dipping deeply into the city's coffers, which he controlled, as well as his own. Surprisingly, he commissioned little in the way of painting, preferring instead to spend money on such things as gemstones and ancient vases, which he believed to be better investments than painting. Many of the precious stones in his collection, for example, were valued at over a thousand florins (the coin of the day), while a painting by Botticelli might be bought for as little as a hundred florins. Spend Lorenzo did, and by the time of his death in 1492, the Medici bank was in financial trouble and Florence itself was verging on bankruptcy.

Although the Medici ruled Florence with minor interruptions until 1737, they never again held the same power and authority as Cosimo and Lorenzo. Outside Florence, the most important patron of the Renaissance in Rome would be Lorenzo's son, Pope Leo X. In generations to come, several female Medici descendants would marry the most powerful figures in Europe—CATHERINE DE' MEDICI (1519–1589) was queen to Henry II of France, and MARIA DE' MEDICI (1573–1642) was Henry IV of France's Queen Consort.

Figure 13.2 Giorgio Vasari, Posthumous Portrait of Lorenzo the Magnificent, oil on canvas, Galleria degli Uffizi, Florence. The impressive presence of Lorenzo, as well as his broken nose, are recorded in this painting by Vasari, author of the Lives of the Most Eminent Painters, Sculptors, and Architects.

THE HUMANIST SPIRIT

Cosimo, Piero, and Lorenzo de' Medici were all humanists—that is, those who believed in the worth and dignity of the individual and who, in seeking to discover what was best about humanity, turned their attention to the culture of classical antiquity. In the literature, history, rhetoric, and philosophy of ancient Greece and Rome, they discovered what the Latin scholar and poet PETRARCH [PEH-trark] (1304–1372) had called a century before a "golden wisdom." Cosimo and Lorenzo worked to make Florence the humanist capital of the world, a place where the golden wisdom of the ancients might flourish once again.

Petrarch is often called the father of humanism, and in many ways he determined its high moral tone. He believed that learning was the key to living a virtuous life, and that life should be an eternal quest for truth. Each individual's leading a virtuous life in the pursuit of knowledge and truth would provide a basis for improving humanity's lot. He wholeheartedly encouraged an appreciation of beauty, in nature and in human endeavor, which he thought to be a manifestation of the divine. The personal letter became one of his favorite modes of writing, and he took to writing letters to the ancients themselves as if they were personal friends, even family. He called the poet Virgil his brother and Cicero his

Cross Currents

Montezuma's Tenochtitlan

While Florence stood as the center of the Early Renaissance world, in the other hemisphere stood a city of equal importance and grandeur, one that the Europeans did not know existed until Hernán Cortés invaded Mexico in 1519. It was called Tenochtitlan, and it was the capital of Montezuma's Aztec empire.

The Aztecs, who founded the city, believed that they had been ordered by their god Huitzilopochtli to wander until they saw an eagle perched upon a prickly pear, or *tenochtli*. They finally encountered such a vision in 1325 on an island in the marches of Lake Texcoco in the Valley of Mexico. There they built their city, connecting it to the mainland by four causeways. By the end of the fifteenth century, it was a metropolis inhabited by 150,000 to 200,000 people and ruled by a priest and emperor, Montezuma.

The *Codex Mendoza* (fig. 13.3) is the fullest account that we have of early sixteenth-century Aztec life. It consists of seventy-two annotated pictorial pages together with sixty-three more

pages of related Spanish commentary. It was compiled under the supervision of Spanish friars and at the request of the Spanish crown in about 1541 to aid in their colonial expansion.

As depicted by Aztec scribes, the city is represented by the eagle on the cactus, the shield and arrows symbolizing war, and the waterways dividing the city into equal quadrants. At the heart of the city was the Great Pyramid, imaged by the scribes in the temple at the top. Here, the Aztecs worshiped both Huitzilopochtli, god of the sun and of warfare, and Tlaloc, god of rain and fertility, and here they engaged in ritual human sacrifice to both gods by cutting out the still-beating hearts of their victims, then decapitating them.

As the cultural center of the Aztec civilization, Tenochtitlan was magnificent, grander in fact than anything in Europe at the time. In the words of one of Cortés's soldiers: "When we saw ... that straight and level causeway going towards Tenochtitlan, we were amazed ... Some of our soldiers even asked whether the things that we saw were not a dream."

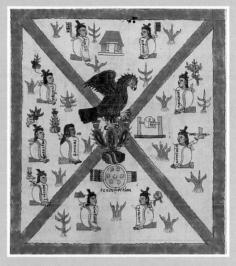

Figure 13.3 The Founding of Tenochtitlan, page from the Codex Mendoza, Aztec, sixteenth century, ink and color on paper, $8\frac{7}{16} \times 12\frac{3}{8}"$ (21.5 × 31.5 cm), The Bodleian Library, Oxford. The skull rack just to the right of center is one of the very few images in the Codex that openly acknowledges the practice of human sacrifice in Aztec life.

father. In the writings of the ancients, Petrarch felt he could sense their uniquely human (noble and ignoble) qualities. Thus, for Petrarch, reading the ancients was like having conversations with them.

Moreover, there were many ancient texts to read. In the middle of the fourteenth century, Petrarch's friend, the writer Boccaccio, had been one of the first men to study Greek since the classical age itself. During the next fifty years, humanist scholars combed monastery libraries for long-ignored ancient Greek texts and translated them into Latin and Italian. By 1400, the works of Homer, Aeschylus, Sophocles, Euripides, Aristophanes, Herodotus, Thucydides, and all of Plato's dialogues were available. In addition, after the fall of Constantinople in 1453, Greek scholars flooded into Italy seeking refuge. Greek learning spread further with the rapid rise of printing in Italy following Johann Gutenberg's invention of printing with movable type and the publication of a Bible in 1455. Between 1456 and 1500, more books were published than had been copied by manuscript scribes in the previous thousand years. Many of these were in vernacular (or native) Italian, such as the works of Dante and Boccaccio. This

contributed to the growing literacy of the middle class, and by the start of the sixteenth century, any educated person could expect to own the complete works of Plato.

THE PLATONIC ACADEMY OF PHILOSOPHY

The center of humanist study during the Renaissance was the Platonic Academy of Philosophy in Florence, founded by Cosimo de' Medici in 1462, and supported with special enthusiasm by Lorenzo the Magnificent. The academy sponsored **Neoplatonism**, or a "new Platonism," which sought to revive Platonic ideals in contemporary culture.

Marsilio Ficino. At the head of the academy was MARSILIO FICINO [fi-CHEE-noh] (1433–1499), who translated into Latin both Plato and Plotinus [Ploh-TINE-us] and wrote the *Theologia Platonica* (1482). Ficino's Neoplatonism was a conscious rereading of Plato (see Chapter 4), particularly his dualistic vision of the psyche (roughly equivalent to the soul or spirit) trapped in the body, but Ficino thought we could glimpse the higher world of Forms or Ideas through

study and learning, and so he looked to the Roman philosopher Plotinus (A.D. 205-270), who was a follower of Plato. Plotinus argued that the material and spiritual worlds could be united through ecstatic, or mystical, vision. Following Plotinus, Ficino conceived of beauty in the things of this world as God's means of making himself manifest to humankind. The contemplation and study of beauty in nature—and in all things—was a form of worship, a manifestation of divine or spiritual love, and Plato's ideas about love were, in fact, central to Ficino's philosophy. Like erotic love, spiritual love is inspired by physical beauty, but spiritual love moves beyond the physical to an intellectual plane and, eventually, to such an elevated spiritual level that it results in the soul's union with God. Thus, in Neoplatonic terms, Lorenzo's fondness for gems was a type of spiritual love, as was Petrarch's love for Laura, celebrated in his sonnets, and so was the painter Botticelli's love of the human form (both discussed later in this chapter). If in real things one could discover the divine, then the determination of Renaissance artists to represent the world in ever more naturalistic terms becomes clear. It could be said that realism becomes, in Neoplatonic terms, a form of idealism. In fact, Ficino saw "Platonic love," the love of beauty, as a kind of spiritual bond upon which the strongest kind of community could be constructed. In this way, Neoplatonism even had political implications. The Neoplatonists envisioned Florence as a city whose citizenry was spiritually bound together in a common love of the beautiful.

Pico della Mirandola. Another great Neoplatonic philosopher at the academy was PICO DELLA MIRANDOLA [PEA-coh DELL-ah mee-RAN-dohlah] (1463-1494), whose religious devotion, intense scholarship, and boundless optimism attracted many followers to the humanist movement. His famous Oration on the Dignity of Man (1486) encapsulates one of the central impulses of the Renaissance: humankind serving as a link between the lower orders of nature, including animals, and the higher spiritual orders, of which angels are a part. For Pico, human beings possess free will and are able to make of themselves what they wish. Though linked with the lower order of matter, they are capable of rising to the higher realm of spirit and ultimately being united with God. Each person's destiny is thus a matter of individual choice.

In the *Oration*, Pico presents God speaking to Adam, telling him that "in conformity with thy free judgment in whose hands I have placed thee, thou art confined by no bonds, and constrained by no limits." God also tells Adam directly that he is "the molder and maker" of himself, who "canst grow downward into the lower natures which are brutes" or "upward from the mind's reason into the higher natures which are divine." This central tenet of humanist philosophy is often misunderstood to

mean that an emphasis on the individual results in or implies a rejection of God. Although Pico, and humanists in general, place the responsibility for human action squarely on humans and not on the Almighty, he also believed that the human mind—with its ability to reason and imagine—could conceive of and move toward the divine. It follows that individual genius, which was allowed to flower in Renaissance Italy as never before in Western culture, is the worldly manifestation of divine truth.

SCULPTURE

One of the ways that Renaissance culture cultivated the notion of individual genius was by encouraging competitions among artists for prestigious public and religious commissions. As early as 1401, the Florentine humanist historian Leonardo Bruni sponsored a competition to determine who would make the doors of Florence Cathedral's octagonal **baptistery**, the small structure separated from the main church where baptisms are performed. Seven sculptors were asked to submit depictions of the sacrifice of Isaac.

Lorenzo Ghiberti. The winner of the competition was the young sculptor LORENZO GHIBERTI [ghee-BAIR-tee] (1378-1455), and his reaction typifies the heightened sense of self-worth that Renaissance artists felt about their artistic abilities and accomplishments: "To me was conceded the palm of victory by all the experts ... To me the honor was conceded universally and with no exception. To all it seemed that I had at that time surpassed the others." He had, admittedly, defeated the much more established sculptor Filippo Brunelleschi in the competition—and perhaps it was losing the competition to the younger Ghiberti, at least in some small part, that caused Brunelleschi to turn away from sculpture to become the preeminent architect of his day (see p. 22) but Ghiberti's pride nevertheless borders on the excessive. Still, we sense in that pride the drive and spirit that would come to define Renaissance individualism.

The subject matter of the baptistery doors was a series of New Testament stories, each told in one of twenty-eight gilded bronze reliefs, which in all took Ghiberti over twenty years to complete. Trained as a painter, Ghiberti pursued concerns of spatial illusion and visual harmony inherited from fourteenth-century painters such as Giotto. Like the reliefs on the ancient Roman Ara Pacis (see Chapter 5), the figures in Ghiberti's *Nativity with the Annunciation to the Shepherds* (fig. 13.4) are set on an empty background that looks more like air than a flat wall—there is, in other words, a sense of physical space behind them. Unlike medieval art, in which the size of figures was determined by their importance, here size reflects position in space: the foreground figures are larger and in higher relief than those in the background.

In addition, the figures themselves not only get progressively larger as they emerge from the depths of the composition, but are arranged in such a way that they connect one to the next, creating a sense of linear movement from back to front. The angel flies forward through the air in a remarkable example of sculptural **foreshortening**, proclaiming the birth of Jesus to the shepherds.

So well were these doors received that as soon as they were completed Ghiberti was immediately commissioned to make a second set for the east side of the baptistery. The eastern doors, depicting ten stories from the Old Testament, were completed in 1452 and are by far the more famous of the two sets. Impressed by their beauty, Michelangelo called them the "Gates of Paradise," and the name stuck. The Gates of Paradise, mounted on the east, face the cathedral facade, occupying the most prominent position on the baptistery.

The panels are fewer in number and larger in size; scenes are set in simple square formats, and this time the whole square is gilded rather than just the raised areas. Each panel actually includes several scenes. The first, for instance, *The Creation* (fig. 13.5), portrays five scenes from Genesis. At the top God creates the heavens and earth. At the bottom left, Adam is created from the earth,

Figure 13.4 Lorenzo Ghiberti, *Nativity with the Annunciation to the Shepherds*, 1403–24, gilt bronze, $20\frac{1}{2} \times 17\frac{3}{4}''$ (52.1 × 45.1 cm), relief panel from the north doors, Baptistery, Florence. The angel announces the birth of Jesus to the shepherds, while Joseph sleeps. Inclusion of the ox and the ass derives from a biblical passage (Isaiah 1:3), "the ox knoweth his owner, and the ass his master's crib."

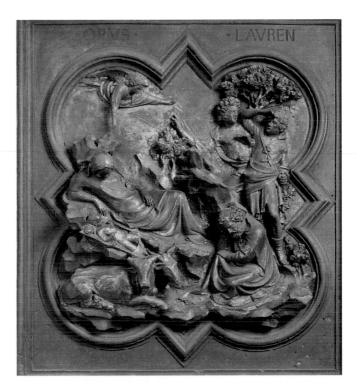

Figure 13.5 Lorenzo Ghiberti, *The Creation of Adam and Eve*, 1425–52, gilt bronze, $31\frac{1}{4} \times 31\frac{1}{4}''$ (79.4 × 79.4 cm), relief panel from the *Gates of Paradise*, cast doors, Baptistery, Florence, now in the Museo dell'Opera del Duomo, Florence. Because of their beauty, Michelangelo referred to these doors as the "Gates of Paradise."

pressing himself up firmly with an extraordinarily muscular right hand. The central scene depicts Eve being created from Adam's rib. To the left, and behind, Adam and Eve are tempted by Satan in the guise of a serpent. And to the right, Adam and Eve are expelled from the Garden of Eden. This is a simultaneous presentation of events that took place sequentially, a technique called continuous narration.

Although medieval artists had depicted events on a single plane, now Renaissance artists allowed the viewer to follow a story through the space of the landscape. The events depicted are organized spatially rather than narratively from left to right. Ghiberti later wrote of the *Gates of Paradise*: "I strove to imitate nature as closely as I could, and with all the perspective I could produce ... The scenes are in the lowest relief and the figures are seen in the planes; those that are near appear large, those in the distance small, as they do in reality ... Executed with the greatest study and perseverance, of all my work it is the most remarkable I have done and it was finished with skill, correct proportions, and understanding."

Donatello. Ghiberti's insistence on correct perspective, proper proportions, and the most accurate representation of nature was shared by DONATELLO [donah-TELL-oh] (1386–1466), who by 1405 was working in

Figure 13.6 Donatello, *Feast of Herod*, ca. 1423–27, gilt bronze, $23\frac{1}{2} \times 23\frac{1}{2}'''$ (59.7 × 59.7 cm), relief panel from baptismal font, baptistery of cathedral, Siena. Donatello's harsh drama contrasts with Ghiberti's fluid charm.

Ghiberti's studio, assisting him on the first set of doors for the baptistery. In 1425, Donatello made the *Feast of Herod* (fig. 13.6), a gilded bronze relief for the font in the baptistery of Siena Cathedral. It is a triumph in the creation of perspectival space. Although perspective had been employed by the ancient Romans in their murals, the general principles of Renaissance **perspective** are believed to have been developed by Filippo Brunelleschi, whom Ghiberti had defeated in the original competition for the Florentine baptistery doors. These principles were later codified by the architect Leon Battista Alberti in his *De pictura* (*On Painting*), published in 1435. In the simplest terms, perspective allows the picture plane (or surface of the picture) to function as a window through which a specific scene is presented to the viewer.

Alberti begins his description of perspective by instructing his reader to draw a rectangle with a figure in the foreground (fig. 13. 7). A horizon line is then drawn at the height of the figure's head. One third of the height of the figure is measured and the foreground is marked off into units of this dimension. A vanishing point—the spot where all orthogonals, or receding lines perpendicular to the picture plane, will appear to converge—is drawn at or near the center of the horizon line, and the orthogonals are then drawn from the foreground units to the vanishing point. To make the horizontal division in the pavement, Alberti advised creating a "small space" beside the drawing. A line is drawn perpendicular to the foreground line, and where this vertical line intersects the orthogonals, horizontals are drawn. Accuracy may be checked with a diagonal line.

The effectiveness of linear perspective in organizing the composition and in creating the illusion of physical space cannot be overestimated. The actual physical space of Donatello's *Feast of Herod* is very shallow, as it is in all

Figure 13.7 Diagram of Alberti's method of drawing in one-point linear perspective. An illusion of three dimensions on a two-dimensional surface can be created by use of his system. Alberti's method used a single vanishing point for lines perpendicular to the canvas, and additional points on either side at which oblique lines seemed to converge (*a* height of person, *b* base line, *c* vanishing point, *d* orthogonals, *e* "small space", *f* distance point, *g* vertical intersection, *h* transversals).

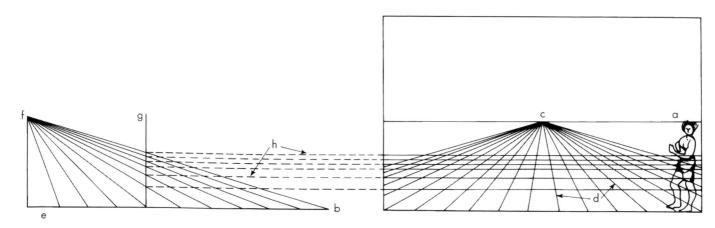

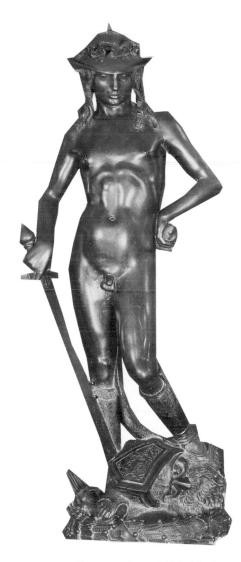

Figure 13.8 Donatello, David, ca. 1425-30s, bronze, height 5'2\frac{1}{4}" (1.58 m), Museo Nazionale del Bargello, Florence. The Early Renaissance interest in antiquity and the accurate portrayal of the nude are evidenced in Donatello's work.

reliefs, but perspective creates the illusion of a very deep space, with two courtvards extending back behind the foreground action. In each courtyard the people are progressively smaller. The floor pattern, drawn in linear perspective, enhances the illusion of recession. Donatello's emphasis on the mathematical discipline of his design and his rigorous application of the laws of perspective are balanced in works such as this one by the dramatic and emotional content of the scene. Indeed, the Feast of Herod possesses a dramatic force never before seen in Italian sculpture. The composition is split down the middle so that there are two competing centers of attention, an unusual device. John the Baptist's head is brought on a platter to Herod on the left and Salome dances seductively on the right. This split adds to the emotional impact and tension of the composition.

Donatello went on to a very different subject, one of special popularity in the Early Renaissance, the shepherd boy David (fig. 13.8) who slew the giant, Goliath, with a stone from his slingshot. For the Florentines, David was a symbol of liberty—he triumphed over Goliath the way tiny Florence triumphed over her mightier enemies. In Christian terms, David symbolized Christ triumphing over Satan, an interpretation that reinforced Florence's sense of its own essential goodness.

In Donatello's David (ca. 1425–30s), the stone is still in David's sling, although Goliath's head lies beneath David's foot. By depicting David both before and after the conflict, Donatello provides a condensed version of the story. With the first life-size nude created since Roman antiquity, Donatello rejects the idealized forms

Donatello, Mary Magdalene, 1453-55, Figure 13.9 wood, painted and gilded, height 6'2" (1.88 m), Museo dell'Opera del Duomo, Florence. Not only beauty, but also its absence can be used to create emotionally moving art, as in this portrayal of the repentant sinner.

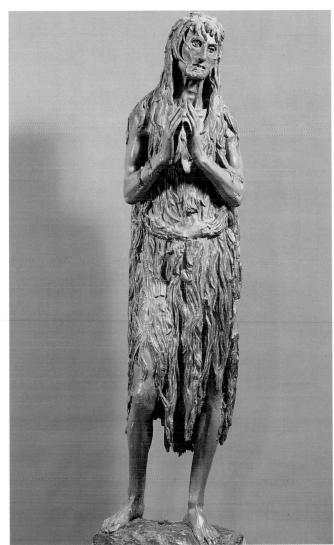

of antique sculpture and portrays his hero as an adolescent male wearing a rather refined hat and boots. (In the Bible, incidentally, David casts off his armor as too cumbersome for battle.) In addition, David adopts the antique *contrapposto* posture, in which the weight of the body rests on one leg, elevating the hip and the opposite shoulder, putting the spine into an "S" curve. Donatello had been to Rome in 1400 and went again in 1431; it may be assumed that he studied antique sculpture on these visits. Although he adopted individual antique motifs, he combined them in un-antique ways. David's posture and nudity may be derived from the ancients, but the body contours are so natural that the story arose that the limbs had been cast from a living model.

Throughout Donatello's career, no matter the subject, scale, or sculptural medium used, he maintained his interest in dramatically powerful imagery. Between 1453 and 1455, he carved one of his most mesmerizing works: the polychromed wooden figure of Mary Magdalene (fig. 13.9), which stands over six feet high. Traditionally known for her physical beauty, Mary Magdalene was the repentant prostitute at Jesus's side, anointing his feet, attending to his burial, guarding his tomb, and discovering his resurrection. Donatello depicts her after years of living in the desert, rejecting the life of the body in anticipation of the immortal life of the soul. Her body now gaunt, her arms and legs withered, she prays. While Ghiberti had taught Donatello to create drama in sculpture (see fig. 13.5), Ghiberti never attempted to challenge his viewer. His work remains delicate, almost sentimental, and appealing. Donatello's figure, by comparison, is intentionally unnerving, even repulsive. Viewers respond to Mary Magdalene with compassion and pity, or they admire her sacrifice, but they are not allowed to respond—at least not in a traditional manner—to the beauty of her appearance.

The beauty Donatello presents is of another kind. Traditionally, we define the aesthetic sense as the appreciation of beauty. Surprisingly, many people find Donatello's Mary Magdalene to be one of the most aesthetically pleasing of his works. In a very Neoplatonic manner, it triggers a higher level of thought and awareness in the viewer, who experiences this intellectual and imaginative stimulus—this higher order of thought—as a form of beauty in its own right. Mary Magdalene may be physically repulsive, but she is spiritually beautiful. This Neoplatonic emphasis on where we locate beauty —in the mind, not the body—typifies the way in which the Renaissance imagination becomes increasingly self-aware. It also frees the Renaissance artist to give up the idealized representations of the Middle Ages and depict the world in more and more realistic detail, since an image of even the most everyday thing might stimulate the imagination to the contemplation of the spiritual.

ARCHITECTURE

As Renaissance artists and thinkers turned their attention more and more to the power of the individual human mind, the powers of reason and logic (which Pico pronounced held us above the beasts) attracted them more than the mind's emotional world. Renaissance architecture in particular reflects a renewed interest in ancient Roman models, with their mathematically determined proportions and emphasis on clarity and logic of construction.

Filippo Brunelleschi. The greatest architect of the Early Renaissance in Italy was FILIPPO BRUNEL-LESCHI [brew-nuh-LESS-key] (1377-1446), who had lost to Ghiberti in the competition to design the doors of the Florence baptistery. Brunelleschi proved to be an excellent architect, and his triumph is the enormous dome he designed for Florence Cathedral (fig. 13.10). Measuring 1381/2 feet wide and 367 feet high, it was the largest dome to have been built since the Pantheon in A.D. 125 (see Chapter 5). Although influenced by antique architecture, the octagonal dome of Florence Cathedral does not look like the hemispherical dome of the ancient Roman Pantheon. Using the basic structural principles perfected in the pointed arches of Gothic cathedrals, Brunelleschi produced a dome with less outward thrust than a hemispherical one. This was necessary because his predecessor, Arnolfo di Cambio, had designed the base of the dome to be of an extraordinary width. Brunelleschi needed to be inventive, and he flanked his octagonal dome with three half-domes that serve to buttress it.

Brunelleschi used different building materials for different parts of the dome: for the bottom, stone; for the upper portion, brick. Use of heavier material at the bottom produced a self-buttressing system, an idea that was not Brunelleschi's own but had actually been used in the Roman Pantheon. Brunelleschi's innovation was to build his dome with an inner and an outer shell—a dome within a dome that was much lighter than the solid concrete dome of the Pantheon. The octagonal dome is reinforced by eight major ribs, visible on the exterior, plus three minor ribs between every two major ribs (fig. 13.11). Finally, Brunelleschi designed an open structure to crown the roof, called a **lantern**. The metal lantern's weight stabilized the whole, its downward pressure keeping the ribs from spreading apart at the top.

Leon Battista Alberti. The other great architect of the day, LEON BATTISTA ALBERTI [al-BEAR-tee] (1404–1472), shared Brunelleschi's love of the antique. He considered Brunelleschi the prime exponent of the new intellectual style that we have come to think of as the "Renaissance style." Born into one of the great families of Florence, Alberti was educated as a humanist, studied at the University of Bologna, and earned a doc-

torate in canon law. Celebrated as an architect and as an author, he was the first to detail the principles of linear perspective so important to Renaissance artists in his treatise *De pictura* (*On Painting*), written in 1434–35. His ten books on architecture, *De re aedificatoria*, completed about 1450, were inspired by the late first-century B.C. Roman writer Vitruvius, who had himself written an encyclopedic ten-volume survey of classical architecture.

Alberti worked to create a beauty in architecture that was derived from harmony among all parts, using mathematics to determine the proportions of his buildings. A prime example is the church of Sant' Andrea in Mantua (fig. 13.12), designed in 1470 and built after his death. Hampered by an older building on the site, Alberti had to adapt his ideal design of the church to the preexisting surroundings. His solution exemplifies Renaissance theory; for the facade he combined the triangular **pediment** of a classical temple with arches characteristic of ancient Roman triumphal arches—one large central arch flanked by two smaller arches. The facade balances horizontals and verticals, with the height of the facade equaling the width. Four colossal Corinthian pilasters paired with small pilasters visually unite the stories of the facade. Large and small pilasters of the same

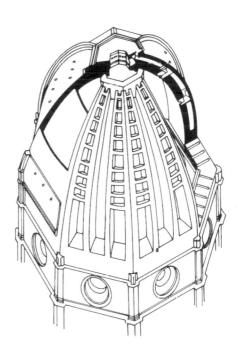

Figure 13.11 Line drawing of Brunelleschi's dome for Florence Cathedral indicating the double shell construction.

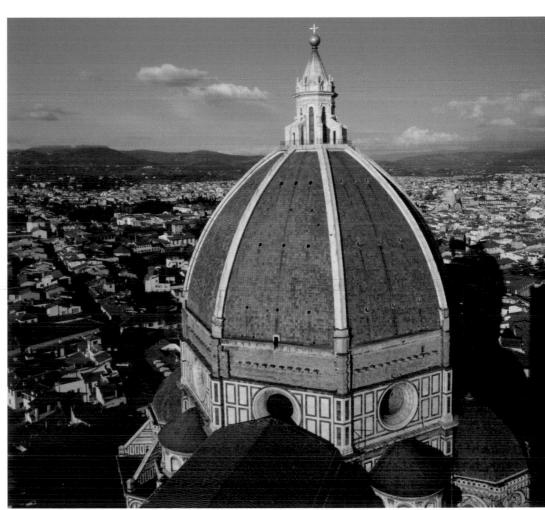

Figure 13.10 Filippo Brunelleschi, Florence Cathedral, dome, 1420–36; lantern completed 1471. Brunelleschi managed to erect this enormous double-shell pointed dome without the use of temporary scaffolding. It is the major landmark of Florence.

dimensions appear in the nave, linking the exterior and interior in a harmonious whole.

Michelozzo di Bartolommeo. In fifteenth-century Florence wealthy families customarily hired architects to build huge fortress-like palaces for them, emblems of their power. One such Florentine palace, the Palazzo Medici-Riccardi (fig. 13.13), was designed by the architect MICHELOZZO DI BARTOLOMMEO [MEE-kel-LOTZ-oh] (1396–1472). The Palazzo Medici-Riccardi was begun in 1445 and probably completed by 1452. Although built for Cosimo de' Medici, the palazzo was acquired in the seventeenth century by the Riccardi family. Standing on a corner of the Via Larga, the widest street in Florence, it was an imposing residence, dignified yet grand, that heralded its resident—the city's most powerful person—literally and metaphorically at the center of the city's cultural and political life.

Michelozzo created an austere three-story stone building. The stonework, beginning with a ground level of rusticated stone (the same rough-hewn masonry used in fortifications), becomes increasingly smoother from bottom story to top. What are now its ground-level windows were originally arches that opened into the street

Figure 13.12 Leon Battista Alberti, Sant' Andrea, Mantua, facade, designed 1470. An ideal demonstration of the Early Renaissance devotion to the antique, the design of this facade combines the form of an ancient temple with that of an ancient triumphal arch.

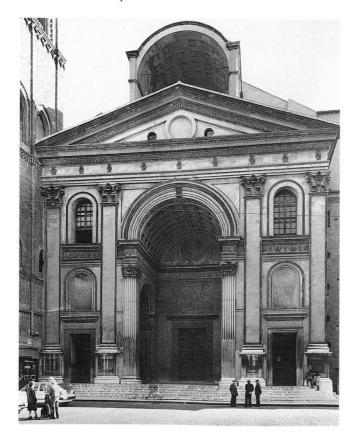

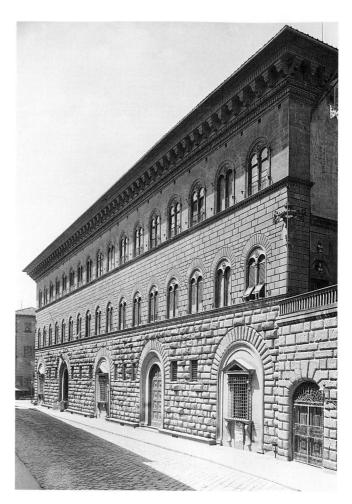

Figure 13.13 Michelozzo di Bartolommeo, Palazzo Medici-Riccardi, Florence, exterior, begun 1445, probably completed by 1452; ground-floor windows by Michelangelo, ca. 1517. Typical of Early Renaissance palazzi, the facades of this massive city residence, built for Cosimo de' Medici the Elder, are neatly divided into three stories with evenly-spaced windows.

creating a *loggia*, or covered gallery. (The arches were filled and the windows added in the sixteenth century by Michelangelo.) The first story provided offices and storage rooms for the Medici business, and the family's living quarters were on the second level. Typically for the Renaissance, the division of the stories is neat and clear, and the divisions are formed by classical moldings. Michelozzo differentiated the levels visually by successively diminishing the height of each, though they all remain over twenty feet high.

The Early Renaissance interest in orderliness is seen also in the even spacing of the windows. The form of window used—two arched openings within an overriding arch—was already popular in the Middle Ages. At the top of the palazzo, a heavy projecting cornice fulfills both aesthetic and architectural roles. The cornice serves visually to frame and conclude the architectural composition.

With a flair for practicality, Michelozzo created a cornice that sent the rainwater wide of the wall. On the corners of the second story is the Medici coat-of-arms with its seven balls.

The rooms of the Palazzo Medici-Riccardi are arranged around a central, colonnaded courtyard, a typical Florentine system in which the palace is turned in on itself, ostensibly for protection but also for privacy and quiet. While the plain exterior reflected the owner's (Cosimo's) own public posture as a careful, even conservative man, the inside, especially the second floor, or piano nobile (the grand and "noble" family rooms of the palace), displayed ostentatious grandeur.

PAINTING

In their emphasis on proper spatial relationships and proportions, architects of the Early Renaissance made an important contribution to the development of the arts at the time. They perfected the art of perspective, the principles of which had been little used since ancient Roman times. In his own day Alberti was known as much for his treatise *On Painting*, which codified the laws of perspective for painters, as for his architectural accomplishments. As was noted in the discussion of Donatello's *Feast of Herod* (fig. 13.6), the system provides the means to

achieve a highly naturalistic and convincing depiction of deep space on a two-dimensional surface. Linear perspective was one tool, among many others, that helped artists to satisfy their desire to create ever more naturalistic images.

Musaccio. Of all the Early Renaissance painters, it was MΛSΛCCIO [mah-SAII-chee-oh] (1401–1429) who, in the short span of his life, carried the naturalistic impulse in painting furthest. In the 1436 Italian edition of On Painting, Alberti named Masaccio, along with Brunelleschi, Donatello, and Ghiberti, as a leading artist of the day.

Masaccio's extraordinary inventiveness is particularly evident in the wall frescoes painted for the Brancacci Chapel in Santa Maria del Carmine, Florence, which he completed in 1428. As Giorgio Vasari later wrote in his important 1550 book on the outstanding artists of the Italian Renaissance, *Lives of the Most Eminent Painters*, *Sculptors, and Architects*: "All the most celebrated sculptors and painters since Masaccio's day have become excellent and illustrious by studying their art in this chapel." In one such fresco, *The Tribute Money* (fig. 13.14), Masaccio utilizes continuous narration, as Ghiberti did later in the *Gates of Paradise*, to depict the scene from the Bible in which Jesus orders his disciples to "render unto Caesar that which is Caesar's, and unto God the things that are God's." In the center, Jesus, in

Figure 13.14 Masaccio, *The Tribute Money*, finished 1428, fresco, $8'1'' \times 19'7''$ (2.3 \times 6.0 m), Brancacci Chapel, Santa Maria del Carmine, Florence. A narrative based on Matthew 17:24–27 is related in a three-part perfectly balanced composition, seemingly illuminated by light coming from the chapel windows. Perspective converges to a point behind Jesus's head, thereby directing the viewer's cycs to Jcsus.

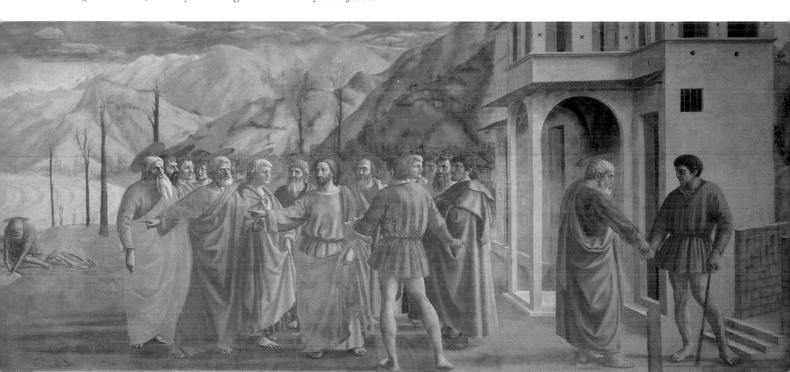

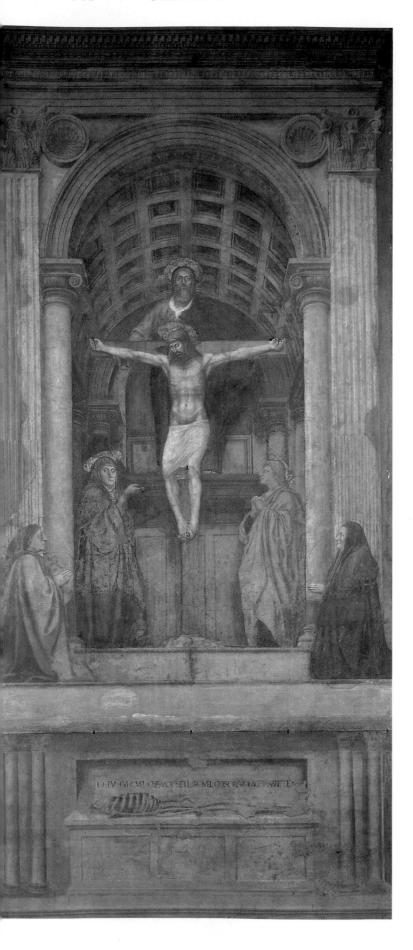

response to the arrival of a Roman tax collector, tells his disciple Peter to look for money in the mouth of a fish. On the left, having removed his cloak, Peter takes the money from the fish. On the right, he gives the money to the tax collector.

Masaccio's figures are harmoniously arranged, the main figure-group placed to the left of center balancing the visually "heavier" group on the far right. As a result, the placement of the figures in the painting seems natural, as if the painter had found the people thus. The entire space is carefully composed by the one-point perspective of the architecture, the vanishing point of which coincides with Jesus's face. The depth of the whole scene is further unified by means of atmospheric (aerial) perspective; that is, objects further away from the viewer's eyes appear less distinct, often bluer or cooler in color, and the contrast between light and dark is reduced.

The individual figures seem to stand in actual space. The tax collector, in the short tunic, has turned his back to us, standing in a contrapposto pose, balanced, relaxed, and natural. When Vasari later wrote that "Masaccio made his figures stand upon their feet," he was praising the naturalism of such poses. The tax collector also echoes our own relationship to the space. We all, viewers and figures alike, look at Jesus. All the faces are individualized, not idealized, and reflect Masaccio's models, real people of the peasant class of Florence. They are also modeled far more carefully than in earlier painting that is, Masaccio's use of light and shadow creates an illusion of three-dimensional, almost sculptural, figures moving in space. They are lit from the right in imitation of reality, since the windows in the Brancacci Chapel are on the right of the fresco.

The bottom part of Masaccio's fresco of the *Trinity with the Virgin*, *St. John the Evangelist*, *and Donors* (fig. 13.15), in Santa Maria Novella in Florence, done as early as 1427–28, is painted to look like a real stone funerary monument. The Renaissance interest in lifelike portraiture can be seen in the life-size depictions of the Lenzi family, who commissioned the work. Unlike the anonymous, marginal figures of donors seen in medieval paintings, the members of the Lenzi family have a real presence in the scene. So successful was Masaccio in his use of perspective that the chapel appears to recede into the wall. The architectural setting is drawn in linear perspective, with the vanishing point just below the bottom of the cross, five feet from the floor, which is approximately eye level for the adult viewer. Situated deeper in the space and therefore

Figure 13.15 Masaccio, *Trinity with the Virgin, St. John the Evangelist, and Donors*, probably 1427 or 1428, fresco, $21' \times 10'5''$ (6.5 \times 3.2 m), Santa Maria Novella, Florence. The architectural setting demonstrates the Early Renaissance interest in the antique and in spatial illusion, while the naturalistic portrayal of the life-size donors indicates the new concern for the individual.

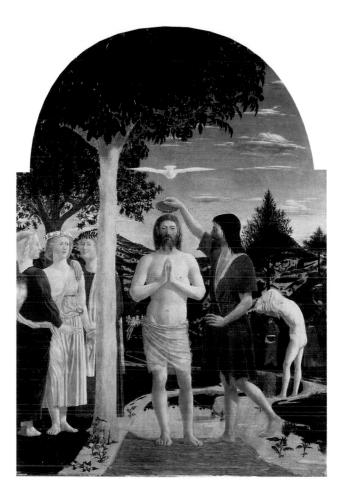

Figure 13.16 Piero della Francesca, Baptism of Jesus, 1450s, oil on panel, $5'6'' \times 3'9^{\frac{3}{4}''}$ (1.68 × 1.16 m), National Gallery, London. Picro's sculpturesque figures, seemingly members of a monumental geometricized race, convey a sense of complete calm.

drawn smaller than the Lenzis, Mary and John the Evangelist act as intercessors pleading with Jesus on behalf of humankind. The only figure to defy natural logic is God; for his feet are on the back wall yet he holds the cross in the foreground.

Piero della Francesca. The new perspectival space defined in Masaccio's painting is realized to an even greater degree in the paintings of PIERO DELLA FRANCESCA [pea-AIR-oh del-uh fran-CHES-kah] (ca. 1406/12–1492). Piero believed that perspective in painting was based firmly on geometry, and he put his ideas on mathematical theory and perspective into writing in his On Painting in Perspective and his On the Five Regular Bodies. According to Piero, mathematics was the key to understanding not only painting, but nature, humankind, and God—the purest manifestation of truth on earth.

More realistic than Masaccio's figures—perhaps because of Piero's insistence on submitting everything, including human anatomy, to the dictates of geometryhis people are smooth and sturdy rather than graceful. In the *Baptism of Jesus* (fig. 13.16), St. John the Baptist pours baptismal water on Jesus, while three substantial angels stand on the left and a man, next to be baptized, undresses on the right. With their oval heads and cylindrical necks, they convey a stately, noble, and authoritative air, yet they have an austere rigidity. Immobile and without facial expressions, the figures display a sculptural quality enhanced by the pale stony colors that Piero employs.

Piero's geometric precision pervades the entire composition of the Baptism. Figures appear in three different sizes, and trees appear in four different sizes, all on four different planes and all created to give the illusion of depth. An excellent observer of nature, Piero not only creates a naturalistic landscape with convincing spatial distance, but he also accurately records the different types of flora found in a cultivated Tuscan landscape. In a highly self-conscious move, he draws attention to the meaning of representation by having the landscape reflected in the water behind Jesus's feet. "What does it mean to reflect the world, to re-present the landscape in painting?" Piero might have asked himself. In Neoplatonic terms, it might mean that nature reflects God's truth, and that the act of painting nature can be a reflection of God's truth.

Piero was also deeply interested in portraiture, which is hardly surprising considering the increasingly humanist nature of society, the popularity of humanistic ideas, and the increase in Florentine wealth. His double depiction of Battista Sforza and Federico da Montefeltro (figs. 13.17 and 13.18) shows wife and husband holding their heads motionless, high above the landscape behind them. They are noble, elevated, grand. The profile presentation was especially popular at this time; Roman coins had shown profiles of important figures. Not only does a profile insist on geometry in the composition—the sitter is at a ninety-degree angle to the viewer—but it can reveal the sitter's most distinctive features.

Piero began the portraits in 1472, the year that Countess Battista Sforza died, suggesting that her portrait was made from her death mask. She is shown in the fashion of the times, with her plucked and shaved forehead, her elaborate hairstyle, and sparkling jewels. Count Federico da Montefeltro was ruler of Urbino, which had begun to compete with Florence as an intellectual center. The Count was a gentleman, scholar, bibliophile, and warrior, whose court included humanists, philosophers, poets, and artists. Piero dedicated his book on perspective to him. A profile view was chosen, not only because of fashion but also because the Count had lost his right eve and the bridge of his nose to a sword in a tournament. It is nonetheles with unsparing realism that Piero presents him "warts and all." We can assume that the Countess and Count looked exactly like this, and that Piero faithfully recorded all the peaks and crevices of their facial terrain.

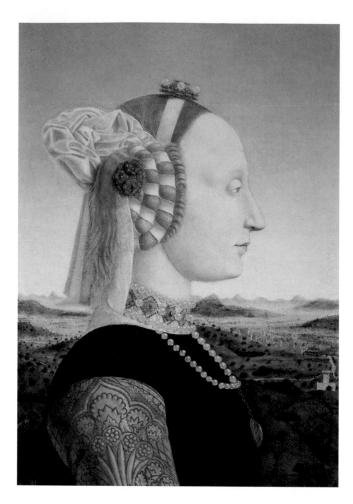

Figure 13.17 Piero della Francesca, Battista Sforza, 1472–73, oil on panel, $18\frac{1}{2}'' \times 13''$ (47 × 33 cm), Galleria degli Uffizi, Florence. The profile portrait was favored in the Early Renaissance; later the three-quarter view became popular.

The growing naturalism evident in the work of Masaccio and Piero della Francesca was not, however, the only direction followed by painters in the fifteenth century. In the work of Fra Angelico and Botticelli, many of the artistic conventions of the Middle Ages are perpetuated. For all the emphasis on the individual, on nature, and on lifelike representation, the fifteenth century remained, in its never-ending quest for manifestations of the divine, an idealist age.

Fra Angelico. Born Guido di Pietro, FRA ANGELICO [FRAH an-JELL-ee-coh] (ca. 1400–1455) was given the name by which we know him now (it means "Angelic Brother") by his brother Dominican monks. The most popular painter in Florence in the first half of the fifteenth century, Fra Angelico was well aware of Masaccio's innovations before the end of his own career, yet he chose not to pursue realistic painting in the way that Masaccio did.

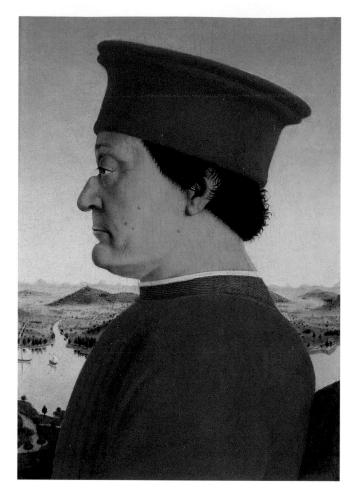

Figure 13.18 Piero della Francesca, Federico da Montefeltro, 1472–73, oil on panel, $18\frac{1}{2} \times 13''$ (47 × 33 cm), Galleria degli Uffizi, Florence. In this pair of portraits, wife and husband are recorded with unsparing realism. An accident in combat accounts for the Count's curious profile.

Consider, for instance, his depiction of the *Annunciation* (fig. 13.19), painted between 1438 and 1445 in the monastery of San Marco in Florence, part of a vast project in which Fra Angelico painted the walls of the ground-floor cloister, the small refectory, and the corridors, landings, and cells of the upstairs dormitory with the help of assistants. For all his conservatism, the *Annunciation* was remarkably contemporary. The scene is accurately set within the architecture of San Marco, newly finished by the architect Michelozzo; thus the Annunciation is shown to take place in a specific and contemporary building. The immediacy and conviction of the event were enhanced for the monks who saw the Angel Gabriel and the Virgin Mary in their own monastery.

It would be difficult to create gentler, more graceful gestures than those of Mary and Gabriel in this scene. Both cross their arms in a sign of respect; they refer to Jesus's cross and prefigure his crucifixion. In the garden to the left are accurate depictions of real plants, but Fra

Angelico, in a more medieval fashion, has placed them perfectly, evenly spaced across the ground so that each maintains its separate identity. While the architecture of the space is rendered with typical Early Renaissance respect for the laws of perspective (clearly, the artist learned well from Brunclleschi and Alberti), Fra Angelico has placed his figures in the architectural setting without regard to proper relative scale. If Mary and Gabriel were to stand, they would take over the space like giants, a prospect entirely at odds with their grace. Fra Angelico has followed a convention from medieval painting: his figures possess an emotional importance that transcends the confinement of physical space. By making them larger than life, Fra Angelico affirms, like his medieval forebears, their spiritual essence.

Sandro Botticelli. The spirituality so evident in Fra Angelico's work was also of particular interest to SAN-DRO BOTTICELLI [bott-tee-CHEL-lee] (1445–1510), who received his artistic training as an assistant to

Fra Filippo Lippi, a Renaissance painter who had worked with Fra Angelico.

His *Primavera* (fig. 13.20), painted about 1482, is a complex allegory of spring taken from the Latin writers Horace and Lucretius. It embodies the growing interest in classical literature and pagan mythology of the Neoplatonists of the Florentine Academy. Botticelli was himself a member of this Neoplatonist circle, which also included Lorenzo de' Medici. The *Primavera* was commissioned by Lorenzo di Pierfrancesco de' Medici, a cousin of Lorenzo's, for a chamber next to his bedroom.

Botticelli seems to have been totally unconcerned with the representation of deep space; his orange grove behind functions more like a stage backdrop than an actual landscape. However, Botticelli is, above all, a master of line, and the emphasis of his work is on surface pattern. Neither solid nor three-dimensional, his figures are clearly outlined, and they seem to flow along the rhythmic lines of a dance or procession. The painting moves

Figure 13.19 Fra Angelico, *Annunciation*, 1438–45, fresco, $7'6'' \times 10'5''$ (2.29 \times 3.18 m), monastery of San Marco, Florence. Fra Angelico cleverly painted the Annunciation as if it were taking place within the actual architecture of the monastery of San Marco.

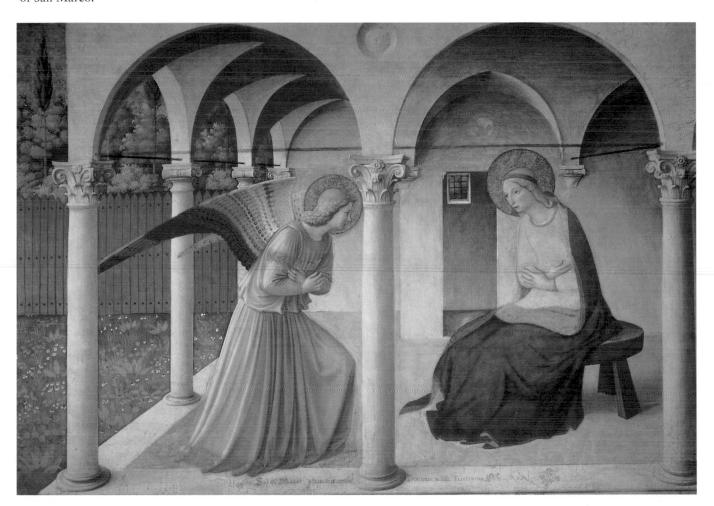

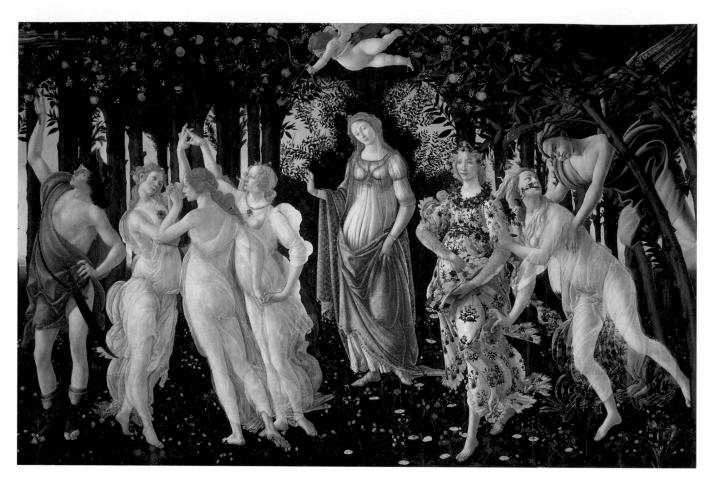

Figure 13.20 Sandro Botticelli, *Primavera*, ca. 1482 (?), tempera on panel, $6'8'' \times 10'4''$ (2.03 \times 3.15 m), Galleria degli Uffizi, Florence. Neoplatonic theory is given visual form in this allegory, perhaps a depiction of the Floralia, an ancient Roman celebration of spring. It was made for a cousin of Lorenzo de' Medici, ruler of Florence.

from right to left, its figures connected by lines of sight and by a sort of spiral or braid of hands and arms that continually reach to the left, as if blown on the breath of Zephyrus, god of the west wind, shown with his cheeks puffed out on the far right. He seems to want to capture Chloris, the spring nymph, who has a leafy vine coming from her mouth. Beside her is Flora, the goddess of flowers, who is strewing their path with petals. In the middle stands Venus, goddess of love, shown pregnant as a symbol of her fruitfulness in spring. With her, the movement of the scene almost comes to a halt, but she gestures toward the three Graces, as Cupid, above her, shoots an arrow in their direction. The three Graces themselves, daughters of Zeus and the personifications of beauty and charm, twirl and whirl us around, but they too seem to spin to the left where finally Mercury, messenger of the gods, holds up his caduceus, or staff, as if to halt the entire procession as he pushes away the remnants of a vaporous cloud. If Masaccio's figures "stand upon their feet," as Vasari put it, Botticelli's seem to stand upon the air, floating just above ground on the gentle breezes of his painted worlds.

But what are viewers to make of such a complex image? In Neoplatonic terms, Venus, the pagan goddess of beauty, is here the embodiment of Heavenly Love. In allegorical terms, she is a type, or figure, for Mary, who would bear the son of God as a sign of God's love for humankind. Her right hand is bent upward in what scholars have come to recognize as a gesture of welcome, as she invites the viewer to enter her garden. "Primavera," the Italian word for spring, can also be translated as "first truth"; in the birth of nature in spring, we are also witnesses to the birth of truth.

The entire composition, but especially the three Graces, recalls a dance for three people composed by Lorenzo the Magnificent in the 1460s and underscores the close connection of the painter to his patron and to the Neoplatonic circle of the Medici court. Called simply "Venus," Lorenzo's dance is based on the movement of two figures around a third one: "First they do a slow sidestep, and then together they move with two pairs of forward steps, beginning with the left foot; then the middle dancer turns round and across with two reprises, one on the left foot sideways and the other on the right foot, also

across; and during the time that the middle dancer is carrying out these reprises the other two go forward with two triplet steps and then give half a turn on the right foot in such a way as to face each other." Thus in the painting Venus, who is, incidentally, dressed in Renaissance costume, oversees a dance that might have taken place in the Medici palace. The music to accompany the dance may have been written by a composer such as Guillaume Dufay. Dufay was hired by Lorenzo to write music for lyrics written in 1467 that might have been one of the "carnival songs" written by Lorenzo himself:

Fair is youth and free of sorrow, Yet how soon its joys we bury! Let who would be, now be merry: Sure is no one of tomorrow.

The *Primavera* takes its place in this idealized world, a world made possible, practically speaking, by the Medici's wealth and, philosophically speaking, by the Medici's constant support of humanist and Neoplatonic thought.

In Botticelli's *Birth of Venus* (fig. 13.21), of ca. 1484–86, also painted for Lorenzo di Pierfrancesco de' Medici, the birth of Venus is equivalent to the birth of the human

soul, as yet uncorrupted by the matter of the world. In Neoplatonic terms, the soul is free to choose for itself whether to follow a path toward sin and degradation or to attempt to regain, through the use of reason, a spiritual perfection manifested in the beauty of creation and felt in the love of God. To love beauty is to love not the material world of sensual things, but rather the world's abstract and spiritual essence. In the *Birth of Venus*, beauty (or the spiritual truth of the soul) is caught between the cold winds of passion, on the left, and the comforting robes of reason, offered by the figure on the right.

Shortly after Florence reached full flower as a cultural center, the city's domination of Italian culture ended. In 1494, a Dominican friar, Girolamo Savonarola, who had lived in the same San Marco convent that Fra Angelico had painted, took control of the city. Savonarola preached to as many as ten thousand people at the cathedral, proclaiming that Florence had condemned itself to perdition. Its painters—artists such as Botticelli—"make the Virgin look like a harlot." The city was populated by prostitutes who were mere "pieces of meat with eyes." "Repent, O Florence," he admonished, "while there is still time." Should Florence reject "the white garments of purification," he threatened that plague, war, and

Figure 13.21 Sandro Botticelli, *Birth of Venus*, ca. 1484–86, tempera on canvas, $6'7'' \times 9'2''$ (2.01 × 2.79 m), Galleria degli Uffizi, Florence. Botticelli painted this important revival of the nude based upon antique prototypes.

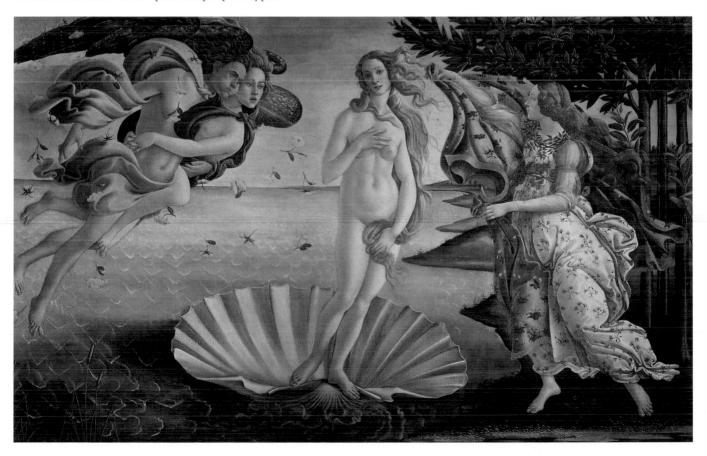

invaders "armed with gigantic razors" would soon follow. A "Bonfire of the Vanities" was built in the Piazza della Signoria, the main square of the city, and on it books, clothing, wigs, make-up, mirrors, false beards, board games, and paintings were burned.

EARLY RENAISSANCE MUSIC

March 15, 1436 was a day of dedication for the completed Florence Cathedral, now crowned by Brunelleschi's extraordinary dome. A procession wound its way through the city's streets and entered the cathedral, led by Pope Eugene IV followed by no fewer than seven cardinals, thirty-six bishops, and untold numbers of church officials, civic leaders, artists, scholars, and musicians. The papal choir included one of the greatest figures in Renaissance music, the composer Guillaume Dufay. The choir performed a motet called "Il Duomo" composed by Dufay especially for the occasion. As one eyewitness recalled, "The whole space of the temple was filled with such choruses of harmony, and such a concert of diverse instruments, that it seemed (not without reason) as though the symphonies and songs of the angels and of divine paradise had been sent forth from Heaven to whisper in our ears an unbelievable celestial sweetness."

Guillaume Dufay. More than any other composer, GUILLAUME DUFAY [dew-FAY] (1400–1474) shaped the musical language of the Early Renaissance. Born in northern France, Dufay served first as a music teacher for the French court of Burgundy, then as a court composer in Italy, working at various times in Bologna, Florence, and Rome. A musical celebrity, he was often solicited to compose music for solemn occasions, such as the dedication of "Il Duomo."

Dufay wrote music in all the popular genres of his time: masses for liturgies, Latin motets, or compositions for multiple voices, for ceremonies, and French and Italian *chansons*, or songs, for the pleasure of his patrons and friends. In each genre, Dufay provided melodies and rhythms more easily identifiable to the listener than those of earlier composers.

Motets. Dufay wrote many motets: one-movement compositions that set a sacred text to polyphonic choral music, usually with no instrumental accompaniment. Dufay's motet Alma Redemptoris Mater, composed in about 1430, fuses medieval polyphony—that is, the simultaneous singing of several voices each independent of the others—with a newer Early Renaissance form. Earlier composers typically put the plainchant melody, or main melody, in the lowest voice, but Dufay puts the main melody in the highest or uppermost voice, where it can be better heard. He also avoids the rhythmic distortion of medieval composition. The three voices of Dufay's Alma Redemptoris Mater—bass, tenor, and soprano—maintain rhythmic independence (also a late

medieval characteristic) until the third and last section of the motet. Then Dufay blocks them together in chords to emphasize the text's closing words, which ask Mary to be merciful to sinners; the chords, arranged in graceful harmonies, soothe the listener's ears more than those of the traditional medieval motet. In this last part Dufay adds an additional voice by giving the sopranos two different parts to sing. In doing so, he moves toward the four-part texture of soprano, alto, tenor, and bass that was to become the norm for later Renaissance vocal music.

Word painting. Dufay's emphasis on the words of his motet for Mary is an early example of what the Renaissance would come to call word painting, in which the meaning of words is underscored and emphasized through the music that accompanies them. One sixteenthcentury musical theorist, for instance, made the following suggestion to composers: "When one of the words expresses weeping, pain, heartbreak, sighs, tears, and other similar things, let the harmony be full of sadness." A composer might also employ a descending melodic line (going from high to low), or a bass line, to express anguish; conversely, an ascending line (going from low to high), utilizing soprano voices, might express joy and hope. This increasing sense of the drama of language, comparable to the Renaissance artists' attention to the drama of the stories they chose to depict— Donatello's Mary Magdalene (see fig. 13.9), for example—led Renaissance composers to use music to enrich the feelings their music expressed, and to support the meaning of a song's text, whether sacred or secular. Though little music had survived from ancient Greece, humanist philosophers like Ficino understood that Aristotle had considered music the highest form of art, and that the rhythms of Greek music imitated the rhythms of Greek poetry, for which it served as a setting. Thus, word painting as the intimate relation of sound and sense has classical roots.

As in the Middle Ages, musicians like Dufay were employed by the churches, towns, and courts. However, unlike music in the Middle Ages, which served mostly religious ends, music in the Renaissance became increasingly secularized. Musicians in the Renaissance still depended upon such patronage, but commissions came from wealthy burghers and aristocrats such as the Medici family, as well as from the Church, which nonetheless remained the staunchest of musical patrons. The secular works commissioned by the nobility were to accompany formal occasions such as coronations, weddings, processions, and even political events. However, before long secular music also found its way into sacred settings. Dufay, for instance, introduced the popular French folksong "L'Homme armé" ("The Man in Armor") into a mass, and other composers soon followed suit, creating an entire musical genre known as chanson masses, or "song masses."

Connections

MATHEMATICAL PROPORTIONS: Brunelleschi and Dufay

Mathematics played an important part in all the arts of the Renaissance. Architects designed buildings guided by mathematical ratios and proportions. Painters employed the mathematical proportions governed by linear perspective. Composers wrote music that reflected mathematical ratios between the notes of a melody and in the intervals between notes sounded together in harmony. Poets structured their poems according to mathematical proportions.

One especially striking set of relationships exists between the proportions of the dome built by Filippo Brunelleschi for Florence Cathedral and "Il Duomo," the motet for four voices that Guillaume Dufay wrote for

its dedication in 1436. Its formal title is Nuper Rosarum Flores (Flowers of Roses), the word flores referring to Florence itself. The mathematical ratios in Dufay's motet are evident in its rhythm rather than its melody. The slowermoving lower voices of the two tenors proceed in strict rhythmic progressions that reflect the ratio of 6:4:2:3. The initial ratio of 6:4 is reducible to 3:2; thus, it is a mirror reverse ratio of 3:2:2:3, which appears in the number of beats in each of the work's four sections: 6, 4, 4, and 6. In addition, Dufay's motet contains a total of 168 measures, proportionally divided into four harmonious parts of 56, 56, 28, and 28 measures each. The last two parts contain exactly half the number of measures of the first two, creating a mathematically harmonious and intellectually pleasing

Brunelleschi's dome's proportions exhibit mathematical ratios that are 6:4:2:3, just as in Dufay's motet. This is the ratio of the internal dimensions to the external ones. And motet and dome both have a doubling. Dufay's motet employs a doubling of the tenor voices, which sing the lower melody five notes apart. Brunelleschi's dome is a double shell, having an internal and an external structure.

In these and numerous other instances of Renaissance architecture and music, as well as perspectivist painting, sculptural proportions, and poetry, mathematics lies at the heart of the harmonious nature of the works. This concern with geometric symmetry and mathematical proportions illustrates one more way in which the arts of the Renaissance were a legacy of the golden age of Greece.

Musical accomplishment was one of the marks of an educated person in the Renaissance, and most people associated with the nobility both played an instrument and sang. Moreover, many uneducated people were accomplished musicians; in fact, the music of the uncducated masses—their songs and dances—was most integral part of an evening's entertainment. While it was common for professionals to provide this entertainment, increasingly individuals at a party might entertain the group. Dance, too, became the focus of social gatherings, and much of the instrumental music of the day was composed to accompany dances.

One final factor that led to the growth and popularity of music during the Renaissance was the rise of music printing. Although by 1455 Gutenberg had perfected the art of printing from movable type, the first collection of music printed in this way, One Hundred Songs, was not published until 1501 in Venice by Ottaviano de' Petrucci. Half a century later, printed music was widely available for use by scholars and amateurs alike. With the greater availability of printed scores, Renaissance composers quickly became more familiar with each other's works and increasingly began to influence one another. Amateurs were able to buy and study the same music, and soon songs and dances in particular achieved the kind of widespread popularity that today might put a song into the "Top Ten."

LITERATURE

Petrarch. The first great figure of Italian Renaissance letters as well as the first important representative of Italian Renaissance humanism was Petrarch, a scholar and prolific writer, whose work simultaneously reflects the philosophy of Greek antiquity and the new ideas of the Renaissance. Born Francesco Petrarca in Arezzo and taken, at the age of eight, to Avignon, where the papal courts had moved in 1309, Petrarch studied law in Bologna and Montpellier, then returned in 1326 to Avignon. Petrarch once said of himself, "I am a pilgrim everywhere," for he also traveled widely in France and Italy, hunting down classical manuscripts.

Unlike his Florentine predecessor, Dante Alighieri, whose *Divine Comedy* (see Chapter 12) summed up the sensibility of late medieval culture, Petrarch positioned himself at the beginning of a new literary and artistic era, one that placed greater emphasis on human achievement. Without rejecting the importance of spirituality and religious faith, Petrarch celebrated human accomplishment as the crowning glory of God's creation but gave human beings praise for their achievements as well. With an emphasis on humanity, Petrarch inaugurated a series of intellectual and literary experiments better suited to his psychological interests and humanist aesthetic.

Petrarch's work is poised between two powerful and inextricably intertwined impulses. One is the religious and moral impulse felt by early medieval thinkers such as St. Augustine; the other is the humanist dedication to the disciplined study of ancient writers, coupled with a striving for artistic excellence.

Petrarch was especially affected by the elegance and beauty of early Latin literature. He disliked, however, the Latin of the Middle Ages, seeing in it a barbarous falling off from the heights of eloquence exemplified by ancient Roman writers such as Virgil, Horace, Ovid, Seneca, and Cicero. Petrarch strove to revive classical literature rather than absorb its elements into contemporary Italian civilization. He considered classical culture a model to be emulated and an ideal against which to measure the achievements of other civilizations. For Petrarch, ancient culture was not merely a source of scientific information, philosophical knowledge, or rhetorical rules; it was also a spiritual and intellectual resource for enriching the human experience. Petrarch would help first Italy, and then Europe, recollect its noble classical past. And although Petrarch did not invent humanism, he breathed life into it and worked tirelessly as its advocate.

Soon after his return to Avignon in 1326, Petrarch fell in love with a woman whose identity is unknown, but whom he called Laura in his Canzoniere (Songbook). This is a collection of 366 poems in various forms—sonnets, ballads, sestinas, madrigals, and canzoni (songs)—which Petrarch wrote and reworked over a period of more than forty years. The poems, many of which are about love, are notable for their stylistic elegance and their formal perfection. Those about Laura are the most beautiful and the most famous. These poems fanned the flames of a passion for Petrarch that would last throughout the Renaissance and beyond, which spawned a profusion of verses written in imitation of him, borrowing situations, psychological descriptions, imagery and other forms of figurative language, and particularly the sonnet form Petrarch devised.

The Petrarchan Sonnet. Thematically, Petrarch's sonnets introduced what was to become one of the predominant subjects of Renaissance lyric poetry: the expression of a speaker's love for a woman and his experience of the joy and pain of love's complex and shifting emotional states. Laura's beauty and behavior cause the poet/speaker to sway between hope and despair, pleasure and pain, joy and anguish. Throughout the sequence of poems, Laura remains unattainable. Like so many figures in Renaissance painting, she is at once a real person and an ideal form, a contradiction expressed in the sometimes ambivalent feelings the poet/speaker has about her.

As an extended sequence, Petrarch's sonnets inspired poets throughout Europe to write their own sonnet sequences. The most famous examples in English are Philip Sidney's *Astrophel and Stella* (1591), Edmund Spenser's *Amoretti* (1595), and William Shakespeare's 154 sonnets. Petrarch's sonnet structure established itself as one of the two dominant sonnet patterns used by poets.

The Petrarchan (sometimes called the Italian) sonnet is organized in two parts: an octave of eight lines and a sestet of six. The octave typically identifies a problem or situation, and the sestet proposes a solution; or the octave introduces a scene, and the sestet comments on or complicates it. The rhyme scheme of the Petrarchan sonnet reinforces its logical structure, with different rhymes occurring in octave and sestet. The octave rhymes *abba abba* (or *abab abab*), and the sestet rhymes *cde cde* (or *cde ced*; *cde dce*; or *cd*, *cd*, *cd*).

The following sonnet was the most popular poem in the European Renaissance; it depicts the lover's ambivalence in a series of paradoxes or apparent contradictions.

I find no peace and all my war is done, I fear and hope, I burn and freeze like ice; I fly above the wind yet can I not arise, And nought I have and all the world I sesan.° That loseth nor locketh holdeth me in prison 5 And holdeth me not, yet can I escape nowise; Nor letteth me live nor die at my devise, And yet of death it giveth me occasion. Without eyes, I see, and without tongue I plain,° I desire to perish, and yet I ask health, 10 I love an other, and thus I hate my self, I feed me in sorrow and laugh in all my pain, Likewise displeaseth me both death and life, And my delight is cause of this strife.

⁴ sesan: seize. ⁹ plain: complain.

The High Renaissance

FRA SAVONAROLA AND THE FLORENTINES

When Fra Savonarola warned the Florentines that if they did not mend their ways invaders "armed with gigantic razors" would soon descend upon them, his promise was not as far-fetched as it might have seemed. Just to the north, in the Po valley, as early as 1487 Leonardo da Vinci had designed an instrument of destruction for the Duke of Milan. Leonardo's scythed chariot was designed to cut down armies, and his "armored car" (fig. 13. 22), when powered by eight men inside, could "take the place of elephants" in battle. Leonardo promised, "There is no host of armed men so great that they would not be broken by them." However, before Leonardo went to Milan, he made his reputation as a painter.

PAINTING

Leonardo da Vinci. Born in Vinci, about twenty miles west of Florence, LEONARDO DA VINCI [lay-o-NAR-doh dah VIN-chee] (1452–1519) was the illegitimate son of a peasant named Caterina and Ser Piero, a Florentine lawyer or notary with a house in Vinci.

Figure 13.22 Leonardo da Vinci, A Scythed Chariot, Armored Car, and Pike, ca. 1487, pen and ink and wash, $6\frac{3}{4} \times 9\frac{3}{4}$ " (17.1 × 24.8 cm), British Museum, London. Leonardo's interest in defensive devices is indicative of the frequent wars in Italy.

Leonardo later joined his father in Florence, and in 1469 he entered the workshop of Andrea del Verrocchio, whose other apprentices included Sandro Botticelli. Giorgio Vasari wrote of Leonardo's "beauty as a person," describing him as "divinely endowed" and "so pleasing in conversation that he won all hearts." But he was, Vasari noted, unstable in temperament, often abandoning projects, constantly searching and restless.

Leonardo was sent to Milan by Lorenzo the Magnificent in 1481 or 1482 as an ambassador, charged with presenting an ornate lyre to the Duke, Ludovico Sforza, as a gesture of peace. Leonardo chose to remain in Milan. In Florence, Leonardo had been known as a painter and sculptor, but he was, he explained to the Duke, primarily a designer of military and naval weaponry and only secondarily an architect, painter, drainage engineer, and sculptor capable of creating a giant bronze horse that Ludovico planned as a memorial to his father. He was, in short, the epitome of what we have come to call the "Renaissance" or "universal man," a person not merely capable but talented in an extraordinarily wide range of endeavors.

Although Leonardo was, by any standard, a Renaissance man, he did not share the Florentine taste for classical humanist scholarship, avoiding philosophy and literature. Rather, he was a student of nature amply evidenced in his *Madonna of the Rocks* (fig. 13.23), begun in 1483, soon after his arrival in Milan. The flowers and plants are minute observations from nature. The geology—cliffs, mountains, and a grotto filled with stalactites and stalagmites—comes out of his lifelong fascination with the effects of wind and water on the environment. Hurricanes and deluges particularly intrigued him, as did the eddies and currents of moving water. The *Madonna of the Rocks* makes evident his preoccupation

with the interrelated effects of perspective, light, color, and optics. The naturalistic lighting and atmospheric perspective developed earlier by Masaccio are taken to new heights. In fact, in his *Notebooks* Leonardo would refine the art of modeling the figure in light and dark developed by Masaccio and codify rules for atmospheric perspective (here, the haze that envelops objects in the distance diminishes the clarity of form and color).

Chiaroscuro is the term used to describe Leonardo's modeling technique. In Italian, chiaro means "clear" or "light," and oscuro means "obscure," or "dark." Chiaroscuro describes the subtle shift from light to dark across a rounded surface. In Leonardo's hands, the technique was used to achieve an extraordinary sense of sculptural dimensionality as well as a powerful emotion-

Figure 13.23 Leonardo da Vinci, Madonna of the Rocks, begun 1483, oil on panel, transferred to canvas, $6'6\frac{1}{2}''\times4'$ (2.0 × 1.2 m), Musée du Louvre, Paris. Leonardo, artist and scientist, created a grotto setting with stalactites, stalagmites, and identifiable foliage, an unusual environment for these religious figures.

al impact. In the Madonna of the Rocks, the child Jesus blesses his cousin John (the infant John the Baptist) who represents the congregation of Christians, literally protected by Mary's cloak but figuratively taken under her all-loving wing. Compositionally, Leonardo has taken a traditional triangular grouping and extended it into three dimensions, making a pyramid. Each figure seems to possess real psychological depth, from the tranquillity and calm of Mary to the seriousness of purpose etched in the infant John's brow. Leonardo's ability to render subtle aspects of human expression, remarkable in itself and the result of a careful study of human nature, is increased by his use not only of chiaroscuro and atmospheric perspective but also of sfumato (in Italian, "smoky"). Sfumato is the intentional suppression of the outline of a figure in a hazy, almost smoky atmosphere. Leonardo's figures do not so much emerge from the darkness of the grotto, as they are immersed in it, surrounded by it, even protected by it, as if the grotto were the womb of the earth itself and Mary the site's resident mother goddess.

Leonardo's greatest achievement in Milan, however, was *The Last Supper* (fig. 13.24), a huge mural located in the refectory of Santa Maria delle Grazie, before which resident monks would themselves take their supper. Painted between 1495 and 1498, it is a painting of supreme physical delicacy. Leonardo, always experimenting, created a new fresco technique, painting on dry plaster with a combination of oil and tempera in order to lengthen the drying time and achieve more naturalistic

effects. Even before he finished, moisture crept behind the paint, causing it to flake off the wall. Subjected to years of dirt and smoke, to say nothing of previously botched restoration efforts and bombing in World War II, the deterioration continued virtually unabated until 1977, when a painstaking restoration process began.

The composition of *The Last Supper* clarifies the painting's meaning. The largest of the three windows on the back wall is directly behind Jesus, thereby emphasizing him. The curved pediment, which arches above his head, serves as a halo. He is perfectly centered in the mural, and all perspective lines converge toward a vanishing point directly behind his head, thereby directing the viewer's eyes to him. The twelve apostles are arranged six on each side, divided into four groups of three figures. The result is a composition that is almost perfectly balanced symmetrically around the central figure of Jesus, whose arms are extended diagonally to the right and left in such a way that he himself forms an equilateral triangle. The arrangement of the five segments is theatrical action comes from the wings but Jesus remains calm in the center.

Leonardo chose the most psychologically powerful moment in the story: Jesus has just announced that one of his apostles will betray him, and they respond in unison, "exceedingly sorrowful, and [begin] every one of them to say unto him, Lord is it I?" (Matt. 21:22). Judas, his betrayer, sits between John and Peter directly to the left of Jesus, his face lost in shadow as he leans away,

Figure 13.24 Leonardo da Vinci, *The Last Supper*, 1495–98, tempera and oil on plaster, $15'2'' \times 28'10''$ (4.60 \times 8.80 m), refectory, Santa Maria delle Grazie, Milan. The mural's poor condition is due to the experimental media in which Leonardo painted. Nevertheless, his ability to merge form and content, using perspective to simultaneously create an illusion of a cubic space and focus the viewer's attention on Jesus, can still be appreciated.

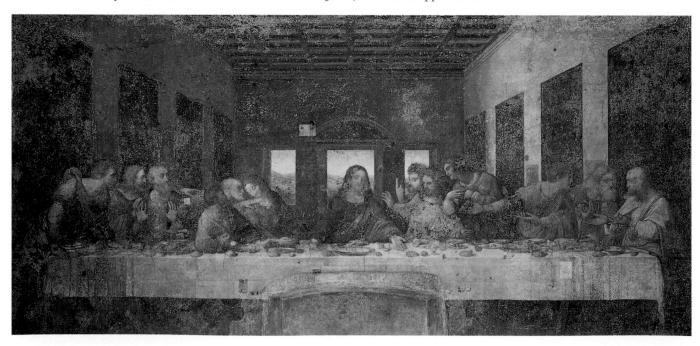

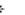

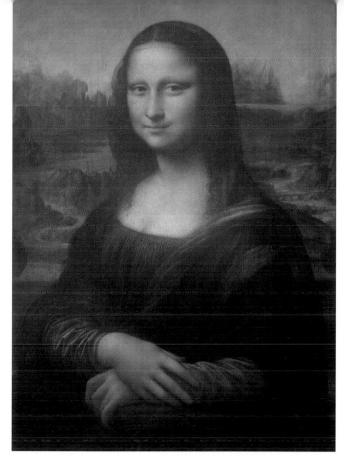

Figure 13.25 Leonardo da Vinci, *Mona Lisa*, ca. 1503, oil on panel, $2'6\frac{1}{4}'' \times 1'9''$ (76.8 × 53.3 cm), Musée du Louvre, Paris. Probably the most famous painting in the world, Mona Lisa's mysterious smile continues to intrigue viewers today.

clutching a money bag in his right hand. We know from preparatory sketches that Leonardo wanted to depict a different emotion on each of the apostles' faces. The most difficult thing to paint, Leonardo said, was "the intention of Man's soul." It could only be shown by pose, facial expression, and surrounding events and figures. Judas and Jesus, apparently, gave him the most difficulty. Vasari tells the story:

The prior [of Santa Maria delle Grazie] was in a great hurry to see the picture done. He could not understand why Leonardo would sometimes remain before his work half a day together, absorbed in thought ... [Leonardo] made it clear that men of genius are sometimes producing most when they seem least to labor, for their minds are then occupied in the shaping of those conceptions to which they afterward give form. He told the duke [Sforza, under whose protection the monastery was] that two heads were yet to be done: that of the Savior, the likeness of which he could not hope to find on earth and ... the other, of Judas ... As a last resort he could always use the head of that troublesome and impertinent prior.

Leonardo solved his problem with Judas by grouping him with Peter and John. "I say," Leonardo explained in his *Notebooks*, "that in narratives it is necessary to mix closely together direct contraries, because they provide a

great contrast with each other, and so much more if they are adjacent, that is to say the ugly to the beautiful."

Sometime in 1503, after Leonardo had been forced to return to Florence, he painted the famous Mona Lisa (fig. 13.25), a portrait of Lisa di Antonio Maria Gherardini, the twenty-four-year-old wife of a Florentine official, Francesco del Gioconda—hence the painting is sometimes called La Gioconda. Compared to Piero della Francesca's rigid portrait of Battista Sforza (see fig. 13.17), Mona Lisa appears relaxed and natural. While Piero presented his sitter in a bust-length profile, Leonardo shows a half-length three-quarter view. With this pose, Leonardo established a type, which has the hands showing—for Leonardo, emotion could be read in the disposition of a figure's hands—and the figure itself set against a landscape. Probably no other painting in history has so successfully conveyed psychological depth and mystery to generation after generation of viewers. It is as if Leonardo has captured in Mona Lisa's face the extraordinary range of Nature's moods depicted in the landscape behind her.

Just before October 1503, Leonardo was commissioned by Florence's new republican government to paint a mural celebrating the Florentine past for the new Council Chamber in the Palazzo Vecchio. He chose the Battle of Anghiari, a great Florentine military victory. By 1505 he had "commenced coloring." Leonardo never finished the *Battle of Anghiari*, though he did a portion, the "Fight for the Standard," which unfortunately has not survived. However, a chalk and pen rendering of this section, done by the Flemish painter Peter Paul Rubens, does (fig. 13.26).

Figure 13.26 Peter Paul Rubens, copy of Leonardo's *Battle of Anghiari*, ca. 1603, chalk worked over with pen and bodycolor, $17\frac{3}{4} \times 25''$ (45.2 × 63.5 cm), Musée du Louvre, Paris. There is some evidence that Leonardo's *Battle of Anghiari* was, like his *Last Supper*, painted in an experimental technique. He may well have abandoned the project due to technical problems.

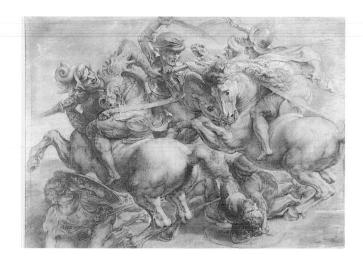

In 1504, while Leonardo was busy preparing the mural and doing sketches, another Florentine artist was working in the Council Chamber—Michelangelo, twenty-three years his junior and fresh from the success of his monumental *David* (see fig. 13.32). He was painting the *Battle of Cascina* (now also known only in a copy of a portion of this composition). It was an unofficial competition to see who was the greatest painter—as exciting a competition as the one Ghiberti and Brunelleschi had engaged in a century earlier. By the end of the summer, a young artist named Raphael, only twenty-one years of age, had arrived in Florence to watch the artists work. With these three masters in Florence—two established masters and one promisingly talented student—the "High" Renaissance was in full swing.

THE REINVENTION OF ROME

It was not in Florence, however, but in a reborn Rome that the Italian High Renaissance came to fruition. By the middle of the fifteenth century, after the papacy had moved to Avignon in 1309, Rome lay in a sorry state of disrepair. When Pope Nicholas V returned the papacy to Rome in 1447, all that changed. Pope Nicholas V had close ties to the Florentine humanist tradition, and accompanying him upon his return to Rome was none other than Leon Battista Alberti. Alberti roamed though the ancient ruins of the city, creating as he went his massive survey of classical architecture, De re aedificatoria. With Alberti as his chief consultant, Nicholas began rebuilding Rome's ancient churches and initiated plans to remake the Vatican as a new sacred city. Nicholas also began assembling a massive classical library, paying humanist scholars to translate ancient Greek texts into Latin and Italian.

Pope Sixtus IV. The Vatican library would become one of the chief preoccupations of Pope Sixtus IV (reigned 1471–83). With his appointment of Platina as its head, the Vatican library established rules for usage, a permanent location, and an effective, permanent administration. It became a true "Vatican," or "public," library. Platina's appointment is celebrated in a fresco painted by Melozzo da Forli for the library (fig. 13.27). The Latin couplets below the scene, written by Platina himself, outline Sixtus's campaign to restore the city of Rome, rebuilding churches, streets, walls, bridges, and aqueducts, but praise Sixtus IV most of all for the creation of the library. By 1508, the Vatican Library was said to be the "image" of Plato's Academy. Athens had been reborn in Rome.

As the city was rebuilt and archaeological discoveries made, its reinvented role was as the classical center of learning and art. Sixtus immediately established a museum in 1474 to house the recently uncovered Etruscan bronze statue of the she-wolf that had nourished Romulus and Remus, the mythical twin founders of the city (see Chapter 5). Other discoveries followed: *Spinario*, a Hellenistic bronze of a youth pulling a thorn from his

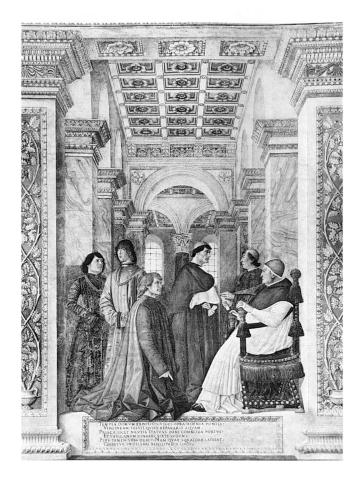

Figure 13.27 Melozzo da Forlì, *Sixtus IV Appoints Platina Head of the Vatican Library*, 1480–81, fresco, 13'1" × 10'4" (3.99 × 3.15 m), Pinacoteca Vaticana, Rome. Platina kneels before Pope Sixtus IV while the Pope's nephews stand behind. In the middle is Cardinal Giuliano della Rovere, later Pope Julius II.

foot; *Hercules*, the life-size bronze discovered in the ruined temple of Hercules in the Forum Boarium; and two antique marble river gods that came from the ruins of the Constantinian baths.

The New Vatican. Executing Pope Nicholas's plans for a new Vatican palace, Sixtus IV commissioned the Sistine Chapel, which he named after himself, and inaugurated plans for its decoration. Perugino and Botticelli, among others, painted frescoes for the Chapel's walls, which were completed in 1482. But it was not until Sixtus's nephew, Pope Julius II (reigned 1503–13), took control of the Vatican that Pope Sixtus's plans would finally be realized. Classical sculpture was placed in the sloping gardens: the *Apollo Belvedere*, which had been discovered during excavations, and the *Laocoön* (see Chapter 4), discovered buried in the ruins of some Roman baths.

Famous composers were hired to write new hymns. Josquin des Près would serve in the small sixteen- to

Timeline 13.2 The New Rome: works commissioned by the Popes.

										X contro Florence 1516–2	e, –	Flo 15	ontrols orence, 523–27	1
7 Nichola	1455 s V Calixí	1458 tus III Pi	1464 us II Po	1471 aul II	Sixtus I\	1484 V Inno	1492 ocent VIII	1503 Alexander VI	Juliu		X (de' ledici)	21 Adria VI		1534 ent VII Aedici)
└ Lit	a for Vatica orary concei Nicholas V	ved	Sist	ine Chap 1475–				Michelange ceiling Sistine Chap 1508– Raphael, Scho Athens, 1510	of del, letter of del o	Brama commi remod Basilic	nte issioned t el St. Pet a, 1505; o vith work	co cer's dies commi		entian ary, –59 angelo paint _

twenty-four-member *Sistina Cappella*, or Sistine Choir, from 1476 to 1484. Soon the rough rhythms of medieval poetry were supplanted by the softer, finer meter of the Horatian odes. To add to the pomp of the liturgical processions, Julius established a large chorus to perform exclusively in St. Peter's, the *Cappella Giulia*, or Julian Choir, which remains active to this day. And, most important of all, Julius invited Raphael and Michelangelo to work in Rome.

PAINTING AND SCULPTURE

Raphael. When RAPHAEL [RAFF-ay-el], born Raffaello Santi of Urbino (1483–1520), was invited to Rome by Julius II in 1508, he was not yet twenty-five years old, but his renown as a painter was already well established. He had grown up surrounded by culture and beauty. He studied painting under his father, Giovanni Santi, a painter for the dukes of Urbino. In Perugia he studied with Perugino, who in 1482 had painted *Christ Delivering the Keys of the Kingdom to St. Peter* for Sixtus IV in the Sistine Chapel.

One of Raphael's first major works is directly indebted to Perugino's Christ Delivering the Keys. It is the Marriage of the Virgin (fig. 13.28), signed and dated in 1504, the year he came to Florence. As in Perugino's work, the composition is divided into a foreground with large figures, a middleground of open space with smaller figures, and a background with a temple and tiny figures. In the foreground, Mary and Joseph wed. The story says that Joseph, although older than the many other suitors, was selected because, among all the symbolic rods presented her, his alone flowered. Beside him a disgruntled suitor snaps his own rod in half over his knee. The absence of facial expression is a stylistic habit derived from Perugino, which Raphael would soon discard under the influence of Leonardo and Michelangelo. Everything in Raphael's painting is

Figure 13.28 Raphael, Marriage of the Virgin, 1504, oil on panel, $5'7'' \times 3'10^{1}_{2}'' (1.70 \times 1.18 \text{ m})$, Brera Gallery, Milan. Raphael's carefully composed scene includes figures in the foreground, middleground, and background. The lines of perspective lead to a central plan building (the type favored by Bramante), while the marriage is shown taking place in the foreground, dividing the composition.

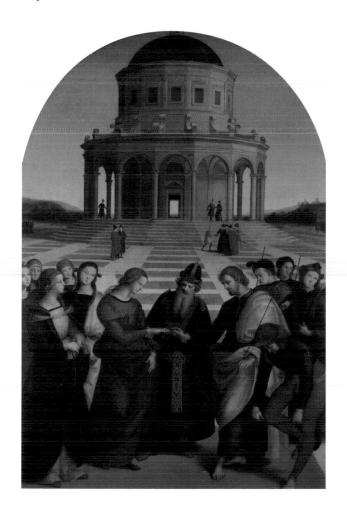

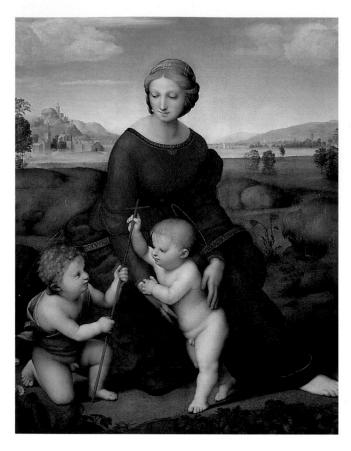

Figure 13.29 Raphael, Madonna of the Meadows, 1505, oil on panel, $44\frac{1}{2}'' \times 34\frac{1}{4}''$ (113 × 87 cm), Kunsthistorisches Museum, Vienna. Often considered the epitome of High Renaissance painters, Raphael was celebrated for his ability to arrange several figures into compact units. Mary, Jesus, and John the Baptist form a pyramid, a favorite Renaissance compositional device.

measured and rendered in careful perspective, as is emphasized in the pattern of rectangles that cross the square. In fact, so powerful is the perspective grid that the viewer's eyes are led away from the marriage in the foreground to the temple behind, and the viewer is left to wonder why, given the deliberateness of this grid.

Raphael became particularly famous for his many paintings of the Madonna and Child. His Madonna of the Meadows (Belevédere) (fig. 13.29), painted in 1505, displays the type of Madonna he repeated and perfected—pale, sweet, and serious. She is meditative, thinking ahead to Christ's passion, prefigured by the cross offered by the infant St. John, who in turn is identified by the camel-hair garment he would wear as an adult. Mary shows maternal tenderness in the gentle but firm hold she has taken of Jesus, as if to ward off what she knows will one day occur. In most Early Renaissance depictions of this subject, the Madonna is usually elevated on a throne. Raphael's Madonna has descended to our earthly level; she even sits upon the ground—in this pose she is referred to as the "Madonna of Humility." The differences between the

sacred and the secular are minimized—even the figures' halos have become thin gold bands.

A master of composition, Raphael contrasts the curved and rounded shapes of his figures with their triangular and pyramidal positions in space. The rounded lines create a sense of serenity, smoothness, and grace. The triangular format recalls that of Leonardo's *Madonna of the Rocks* (fig. 13.23), but the difference between the dark grotto setting of Leonardo's painting and Raphael's pastoral countryside is instructive. Raphael's composition is simpler, possessing far less contrast between light and dark. His figures are more tightly grouped: Jesus and John almost touch in Raphael's painting; in Leonardo's a great deal of space lies between them. Leonardo's children have serious facial expressions, lending them the emotional complexity of adults; Raphael's are far more playful.

Soon after Raphael arrived in Rome in 1508, Julius II commissioned him to paint several rooms in the Vatican Palace, including the Stanza della Segnatura, the room where papal documents were signed. The subjects, determined by Julius II, were to express Neoplatonic ideas in the four areas of learning:

Law and Justice: represented by the *Cardinal Virtues*The Arts: represented by *Mount Parnassus*Theology: represented by the *Dispute over the Sacrament*(which is the revelation of Divine Truth)
Philosophy: represented by the *School of Athens*

Each of these works is extremely complex. The *School of Athens* (fig. 13.30), in fact, could be said to embody, in its entirety, the Renaissance humanist's quest for classical learning and truth.

In the center of this bilaterally symmetrical composition are the ancient Greek philosophers, Plato and Aristotle. The figure of Plato, which might be a portrait of Leonardo da Vinci, holds Plato's Timaeus and points upward, indicating the realm of his ideal Forms. Aristotle holds his book Ethics and points toward earth, indicating his emphasis on material reality. The scene includes representations of Diogenes, sprawling on the steps in front of the philosophers; Pythagoras, calculating on a slate at the lower left; Ptolemy, holding a globe at the right; and Euclid in front of him, inscribing a slate with a compass. Raphael has painted his own portrait, the second figure from the right, looking at us. Pope Julius had made Raphael "prefect of antiquities," in charge of the papal excavation and preservation of antiques. Perhaps because of this, the setting is based on the ancient Roman baths and has the classical statues of Apollo (god of sunlight, rationality, and poetry) and Minerva (goddess of wisdom).

Michelangelo. In his Lives of the Most Eminent Painters, Sculptors, and Architects, Vasari describes how the architect Bramante let Raphael in to see Michelangelo's frescoes on the ceiling of the Sistine Chapel shortly after

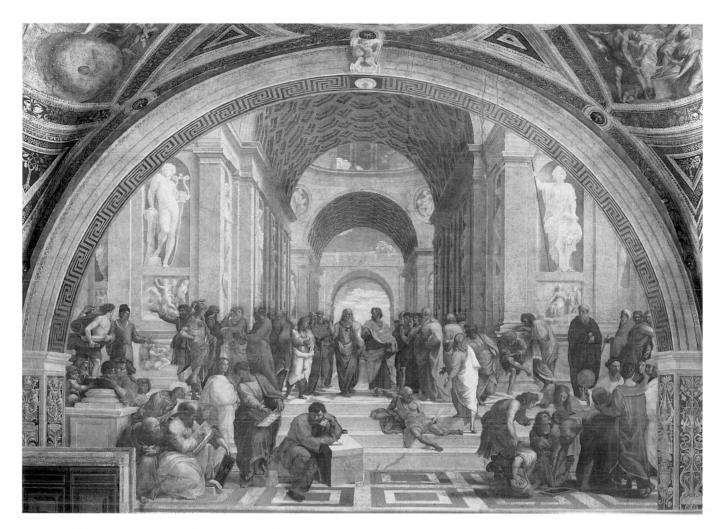

Figure 13.30 Raphael, *School of Athens*, 1510–11, fresco, $19 \times 27'$ (5.79 \times 8.24 m), Stanza della Segnatura, Vatican, Rome. Raphael painted several rooms in the Vatican for Pope Julius II, a great patron of the arts. Statues of Apollo and Minerva flank Plato and Aristotle, shown surrounded by scientists and philosophers of antiquity, some of whom have been given the facial features of Raphael's contemporaries.

Raphael's arrival in Rome, saying, "He profited so greatly by what he had seen in the work of Michelangelo that his manner was inexpressibly enlarged and received henceforth an obvious increase in majesty." In fact, Raphael gave Michelangelo a central place in the *School of Athens*: he is the solitary, brooding figure in the foreground leaning on a block of marble while sketching.

It was as a sculptor that MICHELANGELO BUONARROTI [my-kuhl-AN-gel-oh] (1475–1564) first achieved fame. When he signed the ceiling of the Sistine Chapel in 1511, he obstinately inscribed "Michelangelo, Sculptor." Born near Florence, he lived as a child in the Palazzo Medici, which served not only as Lorenzo the Magnificent's home but also as an art school, and there he studied sculpture under Giovanni Bertoldo, once a student of Donatello. In Lorenzo's palace, bursting with Neoplatonic and humanist ideas, Michelangelo was nurtured on the virtues of antique

classical sculpture. Nevertheless, his skill as a draftsman was notable from the first. According to Vasari, he "copied drawings of the old masters so perfectly that his copies could not be distinguished from the originals, since he smoked and tinted the paper to give it the appearance of age. He was often able to keep the originals and return his copies in their stead." His skill at painting was also not to be dismissed. As a boy, in Florence, he studied fresco painting under Domenico del Ghirlandaio and routinely copied the frescoes by Giotto in Santa Croce and those by Masaccio in Santa Maria del Carmine. He was, like so many Renaissance artists, skilled in many areas—painting, architecture, poetry—but always in his own mind he was a sculptor.

His approach to sculpture was based on the belief that the figure is imprisoned within the block in the same way that the soul is trapped within the body. In fact, to release the figure from the marble was a matter of subtraction, as the

sculptor chiseled away the shell of stone that hid the figure within. Michelangelo's approach to his craft was, in short, profoundly Neoplatonic; sculpture, from his point of view, both revealed and liberated the human ideal, as the first stanza of the following poem by him suggests:

Even the best of artists can conceive no idea That a single block of marble will not contain In its excess, and such a goal is achieved Only by the hand that obeys the intellect.

The evil which I flee and the good I promise myself
Hides in you, my fair, proud, and divine lady;
And working against my very life,
My skill is contrary to my purpose.

10

My ill cannot be blamed upon your beauty, Your harshness, bad fortune, or your disdain, Nor upon my destiny or my fate,

If in your heart you bear both death and mercy At the same time, and if my lowly talent Ardently burning, can draw forth only death.

Unlike Leonardo, who believed that beauty was found in nature, Michelangelo believed that beauty was found in the imagination, and it is the power of the

Figure 13.31 Michelangelo, *Pietà*, 1498/99–1500, marble, height $5'8\frac{1}{2}''$ (1.70 m), St. Peter's, Vatican, Rome. "Pietà" refers to the depiction of Mary mourning over Jesus lying across her lap. Although the subject was developed in Gothic Germany, the most famous *Pietà* is surely

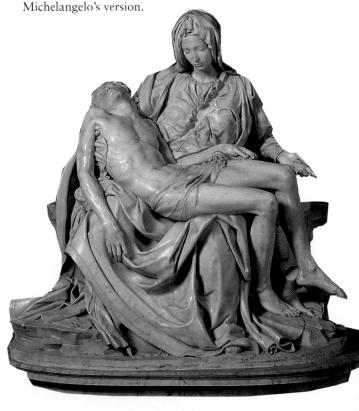

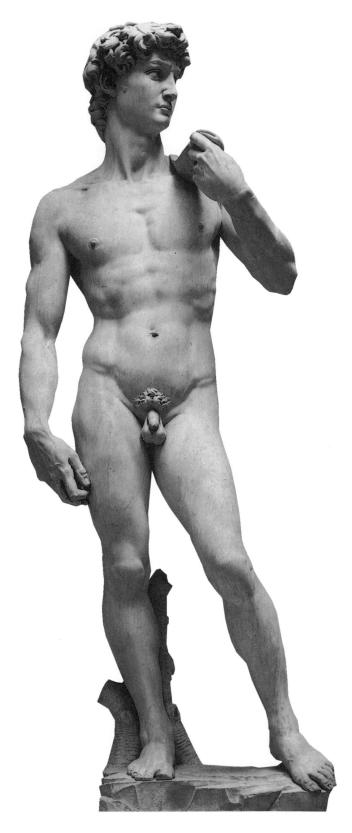

Figure 13.32 Michelangelo, *David*, 1501–04, marble, height 13′5″ (4.09 m), Galleria dell'Accademia, Florence. A magnificent marble man, akin to the heroic nudes of antiquity and undated by costume, David becomes a universal symbol of the individual facing unseen conflict.

human imagination that his sculptures constantly evoke. One of his earliest and most celebrated sculptures is a Pietà (fig. 13.31), which literally means "pity." The term refers to depictions of the Virgin Mary mourning over the dead Jesus in her lap. Commissioned by a French cardinal as a tomb monument in Old St. Peter's in the Vatican, his Pietà would be, Michelangelo bragged, "the most beautiful work in marble that exists today in Rome." In order to heighten the viewer's feelings of pity and sorrow, Michelangelo has made the figure of Jesus disproportionately small in comparison to the monumental figure of Mary. Mary is, furthermore, a young woman here, despite the fact that Jesus died as a grown man of thirty-three. The implication is that Mary thinks back to when Jesus was not dead in her lap but an infant cradled there, adding to the poignancy.

Just before being called to Rome by Pope Julius II, Michelangelo carved what is perhaps his most famous sculpture, the enormous *David* (fig. 13.32), made between 1501 and 1504. Intended as a decoration for Florence Cathedral, its huge scale—it is over 13 feet tall—comes from the fact that it was intended to stand 40 feet above the ground on a buttress. It was carved from a block of marble that had been quarried forty years earlier, a block so cracked that earlier sculptors, including Leonardo, when offered the opportunity to work on the stone, refused. Michelangelo saw in the

block a potential others had been blind to. Once it had been carved, the city fathers designated it a "masterpiece," too good to be placed on top of the cathedral; instead it was placed in front of the Palazzo Vecchio in the Piazza della Signoria. There, in the square where political meetings took place, it would symbolize not only freedom of speech, but the Republic of Florence itself, free from foreigners, papal domination, and Medici rule. (The Medici had been exiled in 1494.)

The *David*'s pose is taken from antiquity, with the weight on one leg in the *contrapposto*, or counterpoise, position. The sculptor's virtuosity is most evidenced in David's tightly muscled form, his tendons and veins recorded. A sense of enormous pent-up energy emerges, of latent power about to explode, and the question seems to be less *if* he will move than *when*. Above all, physical potentiality is mirrored in his confident, focused expression. The Greek respect for the athlete is rekindled in Renaissance terms—this is a mind in control of its body, a body poised to do precisely what it is told.

Michelangelo was called to Rome in 1505 to create the monumental tomb of Pope Julius II. The project was halted by Julius himself soon after Michelangelo's arrival when the Pope decided that finishing the painting of the Sistine Chapel, a project initiated by his predecessor Sixtus IV, should take priority. Michelangelo is reputed

Figure 13.33 Michelangelo, Creation of Adam, 1511–12, fresco, $9'2'' \times 18'8''$ (2.79 \times 5.69 m), detail of Sistine Chapel ceiling, Vatican, Rome. Adam's enormous latent power will be released in the next instant when swift-moving God, with Eve already under his arm, brings him to life.

to have said, "Painting is for women, sculpture for men." He apparently even tried to flee but was called back, and, reluctantly, began to paint.

Michelangelo had not worked with fresco since his youth. The ceiling, which covered more than 5800 square feet, was nearly seventy feet high. The curve and height of the vault posed complex perspective problems. He would have to work long hours on his back, paint dripping on him.

The center of the ceiling (fig. 13.34) shows the story of the Creation—nine scenes from Genesis. Four further scenes from the Old Testament appear in the corner triangles, called vele ("sails" in Italian). In addition, Old Testament prophets and ancient pagan sibyls (female prophets) inhabit the other triangular spandrels (spaces between the curved arches), along with Jesus's ancestors, and assorted medallions, putti (cherubs), and male nudes. There are over three hundred figures in all, many of which have no known meaning. Michelangelo claimed that Julius II let him paint what he pleased, but the complexity of the program suggests that he had advisers. Neoplatonist numerology, symbolism, and philosophy inform much of the composition, although scholars continue to argue over meanings. The notion of prefiguration appears—that is, stories in the Old Testament anticipate those in the New Testament. Pagan stories and motifs are also evident.

In the scene of the Creation of Adam (fig. 13.33), God, noble and powerful, flies in swiftly, bringing Eve with him under his arm. Compare this scene with Ghiberti's depiction in the Gates of Paradise (see fig. 13.5). Michelangelo's dynamic God contrasts with a listless Adam, whose figure Michelangelo derived from an ancient Roman coin. Momentarily, God will give Adam his soul and bring him fully to life, for their fingers are about to touch. Note how the shape of God's billowing drapery is very close to the shape of the human brain, as if all of creation is an idea in the mind of God. In the end, however, it is touch—the touch of the painter and sculptor as well as the touch of God—that brings the figure to life. Consider, too, the masculine musculature of the figures; even the female figures on the Sistine ceiling are based on male models. Michelangelo's figures are heroic and powerful, yet they have a grace and beauty worthy of Raphael.

While painting the ceiling, Michelangelo endured great physical hardship. Vasari claimed that the work impaired his vision so that, for several months afterward, he was unable to read unless he lay on his back and looked upward. When he finished work on the ceiling he

Figure 13.34 Michelangelo, Sistine Chapel, overview of ceiling, 1508-12, fresco, $44 \times 128'$ (13.4×39.0 m), Vatican, Rome. Although Michelangelo considered himself a sculptor, he was compelled to paint the Sistine ceiling by Pope Julius II.

was but thirty-seven years of age. With the death of Julius II in 1513, Michelangelo went to work once again for the Medicis, this time for Lorenzo the Magnificent's son, the new pope, Leo X.

THE NEW ST. PETER'S BASILICA

In 1506, Pope Julius II made the daring decision to tear down the old St. Peter's Basilica, which had stood at the Vatican since the time of Constantine in the early fourth century. He would replace it, he thought, with a new church more befitting the dignity and prestige of the papacy, and to this end he appointed as architect a man dedicated to the revival of Greek and Roman architectural ideals.

Donato Bramante. DONATO BRAMANTE [bra-MAHN-tay] (1444–1514) had a reputation based largely on a building called the Tempietto, or "little temple" (fig. 13.35) constructed from 1502, on the site where St. Peter was believed to have been crucified. Commissioned by Ferdinand and Isabella of Spain (patrons of the explorer Christopher Columbus), the Tempietto is an adaptation

Figure 13.35 Donato Bramante, Tempietto, San Pietro in Montorio, Rome, 1502–after 1511. Small in size but of great importance, the Tempietto demonstrates the reuse of ancient pagan architecture for Renaissance Christian purposes.

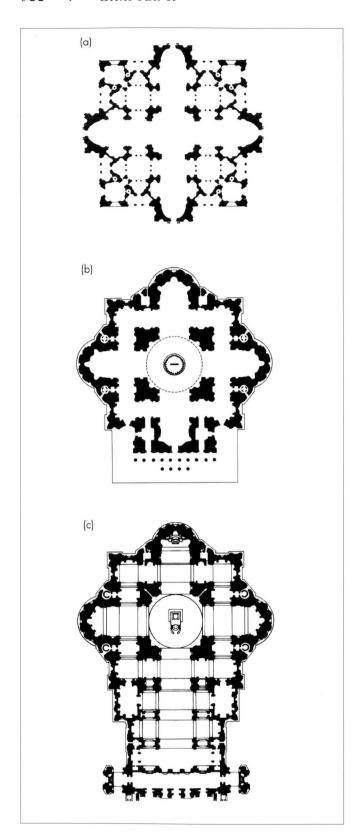

Figure 13.36 Floor plans for St. Peter's, Rome, by a) Bramante, b) Michelangelo, and c) Carlo Maderno. Although Bramante and Michelangelo intended Greek-cross plans, the long nave of the Latin-cross plan was added by Maderno to accommodate the crowds of people.

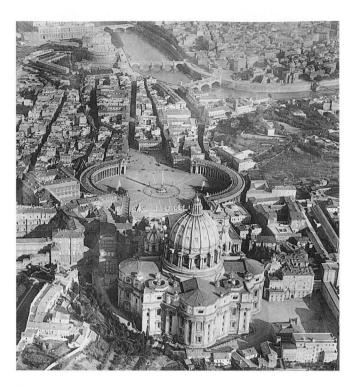

Figure 13.37 View of St. Peter's, Rome. St. Peter's underwent so many changes that only a hint of the simplicity and beauty of Bramante and Michelangelo's original Greekcross plan remains.

of a classical temple of the Doric order (see Chapter 3), including a complete entablature.

The building itself is set on a stepped base and surrounded by a **peristyle**, or continuous row of columns. The first story is topped by a **balustrade**, or carved railing, inside which is a **drum**, or circular wall, upon which Bramante set a hemispheric dome. The plan, with its deeply recessed spaces, creates a dramatic play of light and dark despite the relatively small scale of the building itself.

Bramante's plan for St. Peter's Basilica (fig. 13.36) is, essentially, a grander version of the Tempietto, over 450 feet in diameter instead of fifteen. Instead of basing his plan on the traditional Latin cross (three short arms and one long one), Bramante chose to utilize a Greek cross (four arms of equal length). The result is symmetrical and harmonious, symbolizing the perfection of God, topped by an enormous dome modeled after the Pantheon's.

Michelangelo's St. Peter's. With the death of Julius II in 1513 and Bramante's own death in 1514, the entire project was put on hold, and several other architects, including Raphael, attempted to revise Bramante's plan. Finally, in 1546, Michelangelo was appointed architect. He described Bramante's original design, saying it was "clear and straightforward ... Indeed," he wrote, "every architect who has departed from Bramante's plan ...

Figure 13.38 Vittore Carpaccio, *Lion of St. Mark*, 1516, oil on canvas, $4'6\frac{3}{4}'' \times 12'1''$ (1.40 × 3.70 m), Ducal Palace, Venice. The winged lion was a symbol of the Evangelist Mark and of Venice. This painting documents the early sixteenth-century appearance of the city, with its campanile, Ducal palace, and the domes of St. Mark's Cathedral.

has departed from the right way." Nevertheless, Michelangelo modified the original (fig. 13.36). Instead of an interior of interlocking Greek crosses, which gave the effect of a giant snowflake, Michelangelo simplified the scheme. It was, in part, a matter of engineering. Available masonry was not strong enough to carry the weight of so great a dome. Thus the four main piers supporting the dome in the center of the church had to be massively enlarged, in turn causing him to simplify the remaining interior space. Moreover, he intended a double-columned portico across the front.

Michclangelo did not live to see the completion of his plan. The dome was finished in 1590 (fig. 13.37), with a somewhat higher and slimmer profile than Michelangelo had intended, in part because of engineering requirements. And then, in 1606, Pope Paul V appointed the architect Carlo Maderno to restore the church to a Latin-cross plan (fig. 13.36).

VENICE

Throughout the fifteenth century and into the sixteenth, Venice was one of the most powerful city-states in all of Europe, exercising control over the entire Adriatic and much of the Eastern Mediterranean. Petrarch described the city in glowing terms: "Most august city of Venice, today the only abode of liberty, peace, and justice, the one refuge of the good and haven for those who, battered on all sides by the storms of tyranny and war, seek to live in tranquillity: city rich in gold but richer in fame, mighty in resources but mightier in virtue, built on solid marble but based on the more solid foundations of civic concord, surrounded by salty waters but more secure through her saltier councils." This is the city celebrated

in Vittore Carpaccio's famous Lion of St. Mark (fig. 13.38), painted in 1516 for a government office in the city's Ducal Palace. The lion is the symbol of the city's patron saint, Mark the Evangelist, whom God was said to have visited on the Evangelist's arrival at the Venice lagoon, thereby designating Venice as the saint's final resting-place. Greeting St. Mark, God's angel is said to have announced, "Peace Unto You, Mark, My Evangelist," the Latin words inscribed on the tablet held in the lion's paws. The lion stands with its front paws on land and its hind paws in the water, signifying Venice's dominion over land and sea. Behind the lion, to the left, is the Ducal Palace itself, the seat of government and law and the source of the city's order and harmony. The Byzantine domes of St. Mark's Cathedral rise behind it, the basis of the city's moral fabric, and the giant campanile (bell tower) that dominates St. Mark's Square stands on the far left housing the five bells of St. Mark's, one of which chimed to announce the beginning and end of each working day. Behind the lion to the right is a fleet of Venetian merchant ships, the source of the city's wealth and prosperity.

Venetian Oil Painting. Venice was unique not only because of its enduring peace and prosperity. Surrounded by water and built over a lagoon, its humidity made fresco painting, so popular elsewhere in Furope, a virtual impossibility. From 1475 on, after the introduction of oil painting, a technique first developed in the Netherlands, attempts at fresco painting in the city's public buildings gradually ceased. The use of oil on canvas led, in fact, to a new kind of painting as well. Applying colors in glazes—that is, layers of transparent color—created by mixing a little pigment with

a lot of linseed oil—painters were able to create a light in painting that seemed to emanate from the depths of the painting itself. Often, a small amount of yellow pigment would be added to the final protective layer of glaze, creating what has been called the "golden glow" of Venetian painting. Furthermore, the texture of the canvas itself was exploited. Stroked over a woven surface, the brush deposits more paint on the top of the weave and less in the crevices. This textured surface in turn "catches" actual light, lending, especially to a glazed surface, an almost shimmering vibrancy.

Giorgione and Titian. The two most celebrated Venetian painters of the early sixteenth century were GIORGIONE [GEORGE-jee-oh-nay] (ca. 1477–1510) and Tiziano Vecelli, known as TITIAN [TISH-un] (ca. 1488–1576). When Giorgione died of the plague in 1510, he had completed only a handful of canvases, but he had been working side by side with Titian, whom he had hired as an assistant in 1507. Scholars have long debated just who is responsible for painting the Fête champêtre (fig. 13.39), or Country Festival, completed the year of Giorgione's death: Some say it was Giorgione, others argue for Titian. The confusion simply underscores how completely each of these two artists defined the new Venetian style of painting.

The content of the *Fête champêtre* is ambiguous. Why does the woman to the left pour water into the well? Why does one man appear to be a refined gentleman, the other a rustic peasant? The lute was an instrument played at court, the flute by shepherds—why are they seen together? Perhaps it is an allegory of sacred and profane love, an allegory of poetry, or a treatise on the secularization of contemporary culture.

However, the painting is clearly a play of opposites, as in the play of light and dark across its surface. The

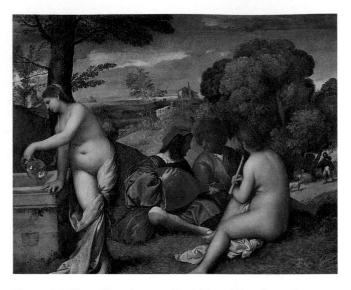

Figure 13.39 Giorgione and/or Titian, Fête champêtre, ca. 1510–11, oil on canvas, $3'1\frac{1}{4''} \times 4'6\frac{8}{8}''$ (1.10 × 1.38 m), Musée du Louvre, Paris. Botticelli's slender Early Renaissance figure type "matured" in the work of later, High Renaissance painters to a full-bodied ideal of feminine beauty, as exemplified in this painting.

effects of light achieved here are quite the opposite of those of the other Renaissance master of light, Leonardo, whom Giorgione met in late 1499. Leonardo tended to emphasize darkness, as a function of both perspectival and emotional depth; Giorgione and Titian emphasized light. In fact, such Venetian paintings are literally built up from light to dark. The effect here is of a palpable sense of sunlight striking the landscape through a series of dark broken clouds with the intensity of a spotlight. Such atmospheric pyrotechnics would have a profound impact on Baroque painters such as Peter Paul

Timeline 13.3 The Renaissance and Mannerism in Italy.

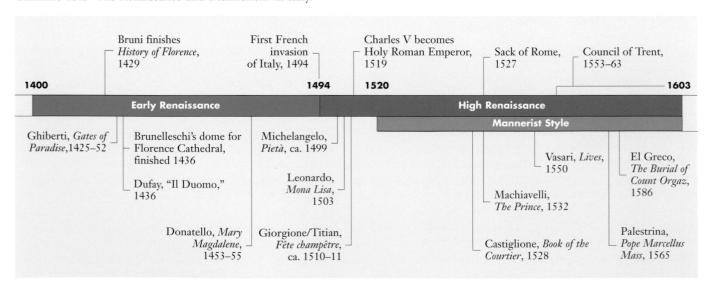

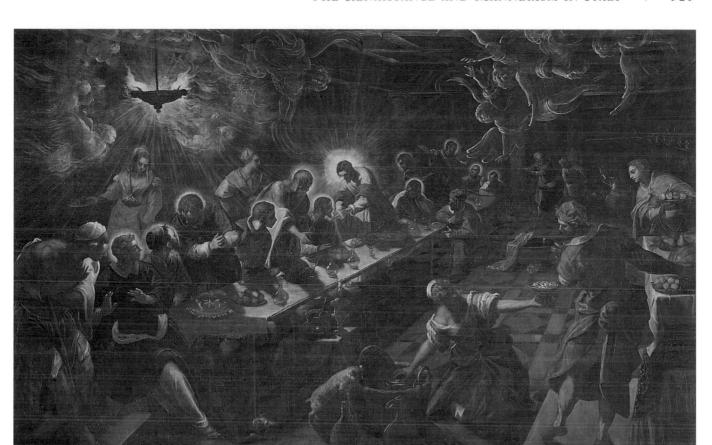

Figure 13.40 Tintoretto, *The Last Supper*, 1592–94, oil on canvas, 12′ × 18′8″ (3.66 × 5.69 m), San Giorgio Maggiore, Venice. In striking contrast to the compositional clarity of Leonardo da Vinci's High Renaissance depiction (see fig. 13.24), the viewer may have some difficulty in locating Jesus in Tintoretto's Mannerist version of this subject, for the perspective leads away from, rather than toward, Jesus.

Rubens (see Chapter 15) and on nineteenth-century painters such as J.M.W. Turner (see Chapter 17), who actually came to Venice to paint.

TINTORETTO [tin-toe-RET-toe] (1518–1594), named "little dyer" after his father's trade, took the techniques of Giorgione and Titian, whom he had served as an apprentice, and heightened and exaggerated them. Tintoretto posted a sign in his studio declaring his intent to combine Titian's color with Michelangelo's drawing ability. His version of The Last Supper (fig. 13.40) can be usefully compared to Leonardo's (see fig. 13.24). Gone is the sense of balance achieved in the earlier work by virtue of its central perspective, with its vanishing point directly behind Jesus in the center. By comparison, Tintoretto's painting seems to be tilted askew. Its perspective is still accurate, but the vanishing point has been moved off-center, toward the upper right. Jesus remains at the center of the painting, but it is light, not geometry, that draws our attention to him. In fact, he competes with the serving woman in the foreground for our attention, and with the cat who seems intent on getting at the fish she is serving. As in the $F\hat{e}te$ champêtre, the painting seems to collapse the distinction between religious and secular imagery. Here, the Last Supper is part and parcel of real life.

MUSIC

The reinvention of Rome would require the reinvention of music—a new St. Peter's needed a new Mass to fill its vast space with sound.

Josquin des Près. The most important composer of the new Rome naturally took on the job: JOSQUIN DES PRÈS [JOZ-skanh de-PRAY] (1440–1521), from Flanders. Josquin is the composer we most closely associate with the High Renaissance. It was he who led the Sistine Choir as Michelangelo painted the ceiling and Raphael worked in the papal suites. Like Dufay, Josquin spent many years in Italy, serving the Sforza family in Milan, the Estes at their court in Ferrara, and finally several Roman popes, including Sixtus IV (for whom he directed the Sistine Choir), Julius II, and Leo X. So

highly regarded was Josquin in his own time that the French King Louis XII and the Austrian Queen Margaret made bids for his services. His contemporaries extolled him as "the Father of Musicians" and "the best of composers." An enchanted Martin Luther remarked that Josquin was "the master of the notes; they must do as he wills."

Josquin composed approximately two hundred works—motets, Masses, and *chansons* (songs). His many motets and *chansons* attest to his interest in exploring new trends in setting words to music. His motet "Ave Maria ... virgo serena" ("Hail, Mary ... Serene Virgin") (1502) exemplifies his style. The opening employs imitative counterpoint with the melody for the words "Ave Maria" first heard in the soprano, then repeated in succession by the alto, the tenor, and the bass, while the original parts continue, as in a round.

On the words "gratia plena" ("full of grace") Josquin introduces a new, second melody, again in the soprano, and which is again passed from one voice to the next. Josquin overlaps the voices in both melodies, allowing the altos to enter, for example, before the sopranos have sung the complete melody. This overlapping of voices enriches the music's texture, giving it body and providing it with a continuous and fluid motion. Josquin also allows two voices, and sometimes three or four, to sing the same melody simultaneously—a duet between the two lower voice parts (tenor and bass), for instance, will imitate a duet between alto and soprano. The motet concludes serenely with emphatic slow chords on the words "O

mater Dei, memento mei" ("O mother of God, remember me"). Just before this ending, Josquin introduces a significant silence that sounds at first like an ending. He uses this silence to focus the listener's attention on the true ending, which comes immediately after. The dignified serenity and graceful restraint of Josquin's "Ave Maria ... virgo serena" can be compared with the quiet beauty and restrained elegance of Raphael's madonnas.

Palestrina. The music of the Italian GIOVANNI PIERLUIGI DA PALESTRINA [pal-uh-STREE-nah] (1525–1594) came to dominate the Church throughout most of the sixteenth century. As the Church came under attack from the north for its excessive spending and ornate lavishness, it responded by simplifying the Mass and the music designed to accompany it. Although it considered banning polyphony altogether, thinking it too elaborate to be easily understood by lay people, in the end the Church endorsed the controlled and precise style of Palestrina.

Palestrina held a number of important Church positions. He was organist and choirmaster of the large chorus that performed exclusively in St. Peter's, the Cappella Giulia (Julian Choir), and he was music director for the Vatican. His music evokes the Gregorian roots of traditional Church music and relies directly upon the emotional appeal of the listener's potential union with God. He wrote nearly a thousand compositions, including over a hundred Masses. Among the most beautiful of all Palestrina's works is his *Pope Marcellus Mass*, written in honor of the pope and set for an a cappella—or unaccompanied—choir in six voice parts: soprano, alto, two tenors, and two basses. It contains music for the Kyrie, Gloria, Credo, Sanctus, Benedictus, and Agnus Dei, as did the Gregorian Mass before it, and Palestrina utilizes the traditional Gregorian melodies connected with each of these parts of the Mass. Still, it is clearly Renaissance in its style, utilizing an orderly and clear imitative polyphony that allows the listener to follow each of the voices in the Mass as they weave in and out of one another with precision. The words that Michelangelo used to praise Bramante's architectural plan for St. Peter's might be used to define Palestrina's music as well—they are both equally "clear and straightforward."

LITERATURE

Baldassare Castiglione. BALDASSARE CASTIG-LIONE [KAS-till-YOH-nay] (1478–1529) spent his life serving as an important and influential courtier and diplomat. He grew up in the company of nobility, counted the princes of Mantua among his friends, and studied at the university in Milan. He served as a courtier to the Italian ducal courts, first at the court of Francesco Gonzaga, the ruler of Mantua in the early sixteenth century, and then at the court of Urbino, established by

Federico da Montefeltro (fig. 13.18), the father of Guidobaldo da Montefeltro, in whose service Castiglione prospered. Later unrest caused him to return to service in Duke Francesco's court. After then serving as ambassador to Rome for a number of years, Castiglione was appointed by Pope Clement VII as papal ambassador to Spain, where he lived out the remaining years of his life.

While at Urbino, Castiglione wrote the Book of the Courtier, which memorializes, celebrates, and idealizes life at court, especially Urbino, where Castiglione was impressed not only with the nobility of the Montefeltro dukes but also with the Duchess of Montefeltro, Elisabetta, who often appears in the book. It is cast in the form of a series of four dialogues spread out over four evenings at the court of Urbino. The central topic is the manners, education, and behavior of the ideal courtier, whose virtues Castiglione extols throughout the book. Most important for the courtier is the range and substance of his accomplishment. He must be a man of courage who has experience in war; he must be learned in the classics and in classical languages; he must be able to serve his prince with generosity. Castiglione's ideal courtier had to be physically and emotionally strong, able to perform feats requiring agility, skill, courage, and daring. His physical prowess was measured by his grace as a dancer and elegance as a singer and musician. He was also expected to be an engaging and witty conversationalist, a good companion, an elegant writer, even a bit of a poet. In short, Castiglione's courtier was the ideal Renaissance gentleman—of sound mind, body, and character, and learned in the ideas of Renaissance humanism. Leonardo da Vinci exemplified this ideal during the Renaissance; people such as Thomas Jefferson have been cited as "Renaissance men" since. In addition to the ideal courtier's range of accomplishments, Castiglione applauds sprezzatura, the ability to make difficult tasks look easy, in the manner of a great athlete or musician.

Castiglione's blending of the soldier and the scholar, his merging of the ideals of medieval chivalry with those of Renaissance humanism, made his Book of the Courtier popular both in its own time and afterward. Its emphasis on good breeding and elegant manners suggests that, as in the codes of chivalry, polish was as important as prowess. Elegant speech, graceful demeanor, and consummate skill were all expected of the courtier. Castiglione himself was no exception and embodied the ideals his book celebrated. Raphael's portrait of him (fig. 13.41) displays many of the qualities Castiglione extols, from the nobility of the graceful head to the intelligence of the shining eyes, complemented by the elegant refinement of the attire.

Niccolò Machiavelli. A contemporary of Castiglione, NICCOLÒ MACHIAVELLI [mak-ee-ah-VEL-ee] (1469–1527) is often paired with him since he also wrote a guidebook on behavior-The Prince, a manual for princes and rulers.

Like Castiglione, Machiavelli was well educated in the Renaissance humanist tradition. Like Castiglione's courtier, Machiavelli's prince is a type or model of an ideal. The difference between the two writers' "ideals," however, is dramatic: Castiglione supported the tenets of Renaissance humanism, but Machiavelli challenged them by introducing a radically different set of standards, standards that inform, among other things, Mannerist art.

Young Machiavelli was employed as a clerk and secretary to the Florentine magistrates responsible for war and internal affairs. From 1498 to 1512, he also served as an ambassador to, among others, the Holy Roman Emperor Maximilian, the King of France, and Pope Julius II. During his lifetime, the Italian city-states were almost continually at war either with one another or with outside countries such as France and Spain. Machiavelli himself suffered from the changing fortunes of various ruling families. Notably, when the Medici

Raphael, Baldassare Castiglione, ca. 1515, Figure 13.41 oil on panel, transferred to canvas, $32\frac{1}{4} \times 26\frac{1}{2}$ " (81.9 × 67.3 cm), Musée du Louvre, Paris. Castiglione wrote about the qualities of the ideal courtier; it is not surprising that Raphael, a refined gentleman, was a personal friend of his. Perhaps some of the calm restraint recommended by Castiglione is seen in Raphael's portrait with its restricted range of color.

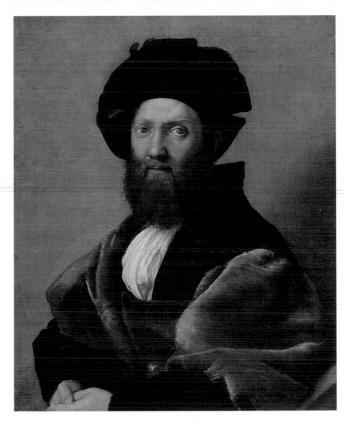

came to power in Florence, he was accused of conspiracy, tortured, then imprisoned. Later, when the Medici government collapsed, he was accused of being a Medici sympathizer. At the time some claimed that he wrote *The Prince* for the Medici as a guide to tyrannical rule.

The Prince was written in 1513 and published in 1532 after Machiavelli's death. It quickly acquired fame or, as some would have it, notoriety. Based on a series of premises about human nature—none favorable—The Prince asserts that people are basically selfish, deceitful, greedy, and gullible. Accordingly, Machiavelli advises princes to rule in ways that play upon these fundamental human characteristics. A prince, therefore, can be, indeed should be, hypocritical, cruel, and deceitful when necessary. He should keep faith with no one but himself, and employ ruthlessness and cunning to maintain his power over the people. For, as Machiavelli writes, "it is far better to be feared than loved," though as he also notes, "the prince must nonetheless make himself feared in such a way that, if he is not loved, he will at least avoid being hated."

The view of human beings that forms the foundation of Machiavelli's arguments in *The Prince* reflects political expediency, based upon Machiavelli's observation of Florentine politics and the politics of other city-states and countries he visited as a Florentine ambassador. Having witnessed the instability of power in Italy, particularly the surrender of parts of Italy to France and Spain, Machiavelli wrote that a ruler must be strong enough to keep himself in power, for only with the strength of absolute power could he rule effectively.

After the Bible, Machiavelli's *The Prince* was the most widely read book of its time. The questions it raises about the relationship between politics and morality, the starkly realistic depiction of power it presents, and the authority, immediacy, and directness with which it is written, ensured its success. Whatever one may think of its vision of human nature or of the advice it offers rulers, it is hard to deny the force of its arguments, the power of its language, and the strength of its convictions. In addition, *The Prince* influenced the creation of a stable state in the section of Italy known as the Romagna, where Cesare Borgia, the illegitimate son of Pope Alexander VI (Rodrigo Borgia), put its ideas into practice.

MANNERISM

>

A stylistic trend began to develop in Italian art as early as 1520 that we have come to call **Mannerism**. The rise of Mannerism coincides with a period of political and religious unrest. Florence had endured a return to Medici rule that, in the eyes of many Florentines, made a mockery of the family name, and certainly of the

republic. First the vicious Giuliano de' Medici ruled the city, and then the syphilitic Lorenzo, Duke of Urbino and a grandson of Lorenzo the Magnificent, who was hardly a Florentine at all. France invaded Italy, and the sack of Rome in 1527 by the troops of the Holy Roman Emperor Charles V, together with the six months of murder and destruction that followed it, undermined the confidence of Renaissance humanists. The Protestant Reformation divided Christendom as a whole, and a century of religious wars was under way.

If Mannerism reflects an age of anxiety and crisis, it is nevertheless a result of the High Renaissance's cult of the individual genius. All of its chief practitioners—Rosso Fiorentino, Pontormo, Parmigianino, Bronzino, and Giulio Romano—were inspired by Leonardo, Raphael, and Michelangelo, the great masters of the generation before them. What they admired most in the great masters' work was its technical virtuosity, a virtuosity synonymous in their minds with genius itself.

PAINTING

Each Mannerist artist cultivated a distinct personal maniera (or "in the manner of"). Although there is no definitive Mannerist style, Mannerism is marked by its rejection of many of the principles of the High Renaissance. While High Renaissance painting is characterized by clear presentations of subject matter, balanced compositions, normal or "natural" body proportions, scientific spatial constructions, and a preference for primary colors, Mannerist painting is notable for its intentional obscurity of subject matter, unbalanced compositions, bodies with distorted proportions and contorted poses, strained, inappropriate, or even monstrous facial expressions, confusing spatial constructions, and a preference for secondary and acidic colors.

Michelangelo. In both the bleakness of its mood and its freewheeling play with human anatomy, Michelangelo's The Last Judgment reflects the Mannerist style. Although his plan for St. Peter's, done in 1546, embodies the ideals of the High Renaissance, much of his other late work leaves those ideals far behind. A new spirit entered his art in The Last Judgment (fig. 13.42), commissioned for the altar wall of the Sistine Chapel in 1534 by a dying Pope Clement VII (a bastard grandson of Lorenzo the Magnificent). Painted between 1536 and 1541, it lacks the optimism and sense of beauty that define Michelangelo's work on the ceiling. His figures, no longer beautifully proportioned, now look twisted

Figure 13.42 Michelangelo, *The Last Judgment*, 1536–41, fresco, 48' × 44' (14.63 × 13.41 m), Sistine Chapel, Vatican, Rome. Michelangelo's optimism and the idealized beauty of the ceiling of this chapel are now replaced with a pessimistic view and anatomical anomalies.

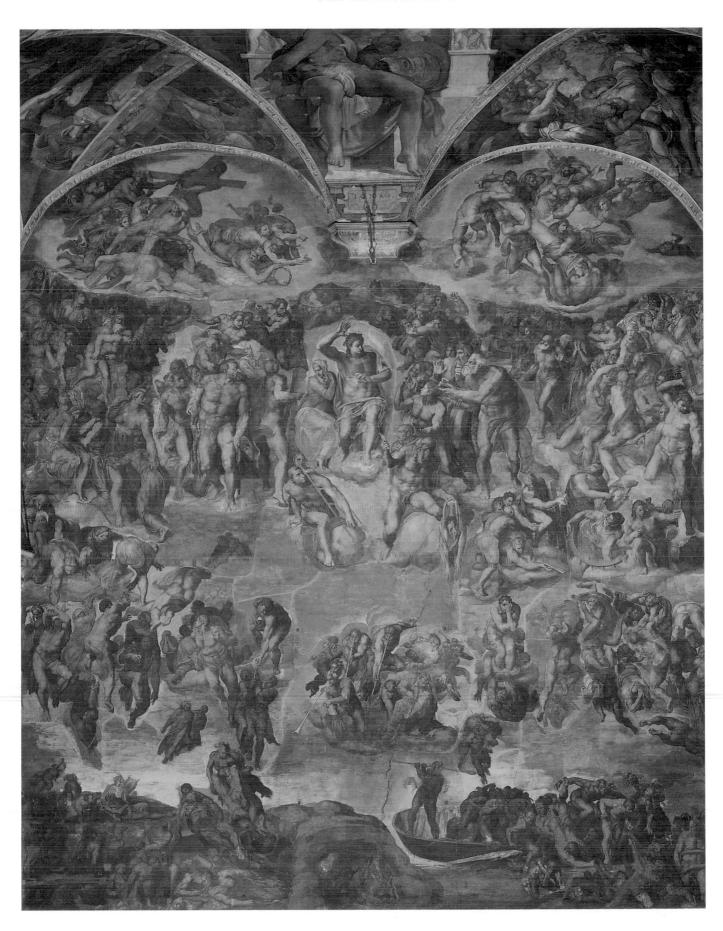

Figure 13.43 Parmigianino, Madonna with the Long Neck, 1534–40, oil on panel, 7'1" × 4'4" (2.16 × 1.32 m), Galleria degli Uffizi, Florence. Comparison with Raphael's High Renaissance Madonna of the Meadows (see fig. 13.29) makes obvious the Mannerist preference for distorted figures and spatial ambiguity.

and grotesque, with heads too small for their giant, lumbering bodies. The figures from Genesis that inhabit his ceiling have now aged, their flesh corrupted and their souls lost.

However, this style befits Michelangelo's subject. The dead are dragged from their graves and pulled upward to be judged by Jesus. Mary, at his side, cringes at the vision. At his feet, to his right, is St. Bartholomew. Legend states that Bartholomew was martyred by being skinned alive, and he holds his grotesquely distorted skin in his hand. But the face is a grim self-portrait of Michelangelo, and such grimness extends to the whole painting. The hands of Bartholomew's flayed skin seem to reach downward, to

the chasm of hell that opens at the bottom of the painting, where a monstrous Charon (the ferryman of the dead) guides his boat across the River Styx, driving the damned before him into perpetual torment. The graves on the left and hell on the right are the bases of the painting's pyramidal structure. Not coincidentally, these are at eye-level.

Parmigianino. Among the most characteristic painters of the Mannerist style is PARMIGIANINO [par-mee-jah-NEE-noh] (1503–1540) of Parma. His Madonna with the Long Neck (fig. 13.43), painted in 1534–40 shows figures that, by contrast with the classical proportions admired in the Renaissance, have unreal features: they are elongated and affected, yet graceful and refined, beyond both the rules of realism and nature's capabilities. Mary is very large, with an almost balloon-like inflation through the hips and thighs. The curving contours of her right hand emphasize her gesture and not the physical structure of her hand.

The composition is unbalanced; the figures crowd the left side. The column in the background is a symbol of the torture of Jesus (he was bound to a column and flagellated), but it is proportionally too large. The whole space is odd and unclear, and the viewer looks up to the main figures but down on the prophet in the bottom right.

Bronzino. Another representative of the Mannerist style is BRONZINO [bron-ZEE-noh] (1503–1572), court painter to Cosimo de' Medici, or Cosimo I, ruler of Florence from 1537 to 1574 (not the original Cosimo but a related descendant). Bronzino's painting of the Allegory with Venus and Cupid (fig. 13.44), ca. 1546, demonstrates the intentional ambiguity of Mannerist iconography. The two main figures, Venus and Cupid, are unquestionably erotic. On the right, Folly throws roses. In the upper right, Father Time uncovers the follies of love—or perhaps he tries to hide them. In the background on the right, Deceit coils with the body of a snake with the left and right hands reversed, while the masks suggest falseness. Figures in the left background could be Hatred and Inconstancy. Typical of Mannerist art are the complexity and obscurity of the allegory, which has been interpreted in various ways by historians.

The absence of a single center of focus is also characteristic of Mannerism—the figures seem to compete with each other for the viewer's attention. Spatial contradictions abound—a floor plan of this space and its inhabitants cannot be drawn, for neither linear nor aerial perspective is used. The figures choke the space. Relative scale is inconsistent. In colors that are acidic and metallic, they assume tense poses, elegant but affected, agitated, and exaggerated—certainly difficult for anyone to actually mimic—and their uneasy expressions cause them to appear psychologically as well as physically distorted.

El Greco. One of the most interesting practitioners of the Mannerist style was not Italian. Known as EL GRECO [el GRECK-oh] (1541–1614), or "the Greek," Domenikos Theotokopoulos was born on the island of Crete. He studied in Venice from about 1566, where he was deeply influenced by Titian, and then for seven years in Rome. In 1577, he emigrated to Spain, first to Madrid and then to Toledo.

The most important of his major commissions is the masterpiece, *The Burial of Count Orgaz* (fig. 13.45) of 1586. Legend held that at the Count's burial in 1323, Saints Augustine and Stephen appeared and lowered him into his grave even as his soul was seen ascending to heaven. In the painting, the burial and the ascension occur in two separate realms, neither of which fits spatially with the other, and both of which are packed with figures. Below, El Greco has painted the local, contemporary aristocracy he knew in attendance at the funeral, not the aristocracy of the Count's day. In fact, El Greco's eight-year-old son stands at the lower left next to St. Stephen, and above him, looking out at the viewer from the back row, is quite possibly El Greco himself.

Figure 13.44 Agnolo Bronzino, *Allegory with Venus and Cupid*, ca. 1546, oil on panel, $4'9\frac{1}{2}''\times3'9\frac{1}{4}''$ (1.46 \times 1.16 m), National Gallery, London. Typically Mannerist are the intentionally complex iconography (including an oddly erotic encounter between Venus and Cupid) and the pictorial space choked with figures.

Figure 13.45 El Greco, *The Burial of Count Orgaz*, 1586, oil on canvas, $16' \times 11'10''$ (4.88 \times 3.61 m), Church of San Tomé, Toledo, Spain. Although El Greco's distorted figures were once attributed to astigmatism, they are now recognized as part of the Mannerist preference for elongated bodily proportions.

The top half of the scene is as spatially ambiguous as any example of Mannerist painting. A crowd of saints enters from a deep space at the top right. A chorus of angels playing instruments occupies a sort of middle space on the left. In the foreground, St. John and the Virgin Mary greet the angel who arrives with the soul of the Count. The soul is shown about the size of a baby, as if to emphasize its innocence. They plead the Count's case with Jesus, who is peculiarly small and seated far enough in the distance almost to occupy the vanishing point to the heavens. The most notable aspect of El Greco's style is exemplified by Jesus's right arm, which stretches far forward into the space above Mary's head. The elongated hands and arms are the most "mannered" feature of El Greco's art, and yet it is difficult to label his work "Mannerist." His aim is to move his audience by conveying a sense of the spiritual, almost mystical power of deeply religious faith and conviction. In this, his painting anticipates that of the Baroque age, and captures something of the power of the great Spanish mystics of his own day, Teresa of Avila and Ignatius Loyola, both of whom would be made saints in Rome in 1622.

SCULPTURE

The Mannerist style spread outside Italy and by the midsixteenth century, Mannerism was the dominant style in France, largely as a result of the influence of Italian artists working there, the result of the sack of Rome in 1527 and the consequent dispersal of artists.

Benvenuto Cellini. BENVENUTO CELLINI [che-LEE-nee] (1500-1571) was a Florentine who worked in France for the King, Francis I (reigned 1515-47). For him, Cellini made an extraordinary gold and enamel Saltcellar (fig. 13.46), between 1539 and 1543. It was functional, yet wonderfully elegant and thoroughly fantastic. Salt is represented by the male figure Neptune, because salt comes from the sea (the salt is actually in a little boat), and pepper is represented by the female figure Earth, because pepper comes from the earth (the pepper is actually in a little triumphal arch). On the base are complex allegorical figures of the four seasons and four parts of the day, meant to evoke both festive seasonal celebrations and the daily meal schedule. The figures are typically elongated, with small heads and boneless limbs. Their postures are a virtual impossibility to maintain—either they are both about to fall backward or they have been captured midway through the process of sitting up.

The Autobiography of Benvenuto Cellini. Among the most widely read of Renaissance works, Cellini's Autobiography is notable for the way it portrays the Mannerist sculptor and goldsmith. Like Montaigne's Essays, published a generation later, Cellini's Autobiography records far more than external facts about his life.

An example of Cellini's Mannerist extravagance can be discerned in his response to his later patron, the Duke

Figure 13.46 Benvenuto Cellini, *Saltcellar of Francis I*, 1539–43, gold with enamel, $10\frac{1}{4} \times 13\frac{1}{8}$ " (26 × 33.3 cm), Kunsthistorisches Museum, Vienna. An example of extreme elegance and opulence, this table ornament contained salt and pepper.

Figure 13.47 Benvenuto Cellini, *Perseus*, 1545–54, bronze, height 18′ (5.4 m), Loggia dei Lanzi, Florence. Even the depiction of the decapitation of the ancient mythological gorgan Medusa, blood gushing, attains elegance in the Mannerist style.

of Florence, Cosimo de' Medici, who had just commissioned a new sculpture, *Perseus* (fig. 13.47). When he questioned Cellini's ability to complete the sculpture in bronze, the artist responded vigorously, exhibiting supreme confidence. He emphasizes his strength of character, portraying himself as heroic, brave, violent, passionate, promiscuous, and entirely committed to his art.

Cellini's *Autobiography* can be considered a work in the Mannerist mode because of its extravagance and its exaggeration. Like the elongated figures in Parmigianino's paintings, Cellini's exaggerated portrayal of himself and others typifies the Mannerist tendency. Unlike Parmigianino's delicacy and grace, however, Cellini is all drama and vigor. Cellini's *Autobiography*, in the end, is akin to his *Perseus*. His sculpture extends the Mannerist style to its very limits—the decorous classical ideal of his Renaissance predecessors is gone.

Then & Now

THE VENICE GHETTO

One of the most horrifying events in twentieth-century history is the Holocaust, the anti-Semitism movement in Hitler's Germany that led to the murder of approximately seven million Jews. One of the reasons Hitler could so easily identify the Jewish population in Europe was that the vast majority of Jews lived in official or unofficial ghettos in the major European capitals. The earliest known segregation of Jews into their own distinct neighborhoods occurred in Spain and Portugal in the fourteenth century, but a large ghetto was established in Frankfurt in 1460. Ghettos in Venice appeared early in the sixteenth century.

A Jewish presence in Venice dates to the early fourteenth century, and by 1381 the city had authorized Jews to live in the city, practice usury—the lending of money with interest—and sell secondhand clothes and objects, which led to the profession of pawnbroking. In 1397, all Jews were expelled, ostensibly because of irregularities that had been discovered in the monetary practices of Jewish bankers and merchants. They were permitted to visit the city for no more than fifteen consecutive days and forced to wear an emblem identifying their religion. But this order became more and more laxly enforced, and the Venetian Jewish community flourished until 1496, when they were once again banished, and this time only permitted to stay in Venice for two weeks a year.

In 1508, Julius II formed an alliance with the rest of Italy and Europe against Venice, and when his army approached the city in the spring of 1509, the large Jewish community that lived on the mainland at the lagoon's edge fled to Venice proper. Many Jewish leaders offered much-needed financial support, and the city found

itself in a quandary about where they should be allowed to live. The issue was hotly debated for seven years. Franciscan sermons routinely warned that God would punish the city if Jews were admitted. Finally, on March 29, 1516, a substantial majority of the Senate approved a proposal to move the Jews *en masse* to an islet linked to the rest of the city by two points of access that could be closed at night. In this way, Venice could make use of the skills—and money—of the Jewish community and still segregate them.

The island to which they were banished was the site of a new foundry. The Venetian word for the smelting process is *getture*, and the new foundry built on the island was named *getto nuovo*. Soon the island itself was called Ghetto Nuovo, and the word "ghetto" entered the language, and came to be used throughout Europe to describe the areas in cities where Jewish communities were to be found.

Figure 13.48 Michelangelo, Vasari, and Ammanati, vestibule of Laurentian Library, begun 1524, staircase completed 1559, monastery of San Lorenzo, Florence. The antique architectural vocabulary has been used to create a space in which the visitor is unlikely to feel comfortable. The stairs, which seem to flow downward, fill most of the floor space, and, because three flights lead to a single doorway at the top, a traffic jam is likely.

ARCHITECTURE

Mannerist architecture reuses the vocabulary of antique architecture in unusual ways. Very different from the revival of the antique seen in Bramante's Tempietto (see fig. 13.35), Mannerist architects responded in extremely unorthodox ways. The vestibule of the Laurentian Library in Florence (fig. 13.48) is one such example, built as the Medici family library above the monastery of the church of San Lorenzo. Begun by Michelangelo in 1524, the staircase was designed between 1558 and 1559, and the room completed by GIORGIO VASARI [va-SAH-ree] (1511-1574) and AMMANATI [ah-mahn-AH-tee] (1511–1592). One of the most peculiar rooms ever built, the foyer has among its oddities a two-story ceiling and a form that is higher than it is long or wide. The niches (wall recesses) are smaller at the hottom than at the top, and the same inversion of the norm is true of the pilasters that flank the niches. The columns are set into the wall, not in front of it, reversing the usual column and wall relationship. Finally, the staircase has three separate flights at the bottom but only one into the doorway at the top—a guaranteed traffic problem. This intriguing and uncomfortable room, in which everything is contrary to the classical rules of architecture, may be regarded as an ingenious Mannerist interpretation of the antique vocabulary.

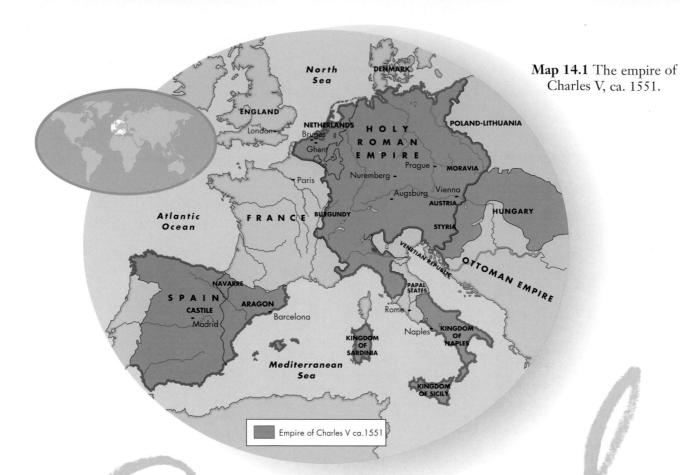

THE RENAISSANCE IN THE NORTH

C H A P T E R 1 4

- The Early Renaissance in Northern Europe
- The High Renaissance in Northern Europe

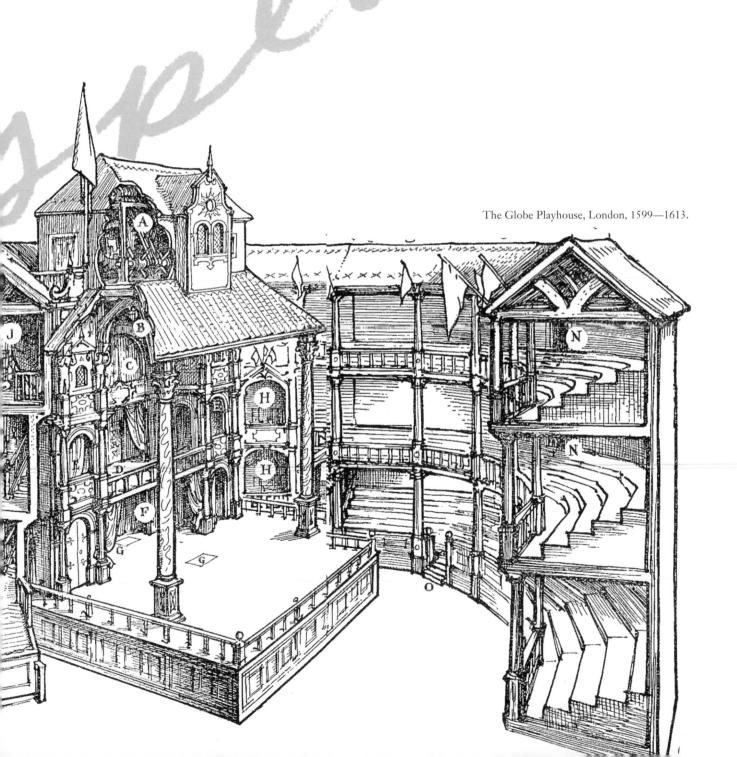

THE EARLY RENAISSANCE IN NORTHERN EUROPE

The traditions of the Renaissance emerged in the north of Europe and in England more slowly than in Italy. (The Renaissance was, after all, a "rebirth" of classical values, including Roman values, and the north, even a thousand years after the fact, still smarted from the knowledge that it had been conquered by Rome, and that its peoples had once served as Roman slaves. Yet trade and commerce inevitably brought Italian ideas northward. There they met with a strong artistic tradition, fostered by the Burgundian dukes and the guild systems that had led to the creation of the great Gothic cathedrals. And as trade grew in the north, particularly the Netherlands, so did wealth, fostering the same conditions of patronage that had led to the Renaissance in Italy—with one important difference. In the north, trade also brought prosperity to an ever more influential merchant class, who soon became the most important patrons of their day.

GHENT AND BRUGES

As in Italy, where the Renaissance developed in the great city-states of Florence, Milan, and Venice, and flourished in the revitalized city of Rome, the Renaissance in northern Europe was also a largely urban phenomenon. But the urban centers of the north—such as Martin Luther's Wittenberg in Germany—were, by comparison with Florence and Milan, small towns. By the early sixteenth century in Germany, for instance, fully seventy per cent of the population still lived in the countryside. The area's largest cities were Cologne and Nuremburg, which doubled in size between 1400 and 1500 to reach populations of between forty and fifty thousand, but the vast majority of cities were much smaller, averaging between two and three thousand inhabitants. It was in such small towns that the literate, educated classes lived. And it was in such towns that new ideas flourished.

In the Low Countries, the areas known today as Belgium and the Netherlands, there were, however, a number of substantial cities by the dawn of the fifteenth century. Cities such as Ghent were commercial centers dedicated to trade, surrounded by agricultural lands and located, for trading purposes, along the rivers and coast. In 1340, Ghent was also the site of a flourishing textile industry producing tapestries, lace, and other fine textiles, which it exported to the world from its own substantial port on the River Scheldt. But by 1400 it had lost its place as the region's commercial center, supplanted by the nearby port of Bruges, which had become the financial capital of all northern Europe. There were many reasons for Bruges's rise, among them Ghent's devastating population loss to the Black Plague. Perhaps the

most important reason was that Bruges, not Ghent, became the favorite city of the dukes of Burgundy, especially Philip the Good (1396–1467). Philip dreamed of creating in Flanders a court culture that might compete with that of the French, and early in the fifteenth century he moved his court from Dijon to Bruges. Meanwhile, the Medici founded an important branch of their own bank in the city, and fresh news of developments on the Florentine cultural scene was always at hand.

Philip's grandfather, Philip the Bold, and his brother, Jean, Duke of Berry, were great patrons of art in fourteenthand early fifteenth-century northern Europe, just as the Medici were in fifteenth-century southern Europe. It was Jean who commissioned the Limbourg Brothers' famous illuminated manuscript of the Book of Hours, the Très Riches Heures du Duc de Berry, completed in 1416 (see Chapter 12). Their court was obsessed with chivalry and consumed by chivalrous entertainments—jousts, tournaments, pageants, and processions. They dressed in gold-threaded cloth, ermine, and jewels; they commissioned the finest tapestries; and they surrounded themselves with poets, musicians, scholars, and painters. Unfortunately, by the late fifteenth century, the harbor at Bruges was filled with silt, and the city, dwindling in size, lost importance as a financial capital. Virtually untouched and forgotten for four hundred years, it remains one of the finest examples of an early Renaissance city in Europe, its streets and buildings still very much as they were.

FLEMISH OIL PAINTING

Oil paint had, in fact, been used for centuries, particularly to paint stone and metal, but it was not used on canvas until the early fifteenth century. In the past painters had used egg tempera, as seen in the paintings of the southern Renaissance. With egg tempera (pigments mixed with egg yolk), the artist must work quickly because the mixture on the surface dries rapidly. Illusions of space, texture, and and subtle modeling are thus almost impossible to achieve since the paint cannot be blended very readily and since, once applied, the paint is opaque. Oil paint (pigments mixed with linseed oil) stays wet a long time, so colors can be mixed with other colors right on the painting surface, and the artist can work and rework a small section, blending and shading the colors. Depicting the texture of things-soft skin, fluffy hair, velvet, wood, metal, or plaster—would have been impossible to achieve with egg tempera. Furthermore, oil paint could be applied in very thin layers called glazes to create a glow to the objects, much as the Venetian painters did (see Chapter 13).

Robert Campin. One of the first important uses of the oil painting technique is the *Mérode Altarpiece* (fig. 14.1). It is attributed to the Master of Flémalle, com-

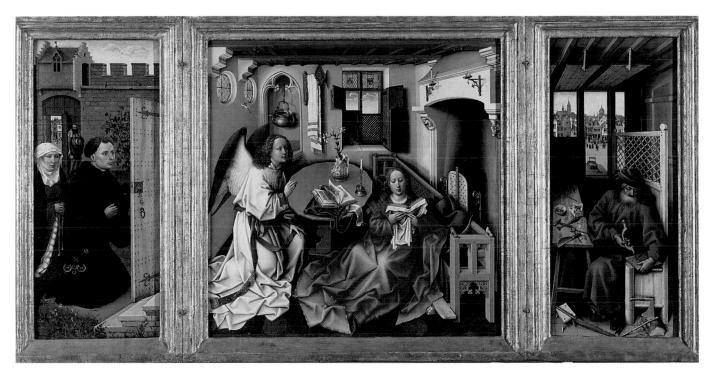

Figure 14.1 Robert Campin (Master of Flémalle), *Mérode Altarpiece*, ca. 1426, oil on panel, center $25\frac{3}{16} \times 24\frac{7}{8}$ " (64.1 × 63.2 cm), each wing $25\frac{3}{8} \times 10\frac{7}{8}$ " (64.5 × 27.6 cm), Mctropolitan Museum of Art, New York. Illusions of texture and atmosphere are made possible by painting in oil rather than egg tempera, the medium favored during the Middle Ages. Equally innovative is the depiction of the Annunciation in a middle-class fifteenth-century Flemish home.

monly supposed to be the same person as ROBERT CAMPIN [cam-PEN] (ca. 1375–1444), a member of both the Tournai painters' guild and the city council.

Flements in the altarpiece echo artistic conventions from the Middle Ages: the two figures of Mary and Gabriel are sized according to their importance, not to the reality of the architectural setting. If they were to stand, they would be a full head higher than the door itself. In his treatment of the Annunciation, Campin inaugurates a new matter-of-factness in painting, an attention to the details of reality never before depicted, facilitated by the use of oil paint. Painting around 1426, Campin employed a "mixed" technique in the altarpiece, using egg tempera for the underpainting, then proceeding immediately to paint over it in oil.

The basic format of the altarpiece is that of a **triptych**—a three-paneled painting. The practical advantages of the triptych format are apparent: the wings are hinged and can be closed to protect the painting inside; when they are opened out at an angle, the altarpiece can stand up unaided. The central panel depicts the Annunciation. Shown sitting on the floor, this Mary is referred to as the Madonna of Humility. Yet more noteworthy is the fact that this is the earliest known case in which the Annunciation was depicted as taking place not in a church or holy realm but in a home. This

traditional religious subject has been combined with an accurate recording of observed daily life.

In the left panel, the patron, Ingelbrecht of Mechlin, and his wife look through an open doorway, the jamb of which is just visible in the central panel. Their rich garments, together with their patronage of the altarpiece itself, are indicative of the prosperity of the early fifteenth-century Flemish merchant class. The coats-of-arms in the windows of the central panel are thought to be those of the families depicted. Ingelbrecht and his wife are looking into the house, witnessing the miraculous event. Not only does this device establish an ingenious spatial relationship uniting the two panels in a continuum of space, but it collapses historical time as well, uniting past and present, thus underscoring the significance of the Annunciation to the everyday life of the Northern Renaissance Christian.

Using tiny details, the artist documents visual facts about each of the many objects portrayed. Every part of the painted surface is covered with something that catches and holds the viewer's eye. Moreover, this interest in microscopic details is infused with religious symbolism. For example, the lions that serve as decorative finials on the bench are symbols of watchfulness as well as of Jesus and his resurrection; the dog finials are symbols of fidelity and domesticity. The candle refers to the light

brought into the world by Jesus. The lily, a symbol of purity, is the flower of the Virgin (Madonna lily). Perhaps the most interesting of these symbolic details is a tiny figure coming in through the window on supernatural rays of golden light, heading directly for Mary's abdomen. This miniature man is a prefiguration of Jesus—in the next instant the Incarnation will take place. Jesus carries a tiny cross, foreshadowing his crucifixion. Together, the motifs would seem to be an amalgamation of the alpha and the omega, the beginning and the end, as Jesus was to call himself.

That seemingly ordinary household items could be subject to religious interpretation was based on the belief that all visible objects were infused with God, and thus virtually every object could carry iconographic (or symbolic) implications. Although the symbolism is often elusive today, ambiguity was not the artist's intent. Perhaps the most curious example of symbolism is that employed in the right panel. Here, Mary's husband Joseph works in his carpentry shop. The painting superbly documents a fifteenth-century Flemish carpenter's shop complete with his tools. Through the window a typical Flemish town, perhaps Tournai itself, is seen. Joseph is shown, most remarkably, making mousetraps. This presumably symbolizes what St. Augustine said, that Jesus's Incarnation was God's trap for catching the devil. The Lord's cross was a mousetrap for the devil, and his death was the bait by which the devil would be caught.

Jan van Eyck. In the 1420s, the painter JAN VAN EYCK [van IKE] (ca. 1390-1441) served Philip the Good, not only as a painter but also as a diplomat, accepting assignments to Spain and Portugal. In Portugal, he painted portraits of Philip's future bride, Princess Isabella, so that Philip, back in Flanders, could see what she looked like. He became a renowned painter, sought after not only by the Burgundian court but by visiting notables from abroad, especially by Italians. By the middle of the next century, Giorgio Vasari was referring to him in his *Lives* as the "inventor of oil painting."

Van Eyck is considered, too, the founder of the Flemish school, a painterly tradition in which artists, like Van Eyck and Robert Campin, recorded the real world in minute detail as a way toward truth. Jan van Eyck completed his own altarpiece in 1432, just a few years after the Mérode Altarpiece was finished. The Ghent Altarpiece is a much more ambitious work in which he was probably aided by his brother Hubert.

In the St. Bavon cathedral in Ghent, this enormous polyptych—or work consisting of more than three panels—has twenty-six panels. Closed, it depicts the Annunciation (fig. 14.2), which takes place across four panels cleverly treated as one room. The frame appears to be part of the architecture; it casts a shadow into the room. In the center of the lower tier are painted sculptures of John the Baptist and John the Evangelist, the

former identified by his camel hair garment and the lamb he is holding, the latter by a chalice with snakes. These figures appear to be set in actual architectural niches. Van Eyck has painted light falling from the right as it would have done in nature, creating a sense of verisimilitude.

St. Bayon was dedicated to John the Baptist, the patron saint of the city of Ghent. The Lamb of God John holds is his identifying attribute and also links him to the wool industry, the source of the city's prosperity. The altarpiece's patrons, depicted in the outside panels of the lower tier, did in fact gain their wealth from wool. A deed dated May 13, 1535 establishes Joos Vijd, on the left, and his wife Elizabeth Borluut, on the right, as founders of the chapel in St. Bavon where the altarpiece stood. On the outer frame, below the donors, is found this inscription: "Hubert van Eyck, the most famous painter ever known, started this work of art at the request of Joos Vijd; his brother Jan, who was the second in art, finished

Figure 14.2 Jan and Hubert van Eyck, *Ghent Altarpiece* (closed), ca. 1425–32, oil on panel, $11'5\frac{3}{4}'' \times 7'6\frac{3}{4}''$ (3.4 × 2.3 m), St. Bavon, Ghent. Although Gabriel and Mary are too large to stand up, the space is ingeniously depicted as if continuous through all four panels behind the frame-which itself appears to cast shadows into the room.

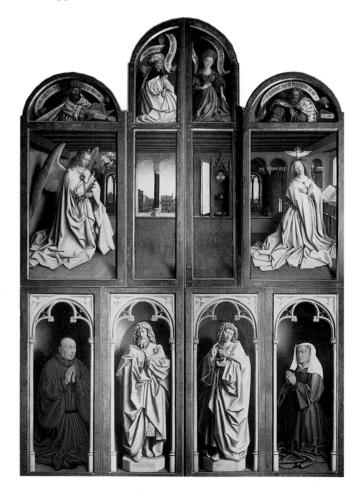

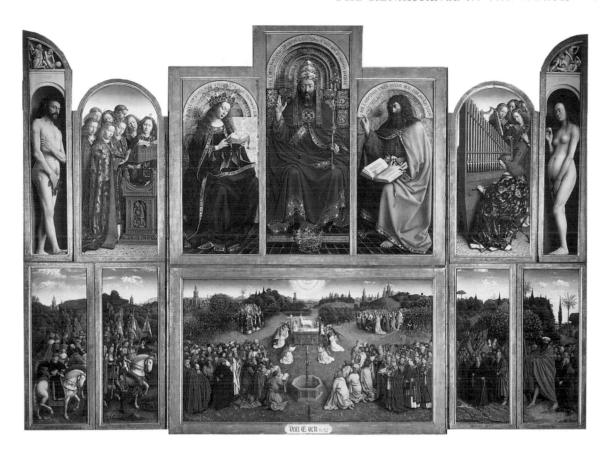

Figure 14.3 Jan and Hubert van Eyck, *Ghent Altarpiece* (open), ca. 1425–32, oil on panel, $11'5\frac{3}{4}'' \times 15'1\frac{1}{2}''$ (3.4 × 4.6 m), St. Bavon, Ghent. Because of the lower center scene in which the multitudes are shown venerating the Lamb of God (Agnus Dei), this monumental polyptych is sometimes referred to as the *Mystic Lamb*.

the monumental commission. With this verse the donor consigns the work to your charge on May 6, 1432." Little is known about Hubert van Eyck, despite the inscription. It is generally believed that Hubert sculpted the original elaborate framework for the piece, a structure long lost, and that Jan went on, as "second in art," to paint it. Still, it is significant that the artists are mentioned on the work itself, indicating a shift from the anonymity of the medieval guild system to recognition of individual artists.

Inside, the altarpiece focuses on the salvation and redemption of humankind (fig. 14.3). The glowing colors of the interior, dominated by red, blue, and green, contrast dramatically with the somber colors of the exterior panels. The central panel on the lower level takes up the theme introduced by John the Baptist, depicting the *Adoration of the Lamb*; the entire altarpiece is sometimes referred to as the *Mystic Lamb*. The Apocalyptic Lamb is sacrificed, its blood spurting into the chalice, which symbolizes Jesus's sacrifice. In the foreground is the Fountain of Life, its twelve jets of water symbolizing the Mass from which grace unceasingly flows.

In an urge for inclusiveness, the crowds of people shown paying homage to the Lamb include Old Testament prophets and patriarchs, classical poets and philosophers, New Testament apostles, and people of all classes, times, and places. Various body types and facial expressions individualize the figures with their blemishes and deformities included.

Realism is further heightened by Van Eyck's use of atmospheric perspective (see Chapter 13). The colors and the edges of objects in the background are not as intense or as sharp as those in the foreground. The distant hills merge with the sky, which is no longer golden but tinged with an appropriate lighter blue near the horizon. Consider how different this is from the *Mérode Altarpiece* in which the artist gave each object equal attention, whether in the foreground or background.

Unlike the lower panels, the upper panels do not form a unified composition. In the center is either God or Jesus, lavishly adorned in a deep scarlet mantle and gemstones that appear, by virtue of Van Eyck's careful glazing, to catch the light. This figure seems to incorporate all aspects of the Trinity within himself—the Father, Son, and Holy Ghost. Inscribed on the throne behind his head is the inscription: "This is God, the Almighty by reason of His divine majesty [the Father]; the Highest

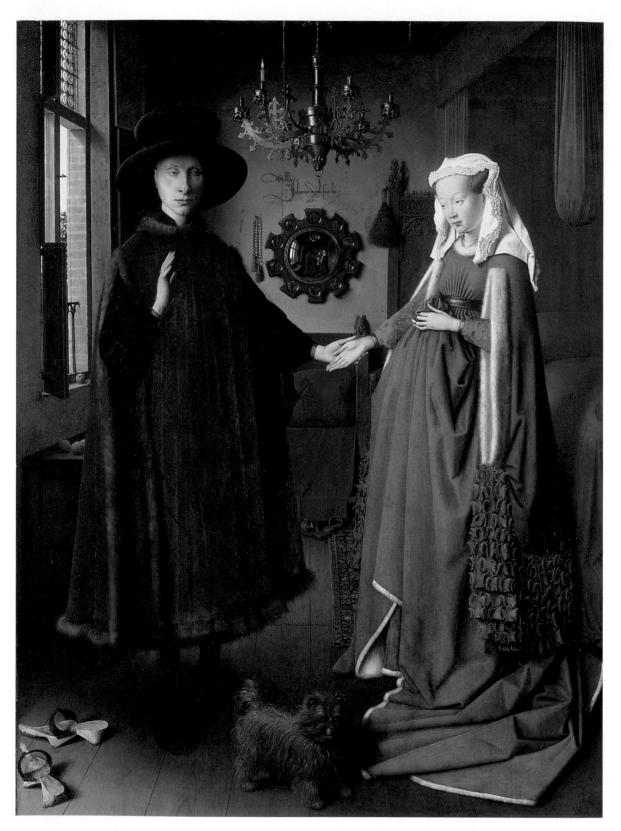

Figure 14.4 Jan van Eyck, *Giovanni Arnolfini and His Wife Giovanna Cenami*, signed and dated 1434, oil on panel, $32\frac{1}{4} \times 23\frac{1}{2}$ " (83.8 \times 57.2 cm), National Gallery, London. The growing interest in portraiture is evidenced here. Cenami's protruding abdomen was a fashion of the times (note Eve's comparable contour in the *Ghent Altarpiece*) rather than an impetus for the exchanging of wedding vows.

and Best, by reason of his goodness [the Son]; the Most Liberal Giver by reason of his boundless generosity [the Holy Ghost, who bestows grace on the elect]." The outermost figures are Adam and Eve, the earliest large-scale nudes in northern European panel painting. Highly naturalistic, they were obviously painted from models; every eyelash is recorded. Adam is shown with his mouth slightly open, as if speaking. Eve's physique, with the protruding abdomen, is the preferred body type of the day rather than an indication of pregnancy. They are drawn as if seen from below. The bottom of Adam's foot is visible as he steps on the frame, because the viewer must look up at these figures.

Because of the enormous ambition involved and the extraordinary realism portrayed, the *Ghent Altarpiece* is one of the most famous paintings of the Renaissance. It came to symbolize the aspirations of an entire age, from the hope of salvation embodied in its commission to the appreciation of the genius of Van Eyck's extraordinary achievement.

Van Eyck's assertion that painting is an act of an individual's particular vision is carried further in his commissioned portrait of *Giovanni Arnolfini and His Wife Giovanna Cenami*, often called *The Arnolfini Wedding* (fig. 14.4). On the back wall, above the mirror, are the words "Johannes de Eyck fuit hic. 1434" ("Jan van Eyck was here, 1434"). We see reflections in the mirror: the backs of Arnolfini and Cenami and, beyond them, two other figures, standing in the same place as the viewer. The man in the red turban is perhaps the artist himself, suggesting that he was, in fact, present.

Giovanni Arnolfini was an Italian merchant working in Bruges as an agent for the Medici, both as a banker and a businessman involved in trade. His wife's protruding abdomen again does not suggest pregnancy but a fashionable physique, probably achieved by a small padded sack over the abdomen and emphasized by the cut of the garment and posture of its wearer.

Though it has long been assumed that the couple are shown in a bridal chamber, exchanging marriage vows before two witnesses, persuasive arguments have recently been made to suggest instead that we are witness here not to a marriage but to an engagement, and that the room is not a bedroom but the main room of Arnolfini's house. The moment is not unlike that described by Shakespeare in Henry V, when the English king proposes to Katherine, the French princess: "Give me your answer; i' faith, do; and so clap hands and a bargain: how say you lady?" Such a touching of the hands was the common sign of a mutual agreement to wed. As for the room itself, it has been pointed out that canopy beds were "furniture of estate," important status symbols commonly displayed in the principal room of the house as a sign of the owner's prestige and influence.

The painting is replete with common objects that seem to hold iconographic significance, in "disguised"

symbolism. Thus St. Margaret, patron saint of childbirth, adorns the bedpost. The couple's shoes are off to signify that they stand on holy ground. Ten scenes in the mirror frame represent the passion of Jesus, and the single candle in the chandelier is thought to represent the all-seeing God. The dog is a symbol of fidelity, especially appropriate in this subject, although dogs were popular everywhere in northern Europe, and the Duke of Berry was said to have 1500. He also notes that wax candles were extraordinarily expensive (the price of tallow was four times that of meat), requiring households to use them sparingly, if at all. Everything that Van Eyck has included in the painting can be justified by reference to everyday reality. However, the power of these objects' potential symbolism is enhanced rather than diminished by such realism. In everyday reality, Northern Renaissance artists found signs of God's presence on earth.

The painting remains a stunning representation of the prosperity of the rising merchant class in fifteenth-century Bruges. With its dazzling play of rich colors, the lavish textures of its textiles, and the beauty of its ornament and finery, it records a prosperity that would not last long.

Hieronymus Bosch. Very different from Jan van Eyck's efforts to portray the real world are those of HIERONYMUS BOSCH [BOSH] (1450 or 1453–1516). He grew up and worked in 's-Hertogenbosch [s-HER-toe-gen-bos] in southern Holland (now called Den Bosch). This town was off the main roads, isolated from the progressive ideas that informed the Burgundian court. It was middle-class and commercial and situated within an area of religious, political, social, and economic unrest. In Bosch's world, people believed in witches. Astrology was taught at the universities, and visions were accepted as fact. Although a member of a Catholic fraternity until his death in 1516, Bosch was openly critical of certain regional religious practices.

As an artist, Bosch displays an extraordinary imagination and a highly personal style. He is best known for his blatantly bizarre and menacing creatures, part human, part animal. It wasn't only subject matter that distinguished Bosch from his contemporaries. He painted alla prima [AH-la PREE-ma]—without any preliminary drawing. His style is based upon delicate draftsmanship; the effect is fragile, fluid, transparent. Where other Flemish painters stressed the solid dimensionality of each object, Bosch chose not to. While his contemporaries tricked the viewer's eyes with their skill in representing texture, Bosch shows no concern for this kind of illusionism. In an era when other artists created atmospheric environments filled with natural light, Bosch disregarded light and shadow. Bosch's interest was in his subject matter and in his moralistic and satirical presentation of it.

Bosch's *Hay Wain* (fig. 14.5), a triptych painted ca. 1495–1500, illustrates the Flemish proverb, "The

world is a hay wagon and each seeks to grab what he can." The hay wagon is a symbol of earthly goods and worldly pleasures, and the painting is a powerful sermon on the evils of greed. As in all his paintings, Bosch fills this one with a multitude of telling vignettes. In the center panel people of all classes, rich and poor, even members of the religious hierarchy (the pope has been identified as Alexander VI), fight each other for the hav. Some are crushed under the wheels. A quack physician fills his purse. Nuns, supervised by a gluttonous monk, push hay into a bag. On top of the hay is a group of lovers. Here a man plays a lute, while the demon on the right plays his nose like a flute, and dances to his own tune. A couple kiss in the bushes. Only the angel on the left notices Jesus above. On the left panel is a scene from the Creation, focusing, however, on sin. Rebel angels are thrown out of heaven; the sky is full of monsters. On the right panel is hell—to which the wagon, pulled by devils, is rolling. People are tortured; buildings are destroyed.

Bosch's most famous painting, the *Garden of Earthly Delights* (fig. 14.6), probably painted between 1505 and 1510, is the most iconographically complex of all his paintings. A triptych like the *Hay Wain*, it is likewise a sermon on folly and its punishment in hell. Again, the

Creation is shown on the left panel, and hell on the right. But here the pleasures of the flesh, portrayed on the central panel, are the focus of punishment.

The central panel is populated by innumerable tiny humans, bizarre animals, and fantastic plants. The huge fruits portrayed are those that are especially soft, fragile, and short-lived, such as cherries, strawberries, and blackberries—rotting fruit is a recurrent image. The implication is that pleasure, too, is fragile and short-lived. In this environment, carefree people cavort amorously. Gluttonous lovers sit inside a berry, luring others in. Other lovers are surrounded by a transparent capsule, unaware that their actions are seen by all.

The left panel shows the creation of Eve, her presentation to Adam, the Tree of Knowledge, and the beginning of sin with the Fall. Cruel beasts abound—sin already lurks in Eden. The right panel shows a terrifying vision of hell. At the top, cities burn. A pair of ears is separated by a knife, but held together by an arrow. There is a convent, roofed by a horse's skull and populated by demons. A knight is devoured by dogs. Musical instruments alluding to lust become instruments of torture in Bosch's hell. At the time lust was called the "music of the flesh," and the bagpipe referred specifically to the male sexual organ. A bird-creature consumes

Figure 14.5 Hieronymus Bosch, Hay Wain, ca. 1495–1500 (?), oil on panel, center $4'7\frac{8}{8}'' \times 3'3\frac{8}{8}''$ (1.40 × 1.00 m), each wing $4'9\frac{7}{8}'' \times 2'2''$ (147 × 66 cm), Museo del Prado, Madrid. Another version of this painting is in the Escorial, near Madrid—scholars debate which is the original. People of all types try to grab the hay which, according to proverb, represents material possessions.

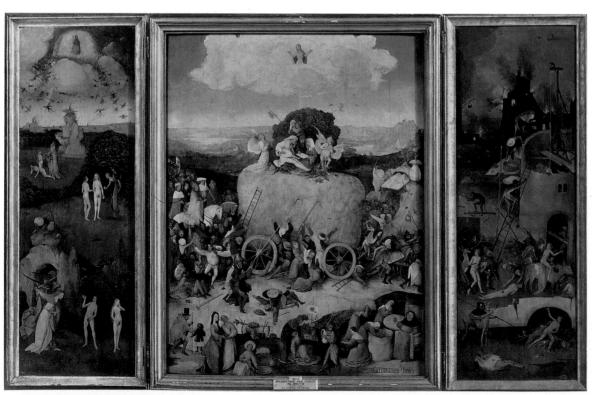

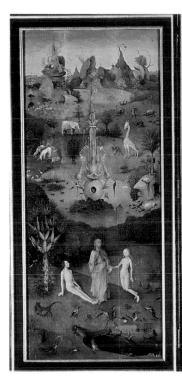

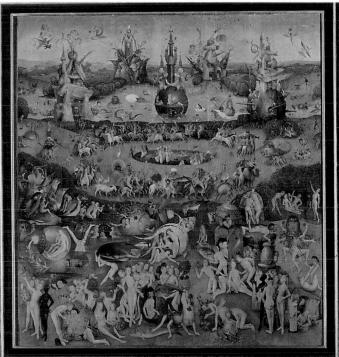

Figure 14.6 Hieronymus Bosch, *Garden of Earthly Delights*, ca. 1505–10, oil on panel, center $7'2\frac{1}{2}''\times 6'4\frac{3}{4}''$ (2.20 × 1.95 m), each wing $7'2\frac{1}{2}''\times 3'2''$ (2.20 × 0.97 m), Musco del Prado, Madrid. Bosch's predilection for the bizarre, his juxtapositions of seemingly unrelated objects, and the irregular scale foreshadow Salvador Dalí and twentieth-century Surrealism (see Chapter 21).

and excretes the damned. A miser vomits gold coins into a sewer. Every type of sin receives appropriate punishment in hell. Is the face looking out at us from behind the egg actually a self-portrait, as has been claimed? If so, then Bosch has placed himself in hell!

Although much of Bosch's meaning is lost to us today, some aspects remain quite clear. When he portrayed a mother superior pig giving a small, naked (i.e. dying) man an unwelcome embrace, Bosch was publicly yet cryptically criticizing current Church practices. He was alluding to the way wills that benefited monasteries were often made under the duress of imminent death. Members of the clergy during Bosch's time were often corrupt, living in licentious luxury even as they preached austerity and abstinence to others.

The German artist Albrecht Dürer later said of Bosch's paintings that nothing like them was ever "seen before nor thought of by any other man." This may be true in purely visual terms; yet soon his critical vision of the Church would become that of the majority, part of a general call for reform. Many artists, writers, and intellectuals were beginning to attack the Church on every front. Those such as Bosch's eventually led the papacy in Rome, under popes Julius II and Leo X, to reinvent Rome as a center of classical learning, unsurpassed artistic accomplishment, and holy endeavors.

The High Renaissance in Northern Europe

THE HABSBURG PATRONAGE

A measure of the centrality of Bosch's themes to the culture of the new century is the fact that he would become the favorite northern painter of Philip II of Spain, the richest and greatest collector of art in the last half of the sixteenth century. Not only did Philip own the *Garden of Earthly Delights*, but he owned over thirty other paintings attributed to Bosch. The painter's work struck a chord with the elegant, highly educated, and refined prince, who saw in Bosch the very reflection of his times.

Philip II was the nephew of both Charles V, Emperor of the Holy Roman Empire, and Mary of Hungary, the Emperor's sister. The Habsburg [HAPS-burg] Charles V controlled Spain, the Low Countries, the German empire, Hungary, Spanish America, and parts of Italy. Though not a strong supporter of the arts, Charles discovered the paintings of the southern Renaissance painter Titian in 1532 and became, together with Mary, the artist's chief patron. Titian's portrait from 1548 of Charles V on Horseback (fig. 14.7) shows the Emperor with

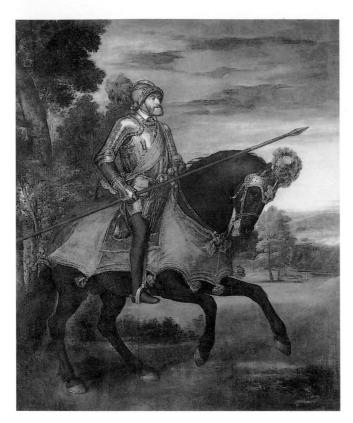

Figure 14.7 Titian, Charles V on Horseback, 1548, oil on canvas, $10'11'' \times 9'2''$ (3.33 \times 2.79 m), Museo del Prado, Madrid. The portrait is notable for its clear representation of the famous Habsburg chin, a hereditary trait shared by all family members.

the thrusting chin that was an inherited Habsburg trait. Mary of Hungary also served as governor of the Netherlands from 1531 to 1556, and in that time developed a passionate taste for fifteenth-century Flemish painting, acquiring, among others, Van Eyck's portrait *Giovanni Arnolfini and His Wife Giovanna Cenami* (see fig. 14.4). She also cultivated the Habsburg habit of collecting the best Flemish work together with the best from Italy.

Financed by gold and silver from the Americas, Philip added to the great collections of his uncle and aunt. Like Charles V and Mary before him, he favored Titian, granting him an annual stipend and allowing him to paint whatever he chose. When Titian died in 1576, Philip had amassed dozens of his paintings. From Flanders Philip collected works by Campin and Bosch. By the time Philip was done, he had brought more than 1500 paintings of indisputable quality to Spain.

ICONOCLASM

While the Habsburgs in Spain during the sixteenth century acquired art and endorsed individual artistic expression, there was a growing iconoclasm further north.

Iconoclasm [eye-KON-o-KLAZ-em] is the systematic destruction of religious icons because of their accepted religious connotations. As anti-Catholic religious reform movements spread throughout northern Europe in the sixteenth century, an iconoclastic fever spread with them. The Old Testament prohibition against images that led to idolatry was widely cited as justification for this destruction. The extraordinary visualization of religious beliefs that had flourished under the patronage of popes Julius II and Leo X at the Vatican in Rome became for many the very symbol of the papacy's corruption. In Switzerland, John Calvin wrote: "Therefore it remains that only those things are to be sculpted or painted which the eyes are capable of seeing: let not God's majesty, which is far above the perception of the eyes, be debased through unseemly representations." Such sentiments led Church supporters to dismantle the Ghent Altarpiece in 1566 and hide it in the tower of St. Bavon, safe from the hands of those who wished to destroy it—"filthy swines," said one eyewitness. In Zurich, the religious leader Ulrich Zwingli [ZWING-glee] even prohibited the use of music in worship.

The most systematic iconoclasm occurred in England, beginning with King Henry VIII's (fig. 14.8) ordering of

Figure 14.8 Hans Holbein the Younger, $Henry \sqrt{VIII_1}$ ca. 1540, oil on panel, $2'9\frac{1}{2}'' \times 2'5\frac{1}{2}''$ (82.6 × 75 cm); Galleria Nazionale d'Arte Antica, Rome. The English monarch is shown in wedding dress—an attire he donned six times. As we can see, at the age of forty-nine he was already, as he was described in his later years, a "man-mountain."

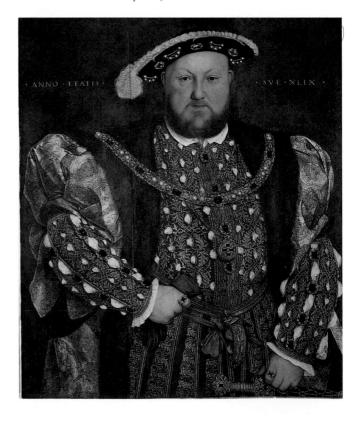

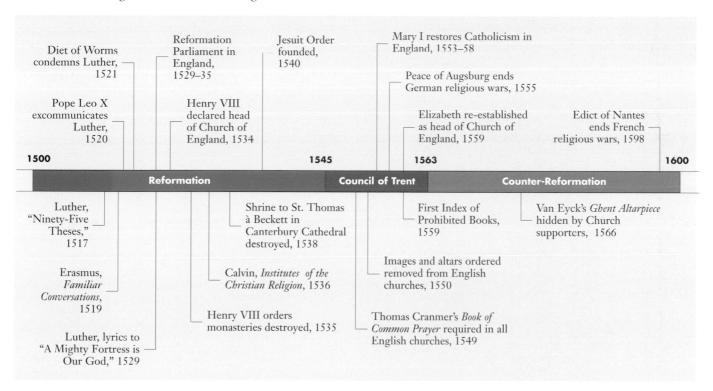

the destruction of the monasteries in 1535. Henry's motives were as much political as they were religious. When he wanted to divorce his first wife, Catherine of Aragon, and marry Anne Boleyn, from whom he hoped for a male heir, as a Catholic he could not do so. After six years of negotiations with Pope Clement VII in Rome, Henry drafted legislation that eliminated papal authority in England. Thus the Church of England was born—the Anglican Church—and it granted his divorce. (An heir was born, though Henry was disappointed, since the child was a girl—the future Queen Elizabeth I.)

Henry first attacked the monasteries, the ruins of many of which still stand: Glastonbury, the mythological burial place of King Arthur, and Tintern Abbey, which later inspired a poem by William Wordsworth. When Shakespeare wrote of "these bare ruin'd choirs where late the sweet birds sang," he was referring to such ruins. Thomas Cromwell, Henry's minister, ordered the destruction of the objects of idolatry, particularly "feigned images ... abused with pilgrimages or offerings." Soon, the shrine to St. Thomas à Beckett in Canterbury Cathedral was torn down and his sainthood recanted.

The widespread destruction of religious images would never have occurred without the acquiescence of the English people themselves. Iconoclasm was, in fact, the logical offspring of sentiments expressed early in the sixteenth century by Frasmus, considered by many the most learned man of his day. In Erasmus's words: "How many dedicate candles to the Virgin and Mother of God, even

in mid-day when it serves no purpose? How few dedicate themselves equally to a life of chastity, modesty, and love to spiritual things?"

ERASMUS AND NORTHERN HUMANISM

Like his contemporary Hieronymus Bosch, the northern humanist scholar DESIDERIUS ERASMUS [ee-RAZmus] (1466–1536), born in Rotterdam, the Netherlands, saw the religious world of late fifteenth- and early sixteenth-century Europe through a highly critical lens, but he was no iconoclast. In fact, in *A Pilgrimage for Religion's Sake*, he marveled at the shrine to Thomas à Beckett in Canterbury Cathedral: "Ye Gods! What a show was there of silken vestments, what a power of golden candlesticks ... Treasures beyond all calculation [were] displayed. The most worthless thing there was gold, every part glowed, sparkled and flashed with rare and large gems, some of which were higger than a goose egg."

Erasmus blended a scholarly study of classical civilization with a strong Christian faith. Combining an acute critical intelligence with deeply held spiritual convictions, Erasmus brought together the thought of Plato with that of St. Paul, and the philosophy of Aristotle with that of St. Augustine. He never pursued learning for its own sake, but, in his own words, "for one object, that we may know Christ and honor Him." He was educated by the Brethren of the Common Life, an order of devout laymen who modeled their lives on that of Jesus Christ.

Then & Now

ICONOCLASM AND THE ATTACK ON THE ARTS

The iconoclastic practices of sixteenth-century European Protestants were focused on the destruction of "idolatrous" images of God. From the Protestant point of view, such images diminished God by making him appear like humankind. This logic quickly extended to all images within churches, which could distract the worshiper from the true contemplation of salvation. It was not a question of artistic merit; they were viewed solely for their sacrilegious content.

Since 1985, artists in the United States have also been attacked for creating art that is considered obscene or blasphemous, specifically those works that, to some people, challenge the very idea of Christianity and the values they associate with a Christian lifestyle. Recent attacks have had a political flavor because the art and artists in question—Robert

Mapplethorpe and Andreas Serrano, for example—were funded in part by the National Endowment for the Arts. The attackers argue that the government, supported by taxpayers' money, should not fund work that offends or upsets those who pay for it.

Senator Alphonse D'Amato, a Republican from New York, tore a photograph of one of Serrano's works into pieces on the floor of the US Senate on May 18, 1989. "This socalled piece of art is a deplorable, despicable display of vulgarity," exclaimed. On July 26, 1989, Senator Jesse Helms, a Republican from North Carolina, introduced an amendment to legislation funding the National Endowment that would prohibit the use of appropriated funds to, among other things, "promote, disseminate, or produce ... obscene or indecent materials, including but not limited to depictions of sadomasochism, homoeroticism, the exploitation of children, or individuals engaged in sex acts; or ... material which denigrates the objects or beliefs of the adherents of a particular religion or non-religion."

Supporters of artists' rights of self-expression found the last word of that statement particularly alarming, since if the amendment were to be passed, the government could prohibit funding of any material that denigrated *anyone's* belief about *anything*. It seemed to many like government-supported censorship.

The amendment failed, and thus began a legislative battle that continues to this day. Should the government take on the role of artistic patron? If not, who will? Many of the country's great dance companies, symphony orchestras, theater companies, artists, and writers depend on government funds to complete their projects.

Thus, the link between Renaissance iconoclasm and today's debates over funding of the arts is clear. How our current society settles the debate

remains in question.

He joined an Augustinian monastery in 1487 and was ordained a priest in 1492. Erasmus traveled widely, studying and teaching in most of the cultural centers in Europe, including England. At Oxford, he became friends with Sir Thomas More; at Cambridge, he was Professor of Divinity and of Greek.

Erasmus wrote his *Familiar Conversations* (1519) to attack abuses occurring within the Catholic Church. Erasmus's readers found the satire of Church figures from local priests to the pope savagely funny and scathingly accurate. Forty editions of the book were published in Erasmus's lifetime, and John Milton, more than a hundred years later, remarked that everyone was still reading it at Cambridge. His *Conversations*, moreover, was so antagonistic to the clergy that Charles V, the Holy Roman Emperor, issued an edict to the effect that any teacher using the work in the classroom would be liable to immediate execution.

Erasmus had never intended to set himself up as a counter-authority to the Catholic Church. His goal was to purify the Church from within by ridiculing its abuses and thereby stimulating a desire for internal reform. In this respect, Erasmus differed from other reformers, who were advocating separation from the Church.

MARTIN LUTHER AND THE REFORMATION

If one individual could be said to dominate the history of sixteenth-century Europe, that person would be MARTIN LUTHER [LOO-ther] (1483–1546). Like Erasmus, Luther (fig. 14.9) was an Augustinian monk and a humanist scholar, and, again like Erasmus, he was no iconoclast, although he was well aware that his teachings sparked the iconoclastic frenzy. He was an avid lover of the arts, especially music. He wrote hymns for his new Protestant church services. Many are still sung, especially "A Mighty Fortress Is Our God." Two centuries later, Johann Sebastian Bach used Luther's chorales, embellishing them in his cantatas.

Luther was a Professor of Philosophy and Biblical Studies at Wittenberg [VIT-en-burg] University. When Shakespeare's Hamlet expresses his desire "to return to school in Wittenberg," he is referring to Luther and Luther's ideas taught at the school. At Wittenberg Latin was the language of instruction, and the method of teaching was a detailed study of the classics with particular attention to Aristotle's logic. The learning process depended on "disputations," or debates. Faculty and students attended weekly disputations, which were judged on success according to the rules of logic.

Figure 14.9 Lucas Cranach, *Portrait of Martin Luther*, ca. 1526, oil on panel, $15 \times 9^{\text{m}}$ (38.1 × 22.9 cm), Ufflzi Gallery, Florence. Cranach was a staunch supporter of Luther, whose criticism of church practices, such as indulgences, began the Protestant Reformation.

The faculty of Wittenberg University came largely from an Augustinian monastery in the city, where Luther was a monk. Luther specialized in the language and grammar of the Bible. After 1516, he studied in particular the Greek New Testament translated by Erasmus. The task of making his own translation into German led him to rethink the question of salvation. Salvation, he now believed, was not delivered through achievement but through faith. According to Luther, the gospel repudiates "the wicked idea of the entire kingdom of the pope ... [with its idea that] a Christian man must be uncertain about the grace of God toward him. If this opinion stands, then Christ is completely useless ... Therefore the papacy is a veritable torture chamber of consciousness and the very kingdom of the devil."

Such language would obviously offend Rome, but the incident that drew Luther to the attention of Pope

Leo X was the publication, on October 31, 1517, of his "Ninety-Five Theses." These were written in the form of a traditional disputation. Attacking the practice of papal indulgences, Luther was inspired by the example of the Dominican monk Tetzel [TET-sel]. Accepting payment for indulgences, which theoretically remitted penalties to be suffered in the afterlife (including release from purgatory) and paved the sinner's way to heaven, had long been practiced by the clergy. The Dominican Tetzel was, in effect, a traveling indulgence salesman. "As soon as the coin into the box rings," Tetzel would remind his audience, "a soul from purgatory to heaven springs." Frederick the Wise had banned Tetzel from Wittenberg, but the city's populace simply went out to meet him in the countryside. The people informed Luther, who also served as their pastor, that they no longer needed to confess or attend Mass because they had purchased lifetime indulgences from the Dominican monk. Luther was outraged, and the "Ninety-Five Theses" soon followed.

Luther's ideas were given greater impact by the advent of printing—Luther considered the printing press a gift from God. In 1500, there were over two hundred printing presses in Europe; soon there were seven in Wittenberg alone, pumping out the writings of the "heretic" Martin Luther as fast as they could. Over 750,000 copies of Luther's German translation of the Bible were in circulation by the time of his death in 1546.

In Rome, Luther was viewed as an Augustinian monk who had made an attack on the Dominican pope Leo X, and a rebuttal was quickly drafted by the papal theologian Prierias entitled *Dialogue Against the Arrogant Theses of Martin Luther Concerning the Power of the Pope.* It was not Luther's questioning of the practice of indulgences that so troubled Rome as much as the fact that his theses argued against papal supremacy and papal practices. Why, for instance, couldn't the pope pardon repentant sinners by an act of love rather than a tribute of money? And why didn't Leo, a Medici, finance the rebuilding of St. Peter's and Michelangelo's painting of the Sistine Chapel with his own money? On August 7, 1518, Luther was given sixty days to appear in Rome to answer the charge of heresy.

Luther avoided going to Rome through the machinations of his protector Frederick III (the Wise), ruler of German Saxony. If Frederick had any doubts about Luther, Erasmus dispelled them. Frederick asked the elder humanist what he thought about the dispute arising out of the publication of the theses, and Erasmus replied: "He has committed a great sin—he has hit the monks in their belly, and the Pope in his crown!"

Luther concluded that to get back to central Christian truths, everything non-essential in religious practice would need to be stripped away. For Luther these non-essentials included scholastic philosophy and Church ritual, along with its hierarchy, sacraments, organizational structure, and even its prayers and services. Believers

could be "justified by faith alone," a faith centered on Scripture.

Even so, Luther was also extraordinarily communityminded. No one, he believed, should have to beg in Wittenberg. Every city should take care of its poor. Disappointed in the unwillingness of the people of Wittenberg to contribute to the community chest (established by him in late 1520 to provide social welfare), Luther scolded his ministry for being "unthankful beasts," and, declaring his unwillingness to be "the shepherd of such pigs," actually quit preaching until the situation was remedied. He argued, "Christ and all saints are one spiritual body, just as the inhabitants of a city are one community and a body, each citizen being a member of the other and of the entire city." Thus in religious practices were the grounds laid for social democracy and equality, attitudes that would, in the next century, lead to social revolution throughout Europe and the Americas.

JOHN CALVIN AND THE INSTITUTES OF THE CHRISTIAN RELIGION

While Luther was reforming the Church in Germany, another more radical Protestant leader was active in Geneva in Switzerland, John Calvin. JOHN CALVIN [KAL-vin] (1509–1564) was a French humanist who underwent a religious conversion of great intensity. His reformist religious views were not well received in France, and he fled to Switzerland, where he first published his *Institutes of the Christian Religion* in Basel and later set up a theocratic state in Geneva—that is, a state ruled by a religious figure or group.

Calvin's reforms, like Luther's, involved stripping away what he considered external and distracting to true Christian piety. He rejected images of saints and limited the use of music to psalms. Many other activities were prohibited in Calvin's Geneva, including feasting and dancing; wearing rouge, jewelry, and lace, and dressing immodestly; swearing, gambling, and playing cards; reading immoral books and engaging in sexual activity outside of marriage. People caught breaking the rules were warned the first time, fined the second, and severely punished after that. Some were banished, others executed.

Like Luther, Calvin recognized the Bible as the supreme source of knowledge and the only recourse for religious living. His *Institutes* drew out the principles embedded in biblical teaching. They include the following:

- (1) human beings are born in total depravity as a result of Adam's fall, whereby they inherit original sin;
- (2) the will of God is absolute and all-powerful;
- (3) faith is superior to good works, since humans lack the capacity to choose to do works that are truly good in God's eyes;
- (4) salvation comes through God's freely given grace rather than through any acts of the people;
- (5) God divinely predestines some to eternal salvation—the Elect—and others to eternal perdition—the Damned; and since no one knows with absolute certainty whether he or she is one of the Elect, all must live as if they were, obeying God's commands.

Timeline 14.2 Science and ideas of the Northern Renaissance.

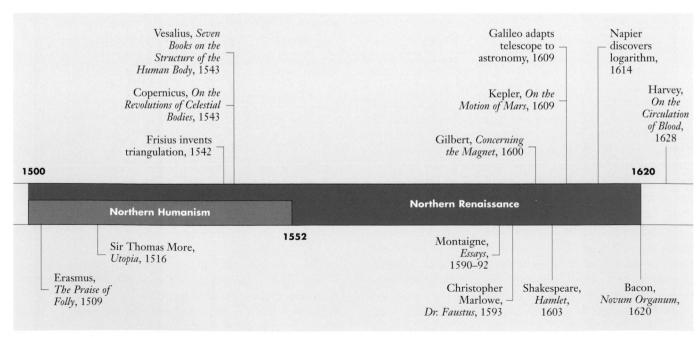

Cross Currents

Dürer Describes Mexican Treasures

When Hernán Cortés landed in Mexico in 1519, he did so as the representative of King Charles V of Spain, the Habsburg ruler who actually lived in Vienna. He sent Charles a series of letters recounting his conquests there, and with them a collection of treasures. When the latter arrived in Brussels, Albrecht Dürer was among the many who came to see them.

Among the collection was the famous Dresden Codex, a folding-screen manuscript made of bark paper dating to as early as the thirteenth

century. It recounts agricultural rituals, establishes the Mayan calendar, and, in the richness of its drawings of costumes and gods, is by far the most detailed description of Mayan life that we have today. Only its having been sent back to Europe saved it from the total destruction of all "pagan" and "idolatrous" manuscripts ordered by Diego de Landa, Charles V's first appointee as bishop of Yucatán.

But Dürer was most impressed by the extraordinary gold- and metalwork sent from the "New World": "I saw the things brought to the King from the New Golden Land," Dürer wrote, "a sun entirely of gold, a whole fathom wide; likewise, a moon, made entirely of silver, and just as big; also, a variety of other curiosities from weapons, to armor, and missiles ... These things were all so precious that they were valued at a hundred thousand gilders. But I have never seen in all my days anything that caused my heart to rejoice so as these things have. For I saw among them amazing art objects, and I marveled over the subtle ingenuity of the men in distant lands who made them." This Aztec goldwork was, however, soon melted down by Charles for currency, the fate of almost all such metalwork sent back to Europe from Mexico.

Calvin identified the Elect by their unambiguous profession of faith, their upright life, and their pious participation in the sacraments, whose number, like Luther, Calvin reduced.

From Geneva Calvinism spread into France, the Netherlands, England, Scotland, and North America, and it had a marked impact on the social, political, and intellectual life of these countries. It can be traced in the rise of the Puritans, in Milton's *Paradise Lost* and the works of seventeenth-century American Puritan writers Edward Taylor and Cotton Mather, and in nineteenth-century works such as Nathaniel Hawthorne's *The Scarlet Letter* and Herman Melville's *Moby Dick*.

THE AGE OF DISCOVERY

Ever since Marco Polo had returned to his native Venice from China in the thirteenth century, the world map had been undergoing almost continual revision. Most of the geographic details of the real world Europeans learned in the two centuries after 1450, in their world explorations. Though this exploration was fueled by both missionary and economic zeal—the twin forces of God and gold—it also spawned an awareness of peoples and cultures hitherto unknown.

Renaissance Explorers. In 1488, the Portuguese explorer Bartolomeu Dias [DEE-es] was blown far south off the West African coast by an enormous storm, and heading northeast afterward he found that he had rounded what would come to be called the Cape of Good Hope. The fact that Africa was surrounded by water was confirmed. In 1497, the Portuguese explorer Vasco da Gama [VAS-koe de GAM-uh] followed Dias's route and

reached India ten months and fourteen days after setting out from Lisbon. Meanwhile, Christopher Columbus had made landfall on a small island in the Bahamas in 1492, and in 1500 the Portuguese Pedro Cabral [ka-BRAHL] had pushed west from the bulge of Africa and landed in what is now Brazil. Magellan had successfully sailed around the tip of South America, across the Pacific to the Philippines, across the Indian Ocean and around Africa, thus circumnavigating the globe and demonstrating that the world was indeed round. On September 8, 1522, Ferdinand Magellan's crew with only eighteen survivors arrived back in Cadiz, Spain, three years after setting out.

However, an age of discovery is also an age of doubt, doubt that what we know about the world is necessarily true. Thus not only the realm of geography underwent revision in the sixteenth century. The Reformation, as we have seen, was a period of intense religious inquiry and questioning and a radical assertion of the individual conscience against the authority of an institutionalized orthodoxy. In asserting that authority resided in the independent heart of each Christian, Luther echoed the humanist trend away from a concern with religion and toward a concern with humanity. Luther's emphasis on individual conscience, on private judgment, and the individual act of faith put the Reformation firmly in the context of a larger cultural transformation that would lead eventually to developments in the secularization of society and the rise of scientific investigation. Scientific study became a secularized activity.

Nicolas Copernicus. It was in the spirit of geographical "discovery" of the world that the Polish astronomer NICOLAS COPERNICUS [koh-PUR-nikus] (1473–1543) published *On the Revolutions of Celestial Bodies* in the year of his death. Building on the work of the Ancient Greek geographer and astronomer Ptolemy, whose writings had been rediscovered and translated in 1410, Copernicus argued that earth and the other planets orbit the sun, rather than the sun and planets revolving around earth. Theologians, Protestant and Catholic alike, refused to believe this—that the earth was not at the center of the universe. Copernicus's book was placed on the Index of Prohibited Books in 1616. But Copernicus's work could not be suppressed. Though the sun *appeared* to move across the sky, it was the earth that was moving in relation to a stationary sun. The appearance of things was not necessarily or empirically true. Other scientists drew a lesson from this.

The New Scientists. In England, FRANCIS BACON (1562–1626) would further the cause by advocating a new "scientific method" in which careful and objective observation of the appearances of things needed to be made in scrupulously controlled experiments. All scientific hypotheses needed to be tested and proved; there was no room in science for blind "faith."

Copernicus's new vision of the universe was just one among many important discoveries. In the same year that he published *On the Revolutions of Celestial Bodies*, ANDREAS VESALIUS [vi-SAY-lee-es] (1514–1564) published his *Seven Books on the Structure of the Human Body*, which illustrated the musculature and anatomy of the human body in unprecedented detail. In England, Sir William Harvey soon discovered the existence of

Map 14.2 The Reformation in Europe, ca. 1560.

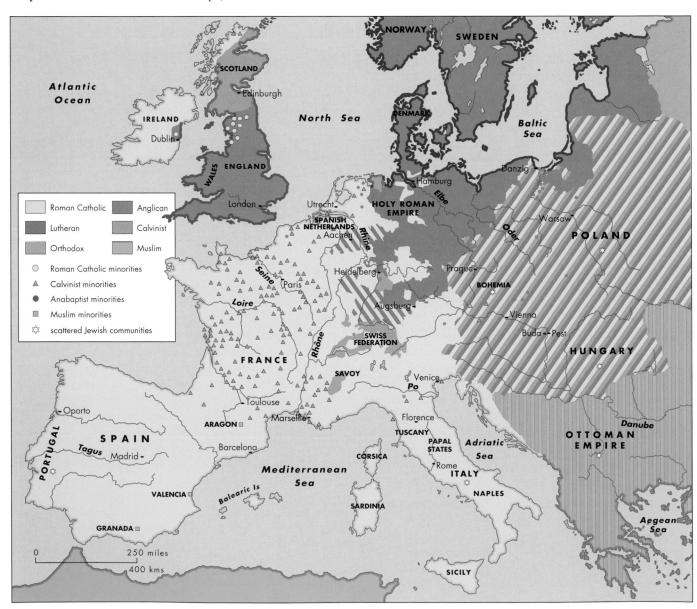

capillaries in the human circulation system, solving the mystery of how blood returned to the heart from the arteries. The English mathematician John Napier [NAY-pee-er] discovered the logarithm, freeing mathematicians forever from long and arduous calculations. Even map-making itself was dramatically improved when, in 1542, GEMMA FRISIUS [FREE-zi-yus] discovered new principles for increasing accuracy in surveying, using the technique of triangulation.

PAINTING AND PRINTMAKING

Albrecht Dürer. If any artist in the north can be said to embody the ideals of the Renaissance and the spirit of discovery that had begun to define it, it is ALBRECHT DÜRER [DYOU-ruhr] (1471–1528), painter, printer, draftsman, theoretician, writer, humanist, and publisher—the very image of the multi-talented Renaissance individual. His lifetime artistic output was enormous, with more than a hundred paintings and over a thousand drawings and prints.

Dürer was born in Nuremberg [NOOR-em-burg]; his mother was a German, his father a Hungarian goldsmith. Like his Italian counterpart Leonardo da Vinci, and subscribing to the general Renaissance interest in the real world, Dürer was fascinated with nature and studied it intensely. An example is his meticulous 1502 watercolor rendering of a rabbit (fig. 14.10). Throughout his career, Dürer made various studies of animals, birds, and plants, all sketched or painted "from life." However, the rabbit

Figure 14.10 Albrecht Dürer, *Rabbit*, 1502, watercolor, $10'' \times 9''$ (25.1 \times 22.9 cm), Albertina, Vienna. Indicative of the Renaissance interest in nature, Dürer drew this rabbit from life. But rather than working out-of-doors, as would later artists, he worked in his Nuremberg studio.

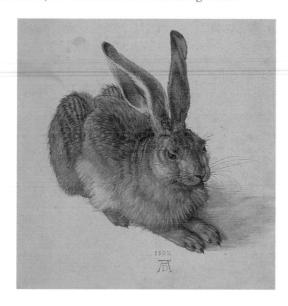

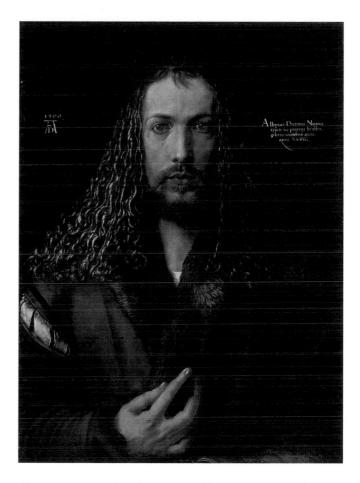

Figure 14.11 Albrecht Dürer, Self-Portrait, 1500, oil on panel, $26\frac{1}{4} \times 19\frac{1}{4}$ " (66.3 × 49 cm), Alte Pinakothek, Munich. Dürer, carrying the Renaissance interest in the self further than most, completed several self-portraits throughout his life. Here, hardly subtle, Dürer depicts himself in Christ-like mode.

was a stuffed one that Dürer painted in his Nuremberg studio.

The artist produced a significant number of self-portraits. In some, such as the *Self-Portrait* of 1500 (fig. 14.11), he recorded himself in a most self-congratulatory way, suggesting not only a Renaissance emphasis on the individual imagination but also on his sense of his own genius. "Art," he wrote, "derives from God; it is God who has created all art; it is not easy to paint artistically. Therefore, those without aptitude should not attempt it, for it is an inspiration from above." Dürer believed that he was endowed with a God-given gift, a humanistic and individualistic view that he shared with Michelangelo.

This Self-Portrait displays the fine finish and meticulous execution of the Flemish oil technique. Dürer shows himself against a black background, in a full-frontal stare. The effect is rigid, commanding, and deliberately Christ-like. Also, it looks amazingly real; it was reported that a dog barked and wagged its tail at one of his self-

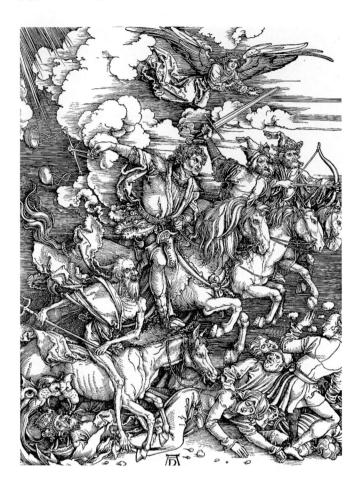

Figure 14.12 Albrecht Dürer, Four Horsemen of the Apocalypse, 1497–98, woodcut, $15\frac{1}{2} \times 11\frac{1}{8}''$ (39.4 × 28.3 cm), Metropolitan Museum of Art, New York. Dürer's genius elevated graphic art (printmaking) to a fine art. When making a woodcut, the artist draws a reverse image on a block of wood, then cuts away the wood from the drawing. The remaining raised areas of the wooden block are inked, the paper is pressed onto the block, and an image of the raised area is made.

portraits. He emphasizes the long fingers of his hand—the hand with which he created this image, through which his God-inspired gift is made manifest. From the turn of the century on, Dürer signed and dated much of his work, using the initials "AD," as seen on the upper left. The painting is inscribed, "Thus I, Albrecht Dürer from Nuremberg, painted myself with indelible colors at the age of 28 years."

Despite his genius at painting, much of Dürer's fame derives from his skill as a printer. In woodcuts and engravings, the precision and detail of his work, the richness of its effects and their variety, raised the standard of printing from a pedestrian craft of illustration to a fine art in its own right. Working without color and on the small scale of a piece of paper, Dürer was able to achieve an extraordinary sense of monumentality. Among the several series of prints Dürer produced on specific sub-

jects is that of the Apocalypse, published in 1498. This consisted of fifteen woodcuts with the text printed on the back of each sheet of paper. Reissued several times, it had great influence on Dürer's contemporaries and did much to spread his fame. From the *Apocalypse* series comes the gruesome Four Horsemen of the Apocalypse (fig. 14.12). Death, War, Pestilence, and Famine are shown to ride rampant over the earth, specifically over the burghers, artisans, merchants, and other citizens of Nuremberg. This is a woodcut, in which the negative, or white (nonprinted), areas of the final print are cut into the block and the black areas are left uncut, thereby raised in relief. Ink is rolled over the surface, paper is placed on the inked surface, and the image transferred to the paper simply by applying pressure to the back of the paper. Dürer's enormous skill becomes readily apparent when one considers how carefully such a complex image, with its dynamic and dramatic sweeping movements and forceful expressiveness, must be cut. Working in a refined technique with the highest level of technical dexterity, the artist executed the details on a seemingly microscopic scale.

Figure 14.13 Albrecht Dürer, Adam and Eve, 1504, engraving, $9\frac{7}{8} \times 7\frac{5}{8}''$ (25.1 × 19.4 cm), Philadelphia Museum of Art, Philadelphia. In an engraving, the recessed areas are printed. The artist cuts the lines into a metal plate, the recessed lines take the ink, paper is applied to the inked plate, and the ink transferred to the paper by the pressure of a printing press.

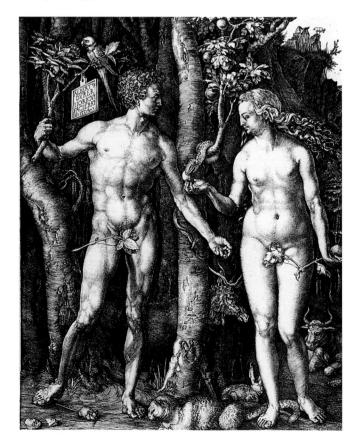

Adam and Eve (fig. 14.13) is an engraving, signed and dated on the plaque on the tree branch, "Albrecht Dürer of Nuremberg made this in 1504." Unlike a woodcut, an engraving is printed from a design inscribed in the surface of a metal plate. Using a sharp burin or steel gouging tool, the design is cut into the surface of the plate. Ink is forced into these recesses and the surface of the plate is wiped clean. Damp paper is then placed on the inked plate. The pressure exerted by a printing press is required to force the paper into the recesses to pick up the ink. For both engravings and woodcuts, the image that is printed is the reverse of the original, so artists had

After studying art in Italy, Dürer became increasingly interested in the human figure, and the subject of Adam and Eve was essentially an excuse to depict ideal male and female nudes. Dürer used mathematical proportions and drew from a male model and from Italian works and interpretations of antiquity. He created an Adam similar to the Hellenistic Greek *Apollo Belvedere*, which had been recently discovered, and an Eve like the *Venus de Milo*.

to draw "backwards."

Dürer believed that a person's physical shape was influenced by one of the four temperaments, a notion derived from classical philosophy. The animals in the detailed background of *Adam and Eve* symbolize these temperaments: the cat is choleric (angry, irate); the rabbit sanguine (confident, optimistic); the elk melancholic (depressed); and the ox phlegmatic (impassive).

In 1515 Dürer was made court painter to Emperor Maximilian I—an important position and a great honor. Now among the rich and famous, Dürer had a shop of people working for him. In later years he worked more and more on theories of measurement and proportion. Like Leonardo da Vinci, Dürer relied on Vitruvius's scheme of human proportions, and in 1525 he published The Teaching of Measurements with Rule and Compass (Manual of Measurements) and later Four Books on Human Proportions. Concerned with practical application, Dürer designed devices to aid the artist in doing perspective drawings. In all, his interests in antiquity, the natural world, anatomy, and perspective were analogous to those of his Italian contemporaries.

Although Dürer did paint and print religious subjects, including a Nativity, a Crucifixion, and a Lamentation, most were executed early in his career. In 1519, Dürer became a devout follower of Martin Luther, siding with the Protestants against the established Church. Perhaps because of his strong religious beliefs, however, his most sympathetic rendering of Jesus could be said to be his own self-portrait of 1500 (see fig. 14.11). As the Reformation gained momentum, and as iconoclasm took hold, painters in the north turned more and more to secular subjects. In fact, Dürer was most renowned and appreciated for his more secular work, which is hardly surprising given the climate of the times.

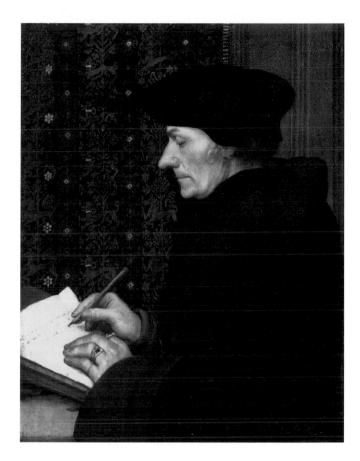

Figure 14.14 Hans Holbein the Younger, Erasmus of Rotterdam, ca. 1523, oil on panel, $16\frac{1}{2} \times 12\frac{1}{2}''$ (42 × 31.4 cm), Musée du Louvre, Paris. Holbein's portrait of the Dutch humanist Erasmus, shown as he records his ideas, conveys his intellectual authority.

Hans Holbein the Younger. The art of HANS HOLBEIN THE YOUNGER [HOLE-bine] (1497/98-1543), reflects this increasing secularity. Holbein's fame grew from his great skill at portraiture, and he painted many important figures. Born in Augsburg into a family of artists, he worked in the shop of his father, Hans Holbein the Elder, and he also studied in Basel, in Switzerland, where in 1519 he set up shop. Around 1523, Holbein painted Erasmus of Rotterdam (fig. 14.14), a portrait of the famous Dutch humanist who had settled in Basel in 1521. Holbein revered Erasmus, became his close friend, and portraved him several times. Erasmus is shown almost half-length, in profile, calm and noble. Using the carefully crafted Flemish oil technique, Holbein created a perfectly balanced arrangement of light and dark tones, a decoratively patterned surface, and a delicate modeling.

Erasmus provided Holbein with letters of introduction to the English court, where he was to become famous. In 1536 Holbein became court painter to Henry VIII, making portraits of the king and his family. In his depiction of Henry VIII (see fig. 14.8) the King wears

wedding dress, fairly typical attire in view of his six marriages. One of Holbein's jobs as Henry's court painter was to paint portraits of his prospective brides. Holbein's working method was to begin with a chalk sketch, the face drawn in careful detail, the body and costume loosely indicated. Later, the portrait was painted in his studio, the face reproduced almost exactly with color added, and the garment made very elaborate and detailed. The sitter could send to Holbein's studio any garment she or he wished to be shown wearing. No one was expected to pose motionless while waiting for Holbein carefully to craft every puff and pleat.

More than mere likenesses, these portraits display exquisite line and sensitive modeling with little concern for spatial illusion. Holbein may have varied the format of his portraits, but he always made the figure look dignified and emotionally composed; thus he was very popular.

Pieter Bruegel the Elder. In contrast to Holbein's work at court, PIETER BRUEGEL THE ELDER [BROY-gul] (ca. 1525–1569) portrayed the peasantry and the countryside. Little is known about his life. When he was born remains uncertain; where, perhaps in Flanders. He was well educated, but he chose not to portray the upper class. He went to Rome to study humanism, classicism, and the new trends, but the trip seems to have had little impact on his art. In 1563 he married his teacher's daughter and moved from Antwerp to Brussels where he was to remain until 1569. His two sons became painters.

Bruegel earned considerable income by imitating the paintings of Hieronymus Bosch, which were extremely popular by the middle of the sixteenth century. But his best paintings depict the peasants and inhabitants of small towns and record the daily life of ordinary people, a type of work that has come to be known as **genre painting**. Typical of his paintings is the *Harvesters* (fig.

Figure 14.15 Pieter Bruegel the Elder, *Harvesters*, 1565, oil on panel, $3'10\frac{1}{2}'' \times 5'3\frac{1}{4}''$ (1.18 × 1.61 m), Metropolitan Museum of Art, New York. A genuine interest in landscape as a subject, rather than as mere background, first appears in Bruegel's series of paintings depicting the seasons and their corresponding labors.

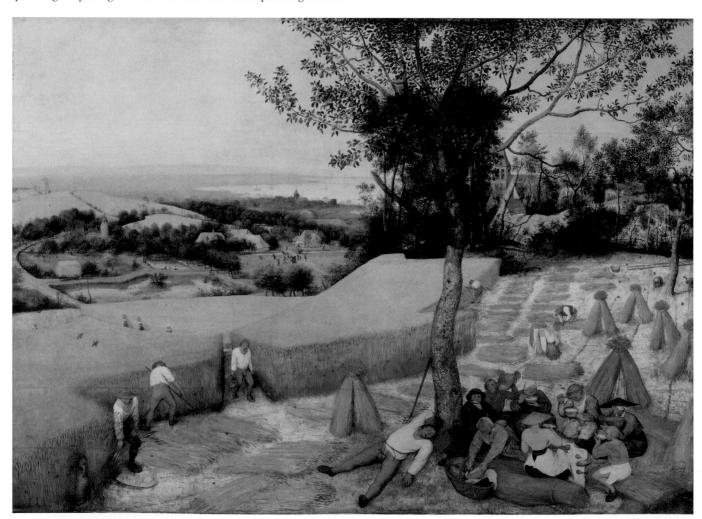

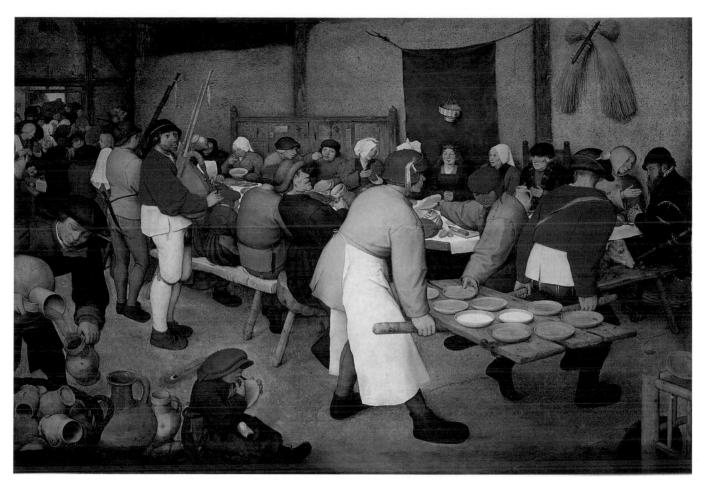

Figure 14.16 Pieter Bruegel the Elder, *Peasant Wedding*, ca. 1566–67, oil on panel, $3'8\frac{7}{8} \times 5'4''$ (1.10 × 1.60 m), Kunsthistorisches Museum, Vienna. Unlike his contemporaries, Bruegel was concerned not so much with the individual as with the type and, in particular, with the peasant class.

14.15) of 1565. Bruegel was commissioned to paint a series of scenes of the months of the year with, presumably, one painting representing every two months; the *Harvesters* represents August and September. Bruegel gave the landscape itself prominence; it no longer served merely as a setting for a portrait or religious event. Theoretically, the wheat is being harvested; in fact, most of the people in the scene are not working but sleeping, eating, or playing. Interested in basic human behavior, Bruegel signed his drawings "*Nart het leven*"—"Made from life."

The Limbourg brothers (see Chapter 12) had completed a series on the months of the year in their Book of Hours in 1416. What is new in Bruegel's paintings is the way in which the landscape is shown. The figures, rather than being placed in front of a landscape background, are now fully integrated into the setting. The colors convey the feeling of a warm summer afternoon—rich yellows and tans in the foreground, cool greens in the background.

Another famous painting of peasant life is Bruegel's *Peasant Wedding* (fig. 14.16), of ca. 1566–67. In this record of country wedding practices, the bride sits before

a dark hanging cloth smiling shyly, hands clasped. Two men carrying bowls of rice pudding on wooden planks create the foreground. The bagpiper looks on at this dessert which, because rice was not a local product, was considered a speciality.

Although the composition of the *Peasant Wedding* appears informal, it is in fact carefully constructed. The foreground is reinforced by the figures in the lower left, including a child licking his fingers. The arrangement in space is diagonal; the diagonal line of the table continues with the plank on which the dessert is served. Rather than modeling his figures with highlights and shadows, Bruegel used flat areas of color and simplified forms to create a decorative, patterned quality. His strong, stocky figures convey the robustness and earthy liveliness of the peasants.

ARCHITECTURE

During the Renaissance, a significant number of castles were built in northern Europe. As the economic situation

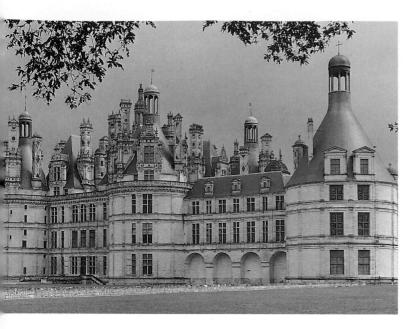

Figure 14.17 Domenico da Cortona (?), Château of Chambord, Loire Valley, begun in 1519, north facade. Ascend the monumental double-spiral staircase to the roof—where a little town has been constructed atop this extraordinary castle.

improved and the merchant class rose in importance, secular patronage of the arts grew, along with the interest in personal luxury and the display of wealth as a means of gaining and maintaining power and prestige. Castles were an effective means of showing one's importance. The most splendid of these were the **châteaux** (castles) of France. A concentration of Renaissance castles is found in the Loire [LWAR] valley, which was an especially agreeable area because of its fine climate and abundant game.

Château of Chambord. Perhaps the most extraordinary of the French Renaissance châteaux is that of Chambord [sham-BORE] (fig. 14.17), begun in 1519 for the king, Francis I. The original architect is believed to have been an Italian, DOMENICO DA CORTONA [dah kor-TOE-nuh] (d. 1549). The largest of all Renaissance châteaux, Chambord has 440 rooms, 365 chimneys (one for every day of the year), fourteen big staircases, and seventy smaller staircases. The plan of Chambord is that of a medieval castle with a central keep, four corner towers, a surrounding wall, and, originally, a moat. Yet Chambord was built not for defense but for display.

The château at Chambord has two extraordinary features, one of which is outside, the other inside. Outside, on the flat roof, is a tiny town with winding streets, squares, and turrets. To walk on the roof is to wander within an intricate, overgrown sculpture, a sort of fairyland in the sky. Inside, the main attraction is the central double-spiral staircase. The spiral in itself was not novel,

but no one had attempted a double one before. It is built within a circle 30 feet in diameter and 80 feet high, going up to the roof. The two spiral staircases intertwine, but do not meet—two people on opposite staircases can see each other across the central well, but they cannot touch.

Hardwick Hall. Although in terms of novelty English architecture lagged behind that of Italy and France, England's fortified castles with massive walls and small windows gradually gave way to airy homes with huge glass windows. These were built for the newly enfranchised nobility created by Henry VIII, when he granted monastery and Church lands to his supporters. When the monasteries fell, the new English aristocracy started to build enormous country houses. Hardwick Hall (fig. 14.18), built in 1591–96 and probably the work of the leading English architect ROBERT SMYTHSON [SMITH-son] (ca. 1535–1614), is one example. It was built for the extremely able and determined Elizabeth of Shrewsbury, also known as Bess of Hardwick, who amassed a fortune not only from her four marriages but as a businesswoman in her own right. Along with Queen Elizabeth I, she represents the growing power of women throughout Europe. Her initials are seen silhouetted several times along the roof line—a Renaissance assertion of the self.

The plan of Hardwick Hall is symmetrical and compact, built with a central great hall and square corner towers. The layout is innovatively arranged to separate rooms used for public functions from those kept for private activities. The floors were divided according to function and the more ceremonial the use of a room, the higher it was located in the house. Thus the great hall and the areas used by servants were on the ground floor;

Figure 14.18 Robert Smythson (?), Hardwick Hall, Derbyshire, 1591–96, facade. The importance of large windows as a sign of wealth is made clear by the comment, "Hardwick Hall, more glass than wall."

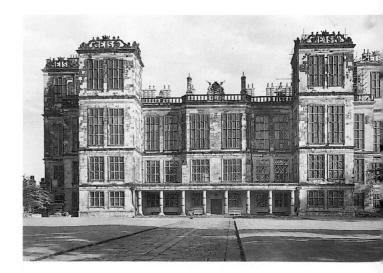

357

the private family apartments on the next floor; and the state rooms at the top of the house. This is the opposite plan of the southern Renaissance homes for families such as the Medici. Those residences had state and ceremonial rooms below and private quarters above (see Chapter 13). Hardwick Hall includes an invention of the English Renaissance, a **long gallery**—an unusually long room in which to take exercise when the weather is bad.

Hardwick Hall's massiveness and symmetry are characteristic of Elizabethan architecture. Its symmetry unifies the four facades and the building's extensive use of glass. Hardwick Hall was noted in particular for the great size of its windows, made memorable by the line coined at the time, "Hardwick Hall, more glass than wall," and indicating the importance and luxury of such large panes of glass. Note, too, that the size of the windows increases as the floors ascend, corresponding to the social uses of the floors.

SECULAR MUSIC

In keeping with the new emphasis on humankind during the Renaissance, secular music (music not associated with religious meanings or ceremonies) became increasingly popular. Giorgione and Titian's Fête champêtre (see fig. 13.39) documents this popularity in its depiction of people playing instruments. Unlike sacred vocal music, which typically set to music Latin or Greek texts, such as those used for the Mass, secular vocal music was composed for texts written in the vernacular, or common language spoken in a particular country or region. Although secular vocal compositions, such as madrigals, were written in many European languages including Italian, French, Spanish, German, Dutch, and English, there were two main schools of madrigal writing—English in the north and Italian in the south.

English Madrigals. The madrigal is a vocal piece composed for a small group of singers, usually with no accompaniment. Like sacred motets (religious texts set to a polyphonic composition), madrigals were composed in polyphonic style, with multiple voice parts. (For an explanation of polyphony, see Chapter 13.) Unlike motets, however, which were typically performed by a small choir singing the same text in polyphony, madrigals were often performed by a few singers, each of whom sang a different vocal part. The madrigal was particularly appealing to an educated audience and was thus a popular court entertainment. Castiglione's circle found the madrigal an enjoyable form of entertainment.

Typically settings of short lyric poems, madrigals were often about love and frivolity. Their language and musical settings were often witty. The madrigalist's challenge was to set the poem's text to music perfectly. Madrigalists often tried to outdo each other in finding musical expression for the passions described in the text. They were especially inventive in setting words associated with weeping, sighing, trembling, and dying.

Figure 14.19 Levina Bening Teerling (?), Elizabeth I as a Princess, ca. 1559, oil on oak panel, $42\frac{3}{4} \times 32\frac{1}{4}$ " (108.5 × 81.8 cm), The Royal Collection © Her Majesty Queen Elizabeth II, Windsor Castle, Windsor, England. The book is indicative of Elizabeth's love of learning and support of the arts.

Thomas Weelkes. A composer best known for his madrigals, THOMAS WEELKES [WILKS] (1575–1623) was the organist at Chichester Cathedral. His madrigal "As Vesta Was Descending" was included in an early sixteenth-century collection of madrigals, The Triumph of Oriana, composed in honor of Queen Elizabeth I (fig. 14.19). Written for six voices—two sopranos, alto, two tenors, and bass—Weelkes's madrigal was a setting of the following poem:

As Vesta was from Latmos hill descending, She spied a maiden Queen the same ascending, Attended only by all the shepherds swain, To whom Diana's darlings came running down amain:

First two by two, then three by three together, Leaving their goddess all alone, hasted thither, And mingling with the shepherds of her train, With mirthful tunes her presence entertain.

Then sang the shepherds and nymphs of Diana, Long live fair Oriana.

Weelkes takes advantage of the opportunities the poem affords for word painting. On the words "descending"

and "ascending," for example, he uses descending and ascending musical lines respectively. He also expresses musically the text's description of the attendants running "two by two, then three by three together, / Leaving their goddess all alone," by having first two singers then three, and finally all six join in before dropping back to a solo singer. Weelkes also uses fast notes for the words "running down amain," and he writes lively and upbeat music for the line "With mirthful tunes her presence entertain." Finally, for the word "long" in the last line, Weelkes provides singers with their longest held note. (For further explanation of word painting, see Chapter 13.)

Thomas Morley. Another well-known composer of madrigals was THOMAS MORLEY (1557–1603). Morley actually favored another form of vocal music: the **ballett**, a dancelike song for a variety of solo voices. The ballett differs from the madrigal in being composed mostly in **homophonic texture**, in which a single melody, not several, is employed with harmonic support. He also uses the same music for each stanza of the poem, with the nonsense syllables *fa-la* sung as a refrain. The playfulness of the music complements the playfulness of the words, which, as with much Elizabethan poetry, reveal a true love of the English language.

Morley's madrigal, "Now Is the Month of Maying," scored for five voices, describes the carefree flirting and courtship games common in the English countryside in spring. Morley's melody has a distinct and readily discernible rhythm and the easy tunefulness of a folk dance. It is structured in two parts, each of which is repeated and each of which concludes with the *fa-la* refrain. Here is the text:

Now is the month of maying, When merry lads are playing, *fa la*, Each with his bonny lass Upon the greeny grass. *Fa la*.

The spring, clad all in gladness, Doth laugh at winter's sadness, *fa la*, And to the bagpipe's sound The nymphs tread out their ground. *Fa la*.

Fie then! why sit we musing, Youth's sweet delight refusing? *Fa la*, Say, dainty nymphs, and speak, Shall we play barley break? *Fa la*.

The lyrics to both Weelkes's and Morley's madrigals depict delicate nymphs and good-natured shepherds, lighthearted diversions that appealed to the privileged classes.

LITERATURE

Michel de Montaigne. The fame of MICHEL DE MONTAIGNE [mahn-TAYN] (1533–1592) rests on his

Essays, a stunning example of Renaissance individualism grounded in humanism. Montaigne was one of the most learned individuals of his time, with a deep knowledge of the writers of Roman antiquity. His Essays, however, are distinguished less by depth of knowledge of the past than by a profound knowledge of the self.

Reflecting his respect for antiquity, Montaigne's early essays (in French, essais) contain numerous quotations from his reading. In his second book of essays, however, Montaigne relied less on the authority of the past and more on expressing his views in his own voice. In his third and last book of essays, Montaigne used quotations sparingly in presenting a vigorous self-portrait.

Montaigne said that he wrote about himself because he knew himself better than he knew anything else. In "Of Experience," he wrote that "no man ever treated of a subject that he knew and understood better than I do this ... and in this I am the most learned man alive." Montaigne notes, however, that like everything else in the world, he exists in a perpetual state of flux. "I must adapt my history to the moment," he wrote, for "I may presently change, not only by chance, but also by intention." And thus his books of essays represent "a record of diverse and changeable events, of undecided, and ... contradictory ideas."

Montaigne asks many questions in his essays, though without providing clear and singular answers. "Perhaps" and "I think" are among his most frequently used expressions, and "Que sais-je?" ("What do I know?") is his most recurring question. The very name he coined for the genre he created, essai, means trial or attempt, which suggests a process rather than a finished product, openness rather than conclusiveness, the journey itself and not the destination. It is one of the wonderful paradoxes of reading Montaigne that, as much as his essays reveal him, they also reveal readers to themselves. Montaigne's emphasis on questions rather than answers, coupled with a celebration of the individual, makes his work distinctly part of the Renaissance.

In his essay "Of Smells," Montaigne explores his own personal sense of smell and then poses some larger meanings for this sense. At one point he concludes that odors can affect the human mind and spirit, an idea that has gained currency today: "The doctors might, I believe, derive more use from odors than they do; for I have often noticed that they make a change in me and work upon my spirits according to their properties; which makes me approve of the idea that the use of incense and perfumes in churches, so ancient and widespread in all nations and religions, was intended to delight us and arouse and purify our senses to make us more fit for contemplation."

"Of Smells" exemplifies a kind of writing that did not exist before Montaigne invented it. Montaigne varied the kinds of essay he wrote without predetermining their form. Both writer and reader share in the mental explo-

Tragicall Historic of HAMLET

Prince of Denmarke

By William Shake-speare.

As it hath beene diuerfe times acted by his Highneffe feruants in the Cittie of London: as also in the two Vniuersities of Cambridge and Oxford, and else-where

At London printed for N.L. and John Trundell. 1603.

Figure 14.20 Title-page, *Hamlet* (1603), The Huntington Library, California. This is the title-page of the first quarto edition of the play that was printed.

ration, making it seem natural, familiar, unstudied. The modern writer Virginia Woolf put it this way: "This talking of oneself, following one's own vagaries, giving the whole map, weight, colour, and circumference of the soul in its confusion, its variety, its imperfection—this art belonged to one man only: to Montaigne."

William Shakespeare. WILLIAM SHAKESPEARE [SHAYK-speer] (1564–1616) is perhaps the greatest writer in the English language. His fame and popularity rest on his thirty-seven plays and 154 sonnets. What accounts for Shakespeare's popularity is his revelation of human character, especially his exploration of complex states of mind and feeling, and his explosive and exuberant language, particularly the richness and variety of his metaphors. His manipulation of language and his revelation of character are particularly evident in his soliloquies, those meditative reflections spoken aloud.

Shakespeare was born in Stratford-upon-Avon in April 1564. He attended the local school, but did not go on to Oxford or Cambridge. Instead, in 1582, at the age of eighteen, he married Anne Hathaway, who bore him three children in as many years. At that time Shakespeare began writing and acting in plays. Although many tributes have been paid to Shakespeare, one stands above the rest: his contemporary Ben Jonson's judgment that "he is not for an age, but for all time."

Shakespeare's soliloquies further reveal the human spirit. The following soliloquy from Act V, Scene i of *Macbeth* occurs when Macbeth discovers that though he is now king, his wife, Lady Macbeth, is dead:

Tomorrow, and tomorrow, and tomorrow
Creeps in this petty pace from day to day,
To the last syllable of recorded time;
And all our yesterdays have lighted fools
The way to dusty death. Out, Out, brief candle!
Life's but a walking shadow, a poor player
That struts and frets his hour upon the stage
And then is heard no more. It is a tale
Told by an idiot, full of sound and fury
Signifying nothing.

Written in **blank verse**—verse in unrhymed **iambic pentameter** (each line has ten syllables with alternating stresses)—the soliloquy portrays Macbeth's despair over the apparent meaninglessness of life. Shakespeare emphasizes life's brevity and fragility implied by the snuffed candle, and he compares life to a shadow, an insubstantial and dark reflection of reality.

Shakespeare's plays have captured the imagination of the world and assured his position as the greatest playwright of all time. The political astuteness of plays such as Julius Caesar and Antony and Cleopatra are complemented by the playful romanticism of comedies such as As You Like It and Much Ado About Nothing, and the more tempered romantic qualities of Shakespeare's final plays, of which The Tempest is the most glorious example.

The drama of Shakespeare's time, the Elizabethan Age (1558–1603), shares some features with Greek drama, though the Elizabethan dramatists extended the possibilities of both comedy and tragedy. The Elizabethan dramatists, including Shakespeare's contemporary Christopher Marlowe, wrote domestic tragedies, tragedies of character, and revenge tragedies, of which Shakespeare's *Hamlet* (fig. 14.20) is one of the most famous and the greatest examples. The Elizabethan dramatists also wrote comedies of manners and comedies of humors, which extended the range of earlier romantic and satiric comedies. In both Greek and Elizabethan theater, props were few, scenery was simple, and the dialogue alone indicated changes of locale and time.

An Elizabethan playhouse such as the Globe (fig. 14.21), where many of Shakespeare's plays were staged,

had a much smaller seating capacity than the large Greek amphitheaters, which could seat thousands. The Globe could accommodate about 2300 people, including roughly eight hundred groundlings who, exposed to the weather, stood around the stage. The stage itself projected from an inside wall into their midst. More prosperous spectators sat in one of the three stories that nearly encircled the stage. The vastly reduced size and seating capacity of the Elizabethan theater and the projection of its stage made for a greater intimacy between actors and audience. Though actors still had to project their voices and exaggerate their gestures, they could be heard and seen without the aid of large megaphonic masks and elevated shoes, as in the ancient Greek theater. Elizabethan actors could modulate their voices and vary their pitch,

stress, and intonation in ways unsuited to the Greek stage. They could also make wider and more subtle use of facial expression and gesture.

In addition to greater intimacy, the Elizabethan stage also offered more versatility than its Greek counterpart. Although the Greek *skene* building could be used for scenes occurring above the ground, such as a god descending from above by means of a crane (*deus ex machina*), the Greek stage was really a single-level acting area. Not so the Elizabethan stage, which contained a second-level balcony, utilized in *Othello* and in *Romeo and Juliet*, for instance. Shakespeare's stage also had doors at the back for entrances and exits, a curtained alcove useful for scenes of intrigue, and a stage-floor trapdoor, from which the ghost ascends in *Hamlet*.

Figure 14.21 Globe Playhouse, London, 1599–1613. This imaginative reconstruction by C. Walter Hodges depicts the open-air theater where *Hamlet* and other plays by Shakespeare were first performed.

Connections

SHAKESPEARE AND MUSIC

Shakespeare employs music in his plays for various purposes. He uses music to suggest a change in locale and time, indicating that the action of a play has shifted scene. Music signals the entrance or exit of an important character; trumpet flourishes announce the arrival or departure of royalty. Trumpets also sound a battle charge.

Music and Character Revelation

Perhaps the most important function of music in Shakespeare's plays is to reveal character. Shakespeare's characters disclose their states of mind through the songs they sing. In Hamlet, the young Ophelia reveals her unstable mental state through singing about love, loss, and death. In Othello, Desdemona, Othello's wife, conveys an ominous foreboding about her imminent death in the "Willow Song."

Musical Imagery

Shakespeare's plays are also rife with musical images. Some of these are simple passing references, such as those in Romeo and Juliet. When Romeo and Juliet part, Juliet cries out in disappointment, "the lark sings so out of tune, / Straining harsh discords and unpleasing sharps." Often, however, Shakespeare developed elaborate patterns of musical imagery. A striking example occurs when Hamlet speaks to his boyhood friends Rosencrantz and Guildenstern, who are about to betray him. In complaining about their deceit, Hamlet likens himself to a recorder, or flute, playing in the background:

HAMLET Why, look you now, how unworthy a thing you make of me! You would play upon me, you would seem to know my stops, you would pluck out the heart of my mystery, you would

sound me from my lowest note to the top of my compass; and there is much music, excellent voice, in this little organ, vet cannot you make it speak. 'Sblood, do you think I am easier to be played on than a pipe? Call me what instrument you will, though you can fret me, you cannot play upon me.

Act III, Scene ii, ll. 349-57

Dramatically, Shakespeare has the everalert Hamlet hear the musicians, then ask Guildenstern if he will play upon him as a musician plays upon a recorder. When Guildenstern responds that he doesn't know how to play the instrument, Hamlet presses him by comparing playing the recorder to the act of trying to find out what someone is really thinking, which is what Guildenstern has been doing all along. In this elaborated metaphor, everything Hamlet says proves to be literally true.

Composers and Instruments

Instruments used for Shakespearean music include brass, woodwind, strings, and percussion (fig. 14.22). Trumpets were the most frequently used brass instrument; wooden flutes and recorders of various sizes were the most common woodwind instruments. Stringed instruments included the violin, harp, lyre, and lute, among others. Percussion was almost always supplied by a tabor or drum, which often was accompanied by a fife, the smallest of the flutes.

Shakespeare did not compose the music that accompanied his plays. In Shakespeare's lifetime, his contemporaries, such as Thomas Morley, set his words to music, including "O Mistress Mine" from Twelfth Night, which Morley may have written at Shakespeare's request. Other music used to accompany songs included traditional arrangements that antedated the plays, as with the "Willow Song," sung by Desdemona in Othello, and the gravedigger's song "In Youth When I Did Love" from Hamlet.

Anon., Le Concert champêtre: la musique (The Musicians of a Country Concert), Italian School, sixteenth century. Musée de l'Hotel l'Allemant, Bourges, Giraudon/Art Resource, New York. Here is a depiction of a typical chamber music ensemble, consisting of a harpsichord, lute, recorder, and bass viol.

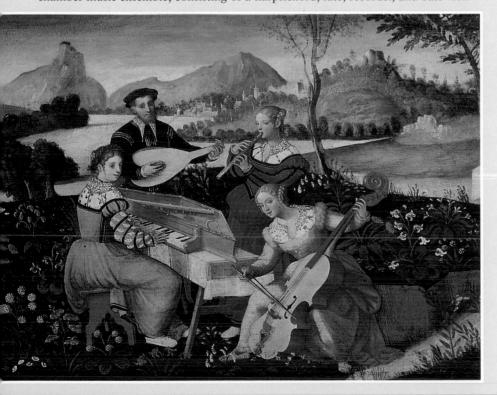

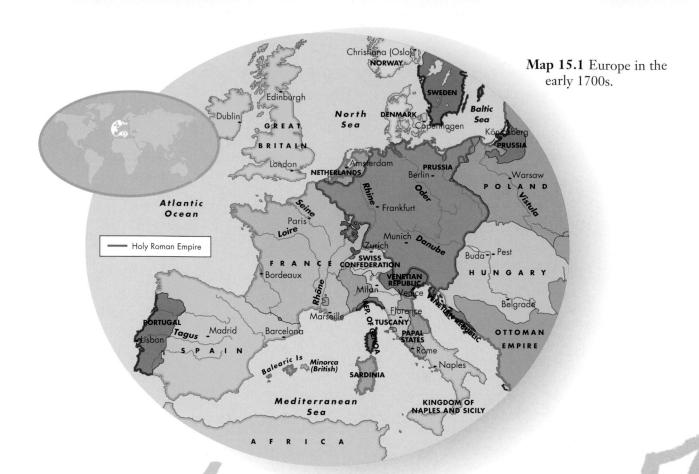

THE * BAROQUE AGE

CHAPTER 15

- + The Baroque in Italy
- ← The Baroque outside Italy

Caravaggio, Calling of St. Matthew (detail), ca. 1599-1602, Rome.

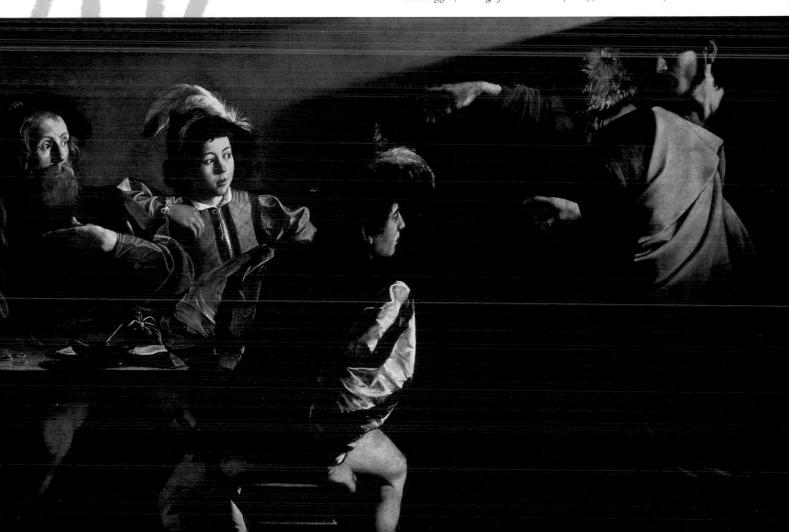

THE BAROQUE IN ITALY

The term **baroque**, from the Portuguese word *barrocco*, originally means a large, irregularly shaped pearl and was initially used as a pejorative, or negative, term. Gradually it came to describe the complex, multi-faceted, international phenomenon—it can hardly be called a style—of the Baroque. The Baroque is defined not so much in formal terms as in attitude and relationship to the audience. Baroque artists intended to involve their audiences emotionally. Formally, the style reflected a heightened realism and sense of motion in its creation of theatrical spaces, its use of classical elements in emotionally charged settings, its figurative sculpture, and in the surprising use of irregular forms in its architecture.

At least as important in defining the Baroque style is understanding the patronage that supported it. During the Counter-Reformation, Church-sponsored art in Rome thrived as it never had before. Though other secular patrons were equally important in the development of Baroque art (particularly Philip IV in Spain and Marie de' Medici and Louis XIV in France), the Church in Rome assumed the role of the center of the Baroque art world.

As pope succeeded pope, each brought with him an entourage of family and friends who expected and received lucrative positions in the government and who vied with each other to give expression to their newfound wealth and position. The popes commissioned palaces and chapels—along with paintings and sculptures to decorate them. Artists flocked to Rome to take

advantage of the situation. And since popes tend to be appointed late in life, their period in power was often short. The promise of a new pope, and with him a new family assuming the powers of patronage, was something that artists could, with some confidence, count on.

THE COUNTER-REFORMATION IN ROME

When Martin Luther posted his famous "Ninety-Five Theses" in 1517, Pope Leo X and the Catholic Church in Rome recognized the powerful threat that the Protestant Reformation represented. The Church sought to remake Rome as the cultural center of the Western world. The strategy it developed to defend Rome's prestige and dominion was continued for over a hundred years, culminating in the twenty-one-year pontificate of Urban VIII (1623–44). The Roman popes thus once again became the great patrons of art and architecture they had been in the early sixteenth century.

A theological justification for this patronage came at the Council of Trent, which convened in three sessions from 1545 to 1563 to address the crisis of the Reformation. The Council decided to "counter" the Protestant threat "by means of the stories of the mysteries of our Redemption portrayed by paintings or other representations, [whereby] the people [shall] be instructed and confirmed in the habit of remembering, and continually revolving in mind the articles of faith." The Council further suggested that religious art be directed toward clarity (to increase understanding), realism (to

Timeline 15.1 The Counter-Reformation in Rome.

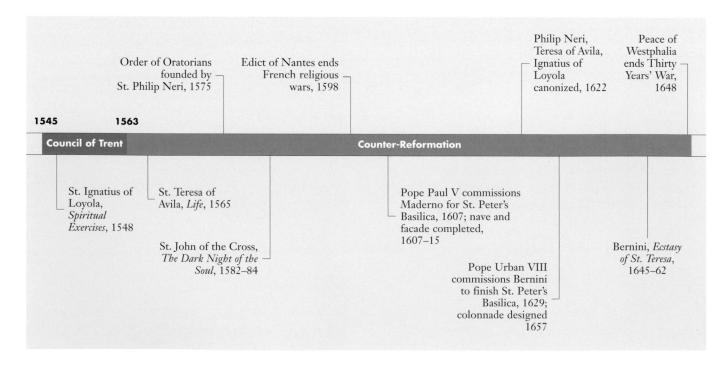

make it more meaningful in everyday fashion), and emotion (to arouse piety and religious fervor).

According to the Council's recommendations, art had to be easily understood; complicated allegories were discouraged. Music had to be accessible and lyrics intelligible; complex polyphonic writing was consequently also discouraged. Literature should celebrate religious values and ideals. These recommendations were designed to counter the ultra-refined and highly stylized paintings of the Mannerist period. Mannerist painting tended to be elegant, anti-naturalistic, technically virtuosic, highly decorative, complex in color and structure, and mythological or allegorical in content. Baroque art was to make direct religious statements on important subjects already familiar to the masses of uneducated common people. Still, from the Mannerists Baroque artists inherited a reliance on emotionally charged and dramatic action. The Council of Trent began a renewal of faith and a fresh stirring of spiritual feeling. Religious fervor was encouraged, through the increased psychological depth and broader emotional range of the Church's art and architecture, and through liturgies, rituals, and dogmas.

Out of the Council of Trent emerged two new religious orders, one for laymen, the Oratorians, and the other for clergy, the Jesuits. Both were of central importance to the religious mission.

The Oratorians. The Oratory movement was founded by a lay person, St. Philip Neri. The Oratorians were groups of lay Catholics who met informally for spiritual conversation, study, and prayer. They met not in churches but in prayer halls called **oratories**. They were not a religious order: they took no vows, and members could leave at any time. Music played an essential role in the religious devotions of the Oratorians, especially vocal music. The composer who was most important for them was Palestrina (see Chapter 13), whose *Laude*, or songs of praise, were easy to sing. Later, musical performances became increasingly dramatic. Eventually, they resembled unstaged miniature music dramas and were the forerunners of the oratorios written by George Frederick Handel.

The Jesuits. In 1534 the Jesuit order of Catholic priests was established by St. Ignatius Loyola, and there was nothing informal about the Jesuits' organization or goals. The order was to follow a militaristic discipline. Members followed strict vows of poverty, chastity, and obedience, while pursuing a rigorous education in preparation for their missionary role. Jesuit priests played an important part in the religious life of the age, serving as confessors and spiritual advisers to prominent artists such as Bernini and to political leaders, including Queen Christina of Sweden.

The most influential aspect of Jesuit spirituality derives from the work written by the order's founder, St. Ignatius. His *Spiritual Exercises*, published in 1548, were designed to guide believers through a sequence of

spiritual practices to intensify their relationship with God. The *Exercises* attempted to involve each of the senses so that the individual might obtain more than just an intellectual understanding of God. For example, when contemplating sin and hell, the soul is exhorted to consider in order: the sights of hell (flames); the sounds of hell (groans of the damned and shrieks of devils); the smells of hell (the fetid stench of corrupting bodies); the tastes of hell (the suffering of hunger and thirst); and the tactile experience of hell (the intense heat, which scorches the body and boils the blood).

Complementing the work of the Oratorians and the Jesuits were the writings of sixteenth- and seventeenth-century Spanish mystics such as St. John of the Cross, who wrote *The Dark Night of the Soul*, and St. Teresa of Avila, who wrote an autobiography. Both exhibited an uncanny ability to blend the contemplative life with a commitment to a life of action.

Philip Neri, Teresa of Avila, and Ignatius of Loyola were all canonized as Catholic saints in a single ceremony in 1622, during the papacy of Gregory XV. Not long after their canonization, the immense work of honoring these saints in painting, music, sculpture, architecture, and literature began. Their lives and miracles were celebrated; their worldly and spiritual missions were depicted. All this was aimed at strengthening the beliefs of the faithful and admonishing them to emulate the saints as well as honor them.

SCULPTURE AND ARCHITECTURE IN ROME

The Church's most visible St. Peter's Basilica. effort to arouse the piety of the people was the continued work on the new St. Peter's Basilica, work initiated by Pope Julius II in 1502 (see Chapter 13). In 1607, Pope Paul V commissioned CARLO MADERNO [mah-DEHR-no] (1556–1629) as Vatican architect to convert Michelangelo's Greek plan into a traditional Latin-cross plan complete with a new facade. There was a practical reason for this: the long nave of the Latin-cross plan provided space for more people to attend services. The interior space Maderno created was the largest of any church in Europe, actually capable of containing almost any other church within its massive interior. It is difficult to measure such vastness with the human eye and to fully appreciate its size. The experience is meant to evoke emotionally the spiritual vastness of God Himself.

Maderno's facade (fig. 15.1) followed Michelangelo's original conception of using colossal orders to unite the stories, and of topping the entrance by a triangular pediment. In fact, Maderno's composition is more theatrical than Michelangelo intended, with wings gesturing to center stage. Pope Paul V conceived of this as a backdrop to his own public appearances and required Maderno to design a balcony from which he could bless the people below. The architectural crescendo rises from the sides

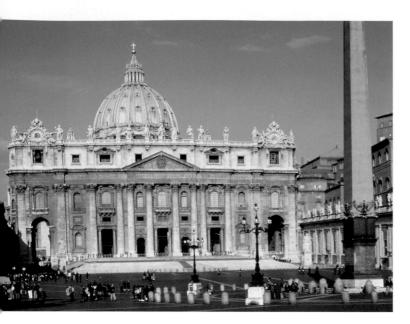

Figure 15.1 Carlo Maderno, facade of St. Peter's, Rome, 1607–15, height 147′ (44.81 m), width 374′ (114 m). The facade is treated like a theatrical performance that builds from the wings: starting from the corners, the pilasters double, then become columns, which then also double, and, finally, the center section seems to push out to meet the visitor.

of the facade toward the central portal: flat corner pilasters become columns, the columns then double, and the center facade projects forward.

Gianlorenzo Bernini. The theatricality of Maderno's facade was, to Pope Urban VIII, only a beginning. When Maderno died in 1629, Urban VIII replaced him with GIANLORENZO BERNINI [ber-NEE-nee] (1598–1680), who had collaborated with Maderno for five years. Bernini considered himself a classicist, but he fused his classicism with an extraordinary sense of the dramatic and the emotional. His sculpture and architecture in many ways define the chief characteristics of Baroque art.

In 1657, Bernini, now working for another pope, designed and supervised the building of a **colonnade** (fig. 15.2), or row of columns, for the giant open area in front of St. Peter's. Beginning in two straight **porticoes**, or covered walkways, the Doric columns extend down a slight incline from the church facade, then swerve into two enormous curved porticoes that surround and embrace the open space of the square, like "the motherly arms of the church," as Bernini himself put it (fig. 15.3). Forgoing the preferred square and circular forms of the Renaissance, Bernini's colonnade used an ellipse and a trapezoid, much more dynamic forms. In

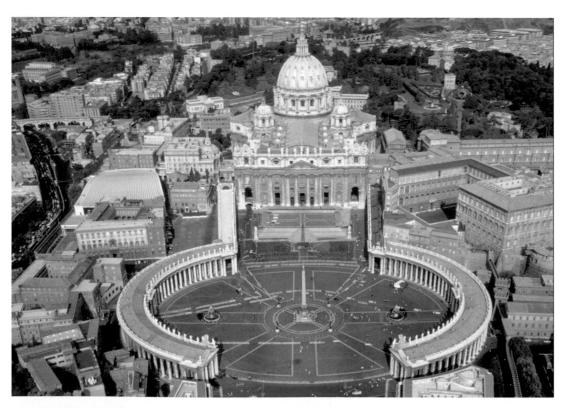

Figure 15.2 St. Peter's, Rome. Facade by Carlo Maderno, dome completed by Giacomo della Porta, and colonnade by Gianlorenzo Bernini. Bernini created an architectural environment for St. Peter's. The visitor passes through elliptical and trapezoidal spaces outlined by colonnaded porticoes before entering the immense basilica.

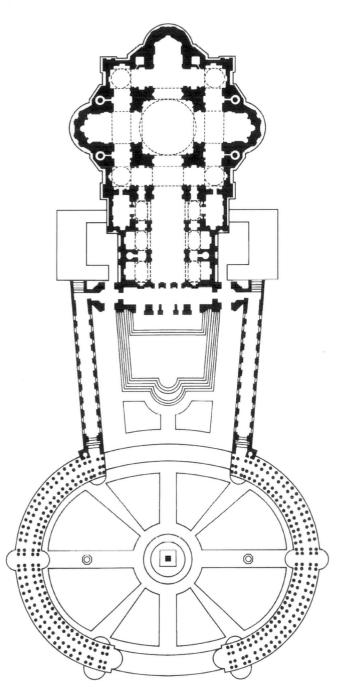

Figure 15.3 Plan of Bernini's colonnade. This plan illustrates the perfect half-moons of the colonnade and the radiating lines in the pavement of the piazza.

the center of the oval stands an **obelisk**, or four-sided shaft topped by a pyramid. From there, lines on the pavement radiate out to the colonnade. Finally, standing over each inner column is a different statue, creating an irregular silhouette along the top of the colonnade.

As Bernini's colonnade makes clear, the virtues of the classical were continually upheld in the Baroque age, but there is in the variety of statues across the top of the columns, for instance, a counter-tendency, a dedication to invention. This opposition between retaining tradi-

tional values and discovering new ones will continue to play a greater and greater role in the development of Western art well into the twentieth century.

Bernini was also commissioned to design an enormous cast-bronze **baldacchino** [ball-dah-KEY-noh], or canopy, for the main altar of St. Peter's (fig. 15.4). Nearly one hundred feet high, the work is at once sculpture and architecture, its twisted columns topped with a sphere, representing the universe, and a cross. Hanging down are tasseled bronze panels that imitate hanging cloth, and

Figure 15.4 Gianlorenzo Bernini, Baldacchino, 1624–33. Gilt bronze, height approx. 100′ (30.50 m), St. Peter's Basilica, Vatican, Rome. The bronze used to make the baldacchino was taken from the beams of the Pantheon roof (see chapter 5), giving rise to the saying, "What the Barbarians did not do, the Barberini have done."

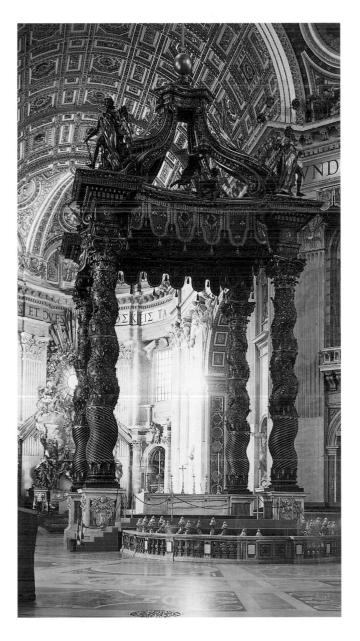

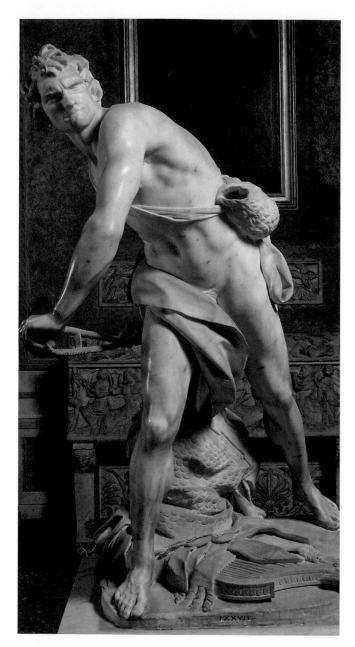

Figure 15.5 Gianlorenzo Bernini, *David*, marble, 1623, height 5'7" (1.7 m), Galleria Borghese, Rome. Unlike Michelangelo's static *David*, Bernini's is caught at the split-second of the action when its direction is about to reverse—much like the ancient Greek *Discus Thrower*. Bernini effectively indicates the position of the giant Goliath, something that is sensed by viewers, who quickly move out of the implied line of fire.

prominently embossed on them are honeybees and suns, and laurel leaves on climbing vines, the emblems of the Barberini, Pope Urban VIII's family. The baldacchino thus is a monument not only to St. Peter, over whose grave it stands, but also to Pope Urban VIII, who commissioned it.

As a child, Bernini had moved from Naples to Rome to study under his father. By the age of eight, he had

already carved marble sculptures of considerable merit. He spent much time drawing the Vatican collection, including the *Laocoon* and the work of Michelangelo and Raphael. His sculpture of David (fig. 15.5), carved in 1623 and characteristic of his style, deserves comparison to Michelangelo's High Renaissance David (see Chapter 13). In its realistic depiction of dramatic action, Bernini's work is closer to the ideals of Hellenistic sculpture as embodied in the *Laocoon*. Michelangelo's *David*, by contrast, seems restrained, controlled. Whereas Michelangelo depicts an unspecified moment before David's conflict with Goliath, Bernini captures the split-second before David releases from his sling the stone that kills the giant. Bernini's *David* implies the presence of a second figure to "complete" the action; it is David's pose and facial expression that indicate with precision the direction in which Goliath is to be found. The space surrounding the sculpture becomes charged with tension. So effective is Bernini in activating this space that people

Figure 15.6 Gianlorenzo Bernini, Ecstasy of St. Teresa, 1645–52, overview of Cornaro Chapel, height of figure group 11'6" (3.51 m), Santa Maria della Vittoria, Rome. This dramatic depiction of Teresa's written description is literally theatrical, for the chapel is arranged like a theater, complete with box seats occupied by marble figures of members of the Cornaro family.

Figure 15.7 Gianlorenzo Bernini, Cornaro Family in Theater Box, life-size figures, Cornaro Chapel, Santa Maria della Vittoria, Rome. By placing sculptures depicting his patrons in boxes at the side of the chapel, Bernini converts religious into theatrical space.

who come to view the statue find that they intuitively avoid standing between David and Goliath.

Bernini's sculptural *Ecstasy of St. Teresa* (fig. 15.6) is one of the most important works created to celebrate the lives of the Counter-Reformation saints. Bernini designed it for the Cornaro Chapel of Santa Maria della Victoria in Rome and positioned it in a huge oval niche above the altar, framed by green marble pilasters. Created between 1645 and 1652, the multimedia sculpture depicts the moment in St. Teresa's autobiography when she says an angel pierced her heart with a flaming golden arrow, causing her to swoon in religious ecstasy—simultaneous pleasure and agony. "The pain was so great that I screamed aloud," she wrote, "but at the same time I felt such infinite sweetness that I wished the pain to last forever ... It was the sweetest caressing of

the soul by God." Abandoning Renaissance restraint, Bernini captures the raw power of the narrative by portraying the sensual reality of her experience, evoking an emotional response in the viewer.

To the left and right of the depiction of St. Teresa, Bernini created theater boxes containing marble spectators, who, like us, witness the highly charged, theatrical moment (fig. 15.7). These spectators are Bernini's patron, Cardinal Federigo Cornaro, his deceased father, and the six other cardinals in the Cornaro family. While two read from prayer books, others talk among themselves, and one leans out as if to look at us as we enter the chapel. This setting makes Bernini's—and the Baroque's—dramatic intentions clear. It is as if, like the Cornaro family, visitors are witness to Teresa's actual swoon.

Francesco Borromini. A nephew of Carlo Maderno, FRANCESCO BORROMINI [bor-ro-MEE-nee] (1599–1667), joined his uncle in Rome in 1619 and soon was working for Bernini on the baldacchino in St. Peter's, some aspects of which are now attributed to him. So powerfully innovative was his sense of design that Borromini soon became Bernini's chief rival in Rome, reasserting the importance of originality, experimentation, and self-expression that had characterized Mannerist art. Very different in personality from the worldly Bernini, Borromini was a secretive and unstable man whose life ended in suicide.

New chapels had to be designed and constructed to celebrate a noble family's promotion, or else older chapels, those associated with the cardinals (often nephews of the pope), required redecoration. Francesco Borromini is best known for his design of one such little chapel, San Carlo alle Quattro Fontane (fig. 15.8), or St. Charles of the Four Fountains, named for the fountains on the junction of four streets where it is located in Rome. The interior of the church was designed between 1638 and 1641, and the facade between 1665 and 1667. On a tiny and irregular plot, Borromini built a tiny and irregular church. San Carlo could fit easily within Saint Peter's. Deviating from the classical tradition in architecture, the columns are of no known order—instead, Borromini designed a new order of his own. Rather than building with the traditional flat surfaces of ancient architecture, Borromini designed this fantastic facade, seemingly elastic, to curve in and out, the stone appearing to undulate in a serpentine concave-convex motion. So three-dimensional is this facade that it almost becomes sculpture, the light and shade pattern created by its ripples and recesses evoking its own drama in Rome's brilliant sunlight.

Borromini designed San Carlo alle Quattro Fontane with a double facade, a clever solution to a practical problem. The church faces a small intersection; it is not possible to stand back far enough to view the facade in its

Figure 15.8 Francesco Borromini, San Carlo alle Quattro Fontane, 1638-67, width of facade 34' (10.36 m). Because this church is located at an intersection of narrow streets, the viewer cannot easily see the entire facade. Borromini therefore created two separate compositions, undulating and sculptural, linked by the entablature of the lower story that forms a balcony for the upper story.

entirety. Borromini's double facade divides the surface into two smaller compositions, yet the entablature of the lower story forms the balcony of the upper story, typical of the Baroque concern for total unity of design.

Borromini's extravagance was immediately popular. The head of the religious order for whom San Carlo alle Quattro Fontane was built wrote with great pride: "Nothing similar can be found anywhere else in the world. This is attested by the foreigners who . . . try to procure copies of the plan. We have been asked for them by Germans, Flemings, Frenchmen, Italians, Spaniards, and even Indians."

PAINTING IN ITALY

As with sculptors and architects, the demand for painters during the Counter-Reformation was enormous. While some were hired to work permanently for a given patron. by far the majority worked in studios in Rome, displaying their works in progress and gladly accepting commissions from all comers. Competition for the best artists was fierce, and as a result they could demand fees that greatly increased their social standing.

Caravaggio. One of the most important art patrons was Cardinal Scipione Borghese, nephew of Pope Paul. Borghese's villa contained a vast quantity of paintings and frescoes and was set in a large park full of niches and statuary. One of Borghese's favorite painters was CAR-AVAGGIO [ka-ra-VAH-joh] (1573-1610), whose real name was Michelangelo Merisi but who took his name as a painter from his birthplace, the village of Caravaggio near Milan. Borghese acquired many of the artist's works after his death. Caravaggio was a bohemian artist with a terrible temper who led a short and turbulent life (with a long police record bordering on the criminal). Despite his lifestyle, Caravaggio was a great religious painter whose work established one of the two major directions of painting in the Baroque age.

Caravaggio painted the Calling of St. Matthew (fig. 15.9) in about 1599-1602 for the private chapel of the Contarelli family in the Church of San Luigi dei Francesi in Rome. A large oil painting on canvas, it depicts the climactic moment of Matthew's calling. Caravaggio deftly portrays the psychological action and reaction of the moment (as told in the Bible, Matthew 9:9). Jesus points to the tax collector Matthew, who gestures with disbelief toward himself, as if to say, "Who? Me?"

This biblical tale is shown in the everyday environment of a Roman tavern and is enacted by people who could have been Caravaggio's contemporaries (who were indeed probably the models for the work). Although Matthew and his associates are richly attired, the two figures on the right are in rags. Jesus's halo is barely visible. Yet a religious atmosphere is created by Caravaggio's dramatic use of light, known as tenebrism—a "dark

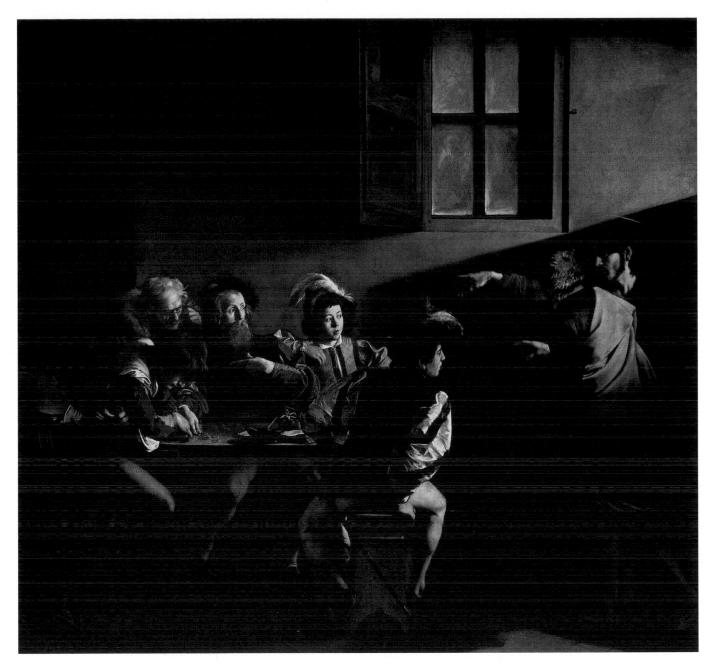

Figure 15.9 Caravaggio, Calling of St. Matthew, ca. 1599–1602, oil on canvas, $11'1'' \times 11'5''$ (3.38 \times 3.48 m), Contarelli Chapel, San Luigi dei Francesi, Rome. Although Matthew is seated in a tavern when he receives Jesus's call, Caravaggio uses tenebristic lighting to reveal the religious nature of this event.

manner," in which light and dark contrast strongly, the highlights picking out only what the artist wants the viewer to see. The light comes from above, like a spotlight centering on an actor on stage, but no obvious light source is shown.

Caravaggio also painted the *Entombment* (fig. 15.10), executed in 1603 for a chapel in Santa Maria in Vallicella, Rome, the church of St. Philip Neri's Congregation of the Oratory. Nothing distracts from the painting's emotional impact. The unnatural theatrical light reveals only

a hint of the setting; clarity is achieved by Caravaggio's highlighting of select figures and features. The platform on which his figures stand is at the viewers' eye level and seems to extend into the viewers' space, increasing the impact of the scene by drawing them toward it, and making them feel virtual participants in the event. Indeed, the implication is that the viewers stand in the tomb itself, about to receive Jesus's body from the bending foreground figure who looks down on them. The physical labor required to lower the body is almost palpable.

The *Entombment* makes the words of the sermon visible, explicit, almost tangible. Caravaggio portrays Jesus's associates as people much like himself. He refused to raise his subjects to the level of the heroic, as had customarily been done. This aspect of Caravaggio's art was not well received by his contemporaries, who felt he had gone too far in reducing the barriers between heaven and earth.

Artemisia Gentileschi. The emotional and dramatic side of the Baroque is demonstrated also by ARTE-MISIA GENTILESCHI [jen-tee-LESS-kee] (1593–ca. 1653). Born in Rome, her style seems to have been influenced by that of her father, Orazio Gentileschi, a painter in Caravaggio's style. She was herself known as one of several "Caravaggisti," or "night painters," those whose work was identifiable by its use of tenebrism.

Figure 15.10 Caravaggio, *Entombment*, 1603, oil on canvas, $9'10\frac{15}{8}'' \times 6'7\frac{15}{16}''$ (3.00 × 2.03 m), Musei Vaticani, Pinacoteca, Rome. The painting's impact is enhanced by bringing the figures close to the picture plane. By locating the stone slab at eye level, Caravaggio suggests the viewer is actually in the tomb, ready to receive Jesus's body.

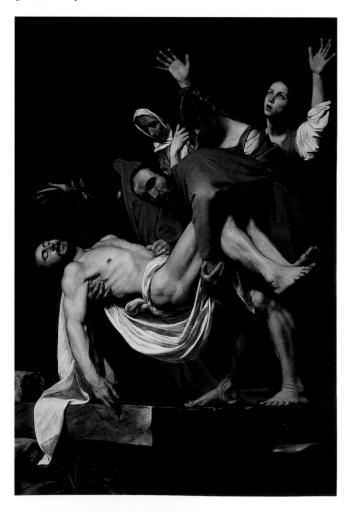

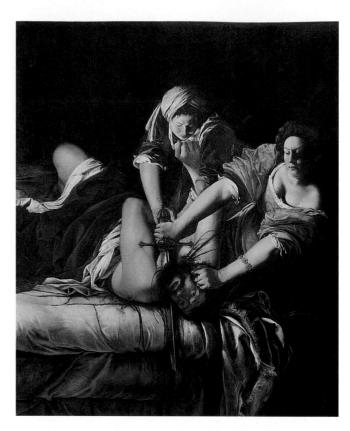

Figure 15.11 Artemisia Gentileschi, *Judith Slaying Holofernes*, ca. 1620, oil on canvas, $6'6^{\frac{1}{2}''} \times 5'4''$ (1.99 × 1.63 m), Galleria degli Uffizi, Florence. Drama and horror are magnified by the proximity of the figures and by the powerful spotlight focusing attention on the beheading, leaving all else in shadow.

Gentileschi's paintings often depicted the popular biblical subjects of Bathsheba and David and of Judith and Holofernes. Her *Judith Slaying Holofernes* (fig. 15.11), painted ca. 1620, effectively conveys a sense of intrigue and violence. The beautiful Jewish widow Judith saved her people from Nebuchadnezzar's Assyrian army by enticing their leader, Holofernes, into a tent where he drank himself to sleep. She then cut off his head with his own sword. The unnerving drama is enhanced by the dark tenebristic lighting that spotlights the actors as if on stage. The large figures fill the picture and seem to press forward as if about to burst through the picture plane.

Her highly charged and emotional paintings have been linked to her own experience. Gentileschi was sexually assaulted at the age of fifteen by one of her teachers. Later she was tortured in court with a thumb-screw (a device designed to compress the thumb to the point of smashing it) to verify the validity of her accusation.

Annibale Carracci. Many Roman priests did not endorse the Caravaggisti style. They preferred the more "academic" approach to painting established in large part

Figure 15.12 Annibale Carracci, *Triumph of Bacchus and Ariadne*, 1597–1600, ceiling fresco, Palazzo Farnese, Rome. The academic classicizing trend of the Baroque exemplified by Annibale Carracci contrasts with the dramatic emotional approach of Caravaggio, Gentileschi, and their followers.

by ANNIBALE CARRACCI [car-RAH-chee] (1560–1609) of Bologna, who came from a family of painters. With his brother Agostino and his cousin Lodovico, Carracci set up a workshop, which led to the establishment of an art academy in Bologna in 1585. The guiding principle of the Carraccis' academy was that art could be taught, and that by examining the works of classical and Renaissance masters, and by long study of anatomy and practice in life drawing, a highly developed and "correct" style could be learned.

Annibale Carracci's greatest work is a large ceiling fresco, painted between 1597 and 1600, in the Palazzo Farnese in Rome, the palace of the powerful Jesuit Cardinal Farnese, himself from Bologna. Turning away from the Mannerist style, Annibale Carracci looked to the High Renaissance, to nature, and to antiquity. Curiously, Carracci painted scenes of love from Ovid's *Metamorphoses* for his very Christian patron. The scenes are painted within an architectural framework and fea-

ture twisting male nudes that recall Michelangelo's Sistine Chapel ceiling. Carracci's framing is intentionally illusionistic, made to appear as if lit from below, the shadows painted in. As on the Sistine Chapel ceiling, the individual scenes are treated as if they were easel paintings applied to the ceiling, without regard for the viewer's position below. The center is occupied by the *Triumph of Bacchus and Ariadne* (fig. 15.12). The happy procession has Baroque exuberance, yet in this classicizing Baroque style the appeal is largely intellectual rather than emotional. Action is carefully controlled, and figures do not appear to fly out of the picture. In this, it differs from the illusionistic ceiling frescoes that were popular in Baroque Rome.

Fra Andrea Pozzo. The epitome of the illusionist ceiling fresco was achieved by FRA ANDREA POZZO [POT-zoh] (1642–1709), in his depiction of the *Triumph of St. Ignatius of Loyola* (fig. 15.13), of 1691–94, on the nave ceiling of Sant'Ignazio, Rome. The effect is aston-

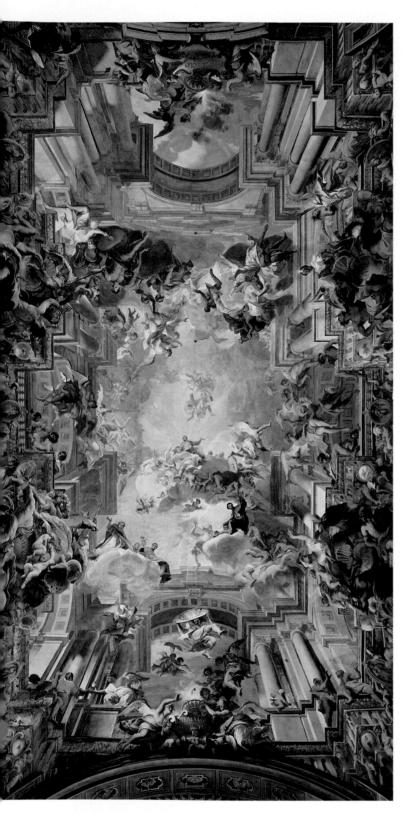

Figure 15.13 Fra Andrea Pozzo, *Triumph of St. Ignatius of Loyola*, 1691–94, ceiling fresco, Sant'Ignazio, Rome. If the viewer stands directly below the center of this quintessentially Baroque illusionistic ceiling painting, it is not possible to see where the actual architecture ends and the painted architecture begins.

ishing; the solid vault of the ceiling has been painted away. It is an extreme example of what the Italians called *quadrattura* and what the French call *trompe-l'oeil* illusionism, used to trick the eye into believing that the architecture of the church, its columns and arches, extends past the actual ceiling. This perspective is calculated to be seen from a specific point on the floor, which is marked. When standing there, it is difficult if not impossible to determine where the real architecture ends and the painted architecture begins. The center of the ceiling appears to be open sky from which saints and angels descend. Some sit on painted architecture or clouds; others fly through space in a dazzling display of Baroque artistic dexterity.

MUSIC IN ITALY

Claudio Monteverdi and Early Opera. It is hardly surprising, given the emphasis on dramatic theatricality so fundamental to Baroque painting, that the Baroque era produced a new musical form, known as opera. Opera is the Italian word for "a work," and opera drammatica in musica, "a dramatic work in music," has been abbreviated to "opera." An opera combines vocal music, instrumental music, and drama; it is essentially a staged work sung to the accompaniment of an orchestra.

The first operas were written and performed before 1600, but the first notable work in the genre, *Orfeo* (*Orpheus*) by CLAUDIO MONTEVERDI [mon-teh-VAIR-dee] (1567–1643), was composed for his patron, the Duke of Mantua, in 1607. It deals with the Greek mythological figure Orpheus, a poet and musician who goes down to Hades, the underworld, to bring back his dead wife, Eurydice.

The opera includes **recitative**, a form of musically heightened speech midway between spoken dialogue and melodic arias. Orpheus's recitative is a monologue in the "agitated style," in which the composer expresses musically the feelings described by the text. Monteverdi created a descending line on the words "più profondi abissi" ("deepest abysses") and an ascending line to accompany the words "a riverder le stelle" ("to see again the stars").

Antonio Vivaldi and the Concerto Grosso. Invented by ARCANGELO CORELLI [ko-REL-lee] (1653–1713), the **concerto** is a musical form consisting of three parts, or movements, featuring contrast, and written in a fast–slow–fast form. Typically, the first movement of a Baroque concerto is energetic, the second is tranquil, and the third and final movement more vigorous than the first.

One of the most prolific Baroque composers of the concerto was ANTONIO VIVALDI [vee-VAHL-dee] (1674–1741), who wrote 450 concertos, forty operas, and numerous vocal and chamber works. Born in Venice in 1678, Vivaldi, an ordained priest, spent most of his life

as music master at a Venetian school for orphaned girls. Many of his works were composed for student recitals.

Vivaldi's most popular work is *The Four Seasons*, a set of four concertos for solo violin and orchestra. Each of Vivaldi's four concertos—Winter, Spring, Summer, and Fall—is accompanied by a sonnet describing the appropriate season. In the original edition, the words were printed above musical passages which depicted in sound the descriptive words. The Spring Concerto, for instance, includes descriptions of chirping birds returning to the meadows, and Vivaldi's music has accompanying sections called "bird calls" in which one violin "calls" and another answers it.

The first eight lines of the sonnet are distributed throughout the first movement of the Spring Concerto, an Allegro in E major. The movement opens with a phrase played twice in succession, once loud and once softly as an echo. This is followed by a *ritornello* passage, one that will return repeatedly throughout the movement. The *ritornello* section is played by the entire instrumental group in alternation with sections for the solo violin. The *ritornello* form pervades not only Vivaldi's music but the Baroque concerto generally. Different textures in solo and ensemble sections are supplemented by abrupt contrasts in dynamics from loud to soft (terraced dynamics), and by contrasting imitations of birdsong and storm.

But interesting as such musical scene painting may be, the primary interest of Vivaldi's music is its use of themes, textures, and tone colors in carefully structured repetitions and contrasts that identify him as a master of the concerto style. Vivaldi's music was soon heard throughout Europe, widely admired and closely studied by Johann Sebastian Bach, the greatest composer of the age. The attraction of Vivaldi's music was its inventiveness and flexibility within a fairly rigid formal structure. It is the play between structure and invention, between control and freedom, that appealed to an age at once attracted to the classicism of a Bernini colonnade and the fluid fantasy of a Borromini facade.

THE BAROQUE OUTSIDE ITALY

To speak of Baroque art, especially painting, as originating outside Italy is to misrcpresent things. Many of the artists whom we identify with other countries either lived, worked, or studied in Rome: the French painters Claude Lorrain and Nicolas Poussin, the Spanish Diego Velázquez, and Peter Paul Rubens from Flanders. If they did not go to Rome, as few of the Dutch Baroque artists did, they were usually deeply influenced by Roman Baroque painting, particularly that of Caravaggio, which enjoyed a considerable reputation outside Italy as early as 1610. Despite its dependency on Rome, the Baroque

thrived outside Italy: in the low countries, Flanders and Holland, where a flourishing mercantile class became deeply interested in the arts; in Spain, where Philip IV amassed an important collection; in England, where Charles I did the same; in France, where Marie de' Medici, regent for the young King Louis XIV, exerted influence over the French court; and in Germany, where Baroque music was particularly well received by an increasingly sophisticated public.

PAINTING IN BOURGEOIS HOLLAND

During the reign of Philip II of Spain, the northern provinces of the Netherlands rebelled against his repression of Protestants and formed a new Dutch republic, while the southern provinces remained Catholic and loyal to Spain. That division created the separate countries of Holland and Flanders.

A distinctly secular brand of Baroque painting emerged in Holland, which in the seventeenth century was a country of bourgeois merchants and tradespeople who found themselves, freed of Spanish rule, the sudden beneficiaries of having Amsterdam, the maritime center and commercial capital of Europe as their capital city. (Amsterdam: World Famous Commercial Center was the title of one 1664 Dutch publication.) Traveling through Holland in the eighteenth century, the French writer and philosopher Denis Diderot described the Dutch as a thoroughly acquisitive but perfectly content people: "It is to Holland that the rest of Europe goes for everything it lacks. Holland is Europe's commercial hub. The Dutch have worked to such good purposes that, through their ingenuity, they have obtained all of life's necessities, in defiance of the elements ... There, wealth is without vanity, liberty is without insolence, levies are without vexation, and taxation is without misery."

In Holland not just religious and political leaders but also merchants and tradespeople collected art, and good taste became almost a social prerequisite. The English trav-eler Peter Mundy in 1640 claimed that "none go beyond" the Dutch "in the affection of the people to pictures ... All in general strive to adorn their houses, especially the outer or street room, with costly pieces. Butchers and bakers not much inferior in their shops, which are fairly set forth, yea many times blacksmiths, cobblers, etc., will have some picture or other by their forge and their stall."

Pieter de Hooch. Paintings even grace the walls within genre paintings of the period, including those of the Dutch artist PIETER DE HOOCH [hoogh] (1629–after 1684). For instance, in *The Bedroom* (fig. 15.14) of about 1663, a seascape is positioned above the door leading to the courtyard while, in this most domestic of scenes, a woman chats with a girl as she changes

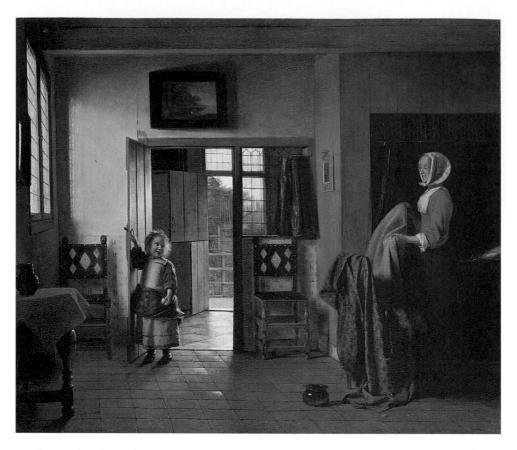

Figure 15.14 Peter de Hooch, *The Bedroom*, ca. 1663, oil on canvas, $20 \times 24''$ (50.8 \times 61.0 cm), National Gallery of Art, Washington, DC. The intimate details of everyday life are the center of interest of Baroque Dutch painting.

linens. For the Dutch, art had become a part of everyday life, and everyday life had equally become the subject of art. Notable is de Hooch's use of scientifically observed lighting. The woman is bathed by light from the window, and the dark interior of the domestic setting contrasts with the warm sunlight on the cityscape visible through the door.

Frans Hals. FRANS HALS [hals] (ca. 1580–1666), born in Antwerp, worked in Haarlem as a portraitist. An extrovert, the painter's jovial personality comes across in a number of his paintings. His Jolly Toper (fig. 15.15) of ca. 1628–30, for example, conveys such robust gusto. Hals's sitters usually appear to be in a good mood and might be more at home in a tavern than in a church. Differing from the stiff formality of earlier portraiture, the Jolly Toper is caught balancing a wine glass and

Figure 15.15 Frans Hals, *Jolly Toper*, ca. 1628–30, oil on canvas, $31\frac{7}{8} \times 26\frac{1}{4}$ " (81.0 × 66.7 cm), Rijksmuseum, Amsterdam. Breaking from the stiffness of earlier portraits, this man appears to have been caught in mid-sentence—perhaps offering that glass of wine. Hals's dashing brushstrokes accord with and enhance the quality of spontaneity.

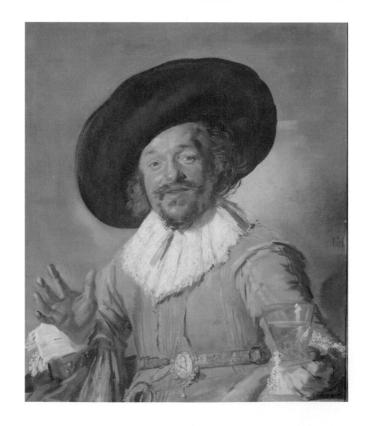

377

Connections

VERMEER AND THE ORIGINS OF PHOTOGRAPHY

It seems probable that Vermeer used a device known as the camera obscura to execute a number of his paintings. First used in the Renaissance as a mechanical device for verifying perspective, the camera obscura was used by Dutch painters as a tool for scientific observation comparable to the microscope and the telescope. At its simplest, the device is an enclosed box with a tiny hole in one side through which shines a beam of external light, projecting the scene outside as an inverted image on the opposite, interior wall of the box. Often

the size of a portable room in which the artist could stand fully upright and trace the image, the *camera obscura* employs the physics of the modernday camera, except that it lacks light-sensitive paper or film on which to record the image.

Not only did the *camera obscura* readily reduce the three-dimensional world to a two-dimensional image; it revealed intriguing details about the play of light on textured surfaces. There are several instances in Vermeer's paintings in which light seems to force the image out of focus. Photographers call such spots in a

photograph "discs of confusion." Though visible to the naked eye, the effects of such shimmerings are so fleeting that they are almost impossible to capture. And yet Vermeer, probably in imitating their appearance as projected by the lens of his *camera obscura*, captured them on canvas. As a result, his paintings depict light as convincingly as photographs themselves.

It would be another 150 years until the earliest photographic camera would be invented. However, the physics if not the chemistry—upon which photography is based is at work in Vermeer's images.

Figure 15.16 Judith Leyster, Boy Playing a Flute, 1630-35, oil on canvas, $28\frac{1}{2}\times24\frac{1}{8}''$ (72.4 × 61.3 cm), Nationalmuseum, Stockholm. Leyster's ability to convey a sense of life, of animation, is comparable to Hals's. The seemingly casual quality of both subject and painting technique is actually achieved with great care.

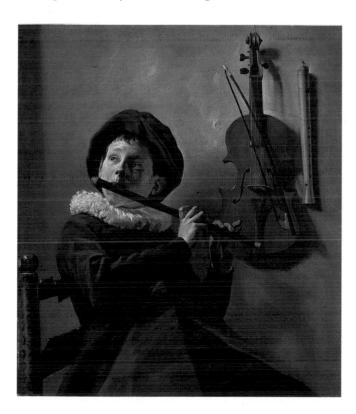

gesturing broadly, perhaps in mid-conversation. Hals broke with the fashion of the time, which was to paint with careful contours, delicate modeling, and attention to detail. Instead, his paint ranged from thick impasto to thin fluid glazes and he left the separate brushstrokes clearly visible. The spontaneity of his style matched the apparent spontaneity of his subject. Hals made his painting technique look easy, but in fact much care was required to achieve the casual impression he conveyed.

Judith Leyster. The most important follower of Frans Hals was JUDITII LEYSTER [LIE-ster] (1609-1660), a Dutch painter whose name came from her family's brewery in Haarlem, the Leysterre (Pole Star). So close are their painting styles that several works long thought to be by Hals have been found to be by Leyster. Like Hals, Leyster depicted scenes from daily life and was able to convey remarkable animation, demonstrated in the Boy Playing a Flute (fig. 15.16), painted 1630-35. The young musician appears totally caught up in his music making. Like Caravaggio, Leyster used a limited range of predominantly dark colors and tenebristic lighting. And, as in Caravaggio's paintings, the figure occupies a shallow space, close to the picture plane. The boy's glance to the left would endanger the balance of this composition, were it not for the musical instruments hanging on the wall to the right. The seemingly casual application of paint and arrangement of the composition add to the sense of relaxed ease, yet, as with Hals, this was painted with great thought and was carcfully composed.

Rembrandt van Rijn. In Amsterdam, painting revolved around the work of REMBRANDT VAN RIJN [REM-brant] (1606–1669), who took Caravaggio's

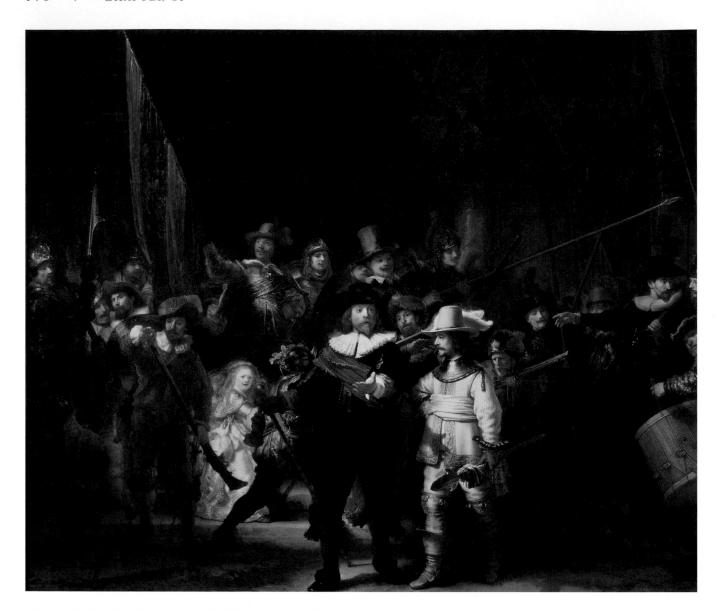

Figure 15.17 Rembrandt van Rijn, *The Night Watch* (*Captain Frans Banning Cocq Mustering His Company*), 1642, oil on canvas, 12′2″ × 14′7″ (3.71 × 4.45 m), Rijksmuseum, Amsterdam. This enormous group portrait is often interpreted as marking the turning point in Rembrandt's life. His wife Saskia died in 1642, his popularity as an artist declined, and his financial problems began. The event depicted took place in the morning, but, because of gradual darkening, the painting has come to be known as the "*Night*" *Watch*.

interest in dramatic Baroque lighting to new heights. Born in Leyden, the son of a miller, Rembrandt abandoned his studies of classical literature at the university of Leyden to study painting. In 1634, he married Saskia van Ulenborch, who came from a wealthy family. Between 1634 and 1642, now brilliant and successful, Rembrandt had many commissions and owned a large house and art collection in Amsterdam. Saskia was one of his great joys and was often his model. Her early death in 1642 marked a turning point in Rembrandt's life—it was in this year that he painted the famous *Night Watch*.

The Night Watch (fig. 15.17) is one of Rembrandt's most important public commissions, paid for by the Amsterdam civic guard. All the men portrayed in this huge informal group portrait had contributed equally to the cost (all their names appear on the shield hanging on the far wall). Its actual title is Captain Frans Banning Cocq Mustering His Company, but it was dubbed The Night Watch in the eighteenth century because it had darkened with age. In actuality, the painting shows the members of Cocq's company in the morning, welcoming Marie de' Medici, Queen of France, at Amsterdam's city gate.

The action of Rembrandt's dramatic Baroque composition moves along diagonals. Originally, Captain Cocq and his lieutenant were not in the center but walking toward it (the painting has been cut on the left and bottom). The viewer's eye is led toward the focus of the subject in the center of the composition.

The most remarkable aspect of the painting is the light. Rembrandt, referred to as "the lord of light," intensified his subject with a strong spotlight. Light creates atmosphere, unifies the composition, links the figures, highlights expressive features, and subordinates unimportant details. The figures of Captain Cocq and his lieutenant received the greatest emphasis; the others felt cheated, but the picture was considered good enough to hang in the company's club house.

Rembrandt also worked as a printer, a medium that depends particularly on the play of light and dark. His etching of Christ Preaching (fig. 15.18), of ca. 1652, is set in Amsterdam's Jewish ghetto. Rembrandt felt sympathy for the Jewish people as victims of persecution. Working at the highest technical level, Rembrandt used crosshatching to model the masses and shadows. His subtle effects range from the faintest lines of gray to the richest areas of black. In an etching, as in an engraving, the design comes from the incisions made in the surface. When an etching is made, first, the metal plate is covered with a waxy substance. Next, the design is scraped or scratched through the wax to expose the plate, a process far less arduous than engraving the plate itself. The plate is then placed in a mild acid bath that eats into the exposed areas of metal. Finally, the waxy coating is

Figure 15.18 Rembrandt van Rijn, *Christ Preaching*, ca. 1652, etching, $6\frac{1}{8} \times 8\frac{1}{8}''$ (15.6 × 20.6 cm), Metropolitan Museum of Art, New York. The strong contrasts of light and dark seen in Rembrandt's paintings have their equivalent in his prints.

Figure 15.19 Rembrandt van Rijn, Self-Portrait, 1669, oil on canvas, $23\frac{1}{4} \times 20''$ (59.0 × 51.0 cm), Mauritshuis, The Hague. Rembrandt painted himself throughout his life, not in a laudatory manner like Albrecht Dürer, but as a means of self-analysis and personal reflection more akin to the later self-portraits of Vincent van Gogh.

removed from the plate, ink is forced into the grooves, and the plate is printed on paper under pressure exerted by a printing press.

Rembrandt recorded his own life in many self-portraits—sixty in oil alone. His last *Self-Portrait* (fig. 15.19) was painted in 1669, the year of his death. The handling of paint continues to be masterful, the textures emphasized, the colors luminous and glowing, but the contours became looser, the brushstrokes broader, the surface not as smooth as in his earlier paintings. Rembrandt portrays himself here as weary and unhappy, disillusioned, self-questioning. Yet he remains dignified; in none of his self-portraits does he appear bitter, resentful, or self-pitying. Introspective and honest, he presented himself as no more handsome than he was.

Jan Vermeer: Like Rembrandt, but a generation younger, JAN VERMEER [vur-MEER] (1632–1675), was fascinated by light, but of a very different kind. Where Rembrandt's light is theatrical, Vermeer's is optical. Vermeer's use of light reveals every textural nuance. Clear and luminous, his light pervades all corners of his world. Used to emphasize contrasts in surface texture, his light informs us that every aspect of every object has been observed and recorded. And yet, Vermeer's light reveals

Figure 15.20 Jan Vermeer, Young Woman with a Water Pitcher, ca. 1664–65, oil on canvas, $18 \times 16''$ (45.7 \times 40.6 cm), Metropolitan Museum of Art, New York. Great importance is given by Vermeer to light—not for Baroque bravura, but to assure the viewer that every detail has been scientifically observed and recorded, every subtle gradation and reflection noted.

the spiritual essence of things in a manner entirely consistent with Protestant theology. The Protestants believed that God revealed himself in even the least significant details of daily life.

Born in Delft and married at twenty, Vermeer painted only for local patrons. He specialized in domestic scenes, which document the conditions of everyday Dutch domestic life in the Baroque age. In Young Woman with a Water Pitcher (fig. 15.20) of ca. 1664–65, a single female figure is depicted in the process of performing an ordinary action, indoors, at a table with objects on it, light coming from a window on the left, the figure silhouetted against a pale-colored wall. Vermeer's clear and luminous light pervades the whole space, unlike Rembrandt's light, which falls in shafts. Neither the subtle gradations across the back wall nor the reflections of the table rug in the metal basin are overlooked. The viewer can almost feel the starched linen headdress, its two sides subtly differentiated by the fall of light, the polished metal pitcher, and the basin. Vermeer's intimate scene of a woman absorbed in household tasks and unaware of the viewer conveys a mood of serenity and peace.

The Love Letter (fig. 15.21), probably painted ca. 1669–70, is almost an inventory of the Dutch good life.

Here a maid, whose laundry basket can be seen below Vermeer's signature, appears to reassure her young mistress that the love letter she has just received will resolve all her anxieties. The room is decorated with an elegant marble mantel, a gilded leather wall covering, and two paintings (a landscape and a seascape). The young woman wears a string of pearls around her neck, bright, almost gaudy earrings, and an ermine-trimmed yellow satin jacket and skirt. She holds a lute, and in the foreground on the bench is an open music book, perhaps the source of the song she was playing before the letter's arrival. Finally, richly woven drapery folds back to reveal the entire scene.

As with the figure in *Young Woman with a Water Pitcher*, these figures are carefully posed within a composition based upon a series of rectangles and a carefully planned perspective system. A sense of patterned geometry and balance predominates. The painting's composition transforms the viewer into a voyeur. It is as if, along with the artist, we lift the drapery and peer into the private scene. Unobserved, standing in the outer darkness, in "public" space, we are privy to a most private communication. Vermeer reverses our expectations: it is the private world that is bathed in light; the public space is shrouded in darkness.

PAINTING IN THE ROYAL COLLECTIONS

Peter Paul Rubens. Although born in Germany, PETER PAUL RUBENS [REW-bens] (1577–1640) established himself as an artist in Antwerp, the capital of Catholic Flanders. Between 1600 and 1608, at the very height of Caravaggio's and Carracci's careers, he was in Italy, where he studied the antique, the High Renaissance, and the two Baroque masters. He copied the "old masters," including Leonardo's Battle of Anghiari (see fig. 13.26), and his copy has become the only surviving record of that work. Rubens enjoyed a good reputation in Italy, painting in a style that combined influences from the north and the south.

Intelligent, talented, sociable, energetic, and equipped with a good business sense, Rubens became extremely successful. He set up shop in Antwerp, and by 1611, with two hundred painters and students working in his studio, Rubens was the most financially successful artist of the age. He built a large home containing his studio and an impressive art collection including works by Titian, Tintoretto, Van Eyck, Bruegel, and Raphael. He received many commissions from the Church, the city of Antwerp, and private individuals, but it was the royal courts of Europe that garnered him the most fame and fortune. He was court painter to the Duke of Mantua, and to the Spanish regents of the Netherlands, Albert and Isabella. Commissions came also from Charles I of England and Philip IV of Spain, both of whom presented him with a knighthood. Marie de' Medici of

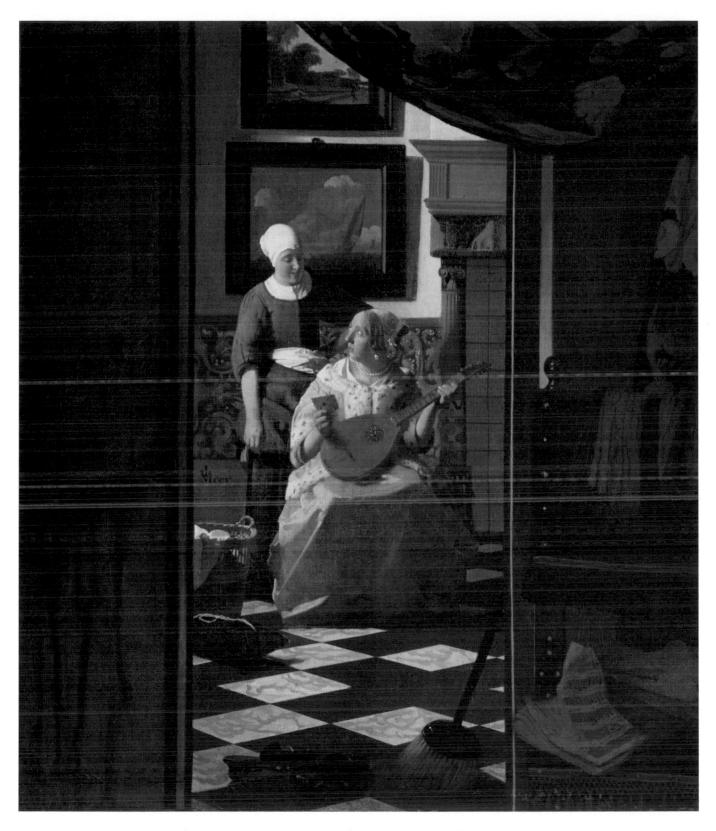

Figure 15.21 Jan Vermeer, *The Love Letter*, ca. 1669–70, oil on canvas, $44 \times 38''$ (112 \times 96.5 cm), Rijksmuseum, Amsterdam. Typical of Vermeer is the intimate view of the daily life of women in middleclass seventeenth-century Dutch homes.

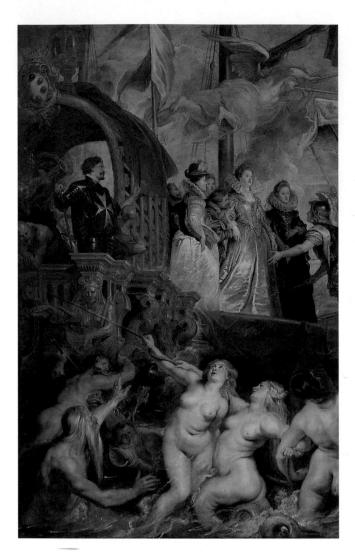

Figure 15.22 Peter Paul Rubens, Marie de' Medici, Queen of France, Landing in Marseilles, 1622–25, oil on canvas, $5'1'' \times 3'11\frac{2}{3}''$ (1.55 × 1.21 m), Musée du Louvre, Paris. With the diagonal movements typical of the Baroque, brilliant color, sensuous textures, and dashing brushwork, Rubens raised his depiction of an unglamorous queen at an ordinary event to the level of high drama.

France in 1621 gave him the commission that would establish his international reputation.

After the death of her husband, Henry IV, Marie de' Medici served as regent for her young son, Louis XIII. She asked Rubens to create a cycle of twenty-one large oil paintings portraying her life. His aim was to glorify the Queen, a difficult task in view of the fact that she was no beauty. A master of narrative portraiture, Rubens's solution was to dramatize even the ordinary. In the scene of *Marie de' Medici, Queen of France, Landing in Marseilles* (fig. 15.22), the Queen is merely disembarking in the southern French city of Marseilles, yet Fame flies above, blowing a trumpet, and Neptune, god of the sea, accompanied by mermaids, rises from the waves to welcome her.

The drama of the composition, arranged on diagonals rather than parallel to the picture plane, is characteristic of the Baroque style, as is the love of movement in an open space. Everyone and everything becomes active to the point of agitation, even when not suggested by the subject. By cutting off figures at the edge of the canvas, Rubens implies that the scene continues beyond the limits of the frame. Rubens painted in terms of rich, luminous, glowing color and light rather than in terms of line, and he juxtaposed textures to contrast their differences. Every stroke, every form, is united by the curving, sweeping movements of Rubens's design and the sheer exuberance of his lush forms, which appeal more to the eye than to the mind.

Aided by his early experience as a court page as well as his fluency in five languages (Greek, Italian, French, Spanish, and Flemish), Rubens served as an advisor and emissary for the Flemish court. When he visited the court of Philip IV in Spain from September 1628 until late April 1629, he stayed in the royal palace in Madrid and was visited almost daily by the young king. In addition to royal portraits, he executed copies of Titian's famous *Poésies*, a series of large mythological paintings hung in the galleries below the king's apartments.

After his first wife died in 1626, Rubens married Hélène Fourment, a distant relative, and began a family. He was fifty years old, his bride sixteen, and they had four children in five years. *The Garden of Love* (fig. 15.23), ca. 1638, is an exuberant visual expression of the pleasures of life, with a robust grandeur approaching animal exuberance. Certainly Rubens's main interest in this work is in the voluptuous female figure. Only with difficulty could this scene be made any more sumptuous—or sensuous. *The Sacrifice of Isaac* (fig. 15.24) evidences a contrasting style of Rubens's work.

Anthony van Dyck. Rubens's assistant from 1618 to 1620, ANTHONY VAN DYCK (1599–1641), became painter to the court of Charles I in England and perhaps the greatest portrait painter of the age. Van Dyck was capable of recognizing and representing the most subtle nuances of the aristocratic personality. His Portrait of Charles I at the Hunt (fig. 15.25), of 1635, captures the king's self-assurance. Van Dyck contrasts the king with the animated and anxious groom and the pawing, nervous horse behind him, underscoring Charles's command of all situations.

Diego Velázquez. Philip IV had become king of Spain in 1621 at the age of sixteen, and from the outset he relied heavily on the advice of Gaspar de Guzmán, the Count of Olivares. Olivares wanted Philip's court to be recognized as the most prominent in Europe, so he appointed DIEGO VELÁZQUEZ [ve-LAHS-kez]

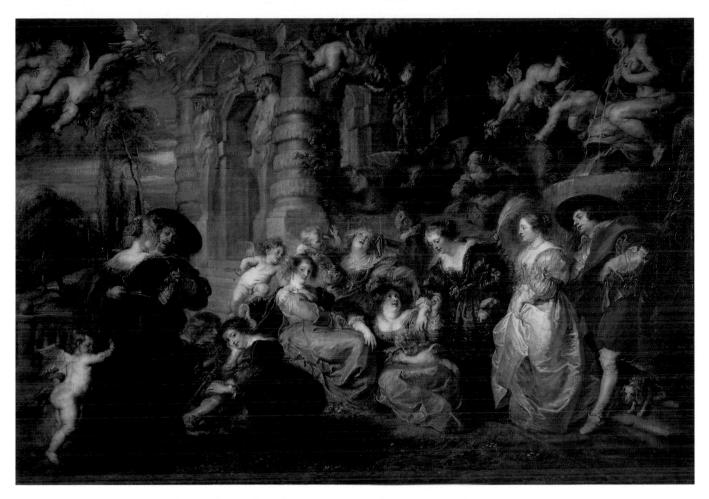

Figure 15.23 Peter Paul Rubens, *The Garden of Love*, ca. 1638, oil on canvas, $6'6'' \times 9'3\frac{1}{2}''$ (1.98 \times 2.83 m), Museo del Prado, Madrid. Rubens is known for his rich, lush style—applied to the setting and, especially, to the figures. The term "Rubenesque" has been coined to describe voluptuous fleshy females.

Figure 15.24 Peter Paul Rubens (1577–1640), Flemish, *The Sacrifice of Isaac*, ca. 1612-1613. Oil on wood panel; $55\frac{1}{2}\times43\frac{1}{2}"$ (141.0 \times 110.5 cm). Nelson-Atkins Museum of Art. Rubens depicts an angel grabbing the hand of Abraham before kneeling Isaac.

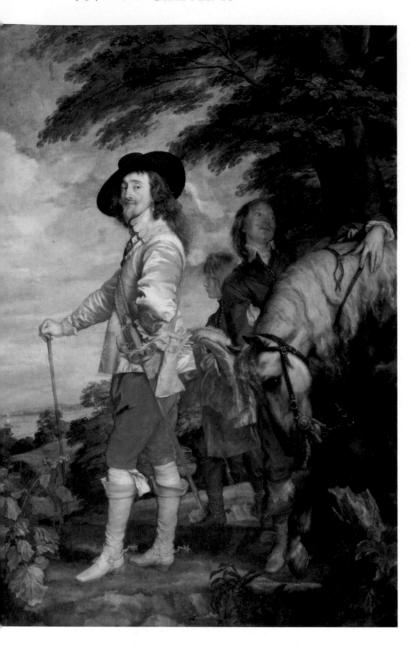

Figure 15.25 Anthony van Dyck, Portrait of Charles I at the Hunt, 1635, oil on canvas, approx. $9 \times 7'$ (2.74 \times 2.13 m), Musée du Louvre, Paris. The king is depicted here displaying all the haughtiness that would soon lead Parliament to rise against him.

(1599–1660) to the position of royal painter. Velázquez was highly honored by the king, who ultimately knighted and conferred upon him the Order of Santiago, usually reserved for noblemen. Velázquez did many portraits of the royal family, painting them with honesty and realism, and he seems to have made his sitters no prettier or more handsome than they actually were. Velázquez lived most of his life in Madrid, though shortly after Rubens's

visit and at Rubens's suggestion, Philip granted Velázquez permission to visit Italy in order to study art in June 1629. There he absorbed the lessons of the Italian Baroque and brought them back to Spain. Throughout his painting career, his style became progressively richer, the color lusher, the figures more animated.

Velázquez's most celebrated painting is the *Maids of Honor*, or *Las Meninas* (fig. 15.26), painted in 1656. Originally entitled *Family of Philip IV*, the painting raises the question: Is this a formal portrait? Or is it a simple genre scene? In fact, it is both. A glass of water has just been brought to Princess Margarita, the five-year-old daughter of Philip IV and his second wife, Queen Mariana. Margarita's maids, friends, a nun, a dwarf, a dog, and others gather round. Yet this scene from everyday life is portrayed on a grand scale. Velázquez even shows himself in the foreground, painting a large canvas, a self-conscious act that serves to comment both on the processes of creativity and on the complexity of representation.

On the back wall of the room are seen the reflections of the queen and king, apparently in a mirror. They stand where the viewer stands in relation to the pictorial space. Does the viewer witness the painting of the Infanta Margarita, as did the queen and king in 1656? Or are the king and queen having their portraits painted by Velázquez and their child has come to watch? What remains unseen is at least as interesting as what is actually represented. Velázquez cleverly unites the world of the picture and the world of the viewer, much as did Jan van Eyck in *Giovanni Arnolfini and His Wife Giovanna Cenami* (see fig. 14.4). But Velázquez implies yet a third area of interest: a man turns back in the far doorway, suggesting a continuation of space beyond.

Velázquez is linked to the Baroque by his feeling for space and light. The princess and her maids of honor are enveloped in an atmospheric space with strong contrasts of light and shadow, while the man in the doorway stands near a source of bright light. In his concern for direct and reflected light, with the subtlest changes in atmosphere, Velázquez looks back to the Venetian painters. Velázquez's technique was to record the details so they could be seen from a distance, not close up, where much of the surface dissolves into indistinguishable shapes and colors.

When Velázquez's masterpiece took its place in Philip IV's collection, it joined over 1500 paintings in the king's collection at the Buen Retiro, the new residence that Olivares and Philip built on the outskirts of Madrid in the early 1630s. Together with Philip II's massive collection, Spain, by 1650, owned much of the Western world's great art. To be sure, Rome had more than its fair share of Italian masterpieces, but Spain's collection reflected developments in Western painting as a whole.

Figure 15.26 Diego Velázquez, *Maids of Honor (Las Meninas)*, 1656, oil on canvas, $10'5'' \times 9'$ (3.17×2.74 m), Museo del Prado, Madrid. Velázquez depicts himself in this group portrait in the process of painting just such a large canvas. Much as in Jan van Eyck's Arnolfini wedding portrait, the presence of people (here the king and queen) in the viewer's space is indicated by their reflection in the mirror on the back wall.

Figure 15.27 Claude Lorrain, *Landscape with St. Mary Magdalene*, oil on canvas, Museo del Prado, Madrid. Claude's compositional scheme would serve as the basic format upon which landscape painting would be based for the next two centuries.

Claude Lorrain and Nicolas Poussin. Two painters who came to be prominently represented in Philip's collection were Claude Lorrain and Nicolas Poussin, both of whom lived and worked in Rome.

CLAUDE LORRAIN [lor-ANN] (1600–1682) painted at least three of the most important landscapes in the seventeenth century, including a Landscape with St. Mary Magdalene (fig. 15.27). Mary is lit in a beam of light, in a manner entirely indebted to Caravaggio, though her presence is essentially incidental to the painting. Nature is Claude's real subject and the effects of atmospheric perspective, and the dramatic play of light and dark are his principle means. Typical of Claude's composition are the realistic flora in the foreground, the framing of the distant landscape by two sets of trees forming an almost oval view, and the movement from dark to light and from clarity to haziness, as the viewer's eye enters the scene and proceeds down a sort of zig-zag path into the distance. All of these devices will influence landscape painting well into the nineteenth century.

NICOLAS POUSSIN [poo-SAN] (1594–1665), who represents the classicizing and restrained tendency within the usually dramatic Baroque, created landscapes that, beside those of Claude, seem positively geometric. His Summer: Ruth and Boaz (fig. 15.28), part of a series depicting the four seasons painted between 1660 and 1664, is dominated by the verticals and horizontals of the grain that is being harvested. In fact, everything in the composition works at right angles: the forelegs of the horses; the whip in their master's hand; and Boaz and Ruth's arms, framing a virtually rectangular space. Where the center space framed by Claude's trees seems oval, Poussin's central space seems diamond-shaped. Where Claude played with atmos-pheric effects of light, Poussin preserved unbroken clarity. It is possible to count each beard of wheat in the field.

Landscape, however, was not Poussin's only subject. He enjoyed the more ambitious mode of academic history painting. His *Rape of the Sabine Women* (fig. 15.29), of ca. 1636–37, for example, shows Romulus, on the left, raising his cloak to signal his men to abduct the Sabine

Figure 15.28 Nicolas Poussin, Summer: Ruth and Boaz, ca. 1660–64, oil on canvas, Musée du Louvre, Paris. Although landscape was only one of Poussin's recurrent themes, he could not resist submitting it to his classical and geometric sense of organization.

women to be their wives. The figures make wild gestures and facial expressions, yet the action is frozen and the effect unmoving. This intellectual style is intended to appeal more to the mind than to the eye; appreciation of the painting depends largely upon knowing the story depicted. Poussin said the goal of painting was to represent noble and serious subjects, and the purpose of art was to elevate or morally improve the viewer. Poussin's approach to painting was disciplined, organized, and theoretical. He worked in terms of line rather than color—in this he was the opposite of Rubens.

The French Academy. Beginning with the reign of KING LOUIS XIV [LOO-ee] (1638–1715), who came to the throne in 1643 as a child and was to rule outright from 1661 until 1715, Paris became increasingly the center of the Western art world, even if many of its most important painters, such as Claude and Poussin, preferred to live and work in Rome. Louis's reign was the longest in European history, and assisted by his chief advisor, Jean-Baptiste Colbert, he soon established what

Figure 15.29 Nicolas Poussin, Rape of the Sabine Women, ca. 1636–37, oil on canvas, $5'\frac{8}{8}'' \times 6'10\frac{8}{8}'''$ (1.55 × 2.10 m), Metropolitan Museum of Art, New York. In spite of the dramatic subject and technical perfection of drawing, Poussin's academic style renders his characters as frozen actors on a stage, unlikely to elicit an emotional response in the viewer.

amounted to dictatorial control over art and architecture. His main tool was the Royal Academy of Painting and Sculpture, established in Paris in 1648 and known more simply as the French Academy. Its purpose was to define absolute standards by which to judge the art of the period. It hardly comes as a surprise that classical art was deemed to be the standard.

Favored above all other painters was Poussin, but the Academy's insistence on Poussin's supremacy alienated many younger members of the Academy inclined not towards Poussin's linear geometric classicism, but towards Rubens's bravura style. By the end of the seventeenth century, the Academy had split into two opposing groups—those who favored line and those who favored color. The former, adherents to the style of Poussin and referred to as "poussinistes," argued that line was superior because it appealed to the mind, whereas color appealed only to the senses. The latter, preferring the style of Rubens, were called "rubénistes" and maintained that color was truer to nature; line appealed only to an educated mind, but color appealed to all. Both sides agreed on this point. Thus, to ask whether line or color is superior in art is to question whether it is the educated person or the lay person who is the ultimate audience for that art. It is a debate that continues to this day.

ARCHITECTURE

The Louvre. In 1664, it was time to design a facade for the new east wing of the royal palace of the Louvre [LOOV], which housed new royal apartments. As head of the Academy, Colbert invited Bernini to Paris to present plans, but restrained Bernini's approach was (imagine what might have been proposed by someone like Borromini!), it was nevertheless too radical to succeed. Furthermore, French architects did not think the design of a French palace should fall to an Italian. So Colbert appointed a French council to conceive a new plan: architect LOUIS LE VAU [luh VO] (1612-1670), painter CHARLES LE BRUN [luh BRUN] (1619-1690), a previous director of the Academy, and architect CLAUDE PERRAULT [peh-ROH] (1613-1688), who later published a French edition of the classical architect Vitruvius. A strict, linear classicism was the result (fig. 15.30). The center of the facade looks like a Roman temple with Corinthian columns; wings with paired columns extend outward from it; the building ends by forms

Louis Le Vau, Charles Le Brun, Claude Perrault, east facade, Palais du Louvre, 1667-70. All vestiges of Baroque sensuality have been banished here in favor of a strict and linear classical line.

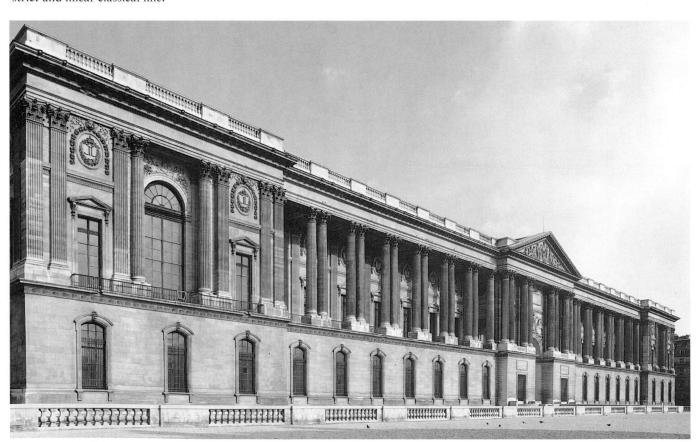

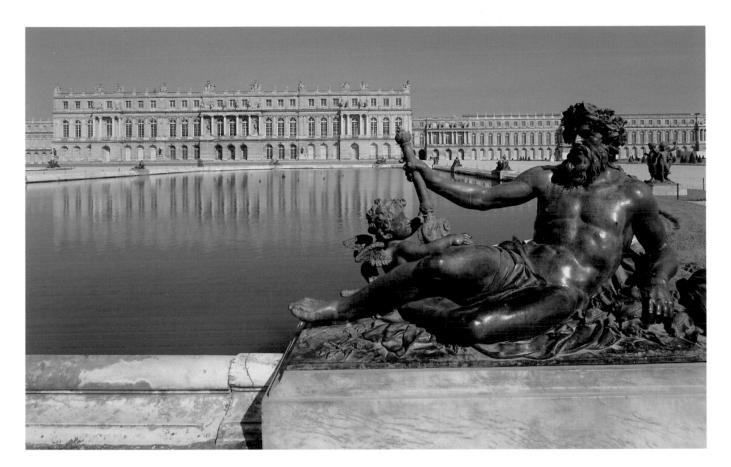

Figure 15.31 Louis Le Vau, Jules Hardouin-Mansart, Charles Le Brun, and Antoine Coysevox, Palace of Versailles, 1669–85. Gardens designed by André Le Nôtre. Louis XIV, the Sun King, created one of the most magnificent palaces of all times, its vast buildings and gardens laid out on a symmetric and geometric plan.

reminiscent of a Roman triumphal arch. The King was so pleased that he insisted the new facade be duplicated on the palace's other faces.

The Palace of Versailles. Louis XIV immediately turned his attention to the building of a new royal palace at Versailles [vair-SIGH] (fig. 15.31), eleven miles southwest of Paris. It was begun in 1669 by Le Vau, who managed to design the garden facade, but who died within the year. JULES HARDOUIN-MANSART [man-SAR] (1646–1708) took over and enlarged the palace to the extraordinary length of 1903 feet.

The visitor arriving at Versailles from Paris is greeted by the principal facade, which is designed to focus on the three windows of Louis XIV's bedroom in the center. The entire palace and gardens are symmetrically arranged on this axis. Several square miles of gardens and parks, designed by ANDRÉ LE NÔTRE [luh NO-truh] (1619–1693), continue the lines of the palace itself, as if the gardens were conceived as a series of outdoor rooms. Nature is controlled in a geometric pattern.

Versailles was the seat of the government of France, and once housed ten thousand people. Even the most humble attic room at Versailles was preferred to living on one's own estate, because only through personal contact with the king was there the possibility of obtaining royal favors. The most spectacular of the many splendid rooms of the palace of Versailles is the Hall of Mirrors (fig. 15.32), designed about 1680, the work of Hardouin-Mansart, Le Brun, and Antoine Coysevox. An extraordinary space, tunnel-like in its dimensions (240 feet long, but only 34 feet wide, and 43 feet high), the Hall of Mirrors overlooks the gardens through seventeen arched windows reflected in seventeen arched mirrors. As the setting for state functions, it was filled in Louis XIV's day with solid silver furniture and orange trees, and hung with white brocade curtains, seen by the light of innumerable flickering candle flames. Mirrors reflect marble, gilding, stucco, wood, and paint in a theatrical tour de force that is among the ultimate examples of the Baroque.

St. Paul's Cathedral. England, meanwhile, had lagged behind the continent artistically. SIR CHRISTO-PHER WREN (1632–1723), however, quickly brought England to the contemporary aesthetic fore. In addition

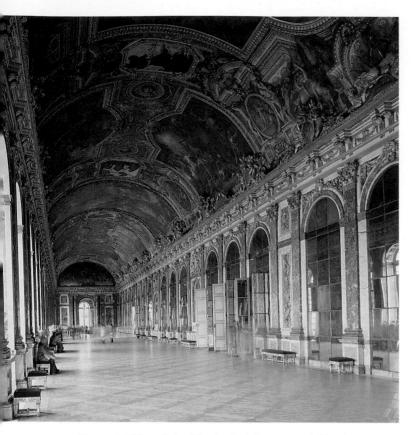

Figure 15.32 Jules Hardouin-Mansart and Charles Le Brun, Hall of Mirrors, Palace of Versailles, ca. 1680. Typically Baroque is the combination of a variety of materials to enhance the opulence of the overall impact. Imagine the effect with the flickering light of hundreds of candles reflected in the arched mirrors.

to being an architect, Wren was also knowledgeable in astronomy (he was Professor of Astronomy at Oxford University), anatomy, physics, mathematics, sailing, street paving, and embroidery. He even invented a device for copying documents by having a second pen attached to the first and writing double.

During the Great Fire of 1666, London burned for an entire week. Much was destroyed, including the original Gothic church of St. Paul's. Wren joined the royal commission for rebuilding the city, and although his plan for reconstructing it in its entirety was rejected, he did design many local churches. His masterpiece, however, was the new St. Paul's cathedral (fig. 15.33), built 1675–1710.

St. Paul's cathedral may be regarded as a Baroque reinterpretation of the ancient Roman Pantheon (see Chapter 5). Wren designed a dome like that of the Pantheon but raised it high on double drums, and he modeled his triangular pediment on the Pantheon's but supported it on two stories of columns, which, characteristic of the Baroque, were grouped in pairs. The lower story of columns is as wide as the nave and aisles, the upper as wide as the nave. Particularly Baroque is the picturesque silhouette created by the towers at each corner.

The dome was constructed of wood and lead on the outside, with a lower dome of masonry within the drum. Like the dome of St. Peter's in Rome, the dome of St. Paul's is as wide as the nave and aisles; it is possible that Wren intended St. Paul's to be the St. Peter's of the north. Although smaller than St. Peter's, St. Paul's generally is considered artistically superior. St. Peter's lacks

Timeline 15.2 French rulers during the Baroque age.

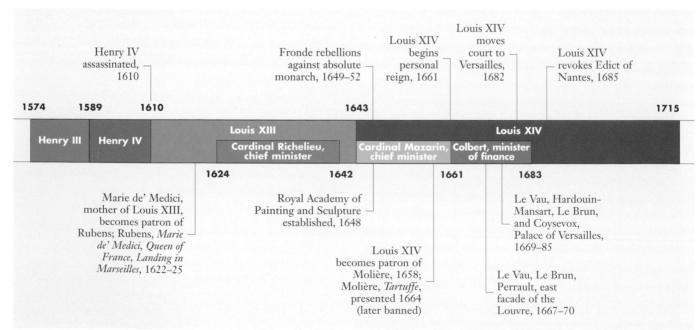

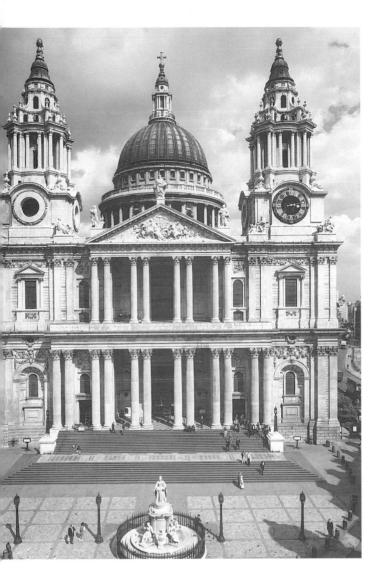

Figure 15.33 Sir Christopher Wren, facade, St. Paul's Cathedral, London, 1675–1710, length 514′ (156.67 m), width 250′ (76.20 m), height of dome 366′ (111.56 m). The facade of St. Paul's in London deserves comparison with that of St. Peter's in Rome. Although the basic dome, pediment, and columns derive from antiquity, the Baroque influence is evident in the paired columns and double facade.

small-scale features with which to interpret the vastness; St. Paul's includes such details on both the exterior and interior. St. Paul's is also the only major cathedral in Western Europe to be completed by the person who designed it.

BAROQUE MUSIC OUTSIDE ITALY

Handel and the Oratorio. Late in the Baroque age, Italian opera such as Monteverdi's began to go out of style, particularly in the north where high-minded Protestants thought the form frivolous. One of the most successful composers of Italian opera of the day was

GEORGE FREDERICK HANDEL [HAN-del] (1685–1759), a German composer who emigrated to England in the early 1700s. Handel was renowned as an accomplished organist, a consummate musician, and a prodigious composer in many musical genres. He was lauded and commissioned by the Hanoverian kings, and profoundly influenced English music for a century after his death.

By the mid-1720s he had composed nearly forty operas, but astutely recognizing the growing English distaste for the form, he turned to composing **oratorios**. An oratorio is an unstaged sacred opera sung without costume and without acting because it was forbidden to present biblical characters in a public theater. However, almost all of the Baroque theatricality of the operatic tradition is maintained. Handel relied on a heightened musical drama to make up for the lack of theater. Written in English, Handel's oratorios employ the many musical forms of opera, such as *arias* (solo songs), recitatives, duets, ensemble singing, and choruses, and all were set to orchestral accompaniment.

Handel's most famous oratorio is his *Messiah*, a composition of enormous scope that rivals the most ambitious projects of Baroque art and architecture—Bernini's colonnade for the Vatican square, Rubens's cycle of paintings celebrating the life of Marie de' Medici, and Milton's epic *Paradise Lost*. The *Messiah* includes more than fifty individual pieces, lasting approximately three hours. Its three parts are based on the biblical texts of Isaiah, the Psalms, the Gospels, Revelations, and the Pauline Epistles. The first part concerns the prophecy of the birth of Christ; the second focuses on his suffering, especially the crucifixion; the third encompasses his resurrection and the redemption of the world.

The tone of the *Messiah* is jubilant and celebratory. One particularly inspirational section is the second part of the oratorio, concluding with the famous "Hallelujah Chorus," which is based on Revelations 11:15. The text is as follows:

- a. Hallelujah! Hallelujah!
- b. For the Lord God omnipotent reigneth
- c. The Kingdom of this world is become the Kingdom of Our Lord and of His Christ.
- d. And He shall reign for ever and ever King of Kings and Lord of Lords And He shall reign for ever and ever Hallelujah! Hallelujah!

The opening of this exultant chorus is noteworthy for its repeated and emphatic Hallelujahs (a), followed by a sudden contrasting quieter section (b). An even softer section begins with (c) "The Kingdom of this world," which is quickly followed by the majestic fugue of (d) "And he shall reign for ever and ever." As the chorus moves exuberantly towards its dramatic conclusion, Handel splits the voices. The top voice is split into

two voices, soprano and alto, and they rise higher and higher on the phrase "King of Kings and Lord of Lords." The bottom voice is also divided into two voices, tenor and bass, which sing "for ever and ever, Hallelujah!" The four voices are bolstered by strong orchestral support with drums beating and brass, especially trumpets, jubilantly blaring. The entire effect is one of highly charged Baroque drama, a magnificent play between the musical "light" offered by the soprano voices and brass contrasted with the "darkness" of the drums and bass line, the whole capturing the essence of the Crucifixion's simultaneous tragedy and joy:

Composed in an astonishing twenty-three days, the *Messiah* was first performed not in London but in Dublin, in 1742, for the relief of prisoners and wards of the state. It wasn't until 1750 that the London public fully responded to the work. Upon completing the *Messiah* Handel's eyes are said to have filled with tears, and he is reputed to have said: "I did think I did see all Heaven before me, and the Great God Himself!" The religious fervor and devotion of the *Messiah* deeply embody this spiritual faith.

Johann Sebastian Bach. The other great Baroque composer is JOHANN SEBASTIAN BACH [bahk] (1685–1750), the grand master of the Baroque style and musical art forms of his age, and as thorough and thoughtful a musician as ever lived. He expertly played and composed solo pieces for a number of instruments, including violin and harpsichord (fig. 15.34). He was master, however, of the organ, on which he could improvise at will the most complicated fugues.

A fugue is composed of three or four independent parts of which one part, or voice, states a theme which is then imitated in succession by each of the other voices. As the second voice takes over the theme from the first, the first continues playing in what is called **counterpoint**, music that differs from the main theme. The third voice takes over from the second, the second continues on in counterpoint, and so on. Bach developed to perfection the art of such **polyphonic** music, or music for

Figure 15.34 Jerome de Zentis, harpsichord, 1658, Metropolitan Museum of Art, New York. A keyboard instrument that was often intricately decorated, the Baroque harpsichord had strings that were plucked by mechanical plectra inside the body of the instrument.

multiple voices. As a young organist, Bach had already demonstrated his talent for improvising on the common church hymn-like chorale tunes, so much so that complaints were lodged against him "for having made many curious variations in the chorale and mingled many strange tones in it." He was at work on his *Art of the Fugue*, an encyclopedic compendium of fugues for study and performance, when he died.

Bach's professional career began with a position as organist at a church in Arnstadt. Then he served for nine years as court organist and chamber musician at the court of the Duke of Weimar, composing many works for the organ. Next Bach served as director of music for the Prince of Cothen, where he composed a set of six concertos dedicated to the Margrave of Brandenburg, subsequently known as The Brandenburg Concertos. Bach's longest musical post was as music director of the Church of St. Thomas in Leipzig, where for twenty-seven years he served as organist, choirmaster, composer, and music director. At Leipzig, Bach produced his religious vocal music, including the B Minor Mass, the St. John and St. Matthew Passions, and numerous church cantatas, of which he wrote nearly three hundred, more than two hundred of which survive. A cantata is a work for a single singer or group of singers accompanied by instruments.

Among these is the famous Cantata No. 80: Ein feste Burg is unser Gott (A Mighty Fortress Is Our God),

Cross Currents

THE BAROQUE IN MEXICO

When the Spanish explorers led by Hernán Cortés came to America in 1519, they spread Catholicism with missionary zeal. With the religious support of the Jesuits, also missionaries, and the political and financial backing of European governments, seventeenth-century South America boasted a strong European cultural connection, including no fewer than five universities, the largest and most important of which was in Mexico City.

Mexican-born writers and artists worked hand in hand with their European-born counterparts to create a native architecture and literature that spoke to the European cultural heritage. Great Baroque structures were built, the leading example of which is the Chapel of the Rosary in the Church of Santo Domingo in Puebla (fig. 15.35), completed about 1690. Like so much Mexican art, it melds local traditions and Catholic icons. Here local artisans crafted images in polychrome stucco that, though they represent Christian figures, possess the faces and dresses of native Mexicans. Meandering vines weave across the ceilings, and gold leaf covers the altar. So elaborate is the whole that the style is called the "exuberant Baroque."

Among the most noteworthy and more influential of Mexican Baroque writers was Sor Juana Inés de la Cruz [soar HWA-nah] (1648–1695), who was born near Mexico City. Hailed as the "Phoenix of Mexico" and "America's Tenth Muse" during her lifetime, Sor Juana is considered one of the finest Spanish-American writers of her time. Though she was a nun, she became the confidante of prominent leaders and intellectuals throughout Spanish America.

Her poetry speaks to women across cultures and centuries in a language that is by turns playful and ironically critical of men's failures, as shown in the first and last stanzas from her aptly titled poem, "She Demonstrates the Inconsistency of Men's Wishes in Blaming Women for What They Themselves Have Caused":

Silly, you men—so very adept at wrongly faulting womankind, not seeing you're alone to blame for faults you plant in woman's mind.

I well know what powerful arms 5 you wield in pressing for evil: your arrogance is allied with the world, the flesh, and the devil.

Figure 15.35 Chapel of the Rosary, Church of Santo Domingo, Puebla, Mexico, ca. 1690. Free of any preconceptions that would limit their decorative impulses, the artists who fashioned this interior were able to press the Baroque sensibility to its very limits.

composed in 1715, revised in 1724, and based on the hymn, or chorale, by Martin Luther. Like many of Bach's sacred, or church, cantatas, this one was written for Lutheran services. The cantatas were performed by eight to twelve singers and an orchestral ensemble of eighteen to twenty-four musicians (though Bach often complained that he had to make do with wretched musicians and underprepared vocalists). Luther's original chorale, which is in itself a centerpiece of Protestant hymnology, appears in eloquent and simple majesty in a four-part harmonization as the final movement of Bach's cantata.

THE SCIENCE OF OBSERVATION

The almost mathematical precision of Bach's fugues and the astute observation of light in Vermeer's paintings are echoed in the scientific spirit of the Baroque age. Francis Bacon's development of the principles of the scientific method (see Chapter 14), with its emphasis on the careful observation of physical phenomena, was echoed throughout the Baroque age in a vast array of scientific discoveries and inventions. Careful observation required new tools for seeing, and these new tools in turn created new knowledge.

Anton van Leeuwenhoek. In Holland, for instance, a lens maker named ANTON VAN LEEUWENHOEK [LAY-ven-huck] (1632–1723) transformed the magnifying glasses used by lace makers and embroiderers into powerful microscopes capable of seeing the smallest organisms. He investigated everything under his microscope (including all of his bodily fluids). Leeuwenhoek quickly realized that the world was teeming with microorganisms that he called "little animals." He was the first person to see protozoa and bacteria and the first to describe the red blood cell. Leeuwenhoek was also fascinated with the mechanisms of sight, particularly with the

fact that the eye is itself a lens. He dissected insect and animal eyes, and literally looked through them himself. He describes looking at the tower of the New Church through the eye of a dragonfly: "A great many Towers were presented, also upside down, and they appeared no bigger than does the point of a small pin to our Eye."

Johannes Kepler. JOHANNES KEPLER [KEPler] (1571–1630) had been equally interested in the eye, and in 1604 was the first to describe it as an optical instrument with a lens used for focusing (fig. 15.36).

Figure 15.36 Illustration of the theory of the retinal image, from René Descartes, *La Dioptrique* (Leiden, 1637), Bancroft Library, Berkeley, California. No image better illustrates the importance of scientific observation to the Baroque sensibility. Even the eye itself is defined here as a scientific instrument.

"Vision," he wrote, "is brought about by a picture of the thing seen being formed on the concave surface of the retina."

This observation, in turn, freed the study of vision from the realm of the spiritual or psychological: "I leave to natural philosophers to discuss the way in which this picture is put together by the spiritual principles of vision residing in the retina and the nerves, and whether it is made to appear before the soul or tribunal of the faculty of vision by a spirit within the cerebral cavities, or the faculty of vision, like a magistrate sent by the soul, goes out from the council chamber of the brain to meet this image in the optic nerves and retina, as it were descending to a lower court." Kepler describes only the *fact* of vision, not its meaning or moral force.

Galileo Galilei. Kepler's friend GALILEO GALILEI [ga-li-LAY-o] (1564-1642) was the first to develop the telescope and use it to observe the heavens. Through it he saw and described craters on the moon, the phases of Venus, and sunspots, and he theorized, in one of the most important advances of modern physics, that light takes time to get from one place to anotherthat, either as a particle or wave, it travels at a uniform speed that is measurable. Galileo's astronomical findings confirmed Copernican theory, a position that the Church still did not accept. In 1615, Galileo was forced to defend his ideas before Pope Paul V in Rome, but his efforts failed, and he was prohibited from either publishing or teaching his findings. When Pope Urban VIII, an old friend, was elected pope, Galileo appealed to the papacy again, but again he was condemned, this time much more severely. He was made to admit the error of his ways in public and was sentenced to prison for the rest of his life. Friends intervened, and in the end he was merely banished to a comfortable villa outside Florence.

PHILOSOPHY

René Descartes. Kepler's effort to distinguish the science of observation from the contemplation of the subjective or spiritual matters of the mind was well known to RENÉ DESCARTES [day-CART] (1595–1650). Descartes actually published the illustrated model of the retinal image (fig. 15.36) in his own work. But Descartes was interested in what Kepler wasn't. He was, in fact, the very "natural philosopher" to whom Kepler left the problem of what happened to the image once it registered itself on the retina. Descartes did for modern philosophy what Bacon had done for science, and so he is often called the "Father of Modern Philosophy."

Descartes used doubt as a point of departure and philosophical debate. He began with a series of systematic questions which led him to doubt the existence of everything. At that point, he asked himself if there was

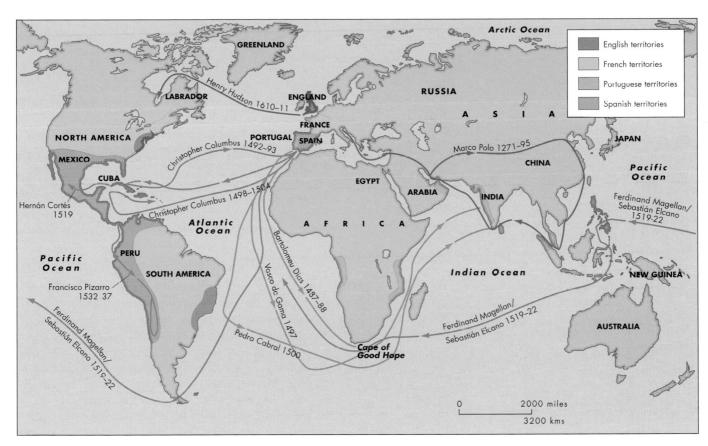

Map 15.2 World exploration, 1271–1611.

anything at all lie could know with certainty. His answer was that the only thing he could conceive of "clearly" and "distinctly" (his two essential criteria) was that he existed as a doubting entity. He could sense himself thinking. Descartes formulated this fundamental concept in Latin: "Cogito, ergo sum," which means "I think, therefore I am." According to Descartes, this cogito provided the foundation, principle, and model for all subsequent knowledge, which he held to the same standards of self-evidence and rationality.

Turning his attention from himself to the world, Descartes quickly realized that the only thing he could know for certain about the material world is that it likewise exists. He believed that there was an absolute division between mind and matter. Matter could be studied mathematically and scientifically, its behavior predicted by the new science of physics. How the mind knew something was quite different. When we observe an object in the distance—the sun, for instance—it appears to be small, but we know through scientific observation that it is much larger than it appears. Knowledge, Descartes knew, cannot rest on perception alone. This had been demonstrated by Copernicus's theory of the universe: we may perceive ourselves to be standing still, but we are on a planet spinning quickly through space.

This recognition led Descartes to consider how we can know that which we cannot perceive. Most important, how can we know that God exists, if we cannot perceive him? Descartes decided, finally, that if we are too imperfect to trust even our own perceptions, and yet we are still able to *imagine* a perfect God, then God must exist. If He didn't, then He would be unimaginable. In other words, what is "clearly" and "distinctly" perceived by the mind—*Cogito*, *ergo sum*—must be true. Descartes's answer was somewhat paradoxical, and would lead to much philosophical debate in the centuries to come.

Thomas Hobbes. During the Baroque age, the question of how to govern increasingly occupied philosophical thinkers. In England, the situation reached a crisis point when Charles I challenged Parliament's identity as the king's partner in rule. Civil war erupted, and in 1649, a Commonwealth was established, led by the Puritan Oliver Cromwell as, essentially, a military dictatorship. The monarchy was restored in 1660 after the republic failed, but the relationship between parliament and monarch remained murky. Finally, in 1688, James II was expelled in the bloodless "Glorious Revolution," and Mary and William of Orange, James's daughter and son-in-law, ascended the throne. They immediately accepted the rights of all citizens under the law, recognizing in par-

Figure 15.37 Frontispiece of *The Leviathan*, 1651, Bancroft Library, Berkeley, California. An image of the social contract, the body of the king is made up of hundreds of his subjects. He rules over a world at peace, its cities well fortified and its countryside well groomed.

ticular Parliament's right to exercise authority over financial matters, and England became a limited monarchy.

In this atmosphere, the debate about the nature of political rule (who should govern and how) was addressed by two political philosophers with very different points of view. Mirroring Descartes's emphasis on the primacy of perception was the philosopher THOMAS HOBBES (1588–1679). Educated as a classicist, Hobbes was particularly impressed by the geometry of Euclid, and he came to believe that the reasoning upon which geometry is based could be extended to social and political life. After visiting with Galileo in Italy, Hobbes became even more convinced that this was true. The power of Galileo's science of observation and its ability to describe the movement of the solar system could be extended to the observation of human beings in their relations to one another.

Hobbes's philosophy, which was published in 1651 in a book entitled *The Leviathan* (fig. 15.37), would be read by many as essentially an apology for, or defense of, monarchical rule. Hobbes believed, quite simply, that humans are driven by two primal forces, the fear of death and the desire for power. If government does nothing to check these impulses, mankind simply self-destructs, and human life becomes essentially anarchical. But Hobbes also believed that humans recognize their essential depravity and therefore choose to be governed. They enter into what he called the **social contract**, by which the people choose to give up sovereignty over themselves and bestow it on a ruler. They agree to carry out all the ruler's commands, and in return the ruler agrees to keep the peace.

John Locke. JOHN LOCKE [lock] (1632–1704), who repudiated Hobbes, believed that people are perfectly capable of governing themselves. Locke's Essay on Human Understanding, published in 1690, argues that the human mind is at birth a tabula rasa, or "blank slate." Then two great "fountains of knowledge," our environment as opposed to our heredity, and our reason as opposed to our faith, fill this blank slate with learning as the person develops. Locke argued, furthermore, in his Second Treatise on Government, also published in 1690, that humans are "by nature free, equal, and independent." They accept the rule of government, he argues, because they find it convenient to do so, not because they are innately inclined to submit to authority. Such ideas set the stage for the political revolutions of the eighteenth century.

LITERATURE

Unlike Renaissance writers, who were often content to catalogue the beauties of the beloved, Baroque writers display an uncommon interest in exploring the mysteries of love, both erotic and divine. They also spend considerably time exploring their relationship to God, often in passionate and dramatic terms. Religious and secular writing, often dramatizes emotional and personal encounters between speaker and listener (whether God or lover).

Molière and the Baroque Stage. During the Baroque era, stage plans differed from those of Shakespeare and classical Greece. Seventeenth-century plays took place indoors on a picture-frame stage, created with a proscenium arch, an arch separated the stage from the auditorium). The plays were enacted on a box stage, which represented a room with a missing fourth wall, allowing the audience to look in on the action. This is still the most popular stage in use.

Though the painted scenery was not elaborate, it served as a backdrop for the action. Candles and lanterns illuminated actors and audience. Costume tended toward the elaborate and ornate, as in Elizabethan drama. On both Elizabethan and Baroque stages, actors were ordi-

Then & Now

THE TELESCOPE

Galileo's telescope (fig. 15.38) changed the way people thought of their solar system, overturning longstanding beliefs in an earth-centered system. It demonstrated nearly conclusively that the earth and other planets orbited around the sun. The modernday Hubble Space Telescope is rapidly changing our understanding of the solar system's place in the universe. Deployed on April 24, 1990, by Discovery astronauts, the 12.5-ton satellite carrying Hubble is able to look clearly at the cosmic skies unhindered by earth's atmosphere. It has revealed galaxy forms as much as twelve billion light-years away. Hubble's observation of distant galaxies has led scientists to theorize about the age of the universe itself. Wendy Freedman of the the Carnegie Observatories estimates the universe is between nine and twelve billion years old.

Galileo was able to see other galaxies, which he called nebulae (clouds). Hubble's photographs suggest that these nebulae are really clumps of gas that generate new stars. Enormous jets of gas erupt out of these gas clumps at speeds up to 300 miles per second and are shot trillions of miles out into space. This is the stuff, scientists believe, of which solar systems are made. Hubble has shown these whirling jets, which rotate faster and faster, all at once form a star and shoot out jets of matter that will form something like our own solar system. The implication is that most stars, even in our own galaxy, possess solar systems similar to our own, and hence the possibility of life.

Figure 15.38 Galileo Galilei, Telescope, 1609, Museum of Science, Florence. With a telescope such as this, Galileo was able to contradict the Ptolemaic view of the universe.

narily costumed in contemporary dress appropriate to the social status of the characters they portrayed. A major innovation in seventeenth-century drama was that female actresses assumed women's roles for the first time, enabling playwrights to include more extensive and realistic love scenes. As in the earlier eras of drama, however, language still did much of the work, so that even in an intimate French Baroque playhouse seating four hundred, action remained subordinate to dialogue.

The conventions of the French theater of the time were inspired by the classical drama. Like its ancient antecedents, the seventeenth-century French theater observed what are known as the three **unities**: the unity of time, the unity of place, and the unity of action. A play's action had to be confined to a twenty-four-hour period. The place should be a single setting. The action must be unified in a single plot. Plays that violated these unities were thought crude by their educated audience, which consisted largely of courtiers and aristocrats. The three great practitioners of the French Baroque theater all observed the unities—its two great tragedians, PIERRE CORNEILLE [kor-NAY] (1606-1684) and JEAN RACINE [ra-SEEN] (1639–1699), and its great comic genius Jean-Baptiste Poquelin, known by his stage name MOLIERE [mol-YAIR] (1622–1673).

Corneille's themes are those of patriotism and honor. Racine's plays concentrate on the moral dilemmas he discovered in the great Greek tragedies. But of the three, Molière's satiric comedy is the most accessible, resorting, as it often does, to slapstick, pratfalls. Among his masterpieces is *Tartuffe*, which satirizes both religious hypocrisy and fraudulence. The play also pokes fun at the fanaticism and gullibility of those who allow themselves to be victimized by the greedy and the self-serving.

When *Tartuffe* was first staged in 1664, it antagonized those who considered it an attack on religion. Even though Molière retitled it *The Impostor* to indicate that Tartuffe's piety is fraudulent, the original version of the play was censored and banned. To defend it against such charges, Molière wrote three prefaces and later changed his ending. The publicity enhanced the play's popularity, and the work was returned to the stage under the protection of the King. Its unending popularity, however, is due neither to royal protection nor to notoriety, but rather to the ingenuity of its plot, the percipience of its characterization, and the brilliance of its language.

John Donne. One Baroque poet who wrote secular and religious verse that displays dramatic qualities is JOHN DONNE [dun] (1572–1631), considered among

the finest poets of his, or indeed of any, age. John Donne is as witty and paradoxical as any writer of his time. He wrote prose as well as verse, and his poetry includes amorous lyrics, philosophical poems, devotional sonnets and hymns, elegies, epistles, and satires. Through intellectual energy, metaphorical ingenuity, and dramatic style, Donne reveals a restlessly inquisitive mind and a deeply religious spirit. He offers profound psychological insights often in a colloquial idiom, something that anticipates modern attitudes.

Donne's "A Valediction: Forbidding Mourning," a deeply philosophical love poem, is recognized for its extended analogy or conceit comparing lovers to the two feet of a geometrician's compasses.

As virtuous men pass mildly away, And whisper to their souls to go, While some of their sad friends do say, The breath goes now, and some say, no:

So let us melt, and make no noise,
No tear-floods, nor sigh-tempests move;
'Twere profanation of our joys
To tell the laity our love.

Moving of th' earth° brings harms and fears,
Men reckon what it did and meant,

But trepidation of the spheres,°

Though greater far, is innocent.

Dull sublunary° lovers' love
(Whose soul is sense) cannot admit
Absence, because it doth remove
Those things which elemented° it.

But we by a love so much refined,

That ourselves know not what it is,
Inter-assured of the mind,
Care less, eyes, lips, and hands to miss.

Our two souls therefore, which are one, Though I must go, endure not yet A breach, but an expansion, Like gold to airy thinness beat.

If they be two, they are two so
As stiff twin compasses are two;
Thy soul the fixed foot, makes no show
To move, but doth, if th' other do.

And though it in the center sit,
Yet when the other far doth roam,
It leans, and hearkens after it,
And grows erect, as that comes home.

25

Such wilt thou be to me, who must
Like th' other foot, obliquely run:
Thy firmness makes my circle just,
And makes me end, where I begun.

Contemporary sources note that Donne addressed this poem to his wife as he was preparing in 1611 for a continental journey. He had premonitions of disaster, which turned out to be well founded since his wife gave birth to a stillborn child while he was abroad. In the first two stanzas the speaker urges his wife not to make a public spectacle of their grief on parting. The poet/speaker compares their leave-taking with the death of virtuous men, who depart life quietly and peacefully. He urges her to emulate their behavior, arguing that theatrical displays of unhappiness profane their deeply private relationship.

Throughout the next four stanzas the speaker contrasts the couple's higher, more spiritual love with the love of the sensual. Their love, intellectual and spiritual, transcends the senses. In these stanzas, Donne introduces the first of his two important conceits: that the lovers' souls are not really separated but are almost infinitely expanded to fill the intervening space between them, as gold expands when beaten into paper-thin sheets. The comparison with gold suggests the value of love and its prominent position in their lives. This use of scientific reality to illuminate a spiritual condition typifies Donne's amalgamation of disparate realms of experience.

The last part of Donne's "A Valediction: Forbidding Mourning," however, extends his conceit over three stanzas. The compass is a symbol of constancy and change since it both moves and remains stationary. The compass also inscribes a circle, symbol of perfection. These ideas of constancy and perfection are worked through in detail as the speaker/poet explains how one foot of the compass moves only in relation to the other, returning "home" when the two feet of the compass are brought together.

Anne Bradstreet. Among Donne's near contemporaries is ANNE BRADSTREET (1612–1672), the first major poet in American literature. Born Anne Dudley to a Puritan family in Northampton, England, she sailed with her parents and her new husband, Simon Bradstreet, to Massachusetts in 1630. As secretary to the Massachusetts Bay Company, Simon often traveled on company business, leaving Anne alone. In his absence she became an accomplished poet, and on several occasions wrote poems about their separation.

Though today best known for her domestic lyrics, in her own day Bradstreet was known for a monumental historical cycle of poems based on the four ages of humanity. Donne's philosophical poems, and Bradstreet's domestic ones, can be compared with the paintings of a northern Baroque painter like Vermeer, whose small body of elegantly and finely honed art embodies near perfection of form and idea.

John Milton. Unlike Donne, JOHN MILTON (1608–1674) had a Baroque conception of grandeur and monumentality that was attuned to the epic, a sensibility Bradstreet shared. Milton, however, stood at the oppo-

⁹ Moving of th' earth: earthquakes. ¹¹ trepidation of the spheres: According to Ptolemaic astronomy, the planets sometimes moved violently, like earthquakes, but these movements were not felt by people on earth. ¹³ sublunary: Under the moon: hence mortal and subject to change. ¹⁶ elemented: composed.

site end of the poetic spectrum, like the architect Bernini, the more monumental Baroque painters such as Rubens, and composers of large-scale musical works, such as Bach and Handel.

No poet more than Milton embodies the ideal of a poetic vocation. Milton believed that one didn't become a poet simply by writing poems. A poet had to prepare intellectually and spiritually through disciplined study and prayer, for great art, Milton believed, could only be written by a mind and soul readied for the enormous challenge the poetic vocation entailed.

What specific kinds of preparation did Milton find necessary? To learn poetry, he studied the great classical writers of ancient Greece and Rome—Homer, Virgil, Ovid, and Theocritus-and he studied the Bible. He sensed that he must write poetry at once serious in outlook and grand in manner, befitting one who wanted to "leave something so written to aftertimes as they should not willingly let it die."

Milton's poetry, from the early apprentice work to the later epics, was grounded in the ideals of classical humanism and biblical morality. Combining these two influential Western traditions more thoroughly than any other writer in English, Milton presents a decisive summation of High Renaissance art and Christian humanism. From the Greeks and Romans Milton derived a sense of civic responsibility. Like his forebears, Milton believed that the primary function of art was to teach, and that one of its primary lessons was civic responsibility. Milton himself was steeped in the tradition that valued great statesmen, who could ensure the survival of civilized and humane spiritual values.

Milton's life can be divided into three parts. First, he prepared for his poetic vocation. This period culminated in the publication of "Lycidas," his elegy on the death of a drowned friend, followed by a two-year tour of Europe. Second, he spent a twenty-year span from about 1640 to 1660 in political involvement, during which he wrote prose rather than poetry. Placing himself in the service of the Puritans, Milton produced pamphlets on various theological and ecclesiastical issues. Milton actually lived the last two decades of his life in blindness brought on, in part, by his exhausting work on behalf of the Puritans in the 1640s. When the English monarchy was restored, Milton was imprisoned and his property confiscated.

Third, after his release from prison, Milton spent the last fifteen years of his life writing his most ambitious works: Paradise Lost (1667), Paradise Regained (1671), and Samson Agonistes (1671). In these poems, especially in Paradise Lost, Milton attempted, in his words, "to justify the ways of God to man." This idea of justification reflected Milton's own blend of Puritan theology and classical humanism. Milton reinterpreted the crucial events of Genesis—humankind's fall into sin and its banishment from the Garden of Eden with all the pain and sorrow that resulted from Adam and Eve's disobedience of God's commandment—and emphasized the central theological belief of Christianity: the incarnation of God-as-man in Jesus Christ, who came to atone for the sin of humanity's first parents and who restored humankind's place of favor with God.

Regardless of one's theological beliefs, Paradise Lost impresses with its remarkable dramatic stories: descriptions of the battle in heaven between the faithful and the rebellious angels; the debate in hell among the various fallen angels on how to proceed against their common enemy, God; the temptation scene in which Satan persuades Eve to eat the forbidden fruit.

Miguel de Cervantes. During the sixteenth century in Spain, a narrative form known as the picaresque began to develop. The picaresque novel details the life of a pícaro, a rogue or knave who wanders from adventure to adventure, encountering various segments of society, and this type of narrative marks the birth of the novel as a literary form. Like Chaucer's Canterbury Tales, the picaresque novel probably developed out of the pilgrimage tradition. But whereas the Canterbury Tales is a compendium of stories about different pilgrims, the picaresque novel focuses on a single hero. One characteristic feature of the picaresque novel is its pseudo-autobiographical nature. Narrated always by the hero, the point of view is clearly his. An observer of society, perhaps as a result he is expert at recognizing fraud and deception. In many ways, his journey is a sort of "fallen" epic. Like Odysseus, the pícaro encounters various obstacles, but instead of Scylla and Charybdis he meets characters such as a blind priest and a lecherous monk.

The greatest of all picaresque novels is *Don Quixote*, by MIGUEL DE CERVANTES [ser-VAHN-tez] (1548– 1616). It is in fact more than a picaresque novel, satirizing the form even as it goes beyond it in complexity and ambition. Don Quixote was translated in the seventeenth century into English, French, Italian, and German. Hailed as the first modern novel, Don Quixote has transcended its time because of the central character. Don Quixote, the hero, is presented by Cervantes as "dry, shriveled, and full of odd fantasies such as never entered another's brain." He wants, most of all, to become a "knight errant," the kind of hero he has read about in books, who saves ladies from evil and defeats dragons in combat. In fact, he is at once noble and a buffoon. What he sees and what is the truth are two entirely different things. His horse is "all skin and bones," but in his eyes, it is a noble "steed." His companion is a peasant boy, redubbed his "squire," Sancho Panza. His lady, the lovely Dulcinea, is actually one Aldonza Lorenzo, who "never knew or was aware of" his love for her. And the giant he eventually fights is not a giant at all, but a windmill. The novel represents, for the first time in Western literature, the conflict between reality and the imagination, and though Don Quixote's imagination brings him to the edge of total madness, it ennobles him as well. His pathos is itself heroic.

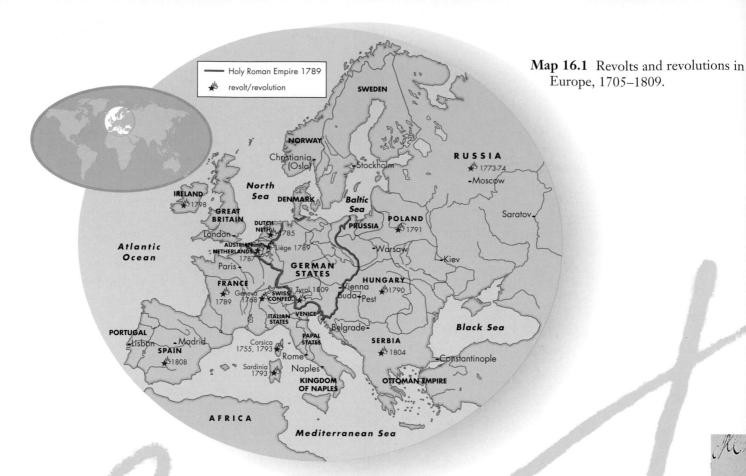

The EIGHTEENTH CENTURY

C H A P T E R 1 6

- ← Enlightenment and Revolution
- * The Rococo
- ← The French Revolution
- Neoclassicism
- ← Toward Romanticism

Holograph copy of Beethoven's Fifth Symphony, Staatsbibliothek zu Berlin, Germany.

ENLIGHTENMENT AND REVOLUTION

Between 1700 and 1800, the world was literally transformed. At the beginning of the century, Louis XIV had firm control of France. The portrait painted in 1701 by Hyacinthe Rigaud (fig. 16.1) shows the Sun King, anointed by God, in ermine coronation robes and surrounded by the earthly riches and furnishings of Versailles. The king's posture is arrogant, suggestive of his status above all other humans; with one hand on his

Figure 16.1 Hyacinthe Rigaud, *Louis XIV*, 1701, oil on canvas, $9'2'' \times 7'10^{\frac{3}{4}}''$ (2.79 × 2.40 m), Musée du Louvre, Paris. Unsurpassed in pompous posturing, Louis XIV literally looks down his nose at the viewer. The column and sweep of red drapery are standard devices used in formal portraiture to enhance the subject's prestige; the red high heels are Louis XIV's own.

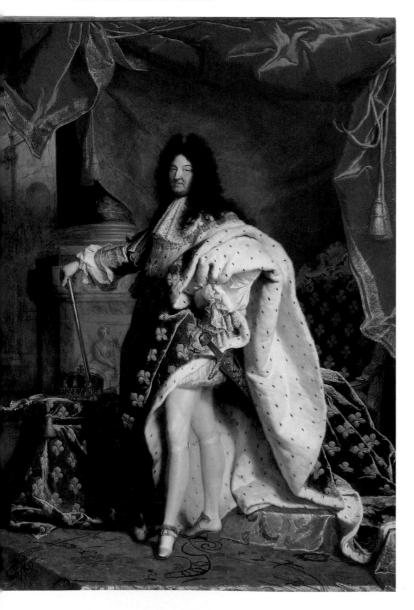

Figure 16.2 Jacques-Louis David, Marie Antoinette Being Led to Her Execution, 1793, ink drawing, Musée du Louvre, Paris. David drew this from a second-story window overlooking the procession that accompanied the Queen to her death.

hip and a facial expression of aggressive disdain, he positively looks down his nose at the viewer.

By the end of the century, the French monarchy had fallen from its lofty place, as Louis XVI (1754–1793), the Sun King's great-grandson, and his Queen, MARIE ANTOINETTE [ann-tweh-NET] (1755–1793), were executed by the National Assembly of the French Revolution. A very different "royal portrait" was done hurriedly by French revolutionary painter David as he stood on a Paris street on October 16, 1793 (fig. 16.2) and watched the Queen's procession to the guillotine in front of the Louvre. The Queen is stripped of all trace of aristocratic grandeur, save perhaps the rigid defiance of her facial expression, her lip and chin thrust forward in disdain for her rabble killers.

The changes that occurred in the eighteenth century were swift and extreme, encompassing revolutions that were not only political, but intellectual, scientific, industrial, and social. Indeed, the eighteenth century has been called the "Age of Reason" because of the dominance of the intellectual revolution that we have come to call the Enlightenment.

THE ENLIGHTENMENT

The term Enlightenment refers to the eighteenth-century European emphasis on the mind's power to reason, in contrast to the mind's yearning for religious faith, which a number of Enlightenment thinkers saw as superstition. The late seventeenth century through the eighteenth century saw two great movements: that of the "Age of Reason," which hallmarks the contemporary emphasis on rationality, and the Neoclassical, which testifies to the influence of classical antiquity.

The Enlightenment did not so much inaugurate something new in the Western intellectual tradition as continue an emphasis on secular concerns that began during the Renaissance and continued with the rise of scientific and philosophical thought during the seventeenth century. Francis Bacon's empirical approach to knowledge and René Descartes's emphasis on logic and human reason both served as a prelude to eighteenth-century political and philosophical ideals. These ideals included freedom from tyranny and superstition, and a belief in the essential goodness of human nature and the equality of men (though not all men, and not women).

Enlightenment thinkers emphasized the common nature of human experience, ignoring differences in social, cultural, and religious values. With an impulse toward the universal, Enlightenment writers often celebrated constancy and continuity, encouraging a respect for tradition and convention, especially in literature and the arts. Enlightenment artists and thinkers must not be seen, however, simply as supporters of the status quo. They used their considerable analytical powers to attack the hypocrisies of the age. As much as they celebrated the powers of reason, they did not fail to notice when

human behavior was guided by passion, selfishness, and irrationality. Voltaire, Swift, and Pope all composed scathing attacks on political and social misconduct.

The Philosophes. As an era dedicated to the kind of philosophical inquiry practiced by René Descartes and to the kind of scientific study championed by Francis Bacon, the Enlightenment was embodied in a group of intellectuals called by the French name *philosophes*. These thinkers believed that through reason, humankind could achieve a perfect society of perpetual peace, order, and harmony.

Faced with the two philosophical positions on political rule that had been defined in the previous century, those of Thomas Hobbes (1588–1689) and John Locke (1632–1704), the *philosophes* really had no choice but to champion the cause of Locke. Hobbes's position essentially supported the idea of the monarchy—or at least the rule of a single individual—while Locke proposed the possibility of democratic rule, and tyranny was what the *philosophes* feared most of all. They denounced intolerance in matters of religious belief, which, since the Reformation, had continued to disrupt society, and they advocated public, as opposed to Church-controlled, education.

Rational humanism. Rational humanism is based on the fundamental belief that through rational, careful thought, progress is inevitable. This is furthered by the notion that progress itself is good and benefits everyone. Like the humanists of the Renaissance, the rational humanists believed that progress is possible only through learning and through the individual's freedom to learn. Humans must, therefore, be free to think for themselves. This logic links the rational humanists with

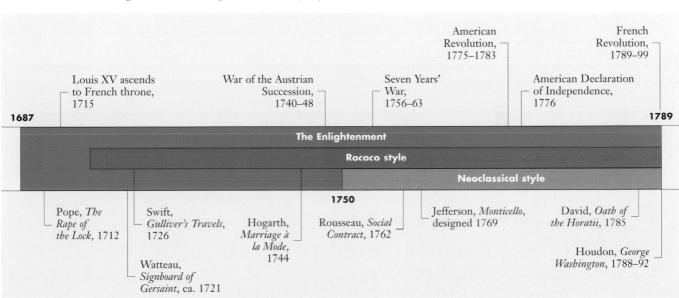

Timeline 16.1 The Enlightenment and eighteenth-century styles.

the two great political revolutions of the day, in America and in France, and with such political documents as the Declaration of Independence and the Declaration of the Rights of Man and Citizen as well as with the Constitution of the United States. The rational humanists believed that any political system that strives to suppress freedom of thought must be overthrown as an obstacle to progress.

THE INDUSTRIAL REVOLUTION

The Birth of the Factory. Over the course of the eighteenth century, the nature of labor began to change. On May 1, 1759, in Staffordshire, England, a twentyeight-year-old man named JOSIAH WEDGWOOD (1730-1795) opened his own pottery manufacturing plant. While Wedgwood initially specialized in unique pottery made by hand, he also began to produce a cream-colored earthen tableware. Designs were then printed by mechanical means (fig. 16.3). In the same year, Wedgwood's friend MATTHEW BOULTON (1728-1809) inherited his father's "toy" factory (small metal objects such as belt buckles, buttons, and clasps were known as "toys"). Soon he had built a factory in London, employing six hundred people in mechanized, large-scale production. The steam engine, patented by James Watt in 1769, transformed the way in which these new factories could be powered. Mechanical looms were soon introduced into the cotton cloth industry, powered by Watt's steam engines. Where once workers had woven fabric at home as "piece work," they now watched over giant looms that did the work for them, in a fraction of the time. Mass manufacturing, and with it what we have come to call the "Industrial Revolution," had begun.

Adam Smith. In 1776, the Scotsman ADAM SMITH (1727–1790) provided the rationale for the

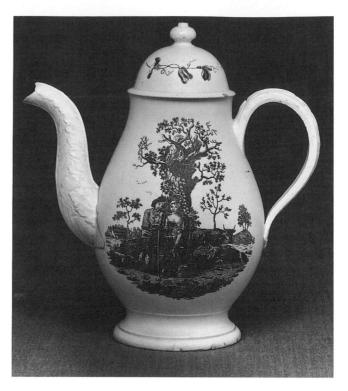

Figure 16.3 Transfer-printed Queen's Ware, ca. 1770, The Wedgwood Museum, Barlaston, England. Even elaborate designs such as this one were mechanically printed on ceramic tableware at Wedgwood's factory. By the turn of the century, pattern books detailing the designs available from Wedgwood were so popular throughout Europe that they were "best-sellers."

entire enterprise. His *Inquiry into the Nature and Cause of the Wealth of Nations* barely mentioned manufacturing, concentrating instead on agriculture and trade, but the business people who ran the new factories saw in his writings the justification for their practices. In a free-market system based on private property, Smith argued

Timeline 16.2 Scientific and industrial achievements.

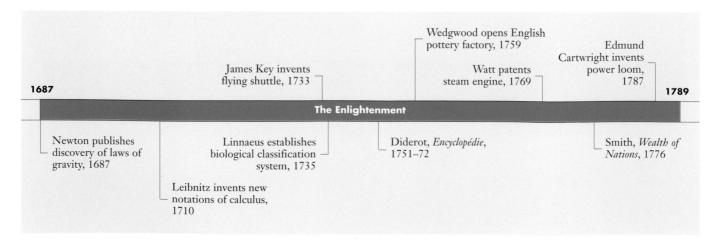

that prices and profits would automatically be regulated to the benefit, theoretically, of everyone, not just the factory owners. He contended that the economy would operate as if with an "invisible hand" beneficently guiding it. The new "working class" that arose out of the Industrial Revolution, however, would find that the free-market system benefited the factory owners a great deal more than themselves, and by the dawn of the nine-teenth century, the factory owners had become the new "kings" of industrial culture—as spendthrift and tyrannical as the monarchs of the previous age.

THE SCIENTIFIC REVOLUTION

Isaac Newton. The positivism of the age was exemplified by Locke's theory of the innate human rights to life and to property and the belief in humanity's capacity for reason, but it was driven by advances in scientific learning. The *philosophes* seized on the discovery by ISAAC NEWTON (1642–1727) of the principle of gravitation, the first physical description of the forces holding the known universe together. The earth and its moon, Jupiter and its four moons, the sun and its planets all formed a harmonious system, with each celestial body relying upon the others to maintain its place and position. Transferring this vision to human society, the

philosophes suggested that with a comparable system of mutual reliance humans could live in harmony. Newton's discovery prompted what can only be called yet another revolution, a "Scientific Revolution." Throughout the eighteenth century, scientists explored the natural world to such a degree that new sciences had to be defined: geology (1795), mineralogy (1796), zoology (1818), and biology (1819).

Denis Diderot and Carolus Linnaeus. The French essayist DENIS DIDEROT [DEED-eh-roe] (1713–1784) conceived of an idea for an *Encyclopédie*, twenty-eight volumes designed to encompass the whole of human knowledge, from science and technology to philosophical thought. Lavishly illustrated (fig. 16.4), the volumes actually contain thousands of illustrations showing the mechanical principles of production and commerce.

In the middle of the century, CAROLUS LIN-NAEUS [leh-NAY-us] (1707–1778) established the biological classification system that is still used to identify species. Both Linnaeus's classification system and the *Encyclopédie* are themselves undertakings that reveal the considerable optimism of the age, the result of two hundred years of scientific advances that had convinced many people that humankind could in fact eventually know everything—and catalogue it.

Figure 16.4 "Casting a Large Equestrian Statue," from Diderot's *Encyclopedia of Trades and Industries*, Vol. VIII, 1771. Typical of the illustrations in Diderot's mammoth work, these engravings depict the complex process involved in casting the giant bronze sculpture of Louis XIV on horseback that was erected in Paris in 1699.

Figure 16.5 Salon de la Princesse, Hôtel de Soubise, Paris, ca. 1737–38, decorated by Gabriel-Germain Boffrand. Turning away from the vast spaces of Baroque architecture, Rococo architects preferred small rooms, as demonstrated by those in this elegant townhouse. This room measures ca. $33 \times 26'$ (ca. 10.06×7.92 m), an ideal space in which to cultivate the art of conversation.

THE ROCOCO

Of all the political systems suppressing the rights of the people in the eighteenth century, that of France was the most audacious. It championed a style of art that was, in the eyes of many, entirely decadent and self-serving. Not only did the Rococo style appear frivolous to many, but it was commissioned by the same powerful aristocratic families who were seen as suppressors of the people's freedom. Its abundant extravagance was interpreted as a reflection of its patrons' uncaring self-aggrandizement. Marie Antoinette famously linked herself to such criticism when, on being told that French women were rioting in the streets for bread, she responded: "Let them eat cake!" Her retort quickly became the emblem of an unenlightened and irrational aristocracy that had lost sight of the values of humanism altogether. The Rococo art of this aristocracy, the poetry, architecture, painting, and sculpture of the court of Louis XV (r. 1715-74), is precisely what the Enlightenment came to define itself against.

The name Rococo is thought to come from the French word rocaille, a type of decorative rock work or grotto work made from pebbles and curving shells. It is also very likely a pun on the Italian word for the Baroque, barocco; certainly, the style's connection to certain elements of the Baroque is strong. Associated especially with the reign of Louis XV of France, who ascended to the throne at the age of five in 1715, Rococo artists rejected the heavier grandeur championed by the young King's grandfather, evident in the design of the east facade of the Louvre (see Chapter 15). Artists instead reshaped and modified the more elaborate aspects of the Baroque style apparent in, for instance, Borromini's design for San Carlo alle Quattro Fontane in Rome (see fig. 15.8).

The Rococo style is marked, particularly, by a shift in court taste from the poussiniste style—the more classical style of the painter Nicolas Poussin-to a somewhat rubéniste mode, indebted to the art of Peter Paul Rubens. The exact moment of this shift could be said to have taken place in the early 1700s, when the Duc de Richelieu wagered his famous collection of paintings (many by Poussin and the Caraccis) against King Louis XIV in a tennis match. To the delight of the King, the Duke lost the match, and Louis acquired the paintings. But to his surprise, the Duke, forced to start a new collection, quickly purchased fourteen paintings by Rubens, and the rubéniste mode, with all its color, motion, and light, was soon firmly established as an accepted style of painting.

THE FRENCH ROCOCO

The New Hôtels. The art of Rubens represented a liberation from the restraint of Poussin, and in almost all

things, the French court indulged its new-found sense of freedom. When Louis XIV died, and the Duc d'Orléans assumed the role of regent for the child-king, Louis XV, Versailles was immediately abandoned and the court reestablished in Paris itself, not so much at the Palace of the Louvre, but in *hôtels*, or townhouses, where clever hostesses oversaw weekly salons. A salon was a reception room intended for fashionable social gatherings of notable people, and the term "salon" came to refer to such events. The hostesses competed with each other in inviting the most powerful and accomplished of their peers. These salons were the scene of extraordinary conversations that turned, very often, into battles of wit and intelligence, or dwelt on matters of love and courtship. Musicians, often the finest of the day, entertained the

The hostesses were free to pursue their own tastes in Paris, unhampered by any "official" court style such as they had experienced at Versailles. They decorated their hôtels elaborately with gilded or painted wood moldings, inlaid China plagues and mirrors, bronze ornaments, marble mantels and countertops, and lacquerwork veneers. One salon of exquisite beauty was created for the Princess de Soubisc (fig. 16.5). Designed by France's royal architect, GABRIEL-GERMAIN BOFFRAND [boo-FRAHN] (1667-1754), it displays the typical Rococo concern for melding ceiling and walls into one curvilinear flow of delicate ornament and grace. Dominated by an interplay of curves and organic lines meant to evoke growing plants, interiors like this would not be seen again until the rise of Art Nouveau at the end of the nineteenth century.

Jean-Antoine Watteau. The paintings decorating the walls of the *hôtels* were generally purchased by the hostesses themselves in shops such as that depicted in The Signboard of Gersaint (fig. 16.6), a painting by JEAN-ANTOINE WATTEAU [WAH-toe] (1684–1721) of about 1721. Originally, Watteau designed it to hang as a sign outside his friend Gersaint's gallery. It was to replace the former signboard, a detail of Hyacinthe Rigaud's portrait of Louis XIV (see fig. 16.1), which is being put away in storage in the crate at the left. A lady sees this happening, but a gentleman gestures her to the new-style paintings on the right wall. Instead of formal portraits, rubéniste paintings, with reclining nudes and mythological scenes, have taken over the walls.

Patrons for Watteau's art were in fact widely diverse in social class. They included noblemen and government officials, as well as middle-class merchants and bankers. Several of these can be seen peering at a large oval painting that itself possesses many of the characteristics of Watteau's work. As a painter, Watteau was most noted for his fêtes galantes, depictions of elegant out-of-doors parties known for their amorous conversations, graceful fashion, and social gallantry.

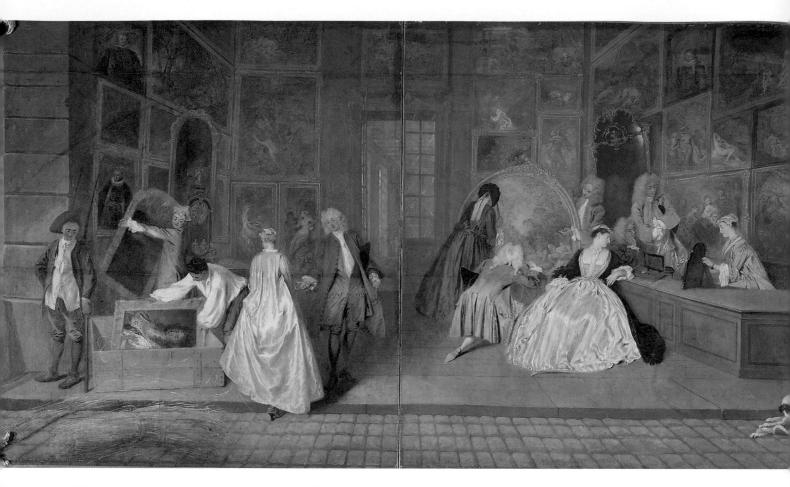

Figure 16.6 Jean-Antoine Watteau, *The Signboard of Gersaint*, ca. 1721, oil on canvas, $5'4'' \times 10'1''$ (1.62 \times 3.06 m), Staatliche Museen zu Berlin, Germany. Note that although the dealer Gersaint has paintings of more traditional subjects on his wall, his patrons seem more interested in the canvases that present sexual motifs.

Watteau's A Pilgrimage to Cythera (fig. 16.7), of 1717, is a mythologized vision of just such an event. The party takes place on Cythera, the birthplace of Venus and the island of love. Lovers go there to honor Venus, portrayed in a statue on the far right. Cupids fly above the crowd, the sun is low, and the lovers are boarding the boat that will return them to the real world. The departure is sad; some figures glance back, reluctant to leave the idyllic setting.

Watteau's painting gained entry into the Royal Academy of Painting and Sculpture even though it did not adhere to Academy rules of size or subject. It is relatively small, and the subject was neither history nor religion nor portraiture, the subjects the Academy favored. Watteau did not glorify the state or flatter the King. Nonetheless, the Academy recognized Watteau's achievement, and in a moment of triumph for the *rubéniste* sensibility, it created a new official category expressly for *fètes galantes*.

By the time Louis XV assumed personal rule of the country in 1743, the court had enjoyed a free rein for

many years. The King essentially adapted himself to its carefree ways, dismissing state officials at whim. In thirty years of personal rule, he had fourteen chief fiscal officers and eighteen different foreign secretaries, creating ceaseless instability in government. Life, for Louis XV, was something of an endless *fête galante*. He surrounded himself with mistresses, at least one of whom, Madame de Pompadour, wielded as much, or more, power than the King himself.

François Boucher. Madame de Pompadour's favorite painter was FRANÇOIS BOUCHER [boo-SHAY] (1703–1770), who began his career, in 1725, by copying the Watteau paintings owned by Jean de Jullienne, the principal collector of the artist's work. Jullienne had conceived of the notion of having all of Watteau's works engraved so that they could be enjoyed by a wider public. Boucher was quickly recognized as the best of the printmakers hired by Jullienne to undertake the task. With his earnings, he set off for Rome in 1727 to study the masters. But he found Raphael "trite,"

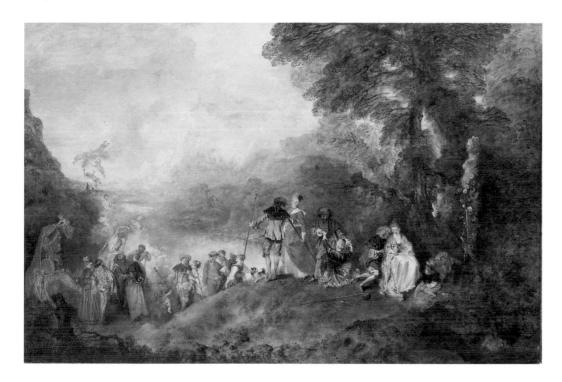

Figure 16.7 Jean-Antoine Watteau, *Pilgrimage to Cythera*, 1717, oil on canvas, $4'3'' \times 6'4\frac{1}{2}''$ (1.30 × 1.90 m), Musée du Louvre, Paris. The Rococo style is characterized by lightness of content and of color; romantic pastimes are portrayed in an atmosphere of lighthearted pastel hedonism.

Michelangelo "hunchbacked," and the work of the Carracci "murky," so he returned to Paris. By 1734, he was an established member of the Academy, specializing in *fêtes galantes* and other similar subjects. Soon he was appointed Director of the Royal Academy and First Painter to Louis XV, and patrons of society were soon clamoring after his work. Astonishingly prolific, Boucher produced over a thousand paintings and ten thousand drawings, and designed tapestries for the Royal Opera and the Opéra-Comique, which were later woven at the royal factories of Beauvais and Gobelins, and porcelain for Madame de Pompadour's favorite project, the Royal Porcelain Manufactory at Sèvres.

Boucher's painting of the *Bath of Diana* (fig. 16.8), of 1742, displays the delicate French grace and charming Rococo sentiment that made him so successful. Boucher painted many female nudes, then a popular subject; but on this occasion, to make it socially acceptable, he presented the figure as the mythological Diana. His goddess of the hunt, however, is lardly strong or powerful. She is aristocratic, delicate, and soft, seemingly straight from the hairdresser. The curving shapes are characteristic of the Rococo style, as are the lush colors that he favors—tender pinks, blues, and soft whites. The artist's friends likened his colors to "rose petals floating in milk." The overall effect is one of quiet sensuality, conveying an air of relaxed indiscretion.

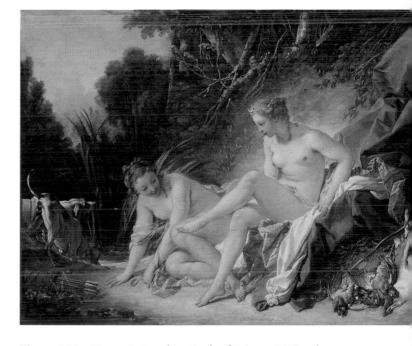

Figure 16.8 François Boucher, *Bath of Diana*, 1742, oil on canvas, $22\frac{1}{2}" \times 28\frac{3}{4}"$ (57.2 × 73 cm), Musée du Louvre, Paris. The portrayal of female nudity was made acceptable by the antique context in which it was presented. The female type admired was not powerful or rugged but pale, delicate, and pampered.

Jean-Honoré Fragonard. The other great painter of the Parisian Rococo was JEAN-HONORÉ FRAGO-NARD [frah-goh-NAR] (1732–1806), Boucher's student, whose work is even more overtly erotic than his teacher's. Sensuous nudes inhabit his paintings, and they are depicted in an equally sensual style, much like that of Rubens in its use of strong fluid color and areas of light and shade. Fragonard is noted for his rapid brushwork: he could paint an entire work inside an hour. His figures float softly, ever graceful, always courtly. Fragonard's most famous work, however, was a series of fourteen canvases commissioned around 1771 by Madame du Barry, Louis XV's last mistress. Designed to decorate her château, they depict a series of encounters between

Figure 16.9 Jean-Honoré Fragonard, *The Meeting*, 1771–73, oil on canvas, $15'5\frac{1}{4}''\times7'\frac{5''}{8}''$ (3.18 × 2.15 m), The Frick Collection, New York. The sculpture that rises above this scene, though an entirely imaginary creation of the artist, is in fact representative of the favored sculptural style of the Rococo. The figure twists and turns in an upward spiral that accentuates the curves of her hip and thigh.

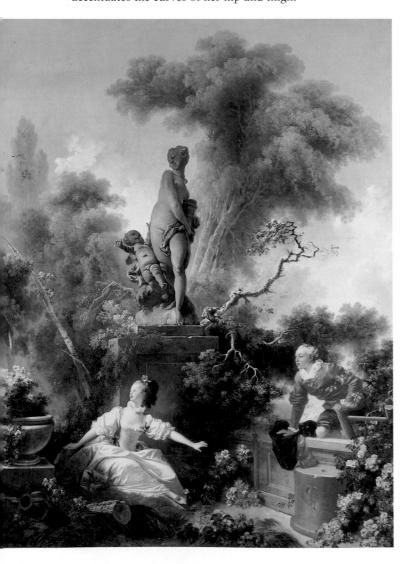

Figure 16.10 Marie-Louise-Elisabeth Vigée-Lebrun, *The Artist and Her Daughter*, ca. 1785, oil on canvas, 4'3" × 3'1" (139.7 × 94 cm), Musée du Louvre, Paris. Vigée-Lebrun's style coincided perfectly with upper-class tastes, making her the highest-paid portrait painter in France (by the age of twenty!) and court painter to Queen Marie Antoinette.

lovers in garden settings, like the gardens of the château itself. *The Meeting* (fig. 16.9) has elements characteristic of the whole series. Below a statue of Venus, a young woman waits to meet her lover, who is climbing over the garden wall. The scene is ambiguous: Is he arriving, or fleeing? Whatever the case, they fear being discovered, as is evident from their anxious glance to the left.

Fragonard endured constant interruption by Madame du Barry, and in the end the paintings were rejected, perhaps because the Rococo was becoming increasingly unpopular. Seen by many as the embodiment of the decadence of the aristocracy, the style was on the wane.

Marie-Louise-Elisabeth Vigée-Lebrun. Paintings like The Artist and Her Daughter (fig. 16.10) by MARIE-LOUISE-ELISABETH VIGÉE-LEBRUN [vee-JHAY le-BRUN] (1755–1842) signaled the arrival of this more restrained and naturalistic classical style. Fatherless as a girl, Vigée-Lebrun supported her mother and brother by her painting. She was a child prodigy; by the time she was twenty, her portraits were commanding the highest

Connections

DIDEROT AS ART CRITIC

One of the very first art critics—ccrtainly the first art critic of any substance—was Denis Diderot (1713–1784), the *philosophe*. He enjoyed art, and his enjoyment is evident in every page of his essays, called the *Salons*. He reviewed all the exhibitions sponsored by the French Academy from 1759 on for a private newspaper, *La Correspondance littéraire*. Subscribers to this newspaper were the elite of Europe—princesses and princes—and it was intended to keep potential patrons abreast of the latest news from Paris.

Though he considered Boucher the most talented painter of his generation, Diderot generally disapproved of his subjects, and he went so far as to condemn him and his contemporaries in the Salon of 1767 for the essentially erotic content of most of what was on display. Four years earlier he had asked, "Haven't painters used their brushes in the service of vice and debauchery long enough, too long indeed?" He preferred what he called "moral" painting, painting that sought "to move, to educate, to improve us, and to induce us to virtue." Diderot could, nonetheless, be extraordinarily cruel. Addressing a now-forgotten painter by the name of Challe, he asked, "Tell me, Monsieur Challe, why are you a painter? There are so many other professions in which mediocrity is actually an advantage."

Anticipating the Impressionists a century later, he celebrated a still life painting entitled *The Brioche* (fig. 16.11) by JEAN-BAPTISTE-SIMÉON CHARDIN [shar-DAN] (1699–1779): "Such magic leaves one amazed. There are thick layers of superimposed color, and their effect rises from below to the surface ... Come closer, and everything becomes flat, confused, and indistinct; stand back again, and everything springs back into life and shape."

Diderot's writing style is anything but as direct as his criticisms. Some of his *Salons* are so long that they cannot be read at a single sitting. They exercise every excuse for a digression. Still, their acuteness of vision and moral purpose have influenced art criticism down to

the present day.

Figure 16.11 Jean-Baptiste-Siméon Chardin, *The Brioche*, 1763, oil on canvas, $18\frac{1}{2}$ " × 22" (47 × 55.9 cm), Musée du Louvre, Paris. A master of still life, which in his day was considered the lowest form of painting, Chardin was nevertheless recognized by his contemporaries as applying paint and color as no one before him had ever done. But his technique was not, he thought, what mattered most. "Who told you that one paints with colors?" he once asked a fellow artist. "One uses colors, but one paints with feelings."

prices in France. Highly sought after and highly paid, Vigée-Lebrun painted portraits of all the important members of the aristocracy, including Louis XVI's queen, Marie Antoinette. Vigée-Lebrun had the ability to convey a sense of power combined with grace and intimacy. Her subjects often seem to be turning to glance at the viewer, as if the viewer just happened into their presence a moment ago. Closely linked to royalty, Vigée-Lebrun fled France during the Revolution, spent many years traveling and painting in Europe, and published three volumes of memoirs, which give an insight into her art and era.

ENGLISH PAINTING

William Hogarth. The influence of the French Rococo on English painting is evident in the work of WILLIAM HOGARTH (1697–1764). Hogarth was a storyteller whose work documents the life of his time. He produced picture series that were equivalent to scenes in a play or chapters in a novel. Hogarth used similar details to help viewers interpret the different scenes of his works, which were much like morality plays. He sought to teach by example, referring to his narratives as "modern moral subjects." A social critic, he

Figure 16.12 William Hogarth, *The Marriage Contract*, scene I from *Marriage à la Mode*, 1744, oil on canvas, $27 \times 35''$ (69×89 cm), National Gallery, London. Through a series of paintings, comparable to scenes in a play, Hogarth told moralizing tales focusing on the hypocritical or dishonest practices of his day. *Marriage à la Mode* shows the disastrous outcome of a marriage arranged for the benefit of the parents of the bride and groom.

satirized the decadent customs of his day by exposing the "character" of society. Thus, unlike his French counterparts, who painted the life of the aristocracy in an unabashedly erotic and glowing light, Hogarth's view of England's aristocracy is overtly critical and moralistic. The engravings he made of these paintings were sold to the public and became wildly popular. Hogarth's financial success presented an important, if ambivalent lesson: lurid stories sell.

Hogarth's most mature work is *Marriage à la Mode*, a series of paintings made in 1744. The first scene, called *The Marriage Contract* (fig. 16.12), introduces the cast of characters. On the right sits the father of the groom, a nobleman who points to his family tree. Through this arranged marriage, he is trading his social position for money that will ensure that the mortgage on his estate is paid off. The bride's father, a wealthy tradesman, inspects the contract. On the left, the engaged couple have their backs to each other. The groom preens himself in the mirror. The bride talks to the lawyer, counselor Silvertongue.

In the five scenes that follow, the marriage, as expected, sours. Husband and wife are both unfaithful.

When the husband finds his wife with Silvertongue, the lover stabs him. The wife is disgraced and takes poison. As she is dying, her father, mercenary to the end, removes her valuable rings. In *Marriage à la Mode* the guilty live on.

Sir Joshua Reynolds. One of the leading painters of London society was SIR JOSHUA REYNOLDS (1723–1792). Thoughtful, intelligent, and hard-working, Reynolds was named the first President of the Royal Academy of London in 1768 and was knighted the following year. Favoring an academic art similar to that championed by Lebrun in France a century earlier, Reynolds developed a set of theories and rules in his fifteen Discourses, positioning history painting as the highest form of art and advocating a "general" view of nature (as practiced in the Italian Baroque) over the "particular" scenery evident in Dutch landscape.

The majority of Reynolds's works are portraits, presumably because portrait painting was lucrative. His style is seen in his portrait *Lady Elizabeth Delmé and Her Children* (fig. 16.13), executed 1777–80 at the peak of his career. Reynolds often portrayed aristocratic ladies as

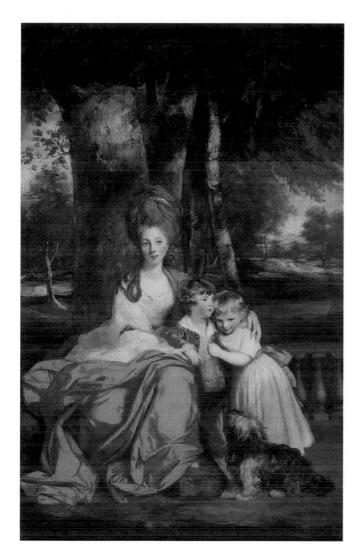

Figure 16.13 Sir Joshua Reynolds, Lady Elizabeth Delmé and Her Children, 1777–80, oil on canvas, $7'10'' \times 4'12\frac{1}{8}''$ (2.39 × 1.48 m), National Gallery of Art, Washington, DC. Reynolds, Gainsborough's rival, places his aristocratic subjects in a landscape setting indicative of the eighteenthcentury appreciation of nature.

elegant and gracious, refined and dignified. Lady Delmé sits on a rock and embraces her oldest children. All are fashionably dressed. The colors and textures are lush in Reynolds's "Grand Manner"—indeed, the canvas itself is enormous and the figures almost life-size.

Reynolds painted rapidly with full, free brushstrokes, without first making sketches. He told one of his patrons that a portrait "requires in general three sittings about an hour and a half each time, but if the sitter chooses it, the face can be begun and finished in one day ... when the face is finished the rest is done without troubling the sitter." Understandably, then, Reynolds's paintings tell us little about his sitters' personalities, and his approach to portrait painting was similar to his approach to landscape. In his fourth Discourse, he says a portrait painter

should give a general idea of his subject and "leave out all the minute breaks and peculiarities in the face ... rather than observing the exact similitude of every feature." Thus, Reynolds painted people the way he thought they should look, rather than how they actually did look.

Thomas Gainsborough. Reynolds's chief rival was THOMAS GAINSBOROUGH (1727–1788). Although Gainsborough began as a landscape painter, a mode he always preferred, he painted portraits to make a living and became the most fashionable portraitist in British society. Most eighteenth-century portraiture, as that by Reynolds, is elegant and courtly, artists flattering their sitters by giving them all the social graces deemed desirable. This is evidenced by Gainsborough's Mary, Countess Howe (fig. 16.14), of 1765. Set in a landscape worthy of Watteau, Gainsborough's figure holds up her skirt as if

Figure 16.14 Thomas Gainsborough, Mary, Countess Howe, 1765, oil on canvas, $8' \times 5'$ (2.59 × 1.52 m), London County Council, Kenwood House (Iveagh Bequest). Though he thought of himself first and foremost as a landscape painter, Gainsborough is best known for large-scale portraits that present his subjects as aristocratic and refined.

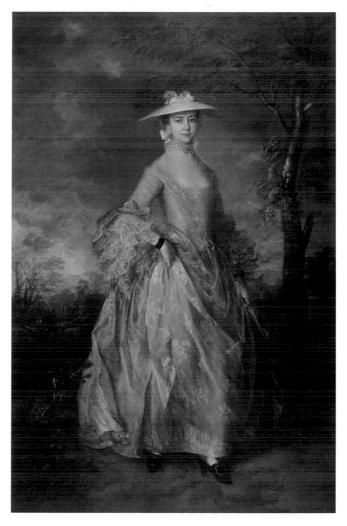

Gainsborough has caught her strolling in a *fête galante*. She is impeccably dressed, elegant, possessing a self-confident air of distinction and social poise. Painting with dash and freedom using a fresh and fluid technique, emphasizing lush textures in decorative colors, Gainsborough displays a technical virtuosity typical of the Rococo.

LITERATURE

During the eighteenth century, throughout Europe literary works reflected the rationalism of Enlightenment. The emphasis on reason in literature recurred across the genres, from essays and fiction to poetry and drama. Essayists such as Benjamin Franklin and Thomas Paine wrote prose pieces that relied on careful reasoning and incisive logic to support their claims about human political and social behavior as well as humanity's irrational beliefs, especially those concerning religious faith. Novelists and satirists, including Daniel Defoe and Jonathan Swift, often used irony to satirize men's claim to reason. Swift suggested, in fact, that although human beings are theoretically "capable" of being rational, few actually possess reason. English poets in particular employed irony and sarcasm as weapons in their fiercely satirical verses on all manner of subjects, especially the behavior of courtiers.

Samuel Johnson's "Club." The London of Hogarth's day was, above all, a city of contrasts. On the one hand, there was Fleet Street, largely rebuilt after the Great Fire of 1666 and dominated at one end by Wren's St. Paul's Cathedral. Fleet Street was the gathering place of the "Club," a group of London intellectuals, writers, editors, and publishers. One of its founders was SAMUEL JOHNSON (1709-1784), author of the 1755 Dictionary of the English Language and editor of Shakespeare's complete plays. The Club was also home to members of refined society. Artists, too, among them Sir Joshua Reynolds, sought each other's company at the Cock Tavern or at George's Coffee House. They dined together at Ye Olde Cheshire Cheese. "When a man is tired of London, a man is tired of life," Johnson boasted of the city's intellectual and cultural stimulation.

On the other hand, there was Grub Street, a lane just outside the London Wall. As Johnson put it in his *Dictionary*, Grub Street was "inhabited by writers of small histories, dictionaries, and temporary poems"—the hacks of the burgeoning publishing trade. A world of difference lay between it and Fleet Street; Newgate Prison was between them, and Bethlehem Royal Hospital, known as Bedlam, the lunatic asylum, was nearby. This was the monstrous side of London, a side that members of Johnson's Club had to witness every day as they strolled from Fleet Street to the tavern where they met. On the way, they passed through Covent Garden, where the city's street-walkers plied their trade.

Alexander Pope. Foremost among satirical poets writing in English is ALEXANDER POPE (1688–1744), whose works set the standard for satiric poetry in eighteenth-century England. No work captures the spirit of Grub Street better than Pope's Dunciad, written in 1743. Pope equates the Grub Street writers with the lunacy of the city itself, and the poem ends with a "dunces" parade through the city. The spectacle culminates in the end of civilization itself:

Lo! thy dread empire Chaos! is restor'd Light dies before thy uncreating word; Thy hand, great Anarch! lets the curtain fall, And universal darkness buries all.

In the face of the monstrosities of Grub Street, Pope writes, "Morality expires." Satire was Pope's chief tool, and the lowly hacks of Grub Street were by no means his only target. Like Hogarth, he attacked the morality of the aristocracy. Perhaps his most famous poem is The Rape of the Lock. This is a mock epic—that is, it treats a trivial incident in a heroic manner and style more suited to the traditional epic subjects of war and nationbuilding. The Rape of the Lock is based on an actual incident in which a young man from a prominent family clipped a lock of hair from one Miss Arabella Fermor, an event that caused her family considerable consternation. Pope describes the gentlemen and ladies of polite society in the same terms as the heroes and heroines of Homer's epic Iliad and Odyssey, his translations of which first established his reputation. Pope's "war" is chiefly one of the words and deeds exchanged between the sexes, all described in heroic style. Applied to the frivolous world of snuffboxes, porcelain, and cosmetics, the effect is undeniably comical, as if Sir Joshua Reynolds's Grand Manner had been brought low.

Jonathan Swift. A far crueler satirist was JONATHAN SWIFT (1667-1745). Born in Ireland, Swift traveled to London, where he became a renowned poet and political writer, as well as an Anglican clergyman. After his appointment as Dean of St. Patrick's Cathedral in Dublin in 1713, he spent the rest of his life in Ireland. Best known for his satirical prose work Gulliver's Travels, Swift for many years was considered a cynical misanthrope—a person who hates the human race. Much has been made of a comment from Gulliver's Travels, spoken by the King of Brobdingnag (the land of the giants). Addressing Lemuel Gulliver, Swift's representative of humanity, the Brobdingnagian King describes human beings as "the most pernicious race of odious little vermin that ever walked the face of the earth."

This bitter satirical strain, however, is only one side of Swift's literary persona; his satirical imagination also had a lighter, more playful dimension. *Gulliver's Travels* is full of fantastic and marvelous events, delightful even to children. The book recounts the adventures of a ship's physi-

cian, Lemuel Gulliver, over four voyages. His first voyage takes him to Lilliput, where the people are only six inches tall; the second to Brobdingnag, the land of giants; the third to Laputa, a region where thought and intellect are privileged; and the fourth and final voyage to the land inhabited by the Yahoos and their masters the Houyhnhnms, horse-like creatures whose lives are governed by reason, intelligence, and common sense. Nonetheless, throughout Gulliver's Travels, Swift uses his hero's adventures to satirize the political, social, and academic institutions of his own time and country, with their abundant display of human folly, stupidity, baseness, and greed. Thus, he contrasts the sensible and wise Houyhnhnms with both the ignorant and filthy Yahoos and with the impractical and eccentric Laputians, who are so far from living effectively in the real world that they carry a large sack filled with a multitude of objects, which they need to communicate with one another.

VOLTAIRE'S PHILOSOPHY OF CYNICISM

One of the most important thinkers of the eighteenth century, François Marie Arouet, known by his pen name VOLTAIRE [Vole-TAIR] (1694–1778), shared Swift's general sense of human folly, as well as Hogarth and Pope's recognition of the moral bankruptcy of the aristocracy. Voltaire was deeply influenced by English political thought, especially by the freedom of ideas that, among other things, allowed writers such as Pope and

Swift to publish without fear. Voltaire himself was jailed for a year, then exiled to England in 1726, for criticizing the morality of the French aristocracy. When he returned to France, in 1729, he promptly published his *Philosophical Letters Concerning the English*, in which, once more, he criticized French political and religious life. This time, his publisher was jailed, and Voltaire himself retreated to Lorraine, in eastern France, where he lived for the next fifteen years.

Voltaire's best-known work, Candide, is a scathing indictment of those who agreed with the philosopher Leibniz that this is the best of all possible worlds, regardless of occasional misfortunes, and that everything that happens is part of the providential plan of a benevolent God. Candide was written just after the 1755 Lisbon earthquake, in which thousands were killed. Voltaire argued that those who explained the catastrophe away, minimizing its destructive consequences, were deceiving themselves. Voltaire reasoned that either God refused to prevent the existence of evil, in which case he was not benevolent, or that he lacked the power to avert evil, in which case he was not omnipotent. Voltaire also rejected the Christian notion of a personal God. Voltaire himself was a Deist, one of those who believed in a God more akin to the pagan notion of a prime mover or a first cause. For Voltaire, religious traditions, such as biblical Christianity that promise eternal joy, happiness, and salvation, were responsible for creating unrealistic expectations and vain hopes.

Map 16.2 The Enlightenment in America and Europe.

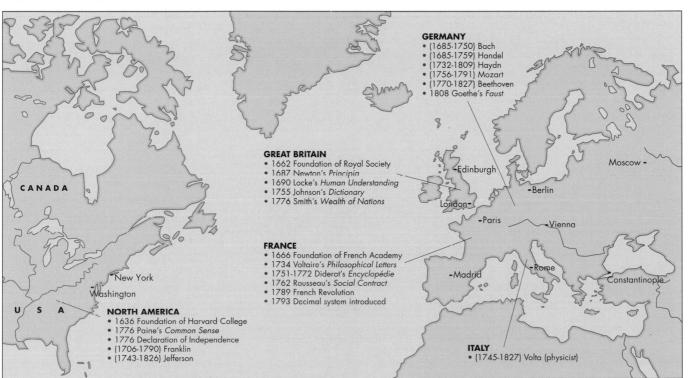

THE FRENCH REVOLUTION

The executions of Louis XVI and Marie Antoinette represented not only the death of the monarchy, but an end to the privilege and extravagance that the monarchy had come to represent in the minds of the people. In death, all are equal. The century's growing belief in the equality of all, in the right of the individual to live free of tyranny, and in the right of humankind to self-governance, culminated in political **revolution**, the overthrow of the existing order for a new one. In fact, revolution itself seemed to many an "enlightened" course of action.

The American Revolution began to stir in 1774, when the colonists convened for the new Continental Congress. An American Declaration of Independence, authored by THOMAS JEFFERSON (1743–1826), unified the colonies in their successful war against the British, and in the following years, a constitutional convention met in Philadelphia to draft a new charter for the American republic. At the convention mechanisms were devised to assess and collect taxes, regulate commerce, and make enforceable laws, all within a government framework of "checks and balances." The legislative, judicial, and executive branches of government all had their own powers, but powers that were overseen by the other branches.

The French bourgeoisie watched with interest. They wanted a "National Assembly" like the Continental Congress; a document drafted along the same principles as the American Declaration; and a republican constitution that would give them life, liberty, and the right to own property. But the French situation was different from the American one. Where the American Revolution pitted against one another two groups with essentially similar cultural values, one simply seeking economic autonomy from the other, the French

Revolution was essentially an internal class struggle and, as such, expressed a clash in values. This type of revolution would have a lasting effect on world history.

Each of the French kings of the eighteenth century— Louis XIV (r. 1643-1715), Louis XV (r. 1715-74), and Louis XVI (r. 1774-93), guillotined on January 21, 1793—had successively led the country further into debt. In May 1789, Louis XVI, succumbing to mounting pressures to deal with the ever-increasing national debt, called for an assembly of the Estates General. This assembly of the clergy (the First Estate), the aristocrats (the Second Estate), and the bourgeois citizens (the Third Estate) resulted in the "The Declaration of the Rights of Man and Citizen," a document modeled on the American "Declaration of Independence." In a memoir written early in the nineteenth century, one witness contrasted the pomp of the clergy and aristocracy to the plain attire of the bourgeois citizens. He outlined, in effect, the conditions that led to the Revolution itself:

The senior clergy, glittering with gold, and all the great men of the kingdom, crowding around the dais, displayed utter magnificence, while the representatives of the Third Estate appeared to be dressed in mourning. Yet their long line represented the nation, and the people were so conscious of this that they overwhelmed them with applause. They shouted "Long live the Third Estate!" just as they have since shouted "Long live the nation!" The unwise distinction had produced the opposite effect to that intended by the court: The Third Estate recognized their fathers and defenders in the men in black coats and high cravats, and their enemies in the others ... These men, who had never before traveled beyond their own provinces, and who had left behind them the sight of destitution in town and country, now saw evidence of the extravagant expenditure of Louis XIV and Louis XV, and of the new court's [Louis XVI's] quest for pleasure. This château here, they were told, cost two hundred million; the fairy palace at Saint-Cloud cost twelve; and no one knows how much has been spent

Timeline 16.3 France at the time of the Revolution.

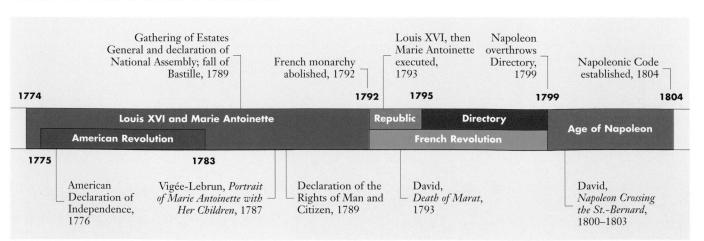

on the Petit Trianon. And they answered, "All this magnificence was produced by the sweat of the people."

Now the Third Estate, representing a large percentage of the population, strove to take control of the nation, and to take back possession of its wealth. If the sweat of the people had made France "magnificent," they reasoned, then the people should benefit from their labor.

THE NATIONAL ASSEMBLY

In the Estates General, each of the three estates—the Church, the aristocracy, and the bourgeois middle class—had one vote. The Third Estate quickly realized that it would be outvoted 2–1 on every question. Thus, on June 20, 1789, the deputies of the Third Estate along with their aristocratic sympathizers declared a "National Assembly" in a building in the grounds of the Louvre called the Jeu de Paume, the King's tennis court. Together they swore an oath that they would not separate until France had a new constitution; Jacques-Louis David, a painter who recorded the Revolution, captured

the moment in *The Tennis Court Oath* (fig. 16.15), although it remained an unfinished work.

Rumors that the King was planning to overthrow the National Assembly led to the formation of a volunteer bourgeois militia, which, on July 14, 1789, went to the Bastille prison in Paris in search of arms and gun powder. The prison governor panicked and ordered his guard to fire on the militia, killing ninety-eight and wounding seventy-three. An angry mob quickly formed and stormed the Bastille, decapitating its governor, and slaughtering six of the guards. The next day, Louis XVI asked if the incident had been a riot. "No, your majesty," was the reply, "it was a revolution."

The National Assembly continued to meet steadily while rioting spread throughout the French countryside, and finally, on August 4, 1789, in a night session, the Viscount of Nouilles and then the Duke of Aiguillon renounced their feudal privileges and revenues. Other nobles did the same, and the clergy in attendance relinquished their tithes. By the end of the evening, all French people suddenly found themselves subject to the same laws and taxes. On August 27, 1789 the Assembly ratified

Figure 16.15 Jacques Louis David, *The Tennis Court Oath*, 1789–91, unfinished, pen and brown ink and brown wash on paper, $26'' \times 42''$ (66×107 cm), Musée du Louvre, Paris. Spectators peer down on the Third Estate, which takes its oath as the "winds of freedom" blow through the windows above.

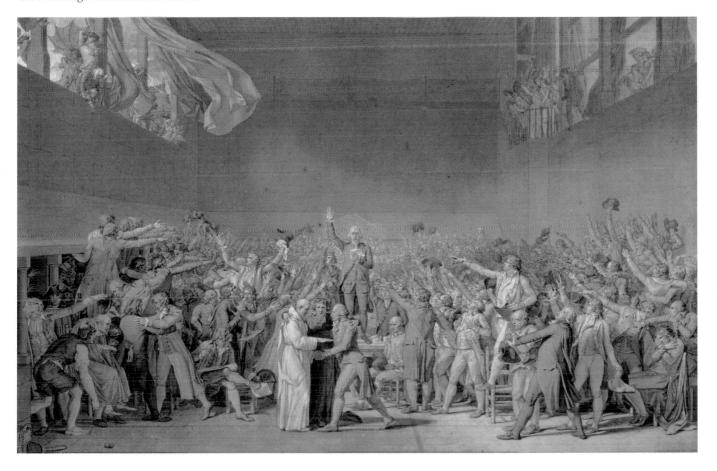

Then & Now

THE RIGHTS OF WOMEN

When the French National Assembly ratified the Declaration of the Rights of Man and Citizen on August 27, 1789, its members did not include women among the "citizens." In 1791, Olympe de Gouges (1748-1793) wrote a "Declaration of the Rights of Women" and demanded that the National Assembly act upon it. This stated that "Woman is born free and remains equal to man in rights," arguing that "the only limit on the exercise of woman's natural rights is the perpetual tyranny wielded by men; these limits must be reformed by the law of nature and the law of reason." The Declaration continued with the then radical claim that women were "equally entitled to all

honors, places, and public employments according to their abilities, without any other distinction than that of their virtues and their talents."

The Englishwoman Mary Wollstonecraft (1759-1797) wrote another important revolutionary manifesto supporting women's rights. A Vindication of the Rights of Women, published in 1792, is a treatise embodying Enlightenment faith in reason and in the revolutionary concepts of change and progress. Wollstonecraft held that women, having an equal capacity for reason, should have an equal standing in society. She offered a scathing critique of the social forces that kept women in a position of inferiority. Wollstonecraft developed her revolutionary ideas in the company of a radical group of English artists and writers, including Tom Paine and William Godwin, who sympathized with the aims of the French Revolution.

To the contemporary American, these demands may seem reasonable enough, but it is worth remembering that women did not gain the right to vote in the United States until 1920. And women continue to fight for equality in the workplace, both in competing for jobs on an equal footing and receiving comparable pay for comparable work. Such demands were certainly not considered reasonable at the time of the French Revolution. De Gouges was charged with treason by the National Assembly and sentenced to the guillotine in 1793.

its Declaration of the Rights of Man and Citizen, and a constitutional monarchy was established.

THE DEMISE OF THE MONARCHY

Despite the events of August 27, as early as October 5, 1789, Parisian women were back in the streets demonstrating for bread (fig. 16.16). It was on this day that Marie Antoinette made her notorious "Let them eat cake!" declaration. The women simply marched on the palace at Versailles and invaded the inner rooms, causing the Queen to flee for her life, but Louis and Marie Antoinette were escorted back to Paris later that day.

The King ostensibly cooperated for a while with the National Assembly, but in June 1791 he attempted to flee with his family to Luxembourg. The royal retinue was captured and returned to Paris. Then, in April 1792, Austria and Prussia took the opportunity to declare war on the weakened nation, and the Prussian Duke of Brunswick declared he would restore Louis XVI to full sovereignty, revealing an already widespread suspicion that the King was collaborating with the enemy. And so the bourgeois leaders, aided by the working class, invaded the Louvre on August 10, 1792, butchering the King's guard and the royal servants, and over the next forty days arrested and executed over a thousand priests, aristocrats, and royalist sympathizers. On September 21, 1792, a newly assembled National Convention abolished the monarchy in France, and on January 21, 1793, Louis XVI was executed by guillotine in the Place de la Révolution, known today as the Place de la Concorde.

The situation continued to deteriorate. In the summer of 1793, a Committee of Public Safety was formed, headed by MAXIMILIEN DE ROBE-SPIERRE [ROBES-pea-air] (1758–1794). For fifteen months, France endured the Committee's Reign of Terror. The Terror had three goals: to win the war with

Figure 16.16 To Versailles, To Versailles, October 5, 1789, 1789, engraving, Musée de la Ville de Paris, Musée Carnavalet. A contemporary portrait of the events of the day, in which the despair on the face of the aristocratic lady at the far left as the working-class women pass her by, captures the poignancy of the moment.

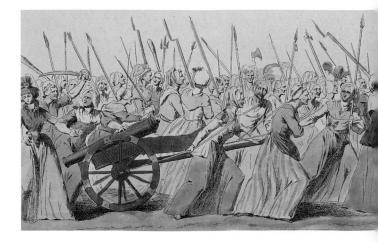

Austria and Prussia; to establish a "Republic of Virtue"; and to suppress all its enemies. To achieve the latter, the Revolutionary Tribunal of Paris alone handed out 2,639 death sentences, including that of Marie Antoinette, who by this time was referred to simply as "the widow Capet." Throughout France, an estimated twenty thousand people were executed.

NAPOLEON BONAPARTE

In 1795, when the term of the National Convention expired, a political body known as the Directory succeeded to power. It managed to establish peace, but otherwise France was effectively rudderless. Finally, in November 1799, General NAPOLEON BONAPARTE [BONE-ah-part] (1769–1821) staged a *coup d'état*, abolishing the Directory and installing himself, on the Roman model, as First Consul (fig. 16.17).

Napoleon was a hero in Marat's mold (see p. 225), a common man who rose to power through talent and civic sacrifice. Yet he was also a man of uncommon presence. The German philosopher George Wilhelm Hegel described him in 1806: "I have seen [Napoleon] that world-soul, pass through the streets of the town on horseback. It is a prodigious sensation to see an individual like him who, concentrated at one point, seated on a horse, spreads over the world and dominates it." He had no shortage of ego, either, for in 1802 he inquired of the people: "Is Napoleon Bonaparte to be made Consul for Life?" The people answered in the affirmative by 3.5 million votes to eight thousand. After another election in 1804, he declared himself Emperor for Life, establishing hereditary "imperial dignity" for the Bonaparte family. He was crowned Emperor Napoleon I in December 1804. France had, effectively, restored the monarchy.

Napoleon's power and appeal tell us much about the Enlightenment itself. He was the very model of enlightened leadership that the philosophes longed for, and he brought to France the stability, peace, and harmony they claimed as the inevitable product of reasoned thought, although his decision to crown himself emperor disillusioned many of his republican supporters. Under Napoleon's regime, the economy boomed again, and he vigorously supported industrial expansion. Cotton production, for instance, quadrupled between 1806 and 1810. In 1800, Napoleon created the Bank of France, which made government borrowing a far easier and more stable matter. But his greatest achievement was the Napoleonic Code, which provided a uniform system of law for the entire country. This was brief and clear, with the aim that every citizen should be capable of understanding it. Together with the Declaration of Independence, the United States Constitution, and the Declaration of the Rights of Man, the Napoleonic Code is one of the great monuments of Enlightenment thought.

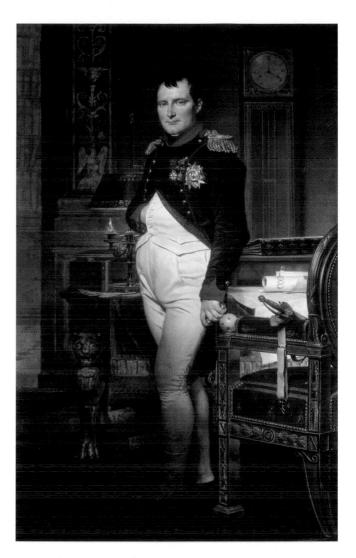

Figure 16.17 Jacques Louis David, Napoleon in his Study, 1812, oil on canvas, 2.05×1.28 m. Coll. Napoleon, Paris, France. In this prime example of art as political propaganda, Napoleon is shown working all night for the people of France while surrounded by objects that refer to his accomplishments. Napoleon compared himself to the leaders of ancient Rome; his portrait deserves comparison to that of Emperor Augustus (Chapter 5, figure 5.8).

Neoclassicism

If many people in France stopped short of Voltaire's overarching cynicism, they were at least suspicious of the behavior and tastes of their own aristocracy. To painters, it seemed as if the sensuous color and brushwork of the *rubénistes* had led not merely to the excesses of the Rococo but had themselves become the visual sign of a general moral decline. Thus, *poussinistes* once again began to take hold. Poussin's intellectual classicism offered not merely an alternative style to the Rococo

but, in its rigor and orderliness, a corrective to the social ills of the state.

As early as 1746, in reviews of the exhibition of the French Academy, critics bemoaned the fact that the grandiose history paintings had disappeared, replaced by the Rococo fantasies Diderot abhorred. Prompted in large measure by the rediscovery of the ancient Roman cities of Herculaneum and Pompeii, in 1738 and 1748 respectively, which were partially excavated from the ashes and volcanic mud that had buried them when volcanic Mt. Vesuvius erupted in A.D. 79, many people began to re-establish classical values in art and state. People identified with the public-minded values of the Greek and Roman heroes who placed moral virtue, patriotic self-sacrifice, and "right action" above all else, and they wanted to see these virtues displayed in painting. By 1775, the French Academy was routinely turning down Rococo submissions to its biennial Salon in favor of more classical subjects, just as Madame du Barry was rejecting Fragonard's panels her new château. A new classicism—a Neoclassicism—replaced the Rococo almost overnight. Neoclassicism was the style that emerged from the turning away from the Rococo and toward the ancient classical ideals.

PAINTING

Jacques-Louis David. Perhaps the clearest demonstration of the Neoclassical style in painting is offered by the French artist JACQUES-LOUIS DAVID [dah-VEED] (1748–1825), a follower of Nicolas Poussin. When he left to study in Rome in 1775, David asserted that antique art lacked fire and passion; but, in fact, he was to be thoroughly seduced by it. David grew to be extremely influential in French art, offering his stark, simple painting as an antidote to Rococo frivolity.

His first major commission was for Louis XVI, the *Oath of the Horatii* (fig. 16.18). Three brothers from Rome, the Horatii, pledge an oath upon their weapons which are being held by their father. They vow to fight to the death with the Curatii, three brothers from Alba, to resolve a conflict between the two cities. All figures are accurately drawn, carefully modeled in cold light, as solid as sculpture. In accordance with Neoclassical ideals, the scene is set against the severe architecture of the Roman revival. David, like Poussin, constructed his composition in a series of horizontal planes arranged parallel to the picture plane. Also like Poussin, David subordinated color to line, because he believed that clarity of statement was most important and that such

Figure 16.18 Jacques-Louis David, Oath of the Horatii, 1785, oil on canvas, $4'3'' \times 6'5^{\frac{1}{4}''}$ (1.30 \times 1.96 cm), The Metropolitan Museum of Art, New York. Neoclassical artists favored subjects taken from ancient literature and history that illustrated high principles or ideals. Excavation of the ancient Roman cities of Herculaneum and Pompeii generated a renewed and widespread interest in the antique.

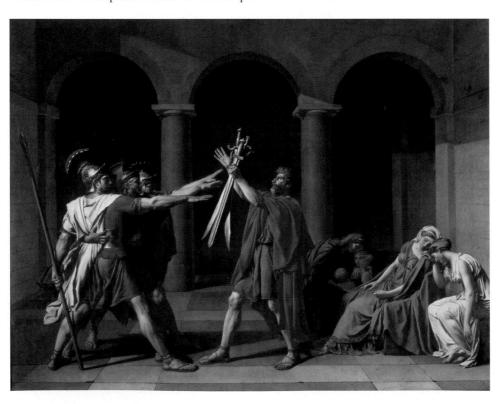

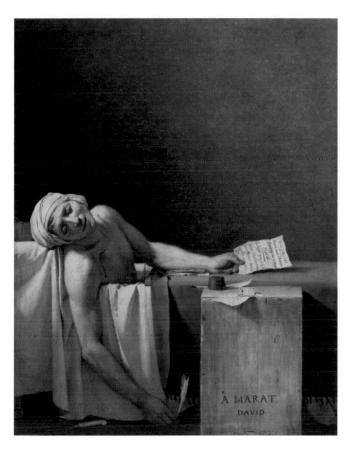

Figure 16.19 Jacques-Louis David, Death of Marat, 1793, oil on canvas, $5'5'' \times 4'2\frac{1}{2}''$ (1.65 × 1.28 m), Musées Royaux des Beaux-Arts de Belgique, Brussels. The powerful impact of this political memorial is enhanced by the proximity of the figure to the picture plane, stark simplicity of the composition, and immense void in the upper half of the painting.

clarity was best achieved by drawing. As a result, his paintings appear to be drawings that have been colored. David's subject is also a display of Roman heroic stoicism and high principles: the Horatii place patriotic duty above concern for themselves and their family.

When the painting was exhibited at the Salon of 1785, it caused an immediate sensation, not so much because of its Neoclassical style, but because it promoted values that many at once recognized were lacking in the King and his court. By the time of the French Revolution in 1789, the painting was read almost universally as an overtly anti-monarchist statement, though David probably did not originally intend it as such. Interpreted as a call for a new moral commitment on the part of the French state, David's art quickly became that most closely associated with the Revolution. David himself was soon planning parades, gala festivals, and public demonstrations, all designed to rally the people behind the Revolution's cause. He persuaded the revolutionary government to abolish the French Academy, and in its

stead to create a panel of experts charged with reforming the public taste.

Meanwhile, the revolutionary government concerned itself with overhauling every aspect of French life. On a minor scale, kings and queens were removed from decks of cards. On a more significant scale, the Christian Sabbath was abolished. Churches were closed and then reopened as "Temples of Reason." Even the traditional Christian calendar was abolished, and the year 1793 became the new revolutionary year 1. David was rapidly commissioned to paint a portrait of the radical journalist and politician Jean-Paul Marat [ma-RAH] (1743-1793), a hero of the Revolution who had been assassinated in his bath by a monarchist sympathizer named Charlotte Corday in July of 1793. Known as the Death of Marat (fig. 16.19), but originally entitled Marat at His Last Breath, the purpose of the painting was to create a public memorial for the revolutionary hero. The painting was first displayed in the courtyard of the Louvre on October 16, 1793, in full view of Marie Antoinette who was in the square awaiting execution. On that very day David managed to sketch her on her way to the guillotine (see fig. 16.2), in liarsh, scornful strokes.

In December of 1793 Marat's bust replaced the crucifix in all the Temples of Reason, and literally hundreds of copies of David's painting were commissioned to hang in public buildings throughout France. On the surface, the painting's style is factual, direct, and simple, to the point of being stark. There is no elaborate setting. The fronts of the tub and box are parallel to that of the picture plane. In David's precise linear style the modeling is hard, the forms smooth, all definitions clear. The large space at the top adds to the drama, as does the contrast of light and dark, reminiscent of Caravaggio. By placing the figure very close to the picture plane, David augments the sense of immediacy and increases the painting's emotional impact. Marat's head seems almost to topple into the viewer's space. But the stark directness of the presentation masks the most important compositional element-Marat's head and right arm hang over the edge of the bath in the traditional manner of Christ at the Deposition. Compare, for example, David's Death of Marat to Caravaggio's Entombment (see fig. 15.10). The position of Jesus's falling arm in Caravaggio's work is so standard that Marat's pose would have been recognized as the traditional pose of the martyred Jesus. Marat is in fact a secularized version of Jesus, the Christ of the new Revolution.

Angelica Kauffmann. The work of ANGELICA KAUFFMANN [KOFF-mahn] (1741–1807) provides us with an even clearer example of what a painterly representation of virtuous behavior and high moral conduct might look like. The Swiss-born Kauffmann was trained in Italy, where she modeled her figures after the wall paintings at Pompeii and Herculaneum. In 1766, she moved to England, and with her friend Sir Joshua Reynolds helped to found the new British Royal Academy.

Kauffmann's Cornelia Pointing to Her Children as Her Treasures (fig. 16.20), of 1785, champions family values, simple dress, and austere interiors. Gone are Rococo depictions of women wearing the elegant and refined dress of the Rococo salon. In their place are the mothers of the new society. When a visitor asks to see her family treasures, Cornelia points with pride to her two sons (the Gracchi), both of whom were to grow up to become leaders of the Roman Republic, repossessing public land

from the decadent Roman aristocracy and redistributing it to the poor. This was precisely the spirit that drove the leaders of the French Revolution.

Benjamin West. One of Kauffmann's closest friends in London was the American painter BENJAMIN WEST (1738–1820), another founder of the Royal Academy. West was best known for his revision of the idea of history painting. For the Academy's exhibition of 1770, he chose to portray a contemporary event, the Death of General Wolfe (fig. 16.21), the British military leader who had been killed in 1759 in a battle with the French for control of Quebec. Sir Joshua Reynolds was horrified. It seemed to him in bad taste to depict con-

Figure 16.20 Angelica Kauffmann, Cornelia Pointing to Her Children as Her Treasures, 1785, oil on canvas, $3'4'' \times 4'2''$ (1.02 \times 1.27 m), Virginia Museum, Richmond. In contrast to Rococo frivolity, Neoclassical art was intended to serve a public role in encouraging virtue. In this story from ancient republican Rome, when asked about her treasures, Cornelia points to her children, who went on to do good deeds on behalf of the poor.

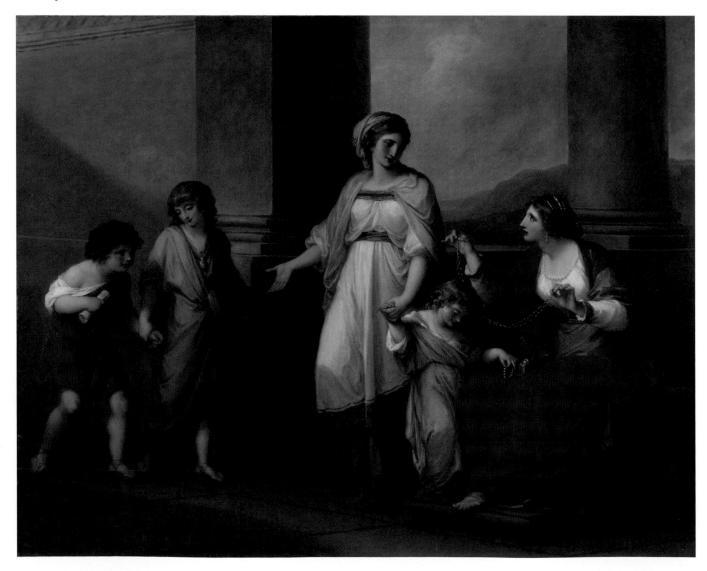

Figure 16.21 Benjamin West, Death of General Wolfe, 1770, oil on canvas, $4'11\frac{1}{2}'' \times 7'$ (1.51 × 2.13 m), National Gallery of Canada, Ottawa. West glorified a contemporary military hero, General Wolfe, who died in 1759 in the war against the French. Although criticized by Sir Joshua Reynolds, president of London's Royal Academy, for showing figures in contemporary clothing, the combination of Wolfe's pose, the spotlight, and the turbulent sky bring to mind depictions of the death of Christ.

temporary heroes, and the British King George III warned that he would not purchase any painting showing British soldiers in modern dress. Despite protest, when the painting was displayed, it quickly won the favor of all viewers because of its dramatic intensity and extraordinary realism. Like David's Marat, Wolfe's pose suggests a traditional posture of Jesus, this time the Deposition (descent from the Cross). A Native American contemplates the hero's death, the scene underscoring the leader's nobility and courage.

John Singleton Copley. Another American expatriate working in London was JOHN SINGLETON COPLEY [COP-lee] (1738-1815) of Boston. New England's leading portraitist, Copley went to England in 1774, studied in London, gained admission to the Royal Academy, and remained there the rest of his life. Copley's Watson and the Shark (fig. 16.22), of 1778, depicts a contemporary event with a kind of immediacy and realism that anticipates the painting of the next century. The event was real: A man named Brook Watson

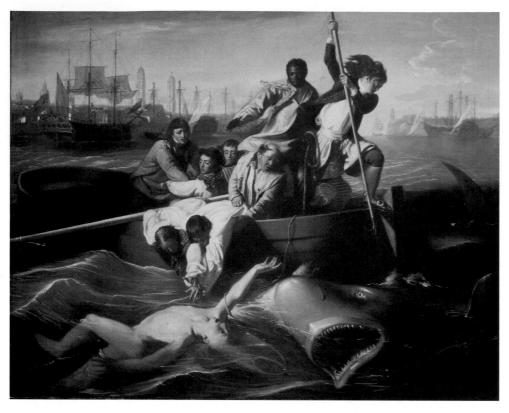

Figure 16.22 John Singleton Copley, *Watson and the Shark*, 1778, oil on canvas, $6'\frac{1}{2}'' \times 7'6\frac{1}{4}''$ (1.84 × 2.29 m), Museum of Fine Arts, Boston. Copley's painting has all the drama of a modern adventure film—a struggle for survival against nature depicted at the climactic moment and with the outcome left uncertain—combined with heroic nudity.

had indeed encountered a shark while swimming in the harbor of Havana, Cuba. The painting shows the scene as the shark lunges for Watson, while two men reach out for him, straining, their faces showing their anguish, and another man grasps the shirt of one to prevent him from falling overboard. The drama is increased by the dramatic lighting and the dynamic diagonal movements. Copley paints a cliff-hanger—the viewer is left wondering whether Watson will survive. In fact, Watson had long escaped the shark when he commissioned the painting years later as a publicity ploy while running for political office.

SCULPTURE

Jean-Antoine Houdon. One of France's greatest sculptors was JEAN-ANTOINE HOUDON [ooh-DON] (1741–1828), born at the Palace of Versailles where his father was a servant. Later his father became the caretaker for the school for advanced students in the French Academy of Painting and Sculpture, enabling Houdon to associate with artists from the time he was eight years old. It is said that as a child he would sneak into class, steal some clay, and imitate what he saw.

He learned well, for he won the Prix de Rome, which enabled him to study in Italy from 1764 to 1769.

Houdon was unrivaled in his day as a portrait sculptor. Even Americans ventured forth to commission him while they were in Paris: Benjamin Franklin (1778); John Paul Jones (1780); and Thomas Jefferson (1789). Houdon worked to create highly lifelike images. He took precise measurements of his sitters and usually made a terra cotta model while working with the sitter. This model was given to his assistants, who blocked out the form in marble; then Houdon did the fine carving and polishing.

The Statue of George Washington. In order to portray George Washington (fig. 16.23), Houdon went to America and stayed for two weeks in October 1785 as a guest in Washington's home at Mount Vernon, Virginia. Houdon made a cast of Washington's face and a plaster bust, but returned to Paris to carve the life-size figure in stone, working on the project from 1788 to 1792.

During that time Houdon also made a statue of Washington in classical garb. Although the version finally selected shows Washington wearing contemporary attire, it, too, has links to the classical past. Washington stands in the antique *contrapposto* pose. His

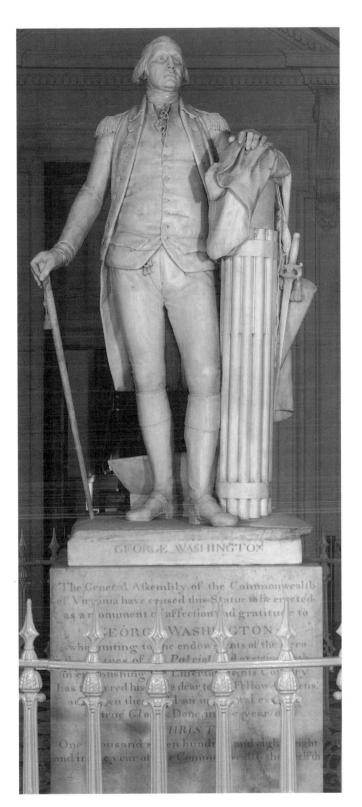

Figure 16.23 Jean-Antoine Houdon, George Washington, 1788–92, marble, height 6'2" (1.88 m), State Capitol, Richmond, Virginia. Calm, composed, and commanding, this version of Washington in his general's attire was favored over another version in classical attire. Still, antique echoes are seen in the contrapposto pose and the thirteen fasces (rods) bound together, representing the States of the Union.

left hand rests on thirteen bound rods, or ancient *fasces*, symbolizing both the original States of the Union and the power and authority of ancient Rome. Behind the *fasces* are sword and plow, representing war and peace.

ARCHITECTURE

Chiswick House. An excellent example of Neoclassical architecture in England is provided by Chiswick House (fig. 16.24) in west London, begun in 1725 and built by LORD BURLINGTON (1694–1753) and WILLIAM KENT (1685–1748). Burlington was himself an amateur architect, but his team included trained architects.

Like its prototypes, including the Roman Pantheon (see Chapter 5), Chiswick House is geometrically simple yet stately. The classical vocabulary and proportions are all-important. Symmetry is maintained at all costs, even when it makes things inconvenient within the home. In the academic Neoclassical style, regularity, reason, and logic dominate over imaginative variation. This is in marked contrast to the emotion and drama of the Baroque as well as the Rococo styles. In Neoclassical buildings, the walls are flat and the decoration relatively austere compared to that of Rococo interiors, with their abundantly ornamented, animated, even undulating architectural elements.

La Madeleine. In France the Neoclassical style was promulgated in particular by Napoleon, who longed to rebuild Paris as the new Rome. The church of La

Figure 16.24 Lord Burlington and William Kent, Chiswick House, begun 1725, west London. The architectural lineage of this house, with its central dome, triangular pediment, and columnar portico, can be traced back to the ancient Roman Pantheon (see Chapter 5).

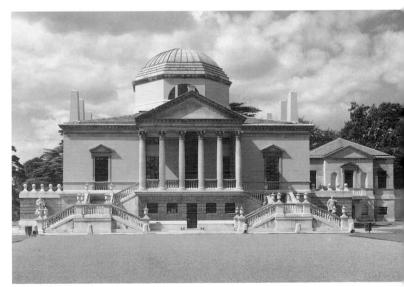

Madeleine in Paris (fig. 16.25) had been started by Louis XVI, but Napoleon himself rededicated it in 1806 as a Temple of Glory to be designed by PIERRE-ALEXANDRE VIGNON [VEE-nyonh] (1762–1829).

Napoleon conceived of La Madeleine as a monument to his military victories and as a repository for his trophies. Reflecting the great interest in archaeology at this time, the exterior is an accurate reconstruction of an ancient Roman temple. It has a raised base, steps across the front only, a colonnade of the Corinthian order, entablature, pediments, and a peaked roof. Although highly dignified, there is something a little stark about La Madeleine's archaeological accuracy. Individual imagination seems absent. The interior belies the exterior, its ceiling consisting of three consecutive domes; thus, unlike its ancient Greek and Roman prototypes, the exterior and interior are not coordinated. After Napoleon's death the building once again reverted to being used as a church.

Monticello. The Neoclassical style of architecture also achieved prominence in the United States where the new American presidents, believing it to embody

enlightened, democratic leadership, championed its use in public architecture. One of the most notable Neoclassical designs in the United States is the private home of President THOMAS JEFFERSON (1743-1826), known as Monticello [MON-tih-CHELL-o], in Charlottesville, Virginia (fig. 16.26). Jefferson drew up the designs for it himself in 1769. An adaptation of Burlington and Kent's Chiswick House, it was built between 1770 and 1806. Unlike its prototypes in stone topped by simple domes, Monticello is constructed of brick and wood and capped with a polygonal dome. The deep portico, or porch, here supported on Doric columns, was to become very popular in the southern United States, as seen in some of the great antebellum homes in Mississippi. The portico provided protection from the sun and added dignity and splendor to the building; the northern equivalent was much shallower. The plan of Monticello reveals the almost perfect symmetry of the house, with entrances on each of the four sides. Its rooms are laid out on either side of a central hall and drawing-room.

A leading architect of his time, Jefferson fostered classical ideas in America. He studied the ancient Roman temple known as the Maison Carrée in Nîmes, France,

Figure 16.25 Pierre-Alexandre Vignon, La Madeleine, Paris, 1806–42, main facade, length 350′ (106.68 m), width 147′ (44.81 m), height of podium 23′ (7.01 m), height of columns 63′ (19.20 m). La Madeleine is based upon the rectangular temple type, such as the Greek Parthenon (see Chapter 4).

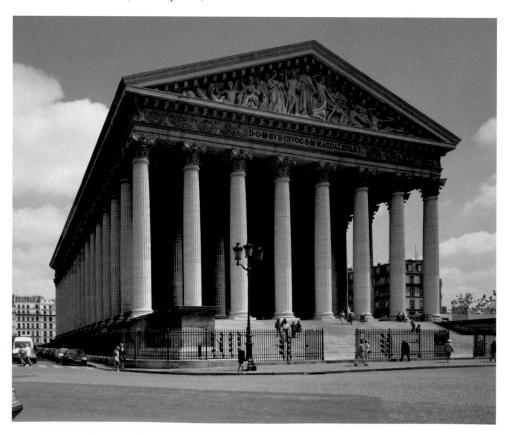

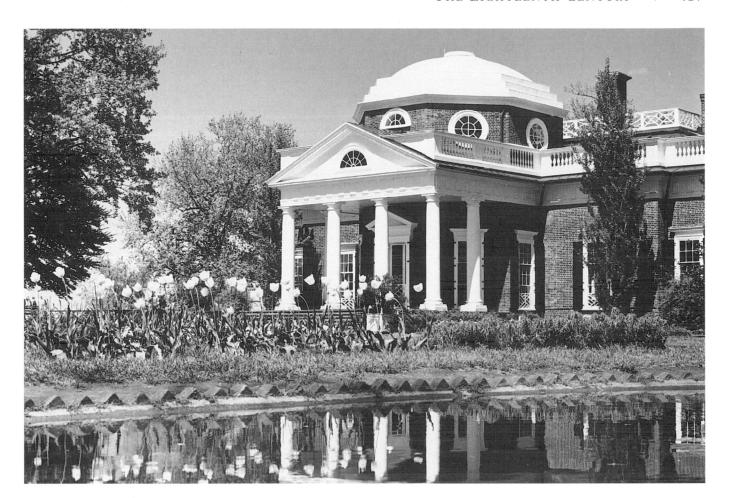

Figure 16.26 Thomas Jefferson, Monticello, Charlottesville, Virginia, 1770–1806, main facade. Neoclassical architecture was favored in America for its formal symmetry and antique associations. Δt Monticello a temple of stone and concrete has been translated into a home of brick and wood.

and used it as the model for the Virginia State Capitol (1785–98), an example of austere Neoclassicism in its deliberate rejection of the Baroque and the Rococo.

LITERATURE

The Novel. During the eighteenth century, the novel as we think of it today came into being. It focused on particular people doing particular things in everyday and ordinary circumstances, and its popularity among the reading public was enormous. Here were characters like the readers themselves, suddenly elevated to the level of heroes and heroines, admired (or, if villainous, despised) by all. Although male writers such as Samuel Richardson, Henry Fielding, and Daniel Defoe created the prototypes of the novel, it was a woman from a country parish who gave it its most enduring popular form.

Jane Austen. One of the most important novelists of her day, JANE AUSTEN (1775–1817) was born the

daughter of a clergyman and spent the first twenty-five years of her life at her parents' home in Hampshire, where she wrote her first novels, Northanger Abbey, Sense and Sensibility and Pride and Prejudice. None of these works was actually published until the second decade of the nineteenth century, when Austen was almost forty. She came from a large and affectionate family, and her novels reflect a delight in family life; they are essentially social comedies. Above all else, they are about manners, good and bad. They advocate the behavioral norms by which "decent" society must and should operate. They are also deeply romantic books that have marriage as their goal and end. Austen was not so naive as to believe that good marriages could come from alliances built solely upon social advantage; it is her scenes showing romantic love, not expedient matrimony, that draw the reader's sympathy.

Austen called herself a "miniaturist," by which she meant that her ambition was to capture realistic and intimate portraits of her characters and the time in which they lived. So convincing is her presentation of human beings, with all their foibles, attempting to enjoy and prosper in life with one another, that her novels have attained an almost monumental status that has lasted from the time of their publication down to the present day.

CLASSICAL MUSIC

Musical classicism, or the Classical style, developed with particular elegance and thoroughness in Vienna. The first of the great Viennese Classical composers was Franz Joseph Haydn, and the greatest of them was Wolfgang Amadeus Mozart. But the composer who began in the Classical vein and later became known for his Romantic style was Ludwig van Beethoven. Beethoven thus serves as a link between the Classical and Romantic eras in Western music.

The Classical period is distinguished by the growth of a popular audience for serious music, highlighted by the rise of the public concert. As in so many other areas of eighteenth-century life, we see a shift in social focus from the aristocracy and the court to the wants and needs of the middle class, a middle class that demanded from composers a more accessible and recognizable musical language than that provided by the complex patterns of, say, a Baroque fugue.

The Symphony. The symphony is what is known as a "large" form: it consists of several distinct parts, called movements, that proceed in a predictable pattern. The challenge the composer faces is to create fresh and inventive compositions without diverging from the predictable format. A symphony typically consists of four movements:

First Movement—The pace of the movement is fast, usually *allegro*, and its mood usually dramatic. Second Movement—This movement is slow (*adagio* or *andante*, for instance), and its mood reflective.

Third Movement—The pace picks up moderately, and the period's most popular dance, the stately and elegant aristocratic minuet, often serves as the basis for the movement.

Fourth Movement—Once again, the fourth movement is fast (*allegro*), spirited (*vivace*), or light and happy.

Over the course of the eighteenth century, audiences became educated in these conventions; in part the excitement of hearing a new composition centered on the anticipation the listeners felt as the composer moved inventively through this predictable pattern. It was in this period that the seating arrangement of the standard symphony orchestra became fixed (fig. 16.27).

Each symphonic movement also possessed its own largely predictable internal form. The first and fourth movements usually employed **sonata** (or sonata-allegro) form, the second was sometimes in this form but just as often a **theme and variations** or a **rondo**, and the third was generally a **minuet and trio**.

The word sonata derives from the Italian *sonare*, "to sound," as distinguished from cantata, which derives from the Italian *cantare*, meaning "to sing." Sonata form itself consists of three sections: Exposition, Development, and Recapitulation, the last of which is sometimes followed by a coda, or tailpiece. The overall structure suggests a pattern of departure and return. The exposition introduces the movement's themes, the development section modifies and advances them, and the recapitulation returns home to the main theme.

Each of the other movements of the symphony employs this pattern of departure and return but in slightly different terms. In the theme and variations, the main theme is introduced and then recurs again and again in varied form. In a rondo, a single theme repeats itself with new material added between each repetition. The minuet and trio possesses an ABA structure. That is, a minuet ("A") is presented, followed by a contrasting trio section ("B"), before the return of the minuet ("A"). The trio section contrasts with the minuet in that it is written for fewer instruments, though not necessarily for three instruments, as the name suggests.

Franz Joseph Haydn. Raised as a choirboy at St. Stephen's Cathedral in Vienna, FRANZ JOSEPH HAYDN [HIGH-din] (1732–1809) entered the employ of Prince Esterházy in 1761, serving as a court musician. Haydn composed so many symphonies—more than a hundred—in so many variations that he is known as the "father" of the form. His career not only defines this transition from court to public music, but it also marks the moment when musicians and composers finally attained the social status that painters, sculptors, and architects had enjoyed since as early as the Renaissance. Recognized at last for their genius, composers became sought-after celebrities, who were wined and dined in Europe's most prestigious social circles.

Haydn worked for Prince Esterházy for nearly thirty years, during which time he remained isolated in his palace at Eisenstadt, about thirty miles south of Vienna; but here he was free to experiment with all the musical forms available to him. He began work in Esterházy's service as essentially a servant, living in a small apartment above the palace kitchen; it was years before the aristocracy viewed composers as worthy society.

Haydn's "Farewell" Symphony No. 45 of 1772 was conceived as an explicit protest at the living conditions at Eisenstadt. Esterházy did not allow his musicians to bring their families to the palace. Thus, living in crowded servant quarters, they were forced to be away from their loved ones for long periods at a time. Performing one evening at court, the musicians played the symphony's three uneventful movements, but in the middle of the fourth movement, the second horn player and the first oboist suddenly stopped playing, packed up their instruments, blew out the candles that illuminated their

Figure 16.27 Plan of the symphony orchestra. The seating plan of the major instruments used in an orchestra has not changed much in centuries.

scores, and left the hall. Slowly, the rest of the orchestra followed suit until no one was left except two violinists, who finished the symphony. The Prince immediately understood the implications of the performance and granted his musicians an extended leave to visit their families.

When Esterházy died in 1790, his son, who did not much care for music, disbanded the orchestra, and Haydn returned to Vienna. By now he was internationally renowned. A concert promoter from London, Johann Peter Salomon, offered him a commission, and in 1791 he left Vienna for England. There, he was received by the royal court, awarded an honorary doctorate at Oxford, and began to reap the financial benefits by conducting public subscription concerts of new work, particularly the famous "London" Symphonies, which were acclaimed by the public as no other music ever had been before.

Wolfgang Amadeus Mozart. Perhaps the greatest of the classical composers was WOLFGANG AMADEUS MOZART [MOAT-zart] (1756–1791), born and raised in Salzburg, Austria. His first music teacher was his father, Leopold, himself an accomplished musician and composer. Young Mozart's musical genius was immediately evident in his early piano- and violinplaying and in his composing, which he began at the age of five. His genius was widely recognized throughout Europe; he toured with his sister Maria Anna (called Nannerl) under his father's tutelage. Though he had enormous musical gifts, Mozart suffered from depression and illness and as an adult had a difficult time securing a regular income. Even though he achieved stunning

successes in Vienna, especially with his operas, when he died at the age of thirty-five he was heavily in debt.

During his brief life Mozart composed more than six hundred works. He wrote forty-one symphonies along with twenty-seven piano concertos and nine concertos for other instruments. He composed large numbers of chamber works and a significant volume of choral music, including his great *Requiem*, which remained unfinished at his death. Mozart also composed some of the most popular operas ever written, including the frequently performed *Marriage of Figaro* (1786), the towering *Don Giovanni* (1787), and the much-loved *Magic Flute* (1791).

Don Giovanni is based on the story of the legendary Spanish nobleman, Don Juan, who was notorious for his seduction of women. Mozart, well aware of the amorous goings-on in all the great courts of Europe, subtly mocked them in this work. His opera begins with Don Giovanni killing the outraged father of a young noblewoman he has just seduced. At the end of the opera, the dead man returns in the form of a statue which comes sufficiently alive to drag Don Giovanni down to hell. Between these two dramatic episodes, Mozart portrays Don Giovanni's seduction of three women, blending seriousness with humor.

An early scene from Act I reveals Don Giovanni at work in music that captures the Don's persuasive appeal for the peasant girl Zerlina (fig. 16.28), whom he has promised to marry if she comes to his palace. Mozart has the would-be lovers sing a duet entitled "Là ci darem la mano" ("There, you will give me your hand"). Don Giovanni begins with an attractive image of their intertwined future. Zerlina's ambivalent response indicates her desire for the Don and her fear that he may be trick-

Figure 16.28 A scene from *Don Giovanni* by Wolfgang Amadeus Mozart. The opera premiered in 1787. Here, in Act I, Don Giovanni (played by Sherrill Milnes) seduces the innocent Zerlina (Teresa Stratas) in the duet "*Là ci darem la mano*."

ing her. Following this initial exchange, Mozart speeds up their interaction to show Zerlina's increasing acquiescence, and then blends their voices to suggest their final mutual accord. The scene is doubly pleasing. It portrays an actual seduction, one that any audience can enjoy, and it exposes Don Giovanni for the rake that he is, thus allowing the audience both to warm to and detest Mozart's anti-hero. The wide range of feelings typifies Mozart's music and in part accounts for his enduring popularity.

TOWARD ROMANTICISM

BEETHOVEN: FROM CLASSICAL TO ROMANTIC

LUDWIG VAN BEETHOVEN [BAY-tove-in] (1770–1827) was born during the age of the Enlightenment, came to maturity during a period of political and social revolution, and died as the Romantic era was in full flower. His work and his life reveal a tension between the Classical style of the past and the newly emerging Romantic tendencies in art. In his middle period, Beethoven enlarged the scope of the Classical style, while in his later works he transcended it, moving in new musical directions.

Beethoven was born and raised in Bonn, in the German Rhineland. At the age of twenty-one he went to Vienna, where he remained for the rest of his life. He became known in his twenties for his prodigious ability on the piano, especially for his improvisational skill. By the time he was thirty, Beethoven was recognized as an innovative and creative composer (fig. 16.29). Unlike other musicians and composers of his time, he was determined to remain a free artist, and, with the help of a number of sympathetic patrons, he supported himself solely through composing and performing his music. Beethoven was aided by the growth of music publishing and an increase in concert life fueled by the rise of a middle-class public with an appetite for serious music.

Among the most significant experiences of Beethoven's life was the onset of deafness, which began to afflict him around 1800, just as his music was attracting serious acclaim. He nearly committed suicide. In 1802, he wrote his famous Heiligenstadt testament—an agonized letter to his brother describing his suicidal thoughts and his eventual victory over them: "I would have ended my life—it was only my art that held me back. Ah, it seemed to me impossible to leave the world until I had brought forth all that I felt was within me."

Figure 16.29 Beethoven Holding His "Missa Solemnis," oil on canvas. This Romantic portrait of a composer obsessed with his work conveys some of Beethoven's passionate genius.

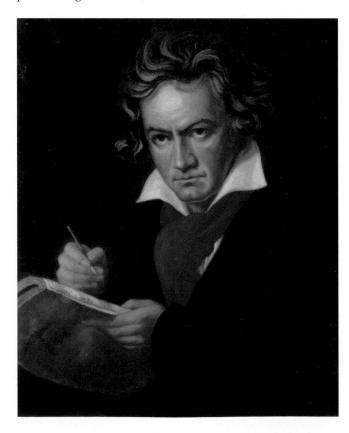

Cross Currents

TURKISH MILITARY MUSIC AND VIENNESE COMPOSERS

Western Europeans had long been fascinated with the "exotic." During the eighteenth century there was increased cultural interaction with Turkey, then part of the Ottoman Empire. Although at the time it represented a threat to Austria, the Austrian Habsburg Empire enjoyed a taste for things Turkish and Ottoman. Viennese cuisine reflected the influence of Turkish spices. Viennese fashion exhibited Turkish influence in flowing garments and brightly decorative ribbons and braiding in women's attire. Viennese music incorporated elements of the music of Turkish military bands, composed of musicians mounted on horseback playing drums and shawms, long-tubed horns used in medieval Western as well as medieval Turkish music. In the seventeenth century, trumpets, cymbals, bells, and additional types of drums were added to Turkish military bands. Later, during the nineteenth century, some pianos were equipped with a special pedal for creating unusual percussive effects reminiscent of these instruments.

All three of the great Viennese composers of the time reveal the influence of the Turkish military band. Haydn wrote three military symphonies, whose titles reflect the martial nature of their music, including the "Drum Roll" and the "Military." Mozart included

Turkish percussive musical elements in his opera The Abduction from the Seraglio. He also entitled the rondo movement from his piano sonata K. 331 "Rondo alla Turca," a spirited piece with a section reflective of Turkish military music. Beethoven was also inspired by Turkish music, as is evidenced by his Turkish March, and in themes from the fourth movement of his Ninth Symphony. Moreover, inspired by the whirling dance of Islamic Turks, Beethoven wrote his Chorus for Whirling Dervishes, a work whose theme is repeated in increasing intensity and in quicker tempos, imitating the trance induced by the whirling dance of the Sufi dervishes (see Chapter 7).

Living through this traumatic experience strengthened Beethoven, and the music he wrote afterwards exhibited a new depth of feeling and imaginative power. By 1815, Beethoven was almost entirely deaf, but this did not stop him from composing and conducting his music. In the end, Beethoven's deafness was more of a social affliction than a musical one. He increasingly separated himself from society, for which his rebellious and fiery temperament ill suited him.

Beethoven produced an abundance of music, including thirty-two piano sonatas and nine symphonies, which set the standard against which the symphonic efforts of all subsequent composers have been measured.

The Three Periods of Beethoven's Music. Beethoven's music can be divided into three periods, each reflecting differences in stylistic development. During the first period, which lasted until about 1802, Beethoven wrote works mainly in the Classical style, adhering to the formal elements established by Haydn and perfected by Mozart before him. In the middle period (1803-14), referred to as the "heroic" phase, his works become more dramatic; they are also noticeably longer than those of his Classical predecessors. The first movement of the Third Symphony is, for instance, as long as many full symphonies of Haydn and Mozart. And his compositions in this period modulate between the most gentle and appealing melodies and the most dynamic and forceful writing—not only between works, but within each work.

Beethoven's final period of composition spans the years 1815–27, during which he was almost completely

dcaf. In this period, Beethoven not only departed from the constraints of Classical compositional practice, but also entered new musical territory and reached new levels of spiritual profundity. Works from the late period include, among many others, his Ninth Symphony, considered by many the greatest symphony ever written; the last piano sonatas; and the deeply spiritual *Missa Solemnis*.

Symphony No. 5 in C Minor, Opus 67. Beethoven's most famous work probably remains, nonetheless, his middle period Symphony No. 5 in C Minor, Opus 67, a work that still defines the idea of the symphony in the popular imagination. He completed it in 1808. One of the most tightly unified compositions Beethoven ever wrote, its opening four-note motif is perhaps the best known of all symphonic themes. Out of that brief fragment of musical material, Beethoven constructs a dramatic and intense opening movement. He uses its rhythmic pattern of three short notes followed by a longer one in each remaining movement and further unifies the work by returning to the theme of the third movement during a dramatic passage in the fourth movement. Overall, the symphony moves from struggle and dramatic conflict to triumphant and majestic exultation.

The first movement, marked *Allegro con brio*, "fast with spirit," opens abruptly with the famous "Fate knocking on the door" theme—short-short-short-long:

Beethoven repeats this musical motif throughout the exposition before a bridge passage leads to a second, contrasting, and more lyrical theme, which is accompanied in the cellos and basses by the first four-note theme. Additional musical ideas fill out the movement, including a development section that breaks the main theme into smaller and smaller units and a recapitulation that features a surprising lyrical oboe solo.

The second movement, in theme and variations form, provides relief from the unabating tension created in the first. Two themes dominate the movement, the first sung by cellos and violas, the second by clarinets. Both receive extensive variation throughout the movement. The overall effect combines noble grandeur with sheer lyrical beauty.

The third movement, a scherzo, begins with a mysterious theme introduced quietly by cellos and basses, followed by a loud theme blared out by the horns on a single repeated note.

The fourth movement, in C Major, is cast in sonata form, with an extensive coda, one of the most dramatic Beethoven wrote. For this, he enlarged the orchestra: a high-pitched piccolo extends the orchestral range upward, a low-pitched contrabassoon extends it downward, and three extra trombones add power. Beethoven presents four themes, then a stunning coda that appears to end a number of times before he finally brings the movement and the symphony to a triumphant conclusion.

It is perhaps because Beethoven became isolated from the natural world by his deafness that he was able to redefine the creative act of composition. It was no longer a function of objective laws and rules of harmony. It is to this interior world that artists of the nineteenth century, the so-called Romantics, turned their attention.

GARDENS

Beethoven's music does not serve as the only bridge between the eighteenth and nineteenth centuries. Quite literally, the seeds of what would blossom as full-blown Romanticism planted in the English garden, which embodies the shifting attitude toward nature.

Gardens during the Baroque era had been designed according to the same aesthetic principles as those followed by disciples of Poussin and his revived classical ideals in painting, exemplified in Bernini's orderly colonnade for St. Peter's and in Le Vau's symmetrical facade for the palace at Versailles. The gardens at Versailles (fig. 16.30) give full expression to the ancient ideals of geometric symmetry. These were classical in design, straight paths, clipped hedges with precise borders, and beds containing orderly arrangements of flowers. Organized around a major central axis running north–south, Versailles is an expression of the mind's—and, by extension, the king's—dominance over nature.

In the seventeenth century, in his Sacred Theory of the Earth (1681), Thomas Burnet wrote that there is "nothing in Nature more shapeless or ill-figured" than a mountain: "if you look upon an Heap of them together, or a mountainous Country, they are the greatest Examples of Confusion that we know in Nature." In contrast, Edmund Burke, a member of Samuel Johnson's "Club" and a late eighteenth-century political theorist, wrote that mountains were "sublime" and capable of creating a sense of infinite awe, as close as we can get on earth to the infinity of God. In the later eighteenth century and the Romantic era, it became fashionable for every educated person of English society to go on a "Grand Tour" of the European continent, which included seeing the Alps as well as visiting Paris, Florence, and

Figure 16.30 The gardens at the château of Versailles, designed by André Le Nôtre, 1662–68. Everything in the gardens of Versailles is carefully planned. Flower beds are carefully and symmetrically arranged, hedges clipped, and pathways edged and groomed.

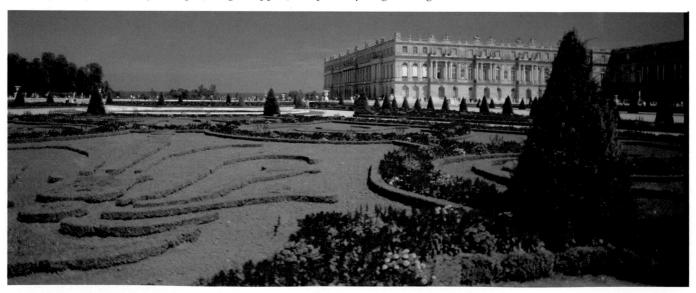

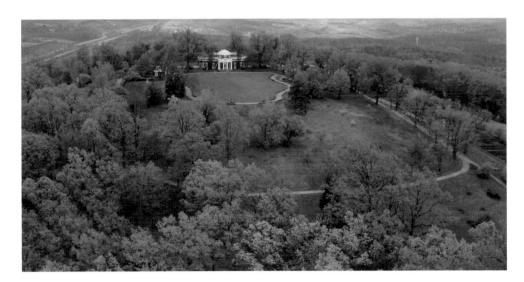

Figure 16.31 View from the garden path at Monticello. Situated on the top of a hill near the Virginia Blue Ridge, Jefferson's garden overlooks a variety of what were in his time near-wilderness landscapes.

Rome. This shift in the human relationship to nature is particularly apparent at Neoclassical houses such as Lord Burlington's estate at Chiswick, which had gardens designed for it in the 1730s by William Kent.

The new English garden, unlike that in the classical Baroque style, looks far less kempt, although it is every bit as calculated in its innovative and non-geometric design. Superficially, the English Neoclassical garden is defined by the variety and surprising nature of its many views. Instead of the straight, geometrical paths of the French garden, it has walkways that are, in the words of one garden writer of the day, "serpentine meanders ... with many twinings and windings." This was not a new idea. In ancient Rome, Pliny had commented on the "wiggly" paths of contemporary gardens. However, the Neoclassicists went beyond this, planning to "throw open" an entire estate to become a garden, a Roman pastoral setting worthy of Ovid, uniting lawns and fields with walks, plantings, woods, lakes (often artificial), and marshes. Instead of the "the neatness and elegance" of Versailles, the English garden is defined by its "artificial rudeness," that is, its (carefully controlled) "wild" look.

It is in just such a garden, Pemberley Woods, that Elizabeth Bennet and her aunt find themselves in Chapter 43 of Jane Austen's *Pride and Prejudice*:

The park was very large, and contained great variety of ground. They entered it in one of its lowest points, and drove for some time through a beautiful wood stretching over a wide extent.

Elizabeth's mind was too full for conversation, but she saw and admired every remarkable spot and point of view. They gradually ascended for half a mile, and then found themselves at the top of a considerable eminence, where the wood ceased, and the eye was instantly caught by Pemberley House, situated on the opposite side of a val-

ley, into which the road with some abruptness wound. It was a large, handsome stone building, standing well on rising ground, and backed by a ridge of high woody hills; and in front, a stream of some natural importance was swelled into greater, but without any artificial appearance. Its banks were neither formal nor falsely adorned. Elizabeth was delighted. She had never seen a place for which nature had done more, or where natural beauty had been so little counteracted by an awkward taste.

Elizabeth is surprised by the views, but it is Mr. Darcy who astonishes her the most with his natural "civility" when she meets him in the grounds. In fact, the Pemberley Woods become for Elizabeth a sort of metaphor for Darcy himself. She soon believes that she has never seen a man for whom "nature had done more."

By the late eighteenth century, many people, including Thomas Jefferson, had come to believe that landscape gardening was one of the highest of the arts, marking the next shift in attitude toward nature—the position held by the Romantics. Jefferson toured England expressly to view gardens, and by 1807 he had designed a serpentine path around the crown of the hill at Monticello (fig. 16.31). Alexander Pope, whose own gardens at Twickenham were of the English variety, wrote: "All gardening is landscape painting," i.e. gardens should be designed in such a way as to astonish and delight the viewer. The art consisted not just in making the artificial appear natural-aim of all representationbut in making the natural appear better and more natural than nature itself. William Chambers wrote that "gardens can arouse greater passions than anything known to man," because they never repeat themselves. At every turn, the prospect should be new. It is the English garden, with its unpredictability and variety, that most stirred the Romantic imagination in the next century.

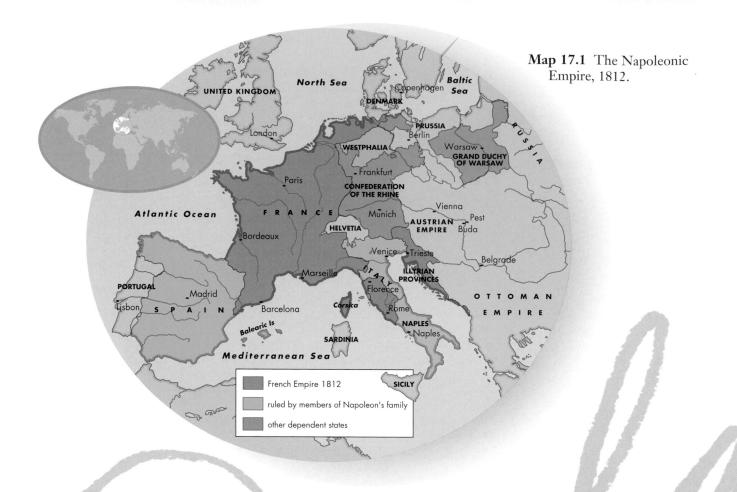

ROMANTICISM * AND REALISM

CHAPTER 17

- * Romanticism
- ← Realism

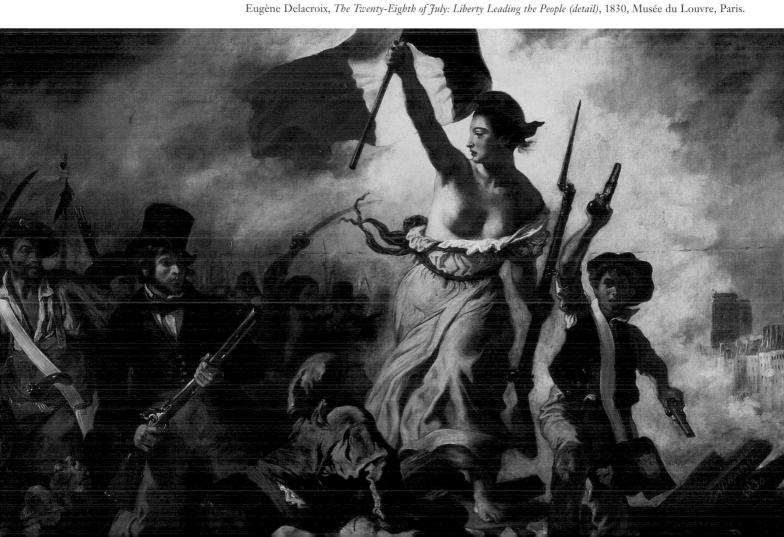

ROMANTICISM

By 1800, Neoclassicism was firmly entrenched as a dominant style in European art and architecture. It was a style that suited Napoleon well. As early as 1805, the latter had begun speaking of his "Grand Empire," conceiving of it as a modern version of the Holy Roman Empire. In 1808, as part of his strategy to subdue the entire European continent, his troops crossed the Pyrenees into Spain, ostensibly on their way to Portugal, which was closely allied with the British. But once in Spain, Napoleon took advantage of the abdication of the unpopular Charles IV, refused to recognize his successor, Ferdinand VII, and took control of the country. At first, there was little resistance, but Napoleon discovered that just because the Spanish did not care for their king did not mean that they were prepared to be ruled by a French Emperor. Soon skirmishes began breaking out across the country. These "little wars," or guerillas (the origin of our word for guerilla warfare), forced Napoleon to withdraw large numbers of troops from Germany to fight in Spain, and soon full-scale war broke out.

In the meantime, an emerging new movement, Romanticism, provided a counter-tendency to the Neoclassical style. The classicism of the eighteenth century was based on a logical mathematical model, first developed by Descartes. Rigor, clarity, exactitude, and certainty were its goals. In the Romantic era, however, things changed. In his Philosophy of the Enlightenment, modern thinker Ernest Cassirer put it this way: "The aesthetic faculty is ... [no longer] the prisoner of the 'clear and distinct.' Not only does it allow a certain margin of indeterminacy, it also creates and demands such a margin, since the aesthetic imagination takes fire and develops only in the presence of something that is not yet fully defined or thought ... The accent falls less on proximity than on distance with regard to the object. The object seems multiplications. We can never visually possess it, or resolve it analytically into parts."

This aesthetic can be seen in the painting of J.M.W. Turner (see fig. 17.11), where the viewer's gaze loses itself in a swirl of light. Inexactitude and indeterminacy characterize this view of the world, and it can be discovered everywhere in this period. The Romantic painter Eugène Delacroix loved the *études* by a contemporary composer, Frédéric Chopin, for "their floating, indefinite contour ... destroying the rigid frameworks of form ... like sheets of mist." Mist was actually a favorite subject of many Romantic painters. The German painter Caspar David Friedrich painted it often (fig. 17.1): "A landscape enveloped in mist seems vaster, more sublime," he wrote, "and it animates the imagination while also heightening suspense—like a veiled woman."

Romanticism is an attitude more than a style, but it depends upon a growing trust in subjective experience,

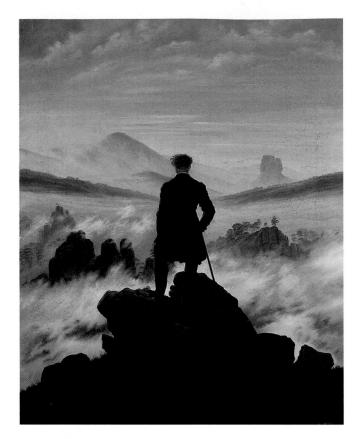

Figure 17.1 Caspar David Friedrich, *The Wanderer above the Mists*, ca. 1817–18, oil on canvas, $2'5\frac{1}{2}'' \times 3'1\frac{1}{4}''$ (74.8 × 94.8 cm), Kunsthalle, Hamburg. Friedrich was the greatest of the German Romantic painters, noted for his depictions of Gothic cathedrals in ruin, bleak metaphors for the crisis in religious faith experienced by many people of the era.

particularly in the emotions and feelings of individuals. The Romantics had a love for anything that elicits such feelings: the fantastic world of dreams, the exotic world of the Orient, the beauty of nature revealed in a sudden vista of hills exposed around a turn in an English garden, the forces of nature in a magnificent or unpredictable moment, such as a sunset after a storm.

The Romantic attitude depends particularly on the concept of *originality* as opposed to virtuosity, which is the sign of the Renaissance genius. Just as no aspect of an English garden should be like any other, no painter or author should imitate any other. The new Romantic genius stands alone, different from the rest, and unsurpassed—a true original.

The Romantic glorification of the self found expression in many ways. Artists, composers, and writers were seen as divinely inspired visionaries with Promethean powers of inspiration and illumination. Many compared the creative power of the artist to the power of the biblical creator. They saw God's power as residing within their own creative genius.

Romantic artists were fascinated by the strange and the marvelous, by dreams and the occult. They celebrated the commonplace, seeing the extraordinary in the ordinary, infinity in a grain of sand and eternity in an hour, to paraphrase William Blake. In addition, Romantic artists expressed an abiding interest in folk traditions. And they were preoccupied as well with the uncanny and the irrational, a fascination that would lead, by the end of the century, in the person of Sigmund Freud, to the rise of psychiatry as a respected branch of medicine. The Romantic sensibility accommodates all these tendencies. Romantic art is multiplicitous, as various as the temperaments that made it.

PAINTING

Francisco Goya. One artist who developed a unique Romantic style based on his temperament was the Spaniard FRANCISCO GOYA [GOY-uh] (1746–1828). He was the most important chronicler of France's war with Spain. Goya's approach was personal: he made drawings on the spot and even wrote on one print, "I saw this." His sense of despair is embodied in a print he made

in which a corpse, sinking into its grave, writes the word "Nada" (Nothing) on its own tombstone.

Goya began his career as a favorite portraitist of Madrid society, and in 1789 he was made a court painter to Charles IV of Spain. In 1794 a serious illness left him totally deaf, and within the isolation produced by his deafness he became ever more introspective. Slowly, gaiety and exuberance were replaced by bitterness. All foreigners living in Spain were obliged to swear allegiance both to the king and to the Catholic Church. Goya did not particularly care for his employer, Charles IV, who preferred hunting to affairs of state, and who was characterized by his critics as dim-witted. During his reign of corruption and repression, the country's borders were sealed, and its newspapers suppressed. Goya, however, was a social and political revolutionary, whose sympathies were with the Enlightenment and the failed French Revolution. He worked for the King not because he felt loyalty but because he desired to make a good living.

In 1800, Goya painted the *Family of Charles IV* (fig. 17.2). Goya's largest royal portrait, it features the entire clan. Goya even includes himself, on the far left, painting in the shadows, in a tribute to Velázquez's painting the

Figure 17.2 Francisco Goya, Family of Charles IV, 1800, oil on canvas, $9'2'' \times 11'$ (2.79 \times 3.36 m), Museo del Prado, Madrid. Principal painter to King Charles IV of Spain, Goya has a technique that glitters but his portraits are hardly flattering and their mood is uncomfortably tense. Like Velázquez in his Maids of Honor (fig. 15.26), Goya included himself, on the left, painting a huge canvas.

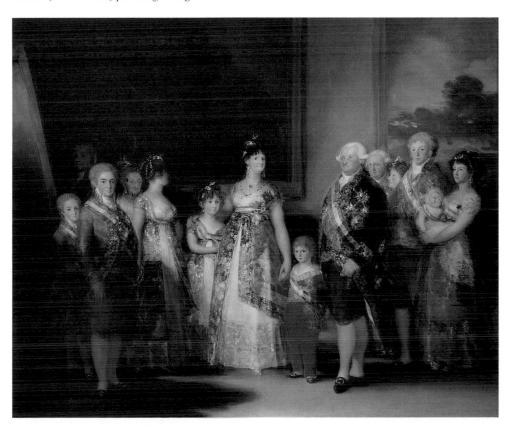

Timeline 17.1 Romanticism and Realism.

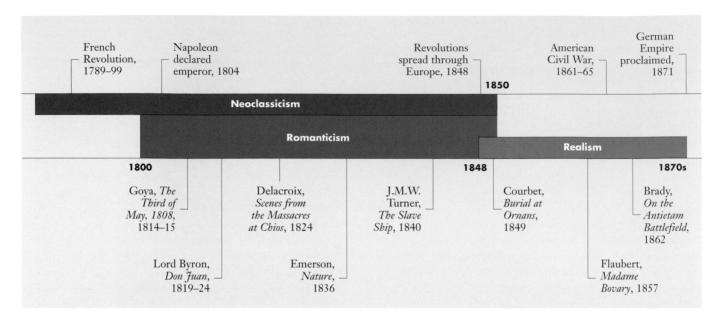

Maids of Honor (see fig. 15.26). A comparison of the two pictures underscores just how far the crown had fallen since Velázquez's time. The scene is set in one of the picture galleries in the palace. Goya's figures are painted with pitiless honesty, so much so that the French writer Théophile Gautier would describe them later in the century as "the corner baker and his wife after winning the lottery." The vulgar Queen and the vulturous King are depicted accordingly. The women are not made pretty nor are the men made handsome. Yet Goya's extraordinary skill in depicting the magnificent costumes, sparkling and lush, and the textures revealed by the light satisfied the royal family, who were evidently blind to their own shortcomings both in everyday life and in their portrayal in the painting.

The fall of Charles IV and Napoleon's invasion of Spain unleashed Goya's real talent. At first, the artist was in favor of Napoleon's invasion, hoping Spain would be modernized as a consequence. But on May 2, 1808, the civilians of Madrid rose up in a guerilla action against the French, and on the following day one of Napoleon's generals executed his Spanish hostages in retaliation. That execution is the subject of one of Goya's most powerful works, *The Third of May*, 1808 (fig. 17.3). Painted several years after the event and commissioned by the newly restored Ferdinand VII, the painting marks Goya's change of heart. The French presence had brought Spain only savage atrocity, death, famine, and violence.

The soldiers on the right are a parody of the brothers in David's *Oath of the Horatii* (see fig. 16.18), but instead of raising their weapons to swear loyalty to the state, they turn their backs to us in anonymity and raise them—now rifles rather than swords—to destroy. The lighting of this night scene is theatrical, as the square light in front of the

soldiers illuminates their next victim. Christ-like, with arms extended, the man accepts martyrdom for his country, but as much as his portrayal here evokes the image of the Savior, he is simply one man among many. Several lie dead in their own pools of blood to his right, and those about to die await their turn. *The Third of May, 1808* is a painting that gives visual form to a sense of hopelessness. Though it possesses all the emotional intensity of religious art, here people die for liberty rather than for God; and they are killed by political tyranny, not Satan. Death becomes a brutal and unavoidable fact.

The terror depicted in The Third of May, 1808 is no match for the series of eighty-two prints known as Los Desastres de la Guerra (The Disasters of War), produced between 1810 and 1823. Goya had worked for some time as a printer, producing several series of etchings that reflect his sarcasm, in their grim humor, and his sense of the macabre, which is often morbid and ghastly. With the same pitiless accuracy that marks his portrait of the royal family, he attacks all the foibles of humankind: one series, made 1794–99, is ironically titled Los Caprichos (Caprices). The nightmare quality of Goya's prints is achieved not only by the subject but also by the way in which it is portrayed. Goya masses the lights and darks, emphasizes dramatic silhouettes, and creates a profound sense of brooding atmosphere. Objecting to the emphasis given to line by the academic painters, he asked, "But where do we see these lines in nature?" Goya said he saw, instead, forms that advance and recede, masses in light and shadow.

The Disasters of War was inflammatory, since it showed the French and the Spanish as unheroic. Goya attacked war head on. As far as he was concerned, there was nothing noble or heroic about it. War was the very image of

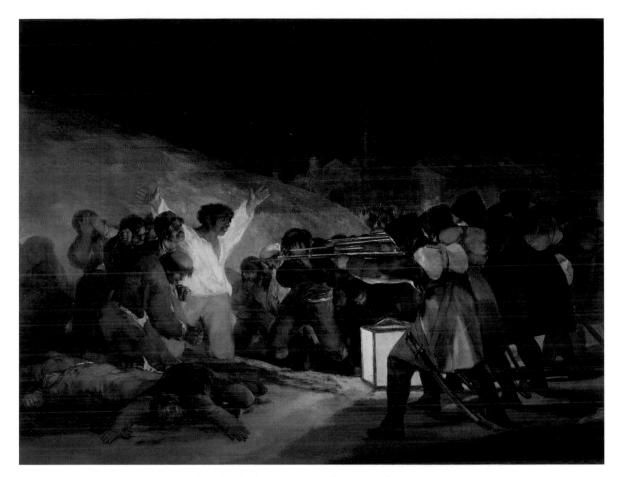

Figure 17.3 Francisco Goya, *The Third of May, 1808, 1814–15*, oil on canvas, $8'9'' \times 13'4''$ (2.67 \times 4.06 m), Museo del Prado, Madrid. One of the most powerful anti war statements ever made, Goya's painting documents the execution of Madrid citizens for resisting the French occupation of their city. The killers are faceless, dehumanized, mechanized; the victim, Christ-like in pose, dies for liberty rather than religion.

human brutality, even bestiality, as his prints demonstrate. Number thirty-nine in the series, called *Great Courage! Against Corpses!* (fig. 17.4), shows war for what it is—a powerful demonstration of humanity's inhumanity. Never issued during Goya's lifetime, *The Disasters of War* is a kind of personal diary, his own version of the "dark night of the soul," which another Spaniard, the mystic St. John of the Cross, experienced over two hundred years earlier. For Goya, there was neither hope of salvation nor, for that matter, any belief in God.

Théodore Géricault. Goya's equal among the French painters of the Romantic movement is THÉODORE GÉRICAULT [jay-ree-COH] (1791–1824), a sensitive man who died young from medical complications resulting from a fall off a horse. Like Goya, Géricault painted subjects that affected him emotionally. His most famous painting, the Raft of the "Medusa" (fig. 17.5), painted 1818–19, was inspired by his outrage at an incident that took place in 1816 in the Mediterranean. The government ship Medusa set sail

Figure 17.4 Francisco Goya, *Great Courage! Against Corpses!*, from *The Disasters of War*, 1810-23, $5\frac{1}{2} \times 7\frac{1}{4}$ " (13.6 \times 18.6 cm), British Museum, London. As in his paintings, Goya works in areas of light and dark in this etching, the stark contrast emphasizing the brutality of the subject. Few artists have approached Goya's ability to portray the horror of war.

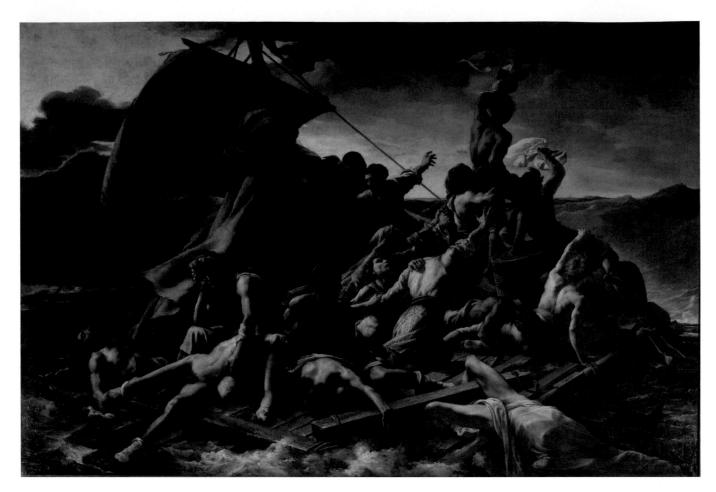

Figure 17.5 Théodore Géricault, *Raft of the "Medusa*," 1818–19, oil on canvas, $16'1'' \times 23'6''$ (4.9 \times 7.16 m), Musée du Louvre, Paris. In this moving depiction of a tragedy in which many lives were lost after days at sea, the impact is enhanced by the raft jutting obliquely into the viewer's space, by the proximity of extremely realistic dead bodies, and by the dramatic contrasts of light and shadow.

overloaded with settlers and soldiers bound for Senegal. When it sank on a reef off the coast of North Africa, the ship's captain and officers saved themselves in the six available lifeboats and left the 150 other passengers and crew to fend for themselves on a makeshift raft. These spent twelve days at sea before being rescued; only fifteen people survived. The others died from exposure and starvation. Some went insane and there were even reports of cannibalism. The actions of the captain and officers were judged criminally negligent and intentionally cruel, and the entire incident reflected poorly on the French monarchy, newly restored to the throne after Napoleon's defeat. The captain had been commissioned on the basis not of his ability but of his noble birth. His decision to save himself was viewed by many as an appalling act inspired by his belief in aristocratic privilege.

Géricault completed the enormous painting ($16'1'' \times 23'6''$) in nine months. In an attempt to portray accurate-

ly the raft and the people on it, Géricault interviewed survivors, studied corpses in the morgue, and even had the ship's carpenter build a model raft, which he then floated. His search for the uncompromising truth led him to produce a vividly realistic painting of powerfully heroic drama. Géricault elected to portray the moment of greatest emotional intensity—when the survivors first sight the ship that will eventually rescue them, just visible on the horizon. It is a scene of extraordinary tension, a thrilling combination of hope and horror. Those who have died or abandoned hope are shown at the bottom of the composition, close to the viewer, large, and extremely realistic. The strongest struggle hysterically upward, led by a black man in a diagonal surge of bodies that rises toward the upper right. Disaster and despair to the bottom and left, hope and salvation at the top and right—these are the countertendencies of the painting.

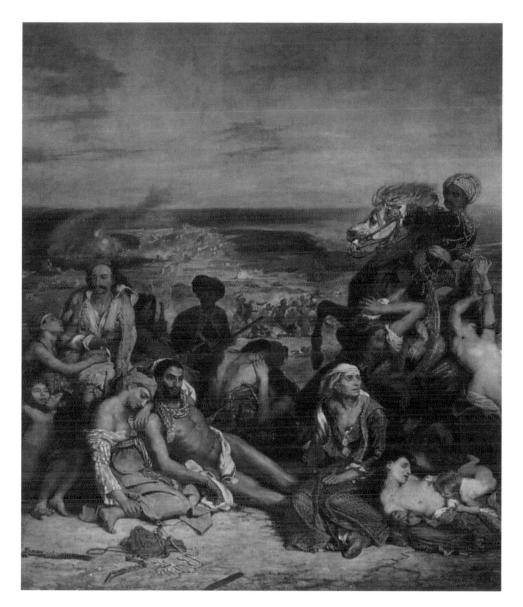

Figure 17.6 Eugène Delacroix, Scenes from the Massacres at Chios, 1824, oil on canvas, $13'8\frac{1}{4}'' \times 11'7\frac{3}{8}''$ (4.17 × 3.54 m), Musée du Louvre, Paris. Reacting to the composition's lack of focus as well as to the looseness of its brushwork, one rival artist called this work "the massacre of painting."

Eugène Delacroix. Another ardent French Romantic painter was EUGÈNE DELACROIX [duh-lah-KWA] (1798–1863), who, as Géricault's friend, served as the model for the central corpse lying face down below the mast in the Raft of the "Medusa." Born into the upper-middle class, Delacroix was known as a fastidious dresser and an attractive personality, yet he was often unsure and melancholy. Believing that an artist's career called for "isolation," he never married.

One of his first major paintings to attract the attention of the press was, like Géricault's *Raft*, based on current events. Its full title underscores its journalistic sources: *Scenes from the Massacres at Chios; Greek Families Awaiting Death or Slavery, etc.—See Various Accounts and*

Contemporary Newspapers (fig. 17.6). In April 1822, the Greeks, who had proclaimed their independence from Turkey in January, were attacked on the island of Chios (the legendary birthplace of Homer) by a Turkish army of ten thousand. Nearly twenty thousand Greeks were killed, and countless women and children were raped and tortured by the Turks and then sold in the slave markets of North Africa. A dead mother lies at the bottom right, her still-living child nuzzling her. An older woman sits resigned to her fate. Behind them a Turk drags a woman into captivity. A fatally wounded Greek soldier lies naked and, further left, yet another mother tries to save herself and her child from captivity.

Figure 17.7 Jean-Auguste-Dominique Ingres, *The Vow of Louis XIII*, 1824, oil on canvas, $13'9\frac{3}{4}'' \times 8'8\frac{1}{8}''$ (4.21 × 2.65 m), Montaubon Cathedral. Ingres had been in Florence since 1820, and Raphael's Madonnas are the clear inspiration for this painting.

When the painting was exhibited at the Salon in 1824, the reaction was vehement. For one thing, the painting was openly antagonistic to the position of the restored French monarchy headed by Charles X, whose Holy Alliance favored the Turks. It was also stylistically challenging. "The massacre of painting," one rival artist called it. In part, he was reacting to Delacroix's extraordinarily fluid use of color. There is almost no drawing in the composition; its forms are defined instead by paint alone. The rival was also reacting to the painting's extraordinary composition: it is a painting without a center. The figures at the front surround a shadowed, hollow core, an uneventful and almost empty space.

Jean-Auguste-Dominque Ingres. Just how radical Delacroix's painting must have been is evident when

compared to the painting prized at the same Salon in 1824, *The Vow of Louis XIII* (fig. 17.7) painted by JEAN-AUGUSTE-DOMINIQUE INGRES [AN-gruh] (1780–1867). A pupil of David, he is perhaps the last Neo-classical painter, for he opposed all Romantics of his day, particularly Delacroix. Stubborn and plodding, he was described as a "pedantic tyrant," and as head of the French Academy, he restricted official art for generations.

Ingres had been studying in Florence since 1820, and *The Vow* is modeled on the example of Raphael. It depicts the moment in 1628 when King Louis XIII officially placed France under the protection of the Virgin Mary, i.e. the Catholic Church, in opposition to Protestantism. Louis kneels in the traditional position of a saint. The painting is ultra-Royalist in its sensibility, in opposition to the liberal sentiments expressed by Géricault and Delacroix. It is classical and intellectual, where Delacroix's paintings are romantic and emotional. French painting would oscillate between these poles for the next forty years.

On the one hand, there was Ingres, who relentlessly pursued his classical prototypes, concentrating particularly on the human form. In Ingres's approach, precision of line is all-important. His *La Grande Odalisque* (fig. 17.8), the word *odalisque* meaning "harem woman" in Turkish, painted in 1814, is the kind of exotic subject also favored by the Romantics. The odalisque is not an individual, and her anatomy is neither academic nor accurate. The elongated, large-hipped proportions recall the Mannerist style rather than the classical ideal. Ingres perhaps had more in common with the Romantics than he would have liked to admit since it is hard to remove *all* sensuality from such a subject. He was shocked when the Neoclassical painters found his work unclassical.

Figure 17.8 Jean-Auguste-Dominique Ingres, La Grande Odalisque, 1814, oil on canvas, $2'11\frac{1}{4}'' \times 5'3\frac{3}{4}''$ (89.7 × 162 cm), Musée du Louvre, Paris. The treatment of the anatomy of this odalisque (harem woman), an exotic and erotic subject, is less academic than Ingres might have liked to believe. In fact, she has much in common with the smooth elongated bodies created by Mannerist artists, such as Parmigianino's Madonna with the Long Neck (fig. 13.43).

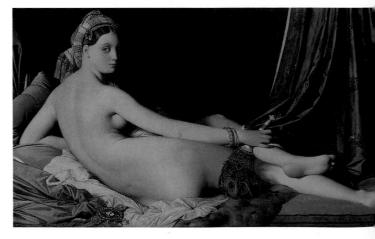

Cross Currents

DELACROIX AND THE ORIENTALIST SENSIBILITY

In January 1832, Delacroix visited Tangiers and Morocco in North Africa, a trip made possible by the French occupation. Writing home from Tangiers, he claimed that he had discovered paradise: "I am quite overwhelmed by what I have seen," he reported. "I am like a man dreaming, who sees things he is afraid to see escape him." The women, he wrote, "are pearls of Eden." He visited a harem, and there, "in the midst of that heap of silk and gold ... the lovely human gazelles ... now tame ... This is woman as I understand her, not thrown into the life of the world, but withdrawn at its heart as its most secret, delicious, and moving fulfillment." (See fig. 17.9.)

Delacroix was by no means the only European to be so moved by the prospect of the notorious harem of the Oriental world. Ingres would paint more harem scenes, such as *La Grande Odalisque* (see fig. 17.8) in 1814. Novelist Gustave Flaubert went to North Africa some years later. In fact, an entire genre of harem paintings would be a focus of French and European art right up to the twentieth century.

The harem in many ways fulfilled a European male fantasy. It was the embodiment, in sexual terms, of political empire. In the harem, men indulged in bodily pleasures, in the irrational, and in the dream world. Perhaps it was a reaction to what was happening in Rome. In Paris, women were strong, gaining independence and a voice. Women like the novelist George Sand and the painter Rosa Bonheur competed openly with men. In Algiers and Morocco, women were obliged to be submissive. They were, in Delacroix's words, "lovely human gazelles." They were, in his eyes, and the eyes of his

male contemporaries, "pure" nature. "Here you will see a nature," he wrote, "which in our country is always disguised, here you will feel the rare and precious influence of the sun which gives an intense life to everything." Like the sun itself, the women so heated his temperament that he became in their presence, he said, "exalted to the point of fever, which was calmed with difficulty by sherbets and fruits."

Both sexist and racist, this point of view embodied the attitude of the nineteenth-century Western male toward colonies and territories. The harem was seen as a utopia, a prize for the taking, not as a separate cultural entity. Looking at the disenfranchisement of world cultures such as these has been the life's work of some twentieth-century scholars such as Edward Said, whose book *Orientalism* explores Western concepts of the "Orient" in detail.

Figure 17.9 Eugène Delacroix, *Odalisque*, 1845–50, oil on canvas, $14\frac{7}{8}" \times 18\frac{1}{4}"$ (37.6 × 46.4 cm), Fitzwilliam Museum, Cambridge, England. It is hard to say which is more sensual in Delacroix's painting, the subject or the brushwork. There is an obvious contrast with Ingres's treatment of an odalisque subject thirty-odd years earlier (see fig. 17.8). Whereas in Ingres's version the emphasis is very much on line, Delacroix is a *rubéniste* and delights in an ecstatic use of color.

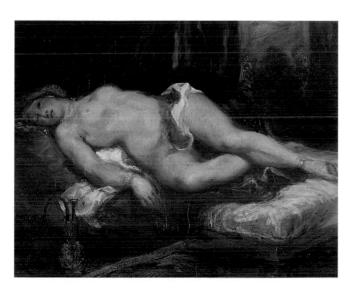

Still, compared to a Delacroix *Odalisque* (fig. 17.9), of 1845–50, Ingres's painting seems positively tame. Delacroix's nude is unabashedly sensual. His painting style is loose, physical, not at all intellectual. Where Ingres explores human form, Delacroix explores the body and the powerful feelings that the body can generate.

John Constable. Delacroix's attraction to the body was paralleled in England by English painters' attraction to the physical aspects of nature. JOHN CONSTABLE (1776–1837) immersed himself in the scenery of his native land and painted places he knew and loved such as Suffolk and Essex. The valley of the River Stour, which divides Suffolk from Essex, was his special haunt. Constable's inheritance enabled him to live comfortably and paint what he wanted, without having to accommodate the tastes of the Royal Academy.

He sketched on walks around the countryside, and studied cloud formations and the light effects created by clouds. Among the most lively nature studies made during the nineteenth century, these sketches were used as the basis for paintings completed later in his studio. The rapidity of Constable's brushwork is immediately evident, as are his intentions. He records, as precisely as possible, not nature in its most minute detail, but nature's effects, the play of light, the movement of water

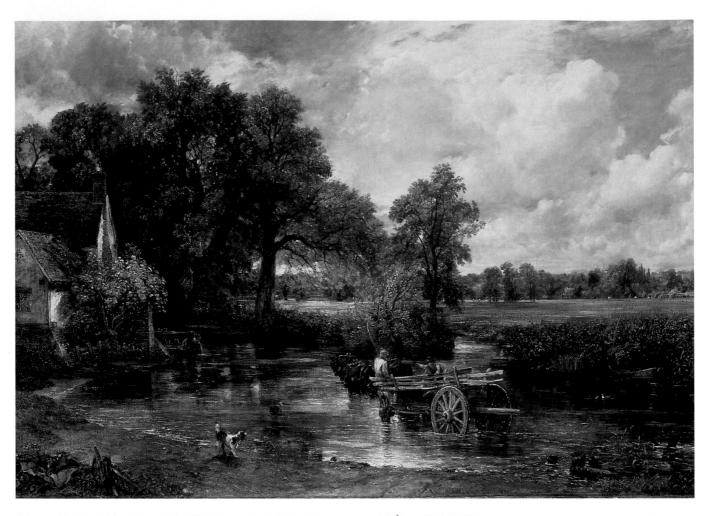

Figure 17.10 John Constable, *The Haywain*, 1821, oil on canvas, $4'3\frac{1}{4}'' \times 6'1''$ (1.30 × 1.90 m), National Gallery, London. The English penchant for landscape painting indicates a growing interest in nature and weather conditions that prefigures late nineteenth-century Impressionism. Although Constable sketched from nature, he did the final painting in his studio.

and air, the uncanny relationship between trees and clouds. "I should paint my own places best," he wrote to a friend in 1821. "Painting is but another word for feeling. I associate my 'careless boyhood' to all that lies on the banks of the Stour. They made me a painter (& I am grateful)."

In the 1820s, in an apparent effort to gain more respect for his work from the Royal Academy, Constable began painting a series of "six-footers," which were large, ambitious landscapes celebrating rural life. *The Haywain* (fig. 17.10), of 1821, depicts a wagon mired beside Willy Lott's cottage in the millstream at Flatford that ran beside the Stour proper, adjacent to Constable's own property. Willy Lott lived in this cottage for eighty years and spent only four nights away from it in his entire life. He embodied, for Constable, the enduring attachment to place so fundamental to rural life. The enduring geometry of the scene—defined precisely by the cottage on the

left and the horizon line on the right—is set against the transience of nature, the momentary effects of atmosphere and light, of storm and sunlight, dense foliage and open field.

J.M.W. Turner: Constable's love of nature was shared by his fellow Englishman JOSEPH MALLORD WILLIAM TURNER (1775–1851). The son of a barber, Turner had no formal education but was interested in art from childhood. His talent was quickly recognized for he was already a full member of the Royal Academy in 1802, when he was still only twenty-seven. Opposing the Academy's classicism, he was to become England's leading Romantic painter.

Although Turner worked from nature, he took even greater liberties with the facts than did Constable. Consequently, it is not always possible to recognize his sites or fully to comprehend his subject. For example,

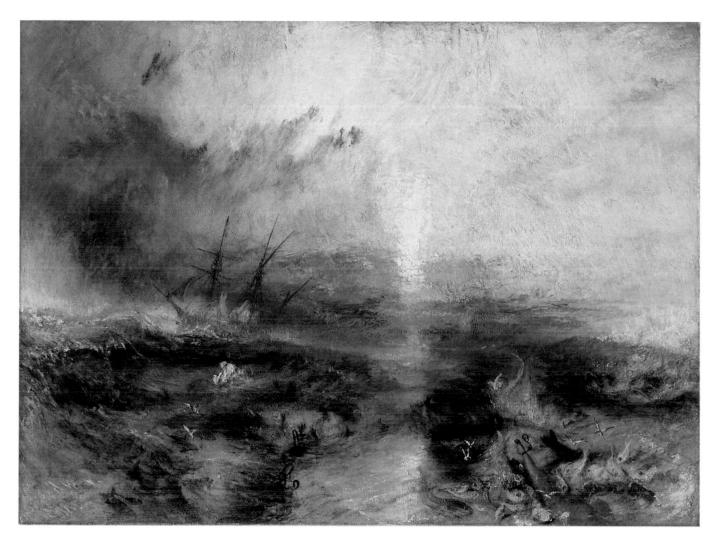

Figure 17.11 Joseph Mallord William Turner, *The Slave Ship*, 1840, oil on canvas, $2'11\frac{3}{4}'' \times 4'$ (90.5 × 122 cm), Museum of Fine Arts, Boston. Constable called Turner's paintings "tinted steam." The original title, "Slavers Throwing Overboard the Dead and Dying—Typhoon Coming On," in spite of its unusual length, hardly clarifies the subject which is, above all, Turner's Romantic response to nature.

Turner's painting *The Slave Ship* (fig. 17.11), of 1840, originally titled *Slavers Throwing Overboard the Dead and Dying—Typhoon Coming On*, illustrates a specific, contemporary event with all the outrage of Géricault and Delacroix. A ship's captain had thrown overboard slaves who were sick or dying from an epidemic that had broken out on board. The captain was insured against loss of slaves at sea, but not against their loss owing to disease.

Turner's figures are lost in the wash of colors of sea and sky, and the political subject threatens to become, in Turner's hands, an excuse for a study of atmosphere. The eye drowns in this painting like the slaves themselves. The forms dissolve into a haze of mist. The swirl of storm and colored light is designed to stir the viewer's emotion, and the blurring of our vision before the scene can be viewed as a metaphor for the blindness of society itself. When the painting was first exhibited, Turner

added a fragment of verse to the title: "Hope, Hope, fallacious Hope! / Where is thy market now?" The painting can be viewed finally as a treatise on the difference between blindness and insight, between what we can see with our eyes and what we know in our hearts.

Thomas Cole. American landscape painting is a painting of solitude. When figures are included in a scene, as, for instance, in American Lake Scene of 1844 (fig. 17.12) by THOMAS COLE (1801–1848), they are barely visible, dwarfed in the landscape that surrounds them. Here a lone Native American warrior sits between two trees on a small island where he has brought his canoe to rest. We share his view, enthralled by the combination of light and open space that fills the scene. In an analogous moment, Cole described his feelings as he looked out across two lakes in Fran-

Figure 17.12 Thomas Cole, American Lake Scene, 1844, oil on canvas, $18\frac{1}{4}'' \times 24\frac{1}{2}''$ (46.4 × 62.2 cm), Detroit Institute of Arts, Detroit. Though his landscape paintings were a popular success, they seemed less important to Cole than his historical and allegorical works, which were not as enthusiastically received.

conia Notch in the New Hampshire mountains: "I was overwhelmed with an emotion of the sublime such as I have rarely felt. It was not that the jagged precipices were lofty, that the encircling woods were of the dimmest shade, or that the waters were profoundly deep; but that over all, rocks, wood, and water, brooded the spirit of repose, and the silent energy of nature stirred the soul to its inmost depths." The same spirit of repose broods over this combination of rock, wood, and water.

Frederic Edwin Church. When there are no figures in the landscape, as in Twilight in the Wilderness (fig. 17.13), of 1860, by FREDERIC EDWIN CHURCH (1826–1900), the viewer is drawn into the scene, standing before the extraordinary sunset alone like a Daniel Boone exploring the continent, encountering the place for the first time. Church's painting combines the structure of Claude Lorrain (see Chapter 15) with the light of Turner, both of whose works he knew well. But for all its seeming realism, the painting is deeply symbolic. An eagle hovers over the scene, perched on the very top branch of the far left-hand tree. It is the

Figure 17.13 Frederic Edwin Church, *Twilight in the Wilderness*, 1860, oil on canvas, $3'4'' \times 5'4''$, $(1.02 \times 1.60 \text{ m})$, Cleveland Museum of Art, Cleveland. Painted on the eve of the Civil War, the work was interpreted by many as anticipating the bloody conflict to come, especially in its blood-red clouds.

Then & Now

AMERICA'S NATIONAL PARKS

In the early eighteenth century, the new American nation prided itself upon its political system, but it lagged far behind Europe in cultural achievement. Rather than in authors and artists, the country took pride in the one thing it had in abundance—land. After Thomas Jefferson purchased the Louisiana territory from Napoleon in 1803, the American landscape became, in effect, the nation's cultural inheritance. And as the country was subsequently explored, the treasures it held, in beauty as well as gold, excited the American populace.

It was the artists and photographers who accompanied the expeditions to the West who publicized the beauty of the landscape. The painter ALBERT BIERSTADT [BEER-shtaht] (1830–1902) accompanied Colonel Frederick Lander to the Rockies in 1859. The photographer C.E. WATKINS (1829–1916) traveled to Yosemite in 1861. The painter THOMAS MORAN (1837–1926) went with Colonel Ferdinand V. Hayden of the National Geographic Survey through the Rockies to Yellowstone in 1871.

Bierstadt's paintings and Watkins's photographs were the primary reason that Lincoln signed into law a bill establishing Yosemite as a national preserve in 1864. In 1872, Congress purchased Moran's *Grand Canyon of the Yellowstone* (fig. 17.14) for \$10,000 and later hung the massive painting in the lobby of the Senate. On March 1, 1872, President Ulysses S. Grant

signed the Yellowstone Park Act into law, establishing the National Park system.

Today the National Park system is increasingly threatened. Automobiles have been banned from Yosemite, parts of Mesa Verde, and others as well. In the early 1980s, developers proposed building a geothermal power plant fifteen miles west of Upper Geyser Basin and "Old Faithful" Geyser in Yellowstone. The project was halted only because no one could demonstrate just where the exact boundaries of the Yellowstone geothermal reservoirs were. In 1980, the National Park

Service explained the situation this way: "Yellowstone, Great Smoky Mountains, Everglades, and Glacier—most of these great parks were at one time pristine areas surrounded and protected by vast wilderness regions. Today, with their surrounding buffer zones gradually disappearing, many of these parks are experiencing significant and widespread adverse effects associated with external encroachment."

The nation is losing one of its myths—the myth that people can live harmoniously with nature, which was illustrated in the landscapes of American Romantic painters.

Figure 17.14 Thomas Moran, *Grand Canyon of the Yellowstone*, 1872, oil on canvas, 7' × 12' (2.13 × 3.66 m), National Museum of American Art, Smithsonian Institution, Washington, D.C. On a visit to England in 1862, Moran studied and copied the paintings of J.M.W. Turner, whose use of light and color he particularly admired.

year 1860 and the dawn of the American Civil War. The sky may not reflect Cole's quiet "spirit of repose" so much as it anticipates the blood of apocalyptic battles to come.

SCULPTURE

Neoclassical sculpture had been bolstered not only by the revival of interest in the values and sentiments of the ancient world, but also, in France, by the patronage of Napoleon himself, who, in his desire to rebuild Paris as a new Rome, commissioned a vast quantity of sculptural work. Surprisingly, in the Romantic era, sculpture fell out of favor. In fact, in 1846 the poet Charles Baudelaire argued that the idea of a Romantic sculpture was impossible. Sculpture, he suggested, can neither arouse subjective feelings in the viewer nor express the personal sensibility of the artist because, as a three-dimensional object, it asserts its objective reality too thoroughly. Baudelaire summed up Romantic sculpture in the title of his essay, "Why Sculpture Is Boring."

Baudelaire did argue, however, that sculpture could escape this fate in the service of architecture. Attached to a larger whole, it can evoke profound feelings. One

Figure 17.15 François Rude, La Marseillaise (The Departure of the Volunteers of 1792), 1833–36, limestone, ca. $42' \times 26'$ (12.80×7.90 m), Arc de Triomphe, Place de l'Étoile, Paris. The use of a triumphal arch to commemorate a military victory, as well as the use of a winged female figure to represent victory, derive from Greek and Roman antiquity.

example is *The Departure of the Volunteers of 1792*, popularly known as *La Marseillaise* (fig. 17.15), by FRANÇOIS RUDE (1784–1855), a huge stone sculpture made for the Arc de Triomphe in Paris. Although sculpted between 1833 and 1836, the subject refers to an event that occurred in 1792—the defense of the French Republic by volunteers rallying to repel invaders from abroad. For Rude, the subject was deeply emotional: his own father had been among the volunteers.

The figures are costumed in both ancient and medieval armor, and the nude youth in front is Neoclassical in pose and physique. A winged female figure representing Victory as in antiquity leads the soldiers forward, and the group below appears to surge upward with a diagonal force that points in the direction of the end of her sword. Thus, in a rectangular format necessitated by the architecture of the Arc itself, Rude creates a dynamic triangular thrust to the left that creates an emotional thrust as well, one that many French people associate with their national anthem to this day.

GOTHIC REVIVAL ARCHITECTURE

The styles of the past were among the sources of inspiration for the Romantic sensibility. The model of Gothic architecture was especially admired by the British who believed (incorrectly) that the Gothic style was British in origin. As architect A.W.N. PUGIN (PEW-gin) (1812-1852) noted: "We do not want to revive a facsimile of the works of style of any particular individual or even period, but it is the devotion, majesty, and response of Christian art, for which we are contending; it is not a style, but a principle." Gothic architecture, with its inventive lines of tracery, recalling the natural forms of vines and trees, and its ability to evoke the sublime and infinite in the rising shapes of its giant interior spaces, was an emotional architecture. As the English writer JOHN RUSKIN (1819-1900) wrote in The Stones of Venice (1851–53): "It is that strange disquietude of the Gothic spirit that is its greatness; that restlessness of the dreaming mind, that wanders hither and thither among the niches, and flickers feverishly around the pinnacles, and frets and fades in labyrinthine shadows along wall and roof, and that yet is not satisfied, nor shall be satisfied." For Ruskin and Pugin both, the Gothic was Romantic.

After the British Houses of Parliament burnt down in 1834, Pugin and SIR CHARLES BARRY (1795–1860) won a competition to rebuild them (fig. 17.16). They chose the Gothic style, and construction began in 1840.

Figure 17.16 Sir Charles Barry and Augustus Welby Northmore Pugin, Houses of Parliament, London, 1836–60, length 940′ (286.5 m). The delicacy of Gothic religious architecture is applied to government office buildings. Among the plethora of pointed pinnacles, turrets, and towers is the clock known as "Big Ben."

Barry designed the basic structure and Pugin the Gothic detailing, interior decoration, and furniture. The building is organized around a central hall and spire, with vertical rectilinear blocks down its side that lend the facade a sense of order, rhythm, and repetition. This facade is punctuated by an irregular silhouette of spires—a tall square spire, a more delicate pointed tower, smaller pointed towers with two different elevations, and a clock tower nicknamed "Big Ben." The whole is designed to evoke the spiritual and ethical values of the Middle Ages.

PHILOSOPHY

Jean-Jacques Rousseau and the Concept of Self. Anticipating the opening lines of Whitman's epic poem Song of Myself was the work of the French philosophical writer JEAN-JACQUES ROUSSEAU [roo-SEW] (1712–1778), whose autobiographical Confessions was the first and most influential exploration of the self in the West outside the tradition of religious autobiography. Unlike St. Augustine's Confessions, written to honor and glorify God, Rousseau's were written to honor and glorify the self in its intellectual and emotional splendor. Rousseau's conception of the largeness and importance of the "self" is among his greatest influences.

Rousseau lived during the period of the Enlightenment, but he was notably antagonistic to its prevailing spirit. As a Romantic rather than an Enlightenment figure, he stood in stark contrast to many of his contemporaries, particularly Swift and Voltaire. Rousseau believed in the basic goodness of humanity, in naturally positive instincts rather than naturally negative ones. Society, he felt, corrupted a person's basic instincts, making people competitive, greedy, and uncaring. Like the Romantic poets and painters who were to follow in his wake, he celebrated the claims of the imagination above all else.

Rousseau was most interested in the subjectivity of the self. His early works concern social themes. In his *Discourse on Inequality* (1754) he provides a critique of the philosophy of Thomas Hobbes, who argued that human beings are spurred by self-interest and that to exist in a state of nature is to exist in a state of war (see Chapter 15). For Hobbes, society existed to regulate the competition and conflict that were natural to human beings. Rousseau argued that although humans are motivated by self-interest, they also possess a natural instinct of compassion.

Rousseau's *Confessions* serves as a powerful example of reflective self-analysis, a model for future philosophical self-explorations. This celebration of the self became so prevalent during the Romantic era that even in the face of crisis, as with the dashed hopes of many in Britain and France at the outcome of the French Revolution, there

was a belief that those aspirations could be profitably redefined. If the Revolution did not create a better society, then the revolutionary ideal should be transferred from the social realm to the personal one to create a better mind. If a transformation of political reality was more complicated than had been imagined, then a transformation of human consciousness could at least be effected.

Ralph Waldo Emerson and Transcendentalism. The sentiments about nature expressed by the Romantic painters were quickly adopted in the United States, where in the nineteenth century more people lived in close communion with nature than in Europe. The union of humanity with nature was a special theme of RALPH WALDO EMERSON (1803-1882), author of the widely influential essay "Nature," first published in 1836. Emerson was one of a number of American thinkers who called themselves Transcendentalists. The Transcendentalists built a philosophical perspective from the poetry of William Wordsworth, on the one hand, and the philosophy of the German IMMANUEL KANT (1724-1804), on the other. Kant had argued that there are two basic elements, "those that we receive through impressions, and those that our faculty of knowledge supplies from itself." The first he called **phenomena**, the second noumena. We can never truly "know" the essence of the things that the mind creates for itself. "In the world of sense, however far we may carry our investigation, we can never have anything before us but mere phenomena ... The transcendental object remains unknown to us." The "transcendental object" is known only through intuition. Emerson was able to intuit the transcendental in nature. As he puts it in the most famous passage in "Nature": "Standing on the bare ground,—my head bathed by the blithe air, and uplifted into infinite space,—all mean egotism vanishes. I become a transparent eyeball; I am nothing; I see all; the currents of the Universal Being circulate through me; I am part or particle of God ... In the wilderness, I find something more dear and connate than in streets or villages. In the tranquil landscape, and especially in the distant line of the horizon, one beholds somewhat as beautiful as one's own nature."

Henry David Thoreau. The American wilderness was raw and vast, and even along the eastern seaboard, where civilization had taken firm hold, it was still easy to leave the city behind, as HENRY DAVID THOREAU (1817–1862) did at Walden Pond. "I went to the woods," Thoreau wrote in Walden (1854), "because I wished to live deliberately, to front only the essential facts of life, and see if I could not learn what it had to teach, and not, when I came to die, discover that I had not lived." Living close to nature was, for Thoreau, the very source of humankind's strength. In an essay entitled "Walking" he echoed the sentiments Emerson had expressed in "Nature":

What I have been preparing to say is, that in Wildness is the preservation of the world. Every tree sends its fibres forth in search of the Wild ... From the forest and wilderness come the tonics and barks which brace mankind. Our ancestors were savages. The story of Romulus and Remus being suckled by a wolf is not a meaningless fable. The founders of every State which has risen to eminence have drawn their nourishment and vigor from a similar wild source. It was because the children of the Empire were not suckled by the wolf that they were conquered and displaced by the children of the Northern forests who were. I believe in the forest, and in the meadow, and in the night in which the corn grows.

Thoreau's belief system, so simple and direct, is clearly a radical departure from the one that had defined civilization for centuries. Nature was his source and inspiration, and he lived in solitude because he could trust nature more than people. Thoreau's sensibility remains common to American experience, most notably in the environmental movement of recent years.

LITERATURE

The British philosopher and politician Edmund Burke, in his *Enquiry into the Sublime and Beautiful*, wrote: "I think there are reasons in nature why the obscure idea, when properly conveyed, should be more affecting than the clear. It is our ignorance of things that causes our admiration, and chiefly excites our passions." This is the theme of much nineteenth-century literature: our ignorance of things. In HERMAN MELVILLE's (1819–1891) novel *Moby Dick* (1851), Captain Ahab is bent on capturing the great white whale, which comes to stand, in his imagination, for something close to a final truth or a first cause. But the whale eludes him, and even when Ahab does indeed "capture" it, the whale drags him to his death. He seeks a knowledge he cannot possess.

ROBERT LOUIS STEVENSON (1850–1894), another of the great authors of the era, wrote a famous short novel, Dr. Jekyll and Mr. Hyde (1886), which embodies the conflict between the classical mind, with its urge for order, and the new Romantic mind, and in which the rational, scientific Dr. Jekyll has to battle with his alter-ego, the violent, irrational Mr. Hyde. In other popular literature, the mystery tale rises into fashion in France in the 1830s and is seen in America a decade later, but culminates, at the end of the century, in the English writer Sir Arthur Conan Doyle's great detective, Sherlock Holmes. In the typical mystery, everyone is, metaphorically, thrown into a fog by murder. No one knows "who done it," a situation that has excited the passions of readers ever since. As a sort of Enlightenment hero, the detective penetrates the fog, clarifies the situation, resolves the conflict, and explains it logically. If our Romantic spirit is excited by inexactitude and indeterminacy, we nonetheless long to be rescued from them.

But in many ways, the Romantic author is akin to the detective character that emerged at this time. Possessed of a vision capable of penetrating the mysteries of life, particularly the mysteries of the self, writers and poets sought to clarify the nature of experience for us all. As William Blake put it: "One power alone makes a poet: Imagination. The Divine Vision."

William Blake. A product of the industrial slums, the poet and artist WILLIAM BLAKE (1757–1827) was born in poverty and, unable to attend school, he taught himself to read and studied engravings of paintings by such Renaissance masters as Raphael, Dürer, and Michelangelo. Samuel Palmer remembers how Blake "saw everything through art, finding sources of delight throughout the whole range of art." At the age of twenty-two, Blake entered the Royal Academy as an engraving student, but unsettling clashes over artistic differences returned him to a life of nonconformist study.

Blake insisted that his "great task" as a poet was "To open the Eternal Worlds, to open the immortal Eyes of Man inwards into the Worlds of Thought." His was a poetry of revelation, not technique. As a boy Blake saw "a tree filled with angels, bright angelic wings bespangling every bough with stars." This ability to see beyond the physical, what he called his "double vision," fueled Blake's imaginative and poetic flights (fig. 17.17).

Blake saw himself as a prophet, and he drew heavily on both the Hebrew and the Christian sacred texts. As a prophet, Blake was more interested in attacking the ways of humanity than in justifying the ways of God. He was, as the poet T.S. Eliot later noted, "a man with a profound interest in human emotions, and a profound knowledge of them." At the core of Blake's work are two contrary archetypal states of the human soul: innocence and experience. Humanity's oscillation between these states forms the focus of much of his poetry.

For Blake, innocence and experience are psychological states that carry political implications. "The Chimney Sweeper" in Songs of Innocence is a young boy who rationalizes his misery and naively declares, "Those that do their duty need not fear harm." Historically, nothing could have been further from the truth. Young "sweeps" who endured this forced labor rarely lived to reach adulthood. Master chimney sweeps found that small children (some as young as four) could easily climb up into chimneys and scour them. Reluctant sweeps were poked with rods and pins as they climbed naked into chimneys where fires were still burning. Young sweeps who did not get trapped and die immediately, often later died of lung ailments. The irony of his final pronouncement escapes the innocent boy, unaware of the horrors of the Industrial Revolution. Readers would have understood the implications, nonetheless.

In *Songs of Experience*, Blake presents another chimney sweep who has also been taught "to sing the notes of

Figure 17.17 William Blake, frontispiece to Europe: A *Prophecy*, 1794, $12\frac{1}{4} \times 9\frac{1}{2}$ " (31.1 × 24.1 cm), British Museum, London. Blake's idea of God, Urizen, is depicted here on the second day of Creation. He holds a pair of compasses as he measures out and delineates the firmament. He is, in fact, faced with the dilemma of all artists—to measure out and make something is restrictive, because to do so necessarily set limits upon the imagination.

woe." His own parents have "clothed" him in the "clothes of death" and have now gone off to praise "God & his Priest & King / Who make up a heaven of our misery."

William Wordsworth and Samuel Taylor Coleridge. Probably the most important literary event in the Romantic era was the publication, in 1798, of the Lyrical Ballads, co-authored by WILLIAM WORDSWORTII (1770-1850) and SAMUEL TAYLOR COLERIDGE (1772–1834). Turning their backs on the sophisticated syntax and vocabulary of Neoclassical writing, they insisted that the language of poetry should be natural; as natural, in fact, as its subject, nature—both human nature and the natural world. Coleridge was particularly interested in folk idioms and songs. Wordsworth's ear was tuned to the everyday language of common folk, "a language really used by men," as he put it. He wrote

about everyday subjects, a poetry of the individual, of the inner life and "the essential passions of the heart."

Exactly how the human imagination delineates a sense of place in nature, and by extension in daily reality, also underlies Wordsworth's lyric "I Wandered Lonely as a Cloud." According to his sister Dorothy's journal of April 15, 1802, they had gone for a walk "in the woods beyond Gowbarrow Park." Together they stumbled upon a stretch of daffodils that "grew among the mossy stones ... some rested their heads upon these stones as on a pillow for weariness; and the rest tossed and reeled and danced, and seemed as if they verily laughed with the wind, that flew upon them over the Lake; they looked so gay, ever glancing, ever changing." The daffodils of Wordsworth's poem are the personified flowers of Dorothy's journal entry, but in the end brother and sister witness different events. While Dorothy draws simple pleasure from her walk among the flowers, the poet's attention becomes fixed on how the imagination interacts with nature. For although Wordsworth takes pleasure in his walk, the "wealth" the poem refers to comes into focus only with the "inward eye" of the imagination. The poem reflects many of Wordsworth's Romantic preoccupations, particularly the power of nature and of remembered experience to restore the human spirit.

Probably no poet of the period was John Keats. more aware of his inability to know the world fully, yet at the same time more compelled to explore it, than JOHN KEATS (1795-1821). Like Wordsworth, Keats believed in the vitality of sensation but did not limit himself to sight and sound. Keats often uses imagery designating one sense in place of imagery suggesting another. For example, he writes of "fragrant and enwreathed light," "pale and silver silence," "scarlet pain," and "the touch of scent." Keats's images register on palate and fingertip as well as within the ear and eye, making the world, the poet, and the poem one complete sensation. This blurring of borders reflects the empathic power Keats termed "negative capability," the poet's ability to empathize with other characters, or entities, living or imagined, animate or inanimate. Free of his own life, "the chameleon poet" is then able to move among "uncertainties, mysteries, [and] doubts, without any irritable reaching after fact and reason."

Negative capability was, for Keats, a way of emptying or "annulling" the self and, as such, a way of making room for his subject. According to his friend Richard Woodhouse, Keats even "affirmed that he can conceive of a billiard Ball that it may have a sense of delight from its own roundness, smoothness, volubility & the rapidity of its motion." Perhaps the most affecting of Keats's efforts at negative capability is "This Living Hand," written shortly before he died of tuberculosis at the age of twenty-five:

This living hand, now warm and capable
Of earnest grasping, would, if it were cold
And in the icy silence of the tomb,
So haunt thy days and chill thy dreaming nights
That thou wouldst wish thine own heart dry of blood
So in my veins red life might stream again,
And thou be conscience-calmed—see here it is—hold it
towards you.

When Keats contracted the disease that had already claimed his mother and brother, he moved to Italy in hope of a cure but died within a few months. At his request, no name marks the tomb that reads, "Here lies one whose name is writ in water," his epitaph itself as mysterious and fascinating as his poems.

One of the other great English Lord Byron. Romantic poets is George Gordon, LORD BYRON (1788-1824). If in America Whitman came to embody the Romantic self, in Europe it was Byron. A free spirit, he was notorious for his unconventional behavior. One of his first books of poems, Hours of Idleness (1807), was subjected to severe criticism in the Edinburgh Review, to which Byron retorted, in 1809, with a biting satire in the style of Swift and Pope, entitled English Bards and Scotch Reviewers. It won him instant fame. That same year, he left England to travel extensively in Spain, Portugal, Italy, and the Balkans (fig. 17.18). Good-looking and flamboyant, Byron socialized with a variety of upperclass and aristocratic women. His most famous poem, Don Juan (1819–24), portrayed the seducer already well known to most audiences. Most of his followers assumed the poem to be semi-autobiographical since it was begun soon after he formed a relationship with Contessa Teresa Guicioli in Italy, who remained his mistress for the rest of his life. As one female friend said of him, not without some real admiration, "He is mad, bad, and dangerous to know." Byron died in the Balkans fighting for the Greeks in the war against Turkey in 1824, the same year that Delacroix painted his Massacres at Chios (see fig. 17.6).

Emily Brontë. In Wordsworth's Lyrical Ballads, nature is a garden full of wonder and joy, relatively benign. However, Wordsworth's nature is not the only one that attracted the Romantic imagination: the turbulent sea in Turner's Slave Ship and the mysterious fog in Friedrich's Mist both suggest the age's fascination with nature at its most horrific and sublime. Wuthering Heights (1847), the masterpiece of EMILY BRONTE [BRON-tay] (1818–1848), is organized with the same structural care in the classical manner of Jane Austen, but it is a fully Romantic work that breaks new ground in the violence of its scenes and the extravagance of its style.

Gone is the decorum that marked Austen's world (the "artificial rudeness" of the English garden) and in its place is a world of storm and turmoil. The novel's central characters display passionate and socially disruptive ten-

Figure 17.18 Thomas Philips, Lord Byron in Albanian Costume, 1814, oil on canvas, $29\frac{1}{2} \times 24\frac{1}{2}$ " (75 × 62 cm), National Portrait Gallery, London. Byron looks particularly dashing in this costume, which signifies the love of the exotic and interest in the cultures of the Balkans reflected in his writings.

dencies entirely at odds with the rational and serene world of the Enlightenment, and it is as if the landscape around them responds. Reason and social decorum are replaced by intense feeling and individual expression. The demands and needs of the self are paramount. Nature is untamed, unruly, and grand, exhibiting patterns of storm followed by calm, similar to the contrasting emotions displayed by Brontë's characters, and analogous to the alternation of quiet lyricism and passionate drama heard in Romantic music such as Schubert's. Moreover, in the work of both artists drama explodes in the midst of serenity and calm, suggesting thereby the potential for abrupt change in both inner and outer weather.

Johann Wolfgang von Goethe. Perhaps the most influential writer of the Romantic era was JOHANN WOLFGANG VON GOETHE [GUR-tuh] (1749–1832), who lived half his life during the Enlightenment and half during the Romantic era. He witnessed the shift in consciousness from the Enlightenment emphasis on reason, objectivity, and scientific fact to the

Romantic concern for emotion, subjectivity, and imaginative truth.

Born and raised in Frankfurt, Goethe studied law at the University of Strasbourg, where he met the German critic and thinker J.G. Herder. With Herder and Friedrich Schiller, Goethe contributed to the beginnings of German Romanticism in the 1770s, leading what was called the Sturm und Drang (storm and stress) movement. Goethe's contribution to this movement was his novel The Sorrows of Young Werther (1774). Enormously influential throughout Europe, the work expressed discontent with Enlightenment ideals of objectivity, rationality, and restraint. In it, an educated young man, Werther, gives up a government position to search for greater meaning in his life. He becomes alienated and unhappy until he meets and falls in love with a young woman, who is unfortunately engaged to a businessman, whom she marries. Werther becomes obsessed with her and finally commits suicide.

The work for which Goethe is best known, his play Faust (1808), is based upon the life of the medieval German scholar Johann Faust, who is reputed to have sold his soul to the devil in exchange for knowledge. Faust has been described as a defining work of European Romanticism, one that epitomizes the temper and spirit of the Romantic era and one that serves to represent the anxiety-ridden Romantic imagination in all its teeming aspiration.

Throughout his life and literary career, Goethe was pulled in two directions. He wrestled with a split consciousness, torn between the intellectual ideals of the Enlightenment and the emotional passions of the Romantic period. The two poles of Goethe's imagination are represented not so much by different works as by diverging strains within particular works. In Faust, for example, readers confront alternative perspectives on life, represented by the characters Faust and the devil, Mephistopheles. In the play, Faust is a man of the mind, a deeply knowledgeable scholar, who abandons himself to the exploration of physical experience, represented by Mephistopheles, who offers Faust the chance to live a more active life of sensation. Faust remains a divided figure, one who cannot integrate harmoniously the two different aspects of his consciousness—his scientific rationalism and his poetic intuition.

During his later life, Goethe was considered a sage, a dispenser of wisdom, an honor he earned through prodigious literary labors across a wide spectrum of styles and genres. Important people from throughout Europe flocked to Weimar to see him, including the young Franz Schubert, who set more than fifty of Goethe's poems to music.

Walt Whitman. Of the American poets writing during the nineteenth century, two stand out above all others: WALT WHITMAN (1819–1892) and Emily

Dickinson. Unlike Dickinson, whose idiosyncratic and elliptical style has found few imitators, Whitman greatly influenced later American poets. William Carlos Williams emulated Whitman's attention to the commonplace and his experiments with the poetic line. Wallace Stevens displayed the meditative, philosophical cast of mind found in poems such as Whitman's "Crossing Brooklyn Ferry." Later, Allen Ginsberg exhibited something of Whitman's early extravagance and outrageousness.

Instead of using the poetic structures of his day, Whitman developed more open, fluid forms. And rather than using old-fashioned poetic diction, he wrote in familiar and informal language, following Wordsworth's "language really used by men." Whitman also mixed exalted language with common speech, resulting in, as he remarked, a "new style ... necessitated by new theories, new themes," far removed from European models. Whitman's stylistic innovations in Leaves of Grass, which he wrote and revised over nearly fifty years and once described as "a language experiment," were intended to "give something to our literature which will be our own ... strengthening and intensifying the national." In this he was like many nineteenth-century artists who expressed their nationalistic tendencies in music, painting, and literature.

Emily Dickinson. In his exalted ambition, Whitman differed markedly from EMILY DICKIN-SON (1830–1886), whose poetic inclination gravitated inward. Although Whitman and Dickinson each brought something strikingly original to American poetry, their poems could not be more different. A glance at a page of their poetry reveals a significant visual difference. Whitman's poems are expansive, with long lines and ample stanzas. Dickinson's poems, by contrast, are very tight, with four-line stanzas that distill feeling and thought.

The openness of Whitman's form is paralleled by the openness of his stance, his outgoing public manner. Dickinson's poetry, on the other hand, is much more private. Her meditative poems are rooted partly in the metaphysical poetry of seventeenth-century writers such as John Donne, and partly in the tradition of Protestant hymnology. Dickinson made frequent and ingenious use of Protestant hymn meters and followed their usual stanzaic pattern. Her adaptation of hymn meter accords with her adaptation of the traditional religious doctrines of orthodox Christianity. For although many of her poems reflect her Calvinist heritage—particularly in the ways their religious disposition intersects with intensely felt psychological experience—Dickinson was not an orthodox Christian. "Some keep the Sabbath going to Church," she wrote. "I keep it, staying at Home." Her love of nature separates her from her Puritan pre-cursors, allying her instead with such Transcendentalist

Timeline 17.2 Classical and Romantic eras in music.

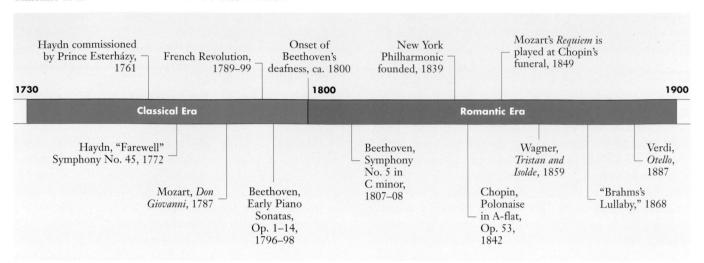

contemporaries as Emerson, Thoreau, and Whitman, though her vision of life was starker than theirs.

Dickinson spent nearly all of her life in one town, Amherst, Massachusetts, living as a near recluse and dying in the house where she was born. Whitman, on the other hand, lived in half a dozen cities in as many states, and spent time with people rather than in private. Social values and political ideals inhabit Whitman's work in ways alien to Dickinson's poems. Moreover, Whitman's poetry is animated by a vision of democratic equality that cuts across barriers of class, race, and creed. His poetry emphasizes a shared humanity, which is rooted in a belief in the intrinsic value of all living things.

Dickinson's poems do not encompass such a wide range of experiences; instead they probe deeply into a few—love, death, doubt, and faith. In examining her experience, Dickinson makes a scrupulous effort to tell the truth, but she tells it "slant," as one of her poems puts it: "Tell all the Truth but tell it slant." Part of her artistry includes the way she invites readers to share her search for truth. Her poems' qualified assertions, along with their riddles and questioning stance, cumulatively suggest that life is mysterious and complex, as it was for so many Romantic artists.

MUSIC

Because it seems capable of unleashing emotions beyond mere words or images, music is perhaps the most "romantic" of Romantic art forms. Romantic composers wrote music that expressed individuality and innovation, exalted nature, and broke new ground formally, harmonically, and stylistically. They also developed a musical language that reflected changing political and social attitudes—their concern was with freedom and self-expression, with the grandeur of nature, with folk traditions,

and with the vicissitudes of romantic love. And above all, their music expressed intense feeling.

Some features of Romantic music resulted from technological advances, such as the invention of valves for brass instruments, which increased their orchestral prominence, and the development of thicker strings for the piano, which deepened and enhanced the instrument's tonal properties. Other features of the Romantic style reflected social changes, such as the movement of musical performance from church and palace to the public concert hall, which occasioned opportunities for musical compositions of larger scope performed by bigger orchestras and choruses. This type of change enriched the orchestral sound, along with new timbres.

Romantic music can be characterized along a spectrum from the miniature to the monumental. Although some Romantic works tended to be, on the whole, larger and longer than their counterparts from earlier centuries, there developed alongside the monumental impulse one toward the miniature. Chopin and Schubert, for example, wrote numerous short piano pieces of only a few minutes' duration. Schubert and Schumann, among others, developed the Lied (or art song), also a small form, designed for performance by a singer and accompanist in a room in someone's house. The monumentality of Romantic music is evident in the size of the orchestra needed to perform symphonic and choral works and the sheer magnitude of some of the works themselves. Some symphonies of Gustave Mahler (1860-1911), for example, last two hours, and require more than a hundred orchestral players as well as a hundred choral singers. And four operas of Richard Wagner (1813-1883) create a linked cycle, the Ring of the Niebelung, which takes thirteen hours to perform.

Program Music. One of the characteristic forms of Romantic composition is program music. As opposed to

absolute music, which does not refer to anything outside of musical sound, form, and tone color, **program music** describes, in musical tones, a scene, story, event, or other non-musical situation. Exploiting the mind's capacity to suggest and evoke, program music attempts to imitate or suggest something beyond the music itself by emphasizing an instrument's special properties or tone.

Earlier composers had used the flute to imitate birdsong, as did the Baroque composer Antonio Vivaldi in *The Four Seasons*. Renaissance composers such as Thomas
Weelkes had imitated human sighing with a downward
melodic motion. But composers of the Romantic era
developed the idea of musical description into something
far more ambitious, creating a musical "program" that
governed an entire symphonic movement or work. In his
Symphony No. 6, for example, Beethoven provides
all five movements with descriptive titles, including
"Awakening of joyful feelings upon arriving in the
country" and "The thunderstorm."

Hector Berlioz. One of the most innovative of Romantic composers was HECTOR BERLIOZ [BEAR-lee-ohz] (1803–1869). After pursuing a medical degree, he turned instead to music. Affected by the Romanticism of the day, Berlioz threw himself into his musical studies, analyzing scores, attending operas, giving lessons, singing in a theater chorus, and composing. Not long out of the Paris Conservatory of Music, Berlioz wrote his Symphonie Fantastique, a work that shocked Parisian audiences with its innovative orchestration, its musical recreation of a bizarre witches' sabbath, and its autobiographical theme about Berlioz's own "endless and unquenchable passion" for the English actress, Harriet Smithson, whom he pursued and married against the wishes of both their families.

The Symphonie Fantastique contains five movements: (1) Reveries, Passions; (2) A Ball; (3) Scene in the Country; (4) March to the Scaffold; and (5) Dream of a Witches' Sabbath. Each movement uses distinctive musical material. The first movement, for example, combines a mood of reverie with an agitated and impassioned section that employs dramatic crescendos and obsessive repetitions of a musical theme Berlioz used throughout this movement and the entire symphony. This idée fixe, or "fixed idea," as he called it, exemplifies musically the image of "the beloved one herself [who] becomes for him a melody, a recurrent theme that haunts him everywhere." Berlioz transforms the beloved's theme of the idée fixe in each movement according to the needs of the program. The idée fixe unifies the symphony and carries it forward to a tragic conclusion. Throughout, Berlioz continually expands the orchestral palette, introducing a wide range of instruments including bells, cymbals, sponge-tipped drumsticks, a snare drum, and four harps.

Franz Schubert and Johannes Brahms. Inspired by the outburst of lyric poetry of the age, many composers turned to writing songs. FRANZ SCHUBERT [SHUbert] (1797–1828) lived in Vienna and was a contemporary of Beethoven's. Over the course of his career, he wrote more than six hundred songs, many of which were settings of Goethe's verse. He also wrote three song cycles, or groups of linked songs, including *Die Schöne Müllerin (The Pretty Miller-Maid*) of 1824, which tells the story of a love affair that starts joyously only to end in tragedy.

Song was also one of the favorite forms of JOHANNES BRAHMS (1833–1897), who composed later in the century. As a boy he played piano in the bars and coffee-houses of his native Hamburg, and during the Hungarian uprising of 1848, when the city was inundated with refugees, he became particularly intrigued by gypsy songs and melodies. His most famous song, known today as "Brahms's Lullaby," was written in 1868 for the baby son of a woman who sang in the Hamburg choir. Only just over two minutes long, the song is one of the most peaceful and serene ever written.

Chopin and the Piano. If Berlioz represents one pole of the Romantic composer's spectrum, FRÉDÉRIC CHOPIN [show-PAN] (1810-1849) represents the other. Where Berlioz wrote mostly in large forms, Chopin wrote in small ones. Where Berlioz composed for orchestra, Chopin wrote almost exclusively for the piano. During the eighteenth and the early nineteenth century, the piano (then called the piano forte) was a smaller instrument than the concert version of today. Throughout the Romantic period, it was used as a solo instrument for short lyric pieces, as an accompaniment to songs, and for orchestral use. Unlike the harpsichord, which plucks its strings, the piano strikes them with small felt-tipped hammers, giving the musician the ability to modulate between soft and loud simply by exerting more or less pressure on the keys—hence the name, piano (soft) forte (loud), later shortened simply to piano.

Half-Polish and half-French, Chopin was educated at the Warsaw Conservatory where he earned early acclaim as a piano prodigy. Settling in Paris at the age of twenty-one, he became part of a circle of artists that included the painter Eugène Delacroix, the poet and novelist Victor Hugo, and the composer and virtuoso pianist Franz Lizst. During the last decade of his life, Chopin was involved in an intense and passionate relationship with George Sand, the popular French female novelist. Elegant and fashionable, Chopin was admired for the refinement and delicacy of his playing and for the atmospheric subtlety, harmonic richness, and deep expressiveness of his compositions.

Chopin composed two piano concertos, two largescale piano sonatas, and a series of semi-long works for solo piano, as well as two sets of *études* (or studies), a group of preludes in different keys, a set of nocturnes (or night pieces) mostly melancholy in tone, along with

Connections

GOETHE AND SCHUBERT: POETRY AND SONG

During the nineteenth century there occurred an explosion of lyric poetry fueled by the Romantic movement. In England, France, and Germany especially, poetry poured from the pens of writers such as William Wordsworth, Samuel Taylor Coleridge, John Keats, Lord Byron, Alfred de Musset, Victor Hugo, and Heinrich Heine, among many others. Of the German poets, the poetry of Johann Wolfgang von Goethe was especially inspiring to the young Viennese composer Franz Schubert.

Schubert set many poems to music, perfecting a form of musical art called the Lied (plural Lieder). The Lied was a type of art song set to an accompaniment, usually for piano, that suited the tone, mood, and details of a poem. Schubert composed more than six hundred Lieder, more than fifty of them to poems by Goethe. Among the most accomplished of Schubert's settings of Goethe texts is a song he wrote as a teenager: Erlkönig (The Erlking).

Based on a Danish legend, Goethe's narrative poem has the Romantic qualities of strangeness and awe. The poem tells the story of a boy who is pursued, charmed, then violently abducted by the king of the elves, as the child rides on horseback through the forest with

his father.

FATHER My son, why hide your face so anxiously?

SON Father, don't you see the Erlking?

The Erlking with his crown and his train?

FATHER My son, it is a streak of mist.

ERLKING Dear child, come, go with me!

I'll play the prettiest games with

Many colored flowers grow along the shore,

My mother has many golden garments.

SON My father, my father, and don't you hear

The Erlking whispering promises to me?

FATHER Be quiet, stay quiet, my child;

The wind is rustling in the dead

ERLKING I love you, your beautiful figure delights me!

And if you're not willing, then I shall use force!

SON My father, my father, now he is taking hold of me! The Erlking has hurt me!

NARRATOR The father shudders, he rides swiftly on; He holds in his arms the groaning

child.

He reaches the courtyard weary and anxious:

In his arms the child—was dead.

In setting Goethe's poem, Schubert was faced with the challenge of delineating in music the lines and voices of four characters-father, son, narrator, and Erlking. His response to the challenge exhibits his early musical genius. Schubert differentiates the poem's characters by giving them very different melodies, and by putting their music in different vocal registers. The child's vocal line is high-pitched and fearful. The father's is in a lower register and conveys confidence. The Erlking's melody is lilting and seductive. Schubert also characterizes the horse, by using galloping triplets in the piano accompaniment. Throughout the alternation of the characters' lines, Schubert builds tension by raising the child's vocal line in pitch and increasing its intensity. By altering the character of the Erlking's music toward the end, he suggests the Erlking's shift from charm and seduction to threatening menace.

Throughout his setting of Goethe's poem, Schubert finds musical analogues for the poet's language, imagery, and story. One of his more dramatic strategies is to slow down the music at the end, and he actually stops singer and accompanist in a dramatic pause in the middle of the final line: "In his arms

the child-was dead."

waltzes, polonaises, and mazurkas, which capture the spirit and flavor of the Parisian salon and of the Polish peasant world. The polonaises and the mazurkas reflect Chopin's nationalistic spirit during a time when Poland was partly under Russian domination. The majestic Polonaise in A Flat, Op. 53, one of Chopin's best-known pieces, expresses both joy and pride in a spirit of noble grandeur. The spirit of the polonaise ennobles it, its melody makes it memorable, and its technical demands make it a bravura piece for the piano virtuoso.

Among his most lyrical and sensuous pieces, Chopin's nocturnes conjure up images of moonlight and reverie. Nocturne No. 2 in E Flat, for example, is slow and suffused with a sense of melancholy which is sustained and embellished throughout. A brief expression of excitement is followed by a quiet ending in keeping with the work's pervasive mood of bittersweet and pensive sadness.

Chopin's ability to bring out the piano's rich palette of sound and to exploit its resonant musical possibilities revolutionized the way later composers wrote for the instrument.

Giuseppe Verdi and Grand Opera. Opera first appeared as a distinct form early in the seventeenth century in Italy. Its popularity was increased by Claudio Monteverdi, who further contributed to its development. During the eighteenth century, it became popular in England and Austria, with Mozart composing his consummate operatic masterpieces, including Don Giovanni and *The Marriage of Figaro*. It was during the nineteenth century, however, that opera became internationally popular, with Romantic composers of many countries participating in the grand flowering of the genre.

The rise of the middle class after 1820 helped usher in a new kind of opera, grand opera, which appealed to the masses because of its spectacle as much as its music. Alongside the drama and passion of grand opera there remained comic opera, which continued to flourish as it had in the previous century.

Italy's greatest and most important Romantic composer of any kind was GIUSEPPE VERDI [VAIR-dee] (1813–1901), whose music epitomizes dramatic energy, power, and passion. Born in northern Italy near Parma, Verdi had little formal musical training but managed nonetheless to have an opera produced at the Milan opera house, La Scala. Verdi's career began with a series of early operas in the 1850s—Rigoletto, Il Trovatore, and La Traviata; it continued with a series of popular operas in the 1860s—Un Ballo in Maschere, La Forza del Destino, and Don Carlos; and it concluded triumphantly with a series of grand operas in the 1870s and 1880s—Aida, Otello (based on Shakespeare's Othello), and Falstaff (based on Shakespeare's Merry Wives of Windsor).

Rigoletto, composed in 1851, is one of Verdi's most dramatic works. Based on a play by the French Romantic writer Victor Hugo, Rigoletto depicts intense passion and violence in a tale of seduction, revenge, and murder. Rigoletto is a court jester, a hunchback who serves the Duke of Mantua. When the Duke seduces his daughter Gilda, Rigoletto plans to kill him in revenge and lures the Duke to a quiet inn with Maddalena, the sister of his hired assassin, Sparafucile. He hopes that Gilda will renounce her love for the Duke when she sees him attempt to seduce Maddalena. His hopes, however, are dashed when Gilda sacrifices her own life to save his.

The melodies Verdi provides for his characters perfectly express their feelings. The Duke sings one of the most famous of all operatic arias, "La donna e mobile" ("Woman is fickle"), which perfectly captures his frivolous and pleasure-loving nature. Following this song, Verdi provides a quartet for the Duke, Maddalena, Gilda, and Rigoletto, giving voice to their individual concerns. In response to the Duke's elegantly seductive melodic line, Maddalena voices a series of sharp broken laughs. Gilda's melody is fraught with pain and sorrow, while Rigoletto's reveals his heated anger as he curses the Duke. Verdi deftly balances the individual singers so that their ensemble singing is blended into a unified and dramatic expression of feeling.

Richard Wagner: As Beethoven had dominated the musical world of the first half of the nineteenth century, RICHARD WAGNER [VAHG-ner] (1813–1883) dominated the musical world of the second half. It was, in

fact, through intense study of Beethoven's works that Wagner became a composer. Late in life, Wagner explained that he had wanted to do for opera what Beethoven had done for symphonic music—to make it express a wide range of experience, and to have it achieve overwhelming emotional effects. "The last symphony of Beethoven," wrote Wagner, "is the redemption of music ... into the realm of universal art ... for upon it the perfect art work of the future alone can follow." Wagner believed that he and he alone could compose this "perfect art work of the future," and he believed that it could not be an orchestral work since Beethoven's mighty Ninth Symphony could never be surpassed. Instead, Wagner would create a new kind of opera, which he called "music drama." Unlike Beethoven, whose works express a profound hope in human possibility, Wagner displays a more pessimistic attitude toward life. Influenced by the philosopher ARTHUR SCHOPEN-HAUER [SHO-pen-how-er] (1788-1860), Wagner emphasizes the blind forces of irrationality and passion that drive human behavior. Wagner's works include the comic Die Meistersinger von Nürenberg, the mystical Lohengrin, and the sensuous Tristan and Isolde, which influenced subsequent European musical style perhaps more than any work of the late nineteenth century. His

Figure 17.19 Brunhilde enveloped in fire, in the 1989 staging of Wagner's tetralogy *The Ring of the Niebelung* at the Royal Opera House, Covent Garden, London.

operas portray characters whose lives are made unhappy by circumstances they cannot control, as in *Tristan and Isolde*, in which the two lovers are kept apart only to be finally united in death.

Wagnerian music drama brings together song and instrumental music, dance and drama and poetry in a single unbroken stream of art. Wagner's ambitious goals were to restore the importance of music in opera, to establish a better balance between orchestra and singers, and to raise the quality of the librettos, or texts of operas. This last Wagner accomplished by finding his subjects in medieval legend and Nordic mythology and by writing his own librettos, or little books, for his operatic music.

Designed to do more than simply provide beautiful accompaniments for arias, Wagner's operatic orchestral writing was meant to arouse intense emotion, to "comment" on stage action, to be associated with incidents in the plot, and to reflect characters' behavior. Wagner accomplished these goals in part by using what were called "leitmotifs." These were usually brief fragments of melody or rhythm that, when played, would remind the listeners of particular characters and actions, somewhat in the way a movie or television theme triggers associations in the mind of the audience. For example, when Tristan and Isolde drink a love potion, several leitmotifs create a harmonic song that portends a tragic ending.

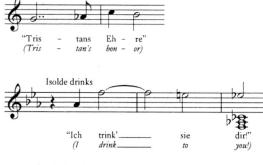

Tristan drinks

After producing a number of failed operas, and after living in political exile in Switzerland for eleven years, Wagner secured the patronage of King Ludwig II of Bavaria, who enabled him to acquire wealth, fame, and power. Wagner's tetralogy *The Ring of the Niebelung*, which is generally considered his greatest work, includes four operas—*The Rhinegold*, *The Valkyries*, *Siegfried*, and *The Twilight of the Gods*. Based on Norse myth, the opera is a profusion of grandeur, in the story it tells, in its singing and orchestration, and in its staging, sets, and costumes (fig. 17.19).

REALISM

Romantic painters such as Géricault and Delacroix wanted to alert their audience to the realities of contemporary life. For them art could serve as an effective social and political tool. Géricault did not paint the *Raft of the "Medusa"* and Delacroix did not paint the *Massacres at Chios* merely for art's sake. Rather, they aligned their art with a political cause, as David had painted his *Death of Marat* a generation earlier and put his art in the service of the Revolution.

Realism is the term used to describe a development in painting in which many artists tried to convey the realities of modern life to their contemporaries. The artist's role was no longer simply to reveal the beautiful and the sublime, but to open the public's eyes to the world around them, not just in its grandeur but in its brute reality as well. In Realist art and literature, the aim is to tell the truth, not to be true to some higher, idealized reality. The higher truth that Keats speaks of when he writes "Beauty is truth, truth beauty" is purely Romantic. Realist artists wanted to be true to the facts. Ordinary events and objects are, to the Realist, as interesting as heroes or the grand events of history. Increasingly, after the Revolution of 1789, it was no longer the aristocracy that made history, it was the working class itself, ordinary people. And so it was to the lives of the working class that Realist art turned for its inspiration. Among the common people, artists could discover and reveal the forces that were driving the times.

THE JULY MONARCHY

Realist art and literature were given their greatest impetus by the revolutions that swept Europe in 1848. But in France particularly, the plight of the working people was at issue throughout the reign of Louis-Philippe, who became king shortly after July 28, 1830, when violent fighting broke out in the streets of Paris, supported by almost every segment of society, and the rule of Charles X quickly came to an end. Within days, Louis-Philippe, who was the former King's cousin, was named the head of what would come to be called the July Monarchy. Eugène Delacroix quickly went to work on a large painting to celebrate this new revolution, so reminiscent of the glorious days of 1789.

Delacroix's Liberty Leading the People. Delacroix named his painting The Twenty-Eighth of July: Liberty Leading the People (fig. 17.20). It was finished in time for the Salon of 1831, but instead of the accolades he thought he would receive, Delacroix was roundly attacked for the painting. It was purchased by the new government and quickly removed to storage. The scene is a set of barricades of the kind traditionally built by

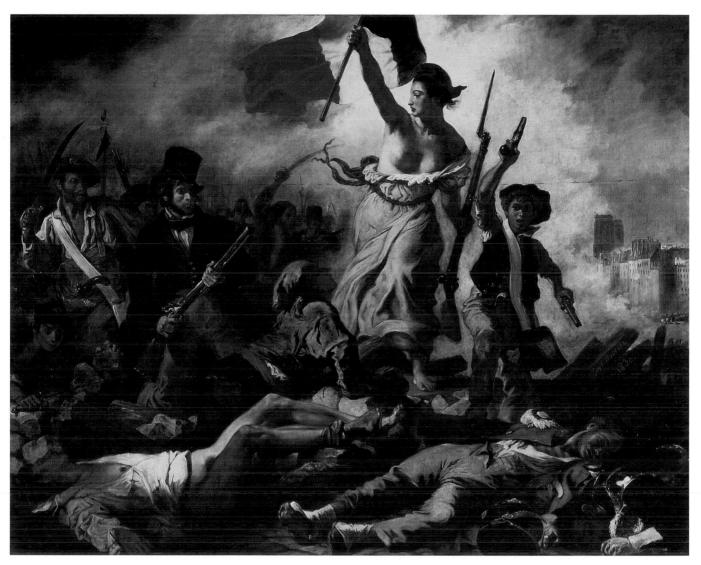

Figure 17.20 Eugène Delacroix, *The Twenty-Eighth of July: Liberty Leading the People*, 1830, oil on canvas, $8'6\frac{3}{8}'' \times 10'8''$ (2.59 × 3.25 m), Musée du Louvre, Paris. In this romanticized representation of the Revolution of 1830, Liberty is personified by a seminaked woman leading her followers through Paris. The Revolution resulted in the abdication of Charles X and the formation of a new government under Louis-Philippe.

Parisians by piling cobblestones up in the street, thus creating lines of defense against the advance of government troops. Behind it, to the right, are the towers of Notre-Dame Cathedral, seen through the smoke of battle across the Seine. In a self-conscious reworking of Géricault's *Raft of the "Medusa*," the composition rises in a pyramid of human forms, the dead sprawled along the base of the painting in poses reminiscent of Géricault's painting, and Liberty herself, waving the French tricolor instead of a torn shirt, crowning the composition. The dead are soldiers, and the one on the left has been stripped of his pants and shoes, evidently by an impoverished rebel. Liberty herself is bare-breasted, as if to underscore her maternal instincts, and broadshouldered, as if to define her peasant stock—the

German poet Heinrich Heine called her an "alley-Venus." Beside her is a recognizable Parisian type, a youth of the streets, the prototype of the youth gang member of our present day and, even in Delacroix's time, a type notorious for antisocial behavior even when not fully armed, as depicted here. To Liberty's right, a working-class rebel in white and a bourgeois gentleman, distinguished by his tie, coat, and top hat, advance with her. Delacroix depicts the cross-section of society that actually took part in the uprising. And the thought evidently horrified the Parisian public. As one writer put it, "Was there only this rabble ... at those famous days in July?"

The decision to hide Delacroix's painting from public view, out of the fear that it might inspire more rebellion,

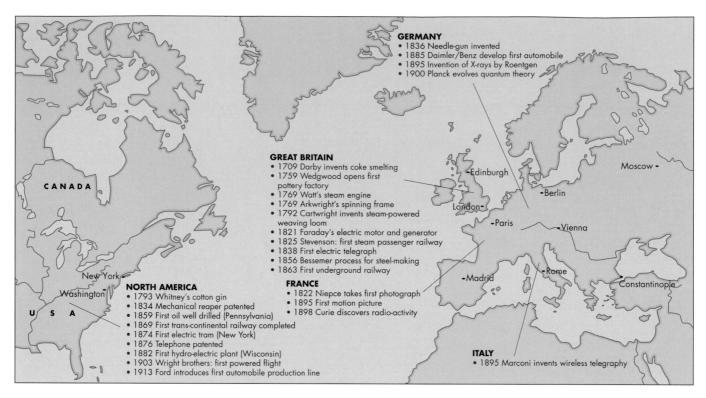

Map 17.2 The Industrial Revolution in Europe and America.

was probably wise enough, but it had little influence in stopping widespread unrest in the country. Even as Delacroix's painting was being exhibited, silk-workers in Lyons went on strike in protest at their wages. The situation would foment for three years, until, in 1834, they fought police and national troops in a six-day battle that resulted in hundreds of deaths. A few days later, Louis-Philippe, tired of all the unrest, suspended publication of

Figure 17.21 Honoré Daumier, Rue Transonain, April 15, 1834, 1834, lithograph, $11\frac{1}{2} \times 17\frac{5}{8}"$ (29.2 × 44.8 cm), The Art Institute of Chicago. Daumier wrote that "One must be part of one's times." This stark and moving image records the repression of the people by the troops of Louis-Philippe.

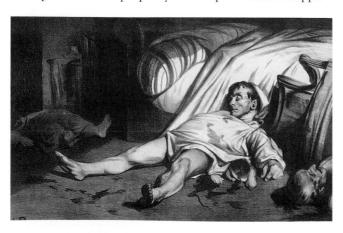

a radical newspaper and arrested the leaders of the working-class Society of the Rights of Man. In protest, workers again took to the streets, battling with government troops. In one working-class neighborhood, troops invaded an apartment building from which, they claimed, shots had been fired.

Honoré Daumier. The cartoonist HONORÉ DAUMIER [DOME-yay] (1801–1879) depicted the results in a large lithograph exhibited in a storefront window a few days later, *Rue Transonain*, *April 15*, 1834 (fig. 17.21). A father, in a nightshirt, lies dead by his bed. Beneath him, face down, lies his child. His wife is sprawled in the shadows, and another, older man, perhaps the child's grandfather, lies to the right. Such a slaughter of the innocent outraged not only the Parisian working class but the intelligentsia as well.

KARL MARX AND FRIEDRICH ENGELS

It was precisely such conditions, common across Europe, that so influenced the thinking of KARL MARX (1818–1883) and his colleague FRIEDRICH ENGELS (1820–1895). Workers, they realized, had no effective political voice other than revolution and, alienated from their labor by an increasingly mechanized industrial system from which they also received no real economic benefit, they were bound to rebel. "The bourgeoisie ... has converted the physician, the lawyer, the priest, the poet,

the people of science into its paid wage-laborers," they wrote in *The Communist Manifesto* (1848). "Constant revolutionizing of production, uninterrupted disturbance of all social conditions, everlasting uncertainty and agitation distinguish the bourgeois epoch ... All that is solid melts into air, all that is holy is profaned, and one is at last compelled to face, with sober senses, the real conditions of life."

Even as Marx was writing these words, Europe was undergoing an unprecendented economic decline. Revolution quickly followed, first in France in February 1848, then in Germany, Austria, Hungary, Poland, and Italy. In France, the government formed National Workshops, known as *ateliers*, in order to put the people back to work. But enrollment quickly swelled to a size that the government could not handle—120,000 by June—and, fearing that they had inadvertently created an army of the dissatisfied and unemployed, the government disbanded the workshops. The reaction was swift and, on June 23, the working class rebelled en masse. Three days later, after some of the bloodiest street fighting in European history, the rebels found themselves surrounded in their neighborhoods, with an estimated ten thousand dead. More died in the mop-up that followed, and eleven thousand others were imprisoned and deported to the French colonies, particularly to North Africa. It was, Marx wrote, "the first great battle ... between the two classes that split modern society." For a few brief weeks, Delacroix's Liberty Leading the People was removed from storage and put on public view, and on December 10, 1848, Louis Napoleon Bonaparte, nephew of the first Emperor, was elected President of France in a landslide election.

THE PAINTERS OF MODERN LIFE

Rosa Bonheur. One of the first truly successful painters of the working class was ROSA BONHEUR [BON-ur] (1822–1899). She disliked life in Paris, where she had grown up, preferring the rural life. A student of zoology, Bonheur made detailed studies out-of-doors and even painted there, directly from nature, which was not yet common practice. When studying the anatomy of animals at the Paris slaughterhouses, or when observing horses at the Paris horse fairs, Bonheur dressed in men's suits because, she explained, women's clothing interfered with her work. By dressing as a man she was able to move in a world from which she would have otherwise been excluded. She described herself as of a "brusque and almost savage nature," as well as "perfectly feminine" and proud of being a woman.

At the 1848 French Salon, Bonheur exhibited eight paintings, winning a first-class medal. Owing to her success, she received a commission in 1849 from the French government to paint Plowing in the Nivernais: The Dressing of the Vines (fig. 17.22), which established her as a leading painter in France. The painting portrays peasant life in harmony with nature, especially with the animal kingdom. Depicted with almost photographic realism is a scene of the good agrarian life: the soil is fertile, the oxen are strong, and the weather is favorable. It seems to illustrate lines written by Bonheur's contemporary George Sand (another woman who dressed in men's clothing) in her 1846 novel The Devil's Pond, which describes "a truly beautiful sight, a noble subject for a painter. At the far end of the flat ploughland, a handsome young man was driving a magnificent team [of] oxen."

Figure 17.22 Rosa Bonheur, *Plowing in the Nivernais: The Dressing of the Vines*, 1849, oil on canvas, $5'9'' \times 8'8''$ (1.75 \times 2.64 m), Musée d'Orsay, Paris. Bonheur studied directly from her subject to create this factual record of nature's grandeur. Previously, such subject matter was not considered worthy of an artist's attention and certainly would not have been depicted on such a large scale.

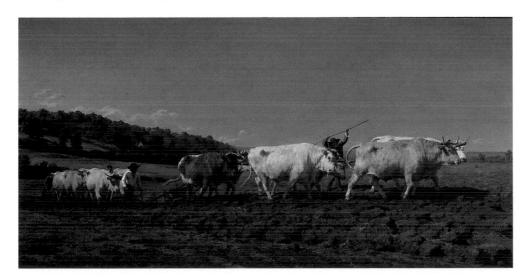

Figure 17.23 Gustave Courbet, *A Burial at Ornans*, 1849, oil on canvas, approximately $10'3'' \times 20'10''$ (3.10×6.40 m), Musée du Louvre, Paris. The extremely hostile reaction of the public to this painting was due to the fact that the subject was not elevated, glorified, or romanticized—Courbet referred to this as the burial of Romanticism. He said, "Show me an angel and I'll paint one."

Gustave Courbet. While Sand and Bonheur glorified the French peasant and literally made plowing the fields a "noble" activity, GUSTAVE COURBET [koor-BAY] (1819–1877), refused to idealize working life. The other great Realist to come into his own after the Revolution of 1848, he wanted simply to tell things as they were. "I am not only a socialist," he would write in 1851, "but a democrat and a Republican as well—in a word, a partisan of all revolution and above all else a Realist ... for 'Realist' means a sincere lover of the honest truth." These words were written in defense of a group of large paintings that he exhibited in the Paris Salon of 1850-51. The canvases outraged the conservative critics, and Courbet found himself defending not only his works but the "honest truth" of the people who were their subjects. "The people have my sympathy," he wrote to some friends as he was at work on the paintings. "I must turn to them directly, I must get my knowledge from them, and they must provide me with a living." He had, in fact, returned to his native village, Ornans, in 1849, after the Revolution and painted the realities of life for the peasant farmers.

A Burial at Ornans (fig. 17.23) enraged the public in part because it seemed, at the very least, pretentious. At $10'3'' \times 20'10''$, it is of a size generally reserved for only the most serious allegories and histories. A distant relative of Courbet's, one C.E. Teste, is being buried, and the Mayor of Ornans, the Justice of the Peace, Courbet's

father, and his three sisters are among the mourners, who line up across the painting in imitation of the landscape (even the grave seems an extension of the Loue valley which cuts through the plateau behind them). Even though it structurally unites the villagers and their environment, the painting is emotionally unfocused. No one's eyes are fixed on the same place, not even on the grave or the coffin. The dog stares away uninterestedly. The religious import of the scene is undermined by the way the cross seems to sit askew on the far horizon. The emotional impact of death is entirely de-Romanticized as well. We are witness here to a simple matter of fact.

The work's lack of idealism is especially evident if we compare it to Bonheur's *Plowing in the Nivernais*. Where the figures in Courbet's painting seem static, forming an almost flat wall of humanity in front of the viewer, Bonheur's similarly horizontal format is dynamic. On the left, the hills lead downward and away from the viewer, while on the right, the oxen move upward and toward the viewer.

Courbet's next major painting, *The Painter's Studio* (fig. 17.24), met with even less success than his earlier work. Turned down for the Exposition of 1855, the painting was displayed to all by Courbet in a sort of "counter-exhibition" that he mounted himself in a circus tent across from the exposition. He called it the "Pavilion of Realism," and for the most part was ignored for his trouble.

As its subtitle suggests—A Real Allegory Summing Up Seven Years of My Artistic Life—the painting is complex and symbolic. Not the least symbolic element is the title itself, The Painter's Studio (the word in the original French title is *atelier*), evoking the National Workshops of 1848, the same ateliers that had led to the Revolution. Courbet portrays himself painting the Loue canyon and behind him stands a nude in full view of all. The only idealized element in the composition is the working-class youth who watches him paint. He represents, on some level, possibility. Courbet is positioned in the very middle of the scene, as if caught between the opposing forces of his surroundings. On the left are Courbet's origins, the working people of the countryside where he was raised. On the right are his supporters, including his patrons and collectors and the poet Charles Baudelaire on the far right reading a large book.

Édouard Manet. Probably no artist of the period better fills the prescription for the painter of modern life than ÉDOUARD MANET [man-AY] (1832–1883). Born into a well-to-do family, Manet was a sensitive and cultured person who studied literature and music (he married his piano teacher). After Manet twice failed the

entrance exam to the Naval Training School, his family permitted him to study art. Manet had academic training, which included copying paintings at the Louvre. He particularly admired the artists Hals, Velázquez, and Goya, all of whom worked in a painterly style, letting the brushstrokes show. Manet's training had a significant impact on his art, especially on the structural organization of work.

His Luncheon on the Grass (fig. 17.25), often referred to by its French title Le Déjeuner sur l'herbe, was painted in 1863. That year, the official Salon jury rejected over four thousand paintings, producing such an uproar from disappointed painters and their supporters that Napoleon III set up a separate salon to exhibit the rejected paintings, the Salon des Refusés (Salon of the Rejected). Thus, there were two salons, and the monopoly of academicism had been broken. But even at the Salon des Refusés, Luncheon on the Grass was regarded as shocking and scandalous by many. In fact, Manet had not painted an actual event, as the public thought; instead, his sources were highly respectable. The poses of the three central figures were derived from an engraving made about 1520 by the Italian artist Marcantonio Raimondi after a painting of the Judgment of Paris by

Figure 17.24 Gustave Courbet, *The Painter's Studio: A Real Allegory Summing Up Seven Years of My Artistic Life*, 1854–55, oil on canvas, 11'10" × 19'8" (3.61 × 5.99 m), Musée d'Orsay, Paris. The nude and the landscape are at the center of Courbet's art, as their position in this painting makes clear.

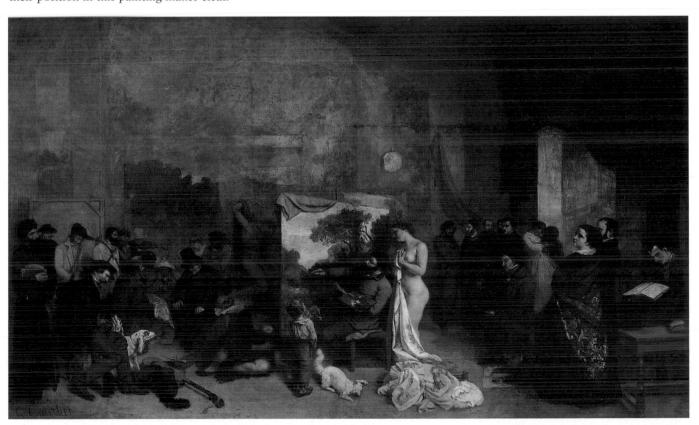

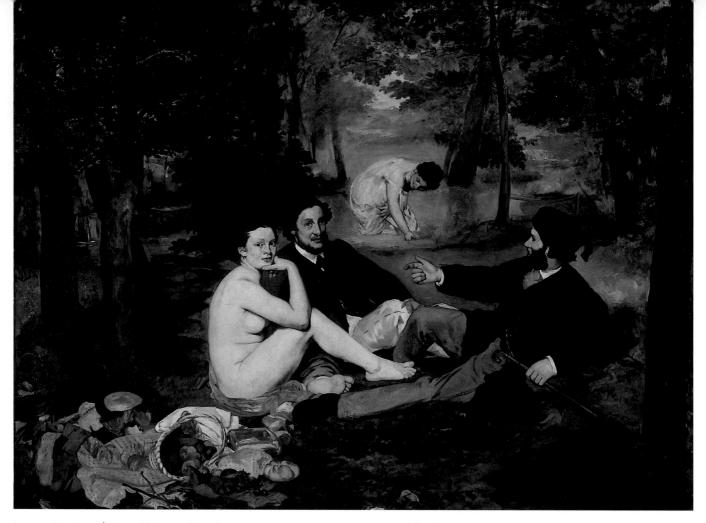

Figure 17.25 Édouard Manet, *Luncheon on the Grass (Le Déjeuner sur l'herbe)*, 1863, oil on canvas, $7' \times 8'10''$ (2.10 \times 2.60 m), Musée d'Orsay, Paris. An outraged public deemed this painting indecent for depicting a naked woman out-of-doors with two clothed men. Actually painted in Manet's studio from models, it was based on a print by Marcantonio Raimondi after a painting by Raphael, ca. 1520, of the Judgment of Paris.

Raphael, and the theme of the piece is closedly tied to Giorgione/Titian's *Fête champêtre* (see fig. 13.39), which Manet had copied at the Louvre as a student, and which similarly depicts two fully clothed men in the company of two unclothed female companions.

Manet's sources went largely unrecognized; it was as if he were at war with the official Academy. By incorporating such traditional sources as Raphael and Giorgione into his work, he was, in a very real way, lampooning them. It was in fact his painting style that offended many. His technique was categorically anti-classical. He painted directly on the canvas with thinned oil paint, which permitted him to wipe off any mistakes, the traces of which can still be seen. When the composition was determined, he executed the final painting directly with large brushstrokes. Instead of the smooth surfaces admired by the public, Manet's brushstrokes were strong, quick, and remain fully visible.

His painting *Olympia* (fig. 17.26), also of 1863 though accepted for the Salon of 1865, did not receive the Academy's approval: it was, they said, too much like a sketch. The public, too, objected: to the artist's use,

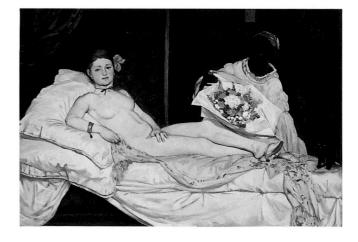

Figure 17.26 Édouard Manet, Olympia, 1863, oil on canvas, $4'3\frac{1}{4}'' \times 6'2\frac{3}{4}'''$ (1.30 × 1.90 m), Musée d'Orsay, Paris. Rather than trying to trick the viewer's eye, Manet treats his paintings as colored pigment on a flat surface and emphasizes the subtle play of tonalities within a restricted range of colors. Manet's Olympia deserves comparison with Ingres's La Grande Odalisque (fig. 17.8).

particularly, of flat areas of color and heavy outlines. Yet Manet's way of painting is fresh and direct—it embodies "the transitory, the fleeting, and the contingent," which the poet Charles Baudelaire claimed as the basis of the modern. Rather than using carefully wrought highlights and shadows to make forms appear three-dimensional, Manet's flattened forms and rapid, loose brushwork are the result not of carelessness or incompetence, as so many of this critics believed, but of his insistence on being contemporary, absolutely of the moment.

Olympia upset its audience not only because of its technique but because of its content. Again, the painting is based on a traditional source—this time Titian's Venus of Urbino-but again the source went largely unrecognized. The painting's title evokes classical precedents— Olympia is the home of the Greek gods—but its subject is no ancient goddess. Indeed, a hostile critic said she looked like a prostitute. What is particularly startling is the way that Manet's Olympia seems to acknowledge, in the directness of her gaze, the very presence of the viewer. It is as if the viewer has just now arrived within the space of this painting; the cat at the end of the bed arches its back to hiss at the intruder, who has brought flowers that are presented by the maid. The recipient is not embarrassed in the slightest by the viewer's gaze for, in fact, Manet's Olympia was a professional model who also posed for his painting Luncheon on the Grass.

THE RISE OF PHOTOGRAPHY

Courbet's refusal to "heroize" his subjects, as Bonheur had done, his insistence on their mundane reality, their matter-of-factness, reminds one of photography, particularly in the insistent black-and-white color scheme of A Burial at Ornans. And in fact photography, in 1850, was barely a decade old. Invented simultaneously in England and France in 1839 by WILLIAM HENRY FOX TALBOT (1800-1877) and LOUIS-JACQUES-MANDÉ DAGUERRE [duh-GARE] (1787-1851), photography literally changed the way that we see the world. Before photography, an image could look spontaneous and immediate; now it could be spontaneous and immediate. Moreover, since the photographic image was the product of a machine, it had the aura, at least, of being purely objective, lacking the subjective intervention of the artist, and thus free of the emotional constraints of the Romantic imagination.

The Daguerreotype. Through competition from photography, painted portraits underwent a rapid decline and photographs largely replaced them for a while. The daguerreotype, named for Daguerre's process, was the earliest photograph, produced on silver or silver-covered copper plate. In Paris in 1849 alone, over a hundred

Figure 17.27 Richard Beard, Maria Edgeworth, 1841, daguerreotype, $2\frac{1}{8} \times 1\frac{3}{4}$ ", National Portrait Gallery, London. Beard's was the first British portrait studio, and the author Edgeworth one of his earliest customers. "It is a wonderful mysterious operation," she wrote.

thousand photographic daguerreotypes, mostly portraits, were sold to people of every rank and class. A similar situation prevailed in England, where photography studios sprang up everywhere to satisfy the craze for photographic portraits (fig. 17.27). It is no surprise, then, that a medium and "look" that even the working class could afford should raise the ire of conservative critics, one of whom reacted to Courbet's paintings of 1850–51 by calling them "local" scenes "worthy only of the daguerreotype." They seemed to him to lack any lasting value. But the photograph had the advantage of capturing reality accurately and immediately, and as its technology rapidly developed, making it easier and easier to use, it captured the Realist imagination.

The American Civil War was the first war to be documented in the new medium of photography. It was not action, however, that the photographers captured—the time required to expose film was still too long to permit that. Instead, it was the aftermath of war that they recorded, and it was a gruesome sight.

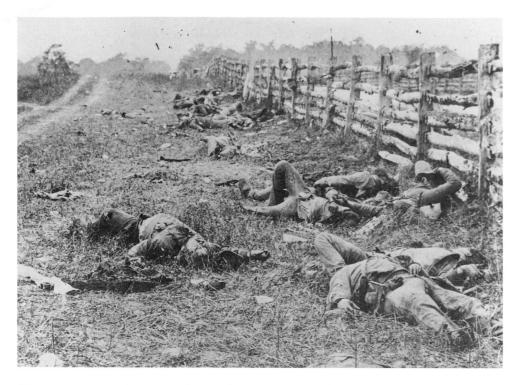

Figure 17.28 Mathew B. Brady, *On the Antietam Battlefield*, 1862, photograph, Library of Congress. Brady photographed President Lincoln so often that he became known as "the President's Cameraman."

Mathew B. Brady. MATHEW B. BRADY (ca. 1823–1896) was the best known of the war photographers, and his On the Antietam Battlefield (fig. 17.28) of 1862 is representative of his work. In the battle at Antietam, Maryland, on September 17, nearly five thousand men died and eighteen thousand were wounded. Brady makes dramatic use of the single vantage point that the camera eye so rigorously asserts: bodies lie beneath the fenceline, stretching as if to infinity. This was the reality of war as it had never before been seen.

Eadweard Muybridge. As camera technology quickly improved, it revealed more and more about the nature of reality. When, in 1872, the former Governor of California, Leland Stanford, bet a friend \$25,000 that a running horse had all four feet off the ground when either trotting or galloping, he hired EADWEARD MUYBRIDGE [MWE-bridge] (1830–1904) to photograph one of his horses in motion. Along a racetrack at Stanford's ranch in Palo Alto, California, Muybridge lined up a series of cameras with trip wires that would snap the shutter as the horse ran by. For the first time, the muscular and physical movements of an animal in motion were recorded. In 1883, Muybridge began to make studies of animal and human locomotion at the University of Pennsylvania (fig. 17.29); these would have a major impact on later painters.

AMERICAN PAINTING

Winslow Homer. During the time that France and the rest of Europe were enduring class struggle and adjusting to the new industrial world, Americans had one thing on their minds—the Civil War. It was the Civil War that gave impetus to American Realism. Recording events in the Civil War for *Harper's Weekly* was a young illustrator named WINSLOW HOMER (1836-1910). He specialized in camp life and avoided the brutal scenes of battle captured by the new medium of photography. Homer's painting career began soon after the war with Prisoners from the Front (fig. 17.30), of 1866. This work depicts the surrender of three Confederate soldiers to a Union officer, a recognizable portrait of General Francis Channing Barlow, a distant cousin of Homer's. Two Union soldiers, one with a gun, stand behind the Confederates, whose own guns lie at their feet. The painting was considered remarkable, even at the time, for the unrepentant, even arrogant attitude of the central figure, who, hand on hip, stares defiantly at General Barlow. Here, some felt, was an image of a nation at odds with itself.

After the painting's exhibition at the National Academy of Design in 1866, it was displayed in Paris at the World Exposition of 1867. Homer accompanied it and, once there, became acquainted with the work of Gustave Courbet and Édouard Manet. Manet's willingness

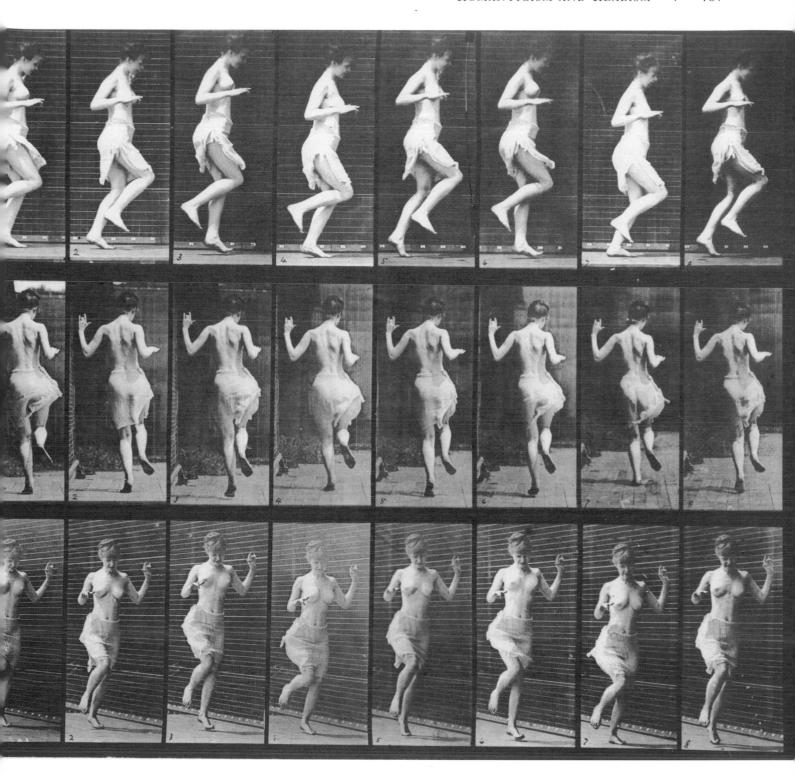

Figure 17.29 Eadweard Muybridge, Female Figure Hopping, 1887, sequence photograph, plate 185 from Animal Locomotion (Philadelphia, 1887), National Museum of Design, Cooper-Hewitt Museum, New York City. Muybridge's sequence studies would lead to the invention of the motion picture by the century's end.

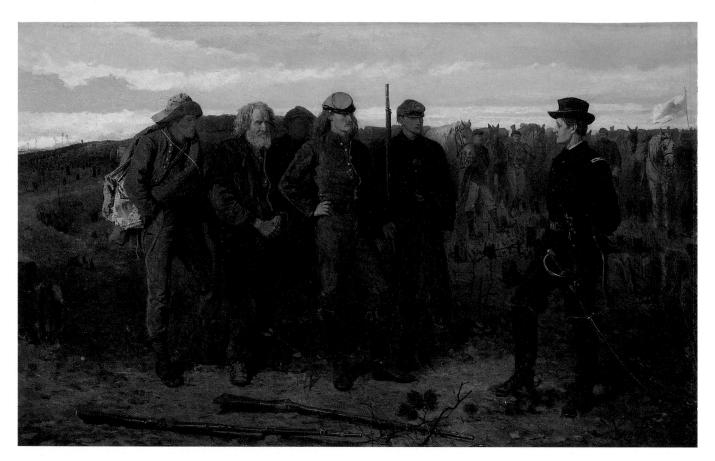

Figure 17.30 Winslow Homer, Prisoners from the Front, 1866, oil on canvas, $24 \times 38''$ (60.9×96.5 cm), Metropolitan Museum of Art, New York. For such factual narrative depictions of aspects of life in America, Homer was known during his lifetime as "the greatest American artist."

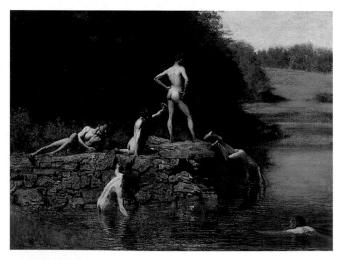

Figure 17.31 Thomas Eakins, *The Swimming Hole*, ca. 1883–85, oil on canvas, 27×36 " (68.5 \times 91.4 cm), Amon Carter Museum, Fort Worth, Texas. As part of his quest for realistic factuality, in the foreground, Eakins has painted himself as part of the group.

to paint everyday life in a direct and informal way especially appealed to Homer. His later paintings continued to evoke the aesthetics of photography, but they also showed brilliant color and brushwork, borrowed from Manet, which insisted on their status as paintings.

Thomas Eakins. Chief among the American painters was THOMAS EAKINS [AY-kins] (1844–1916). Eakins was fascinated by Muybridge's work from the moment he heard of it. By 1879, he had utilized Muybridge's photographs of horses in order to portray a carriage moving through the Philadelphia Streets, and in The Swimming Hole (fig. 17.31), painted between 1883 and 1885, the different figures could as well be a motion study of a single boy, caught at different moments of diving, swimming, and sunbathing. Eakins was fascinated by the human body and dedicated to the accurate presentation of it in motion. After Muybridge came to Philadelphia in 1883, Eakins worked together with him on his studies.

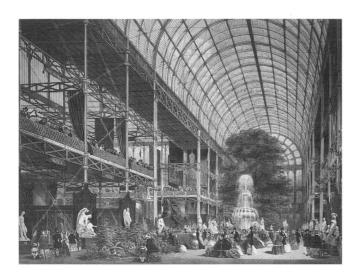

Figure 17.32 Joseph Paxton, Crystal Palace, London, 1851, cast iron and glass, length 1851′ (564.18 m), width 408′ (124.36 m), height 108′ (32.92 m). Designed by a gardener, Crystal Palace was, in its time, the largest enclosed space ever created. Built as an exhibition hall to display industrial and technological accomplishments, it was in itself an impessive demonstration of new technology.

ARCHITECTURE AND SCULPTURE

By the second half of the nineteenth century, new technological achievements, particularly the development of cast iron as a construction material, offered architects and sculptors new possibilities. In fact, two of the most innovative works of the day, Crystal Palace in London and the Statue of Liberty in New York harbor, were considered by some to be more feats of engineering than works of art.

Crystal Palace. Built for the Great Exhibition of 1851, Crystal Palace (fig. 17.32) was designed by JOSEPH PAXTON (1803-1865), who was once gardener to the Duke of Devonshire and was trained neither as an architect nor as an engineer. When Prince Albert called for a competition to design the Exhibition site, the judges, among them Charles Barry, who had designed the Gothic Revivalist Houses of Parliament, deemed none of the large number of entries suitable. The judges themselves prepared a design, but it, too, was rejected. Finally Paxton offered his proposal. Instead of a giant brick edifice, as everyone else had proposed, Paxton extended the concept of the glass-frame greenhouse. Employing a cast-iron prefabricated modular framework—the first such building of its kind—Paxton used glass for his walls. Over 900,000 square feet of glass nearly a third of Britain's total annual production—were fitted into a building 1851 feet long and 408 feet wide. The result was not only in harmony with the building's site in Hyde Park, but offered the simplest solution to the problem of lighting the interior of a vast exhibition

space. Soon Paxton's model was adapted to other similar spaces, particularly to railway stations.

The Statue of Liberty. In 1875, a year before the centennial celebration of the American Revolution, organizers in France conceived the idea of commemorating the event with a colossal statue. A Franco-American Union was founded to raise funds, and the architect FRÉDÉRIC-AUGUSTE BARTHOLDI (1834–1904) was hired to design the work. Liberty Enlightening the World, commonly known as the Statue of Liberty (fig. 17.33), is the result. Bartholdi first made a nine-foot model of the sculpture, and then GUSTAVE EIFFEL [I-ful] (1832–1923)—the French engineer who created the Eiffel Tower—designed a huge iron framework to support the giant sheets of copper, molded in the shape

Figure 17.33 Frédéric-Auguste Bartholdi, Statue of Liberty (Liberty Enlightening the World), 1875–84, copper sheeting over iron armature, height of figure 151' 6" (46.18 m), Liberty Island, New York Harbor. A gift of the French people, the Statue of Liberty has become the symbol of the United States. The monument portrays a crowned woman in classical garb, holding the torch high, while breaking underfoot the shackles of tyranny.

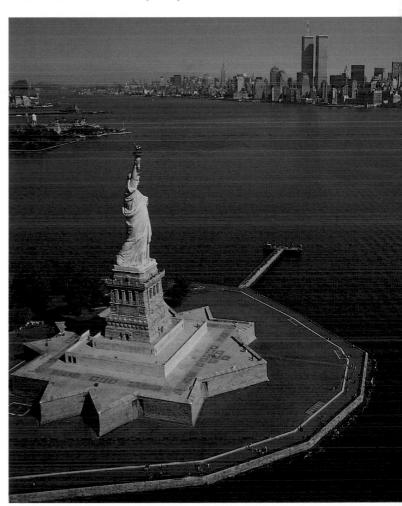

Then & Now

CHARLES DARWIN AND THE KRITZKY MOTH

In 1862, three years after publishing On the Origin of Species, Charles Darwin stated that a moth with a twelve-inch tongue existed, even though one had never been seen. Darwin based his assumption on his discovery of a species of orchid that had its nectar twelve inches deep inside the flower. Darwin's orchids, which were found Madagascar, could not be pollinated by insects that crawled into them; they could only be pollinated by moths with tongues long enough to reach the pollen deep inside their flowers. Darwin reasoned that species develop and change to enhance their opportunities for continued successful existence. Since moths with slightly shorter tongues pollinate slightly smaller orchids, then, according to the principle of natural selection that Darwin himself discovered, a longer-tongued species of moth would pollinate the deeper flower. According to a kind of evolutionary necessity, the moth would have to exist, or the orchid species would never have developed.

In a manner similar to Darwin, a contemporary scientist named Gene Kritzky suggested that a moth with a fifteen-inch tongue exists—though there is no record of anyone ever having seen one. Kritzky made his statement after learning of the existence, in Madagascar, of an orchid species whose nectar lies fifteen inches deep in its flowery interior. Darwin's twelve-inchtongued moth was actually found in 1902, forty years after his suggestion. It

is only a matter of time before Kritzky's longer-tongued moth is also found.

Darwin's contemporary impact extends beyond his explanation of the mechanism of evolution to include ideas about animal behavior and race. Animal behaviorists, such as Konrad Lorenz, and contemporary sociobiologists, including Edward O. Wilson and Richard Dawkins, use Darwinian categories to explain aggression and altruism in animals and humans. Other contemporary scientists have continued to invoke Darwin in their debate about human intelligence, particularly in the sometimes bitter controversy over the relationship between intelligence and race, which has raged ever since Hitler proposed the mastery of the Germanic peoples above all others.

of Bartholdi's model. All the components were transported across the ocean, and in 1884 construction began on Bedloe's Island in New York Bay. The sculpture, dedicated in 1886, is itself over 151 feet high and rests on a concrete pedestal faced with granite that is 150 feet high. Sculpture and pedestal in turn sit on an eleven-point star, the walls of which are part of old Fort Wood. It remains a symbol of welcome and freedom to generations of people immigrating to the United States.

LITERATURE

Honoré de Balzac. Like the painters of modern life, Realist writers aimed, above all, to represent contemporary life and manners with precision. In the case of HONORE DE BALZAC [BALL-zak] (1779–1850), the project was extensive: Balzac sought to represent contemporary life with encyclopedic completeness. In the nearly one hundred novels and stories that make up his series La Comédie humaine, Balzac touched upon virtually every aspect of French society, from the urban working class and the country peasant, to the middleclass merchant, the new industrialists, and the bankrupt aristocracy. By 1816, while working as a law clerk in Paris, he would spend his evenings wandering through the streets, gathering details for his novels. "In listening to these people," he later recalled, "I felt I could champion their lives. I felt their rags upon my back. I walked with my feet in their tattered shoes; their desires, their wants-everything passed into my soul." His characters—there are over two thousand—often appear in more than one novel, establishing a sense of the interconnectedness of French life. Chief among them is Eugène Rastignac, the son of a poor provincial family who comes to Paris, mixes with nobility, builds a career as a politician, and generally leads a life of gambling and debauchery. At the climax of Le Père Goriot, Rastignac climbs to the top of the hill at Père Lachaise cemetery and, in one of the most famous moments in French literature, faces the city that threatens to consume him: "There lay the glittering world that he had hoped to conquer. He stared at the humming hive as if sucking out its honey in advance and pronounced these impressive words, 'It's you or me now!" Rastignac's moment on the top of the hill is entirely Romantic. Pitting himself against the world, he is caught in the web of his own Romanticism; from a Realist's point of view, a self-indulgent fate.

Charles Baudelaire. The poet CHARLES BAUDELAIRE [BO-duh-lare] (1821–1867) was a member of Courbet's salon. Indeed, the latter may have painted A Burial at Ornans in response to Baudelaire's ideas. In a review of the Salon of 1846, Baudelaire had called for a painter to celebrate "the heroism of modern life." The painter of modern life should begin, he says, by recognizing the grandeur of "everyday dress." "Is it not the necessary garb of our suffering age," he wrote, "which wears the symbol of perpetual mourning even upon its thin black shoulders? ... We are each of us celebrating some funeral."

But if Baudelaire for a time admired Courbet, by the middle of the next decade, when he finally published his book The Painter of Modern Life, he had retreated from Courbet's brand of Realism. The painter of modern life was no longer interested in social criticism; by 1866, he was hot in pursuit of the good life. "The crowd is his element," Baudelaire wrote. "He delights in fine carriages and proud horses ... the sinuous gait of women, the beautiful happy and well-dressed children ... [He] has contrived to distill in his paintings the sometimes bitter, sometimes heady bouquet of the wine of life." Baudelaire was among the first to define the modern. It was, he wrote, "the transitory, the fleeting, the contingent, that half of art whose other half is the eternal and the immutable." The modern, in other words, was about change. If a part of art would always be about eternal and lasting truths, the modern artist would add to this a sense of the dynamic present. The artist would try to capture the special, ever-changing character of daily life, especially its increasingly frantic and fast-paced quality in the urban center.

Gustave Flaubert. The Realist novel that represents the most thorough attack on the Romantic sensibility is Madame Bovary, published in 1857 after five years in the writing, by GUSTAVE FLAUBERT [floh-BEAR] (1821-1880). Flaubert's heroine—if, indeed, "heroine" is a word that can be used to describe her, she is such a banal figure—is Emma Bovary, the wife of a country doctor who seeks to reinvent her life in the manner of the romantic novels that she reads so voraciously. At first, Flaubert had a difficult time imagining her. She was modeled, in fact, on one Louise Colet, a woman Flaubert had known some years before and who reinstigated their relationship after her husband's death. "For two days I have been trying to enter into the dreams of young girls," he wrote to her as he worked. "I am navigating in a milk-white ocean of literature about castles and troubadours with white-plumed velvet caps. Remember to ask me about this when I see you. You can give me some exact details that I need."

Before long, Emma Bovary had become a barely fictionalized version of Louise Colet, but the more Flaubert wrote, the more he began to identify with her himself, so real did she seem. Emma deseperately takes lovers to overcome the incessant boredom of everyday life, spends money as if she were nobility, falls into the deepest debt, and finally, in the most "Romantic" gesture of all, commits suicide by swallowing arsenic. Flaubert came to identify with her wholly. "When I was describing the poisoning," he would later recall, "I had such a taste of arsenic in my mouth and was poisoned so effectively that I had two attacks of indigestion one after the other—two very real attacks, for I vomited my entire dinner." It is in this final scene, which Flaubert stretches out to an almost tortuous length, that the discrepancy between Emma's

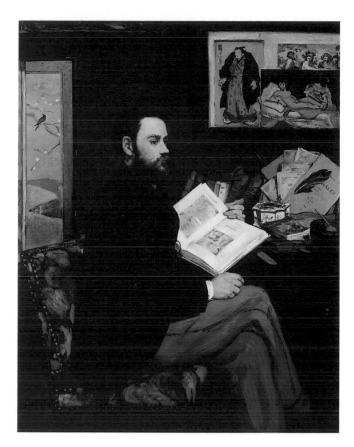

Figure 17.34 Édouard Manet, *Portrait of Émile Zola*, 1868, oil on canvas, 4'9" × 3'9" (1.44 × 1.14 m), Musée du Louvre, Paris. Behind the drawing of *Olympia* on the wall above Zola's desk is a print by Goya, while beside it is a Japanese print, all the rage in Paris at the time, the flatness of which surely influenced Manet's flat and shadowless style.

Romantic sensibility and the stark reality of her desperately painful death is made most clear.

But as much as Flaubert identified with Emma Bovary, that sense of identification was made possible, he believed, by his strict desire to describe her as accurately as possible, without either romanticizing or judging her. The novel took five years to write because he sought, in every sentence, to find what he called "le mot juste," exactly the right word needed to describe each situation. In this, Flaubert felt, he was proceeding like the modern scientist, investigating the lives of his characters in precisely the same way that the scientist pursues research through careful and systematic observation.

Émile Zola. Flaubert's scientific approach to writing became the standard for all subsequent French Realist writing, particularly the work of the so-called French naturalists, who emphasized the influence of heredity and environment in determining the fate of the literary characters they created. A prominent naturalist, ÉMILE ZOLA [ZOH-la] (1840–1902) saw society as a kind of grand laboratory and the people in it as data for

his study of the ways in which humans were determined. In books such as *Germinal*, which chronicled the life of French miners, and *Nana*, which detailed the life of a prostitute, Zola used naturalistic techniques to reflect his fatalistic vision of the world.

Nor surprisingly, one of Zola's closest friends was Manet, who painted a portrait of the writer (fig. 17.34) sitting at his desk, with a sketch of *Olympia* pinned to the wall above. Posing for the portrait had produced, he wrote to another friend, an almost narcotic feeling in him: "In the numbness that overtakes motionless limbs, in the fatigue of gazing with eyes open into full light, the same thoughts would always drift through my mind with a soft, deep murmur. The nonsense of the streets, the lies of some and the inanities of others, the flow of all that human noise, worthless as foul water, was far, far away." But it was, of course, the "foul human noise" of the streets that was the subject of Zola's writing.

Realist Writing. Important English Realist novelists of the time include CHARLES DICKENS (1812-1870), ANTHONY TROLLOPE (1815-1882), and GEORGE ELIOT (1819-1880), the pen name of Mary Ann Evans. Eliot's ambitious Middlemarch (1872), a portrayal of nineteenth-century life in an English country village, is considered by many to be the greatest English novel. Trollope, an inspector of rural mail deliveries, created an imaginary English county called Barsetshire, the cathedral town of which he named Barchester, and he set a long series of novels in and around this fictional locale. Though not as ambitious as Balzac's Comédie humaine, the Barchester novels capture the spirit of nineteenth-century rural life in a series of similarly interconnected tales. Where Trollope and Eliot chronicled country life, Dickens wrote mostly about the increasingly dark urban environment epitomized by London, attacking conditions in the English workhouses in Oliver Twist, published serially in 1837-38, and the evils brought on by industrialization in Hard Times (1854). Like their continental counterparts, the English novelists wrote about the world in which they lived and which they knew most thoroughly.

In America, nineteenth-century fiction writers tended toward Romantic themes and styles until very late in the century. While Realism was spreading through Europe, American writers, such as EDGAR ALLAN POE (1809–1849), NATHANIEL HAWTHORNE (1804–1864), and HERMAN MELVILLE (1819–1891), wrote fiction characterized, in Hawthorne's terms, as "romances" rather than as "novels." In the fiction of these romance writers, characters and settings were not depicted with the social realism of their European counterparts. In Hawthorne, dialogue borders on the archaic and in Melville on the theatrical. Description in the works of both is highly symbolic and often poetic, rather than serving as a vehicle for a sharp-edged realism.

THE NEW SCIENCES: PASTEUR AND DARWIN

The interest in the precise, objective description of things evidenced in Realist painting and literature was shared as well by the philosophers and scientists of the age. The social philosophy of Marx and Engels, for instance, is based on their careful observation of the quality and nature of working-class life. In France, the scientist LOUIS PASTEUR [pass-TER] (1822–1895) began to look at organisms smaller than the eye can see—micro-organisms that he claimed were responsible for the spread of disease. Sterile practices could radically reduce the chance of infection in medical procedures, and by heating food, spoilage could be eliminated, a process that led to the "pasteurization" of milk.

But by far the most influential scientist of the age was CHARLES DARWIN (1809-1882), whose theory of evolution by natural selection had a profound impact on not only science but also philosophy and history. Darwin was a naturalist, an experimental scientist whose abiding interest was natural history. In his first important work, Zoology of the Voyage of the Beagle (1840), Darwin described his findings during research conducted from 1831 to 1836 on an expedition to the Galapagos Islands and the coast of South America with the HMS Beagle. He noticed differences between the species on the islands and those on the coast and later developed a theory to account for those differences. Drafted in 1844 but not published until 1859, Darwin's On the Origin of Species laid out his theory of evolution by natural selection. A landmark work, it had an immediate and profound impact on late nineteenth-century thought.

Darwin noted that, in the struggle for existence, since nature cannot provide sufficiently for all the animals that come into being, only the fittest will survive, suggesting that more than simple luck accounted for the survival of individual members of a species. Darwin proposed that, in any given environment, those individuals best able to adapt to that environment have the greatest chance of surviving. He suggested that it was the strongest members of the species that survive long enough to breed and pass on to future generations genes enabling them to survive as well. He also suggested that as an environment changes, those individual members of a species that adapt to the changes will survive to pass on their genetic inheritance.

Darwin's emphasis on the mechanism of natural selection undermined conventional theological and philosophical assumptions about the special place of human beings in the divine order of creation. Instead of a world providentially designed by God with humankind as its guardian and guide, Darwin postulated a world that followed the blind laws of chance and saw human beings simply as a species of animal that has successfully adapted to its world, ensuring its capacity for survival. Moreover, there was no indication that humans were the

highest point of creation, nor was their survival assured in future centuries.

Darwin's *The Descent of Man* (1871) suggested that humanity was not created in a single moment by a special act of God—as the Bible describes. Instead, humans were derived from lower life forms that evolved. The distinguishing feature of humans, their spiritual nature and their consciousness, was diminished to emphasize their biological origins and their relationship to their simian ancestors. At stake in this revolutionary shift was humanity's ultimate place in the cosmos. At stake, too, were theological beliefs that had withstood the scientific revolution of the seventeenth century, but which seemed

incompatible with Darwinian scientific explanation and the profusion of evidence he brought to support it.

Darwin did not deny that humankind represented the high point of creation so far, only that its origins were other than had been believed for centuries. As he wrote in *The Descent of Man*: "[W]ith all his noble qualities, with sympathy which feels for the most debased, with benevolence which extends not only to other men but to the humblest living creature, with his god-like intellect which has penetrated into the movements and constitution of the solar system—with all these exalted powers—Man still bears in his bodily frame the indelible stamp of his lowly origin."

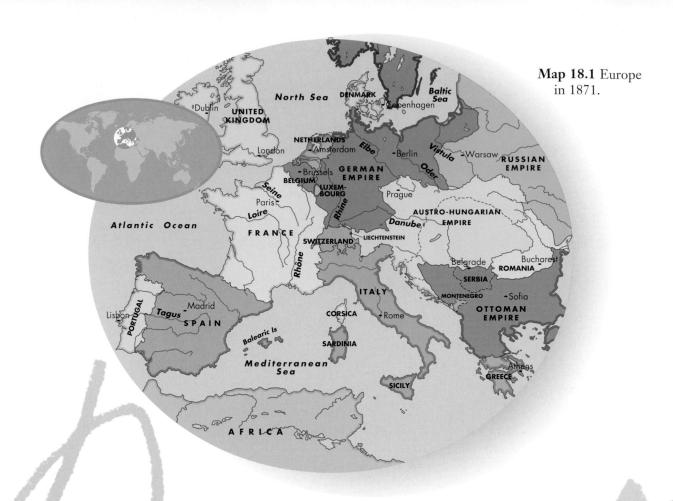

THE * Belle Époque

CHAPTER 18

- Impressionism
- + The Fin de Siècle
- ← The Avant-Garde

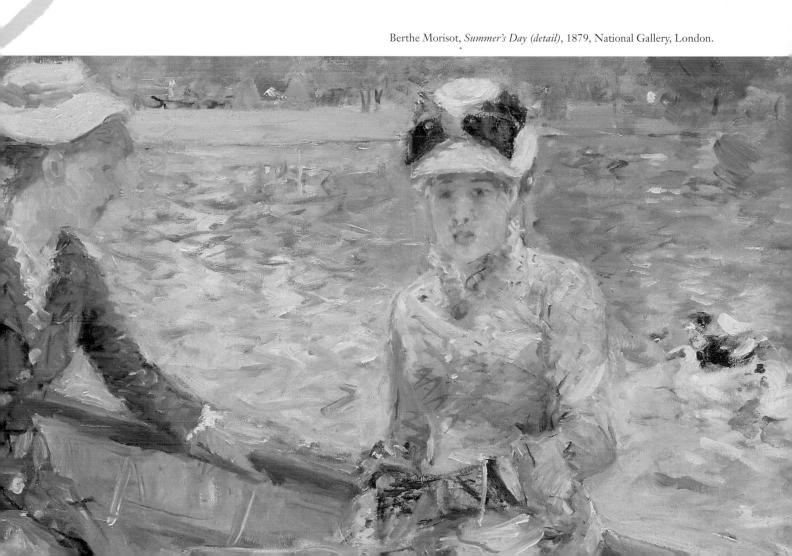

IMPRESSIONISM

The term Impressionism was originally applied with some measure of condescension and distaste to a particular style of painting. It referred to the work of a group of French painters who seemed determined to depict a kind of fleeting and transient look at the world, one that French poet Charles Baudelaire declared to be the chief characteristic of the modern. An "impression," as distinct from a "representation," was a sketch of the way the world appeared to the artist's eye. In the minds of those who first saw Impressionist painting, such an approach seemed casual to the point of carelessness. Impressionism was, for them, not so much a virtue as a vice. A hostile public objected to the little dabs of color, claiming it destroyed form and led to a loss of solidity, structure, and composition. It was as if the Impressionist painter offered, as a finished work, what was only a sketch. To

Furthermore, the Impressionists changed the focus of artistic subject matter. In turning away from traditional religious, mythological, historical, or literary subjects, they were very similar to the Realists in temperament, but instead of looking objectively at the ordinary life of the working class, they looked to the good life and the entertainments of the middle class in a new "beautiful age"—the *belle époque*. It was an age of leisure, in which life on Paris's "grands boulevards," weekend outings in its suburbs and gardens, a day at the races, or boating and swimming on the Seine, all seemed truer to their experience than the harsh realities depicted by Realist painters and writers. It was a period of possibility, however, that ended abruptly in August 1914, with the outbreak of World War I.

many Parisians, it looked like a scam.

HAUSSMANN'S PARIS

Before 1848, Paris was characterized by narrow streets and dark alleys, a maze that had been fortified with rebel barricades nine times since 1830. GEORGES EUGÈNE HAUSSMANN [OUSE-mun] (1809–1891) was commissioned to rebuild the city. He had three principal aims, the first being "to disencumber the large buildings, palaces, and barracks in such a way as to make them more pleasing to the eye, afford easier access on days of celebration, and a simplified defense on days of riot." Second, he recognized that slum conditions had a detrimental effect on public health, a situation he sought to rectify by the "systematic destruction of infected alleyways and centers of epidemics." Finally, he stated his plans "to assure public peace by the creation of large boulevards which will permit the circulation not only of air and light but also of troops." By the time Haussmann had completed his work in 1870, hundreds of miles of streets had been widened, new water and sewage systems were in place, the so-called "grands boulevards" of modern Paris had been built, the banks of the Seine had been cleared of hovels, new bridges built, and tens of thousands of working-class poor evicted to the suburbs—nearly fourteen thousand, for instance, from the Île de la Cité, where the most radical political communities had developed.

Thanks to Baron Haussmann, Paris was suddenly as much a park as it was a city. It was, moreover, a park purged of its politically dangerous working class. In 1850, there were forty-seven acres of parkland in the city; by 1870, there were over 4500, an increase of almost one-hundred fold. Haussmann doubled the number of trees lining the streets to over 100,000. The Bois de Boulogne, a neglected royal hunting ground to the west of the city, was redesigned between 1852 and 1858 as a giant English garden, with twisting, meandering paths, and a racecourse, Longchamp, which was built to please the politically powerful Jockey Club.

Life was no longer a question of where the next meal might come from, but rather which opera or concert to go to, or which café to frequent. At the center of this world were the "grands boulevards" that radiated from the Opéra. As one visitor from London put it in 1867:

Other streets are as fresh and gay, have the same advantages of lightness, airiness, verdure of trees in the midst of rush and crowds, but no longer the same prestige. The boulevards are now *par excellence* the social centre of Paris. Here the aristocrat comes to lounge, and the stranger to gaze. Here trade intrudes only to gratify the luxurious . . . On the *grands boulevards* you find porcelains, perfumery, bronzes, carpets, furs, mirrors, the furnishings of travel, the . . . latest picture, the last daring caricature in the most popular journal, the most aristocratic beer, and best flavored coffee.

So powerful was the sense of the good life that even when France was invaded in 1870 by the Prussian army, and Paris subsequently beseiged, little changed. The seige did, however, last long enough to make it necessary for the slaughter of the animals in the zoo to feed the people at the boulevard cafés. As one gentleman reported in his diary of December 6, 1870, "On today's bill of fare in the restaurants we have authentic buffalo, antelope, and kangaroo." A few days later, the zoo's celebrated elephants, Castor and Pollux, were killed, and their various meats made available in the butcher shops.

PAINTING

As peace descended once again on the Parisian boulevards, a group of artists began discussing the possibility of showing their work together in an exhibition. They met regularly at the Café de Guerbois, on the Boulevard des Batignolles, and thus called themselves the "Batignolles" group. They would soon, however, come to be called the Impressionists, a term which, as has been

noted, was not a favorable one. They included Mary Cassatt, Edgar Degas, Claude Monet, Berthe Morisot, Camille Pissarro, Pierre Renoir, and Alfred Sisley. Although he did not exhibit with them, they received the full support of Édouard Manet, who was particularly good friends with Monet and often painted with members of the group in the French countryside.

It is Manet who most clearly bridges the gap between the Realists and the Impressionists. He worked closely with the latter set after 1870. His paintings of 1863, *Olympia* and *Luncheon on the Grass* (see Chapter 17), were not only Realist works but were also seen as precursors of the new movement.

In 1862, Manet painted a scene that was one of the first to capture a contemporary social event, *Music in the Tuileries* (fig. 18.1), and in this respect alone it anticipated Impressionism almost entirely. On the far left, with top hat and cane, is Manet himself. Many of the other figures were members of Manet's circle, including his younger brother Eugène, in white trousers, and a rather peculiar-looking man, silhouetted against the tree, who is Jacques Offenbach, the most popular composer of the

day. Offenbach was a master of burlesque. His comic operas were all the rage, the highlight of which was wild dancing to songs that exhorted, "Let's waltz! Let's polka! Let's jump! Let's dance!" In the *belle époque*, it was music such as Offenbach's that entertained the crowds of Paris, not Richard Wagner's.

In the early 1860s, Manet went to the Tuileries gardens almost every day between two and four o'clock, accompanied usually by Baudelaire, to sketch the women who gathered there with their children. It is little wonder that by 1863 Baudelaire had given up on Courbet and adopted Manet as his painter of modern life. Courbet painted a working class that, for all practical purposes, had disappeared. Manet painted the new bourgeois, "Haussmannized" Paris (Luncheon on the Grass is probably set in the Bois de Boulogne). The two painters were among the most famous flâneurs in Paris, a distinct type known for impeccable manners, top hats and formal attire, their penchant for idle strolling, and devotion to conversation, gossip, and current events. Theirs was a life of dedicated leisure, what would become the Impressionist lifestyle.

Figure 18.1 Édouard Manet, *Music in the Tuileries*, 1862, oil on canvas, $30 \times 46\frac{1}{2}$ " (76 × 118 cm), National Gallery, London. The painting embodies the sense of social well-being, of Parisians enjoying the good life, that would dominate French painting for the next forty years.

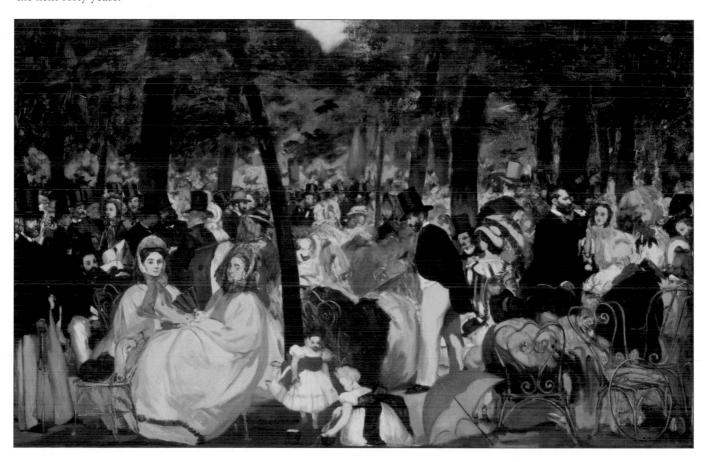

The name "Impressionism" was Claude Monet. derived from a painting by CLAUDE MONET [moh-NAY] (1840-1926) shown at the first exhibition of Impressionist art. Painted in 1872, it was called Impression, Sunrise (fig. 18.2), a title suggested by Renoir's brother. The painting encapsulates many of the features characteristic of Impressionist art. The way the Impressionist painters worked was as important to them as the subjects they painted. The traditional method of oil painting was to begin with a dark background base color and work up to the lighter colors. The Impressionists reversed this, beginning with a white canvas and building up to dark colors. They tried to convey a sense of natural light in a painting, and to that end they painted in the open air, rather than in the studio. They also tried to depict a momentary impression of nature's transitory light, atmosphere, and weather conditions; in Monet's painting the sun rises on a misty day over the harbor at Le Havre on the northern French coast. Behind this painting, and Impressionism as a whole, there also lies a major technological advance—the availability of oil paint in small, portable tins and tubes, which allowed painters to transport their paints out-of-doors.

Monet's brushwork is deliberately sketchy, consisting of broad dashes and dabs of paint. He suggests waves in the water with strokes of black. He shows the reflection of the sunrise in a series of orange and white strokes

Figure 18.2 Claude Monet, *Impression, Sunrise*, 1872, oil on canvas, $17\frac{3}{4} \times 21\frac{3}{4}$ " (48 × 63 cm), Musée Marmottan, Paris. The term "Impressionism," originally meant as an insult, derives from the title of this painting. Critics objected to the style, saying artists created *merely* an impression of a scene, without detail or compositional structure.

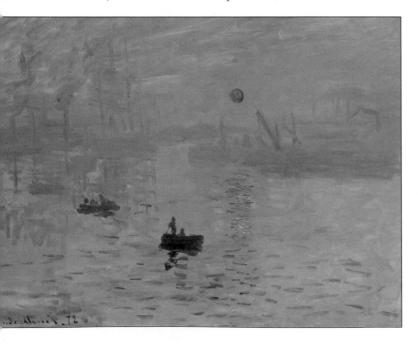

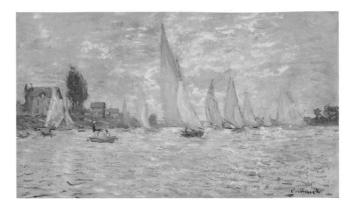

Figure 18.3 Claude Monet, Sailboats at Argenteuil, 1872, oil on canvas, $17\frac{3}{4} \times 29\frac{1}{2}$ " (48 × 75 cm), Musée d'Orsay, Paris. With income derived from paintings sold in 1872, Monet purchased a small boat, fitted it with a cabin, and used it as a floating studio, allowing him to paint the shoreline from the middle of the Seine.

mixed together while still wet, right on the canvas. Of particular note is a small area of vertical gray strokes half way up on the left-hand side. It is as if Monet simply used the canvas to wipe the excess paint off his brush and left the resulting mark where it was. Although Monet's brushwork is loose, his composition is tightly controlled. Everything is carefully placed within a grid, defined horizontally by the horizon and vertically by the masts and the pattern of light and shadow that forms vertical bands across the composition.

Monet's compositional sense is even more readily apparent in Sailboats at Argenteuil of 1872 (fig. 18.3). This work, painted in the full light of the French summer, is in fact more representative of the Impressionist use of color. During the late nineteenth century, scientists and painters—particularly the Impressionists—were developing theories about color. They both discovered that if two bright colors are juxtaposed, both appear even brighter, especially if complementary colors are used. Complementary colors consist of one primary color and one secondary color, which is formed by mixing the remaining two primaries. The primary colors are red, yellow, and blue. Secondary colors are formed when two primary colors are mixed: red + yellow = orange; yellow + blue = green; and blue + red = purple. Thus, the complementary pairs are red (primary) and green (secondary), blue and orange, and yellow and purple. The entire right side of Monet's painting exploits the first two of these complementary pairs. The green of the foliage complements the red roofs, and the blue of the water and sky complements the orange walls of the buildings and their reflections. Accentuated by the whiteness of the sails, the brightness creates an almost shimmering effect on the picture plane, not unlike the shimmering of the surface of the water itself. Sailboats at

Timeline 18.1 Art of the Belle Époque.

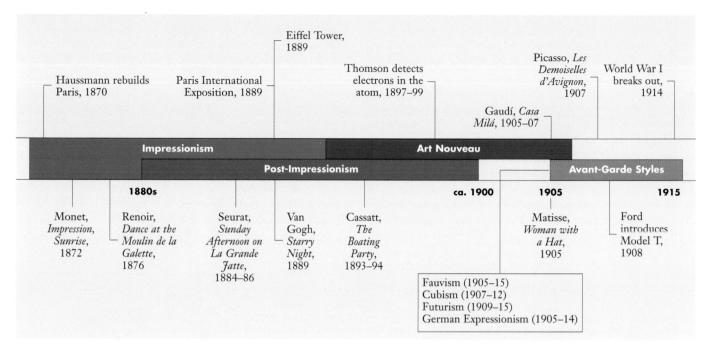

Argenteuil might, in fact, be viewed as a summary of the Impressionist method. The surface of the painting is to reality as the reflection on the surface of the water is to the real boats and houses on the shoreline. The reflection in the bottom half of the painting is so cursory and abbreviated that it is barely legible without reference to the top half of the painting, but it represents, in an intentionally overstated way, the kind of flickering vision that Impressionism embodies.

Monet had moved, in 1872, to Argenteuil, a small town on the Seine just nine kilometers north of Paris, in order to live and paint in an atmosphere of rural leisure. He lived there until the threat of increasing industrialization forced him further downstream, first to Vétheuil in 1878, and then to Giverny in 1883, where he developed an extensive private garden complete with the lily ponds that he was to paint for the rest of his life.

At Giverny, Monet embarked on a number of projects designed to investigate the way in which changes in light and weather alter what we see. Among the most famous of these projects, begun in 1888, is a series of paintings of haystacks, executed in all seasons of the year and at different times of day. In *Haystacks at Giverny* (fig. 18.4), the color actually creates a feeling of heat. Greatly concerned with natural light, Monet realized that it changed color constantly and that many different colors in fact made up what was perceived to be a single one. The myriad dabs of "broken" color blend in the viewer's eyes, creating sparkle and vibration. When a group of fifteen of these paintings was exhibited in Paris in 1891, they caused an immediate sensation. As the critic Gustave

Geffroy wrote in the introduction to the show's catalogue: "[Monet] knows that the artist can spend his life in the same place and look around himself without exhausting the constantly renewed spectacle ... These stacks, in this deserted field, are transient objects whose surfaces, like mirrors, catch the mood of the environment, the states of the atmosphere with the errant breeze, the sudden glow."

Figure 18.4 Claude Monet, *Haystacks at Giverny* (end of summer, morning), 1891, oil on canvas, $23\frac{3}{4} \times 39\frac{1}{2}''$ (60.5 × 100 cm), Musée d'Orsay, Paris. Rather than painting in the studio as did earlier artists, Monet painted out-of-doors. Instead of mixing colors on a palette beforehand, he applied paint in dabs of pure color, referred to as "broken color."

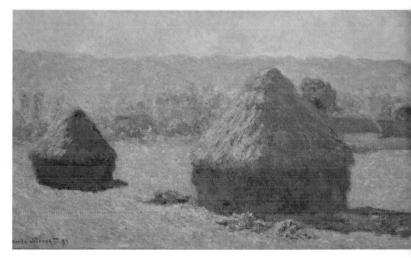

Pierre-Auguste Renoir. PIERRE-AUGUSTE RENOIR [ren-WAHR] (1841-1919) was a good friend of Monet when both were poor and struggling, and the two often painted together, in Paris and at Argenteuil, where Renoir was a frequent visitor. His joyous personality and his zest for living, which reflect the age itself, inform his paintings.

Dance at the Moulin de la Galette (fig. 18.5), of 1876 which is reminiscent of Manet's earlier Music in the Tuileries, is a good example. The painting, of a restaurant and open-air dance hall in Montmartre, in the northern section of Paris, captures the sense of gaiety that marks the belle époque. Renoir painted outdoors, working rapidly with his colors to capture the atmosphere of the moment. Light comes through the trees, falling in patches, dappling the surface—note the pattern of round splotches of light that illuminate the back of the man in the foreground. An orchestra played at the Moulin de la Galette every Sunday from three o'clock in the afternoon until midnight. Renoir's figures appear relaxed (perhaps it is their day off), rather than stiffly posed. Interestingly, the couple dancing on the left gaze at the viewer. They seem aware that they are being watched, a photographic effect that lends the painting an aura of spontaneity. They are, in fact, friends of the artist: Margot, one of his models, and Solares, a Cuban painter. As in all of his paintings, the men are handsome, the women are pretty, the activity in which they engage is pleasant, and the sun is shining. According to Renoir, "a picture ought to be a lovable thing, joyous and pretty, yes pretty. There are enough boring things in this world without our making more."

Berthe Morisot. The only woman to exhibit at the first Impressionist exhibition was BERTHE MORISOT [more-ee-SOH] (1841-1895). Married to Manet's younger brother Eugène, her work was almost immedi-

Pierre-Auguste Renoir, Dance at the Moulin de la Galette, 1876, oil on Figure 18.5 canvas, $4'3\frac{1}{2}'' \times 5'9''$ (1.30 × 1.80 m), Musée d'Orsay, Paris. Instead of choosing traditional subjects, the Impressionists depicted pleasant places where people congregated. In Renoir's paintings the women are always attractive, the men handsome, and the weather good—here the sun falls in patches through the leaves.

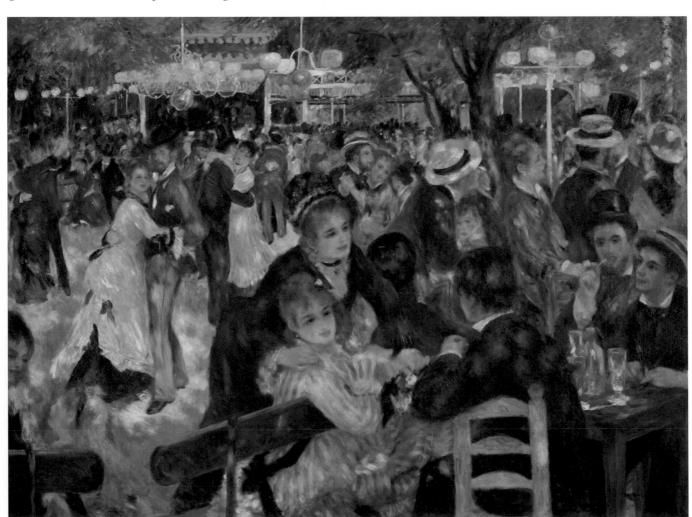

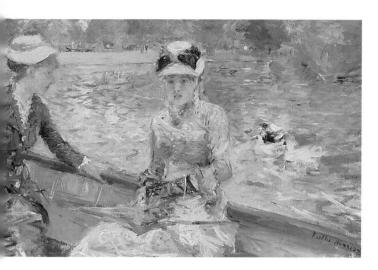

Figure 18.6 Berthe Morisot, *Summer's Day*, 1879, oil on canvas, $18 \times 29\frac{3}{4}$ " (45.7 × 75.2 cm), National Gallery, London. Note in particular Morisot's handling of the three ducks swimming on the right. They are so loosely painted that they have become almost unrecognizable.

ately given the negative label "feminine" by the critics, perhaps because her subject matter was, almost exclusively, women and children. Whatever she depicted, it is clear that she was the most daring of all the Impressionist painters. Summer's Day (fig. 18.6), exhibited at the fifth show in 1880, is remarkable for the looseness of its brushwork. It is as if the brushwork can hardly be contained within the contours of the forms it depicts. It zigs and zags across the surface in a seemingly arbitrary manner. Yet in the small rapid movements of her strokes, one can almost feel the breeze on the water, see the lapping and splashing of the water on the oars, and hear the wisps of conversation between the two women as they enjoy their outting.

Edgar Degas. A very different type of French Impressionism was created by EDGAR DEGAS [DUHGAH] (1834–1917). An aristocrat from a banking family, Degas was independently wealthy and therefore able to paint to suit himself. Many other painters disliked him, and with reason, for he was snobbish and unfriendly, with a nasty wit. Politically and socially conservative, Degas did not think art should be available to the lower class.

Degas's strict academic training resulted in a style based upon draftsmanship. In 1865 he met Ingres, then eighty-five years old. Ingres told him to "do lines and more lines, from nature or from memory, and you will become a good artist." Because of this linear approach, Degas has been called a "linear Impressionist," which may seem at first to be a contradiction. Degas, however, liated the word "Impressionist" because of the negative connotations of "accidental" or "incomplete." He

abhorred, in particular, the idea that painting could be the "fleeting, transitory, and contingent" practice that many Impressionists claimed it to be. Degas worked methodically, sometimes determining the proportions of the work by ruling off squares and often making many sketches before painting. Color and light were added to define forms, not to make them. He once remarked, "No art was ever less spontaneous than mine. What I do is the result of reflection and study of the great masters; of inspiration, spontaneity, temperament, I know nothing."

What makes Degas an Impressionist, nonetheless, is the *sense* of spontaneity visible in his work, not only in the looseness of his brushwork, but in the choice and treatment of his subject matter. However calculatingly hard he worked, he aimed to *appear* unstudied. His effect is one of instantaneous and immediate vision. More than, or at least as much as, any other painter of his day, Degas seems to have been influenced by photography, and by the snapshot in particular. His paintings are often severely cropped, cutting figures in half, as if they are just entering or leaving the viewfinder of a camera.

In Degas's depictions of ballet dancers, for which he is perhaps best known, he takes us behind the scenes. In *The Dancing Class* (fig. 18.7), of about 1874, he seems to have

Figure 18.7 Edgar Degas, *The Dancing Class*, ca. 1874, oil on canvas, $33\frac{1}{2} \times 29\frac{1}{2}$ " (85 × 75 cm), Musée d'Orsay, Paris. Degas was called a "linear Impressionist"—seemingly an oxymoron. Interested in figures in motion, he made many pictures of ballerinas. He seems to have preferred them at their least graceful, when leaning tired against the barre, stooping over their aching feet, or adjusting their costumes.

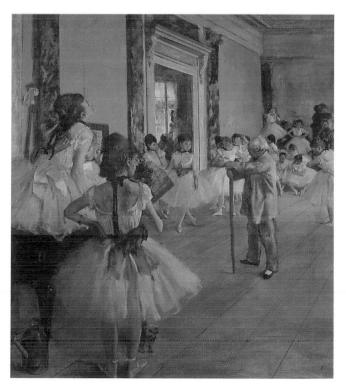

Cross Currents

Japanese Prints and Western Painters

The influence of the Japanese print on Western painters of the nineteenth century, especially the Impressionists, is the direct result of the opening of Japan to trade with the West after Commodore Matthew Perry sailed into Tokyo Bay in 1853, demanding that Japanese ports be opened to foreigners. Perry's arrival ended over two hundred years of Japanese isolationism, which had started as a result of the negative reception of Christian ideas introduced into the country by foreign missionaries.

After trade began, Japanese color prints flooded Europe to such an extent that they became commonplace. Their influence is evident in Manet's Portrait of Émile Zola (see fig. 17.34), which contains, alongside a print of Manet's own Olympia, a Japanese print of a wrestler (by Kuniyaki II), and, behind the figure of Zola, a Japanese landscape screen. Western artists were attracted especially to the flatness of Japanese forms, the flatness of the space behind them, and the oblique perspective that characterized the Japanese treatment of space. The cropped but close-up renderings of occurrences in everyday life that so enthralled the Japanese artists, influenced, in particular, the work of Edgar Degas and Mary Cassatt.

Claude Monet discovered the first of the many Japanese prints that would decorate his house at Giverny wrapped around a cheese purchased at the market. What especially attracted him to Japanese landscapes were the ways in which they organized the natural elements, such as rocks and trees. Perhaps the clearest example of Monet's enthusiasm for Japanese art and culture is the garden he created at Giverny and the paintings it inspired. The Far Eastern influence is evident in the small pond he created which was spanned by a little arched bridge, with blue wisteria flowers arranged so as to hang down on either side. There were irises, bamboo, and willows, all common plants in Japanese paintings.

Perhaps the artist most thoroughly influenced by the Japanese print was Vincent van Gogh. He owned hundreds of prints, and one of the reasons he went to Arles in 1888 was that he believed he would find a landscape there similar to that of Japan. His letters to his brother Theo repeatedly refer to his idealized image of Japanese life, in which painters and printmakers lived in close contact with ordinary people and in harmony with the rhythms and cycles of nature.

While still in Paris, in 1887, Van Gogh copied a print by Ando Hiroshige, *Plum Estate*, of 1857. Van Gogh's painting, entitled *Japonaiserie*:

The Tree (fig. 18.8), is an almost exact copy. What particularly impressed Van Gogh was the relation between the tree in the foreground, and the space behind it, the gulf between the nearby detail and the landscape beyond. This is an effect that would dominate his paintings in the future.

Figure 18.8 Vincent van Gogh, Japonaiserie: The Tree, 1887, oil on canvas, $21\frac{5}{8}" \times 18\frac{1}{8}" (55 \times 46 \text{ cm})$, National Museum Vincent van Gogh, Amsterdam. Van Gogh was influenced in this painting and in others by the unusual vantage point, flat pattern, and dark outlines characteristic of Japanese prints.

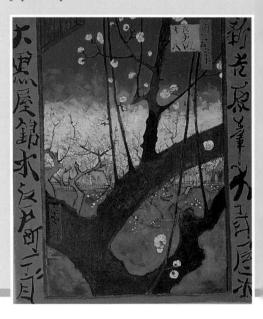

tried deliberately to capture the dancers at their least graceful—straining, stretching, scratching, and yawning. Known for his unusual compositions, Degas constructs in this work a box-like space in which the walls are not parallel to the picture plane but at oblique angles. The point of view from which the scene is recorded is striking—from above and to the side. It anticipates, in effect, the freedom of perspective that photographers would discover with the handheld camera, an invention that the Kodak Corporation had introduced by the end of the century.

Mary Cassatt. In addition to French Impressionist painters, there were a number of American Impressionists. One of the foremost among them was

MARY CASSATT [kah-SAHT] (1844–1925), who left her wealthy Pittsburgh family and moved to Europe where she became absorbed in the art world. Her parents opposed her study of art so strongly that her father is reported to have said, "I would almost rather see you dead." She soon gained recognition, however—she was called a madwoman because of her style. Cassatt was a close friend of Degas, who claimed he never would have believed that a woman could draw so well. As early as 1879, Cassatt was exhibiting with the Impressionists.

Cassatt's *The Boating Party* (fig. 18.9), painted 1893–94, was criticized when first shown; the foreground figure has rudely turned his back on the viewer. Rather than being the center of attention, however, he acts as a

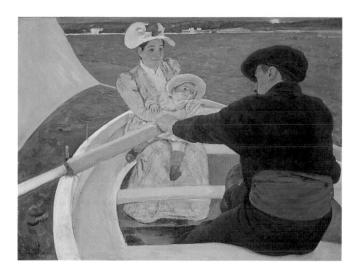

Figure 18.9 Mary Cassatt, *The Boating Party*, 1893–94, oil on canvas, $35\frac{1}{2} \times 46\frac{8}{8}"$ (90 × 117 cm), National Gallery of Art, Washington, D.C. An American working in France, Cassatt paints a typical Impressionist subject—pleasant and out-of-doors. The composition directs the viewer's eyes to the squirming child.

compositional device directing the viewer's gaze in: his arm and oar point inward, and he looks toward the mother and child, just as the viewer does. The contours of the boat and sail also point to the mother and child. A sense of realism is achieved in the awkward movements of the child.

The influence of Degas, and of the Japanese print, is apparent in the asymmetrical composition, the emphasis on sharp silhouettes and linear rhythms, the broad flat areas of color, the "snapshot" quality of the scene, the high positioning of the horizon, and, moreover, the unusual perspective—we look down into the boat, which is abruptly cut off. The brilliant light effects that are so typical of the French Riviera are recorded in the painting, but these are not achieved through the use of Impressionist broken color. Instead, Cassatt juxtaposes large areas of bright color. The light appears intense, but is not realistic—the interior of the boat should, for instance, be dark. "Facts" are manipulated for art, and in this respect Cassatt's painting can be seen as anticipating the art of the next century.

James Abbott McNeill Whistler. The work of another expatriate American, JAMES ABBOTT McNEILL WHISTLER (1834–1903), also foreshadows twentieth-century art. After a disappointing stint at West Point, and being fired from a government job in Washington, D.C., Whistler went to Paris, in 1855, where he lived as a bohemian art student. Then, in 1859, he moved to London, where he was to remain for the rest of his life. He visited Paris several times and learned about Impressionism, but he never used Impressionistic broken color or light effects.

In 1863, his mother came to keep house for him (she supported him financially), and in 1871 he immortalized her in a work entitled *Arrangement in Black and Gray: The Artist's Mother* (fig. 18.10), known popularly as *Whistler's Mother*. Whistler referred to his paintings by musical terms such as nocturnes, symphonies, and harmonies. This painting is first and foremost an "arrangement," and only secondarily a portrait. Abstract and formal, the pictorial space is flattened, depth receives little emphasis. Light, shadow, and modeling are minimal.

Whistler maintained that art should not be concerned with morality, education, or story-telling, but should appeal to the aesthetic sense. He believed in art for art's sake. His subject matter was at times entirely lost in a kind of late evening atmosphere, a light where things are barely visible.

LITERATURE

The Symbolists. Related to the Impressionists because they also attempted to convey reality by impression and sensation, the Symbolist poets felt liberated by their medium, words, and from the necessity of rendering the "facts" of vision. Words, they believed, could do more than simply portray these "facts" of external

Figure 18.10 James Abbott McNeill Whistler, Arrangement in Black and Gray: The Artist's Mother, 1871, oil on canvas, $4'9'' \times 5'4\frac{1}{4}''$ (1.50 × 1.60 m), Musée d'Orsay, Paris. Whistler's mother, as subject, is treated much the same as the other elements in this intellectual arrangement in restricted colors.

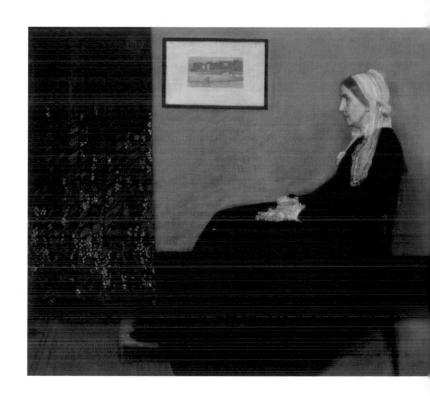

Connections

DEBUSSY AND MALLARMÉ: IMPRESSIONIST AND SYMBOLIST

Claude Debussy's chamber orchestral composition *Prelude to the Afternoon of a Faun* was inspired by Stéphane Mallarmé's poem "The Afternoon of a Faun." Both composer and poet convey the faun's experience through suggestive uses of sound and language. Mallarmé's poem describes the reveries of a creature from classical mythology, with the body of a man and the horns, ears, legs, and tail of a goat. The poem's dreamlike tone raises the question as to

whether the faun has actually been chasing nymphs or whether he has only been dreaming about doing so. Equally ambiguous is the poem's sense of time and place. Debussy's composition does not attempt to portray the content of the poem so much as to evoke its atmosphere of languor and fantasy.

Debussy wrote the music to suggest "the successive scenes through which pass the desires and dreams of the faun in the heat of [an] afternoon." He accomplishes this with a musical language that includes the sounds of woodwind and harp, while excluding

those of trumpets and trombones. Rather than the clearly articulated, symmetrical themes of the Classical and Romantic styles that were developed and recapitulated, Debussy creates a more dreamlike and evocative music. His themes appear and disappear, often in misty fragments and brief orchestral swells. The music ebbs and flows continuously in a series of subtly shifting rhythms, the flute suggesting the musical pipes associated with the mythological faun. The overall musical effect is one of reverie, which suits the mood of Mallarmé's poem.

experience; indeed, they could capture a sense of the shifting and fluid nature of our entire mental experience. Language could encompass not only our perceptions of the outside world, but our internal lives as well. The Symbolists sought to evoke states of mind and feeling beyond the surface of everyday reality. And since they did not believe that they could successfully render the external world objectively, they were free to present it from their own unique and idiosyncratic perspectives. Reality was at best, they argued, an irretrievably personal affair.

Poetry, they felt, had long been mired in the ordinary, caught up in conventions of meaning and usage that blinded the reader to language's potential to reveal the extraordinary and the unknown. For the Symbolists, an image or symbol did not so much stand for something as suggest a cluster of ideas and feelings. They preferred the vagueness of symbolic suggestion to a more precise rendering of experience. As Stéphane Mallarmé wrote, "To name an object is to do away with three-quarters of the enjoyment of the poem, which is derived from the satisfaction of guessing little by little; to suggest it, to evoke it, this is what charms the imagination."

Among the poets associated with the Symbolist movement, CHARLES BAUDELAIRE [bow-duh-LAIR] (1821–1867) is considered an important precursor, but STÉPHANE MALLARMÉ [mal-are-MAY] (1842–1898) was the group's leading theoretician and certainly its most influential practitioner. Both Baudelaire and Mallarmé attempted to create poems that contain images that fuse the senses and attain the expressiveness of music. In Baudelaire's "Hair," for example, the speaker pays homage to a lover's hair by describing it as "A port resounding where, in draughts untold, / My soul may drink in colour, scent, and sound." A similar combination of the senses occurs in Mallarmé's "Windows," in lines such as "His eye on the horizon gorged with light, / Sees

golden ships, fine as swans, / On a scented river of purple." In addition to this attempt to convey the rich sensuousness of imagined experience, Symbolist poets tried to make their verse musical, so that the sounds of the words themselves would be suggestive in a musical sense rather than purely representational, a characteristic difficult to demonstrate in translation.

Naturalism. The impulse toward Romanticism in the nineteenth century was countered by the writing of a number of American women. Writers such as SARAH ORNE JEWETT (1849–1909), CHARLOTTE PERKINS GILMAN (1851-1904), and KATE CHOPIN [SHOW-panh] (1851–1904) all deal with the concerns of middle-class women in naturalistic detail, with a psychological realism often reminiscent of Freud. Jewett's stories center on the everyday lives of New England characters; Gilman focuses on the ways in which nineteenth-century attitudes toward women kept them physically and psychologically imprisoned; and Chopin's fiction depicts strong women who insist upon their independence and their right to determine their own destinies.

Kate Chopin was especially adept at depicting the lives of the Creole, Cajun, African American, and Native American communities of Louisiana, and her popularity soared as readers avidly consumed her stories filled with local customs and dialects. Chopin's best-known work is the short novel *The Awakening*, published in 1899. It is intensely psychological in its portrayal of its heroine Edna Pontellier's passionate emotional life, her boredom with her constricting marriage, and her flirtatious adventures with another man. But the novel was considered virtually obscene in its day, banned from most libraries, and Chopin's reputation suffered until the 1950s, when the work was rediscovered.

Along with the novel, drama began to develop along naturalistic lines, especially in Europe. Among the great nineteenth-century realist dramatists was the Norwegian playwright HENRIK IBSEN (1828–1906), whose plays touched on such themes as the roles and rights of women (A Doll's House), the scourge of venereal disease (Ghosts), and the death of a child (Little Eyolf'). Ibsen's dramatic intensity and electrifying revelations were matched by the Swedish playwright AUGUST STRINDBERG (1849–1912), whose plays The Father, Creditors, and Comrades were all written in a strongly realistic style. The plays of Ibsen, Strindberg, and the numerous other naturalist dramatists of the time were staged in ways that emphasized the authenticity of the characters, settings, and situations dramatized.

MUSIC

Debussy's Musical Impressionism. The composer CLAUDE DEBUSSY [day-byou-SEE] (1862–1918) was to nineteenth-century French music what Claude Monet was to nineteenth-century French painting. Like Monet, Debussy revolutionized his artistic medium. As Monet altered the way external reality was rendered in pigment, so Debussy altered the way music suggested extramusical sensations and impressions. Working with a palette of sound instead of color, he mixed musical tones, combining them in ways never heard before, thus influencing the music that would be written after him.

Debussy studied at the Paris Conservatory from the age of ten until he was twenty-two, during which time the Impressionist painters were exhibiting their work. He won the most prestigious prize for French composers, the "Prix de Rome," and went to the Italian capital for two years. In 1887, he returned to Paris, supported himself by giving piano lessons, and became part of a circle of artists and writers. Another of the members was Stéphane Mallarmé, whose poem, "The Afternoon of a Faun," would later serve as inspiration for Debussy's most famous musical composition, *Prelude to the Afternoon of a Faun*.

Debussy insisted that "French music is clearness, elegance, simple and natural declamation. French music aims first of all to give pleasure." This he did in a wide range of compositions—some for orchestra, such as Fêtes (Festivals) and La Mer (The Sea), and others for piano, including the popular Claire de Lune (Moonlight), inspired by the Symbolist poet Paul Verlaine. Rather than duplicating the poem's images or details, Debussy created a parallel or analogous musical image of moonlight through beautiful sounds and suggestive harmonies, without a long lyrical melodic line.

The new sounds achieved through Debussy's piano music were the result of the composer's rejection of the dramatic dynamics of theme employed by Classical and Romantic composers in favor of greater tonal variety. He

accomplished this effect partly by encouraging the use of the piano's damper pedal, which allows the strings for different notes to resonate simultaneously, creating a hazv but rich blend of sounds. He complemented this with a fluctuating sense of rhythm. In masking the basic musical pulse, Debussy created music that avoided the familiar melodic, harmonic, and rhythmic patterns of the past. One of the most important influences on his melodic style was Asian music, which he heard demonstrated at the Paris International Exposition in 1889. There Debussy heard Javanese and Southeast Asian music that he could not duplicate on Western instruments. In response, he created a new scale of six whole tones, entirely of whole-step intervals. The effect of using such a scale was to make all the scale tones equal in weight, without the strong pull of any one home key. The unfocused quality of music that resulted from a whole-tone scale is comparable to the effects Impressionist painters used in creating a shimmering atmosphere across a canvas, and to the lack of representation achieved by Symbolist poets in their deliberate avoidance of strict linguistic referentiality.

The Fin de Siècle

As the nineteenth century came to a close, and as a new one was about to dawn, the Western world was overtaken by a sense that an era was ending. The French, in particular, took up the habit of referring to themselves as a fin de siècle culture, a culture "at century's end." It was a time of extraordinary material innovation: in the 1880s and 1890s, the telegraph and telephone, the bicycle and the automobile, the typewriter and phonograph, the elevator and the electric lamp, all came into being. At the 1889 World Fair in Paris, which marked the one-hundredth anniversary of the Revolution, the engineer GUSTAVE EIFFEL (1832-1923) constructed the tallest structure in the world, a tower that stood 984 feet high (fig. 18.11). At first, many Parisians hated it. The author Guy de Maupaussant, for instance, preferred to lunch at the restaurant in the Eiffel Tower because, he said, "It's the only place in Paris where I don't have to see it." Despite the negative reception, its skeletal iron frame prepared the way for the most prevalent of twentiethcentury buildings-the skyscraper-which would define the terms of the new urban workplace as surely as the telephone and the typewriter. By 1900, when it was the focal point of a second International Exposition, the Eiffel Tower had become the very symbol of French cultural ascendancy.

The *fin de siècle* was also an age of profound and disturbing social unrest and, to many, one of moral decay. Starting in the 1880s, severe economic depression in England marked the beginning of the end of the coun-

try's supremacy as a world power. The Dockers' Strike of 1889 led to the unionization of unskilled workers, and by 1900 the Labour Party had been founded. In France meanwhile, the working classes, it seemed, turned more and more to alcohol for pleasure. Beginning in 1891 and continuing for twenty more years, three thousand new bistros opened in Paris every year, and by 1910, there was one for every eighty-two Parisians. By 1906, most French workmen drank over three liters of wine a day. Drug use was on the rise, with opium, and its derivative morphine, finding special favor. With addiction and poverty came crime, so much so that electric light was championed more for its ability to deter criminal behavior than for anything else.

In 1898, the Dreyfus Affair undermined the moral authority of the state. Captain Dreyfus of the Army General Staff had been arrested in November 1894 for passing information to the Germans. Tried and condemned, he was deported to Devil's Island to serve a life sentence, but his family would not give up, protesting that the verdict had been illegally obtained. The novelist Emile Zola took up Dreyfus's cause, writing a scathing letter to the Parisian papers in January 1898 and publishing a book on the affair, J'Accuse, several months later. Zola argued that the man had been railroaded on orders from the highest level of the French military, and a hot debate ensued. The entire affair was quickly complicated by the question of Drevfus's Jewishness, and the whole of France ended the century violently divided.

The period also witnessed a challenge on the part of European intellectuals to the accepted code of moral behavior of the day. Some writers styled themselves "decadents." In England, OSCAR WILDE (1854–1900) flaunted his homosexuality. This identifiable "type" suddenly became visible to such a point that in Vienna, in 1905, Sigmund Freud would include homosexuality in his *Three Essays on the Theory of Sexuality*. George Sand and Rosa Bonheur had worn men's clothing in midcentury, but now, in the 1890s, many women, particularly intellectuals, wore trousers, and were consequently decried for betraying their sex. Moreover, they asked with increasing intensity for the right to vote. At the *fin de siècle*, all conventional standards of behavior seemed at risk.

NEW SCIENCE AND NEW TECHNOLOGIES

Even as prosperity seemed to promise a limitless future, the technology it spawned contributed to the breakdown of established patterns of social organization. New means of communication, such as the telephone, and new forms of transportation, such as the automobile, complicated life rather than simplifying it. The rules of the road

Figure 18.11 Gustave Eiffel, Eiffel Tower, Paris, 1889. This demonstration of engineering technology, which was extremely controversial when erected and has remained unique, is now considered the symbol of France. An elevator takes tourists up to enjoy a spectacular view of Paris.

remained largely uncodified, and further exacerbating the rapid changes everywhere was the continuing process of industrialization, which spurred the growth of urban centers at the expense of agrarian life. Modern intellectual developments greatly accelerated the transformation of traditional ways of thinking. In particular, discoveries in quantum physics and depth psychology played a significant role in transforming twentieth-century thought. The most important of these developments were Freud's

invention of psychoanalysis and Einstein's promulgation of his theory of relativity.

The Theory of Relativity. In 1905, ALBERT EINSTEIN (1879–1955) proposed that space and time are not absolute as they appear to be, but are instead relative to each other in a "space-time continuum." Not until 1919 could the mathematical equations central to Einstein's special theory of relativity be confirmed through scientific experiment. Subsequent experiments further established the legitimacy of his ideas. All modern developments in space technology were influenced by his discoveries, those developments proving the accuracy of his theory right into the 1980s. Einstein's notion of relativity was widely circulated even though it undermined traditional ways of thinking about the universe, similar to the way in which Copernicus's theory had overturned the Ptolemaic universe.

The Atom. Equally important in its implications was the work of J.J. THOMSON (1856–1940) in Cambridge, England, who between 1897 and 1899 managed to detect the existence of separate components, which he called electrons, in the structure of the atom, which had previously been thought indivisible. By 1911, his colleague ERNEST RUTHERFORD (1871–1937) had introduced his revolutionary new model of the atom. It consisted of a small, positively charged nucleus, which contained most of the atom's mass, around which its electrons orbited. To many, the world no longer seemed a solid whole.

PHILOSOPHY AT THE TURN OF THE CENTURY

Friedrich Nietzsche. Another impetus to changing modes of thought in the early twentieth century came from the nineteenth-century philosopher, FRIEDRICH NIETZSCHE [NEE-chuh] (1844-1900). Nietzsche emphasized the rebellious nature of the "superman," a superhuman being who refused to be confined within the traditional structures of nationalist ideology, Christian belief, scientific knowledge, and bourgeois values. Proclaiming that "God is dead," Nietzsche asserted the complete freedom of the individual, who could now begin to channel "Dionysian" (instinctual) and "Apollonian" (intellectual) tendencies in ways that were unrestricted by social conventions. Nietzsche influenced twentieth-century philosophical thought in significant ways. Early modernist art, in part, owes its rebellious anti-authoritarianism to Nietzsche's example. So too, in part, do developments in literary theory and in philosophy, especially existentialism.

Sigmund Freud. The psychology of SIGMUND FREUD [FROYD] (1856–1939) further influenced modernist trends in culture and the arts. Freud's analysis

of unconscious motives and his description of instinctual drives reflected an anti-rationalist perspective that undermined faith in the apparent order and control in human individual and social life. His emphasis on the irrational provided a quasi-scientific explanation of impulses and behaviors that had formerly been displayed in works of literature, which could now be analyzed with the language and concepts of psychoanalysis that he developed. Freud's splitting of the human psyche into the "ego," the "id," and the "superego" provided a psychoanalytical analogue for the growing concern with social fragmentation and cultural disharmony, the distressing feeling that all was not well, even if the period was known as the belle époque.

POST-IMPRESSIONIST PAINTING

By the early 1890s the Impressionist style of painting was widely accepted. However, since the time of Courbet, painters had defined themselves against the mainstream of "approved" art, and a certain number continued to defy the public's expectations even after the rise of Impressionism. The next wave of artists to challenge the mainstream were called the Post-Impressionists.

The term Post-Impressionism is, in fact, an extremely broad one, for the Post-Impressionists did not band together but worked in isolation. Rather than a rejection of Impressionism, Post-Impressionism, which began in France in the 1880s, was an attempt to improve upon it and to extend it. The Post-Impressionists considered Impressionism too objective, too impersonal, and lacking control. They did not think that recording a fleeting moment or portraying atmospheric conditions was sufficient. Placing greater emphasis on composition and form, on the "eternal and immutable," what Baudelaire described as the "other half" of art, the Post-Impressionists worked to control reality, to organize, arrange, and formalize. The Post-Impressionist painters wanted more personal interpretation and expression, greater psychological depth.

Paul Cézanne. Born into a middle-class family, PAUL CÉZANNE [say-ZAHN] (1839–1906) was in Paris at the beginning of the Impressionist phenomenon. Introverted, however, to the point of being reclusive, he led an almost completely isolated existence in the south of France from 1877 to 1895. People there considered him a madman and jeered at him. He became ever more irritable as a consequence, and turned ever more inward.

Reacting against the loose and unstructured quality of Impressionist art, Cézanne's greatest interest was in order, stability, and permanence. He said he wanted "to make of Impressionism something solid and durable, like the art of the museums." All of Cézanne's paintings are

carefully constructed. His usual technique was to sketch with thin blue paint and then apply the colors directly. He washed his brush between strokes so that each color would be distinct, sometimes taking as long as twenty minutes between brushstrokes. In fact, he referred to his brushstrokes as "little planes." An apple, for example, is viewed as a spherical form consisting of a series of small planes—each plane is a specific color according to the apple's form. This revolutionary style of painting would lead to the innovative ideas of the early twentieth century. Indeed, some critics feel that Cézanne was the first artist to profoundly redirect painting since Giotto (see Chapter 12) in the early fifteenth century.

Cézanne's favorite subject was still life, an example of which is *Still Life with Peppermint Bottle* (fig. 18.12), of ca. 1894. Inanimate objects permitted Cézanne's intensive and lengthy study. The subject was not as important to him as *how* he painted it, and he often combined unrelated objects in his still lifes. No attempt at photographic reproduction was made, for he consciously distorted edges and shapes, emphasizing the contours and the space between objects. Disregarding the conventions of perspective, he created a tension between the three-dimensional subject and the two-dimensional surface.

Figure 18.12 Paul Cézanne, Still Life with Peppermint Bottle, ca. 1894, oil on canvas, $26 \times 32\frac{3}{8}"$ (66×82.3 cm), National Gallery of Art, Washington, D.C. Post-Impressionists used the bright colors of Impressionism for different purposes. Using broken color in a more scientific and studied way, Cézanne referred to each brushstroke as a "little plane," which he used to establish the contours of an object in space.

Figure 18.13 Paul Cézanne, *The Great Bathers*, 1906, oil on canvas, $6'10'' \times 8'2''$ (2.08 \times 2.49 m), Philadelphia Museum of Art. Humans were not the best subject for Cézanne's slow working method. His innovative approach to depicting objects in space, without using traditional methods of perspective, would prove to be influential for twentieth-century painting.

Figure 18.14 Georges Scurat, Sunday Afternoon on La Grande latte, 1884–86, oil on canvas, $6'9\frac{4}{4}'' \times 10'1\frac{4}{4}''$ (2.00 × 3.00 m), Art Institute of Chicago. Seurat has taken bright color and applied it systematically in tiny dots intended to blend in the viewer's eyes when the painting is seen from a distance. The technique is formal, and the composition is carefully unified by repetition of curving shapes.

Cézanne found it difficult to paint the human figure. He was ill at ease with models, and he took too long to paint them. He once yelled at a model, who had fallen asleep, saying, "You must sit like an apple. Does an apple fidget?" In *The Great Bathers* (fig. 18.13), of 1906, Cézanne created a geometric composition, for the trees tilt inward to form a pyramid, while the nudes reinforce the sides, and an echoing V-shape is created by the arms below. The planes of the background, moreover, provide a stabilizing horizontal. Thus the figures and setting form a deliberate pattern. The facts of nature are manipulated for the sake of the design and structure of the composition. Indeed, Cézanne proclaimed that a painter is allowed to distort nature, to "recreate" nature, rather than slavishly copy it.

Always striving, yet chronically dissatisfied with his work, Cézanne felt he did not reach his goal. "I am the primitive of the way I have discovered," he claimed. Yet much of carly twentieth-century painting is indebted to Cézanne, who has been called the "Father of Abstract

Art." His phrase, "You must see in nature the cylinder, the sphere, and the cone," became the basis of the Cubist painting of Pablo Picasso and Georges Braque.

Georges Seurat. Another important French Post-Impressionist artist, GEORGES SEURAT [sir-AH] (1859–1891), had an approach to painting that was intellectual and scientific. He believed that art could be created by a system of rules. Like Cézanne, he made many sketches and studies before painting and worked very slowly.

Sunday Afternoon on La Grande Jatte (fig. 18.14), painted between 1884 and 1886, is a monumental work. The subject is Impressionistic: a sunny afternoon in a public park with a gathering of French society. Yet, in an effort to give structure to the disintegrating forms of Impressionism, Seurat solidified and simplified them and defined their boundaries. Edges reappear and silhouettes are sharp. All is tidy, balanced, and arranged with precision.

Seurat's working method was to first create silhouettes of simple lines and precise contours. He then organized the composition's surface and depth. Spaces between figures and shadows were considered part of the composition, and shapes were repeated for unity. He then painted in his petits points, a technique called "Pointillism," though Seurat called it "Divisionism." Pointillism or Divisionism is the almost mathematical application of paint to the canvas in small dots or points of uniform size, each dot precisely placed. This technique is underpinned by color theory—Seurat believed that the human eye could optically mix the different colors he applied as dots. Thus, where a blue dot was placed next to a red dot, theoretically the eye would see purple. It is difficult to imagine the patience required to paint in this technique, which Seurat even used to sign his name and to paint the frames. Each shape, its color, size, and location, is calculated—very different from Impressionism's informal, seemingly accidental quality.

Vincent van Gogh. In contrast to Seurat, VIN-CENT VAN GOGH [van GOH] (1853-1890) is famed for his rapidly executed paintings, which use expressive and emotional color. Dutch by birth, Van Gogh lived and worked in France for most of his life. His brother Theo, director of a small art gallery, supported him. Van Gogh met the Impressionists and used their bright colors and vivid contrasts, not to capture light effects but, instead, to convey emotion. When he moved to Arles in the south of France, Van Gogh painted and drew at a rate of almost one piece a day. Among his most famous works of that period is The Night Café (fig. 18.15). "I have tried to express the idea that the café is a place where one can

Figure 18.15 Vincent van Gogh, The Night Café, 1888, oil on canvas, $28\frac{1}{2}'' \times 36\frac{1}{4}''$ (72.5 × 92 cm), Yale University Art Gallery, New Haven, Connecticut. The bright Impressionist colors record Van Gogh's emotional fluctuations rather than the moods of Nature.

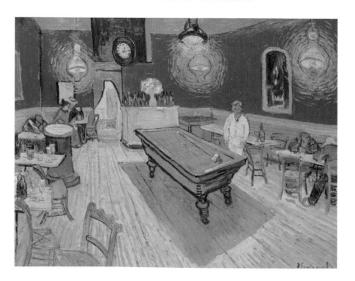

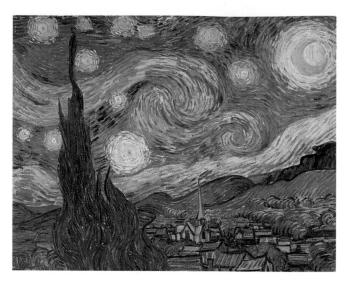

Figure 18.16 Vincent van Gogh, Starry Night, 1889, oil on canvas, $28\frac{3}{4} \times 36\frac{1}{2}$ " (73 × 92 cm), Museum of Modern Art, New York. Although seemingly conceived and executed without restraint, as if painted in a fevered rush, this was actually preceded by a complete preliminary drawing.

ruin oneself, run mad, or commit a crime," he wrote to his brother in September 1888. "I have tried to express the terrible passions of humanity . . . Everywhere there is a clash and contrast of red and green . . . color to suggest the emotion of an ardent temperament."

Another of Van Gogh's most celebrated paintings is Starry Night (fig. 18.16), of 1889, painted on a hillside overlooking St.-Rémy, a small town just south of Arles. Starry Night is anything but calm. In this unusually turbulent landscape his highly expressive brushwork implies the precarious balance of his emotions. Pigment appears slapped on, sometimes applied with a brush, sometimes a palette knife, sometimes squeezed directly from the tube—as if Van Gogh was desperate to get his ideas on canvas as quickly as possible. As spontaneous as it appears—almost as if he started painting and could not stop himself—the result is an emotional landscape, frenzied, passionate, flame-like, undulating, the sky swirling and writhing. Yet the composition was planned in advance. Furthermore, it is organized and balanced by traditional methods. The composition flows from left to right, the trees and church steeple slowing the movement down, with the hills rising on the right-hand side of the picture for balance. Vincent wrote to Theo explaining his working method; he would think everything out "down to the last detail" and then quickly paint a number of canvases.

Van Gogh suffered from extreme emotional swings. During one of his periods of depression, he shot himself in a field in Auvers. He died two days later, on July 21, 1890, in Theo's arms. He was thirty-seven. He never knew fame, but today he is one of the most celebrated of all painters.

Then & Now

POINTILLISM AND TELEVISION

Seurat's pointillist technique involved putting small dabs of different colored paint next to one another and allowing the eye to blend them into a single tone. Television works in much the same way. A standard set contains one picture tube and three electron guns. Each gun makes a complete picture on the screen in one of the primary light colors—red, blue, and green (not yellow as in surface primary colors). The screen itself is made of small dots, each dot capable of being hit by only one of the guns. When the three primary colors are projected simultaneously through the dots on the screen, they blend, projecting a full range of colors to the viewer's eye. If you look at the

screen of a color television with a magnifying glass before turning it on, you can see the pattern of dots. Then look at the screen after turning it on, and you can see how the manufacturer has arranged the different primary colors (every manufacturer employs a different pattern) in an array that they believe will best create vivid color images.

Paul Gauguin. Fellow Post-Impressionist PAUL GAUGUIN [go-GAN] (1848–1903) was born to a Peruvian mother and a French father. A successful banker and stockbroker in Paris, Gauguin had a personal crisis at the age of thirty-five. He decided to become a full-time artist, and rebel against the established way of life, leaving his wife and five children to embark on an exotic life, which he recorded in his autobiography, Noa Noa (Fragrance). Gauguin shared with the Symbolist poets a desire to escape the everyday world and retreat into what Mallarmé called metaphorically "the afternoon of a faun." To that end, he auctioned off about thirty of his paintings and sailed to Tahiti in 1891.

Gauguin wrote about his painting Manao Tupapau (Spirit of the Dead Watching) (fig. 18.17), of 1892, in Noa

Noa. One night, he returned to his hut, only to find it in complete darkness. Lighting a match, he found Tehura (his new wife) lying as shown in the work, terrorstricken by the dark. The woman in the background is the "Spirit of the Dead." The white areas in the background are phosphorescent fungi which, according to Maori legend, symbolize the spirits of ancestors. "Tehura's dread was contagious," Gauguin wrote, "it seemed to me that the phosphorescent light poured from her staring eyes. I had never seen her so lovely . . . above all, I had never seen her beauty so moving." Gauguin's reaction to the scene is typical of the Symbolist: feelings of dread combined with admiration of beauty. As in Symbolist work as a whole, such ambiguities dominate the painting.

Figure 18.17 Paul Gauguin, Manao Tupapau (Spirit of the Dead Watching), 1892, oil on burlap mounted on canvas, $28\frac{1}{2}'' \times 36\frac{3}{8}'''$ (72.4 × 92.5 cm), Albright-Knox Art Gallery, Buffalo. The phosphorescent spots were believed by the Maoris to signify the spirits of the dead. In spite of his claims, Gauguin remained a sophisticated artist, drawing more on the art of the museums than from his surroundings.

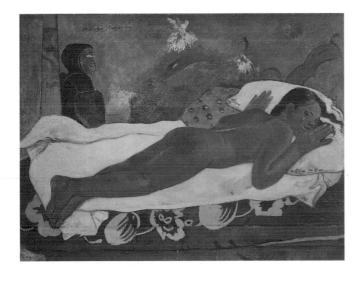

NEW DIRECTIONS IN SCULPTURE AND ARCHITECTURE

Auguste Rodin. For the better part of the nineteenth century, many sculptural concepts had amounted to little more than variations on classicism, but toward the end of the century a major new sculptor appeared. The Frenchman AUGUSTE RODIN [roh-DAN] (1840–1917) became the most influential sculptor in Europe. He studied the human form from nude models in his studio, but rather than having them remain immobile as was the tradition, Rodin's models walked around so he could study the human body in motion. He had a wonderful ability to convey emotion and ideas through his representations of the human form.

Rodin's bronze sculpture *The Thinker* (fig. 18.18) was made between 1879 and 1889 and was intended to form part of a larger work marking the entrance to the Museum of Decorative Arts in Paris: the *Gates of Hell*, based on Dante's *Inferno* (see Chapter 12), with *The Thinker* looking down on Hell, brooding over the gates. Rodin's superb understanding of "body language" can be seen in the details, for example, in the tension in the toes of the figure that seem to grip the base.

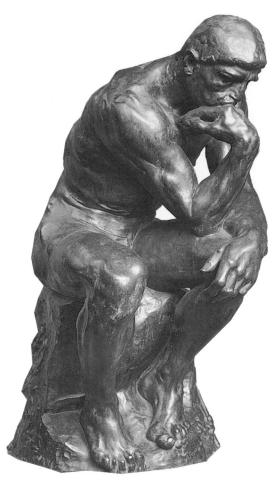

Figure 18.18 Auguste Rodin, *The Thinker*, 1879–89, bronze, height $27\frac{1}{2}''$ (69.8 cm), Metropolitan Museum of Art, New York. Like the Impressionist painters' concern with light flickering over forms, Rodin's broken surface creates a similarly dappled and unfinished effect.

Also created for this entrance was an over-lifesize marble sculpture called *The Kiss* (fig. 18.19), made between 1886 and 1898. In this work Rodin displays a sensuous love of the body as well as amazing virtuosity in carving two intertwined figures. The completed sculpture has portions of stone that have been left intentionally rough, thereby emphasizing a contrast of textures between the soft skin of the subject and the hard marble it came from. Michelangelo's work also has this contrast, but this is because he lacked the time or the will to finish the pieces. Rodin used it as a conscious aesthetic.

American Architecture. Toward the end of the nineteenth century, a new style in architecture developed as well. It was the public and commercial buildings—the stores, offices, and apartments—that defined the new architecture of the belle époque. The use of iron, steel, concrete, and large sheets of glass radically changed architectural language. As steel construction and concrete forms were developed, thick masonry walls were no longer required to support the whole structure of a

building. Expression was given freely to the new underlying skeletal frames. The idea of a building as a solid and closed space was replaced by that of the building as an open and airy environment. Height could be more easily increased. Buildings began to define the city skyline.

The American architect LOUIS SULLIVAN (1856–1924) designed such a structure with the Wainwright Building in St. Louis, Missouri (fig. 18.20). Built between 1890 and 1891, it uses a supporting steel structure and has a brick exterior. Sullivan's design stresses the continuous verticals that reflect the internal steel supports, thus emphasizing the building's height. Sullivan doubled the number of piers necessary, creating a dense effect. The corners are stressed, and thereby visually strengthened. Horizontals at the top and bottom

Figure 18.19 Auguste Rodin, *The Kiss*, 1886–98, marble, over-lifesize, height 6'2" (1.90 m), Musée Rodin, Paris. The seemingly warm soft flesh is emphasized in contrast to the hard cold stone from which it was carved.

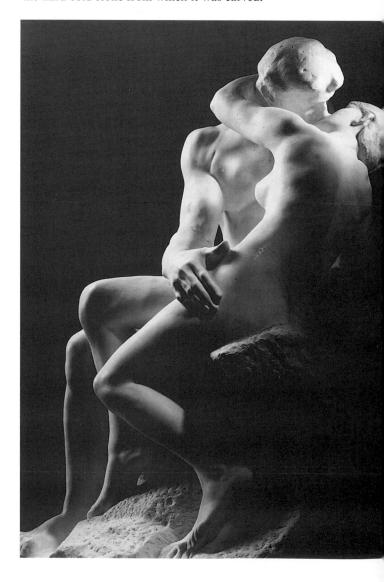

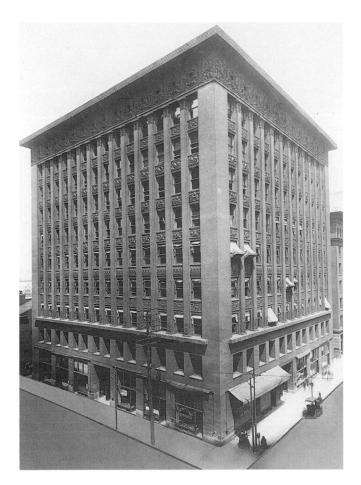

Figure 18.20 Louis Sullivan, Wainwright Building, St. Louis, Missouri, 1890–91. Moving in the direction of the skyscraper, the Wainwright Building has an underlying steel skeleton and brick skin. The architect, Louis Sullivan, coined the now famous phrase, "form follows function."

provide a visual frame—in a sense, a start and a conclusion to the composition.

Sullivan saw a building as being like the human body: the steel is the bone; the brick is the flesh and skin. It was Sullivan who coined the phrase, "form follows function." Yet this does not mean that the decorative elements of the design are integral to the architectural design, as is commonly thought. For Sullivan, "the function of all functions is the Infinite Creative Spirit," and this spirit could be revealed in the rhythm of growth and decay that we find in nature. Thus the elaborate, organic forms that cover his building were intended to evoke the infinite. For Sullivan, the primary function of a building was to elevate the spirit of those who worked in it. His belief led to a new school of Functionalist architecture. Tall buildings were becoming progressively more desirable as the concentration of businesses in downtown areas of cities grew, and real estate became ever more expensive, a trend that led to the emblem of twentieth-century American architecture, the skyscraper.

Art Nouveau. Sullivan's belief in nature was mirrored in Art Nouveau (literally, New Art), a short-lived style that began in Europe and was popular from the 1890s to the early 1900s. It is characterized by decoration, especially curvilinear patterns, based upon the forms of nature. The influence of Art Nouveau extended beyond architecture to include things such as home furnishings, clothing, and typography.

The home of Dr. Tassel in Brussels, designed by the architect VICTOR HORTA [OAR-ta] (1861–1947) and built 1893, is an ideal example of the Art Nouveau style. Horta liked to be able to design "each piece of furniture, each hinge and door-latch, the rugs and the wall decoration." Consequently, in the Tassel house every part is in harmony, characterized by curve and counter-curve, by its small scale, grace, and charm. The staircase (fig. 18.21) is illuminated by a skylight and made with large amounts of glass and metal, used both for ornamentation and for structure. It is especially characteristic of the Art Nouveau style with its swirling and sensuous forms.

In Spain, another exponent of Art Nouveau was ANTONÍ GAUDÍ [GOW-dee] (1852–1926), the

Figure 18.21 Victor Horta, staircase, Dr. Tassel's house, Brussels, 1893. Art Nouveau favored forms derived from nature such as foliage and curling tendrils. To achieve a certain harmony, Horta designed everything in the house, from the furniture and rugs, down to the small details such as the hinges.

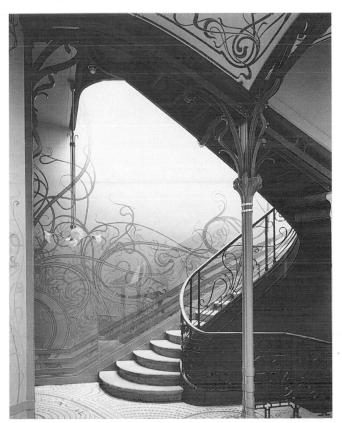

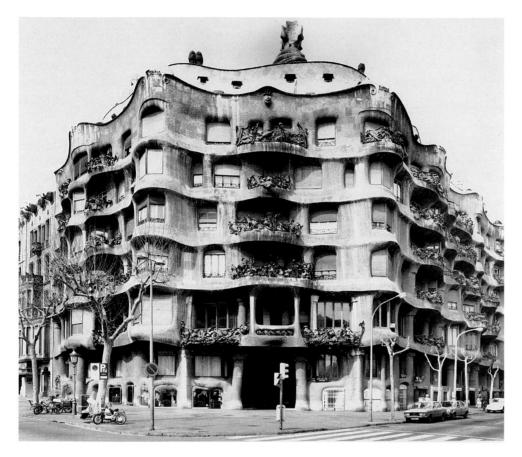

Figure 18.22 Antoní Gaudí, Casa Milá Apartment Building, Barcelona, 1905–07. Although made of traditional cut stone, the forms appear eroded by nature, weathered into curves, and the metal balcony railings look like seaweed.

architect of the Casa Milá in Barcelona (fig. 18.22), built 1905-07. This apartment building bears no relation to anything that had gone before. His Art Nouveau style has few flat areas or straight lines, favoring instead constantly curving lines and asymmetry over symmetry. Although made of cut stone, the Casa Milá looks like it was molded from soft clay. Gaudí created a sort of "organic" style influenced by the forms of the natural world. The building looks eroded, as if nature has worn away all the sharp angles. The facade seems to ripple around the corner of the building, and the roof appears to undulate. The chimneys look like abstract sculptures. Gaudí did much of his designing on the actual building site, which was quite unusual then as it is now, and produced a highly personal and thoroughly eccentric style.

THE AVANT-GARDE

Ever since the Salon of 1824, when the young radical Delacroix first challenged the old conservative Ingres for supremacy in French painting, the long-standing split between the *rubénistes* (color) and the *poussinistes* (line) had assumed a political and generational flavor. The Realism of Courbet and Manet was seen by the French Academy as an affront to good taste. The Impressionists organized their own exhibitions beginning in 1874, in part to assert their independence from this official definition of taste. Post-Impressionist masters such as Van Gogh, Gauguin, and Cézanne went one step further by removing themselves from Paris altogether.

Yet, for all the apparent freedom of their various approaches to painting and their seeming liberation from tradition, the work of Courbet, Manet, Monet, Van Gogh, Cézanne, and others was soon championed by the French public and quickly appropriated as part of the great tradition. In 1890, at Monet's behest, the Louvre purchased Manet's *Olympia* from his estate, and the painting was finally hung in the museum in 1907. In 1901, a huge retrospective exhibition of Van Gogh's work fascinated Paris. And after Cézanne died in 1906, his oil paintings became the centerpiece of the 1907 Salon. The French had a word for artists such as these. They were the **avant-garde**, a military term referring to

the foremost unit in an attack, the "advanced guard" or "vanguard."

Separated from the mainstream, the avant-garde led the way, against all traditions and expectations, to a bold "new" art. By the start of the twentieth century, Baudelaire's definition of the modern in terms of "the transient, the fleeting, the contingent" had been modified. The *modern* was the *new*, and the modern avant-garde artist sought to discover and reveal the new in art. In the never-ending quest for the new, movement after movement, "ism" after "ism," came and went—before the end of the *belle époque*, Realism, Impressionism, Symbolism, Pointillism, Fauvism, Cubism, Futurism, and German Expressionism all had their day, each new movement giving way to the next.

Characteristic of the avant-garde was an increasing distrust of realistic representation and a developing interest in **abstraction**. As early as Berthe Morisot's abbreviated depiction of three ducks in *Summer's Day* (see fig. 18.6), such a tendency is identifiable. Van Gogh and Gauguin both liberated color from its purely descriptive function, using it to represent their emotions rather than the actual look of things. Indeed, the Symbolist desire to capture an internal reality rather than the external one reflects a similar concern.

The interest in abstraction takes three forms: (1) an expressive art that is emotional, gestural, and free in its use of color; (2) a formalist art that is concerned with structure and order; and (3) an art of fantasy that is concerned with the individual imagination and the realm of dreams. In all three, the world of surface appearances is gradually left behind. Abstract art is based less and less on the artist's perception and increasingly on the artist's conception of things.

FAUVISM

The 1905 Salon d'Automne (Autumn Salon) in Paris was quite liberal in its acceptance policy and included a room of paintings by Henri Matisse, Maurice de Vlaminck, André Derain, Georges Rouault, and others who were exhibiting together for the first time. The art critic Louis Vauxcelles reviewed the show and was quick to label these artists Les Fauves (The Wild Beasts) because of their paintings' violent and arbitrary colors. The artists who launched Fauvism had learned from Van Gogh and Gauguin that color could be an expressive force in its own right, and that it could correspond, not to reality, but to what Van Gogh had called "the artist's temperament." Furthermore, they rejected the small "dots and dashes" of color that characterized Impressionist painting and, particularly, the Post-Impressionist painting of Seurat. They wanted to draw on the canvas, with long and sensuous strokes. Their work was intended to shock the viewer, visually and psychologically, with its intensely surprising color. It was, above all, new.

The leader of the Fauves was Henri Matisse. HENRI MATISSE [mah-TEECE] (1869-1954). At the age of twenty-two, Matisse had abandoned a career in law for one in art. At the 1905 Autumn Salon, he exhibited Woman with a Hat (fig. 18.23), a portrait of Madame Matisse. It appeared to many viewers little more than a smearing of brilliant, arbitrary, and unnatural colors across the subject's face and background. In its subject matter, the painting is of the belle époque, depicting Madame Matisse dressed for an outing in gloves and an enormous hat, yet it bears almost no resemblance to any earlier work. Rather than employing dots of color, Matisse broke the color into broad zones. Not only are they seemingly arbitrary, the artist makes no attempt to harmonize them. Red, green, and purple are used at maximum intensity. Maurice Denis, a painter and critic, understood the implications of Matisse's painting: "One

Figure 18.23 Henri Matisse, Woman with a Hat, 1905, oil on canvas, $32\frac{1}{4} \times 23\frac{3}{4}''$ (82 × 60.5 cm), Collection of Mrs. Walter A. Haas, San Francisco. The American author Getrude Stein and her brother Leo purchased this painting at the Autumn Salon in 1905, inaugurating one of the greatest collections of modern art in Paris in the twentieth century. Americans, in particular, flocked to Stein's evening gatherings in her apartment on the Rue des Fleurs to see the work of Matisse and Picasso, and to meet the artists themselves, who were in regular attendance.

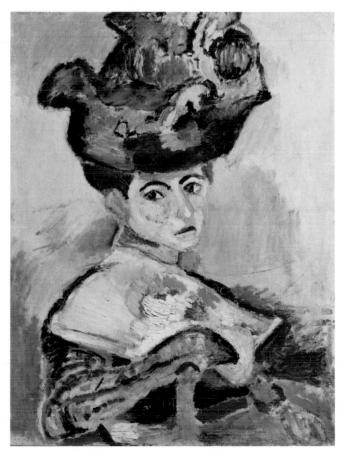

feels completely in the realm of abstraction ... It is painting outside of every contingency, painting in itself, the act of pure painting ... Here is in fact a search for the absolute. Yet, strange contradiction, this absolute is limited by the one thing in the world that is most relative: individual emotion."

Matisse soon realized that *Woman with a Hat* lacked something that profoundly interested him—drawing. Beyond depicting raw contrasts of pure color in flat planes, he wanted to emphasize line. "What I am after, above all," Matisse explained, "is expression . . . Composition is the art of arranging in a decorative manner the various elements at the painter's disposal for the expression of his feelings." The painting has a joyous feeling, a sense of springtime and of life, which is once

again typical of the *belle époque*. Through the expressive use of color and line, Matisse discovered that even the most ordinary scene could achieve expressive force. *Harmony in Red (Red Room)* (fig. 18.24), painted 1908–09, is an everyday scene distinguished by pattern and harmony between the colors, shapes, and lines. This painting oscillates between two-dimensional pattern and three-dimensional representation. The tablecloth and the wall share the same pattern and colors; the only indication Matisse provides that the table is a horizontal surface is the placement of fruit on it. Are we looking out of a window on the left or at a flat painting hanging on the wall? All objects are used to play a role in forming an overall surface pattern. This differs from the efforts made by earlier artists to construct an illusion of space

Figure 18.24 Henri Matisse, *Harmony in Red (Red Room)*, 1908–09, oil on canvas, $5'11\frac{1}{4}'' \times 8'\frac{7}{8}''$ (1.81 × 2.46 m), State Hermitage Museum, St. Petersburg. Traditional methods of creating an illusion of three dimensions on a two-dimensional surface are not used in many twentieth-century paintings. Here, indications that the table top is horizontal and the wall vertical are avoided, creating a flat and decorative effect.

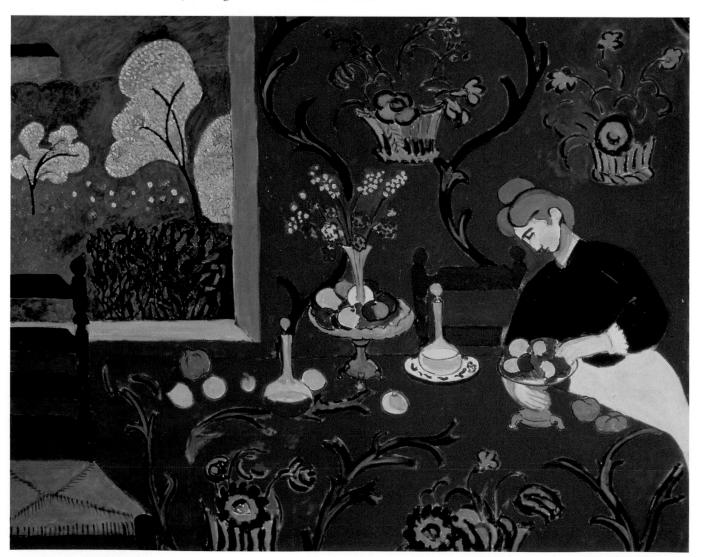

497

behind the picture plane. Matisse, like many later painters, intentionally compressed the space and emphasized the picture plane, making clear that this is a painting, not an illusion of the visible world.

CUBISM

The Fauvist emphasis on the reality of the picture plane is also apparent in the work of the Cubist painters. Derived from Cézanne's famous dictum, "You must see in nature the cyclinder, the sphere, and the cone," Cubism differs, first, in its depiction of objects in their most reduced geometric form, particularly, as its name implies, in cubes. It differs, secondly, in the way in which objects are represented simultaneously from as many different points of view as possible—from the front, the back, the side, and from above. Rather than presenting the object from one angle or point of view, the Cubists wanted to present all aspects of the object simultaneously. Reality, they argued, is not just what we see, but what we know about what we see, in the same way that when we see a person's back, we can infer that person's face.

Cubism was the invention of two relatively unknown painters at the time, Pablo Picasso and Georges Braque, both of whom arrived separately at the same conclusions about the nature of our experience of the world. They soon discovered one another's shared convictions and proceeded to work together for seven years until the outbreak of World War I.

Pablo Picasso. Often considered the single most important painter of the twentieth century, PABLO PICASSO [pi-KAH-soh] (1881–1973) never ceased searching for the "new." He went through many styles in his long life and worked in a wide variety of media including painting, graphics, sculpture, and ceramics. He might draw and paint with extraordinary realism one day and with consummate abstraction the next.

In 1900, Picasso, who had trained in the Spanish cities of Barcelona and Madrid, moved to Paris, where he studied Impressionism and Post-Impressionism. From 1900 to 1905 he painted in a more or less Symbolist vein, but in 1905 he began working on a portrait of the American writer Gertrude Stein (fig. 18.25), and his approach to painting changed dramatically. Throughout the fall of 1905 and into the following year, Stein would cross Paris to Picasso's studio in the Bateau Lavoir, or "Laundry Boat," and Picasso would undertake to paint her. After some eighty or ninety sittings, however, Picasso became irritated with the entire operation and in a fit of pique painted out her face, leaving the painting to sit all summer in the studio while he traveled to Spain. On his return, he completed the painting from memory-without his model. A year later, Alice B. Toklas, Stein's friend and companion, told Picasso how much she liked the portrait. "Yes," he said, "everybody says that she does not

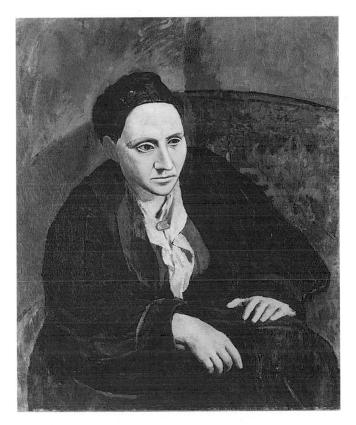

Figure 18.25 Pablo Picasso, *Gertrude Stein*, 1906, oil on canvas, $39\frac{1}{4}$ " \times 32" (99.5 \times 81 cm), The Metropolitan Museum of Art, New York. Picasso had been looking at ancient Iberian sculpture on his trip to Spain in the summer of 1906, and Stein's simplified features, particularly her oval eyes and sculpted brow, are indebted to his study.

look like it but that does not make any difference, she will." Picasso's painting had passed from a retinally based image into a cerebral one. The actual Gertrude Stein was eclipsed by Picasso's idea of her, or his idea of what she would become.

Picasso pursued this conceptual approach seriously. His next work, the famous Les Demoiselles d'Avignon (The Ladies of Avignon) (fig. 18.26), of 1907, seems liberated from the "reality" of perceptual experience altogether. Although the word demoiselles means "gentlewomen," here it refers to prostitutes, and Avignon refers to Avignon Street in Barcelona rather than the city of the Popes in southern France. The anatomy of the figures shows distorted proportions, their bodies turned into rhythmic shapes and broken, angular pieces. Space is treated in the same way. Solid and void are depicted in terms of structural units, similar to Cézanne's "little planes." The style is also deliberately "primitive." African sculpture, particularly masks, inundated Paris in the first decade of the century, and Picasso took full advantage of their expressive force. "Men had made these masks," Picasso explained, "as a kind of mediation between themselves and the unknown hostile forces that surrounded them, in

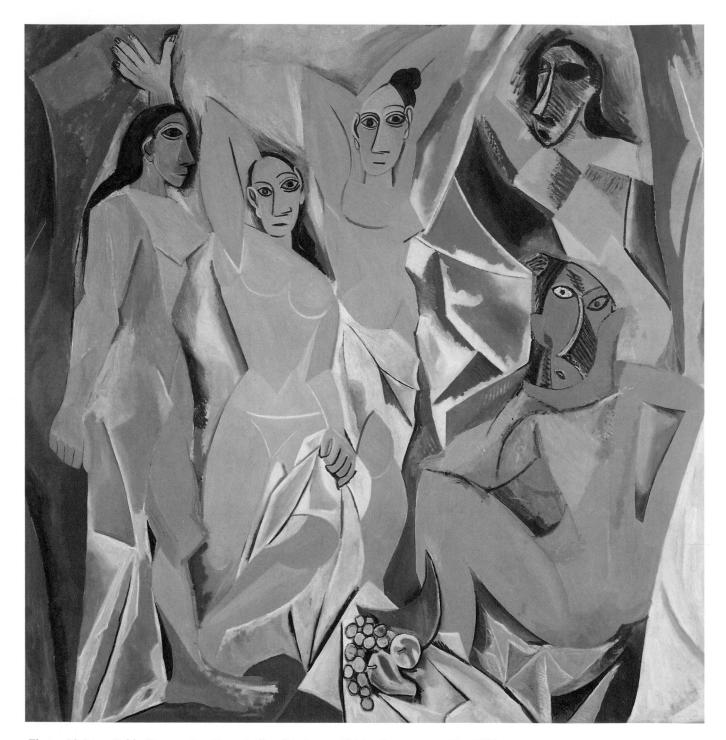

Figure 18.26 Pablo Picasso, Les Demoiselles d'Avignon, 1907, oil on canvas, $8' \times 7'8''$ (2.40 \times 2.30 m), Museum of Modern Art, New York. With motifs that echo African art, the angular lines and overlapping planes of this painting initiated a new way of analyzing three-dimensional forms in space. The work's primitive energy sent shock waves through the art world when it was first shown in Paris, allying it with Stravinsky's *Rite of Spring*, which had a similar effect on the world of music six years later.

order to overcome their fear and horror by giving [them] a form and image. And that moment I realized that painting ... [is] a way [of] seizing power by giving form to our terrors as well as our desires."

Georges Braque. One of the first people to see Les Demoiselles, and to approve of it, was GEORGES BRAQUE [BRAHK] (1882–1963). Braque had worked with Matisse as a member of the Fauves, and it was probably Matisse, who was himself horrified by Les Demoiselles, who introduced him to Picasso. But Braque

saw in it a flattening and simplification of form that he believed Cézanne had championed in works such as *The Great Bathers* (see fig. 18.13). Energized by Picasso's achievement, Braque went even further. In the summer of 1908, in southern France, Braque began a series of paintings that would reduce the landscape to its basic geometric forms. So simplified are the forms of *Houses at L'Estaque* (fig. 18.27) that, when the painting was exhibited at the Bateau Lavoir in the fall of 1908, Matisse complained to Louis Vauxcelles that the painting looked

Figure 18.27 Georges Braque, Houses at L'Estaque, 1908, oil on canvas, $36\frac{1}{4}^{1} \times 23\frac{5}{8}^{1}$ (92 × 60 cm), Kunstmuseum, Bern, Switzerland. Note the way in which the upper branches of the tree on the left seem to merge with the walls of the houses in the distance, uniting foreground and background in a single plane.

Figure 18.28 Georges Braque, *The Portuguese*, 1911, oil on canvas, $45\frac{1}{8}'' \times 32\frac{1}{8}''$ (114.5 × 81.5 cm), Kunstmuseum, Basel, Switzerland. In Cubism the forms are broken and faceted as if portions of cubes, and the forms are portrayed from multiple viewpoints. The range of color is restricted so that it will not distract from this new way of analyzing form in space.

like a pile of cubes. By 1909, Vauxcelles, the same man who had named the Fauves, was writing about Braque's "bizarre cubics," and the name Cubism was coined.

For several years, Picasso and Braque worked so closely together that their work is virtually indistinguishable to the untrained eye. Braque tended to paint more landscapes than Picasso, Picasso more figures than Braque, but both worked in a similar style and progressed in tandem.

Braque's *The Portuguese* (fig. 18.28), of 1911, depicts a guitarist playing at a café, but there is no fully realized figure. We can see the guitar's soundhole and strings in the lower-middle part of the painting. There are fragments of lettering—OCO and BAL—and something is offered at a price of 10.40 francs. A rope is wrapped around a post, and perhaps that is the guitarist's broad smile in the upper-middle part of the piece. All is a fleeting glance as if seen through a window in which the reflections of activity and movement outside distort everything seen inside.

Figure 18.29 Pablo Picasso, Still Life with Chair Caning, 1912, oil, oilcloth, and pasted paper simulating chair caning on canvas, rope frame, $10\frac{1}{2} \times 13\frac{3}{4}''$ (26.7 × 35 cm), Musée Picasso, Paris. This collage (French for "pasting" or "gluing") is created from scraps of ordinary materials that became art when arranged into a composition.

Both artists began to introduce recognizable pieces of material reality into their compositions, asking the questions: What is real and what is art? If something is real, can it be art? And vice versa, if something is art, is it real? By pasting real materials on the canvas they engaged in a technique called **collage** (from the French word *coller*, "to glue" or "to paste"). Picasso's *Still Life with Chair Caning* (fig. 18.29), of 1912, contains rope and a piece of oilcloth with imitation chair caning printed on it, a cigarette, and a fragment of a newspaper (*Le Journal*). All we see are the first three letters, a fragment of the whole, but this fragment tells us much about Braque and Picasso's intentions. The letters "jou" also form the beginning of the verb *jouer*, the French for "to play." Collage is the new playground of the artist.

FUTURISM

One significant offshoot of Cubism is **Futurism**, a movement based in Italy before World War I which used Cubist forms in a dynamic way. It was the first art movement to have been founded almost exclusively in the popular press, conceived by its creator, the poet FILIP-PO MARINETTI [mah-ri-NET-ee] (1876–1944), in his "Manifesto of Futurism," published on February 20, 1909, in the French newspaper *Le Figaro*.

The "Manifesto" is a peculiar document that outlines an eleven-point pledge, including the Futurists' intention to "sing the love of danger," to "affirm that the world's magnificence has been enriched by a new beauty, the beauty of speed," to "glorify war—the world's only hygiene," to "destroy the museums, libraries, and academies of every kind," and, finally, to "sing of great crowds excited by work, by pleasure, and by riot."

Gino Severini. In February 1910, seven painters, including GINO SEVERINI [sev-err-EE-nee] (1883–1966), signed a "Manifesto of Futurist Painters" that pledged, among other things, "to rebel against the tyranny of terms like 'harmony' and 'good taste,'" "to demolish the works of Rembrandt, of Goya, and of Rodin," and, most importantly, "to express our whirling life of steel, of pride, of fever, and of speed." The Futurists wanted, they claimed, to render "universal dynamism" in painting.

The Futurists' interest in expressing speed was aided by the forms of Cubism. Severini's *Suburban Train Arriving at Paris* (fig. 18.30), of 1915, depicts speed as a sequence of positions of multifaceted forms. Similar to a series of movie stills, or to a multiple exposure photograph, the artist expresses the direction of the force by the abstract fragmentation of the speeding forms. The Futurists privileged simultaneous perspective, as did the Cubists, but the Futurists recorded the various aspects of a moving object, whereas the Analytical Cubists recorded those of a static one.

GERMAN EXPRESSIONISM

The last of the great pre-war avant-garde movements was German Expressionism, which consisted of two separate branches, *Die Brücke* ("The Bridge"), established in Dresden in 1905, and *Der Blaue Reiter* ("The Blue Rider") formed in Munich in 1911. Both were directly

Figure 18.30 Gino Severini, Suburban Train Arriving at Paris, 1915, oil on canvas, $35 \times 45\frac{1}{2}$ " (88.6 × 115.6 cm), Tate Gallery, London. The Italian Futurists sought to destroy museums and anything old, praised what they called the "beauty of speed," glorified war and machinery, and favored the "masculine" over the "feminine."

Figure 18.31 Emil Nolde, Dancing around the Golden Calf, 1910, oil on canvas, $34\frac{3}{4}'' \times 39\frac{1}{2}''$ (88 × 100 cm), Staatsgalerie Moderner Kunst, Munich. Much of the shock of this painting derives from its depiction of a biblical subject in such openly sexual terms.

indebted to the example of the Fauves in Paris, especially in terms of the liberation of color and the celebration of pagan, almost animal, sexuality.

Emil Nolde. One of the most daring members of Die Brücke in terms of his use of color was EMIL NOLDE [NOHL-(duh)] (1867–1956). What distinguishes his Dancing around the Golden Calf (fig. 18.31) from the work of Matisse and the Fauves is the painting's lack of contour and outline. Instead, emphasis is on the use of color which fully exploits the dissonances between its bright reds, orange-yellows, and red-violets. The energy of this style—almost slapdash in comparison to Matisse—helps to create a sense of violence, fury, and wanton sexuality that is alien to Matisse's vision. This rough-hewn, purposefully inelegant approach is typical of Die Brücke work, and owes much to the example of Picasso's Les Demoiselles and its "primitivism."

Vassily Kandinsky. The leader of Der Blaue Reiter was VASSILY KANDINSKY [kan-DIN-skee] (1866–1944), who was born in Moscow. A practicing lawyer with a professorship in Moscow, Kandinsky saw one of Monet's Haystacks paintings in 1895 and was so moved by the experience that he traveled to Munich to study art. He became friendly with the Fauves and the Cubists, bringing their work to Germany in 1911 for a major exhibition.

The name *Der Blaue Reiter* refers to St. George slaying the dragon, the image that appeared on the city emblem of Moscow. Tradition held that Moscow would be the capital of the world during the millennium, the

Figure 18.32 Vassily Kandinsky, *Improvisation No. 30 (Warlike Theme)*, 1913, oil on canvas, $43\frac{1}{4}'' \times 43\frac{1}{4}''$ (110 × 110 cm), Art Institute of Chicago. Although Kandinsky did produce completely non-representational paintings, beginning in 1910, that were intended to stir the viewer's emotions, this painting includes recognizable subjects having political and religious implications.

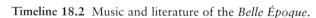

thousand-year reign of Jesus on earth after the Apocalypse. *Improvisation No. 30 (Warlike Theme)* (fig. 18.32) includes, at the bottom of the composition, two firing canons, which announce the second coming of Jesus. Crowds of people march toward the millennium across the canvas. Above them are the churches of the Kremlin and, circling round the horizon, the streets of Moscow itself. Kandinsky did not so much want to convey the meaning of his work through its imagery as through its color. Color, he believed, caused "vibrations [or, in German, *Klangen*] in the soul," and his painting was designed, he wrote in 1912 in his *Concerning the Spiritual in Art*, to "urge" the viewer to a spiritual awakening in preparation for the second coming.

MUSIC

Igor Stravinsky. IGOR STRAVINSKY [strah-VIN-skee] (1882–1971) is considered the single most important composer of the modern era. His works revolutionized twentieth-century musical styles and affected artists such as Picasso, writers such as T.S. Eliot, and ballet choreographers such as George Balanchine. Stravinsky was born in Russia, near St. Petersburg. Although groomed for a law career, Stravinsky studied music and achieved early success composing for the Ballets Russes, a Russian ballet troupe performing in Paris under the artistic direction of Serge Diaghilev. His early scores, *The Firebird* (1910) and *Petrushka* (1911), were both ballets based on Russian themes and were musically influenced by Debussy.

The Rite of Spring. The most spectacular of Stravinsky's early ballet scores was Le Sacre du Printemps

(*The Rite of Spring*) of 1913. *The Rite of Spring* broke new ground. The music was filled with harmonic shifts, rhythmic surprises, and melodic irregularities. The public was shocked by the near violence of the sound and by its disruption of their emotional expectations. It was a wholly new audience experience.

The origin of *The Rite of Spring* came to Stravinsky in a vision: "a solemn pagan rite: wise elders, seated in a circle, watch a young girl dance herself to death. They are sacrificing her to propitiate the god of spring." Stravinsky linked this vision to his childhood memories of the "violent Russian spring that seemed to begin in an hour and was like the whole earth cracking." The work depicts the fertility rites of a primitive tribe in pagan Russia. The first part, "The Fertility of the Earth," opens with a suggestion of the rebirth of spring. A bassoon solo begins the introductory section and is soon followed by other woodwinds, and then the brasses which play the melody, all without a home key, i.e. without a harmonic center. The music builds to a climax and then abruptly stops, leaving the solo bassoon to echo the introductory notes.

Without pause, a brief four-note theme repeated softly by the violins opens the second part, "The Sacrifice." Immediately comes the "Dance of the Youths and Maidens," in which Stravinsky builds intensity through the heavy use of percussion, sharply irregular rhythmic accents, and the shrill syncopation of the horns. All this is emphasized further by both polytonal harmonies and strong dissonance. Stravinsky's "Introduction" to *The Rite of Spring* can be seen to reflect the modern composer's new directions in melody and harmony, while "The Dance of the Youths and Maidens" displays a corresponding rhythmic freedom.

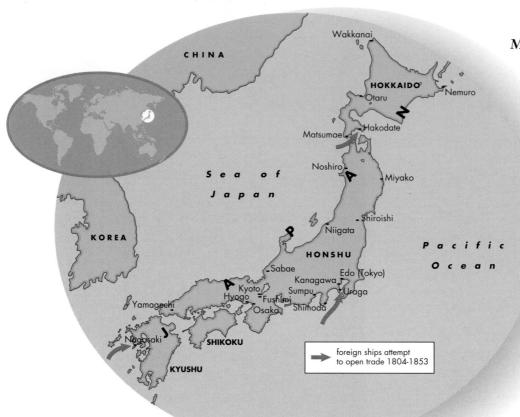

Map 19.1 Japan in 1853, when Commodore Perry reopened trade with the West.

CHINESE AND JAPANESE CIVILIZATIONS

CHAPTER 19

- Chinese Culture after the Thirteenth Century
- Japanese Culture after the Fifteenth Century

Hokusai Katsushika, *The Great Wave off Kanagawa*, ca. 1831, Honolulu Academy of Arts, Hawaii.

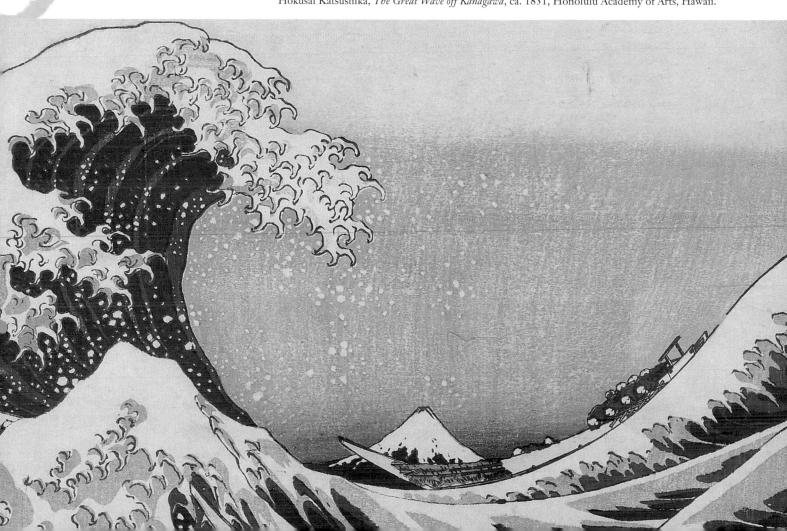

The last of the great medieval dynasties of China was the Yuan, a Mongol dynasty. In 1271, the Mongolian leader KUBLAI KHAN [koob-lie KON] (1214–1294), a grandson of Genghis Khan, adopted the Chinese dynastic name Yuan. By 1279 Kublai Khan had conquered the Southern Song and ruled from Beijing [bay-JHING] as emperor of China. He turned Beijing into a walled city and extended the Grand Canal to provision it. The Mongol ruling class kept the principal offices of governmental administration to themselves, appointing the Chinese only to the lowest posts. While the Mongols wanted to maintain their ethnic separateness during their rule, they nonetheless needed Chinese officials to maintain order, collect taxes, and settle disputes.

The period of Yuan rule was the shortest of China's major dynasties. A subtle and quiet resistance to the uneasy foreign occupation pervaded almost every aspect of Chinese life, including, for instance, its painting. *Bamboo* (fig. 19.1) by WU ZHEN [WOO JUN] (1280–1354), one of the Four Masters of the Yuan dynasty, is ostensibly a simple representation of the plant, but it had widely understood social significance. Bamboo, one of the strongest of materials and a symbol of survival, is like the Chinese under foreign rule: They might bend, but they would never break. Similarly, orchids, which nurture themselves without soil sur-

Figure 19.1 Wu Zhen, *Bamboo*, China, Yuan dynasty, 1350, album leaf, ink on paper, $16 \times 21^{\circ}$ (40.5×53.3 cm), National Palace Museum, Taipei, Taiwan. Despite Mongol rule, Wu Zhen worked in an intensely intellectual environment, dominated on the one hand by gatherings organized for the appreciation and criticism of poetry, calligraphy, painting, and wine, and, on the other, by deep interest in Buddhist and Taoist thought.

rounding their roots, are a commonly used symbol of Chinese culture in this period. Like the nation, the orchid could survive even though the native Chinese soil had been stolen by the Mongol invaders. In 1368, Zhu Yuanzhang drove the last Yuan emperor north into the deserts, declared himself the first emperor of the new Ming dynasty, and China was once again ruled by the Chinese.

The Ming (1368–1644) and Qing [CHING] (1644-1911), China's last dynasties, maintained the centralized bureaucratic political organization developed by the earlier Tang and Song dynasties. The Ming and Qing were remarkably alike in their continued reliance on Confucian ideals and in their high level of cultural achievement. The patriarchal nature of Confucian society (see Chapter 9) was evident at every level: the family, headed by the father, was the model unit. Politically, the emperor, as the Son of Heaven, was the father of the country. The magistrates, who carried out the rule of the emperor, also served as authority figures. The entire Ming-Qing system, one of unity and integration, benefited from the ability and commitment of its parental governing officials, who became known as mandarins, or counselors.

During the twentieth century China abandoned the tradition of imperial rule that had provided such social stability during the Qing period. First, Confucian ideals of governance began to be discarded. Then, with the overthrow of the Qing dynasty in 1911, came a period of political instability that lasted until the establishment of the Communist state in 1949.

Communism remains the dominant political system in contemporary China. Despite the tumultuous Cultural Revolution in the late 1960s—a period of upheaval in all aspects of Chinese culture and society—and despite the Tiananmen Square protests in 1989, which sought greater democratic liberties for the Chinese people, the Communist party has managed to maintain its political control.

LANDSCAPE PAINTING

Among the most important paintings created in China under the Ming dynasty were landscapes. Landscape painting of the Ming period has a close affinity with Chinese lyric poetry in its directness and expressive spontaneity. Ming landscape painters typically selected only essential details to include in their paintings. Their goal was to express an "inner rhythm and freedom" in their work's "spiritual content," as the seventeenth-century painter Wu Li put it.

Shen Zhou. This is particularly evident in the work of SHEN ZHOU [SHUN JOH] (1427–1509), who was less a professional artist than a gentleman scholar who, unlike a typical member of his social class, never held an

Figure 19.2 Shen Zhou, *Poet on a Mountaintop*, China, Ming dynasty, ca. 1500, album painting mounted as a handscroll, ink and color on paper, $15\frac{1}{4} \times 23\frac{3}{4}$ " (38.1 × 60.2 cm), Nelson Atkins Museum of Art, Kansas City, Missouri. Like much Chinese nature painting, this work portrays human beings as a small element within a large natural scene.

official government position. Described as a "poet of the brush," Shen Zhou was the founder of the Wu school, a group of amateur scholar-painters for whom painting was an intimate expression of personal feeling. (The name "Wu" derives from Wu-hsien, the Yangtze river delta where Shen Zhou and other painters lived and worked.)

Among Shen Zhou's most striking compositions is Poet on a Mountaintop (fig. 19.2), one of five album paintings mounted as a handscroll. Using black ink with a few touches of color, the artist balances white spaces (often simply blank sections) with bold strokes and spots of black, to define the forms of trees and to suggest the outline of vegetation. He sets off the poet and the mountain in the center against lighter surroundings—washes of soft color and white space. The poet, tiny and simply sketched, stands poised at the edge of a cliff, on an inclined plane, propped up by his walking staff. Tucked away on the right is a mountain pavilion, a part of the natural scene, which is used by inhabitants as a place of reflection to put themselves in tune with the natural surroundings. Unlike many of his predecessors, Shen Zhou does not attempt to portray nature in an especially beautiful fashion, nor render the natural scene in carefully drawn, realistic detail. Instead, his painting conveys a sense of nature's serene grandeur.

Qiu Ying. A Harp Player in a Pavilion (fig. 19.3) by QIU YING [CHEE-OO YING] (1494–1552) also expresses nature's magnificence, though with greater delicacy and refinement. Unlike Shen Zhou, Qiu Ying renders the scene in exquisite detail, from carefully drawn tree trunks with elegant branches, buds, and leaves, to the delicate pavilion and its miniature inhabitants.

Figure 19.3 Qiu Ying, A Harp Player in a Pavilion, China, Ming dynasty, sixteenth century, hanging scroll, ink and color on paper, height $35\frac{1}{8}$ " (89.2 cm), Museum of Fine Arts, Boston. Qiu Ying's elegant painting suggests that space extends from the foreground to the distant expansiveness of the background, without using the Western artists' linear and aerial perspective.

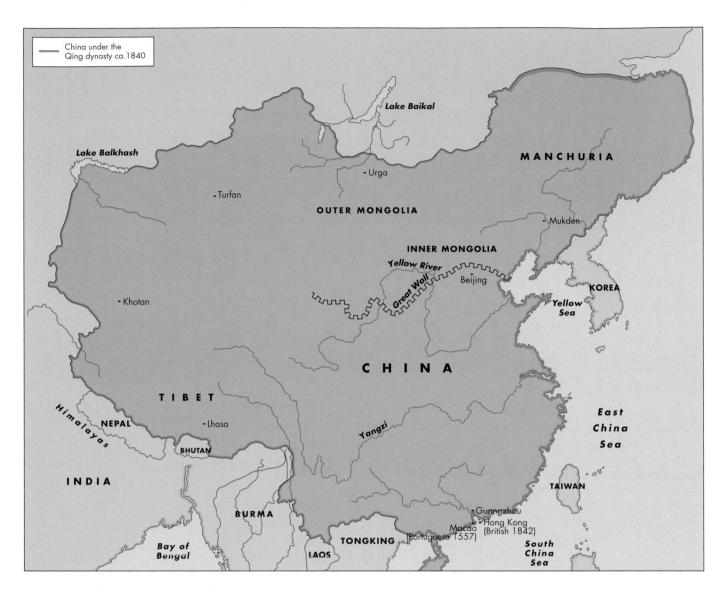

Map 19.2 China under the Qing Dynasty, ca. 1840.

Distance is suggested by the horizontal areas of whiteness in the foreground and background and the trees running diagonally from the lower center to the upper right. The mountains and the horizontal projections of land gently edging into the lake are freer in style, more suggestive than detailed. The inktones of Qiu Ying's A Harp Player in a Pavilion, softer and less dramatic than those of Poet on a Mountaintop, contribute to the overall effect of sensitivity and refinement.

ARCHITECTURE: CITY PLANNING

Architecture in traditional China signified the connection between the rule of the emperor and the order of the universe. Cities were constructed on a grid system, surrounded by a wall, which represented stability. The ruler's palace was generally situated at the north end, looking south, so that the emperor's back was turned

against the north from which evil (including the Mongol invaders) was always believed to come, and so that his gaze overlooked and protected the people, who lived in the city's southern half. The emperor looked down upon the city just as the Pole Star, from its permanent position in the north, looks down upon the cosmos. So long as the emperor fulfilled his function as the Son of Heaven, peace and harmony, it was believed, would be enjoyed by all.

Under the rule of the so-called Yongle Emperor (r. 1402–24), present-day Beijing was reconstructed as the imperial capital (fig. 19.4). Following traditional architectural plans, the principal buildings and gates of the government district, called the Imperial City, faced south, and almost all structures were arranged in a gridded square (fig. 19.5). The palace enclosure where the emperor and his court lived, called the Forbidden City, was approached through a series of gates: The Gate of

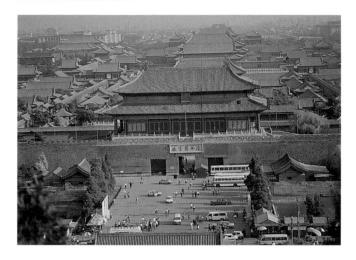

Figure 19.4 The Forbidden City, Beijing.

Heavenly Peace (called Tiananmen) is first, then the Noon Gate, which opens into a giant courtyard. Next, the Meridian Gate leads into the city's walled enclosure and opens out onto the first spacious courtyard, which has a waterway with five arched marble bridges. These bridges represent the five Confucian relationships as well as the five virtues (see Chapter 9). Past the bridges, high on a marble platform, stands the Gate of Supreme Harmony. Beyond the gate is the largest courtyard with three ceremonial halls. The most important is the Hall of Supreme Harmony, used for the emperor's audiences and special ceremonies.

With its series of interlocking gates and courtyards, its walled-in sections within larger walled-in areas, Beijing gives the visitor a rather different experience from Western cityscapes, which have open vistas with few walls and numerous opportunities to see up and down

Figure 19.5 Plan of the Imperial Palace, Beijing. Outside the palace enclosure is Tiananmen Square. 1 Gate of Divine Pride; 2 Pavilion of Earthly Peace; 3 Imperial Garden; 4 Palace of Earthly Tranquillity; 5 Hall of Union; 6 Palace of Heavenly Purity; 7 Gate of Heavenly Purity; 8 Hall of the Preservation of Harmony; 9 Hall of Perfect Harmony; 10 Hall of Supreme Harmony; 11 Gate of Supreme Harmony; 12 Meridian Gate; 13 Kitchens; 14 Gardens; 15 Former Imperial Printing House; 16 Flower Gate; 17 Palace of the Culture of the Mind; 18 Hall of the Worship of the Ancestors; 19 Pavilion of Arrows; 20 Imperial Library; 21 Palace of Culture; 22 Palace of Peace and Longevity; 23 Nine Dragon Screen.

Timeline 19.1 China after the thirteenth century.

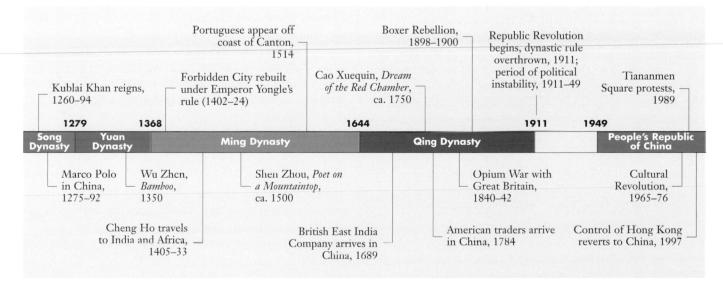

Then & Now

Hong Kong

The history of Hong Kong, the island city just off the coast of the Chinese mainland, has long been bound up with China's relations with the West. In the nineteenth century, the West began to pursue colonial ambitions in Asia, and the emperors of the declining Ming dynasty were forced to make trade and territorial concessions to encroaching Western powers. Defeated by Great Britain in the Opium War (1840-42), China ceded Hong Kong to Britain by the Treaty of Nanking (Nanjing) in 1842. In a renegotiated settlement in 1898, Hong Kong, along with two other local Chinese territories, was "leased" to Britain until 1997, when control of the city reverted to China.

With one of the greatest deep-water harbors in the world, Hong Kong has always been a trading center, in part because the land is unsuitable for agriculture and lacks minerals and other natural resources. Since the 1960s, Hong Kong has developed one of the most successful economies in Asia, outperforming those of some Western countries, including Great Britain. As Hong Kong's economic value has increased, the city has become a symbolic bone of contention between China and Britain. Although the countries share an interest in Hong Kong's stability and prosperity, they have contrasting visions of Hong Kong's purpose and management. For Britain, Hong Kong represented the crowning achievement of its global economic expansion. For China, Hong Kong stands as an economic catalyst for the rest of the country. Its peaceful return marks a step closer to the absorption of Taiwan, which Beijing considers a "renegade" province, into the People's Republic of China.

In 1984, an agreement between China and Britain called for the termination of British rule in Hong Kong

while maintaining its capitalist economy and democratic governmental structure until 2047. In 1997, with Hong Kong officially incorporated into the People's Republic of China, ostensibly it retains a social structure and democratic government elected by the people of Hong Kong. The jittery diplomacy surrounding the agreement has swerved around China's real intentions toward Hong Kong. These intentions have become increasingly suspect since the Tiananmen Square massacre in 1989, when government troops killed hundreds of peaceful protesters calling for greater political openness. Moreover, Beijing's control over the transitional governing council, and its increasing disregard for Hong Kong's democratic political culture, raise questions about the city's future as an engine of free economic enterprise. It remains to be seen whether, with its new political status, Hong Kong will sustain its economic vitality and global influence.

thoroughfares. An analogy can be made by comparing a Western landscape painting, which is seen in totality from a fixed perspective, to a Chinese landscape scroll, which must be viewed section by section as it is unrolled. In Chinese architecture and in such scrolls, the viewer experiences a series of discrete visual incidents, which only cumulatively provide an impression of totality.

LITERATURE

Traditional Poetry. Much of the poetry written during the Ming dynasty was used in other art forms such as drama, fiction, music, and painting. The calligraphy at the upper left of Shen Zhou's *Poet on a Mountaintop* is, in fact, a poem. Shen Zhou was not only an accomplished painter but a fine poet and, like one of Castiglione's "Renaissance men" and many of his fellow artists of the Yuan and Ming dynasties, was skilled at most if not all of the arts. Zhou's poem reads:

White clouds like a belt encircle the mountain's waist A stone ledge flying in space and the far thin road. I lean alone on my bramble staff and gazing contented into space

Wish the sounding torrent would answer to your flute.

Not only does the poem express an affinity for nature, it contrasts the speaker's isolation with the need for com-

panionship, the sound of the flute announcing the arrival of a lover or companion along the "far thin road" shrouded in mist. The comparison of the fog to a belt, furthermore, transforms the landscape into human terms. Removing the belt causes the landscape's hypothetical robe to fall open and reveal the beauty to the poet's eye, offering the promise of human intimacy and love—which the image on its own does not even begin to suggest.

Shen Zhou's poem continues a long tradition of Chinese poetry and fits comfortably into it. Almost all of the emperors themselves were poets, and some wrote vast quantities. For example, over 42,000 poems have been attributed to the emperor Qianlong (1736–1796). Although poetry continued to be written in the styles and forms of the great poets of previous centuries, it was prose fiction, evidenced especially by increasing amounts of literature focusing on the lives of urban merchants, servants, and petty officials, that was the most innovative development of the Qing dynasty.

Cao Xuequin's Dream of the Red Chamber. The most important work of Chinese literature written in the eighteenth century, considered by some the greatest Chinese novel ever written, is *The Dream of the Red Chamber* by CAO XUEQUIN [TSAO SOOEH-CHIN] (1715–1763). The novel is enormous, with 120 chapters.

The "red chamber" is where the female characters live, while the "dream" refers to the foretelling of the fates of these characters.

The Dream of the Red Chamber has been read as a story about the decline of a family, an allegory of Buddhist attitudes toward the world, and an autobiographical fiction adhering closely to the life of its author. It has also been considered a love story, a search for identity, and a quest for understanding the purpose of human existence. The book can be seen as a reflection of the many elements of mid-Qing elite life, including politics and religion, economics and aesthetics, love and family. Blending realism with dream and fantasy, *The Dream of the Red Chamber* has been hailed as one of the most revealing works ever written about Chinese civilization.

Modern Chinese Poetry. Although fiction and drama have long been a part of Chinese literary tradition, pride of place has always been accorded to poetry. Even when poets swerved away from refined classical Chinese and began to write in the modern vernacular, poets and poetry continued to command more respect than other literary genres. While working within an ancient Chinese poetic tradition, modern Chinese poets have experimented with free verse and with styles and forms that emerged in Europe during the nineteenth and twentieth centuries. Without directly imitating the literature of the Western world, modern Chinese writers absorbed Western influences to express contemporary Chinese cultural experiences, including the political circumstances of the age. Chairman MAO ZEDONG [ZAY-DUNG (1893-1976), the father of Chinese Communism, wrote a number of poems celebrating the revolutionary ideal. Also political, but in direct opposition to the established order of contemporary China, the poems of BEI DAO [BAY DOW] (b. 1949) repudiate the oppressiveness of a society that, if it does not execute its dissenters, jails them. The Tiananmen Square massacre of 1989 gives urgent meaning to the sentiments expressed in the poems by these and other contemporary Chinese poets.

MUSIC

Chinese Theater Music. From the fourteenth through to the seventeenth century, Chinese music was largely associated with drama, especially with a form of musical drama known as Hsi-wen, which included musical arias or lyrical songs, spoken dialogue, dance, and mime—all with instrumental accompaniment. Two different styles developed. There was a northern style, 'eichu, in which a pear-shaped lute (pi-pa) was the primary instrument for accompaniment, and singing was performed by one individual. In the southern style, ti, the transverse flute (dizi) was the primary instrument for accompaniment and nearly all the characters sang.

During the 1500s these two styles of musical drama merged in the Kun opera, which incorporated elaborate poetic texts and intricate plots with numerous scenes. Although Kun opera became a more or less elitist form of musical drama owing to its intricacy and complexity, it did have an influence on more popular forms of musical drama that developed in later centuries, including the Beijing opera (*Ching-hsi*), a nineteenth-century development.

Beijing Opera. Beijing opera has become one of the most popular musical forms of the twentieth century. Incorporating traditional styles of acting absorbed from the history of Chinese drama, Beijing opera possesses a distinctive liveliness, with colorful, fast-paced scenes based on ancient Chinese myths, legends, and fables.

The dramatic action of Beijing opera is highly stylized. There are, for example, twenty-six distinct ways to laugh and thirty-nine specific ways to manipulate the twenty different types of beards. The performers' roles are divided into four major categories: male (sheng), female (tan), painted male face (ching), and clown (ch'ou). The male and female roles, all performed by men, are subdivided into roles for old men and roles without beards for young men, such as the flirtatious female or the lady of propriety (fig. 19.6).

Figure 19.6. An actor from the Beijing opera performing as the heroine Mu Guiying. Mu Guiying is a popular character who comes from the Yang family of the eleventh century and is the most important of the women generals of the family—women who fought their enemies from the north.

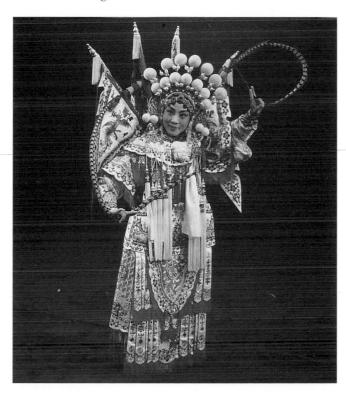

The music for Beijing opera is performed by an orchestra arranged in two sections: a percussion section composed of gongs and drums, and a melodic section of strings and wind instruments. The percussion instruments play introductory music prior to the characters' entrances; they are also played between the singing and acting. The melodic instruments accompany the singing. While the melodies for the Beijing opera arias derive from traditional music, there is often originality in their embellishment.

With the founding of the Communist People's Republic of China in 1949, Chinese music was directed toward social revolutionary purposes. Mao Zedong conscripted all the arts, remarking that they "operate as powerful weapons in unifying and educating the people and for attacking and destroying the enemy." Mao introduced two influential artistic directives: (1) a return to folk tradition and (2) an emphasis on political ideals and content in music. From 1966 to 1969, at the height of the Cultural Revolution, the only opera performances permitted in China were eight revolutionary works deemed pure of the taint of "bourgeois" ideas and influences.

In the late twentieth century the necessity for such strict adherence to political ideology for musical composition and performance has diminished. Although revolutionary themes dominate many modern Chinese musical works, Western influences, instruments, and performance practices are now apparent.

Japanese Culture after the Fifteenth Century

Toward the end of over a century of feudal warfare, known as the Warring States period (1477–1600), TOKUGAWA IEYASU [TOH-KOO-GAH-WAH] (1542-1616) became the first shogun, or ruler, of post-feudal Japan. The Tokugawa family was to rule the country from 1600 until 1868. The shogun retained a figurehead emperor in Kyoto, while making Edo (present-day Tokyo) the effective capital of the country. Confucian influence was strong. Society was ordered into classes of ruler-warriors, or samurai, farmers, artisans, and merchants, who rose in power and importance during the period. The Tokugawa shogunate both unified the country and isolated it from the outside world. Only the Dutch were permitted to trade with Japanese merchants, and it was through Dutch traders that Japan was apprised of developments in the West, all the while preserving Japan's distinctive national culture and identity immune to outside influence.

In 1868 Japan returned to rule by an emperor, inaugurating a period known as the Meiji era (1868–1912), during which it enjoyed rapid economic development

and a growth in national power. After the American military expedition led by Commodore Perry forced the Tokugawa regime to open its trade doors in the 1850s, Japan began to look to the West, instead of to China, in its effort to transform itself into a modern nation-state. Japan adopted a constitution modeled on that of Germany; it eliminated the power of the shogunate, the warlord samurai, and their local vassals; and it began programs of industrialization and universal education.

Japan also began to exert its influence throughout the western Pacific. Through its victory in the war with China of 1894–95, it acquired the island of Taiwan (then called Formosa) and gained influence over Korea. After its triumph in the Russo-Japanese War (1904–05) and its alliance with the victorious nations in World War I, Japan colonized Korea and parts of the Chinese mainland. When Japan had to face the defeat of World War II, it turned to economic rather than military means to achieve international power and influence.

THE SHINTO REVIVAL

With the rise of the Tokugawa dynasty, Shinto was resurrected as a state religion. **Shinto**, which literally means "the way of the gods," is a belief system indigenous to Japan and that involves rituals and venerations of local deities, known as *kami*. In its most general sense, Shinto is a "religion" of Japanese patriotism. Less a system of doctrines than a reverential attitude toward things Japanese, Shinto emphasizes the beauty of the Japanese landscape, especially its mountain regions, and views the Japanese land and people as superior to all others.

Accompanying the revival of Shinto was the rise of the feudal knight, or samurai, who was idealized as a native hero. Much like the medieval knight of Christendom, the samurai was held to a strict code of conduct that emphasized loyalty, self-sacrifice, and honor. The rejuvenation of Shinto and of the samurai reflected an intense Japanese ethnocentrism and contributed to the isolationism of the Tokugawa dynasty.

LANDSCAPE PAINTING

The respect for the land that distinguishes the Shinto religion was anticipated in landscape painting of the Muromachi period (1392–1568), which shows reverence for the grace and grandeur of nature and the humble place of human beings within it. Japanese painting suggests less a naturalistically rendered scene than an extension of unseen vistas beyond the explicitly depicted view. This pictorial tradition characterizes the Zen ideal of "capturing the principle of things as they move on."

Of Japanese Muromachi artists, the priest-painter SESSHU [SES-SHU] (1420–1506), more than anyone

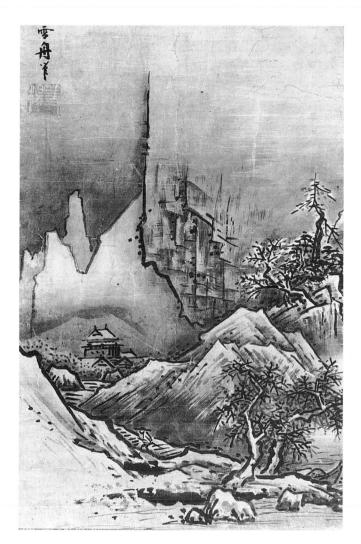

Figure 19.7 Sesshu, *Winter Landscape*, Japan, Ashikaga period, ca. 1470s, hanging scroll, ink and slight color on paper, $18\frac{1}{4} \times 11\frac{1}{2}$ " (46.3 × 29.3 cm), Tokyo National Museum, Tokyo. The harshness of the pictorial style, seen in this unsentimental representation of a wintry world, is characteristic of Sesshu.

else, took Chinese ink-style painting and made it Japanese. In 1467–69 he traveled to China, where examples of landscape painting greatly influenced his work. However, Sesshu was to put a distinctive, Zen-like mark upon the tradition.

His Winter Landscape (fig. 19.7), one of four seasons Sesshu painted on a scroll entitled Landscape of the Four Seasons, suggests the varied moods the seasons inspire. In the Winter Landscape, the most austere of the four seasonal evocations, Sesshu employs bold brushstrokes and diagonal lines to suggest the power of winter. He leaves patches of paper blank to signify snow and to depict the season's starkness. In striking contrasts of black and white, the painting's outlines convey a cold strength.

Scsshu's landscape scrolls possess some of the boldness of his Chinese contemporary, Shen Zhou. Sesshu's work,

however, reveals an emphasis on strong lines. His extended vistas are consistently subordinated to the visual drama and experience, reflecting the importance of the Zen qualities of immediate apprehension and intuitive understanding.

WOODBLOCK PRINTS

During the seventeenth and eighteenth centuries, a style of art called *ukiyo-e* arose, which became especially associated with woodblock prints. *Ukiyo* means "floating world" in the Buddhist sense of "transient" or "evanescent," and *ukiyo-e* means "pictures of the floating world." The Impressionist painters of nineteenth-century Europe admired *ukiyo-e* prints enormously because, like them, the Japanese artist was concerned with the world of everyday life, particularly of cultural enjoyments, such as dance, theater, music, and games.

Prior to the seventeenth century, woodblock prints were used almost exclusively to illustrate textbooks, painting manuals, and religious works. With the increased interest in everyday life shown during the Tokugawa period, woodblock prints that depicted things of interest to various social classes began to appear. Moreover, prints were inexpensive enough to be afforded by ordinary people.

New techniques for color reproduction were soon discovered. With their increasing range of subjects, these color woodblock prints became enormously popular. Between the mid-eighteenth and mid-nineteenth century, color woodblock prints represented all facets of existence from the lives of the wealthy to the beautiful courtesans of the Yoshiwara, or pleasure district, of Tokyo. In addition, artists turned their attention to the Japanese landscape, providing fresh interpretations of nature.

Woodblock prints were also closely linked with the world of the Kabuki theater, which had a large and enthusiastic audience. Prints of Kabuki actors were popular, as were posters and programs featuring the actors in various Kabuki roles. In fact, print publishers would frequently book seats so their artists could create up-to-date images of the actors to sell during the run of a play. Actors often obliged the artists by striking formal poses that were suited to the stylized prints.

Utamaro Kitagawa. Of the artists producing woodblock prints for popular consumption, UTAMARO KITAGAWA [OO-TAH-MAH-ROH] (1753–1806) is among the best known. Utamaro portrayed women so beautifully that he is generally recognized as the greatest among the Japanese artists. Utamaro's elegant, willowy, and languorous women are typically rendered in full-length portraits characterized by delicacy and refinement. II is most famous work, published in 1794, is Ten Physiognomic Types of Women, in which Utamaro used

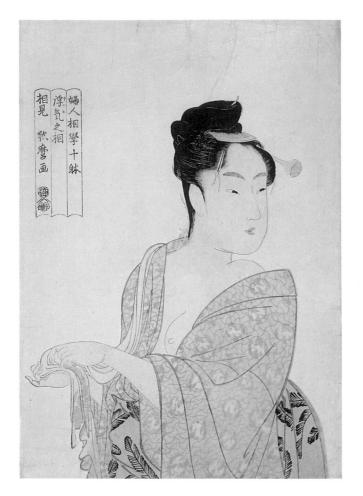

Figure 19.8 Utamaro Kitagawa, A Beautiful Lady Dressed in Kimono, Japan, Tokugawa period, 1794, polychrome woodblock print, $14\frac{3}{4} \times 9\frac{1}{2}''$ (37.9 × 24.4 cm), British Museum, London. This print shows the "coquette," a type from Utamaro's Ten Physiognomic Types of Women, one of a number of print series popular among Japanese urbanites in the late eighteenth century.

tinted mica backgrounds to enhance the decorative quality of his portraits. One of the full-color woodblock prints, *Bust of a Beautiful Lady Dressed in Kimono* (fig. 19.8), shows a woman's exposed white skin set off against the color and intricate design of her clothing. The slightly turned position of her head and torso add visual drama without disrupting the elegance of her posture.

Hokusai Katsushika. HOKUSAI KATSUSHIKA [HOK-KOO-SAI] (1760–1849), along with his contemporary Hiroshige Ando (1797–1858), represents the artistic culmination of the Japanese woodblock print. Both preferred landscapes to portraits, and both created a multitude of designs and a vast number of prints, which were produced in large editions. Hokusai created some of his finest works after he was over seventy, including his popular series *Thirty-Six Views of Mount Fuji*, which reveals his astonishing imagination. Hokusai's unusual

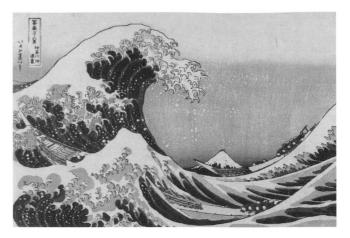

Figure 19.9 Hokusai Katsushika, *The Great Wave off Kanagawa*, Japan, Tokugawa period, ca. 1831, from *Thirty-Six Views of Mount Fuji*, polychrome woodblock print, $9\frac{7}{8} \times 14\frac{5}{8}"$ (25.5 × 37.1 cm), Honolulu Academy of Arts, Honolulu, Hawaii. Among the best known of all Japanese woodblock prints, this image, an icon representing Japan, contrasts the powerful energy of the ocean's waves with the stable serenity of the distant snow-capped mountain in the background.

perspectives provide a visual counterpart to the unexpected encountered in haiku, as in his *The Great Wave off Kanagawa* (fig. 19.9). What is remarkable here is the odd view of Fuji, a symbol for the Japanese of the enduring beauty and stability of the nation itself. Though almost centered in the print, Fuji is dwarfed by the giant wave, which threatens to crash on the boat beneath it. In essence, Hokusai contrasts the transience of everyday existence, the fragility of life itself, to the more enduring, even eternal qualities of Fuji.

ARCHITECTURE

Architectural styles in Japan from the Muromachi to the Tokugawa period differed from those of previous eras and from one another as well. During the Muromachi period, the Ashikaga shoguns attempted to fuse styles inherited from their predecessors. During the next era, the Momoyama era, secular architecture became increasingly grandiose and elaborate. This architectural exuberance was tempered during the next period, the Tokugawa, with a more restrained aesthetic.

The Temple of the Golden Pavilion (Kinkakuji). One of the most interesting and elegant buildings constructed during the Muromachi period was the Kyoto landmark, Kinkakuji or the "Temple of the Golden Pavilion" (fig. 19.10). Erected in 1397 under the shogun Yoshimitsu (1358–1408), the Golden Pavilion, so named because parts of the interior are covered with gold leaf, was originally a private chapel designed for Yoshimitsu's use at his villa in Kyoto. After his death, it was convert-

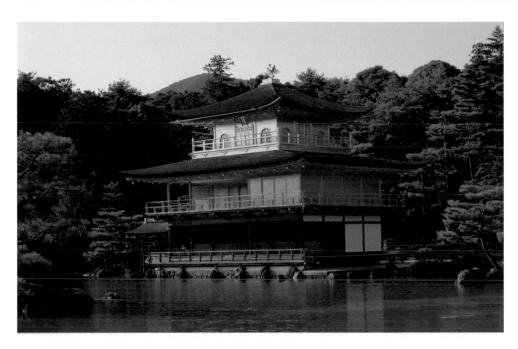

Figure 19.10 The Temple of the Golden Pavilion (Kinkakuji), Kyoto, Japan, Muromachi period, 1397. The building was constructed for the shogun as a retreat and was converted to a temple after his retirement.

ed into a Buddhist temple and monastery, containing a Zen chapel and rooms for contemplating the landscape and the moon. Its three stories culminate in a curving Chinese-pyramidal and Japanese-shingled roof. The pavilion is set on a platform constructed to jut out into a pond surrounded by trees carefully planted to create a look of natural profusion and variety. The structure seems simultaneously set off from and set into the landscape in a harmonious blending of nature and civilization. The overall effect is one of spontaneous simplicity.

Figure 19.11 Himeji Castle, Hyogo (near Osaka), Japan, Momoyama period (1581–1609). Popularly known as White Heron Castle, Himeji was built as a fortress by powerful Japanese warlords.

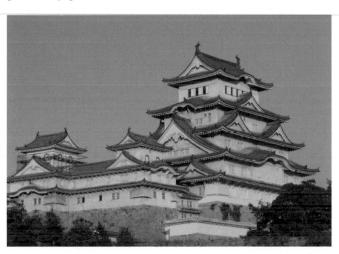

Himeji Castle. In contrast to the elegant simplicity of Muromachi domestic architecture, as illustrated by the Golden Pavilion, was the development of military architecture in the Momoyama period. In earlier military fortresses, the living quarters of the daimyo, or lord, were separated from the defensive fortifications. During the Momoyama, home and fortifications were combined into a single massive edifice designed to discourage attack. The interior was richly decorated to impress visitors with its owner's wealth.

An outstanding example is Himeji Castle (fig. 19.11), begun by the shogun Hideyoshi in 1581 and enlarged and completed in 1609. The exterior of the castle's main building is constructed of massive masonry, made necessary by the introduction of Western firearms and canons. The castle rises from a moat below, with towers soaring fifty to sixty feet above the water. Atop this impregnable masonry foundation sits a four-story wooden structure reminiscent of temple architecture.

THE JAPANESE GARDEN

The Japanese garden is essentially landscape architecture. Aesthetically, it is tied to Japanese painting. Many Muromachi gardens were designed by prominent painters, including Sesshu, who shaped the raw materials of nature to appear like a carefully inked canvas or scroll. Gardens such as these were designed for contemplation rather than for meandering. With its neatly raked patterns of sand and carefully positioned shrubs and stones, the typical Japanese garden is conducive to meditation.

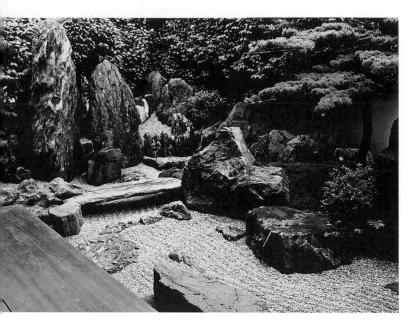

Figure 19.12 Attributed to Kagaku Soku, Garden of the Daisen-in monastery, Daitokuji temple, Kyoto, Japan, sixteenth century. Although used primarily for meditation, this garden served also as a place of assembly for Zen priests and samurai to compose *renga*, linked verses of poetry composed communally.

Gardens might also be carved out of nature in the manner of the large glen surrounding the Golden Pavilion of Kinkakuji. Or a garden might be designed with dry sand, which was used to suggest water, and punctuated by "islands" of trees, shrubs, and flowering plants.

Other types of Japanese gardens include moss and Zen-inspired gardens, which present nature in microcosm. One of the most famous of the Zen-inspired gardens is the Daisen-in monastery garden (fig. 19.12) in Kyoto, designed by the painter Soami (d. 1525). This 1100-square-foot garden lies alongside the priest's house. Its vertical rocks represent cliffs, while horizontal stones represent embankments and bridges. The trees in the background symbolize distant mountains.

Larger, more elaborate landscape gardens include bridges and pagodas as well as plants. The landscape designs are meant to evoke the essence of the Japanese landscape as well as to follow representations of nature in Japanese art. As a result, the gardens reflect Japanese cultural aesthetics, including balance, proportion, unity, scale, and harmony.

LITERATURE

Prior to 1600, literature in Japan had been aristocratic in focus, written about court figures for a court audience by authors from among the nobility. After 1600, literature, especially fiction, contained more popular subject matter and it was produced by writers from a wider social spectrum.

Saikaku Ihara. While Murasaki's twelfth-century The Tale of Genji (see Chapter 9) is generally considered the first great Japanese novel, high regard is also accorded the novels of SAIKAKU IHARA [SIGH-KAY-KOO] (1642–1693), especially his The Life of an Amorous Man, The Life of an Amorous Woman, and Five Women Who Loved Love. Earlier adventure novels had explored sexuality in ways that became culturally accepted, but Saikaku's inventive technical experiments with style and

Timeline 19.2 Japan after the fourteenth century.

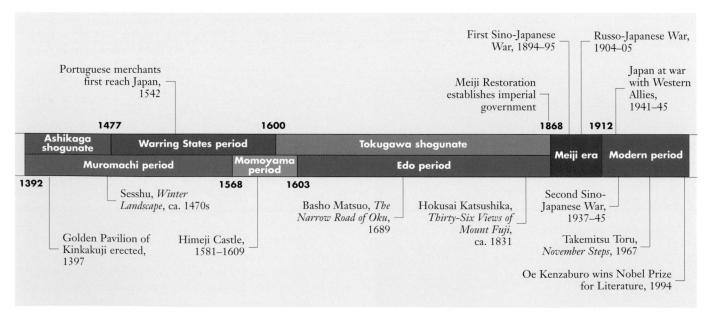

Cross Currents

EAST MEETS WEST: TAKEMITSU TORU

Of contemporary Japanese composers, among the best known in the West is TAKEMITSU TORU [TAII-KEY-MET-SOO] (1930–1996). Takemitsu wrote for film and television as well as for the concert hall. His concert works include symphonic orchestral pieces, compositions for chamber orchestras, and works for voices. Takemitsu scores his orchestral works for Western

instruments and traditional Japanese instruments, such as the *biwa* and the *shakuhachi*.

Takemitsu became known in the West through Igor Stravinsky (see Chapter 18), who championed his work, and Aaron Copland (see Chapter 21), who considered him "one of the outstanding composers of our time." Serving as a bridge between East and West, Takemitsu brought works by Japanese composers to the attention of Western performers and introduced

Western musical innovations to Japan. He was also instrumental in organizing cultural exchanges between Japan and the US. Takemitsu enriched his harmonic palette through the influence of French Impressionist composers such as Debussy. He also found inspiration for his music in nature, at one time describing himself as "a gardener of music," a title that reflects his interest in the combination of natural beauty and cultured formality that is typical of Japanese landscape gardens.

point of view in these novels were largely responsible for the legitimation of the subject matter.

Five Women Who Loved Love remains Saikaku's most highly regarded book today. By exploring the desires of his five female protagonists, Saikaku suggests their kinship with the courtesans of earlier Japanese literature. His merchant wives experience the same passions as the courtesans, but they are more willing to sacrifice everything for love, even their lives. Though modeled on actual people, Saikaku's five heroines are not as highly individualized or psychologically complex as characters from nineteenth-century European novels, such as Flaubert's Emma Bovary or Tolstoy's Anna Karenina. Saikaku's characters, however, are engaging figures, whose actions anticipate the behavior of more modern Japanese fictional heroines.

The Haiku. Haiku are three-line poems consisting of a total of seventeen syllables in a pattern of 5, 7, and 5 syllables per line. Of all forms of Japanese poetry, it has long been the most popular and the most heavily practiced in Japan. It is also the poetic form most influential in the West. The essence of good haiku poetry is a momentary, implicitly spiritual insight presented through images and without explicit comment. According to conventions established in the seventeenth century, the haiku must have imagery from nature, must include reference to a season, and must avoid rhyme. The haiku poet attempts to create an emotional response in the reader by penetrating to the heart of the poem's subject, thus evoking in the reader a sudden moment of Zen-like awareness.

Basho Matsuo. It was with the poems of BASHO MATSUO [BAH-SHOH] (1644–1694), who served the local lord as a samurai, that haiku reached its greatest artistic heights. Strongly influenced by the Tang poets Du Fu and Li Bai (see Chapter 4), Basho took from his Chinese predecessors their austerity and loneliness, while

also absorbing their sense of humor. His poems, like theirs, convey an enjoyment of life while expressing regret at life's impermanence.

His desire to distance himself from other forms of haiku popular in his day led Basho to develop his own distinctive style, one that reflected the realities of every-day living while suggesting spiritual depths and intellectual insights. Humor is readily apparent in this haiku, written on a journey Basho made in 1689. On the road he saw a monkey caught in a sudden rainshower, and moved by its evident distress, he composed the following:

hatsushigure saru mo komino wo hoshige nari First rain of winter—
The monkey too seems to want
A little straw raincoat.

Even in this humorous vision, we can detect Basho's profound sense of what the Latin poet Virgil called "the tears of things." When Basho was ill and approaching death, he composed the following haiku, which evokes his sense of loneliness, sadness, and pain:

tabi ni yande yume wa kareno wo kakemeguru Sick on a journey, My dreams wander the withered fields.

The last Basho ever wrote, this haiku was given the title "Composed in Illness" by the poet. Providing a title was highly unusual; Basho knew the severity of his illness. He used the image of the journey both literally, for he became ill while traveling, and metaphorically, for the journey of life. His wandering dreams indicate a mind at work, though one weakened and unfocused. The final word *kakemeguru*, translated here as "withered fields," brings home with precision and elegance the inevitable fact of his dying.

Modern Fiction. Modern Japanese literature is traditionally dated from the beginning of the reign of the Meiji emperor in 1868. During the Meiji era

Connections

Bunraku: Japanese Puppet Theater

Although puppets were used in Japanese ceremonies and festivals as early as the eleventh century, it was during the Tokugawa period that the puppet theater, or **Bunraku**, developed and flourished. The texts of Bunraku plays were more distinguished than those of Kabuki, with the best of them composed by CHIKAMATSU MONZAEMON [CHICK-A-MAHT-SU] (1653–1724), who is considered by many the greatest Japanese dramatist. Written in poetic language, Chikamatsu's

Bunraku plays had a narrator and were accompanied by a *samisen* player, both of whom typically sit on a dais set off to the side of the stage. Unlike Kabuki actors, who are the main attraction for a Kabuki audience, the puppeteers, the *samisen* accompanist, and the narrator are all self-effacing. Their job is not to impress the audience and win applause, but rather to bring the play to the audience in such a way that they are all but forgotten while the audience concentrates on the action of the puppets and the language of the play.

In its reliance upon the rhythmic pacing of the stringed *samisen* and the

narrator's chanting, Bunraku can be compared with the earliest Greek dramas, in which a single actor-speaker recounts tales from the ancient myths and legends. In Bunraku the narrator is the voice of all the puppets, whose strings are controlled by three puppetmasters dressed in black. Like their ancient Greek counterparts, the early Bunraku plays celebrate ancient tales of Japanese culture, stories from The Tale of Genji (see Chapter 9), for example. Chikamatsu shifted the grounds of Bunraku from an emphasis on heroic stories of the past to situations involving ordinary people in his own time.

(1868–1912) a number of Westernizing reforms were introduced into Japanese economic, social, educational, and cultural life. Literacy was increasing dramatically, and writers began to use colloquial Japanese rather than the language of classical Japan. These changes, which parallel those in China at the turn of the twentieth century, inaugurated a period of modern fiction that is recognized the world over for its elegance, subtlety, and grace.

The fiction of modern Japan reflects a strong concern with identity, both cultural and individual. Prizing conformity and group identity; Japan has always struggled with the Western emphasis on the autonomy of the individual self. As the country became less isolated in the twentieth century, Japanese writers began to explore the tension between traditional Japanese cultural norms and Western practices, and their works reflect an active engagement with Western cultural ideals.

One novelist to explore themes of cultural and personal identity is TANIZAKI JUN'ICHIRO [TAH-NEE-ZAH-KEE] (1886–1965). Depicting Japan's changing cultural terrain, his work examines the consequences individuals face when set free from cultural constraints to pursue personal ambitions and desires. Many of Tanizaki's characters live like the modern Japanese, and the results of their self-assertion and self-aggrandizement revolve around guilt and alienation: guilt for abandoning long-valued cultural norms and alienation as a result of being cut off from the solidarity of the group.

THEATER

There are two primary types of Japanese music for theater: Noh and Kabuki. Each is a distinctive form of Japanese theater, with different musical conventions. Noh drama was developed in the fifteenth century; Kabuki theater emerged in the seventeenth century.

Noh. Noh, which means literally "an accomplishment," consists of dialogue and songs sung by the main actors in addition to music sung by a *ji*, or chorus. The instruments used to accompany the singing are collectively referred to as the *hayashi*. The hayashi ensemble consists of a *nokan*, or flute, an *o-tsuzumi*, a type of hourglass drum held on the hip, a *ko-tsuzumi*, a shoulder drum, and a *taiko*, or stick drum on a stand. During the entire time actors perform a Noh drama, the musicians of the *hayashi* remain on stage, their musical actions choreographed as part of the drama alongside the words and gestures of the actors.

The Noh is distinguished from other forms of drama by its solemnity. Even happier moments are performed with a seriousness and gravity that make them sound almost funereal. Originally, Noh plays were performed by Shinto priests to placate the gods. Later, from the fourteenth through to the seventeenth century, the plays were performed by professional actors wearing masks, one of the genre's distinguishing features. The limited plot action, the highly poetic texts, and the understated stylized gestures differentiate Noh plays from the realistic plays of Western theater.

Kabuki. During the first year of the Tokugawa shogunate a type of theater that includes song and dance was performed in Kyoto. Kabuki, originally, were short dramatic dances accompanied by song and percussion that celebrated the exploits of heroes, especially the samurai. During the eighteenth century, however, with the Kabuki works of Chikamatsu, Japanese theater

developed a repertoire of plays based on the daily lives of peasants and merchants. Unlike Noh drama, which looked back to the glories of the Middle Ages, Kabuki focused on the present. In contrast to the solemnity and decorum of Noh drama, Kabuki performances were melodramatic and suggestive of the seductive charms of the actors and actresses. Developed in response to the needs of an urban audience, Kabuki includes popular drama along with various types of dance and music, some of which are performed onstage and some offstage.

CONTEMPORARY MUSIC

Oe Hikari. The story of the contemporary composer OE HIKARI [OH-AY HEE-KAH-REE] (b. 1963), son of the Nobel Laureate for Literature in 1994, Oe Kenzaburo, is one of the more unusual accounts of the making of an artist. Oe Hikari was born with an abnormal growth on his brain that threatened his life. Against the advice of doctors, his parents decided to have the

growth removed, even though part of Hikari's brain had to be sacrificed. The surgery saved his life, but left him severely brain-damaged, which made it difficult for him to communicate using language. He did not make a sound until the age of six, when he responded to bird calls in the wild by imitating them perfectly, an early indication that he possessed an unusual aural imagination. Only then did his parents realize that he had memorized more than seventy distinctive bird calls from a recording given to him at the age of four.

Although Oe's verbal language remains limited, his imagination has allowed him to compose music, beginning after some piano lessons at the age of eleven. His work displays an instinctive appreciation of melody and an inclination toward the harmonic traditions of Western music from the seventeenth through the nineteenth century. Oe's music is deeply indebted to the musical styles of Bach, Mozart, and Chopin. Most of his compositions are brief and lyrical, conveying sorrow and joy, serenity and exuberance.

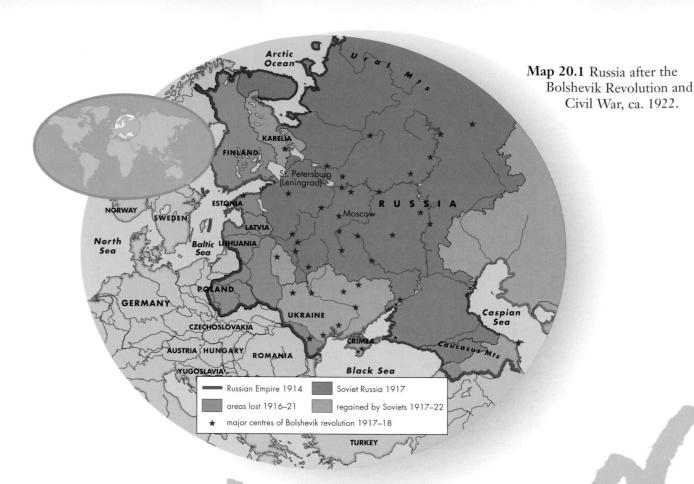

Russian Civilization

CHAPTER 20

- * Russia before the Revolution
- ← The Revolution and After

View of the Kremlin churches, Moscow.

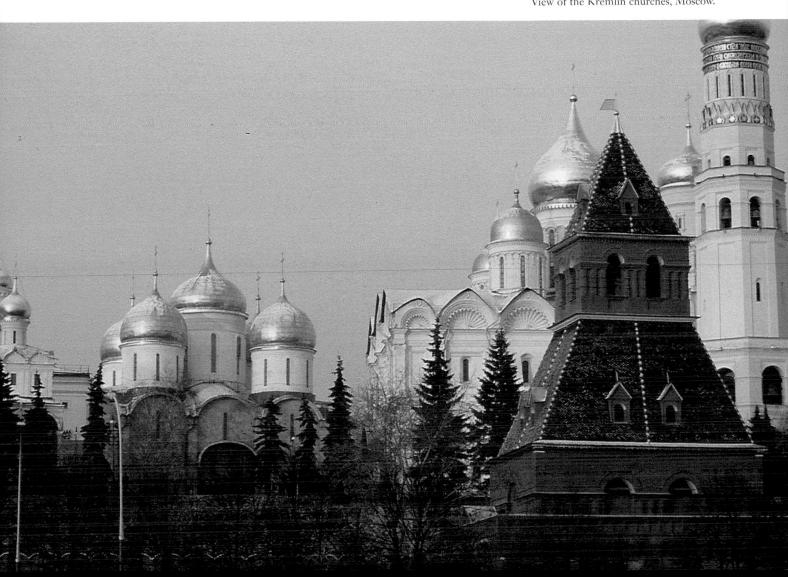

Russia before the Revolution

Russia, prior to the Revolution of 1917, was characterized by a solid autocratic government, a strong influence from the Russian Orthodox Church, and ambiguous relations with the West. Since IVAN IV (1533-1584), had named himself "Tsar" ("Caesar") at his coronation in 1547, the Moscow Grand Princes had exercised such complete authority that no person or institution could challenge them. Known as "Ivan the Terrible," he initiated a tradition of despotic rule that many historians have regarded as the root of Communist totalitarianism in the twentieth century. Russia remained the most repressive society in Europe until 1861, when Tsar Alexander II abolished serfdom. Long after the rest of its European neighbors, it had remained a feudal society, in which a small number of wealthy and titled landlords owned the land worked by peasant farmers whose servitude amounted to little more than slavery. Most rarely saw their master, let alone a government official. It was only the Church that brought Russians together as a society.

THE EASTERN ORTHODOX CHURCH

In providing a foundation of belief and establishing forms of artistic expression, Eastern Orthodox Christianity was responsible almost exclusively for the early development of a distinctively Russian culture. The conversion of Russia to Christianity began in the ninth century through the efforts of two Greek brothers from the Byzantine Empire, Cyril (d. 869), a renowned scholar, and Methodius (d. 884), an administrator, both of

whom served as missionaries among the Slavic peoples in Moravia, Bulgaria, and the land that was then known as Rus, which had Kiev as its capital. They transcribed the Bible into the Cyrillic alphabet and translated other religious texts into Slavic, which resulted in Church Slavonic becoming not only the language of Christian liturgy throughout Russia but also the primary written language for seven hundred years, much as had Latin in the west.

For Russians, religion centered on community, with wealthy nobles worshiping together with their peasant serfs during Orthodox services. Orthodox priests, who were considered as representatives of God, moved comfortably among the people. This communal quality of Russian Christianity, however, did not detract from the sense of the sacred that separated the earthly world of humanity from the heavenly kingdom of the divine.

Religious Icons. From the beginning, Russian art was firmly grounded in the Eastern Orthodox religion. However, it was the aesthetic appeal of the liturgy and rituals, rather than the theology, that inspired and attracted early Russians. The power of Orthodox Christianity was seen as historically inevitable and divinely sanctioned to endure until the end of time. Moscow, they believed, would be the "Third Rome." Grand Prince Vasily III (1505–1533) argued that just as Ancient Rome had been the center of its world, and Constantinople had next become the "New Rome," so Moscow would finally ascend to preeminence, as the last great Rome, after which the Last Judgement would ensue.

Russia was unified by its acceptance of a common religious faith with established forms of worship, especially of those artistic objects invested with deep spiritual significance. These objects, very often depicting the Virgin

Timeline 20.1 Russia before the Revolution.

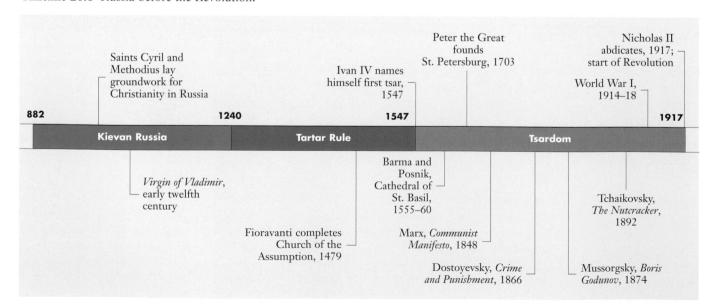

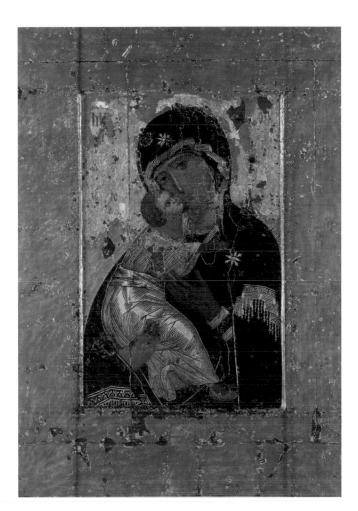

Figure 20.1 Virgin of Vladimir, early twelfth century, tempera on wood, height approx. 31" (78 cm), Tretyakov Gallery, Moscow. This painting is the most revered of all Russian religious icons and was thought to have the power to protect the town that possessed it.

Mary, are known as **religious icons**. Found not only in small churches and great cathedrals, but also in the homes of ordinary people from all social ranks, icons were usually small images painted on wood. They were a common and popular way to remind people of the essential qualities of Christianity as reflected in the lives of the saints and found in stories from Scripture. Icons were used, therefore, as much for teaching as for devotion and prayer.

In Russian Orthodox churches, statues representing God and the saints were forbidden, but icons were permitted to take their place. Depicted on icons are not only figures from the Bible—patriarchs and apostles, for example—but also the early Church Fathers, including St. Cyril and St. Methodius. Panels of these icons separate the priests from the congregation, forming an iconostasis, or icon screen. The screen contains three doors, the central one of which—the "Royal Door"—opens and closes during religious services.

Virgin of Vladimir. One of the most enduring of all icons is known as the Virgin of Vladimir (fig. 20.1). An image of the Virgin Mary, this twelfth-century picture was created in Constantinople but was moved first to Kiev, then to Vladimir, and finally, in the fifteenth century, to the Cathedral of the Assumption in the Kremlin, where it has long been revered as a symbol of national unity. A particularly expressive work, the Virgin of Vladimir soon came to be known as "Our Lady of Tenderness," due to the tilt of the Virgin's head toward the child, the lightness of her supporting hands, and her sweetly sorrowful countenance. Like other Russian icons, the Virgin of Vladimir possesses a two-dimensionality that distinguishes it from traditional Western art. So highly regarded was this piece that it was often followed in procession during religious festivals, and frequently used to bless military troops preparing for battle.

ST. PETERSBURG

The influence of Western Europe on Russian society precipitated a struggle between those in favor of the country's Westernization and the Slavophiles, who argued for a pure traditional Russia. At the center of this debate was the majestic city of St. Petersburg, created by Tsar Peter the Great in the early eighteenth century (fig. 20.2).

Figure 20.2 View of St. Petersburg. So many laborers died constructing the city that it is believed their bones, three hundred years later, still infest the waters surrounding it.

Peter moved the capital from Moscow in the east to an island in a swamp in the extreme northwest of the country, not far from Finland and Sweden, both historic enemies of Russia. He built his new city to provide "a window on Europe," a plan unsurpassed in its revolutionary brashness, given Moscow's definition of itself as the "Third Rome." Peter himself traveled throughout Western Europe and brought back to Russia plans for municipal design and for manufacturing based on Western ideas and techniques. He sent young noblemen, to England in particular, to study navigation and shipbuilding, in order that he could construct a commanding naval fleet.

St. Petersburg was a modern city, on a par with London and Amsterdam. It had canals like Amsterdam, wide boulevards like Paris, a grid-like organization, and formal gardens with fountains like Versailles, planted with flowers and trees from Germany and Holland, as well as from throughout Russia. As a city, however, St. Petersburg never captured the Russian imagination in the way that Moscow did. In *Crime and Punishment*, Dostoevsky's hero, Raskolnikov, stands on a bridge overlooking the city and we learn of his feelings, shared by most Russians, toward the place: "When he was walking to the University it would usually happen, most often on

Figure 20.3 Aristotele Fioravanti, Church of the Assumption, 1479, Kremlin, Moscow. In this first Kremlin church, Russian tsars held their coronations.

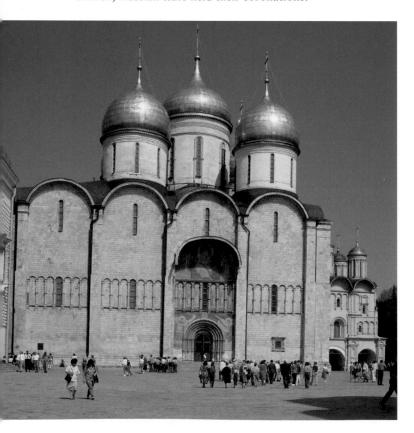

Figure 20.4 Cathedral of the Annunciation, 1484–89, Kremlin, Moscow. A favorite of rulers and their families, this church was used for the baptisms and marriages of the Russian tsars.

his way home, that perhaps a hundred times he would stop at just this spot, peer intently at what was truly a magnificent panorama, and wonder almost every time at the vague and unresolved impression it made on him. An inexplicable coldness always came over him as he contemplated its magnificence: the soul of the sumptuous vista was deaf and dumb for him."

ARCHITECTURE

Following the lead of Constantinople, which had experienced a political, military, and cultural resurgence in the ninth and tenth centuries, Russia strove to create beautiful works of art and architecture that rivaled those of the Byzantine city. In a desire to apprehend spiritual truth and make it comprehensible in concrete form, many cathedrals were built and decorated with elaborate mosaics and frescoes.

The Kremlin. The Kremlin, a walled city in the center of Moscow, was given its name in 1331, after the Mongol word kreml, which means "fortified." Encouraged by Princess Sophia, Ivan III, the Grand Prince of Moscow, embarked on a vast building program, replacing the wooden walls with red brick and constructing a set of dramatic and splendid churches. This effort was intended to secure Moscow's claim as the "Third Rome."

The cathedrals, although built partly by Italian architects, were Russian in style. The first of them was the

525

Church of the Assumption (fig. 20.3), completed in 1479. It came to be used for coronations. Decorated in the Byzantine style (see Chapter 7), its walls are covered with frescoes on gold backgrounds, and its columns are decorated with religious figures. It was in this church that the *Virgin of Vladimir* was found.

The Cathedral of the Annunciation was constructed close by, with its white walls and five gold cupolas (fig. 20.4). This intimate little church was used for the baptism and marriage of Russian tsars, and it became the favorite chapel of the wives and sisters of the rulers of Moscow. It had elaborately inlaid mosaic floors, richly adorned frescoes, and a resplendent iconostasis painted by two of the finest icon artists, Theophanes the Greek and Andrei Rublev. A third Kremlin church, the Cathedral of the Archangel Michael, which was built at the beginning of the sixteenth century, served as the burial place of the Muscovite rulers until the eighteenth century.

These churches were accompanied by seven others and by a concurrent building of palaces, including that of the splendid Palace of the Patriarch. In addition, important citizens built their own residences and private chapels within the confines of the Kremlin walls. Taken together (fig. 20.5), the sacred and secular structures, with their multitude of gilt roofs and colored cupolas, make a splendid sight. With the later addition of the Cathedral of St. Basil just across from the Kremlin, the center of Moscow was the most dazzling site of architectural splendor in the world.

The Cathedral of St. Basil. The Cathedral of St. Basil (fig. 20.6) was erected between 1555 and 1560 by the Russian architects Barma and Posnik. Ivan "the Terrible" intended the church to commemorate his conquest of the Mongolian khanates of Kazan and Astrakhan, making it a national votive shrine to his victorious military campaign.

Figure 20.5 View of the Kremlin churches, Moscow.

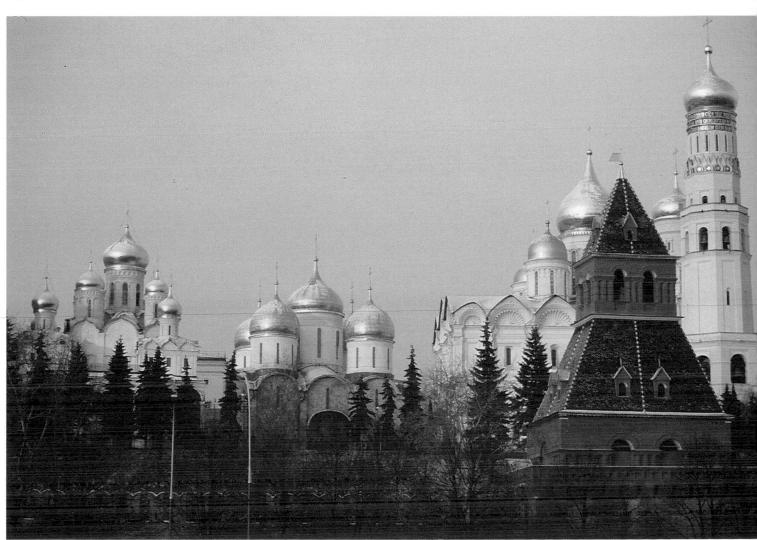

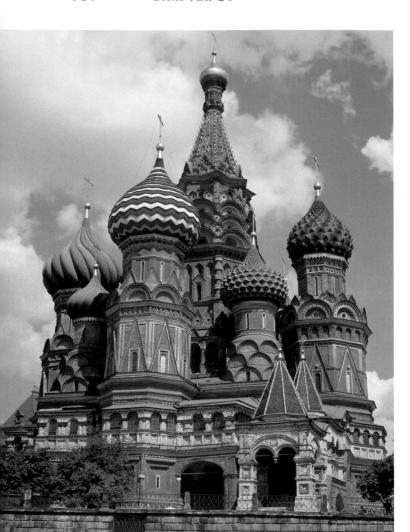

Figure 20.6 Barma and Posnik, Cathedral of St. Basil, 1555–60, Red Square, Moscow. This Russian Baroque church has become a landmark identifying Moscow in the way that the Eiffel Tower symbolizes Paris.

The central part of St. Basil is flanked by four large octagonal chapels on the cathedral's main axes and four additional, smaller polygonal chapels situated in the angles between them. Right in the center of the eight onion-domed towers is the tallest spire of the central church, and to the left, its belfry. It was in the seventeenth century that the polychrome decoration was painted onto the cupolas.

LITERATURE AND DRAMA

One of the glories of Russian art is the development of the Russian novel in the middle to late nineteenth century. Of the many novels written during this halfcentury period, those of Fyodor Dostoyevsky and Leo Tolstoy tower above the rest. Among the most accomplished of realist writers, they wrote novels on a grand scale, covering all aspects of Russian culture and society. Another important figure is the dramatist and short-story writer, Anton Chekhov, who wrote realist plays that capture both the demise of an aristocratic world and the rise of a new modern, industrial, and even socialist one.

Fyodor Dostoyevsky. FYODOR DOSTOYEVSKY [doss-toh-YEF-skee] (1821–1881) was the son of a Moscow doctor and landowner who was murdered by his serfs when Fyodor was eighteen. After studying military engineering, Dostoyevsky spent a year in the army before taking up a literary career, the most dramatic event of which was his arrest and imprisonment for conspiring to set up a secret printing press and discussing political and social ideas banned by the tsarist regime. After eight months, Dostovevsky was sentenced to death, only to receive a last-minute reprieve; his sentence was commuted to four years of hard labor and an additional four years of military service. His prison reading was restricted to the New Testament, which he read avidly, and which informs the novels he wrote upon his release, especially Crime and Punishment (1866) and The Brothers Karamazov (1881).

Dostoyevsky's life was filled with other crises, including the death of his first wife from tuberculosis, the death of his beloved brother, Mikhail, and that of his infant daughter. In addition, he was constantly beset by financial troubles. It is hardly surprising, one might argue, that his works usually focus on a tormented, neurotic, or psychologically disturbed character or group of related characters. His ability to probe beneath the surface and reveal the competing forces within the psyche brought him the admiration of Freud and other modern thinkers.

Dostoyevsky's realism (which he described as a "higher realism") is underpinned by the psychological rather than the social. His interest lies not so much in presenting a panorama of Russian urban life, but in probing the tensions and anxieties that animate and motivate behavior.

His narrative impulse is richly dramatic, realizing itself forcefully in scenes of conflict. The interview scenes with the ax-murderer Raskolnikov and the detective Porfiry Petrovich in *Crime and Punishment* exemplify the drama inherent in his dialogue. Raskolnikov's behavior throughout the novel reflects Dostoyevsky's acute understanding of human psychology, and reveals the author's belief that any transgression of the moral law—in Raskolnikov's case, murder—no matter how reasonable it may appear, results in the guilt of a tormented conscience. The punishment is internal, undeniable, and tortuous.

Leo Tolstoy. LEO TOLSTOY [TOHL-stoy] (1828–1910) was born into an aristocratic world, one replete with the trappings of high society, including servants, fine cuisine, extravagant clothing, and the manifold opportunities that come with great wealth. As a

young man, Tolstoy studied oriental languages at the University of Kazan, but left without taking a degree, returning to run the family estate in Yosnaya Polyana, south of Moscow.

War and Peace, considered by many his greatest work, was published in 1869. Set in the Napoleonic age, the novel explores the nature of history and the role that great men play in influencing the development of historical events. The book combines speculation on philosophical questions, such as necessity and free will, causation, and human destiny, with social concerns, such as agrarian reform. It also dramatizes ideas about the nature of the Russian state, as well as being a chronicle of the lives of several Russian families, with an emphasis on the philosophy of marriage. The novel contrasts the glories of nature and the simple life with the superficiality and artifice of civilization, celebrating the natural, privileging intuition over analysis, and emphasizing hope in the basic goodness of life rather than more studied forms of civilized learning and behavior.

During the writing of his second masterpiece, *Anna Karenina* (1873–1877), Tolstoy experienced a moral and religious crisis that set him on a course that would change his life irrevocably. *Anna Karenina* possesses all the realism of Tolstoy's earlier novel, but during its writing, the author began to have doubts about the book's secular emphasis, and so introduced a tone of moral criticism into the work, not only of Anna's adultery, but also of other characters' violations of society's moral norms. Even so, Tolstoy keeps the didactic impulse from overwhelming his literary artistry. Although he disapproves of Anna's adulterous behavior, he portrays her as a powerfully attractive woman, the site of struggle between his artistic sympathy and his moral judgment.

Anton Chekhov. The finest examples of Russian drama are the plays of its foremost dramatist, ANTON CHEKHOV [CHECK-off] (1860–1904). A short-story writer as well as a playwright, Chekhov began publishing fiction and sketches in newspapers and journals while studying medicine, in order to help support his large family. His fiction was well received, far better, initially, than the plays he would begin writing in the 1880s. Although Chekhov is celebrated as a major influence for later writers such as James Joyce and Ernest Hemingway, his plays are heralded in their own right as Modernist masterpieces and as precursors of important trends in modern theater.

Chekhov's plays, such as *The Three Sisters* and *The Cherry Orchard*, lack the intense melodramatic character of those by other realist dramatists, such as Henrik Ibsen. They don't tell stories, nor do they build toward tragic climaxes. Instead, Chekhov creates characters that are very lifelike in their inability to find happiness, their uncertainty about the future, and their indecisiveness in achieving their desires.

Because Chekhov was writing at a time when the old social order in Russia was dying, his plays have often been seen as dramatizations of the disappearance of the land-owning gentry as a source of authority and cultural value. Yet the playwright's interest lies in human nature, in individuals caught in a world undergoing great transformation. The characters in plays like *The Three Sisters* and *The Cherry Orchard* are neither heroes nor villains. They do not operate as mouthpieces for the dramatist's views. Indeed, their very inability to articulate their feelings, or even to act on them, adds poignancy to their suffering. Chekhov's insight into the truths of human experience is unmatched in modern drama.

MUSIC

Before Peter the Great's Europeanization drive in the eighteenth century, Russian music consisted primarily of religious and folk music. After the Tsar's return from the West, however, European music, particularly that composed during the eighteenth and nineteenth centuries, greatly influenced what was being produced in Russia. Among the composers who were able to synthesize the two musical styles were Modest Mussorgsky, whose operas commemorate great Russian leaders, and Peter Ilyich Tchaikovsky, whose ballets, operas, symphonies, and chamber works made him an internationally acclaimed figure.

Modest Mussorgsky. Supporting himself by working as a government clerk, MODEST MUSSORGSKY [moo-ZORG-skee] (1839–1881) composed relatively few works, though each reflected important qualities of the Russian national character. Mussorgsky lcd the school of Russian nationalist music in the 1860s that incorporated elements of Russian folk music into its compositions and used ancient Russian church modes in addition to the Western major and minor scales.

Most prominent among Mussorgsky's works is *Boris Godunov*, an opera that reveals the human soul in all its profundity. *Boris Godunov* is based on a poem by the Russian ALEXANDER PUSHKIN (1799–1837). It is in four acts and opens with a prologue that contains two important choral scenes, set in front of the Kremlin churches, which convey the national and religious spirit of old Russia. Mussorgsky includes the sound of the church bells, almost as important an emblem of Russian religious fervor as religious icons.

Peter Tchaikovsky. If Mussorgsky is to be considered one of the most nationalistic of Russian composers, PETER ILYICH TCHAIKOVSKY [cheye-KOV-skee] (1840–1893) can be said to be one of the most European. Tchaikovsky is best known for his ballet music, such as *Swan Lake, Sleeping Beauty*, and *The Nutcracker*. His work exhibits a gift for melodic invention and demonstrates his skill as an orchestrator, highlighting the tonal color and

Cross Currents

THE BALLETS RUSSES

 $B_{\rm allet}$ as a dance form did not originate in Russia, but it certainly flourished there. The most influential nineteenth-century choreographer in Russia was the French-born MARIUS PETIPA [PET-ee-pah] (1819-1910), who worked for the Tsar in St. Petersburg. Petipa collaborated with Tchaikovsky on both Sleeping Beauty and The Nutcracker to create two of the most popular ballets ever. After Petipa, Michel Fokine rose to prominence and became the principal choreographer of the Ballets Russes, a Russian dance company set up in Paris under the direction of the impresario SERGEI DIAGHILEV [dee-AHG-uh-LEF] (1872-1929), who was responsible for popularizing ballet throughout Europe.

Diaghilev set himself the goal of bringing Russian culture to the attention of the West, moving to Paris to do so. In 1906, he held a large-scale exhibition of Russian art, and in 1907 he began a series of concerts of Russian music. It was his presentation of Mussorgsky's Boris Godunov in 1908 that dazzled Western audiences with its originality and splendor. In 1909, he ventured a second season, which featured some ballets that included scenes from Borodin's opera Prince Igor, arranged for dancers rather than singers. The Russian ballerina Tamara Karsavina and her male counterpart, Vaslav Nijinsky, so stunned and enthralled Parisian audiences that they streamed onto the stage during the intermission of the first performance.

With dancers like Nijinsky and choreographers that included George Balanchine, and with set designs commissioned by painters such as Pablo Picasso and Henri Matisse, the Ballets Russes brought together a wealth of talent from a wide range of cultures and art forms. Composers who produced music for the Russian ballet included Claude Debussy, Maurice Ravel, and the Russian Serge Prokofiev.

The international acclaim of Russian ballet was furthered when George Balanchine defected from Russia in 1924, and eventually came to the United States in 1933 to choreograph. He founded and directed his own company, The New York City Ballet, and his own school. Here, Balanchine created a style of ballet that suited the American ethos-fast, sleek, conceptual, and thoroughly modern. During the Communist era, many dancers, including Rudolf Nurevev and Mikhail Barishnikov, defected from the Soviet Union to enjoy the artistic freedom of the West, much to the delight of Western audiences

varied expressive qualities of the full range of orchestral instruments. In its sense of drama and intense emotion, Tchaikovsky's music shares important affinities with other nineteenth-century Romantic composers from France, Italy, Germany, and Austria.

THE REVOLUTION AND AFTER

The influence of the West on Russia, so evident in St. Petersburg, was counterbalanced by later political developments that undermined the autocratic monarchy of the Tsars. The Russian Revolution officially began when the last Russian Tsar, Nicholas II, abdicated in 1917. However, it had in fact started earlier, on Bloody Sunday, January 9, 1905, when government troops fired on a peaceful demonstration by workers outside the Winter Palace in St. Petersburg. The workers quickly organized themselves into "soviets," or councils of workers elected in the factories, while the police responded swiftly by arresting dissenters. Most leaders were either sent to Siberia or chose self-imposed exile, as did Lenin, removing himself with many others to Switzerland.

Yet it was World War I that precipitated the real crisis. The Russian army was crushed in the fight with Germany, resulting in over five million casualties between 1914 and 1917. Germany penetrated deep into

western Russia. The flow of refugees into Moscow could almost not be supported.

In February 1917, popular demonstrations forced Nicholas from power. (He and his family were later executed on the night of July 16, 1918.) A democracy was promised, the nature of which was to be determined by a constituent assembly, elected by the people at the earliest opportunity. From February to October 1917, Russia was ruled by a provisional government, but in October, to cries of "all power to the soviets," the Bolshevik party seized power, led by VLADIMIR ILYICH LENIN (1870-1924). The Bolsheviks were Marxists—that is, those who believed in the writings of Karl Marx (see Chapter 17) and called for a new society ruled by the proletariat, the working class. In Marx and Engels's words, from The Communist Manifesto: "In place of the old bourgeois society, with its classes and class antagonisms, we shall have an association, in which the free development of each is the condition for the free development of all."

Within a few months, Russia was embroiled in a bitter civil war, which would last for three years. The war pitted the Red Army of the working proletariat against the White Army of the anti-Bolshevik bourgeoisie. The Reds won, but since Britain and France had openly supported the Whites, and Japan and the United States had sent troops to Siberia, the new Bolshevik government was almost totally isolated from the West. It nationalized

almost all industry, organizing the workers, and created what it called a "dictatorship of the proletariat." Yet a deep economic crisis soon followed, and Lenin, recognizing that he had moved too quickly, inaugurated a New Economic Policy (NEP) in 1921, legalizing private trade, abandoning the nationalization of industry, and allowing the private sector of the economy to reestablish itself. It was a full retreat from Communist principles, but one necessitated, Lenin believed, by reality.

Meanwhile, the new Soviet bureaucracy began to establish itself. Rising to the position of General Secretary of the Bolshevik party was JOSEPH STALIN (1879–1953). When Lenin died in 1924, Stalin overcame his rival LEON TROTSKY (1879–1940) and took over, making it clear that the primary goal of the Soviet Union was industrialization. His Five-Year Plan, implemented in 1929, modernized the country and built the basic structure of Soviet society, which remained intact until December 1991.

The Russian Revolution created a new order that affected not only Russians, but other peoples around the globe. Its complex web of causes included popular grievances, radical ideas espoused by intellectuals, idealism coupled with a lust for power, and a breakdown of public order. Its consequences included helping to prevent the restoration of peace after World War I—which contributed to the rise of Nazi Germany and the outbreak of World War II—and increasing world tension throughout the twenticth century, resulting in a "cold war."

Figure 20.7 Kazimir Malevich, White on White, 1918, oil on canvas, $31 \times 31''$ (78.7 × 78.7 cm), Museum of Modern Art, New York. Malevich's Suprematism is a type of Cubism taken to the extreme, Cubism in its most minimal form.

REVOLUTIONARY ART

Taking their lead from the avant-garde movements in Europe, particularly Cubism and Futurism, Russian artists reacted to the Revolution with an almost frenetic zeal. Early in 1918, the Soviet Department of Fine Arts (IZO) was formed with a view to organizing the arts. Native Russians in Europe were called back to Russia to lead the way. Marc Chagall was appointed Commissar of Art in his hometown of Vitebsk, and for the first anniversary of the Revolution, in October 1918, he covered the city's buildings with the Cubist shapes, green cows, and flying horses for which he is famous. Vassily Kandinsky returned home to Moscow from Germany to develop the art program at the Institute of Artistic Culture. But the young native painters of the Revolution wanted nothing to do with the expressive impulses of either Chagall or Kandinsky.

Kazimir Malevich. Chagall's art school in Vitebsk was taken over in 1919 by a young revolutionary artist named KAZIMIR MALEVICH [MAH-lay-vich] (1878–1935), who informed Chagall that his work was old-fashioned and irrelevant. Malevich called himself a "Suprematist."

His paintings were based solely on the simplest of geometric forms, particularly the square. "In order to free art from the ballast of objectivity," he wrote, "I took refuge in the square." His was thus a "nonobjective" art, an art freed of personal emotion, but one that dealt with such basic forms that it spoke, he believed, a universal language. In White on White (fig. 20.7), of 1918, a white square floats sideways on a white field. For Malevich, the painting embodied "pure energy" and "pure mind." It was a painting that antithetically opposed the materialist aesthetic that had defined bourgeois art. The square floats above the other square field of the canvas as though in boundless space, suggesting an infinite regression, as if the white square of the canvas is itself set upon another white square, the white field of "pure mind." When Lenin died in 1924, Malevich proposed a cube for his mausoleum. The cube, he said, "is the symbol of eternity . . . the view that Lenin's death is not death, that he is alive and eternal, is symbolized in a new object, taking its form as a cube."

El Lissitzky. Malevich's collaborator in Vitebsk was Lazar Markovich Lisitskii, known as EL LISSITZKY [lih-ZIT-skee] (1890–1941). Together they renamed the school "Unovis," meaning College of the New Art. An engineer by training, El Lissitzky created a kind of art that he labeled "Prouns," which stands for "Projects for the establishment [or affirmation] of a new art" and which he described as "changing-stations between painting and architecture." Proun 99 (fig. 20.8), of 1924, is dogmatically two-dimensional, but the perspectival grid at the bottom and the floating quality of the cube suggest

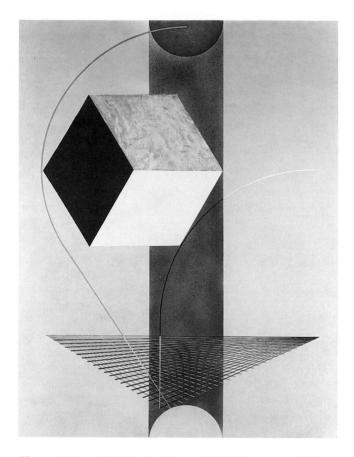

Figure 20.8 El Lissitzky, *Proun* 99, 1924, water soluble and metallic paint on wood, $50\frac{1}{4} \times 39''$ (129 × 99.1 cm), Yale University Art Gallery, New Haven, Connecticut. El Lissitzky was one of Russia's chief contacts with the West.

three-dimensional space as well. Even as Prouns recede, they simultaneously seem to project forward into the viewer's space.

FILM

One of the great figures of cinematic history, SERGEI EISENSTEIN [EYE-zen-stine] (1898–1948) was a film theorist as well as a film director. His wideranging knowledge of history, philosophy, science, and the arts is reflected in his films. For Eisenstein, film was the most complete of the arts. It included all the various artistic expressions of conflict—the kinetic conflict of dance, the visual conflict of painting, the verbal conflict of literature and theater, and the conflicts of character essential to fiction and drama.

A masterful editor, Eisenstein built his films shot by shot and frame by frame, calculating the dramatic tension until it finally exploded on film. Eisenstein achieved striking effects with lighting, time lapses, designs, and backgrounds in various camera shots, using narratives that were loosely structured and episodic in construction.

In his silent film *Battleship Potemkin*, first shown in 1926, Eisenstein dramatizes the mutiny on board the tsarist ship *Potemkin* in 1905, and the ensuing street demonstrations in the port of Odessa. Eisenstein was commissioned to make the film as part of the twentieth anniversary celebrations of the 1905 Revolution. Eisenstein structures his film like a symphony. The first section presents the bloody mutiny and the conditions that precipitated it. The second provides a respite as the ship drops anchor in the harbor after the

Timeline 20.2 The Russian Revolution and after.

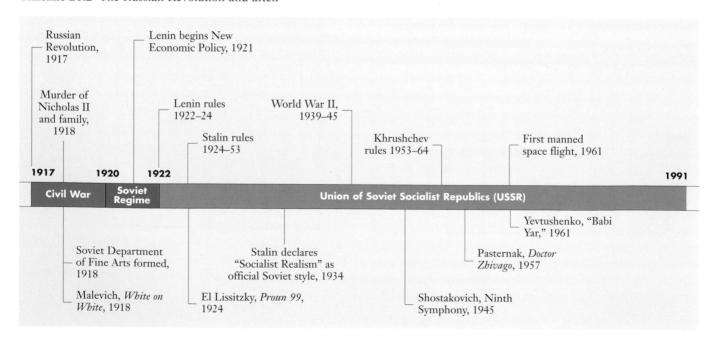

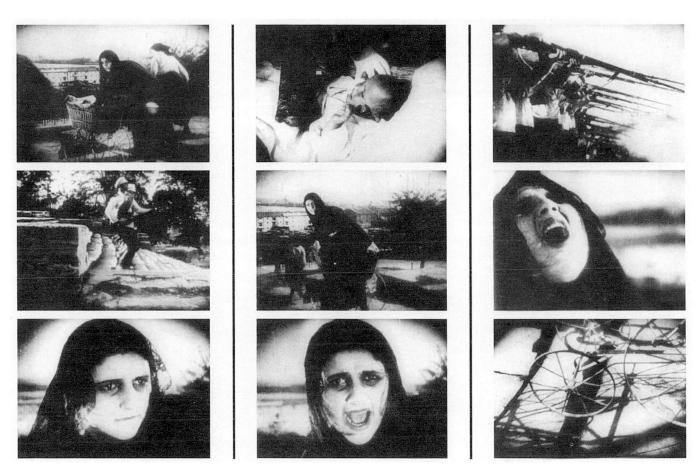

Figure 20.9 These consecutive film stills from Sergei Eisenstein's *Battleship Potemkin* (1924) reveal the director's dramatic use of close-up and of the contrast between human and inanimate images.

revolt. Following this lull, a third section focuses on the people of Odessa. Here Eisenstein creates his most brilliant editing effects, alternating between the panic-stricken and defenseless masses who support the mutinous sailors and the Cossack soldiers, armed with bayonets, who march relentlessly through the crowd, massacring those who fall in their path. The final section shows the ship returning to sea, with cheers coming from other ships in the fleet. It marks a call to action.

Eisenstein's Odessa sequence (fig. 20.9) includes a formal technique called **montage**, a set of edited units of impression used to achieve dramatic effect or, here, to increase tension in the viewer to the point of "emotional saturation." Eisenstein believed that viewer tension would find release in an emotional bonding with the victims, whose oppression he depicted on screen. Yet, for all its stunning formal innovations, the film is an intentional and whole-hearted attempt at propaganda and was made to legitimize and celebrate the Revolution.

KHRUSHCHEV'S RUSSIA

Until his death in 1953, Stalin ruled Russia with an iron hand, largely through the use of secret police who, in turn, filled prison and labor camps with political dissenters. In the Great Purge of 1937–38, Stalin eliminated Russia's ruling intelligentsia, replacing it with a new one. Hundreds of Soviet officials were convicted and executed. In June 1937, every Red Army top commander was shot. Each member of Lenin's government was either killed or committed suicide. By the end of 1938, at least a million Russians were in prison, another 8.5 million had been sent to prison camps, and nearly 700,000 had been executed. Henceforth, nobody questioned Stalin's rule.

Soon after Stalin's death, however, things changed. NIKITA KHRUSHCHEV [KROOS-cheff] (1894–1971) was named party secretary, and Lavrenty Beria, Stalin's chief of the secret police, was executed for treason. Khrushchev emptied the prisons and labor camps, returning the people to their homes. In 1956, he officially denounced Stalin, proclaiming a return to "Leninist norms."

Connections

ART AS POLITICS

An art as abstract as that of Malevich and El Lissitzky might seem ineffectual as a political tool, but it was in fact conceived in quite the opposite terms, as a means of bringing art to the masses. In the late nineteenth century, a number of St. Petersburg artists, calling themselves the Wanderers, sought to champion the newly emancipated peasant class by bringing art to the people through traveling exhibitions. This initiative of popularizing art took a new form soon after the disturbances of 1905, when the Bolsheviks began to use wall posters extensively: they were inexpensive, and their visual impact appealed directly to the mostly illiterate masses. By 1917, the poster was a major Russian art form. El Lissitzky's Beat the Whites with the Red Wedge (fig. 20.10), of 1919, is a perfect example. Using basic geometric shapes, the Red Army is represented by the triangle that pierces the circular form, which in turn represents the White Army. In starkly figured elements, the active Reds invade the passive Whites. The sense of aggression, originating both figuratively and literally from "the left," is unmistakable.

Such propaganda art was soon disseminated throughout Russia; primarily by means of Agit-trains. Agit-trains consisted of seven or eight railway cars sent to various places "to establish ties between the localities and the center, to agitate, to carry out propaganda, to bring information, and to supply literature." Each was also equipped with a film projector. The peasants were fascinated by film, and Lenin quickly realized the power of the medium in propaganda terms. Sitting on the train, the people watched newsreels of Lenin and in doing so were not merely entertained, but also indoctrinated in the Bolshevik cause.

At first, the Agit-trains were decorated with abstract Russian art, but the

peasants objected strongly. They were repainted with pictures of soldiers, workers, and peasants, a development that foreshadowed the fate of Russian modernist art as a whole. It seemed that abstraction did not speak to the masses after all. At the end of the first Five-Year Plan in 1932, Stalin outlawed all independent artistic organizations, and in 1934 he proclaimed "Socialist Realism" as the official Soviet style. Abstraction was permanently banned in the Soviet Union.

Figure 20.10 El Lissitzky, Beat the Whites with the Red Wedge, 1919, lithograph, $20\frac{7}{8} \times 27\frac{1}{2}$ " (53 × 70 cm), Stedelijk Van Abbemuseum, Eindhoven, The Netherlands. Russian poster design would soon begin to incorporate photographic images in photomontages that addressed the people even more directly.

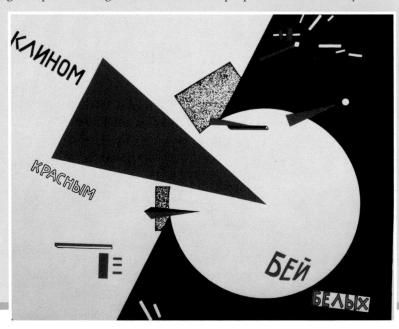

THE LITERATURE OF DISSENT

Khrushchev's de-Stalinization of Russia extended to literature and the other arts. The period became known among artists as "the thaw." A novel by BORIS PASTERNAK [PASS-ter-nack] (1890–1960), chronicling the life of a Russian doctor through World War I and the Revolution, entitled *Dr. Zhivago*, was accepted for publication in the Soviet Union and in Italy. But the novel offended Khrushchev, perhaps because of its author's Jewish origins or its central character's avowed individualism, and so the Soviet censors changed their minds. After the novel's publication in the West, Pasternak was awarded the Nobel Prize for

Literature. Threatened with exile if he accepted, he turned it down.

By 1963, however, the atmosphere had thawed even more. ALEXANDER SOLZHENITSYN [sol-zhuh-NEET-sin] (b. 1918) wrote a short autobiographical novel, entitled *One Day in the Life of Ivan Denisovich*, about life in one of Stalin's labor camps, and it was accepted for publication. Khrushchev, who was personally responsible for its acceptance, viewed the book as a tool in his campaign against the legacy of Stalin. For the first time, the camps that haunted the Soviet imagination were talked about in print. Solzhenitsyn himself continued to write about Stalin's Russia, but his next novel, *The First Circle*, completed after Krushchev had been

removed from power, was denied publication by the censors, and in 1974 he was expelled from the Soviet Union. In 1970, he accepted the Nobel Prize for Literature, deeply offending the Soviet leadership.

Two years before Solzhenitsyn was to publish *One Day in the Life*, a twenty-eight-year-old poet named EVGENY YEVTUSHENKO [yiv-tuh-SHEN-koh] (b. 1933) published a poem entitled "Babi Yar" in Moscow's *Literary Guzette*. The poem caused an immediate sensation. Babi Yar is a large ravine on the northern edge of the city of Kiev, where, during World War II, German SS troops buried over 100,000 Russian Jews and Communist officials. There were Soviet plans to build a sports stadium on the site, a decision that Yevtushenko found callous and believed was informed by the anti-Semitism of Soviet leadership.

THE MUSIC OF DISSENT

Reading Yevtushenko's poem in the *Literary Gazette*, the composer DMITRI DMITRYEVICH SHOSTAKOVICH [shos-tah-KOH-vich] (1906–1975) was deeply moved and immediately set it to music. Yevtushenko was delighted, and four more poems were quickly added to the set, one for each of the five movements of the composer's Thirteenth Symphony.

A veteran of the Soviet musical scene, Shostakovich had been composing symphonies since the 1920s. His work tended to move back and forth between the kind of grand public statements demanded by Stalin and more private, personal expressions. The Thirteenth Symphony is one of the latter, and Stalinist factions in the government swiftly moved to suppress its first performance, scheduled for December 18, 1962.

Just a few weeks earlier, on December 1, Khrushchev had flown into a rage at an exhibition of Russian avantgarde art, calling the artists "abstractionists and pederasts." On December 17, the day before the premiere, Khrushchev convened an assembly of writers and artists at the Kremlin. He attacked the abstract painters and sculptors again and then began to denounce Shostakovich. "Shostakovich," he proclaimed, "his music's nothing but jazz-it gives you a belly ache." Yevtushenko, who was present, leaped to the defense of the artists. "Who would deny," he asked, "that there are great artists amongst the abstractionists? Can we exclude Picasso?" Khrushchev responded with a Stalinist proverb: "The grave straightens out even the hunchbacked." Yevtushenko boldly replied, addressing the leader by his first names, "Nikita Sergeevich, we have come a long way since the time when only the grave straightened out hunchbacks. Really, there are other ways." The symphony went ahead as planned, but after its second performance, it was banned. Khrushchev was ousted from power in 1964 by Leonid Brezhnev and the "thaw" came to an official end.

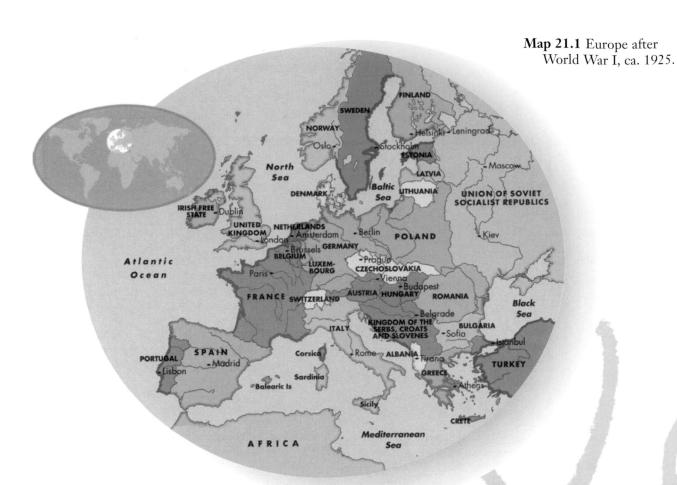

THE AGE OF ANXIETY

THE GREAT WAR AND AFTER

"On or about December 1910 human character changed," wrote Virginia Woolf, the English novelist and feminist. "All human relations shifted," Woolf noted, "those between masters and servants, husbands and wives, parents and children. And when human relations shift there is at the same time a change in religion, conduct, politics and literature." We do not know precisely what these changes were that Woolf was alluding to, but they were made more dramatic by the Great War (as World War I was then called), which began in August 1914. Another English novelist, D.H. Lawrence, wrote that "in 1915 the old world ended." The war gave new and frightening meaning to the radical cultural changes occurring in the early years of the twentieth century, creating what has been termed an "Age of Anxiety." It was a time of "disorder and early sorrow," as German writer Thomas Mann wrote in one of his stories. It was a world in which "things fall apart; the centre cannot hold," as the Irish poet William Butler Yeats noted. No one was sure what would happen next, but many were certain that it would be negative.

WORLD WAR I

In November 1912, Pablo Picasso made a collage depicting a Parisian café table. The work was named after a bottle of aperitif from the Balkans called Suze—Glass and Bottle of Suze (fig. 21.1). A piece of newspaper from Le *Journal* is also pasted onto the canvas. But the story in the newspaper belies the atmosphere of ease in the café. It describes the ongoing war in the Balkans, the advance of the Serbs into Macedonia, and, in particular, the outbreak of cholera among Turkish troops: "Before long I saw the first corpse," it reads. "Then I saw two, four, ten, twenty; then I saw a hundred corpses ... How many cholera victims did I come upon like this? Two thousand? Three thousand? I don't dare give an exact figure. Over a distance of about twenty kilometers, I saw cadavers strewing the cursed ground where a wind of death blows and I saw the dying march ... preparing themselves for combat. But I had seen nothing yet."

From 1912 to 1914, Europe became gripped by the developments in the Balkans. It seemed increasingly clear to all that, sooner or later, the entire continent would be involved. Then, on June 28, 1914, a Serbian nationalist named Gavrilo Princip assassinated the Habsburg archduke, Francis Ferdinand, heir to the throne of Austria and Hungary, and his wife, Sophie Chotek, on the street in Sarajevo, Bosnia. Within weeks, Europe was at war, the Central Powers (Austria, Hungary, Germany, Turkey, and later, Bulgaria) against the Allies (Serbia, Russia, France, and Britain, and later, the United States).

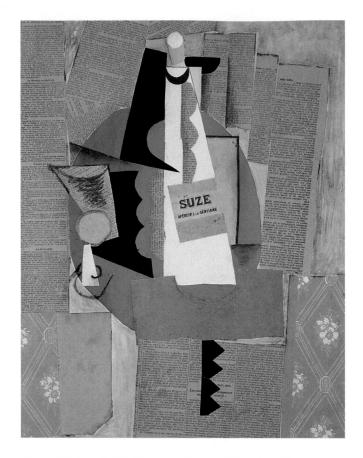

Figure 21.1 Pablo Picasso, *Glass and Bottle of Suze*, 1912, pasted papers, gouache, and charcoal on paper, $25_5^2 \times 19\frac{2}{3}$ " (64.5 × 50 cm), Washington University Gallery of Art, St. Louis. For many years, collages such as this were interpreted in purely formal terms, as arrangements of objects in space, but the coincidence of the Balkan apertif and the material about the Balkan war in the newspaper fragments suggest that Picasso had more political concerns in mind.

It is hard to overstate the impact of the Great War on the public imagination in the West. It took the lives of over eight million soldiers in action, and many millions more through malnutrition and disease. A new brand of trench warfare created a kind of horror never before seen or endured. Along the Western Front, which extended from the English Channel to the Swiss border with Alsace, near Basel, hundreds of thousands of soldiers faced each other in parallel trenches across a stationary line. The distinguished British historian Charles Carrington (1897–1981) remembers life in the trenches on the Somme, as a young man barely twenty years of age:

The killed and wounded were all lost by harassing fire, mostly on their way up or down the line. Once in position ... you could not show a finger by daylight, and by night every path by which you might be supposed to move was raked by machine-guns which had been trained on it by day ... If you could reach your

Käthe Kollwitz, The Mothers, 1919, lithograph, $17\frac{3}{4} \times 23''$ (45 × 58.4 cm), Philadelphia Museum of Art. Kollwitz captures the tragedy of World War I in this image of lower-class German mothers left to fend for themselves and their children after the war. The blackand-white medium emphasizes the harshness of the reality.

funk-hole and crouch in it, there was a fair chance of your coming out of it alive next day to run the gauntlet ... again. In your funk-hole, with no room to move, no hot food, and no chance of getting any, there was nothing worse to suffer than a steady drizzle of wintry rain and temperature just above the freezing point. A little colder and the mud would have been more manageable. Life was entirely numbed; you could do nothing. There could be no fighting since the combatants could not get at one another, no improvement of the trenches since any new work would instantly be demolished by a storm of shell-fire.

Another chronicler of the war, the German Erich Maria Remarque, described in the novel All Quiet on the Western Front (1929) the sense of doom that dominated the German lines: "Monotonously the lorries sway, monotonously come the calls, monotonously falls the rain. It falls on our heads and on the heads of the dead up the line, on the body of the little recruit with the wound that is so much too big for his hip; it falls on Kemerich's grave; it falls in our hearts." In describing the retreat from the Italian front in his novel A Farewell to Arms (1929), American writer Ernest Hemingway expressed how the war emptied life of meaning: "I had seen nothing sacred, and the things that were glorious had no glory, and the sacrifices were like the stockyard at Chicago if nothing was done with the meat except to bury it ... Abstract words such as glory, honor, courage, or hallow were obscene." After the Great War, it seemed as if the whole world mourned, a mood evoked in this lithograph by the German artist KATHE KOLLWITZ [KOL-vits] (1867–1945) (fig. 21.2).

THE DADA MOVEMENT

The war had an immense impact on art. Profoundly affected by the destruction, a group of artists, writers, and musicians founded a new art movement—Dada. Beginning in Zurich and New York during the war, it flourished in Paris and Germany after it. Dada, from a nonsense word indicating a child's first utterance or "Da, da' ... 'yes, yes' to life," was meant to be as ambiguous as the war itself.

In Zurich, artists and intellectuals who had gathered to escape the war met regularly at the Café Voltaire as early as 1916. Swiss sculptor HANS ARP (1886-1966) defined Dada in the following way: "Repelled by the slaughterhouses of the world war, we turned to art. We searched for an elementary art that would, we thought, save mankind from the furious madness of these times." This it attempted to do in an irreverent manner. Arp himself made relief sculptures by dropping liquid into a series of small puddles, outlining each, and then cutting out wooden replicas and finally putting them together. His Portrait of Tristan Tzara (fig. 21.3) portrays his friend, a Dada poet, in exactly these terms. TRISTAN TZARA [ZAHR-ah] (1896-1963) wrote poems using these same "laws of chance." Tzara would cut up a newspaper article word by word, then draw the words out of a hat, and write a poem. Tzara also performed a kind of "noise" poetry at the Café Voltaire—"bruitisme," he called it, after the French word for "noise"—consisting

Figure 21.3 Hans Arp, Portrait of Tristan Tzara, 1916, relief of painted wood, $20\frac{1}{8} \times 19\frac{3}{4} \times 4''$ (51 × 50 × 10 cm), Musée d'Art et d'Histoire, Geneva, Switzerland. Before the war, Arp had been a contributor to Vassily Kandinsky's Blaue Reiter magazine.

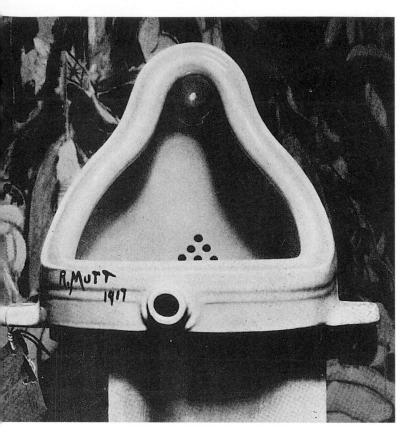

Figure 21.4 Marcel Duchamp, Fountain, porcelain urinal, exhibited 1917, height $24\frac{5}{8}$ ", (62.2 cm), photograph by Alfred Stieglitz, Philadelphia Museum of Art. Duchamp argued that he "created a new thought for that object" by forcing the viewer to see it in a new context. He labeled such works "ready-mades."

of vowels, consonants, and guttural sounds, strung together in a nonsense parody of German *Lieder* (songs). The Dadaists thought that if tradition had created the madness of the Great War, then tradition deserved no respect. The childlike, sometimes imbecilic behavior of the Dadaists was a conscious attempt to start again from square one.

Marcel Duchamp. One of the most important Dadaists, MARCEL DUCHAMP [doo-SHAH(n)] (1883–1968), worked as a painter before the conflict, but the war ended that. When Duchamp arrived in New York in 1915, he said that Dada meant "hobby horse" in French (yet another meaning), and claimed that he had picked the word at random from a French dictionary (yet another conflicting story of its origins). Duchamp saw Dada as a kind of "anti-art," one that embodied imagination, chance, and irrationality, and that opposed all recognized values in art and literature.

In 1917, Duchamp submitted a "sculpture" to the Independents exhibition in New York. Entitled *Fountain* (fig. 21.4), it was a porcelain urinal signed with a pseudonym, "R. Mutt." Needless to say, the piece caused an

uproar. Duchamp let it be known that he was "Mutt" himself, suggesting that what mattered most about a "work of art" was not aesthetic concerns, but who made it. Furthermore, the significance of the urinal changed in different contexts. It was one thing in a plumbing shop or bathroom, quite another on a plinth in an art exhibition. It seemed that where things were seen changed how they were understood or interpreted. Duchamp had, as sculptor, acted like a photographer. He had seen something mundane, and by reframing it, had revealed its aesthetic dimension.

Duchamp engaged in many other demonstrations and attacks on traditional aesthetics. He retouched a poster of Leonardo da Vinci's *Mona Lisa*, adding a mustache and goatee. He used puns in many of his works because he thought that wordplay undermined the stability of meaning, and in so doing encouraged new ways of seeing.

Kurt Schwitters. After the war, the Swiss Dada movement migrated to Germany. There, its most accomplished artist was KURT SCHWITTERS [SHVIT-ers] (1887–1948), who began working with junk and the vestiges of a destroyed German landscape. He

Figure 21.5 Kurt Schwitters, Merz 600, Leiden, 1923, collage, $6\frac{1}{4} \times 5\frac{1}{8}''$ (15.8 × 13 cm), Kunsthalle, Hamburg, Germany. Schwitters's impulse to make new art out of refuse was not limited to merely small-scale work. Beginning in 1923, he transformed his house in Hanover into a Merzbau, a large-scale sculptural environment made out of all manner of materials. It was destroyed by an Allied bomb in 1943.

539

called his works "Merz," which derived from a fragment of advertisement that appeared in one of his collages. The collages were modeled after Picasso and Braque, but were far less oriented to the themes of the belle époque (music, wine, the daily news) and far more concerned with the new industrialized society and its discards. Indeed, it is possible to trace Schwitters's geographical movements from the ticket stubs and stamps included in his works. In this sense the works are autobiographical—Merz 600 (fig. 21.5), of 1923, contains a stamp and ticket from The Hague in Holland. The basis of Schwitters's art is the contradiction between its arbitrary "junk" content and its sometimes stunning formal beauty. On the one hand, he said, "I favor nonsense ... up to now it has so seldom been given artistic form and for that reason I love nonsense." On the other, he noted, "Because I balance different kinds of material against one another, I have an advantage over oil painting, for in addition to evaluating color against color, line against line, form against form, and so on, I also evaluate material against materialwood against burlap, for example ... Every artist should be permitted to put together a picture out of nothing more than, say, blotting paper, as long as he knows how to give it form."

THE DE STIJL MOVEMENT

If Dada represents a negative or nihilistic reaction to World War I, De Stijl ("The Style" in Dutch), sometimes called Neo-Plasticism, represents an affirmative, hopeful response. Founded in 1917 in Holland, the movement sought to integrate painting, sculpture, architecture, and industrial design, and championed a "pure" abstraction, believing that in it universal harmony could be rediscovered. In the movement's first manifesto, the De Stijl artists wrote: "The war is destroying the old world with its contents ... The new art has brought forward what the new consciousness of the time contains: balance between the universal and the individual."

Piet Mondrian. The leading painter of the De Stijl school was PIET MONDRIAN [MON-dree-on] (1872-1944). Dutch by birth, he moved to Paris in 1912 and turned his attention to Cubism, which he quickly took to its logical conclusion. His work referred less and less to nature, until it finally became completely non-objective abstraction. Pier and Ocean (fig. 21.6), a drawing made in 1914, is almost completely abstract, yet the subject, taken from nature, is still recognizable. Mondrian has divided the surface into small sections, identifying the geometry in nature not the solid three-dimensional geometry of

Piet Mondrian, Composition No. 10: Pier and Ocean, 1914, oil on canvas, Figure 21.6 $33\frac{1}{2} \times 42\frac{5}{8}$ " (85.1 × 106.7 cm), Kröller-Müller Museum, Otterlo, Netherlands. The vertical and the horizontal came to represent for Mondrian all the oppositions inherent in nature—from male and female to life and death—and the right angle was the sign of their unity and balance.

Timeline 21.1 The United States between the wars.

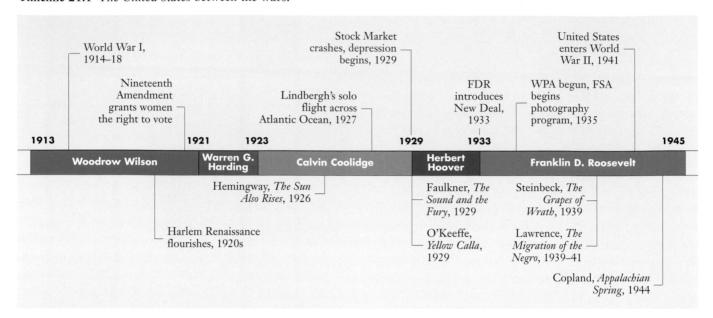

Cézanne, but a two-dimensional plane geometry. Mondrian believed the flat plane was integral to painting and that it must be respected rather than falsified by perspective. Thus, Mondrian turns the pier and ocean into an arrangement of horizontal and vertical lines.

By 1920, Mondrian had defined a mature style, as seen in *Composition in Red*, *Yellow*, *and Blue* (fig. 21.7). Seeking

Figure 21.7 Piet Mondrian, Composition in Red, Yellow, and Blue, 1920, oil on canvas, $20\frac{1}{2} \times 23\frac{5}{8}"$ (52 × 60 cm), Stedelijk Museum, Amsterdam. Mondrian actually called his style Neo-Plasticism, but the name De Stijl, the title of the Dutch magazine that published not only his own but also the writings of other figures from the movement, is now generally used.

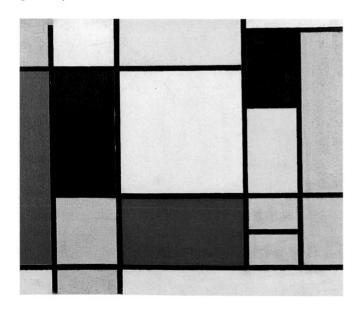

perfection within a strictly imposed set of limitations, Mondrian created a surface grid of horizontal and vertical lines; the rectangle and square are its basic shapes. The colors are restricted to the primary colors—red, yellow, and blue—plus black, white, and, in a few places, gray. Using these few elements, Mondrian established a sense of balance. As he would assert, while writing about a drawing of this time: "If one does not represent things, a place remains for the Divine."

THE SURREALISTS

As both Dada and De Stijl demonstrate, the spirit of the avant-garde in the arts continued to thrive after the war. Paris was its center, "the laboratory of ideas in the arts," as the American poet Ezra Pound put it. Tristan Tzara organized a massive Dada festival in Paris, in 1920. In May 1917, Diaghilev's Ballets Russes performed *Parade*, a dance with music by French composer Eric Satie and complete with the sounds of dynamos, sirens, express trains, airplanes, and typewriters. The stage set was designed by Picasso (fig. 21.8). The whole creation seemed to the poet Guillaume Apollinaire like the space of a "sur-réalisme" or "super-realism".

In 1924, the poet André Breton appropriated the word *sur-réalisme* to name his own new movement in the arts. He defined Surrealism as "psychic automatism in its pure state, by which one proposes to express—verbally, by means of the written word, or in any other manner—the actual functioning of thought. Dictated by thought, in the absence of any control exercised by reason, exempt from any aesthetic or moral concern."

In its privileging of the irrational, and its lack of "aesthetic or moral concern," Surrealism was indebted

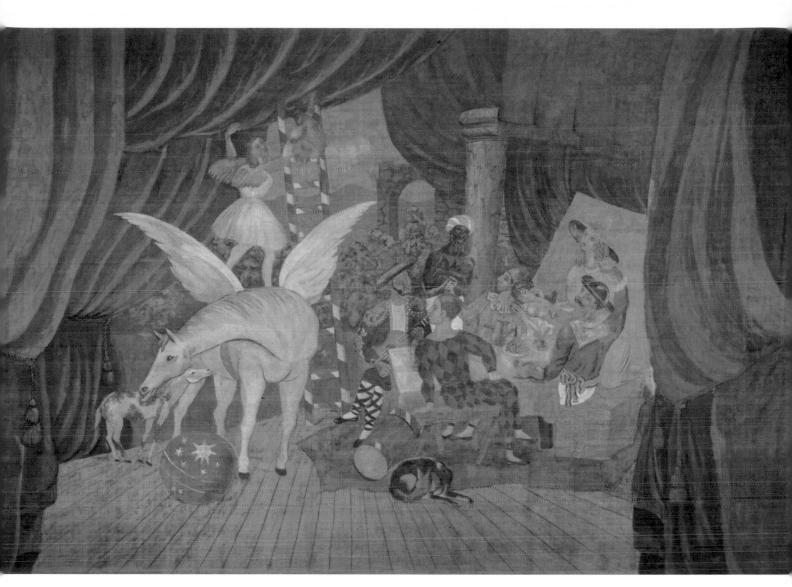

Figure 21.8 Pablo Picasso, curtain for the ballet *Parade*, 1917, tempera, $35'3\frac{1}{4}'' \times 57'6''$ (10.60 × 17.24 m), Musées Nationaux, Paris. The ballet was based on a poem by Jean Cocteau, another member of the avant-garde circle. It is a "realistic ballet," meaning its concerns arise within an everyday street setting, complete with street musicians and performers, car horns and sirens, business people, tabloids, and skyscrapers.

to Dada. Where it differed was in its fascination with, and dedication to, the realm of dreams, supported by a perhaps willful misunderstanding of Freud. Where Freud understood neurosis as an illness demanding psychoanalysis and cure, Breton found it liberating. The neurotic, for Breton, was free to behave in any manner, and the valorizing of dreams opened up whole new vistas of subject matter, many of them previously taboo.

There were two approaches to depicting this new subject matter: one abstract, the other representational. The abstract vein was based on Breton's notion of pyschic automatism that is, drawing liberated from the necessity of representation and of plan. Surrealists, according to this idea, should

accept any apparent accident as psychologically predetermined and therefore revelatory. The second approach was focused on representing the world of dreams accurately, deliberately, particularly, without self-censorship.

Joan Miró. One of the most accomplished practitioners of automatism is JOAN MIRÓ [mee-ROH] (1893–1983). Though Miró never called himself a Surrealist, he acknowledged the Surrealist influence on his art. Soon after arriving in Paris from his native Spain in 1922, he was, he said, "carried away" by their example, and by 1925 "was drawing almost entirely from hallucinations. At the time I was living on a few dried figs a day."

His *Painting* (fig. 21.9) of 1933 is an abstract rendering of machine forms that he saw in a catalogue. It is as if the machines have suggested these forms, which, in his own psyche, have been transformed into abstract shapes, more organic than mechanical. The two bands of color in the background create a landscape, which the forms inhabit. They remain entirely abstract, existing at the very edge of rational thought.

Salvador Dalí. Probably the most famous of the Surrealist artists is SALVADOR DALÍ [DAH-lee] (1904–1989), of Spain, who arrived in Paris in 1929 and was to change the course of Surrealist painting. He consciously constructed himself as a Surrealist cult figure. His foot-long mustache was "sculpted" into various shapes. He claimed he could remember life in his mother's womb. He had himself buried and resurrected. One might argue that although Dalí lived a life of irrational behavior, his publicity-generating activities garnered fame and fortune—considered highly rational and worldly goals.

Dalí's painting entitled *The Persistence of Memory* (fig. 21.10), of 1931, is remarkably disturbing, for he painted an unconscious dream world with a nightmare quality. An attempt is made to resolve two apparently contradictory states—those of dream and reality. The enigmatic image depicts four watches that are limp, eroded by rust, and attacked by ants. Consider the various meanings in this puzzling picture: Can time itself decay and be destroyed, even as it causes decay and destruction? Has time been made flexible, or is it distorted? Can the artist

Figure 21.9 Joan Miró, *Painting*, 1933, oil on canvas, $4'3_4^{1''} \times 5'3_2^{1''}$ (1.30 × 1.61 m), Wadsworth Atheneum, Hartford, Connecticut. One of the reasons that this painting, when it is seen in real life, seems so alive, as if inhabited by abstract creatures, is that it is very large, so that the forms depicted in it are on a human scale.

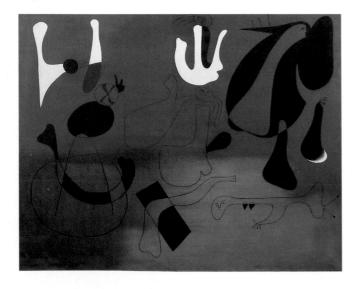

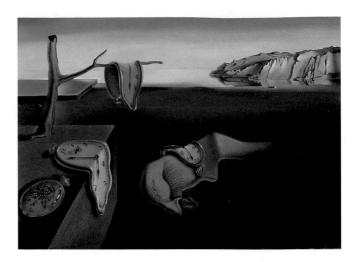

Figure 21.10 Salvador Dalí, *The Persistence of Memory*, 1931, oil on canvas, $9\frac{1}{2} \times 13''$ (24.1 \times 33 cm), Museum of Modern Art, New York. Combining psychology and art, Surrealist artists sought to express the unconscious. Intentionally enigmatic and mysterious, Dalí's painting depicts the impossible and irrational with absolute conviction.

"bend time"? Is creativity a means to immortality? Can art defeat time? Such are the questions the painting seems to pose.

Perhaps most unnerving is the slug-like object on the ground, which appears to be a distorted self-portrait. "I want to paint like a madman," Dalí said, and the painting is perhaps the very image of this madness. As he pointed out, if Surrealism was to investigate the unconscious, then it had to explore whatever the unconscious had to offer. In this painting and others, Dalí depicted illogically juxtaposed objects, impossibly distorted forms, and undefined spatial settings. Yet when rendered in his meticulously detailed painting technique, the inconceivable appears incontestably real.

ABSTRACTION IN SCULPTURE

A number of sculptors sought to explore the possibilities of abstraction in three-dimensional terms. Like Miró and Arp, sculptors created forms that were organic and fluid. They suggested human or figurative forms at the same time that they resisted any clear representation of such forms. Thus, their work appears at once mysterious and elemental, and universal in its simplicity.

Constantin Brancusi. A Romanian who moved to Paris in 1904, CONSTANTIN BRANCUSI [Bran-KOO-zee] (1876–1957), "rediscovered" primitive sculpture while working with the Expressionist painters, and came to admire the lives of primitive people. Brancusi favored simple geometric forms—rectangles, ovals, and

Connections

GRAHAM AND NOGUCHI: THE SCULPTURE OF DANCE

For the pioneer of modern dance MARTHA GRAHAM (1894-1991), modern sculpture proved to be one of the most useful ways of thinking about the movement of the body in space. Dance was, for Graham, a trajectory into space, a composition of mass moving through void. She also began to recognize that set design, formerly a painter's craft, could easily move from its position as a painted backdrop and occupy the same territory as the dancers themselves. Dancers could move in it, around it, over it, under it, through it, and beside it. They could lean on it, jump over it, hide behind it. Her dances showed humans interacting with art.

In 1935, for the dance *Frontier* (fig. 21.11), Graham initiated what was to be a long-lasting relationship with Isamu Noguchi. Noguchi devised a simple fence, set at center stage, with

two ropes attached to it, extending from each end of the fence forward and upward to the portals of the theater. This giant V-shape created the illusion of space when viewed from a traditional, single-point perspective, receding in a steep plane toward a vanishing point below and behind the fence rail. "It's not the rope that is the sculpture," Noguchi later explained, "but the space that it creates that is the sculpture. It is an illusion of space ... It is in that spatial concept that Martha moves and creates her dances. In that sense, Martha is a sculptor herself." Graham herself forms the apex of the V as the dance opens, and as she moves forward and backward in front of the fence, it is as if she is in a vast landscape, the prairies and basins of the American frontier.

"Isamu Noguchi's vision of space," Graham later said, "and the integral meaning of his sculpture set me on a direction which sustained me throughout my career."

Figure 21.11 Martha Graham in *Frontier*, set by Isamu Noguchi, 1935. Noguchi designed over thirty-five sets for Graham, this being his first. To create sculptural forms with her body, Graham had her costume designed with a full circle skirt to swoop and arc through the air, creating linear curves as she moved.

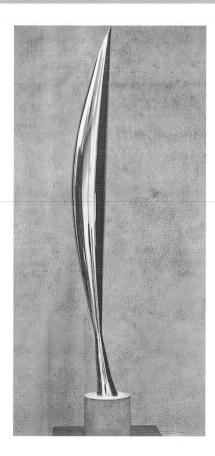

rising verticals. His *Bird in Space* (fig. 21.12), in polished bronze, is an elongated vertical shape. Its purity of form is bound up with the material: bronze is strong and can be highly polished. The sculpture does not represent the bird, but rather the flight of the bird. Nevertheless, the work is almost completely abstract; its expressive quality depends on our knowing the title. "Don't look for obscure formulas or mystery," Brancusi said of his work. "It is pure joy that I am giving you."

Henry Moore. The human figure was the point of departure for British sculptor HENRY MOORE (1898–1986). Yet, Moore's human figure is so simplified and abstract that it is barely identifiable. It often appears as a form of nature, capable of growth but beaten by the elements like an inanimate object. He admired

Figure 21.12 Constantin Brancusi, *Bird in Space*, 1928, polished bronze, $54 \times 8\frac{1}{2} \times 6\frac{1}{2}''$ (137.2 × 21.6 × 16.5 cm), Museum of Modern Art, New York. One of Brancusi's *Bird in Space* sculptures was the center of a battle between Brancusi and the United States Customs Office in 1927. Customs officials called it "bric-à-brac" and said it should therefore be taxed, while Brancusi said it was a work of art and was thus duty free. Brancusi won—a victory for modern art, now officially recognized as abstract art.

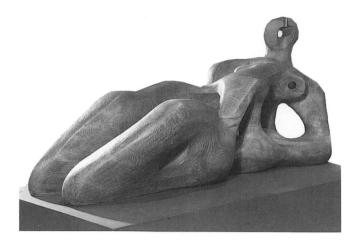

Figure 21.13 Henry Moore, *Reclining Figure*, 1939, carved elm, height 3'1" (94.0 cm), Detroit Institute of Arts. Moore's monumental figure, although in a classical reclining pose, appears to have been weathered into this organic shape.

prehistoric Stonehenge and similar forms eroded by nature and time. His *Reclining Figure* (fig. 21.13), of 1939, looks weathered and suggests the power of natural forces at work. Moore's sculptures often look more effective when seen in a park than in a museum.

Moore's smooth, flowing forms include large openings and hollows. He shapes the masses but gives equal importance to the voids. The masses can be viewed as "positive volumes," while the depressions and holes may be seen as "negative spaces."

Alexander Calder. A new kind of sculpture was created by the American ALEXANDER CALDER (1898–1976), whose father was also a sculptor. The younger Calder first gained recognition as a toy maker in Paris in the 1930s, having made a miniature circus that fascinated the Surrealists, and in particular Miró. By this time, he was already making mobiles, sculptural forms suspended from the ceiling that are driven by mechanical means, or, outside, by the air itself (fig. 21.14). Though almost everyone today knows what a mobile is, it was Calder who invented the form, and Marcel Duchamp who gave it its name. Because a mobile moves in the

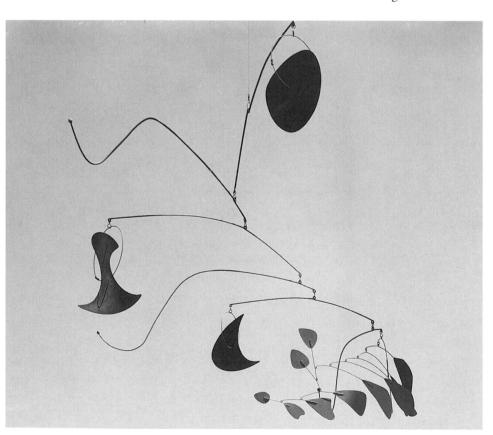

Figure 21.14 Alexander Calder, *Red Gongs*, completed 1950, hanging mobile, painted aluminum, brass, steel rod and wire, overall size $5 \times 12'$ (1.50 \times 3.70 m), Metropolitan Museum of Art, New York. Calder invented this type of hanging sculpture, called a "mobile" because its component parts, highly responsive to the environment, are moved by the faintest breeze. He also made "stabiles" out of similar thin flat shapes that did not move.

Figure 21.15 Isamu Noguchi, *Kouros*, 1944–45, pink Georgia marble, height 9'9" (2.97 m), Metropolitan Museum of Art, New York. Noguchi turned to these flat slabs of marble because, used in the commercial building industry for facades, countertops, and the like, they were inexpensive and widely available.

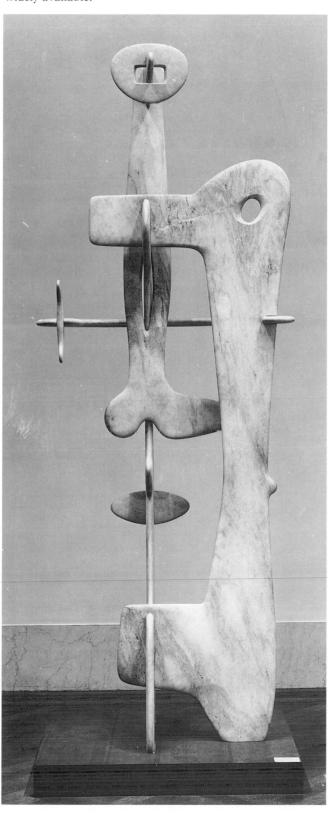

faintest breeze, its form is always changing. The simple shapes constantly form new relationships. Thus, a mobile has many identities; it can never reveal its total identity at any one time. A mobile uses color, shape, composition, motion, time, and space. The artist must be concerned with everything.

Isamu Noguchi. A student of Brancusi's in Paris in the 1920s, Japanese-American sculptor ISAMU NOGUCHI [No-GOO-chee] (1904–1988), was particularly influenced by Brancusi's sense of sculpture as possessing an inherent expressive power. Noguchi drew on his own Japanese heritage in an attempt to discover in stone what the Japanese call wabi—the "ultimate naturalness" of an object.

Kouros (fig. 21.15) is one of Noguchi's works from the period of World War II, during which time he voluntarily entered a Japanese internment facility at Poston, Arizona, in order to help those being held there. "Kouros" is the ancient Greek term for "boy" or "young man" and is used to denote the series of realistic life-size sculptures of the nude male that began to appear in Greece in the seventh century B.C. (see Chapter 3). Despite the title, Noguchi's the form of the work is more obviously related to those of the Surrealists, particularly Arp and Miró. The piece unites two opposing techniques: on the one hand, it is carved; on the other, it is constructed. One of its most important characteristics is that, when viewed from two different angles—that is, from the front and from the side—it appears to be two entirely different works of art. In other words, it precipitates the viewer's movement, or indeed demands it.

AMERICAN MODERNISM

In 1913, just before World War I, a number of American artists worked together to plan an International Exhibition of Modern Art at the 69th Street Regiment Armory, in New York City. Thousands of people jammed into what was soon known as "the Armory Show," to see the Post-Impressionist, Fauve, and Cubist works. Most gawked at the show in amazement and ridiculed it mercilessly, but some American artists were inspired by the exhibition, especially those who frequented the New York City gallery known simply as 291, run by Alfred Stieglitz.

Alfred Stieglitz. Photographer ALFRED STIEGLITZ (1864–1946) had been interested in European modernist work since the turn of the century. Stieglitz was the first American to buy a Picasso, a small drawing of a nude that was so abstract that he himself called it "The Fire Escape." His own photographic talents captured the early modern cra, its hustle, streets, and skylines. One classic photograph captures New York's most important thoroughfare at the time: Winter,

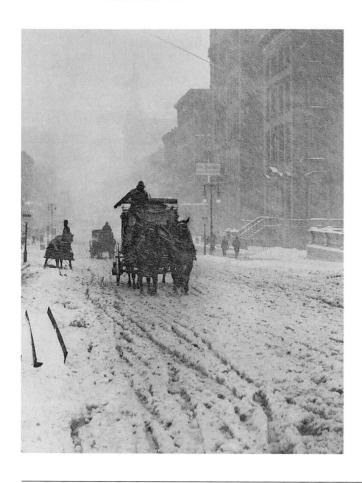

Figure 21.16 Alfred Stieglitz, Winter, Fifth Avenue, 1893, photogravure, $8\frac{5}{8} \times 6\frac{1}{16}''$ (21.9 × 15.4 cm), Museum of Modern Art, New York. Stieglitz was not only the leading photographer of his day but, through his gallery 291 in New York, was the person most responsible for introducing European avant-garde art to the United States.

Fifth Avenue (fig. 21.16). It was a scene from everyday life; even progress and the growth of industry cannot protect those unlucky enough to be caught in this fierce storm.

Georgia O'Keeffe. Among the painters most influenced by Stieglitz's style was GEORGIA O'KEEFFE (1887–1986). Born in Wisconsin, O'Keeffe was a student at the Art Institute of Chicago and the Art Students League in New York. When, in 1915, she sent Stieglitz a bundle of drawings and watercolors, he immediately exhibited them. They later married.

O'Keeffe is best known for the type of painting represented by *Yellow Calla* (fig. 21.17), of 1929, a large-scale abstraction of a natural form. O'Keeffe favored flowers and animal bones as her subjects. *Yellow Calla* is a flower seen from very close up and painted very large, emphasizing its abstract form and pattern. Simple yet carefully designed, O'Keeffe's painting makes use of subtle shading to create filmy, translucent, fluttering forms that are

Figure 21.17 Georgia O'Keeffe, *Yellow Calla*, 1929, oil on fiberboard, National Museum of American Art, Smithsonian Institution, Washington, DC. Concerned with expressive organic abstractions of nature throughout her long career, O'Keeffe made it clear she was an artist—not a "woman artist."

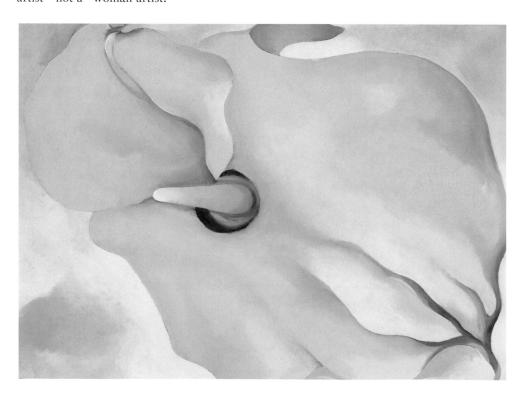

rich and sensuous. Intrigued by light and color, she said that "Color is one of the great things in the world that makes life worth living to me." While many read strong sexual symbolism into her work, O'Keeffe repeatedly made clear that this was not true. She was, she insisted, only a painter of nature and of nature's forms and colors.

The same year that she painted Yellow Calla, O'Keeffe began spending her summers near Taos, New Mexico. After Stieglitz's death in 1946, she moved there permanently. The forms of the desert Southwest became her primary subject matter, its colors, her palette. "I climbed way up on a pale green hill," she wrote, "and in the evening light—the sun under the clouds—the color effect was very strange—standing high on a pale green hill where I could look all around at the red, yellow, purple formations—miles all around—the colors all intensified by the pale grey green I was standing on." It is as if she discovered, in the American landscape, the palette of the Fauves.

Charles Demuth. Among the other American artists championed by Stieglitz was CHARLES DEMUTH (1883–1935). Unlike O'Keeffe, whose primary interest was in natural forms and colors, Demuth was concerned with the architectural forms of the American scene. He reduced them to flat compositions in a manner intentionally reminiscent of the Cubist landscape paintings of Picasso and Braque. In Aucassin and Nicolette (fig. 21.18), of 1921, for instance, the geometric shapes of the industrial landscape near Demuth's home in Lancaster, Pennsylvania, are rendered in flat, hard-edged forms, the lines of which extend into the sky like facets on a polished gem.

MODERNIST LITERATURE

If Parisians seemed to accept all manner of behavior without a second thought, Americans were quite the opposite. Radicals of all kinds flocked to Paris and Europe to escape Prohibition and other social restrictions at home. There, American expatriates discovered liberation from what they considered the stultifying Puritanism of America.

It was in Paris during and after the war that the most adventurous new writing in English was published: James Joyce's *Ulysses*, in 1922, quickly banned for obscenity in America and Britain until 1933; T.S. Eliot's *The Waste Land*, in 1922; William Carlos Williams's prose and poetry *Spring and All*, in 1923; F. Scott Fitzgerald's *The Great Gatsby*, in 1925; Ezra Pound's first sixteen *Cantos*, in 1926; and Ernest Hemingway's *The Sun Also Rises*, also in 1926. It was Hemingway who defined the mood of what he called the "lost generation."

Ezra Pound and T.S. Eliot. EZRA POUND (1885–1972) and T.S. ELIOT (1888–1965) are generally recognized as the two most influential American modernist poets. What distinguished their work from that of

Figure 21.18 Charles Demuth, Aucassin and Nicolette, 1921, oil on canvas, $23\frac{9}{16} \times 19\frac{1}{2}$ " (59.8 × 49.5 cm), Columbus Gallery of Fine Arts, Columbus, Ohio. The painting's ironic title, referring to the famous lovers of medieval romance, is attributed to another member of the Stieglitz circle during World War I, Marcel Duchamp. In fact, Demuth records the industrialization of rural Pennsylvania.

their contemporaries was that they wrote extremely complex, multi-faceted poems that were technically innovative and densely allusive. Pound and Eliot relied heavily on rapidly shifting images, typically presented without explanation. Readers are left to make connections among the poems' images and allusions, and to arrive at understanding for themselves.

Pound and Eliot are sometimes considered "difficult" for all but the most learned and experienced of readers to understand. Both poets believed that poetry *should* be difficult, in part to reflect the complexities and ambiguities of experience, especially that of World War I, which Eliot once described as an "immense panorama of futility and anarchy." Eliot's most influential poem, *The Waste Land*, burst onto the literary scene in 1922. Eliot was aided in his work by his friend Ezra Pound, who cut more than a hundred lines from an early draft and suggested alterations to help unify the poem. In appreciation Eliot dedicated the poem to Pound and honored him further as "il miglior fabbro" (the better maker).

"I had not thought death," Eliot writes in the poem, "had undone so many," speaking of the benumbed

people inhabiting the "unreal city" of post-war London. To Eliot, London seemed as if it had been stricken by the gas warfare on the Western Front. His poem is but a contingency action, a work designed to stop the bleeding, so to speak—"fragments I have shored against my ruin," as he describes it at poem's end.

Pound's early poetry is a concerted attack on World War I. The five-part "Hugh Selwyn Mauberley," published in 1920, ends with this damning indictment of the value of what the soldiers had been fighting for:

There died a myriad, And of the best, among them, For an old bitch gone in the teeth, For a botched civilization ...

In 1926, he published the first sixteen poems of what would become his lifelong work, *The Cantos*. The last Canto was an inventory of those he knew who had gone to war, among them his fellow poet Richard Aldington:

And because that son of a bitch,
Franz Josef of Austria ...
They put Aldington on Hill 70, in a trench dug through corpses
With a lot of kids of sixteen,
Howling and crying for their mamas,
And he sent a chit back to his major:
I can hold out for ten minutes
With my sergeant and a machine-gun.
And they rebuked him for levity.

So disillusioned was Pound with the political and economic policies of England, France, and the other Allies that, when Mussolini took power in Italy in the early 1930s, he became one of his greatest champions. Fascism, and the anti-Semitism that went with it, appealed mightily to Pound, and he supported Mussolini throughout World War II. After the war he was imprisoned, tried for treason, and certified insane. For thirteen years, he was kept at St. Elizabeth's mental hospital in Washington, D.C. Finally, at the request of a number of writers, including Hemingway, Williams, and Eliot, he was released, and returned to Italy, where he died in 1972.

James Joyce. JAMES JOYCE (1882–1941) accomplished for modern fiction what T.S. Eliot did for modern poetry: he changed its direction by introducing startling technical innovations. Like Eliot, who employed abundant and wide-ranging literary and historical allusions in *The Waste Land*, Joyce, in his monumental *Ulysses*, which was published the same year as Eliot's poem, complicated the texture and structure of his narrative with intricate mythic and literary references.

Joyce used a **stream of consciousness** narrative technique that took readers into the minds of his characters. His innovations include such techniques as shifting abruptly from one character's mind to another; moving from description of an action to a character's response to it; mixing different styles and voices in a single paragraph

or sentence; combining events from the past and the present in one passage. These and similar devices convey a sense of a mind alive, a consciousness that is absorbing and connecting the experiences it perceives—what one critic has described as "the shifting, kaleidoscopic nature of human awareness."

Ulysses grows out of the tradition of the nineteenth-century realist novel. Combining a microscopic factual accuracy in depicting Dublin with a rich language, it is an intricate recreation of the events of one day (June 16, 1904) in the life of Leopold Bloom. Organized into eighteen increasingly complex chapters, it echoes major events in Homer's Odyssey.

Virginia Woolf. As James Joyce was experimenting with techniques in fiction, VIRGINIA WOOLF (1882–1941), one of the founders of the Bloomsbury group in London, was developing ways of rendering a literary character's inner thoughts. Both writers explored techniques for conveying stream of consciousness, the representation of the flow of mental impressions and perceptions through an individual's consciousness, conveying a sense of his or her subjective psychic reality. Woolf, in particular, was interested in revealing a character's inner being through what that character thinks and feels, rather than what that character says or does.

Mrs. Dalloway (1925) and To the Lighthouse (1927) are two of Woolf's novels that illustrate her use of the stream of consciousness technique. Like Joyce, Woolf in Mrs. Dalloway focuses on a single day in the life of a person, in this case a middle-aged English woman, Clarissa Dalloway. Readers overhear Mrs. Dalloway's thoughts and feelings as she reflects on her life, especially her marriage. External events are indicated only through the characters' subjective impressions of them. The novel's point of view shifts among a series of characters, including Septimus Warren Smith, a shell-shocked war veteran, who functions to a certain extent as her alter ego.

In *To the Lighthouse*, Woolf commemorates her mother Julia Stephen, who had died in 1895. The novel explores aspects of gender and sexual difference by contrasting Mrs. Ramsay, the book's central character, with her husband, a philosopher. Another central character, Lily Briscoe, is an artist who paints a portrait of Mrs. Ramsay. As critic Lyall Gordon notes, "The artist behind her easel, the biographer behind her novel reproduce the action of the lighthouse: together they light up a woman's uncharted nature." *To the Lighthouse* is a masterpiece of literary modernism, full of the subjective experiences of a central character who is at odds with the world, and replete with poetic symbols that reveal the character's "true" nature.

Ernest Hemingway. Hailed as one of the most influential and imitated of American writers, ERNEST HEMINGWAY (1899–1961) wrote novels and short stories that established a style and manner that came to

Then & Now

ROBIN HOOD AT THE MOVIES

The adventures of Robin Hood is one of the most often retold stories in movie history, and Robin Hood one of the most popular screen characters of all time. When the 1938 version, The Adventures of Robin Hood, appeared, audiences raved about the charismatic Errol Flynn as Robin Hood and Olivia de Haviland as the demure Maid Marian (fig. 21. 19). This was Robin Hood at his swashbuckling finest.

The version with Errol Flynn is the one many Americans grew up with, but it is in itself a remake of one of the greatest silent films. In 1922 Douglas Fairbanks and Mary Pickford, two of the four co-founders of United Artists, created a feature-length film of the story. It was 170 minutes, long for a silent film. They spent over 1.5 million dollars-unheard of in 1922; even Warner Brothers lavished only two million dollars on the Flynn remake in 1938. Fairbanks hired armies of workers to construct the sets on Santa Monica Boulevard in Hollywood. He had built the largest interior ser ever made in the history of the movies, and his outdoor sets rivaled the size of any set made before. No film had ever had a larger cast of extras, and virtually all of them appeared in the archery competition and the early jousting scene in which Robin wins the heart of Maid Marian by defeating the evil Black Knight.

The Warner Brothers version, in 1938, added sound and color, and Robin Hood came to life. Filmed in early Technicolor, it contained deep blacks, dark purples, and luscious greens, and utilized stunning contrasts of light and dark that literally dazzled audiences who had probably never seen a color film. The addition of sound made it possible to speed up the pace, since a silent film requires many stills of narrative and dialogue. With music, trumpets calling, hoofs thundering, and swords clashing, this Robin Hood had a thrilling triumph of good over evil.

Perhaps the greatest distinction between the two early versions lies in the change in the country's ethos and in the studio system's huge marketing effort to promote Errol Flynn as the embodiment of the character. In the depressed thirties, Americans needed Robin Hood, a man who "steals from the rich to give to the poor." Robin Hood's character destroys greed (a loathsome trait in the 1930s) and validates the nobility of the humble masses. Flynn's flashing smile and good looks only reinforced the appeal. When the film was released, newspapers and magazines covered it; radio shows dramatized parts of the story. A paperback edition was published with Errol Flynn as Robin Hood on the cover, and Robin Hood was added to summer reading lists.

Over the years, new versions have been produced. Disney created an animated feature in 1973 in which Robin Hood is a fox. Mel Brooks spoofed the legend in *Robin Hood: Men in Tights* (1993). Brooks's film parodied another current film, *Robin Hood: Prince of Thieves* (1991), directed by Kevin Costner, in which Robin and his band of Merry Men are portrayed as deepthinking, politically correct rebels. There was even a version that depicted Robin and Marian in later life, played by Sean Connery and Audrey Hepburn, *Robin and Marian* (1976), but the public seemed little interested.

Figure 21.19 Errol Flynn and Olivia de Haviland in Warner Brothers' 1938 movie *The Adventures of Robin Hood.*

characterize one pole of the modern fictional idiom. His language is laconic and spare. His plots are simple. The complexity of his fiction lies in its suggestiveness, in the implications of what is said and in that which is left unspoken. Hemingway believed that fiction should reveal less rather than more, like an iceberg with only its tip exposed above water. Thus, reading Hemingway's fiction requires as much attention to what he leaves out as to what he includes.

Hemingway's first successful novel, *The Sun Also Rises*, chronicles the adventures of a group of expatriates in Paris. Narrated in the first person, the novel defines this "lost generation" as impotent survivors of a meaningless fate.

MODERN MUSIC

Probably no art form better embodies the Western world's sense of discord and disharmony precipitated by World War I than music. Before the war, Stravinsky's *The Rite of Spring* had shaken the foundations of tonality, and hence traditional harmony. Stravinsky's use of multiple tonal centers created dissonance and harmonic disorientation. Fleeing to Switzerland during the war, and returning to Paris in 1920, Stravinsky began work on a new ballet for Diaghilev, entitled *Pulcinella*. Taking a number of sonatas by Classical composers, Stravinsky reworked their harmonies to make them more dissonant, changing phrase lengths to make them irregular, and

altering rhythms to make them lively and syncopated. "Pulcinella," he would later admit, "was my discovery of the past." But his was a past thoroughly modernized.

Arnold Schoenberg. The Viennese composer ARNOLD SCHOENBERG [SHONE-berg] (1874–1951) undermined the stability of Western classical music even further by writing music that lacked a tonal center or home key. Atonality, he called it. Much of this work was done before the war and was badly received. During the war and after, Schoenberg ceased composing. He was convinced that tonality was a "straitjacket," but also realized that atonality was structureless. His response was to develop a twelve-tone musical scale, as used in the Variation for Orchestra (1931):

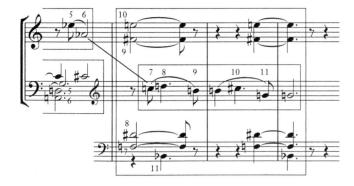

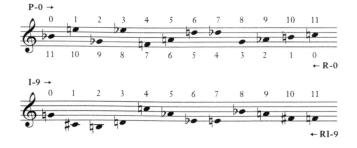

The twelve-tone scale was based on the traditional octave, counting all the half steps. Twelve-tone composition would "level" each tone, giving none more weight than any other, by predetermining the order in which the tones would be played. This order would be used for the entire composition, sequence after sequence.

The music is difficult to listen to for audiences who are accustomed to traditional harmony, but, given the proper theme, it can be very moving. Schoenberg had his theme. Jewish by birth, he based many of his works on Jewish liturgy, including his first stunning success in twelve-tone composition, the opera *Moses and Aaron* (1923). When the Nazis came to power in his native Germany in 1933, he was fired from his job in Berlin. Schoenberg's anger came to the forefront of his musical imagination. The twelve-tone system was the perfect vehicle for its expression.

Repression and Depression: The Thirties

World War I seemed to many to be a war to end all wars, but it nonetheless left a sense of disillusionment and fear that led many people to seek security. Some found it in the authority of Fascist leadership, a dictatorship that ruled with an inflated sense of national pride and which blamed adverse social conditions on others, particularly the Jews. While the end of the war had brought a semblance of peace to Europe, it had not brought political harmony. As the Russian Communist experiment took hold, it threatened to topple long-standing democracies. Workers throughout Europe looked to the Russian Communists for a new sense of vision and identity. When worldwide economic depression struck in 1929, the simple explanation offered by Fascists, such as blaming Jewish bankers for all economic woes, appealed to many.

FASCISM IN EUROPE

Benito Mussolini. In many respects, BENITO MUSSOLINI [moo-soh-LEE-nee] (1883–1945) is responsible for the invention of Fascism, which was first established in Italy. Expelled from the Italian Socialist party for advocating Italian entry into World War I, Mussolini formed groups of so-called fasci (from the Latin word for the bundle of rods that symbolize the Roman Republic). These groups consisted of young men like himself who called for Italy's entry into the war in 1915.

Mussolini's power base expanded rapidly after the war ended. He organized a broad group of Italians who were dissatisfied with the government and who opposed the Socialist cause as Bolshevik. Mussolini's Fascist bands, with the strong support of the Italian police, began openly to attack labor union offices, opposition newspapers,

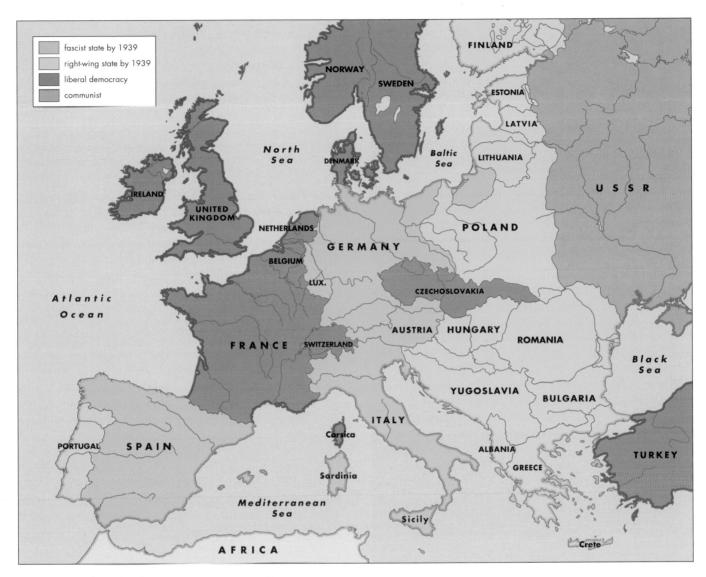

Map 21.2 Left- and right-wing Europe, 1918–39.

and anti-Fascist politicians. Nearly two thousand people were killed between October 1920 and October 1922. Meanwhile, Mussolini gained power, and on October 29, 1922, was named premier. By the late 1920s, the government was totally controlled by the Fascist party, and Mussolini had become more dictator than premier, both head of the party and chief of state. He outlawed emigration, advocated the largest possible families by reducing taxes with each successive child, and taxed bachelors in an attempt to encourage them to marry. His dream was to create, in a single generation, a huge Italian army and a country thoroughly loyal to the goals of the Fascist state. Education, from textbooks to professors, became a propaganda arm of the government itself. The police actively sought out dissenters and eliminated them.

The people supported Mussolini because, in fact, the Italian economy thrived under his leadership. Despite worldwide economic depression, Mussolini made Italy

virtually self-sufficient in agriculture, extended electricity to even the most rural parts of the country, and regulated public transportation.

Adolf Hitler. Meanwhile, the Fascist approach to government spread to Germany, where ADOLF HITLER (1889–1945) took advantage of public despair over the state of Germany's economy after World War I. In 1923, the value of the German currency decreased from a few thousand marks to the dollar to literally trillions of marks to the dollar by the end of the year. Lifetime savings were suddenly worthless. Workers found themselves earning starvation wages as even the price of bread rocketed. In Munich, Adolf Hitler created the National Socialist Party of the German Workers—the Nazi (abbreviation for "National") party.

In 1921, Hitler named himself *Führer* (or leader) of the Nazi party. He became chancellor of the Nazi party

in January 1933, backed by the party's new *Schutzstaffel*, or *SS* (literally, the Defense Force), an elite honor guard, and by the *Sturmabteilung*, or *SA* (literally, "Storm Troops"), a huge private army. A month later, a fire broke out in the Reichstag, the central buildings of German government, and Hitler quickly blamed it on the Communists. By noon the next day, four thousand members of the Communist Party had been arrested, and

their citizenship rights had been suspended.

In August 1934, Hitler became president and chancellor of Germany. Every political party that opposed him was banned. Like Mussolini in Italy, Hitler was convinced that the Bolsheviks-by which he meant the Jews—were responsible for the catastrophic state of the German economy. The Jews became Hitler's primary target. The "Nuremberg Laws" of September 1935 defined a Jew as anyone with one Jewish grandparent. It denounced marriage between Jews and non-Jews as "racial pollution" and prohibited it. Jews were forbidden to teach in educational institutions and were banned from writing, publishing, acting, painting, and performing music. Nor were they allowed to work in hospitals or banks, bookstores or law offices. In November 1938, after a seventeen-year-old Jewish boy shot and killed the secretary of the German Embassy in Paris, mobs looted and burned Jewish shops and synagogues all over Germany. They swept through the streets, entering Jewish homes, beating the occupants, and stealing their possessions. After this night, known as Kristallnacht, the extent of German anti-Semitism was apparent to the entire world.

From the beginning, Hitler's Nazi party was militaristic in its discipline, organization, and goals. Nazis were

proponents of the policy of *Lebensraum* ("living space"), which justified the geographic expansion of the state into other countries' territories to make room for the "superior" German race of people. By the mid-1930s, Hitler was preparing for war.

Francisco Franco. Spain had been in political disarray since the King's overthrow in 1931. Spain's Popular Front, consisting of a coalition of Republicans, Socialists, labor unions, Communists, and even anarchists, won a decisive electoral victory in February 1936. Shortly thereafter, however, Spain's right formed the Falange ("Phalanx"), a coalition of monarchists, clerics (whose church schools had been closed), and the military, who desired to overthrow the new Republican government. At the Falange's head was General FRANCISCO FRANCO (1892–1975), who on July 17, 1936, with his right-wing army, led a coordinated revolt in Spanish Morocco and in a number of towns in mainland Spain—Córdoba, Seville, and Burgos, among them.

The Spanish Civil War had begun. Within a few weeks, about a third of the country was under Franco's control, but Barcelona, Madrid, and Valencia remained Republican strongholds, as did the Basque provinces in the north. The Soviet Union actively supported the Republican cause, furnishing them with military advisers and organizing international brigades of volunteers (among them Ernest Hemingway).

Mussolini and Hitler supported Franco. Hitler even provided Franco with an air force. On April 26, 1937, Wolfram von Richthofen, the cousin of the almost mythical German ace pilot, Manfred von Richthofen, the Red Baron of World War I, planned an attack on the town of

Timeline 21.2 Art and literature during the Age of Anxiety.

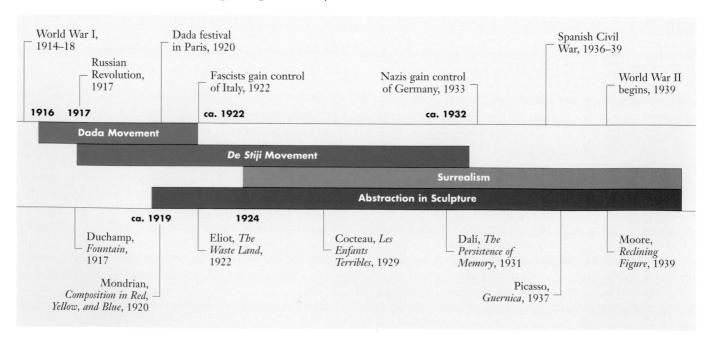

Figure 21.20 Pablo Picasso, *Guernica*, 1937, oil on canvas, 11'5½" × 25'5¼" (3.49 × 7.75 m), Centro de Arte Reina Sofia, Madrid. After Franco's victory in 1939, *Guernica* was exhibited at the Museum of Modern Art in New York where Picasso placed it on "extended loan." He did, however, affirm that the painting belonged "to the Spanish Republic," but he forbade its return to Spain until such time that democracy and "individual liberties" were restored there. With the death of Franco in 1975, the subsequent crowning of Juan Carlos as constitutional monarch in 1977, and the adoption of a democratic constitution in 1978, the painting was finally returned to Spain in 1981.

Guernica in northern Spain, where Basque Republican forces were retreating. It was a sudden, coordinated attack that came to be known as *Blitzkrieg*, or "lightning war." Beginning at half past four in the afternoon and lasting for three and a half hours, a strike force of thirty-three planes, each loaded with three thousand pounds of bombs, pummeled the city. By the time the fires subsided three days later, it was evident that the entire town center had been razed to the ground—fifteen square blocks—and that a thousand innocent citizens had been killed. As news of the event spread, Pablo Picasso, living in Paris, began work on a giant canvas commemorating the disaster, a disaster that foreshadowed the massive, impersonal, and inhumane bombing of European cities in World War II.

Guernica (fig. 21.20) is the culmination of Picasso's Surrealist style. It is painted only in black, white, and grays. It contains a Pietà theme. Many elements of the composition refer to Surrealist dream symbolism. The horse, speared and dying in anguish, might be seen as representing the fate of the dreamer's creativity. The entire scene is surveyed by a bull, on the left, which represents Spain, and in particular its heroism and tragedy, which the bullfight—the struggle of life and death—embodies. But the bull is also the Minotaur, the bull-man of Greek mythology, which for the Surrealists stood for the irrational forces of the human psyche (Picasso had

earlier designed the cover for the Surrealist magazine *Minotaur*). The significance of the electric light bulb, at the top center of the painting, and the oil lamp, held by the woman reaching out of the window, have been much debated, but they represent, on a fundamental level, old and new ways of seeing.

Franco finally captured the Republican strongholds of Madrid and Barcelona in 1939 and ruled Spain as a Fascist dictator until his death in 1975. The attack on Guernica and other Fascist victories in Spain outraged the Allies, but they proved to Hitler just how effective his military forces and tactics, especially the *Blitzkrig*, were. While the Spanish Civil War was winding down, Hitler sent troops into Czechoslovakia, in March 1939. They met with little or no resistance, and shortly thereafter Hitler set his designs on Poland—and the world.

FRANKLIN DELANO ROOSEVELT AND THE NEW DEAL

Throughout the 1920s, the United States had enjoyed unprecedented prosperity, fueled by speculation on the stock market and the extraordinary expansion of the industrial infrastructure. For the first time in world history, a country could define itself not as an agricultural society, nor as an industrial one, but as a consumer society. Houses, automobiles, and everyday goods were

purchased on credit, in an almost unregulated economic climate. Unfortunately, it soon became evident that the prosperity was a house of cards. On October 29, 1929, it all came tumbling down in the stock market crash. Many of the wealthiest people in America were devastated, as thirty billion dollars of assets disappeared within two weeks. Faced with massive withdrawals that they could not sustain, banks closed. Families lost their life savings. By the early 1930s, over sixteen million American men were unemployed, nearly a third of the workforce. To make matters worse, whole areas of the Midwest suffered severe drought. The effect, exacerbated by overplowing, was the creation of a giant "Dust Bowl." Whole populations left the hardest hit areas of Arkansas and Oklahoma for California, an exodus depicted by John Steinbeck in his novel *The Grapes of Wrath*.

Fearing that such economic catastrophe would lead to the rise of the kind of Fascism seen in Europe, or worse, Communism, the United States government decided to intervene. President FRANKLIN DELANO ROO-SEVELT (1882-1945), or "FDR" as he was called, declared a bank holiday in 1933; gradually those institutions that were financially sound reopened. Roosevelt recognized that at the root of the Depression was a deep social imbalance between the haves and the have-nots. He wanted to give the have-nots what he called a "New Deal." In 1935, a Social Security Act inaugurated unemployment insurance and old-age pensions. Tax codes were revised to increase the tax burden on wealthier Americans in an effort to close the social gap. Agricultural subsidies were given to farmers to maintain agricultural production and to steady the economy. For the arts, the Works Progress Administration (WPA) was established to subsidize authors, artists, and musicians.

PHOTOGRAPHY AND THE FSA

Perhaps the most effective tool for creating a sense of national consensus for Roosevelt's social reforms was the work of the photographers subsidized by a program inaugurated by the Farm Security Administration (FSA) to portray the plight of the American farmers and share-croppers devastated by the Depression and drought.

Dorothea Lange. One of the most talented photographers to be part of the plan was DOROTHEA LANGE (1895–1965). Lange's documentary style, though seemingly objective, is driven by a social reformist impulse. Lange's most famous photograph, Migrant Mother, Nipomo, California (fig. 21.21), depicts a young widow with three of her ten forlorn children, migrants on the way to California, the sort that Steinbeck described. She stares obliquely into space, pensive and anxious about the future. Her glance avoids the camera, dissociated from the viewer's gaze. Her face is prematurely aged, for she was just thirty-two when the

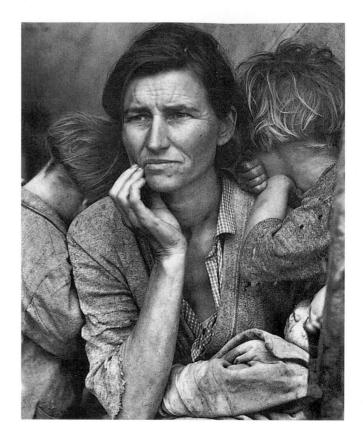

Figure 21.21 Dorothea Lange, Migrant Mother, Nipomo, California, 1936, gelatin silver print, Library of Congress, Washington, D.C. Lange chose to include only three of the mother's ten children in this photograph because she did not want to add to widespread resentment in wealthier parts of American society about over-population among the poor.

picture was taken. The children turn inward, seeking shelter against the mother, who has none for herself. The picture's mood of desperation is heightened by its grainy gray tones.

Walker Evans. Another FSA photographer, WALKER EVANS (1903-1975), is best known for a series of photographs made for the book Let Us Now Praise Famous Men by James Agee published in 1941, which details Evans and Agee's life with a family of sharecroppers in Hale County, Alabama, in 1936. Agee's "famous" men are the heroes of the forgotten people of the Depression and poverty. He describes, for instance, the sharecroppers' house as nightfall creeps over it: "The house and all that was in it had now descended deep beneath the gradual spiral it had sunk through; it lay formal under the order of entire silence." Such formal coherence, underlying the veneer of poverty, is precisely the subject of Evans's Washroom and Dining Area of Floyd Burroughs's Home, Hale County, Alabama (fig. 21.22). It is a powerful composition dominated by verticals and horizontals, a grid punctuated by the single oval washbowl

on the right, and the oil lamp on the left. The work contains visual echoes of Mondrian's De Stijl abstractions. Even as it embodies the stark realities of a sharecropper's life, Evans's photograpy reveals a beauty in the clean lines of this sparse world, a dignified beauty that also marks Agee's accompanying prose.

Margaret Bourke-White. Like Evans, MARGARET BOURKE-WHITE (1904–1971) collaborated with a writer, her husband Erskine Caldwell, to depict the social realities of the Depression. Their best-known project is You Have Seen Their Face (1937). But it was Bourke-White's work as a photojournalist that earned her worldwide recognition. One of the first photographers hired by Life magazine after it was founded in 1936, Bourke-White came to define the profession.

Her photographs of the Depression depicted industry as well as the harsh social and economic conditions of the

Figure 21.22 Walker Evans, Washroom and Dining Area of Floyd Burroughs's Home, Hale County, Alabama, 1936, photograph, Library of Congress, Washington, DC. The power of this photograph rests not only in its formal coherence, but in it stunning focus, its ability to capture the texture of wood, cloth, glass, and vinyl in a manner that makes everything almost real enough to touch.

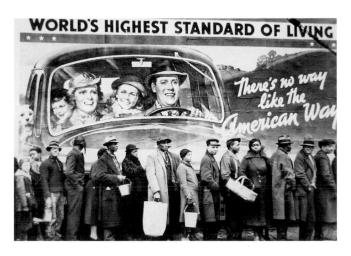

Figure 21.23 Margaret Bourke-White, At the Time of the Louisville Flood, 1937, photograph. Life magazine offered many photographers the opportunity to work professionally. Reacting to the arrival of Life magazine on the publishing scene, Bourke-White said: "I could almost feel the horizon widening and the great rush of wind sweeping in ... This was the kind of magazine that could be anything we chose to make it."

time. At the Time of the Louisville Flood (fig. 21.23) shows the effect of the flooding of the Ohio river in January 1937. It inundated Louisville, Kentucky, and left over nine hundred people dead or injured. On assignment for Life, Bourke-White arrived in the city on the last flight before the airfield was flooded, and hitchhiked on rescue rowboats shooting photo after photo of the scene. At the Time of the Louisville Flood is an indictment of the American dream, juxtaposing the reality of the lives of many African-Americans with the idealized space of the advertising billboard behind them. The government billboard is exposed for the propaganda tool that it is.

Bourke-White worked throughout the world, covering World War II and the Korean War as a correspondent. She was the first woman photographer attached to the U.S. armed forces, and the only U.S. photographer to cover the siege of Moscow in 1941.

REGIONALISM IN AMERICAN PAINTING

The success achieved by the photographers working for the FSA was underpinned by a realist impulse in American culture. Many American artists, especially in the Midwest, rejected the abstraction that dominated European painting and turned instead to a more naturalistic representation of the world's experiences through regional scenes.

Edward Hopper: Though he traveled to Europe several times between 1906 and 1910, EDWARD HOP-PER (1882–1967) did not seem to be affected by what he saw there. For his 1933 exhibition at the Museum of

Modern Art, he wrote, "A nation's art is greatest when it most reflects the character of its people ... We are not French and never can be and any attempt to be so is to deny our inheritance and to try to impose upon ourselves a character that can be nothing but a veneer upon surface."

Hopper's paintings are an accurate record of the American architectural scene. Its cafés, restaurants, stores, and barber shops are his subject matter. Hopper paints neither the most salubrious part of town nor the shabbiest, but those places inhabited by the middle class. Hopper attempted to represent the ordinary, things that had previously been deemed unworthy of an artist's attention. Yet, he is also adept at conveying emotion. though not entirely pleasurable emotion. Nighthawks (fig. 21.24), of 1942, creates a sense of haunting loneliness through its depiction of the alienation of urban life, its stark and sometimes bleak nature. Few human figures are portrayed. Often there is no one at all in Hopper's paintings. There is also often no movement. Is someone about to come out of one of those doors? Appear at one of those windows? Come around the corner?

Thomas Hart Benton. The regionalist impulse in painting was supported by the Works in Progress Administration (WPA), which initiated a mural project to decorate public buildings across the country. The murals

were to represent American themes and experiences. Over two thousand murals were painted between 1935 and 1939, and among the best of them were those by THOMAS HART BENTON (1889–1975). Benton was radically anti-European. "The fact that our art was arguable in the language of the street," he wrote, "was proof to us that we had succeeded in separating it from the hothouse atmosphere of an imported, and for our country, functionless aesthetics."

One of his most ambitious undertakings was a set of murals for the Missouri State Capitol, depicting the social history of Missouri (fig. 21.25). Almost every aspect of Missouri life is depicted. In a domestic scene, an old woman rolls out dough while an old man reads and a young boy drinks a glass of milk. To the left are various farming scenes: a cow is milked; pigs are fed; a farmer sits atop his tractor. To the right a lawyer argues a case before the jury in a courtroom.

Jacob Lawrence. Another, earlier migration, reminiscent of the migration of Oklahoma farmworkers, was that of African-Americans after World War I. They moved steadily from the South to the North seeking employment in rapidly expanding industries. Between 1916 and 1923, the African-American population in major Northern cities increased by 100 per cent. African-American artist JACOB LAWRENCE (b. 1917),

Figure 21.24 Edward Hopper, *Nighthawks*, 1942, oil on canvas, $2'6'' \times 4'8^{11}_{16}''$ (76.2 × 143.9 cm), Art Institute of Chicago. Using carefully constructed compositions to depict ordinary subjects, especially the loneliness of urban life, the artist documented the American scene.

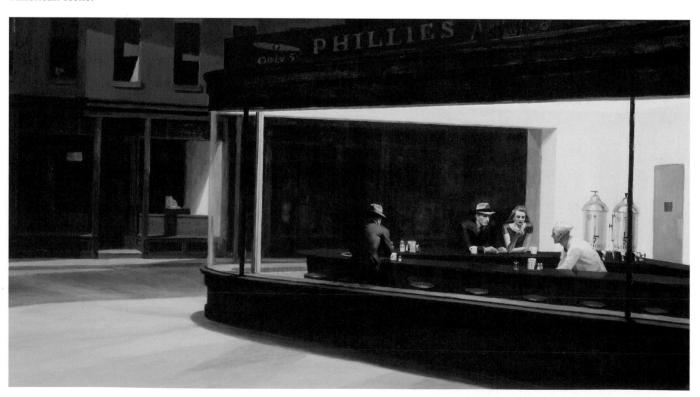

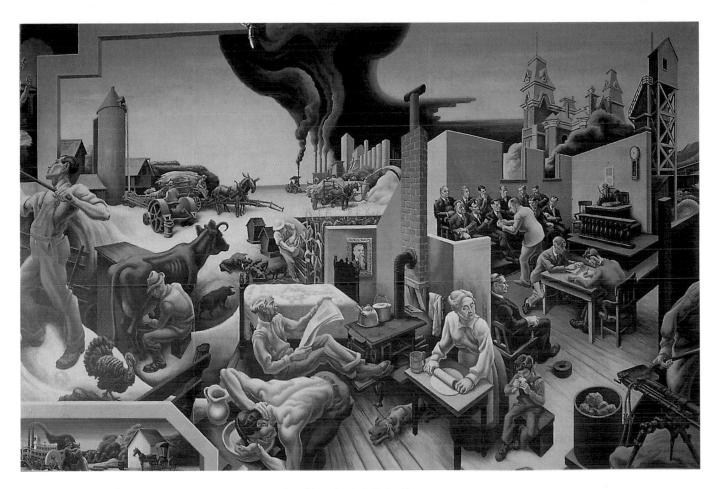

Thomas Hart Benton, Missouri Mural (section), 1936, oil on canvas, Figure 21.25 Missouri State Capitol, Jefferson City, Missouri. The WPA's mural project was directly inspired by the example of the Mexican muralists, one of whom, Diego Rivera, is discussed in the Cross Currents box in this chapter, and whose efforts were supported by the Mexican government.

supported by the WPA, captured this movement in a series of tempera paintings, The Migration of the Negro, made between 1939 and 1941.

Those who migrated first found jobs in the North because of labor shortages resulting from World War I, but as others followed, life in the North soon revealed itself to be little different from that in the South. The Migration series, as it is generally known, depicts the entire saga. The large number of people arriving in Chicago, St. Louis, Pittsburgh, and New York encounter social injustice, racism, inadequate housing conditions, and have to come to terms with race riots. In one panel, They Also Found Discrimination (fig. 21.26), Lawrence depicts, with stunning simplicity, the division between white and black that the African-American population encountered in the North. One of the most subtle, but startling effects of the piece is the almost complete absence of facial features on the African-Americans. They are anonymous, undifferentiated, almost "invisible," to use the word of African-American writer Ralph Ellison, who explored the effects of this experience in his classic novel, Invisible Man.

SOUTHERN REGIONALIST WRITING

The inspiration for regionalism in American painting was in fact the regionalist emphasis identifiable in American fiction between the two world wars. A distinct brand of writing developed, especially in the South. The South's "tall-tale" tradition was enhanced by a colorful dialect and a peculiar usage of the English language, and, in no small part, by the memory of the Civil War, which had fostered a sense of regional pride and identity. The writing of the Southern regionalists is often marked by violent and frequently grotesque characters who are often treated with colloquial humor. It is also distinguished, in particular, by its sense of place.

William Faulkner. Unlike Hemingway, who chose fictional settings in various parts of America, Europe, and Africa, WILLIAM FAULKNER (1897–1962) chose

Figure 21.26 Jacob Lawrence, *They Also Found Discrimination*, from the series *The Migration of the Negro*, 1940–41, tempera on wood, $21\frac{1}{4} \times 18''$ (54×45.7 cm), Philips Collection, Washington, D.C. When the series was exhibited in 1941, Lawrence achieved instant fame, and the series was purchased jointly by the Philips Collection and the Museum of Modern Art, in New York, who divided the panels between them. It was reassembled as a complete series in the mid-1990s when it toured the country once again to national acclaim.

to remain a chronicler of the American South. Most of his fiction is set in Yoknapatawpha County, very much like his native Lafayette County, Mississippi. In his Yoknapatawpha works, Faulkner describes the decline of the local families. His body of work, which ranges widely in style, tone, and technique, earned him a Nobel Prize in 1950.

Faulkner experimented widely with narrative. In *The Sound and the Fury*, for instance, he tells the story of the increasing misfortunes of the Compson family from four different points of view. Each narrative perspective provides the context for the others, so that the whole story

is known through compilation. He also uses a stream of consciousness technique.

Faulkner realized at an early stage that in exploring the world close to him he was also exploring ideas that resonated far beyond the particular locales he was describing. As Faulkner himself put it: "I discovered that my own little postage stamp of native soil was worth writing about and that I would never live long enough to exhaust it." For all its intricacy of form and rhetorical brilliance, Faulkner's work derives its power from his depiction of characters, whose struggle to endure remains both familiar and remarkable. In his Nobel Prize acceptance speech, Faulkner noted that "man will not merely endure: he will prevail ... because he has a soul, a spirit capable of compassion and sacrifice and endurance."

Flannery O'Connor. One dynamically unique voice in modern American fiction is that of FLANNERY O'CONNOR (1925–1964). Her stories explore humor, irony, and paradox, especially evil and redemption, within the Christian belief system. O'Connor is a social satirist often challenging American attitudes toward issues such as random violence, race relations, and class discrimination.

Though O'Connor set her fiction in the South, she explored ideas from Roman Catholicism that transcend the confines of regionalism. "The woods are full of regional writers," she once said, "and it is the great horror of every serious Southern writer that he will become one of them." Several of O'Connor's stories begin with a comic protagonist who indulges in fantasies of moral or social superiority or who has a false sense of the certainty of things. The protagonist then has an ironic and traumatic encounter with other characters, or with situations that suggest a disturbing and incomprehensible universe. Though her stories blend comedy and tragedy, several works end quite gruesomely, such as "A Good Man Is Hard to Find."

THE AMERICAN SOUND

Just as American painters and writers evoked the distinct character of America's regions, a number of composers and musicians sought to convey their own sense of a distinctively American "sound." For over two centuries, people had brought their own musical customs and instruments from many different countries, and, as they settled into communities, different folk sounds developed across the land. Spirited banjo and fiddle music grew popular in the Appalachian mountains; cowboy songs thrived on the American Prairie; gospel music arose in African-American communities in the South; and jazz, which developed in New Orleans, spread to big cities around the country, including New York, Chicago, and Los Angeles. A rich cultural resource was there for composers to adopt and exploit.

Cross Currents

DIEGO RIVERA AND THE DETROIT MURALS

In the early 1920s, the Mexican government initiated a mural movement designed to give the Mexican people a sense of identity and national pride. One of the leading painters of this movement was DIEGO RIVERA (1886–1957). Rivera had lived in Paris, studying the work of Picasso and Braque. He had developed a fluid Cubist style, but when confronted with the task of creating a national revolutionary art, he traveled to Italy to study the Italian fresco. He also immersed himself in Mexico's pre-Columbian heritage.

In 1931, Rivera was commissioned by Edsel B. Ford and the Detroit Institute of Arts to create a series of frescoes for the museum's Garden Court. Rivera was to depict something directly associated with Detroit. Being fascinated both by the promise of modern industry and the plight of the industrial workers, Rivera decided to represent Detroit's industry—its famous automobile factories, pharmaceutical and chemical companies, its aviation facilities and power plants.

Working from drawings and photographs, Rivera made panels for all four walls of the court, with large panels for the north and south walls. At the top of the north panel (fig. 21.27) are

depictions of two of what he regarded as the four races of humanity—the Native American and the African-American. Opposite them, on the south panel, are images of the Caucasian and Asian races. The main part of the north panel depicts the assembly line of automobile manufacturing, showing people molding engine blocks, boring cylin-

ders, and making the final touches. Rivera was not oblivious to the reality of the workers' lives. At the bottom left, a line of workers punch into a time clock. At the bottom right, they cat lunch. Between the two, Rivera captures the extraordinary exertion and strength required of these workers, all day, every day.

Figure 21.27 Diego Rivera, *Detroit Industry* (north wall), 1932–33, fresco, main panel $17'8\frac{1}{2}'' \times 45'$ (5.40 × 13.20 m), The Detroit Institute of Arts. At once a celebration of industry and an exposé of the workers' plight, Rivera's mural is a relatively optimistic plea for social and economic reform through, and by means of, industrial progress.

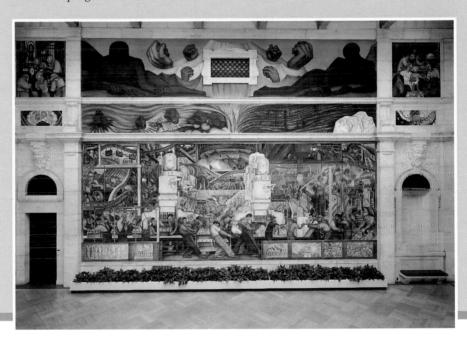

Born in Brooklyn, AARON Aaron Copland. COPLAND [COPE-land] (1900-1990) is one of the most highly esteemed American composers. After his early training, Copland went to Paris for four years, where he experienced first hand the artistic energy of Picasso, Stravinsky, Hemingway, and Pound, as well as that of many other modernist writers, artists, and composers. Returning to America in the mid-1920s, Copland was determined to compose music with a distinctively American style, music that would appeal to a wide and diverse audience. He achieved this with a series of ballet scores that relied heavily on American folk elements. Copland worked closely with two leading choreographers of the time, who were themselves striving for uniquely American dance aesthetics. Agnes de Mille choreographed the ballet Rodeo to Copland's music in

1942; in 1944 Martha Graham choreographed Appalachian Spring. De Mille went on to arrange the stage dance for several leading Broadway musicals, including Oklahoma! (1943) and had her own touring company for years. Graham's internationally renowned dance company still exists (see box on p. 543).

Although Copland's score for the ballet *Rodeo* has been a favorite among American audiences, his *Appalachian Spring* is performed more frequently as a concert piece. The work's subject is, as he said, "a pioneer celebration in spring around a newly built farmhouse in the Pennsylvania hills" in the early nineteenth century. A bride and groom, their neighbor, and a preacher and his congregation constitute the piece's characters. Copland's music imitates American fiddle tunes and hymns, including the traditional Shaker hymn, *Simple Gifts*.

Figure 21.28 A scene from a production of George Gershwin's *Porgy and Bess* at Glyndebourne, England.

George Gershwin. More inspired by African-American blues and jazz is the music of GEORGE GERSHWIN (1898–1937). In its fusion of classical and jazz elements and its mingling of a wide range of sounds, Gershwin's work stands for the "sound" of the modern age, as signified by the four taxi horns in *An American in Paris* (1928), his tribute to the expatriate scene.

An accomplished jazz pianist himself, Gershwin's Rhapsody in Blue (1924) and his Piano Concerto in F (1925) were both composed with a view to taking advantage of his own skill at the keyboard, and both include long piano solos accompanied by full orchestra. But Gershwin is probably best known for Porgy and Bess (1935), one of the earliest and most important American operas (fig. 21.28). It addresses the lives of poor black people in Charleston, South Carolina, and contains some of the most widely heard songs of the 1930s, including the hit "Summertime." Gershwin traveled to South Carolina to familiarize himself with the local dialect and the region's performance rituals, witnessed in church services and public gatherings.

THE JAZZ AGE

The origins of American jazz go back to the African rhythms and organizational principles that characterize its form. In vocal music, the call and response pattern of ritual tribal practice, in which the leader sings a phrase to which the community replies, can be heard in gospel, jazz, and even rock and roll. The jazz **riff**, a short phrase repeated over and over, often unifies the music, as it does today in the so-called "samples" that are the basis of rap and hip-hop. Syncopated and off-beat rhythms, together with improvisation of a basic melody or phrase, are the most characteristic features of jazz.

Scott Joplin. SCOTT JOPLIN (1868–1917) made famous ragtime, a type of jazz piano composition in which the left hand plays a steady beat while the right improvises on a popular or even classical melody in syncopated rhythm. Syncopation means accenting a beat where it is not expected, in particular an off-beat or inbetween beats. Joplin, the son of a slave, began his career as the pianist at the Maple Leaf Saloon in Sedalia, Missouri. His score of the "Maple Leaf Rag," published in 1899, quickly sold hundreds of thousands of copies and ranks as one of the first true pop "hits."

Louis Armstrong. One of the best-known jazz musicians of all time is LOUIS ARMSTRONG (1900–1971). Also known as "Satchmo," Armstrong was a vocalist and a trumpeter. Born and raised in New Orleans, a mecca for jazz in America, Armstrong first played in a New Orleans jazz combo. A few years later, Armstrong left to play cornet in Chicago with King Oliver's Creole Jazz Band. In no time, he had recorded with his own bands and had secured his place as a premier jazz trumpeter.

A stunning improviser, Armstrong could take a simple melody and transform it into a singing, swinging piece by changing its rhythm and altering its pitches. He could also play the trumpet in higher registers than anyone ever before, accurately and powerfully, and he made his music distinctive and original with an array of vibratos and note-altering variations.

His gravelly voice, though, some might say, neither elegant nor beautiful, conveyed spirit and fire. Among his vocal techniques was **scat** singing, in which Armstrong vocalized nonsense syllables on a melody. Ella Fitzgerald, after him, was to take scat to new heights of artistry.

Duke Ellington. One of the greatest jazz pianists and arrangers was EDWARD KENNEDY ("DUKE") ELLINGTON (1899–1974). Ellington served as composer and conductor of a jazz ensemble, or swing band (fig. 21.29). Unlike the New Orleans-style combo featuring improvisations by each of the five to eight members of the group, **swing** music was a jazz style played by big bands of approximately fifteen musicians arranged in

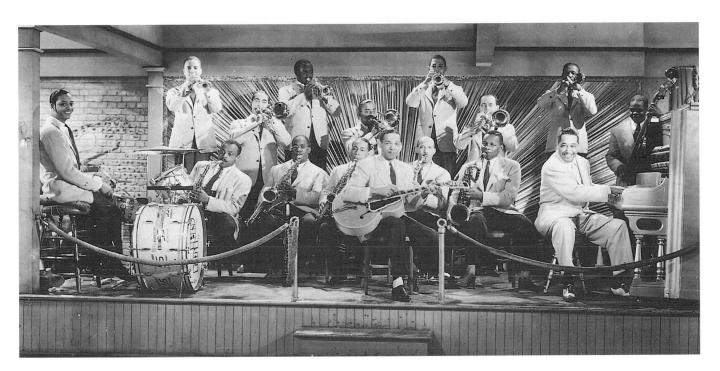

Figure 21.29 The Duke Ellington Orchestra in 1949. Ellington was a dynamic and creative performer. He and his band were immensely popular at the famous Cotton Club in Harlem.

three groups: saxophones/clarinets; brasses (trumpets/trombones); and rhythm (piano, percussion, guitar, and bass). Although swing often included improvised solos, its music was most often arranged due to the larger size of the group. The members of the swing band did more ensemble playing, with each section taking its turn: saxes, brasses, and rhythm, playing in unison. The saxophone became a popular solo instrument during the swing era

(1925–45), with percussion instruments and the piano also becoming prominent instruments of jazz expression.

Ellington provided his musicians with opportunities to display their musical prowess. He composed miniconcertos within pieces. One example, his *Concerto for Cootie* (1940), showcases Ellington's trumpeter Cootie Williams, who had a vast command of tonal color in ways that differed markedly from those of Louis Armstrong.

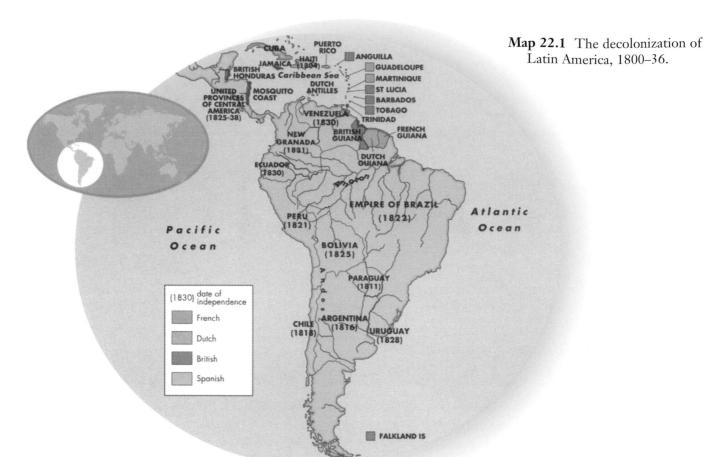

Modern -- Africa and Latin America

CHAPTER 22

- * Modern Africa
- Modern Latin America

David Alfaro Siqueiros, Cuauhtémoc Against the Myth (detail), 1944, Tlatelco, Mexico.

Modern Africa

The second largest continent in the world, Africa is home to millions of people who, between them, speak nearly a thousand different languages. The cultures of the many African peoples are as diverse as the continent they inhabit, with its broad flat savannahs, or grasslands,

its majestic mountain peaks, its expansive deserts, and its tropical forests.

There are at least three distinctive "Africas." North of the equator is the area known as the Maghreb, dominated by the Sahara desert and Islam. Historically the area was closely tied to Mediterranean culture. In the Maghreb, Islam and the Arab language have served as a unifying force for over eight hundred years. South of the

Map 22.2 The decolonization of Africa in the twentieth century.

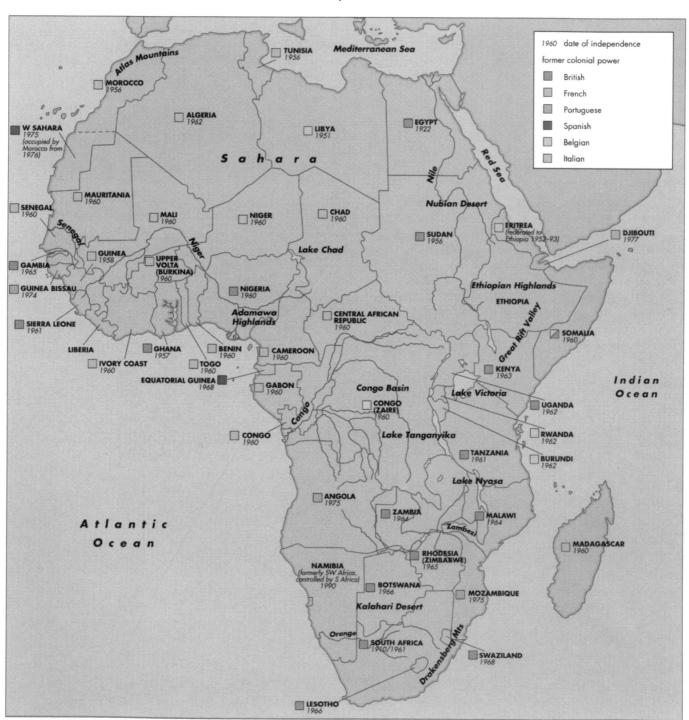

desert, in West Africa, are the sub-Saharan cultures, including the countries of Liberia, Ivory Coast, Ghana, Togo, Benin, Nigeria, Burkina Faso, Niger, and Mali. In sub-Saharan Africa, hundreds of diverse cultures and languages have flourished. Until the arrival of the Europeans and the introduction of the slave trade, all of the countries along the Atlantic coast looked north to the sub-Saharan cultures and the Maghreb for cultural leadership. The Europeans, however, brought with them firearms, and by the end of the eighteenth century, it was those cultures nearest the coast that had traded with the Europeans for guns that came to dominate the region.

The third distinctive "Africa" lies south of the equator. It is geographically more diverse than the rest of the continent, with its high, grassy steppes, an immense tropical rainforest in the Congo, humid woodlands, and even a vast desert, the Kalahari. Many of the inland communities had no contact with the West until the late eighteenth century. All of the peoples speak *bantu* (the word for "people," which is the plural of the word for "man," *muntu*), so the language unifies them culturally.

The history of African culture falls into three periods: pre-colonial, colonial, and post-colonial. Of the first we know very little. As the slave trade flourished, and as the West's knowledge of the continent increased, so did the will to dominate it by exploiting Africa's vast natural resources. What began as diplomatic negotiation between European and African political leaders over access to Africa's resources resulted, by 1914, in European colonial rule of almost the entire African continent.

The catalyst for African independence was World War II, in which African human and natural resources made a significant contribution. Following the war, European countries began relinquishing their colonial empires in Africa. In 1950, only four African countries were sovereign states; by 1980, only two were not. African nationalism and the desire for self-determination were identifiable throughout the continent. Even in South Africa, where once a small minority of whites held power in a country composed of Africans, Indians, and people of mixed race, the tide has finally turned. Following the release of NELSON MANDELA (b. 1918) from prison in 1990, apartheid (the legal separation of the races) has been abolished and a coalition government, led by President Mandela and the African National Congress, has assumed power.

SCULPTURE

What we know of pre-colonial African art has come to us by way of strong oral traditions (which have encouraged a perhaps somewhat exaggerated belief in the continuity of African cultural traditions) and through a few surviving artifacts. The reason for the survival of so few artifacts from the pre-colonial period is that African cultures used wood to create most of their implements and images, and so they have long since disappeared. In sub-Saharan culture, however, objects were created from more permanent materials, beginning in the sixth century B.C., when ironwork spread across the Sudan, soon followed by work in clay.

Pre-Colonial Sculpture in Benin. The Yoruba [YOR-ub-ah] culture has its center in the city of Ife, which is situated in present-day Nigeria. The Yoruba people were making bronze and terracotta, or clay, images by the end of the tenth century. Within four hundred years, the techniques of bronze casting had spread southeast to the kingdom of Benin, where artists developed a bronze and brass sculptural tradition closely related to court life.

The sculpture of Benin reveals much about the role of art in pre-colonial African cultures. The *Head of an Oba* (fig. 22.1) dates from the eighteenth century. It is not so much a portrait as a symbol of authority; the Oba is the

Figure 22.1 Head of an Oba, Edo, Court of Benin, Nigeria, eighteenth century, brass, iron, height $13\frac{1}{8}$ " (33 cm), Metropolitan Museum of Art, New York. All Oba heads include representations of broad coral-bead necklaces which cover the entire neck—a part of the royal costume to this day.

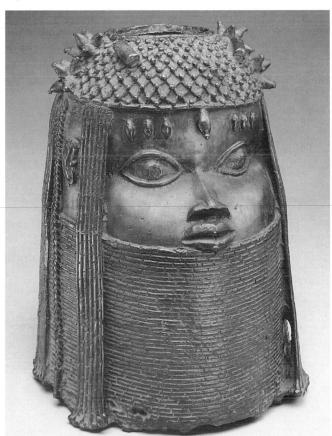

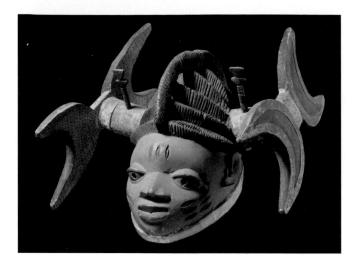

Figure 22.2 Mask, Yoruba, Republic of Benin, paint on wood, height $14\frac{1}{2}''$ (37 cm), Musée de l'Homme, Paris. The reference to the moon in the crescent-shaped horns of this mask echoes a *gelede* song that begins, "All-powerful mother, mother of the night bird."

king of a dynasty. When an Oba dies, the new Oba establishes an altar commemorating his predecessor (usually his father) and decorates it with newly cast heads. In this way, the history of the dynasty is recorded. The head also has a special signficance in Benin ritual. According to British anthropologist R.E. Bradbury, the head "symbolizes life and behavior in this world, the capacity to organize one's actions in such a way as to survive and prosper. It is one's Head that 'leads one through life' ... On a man's Head depends not only his own wellbeing but that

of his wives and children ... At the state level, the welfare of the people as a whole depends on the Oba's Head." The bronze head, in other words, not only signifies but is also integral to social and political life.

Colonial Sculpture. African sculpture created during colonial rule displays, at first glance, few signs of European influence. This reflects, one might argue, the fact that although Africans have consistently regarded Europeans as powerful, they have also seen them as largely ignorant and uncivilized. How else could the Africans interpret the behavior of the slave traders, or of the French Congo government administrators, Gaud and Toqué, who in 1905 forced one of their servants to drink soup made from a human head, and on Bastille Day, 1903, dynamited an African guide as a sort of human firework to celebrate the French Revolution and to "intimidate the local population"? Yet it is true to say that colonial rule stimulated the production of African art. During the nineteenth century, as missionaries destroyed "pagan" images and collectors sent art in large consignments to the West, the works had to be replaced. It is probable that over half the African art in the West today was made during this century of plunder. As a result of indigenous disrespect for European culture and the need to produce work, many long-standing traditions remained intact throughout the colonial period.

The Yoruba *gelede* mask (fig. 22.2), acquired in 1937 by the Musée de l'Homme (the Museum of Mankind) in Paris, is used in a traditional performance ritual to appease "the mothers." "The mothers" represent all women, whom the Yoruba believe possess special powers, positive and negative. On each side of the mask are moon

Figure 22.3 Kane Kwei, Cocoa-Pod-Shaped Coffin, early 1970s, wood and enamel paint, length 8'9" (2.67 m), M.H. De Young Memorial Museum, The Fine Arts Museums of San Francisco. When reproduced in a photograph, as it is here, Kwei's coffin seems smaller than it actually is. It is, literally, a coffin, over $8\frac{1}{2}$ feet long overall.

Connections

THE MASK AS DANCE

For the Baule [BOW-LAY] carvers of the Ivory Coast, the helmet mask illustrated here (fig. 22.4) is a pleasing and beautiful object, but has another significance as well. It is the Dye sacred mask. As the carver explained to Susan Vogel, "The god is a dance of rejoicing for me. So when I see the mask, my heart is filled with joy. I like it because of the horns and the eyes. The horns curve nicely, and I like the placement of the eyes and ears. In addition, it executes very interesting and graceful dance steps ... This is a sacred mask danced in our village."

While the Baule carver pays attention to the physical features of the

mask, he also sees the mask as dance. In its features, he sees its performance. A mask is thus more than an ornament disguising or hiding the face. These Africans have no separate word for "mask," rather the word "mask" includes the whole person performing the dance. In this sense, masks can be said to dance, and the mask or the dancer is a vehicle through which the spirit of the place passes.

Figure 22.4 Helmet mask, Baule, Ivory Coast, nineteenth–twentieth century, wood and color, length 38" (95.8 cm), Metropolitan Museum of Art, New York. This African mask "makes us happy when we see it," explains a Baule carver.

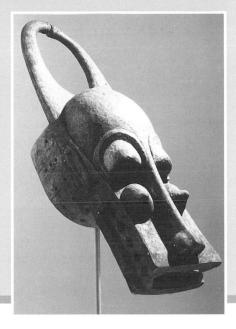

crescents that signify night-time, when "the mothers" exercise their powers. For the Yoruba, a beautiful thing is a good thing, and its goodness extends to all levels of life—the spiritual, the social, and the political. Aesthetically speaking, a mask such as this one should be "not too real and not too abstract, but somewhere in between." It should possess a luminous surface, and a roundness of form. To please "the mothers," the masks reflect these standards of physical perfection, which imply the highest moral standards.

Post-colonial Sculpture. The *gelede* performances of the Yoruba are still popular, and masks continue to be made. Increasingly, there are fewer *visual* connections between traditional and contemporary African arts, but the African conception of art's purpose has remained unchanged. Susan Vogel, a prominent African art historian, explains:

Content ... is of prime importance for African artists, critics, and audiences, who tend to share an expectation that works of art will have a readable message or story. African art of all kinds is likely to be explainable in terms of a narrative or a religious, social, or political text known to both artists and audiences ... All forms of contemporary African art are seen as functional, or as serving some common good ... Most kinds of African art ... seem to have a kind of seriousness, a higher mission than pleasure or decoration alone. The general consensus is that it must honor, instruct, uplift, clarify, or even scold, expose, and ridicule, to push people to be what they must be. Even at its most lighthearted, it is never trivial.

The coffins of KANE KWEI [KWHY] (b. 1924) of Ghana are a perfect example. Kwei never received any

formal training as a carpenter. In the mid-1970s, a dying uncle, who had worked as a fisherman, asked him to produce a coffin in the shape of a boat. Kwei's work delighted the entire community, and he was soon creating many types of coffins—fish and whales (for fishermen), hens with chicks (for women with large families), Mercedes-Benz coffins (for the wealthy), and cash crops (for farmers), among them the cocoa-bean (fig. 22.3). These coffins disappeared underground soon after they were made. Coffins in Ghana are seen as serving the community and also have a ritual purpose: they celebrate the successful life of the person and form part of the traditional Ghanaian funeral celebrations that often last for days. In 1974, an American art dealer exhibited Kwei's coffins in San Francisco, and now Kwei's large workshop turns out coffins for both funerals and the art market.

MUSIC

Music pervades the lives of the sub-Saharan African peoples. Its performance is found in every aspect of life, from hunting to the planting and harvesting of crops, from singing during the treatment of illness to the musical chanting that accompanies proceedings in court. As with sculpture, music plays a functional role rather than one of mere entertainment in African life. At all rites of passage, from birth to death, music expresses their belief system. Even today, music provides the glue that holds communities together.

Perhaps the most distinctive feature of African music is the intricacy of its rhythms and its formal repetitive patterns. Very often, African musical rhythms are played off against each other, by turns clashing and coming together. **Polyrhythms**, or multiple rhythms, are common, as are short melodic phrases, which are the origin of the jazz "riff" and which are often improvised upon and varied for musical diversity and complexity.

Music in Africa is for the most part "popular" music—that is, there is little distinction between "traditional" and "popular," or "classical" and "contemporary." Western jazz and rock and roll have their origins in African music. Contemporary musicians like SONNY OKOSUN [OAK-ka-sun] (b. 1947) blend African and Western sounds. His *Fire in Soweto* captured the imagination of the continent in 1978. Okosun's work is based on a brand of African music known as **highlife**, a fusion of indigenous dance rhythms and melodies with Western regimental marches, sea chanteys, and church hymns, that emerged in the coastal towns of Ghana in the early twentieth century. To this mélange, Okosun added the rock and roll sounds of American guitarist Manuel Santana, as well as the influence of Caribbean reggae.

LITERATURE

In the post-colonial period, many writers of contemporary African fiction have become engaged in the political and cultural struggles for African independence.

Chinua Achebe. Nigerian CHINUA ACHEBE [ah-CHAY-bay] (b. 1930) writes about traditional Ibo culture. In *Things Fall Apart* (1958), his first novel,

Achebe describes the conflict that arises when modern Western ways make incursions into traditional African society. This culture clash is examined in greater detail in *Arrow of Gold* (1964), in which religion and politics become the arenas of conflict where traditional African cultural practices collide with Christianity and colonial power. Achebe writes in a direct style, uncomplicated by the experimental techniques of literary modernism. Instead, he draws on folklore, and especially proverbs, which are central to the African oral tradition, to convey the spirit and substance of his themes.

Wole Soyinka. WOLE SOYINKA [soy-INK-ah] (b. 1934) from Nigeria became the first African writer to win the Nobel Prize for Literature in 1986. Although best known as a playwright, Soyinka is also a poet, essayist, political activist, social critic, and literary scholar. His poetry and plays are deeply political: as he noted in a New York Times interview, "I cannot conceive of my existence without political involvement."

During the Nigerian Civil War, Soyinka was imprisoned and kept in solitary confinement for his antigovernment activism. There he composed *Poems from Prison* (1969) and *The Man Died: Prison Notes of Wole Soyinka* (1988), both written in secret on toilet paper and later smuggled out. During the 1960s he worked tirelessly to develop a Nigerian national drama. Two of his bestknown plays depict political intrigue in an imaginary kingdom, *Death and the King's Horseman* (1976) and *A Play for Giants* (1984), a satire on African dictators.

Timeline 22.1 Modern Africa.

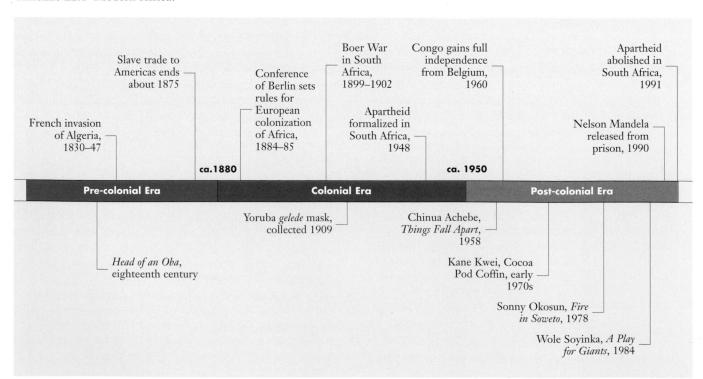

Then & Now

TWINS

The Yoruba have one of the highest rates of twin births in the world. Yet, for the Yoruba, twins remain "gifts of the gods" who possess, or rather are possessed by, the deities of creativity. They are empowered by their inborn ability to perceive a dimension beyond the everyday, communicating with a universe beyond our own.

The Yoruba believe that a mother is blessed with twins as a reward for her patience and virtue, and hence, after their birth, she is treated as if she were a member of the highest royalty. Indeed, any woman who gives birth to twins three times is considered the most powerful person of all, higher than kings. This is a particularly

remarkable honor given that the Yoruba have a patriarchal culture, in which the oldest male member leads his entire clan.

Traditionally, the Yoruba have images carved of the twins, or *ere ibeji*, which are used in a cult should one of the twins die, which sometimes happens since twins are often smaller and more fragile than single babies. Until the twentieth century, these figures were carved out of wood, but they have been increasingly replaced by massproduced Western dolls (fig. 22.5). The mother cares for the "twin" doll of the dead child as if it were still alive, placing it in a shrine in her bedroom. Its spirit, the Yoruba believe, will bring good fortune to the family

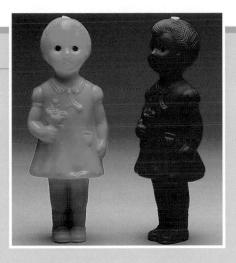

Figure 22.5 Dolls used as *ere ibeji*, mid-twentieth century, unknown factory (Nigeria), molded plastic and metal, height $9\frac{4}{3}$ " (25 cm), Fowler Muscum of Cultural History, UCLA. *Ere ibeji* dolls, images of twins, represent hope for the future to the Yoruba.

Modern Latin America

Like Africa, Latin America had long been under the rule of colonial Europeans—chiefly the Spanish and Portuguese. Then, in the early nineteenth century, grass-roots movements fueled wars of independence throughout the region and inspired the Latin American social elite to break the economic trade monopolies of the colonial rulers, while preserving the existing social structure.

Latin America is marked by the collision and intermingling of two separate cultural and economic traditions. The colonists and their heirs are largely well-to-do Roman Catholics, while the diverse, indigenous peoples maintain their own traditional cultural practices and make up an underprivileged, subsistence-based social class. As distinct from the situation in North America, where a biracial society developed after the advent of slavery, a multiracial society developed in Latin America as the colonists and the indigenous population mixed. In Argentina and Uruguay, the few natives were essentially wiped out by European diseases in the early years of colonization. A Eurocentric culture developed when over one million Europeans, mostly Spanish and Italian, emigrated there between 1905 and 1910. Yet, in Central America and Peru, strong native communities, of Mayan and Incan ancestry, survive to this day, with their own thriving indigenous cultures.

PAINTING

Colonial Art. The joining of Native American and European traditions is evident in much of the art and architecture produced during the colonial period. In Mexico, for instance, Baroque architecture flourished, but with a native exuberance and love for naturalistic detail that far exceeds most Baroque architecture in Europe (see Chapter 15). In painting, native artists combined their own traditions with those of the Catholic Church.

A depiction of a Corpus Christi procession in Santa Ana, Peru (fig. 22.6) shows European and Native American traditions converging. The work was painted in about 1660 by the followers of QUISPE TITO [TEEtoh] (1611-1681), a painter of Inca origin, who worked in Cuzco, Peru. At the head of the procession, on the left, is an Indian leader in royal Inca dress, wearing a headdress decorated with a combination of Spanish and pre-Conquest symbols, including a bird, which, for the Incas, had magical significance (a live bird, with brilliant plumage, also sits on the wall above his head). Following the Inca leader are the priest and acolytes, then the Corpus Christi glory cart with a statue of the parish saint holding onto a palm tree with a cupid-like angel on his shoulder. To the right are the native parishioners. Behind the scene, the European elite watch from their balconies, from which hang brightly colored sheets from Spain.

Figure 22.6 Followers of Quispe Tito, Corpus Christi Procession with the Parishioners of Santa Ana (detail), ca. 1660, fresco, Museo de Arte Hatun Rumiyoc, Cuzco, Peru. Another section of this fresco depicts a giant altar erected especially for the occasion, decorated with silver-framed paintings and sculptures of angels who wear feathered helmets derived from Inca tradition.

The Mexican Mural Movement. Despite the merging of traditions evident in colonial art, the Church and the European cultural elite wanted to suppress native customs. In Mexico particularly, where strong native populations had begun to rebel against the European elite by the early twentieth century, these customs were a source of identity and pride. Beginning in 1910 with a violent revolt against the regime of Porfirio Diáz, Mexico was rocked by social and political unrest. Civil

war lasted until the inauguration of the revolutionary leader, Alvaro Obregón, as President in 1920. Obregón believed that the aesthetic faculty, and the appreciation of painting in particular, could lead the way to revolutionary change. He also believed in restoring Mexico's indigenous cultural identity. He thus began a vast mural project designed to cover the walls of public spaces across the country with images celebrating Mexico's past and future. By the mid-1920s, the mural movement was in

Timeline 22.2 Modern Latin America.

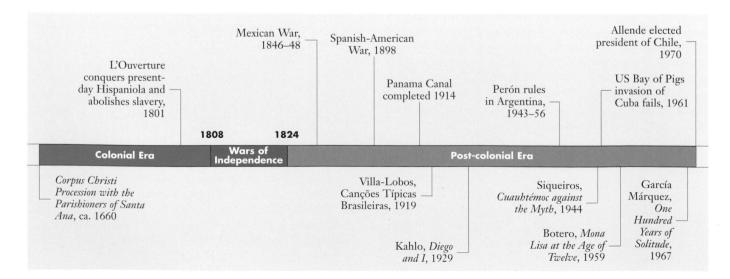

Figure 22.7 David Alfaro Siqueiros, Cuauhtémoc Against the Myth, 1944, mural, pyroxylin on celtex and plywood, 1000 sq. ft. (92.9 sq. m), Teepan Union Housing Project, Tlatelco, Mexico. Siqueiros's experimentation with synthetic paints would lead to the invention of acrylics, much in use today.

the hands of three painters, *Los Tres Grandes*, as they were called, "The Three Giants"—DIEGO RIVERA [rih-VAY-rah] (1886–1957), JOSÉ CLEMENTE OROZCO [oh-ROZ-coe] (1883–1949), and DAVID ALFARO SIQUEIROS [see-KAYR-ohs] (1896–1974).

All three artists began their careers painting al fresco, but the sun, rain, and humidity of the Mexican climate damaged their efforts. In 1937, Siqueiros organized a workshop in New York City, close to the chemical industry, to develop and experiment with new synthetic paints. One of the first media used in the workshop was pyroxylin, commonly known as Duco, a lacquer developed as an automobile paint. It is used in the large-scale mural by Siqueiros, Cuauhtémoc Against the Myth (fig. 22.7), which was painted in 1944 on panel so that it could withstand earthquakes and is housed today in the Union Housing Project at Tlatelco, Mexico. It depicts the story of the Aztec hero who shattered the myth that the Spanish army could not be conquered. This message had great significance for the people: the indigenous people could regain power. Siqueiros also meant it as a commentary on the susceptibility of the Nazis to defeat in Europe.

Frida Kahlo. Rivera was married to another prominent Mexican painter, FRIDA KAHLO [KAHloh] (1907–1954), whose work was initially overshadowed by that of her husband, but whose reputation has increased to such a degree that she is now considered the greater artist and is surely the more famous. Kahlo is best known for her highly distinctive self-portraits in a wide range of circumstances and settings. "I paint self-

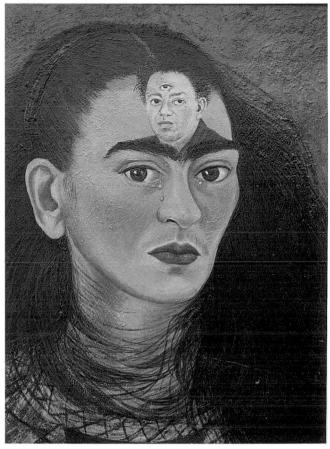

Figure 22.8 Frida Kahlo, *Diego and I*, 1929, oil on canvas, $24 \times 18\frac{1}{2}$ " (29.8 \times 22.4 cm), Private collection. Kahlo and Rivera's marriage was, her parents said, "like the marriage between an elephant and a dove." Kahlo described her marriage as her "second accident" (a traffic collision at the age of eighteen was her first).

portraits because I am so often alone," she once said, "because I am the person I know best." Her self-portraits, it has been argued, created a series of alternative selves that helped to exorcise life's pains. She suffered almost her entire life: first from polio, which she contracted at age six, and which left her with a withered right leg; then from a bus and trolley collision at age eighteen, in which her pelvis and spinal column were broken, her foot was crushed, and her abdomen and uterus were pierced by a steel handrail, resulting in a lifelong series of operations; and finally from her volatile relationship with Rivera, whose many adulterous affairs, including one with her own sister, hurt her deeply.

The self-portrait entitled *Diego and I* (fig. 22.8) reveals the pain Kahlo experienced in her marriage and the extent to which her husband's infidelities tormented her. The work is heightened by the surrealistic detail. Kahlo's hair, for example, is partly wound around her neck to suggest strangulation. Three pearly tears accen-

tuate the deep sadness of her face and eyes. Her husband's image painted on her brow might indicate how he dominates her thoughts and is the cause of her anguish. The eye painted onto his forehead suggests what she considered to be his god-like omniscience.

Wilfredo Lam. The work of Cuban painter WIL-FREDO LAM (1902–1982), of Chinese and mulatto ancestry, demonstrates the close connection between European and Latin American cultures. Lam left for Europe in 1923 at the age of twenty-one and did not return to the Caribbean for eighteen years, until 1941, when he was sent by the Nazis to a prison camp in Martinique. Within forty days, he was released and sent back to Havana, where he discovered that the idyllic Cuba of his childhood had been destroyed by the collapse of sugar prices.

Lam's masterpiece, *The Jungle* (fig. 22.9), painted in 1943, is a record of his reaction. It is almost exactly the same size as *Les Demoiselles d'Avignon* (see fig. 18.26) by Picasso, who had befriended Lam in Paris in 1939. The faces of Lam's totemic figures are based, like Picasso's, on African masks. But crucially different from Picasso's painting is the density of Lam's image. Every space is occupied, not only by shoots of sugar cane and jungle foliage, but by the figures themselves, whose arms and hands seem to reach to the ground. This natural world is inhabited by a mysterious, mythical virgin-beast, both productive and destructive, whose origins are to be found in Lam's fascination with the world of *santería* or voodoo.

Fernando Botero. Columbian artist FERNANDO BOTERO [bo-TAIR-oh] (b. 1932) is known for his "swollen" or "inflated" figures that fill the canvas like balloons and satirize the Latin American ruling elite. "When I inflate things," he has explained, "I enter a subconscious world rich in folk images." Mona Lisa at the Age of Twelve (fig. 22.10), painted in 1959, condenses three images: Leonardo da Vinci's original painting (see fig. 13.25), the Infanta Margarita in Diego Velázquez's Maids of Honor (see fig. 15.26), and Alice in Wonderland. Mona Lisa's oft-noted "inscrutable" smile here becomes grotesquely pig-like, Botero revealing in it the gluttony of the Latin American aristocracy and their ability to "consume" the land and its people.

MUSIC

Latin America has a rich musical heritage, both popular and traditional. The most prevalent forms of popular music are those associated with dance. The tango came from Argentina, the samba from Brazil, and the pasillo from Colombia. Latin-inspired dances include the Caribbean calypso, the Cuban rumba, the Brazilian lambada, and even the macarena.

One of the most popular instruments used in Latin

American music is the guitar, which has a long history in Spain and Spanish American cultures. The guitar has been used both in folk and classical music, by many composers, including the Brazilian HEITOR VILLA-LOBOS [VEE-yah LOW-bows] (1887–1959).

Latin America's best-known classical composer, Villa-Lobos was born in Rio de Janeiro. After studying music with his father, he earned a living by playing the cello in cafés. He researched and collected authentic folk and Indian songs, both of which he later used as melodies in his classical compositions. Villa-Lobos believed that folk music revealed the special vitality and spirit of a people, their unique essence, and he conveyed this in his large works for chorus and orchestra.

LITERATURE

The literature of Latin America is written primarily in two languages, Spanish and Portuguese. Yet the plurality of voices and visions that emerge in modern Latin American fiction is staggering. A concern many writers share is an exploration of the imagination. Three writers

Figure 22.9 Wilfredo Lam, *The Jungle*, 1943, gouache on paper, mounted on canvas, $7'10'' \times 7'6\frac{1}{2}''$ (2.39 \times 2.30 m), Museum of Modern Art, New York. The son of a Chinese immigrant and an Afro-Cuban mother, Lam studied African art in Paris and adopted Picasso's style in an attempt to explore his own origins.

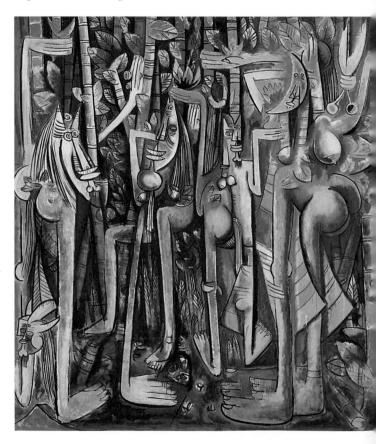

Cross Currents

BACH IN BRAZIL

One interesting musical cross current between Latin America and Europe is Villa-Lobos's *Bachianas Brasileiras*, a piece inspired by the German Baroque composer Johann Sebastian Bach, and written as a tribute to his memory and legacy. In this work, Villa-Lobos couples Brazilian rhythms with Bachian counterpoint to create a fusion of Latin

and Germanic musical styles that spans cultures, oceans, and centuries.

Bach was the archetypal composer for Villa-Lobos, since Bach also drew inspiration from simple folk melodies, which he then developed into complex polyphonic compositions. *Bachianas Brasileiras* consists of nine parts, each scored for different instrumental combinations. No. 1, for example, is scored for eight cellos, No. 3 for piano and

orchestra, No. 6 for flute and bassoon.

One of the most notable parts of *Bachianas Brasileiras* is No. 5, which includes a beautiful aria based on a Brazilian folk song. Villa-Lobos sets this piece for soprano voice and eight cellos, with a solo cello line. Its elegant beauty in the alternative arrangements is but one example of the way cultures interact to produce new and exciting artistic forms and styles

can be singled out for special attention: Argentinean novelist, essayist, and short-story writer Jorge Luis Borges; Colombian novelist and short-story writer Gabriel García Márquez; and Chilean novelist Isabel Allende.

Jorge Luis Borges. JORGE LUIS BORGES [BOR-haze] (1899–1986) is best known for what he calls his ficciones—short, enigmatic, fictional works that invite philosophical reflection, especially speculation about the mysterious universe that human beings inhabit. Borges's fiction is situated at the interface between essay and autobiography; he mixes facts and names from his family chronicles with reflections on philosophical matters. His stories frequently involve a central character confronted with a puzzle, much in the manner of detective stories.

One of Borges's most powerful metaphors is that of the labyrinth, a maze into which the central character (and the reader) is placed, and from which extrication comes as the character gains realization about the imaginative world. Borges often merges the "real" with the imaginary, the historical with what is invented, so that his readers become disoriented and are forced to reconsider the relationship between fiction and reality.

Gabriel García Márquez. If Borges is the master of the short story, GABRIEL GARCÍA MÁRQUEZ [gar-SEE-ah MAR-kez] (b. 1928) is the master of the novel. His One Hundred Years of Solitude (1967) blends the "real" with the imaginary in unpredictable yet convincing ways, in a style known as magic realism. This weaves realistic events with incredible and fantastic ones, in an attempt to convey the truths of life. Key events do not necessarily have a logical explanation; mystery is an integral part of experience. Remarking that "There's not a single line in all my work that does not have a basis in reality," García Márquez sees his work as conveying simultaneously the truths of the imagination and those of "reality."

Isabel Allende. In the year García Márquez won the Nobel Prize for Literature, Isabel Allende [ay-END-eh]

(b. 1942) published *The House of Spirits* (1982) creating a fictional world to reconstructs the history of a country—here, modern Chile, from which she was exiled when her uncle, President Salvador Allende, was assassinated in 1975. She uses the techniques of magic realism, for, as she says, "in Latin America, we value dreams, passions, obsessions, emotions...[it is appropriate to] our sense of family, our sense of religion, of superstition, too." But mostly it is because "Fantastic things happen every day in Latin America—it's not that we make them up."

Figure 22.10 Fernando Botero, Mona Lisa at the Age of Twelve, 1959, oil and tempera on canvas, $6'11'' \times 6'5''$ (2.11 \times 1.96 m), Museum of Modern Art, New York. In the 1970s, Botero moved to Paris, where he began to make large bronze sculptures of his swollen figures.

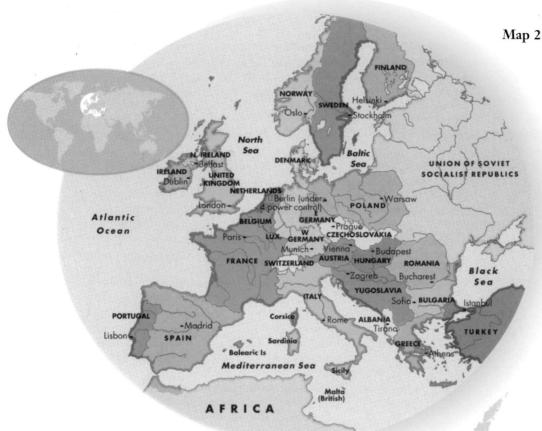

THE AGE OF AFFLUENCE

CHAPTER 23

- ← World War II and After
- + Pop Culture

Frank Lloyd Wright, Fallingwater, Bear Run, Pennsylvania, 1936.

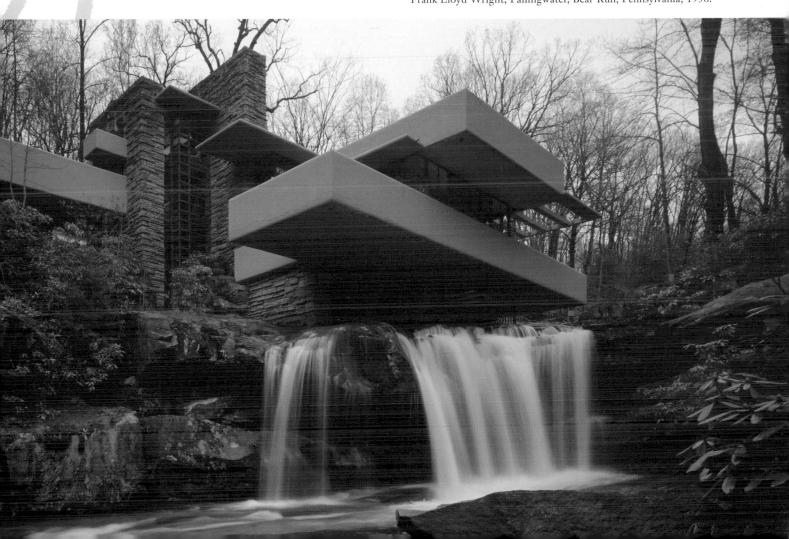

WORLD WAR II AND AFTER

The world as we know it today came into being after World War II. At least seventeen million soldiers had died fighting this war, and eighteen million civilians because of it. The economies of Europe and Asia had been decimated. The Allied victory was undermined by political mistrust of the Soviets, members of the Allied forces, whose Communist tenets threatened Westernstyle capitalism. Only one thing was certain: humankind was now capable of total self-destruction.

On May 10, 1940, nine months after Hitler's invasion of Poland had forced France and Britain to declare war on Germany, German troops moved north into the Low Countries. From Belgium, German troops poured into France, driving not directly to Paris but to the English Channel, thus separating France from its British allies. Britain withdrew over 300,000 French and British troops trapped on the beaches at Dunkirk, and then Hitler marched on Paris. On June 13, the French declared Paris an open city and evacuated it without fighting. On June 22, Marshal Henri Pétain signed an armistice with the Germans, handing over two-thirds of the country to German control, leaving himself in charge of the Mediterranean areas. His headquarters were in the small resort community of Vichy, and his government, despised by many French people after the war for its collaboration, was known simply as Vichy France.

Hitler apparently believed that, without France's support, Britain would give in as well. Britain did noth-

ing of the kind. When Britain's new prime minister, WINSTON CHURCHILL (1874–1965), addressed the House of Commons, he spoke with such force that his speech became a kind of national imperative:

I have nothing to offer but blood, toil, tears, and sweat. We have before us an ordeal of the most grievous kind. We have before us many, many long months of struggle and of suffering. You ask, what is our policy? I will say: It is to wage war, by sea, land, and air, with all our might and with all the strength that God can give us; to make war against a monstrous tyranny, never surpassed in the dark, lamentable catalogue of human crime. That is our policy.

You ask, what is our aim? I can answer in one word: It is victory, victory at all costs, victory in spite of all terror, victory, however long and hard the road may be; for without victory there is no survival.

In August and September of 1940, Hitler began to test the British resolve by conducting full-scale bomber attacks on the country. But, in what Churchill would label the "nation's finest hour," Germany failed to win superiority in the air over Britain, and British resolve was strengthened even more deeply.

Meanwhile, in the Pacific, Japanese leaders, who had struck a deal with Vichy France, invaded French Indochina (Vietnam) and pressed into China. The Japanese Emperor HIROHITO (1901–1989) entered into an alliance with Hitler and Germany, agreeing to enter the war once Japan was militarily prepared to do so or if the United States joined the Allied forces and entered the war in Europe. Apparently impatient, on

Timeline 23.1 The United States after the war.

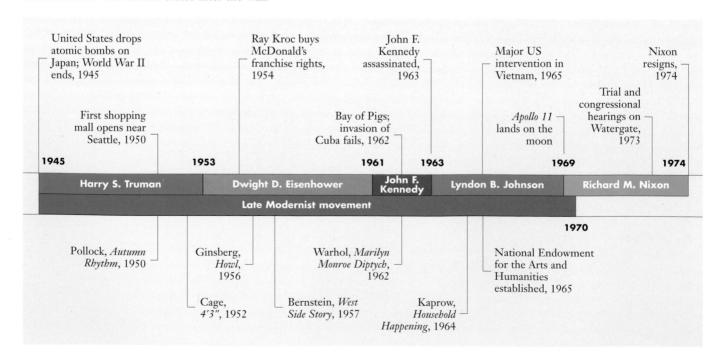

December 7, 1941, Japanese forces attacked the American naval base at Pearl Harbor, Hawaii. An outraged United States immediately declared war on Japan, and Germany honored its alliance with the Japanese and declared war on the United States. By the end of 1941, it seemed like the entire world was at war.

Slowly, the Allies gained the upper hand both in Europe and in the Pacific. There were many turning points. In North Africa, Allied troops defeated the German General Erwin Rommel, the "Desert Fox." In Russia, the Soviets successfully defended Stalingrad (Volgograd) against Germany. In Italy, the Allied invasion of Sicily soon took Italy out of the war. Then came "D-Day" on June 6, 1944, and the Allies regained the beaches of northern France (fig. 23.1). Perhaps a decisive factor in defeating Germany was simply Allied air superiority, which almost completely devastated Germany's industrial base and oil production capabilities, drawing to a halt resupply of its troops in the field.

As the Allied troops marched into Germany, Hitler shot himself in defeat, having started a war that had resulted, at a conservative estimate, in the death of seventeen million soldiers, eighteen million citizens, and between six and seven million Jews in death camps such

as Auschwitz, in Poland, where as many as twelve thousand Jews were executed in a single day. On May 8, 1945, Churchill and the American President, HARRY S. TRUMAN (1884–1972), declared the war in Europe over. The United States chose to end the war with Japan by dropping its newly developed atom bomb on the Japanese cities of Hiroshima, on August 6, 1945, and, three days later, on Nagasaki. On September 2, 1945, Japan surrendered as well.

COLD WAR AND ECONOMIC RECOVERY

From the point of view of many historians, World War II represents a rekindling of hostilities that had remained unresolved since World War I. In this light, the 1920s and '30s can best be viewed simply as an extended truce. So devastating was the war that Europe lost its central place in world politics and culture and Japan was left so battered that its emperor, Hirohito, referred to the situation as "the unendurable that must be endured."

Peace was a necessity, but quarrels were a certainty. The rebuilding of Europe and Japan required huge investment, but only economic recovery could underwrite it. The American Secretary of State, GEORGE C.

Figure 23.1 Allied troops landing in Normandy. This photograph, taken two days after D-Day, on June 6, 1944, shows reinforcements arriving on French soil. From the ships in the bay to the blimp flying above and the tanks on the ground, the dimension of the Allied effort is evident.

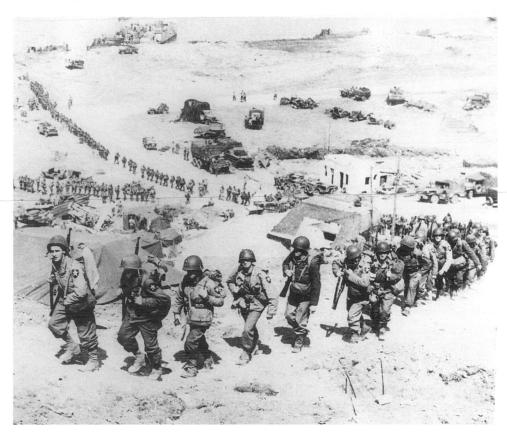

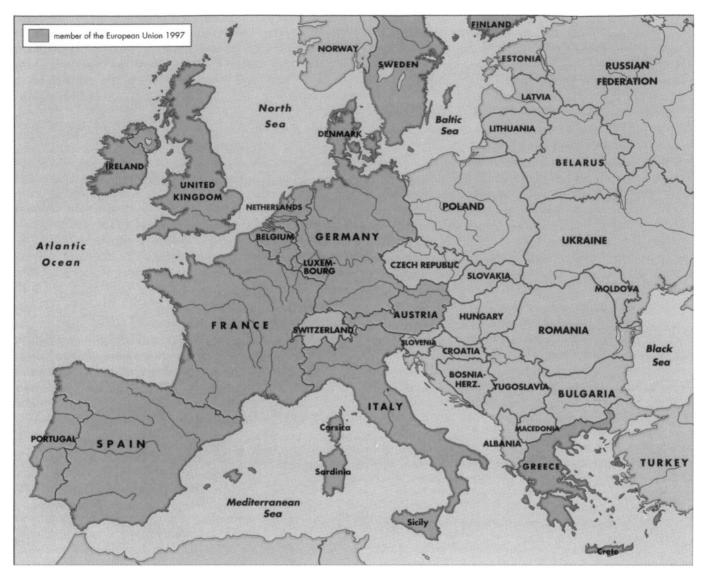

Map 23.2 Membership of the European Union, 1997.

MARSHALL (1880–1959), conceived the idea of providing economic aid to the European countries on the condition that they work together for their mutual benefit. It was called the "Marshall Plan," and it allowed for unprecedented prosperity and affluence in Europe. In Japan, General DOUGLAS MACARTHUR (1880–1964) helped to install a new democratic constitution forbidding the manufacture of arms for "land, sea, or air force ... [and] other war potential." Japan thus became the only world power without a significant defense budget, which freed its economy.

Europe was so weakened that it became the focal point of a struggle for world power called the "Cold War," fought without open warfare between the United States and the Soviet Union. The United States had as its ally much of Western Europe while the Soviet Union dominated Eastern Europe. By 1950, the former

imperial powers of Europe had also lost control of most of their territories and empires overseas, and many of these countries in Southeast Asia, Africa, and Latin America, became points of conflict in the U.S./Soviet power struggle. In 1961, the United States supported Cuban exiles in their efforts to overthrow the Communist regime of FIDEL CASTRO (b. 1926), support that culminated in the embarrassingly unsuccessful invasion at the Bay of Pigs. A year later, Castro allowed the Soviets to establish missile bases in Cuba itself, and the Cold War threatened to go nuclear. But calmer minds prevailed, and the cool relations of Cold War politics once again took center stage.

Even as Western Europe lost political clout worldwide, it developed a strong economic union, the European Community, or the Common Market as it was known (it has now been renamed once more as the European Union), which brought unparalleled affluence, or wealth, to the continent. As opposed to Eastern Europe, where shortages of food and goods remained a constant throughout the life of the Soviet regime, both Western Europe and the United States enjoyed fifty years of expansion in the availability of consumer goods and services. Japan, too, freed from military obligations by its treaty with the United States, turned its attention on its devastated economy, and by 1970 it led the world in the production of quality consumer goods. By 1996, its Gross National Product was nearly four times that of France and three times that of Germany.

The period after World War II can thus be represented as a steady movement from destruction and devastation to affluence and prosperity. In this climate, anything seemed possible. Visionaries speculated that one day every family might own a television. Music might be played in stereophonic sound. People might fly to the moon. Computers might interpret data, drive cars, or clean houses. Even more important, racism might end, women might achieve equality, world peace might be possible. Such were the dreams.

THE PHILOSOPHY OF EXISTENTIALISM

The reality of the horrors of the German concentration camps, of human being's inhumanity to one another, and, in France particularly, the fact that thousands had willingly collaborated with the Nazis in the Vichy government or, at the very least, turned their eyes from Nazi atrocities, fueled a philosophical discourse that focused on the individual's responsibility to make ethical choices and decisions-existentialism. Its seeds lay in the ideas of the Danish philosopher SØREN KIERKEGAARD [KEAR-kah-gard] (1813–1855), who insisted on the irreducibly subjective and personal dimension of human life. Kierkegaard used the term the "existing individual" to characterize the subjective perspective, and from this the term "existential" later developed. Kierkegaard emphasized the essentially ethical nature of human life, with each individual responsible for making choices and commitments. Kierkegaard also insisted that the kinds of choices individuals need to make are ethically appropriate ones involving respect for other people, virtuous behavior on their behalf, and a faith in spiritual things that transcends the limitations and vicissitudes of material life.

Jean-Paul Sartre. Like Kierkegaard, the French philosopher Jean-Paul Sartre [SAHR-truh] (1905–1980) emphasized the ethical aspect of existential thought. Unlike Kierkegaard, however, Sartre, who was an atheist, disavowed any spiritual or religious dimension as necessary for existential living. The central tenets of Sartre's existential philosophy begin with his idea that "existence precedes essence," which suggests that human beings are

defined by their choices and actions. Nothing is fixed or pre-established in "human nature." That is, there is no essential human nature that exists as a given beyond physical life. What is important is what human beings become, what they make of themselves through their choices, decisions, and commitments, which are always in question and never finally settled.

This fundamental idea is related to another: that human beings exist relative to one another; they exist in interpersonal and social situations that affect them, situations that also involve repeated decisive choices. The choices human beings make are necessary and inescapable. Those choices, moreover, not only make individuals who they are, since a person is what he or she does, but they also make people responsible for each other as well as for themselves. When people evade responsibility for themselves or for others, they exist in a state that Sartre describes as "bad faith," which results from denying their freedom to do, think, act, or be otherwise than they are.

Sartre recognized that people might live in a state of "bad faith" because the burden of responsibility is very great and at times frightening. But he insisted that in evading responsibility, individuals were ignoring, repressing, or otherwise hiding from truth. Complicating the decisions individuals confront every day is the lack of any fixed or absolute standard by which they make decisions about right and wrong. Standards of good and evil can be and indeed are established, but individuals must decide to abide by them for themselves. This position had particular impact after World War II, when the West had to deal with revelations about Nazi attempts to exterminate the Jews and the collaboration of both ordinary Germans and the governments of occupied Europe in the process.

The responsibility for choosing and the freedom to decide about such matters belong to the individual alone. So too do decisions about how to respond to situations that are beyond one's power to change—one's race or physical attributes, for example. Whether to see unchangeable dimensions of one's life as handicaps or attributes, as limitations, advantages, or opportunities lies within the decision-making power of the individual.

Sartre developed his philosophy in the context of World War II, including the Nazi occupation of France. During that time he came to recognize the ways one's physical freedom could be curtailed and one's life endangered. Nonetheless, he remained uncompromising in his insistence that, regardless of one's situation, one always had the conscious power to negate it and to transcend it in thought. What people make of such situations, much as what they make of themselves through the many roles they perform in life, determines who they become. It is not the situations themselves or the roles people find themselves in that fix their identities but the choices they make in response to those roles and situations.

Simone de Beauvoir: SIMONE DE BEAUVOIR [boh-VWAHR] (1908–1966) shared with Sartre ideas about the necessity for responsibility in choosing what one makes of one's life. De Beauvoir stressed more than Sartre the ambiguity that is frequently a factor in the ethical decisions people need to make. In her Ethics of Ambiguity (1947) she emphasized the typical complexity of choices between right and wrong. Beauvoir worked closely with Sartre throughout their adult lives. She met him while they were both students at the Sorbonne in Paris, and lived with him for many years as mate, companion, partner, and intellectual associate.

De Beauvoir's most important contribution involves her study of women. In her groundbreaking book *The Second Sex*, she reviewed history and myth, bringing them to bear on the situation of women at mid-century. She also analyzed the biological bases of female experience, concluding that although biological differences between men and women are incontrovertible, it is social differentiation that determines their very different life experiences. De Beauvoir was especially eloquent on women's need to distinguish themselves from men, to break the pattern of being seen only in relation to them. She was far ahead of her time in advancing the belief that, in a man's world, women need to band together collectively to assert the pressure for change. She was equally in advance of her

time in calling for economic opportunities that might help to create equality. Most important of all, perhaps, is her insistence that women should have their "independent existence," so that as women and men mutually recognize each other "as subject, each will yet remain for the other an *other*." For de Beauvoir, women, even more than men, need to claim themselves for themselves, recognizing their responsibility to choose what they will become, even as they acknowledge the limitations and constraints they are compelled to live with.

ABSTRACTION IN AMERICAN ART

Even as existentialism became the dominant post-war philosophy, the arts too began to emphasize the value of individual expression. In the United States, in particular, a brand of highly personal and subjective abstract painting developed that became known as **abstract expressionism**. Many of the artists involved rejected the term; as one wrote, "I never think of my pictures as abstract ... Nothing can be more concrete to a man than his own felt thought, his own thought feeling." Yet the work of the Abstract Expressionists, though widely varied in style, was unified in its rejection of direct representation of the objective world and its emphasis on the expressive capacities of one's own gestures and techniques.

Figure 23.2 Jackson Pollock, *Autumn Rhythm: Number* 30, 1950, oil on canvas, $8'9'' \times 17'3''$ (2.66 \times 5.25 m), Metropolitan Museum of Art, New York. Because there is no recognizable subject, such work is referred to as "Abstract Expressionism." Pollock's personal technique is known as "action painting" because of the highly active physical process—he splattered, flung, and dripped paint onto canvas unrolled on the floor, the result being largely accidental.

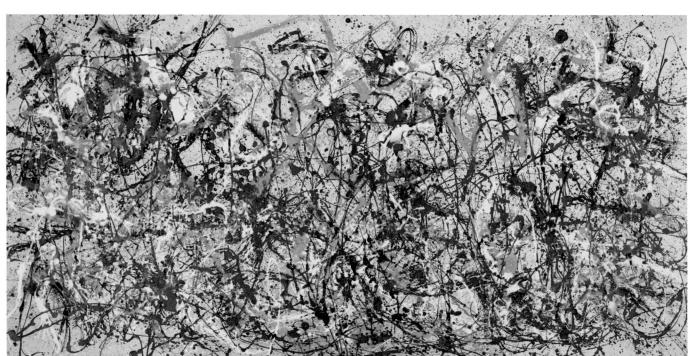

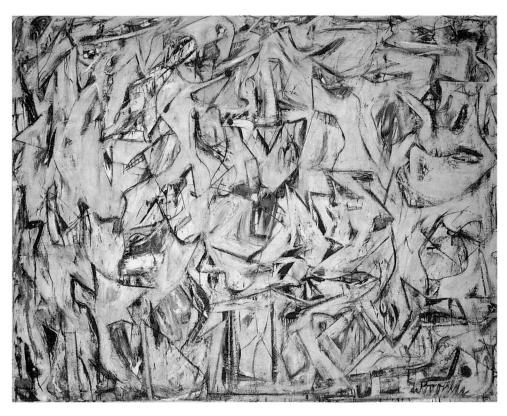

Figure 23.3 Willem de Kooning, Excavation, 1950, oil on canvas, $6'8\frac{1}{2}'' \times 8'4\frac{1}{8}''$ (2.04 × 2.54 m), Art Institute of Chicago, Chicago. Fragments of human anatomy seem to reveal themselves behind, through, and across the webbed surfaces of many de Kooning paintings.

In the 1930s many artists were not working on the kind of mural painting supported by the WPA, and the government recognized this. As part of the "New Deal," an easel painting project was initiated that paid artists \$95 a month to live on. While not a fortune, this represented a living wage, and many of the artists under this plan soon led America to a position as the focal point of the avant-garde in the 1940s. Among them were Jackson Pollock, Willem de Kooning, and Mark Rothko.

Jackson Pollock. Perhaps the best known of the Abstract Expressionist painters is the American JACK-SON POLLOCK (1912–1956). Born in Wyoming, Pollock moved to New York in the 1930s, studying with Thomas Hart Benton, whose interest in large-scale work greatly influenced him. By the mid-1940s, Pollock had begun developing a body of work sometimes referred to as "drip" paintings. These have been linked to the fact that he was in psychoanalysis when he created them and was interested in the role of the unconscious in art. In fact, many Surrealists had escaped the war in Europe, seeking asylum in the United States, and Pollock was intrigued by their notion of psychic automatism. In addition, he had been especially affected by Picasso's Guernica (see Chapter 21) when it was first displayed in New York in 1939.

His working method, the results of which are seen in *Autumn Rhythm. Number 30* (fig. 23.2), of 1950, was to unroll a huge canvas on the floor and throw, drip, and splatter paint onto it as he moved over and around it. Although Pollock said he knew what he was trying to achieve before starting work on a canvas, he created his compositions largely by accident. The paint is spread over the entire surface with swirls racing out toward the edge only to turn back into the center. Nor is there a clear top or bottom to the work: Pollock determined this only when he signed it. The entire large surface is unified by a web of paint, built of countless layers of swirling marks, forces that push and pull one another.

Pollock's style became known as **action painting** because this style of painting conveys the sense of the artist's physical activity, animation, and vitality. Pollock swung his arms and moved his entire body when making his drip paintings. For him, the actual process of getting paint onto the canvas was the most important part of the work, and the "work" is not so much the finished product as the action of making it.

Willem de Kooning. Like Pollock, the paintings of WILLEM DE KOONING (1904–1997) reveal an interest not so much in representing a preconceived idea but rather in experiencing the act of painting. When de

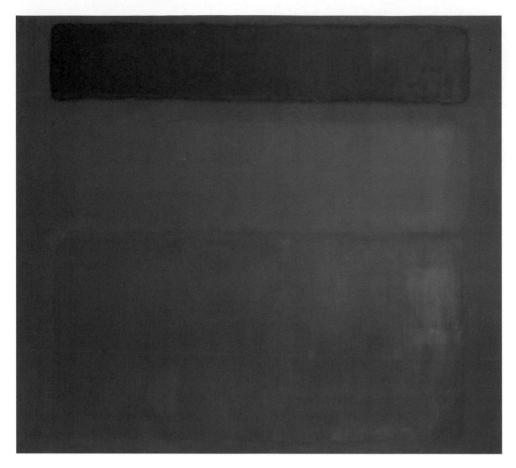

Figure 23.4 Mark Rothko, *Red, Brown, and Black*, 1958, oil on canvas, $8'11'' \times 9'9''$ (2.72 \times 2.97 m), Museum of Modern Art, New York. Working in a style known as Color Field Painting, Rothko produced a series of paintings consisting of soft-edged rectangles of various colors that are theoretical and philosophical representations of contrasting states of emotion and discipline.

Kooning emigrated to the United States from his native Holland in 1926, he was a figure painter, albeit one deeply influenced by the Cubists. But very soon after, he became influenced by the Surrealists and began approaching the canvas with broad, slashing strokes of paint. In Excavation (fig. 23.3), of 1950, a continuous surface of interlocking, neutral-colored abstract shapes that seem simultaneously organic and geometric rise out of what appears to be a multi-colored ground. Through this web of shapes can be detected, at various points, sets of teeth, eyes, fleshtones—even, in the very middle, a red, white, and blue area that suggests the American flag. De Kooning's aim was to create an afocal surface, that is, one on which the eye can never quite come to rest. For de Kooning, this disorientation, comparable to the disorientation felt by the immigrants and disenfranchised refugees from Europe who came to the United States after World War II, represents the modern condition.

Mark Rothko. The anguish conveyed in de Kooning's work is even more evident in the Color Field abstraction of MARK ROTHKO (1903–1970), whose

style is characterized by the absence of a recognizable figurative subject, an absence of an illusion of space, and large areas of flat color. A Russian who moved to America, Rothko was a withdrawn and introspective artist whose anguish about himself and his work led to his eventual suicide in his studio in 1970. Red, Brown, and Black (fig. 23.4), of 1958, is characteristic of the large canvases covered with rectangles of subtle, rich colors for which Rothko is best known. Working with layers of thin paint, Rothko made the edges of his rectangles fuzzy and soft, rendering the rectangles cloudlike, seemingly able to float one on top of another. Rothko created color harmonies, tones nuanced and graded, rich and intense. Intellectual as well as sensual, the rectangles seem to hover in an ambiguous space, sometimes appearing to advance and at other times recede. This ambiguity produces oddly powerful images, for Rothko intended to evoke emotion. Referring to his paintings as both "tragic and timeless," Rothko thought of his canvases as backdrops or stage sets before which viewers exercised their feelings, ranging from calm to happy to sad.

Cross Currents

ABSTRACT EXPRESSIONISM IN JAPAN

In the summer of 1955, a group of young Japanese artists who called themselves the Gutai Art Association organized a thirteen-day, twenty-fourhour-a-day, outdoor exhibition in a pine grove park along the beach in Ashiya, a small town outside Osaka. Their name, Gutai, literally means "concreteness," but more importantly it derives from two separate characters, gu, meaning "tool" or "means," and tai, meaning "body" or "substance." Taking Jackson Pollock's physical confrontation with his paintings as a starting point, they approached their work with their entire bodies, literally throwing themselves into it.

They called the exhibition in Ashiya the Experimental Outdoor Exhibition of Modern Art to Challenge the Mid-Summer Sun. A vear later, in Tokyo, Gutai held another exhibition. The spirit of experimentation marked both occasions. Paint was applied to canvas with watering cans and with remote control toys. Shimamato Shozo, wearing goggles and dressed for combat, made paintings by throwing jars of paint against rocks positioned across a canvas in a manner reminiscent of a Japanese Zen garden. The finished works were deeply encrusted in paint and glass, the record of a new kind of "Action Painting." Shiraga Kazuo painted on large canvases stretched across the floor, in the manner of Pollock, but used his feet as his brush as he slid through the

oil paint. In a piece called *Challenging Mud*, he submerged himself half-naked in a pile of dense mud. Rolling in it, squeezing it, wrestling with it, he created a sculptural version of his physical presence. Murakami Saburo built large paper screens six feet high by twelve feet wide, and then flung himself through them.

As violent as these activities seemed to many, they were deeply rooted in Zen. Concrete enactments of the individual's emotional condition unite the physical and spiritual in a single image. And if, in post-World War II Japan, the spiritual life tended toward violence and anger, this may be understandable given their political and economic situations and their having suffered a nuclear attack.

Figure 23.5 Helen Frankenthaler, Mauve District, 1966, polymer on unprimed canvas, 8'7" × 7'11" (2.62 × 2.41 m), Museum of Modern Art, New York. Frankenthaler was deeply impressed by the work of Jackson Pollock. However, where Pollock's oil paint was thick, Frankenthaler achieved soft stained effects, similar to watercolor, by painting with thinned paint on absorbent raw canvas.

Helen Frankenthaler. Rothko's color field painting, with its chromatic subtleties, is given freer form by the American artist HELEN FRANKENTHALER (b. 1928), a second generation Abstract Expressionist. Her Mauve District (fig. 23.5), of 1966, is an example of this non-objective style of painting. Like Pollock, Frankenthaler worked on raw, or unprimed canvas, i.e. canvas without glue and gesso (white paint) primer. Like Pollock, she worked on huge canvases laid out flat on the floor rather than placed on an easel. Unlike Pollock, however, Frankenthaler poured paint onto the canvas, soaking and staining the canvas. At first she used oil paint, thinned with turpentine until it was very fluid. Later she used acrylic paints which can be thinned with water and handled much like watercolor.

Frankenthaler's experiments resulted in a technical innovation, the ability to achieve the effects of water-color on a grand scale. Soft and silky biomorphic forms and shapes in color harmonies produce floating, lyrical effects. This technique of staining eliminates all brushstrokes and textural differences. Some areas of the canvas have been intentionally left unpainted, negative shapes defined by the painted areas abutting them.

Frankenthaler's paintings have a look of ease and spontaneity, an extreme fluidity, as if they were created in an instant, but this look is artfully constructed. Frankenthaler said that she threw away her works that had lost the quality of fresh spontaneity.

Timeline 23.2 Architecture of the modern world.

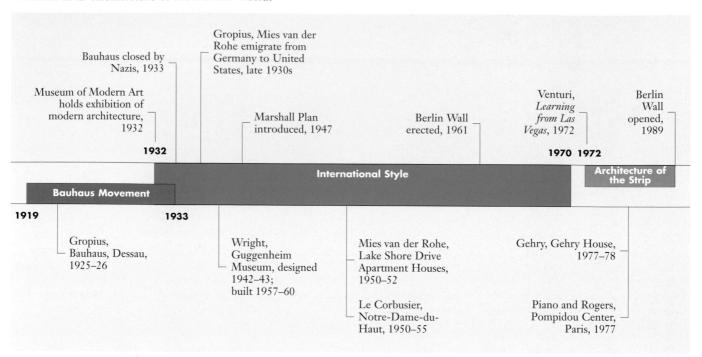

CONTEMPORARY ARCHITECTURE

Most of the great post-war architects began working in the first two decades of the twentieth century. In order to fully comprehend their post-war creations, we must consider their careers as a whole. Unlike the other modern arts, in architecture a single, "international" style developed over the first half of the twentieth

Figure 23.6 Walter Gropius, Bauhaus, Dessau, Germany, 1925–26. The Bauhaus (House of Building), closed by the Nazis in 1933, was a school that sought to adapt to the modern world by combining the methods and disciplines of fine art, craft, graphic design, architecture, and industry. Built of reinforced concrete, steel, and glass, the Bauhaus building itself looked like a painting by Mondrian made three-dimensional.

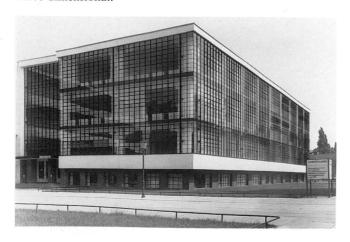

century that almost all architects acknowledged, if not all wholly accepted it. Several factors led to recognition of this style. First, the Museum of Modern Art in New York held an exhibition of modern architecture in 1932 that identified a new "International Style ... based primarily on the nature of modern materials and structure ... slender steel posts and beams, and concrete reinforced by steel." Second, many of these architects left Europe in the 1930s due to the worsening situation there and came to the United States. Third, thanks to the Marshall Plan, in Europe and the U.S., the booming economic climate after the war called for many new buildings.

Walter Gropius. One of the leading architects in Germany was WALTER GROPIUS (1883–1969), director of the **Bauhaus** art school in Dessau, Germany, and designer of its chief buildings (fig. 23.6), built 1925–26. When Adolf Hitler closed the Bauhaus, Gropius moved to America and became the chair of the Architecture Department at Harvard University.

The main principle of the Bauhaus was to closely connect art, science, and technology so that there was no dividing line between the fine arts, architecture, and industrially produced functional objects. The artist, the architect, the craftsperson, and the engineer were brought together.

The Bauhaus building is essentially a cage of glass. Its steel frame makes possible walls entirely made of glass because the walls do not support the structure. The cornice at the top is no longer functionally necessary

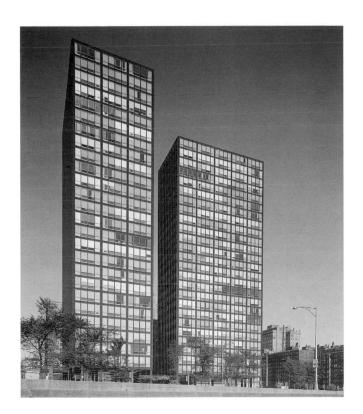

Figure 23.7 Ludwig Mies van der Rohe, Lake Shore Drive Apartment Houses, Chicago, 1950–52. Modern office and apartment buildings favor simplified and standardized rectangular buildings of steel and glass, the vertical emphasized and the structural frame made obvious.

Figures 23.8 and 23.9 (below left and right) Le Corbusier (Charles Édouard Jeanneret), The Savoye House, Poissy-sur-Seine, France, 1929–30. Le Corbusier called the functional homes he designed *machines à habiter*—"machines to live in." Made of reinforced concrete and glass in simple geometric shapes, this home is an example of the International Style of the 1920s.

to protect a building of glass, steel, and concrete from the elements, but it is *aesthetically* necessary as a visual conclusion to the architectural composition, to frame the building.

Ludwig Mies van der Robe. Among Walter Gropius's colleagues at the Bauhaus in Dessau was LUD-WIG MIES VAN DER ROHE [mees-van-duh-ROW] (1887–1969). When Hitler closed the school, Mies moved to Chicago where he concentrated his efforts on designing a new campus for the Illinois Institute of Technology. Later Mies created what we now think of as the modern skyscraper.

Typical of his work are the Lake Shore Drive Apartment Houses (fig. 23.7), built 1950–52. Mies's motto, "Less is more," is embodied in these buildings, which achieve the utmost with the least means. Emphasis on mass is gone as supporting masonry walls are replaced by a steel frame, the skeleton emphasized by the surface pattern of rectangles. Ornament is rejected. Simplicity has been taken to the point of austerity. Solid and void are given equal aesthetic consideration.

Le Corbusier. Another leader of the International Style and a very influential architect was Charles Édouard Jeanneret, known as LE CORBUSIER [corBOO-see-ay] (1886–1965). The Savoye House in Poissysur-Seine in France (fig. 23.8, exterior; fig. 23.9, interior), built 1929–30, is a private home that caused a revolution in domestic architecture. Corbusier called such houses he designed "machines à habiter" (machines to be lived in). Corbusier admired machines, praising their neat and precise shapes.

The Savoye House is elevated on stilts made of reinforced concrete. Smooth walls in pure geometric shapes enclose space. Aesthetically, the Savoye House is an abstract composition of simple flat and curved planes and sharp clean lines. It is much like a very large piece of non-representational sculpture, but one that can be inhabited, and its interior is treated as blocks of space of differing sizes. Glass walls divide one area from another.

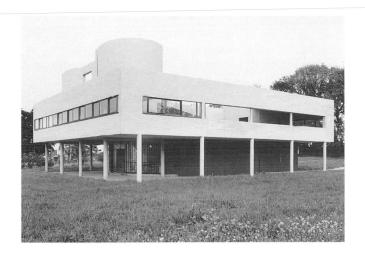

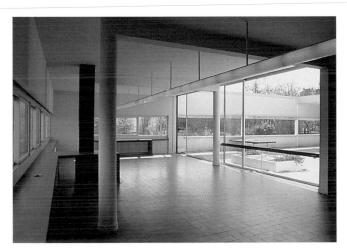

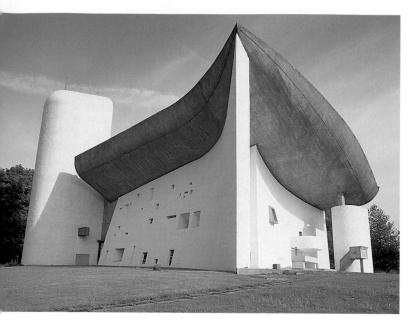

Figure 23.10 Le Corbusier, Notre-Dame-du-Haut, Ronchamp, France, 1950–55. Le Corbusier turned away from the International Style and designed this extraordinary pilgrimage church. Thick masonry walls are covered with sprayed concrete to form curved sculptural surfaces that appear natural and organic rather than rigid and stiff.

The effect is open but private. Because the house is elevated up on stilts, outsiders cannot see in, although the inhabitants can see out. Elegant materials are used in ways that are ornamental, but none of the decoration is structurally extraneous.

Although the major accomplishments of twentieth-century architecture were made in domestic and commercial structures, religious architecture was not ignored. Le Corbusier designed the church of Notre-Dame-du-Haut at Ronchamp in eastern France (fig. 23.10, exterior; fig. 23.11, interior) between 1950 and 1955. The name of the church refers to its location high on a mountain top. In a revolutionary approach, what appears to be large-scale sculpture is created of sweeping curves and countercurves, concave and convex. Le Corbusier built with masonry and sprayed concrete, leaving the surface rough. As a result, the church looks as if it were made out of sheets of a soft tan material that could be cut with enormous scissors and bent into these shapes.

The interior of Notre-Dame-du-Haut is equally unusual. Unlike the symmetry that has characterized religious architecture for centuries, here symmetry has been abandoned. The windows form a carefully composed abstract arrangement across the walls. As in a Gothic cathedral (see Chapter 12), Le Corbusier makes artistic use of light and stained glass, but the effect achieved at Notre-Dame-du-Haut is very different and very modern. Windows of different sizes and shapes are set back into the thickness of the wall. As in the Gothic

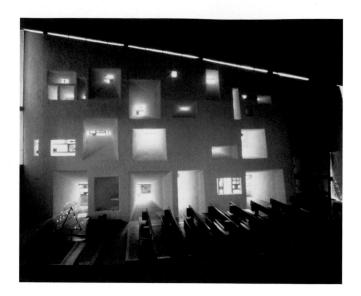

Figure 23.11 Le Corbusier, Notre-Dame-du-Haut, Ronchamp, France, 1950–55.

era, the windows are filled with stained glass, but here, rather than being representational, the designs are geometric. Some of the windows are so tiny as to to be slits in the walls.

Frank Lloyd Wright. Perhaps the most influential architect of the age, however, was the American FRANK LLOYD WRIGHT (1867-1959), a student of Louis Sullivan (see Chapter 21). Early in his career, in the first decade of the twentieth century, he designed what he called "prairie houses," of which the Robie House, in Chicago, is an example (figs. 23.12 and 23.13). Designed in 1906 and built in 1909, the house embodies Wright's belief that the character of a building must be related to its site and blend with the terrain. He therefore used shapes related to the surrounding landscape—like the prairie on which it stands, the house is low and flat, stressing the horizontal as it seems to spread out from its walls. The brick used to build the house is made from sand and clay from a nearby quarry. In order to make the house seem part of the surrounding natural environment, Wright uses extensive windows and broad reinforced concrete cantilever overhangs to relate interior and exterior. Although critics have called modern architecture "impersonal," Wright considered his buildings "organic."

Perhaps the best known of Wright's homes is Fallingwater, in Bear Run, Pennsylvania (fig. 23.14), built in 1936 for the Kaufmann family. Appearing like a three-dimensional painting by Piet Mondrian, the house nevertheless blends into the rising cliffs of the Pennsylvania landscape. Another example of Wright's "organic architecture," it further demonstrates his love of natural materials—the native stone used for its walls

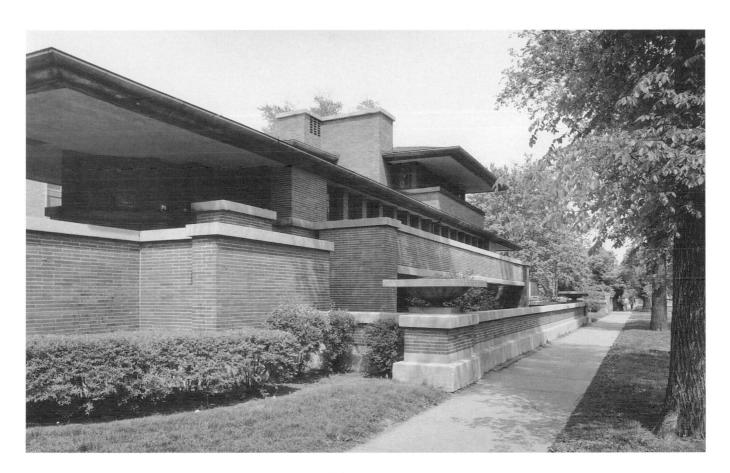

Figure 23.12 Frank Lloyd Wright, Robie House, Chicago, 1906–09. Considered the most important architect of the twentieth century, Wright designed what he called "organic" houses that were made to fit into their surroundings and were constructed of materials appropriate to the site.

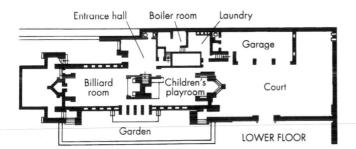

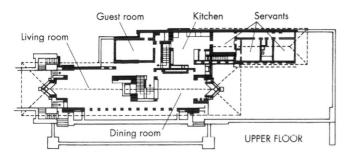

Figure 23.13 Frank Lloyd Wright, Robie House, Chicago, 1906–09.

Figure 23.14 Frank Lloyd Wright, Fallingwater, Bear Run, Pennsylvania, 1936. Seeking to unite structure and site, Wright used cantilevered construction to build this home over a waterfall. As in contemporary painting and structure, solid and void are given equal consideration in this composition.

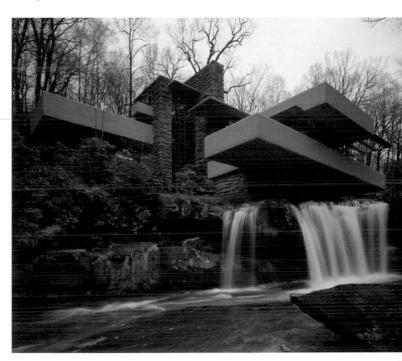

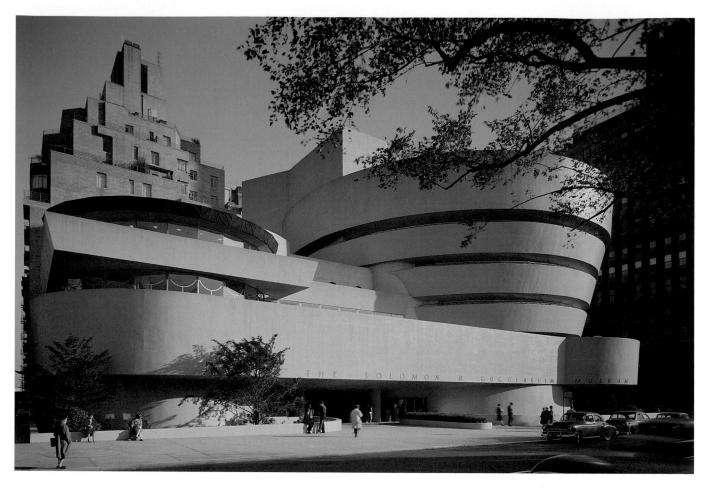

Figure 23.15 Frank Lloyd Wright, Guggenheim Museum, New York, 1957–60. Wright believed that people are greatly influenced by their architectural surroundings. Essentially an enormous concrete spiral, a sort of sculpture one can enter, the Guggenheim Museum is itself a work of art.

next to the cantilevered concrete balconies and decks that project out over the waterfall like the cliffs themselves. Another architect would have positioned the house to provide the residents with a view of the waterfall, but Wright put the house over it, integrating it into the design.

Inside, Fallingwater is a very open house, one that seems to look outward. Windows extend floor to ceiling. Walls are made of screens as Wright tried to minimize the number of rooms. The furniture in the house, as in other homes designed by Wright, is largely built-in.

Wright's range of structures included not only private homes but also public spaces, such as office buildings, churches, hotels, and museums. Perhaps the most visually arresting is the Guggenheim Museum in New York City (fig. 23.15), designed 1942–43 and built 1957–60, which looks like a huge piece of sculpture set in the crowded streets of Manhattan. Constructed of reinforced concrete, the striking spiral shape derives from the spiral ramp inside: visitors ride an elevator to the top and then

descend on foot, viewing the art work along the curving spiral walkway.

MODERN DRAMA

Modern drama begins in the nineteenth century with the plays of the Norwegian dramatist Henrik Ibsen (see Chapter 17), whose brutally realistic plays shocked his contemporaries and propelled the theater in new directions. Ibsen's emphasis on the psychological makeup of his characters was developed by later playwrights in an effort to examine and depict the new existential thought. Sartre himself was a playwright, and his play *The Flies*, of 1943, revolves around the concept of human freedom—the freedom of each individual to create his or her own unique value system in the face of the general absurdity of existence.

In fact, an existentialist sense of the absurd dominated post-war theater. Rejecting the conventions of realism, a full-blown Theater of the Absurd substituted storyless action for well-contrived plots and disconnected dialogue for witty responses and grand speeches. Absurdist dramatists rejected the idea that characters can be understood or that plot should be structured, just as they rejected the order and coherence of character and action in everyday life. People were incoherent and inconsistent, and life was confused. Behind absurdist theater is an image of human experience as lacking in purpose and meaning.

Among the most important and influential of absurdist dramatists is the Irish-born playwright SAMUEL BECKETT (1906–1989). Beckett's best-known works include *Waiting for Godot* and *Endgame*. In both plays, but especially in *Godot*, Beckett mixes humor with pathos. Relying on the farcical gestures of vaudeville performers and circus clowns, Beckett's characters typically display a dark intelligence and a bleakly pessimistic view of their tragi-comic situation. With their lives lacking in purpose and meaning, they wait for the inevitable degeneration of their physical and mental faculties and for death. Their relationships tend toward mastery and subservience, as Beckett reduces them to a pathetic interdependence grounded in power.

Waiting for Godot (1952) portrays two tramps, Vladimir and Estragon, who wait fruitlessly for someone named Godot, who never comes. As they wait, the tramps quarrel, contemplate suicide, separation, and departure. Dependent upon one another, they wait until they become dependent upon waiting itself. Two additional characters, a master and servant named Pozzo and Lucky, share the stage for a time with the tramps. The

rich Pozzo mistreats Lucky cruelly, until Pozzo becomes blind, at which point he needs the now mute Lucky to lead him. Their dependence, like that of Vladimir and Estragon, is limited but necessary. Each pair has nothing more in life than one another. It is a testimony to Beckett's theatrical genius that in depicting such a stark vision of human experience, his plays are also humorous in their portrayal of the human will to survive despite the direct of circumstances.

POP CULTURE

In the 1950s and 1960s, all of the dreams of the post-war era seemed to come true, at least the material ones. The age is distinguished by an explosion of consumer culture that quite literally changed the face of society. In 1947, 75,000 homes in the United States were equipped with television sets. By 1967, over 55 million sets were in operation and over ninety-five per cent of American families owned at least one. That same year, Swanson introduced the first frozen "TV Dinner"-turkey, mashed potatoes, and peas. In 1955, McDonald's was founded, inaugurating the fast food industry. The growth of the automobile industry, which made the fast food industry possible, was staggering. By 1949, Detroit was producing 5 million automobiles a year, a year later 8 million, and the number continued to grow until 1955, the apex of the boom. In response to this, shopping patterns changed. In 1950, just north of Seattle, Washington, the Northgate

Timeline 23.3 Artistic syles of post-war culture.

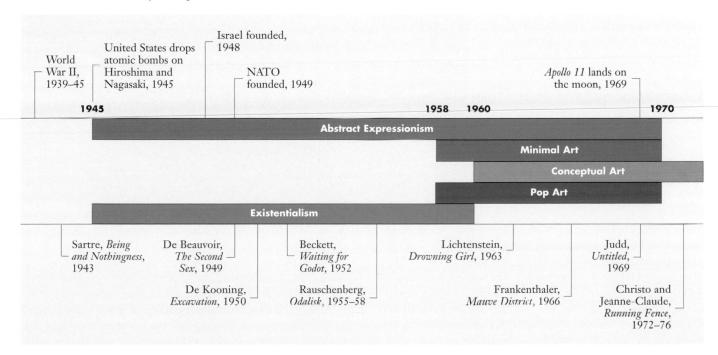

Then & Now

McDonald's

With the possible exception of Coca-Cola and Microsoft, no corporate entity has come to dominate any given sector of the consumer economy more McDonald's. than The McDonald's, which opened at 14th and E Streets in San Bernadino, California, in 1940, was owned by Richard and Maurice McDonald, Dick and Mac. The restaurant was a glass box without the golden arches that would come to distinguish the chain. But when, in 1950, the brothers put a neon sign in front that bragged, "Over one million sold," the McDonald's story had begun. Ray A. Kroc, a food service equipment salesman who owned the national marketing rights to the Multimixer milkshake maker, was intrigued by the McDonald brothers' restaurant because it used ten mixers where virtually every other restaurant on his accounts used no more than one or two. When, in 1954, he saw the McDonalds' restaurant in operation, selling literally hundreds of orders of 15¢ burgers, 10¢ french fries, and 15¢ shakes with unheard-of speed, he declared, "I've got to become involved in this." In Kroc opened his McDonald's in Des Plaines, Illinois (fig. 23.16), this one complete with the golden arches that the McDonalds had themselves added to a new drive-in at a second San Bernadino site in 1952. Soon Kroc was successfully franchising the business throughout the mid-West. "Over one million sold" was etched on the marquee of each and every one. Today, most children can tell you, because they have read the sign under the golden arches themselves, that McDonald's has served over 100 billion hamburgers worldwide.

In fact, today, McDonald's captures fourteen per cent of all restaurant visits in the United States, one in every six. It sells thirty-four per cent of all the hamburgers sold in the country and twentysix per cent of all the french fries, and it takes in 6.6 per cent of all the dollars Americans spend on eating out. Fully one-twentieth of the entire United States potato harvest went directly to McDonald's, and surprisingly, two per cent of all the chicken raised in the country. It goes without saying that the chain is the nation's largest purchaser of beef. Even more stunning is the fact that 12.5 per cent of the American workforce has at some time been employed by McDonald's, and one out of every fifteen Americans got his or her first job working there. It is, in short, the largest job training organization in the country, followed by the U.S. Army.

And today, McDonald's is a worldwide concern. When McDonald's opened on January 31, 1990, on Moscow's Pushkin Square, more than thirty thousand people lined up to eat there-more customers than had ever been served in a single day before. A year later, on April 23, 1991, in Beijing, China, forty thousand customers jammed a restaurant equipped with twenty-nine cash registers to handle the flow. No one could have even guessed at such numbers back in 1954 when Ray Kroc saw 150 paying customers pack a drive-in parking lot in San Bernadino.

Figure 23.16 Ray Kroc's "original" McDonald's restaurant in Des Plaines, Illinois, 1955. Today Kroc's first McDonald's is preserved as a museum.

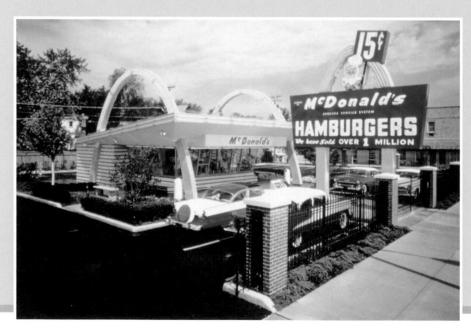

Shopping Center opened, accessible only by car and consisting of forty shops clustered around the Bon Marché department store. Six years later, the first covered mall, Southdale Center, opened in Minneapolis. Beginning in 1953, the sexual revolution took hold with the publication of the Kinsey Report on sexual behavior in the United States, and in 1966 the oral contraceptive, the so-called "Pill," was available to the public.

As American life became increasingly dominated by consumer goods, many artists and intellectuals turned their attention to the cycle of production, consumption, and waste that seemed more and more to define everyday experience. Like the Dadaists of a previous generation, they soon realized that art might be made of almost anything.

The leading theoretician of this point of view was the composer JOHN CAGE (1912–1995), who first taught

at Black Mountain College in North Carolina in the early 1950s, and at the New School in New York City in the late 1950s. Many of the most important artists of the day were his students, and he exerted enormous influence over an entire generation. These artists began to investigate the implications of his musical compositions in their work. His piece 4'33", for instance, is literally four minutes and thirty-three seconds of silence, during which the audience becomes aware that all manner of noise in the room—"traffic sounds," in the words of one audience member at a performance at the Carnegie Recital Hall in New York, "chairs creaking, people coughing, rustling of clothes, then giggles ... a police car with its siren running ... the elevator in the building ... the air conditioning going through the ducts." All these sounds are, in the context of the piece, "music." First performed at Woodstock, New York, on August 29, 1952, the work possesses at least three distinct features that artists would subsequently adopt. First, it is composed of the most minimal of elements—silence. Second, it consists of everyday sounds, commonplace events that occur by chance, which links the piece to Surrealism. Third, because of this inherent element of chance circumstance, no two performances are ever alike.

ARTISTS OF THE EVERYDAY

Robert Rauschenberg. One of Cage's Black Mountain students, ROBERT RAUSCHENBERG (b. 1925), was deeply influenced by Cage's composition of the everyday. Rauschenberg began making assemblages, a variation on the idea of the collage (see Chapter 21). taking junk and trash, materials one would normally discard, and combining them to create "art." Creation, he said, is "the process of assemblage." Odalisk (fig. 23.17), made between 1955 and 1958, is made up of a stuffed rooster, a pillow, magazine illustrations (including nude photographs), and paint, all on wood. The title is a clever pun, combining "odalisque" (harem girl) and "obelisk," a four-sided stone pillar capped by a small pyramid.

Like Cage, Rauschenberg brings together daily life and art. Other works include buttons, mirrors, stuffed birds, a ram, an automobile tire, a mattress, pillows, quilts, sheets, photographs, posters, and reproductions of works of art. Parts are painted on, the paint then being made to drip. It is a messy art, an art of disorder, of chance, indeterminate, unpredictable, and multilayered. The many images are not arranged neatly side by side but are instead made to overlay one another, one image being invaded by, or intruded upon, portions of another. Rauschenberg called this work "combine painting."

Louise Nevelson. A different type of assemblage was created by LOUISE NEVELSON (1899–1988), who was born in Kiev, Russia, and moved to Maine as a child. Nevelson studied all the arts—music, dance, theater, painting, and print-making. In her fifties, she began

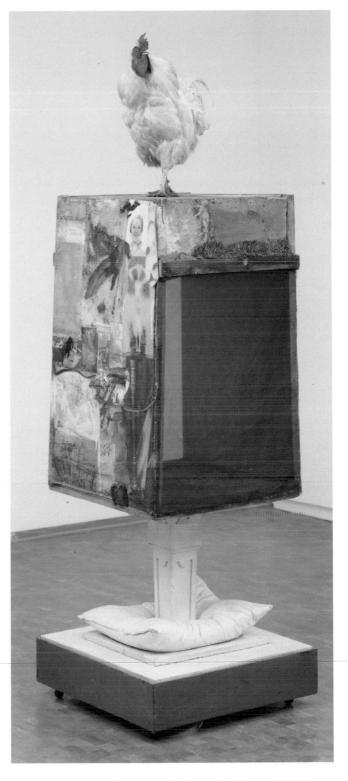

Figure 23.17 Robert Rauschenberg, *Odalisk*, 1955–58, assemblage, including stuffed rooster, pillow, and paint, on wood, $6'9'' \times 25'' \times 25'' \times 25'' \times 25'' \times 63.5 \times 63.5$

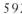

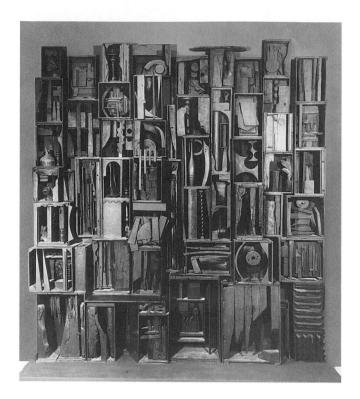

Figure 23.18 Louise Nevelson, Sky Cathedral, 1958, assemblage, wood, painted black, $11'3\frac{1}{2}'' \times 10'\frac{1}{4}'' \times 1'6''$ $(3.44 \times 3.05 \times 0.46 \text{ m})$, Museum of Modern Art, New York. From a series of small compositional units made of pieces of wooden furniture and furnishings, Nevelson compiled wall-size assemblages, which she unified by painting a single solid color.

assembling small wooden objects, scraps and remnants that she found in furniture shops. These pieces or fragments were glued and nailed together, creating compositions within wooden boxes, which were then joined together to create an architectural wall, a kind of largescale relief. The entire assemblage was painted one color—most often black, white, or gold.

Nevelson's Sky Cathedral (fig. 23.18), made in 1958, is painted black, the color that, according to the artist, "encompasses all colors." Nevelson called black the most aristocratic color. This single color unifies and links together what would otherwise appear fragmentary; thus, color is used for coherence. The viewer is inclined to peer into each compartment of curiously crafted wooden shapes, as well as to view the structure at once in its entirety. With this rational, intellectual approach, Nevelson assembled large-scale environments that look like cityscapes of many buildings, all compressed into a single wall-like plane.

Andy Warbol. Perhaps the most "everyday" objects of all in the 1950s and 1960s were images of popular culture itself—advertising and newspaper images, heroes and heroines from the movies, labels and signs designed to catch our eye on the grocery shelf or the highway billboard. All of these, from consumer goods to Hollywood stars, were equally "packaged," as one young artist soon recognized. His name was ANDY WARHOL (1928–1987). He started in the commercial art business in the late 1950s, but soon turned his own studio into

Andy Warhol, Marilyn Monroe Diptych, 1962, oil on canvas, in two panels, 6'10" × 9'6" (2.08 × 2.90 m), Tate Gallery, London. The way in which Marilyn Monroe's face is both obliterated and fades away in the right-hand panel epitomized, for Warhol, her own tragic end.

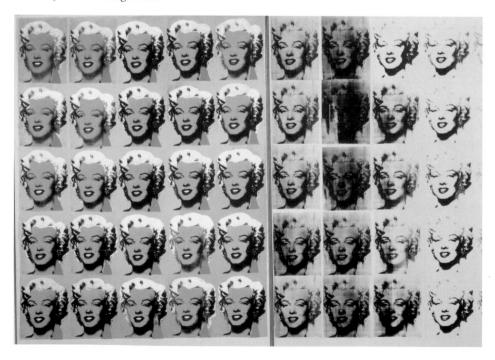

what he called The Factory. There he began churning out large editions of lithographs, as well as unique paintings. His work seemed to embody the world of mass production—Campbell's soup cans, Coca-Cola bottles, dollar bills, and images of Elvis Presley and Marilyn Monroe (fig. 23.19). The style was quickly labeled **Pop Art**—popular art.

Warhol's world was full of spectacle, but behind it lay an almost uncanny sense of widespread social malaise. Unstated in each repeated image of Marilyn Monroe in Warhol's diptych is the clearly implied idea that she was, in the end, nothing more than the image Hollywood created for her, and that her suicide by drug overdose was a final desperate move. Warhol would, in fact, brood deeply about the self-destructive tendencies of American society, creating images of electric chairs, automobile accidents, the Kennedy assassination, and, late in his career, endangered species.

Roy Lichtenstein. This same sense of underlying despair and destruction lies at the heart of the work of another of Warhol's contemporaries, ROY LICHTEN-STEIN (b. 1923). Lichtenstein painted comics, but comics blown up to a large scale. He specialized in two kinds—war comics, which were popular in the 1950s, and comics depicting the lives of young women, akin to television soap operas. Drowning Girl (fig. 23.20) shows, with deadpan humor, a young woman in a patently absurd situation. But it also asks us to take it seriously,

Figure 23.20 Roy Lichtenstein, *Drowning Girl*, 1963, oil and synthetic polymer paint on canvas, $5'7\frac{3}{8}'' \times 5'6\frac{3}{4}''$ (1.72 \times 1.70 m), Museum of Modern Art, New York. Lichtenstein recognized that, even though his audience would laugh at a cartoon image such as this, they would identify with the

Figure 23.21 Claes Oldenburg, Two Cheeseburgers, with Everything (Dual Hamburgers), 1961, burlap soaked in plaster, painted with enamel, $7 \times 14\frac{3}{4}$ " (17.8 × 37.5 cm), Museum of Modern Art, New York. Pop Art seems simultaneously to laud and laugh at popular culture. Should art reflect the most characteristic aspects of a culture, or strive to raise the level of culture?

and it is precisely in the distance between the two that the power of Lichtenstein's art lies.

The basis of Lichtenstein's style is the large printer's dot—the so-called ben-day dot—used to create color in the comic strips. The style is a parody of both Seurat's Pointillism (see Chapter 18), which Lichtenstein reduces to absurdity, and the Abstract Expressionist gesture, which he negates. Our reaction to its style is thus similar to our reaction to its subject matter: *Drowning Girl* is over five feet square, thus asking us to take it seriously as art, even as it refuses to take the act of "painting" seriously itself.

Claes Oldenburg. In December 1961, at 107 East Second Street in New York City, CLAES OLDEN-BURG (b. 1929), a Yale graduate and son of a Norwegian diplomat, opened an exhibition of real-scale replicas of actual commodities—meat, vegetables, candy, cakes, pies, ice cream sundaes—in a shop front that he named, quite appropriately "The Store." One replica was Two Cheeseburgers, with Everything (Dual Hamhurgers) (fig. 23.21). At Oldenburg's store a plate of meat cost \$399.98, a sandwich \$149.98. "I do things that are contradictory," Oldenburg explained. "I try to make the art look like it's part of the world around it. At the same time I take great pains to show that it doesn't function as part of the world around it." The following summer, Oldenburg recast some objects in giant scale and redid others as soft sculptures, sewn and stuffed with foam rubber. What should be soft—a hamburger, for instance—was hard plaster. What should be hard—a typewriter—was suddenly soft

Figure 23.22 Allan Kaprow, *Household*, May 3, 1964, Happening, Ithaca, New York. In this "Happening," Kaprow directed Cornell University students through a series of activities at the local dump, including licking jam off an old car.

and sagging. Oldenburg's jokes play on his audience's expectations. In Oldenburg's world, consumable goods cannot be consumed, even if they can be purchased, and giant versions of the most banal things, such as clothespins, spoons, electric plugs, scissors, trowels, and faucets, transform the everyday into the monumental. His objects seem to function like Russian icons, objects of veneration for a society that values shopping above all other activities.

The Happening. One of John Cage's most attentive students, ALLAN KAPROW (b. 1927), believed that he saw in Cage's work the possibility for a new "total art." Kaprow's artistic vision sprang from an "Event" that Cage staged at Black Mountain College in 1952, entitled Theater Piece #1. The event included Robert Rauschenberg playing old phonograph records on an ancient Victrola while movies were being projected simultaneously on his White Paintings suspended from the ceiling. Poets M.C. Richards and Charles Olson read from their works, and choreographer Merce Cunningham danced around the room trailed by a small dog. Cage stood on a ladder delivering a lecture, and pianist David Tudor played a Cage composition. Based on this model, Kaprow envisaged "an assemblage of events ... [which] unlike a stage play, may occur at a supermarket, driving along a highway, under a pile of rags, and in a friend's kitchen, either at once or sequentially." He called such a work a Happening. "It is art," he said, "but seems closer to life."

One of Kaprow's most important tactics was to destroy the distinction between audience and artwork. The audience was required to participate in the event. In the Happening *Household*, for instance, which took place in a dump near Cornell University in Ithaca, New York,

on May 3, 1964, a group of men built a tower of trash while a group of women built a nest of saplings and string. A smoking wrecked car was towed to the side, and the men covered it with strawberry jam. The women, who had been screeching inside the nest, came out to the car and began licking the jam (fig. 23.22) as the men destroyed the nest. Then the men returned with white bread, and began to wipe up the jam off the car and ate it themselves. Eventually, the men took sledge hammers to the wreck and set it on fire. Everyone gathered round and watched until the car was burned up, and then left quietly. Kaprow made no specific point and had no set expectations as to the outcome of the event. What this Happening "means" is not entirely clear, but it does draw attention to the way in which bizarre actions, as well as violence, can draw people together.

MINIMAL AND CONCEPTUAL ART

Cage's minimalist tendencies were attractive to a number of sculptors as well. They saw in them two avenues for artistic exploration. First, a formal but minimal sculptural statement would be variously interpreted according to its situation; and, second, if that simple sculptural statement were repeated, as in mass manufacture, it would, through accumulation, be itself changed. In other words, not only would a given form seem different if encountered in the middle of a field as opposed to in the center of a

Figure 23.23 Donald Judd, *Untitled*, 1969, anodized aluminum and blue Plexiglas, each of four units, $47\frac{1}{2} \times 59\frac{7}{8} \times 11\frac{7}{8}$ " (121 × 152 × 30 cm), City Art Museum of St. Louis. Judd's work may be thought of in terms of existentialism, as a kind of "pure being," but without existentialism's sense of moral imperative.

Connections

RAUSCHENBERG, CAGE, AND CUNNINGHAM

One of the most prolific collaborations of the modern era, one that lasted over three decades, is that of artist Robert Rauschenberg, composer John Cage, and choregrapher Merce Cunningham, initiated at Black Mountain. At the heart of their collaborative practice was a belief in, as one critic described Rauschenberg's combine paintings, "an aesthetics of heterogeneity." It was their more or less freewheeling trust that, in the chance encounter of diverse materials, areas of interest and moments of revelation will be generated.

Both Cage and Rauschenberg were willing to admit almost anything into their work. So was Cunningham. "In classical ballet," Cunningham has written, "the space was observed in terms of the proscenium stage, it was frontal. What if, as in my pieces, you decide to make any point on the stage equally interesting? I used to be told that you see the center of the space as the most important: that was the center of interest. But in many modern paintings this was not the case and the sense of space was different ... When I happened to read that sentence of Albert Einstein's: "There are no fixed points in space," I thought, indeed, if there are no fixed points, then every point is equally interesting and equally changing." An

example of such a dance is the 1958 Summerspace (fig. 23.24), with sets by Rauschenberg. "When I spoke to Bob Rauschenberg-for the decor-I said, 'One thing I can tell you about this dance is that it has no center ... 'So he made a pointillist backdrop and costumes." In another piece, Variations V, the movement of the dancers triggers electronic sensors which in turn trigger an "orchestra" of tape recorders, record players, and radio receivers containing sounds "composed" by Cage. A member of Cunningham's dance company, Gordon Mumma, describes the result as "a superbly poly: -chromatic, -genic, -phonic, -morphic, -pagic, -technic, -valent, multi-ringed circus." In the typical Rauschenberg, Cage, and Cunningham collaboration, the music does not support the dance, nor do the sets frame it; instead each elementdance, music, and sets-remains independent of the others.

Figure 23.24 Merce Cunningham, Summerspace, 1958. Dancers: Robert Kovich and Chris Komar. Cunningham tries to devise dances in which so much is happening at once that the effect is not unlike trying to watch all three rings of a circus simultaneously.

gallery, but ten examples of the form seen at once would be different than seeing just a single, unique form.

Donald Judd. One of the most successful of these minimalist sculptors was DONALD JUDD (b. 1928). Beginning in 1965, he created a series of what he called "Specific Objects," which were uniform, modular boxes made of industrially produced galvanized iron. Judd cantilevered equally spaced groups of them from the wall in vertical columns or horizontal lines. Without any reference whatsoever to figure or landscape, the boxes insist on their existential being, so to speak. By the late 1960s, Judd recast his boxes as freestanding floor pieces (fig. 23.23), now made of materials such as copper, brass, and stainless steel, often polished so as to reflect the surrounding space, each other, and the viewer. He also began to paint them, especially their interiors, with

enamel or lacquer, and sometimes sealed them on top and bottom with sheets of colored Plexiglas. When colored, they seem to transcend their status as meaningless objects and achieve exceptional elegance.

Sol LeWitt. Also working in modular units, SOL LEWITT (b. 1928) created frameworks of white, baked enamel beams arranged as an open cube and repeated according to various mathematical formulas. A work such as Open Modular Cube (fig. 23.25), for instance, seems relatively straightforward. But as the light changes over the course of a day, patterns emerge in the cast shadows. As the viewer moves around the work, its appearance also changes dramatically; LeWitt's apparently stable structure becomes a constantly changing one.

For LeWitt, a work of art is "pure information," and a work of art could exist simply as information rather

Figure 23.25 Sol LeWitt, Open Modular Cube, 1966, painted aluminum, $5 \times 5 \times 5'$ (1.52 \times 1.52 \times 1.52 m), Art Gallery of Ontario, Toronto. "The new art," LeWitt wrote, "is attempting to make the non-visual (mathematics) visible (concrete)."

than as an object per se. That is, it could be so minimal that it could exist solely as a *concept*. In the context of consumer culture, there was one real advantage to this position: it removed the work of art from the market system, in which a Jackson Pollock painting, *Blue Poles*, sold in 1973 for two million dollars. LeWitt soon started making verbal proposals for artworks rather than making the art itself. He would formulate a set of basic instructions for a wall drawing—"Draw lines from the middle of the edge to a point in the center, in each of four colors, one color for each side," and so on. Then the drawing would be executed by whomever at whatever site. The works were each different and were short-lived.

Christo and Jeanne-Claude. The willingness to let a work exist only for a short while is the hallmark of the site-specific sculptor CHRISTO (b. 1935) and JEANNE-CLAUDE (b. 1935). Their work is usually outdoors, public, large scale, and temporary. Noted for using large things such as buildings, bridges, islands, valleys, and coastlines, Christo and Jeanne-Claude are interested in working with other groups in the art community. Work together begins with a discussion on the question "What is art?", a question few communities have debated.

One of their best-known works is *Surrounded Islands* (fig. 23.26), which in its completed form existed for two weeks in 1983 in Biscayne Bay, Miami, Florida. Christo

and Jeanne-Claude said they were inspired by Monet's water-lily paintings, and the surrounded islands in fact looked like huge pink lily pads. The work required \$3,500,000 in funds to produce, which Christo and Jeanne-Claude paid entirely through the sale of Christo's prints, early packages, and preparatory drawings. It also required 6.5 million square feet of fabric, numerous lawyers, and permission from a multitude of government organizations and environmentalists. Christo and Jeanne-Claude were required to prove that there would be no negative effects on the environment.

Christo and Jeanne-Claude's work is highly controversial; rarely have artists had such obstacles to overcome and shown such determination and perseverance in doing so. Yet all of this preparation was considered to be part of the work of art, as was the bringing together of peoples of different backgrounds and orientations in order to create it.

Figure 23.26 Christo and Jeanne-Claude, *Surrounded Islands*, 1980–83, Biscayne Bay, Greater Miami, Florida, existed in its final state for two weeks, now gone. The artists' "environmental art," which has included wrapping large structures such as the Reichstag in Berlin and the Pont Neuf in Paris, is intentionally transitory. Creation of a work such as *Surrounded Islands*, in which eleven islands were surrounded by 6.5 million square feet of pink polypropylene fabric, is an event, a sort of Happening, involving many people.

THE ARCHITECTURE OF THE STRIP

In his important 1972 book Learning from Las Vegas, the architect Robert Venturi suggested that the collision of styles, signs, and symbols that marks the American commercial "strip" in general, and Las Vegas in particular, could be seen as composing a new sort of unity. "Disorder," Venturi writes, "[is] an order we cannot see ... The commercial strip with the urban sprawl ... includes all levels, from the mixture of seemingly incongruous advertising media plus a system of neo-organic or neo-Wrightian restaurant motifs in Walnut Formica." On the strip, one structure is designed and built next to another with no consideration of its surroundings. In particular, franchises are designed completely independently of their various locales. On the strip anything goes. This is unlike traditional architectural practice, in which the architect works to harmonize the building with its environment.

Frank Gebry. No architect's work epitomizes pop culture's collision of styles more than that of FRANK GEHRY (b. 1929). His own home, in Santa Monica, California, which he purchased and began to remodel in 1976, is a consciously eclectic version of Venturi's

Figure 23.28 Axonometric drawing of the Gehry house.

Figure 23.27 Frank Gehry, Gehry house, Santa Monica, 1977–78. Gehry's house represents the consciously assembled style of past and present elements that has come to distinguish what is known as "postmodern" architecture.

principles (fig. 23.27). Bored with the typical 1940s two-story frame house he had purchased, but unable to afford anything more, Gehry decided to surround the original with a new one, making the division between old and new visually clear. His building materials—plywood, concrete blocks, corrugated metal, and chainlink fence—were basic everyday materials in popular culture. Needing a new kitchen, he built it at ground level, outside the original house's dining room on an asphalt pad (fig. 23.28). The new design included a long corrugated metal side which faced the street and deeply offended Gehry's neighbors, but Gehry did not want his new house to "fit in." Its discontinuity from the rest of the neighborhood announced that Gehry was different, and that difference was, perhaps, a good thing.

LITERATURE: THE BEATS

Not everyone felt that the consumer culture developing in the United States during the 1950s was such a good thing. The so-called "Beat" generation of writers saw American prosperity as something negative, as something leading to conformity, complacency, and even oppression. Theirs was the first of a series of critiques of the American scene after World War II, critiques that would surface again in the Civil Rights and anti-Vietnam War movements in the 1960s, and the feminist movement in the 1970s.

Fack Kerouac. Perhaps the leading voice of the Beat Generation was JACK KEROUAC (1922-1969). For Kerouac, the "Beats" were a resurgence of the lost American type, the "wild self-believing" individuals who had founded the country. In On the Road, written in 1951 and published in 1957, Kerouac reinvents the American archetype of the frontiersman and cowboy, as his narrator, Sal Paradise, a "wild yea-saying overburst of American joy" who seeks to escape the confines of American civilization in Denver's skidrow and Cheyenne, Wyoming's Wild West Week. Guided by a mad father figure, Dean Moriarty, who drives "at incredible speeds across the groaning continent, serious and insane at his raving wheel," Sal Paradise learns how far America has fallen, and comes to the recognition that he probably can't escape it.

Kerouac wrote in "spontaneous prose," as he called it. With roots in the automatic writing of Surrealism and the expressive gesture of the Abstract Expressionist painters, Kerouac's contemporaries, his prose has been described by the poet Allen Ginsberg as a style that is "completely personal, [that] comes from the writer's own person—his person defined as his body, his breathing rhythm, his actual talk." It seems, in fact, as high speed as the automobiles that Sal and Dean race across the country, a kind of rush of language.

Allen Ginsberg. This style is, essentially, also that of ALLEN GINSBERG (1926-1997) himself. His long poem Howl (1956)—of which the first section and part of the third were drafted in one day in August 1955, in San Francisco, the rest following shortly after—is indeed a rush of language, as its title suggests. It is an outcry against the way in which American bureaucracy turns individuals into abstractions, an outcry against a world in which parents mindlessly turn their children over to the ancient god Moloch, a figure standing for American culture as a whole, who promptly consumes them. Dedicated to Carl Solomon, a patient in a mental hospital in New York-and in the poet Ginsberg's mind, thus a sort of political prisoner—the poem is a celebration of madness. Madness, for Ginsberg, is a sign of salvation, a sign of rebellion against the all-consuming American Moloch. By rejecting reason, and accepting the innate rhythms of the body itself, Howl seeks to transcend the constrictions of civilization.

THE POPULARIZATION OF CLASSICAL MUSIC

The Boston Pops. In the 1950s and 1960s, culture was defined more and more by the consumer, and musical tastes responded more and more to the demands of a popular audience. The Boston Pops Orchestra, led by ARTHUR FIEDLER (1894–1979), became a national institution, famous for its concerts of folk tunes, marches such as John Philip Sousa's "Stars and Stripes Forever," and classical hits such as George Gershwin's Rhapsody in Blue. Bridging the gap between popular song and classical repertoire, the pops served as "the door through which young people enter into the magic domain of musical comprehension," as one critic put it.

Leonard Bernstein. One of the contemporary era's most highly regarded musical talents, and one of the most successful at popularizing classical music, was LEONARD BERNSTEIN (1918–1990), composer, conductor, pianist, and mentor. His lecture demonstrations with the New York Philharmonic Orchestra offered children an engaging introduction to the world of classical music and were later published as the Young People's Guide to the Orchestra. His numerous recordings and video performances with major American and European orchestras demonstrate his exciting and dramatic conducting abilities.

Yet it is Bernstein's genius for composing popular and classical music that sets him apart in his generation. He is perhaps best known for his works for the musical theater: *Candide* (1956) and *West Side Story* (1957), a contemporary version of Shakespeare's *Romeo and Juliet*, in an urban setting with intercultural tensions. Bernstein transforms Shakespeare's warring Capulet and Montague

families into two rival gangs from New York City's Spanish Harlem, the Italian Jets and the Hispanic Sharks.

Like Tchaikovsky, whose Romeo and Juliet Fantasy Overture was also inspired by Shakespeare's tragic play, Bernstein writes music that is both lyrical and dramatically compelling. Songs like "Maria," a lyrical love song, intermingle with Latin-inspired pieces such as "America" and "Tonight," set in quasi-operatic style for four voices.

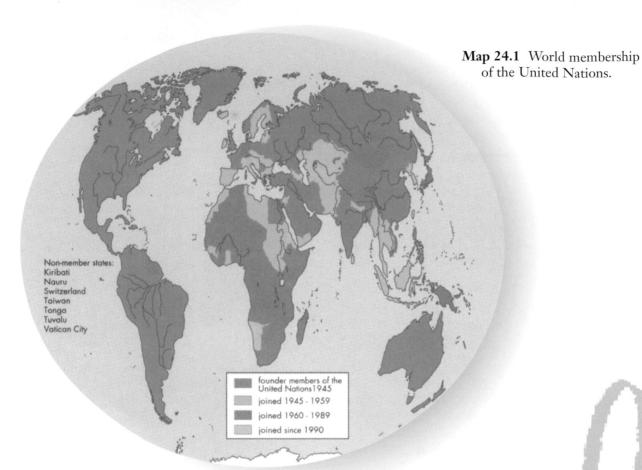

THE DIVERSITY OF CONTEMPORARY LIFE

CHAPTER 24

- Diversity in the United States
- ← The Global Village

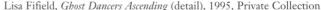

DIVERSITY IN THE UNITED STATES

Throughout the 1960s and into the 1970s, American society underwent a profound shift in attitude and structure largely as a result of three major catalysts for change: the Civil Rights Movement, the Vietnam War, and the Women's Movement. All three caused many Americans to examine and question long-held ideas and values. The quest for rights for African-Americans and for women, especially, contributed to an increased awareness on the part of many Americans of the value and power of diversity.

Economic developments also contributed to this growing sense of a diverse and pluralistic world. Beginning in the mid-1970s, marketing strategies in the United States began to shift dramatically. Instead of trying to create products that would necessarily have mass appeal, marketing experts began to shift their focus to particular interest groups, "niche" marketing as it became known. While the target audience for a "niche" product might be small in relation to the population as a whole, it might still represent millions of potential buyers. In the words of one advertising executive, "There will be no market for products that everybody likes a little, only for products that somebody likes a lot." Direct mail "lists" of similarly minded people were soon developed, and the creation of consensus as a marketing strategy gradually gave way to an approach based on the plurality and diversity of American culture and taste.

STRUCTURALISM AND DECONSTRUCTION

Beginning in the late 1960s, the work of a number of French philosophers and thinkers made a profound case for the plurality of experience and developed clear strategies for challenging the accepted cultural tradition. They established a philosophical basis for the growing acceptance of the diversity of contemporary culture. One of the most important of these thinkers was ROLAND

Figure 24.1 Guerilla Girls, Do Women Have to be Naked to Get into the Met. Museum, 1989, poster, $11 \times 28''$ (27.9 \times 71.1 cm), Private collection. The Guerilla Girls' posters outline an art scene that was, as late as the mid-1980s, still dominated by men, where women were either excluded or underacknowledged.

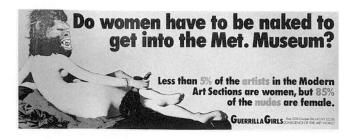

BARTHES [BAR(t)] (1915–1980), whose early work was based on so-called "structural" linguistics, and whose approach to culture was thus called "structuralism." At the heart of structural linguistics is an approach to "meaning" that is based on the notion of the plurality of the "sign." The "sign" is composed of a ratio or relation between the so-called "signifier" and the "signified." For instance, the word "tree" is a signifier and the tree itself is the signified object. In French, the word for tree is arbre, in Swahili, it is mti. The signifier (the word) changes from language to language, then. In addition, the signified itself encompasses all possible trees. The signified is so plural and various that, on contemplation, it seems astonishing that language can enable us to communicate meaningfully at all. What determines the particulars of the tree we are talking about when we say or write the word "tree" is its context. The pine tree in the backyard is different from the oak tree in the square. Context determines meaning. It follows then, philosophically, that when we consider any object, the object's meaning is determined not by its existence in its own right but by the situation in which we observe it. And this situation is always subject to change. Thus "meaning" is never absolute. It is as plural as the situations in which it comes to exist.

What is known as "poststructuralist" thought is essentially a radical application of this way of thinking. Poststructuralist thought is based on the assumption that speech—the meaning of which is never fully "determined"—can as easily mask reality as reveal it. Barthes himself, especially in his book Mythologies, analyzes the myths upon which popular culture is constructed. But the chief practitioner of poststructuralist thought is the French philosopher JACQUES DERRIDA [dare-ree-DAH] (b. 1930). Derrida's method, known as decon**struction**, consists of a thorough analysis, or taking apart, of received philosophical traditions made on the assumption that there are, in all philosophies and cultural systems, leaps in logic and inconsistencies, and that the revelation of these tells us more about the philosophy than the philosophy itself does. That is, what is not said in a philosophy is at least as important, and probably more important, than what is said. For Derrida, even the self is a fiction or construction, built out of the unexamined assumptions of traditional culture, and it, too, must be deconstructed for true understanding. In sum, in the poststructuralist mind, there are no facts, only interpretations. Such a philosophical stance, which amounts in many ways to a profound skepticism, has led to a thorough critique of much of Western philosophical thought and of the culture's so-called "truths."

PAINTING AND SCULPTURE

In art especially, diverse visions have had a considerable impact. The single most important development in the

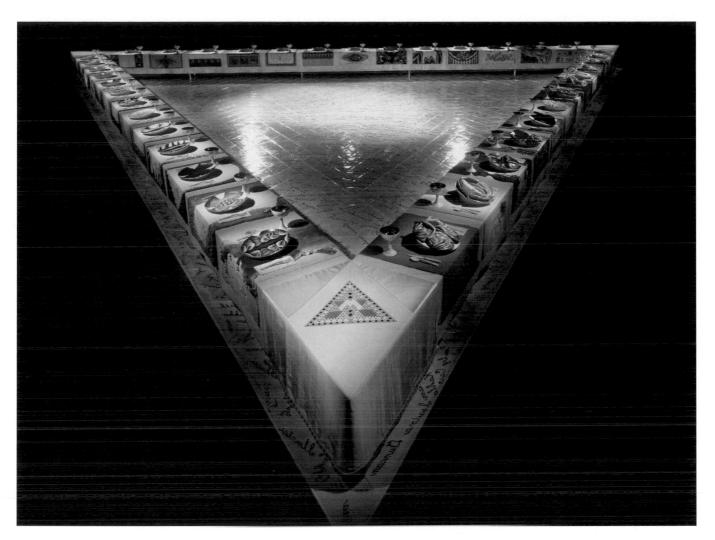

Figure 24.2 Judy Chicago, *The Dinner Party*, 1974–79, installation view, San Francisco Museum of Modern Art, mixed media, 48′ (14.63 m) on each side. Asserting the importance of the accomplishments of women throughout western history, this giant triangular table has place settings for thirty-nine specific women, arranged thirteen to a side, recalling Jesus's last supper.

art world in the last three decades has been the rise to prominence of visions previously excluded from the mainstream. This has been, in part, a function of the art world's ceaseless quest for innovative approaches to experience, but it is also true that the art world has become increasingly willing to acknowledge the "outsider's" point of view.

Women have contributed significantly to the contemporary visions that have gained attention in the art world. In 1970–71, only 13.5 per cent of the artists shown in New York were women. Worse, in the 1970s only 10 per cent of the shows given to living artists in New York were one-person exhibitions by women. As late as 1982, the Coalition of Women's Arts Organizations reported that only 2 per cent of museum exhibitions by living artists were given to women. In the last two decades, this has changed dramatically. The imbalance was the focus of the GUERILLA GIRLS, a group of anonymous women

artists who dressed in costume gorilla masks and plastered New York City with posters drawing the public's attention to the situation (fig. 24.1).

Judy Chicago. Probably no single woman artist has had a greater impact on the public's opinion of women in the arts than JUDY CHICAGO (b. 1939). Chicago changed her name, she explained in her memoir, Through the Flower, "from Judy Gerowitz to Judy Chicago as an act of identifying myself as an independent woman." In 1974, she started working on a giant sculptural installation known as The Dinner Party (fig. 24.2). The place settings range from the Great Goddess of prehistory and the Cretan Snake Goddess to modern novelist Virginia Woolf and painter Georgia O'Keeffe. The names of 999 other women were added to the table's runner as well. One of Chicago's most impressive achievements was

her inspiration and courage in taking the arena traditionally thought of as woman's domain and transforming it into a major work of art. Chicago brought women's work and women's arts to center stage. As Carrie Richey wrote in *Artforum* magazine in 1981: "[*The Dinner Party*] is a glossary of the so-called 'lesser arts'—tatting, lace[making], weaving, making ceramic household vessels, embroidering—that women have been confined to for thousands of years. But that all these crafts have been brought together, synthesized for a ritual ... [This] is just one of the canny reversals that *The Dinner Party* undertakes. It proposes that the sum of the lesser arts is great art."

Eleanor Antin. It seemed difficult for women to "make it" in the traditional sense in the art world as painters or sculptors. Women artists turned in increasing numbers to new, experimental media, especially performance art, for innovative expression. One of the innovators of the performance art movement is ELEANOR ANTIN (b. 1935), an artist notorious for developing a series of personae, or characters, including Eleanora Antinova, a fictional black ballerina in Diaghilev's Ballets Russes. By playing Antinova, Antin freed herself to investigate aspects of her own situation that might otherwise have remained hidden or unknown. A drawing from her memoir, Being Antinova (fig. 24.3), indicates exactly how removed Antinova is from the traditional, Western ballet world. Not only is Antinova black, but her own sense of physical freedom contradicts the traditional regimen and routine of ballet. Imagine, she points out, a black ballerina in Swan Lake. The world of ballet is, in her words, a "white machine," in which Antinova experiences not only the alienation of racial prejudice but the subjugation of personal expression to the demands of "tradition."

Cindy Sherman. The photographer CINDY SHERMAN (b. 1954) took to greater extreme Antin's idea of creating a fictional persona through which to investigate different aspects of the self. Beginning in the late 1970s, Sherman began to photograph herself in a variety of "self-portraits" called *Untitled Film Stills*

Figure 24.3 Eleanor Antin, drawing from *Being Antinova*, 1983. The physical freedom enjoyed by Antinova in this drawing is mitigated by her exclusion from the troupe.

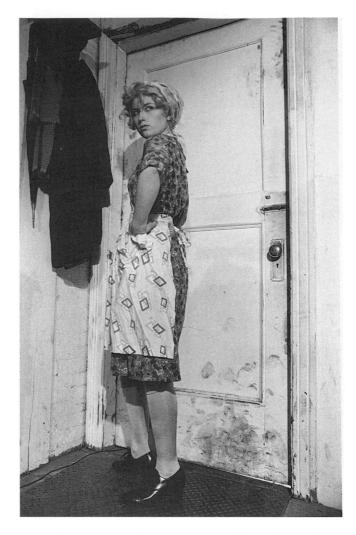

Figure 24.4 Cindy Sherman, *Untitled Film Still* #35, 1979, black-and-white photograph. In this version of herself, Sherman takes on the appearance of, say, Sophia Loren playing the part of a bedraggled Italian housewife. In other words, Sherman depicts a media image, not a real person.

(fig. 24.4). In each, Sherman wears a different wardrobe, makes herself up to look a different part, stages herself, and announces, in effect, that the "self" is a fictionalized construction. We are whoever we choose to look like. And what we choose to look like, perhaps more devastatingly, is one or another of a series of media images. Her work attempts to undermine the very idea of an "authentic" personality behind our repertoire of selves.

Susan Rothenberg. Despite the discrimination against women working in the traditional art world, a number have nonetheless succeeded. Among the many women painters who have achieved a major place in American painting since the early 1980s is SUSAN ROTHENBERG (b. 1945), who works in New Mexico. Rothenberg achieved early success with her first exhibition in New York in 1976. Rothenberg expressed

surprise at so favorable a reaction to her subject matter. It is for her images of horses, as in *Axes* (fig. 24.5), painted in 1976, that she is best known.

In Axes a lone animal is seen moving, stark and ghostly. Rothenberg creates a hallucination, an apparition, or a dream image of an emerging animal. Simultaneously primitive and sophisticated, Rothenberg's work is characterized by rough strokes that build up the form. Color is restricted: lines are color and color is line. The entire surface is treated this way. From this fragmented weblike mesh, forms emerge, as if through a heavy fog, or from dense underbrush, effectively implying movement. In Axes, the axis of the center of the canvas and the axis of the horse's body are not clearly aligned, and this sense of imbalance, or what might be called "double-balance," animates the canvas.

Betye Saar. One of the most famous images in contemporary art is a Pop Art-like construction created in 1972 by artist BETYE SAAR (b. 1926) entitled The Liberation of Aunt Jemima (fig. 24.6). Saar's image openly acknowledges the American "popular" conception of the African-American "mammy"—Aunt Jemima of pancake and syrup fame, as ubiquitous as Campbell's soup. Aunt Jemima was conceived by white marketing experts as a symbol of surrogate motherhood, so trustworthy that any "real" mother would not hesitate to leave her child in Aunt Jemima's hands and so caring that anyone would assume that her pancakes and syrup were nourishing and wholesome. Saar transforms the trusting and caring Aunt Jemima smile into something almost sardonic. As Aunt Jemima takes up arms, with the black fist, a symbol of black power, rising in defiance across the scene, the white baby is not merely unhappy, but has become terrified.

Figure 24.5 Susan Rothenberg, Axes, 1976, synthetic polymer paint and gesso on canvas, $5'4\frac{5}{8}'' \times 8'8\frac{7}{8}''$ (1.64 × 2.66 m), Museum of Modern Art, New York. In this Neo-Expressionist work, form is suggested rather than specified, hinted at rather than defined. The perfect balance within the rectangle of the canvas is based upon the horse's implied movement to the left.

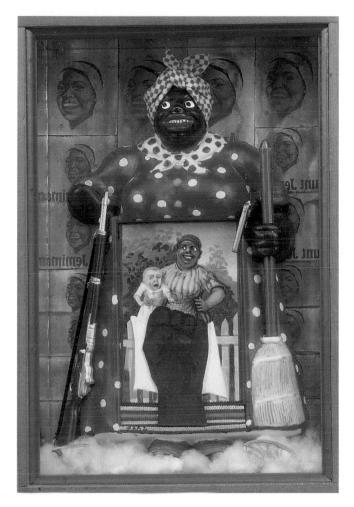

Figure 24.6 Betye Saar, *The Liberation of Aunt Jemima*, 1972, mixed media, $11\frac{3}{4} \times 8 \times 2\frac{3}{4}$ " (29.8 × 20.3 × 6.9 cm), University Art Museum, University of California at Berkeley. Saar's image not only attacks racism but sexism as well, and the expectations of the dominant culture.

Politics for Aunt Jemima are revealed; an advertising image, this figure, both servant and slave, takes matters into her own hands. The painting announces the necessity—the actuality—of change for the African-American.

Jean-Michel Basquiat. Especially brief and highly successful was the career of JEAN-MICHEL BASQUIAT (1960–1988). As a teenager in New York, Basquiat achieved notoricty as "Samo," a graffiti artist writing on walls in Soho and Tribeca. By early 1981, gallery owners in New York, Zurich, and Milan had convinced him to apply his graffiti to canvas, and soon after he became an art world media darling. The value of his paintings, which many critics found naive, rose with meteoric speed. By the time he was twenty-three years old, a work of his had already sold at a Sotheby's art auc-

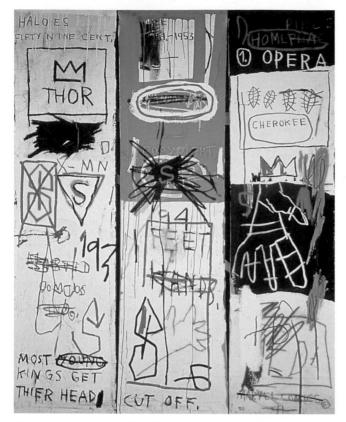

Figure 24.7 Jean-Michel Basquiat, Charles the First, 1982, acrylic and oilstick on canvas, triptych, $6'6'' \times 5'2\frac{1}{4}''$ (1.98 \times 1.58 m), Robert Miller Gallery, New York. The "X" crossing out elements in Basquiat's work is never entirely negative. In a book on symbols, Basquiat discovered a section on "Hobo Signs," marks left, graffiti-like, by hobos to inform their brethren about the lie of the local land. In this graphic language, an "X" means "O.K. All right."

tion for \$19,000. Basquiat was the son of a middle-class Haitian-born accountant and his white, Puerto Rican wife, and his work possessed an aura of authenticity—raw, direct, and, stylistically at least, unmediated by tradition.

In Charles the First (fig. 24.7), Basquiat pays homage to one of his heroes, jazz saxophonist Charlie Parker. The immediacy of Basquiat's style is readily apparent. Notice, for instance, that he doesn't even bother to overpaint "mistakes"—he simply crosses them out and moves on. As one of Basquiat's heroes, Parker is a king—hence the painting's title, the crown, and the word "Thor" (the god of Norwegian myth). At the bottom is Basquiat's admonition to kings; the word "young" is crossed out. Parker's fall from grace is imaged everywhere in the painting, in the drips that fall from the blue field in the middle of the painting, in the X-ed out Ss, and, especially, in the way that, above the word "Cherokee," the name of one of Parker's most important compositions, one of the feathers (feathers because Parker was known as "Bird") falls into a dollar sign. It is as if the market structure of the

recording industry destroyed Parker: the dollar sign, if one considers it, is the superhero's symbol lined through.

Much of Basquiat's art is a protest against the exploitation of black heroes—Sugar Ray Robinson, Hank Aaron, Cassius Clay, Dizzy Gillespie, and Louis Armstrong—and Basquiat identified closely with them all. It is as if he knew that his own meteoric rise to fame and fortune would end in tragedy. He died at the age of twenty-seven of a drug overdose.

Judith F. Baca. Basquiat's vision has much to do with his independence from mainstream Western traditions, certainly his dismissal of traditional notions of "quality." The mural painting of Chicana artist JUDITH F. BACA (b. 1948) also asserts its independence from traditional approaches to painting, even as it recovers and revitalizes the Mexican mural tradition of "Los Tres Grandes"—Rivera, Orozco, and Siguieros (see Chapter 22). Mural painting is public art, and as a result it cannot be purchased or collected. It operates, that is, outside the art market. It is also a collaborative endeavor; many other artists participate in painting Baca's murals. "Collaboration is a requirement," Baca says, not only because the projects are large, but because they are public—the community must participate in the creation of the work.

In 1974, Baca inaugurated the Citywide Mural Project in Los Angeles, which in total completed 250 murals, 150 of which she directed herself. Since then she has continued to sponsor and direct murals through SPARC, the Social and Public Art Resource Center, which she founded. The Great Wall of Los Angeles, begun in 1976, is her most ambitious project. Nearly a mile long, it is located in the Tujunga Wash of the Los Angeles river, which was entirely covered with concrete by developers as Los Angeles grew. This concrete conduit is, says Baca, "a giant scar across the land which served to further divide an already divided city ... Just as young Chicanos tattoo battle scars on their bodies, Great Wall of Los Angeles is a tattoo on a scar where the river once ran." The wall narrates the history of Los Angeles, but not the history told in textbooks. It recounts the history of indigenous peoples, immigrant minorities—Portuguese, Chinese, Japanese, Korean, and Basque, as well as Chicano and of women from prehistory to the present. The detail reproduced here (fig. 24.8) depicts how four major freeways intersected the middle of East Los Angeles's Chicano communities, dividing them, weakening them, and turning them against each other. To the right a Mexican woman protests against the building of Dodger Stadium, which displaced a historic Mexican community in Chavez Ravine.

Baca worked on the *Great Wall* project as director and facilitator but it is nearly four hundred innercity youths, many from the juvenile justice system, who did the actual painting and design. Rival gang mem-

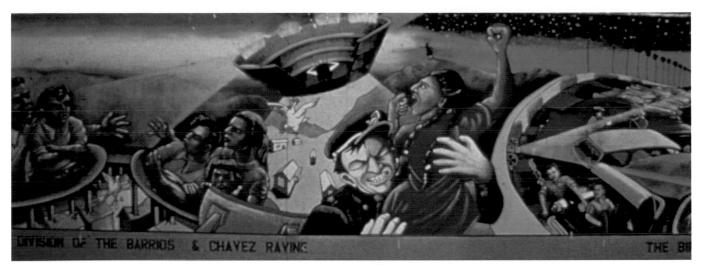

Figure 24.8 Judith F. Baca, *Great Wall of Los Angeles* (detail: Division of the Barrios and Chavez Ravine), 1976–continuing, mural, height 13′ (3.96 m) (whole mural over 1 mile long), Tujunga Wash, Los Angeles, California. The collaborative process of making murals is, in Baca's words, "the transforming of pain ... rage ... and shame."

bers, of different races and from different neighborhoods, found themselves working on the project together. They represented a divided city, but Baca's goal was to help them communicate with one another and learn to work together. For Baca, the collaborative mural process heals wounds, brings people together, and helps to recreate communities that have been destroyed.

Lisa Fifield. Among the Native American painters working in the Midwest is LISA FIFIELD (b. 1957) of Iroquois-Oneida descent, who lives and works in Minnesota. Fifield has painted a large number of canvases devoted to the traditions and beliefs of Native American peoples.

Among Fifield's most important works are a series of paintings based on the slaughter of Native Americans, including women and children, at Wounded Knee at the hands of the United States Army. One painting inspired by the Wounded Knee tragedy, *Ghost Dancers Ascending* (fig. 24.9), depicts the spirits of the dead ascending, suspended in the air above the earth. The attire worn by the figures is based on the actual clothing worn by the American Indians killed at Wounded Knee, clothing their wearers mistakenly believed could not be pierced by bullets. Fifield depicts their transcendent spirits rising above the material fact of their physical death in a painting vibrant with primary colors and deeply reverential in spirit.

The Ghost Dance was developed by the Plains Indians in the 1890s after they had lost their ancestral lands and had been relegated to reservations. They danced for the return of warriors, for the return of the bison that had been slaughtered, and the reestablishment of their former way of life.

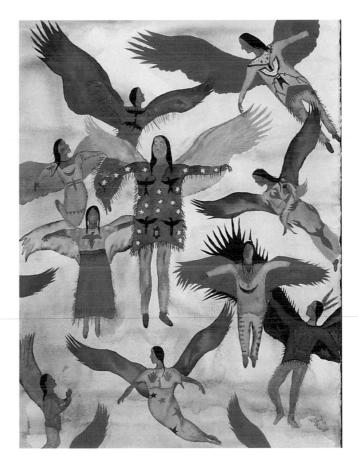

Figure 24.9 Lisa Fifield, Ghost Dancers Ascending, 1995, watercolor on paper, $30 \times 22''$ (76.2 \times 55.9 cm), Private Collection. Fifield depicts the spirits rising above the battlefield at Wounded Knee, their powerful colors and effortless floating making them seem to transcend their tragic deaths.

Faune Quick-to-See Smith. A sense of social injustice is captured forcefully in the work of JAUNE QUICK-TO-SEE SMITH (b. 1940), a Native American painter of the Salish and Kootenai Confederation. In her 1991 Paper Dolls for a Post Columbian World with Ensembles Contributed by the U.S. Government (fig. 24.10), she depicts her ancestors of Montana's Flathead tribe as Ken and Barbie paper dolls, together with their son Bruce. Their Anglicized first names stand in direct opposition to their Native American family name, Plenty Horses, a name suggesting high status in previous generations, since horses were a measure of wealth in the Native American community. Overseeing the entire scene is Father Le de Ville, the Jesuit priest who has "civilized" them. At the bottom is a traditional headdress "collected by white people to decorate their home after priests and the U.S. government banned cultural ways such as

Figure 24.10 Jaune Quick-to-See Smith, Paper Dolls for a Post Columbian World with Ensembles Contributed by the U.S. Government, 1991, pastel and pencil on paper, $40 \times 29''$ (102×73 cm), Steinbaum Krauss Gallery, New York. The box in the lower center of this contains all-"white" supplies furnished the Native American community by the federal government, including "canned milk which gives us lactose intolerance, white sugar which gives us diabetes, white flour which gives us wheat allergies, and lard which gives us gall bladder trouble."

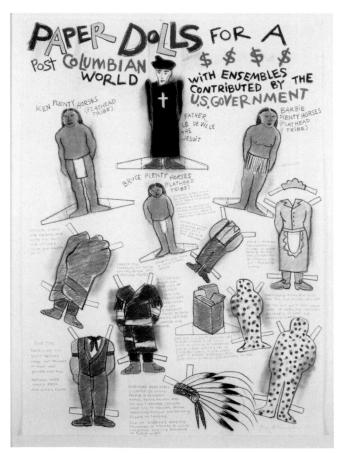

speaking Salish, practicing religion and drumming, singing, or dancing. Sold at Sotheby's [fine art auctioneers] today for thousands of dollars to white collectors seeking romance in their lives." Ken's suit for receiving government rations is at the left, below his "special outfit" for trading land to the whites for whiskey, a traditional blanket. Barbie's outfit is a maid's uniform "for cleaning houses of white people after good education at Catholic or government boarding school." To the bottom right are the two most horrific costumes of all, "matching small pox suits for all our Indian families." The entire piece protests against the colonization of Native Americans and the lack of respect for their traditions.

Maya Lin and the Vietnam Veterans' Memorial. The Vietnam Veterans' Memorial in Washington, D.C. (fig. 24.11) was constructed and dedicated in 1982. Funded entirely by contributions from corporations, foundations, unions, veterans, civic organizations, and nearly three million individuals, the memorial achieved the wishes of the charitable organization founded to establish it: to begin a process of national reconciliation.

The memorial was designed by MAYA YING LIN (b. 1960), at the time a twenty-one-year-old graduate architectural student at Yale University. Lin, who won a national competition that included more than 1400 design submissions, is an American woman of Chinese descent who described herself then as "a country girl from Athens, Ohio," the town where her parents, who fled China before the Communist takeover in 1949, were professors. She wished to establish the memorial in a quiet protected place where it would harmonize with its surroundings, which include the Washington Monument and the Lincoln Memorial, toward which its two walls point. On the surface of polished black granite are inscribed the more than 58,000 names of those killed or missing in action during the war. Viewed from a distance, the wall is shaped like a giant V, whose vertex is set at an angle of approximately 125 degrees. Some have described the two sides of the walls as "arms," which embrace those who enter the memorial. In walking toward the vertex of the wall, where its two arms meet, viewers move back into history. At one end of the wall are inscribed the names of the first casualties, which then continue in chronological order of their dying to the other end, thus symbolically denoting the span of United States' involvement in the war. Taken together, the names represent the sum of the sacrifices made, providing each individual with a place in the country's historical memory. As Maya Lin said about the design for the memorial, "The names would become the memorial."

More than any other national monument, the Vietnam Veterans' War Memorial has won national approval and respect, despite some dissenting voices at first. Thousands visit the memorial every year; many

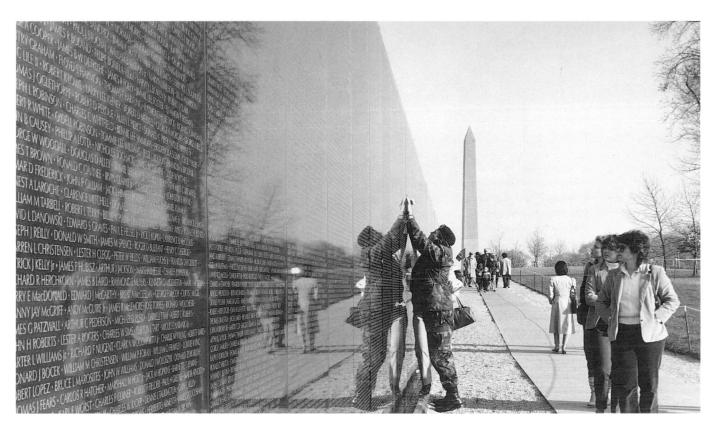

Figure 24.11 Maya Lin, Vietnam Veterans' Memorial, Washington, D.C., 1982, black granite, length 250′ (820.21 m). Known simply as "the Wall," this memorial tribute to those killed in the Vietnam War has become a national symbol of recognition and reconciliation.

return again and again. The wall represents not just one war but all wars, the multiplicity of names and the multiplicity of wars extending from horizon to horizon. As viewers look at the names on the wall's granite slabs, which are polished to a mirror-like sheen, they see themselves reflected in the wall's surface. As in a ritual, visitors more often than not touch the names on the wall, as if to put themselves in contact with the individuals who died, and murmur a prayer. Visitors come away profoundly moved by the wall's homage to suffering and death and to the sense that here healing and reconciliation can begin.

THE DIVERSITY OF AMERICAN VOICES

Adrienne Rich. Perhaps no other voice has spoken more passionately for the liberation of women and men from a prejudice that blinds perception and stunts the mind than ADRIENNE RICH (b. 1929). Rich has become an important spokeswoman for feminist consciousness.

Although Rich is associated with radical feminist ideology, she is not readily constrained by it. Her prose and poetry, while rooted in ideological concerns, nonetheless dramatize a self-discovering freedom in language and art. In her best writing, Rich is less a polemicist and publicist than an artist who challenges readers' preconceptions about women, especially those involving their relationships to men and to one another.

In "When We Dead Awaken: Writing as Re-Vision," Rich has charted the changing perception of herself as woman and poet. She describes how she needed to change the images that represented, for her, ideals of both woman and poet, since her images of both had been dominated by men. She explores the concept of revision, which she considers "the act of looking back, of seeing with fresh eyes." It is an act essential for writers. And as Rich insists, it is essential for women living in a male-dominated society. Re-vision is "an act of survival."

Over the course of her career, she has been a vocal defender of women's rights in all areas, including female sexuality. Herself a lesbian, Rich defines lesbianism as more than a sexual preference. It is "a sense of desiring oneself, choosing oneself," Rich states, part of the formation of identity, the self's power to discover and define itself. It is also, as she has remarked, "a primary intensity between women," which energizes them, propels them toward one another, both challenging and charging their imaginations.

Cross Currents

THE CYBERNETIC SCULPTURE OF WEN-YING TSAI

Cybernetic sculpture fuses art and technology. Through electronic feedback control systems that include high-frequency lights, microphones, and harmonic vibration, a work of cybernetic sculpture such as Wen-Ying Tsai's Cybernetic Sculpture, 1979 comes to life when music is played or hands are clapped in its presence (fig. 24.12). The photograph here makes the figure appear two-dimensional, but it is a three-dimensional sculpture.

Cybernetic Sculpture is constructed of a series of fiberglass rods about 10 feet in height. Each rod is set on a base under which is a small motor. With the motors beneath each base switched on, the rods vibrate slowly but remain perfectly vertical. When stimulated by sound and light, they vibrate synchronously in gently swaying arcs. As long as the stimuli continue, the rods undu-

late in elegant dance-like movement.

Tsai's cybernetic sculptures are selforganizing systems that maintain equilibrium whether in motion or at rest. His works blend not only art and technology, but also Eastern and Western traditions. In fulfilling what Hsieh Ho, a fifth-century Chinese master, identifies as the primary requirement of all art—"rhythmic vitality, a kind of spiritual rhythm expressed in the movement of life"—Tsai's cybernetic sculpture takes its place in a long-established Chinese aesthetic.

Another way Tsai's cybernetic sculpture reflects Chinese aesthetic ideals is in its harmonious blending of the human, the mechanical, and the natural. Each of the elements of a Tsai sculpture contributes harmoniously to the unity of the whole. The spirit of his sculpture is Taoist, as are its effects—a refined equilibrium that merges wisdom with wit, seriousness with humor, mysticism with modernity.

Figure 24.12 Wen-Ying Tsai, Cybernetic Sculpture, 1979, fiberglass mounted on steel plates covering an electronic feedback system, $10 \times 10'$ (3.05 \times 3.05 m) Taiwan Museum of Art. The work responds to changes in light and sound by vibrating with graceful, dance-like undulations.

Maxine Hong Kingston. One of the characteristics of contemporary writing is the way literary works combine elements from different genres. Writers often blend fiction with autobiography. The autobiographical novel The Woman Warrior (1976), by Chinese-American writer MAXINE HONG KINGSTON (b. 1940), has been described by the author as "the book of her mother" since it is filled with stories her mother told her, stories about her Chinese ancestors, especially the women whom Kingston describes as the ghosts of her girlhood. A second book, China Men (1980), is her father's book; it tells the stories of her male ancestors, including her father and grandfathers, although she learned these male stories from women, mostly from her mother. Mixing fact and fiction, autobiography and legend, Kingston's books combine in imaginative ways family history with fictional invention. Kingston's identity as a Chinese-American woman and her attempts to create images of her experience reveal a complexity in her relationship to her ancestral past.

The stories Kingston recounts and invents in *The Woman Warrior* and in *China Men* derive from an oral tradition—the Chinese "talk story," a Cantonese tradition kept alive mainly by women. The talk-story narrators of Kingston's books tell their stories in multiple versions,

varying the amount of detail each reveals. Kingston's narrators' stories contain silences that invite the reader to engage in the imaginative world of the writer, who occasionally hints at her fictionalizing imagination with cues such as "I wonder," "perhaps," and "may have." These and other cues reveal how one writer signals to readers the shift from fact to fiction.

By inscribing her mother's stories and imagining her own variants of them, Kingston marks the talk-story tradition with her own distinctive imaginative imprint. In the process, she demonstrates the power of these stories to enthrall readers outside the Chinese cultural tradition. To some extent, Kingston's work appeals to women precisely because she gives public voice to things women had spoken only in private or not at all. She also transmits to us her Cantonese heritage. However, through her imaginative sympathy and literary artistry, Kingston invents a world and constructs a self that are at once strange and familiar, both "other" and inherently recognizable.

Toni Morrison. African-American writers are among the most prolific working today. One important voice is 1996 Nobel Prize winner TONI MORRISON (b. 1931). Morrison's novels focus on revealing the complexities of African-American communities, particularly

the balance between personal identity and social identity required as a member of a minority American race. Mixing feminist concerns with racial and cultural issues, Morrison's fiction explores the cultural inheritance of African-Americans facing hardship and conflict through memory, relationships, and actions.

In her first novel, The Bluest Eye (1969), Morrison explores what it is like to be of mixed descent—white and black-and thus light-skinned, capturing not only racial prejudices based on color but also the tragedy of unrecognized beauty. In Sula (1973), she portrays the family consequences of a woman achieving her own independence and freedom, and in Song of Solomon (1977), she portrays a black man's attempt to come to terms with his roots. The power of eroticism is the subject of Tar Baby (1981), and Beloved (1987) explores the degrading effects of slavery. Though every book is deeply embedded in pain, Morrison's work is about survival, and the very urgency with which she writes seems to further her own unending quest to survive. "I think about what black writers do," she has said, "as having a quality of hunger and disturbance that never ends."

Sandra Cisneros. Contemporary American literature is rich in Chicano and Hispanic voices and perspectives. The poet and fiction writer SANDRA CISNEROS [sis-NAIR-oss] (b. 1954), of Mexican and American descent, explores how art and talent survive the most adverse of circumstances. Her Hispanic female characters who live amidst an alien culture repeatedly exemplify the struggle to find a place in our society. In each story, beleaguered Chicana girls and women seize control of their lives, somehow rejecting or transcending the limitations placed upon them. Works such as Loose Woman (1994), a collection of poems, and the novel Woman Hollering Creek (1991) reveal Cisneros's rebellious side, while others, such as House on Mango Street (1994) reflect her sense of ethnic pride.

Judith Ortiz Cofer. From Puerto Rico, JUDITH ORTIZ COFER [CO-fur] (b. 1952) has published poetry and prose, in volumes such as Silent Dancing and The Latin Deli. These display Cofer's knack for conveying the experience of the lives of immigrants with vivacity and compassion. Her stories, both autobiographical and fictional, show characters' conflicts with their new lives in mainland America and their memories of Puerto Rico.

Cofer's stories, poems, and autobiographical essays analyze and celebrate the double perspective of seeing life through the lens of two cultures and languages. Her work is elegant and lyrical and possesses a vigorous and convincing authority.

Oscar Hijuelos. Prominent Hispanic Caribbean writers include OSCAR HIJUELOS [hi-YAIL-oss] (b. 1951), whose fiction captures the pre-Castro immigrant experience in the U.S., particularly in New York. His

novel The Mambo Kings Play Songs of Love won the Pulitzer Prize in 1990, the first book by a writer of Hispanic origin to win the prestigious award. In chronicling the lives of Cuban immigrants, their quest for the American dream, and their ultimate disillusionment, Hijuelos evokes the social and musical environment of the 1950s. Throughout his work Hijuelos explores the influence of Hispanic culture on American popular culture. His fascination with the diverse cultural threads woven into the fabric of contemporary American life brims over in his pages. An important influence on younger Hispanic Caribbean and Latino writers, Hijuelos captures and celebrates the singular spirit of place, a particular locus that inspires his work and in which his values and rooted. He emphasizes the necessity for preserving cultural heritage in the face of pressure to blend into the majority American culture. Yet Hijuelos also revels in the way contemporary life reflects a mosaic of cultural inflections.

N. Scott Momaday. The works of N. SCOTT MOMADAY [MOHM-ah-day] (b. 1934) were among the first of those written by Native Americans to garner attention from a wide audience. Born in Oklahoma of Kiowa ancestry, Momaday has written poetry, fiction, and autobiography. His 1969 novel, House Made of Dawn, won a Pulitzer Prize. In it a young Native American man returns from military service in Vietnam to find himself without a place in either Indian society or in mainstream America. Momaday's two autobiographical works, The Way to Rainy Mountain (1969) and The Names (1976), display his ability to mingle Kiowa legends with American history and with his family's personal experience.

Leslie Marmon Silko. LESLIE MARMON SILKO (b. 1948) has written poetry and prose that reflects her mixed ancestry: she is descended from the Laguna tribe but has white and Mexican ancestry as well. Her novel Ceremony (1978), the first published by a Native American woman, and her collection of prose and poetry Storyteller (1981) both emphasize the cultural values and spirit of her Pueblo ancestors. Ceremony makes a connection between the shared cultural heritage of the tribal community and the experience of a contemporary Native American Indian veteran of the Vietnam War, who returns to his Pueblo reservation to reclaim a sense of personal and social identity. Storyteller, a collection of tribal folktales, family anecdotes, photographs, stories, and poems, reflects the intersection of the spiritual and material worlds, as well as connections between history and personal experience. Like much of Silko's writing, the relationship between nature and culture permeates this work, emphasizing the way Native American peoples have lived in harmony with the natural world, the land becoming part of their identity, and not merely a place to live.

Then & Now

NAVIGATING THE WEB

Perhaps no single technological development has succeeded in "shrinking" the scope of the world more than the development of the Internet, and its network, the World Wide Web, which links almost immediately every computer connected to it around the globe.

Not only is text available on the Web, but also images, videos, sound, and film. At the time of writing, over five hundred museum and gallery sites are accessible on the Web, including such sites as the A.I.R. Gallery in New York (women artists), the Andy Warhol Museum in Pittsburgh, and the Louvre

in Paris, where one can view such works as Leonardo's *Mona Lisa* (see Chapter 13), or Géricault's *Raft of the "Medusa"* (see Chapter 18). By seeking out museums and galleries in different countries around the globe, it is possible to view both traditional and contemporary work by artists from over fifty countries worldwide. You can browse the collection of the Ho-Am Art Museum in Seoul, Korea, viewing masterpieces from its painting, ceramics, and bronze collections, or you can tour galleries in Taipei, Taiwan.

There are many other sites as well. You can watch a video clip of a war dance by the Anlo-Ewe people of Ghana, West Africa, or listen to music

samples from the newest CD releases in South America. Alternatively, you can browse the current issue of Critical Inquiry, one of the most important scholarly journals in the United States, or check out LIVEculture, an on-line publication of the Institute for Learning Technologies at Columbia University, which focuses on contemporary art, literature, media, communications, and cultural studies. The possibilities are almost unlimited, and the availability of up-to-date information about almost anything is totally unprecedented. The World Wide Web promises to change permanently the way in which we learn about the world around us.

THE GLOBAL VILLAGE

Probably no event symbolizes awakening tolerance in the contemporary world between diverse cultures more than the opening of the Berlin Wall in November 1989, and, in turn, the collapse of the Communist regime in the Soviet Union two years later. For the first time since World War II, the citizens of the two Germanies were able to come together freely and openly. The implications for Europe as a whole were enormous. As VACLAV HAVEL (b. 1936), the president of the Czech Republic, put it in 1993: "All of us—whether from the west, the east, the south, or the north of Europe—can agree that the common basis of any effort to integrate Europe is the wealth of values and ideas we share ... All of us respect the principle of unity in diversity and share a determination to foster creative cooperation between the different nations and ethnic, religious, and cultural groups—and the different spheres of civilization—that exist in Europe." Havel's message is easily extended to the globe as a whole. We have increasingly come to recognize and accept a worldwide imperative. We now live in a pluralistic global community of nearly five billion people. To survive and thrive, we need to communicate and share with one another as if we lived in a single village.

MAGICIANS OF THE EARTH

In 1989, an exhibition in Paris, France, announced itself as "the first worldwide exhibition of contemporary art." Called *Magiciens de la terre*, or *Magicians of the Earth*, the show consisted of works by one hundred artists, fifty

from the traditional "centers" of Western culture (Europe and America) and fifty from Asia, South America, Australia, Africa, and, incidentally, Native American art from North America. It was, in the words of Thomas McEvilley, an American art critic, "a major event in the social history of art," if not in its aesthetic history.

Organizationally, it was something of a failure, but unity of approach was, perhaps, not the point. While it was difficult for most viewers to detect coherent themes or influences among artists and cultures, the exhibition sought, in McEvilley's words, to arrive at "a new definition of history that will not involve ideas of hierarchy, or of mainstream and periphery, and a new, global sense of civilization," exhibiting works "in a neutral, loose, unsystematic way that would not imply transcultural value judgments." The exhibition succeeded in underscoring the diversity and plurality of world art. As the exhibition's chief curator, Jean-Hubert Martin, put it, "Rather than showing that abstraction is a universal language, or that the return to figuration is now happening everywhere in the world, I want to show the real differences and the specificity of different cultures."

THE EXAMPLE OF AUSTRALIAN ABORIGINAL PAINTING

No better example of difference can be found than the art of the Australian Aborigines. Ceremonial body, rock, and ground paintings were made for centuries by the Aboriginal peoples of Central Australia's Western Desert region. The sand painting in the installation view of the *Magicians of the Earth* (fig. 24.13) is one such work, exe-

cuted on the spot by the Yuendumu community. Today, Aboriginal artists are best known for their acrylic paintings, which were not produced in the region until 1971. In that year, a young white art teacher named Geoff Bardon arrived in Papunya, a settlement on the edge of the Western Desert organized by the government to provide health care, education, and housing for the Aborigines. Several older Aboriginal men became interested in Bardon's classes, and he encouraged them to paint in acrylic, using traditional motifs. Between July 1971 and August 1972, they produced 620 paintings, which were subsequently sold. Money was clearly a major factor in prompting this explosion of work. In 1984, for instance, the women of one village took up painting to buy a truck.

Each painted design still carries with it its traditional ceremonial power. It is also considered actual proof of the identity of those who made it. The organizing logic of most Aboriginal art is the "Dreaming," a system of belief unlike that of most other religions in the world. The Dreaming is not literal dreaming, not what goes on in that other world we inhabit in our sleep. For the Aborigine, the Dreaming is the presence, or mark, of an ancestral being in the world. Images of these beings—representations of the myths about them, maps of their travels, depictions of the places and landscapes they inhabited—make up the great bulk of Aboriginal art. The Australian landscape is thought of, in fact, as a series of marks made upon the earth by the Dreaming.

Geography itself is thus full of meaning and history. And painting is understood as a concise vocabulary of abstract gestures conceived to depict this geography.

Each painting depicts a Dreaming for which the artist is *kirda*. Artists are *kirda* if they have inherited the "rights" to the Dreaming from their father. Every Dreaming is also inherited through the mother's line, and a person who is related to a Dreaming in this way is said to be *kurdungurlu*. *Kurdungurlu* must insure that the *kirda* fulfill their proper social and ritual obligations to the Dreaming. As a result, several people usually work on any given painting. The person that Westerners designate as the "artist"—a distinction not employed in Aboriginal culture before the advent of acrylic painting—is generally the person who has chosen the specific Dreaming to be depicted.

Erna Motna's *Bushfire and Corroboree Dreaming* (fig. 24.14) depicts the preparations for a corroboree, or celebration ceremony. The circular features at the top and bottom of the painting represent small bushfires that have been started by women. As small animals run from the fire (symbolized by the small red dots at the edge of each circle), they are caught by the women and hit with digging sticks, also visible around each fire, and then carried with fruit and vegetables to the central fire, the site of the *corroboree* itself.

Unlike most other forms of Aboriginal art, acrylic paintings are permanent and are not destroyed after

Figure 24.13 Installation view of *Magiciens de la terre* (*Magicians of the Earth*), La Villette, Paris, 1989. This exhibition attempted to put works from the "third world" beside works from the West in a non-judgmental way. Here a sand painting by the Australian aboriginal Yuendumu community lies on the floor beneath English artist Richard Long's *Red Earth Circle*.

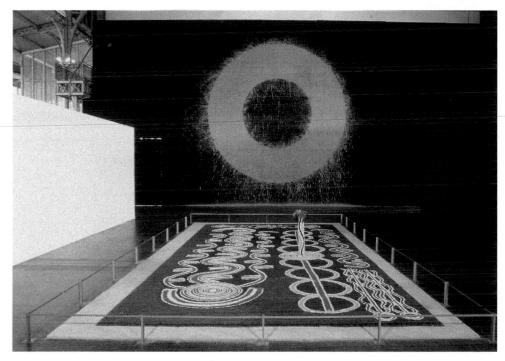

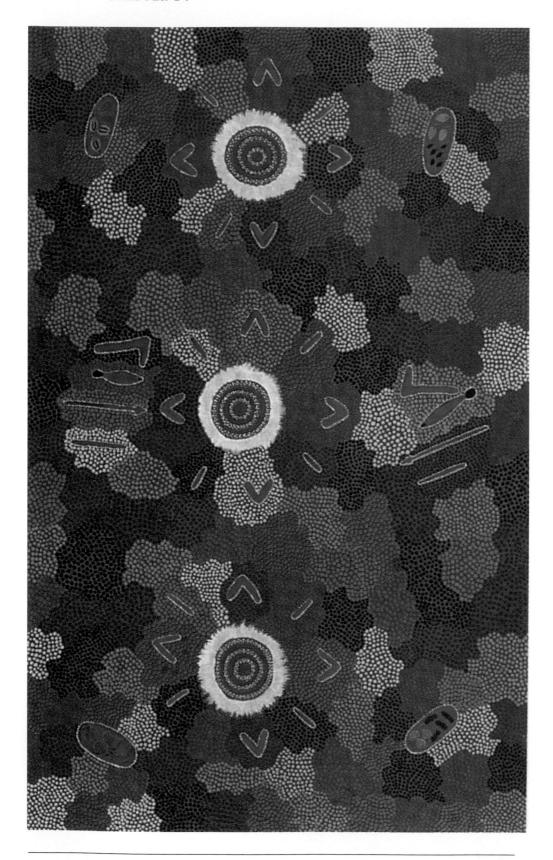

Figure 24.14 Erna Motna, *Bushfire and Corroboree Dreaming*, 1988, acrylic on canvas, $48 \times 32''$ (121.9 \times 81.3 cm), Australia Gallery, New York. Surrounding each of the three fires—the white circles in the painting—are a number of weapons used to kill larger animals—boomerangs, spears, *nulla nullas* (clubs), and *woomeras* (spear throwers).

serving the ceremonial purposes for which they were produced. In this sense, the paintings have tended to turn dynamic religious practice into static representations, and even worse, into commodities. Conflicts have arisen over the potential revelation of secret ritual information in the paintings, and the star status bestowed upon certain, particularly younger, painters has had destructive effects on traditional hierarchies within the community. On the other hand, these paintings have tended to revitalize and strengthen cultural traditions that were, as late as the 1960s, thought to be doomed to extinction as Westerners gained footholds in the Australian desert region.

The major difference between Western art and the art of other, non-Western cultures, as Aboriginal painting makes clear, is that the latter is often participatory and ceremony-based. Even when we can identify the "artist"—Erna Motna, for instance—it is his or her relationship to the whole community that is emphasized as well as the work's place in community life as a ceremonial object. In the West, on the other hand, the work of art tends to be a commodity, the artist a

solitary individual, and the audience non-participants, mere spectators.

Still, aspects of each approach inform most art made today in the global village. On the wall behind the Yuendumu sand painting at the Magicians of the Earth exhibition was a large circle made by English artist Richard Long. It was, in fact, made of mud that Long had collected on a visit to the Yuendumu com munity. Its juxtaposition with the Yuendumu sand painting bestowed on it a ritual power it otherwise lacked. At the same time it dominated the room like a giant colonist's eyeball, gazing down upon the Yuendumu sand painting in a gesture of Western mastery and control. Such give-and-take is the distinctive feature of the global village. As Jean-Hubert Martin explained: "Successful and dominant countries impose their laws and styles on other countries, but they also borrow from them and so become permeated by other ways of life. The notion of cultural identity . . . is the product of a static concept of human activity, whereas culture is always the result of an ever-moving dynamic of exchanges."

GLOSSARY

- Words in **boldface** indicate terms defined elsewhere in the glossary.
- a cappella (ah kuh-PELL-uh) Italian for "chapel style." In music, a composition for voices only, not accompanied by any other instruments.
- absolute music Instrumental composition that does not attempt to tell a story or describe a scene, but deals only with musical sound, form, and tone color. Compare program music.
- Abstract Expressionism Mid-twentiethcentury painting style that rejected direct representation and emphasized the artist's spontaneous and emotional interaction with the work.
- **abstraction** Art that does not portray the visual reality of a subject but reflects an artist's nonrepresentational conception of it.
- Absurdism; Theater of the Absurd
 Theater form, influenced by existentialism, that features incoherent plots and
 incomprehensible characters.
- **academy** Generally, a society of artists or scholars. The Academy was Plato's school for the study of philosophy.
- acanthus A Mediterranean plant whose leaves were often copied as decoration on the capitals of Corinthian columns.
- acropolis Meaning literally "high city," this was the fortified, elevated point in an ancient Greek city. The Acropolis is the specific site in Athens where the Parthenon was built.
- acrylic Paint made of pigment in a solution of a synthetic resin.
- action painting Mid-twentieth-century painting style popularized by Pollock in which the artist throws, drops, or splatters paint on a canvas to convey a sense of physical activity and vitality.
- adagio (uh-DAH-joe; uh-DAH-jee-oh) Musical direction for an "easy" or slow tempo.
- **aesthetic** Related to the appreciation of beauty in the arts.
- **agit-trains** Trains that disseminated propaganda art in post-revolutionary Russia.
- **agora** A meeting place in ancient Greece, especially a marketplace.
- aisle A long side passageway of a church. Aisles run parallel to the central nave.
- alap In music, an improvised prelude to an Indian raga composition.
- allegory A symbolic narrative in which a deeper, often moral meaning exists beyond the literal level of a work.
- alla prima (AH-la PREE-ma) To paint without any preliminary drawings.
- allegro Musical direction for a fast tempo. altar A raised platform or table at which

- religious ceremonies take place. It is where the Eucharist is celebrated in Christian churches.
- **altarpiece** A painted or carved panel behind or above the *altar* of a church.
- **alto** In music, the range of the lowest female voice.
- **ambulatory** A passageway or **aisle** around a church.
- **amphitheater** An oval or round theater with tiers of seats gradually rising from a central arena.
- amphora (AM-fur-uh) A two-handled jar with a narrow neck, used by ancient Greeks and Romans to carry wine or oil.
- **anagnorisis** In drama, the point at which a character experiences recognition or increased self-knowledge.
- andante (ahn-DAHN-tay) Musical direction for a tempo "at a walking pace."
- animal interlace An ornamental pattern of intertwined, elongated animal forms, common in medieval art.
- animal style An artistic design popular in ancient and medieval times, characterized by decorative patterns of intricate animal motifs.
- anthropomorphism The act of attributing human characteristics to non-human entities, such as gods or animals.
- antiphony Vocal or instrumental music in which two or more groups sing or play in alternation.
- apse The semi-circular projection at the end of a church sanctuary, often highly decorated; usually the location of the altar.
- arcade A series of connected arches, supported by columns or piers.
- arch In architecture, the curved or pointed structure spanning the top of an open space, such as a doorway, and supporting the weight above it.
- **Archaic period** The Greek cultural and artistic style of about 600–480 B.C.
- **Archaic smile** An enigmatic facial expression, almost a half-smile, typical of early ancient Greek sculpture.
- architrave The bottom part of an entablature, directly above the capital.
- archivolt The semi-circular molding outlining an arch.
- aria (ARR-ee-ah) Section of an opera or oratorio for a solo singer, usually with orchestral accompaniment.
- Art Nouveau (arr new-VOE) Literally, "new art" in French. A late nineteenthand early twentieth-century movement of art and crafts noted for its ornamental decoration based on the forms of nature, especially the frequent use of curvilinear and floral patterns.
- art song Song in which words and music are artistically combined so that the composition reflects the tone, mood, and meaning of the lyrics.
- **ashlar masonry** (ASH-luhr) Masonry of dressed or square-cut stones.
- assemblage Three-dimensional art collage, developed by Rauschenberg in

- the early twentieth century, constructed of found objects such as tires, trash, and mattresses.
- assonance Similarity of sound, especially the half-rhyme of words with the same vowel sounds but different consonants, as in *beap* and *leak*.
- ateliers (AT-ul-yay) Workshops, especially those funded by the French government to employ people after the European revolutions of 1848.
- **atlas** (plural, **atlantes**) A sculpted male figure used as a supporting **column**.
- atmospheric perspective See perspective.
- **atonality** Lack of a home key or **tonal center** in a musical composition.
- **atrium** In architecture, the open room in the center of a Roman house.
- automatism Surrealist artistic technique of the early twentieth century in which the artist gives up intellectual control over his or her work, allowing the subconscious to take over.
- avant-garde (ah-vahnt GUARD)
 Literally, "advance guard" in French.
 A military term used to describe artists
 on the cutting edge, especially those
 vanguard artists of the early twentieth
 century in France who focused on
 abstraction.
- axis An imaginary straight line on either side of which components of a piece of art are evenly arranged.
- *baldacchino* (ball-dah-KEY-noh) In architecture, a canopy placed over a sacred space, such as an altar.
- **balustrade** In architecture, a carved railing supported by small posts, or balusters, as along a staircase.
- **baptistery** A small, octagonal structure where baptisms are performed, usually separated from the main church building.
- Baroque (bah-ROKE) Seventeenth-century artistic period characterized by opulence, emotionalism, and use of curving lines and ornamentation. In music, a composition style of the seventeenth and eighteenth centuries characterized by ornamentation and rigid structure.
- **bas relief** French for "low" relief. In sculpture, **relief** that projects only slightly from its background.
- basilica A large rectangular building with a wide central nave and an apse at one or both ends, originally used in Rome for business and legal meetings, later adapted for Early Christian churches.
- **basilica plan** A building modeled after the rectangular **basilica** floor plan, with a longitudinal **axis**.
- bass In music, the range of the lowest male voice.
- **battered** In architecture, sloping inward toward the top, as in a wall.
- Bauhaus Early-twentieth-century German art school led by Gropius that attempted to blend all forms of art,

617

- science, and technology.
- bay In architecture, a spatial unit that is repeated.
- **beat** A unit of rhythm in a musical composition, or the accent in that rhythm.
- **Beijing opera** Chinese musical drama developed in the nineteenth century that featured fast-paced, stylized scenes based on ancient Chinese myths.
- belle époque (bell-lay-POCK) French for "beautiful age." The era of leisure and elegance in Paris during the late nineteenth and early twentieth centuries.
- **Benedictines** Members of the religious order founded by St. Benedict in 529.
- **bhakti** (BUCK-tee) In Hinduism, the expression of personal devotion to a particular deity, especially in the form of poetry.
- **black-figure style** Greek vase painting style featuring black figures painted on a red clay background, with details incised to reveal the red clay below.
- blank verse Unrhymed verse in iambic pentameter, frequently used in Elizabethan drama.
- **blind arcade** A decorative **arcade** in which the **arches** and **columns** are attached to the background wall.
- bodhisattva (boe-di-SUTT-vuh) In Buddhism, an enlightened being on the brink of buddhahood who forgoes nirvana to allow others to attain salvation.
- brass instrument Musical instrument, such as a trumpet or tuba, played by blowing through a detachable brass mouthpiece.
- Bunraku (boon-RAH-koo) Traditional Japanese puppet theater featuring large puppets and puppeteers on stage, and a samisen accompanist and narrator who sit just off the side of the stage.
- **buttress** In architecture, a projecting support or reinforcement.
- Byzantine (BIZ-un-teen) Artistic style of Eastern Europe in the fourth through fifteenth centuries that featured rich colors, Christian imagery, domed churches, and mosaics.
- cabochon (CAB-uh-shawn) A gem that is not cut in facets, but is smoothed and rounded
- caliph One of a succession of leaders who assumed religious and secular control of Islam after Muhammad's death.
- Calvinism Theological belief system, based on John Calvin's (1509–64) writings, that held that some individuals—the Elect—are predestined to be saved; noted for its strict moral code.
- camera obscura (ub-SKOOR-a) Crude cameralike device for verifying perspective, first used in the Renaissance; consisted of a box with a tiny hole in one side through which a beam of light passes, projecting the scene, now inverted, on the opposite wall of the box.
- campanile (camp ah-NEE-lee) A bell tower, especially one that stands apart from other main church buildings.
- canon In religion, the books of the Bible

- officially sanctioned by a church as inspired by God.
- canto A main division of a poem.
- **cantus firmus** (CAN-tuss FURR-muss) A preexisting melody line around which a new polyphonic composition is constructed.
- cap stone The topmost stone in a corbeled arch or dome, which joins the two sides.
- **capital** The decorative top part of a **column** that supports the **entablature**.
- cartoon A full-scale preparatory drawing made for a large work such as a tapestry or mural.
- **caryatid** (cah-ree-ATT-id) A sculpted female figure used as a supporting **column**.
- catacombs Underground cemeteries of Early Christians, especially those on the outskirts of Rome.
- **catharsis** Purging of emotional tension, especially by art; originally described by Aristotle as the effect of **tragic** drama on the audience.
- cantata From the Italian word for "to sing." Small-scale musical work for a solo singer or small group of singers and accompanying instruments. Compare sonata.
- cantilever In architecture, a self-supporting extension from a wall.
- canzone; canzoni (can-TSOE-neh; can-TSOE-nee) A song, especially one performed by troubadours in the eleventh through thirteenth centuries and using a love poem as text.
- capital The decorative top part of a column that supports the entablature.
- **cast iron** Casted alloy of iron with silicon and carbon.
- cella (SELL-uh) The inner room of a Greek or Roman temple, where the temple's cult statue was kept.
- centering In architecture, a temporary wooden semicircular device used for support during construction of an arch, vault, or dome.
- **central plan** A building having no longitudinal **axis**, such as one with a polygonal or circular floor plan.
- cha-no-yu Japanese ritualistic tea ceremony.
- chanson (shawn-SFWN or SHANN-sen)
 French for "song." A general term for a song with French lyrics, especially one performed by troubadours in the eleventh through sixteenth centuries.
- chanson de geste (shawn-SAWN duh JZEST) French for "song of deeds." A medieval epic poem that celebrates the actions of historical figures or heroes.
- château (pural, châteaux) Grand castle, especially of a French aristocrat.
- chapel A small area for worship, usually set in an alcove of a larger church or within a secular building.
- *chiaroscuro* (key-are-oh-SKOO-roe)
 From the Italian *chiaro*, "light," and *oscuro*, "obscure" or "dark." In painting, a method of **modeling** that combines sub-

- tle shifts of light to dark across a rounded surface to give the impression of depth.
- **chiton** A soft clinging outer garment worn by women in ancient Greece.
- **chivalry** The system of ethical conduct of the Middle Ages based on a blend of Christian and military morals.
- **choir** In architecture, the part of a church where the singers perform, usually between the **transept** and the **apse**.
- chorus In ancient Greek drama, the group of actors who spoke or chanted in unison, often while moving in a stylized dance; the chorus provided a commentary on the action. Later, the term was generalized to mean a company of singers.
- **chorale** Simple Protestant hymn sung in unison by a church congregation.
- Christian humanism Sixteenth-century belief system that combined the ideals of classical humanism with biblical morality.
- Cistercians Members of the austere order of monks established at Citeaux in 1098.
- civilization A culture's development to a stage marked by written language, social organization, and artistic expression.
- Classical Artistic style of ancient Greece or Rome that emphasized balance, restraint, and quest for perfection. In music, the eighteenth-century style characterized by accessibility, balance, and clarity.
- classicism Any later artistic style reminiscent of the ancient Greek or Roman Classical style and its values of balance, restraint, and quest for perfection.
- clerestory (CLEER-story) In church architecture, the upper part of the wall containing a row of windows for light.
- cloister A square or rectangular open courtyard surrounded on all sides by covered arcaded walkways, and often with a source of water in the center. Generally part of a monastery.
- **coda** A repeated section of music at the end of a movement in **sonata form**.
- **coffer** In architecture, a squarish indentation in a **dome** or **vault**.
- collage From the French word for "gluing" or "pasting". A visual art form in which bits of familiar objects, such as rope or a piece of newspaper, are glued on a painted canvas surface.
- **colonette** A small **column**, usually attached to a **pier** in **Gothic** cathedrals.
- **colonnade** In architecture, a row of **columns** placed side by side, usually to support a roof or series of **arches**.
- **color field** Twentieth-century abstract painting style, popularized by Rothko, that featured large rectangles of flat color intended to evoke an emotional response.
- **column** A vertical architectural support, usually consisting of a base, **shaft**, and decorative **capital**.
- **comedy** An amusing play or novel with a happy ending, usually including a marriage.

- **comic opera** Light **opera**, especially of the **Classical** era, that featured simple music, an amusing plot, and spoken dialogue.
- complementary colors A combination of one primary color and one secondary color that is formed by the two other primary colors. Red and green, blue and orange, and yellow and purple are complementary colors. See also primary colors; secondary colors.
- Composite order Roman combination of the Greek Ionic and Corinthian orders, with a slender column and a capital with both acanthus leaves and a volute.
- Conceptual art Twentieth-century artistic style whose works were conceived in the mind of the artist, often submitted in a written proposal, and did not originate in the commercial art scene.
- concerto (kun-CHAIR-toe) A musical composition for solo instrument and orchestra, usually in three contrasting movements in the pattern fast-slow-fast.
- **concrete** A hard building material made of cement, sand, and gravel; popularized by the ancient Romans.
- **Confucianism** Chinese philosophical perspective based on the teachings of Confucius that emphasized morality, tradition, and ethical behavior.
- **continuous narration** In art, simultaneous depiction of events that are occurring at distinct chronological times. Compare with linear narration, in which events are ordered chronologically from left to right.
- contrapposto (CONE-truh-POSE-toe) In sculpture and painting, an asymmetrical positioning of the human body in which the weight rests on one leg, elevating the hip and opposite shoulder.
- **corbel** In architecture, a bracket of metal, wood, or stone.
- corbeling In architecture, the successive layering of stones, with each layer slightly overlapping the one below it until the stones meet at the top of the opening, such as in an arch or dome.
- Corinthian The most ornate of Greek architectural orders, featuring thin, fluted columns and capitals elaborately decorated with acanthus leaf carvings. See also Doric; Ionic.
- **cornice** In architecture, a horizontal molding that forms the uppermost, projecting part of an **entablature**.
- **cosmology** Philosophical study of the evolution of the universe.
- **Counter-Reformation** Sixteenth-century Roman Catholic response of reform to the Protestant **Reformation**.
- **counterpoint** In music, weaving two or more independent melodies into one harmonic texture.
- **couplet** A unit of poetry consisting of two successive rhyming lines.
- **covenant** In theology, an agreement or contract between God and humans.
- **crenelated** Notched or indented, as at the top of a wall or battlement.
- **crepidoma**; **crepis** The three visible steps of a **column**'s **platform**.

- cromlech (CROM-leck) A prehistoric monument of huge stones arranged in a circle.
- **crossing** The intersection of the **nave** and the **transept** in a cross-shaped church.
- **crypt** An area underneath a church, usually beneath the apse, that is used as a burial place.
- **Cubism** Early twentieth-century painting style characterized by geometric depiction of objects, especially using cubes, and multiple views of one object; leading Cubists were Picasso and Braque.
- **culture** A group's way of living, including its beliefs, art, and social organization, that is transmitted from one generation to the next.
- **cuneiform** (KYOO-nee-ah-form) The ancient Mesopotamian system of writing that uses wedge-shaped characters.
- **cupola** (KYOO-puh-luh) A rounded roof or small dome on a roof.
- **Dada** Artistic and literary movement during and just after World War I that rejected tradition and championed the irrational and absurd.
- daguerreotype (duh-GARE-oh-type) An early photograph form, produced on silver or silver-coated copper plates. Named for Daguerre, the French painter who invented the method.
- De Stijl (duh-STYLE) Dutch for "The Style." Artistic movement founded in 1917 in Holland that integrated all visual arts and championed total abstraction. Noted for its use of primary colors, black and white, and geometric lines, as seen in Mondrian's paintings. Also called Neo-Plasticism.
- **decadents** Label *fin-de-siècle* writers used for themselves to describe their moral decadence, mannered style, and fascination with morbid or perverse subject matter.
- deconstruction Twentieth-century philosophical approach, especially in linguistics, of breaking apart the whole, assuming that in all systems there are gaps or inconsistencies, and that those gaps reveal the most about the whole system.
- **Deism** (DEE-izm) Belief system based on the premise of a God who created the universe and then left it to run by itself.
- Der Blaue Reiter Literally, "The Blue Rider" in German. A branch of early twentieth-century German Expressionist art characterized by abstract forms and pure colors.
- **dharma** The Hindu notion of duty or moral responsibility.
- Die Brücke Literally, "The Bridge" in German. A branch of early twentiethcentury German Expressionist art characterized by bold colors, landscapes, and violent portraits.
- **Dionysos** Greek god of wine (Roman name Bacchus), whose worship developed into an orgiastic cult of fertility and immorality in ancient Rome.
- **diptych** (DIP-tick) A pair of painted or carved panels hinged together.

- **dissonance** In music, a chord or interval that sounds unfinished and seems to need resolution in a harmonious chord.
- dome A hemispherical vault.
- **Doric** The earliest and simplest of Greek architectural **orders**, featuring short, sturdy **columns**, often unfluted, and a simple **capital** shaped like a square block and a circular cushion. See also **Corinthian**; **Ionic**.
- **drum** In architecture, a circular wall, usually topped by a **dome**.
- **dualism** A religious system that divides the universe into two opposing forces, good and evil, e.g. Zoroastrianism.
- **Duco** Brand name for pyroxylin, a lacquer first developed for automobiles and commonly used in Mexican murals.
- **duplum** The higher pitched of two voice parts in medieval **organum**.
- **earthenware** Pottery made of porous clay fired at a relatively low temperature.
- earthwork A large-scale artwork created by altering the land or a natural geographic area.
- echinus (ee-KYE-nuhs) The cushionlike molding below the abacus of a **Doric** capital.
- **enamel** The artistic technique of fusing powdered colored glass to a metal surface in a decorative pattern, or the object created by this method.
- **engaged** Attached to a background wall, as in a **column**.
- **engraving** A type of print made by cutting an image onto metal or wood and inking the impression.
- Enlightenment Eighteenth-century European intellectual movement that emphasized the mind's power to reason, challenged the traditional, and favored social reform.
- entablature In architecture, the horizontal structure above the columns and capitals and below the roof.
- entablature In architecture, the horizontal structure above the columns and capitals and below the roof.
- entasis (EN-tuh-sis) A slight bulge in the shaft of a column.
- **epic** An extended narrative poem written in a dignified style about a heroic character or characters.
- **Epicureanism** Greek philosophy founded by Epicurus that held that pleasure, or the avoidance of pain, was the ultimate good.
- epistle A book of the New Testament originally written as a letter.
- ere ibeji Yoruban carvings of twins, who are believed to be gifts of the gods.
- **essay** French for "attempt." A short literary composition, usually expressing the author's personal views.
- etching A type of print made by incising an image on a waxed metal plate, corroding the exposed metal in an acid bath, removing the wax, then inking the design.
- **étude** (AY-tood) A solo musical study focusing on a particular technique.
- **evangelists** From the Greek term for "bearer of good news." The name given

- to Matthew, Mark, Luke, and John, who wrote the gospel books of the New Testament; generally, one who preaches or attempts to spread the gospel.
- **Existentialism** Twentieth-century philosophy based on the notion that it is the individual's responsibility to make ethical decisions, and that this responsibility is often the source of feelings of anguish.
- **Expressionism** Modern artistic and literary movement characterized by emotional expression, often with agitated strokes, intense colors, and themes of sexuality. See also *Die Brücke*; *Der Blaue Reiter*.
- facade The front face of a building. faience (FYE-uhns) Lustrous glazed earthenware.
- fan vaulting A decorative style of vaulting with ribs radiating like those of a fan.
- fang ding A square bronze vessel with four legs, used for storing ceremonial offerings during the Chinese Shang dynasty.
- **fète galante** In **Rococo** painting, a depiction of an elegant outdoor party, featuring amorous conversations, graceful fashion, and social gallantry.
- **ficciones** Term coined by Borges for his short, puzzling fictional works that invite philosophical reflection.
- fin de siècle (fan duh SYEH-cle) French for "end of the century." Describes the last years of the nineteenth century, generally noted for inventiveness, social unrest, and decadence.
- finial The decorative part at the top of a spire, gable, lamp, or piece of furniture.
- Flamboyant A late stage of Gothic architectural style of the fifteenth and sixteenth centuries, characterized by wavy, flamelike tracery and elaborate decoration.
- *flâneur* (flah-NERR) A type of a person in *belle époque* Paris noted for his or her lifestyle of leisure, elevated manners, elegant attire, idle strolling, and light conversation.
- fluting In architecture, a decorative motif of a series of parallel vertical grooves, such as on a **column**'s **shaft**.
- flying buttress An architectural support consisting of an external buttress connected to the main structure by an arch which transfers the lateral thrust of the vaulting to it; invented and used frequently during the Gothic era.
- folio A large sheet of paper folded once down the middle, forming two leaves, or four pages, of a book or manuscript; generally, a page in a manuscript or book.
- **foreshortening** A painting and drawing technique of shortening the lines of an object to create the illusion of three-dimensional space in a composition.
- forum (plural, fora) A public square of an ancient Roman town, often used as a marketplace or gathering spot.
- Franciscans Members of a Christian order of monks founded by St. Francis of Assisi in 1209; noted for their emphasis on poverty and humility.

- fresco A painting technique in which pigments are applied to fresh wet plaster, or an artwork created in this technique.
- **fret** A ridge on the fingerboard of a stringed instrument.
- friar A male member of certain Christian monastic orders.
- frieze A band of ornamental carving, especially the middle section of an entablature, between the architrave and cornice.
- free verse Poetry that uses the natural rhythm of words and phrases instead of a consistent pattern of meter and rhyme.
- **fresco** Painting style in which pigments are applied to fresh wet plaster, or an art work created in such a style.
- **fugue** (FYOOG) Musical composition of three or four highly independent parts in which one voice states a theme which is then imitated in succession by each of the other voices in **counterpoint**.
- **Functionalism** Architectural theory that a building's design should be adapted to its function.
- **Futurism** Early twentieth-century artistic movement that rejected conventional art and sought to show the fast-paced, dynamic nature of modern life and the machine age, often by portraying various views of a moving object.
- gable In architecture, the triangular section at the end of a pitched roof, between the two sloping sides.
- gallery In architecture, a long narrow passageway, especially found above the side aisles of a church, overlooking the nave.
- gargoyle Λ gutter, carved usually in the form of a fantastic creature, the mouth serving as a waterspout. Found especially on Gothic churches and cathedrals.
- **garth** An enclosed garden, especially that within a **cloister**.
- gelede Traditional Yoruban masked ritual, performed to appease "the mothers," women thought to posses special powers.
- **genre** (JON-ruh) A category of art, music, or literature.
- **genre painting** Painting depicting the daily life of ordinary people.
- **geoglyph** A huge earthen design, such as the Nazca lines.
- Geometric period The Greek cultural and artistic style of about 1000–700 B.C., noted for abstract geometric designs, especially on pottery.
- **gesso** (JESS-oh) Italian for "gypsum" or "plaster." White Plaster of Paris or clay used as a primer.
- glaze A thin, transparent layer of oil paint, usually applied on top of another layer or over a painted surface to achieve a glowing or glossy look.
- glissando (plural, glissandi) (gli-SAHN-doe) In music, a rapid slide of a succession of adjacent tones.
- Gnosticism (NOHS-tih-sizm) The dualistic doctrine of certain pagan, Jewish, and Early Christian sects that redemption is achieved through an occult knowledge of God, revealed to their believers alone.
- Golden Section A mathematical formula,

- developed in ancient Greece, for ideal proportions in fine art. The smaller of two dimensions is the same proportion to the larger as the larger is to the whole work, a ratio of about five to eight.
- gospels The first four books of the New Testament (Matthew, Mark, Luke, John), which describe the life and teachings of Jesus.
- Gothic The style of architecture and art of the twelfth through sixteenth centuries in Western Europe and revived during the Romantic era. Characterized, especially in churches, by ribbed vaults, pointed arches, flying buttresses, stained glass, and high, steep roofs.
- **grand opera** Nineteenth-century form of **opera** that appealed to the masses because of its spectacle.
- **Greek cross** In architecture, a floor plan of four arms of equal length. Compare to **Latin cross**.
- **Greek cross** In architecture, a floor plan having four arms of equal length. Compare with **Latin cross**.
- Gregorian chant A monophonic liturgical chant, usually sung with no accompaniment; named after St. Gregory, who was pope 590–604. Also called plainchant; plainsong.
- **ground bass** In music, a phrase in the **bass** that is repeated continually throughout the composition or musical section.
- guild An association of people in the same craft or trade, formed during the Middle Ages or Renaissance to give economic and political power to its members and to control the trade's standards.
- hadith The Islamic document containing the sayings of Muhammad and anecdotes about him.
- buiku (HIGH-koo) Japanese poetry form in three lines, with seventeen syllables in the pattern five, seven, and five syllables per line; usually features imagery from nature, includes a reference to a season, and avoids rhyme.
- Happening Spontaneous art form of the 1960s that incorporated theater, performance, visual arts, and audience involvement.
- Harlem Renaissance Mid-twentiethcentury literary and artistic movement centered in the African-American community of New York City's Harlem neighborhood.
- harmony In music, playing or singing two or more tones at the same time, especially when the resulting sound is pleasing to the ear; generally, the arrangement of chords.
- Hellenic Relating to the culture of Classical Greece (from 480 to 323 B.C.).
- Hellenistic Relating to the post-Classical period in Greek history (after 323 B.C.), during which basic tenets of Classical Greek culture and thought spread throughout the Mediterranean, Middle East, and Asia.
- **henge** A prehistoric circle of stones or posts.
- **hieroglyphics** A writing system, such as that of the ancient Egyptians, that uses pictorial characters to convey sounds or meanings.

- highlife Style of contemporary African music featuring a fusion of indigenous dance rhythms and melodies with Western marches, sea chanties, and church hymns.
- Hijrah (or Hegira) (hi-JYE-ruh) Muhammad's flight from Mecca to Medina in A.D. 622, which marks the beginning of the Muslim era.
- **himation** A rectangular piece of fabric draped over one shoulder as a garment in ancient Greece.
- **homophony; homophonic** In music, the playing or singing of a single melodic line with harmonic accompaniment.
- huaca (WAH-cah) A pyramid made of sun-dried bricks, around which the Moche lived in Peru.
- humanism The belief system, especially during the Renaissance, that stressed the worth, dignity, and accomplishments of the individual. Stemmed from renewed interest in Classical values of ancient Greece and Rome.
- icon A religious image, such as a figure from the Bible, painted on wood and used as a sacred reminder of important elements of Christianity.
- iconoclasm; iconoclastic controversy (eye-KON-o-KLAZ-em) Opposition to the use of religious images; the systematic destruction of religious icons.
- **iconography** In visual arts, the symbols used to communicate meaning.
- iconophile A lover of artistic images, at odds with iconoclasts in the iconoclastic controversy of the Byzantine era.
- **iconostasis** A panel of **icons** that typically separates the priests from the rest of the congregation in the Eastern Orthodox Church.
- idée fixe (ee-day FEEKS) French for "fixed idea." In music, a recurring musical theme or idea used throughout a movement or entire composition.
- **ideogram** A symbol that represents an idea, not just a word or its pronunciation.
- illumination The technique of decorating manuscripts and books with richly colored, gilded paintings and ornamental lettering and borders; also, the painting achieved by this method.
- **illusionism** Appearance of reality in art; specifically, the technique used to make a created work look like a continuation of the surrounding architecture.
- imago A Roman death mask.
- **impasto** (im-POSS-toe) Paint applied thickly so that an actual texture is created on the painted surface, or this painting process.
- impost block In architecture, a block placed between the capital and the arch, used to channel the weight of the arch down onto the column.
- Impressionism Late nineteenth-century artistic style that sought to portray a fleeting view of the world, usually by applying paint in short strokes of pure color. In music, a style that suggested moods and places through lush and shifting harmonies and vague rhythms.

- incarnation Generally, the act of assuming a human body, especially by a god or spirit. In Christian theology, the doctrine of the birth of God in human form as Jesus Christ.
- International style Twentieth-century architectural style focusing primarily on modern materials, especially steel and concrete, and boxlike shapes.
- interval In music, the difference between any two pitches.
- Ionic Somewhat ornate Greek architectural order characterized by its slim, fluted columns and capitals in the form of spiral scrolls. See also Corinthian; Doric.
- **irony** Language that states something different from or opposite to what is intended; *dramatic irony* puts characters in a position of ignorance about such an incongruity, while keeping the audience aware of the situation.
- Isis The Egyptian goddess of fertility, whose cultlike worship gradually extended throughout the Roman Empire.
- jamb The sides of a doorway or window.
- **jazz** Category of music, first developed by African Americans in the early twentieth century, that usually features **syncopated** rhythms and improvisation of the melody or a phrase.
- **Jesuits** Members of the Society of Jesus, an order of Roman Catholic priests established by St. Ignatius of Loyola in 1540.
- ka The ancient Egyptian concept of the human soul or spirit, believed to live on after death.
- Kabuki (kuh-BOO-key) Japanese musical theater developed in the seventeenth century, noted for its melodramatic dancing, lively drama, and instrumental accompaniment. Traditionally performed by an all-male cast.
- Kamares Ware Minoan ceramic ware painted white and orange-red on a dark purple-brown background, distinguished by its designs from nature and patterns swirling over the surface of the vessel.
- **karma** The Hindu and Buddhist doctrine that one's moral actions have a future consequence in determining personal destiny.
- kiva (KEE-vah) A large underground ceremonial room in a Pueblo village.
- Koran See Quran.
- kore (plural, korai) (KOR-ay) Archaic Greek statue of a standing clothed female.
- kouros (plural, kouroi) (KOR-oss)
 Archaic Greek statue of a standing nude male.
- krater A large bowl with a wide mouth, used in ancient Greece and Rome for mixing wine and water.
- lancet A window with a narrow arch shape, used frequently in Gothic architecture.
- landscape A painting, photograph, or other visual art form that uses a natural outdoor scene as its main subject.

- lantern In architecture, an open or windowed structure placed on top of a roof to allow light to enter below.
- Latin cross In architecture, a floor plan of three short arms and one long one. Compare to Greek cross.
- *leitmotif* (LIGHT-moe-teef) German for "leading motive." In Wagnerian music, brief fragments of melody or rhythm that trigger the audience to think of particular characters, actions, or objects.
- **lekythos** (plural, **lekythoi**) A small cylindrical oil jug with one handle and a narrow mouth, used as a funeral offering in ancient Greece.
- Les Fauves; Fauvism (FOVE; FOVEizm) Literally, "wild beasts" in French. Early twentieth-century artistic movement characterized by violent, arbitrary colors and long, sensuous strokes, as seen in the paintings of Matisse.
- **libretto** Words for an opera or other textual vocal work.
- *Lied; Lieder* (LEED; LEED-er) Romantic German **art song** designed for a vocalist and accompanist performing in a room of a home.
- **lightwell** An uncovered vertical shaft that allows light into the lower stories of a building.
- linear perspective. See perspective.
- lintel (LINN-tuhl) In architecture, a horizontal beam above an opening such as a door or window, which usually supports the structure above it.
- lithograph A type of print made when an image, drawn with a greasy substance on a stone block, is first wetted, then inked. Because the greasy areas repel water, only the image attracts the ink.
- **liturgy** Religious rite used in public, organized worship.
- loggia (LOH-juh) In architecture, a covered, open-air gallery.
- **logic** The study of reasoning, or a particular system of reasoning.
- **long gallery** In Renaissance architecture, an unusually long room used for exercise during bad weather.
- lost-wax process (also known as the "cire-perdue" process) A method of metal casting in which a wax mold is coated with plaster or clay, then heated so the wax melts and runs out of vents. Molten metal is then poured into the hollow space and, when cooled, the clay or plaster mold is broken, leaving a metal core.
- lozenge An ornamental diamond-shaped motif.
- **Lutheranism** Theological belief system and denomination founded by Martin Luther (1483–1546) that held that salvation is delivered by faith, not by achievement.
- lyric poetry Poems that have a songlike quality; usually emotional in nature.
- madrigal Polyphonic music composed for a small group of singers, usually based on short secular lyric poems and sung with no accompaniment.
- magic realism Latin American literary

- style that weaves together realistic events with incredible and fantastic ones to convey the often mysterious truths of life.
- mandorla The almond-shaped area of light shown to surround Jesus or other religious figure.
- Manicheism (MAN-i-key-izm) The religious philosophy, founded by the Persian prophet Manes in the third century A.D. and synthesized from elements of Christianity, Gnosticism, and Zoroastrianism, that divided the world between good and evil forces.
- Mannerism Artistic style of the sixteenth century that rejected Renaissance aesthetic principles; noted for its obscure subject manner, unbalanced compositions, distorted bodies and poses, strange facial expressions, confusing spatial constructions, and harsh colors.
- manuscript A handwritten book or document.
- mass The musical setting of parts of the Mass.
- Mass A central religious ritual, principally in the Roman Catholic church.
- mausoleum A monumental tomb, or the building used to store one or more such tombs.
- mazurka A lively Polish dance in triple meter.
- **meander** An ornamental maze pattern common in Greek art.
- **megalith** A huge stone, especially used as part of a prehistoric monument.
- menhir (MEN-hear) A prehistoric monument of a single, huge slab of stone, set in an upright position.
- Mesolithic Describing a period between the Paleolithic and Neolithic periods, about 10,000–8,000 B.C., characterized by domestication of animals and an increasing emphasis on farming.
- metope (MET-uh-pee) In architecture, a square or rectangular space, often decorated; metopes alternate with **triglyphs** in a **Doric frieze**.
- mihrab (ME-rahb) A small niche marking the side of an Islamic mosque facing Mecca.
- mille-fleurs (meel-FLUHR) French for "a thousand flowers." A background pattern consisting of many flowers and plants, particularly in tapestry designs.
- minaret (min-uh-RET) In Islamic architecture, a tall slender tower attached to a mosque, from which a muezzin calls the faithful to prayer.
- miniature Λ detailed, small-scale painting, often on an illuminated manuscript.
- Minimal art Twentieth-century artistic style featuring a small number of objects arranged in a simple, often repeated, pattern.
- minstrel A traveling entertainer of the Middle Ages, especially one who performed secular music.
- minuet A slow, elegant dance in triple meter.

- minuet and trio form Organizing structure for a musical work in the pattern minuet-trio-minuet. Usually the form of the third movement of a symphony. See also minuet; trio.
- Mithras The Persian god of light and wisdom, whose cultlike worship spread throughout the Roman Empire, eventually rivaling Christianity.
- mobile Sculptural form suspended from the ceiling, mechanized or moved by air currents; invented by Calder in the 1930s.
- **mock epic** An extended narrative poem that treats a trivial incident in a heroic manner. See also **epic**.
- mode The organization of musical intervals into scales, used in ancient and medieval music; later limited to just the major and minor scales.
- **model** In painting, to create the illusion of depth by using light and shadow. In sculpture, to shape a pliable substance into a three-dimensional object.
- Modernism; the modern Artistic and literary movement of the late nineteenth and twentieth centuries that sought to find new methods of artistic expression for the modern, dynamic world, and rejected the traditions of the past.
- monastery A residence for monks.
- monasticism The life of organized religious seclusion, as in a monastery or convent.
- monolith A single slab of stone.
- **monotheism** Belief in and worship of a single god.
- monophony Musical texture with a single melody and no accompaniment. Compare polyphony.
- montage In film, a set of abruptly edited images used for dramatic effect.
- mosaic A design or picture created by inlaying pieces of colored glass, stone, or tile in mortar; mosaics are usually placed on walls or floors.
- mosque An Islamic house of worship. motet In Renaissance music, a multivoiced composition, usually based on a sacred Latin text and sung *a cappella*.
- moundbuilders Early Native American cultures in the Mississippi or Ohio river valley noted for their construction of monumental burial mounds.
- **mudra** (moo-DRAH) A symbolic, stylized position of the body or hand in Indian art.
- muezzin (myoo-EZ-in). The crier who calls the Muslim faithful to prayer five times a day.
- mural A large wall painting.
- music drama Musical term first used by Wagner to describe his operas that combined song, instrumental music, dance, drama, and poetry with no interruptions and without breaking the opera up into conventional arias or recitatives.
- mystery play A medieval drama form based on biblical narratives.
- myth A traditional story, usually featuring heroes, gods, or ancestors, that explains

- important cultural practices or beliefs.
- narthex A rectangular entrance hall or vestibule leading to the nave of a church.
- **natural law** A set of rights derived from nature and therefore superior to those established in the civil code.
- naturalism Late nineteenth-century literary movement that strove to depict characters in naturalistic, objective detail, focusing on the authenticity of characters, setting, and situations; emphasized biological and cultural determinants for the behavior and fate of literary characters.
- nave The long central space of a church, which is flanked on both sides by smaller aisles.
- Neoclassicism Late eighteenth-century artistic style, developed in response to the more ornate Rococo style, that revived an interest in the ancient Classical ideals; characterized by simplicity and straight lines.
- Neolithic The New Stone Age, about 8000 B.C. to 2000 B.C.; a period characterized by the use of pottery, agriculture, development of early writing, and construction of megalithic structures.
- Neoplatonism A revival of the philosophy of Plato, developed by Plotinus in the third century A.D. and prevalent during the Renaissance; based on the belief that the psyche is trapped within the body, and that philosophical thought is the only way to ascend from the material world to union with the single, higher source of existence.
- neume A basic musical notation symbol used in Gregorian chants.
- niche In architecture, a hollow part in a wall, often used to hold a statue or vase.
- nirvana In Buddhism, Hinduism, and Jainism, the state of ultimate bliss.
- **nocturne** A musical composition for night, usually melancholy in tone and for solo piano.
- **Noh** (NO) Japanese musical theater developed in the fifteenth century, noted for its solemnity, highly poetic texts, stylized gestures, and masked actors.
- **notation** In music, a symbolic method of representing tones.
- **novella** (plural, **novelle**) A short story, usually satirical and with a moral.
- **obelisk** In architecture, a four-sided shaft topped by a pyramid.
- octave An eight-line section of a poem, particularly the first section in a **Petrarchan sonnet**; in music, an eight-note interval.
- **oculus** Latin for "eye." In architecture, a circular opening or window, usually at the top of a **dome**.
- **ode** A **lyric** poem, usually addressed to a person or object and written in a dignified style.
- **oinoche** A Greek wine jug with a pinched lip and curved handle.
- oligarchy Λ form of government in which a few people rule.
- olpe A Greek vase or jug with a broad lip.

- **opera** Italian for "a work." Musical form, first introduced in the **Baroque** era, that combines drama, a text set to vocal music, and orchestral accompaniment.
- **orans** In Early Christian art, the pose of a person in prayer, with hands raised to heaven.
- **Oratorians** Group of lay Catholics, founded in 1575 by St. Philip Neri, who met for spiritual conversation, study, and prayer.
- **oratorio** A sacred opera performed without costume or acting, featuring solo singers, a chorus, and an orchestra.
- oratory Prayer hall.
- order In architecture, a style of architecture, determined by the type of column used. See also Doric; Ionic; Corinthian.
- organum (ORE-guh-num) Early polyphonic music with the voices a fourth, a fifth, or an octave apart. The organum duplum is such a chant with two voices, with the lower voice holding long notes and the higher voice moving more quickly. Such a chant with three voices is an organum triplum; such a chant with four voices is an organum quadruplum.
- Orientalizing period The Greek cultural and artistic style of about 700–600 B.C. that was influenced greatly by the Near East.
- **orthogonal** In visual arts, a receding line perpendicular to the picture plane. In linear **perspective**, orthogonals converge and disappear at a **vanishing point**.
- **pagoda** A Buddhist temple in the shape of a tower, with many stories that each have an upward-curving roof.
- Palace Style Minoan ceramic ware painted with dark colors on a light background, distinguished by its designs from nature and patterns that appear to grow up the sides of the vessel.
- **palaestra** (plural, **palaestrae**) A public place in ancient Greece where young men learned to wrestle and box under the guidance of a master.
- Paleolithic The Old Stone Age, about 2,000,000–10,000 B.C.; a period characterized by hunting, fishing, the use of stone tools, the increasing dominance of *homo sapiens*, and the creation of the earliest works of art.
- palette An artist's choice of colors for a particular work of art, or the surface on which such colors are placed and mixed.
- pallium An ancient Roman garment made of a rectangular piece of fabric.
- of a rectangular piece of fabric.

 palmette A stylized palm leaf ornament.
- pantheon All the gods of a people, or a temple dedicated to all the gods; the Pantheon is the specific circular temple in Rome dedicated to all gods.
- parchment Animal skin used to make manuscript folios.
- patrician A member of the noble family class in ancient Rome that was originally granted special civil and religious rights.
- **patron** A person who financially sponsors art or artists.
- patronage Originally, a system of

- **patrician** support and protection of a **plebeian** in ancient Rome; later, a system of financially sponsoring art or artists.
- pediment In Classical architecture, a triangular space at the end of a building, formed by the **cornice** and the ends of the sloping roof.
- **pendentives** Four triangular sections of a large **dome** used as a transition from a square base to the circular rim of a smaller dome above it.
- **peplos** A loose outer garment worn by women in ancient Greece, hanging from the shoulders and belted at the waist.
- **percussion instrument** A musical instrument, such as a timpani or bass drum, played by hitting or shaking.
- **peripteral** Having a single row of **columns** on all sides.
- **peristyle** In architecture, a continuous row of **columns**, forming an enclosure around a building or courtyard.
- **perspective** A method of creating the illusion of three-dimensional space on a two-dimensional surface. Achieved by methods such as *atmospheric perspective*, using slight variations in color and sharpness of the subject, or *linear perspective*, creating a horizon line and **orthogonals**, which meet at **vanishing points**.
- Petrarchan sonnet; Italian sonnet Poem of an octave of eight lines, which introduces the scene, and a sestet of six lines, which expands on or complicates the scene. The octave rhymes abba abba (or abab abab), and the sestet rhymes cde cde (or cde ced; cde dce; or cd cd cd). Devised by the poet Petrarch in the fourteenth century. See also Shakespearean sonnet.
- petroglyph Wall painting.
- phenomena (fuh-NOM-uh-nuh) In Kantian philosophy, elements as they are perceived by worldly senses, not as they really are.
- pbilosophes (fill-uh-SOFF) Group of intellectuals of the Enlightenment who believed that, through reason, humans could achieve a perfect society.
- pianoforte (pee-ANN-oh-FOR-tay) Literally, "soft loud" in Italian. Name originally used for the piano because of its ability to differentiate between soft and loud tones, which the harpsichord could not do.
- **piazza** (pee-AHT-zuh) A public square in Italy.
- **picaresque** In literature, a narrative form that originated in Spain and details the adventurous life of a *picaro*, a rogue hero.
- **pictograph** A picture used to represent a word or idea.
- **pier** In architecture, a vertical support structure similar to a **column**, but usually square or rectangular in shape, rather than cylindrical.
- Pietà (pee-ay-TAH). Italian for "pity." In visual arts, a work that shows the Virgin Mary mourning over the dead Jesus in her lap.
- pilaster In architecture, a flat, decorative pillar attached to a wall, projecting just

- slightly, that may reinforce the wall.
- pillar A freestanding vertical element, usually used as an architectural support.
- plainchant; plainsong In music, the monophonic, unmetered vocal music of the Early Christian church, as in Gregorian chant.
- **platform** A raised horizontal surface, especially one on which **columns** sit.
- Platonism The philosophy of Plato, focusing on the notion that Ideal Forms are an absolute and eternal model that all worldly phenomena strive toward.
- **plebeian** A member of the common lower class in ancient Rome that at first lacked many of the rights that **patricians** enjoyed.
- **plinth** A slab that supports a sculpture or **column**.
- Pointillism (PWAHN-tuh-liz-um) Post-Impressionistic painting technique that used an almost exact application of paint in small dots or points to create an overall color perceived by the human eye.
- **podium** In architecture, an elevated **platform**; often the foundation of a building, especially an ancient temple.
- **polis** (plural, **poleis**) An independent city-state in ancient Greece.
- polyphony The simultaneous playing or singing of several independent musical lines. Compare monophony.
- **polonaise** A stately, proud Polish dance in triple meter.
- **polyptych** (POL-ip-tick) A painting or relief with four or more panels, often hinged so panels can be folded. See also **triptych**.
- **polyrhythm** Multiple rhythms played or sung simultaneously within the same musical composition.
- **polytheism** Belief in or worship of more than one god. Compare **monotheism**.
- Pop Art Mid-twentieth-century artistic style whose subjects were everyday items from the mass media or were mass produced, such as comic strips, soup cans, or images of famous figures.
- **portal** In architecture, a grand entrance or doorway.
- **portico** In architecture, a porch or walkway covered by a roof supported by **columns**. It often marks an entrance to the main building.
- post and lintel An architectural construction system with two vertical posts supporting a horizontal beam—the lintel.
- Post-Impressionism Artistic movement beginning in the late nineteenth century that attempted to improve upon Impressionism by deepening the personal and psychological level and emphasizing the formal arrangement of a work of art.
- poststructuralism The approach of structuralism taken one step further, which emphasizes that speech can mask reality as well as reveal it and that meaning is relative to context.
- potlatch A lavish ceremony among some Native Americans of northwest North

- America at which the host distributes gifts to guests according to their rank or status.
- poussiniste French Academy adherent to the style of Poussin during the **Baroque** era; favored line over color. Compare rubéniste.
- **prelude** (PRELL-yood) A short instrumental composition that usually precedes a larger musical work.
- primary colors The colors red, yellow, and blue. See also secondary colors.
- program music Instrumental composition that musically describes a scene, story, or other nonmusical situation. Popularized in the Romantic era. Compare absolute music.
- **pronaos** The enclosed vestibule of a Greek or Roman temple, supported by columns.
- **propylon** (plural, **propylaia**). A gateway to a temple or a group of buildings.
- proscenium arch In theater, the framing device that separates the stage from the audience.
- **pseudo-peripter**al Having a single row of **engaged columns** on all sides.
- Puritanism Belief system of the Puritans, a religious group in the sixteenth and seventeenth centuries who sought to reform the Church of England; its members advocated strict religious and moral discipline.
- **pylon** A massive gateway, especially to an Egyptian temple.
- **qasidah** A highly formalized Arabic ode of 30–120 lines, each line ending with the same rhyme. It focuses on the poet's attempt to find his beloved.
- qibla (KIB-luh) The direction facing Mecca, to which a Muslim turns when praying.
- **quadrivium** The program of arithmetic, astronomy, geometry, and music in medieval universities.
- quatrain A four-line unit of poetry.
- Quran; Koran The sacred text of Islam.
- radiating chapels Several chapels that are arranged around the ambulatory or apse of a church.
- raga An Indian musical composition, usually partly improvised, that attempts to convey a mood or feeling.
- ragtime Jazz piano composition in which the left hand plays a steady beat while the right hand improvises on a melody using a syncopated rhythm.
- Ramadan The holy ninth month of the Islamic lunar calendar, during which Muslims must fast from sunrise to sunset.
- rational humanism Philosophical belief system of the Enlightenment based on the idea that progress is possible only through learning, and through the individual's freedom to learn.
- Rayonnant (ray-yo-NAHN) From the French term for "to radiate." The High Gothic architectural style of the midthirteenth century, noted for its radiating tracery patterns and liberal use of stained glass.

- **Realism** Nineteenth-century artistic and literary movement that attempted to convey to the public the realities of modern life, not just to depict the beautiful.
- recitative (ress-uh-tuh-TEEV) In opera, a form of musically heightened speech halfway between spoken dialogue and melodic singing.
- **red-figure style** Greek vase painting style featuring red figures surrounded by a black background, with details painted on the surface.
- refectory The dining room of a monastery or convent.
- **Reformation** Religious movement of the sixteenth century that sought to reform the Roman Catholic Church; led to the development of Protestant churches.
- **Regionalism** Literary and artistic style that depicts a particular geographic region in a naturalistic manner.
- **register** In music, a particular range of tones that a voice or instrument can make.
- register system The method of organizing an artistic composition in horizontal bands or rows, each of which depicts a different event or idea.
- regular temple Architectural plan for a temple in which the number of **columns** along the sides of the temple is double the number of columns on the ends plus one (e.g. an eight by seventeen proportion).
- relic A memento or keepsake of religious veneration, especially a body part or personal effect from a saint.
- **relief** In sculpture, a figure projecting from a flat, two-dimensional background; in painting, the *apparent* projection of a figure from its flat background.
- relieving triangle In architecture, an opening built into a heavy wall above a post and lintel structure that helps to relieve the weight on the lintel.
- **reliquary** A container for holding or displaying a **relic**.
- **repoussé** (ruh-poo-SAY) The technique of creating **relief** in metal by hammering out details from the back.
- representational Art that attempts to portray the visual reality of an object.
- revolution The overthrow of an existing government for a new one.
- rhyton An ancient Greek drinking horn which may be shaped like an animal head.
- rib In architecture, a curved, projecting arch used for support or decoration in a vault.
- riff In jazz, a short phrase repeated frequently during improvisation.
- ritornello (rit-or-NELL-low) A musical passage that will recur several times throughout a concerto movement.
- Rococo (ruh-KOE-koe) Eighteenthcentury artistic style, developed from the Baroque style, that was characterized by curved shapes, pastel colors, smaller scale, and often frivolous subject matter.
- romance A long medieval narrative form that related **chivalric** Celtic stories,

- especially the exploits of King Arthur and his Knights of the Round Table.
- Romanesque The style of architecture and art of the eleventh and twelfth centuries in Western Europe. Characterized, especially in churches, by semicircular arches, barrel vaults, and thick walls
- Romanticism Late eighteenth- and early nineteenth-century artistic, literary, and cultural movement that developed as a reaction against **Neoclassicism**; emphasized emotion, originality, nature, and freedom of form.
- rondo form Organizing structure for a musical work in which the main theme repeats itself frequently, with new, contrasting material added between each repetition. Often the form of the second or last movements of a concerto.
- **roof comb** A crestlike extension along the roof of a Mayan temple that resembles the comb of a rooster.
- rose window A round stained glass window with tracery lines in the form of wheel spokes; a standard feature in the facade of Gothic cathedrals.
- **rosette** A roselike ornament that is painted or sculpted.
- **rotunda** A circular building, usually topped by a **dome**.
- ruba'i (plural, ruba'iyat) A Persian poetry form of four lines with a rhyming pattern of AABA.
- rubéniste French Academy adherent to style of Rubens during the Baroque era; favored color over line. Compare poussiniste.
- sacramentary A liturgical book of prayers and rites of the sacraments of the Roman Catholic church.
- salon; Salon Large reception room in a townhouse, or the social gathering held in such rooms; an annual exhibition of works of art, especially by the French Academy in the eighteenth and nineteenth centuries.
- Salon des Refusés French for "Salon of the Rejected." Artistic salon established by Napoleon III in 1863 to exhibit paintings rejected by the official French Academy Salon.
- samsara The Hindu notion of the eternal cycle of birth and death.
- samurai Ruler-warriors of Japan, especially during the feudal era.
- sarcophagus A stone coffin.
- satire Literary or dramatic work that exposes vice or follies with ridicule or sarcasm, often in a humorous way.
- satori The Zen Buddhist state of enlightenment.
- **scat** Method of vocal singing in nonsense syllables.
- **score** Written or published version of a musical composition showing parts for all instruments and voices.
- scale In music, an ascending or descending series of notes.
- **scroll** In Chinese and Japanese art, a painting or text drawn on vertical pieces

- of silk fabric; the scroll is conventionally kept rolled and tied except on special occasions, when it is hung. Also called *banging scroll; hand scroll;* Japanese narrative scrolls are called *emaki-mano*.
- secondary colors The colors orange, green, and purple, formed when two primary colors (red, yellow, or blue) are mixed. See also primary colors.
- secular Not sacred or religious.
- serdab The cellar of an Egyptian mastaba, containing the ka statue.
- **sestet** A six-line section of a poem, particularly the last section in a **Petrarchan sonnet**.
- **sfumato** (sfoo-MA-toe) The Italian word for "smoky." In painting, the intentional blurring of the outline of a figure in a hazy, almost smoky atmosphere.
- **shaft** The vertical section of a **column** between the **capital** and the base.
- Shakespearean sonnet; English sonnet Poem of three four-line stanzas and a final two-line couplet, usually rhyming abab cdcd efef gg. See also Petrarchan sonnet.
- shastras Ancient Hindu texts that describe instructions for various activities, including temple building, cooking, warfare, and music.
- **Shinto** A principal and former state religion of Japan characterized by rituals and venerations for local deities and strong patriotism.
- **shogun** Λ hereditary military dictator of Japan; originally, commander-in-chief of the **samurai**.
- sitar A long-necked, lute-shaped instrument from India.
- **skene** (SKAY-nuh) In Greek theater, a building behind the acting area that functioned as a dressing room and as scenic background.
- **Skepticism** Greek philosophic doctrine that absolute knowledge is not usually possible, and that inquiry must therefore be a process of doubt.
- social contract In political theory, especially of Hobbes and Locke, the agreement among individuals of an organized society to surrender certain freedoms in exchange for government's protection over them.
- Socialist Realism Artistic style declared by Stalin in 1934 as the official Soviet style; it rejected abstraction and focused on images of soldiers, workers, and peasants.
- soliloquy (suh-LILL-uh-kwee) In drama, a character's private reflections spoken aloud toward the audience, but not to the other characters.
- sonata From the Italian word for "to sound." Musical composition for one or two instruments, usually in three or four movements. Compare cantata.
- sonata form Organizing structure for a musical work with three main sections: exposition, development, and recapitulation, often followed by a **coda**. Usually the form of the first and fourth movements of a **symphony**.

- **Sophists** Ancient Greek philosophers and teachers, less interested in the pursuit of truth than in the use of clever rhetoric and argumentation.
- **soprano** In music, the range of the highest voice of females or young boys.
- **staff** In music, the five horizontal lines and four spaces used in **notation**.
- stained glass Artistic technique in which many small pieces of glass are colored with internal pigment or surface paint and then held together with lead strips; used extensively in **Gothic** cathedrals.
- **statue in the round** Sculpture that stands free of a background and is fully formed to be seen from all sides.
- **stele** (STEE-lee) An upright slab of stone that serves as a marker or monument.
- stigmata The physical marks or scars on humans that resemble the crucifixion marks of Jesus; said to appear during states of religious ecstasy.
- **stream of consciousness** Modern literary technique that records the free flow of a character's mental impressions.
- structuralism; structural linguistics
 Twentieth-century approach to culture, especially linguistics, that analyzes the basic elements of a system according to binary oppositions to understand the meaning of the system as a whole.
- Sufi An Islamic mystic.
- **Surah** A chapter in the **Quran**.
- Surrealism Artistic and literary movement of the early twentieth century, noted for its total acceptance of the irrational, lack of moral concern, and fascination with the world of dreams and the unconscious.
- **swing Jazz** style of big bands of the 1930s and 1940s, usually fast and arranged instead of improvised.
- syllogism A form of deductive reasoning consisting of a major premise, a minor premise, and a conclusion. For example: All philosophers are mortal; Aristotle was a philosopher; Aristotle was mortal.
- **Symbolists** Poets of the late nineteenth century who used symbolic words and figures to express ideas, impressions, and emotions and rejected the realistic depiction of the external world.
- **symphony** Large orchestral work, usually in four distinct movements.
- **syncopation** A musical rhythm in which **beats** that are normally unaccented are stressed.
- synoptic gospels The gospels of Matthew, Mark, and Luke, which are similar. The gospel of John is unique.
- tambura An unfretted lute, used to sustain the drone chord in Indian music.
- **tapestry** A heavy piece of fabric used as wall decoration. The design is created as the tapestry is woven.
- **teleology** In philosophy, the study of an end and how it relates to the natural processes leading up to it.
- tempera (TEM-purr-uh) Paint made of egg yolks, water, and pigments.

- **tempo** The speed at which music should be played.
- **tenebrism** A painting technique that dramatically contrasts light and dark and concentrates little on middle tones.
- tenor In music, the range of the highest male voice, which usually carries the melody; also, the bottom, slower line of an organum duplum.
- terra cotta Italian for "baked earth." An orange-red baked clay used for pottery or sculpture.
- terza rima (turr-tsah-REE-ma) Poetry form consisting of three-line stanzas in which each stanza's middle line rhymes with the first and third lines of the subsequent stanza (ABA, BCB, CDC, etc).
- tessera (plural, tesserae) (TESS-ur-ah) A small stone or other material used in making a mosaic.
- theme and variations form Organizing structure for a musical work in which a theme is presented and repeated several more times, each time in a slightly varied way. Often the form of the first and fourth movements of a symphony.
- **theocracy** A political entity ruled by a religious figure or group claiming to have divine authority.
- **tholos** (plural, **tholoi**) Any round building.
- **thrust** In architecture, outward or lateral pressure in a structure.
- toga An ancient Roman garment.
- tonality In music, the arrangement of all tones of a composition in relation to the central key, or tonic.
- **Torah** Hebrew for "instruction." The first five books of Hebrew scripture.
- totem pole A post carved with animal and spirit images and erected by some Native Americans of northwest North America to memorialize the dead.
- tracery An elaborate pattern of interlacing stone lines, especially in Gothic windows.
- **tragedy** A serious literary or theatrical work about a central character's problems, with an unhappy ending.
- **tonal center** Home key of a musical composition.
- **tragedy** A serious play or drama about a protagonist's problems, caused by his or her own tragic character flaw.
- Transcendentalism Romantic philosophical theory that there is an ideal reality that transcends the material world, known only through intuition, especially in nature. See also phenomena.
- **transept** Either of the two lateral "arms" of a church laid out in a cross pattern; transepts cross the nave at right angles.
- **treasury** A building, room, or box for storing valuables or offerings.
- **triclinium** A dining room in an ancient Roman home, named for the three couches on which the diners reclined.
- **triforium** In **Gothic** architecture, the elevated gallery or **arcade** just below the **clerestory** of a cathedral.

- triglyph In Greek architecture, a rectangular block with three vertical grooves; triglyphs alternate with metopes in a Doric frieze.
- **trio** In music, the middle section of the **minuet** and **trio form**, usually similar to the **minuet** but contrasting in instrumentation and texture.
- triptych (TRIP-tick) A three-paneled painting or relief, often hinged so side panels can be folded over the center panel.
- triumphal arch A grand freestanding gateway with a large arch, which often serves as an urban monument.
- trivium The program of grammar, logic, and rhetoric in medieval universities
- trompe-l'oeil (trohnp-LEH-ee) French for "trick the eye." An artistic effect that creates an optical illusion of reality for the viewer.
- trope In music, a new word or phrase added to an existing chant as an embellishment.
- **troubadour** (TRUE-buh-door) A poetmusician of medieval southern France.
- trumeau A central post or column that supports the lintel of a large portal.
- tufa A porous stone that is soft when cut but hardens after exposure to air.
- Tuscan order Roman modification of the Greek Doric order, but with an unfluted shaft, a base, a plain architrave, and an undecorated frieze.
- twelve-tone composition Musical composition style developed by Schoenberg that uses a twelve-note scale, which is the traditional octave plus all internal half steps; each tone is used equally and in a highly organized manner.
- tympanum (plural, tympana) (TIM-puhnum) The ornamental semi-circular area between an arch and the lintel above a doorway or window.

- ukiyo-e Literally, "pictures of the floating world" in Japanese. Style of Japanese woodblock prints of the seventeenth and eighteenth centuries noted for their everyday subject matter.
- vanishing point In linear perspective, the horizon point at which all orthogonals—receding lines perpendicular to the picture plane—appear to converge and disappear.
- vault An arched masonry roof or ceiling. A barrel or tunnel vault is an uninterrupted semi-circular vault made of a series of arches. A cross or groin vault is created by the intersection of two barrel vaults set at right angles. A ribbed vault is a form of groin vault in which the groins formed by the intersection of curved sides are covered with raised ribs.
- Vedas The oldest sacred Hindu writings, composed 1500–1000 B.C. by the Aryans in present-day India.
- vellum The finest quality of parchment.
- veneer In architecture, a thin layer of high-quality material used as a **facade**, often covering inferior materials.
- **verisimilitude** (ver-uh-si-MILL-uh-tude) The appearance of being true to reality.
- vernacular The common language spoken in a particular country or region.
- vibrato (vi-BRAHT-oh) In vocal or instrumental music, a pulsing effect achieved by slight, rapid variations in pitch.
- volute A spiral scroll ornament, as on an Ionic capital.
- voussoirs (voo-SWAHRS) The wedge-shaped stones or blocks that form an arch.
- waltz A ballroom dance in triple meter.
- warp The thick threads that run vertically on a loom and provide the structure for a piece of fabric woven of the weft threads.
- weft The threads that run horizontally on a loom and usually form the visible

- pattern on a piece of woven fabric.
- westwork The monumental western entryway in a Carolingian, Ottonian, or Romanesque church.
- white-ground ceramics Ancient Greek pottery ware in which a white matte slip is painted over the surface of a reddish clay vessel, with details painted on the surface with a fine brush.
- whole tone; whole step In music, the interval between any first and third consecutive keys on the piano; made up of two half steps.
- woodcut A type of print made by carving a design in a piece of wood and inking the raised surfaces.
- woodwind instrument Musical instrument, such as a flute or clarinet, played by blowing through a reed or mouthpiece attached to the main body of the instrument.
- word painting In Renaissance music, a composition style that emphasizes the meaning of words through the accompanying music. For example, the word "weep" might be expressed by a descending melodic line.
- yin and yang The Chinese dualistic philosophical image that represents simultaneous contrast and complement. The yin form represents the passive, negative, feminine, dark, earthly; the yang form represents the light, masculine, positive, constructive, and heavenly. The two are in perpetual interplay.
- Zen Buddhism Chinese and Japanese form of Buddhism that emphasizes enlightenment achieved by self-awareness and meditation instead of by adherence to a set religious doctrine.
- ziggurat An ancient Mesopotamian stepped pyramid temple.

PICTURE CREDITS AND FURTHER INFORMATION

The authors, Calmann & King Ltd, and Prentice Hall wish to thank the institutions and individuals who have kindly provided photographic materials for use in this book. In all cases, every effort has been made to contact the copyright holders, but should there be any errors or omissions, the publishers would be pleased to insert the appropriate acknowledgment in any subsequent edition of this publication

Key: A=Alinari, BAL=Bridgeman Art Library, S=Scala, SFQ=© Studio Fotografico Quattrone,

Introduction/Starter Kit

0.1 © Studio Fotografico Quattrone, Florence; 0.2 © Succession Picasso/DACS 1998; 0.3 Photo: J. Lathion,© Nasjonalgalleriet, Oslo; 0.5 Robert Harding Picture Library, London

Chapter One

Chapter One
1.1 AKG London; 1.2 © YAN, Toulouse;
1.4 Institut Amatller D'Art Hispanic, Barcelona;
1.5 Robert Harding/Adam Woolfitt; 1.6 HV;
1.8 Fletcher Fund 1940; 1.9 Harris Brisbane Dick
Fund 1959; 1.11,12+Detail page vi Photo:
University of Pennsylvania Museum; 1.15 Gift of
John D. Rockefeller Jr. 1932; 1.19 BPK; 1.20
RMN-Hervé Lewandowski; 1.21 © Comstock/Peter
Keen 1997; 1.22 Ancient Art & Architecture
Collection Collection

Chapter Two
2.1,3 HV; 2.4,5 Spectrum; 2.6,8,9 HV; 2.10 Rogers
Fund and Henry Walters Gift 1919; 2.11 AFK; 2.12
HV; 2.14 Lorna Oakes, Hertfordshire; 2.16 Robert
Harding; 2.19,20,21 BPK/Margarete Büsing; 2.22
Robert C. Lamm,Scottsdale; 2.23 photo: Stephen Petegorsky

Chapter Three

Chapter 1 hree
3.1. Gift of Christos G. Bastis 1968; 3.2 TAP;
3.3,5 Ancient Art & Architecture Collection; 3.6
Spectrum; 3.7,8 TAP; 3.9 C.M. Dixon; 3.10 AFK;
3.12 Ancient Art & Architecture Collection; 3.13
HV; 3.14 TAP; 3.15 Rogers Fund 1914; 3.16 BPK;
3.17 RMN-Hervé Lewandowski; 3.20 Classical Purchase Fund 1978; 3.21+Detail page vii Purchase, Bequest of Joseph H. Durkee, Gift of Darius Ogden Mills and Gift of C. Ruxton Love, by exchange, 1972; 3.23 Fototeca Unione, Rome; 3.24 Robert Harding/Mark Vivian; 3.25 Fletcher Fund 1932; 3.26 Alison Frantz, Princeton NJ

Chapter Four

Chapter Four
4.1 Spectrum; 4.4,5+Detail Page vii AFK; 4.8 HV;
4.9 RMN-Hervé Lewandowski; 4.11 World
Pictures, London; 4.12 Alison Frantz, Princeton NJ;
4.13 HV; 4.14 Fotografia Foglia, Naples; 4.15 S;
4.16 A; 4.17 Christa Koppermann, München; 4.18
Robert Harding; 4.19 HV; 4.22 AFK; 4.24 BPK;
4.26 BPK/Erich Lessing; 4.27 RMN-Gérard
Blot/lean; 4.28 S Blot/Jean; 4.28 S

Chapter Five
5.2 \$; 5.3 Robert Harding; 5.4 HV; 5.5 A; 5.6 S;
5.7,8,9 AFK; 5.11 D.A.I. Rome; 5.12 Hutchison
Library/Bernard Régent; 5.13 AFK; 5.14 AKG
London; 5.15 AKG/Erich Lessing; 5.17 A; 5.19
Janetta Rebold Benton; 5.20 A; 5.21+Detail
page viii Janetta Rebold Benton; 5.22 © Von Matt;
5.23 Samuel D. Lee Fund 1940; 5.24 Janetta
Rebold Benton; 5.25 AFK; 5.26 A; 5.27 S; 5.28
C.M. Dixon; 5.29 Rogers Fund 1903. Photo:
Schecter Lee; 5.30 S; 5.31 Fotografia Foglia,
Naples Naples

Chapter Six 6.1, Detail page viii Canali Photobank, Rome; 6.5 AFK; 6.7 HV; 6.8 C.M. Dixon; 6.9 S; 6.10 A

Chapter Seven
7.1 Sonia Halliday; 7.2 AFK; 7.3 4 S; 7.5 © Cameraphoto Arte, Venice; 7.6 Robert Harding/Adam Woolfitt; 7.8 Lionel F. Stevenson/Photo Researchers, Inc. 7.9,10 © Cameraphoto Arte, Venice: 7.11 Andrew Mellon Collection 1937; 7.12 Venice; 7.11 Andrew Mellon Collection 1937; 7.12 Spectrum; 7.13 Robert Harding/Robert Frerck; 7.15 AFK; 7.16 Sonia Halliday; 7.17 Robert Harding/Robert Frerck; 7.18 Hutchison Library/Patricio Goycoolea; 7.19 The Nasser D. Khalili Collection of Islamic Art (POT 12). Photograph © NOUR Foundation; 7.21 Francis Bartlett Donation of 1912 and Picture Fund; 7.22+Detail page ix Bodleian Library, Oxford

Chapter Eight 8.1 Dinodia Picture Agency, Bombay; 8.3,4 AFK; 8.5,6 AKG London; 8.7 Dinodia Picture Agency, Bombay; 8.8,9+Detail page ix AFK; 8.11 Redferns

Chapter Nine

9.2 China Pictorial, Beijing; 9.4+Detail page ix BAL; 9.5 Werner Forman Archive; 9.12 Arcaid/Bill Tingey

Chapter Ten

10.1 South American Pictures; 10.2 Comstock/ Georg Gerster; 10.3 Photo:University of Pennsylvania Museum; 10.4 South American rennsylvania Museum; 10.4 South American Pictures; 10.5+Detail page x Copyright Merle Greene Robertson, 1976; 10.6 South American Pictures; 10.7 Comstock; 10.8 Buckingham Fund, 1955.2281 Photo: © 1994 The Art Institute of Chicago. All Rights Reserved; 10.9 Hutchison Library/Robert Francis; 10.10 South American Pictures; 10.11 Pagua Anthrea placiful. Pictures; 10.11 Royal Anthropological Institute; 10.12 Robert Harding/Tony Waltham; 10.13 Comstock/Georg Gerster

Chapter Eleven
11.5 Dr. H. Busch; 11.8 Pierpont Morgan Library/
Art Resource NY; 11.12 © YAN/Jean Dieuziade;
11.14 CAISSE © Arch. Phot. Paris SPADEM/
DACS; 11.15 AFK; 11.16 Spectrum; 11.17 S;
11.18,19 © Paul M.R. Maeyaert; 11.20 Ancient Art & Architecture Collection; 11.21 Foto Ritter,

Chapter Twelve

12.1 BAL; 12.2 Robert Harding; 12.4 HV; 12.5 Spectrum; 12.6 AFK; 12.7 © Angelo Hornak, London; 12.8 AFK; 12.10 © James Austin, 1994; 12.11 Sonia Halliday; 12.12 Giraudon, Paris; 12.13,14 12.11 Sonia Haliday; 12.12 Giraudon, Paris; 12.13,14 AFK; 12.15 Spectrum; 12.16 AFK; 12.17,18 Janetta Rebold Benton; 12.19 Giraudon, Paris; 12.20 Janetta Rebold Benton; 12.22+Detail page x BAL; 12.23 Sonia Halliday; 12.24 Hutchison Library/ Christine Pemberton; 12.25 Gift of John D. Rockefeller Jr. 1937; 12.26,27,28,29 S; 12.30 © Studio Fotografico Contrology Elements, 12.31,23 Quattrone, Florence; 12.31,32 S

Chapter Thirteen

13.1 SFQ; 13.2 S; 13.3 Bodleian Library; 13.4 S; 13.5 S; 13.6 SFQ; 13.8 SFQ; 13.9 S; 13.10 SFQ; 13.12 Ralph Lieberman; 13.13 A; 13.14 SFQ; 13.15 SFQ; 13.17 S; 13.18 S; 13.19 SFQ; 13.20 SFQ; 13.21 S; 13.23 RMN-Gérard Blot/Jean; 13.24 S; 13.25 SFQ; 13.26 RMN; 13.27 A; 13.28 © Giancarlo Costa, Milan; 13.29 AKG London/Erich Lessing; 13.31 © Araldo de Luca, Rome; 13.32 SFQ; 13.33 BAL; 13.34 BAL; 13.35 © James Morris, London; 13.37 A; 13.38 © Cameraphoto-Arte, Venice; 13.39 RMN; 13.40 S; 13.41 RMN-J.G. Berizzi; 13.42 S; 13.43 SFQ; 13.45 Oronoz, Madrid; 13.47 S; 13.48 A

14.1 The Cloisters Collection, 1956 (56.70) Photograph © The Metropolitan Museum of Art; 14.2, 3 © St. Baafskathedraal, Gent, © Paul M.R. Maeyaert; 14.4 Reproduced by courtesy of the Trustees, The National Gallery, London; 14.5 BAL; 14.6, 7 Copyright © Museo Del Prado, Madrid; 14.8, 9 S; 14.10 AKG London/Erich Lessing; 14.11 BAL; 14.12 Gift of Junius S. Morgan, 1919; 14.14 RMN; 14.15 Rogers Fund, 1919; 14.16 AKG/Erich Lessing; 14.17 © James Austin; 14.18 A.F. Kersting; 14.19 THE ROYAL COLLECTION © Her Majesty Queen Elizabeth II; 14.20 by permission of

The Huntington Library, San Marino, California; 14.21 C. Walter Hodges *Shakespeare and the Players*, London 1948 pp. 62-63; 14.22 Giraudon

Chapter Fifteen

15.1 Romer/Explorer/Photo Researchers, Inc.; 15.2 Dan Budnick/Woodfin Camp & Associates; 15.4 S; 15.5 ©Araldo De Luca, Rome; 15.6 © Araldo De Luca, Rome; 15.7 © Araldo De Luca, Rome; 15.8 © Araldo De Luca, Rome; 15.9 S; 15.10 S; 15.11 S; 15.12 S; 15.13 S; 15.14 Widener Collection; 15.20 Gift of Henry G. Marquand, 1889; 15.22 RMN-Jean/Lewandowski; 15.24 Nelson-Atkins Museum of Art, Kansas City, Missouri (Purchase: Nelson Trust); 15.25 RMN-Jean; 15.28 RMN; 15.30 © James Austin; 15.31 Robert Harding; 15.32 © Paul M.R. Maeyaert; 15.32+33 A.F. Kersting; 15.34 Robert Harding; 15.35 The Crosby Brown Collection of Musical Instruments, 1889; 15.37 S

Chapter Sixteen

16.1 RMN - Hervé Lewandowski; 16.2 RMN; 16.3 Trustees of The Wedgwood Museum, Barlaston, Staffordshire, England; 16.5 Photo Bulloz; 16.6 BAL; 16.7 RMN-Gérard Blot; 16.8 RMN-René-Gabriel Ojeda; 16.10 RMN-G. Blot/C. Jean; 16.11 RMN-Hervé Lewandowski; 16.13 Andrew W. Mellon Collection; 16.14 English Heritage Photographic Library; 16.15 RMN; 16.16 Giraudon; 16.17 Giraudon/Art Resource, NY; 16.18 Giraudon/BAL; 16.19 Giraudon; 16.20 photo: Ann Hutchison, ©1992 Virginia Museum of Fine Arts; 16.21 Transfer from the Canadian War Memorials, 1921 (Gift of the 2nd. Duke of Westminster, Eaton Hall, Cheshire, 1918); 16.22 Gift of Mrs. George von Lengerke Meyer; 16.23 Virginia State Library and Archives; 16.24 A.F. Kersting; 16.25 © Paul M.R. Maeyaert; 16.26 Balthazar Korab; 16.28 Donald Cooper/Photostage; 16.29 AKG London; 16.30 Spectrum; 16.31 Guildhall Library, London; 16.32 John Troha/Black

Chapter Seventeen

17.1 Photo: Elke Walford, Fotowerkstatt, Hamburger Kunsthalle; 17.5 RMN-Arnaudet; 17.6 RMN-Hervé Lewandowski; 17.7 Giraudon; 17.8 RMN; 17.9 photo © Fitzwilliam Museum; 17.11 Henry Lillie Pierce Fund; 17.12 Gift of Douglas F. Roby; 17.13 Mr. and Mrs. William H. Marlatt Fund; 17.14 Lent by the U.S. Department of the Interior, Office of the Secretary. National Museum of American Art, Washington DC, Photo: National Museum of American Art, Washington DC/Art Resource; 17.15 Bulloz, Paris; 17.16 A.F. Kersting; 17.19 Donald Cooper/Photostage; 17.20 RMN-Hervé Lewandowski; 17.21 Charles Deering Fund, 1953.530; Photograph ©1997, The Art Institute of Chicago, All Rights Reserved; 17.22 RMN; 17.23 RMN; 17.24 RMN; 17.25 RMN; 17.26 RMN-J.G. Berizzi; 17.28 Peter Newark's American Pictures; 17.29 Smithsonian Institution Libraries, Cooper-Hewitt, National Design Museum Branch, Smithsonian Institution/Art Resource, NY; 17.30 Gift of Mrs. Frank B. Porter, 1922; 17.31 Purchased by the Friends of Art, Fort Worth Art Association, 1925; acquired by the Amon Carter Museum. 1990, from the Modern Art Museum of Fort Worth through grants and donations from the Amon G. Carter Foundation, the Sid W. Richardson Foundation, the Anne Burnett and Charles Tandy Foundation, Capital Cities/ABC Foundation, Fort Worth Star Telegram, the R.D. and Joan Dale Hubbard Foundation and the people of Fort Worth; 17.33 Spectrum; 17.34 RMN-Jean

Chapter Eighteen

18.2 Giraudon; 18.3 RMN-H. Lewandowski; 18.4 RMN-B. Hatala; 18.5 RMN-H. Lewandowski; 18.7 RMN-Arnaudet; 18.9 Chester Dale Collection; 18.10 RMN-Jean Schormans; 18.11 A.F. Kersting; 18.12 Chester Dale Collection; 18.13 Philadelphia Museum of Art: Purchased with the W.P. Wilstach Fund. Photo by Graydon Wood 1988; 18.14

Chapter Nineteen

London 1998

10.4 Spectrum; 19.6 Donald Cooper/ Photostage; 19.9 The James A. Michener Collection (HAA 13,695); 19.10+11 Spectrum; 19.12 Japan Information and Cultural Centre, London

Chapter Twenty

20.1 AKG London; 20.2 Robert Harding/ David B.A. Jones; 20.3 Robert Harding/ Philip Craven; 20.4 Robert Harding/Philip Craven; 20.5 Hutchison Library; 20.6 Spectrum; 20.8 Gift of the Société Anonyme, October 11, 1941. © DACS 1998; 20.9 Stedelijk Van Abbemuseum, Eindhoven. © DACS 1998; 20.10 R. & S. Madell, Russian Film Library

Chapter Twenty-One

21.1 © Succession Picasso/DACS 1998; 21.2 © DACS 1998; 21.3 Musée d'art et d'histoire, Ville de Genève, photo: Jean-Marc Yersin. © DACS 1998; 21.4 © ADAGP, Paris and DACS, London 1998; 21.5 © DACS 1998; 21.8 © Succession Picasso/DAC S 1998; 21.9 © ADAGP, Paris and DACS, London 1998; 21.10 © DEMART PRO ARTE BV/DACS 1998; 21.10 © DEMART PRO ARTE BV/DACS 1998; 21.13 © ADAGP, Paris and DACS, London 1998; 21.13 © ADAGP, Paris and DACS, London 1998; 21.15 Courtesy Morgan Archives N.Y.; 21.17 Art Resource N.Y. © ARS, NY and DACS, London 1998; 21.18 Ferdinand Howald Collection; 21.19 The Ronald Grant Archive; 21.20 © Succession Picasso/DACS 1998; 21.23 Peter Newark's American Pictures; 21.24 Friends of American Art Collection,

1942.51, photograph © 1997, The Art Institute of Chicago, All Rights Reserved; 21.25 © Estate of Thomas Hart Benton/VAGA, NY/DACS, London 1998; 21.28 Donald Cooper/Photostage; 21.29 Max Jones Archive

Chapter Twenty-Two

22.1 Gift of Klaus G. Perls, 1991; 22.2 photo: Ch. Lemzaouda; 22.3 Michael C. Rockefeller Memorial Collection, Gift of Adrian Pascal LaGamma, 1973; 22.4 Gift of Vivian Burns Inc.; 22.5 photo: Denis J. Nervig; 22.6 photo: Damián Bayón; 22.7 photo: Dr. Desmond Rochfort; 22.8 AKG London; 22.9+10 Inter-American Fund

Chapter Twenty-Three

23.1 Peter Newark's American Pictures; 23.2 George A. Hearn Fund, 1957. © ARS, NY and DACS, London 1998; 23.3 Gift of Mr. & Mrs. Noah Goldowsky and Edgar Kaufmann Jr.; Mr. & Mrs. Frank G. Logan Purchase Prize, 1952.1 Photograph ©1997, The Art Institute of Chicago, All Rights Reserved © Willem de Kooning/ ARS, NY and DACS, London 1998: 23 4 Mrs. Simon Guggenheim Fund, © ARS, NY and DACS, London 1998; 23.5 Mrs. Donald B. Straus Fund; 23.6 Wayne Andrews/ESTO; 23.7 Ezra Stoller/ESTO; 23.8 © Tim Benton; 23.9 ©Tim Benton; 23.10 @ Paul M. R. Maeyaert, Mont de l'Enclus, (Orroir), Belgium; 23.11 © Tim Benton; 23.12 Ezra Stoller/ESTO; 23.14 Scott Frances/ESTO; 23.15 Ezra Stoller/ ESTO; 23.16 Used with permission from McDonald's Corporation; 23.17 © Robert Rauschenberg/DACS, London/VAGA, New York 1998; 23.19 © ARS, NY and DACS, London 1998; 23.20 Philip Johnson Fund and gift of Mr. and Mrs. Bagley Wright, © Roy Lichtenstein/DACS 1998; 23.21 Philip Johnson Fund; 23.22 Sol Goldberg, Ithaca, NY; 23.23 © Jack Mitchell; 23.24 © DACS, London/VAGA, New York 1998; 23.25 © ARS, NY and DACS, London 1998; 23.26 Wolfgang Volz; 23.27 Tim Street-Porter/ESTO

Chapter Twenty-Four

24.1 by permission of The Guerilla Girls; 24.2 © Judy Chicago, photo © Donald Woodman; 24.3 courtesy: Ronald Feldman Fine Arts, N.Y.; 24.4 courtesy of the artist and Metro Pictures; 24.7 © The Estate of Jean-Michel Basquiat, © ADAGP, Paris and DACS, London 1998; 24.8 photo © SPARC, Venice, CA.; 24.9 courtesy of the artist; 24.10 courtesy: Steinbaum Krauss Gallery, NYC; 24.11 ESTO

LITERATURE AND MUSIC CREDITS

Every effort has been made to obtain permission from all the copyright holders of material included in this edition, but in some cases this has not proved possible. The publishers therefore wish to thank all the authors or copyright holders who are included without acknowledgment. The publishers apologize for any errors or omissions in the list below and would be grateful to be notified of any corrections that should be incorporated in any future edition.

For permission to reprint copyright material the publishers gratefully acknowledge the following:

Bantam Doubleday Dell Publishing Group, Inc: Erlkönig (the Erlking) by Johann Wolfgang von Goethe from The Ring of Words, ed. Philip L. Miller. The Ecco Fress: Selections of balku by Matsuo Basho from The Essential Haiku: Versions of Basho, Buson, & Issa, Edited and with Verse Translations by Robert Hass, © 1994 by Robert Hass (First published by The Ecco Press in 1994), reprinted by permission of the publisher. John L. Foster (trans.): Song of the Harper and Hymn to the Sun from Echoes of Egyptian Voices (University of Oklahoma Press), by permission of the translator and publisher. Harvard University Press: She Demonstrates the Inconsistency of Men's Wishes in Blaming Women for What They Themselves Have Caused by Sor Juana Inés de la Cruz, trans. Alan S. Trueblood, from A Sor Juana Anthology (Harvard University Press). Alfred A. Kalmus Ltd: Variations for Orchestra from Op.31: Forms of the Twelve-Tone Row, First Half of Theme, copyright 1929 by Universal Edition, renewed 1956 by Gertrude Schoenberg.
Penguin USA: Sonnet by Michelangelo from The Italian Renaissance Reader, eds. Julia Conaway Bondanella and Mark Musa (Penguin/ Meridian). Random House Inc.: from Aeneid by Virgil, trans. Robert Fitzgerald.

INDEX →

Figures in *italics* refer to illustration captions, and to Maps and Timelines

a cappella 326 Aachen 237–38, 238, 242 Aaron, Hank 606 abacus (architectural) 87, 87 Abbas, Abu'l 177 Abbasid dynasty 177, 179, 187 Abbeville, France: Saint-Riquier 238, Abd al-Rahman I 180 Aboriginal painting 612–13, 614, 615 Abraham 24, 146–47, 149, 176, 179 absolute music 455 abstract art/abstraction 4, 495 abstract expressionism 216, 580-82, 583, 589
Absurd, Theater of the 588–89
Abu Simbel 48, 49
Abu temple figures, Tell Asmar 21, 21–22 Achebe, Chinua 568 Achilles 70, 72–73, 75, 75 "Achilles Painter" 97, 98 acoustics (definition) 10 Acropolis 86, 86-87, 88 Erechtheion 83, 88, 92, 93 Parthenon 7, 7, 79, 88, 89, 89–93, 90–92 Propylaia 88, 88 Temple of Athena Nike 88, 93, 93 action painting 581 Adam 24, 146, 149, 157, 162, 163, 174, 341 Adena culture 231, 231 Adrian VI, Pope 315 Adrian VI, Pope 313 Aegean cultures 56, 58–67 Aegina: Temple of Aphaia 78–79, 79 Aeneid (Virgil) 72, 132, 142 Aeschylus 85, 98–100, 293 aesthetics 3, 11, 436 Africa 120, 349, 443, 564, 564–65, 569 language 565 literature 568 music 567-68 sculpture 565-67 African Americans: art 556–57, 605–6 literature 540, 610–11 music 558 Agamemnon 58, 64, 66, 67, 99 Agee, James 554 agit-trains 532 agora 86 Agra: Taj Mahal 199, 199 agriculture 19, 43, 204, 224-25, 229, 230 Agrippa, Marcus 134 ahimsa 193 Ahmose I, of Thebes 45 Ahuitzotl, Mexican king 225 Ahuramazda (deity) 31
Aiguillon, Duke of 417
aisles 153, 156
Ajanta cave paintings 197, 198, 198
Akhenaten 50–51, 51 "Hymn to the Sun" 53-54 Akhetaten 50 Akkad/Akkadians 12, 19, 20, 23, 24–25, 146 Akrotiri 58, 59, 59 alap 201 Albert, Prince 469 Alberti, Leon Battista 296, 296, 298–300, *300*, 301, 314 Alcmena 69 Alcuin of York 240, 241 Alcuin of York 240, 241 Aldington, Richard 548 Alexander the Great 96, 103, 105, 105–6, 106, 109, 176, 193, 195

Alexander II, Tsar 522 Alexander VI, Pope 315, 328, 342 Alexandria 106, 107 Algeria 443, 568 Alhambra Palace, Granada 165, 183, 183 - 84Ali, caliph 177 Al Khanum 109 Al Knanum 109
al-Kindi 187
Allah 177, 178–79
Allende, Isabel 573
Altar of Peace see Ara Pacis
Altar of Zeus, Pergamon 108, 109–10
Ambras see el-Amarna, Tell Ambrose, St. 162 ambulatories 156, 259, 259 Amen-Mut-Khonsu, Temple of 46, 46-47, 47 Amenhotep III, pharaoh 46, 47 Amenhotep IV see Akhenaten American Civil War 447, 465-66, 466, American Revolution 404, 416 Americas, the see Latin America; Mesoamerica; Native Americans; United States of America Ameterasu (deity) 212 Amiens Cathedral (Notre-Dame) 263, 263, 265 Ammanati, Bartolommeo 333, 333 amphitheaters 98, 99, 130-31; see also Colosseum amphora 75, 75, 76, 76 Amsterdam 375, 377, 378, 379 Anasazi culture 230, 230 Anaxagoras 102 Andalusia: poetry and music 185-86, 187 Andes 225–28 Andhras, the 196 Angelico, Fra 304-5, 305 Angles/Anglo-Saxons 166, 234, 236, 245 Anglican Church 345 animal behaviorists 470 Animal Style: Celto-Germanic 234, 234-35, 235 Persian 29-30, 30 antagonists (definition) 9 Anthemius of Tralles see Hagia Sophia Antietam, battle at 466, 466 Antigonids 84 Antin, Eleanor 604, 604 Antiochus Epiphanes 176 antiphonal singing 161 anti-Semitism 333, 548, 550, 552 Antoninus Pius, Emperor 125, 141 Antwerp 354, 381 Anu (deity) 20, 24 Anyang, China 204 apartheid 565 Aphrodite/Venus (deity) 67, 68, 120 Aphrodite of Knidos 95, 95–96 Apocalypse (Revelation) 28, 160, 161 Apollinaire, Guillaume 540 Apollo (deity) 67, 68, 70, 105, 120 Apollo Belvedere 314, 353 Apollodorus of Damascus 130, 130, 133, 133 Apoxyomenos 96-97, 97 apse 153 aqueducts, Roman 113, 114, 122, 122, 127 Aquinas, St. Thomas 180, 276, 279, 280 Ara Pacis 132, 132–33, 134 Arabic poetry 184–85 Arachne 68 Arc de Triomphe, Paris 448, 448 arch construction 7, 7, 181, 248, 258, 259 Arch of Constantine, Rome 136, 136–37, *137*, 157 Archaic period (Greece) 67, 74–81 architects 7 architecture 7 American 426–27, 492–93, 586–88,

Art Nouveau 493-94

Baroque 365–68, 369–70, 388–91, 393, 407

Bauhaus 584-85 British see Britain Byzantine 155, 168-75, 177 Carolingian 237–38, 239, 240–41 Chinese 508–10 early Christian 153–56 Egyptian 37–40, 44, 45–48 Elizabethan 356–57 Etruscan 115 French see France Functionalist 493 German 237–38, 584–85 Gothic 7, 257–69 Gothic Revival 448–49 Greek 75, 77–79, 85–90, 93, 99, 107–9 Indian 189, 196, 196, 199, 199-200 International Style 585-86 Islamic 177, 181–84 Italian Renaissance 298–301, 321–22 Japanese 213, 217, 514–15 Mannerist 333 Minoan 60-62, 7 Mycenaean 64, 65–66 Neoclassical 425–27 Neolithic 18 Northern European castles 355-56 Persian 30-31 Roman 121–22, 127, 128–31, 136 Romanesque 7, 11, 246–49, 258 Russian 523, 524–26 Spanish 493 Sumerian 20-21 architrave 78, 78 archivolts 250 Arena Chapel, Padua: frescoes 284, 284 Ares/Mars (deity) 67, 120 Argenteuil 479 Argentina 569, 572, 573 Aristides, Aelius 125 Aristophanes 101, 293 Aristotle/Aristotelianism 100, 101, 103-4, 105, 180, 276, 308, 345, 346 Ark of the Covenant 147 Arles 482 Armory Show, New York (1913) 545 Armstrong, Louis 560, 606 Arnolfini, Giovanni 340, 341 Arp, Hans (Jean) 537, 537 ars nova 287 Art Nouveau 407, 479, 493-94 Artemis/Diana (deity) 67, 120 Arthur King/Arthurian legends 252, 253, 345

arti see guilds, medieval artists, role of 2 Aryan tribes 190, 191 Ashikaga period (Japan) 216–17 ashlar masonry 66, 121 Ashoka, Mauryan emperor 193, 195, 196 Ashurbanipal, of Assyria 23, 28, 28 Ashurnasirpal II, of Assyria 26, 26, 27, Asmar, Tell: Abu temple figures 21, 21–22 assemblages *591*, *591–92*, *592* assonance 238 Assyria/Assyrians 20, 26-29, 45, 148 astrology 341 astronomy 220, 222, 394, 395, 396, 397, 398n, 487 Asuka period (Japan) 213 Aswan Dams 37 ateliers 461, 463 Athanodoros 110, 110 Athena/Minerva (deity) 67, 68, 75, 76, 93, 108, 109, 120 Athena Parthenos 89, 90 Athena Promachus 90
Temple of Athena Nike see Acropolis
Athens 69, 70, 71, 75, 77, 81, 84–85,
86, 87, 93, 96, 105
Temple of the Olympian Zeus 107, see also Acropolis atlantes 93

Atlas 69 atom, the 487 atom bombs 576, 577, 589 atomists, Greek 81 atonality 550 Atonement 161 Atreus, Treasury of 65, 65-66 atrium 153 Attalos I, of Pergamon 107, 109
Augustine, St., Archbishop of
Canterbury 234
Augustine, St., Bishop of Hippo 9,
162–63, 338, 345 Augustus, Emperor 120, 124–25, 127, 128, 131, 132, 132, 134, 151

Augustus of Primaporta 131–32, 132

Aurelius, Marcus 141–42

equestrian statue 134, 134–35 Auschwitz death camp 577 Austen, Jane 427–28, 433, 452 Australia see Aboriginal painting Austria 252, 403, 461, 536 see also Viennese composers autobiography 9, 610 automatism, psychic 541, 581 automatism, psychic 541, 581 automobile industry 479, 503, 559, 589 Autun Cathedral (Saint-Lazare) 249, 250, 251 avant-garde, the 479, 494-95 avatars 191 Averroes 180 Avicenna 180 Aztecs 220, 224, 225, 225, 228, 293, 293, 349 Babel, Tower of 29 Babylon/Babylonians 12, 19, 20, 25–26, 28, 28–29, 29, 106, 146, 148, 176 Baca, Judith F. 606–7, 607 Bacchus (deity) 120, 160; see Dionysos Bach, Johann Sebastian 253, 346, 375, 392-93, 573 Bacon, Francis 350, 393, 403 Baghdad 177, 187 Bahlum Kuk, king of Palenque 223 Balanchine, George 503, 528 Baldacchino, St. Peter's 367, 367–68 ballet 481–82, 527, 528, 559; see also Ballets Russes Ballets Russes 503, 528, 540, 541, 549-50 balletts 358 balustrade 322 Balzac, Honoré de 470 Bangladesh 199 bantu 565 barbarians 166 Barcelona 494, 494, 552, 553

Bardon, Geoff 613

Baroque age 364, 407

gardens 432

Barthes, Roland 602

Baryshnikov, Mikhail 528 Basel 348, 353

Basho Matsuo *516*, 517 basilicas *153*, 153–54, 246 Basques *552*–53

Baule masks 567, 567

Bay of Pigs 576, 578

388-91, 393, 407

Barlow, General Francis Channing 466

Barma (architect) 522, 525, 526

architecture 365-68, 369-70,

gardens 432 literature 396–99 music 365, 374–75, 391–93, 455 painting 365, 370–74, 375–88 philosophy 394–96 science 393–94

sculpture 367–69 Barry, Sir Charles 448, 448–49, 469

Bartholdi, Frédéric-Auguste 469, 469

Basquiat, Jean-Michel 605–6, 606 Bastille, Paris 257, 417 Baths of Caracalla, Rome 131, 131

Battleship Potemkin (Eisenstein) 530–31, 531
Baudelaire, Charles 447, 463, 465, 470–71, 476, 477, 484, 487, 495
Bauhaus 584, 584–85

4

Bayeux Tapestry 244, 244 Beard, Richard 465 Beats, the 453, 598 Beauvoir, Simone de 580 Becket, St. Thomas à 345, 345 Beckett, Samuel 589 Bede, The Venerable 236 Beethoven, Ludwig van 401, 428, 430, 430–32, 454, 455, 457 Bei Dao 511 Beijing 211, 506, 508–10, 509, 590 Beijing opera 511, 511–12 Belize 220, 222 belle époque 476 Benedict, St. 238, 240 Benedictine order 240, 253 Benin sculpture 565, 565-66 Benton, Thomas Hart 556, 557, 581 Benton, I nomas frart 536, 33 Beowulf 236 Beria, Lavrenty 531 Berlin Wall 584, 612, 615 Berlioz, Hector 455 Bernard of Clairvaux, St. 240 Bernart de Ventadorn 253 Bernini, Gianlorenzo 366, 366–69, 367, 368, 369, 388 Bernstein, Leonard 598-99 Derussus 2 Berry, Jean, Duke of 256, 256–57, 336, 341 Bertoldo, Giovanni 317 Bertoido, Giovanni 317

Bhagavad Gita 192–93

bhakti poetry 200

Bible, the 150, 293

Hebrew (Old Testament) 24, 146–50, 158, 160, 162, 163

New Testament 151, 152, 159–61 see also Gospel books, Gospels Bierstadt, Albert 447 Bindusara, Mauryan emperor 193 Bindusara, Mauryan empetor 193 biography (definition) 9 Black Death 234, 280, 336 black-figure vases 75, 75–76, 76 Black Mountain College, North Carolina 591, 594, 595 Blake, William 437, 450–51, 451 Blanche of Castille 252 blank verse 8, 359 blasphemy 346 Blaue Reiter, Der ("Blue Rider") 501 Bloomsbury group 548, see also Woolf, Virginia
Bo (Bodhi) Tree 194
Boccaccio, Giovanni 284–85, 287, 293
Decameron 284, 285, 291
bodhisattvas 197, 198, 198
Boffrand, Gabriel-Germain 406, 407 Boleyn, Anne 345 Bolsheviks 520, 528–29, 532 Bonheur, Rosa 461, 461, 462, 486 Book of Kells 235–36, 236 Book of Songs, The 207 books see fiction; manuscript illumination; novels; printing Borges, Jorge Luis 573
Borghese, Cardinal Scipione 370
Borgia, Cesare 328
Borluut, Elizabeth 338
Borodin, Alexander 528 Borromini, Francesco 369-70, 370, Bosch, Hieronymus 341-43, 342, 343, 344 344
Boscoreale, villa at 138–39, 139
Boston Pops, the 598
Botero, Fernando 572, 573
Botticelli, Sandro 289, 294, 304, 305–7, 306, 307, 311, 314
Boucher, François 408–9, 409, 410, 411 Boulton, Matthew 404 Bourke-White, Margaret 555, 555 Boxer Rebellion 509 Bradbury, R. E. 566 Bradstreet, Anne 398 Brady, Mathew B. 466, 466 Brahma 191 Brahman 191, 192 Brahmins 191, 194

Brahms, Johannes 455 Bramante, Donato 316, 321, 321-22, 322, 326 Brancacci Chapel frescoes 301, 301–2 Brancusi, Constantin 542–43, 543 Braque, Georges 489, 499, 499–500, 500 brass instruments 10, 361, 454 brass instruments 10, 361, 454
Brazil 349, 537, 572, 573
Brethren of the Common Life 345
Brcton, Andié 540, 541
Brezhnev, Leonid 533
"Bridge, The" see Briicke, Die
Britain 126, 166, 344–45, 349, 395–96, 485-86, 528 architecture 266, 267, 268, 356-57, 389-91, 425, 448-49, 469 gardens 432-33 Industrial Revolution 404-5, 460 literature and drama 236–37, 397–99, 414–15, 427–28, 450–52, 472, 536, 548, see also Shakespeare Magna Carta 245–46 medicine 350–51 medieval culture 234–35, 236–37, 240 music 287, 357-58, 361, 391-92 Norman Conquest 244, 244-45 painting 353–54, 375, 382, 411–14, 436, 443–45 philosophy 276-77, 395-96 photography 465 pottery 404 science and mathematics 350, 351, 470, 472–73 sculpture 543–44 World War I and II 536-37, 576 British East India Company 509 Brittany: menhirs 18 Brontë, Emily 452 Bronze Age 19, 58, 67 bronze work: Benin 565–66 Chinese 204, 204, 205 Etruscan 117, 117 Greek and Hellenistic 71-72, 314 Indian (Chola) 200, 200 Islamic 249, 249 Japanese 213, 213 Roman 133, 134, 134-35 Bronzino, Agnolo 328, 330, 331 Brooks, Mel 549 Briicke, Die ("The Bridge") 501 Bruegel, Pieter, the Elder 354, 354–55, 355 Bruges 336, 341 Brunelleschi, Filippo 268, 294, 298, 299, 309 Bruni, Leonardo 292, 294 Brunswick, Duke of 418 Brussels: Horta house 493, 493 Brutus 120 Buddha 193-94 statues 197, 197–98, 198, 209, 209, 213, 213 Buddhism 197 in China 209, 209, 210, 211 in India 190, 191, 193–98 in Japan see Zen Buddhism buffalo hunters, American 231 Bunraku 518 Burgos 552 Burgundians 166 Burgundy, dukes of 336 burial see coffins, moundbuilders; pyramids; sarcophagi; tombs Burke, Edmund 432, 450 Burlington, Lord 425, 425, 433 Burnet, Thomas 432 Burroughs, Floyd 554–55, 555 Buscheto (architect) 249 Busshyi, Tori 213, 213 Byron, Lord 452, 452, 456 Byzantine civilization 164, 166 architecture and mosaics 155, 168–75, 17 Constantinople 166 8 icons and painting 168, 175, 175,

music 162

cabochons 242 Cabral, Pedro 349 Caedmon's Hymn 236-37 Caesar, Julius 119, 119-20, 128, 141 Café Voltaire, Zürich 537 Cage, John 216, 590, 591, 594, 595 Cahokia 231 Calder, Alexander 544, 544-45 Caldwell, Erskine 555 calendars 18, 35, 222, 224, 421 Caligula, Emperor 125
Calixtus III, Pope 315
Callicrates see Kallikrates calligraphy 183 Calvin, John/Calvinism 163, 344, 348–49 calyx krater 76, 77 Cambio, Arnolfo di 268, 268, 298 Cambridge University 276 camera obscura 377
campanili 248, 248–49, 268, 268, 291
Campin, Robert 336–38, 337, 344
Canaan 146, 147, 148 canon (musical) 11 cantatas 253, 392-93 Canterbury Cathedral 345, 345 Canterbury Tales (Chaucer) 161, 284, 285–86 399 cantus firmus 279 Cao Xuequin 510-11 Capet, Hugh 244 Capetians 244, 245, 256 capitals (architectural) 78, 78, 87, 87, 88, 107 Capitoline She-Wolf 117, 117, 314 Cappelanus, Andreas 252 Caracalla, Emperor 131, 135, 135 Caravaggio (Michelangelo Merisi) *363*, 370–72, *371*, *372*, 375, 377, 421 Caribbean 572, 611 Carnac 18 Carolingian era 232, 237–43 Carpaccio, Vittore 323, 323 carpet pages 235, 235 Carracci, Agostino 373, 407 Carracci, Annibale 372–73, 373, 407 Carracci, Lodovico 373, 407 Carrington, Charles 536 37 Carter, Howard 52 Carthage 118, 122 cartoon (definition) 274 Cartwright, Edmund 404 carving see relief sculpture; sculpture caryatids 92, 93 Cassatt, Mary 477, 482–83, 483 Cassirer, Ernest 436 Cassius 120 caste system, Hindu 191, 199 Castiglione, Baldassare 326-27, 357 Castro, Fidel 578 catacomb paintings, Rome 158-59, 159 catharsis 100 cathedrals and churches: Baroque 389–91 Byzantine 166–75 Gothic 257–72, 273–74 Renaissance 298–300 Romanesque 246–52, 258 Russian 524–26 see also St. Peter's, Rome Catherine of Aragon 345 Catholicism see Roman Catholic Church Catullus 124 cave paintings: Ajanta 197, 198, *198* prehistoric 14–15, *15* cella 89, 121 Cellini, Benvenuto 332, 332 Celtic cultures 234-37 ceramics see pottery and ceramics Ceres/Demeter (deity) 120 Cervantes, Miguel de 399 Cerveteri, tombs at 115, 115–17, 116 Cézanne, Paul 487–89, 488, 494, 497, 499, 540 Chaco Canyon, Arizona 230 Chagall, Marc 529 Chambers, William 433

Chambord, Château of 356, 356 Champollion, Jean-François 36 Chamula, Mexico 224 Chan Bahlum, king of Palenque 223 Ch'an Buddhism see Zen Buddhism Chandragupta I, Mauryan emperor Chandra Gupta II 197 chansons de geste 238 chansons masses 308 chant 10, 161, 243, 253, 279–80, 308 characters (definition) 9 Chardin, Jean-Baptiste-Siméon 411, Charlemagne 237, 238, 238, 240, 242, Charles I, of England 375, 380, 382, Charles I, of England 375, 380, 382, 384, 395 Charles IV, of Spain 436, 437, 437–38 Charles V, of France 256, 257 Charles V, Holy Roman Emperor 324, 328, 334, 343–44, 344, 346, 349 Charles X, of France 442 Chartres cathedral (Notre-Dame) 260, 261, 262, 262-63 sculpture 269, 269-70, 280 châteaux 356
Charris, Groffiey, Gamerbury Taks
161, 284, 285–86, 399 Chefren, Pharaoh 40-41 Pyramid 39, 39–40 statue 41, 41 statue +1, +1 Cheilon of Patrai 97 Chekhov, Anton 526, 527 Cheng Chow, China 204 Cheops, Pyramid of 39, 39–40 Chiapas, Mexico 224 chiaroscuro 311-12 Chicago 585, 585, 586, 587 Chicago, Judy 603, 603–4 Chikamatsu Monzaemon 518 Chilean literature 573 China: architecture 508–10 Buddhism 197, 209, 209, 210, 211 Communism 506, 511, 512 Confucianism 204–6, 207, 208, 209 Cultural Revolution 512 Great Wall 202, 207–8 Han dynasty 202, 208–9 literature 207, 209–10, 510–11 McDonald's 590 McDonald's 590
Ming dynasty 506–8
music and opera 207, 511–12
painting 210–11, 506–8
Qin dynasty 207–8, 208
Qing dynasty 506, 508
sculpture 208, 209 Shang dynasty 204, 204 silk trade 169, 190, 202, 209 Six Dynasties 209, 210 Six Dynasties 209, 210
Song dynasty 210–11, 212
Tang dynasty 209–10
Taoism 204, 206–7, 209, 210
Yuan dynasty 506
Zhou dynasty 204–7, 205
Chinese-Americans 608–9, 610 Chiswick House, London 425, 425, 426, 433 chivalric tradition 252-53 choirs (architectural) 238, 259-60 Chola dynasty (India) 199 sculpture 200, 200 scuipture 200, 200
Chopin, Frédéric 454, 454, 455–56
Chopin, Kate 484
Chotek, Sophie 536
Chrétien de Troyes 253
Christianity, early 121, 127, 146, 151–53 architecture 153-56 music 161-62 painting 158-59 philosophy 162–63 sculpture 156–58 see also Bible; cathedrals; Eastern Orthodox Church; Jesus; Protestantism; Roman Catholic Church Christina, Queen of Sweden 365 Christine de Pizan 286, 286–87

Christo 596, 596 Church, Frederic Edwin 446, 446–47 Churchill, Winston 576 Cicero, Marcus Tullius 141, 292, 310 cinema see films Circus Maximus, Rome 127 Circus Maximus, Rome 127 cire perdue (casting process) 200 Cisneros, Sandra 611 Cistercian order 240 city-states 70, 234, 288, 290 Civil Rights Movement 598, 602 American 447, 465–66, 466, 557 English 395 Spanish 3, 3, 552–53 civilization 14, 27 Classical music 428-32, 454 Classical period (Greece) 2, 67, 82, 84-105 Claude Lorrain 375, 386, 386, 387 Claude Lorrain 375, 386, 386, 387 Clay, Cassius 606 Cleisthenes 84 Clement VII, Pope 315, 327, 345 Cleopatra, Queen of Egypt 84, 120 clerestory windows 153–54, 258 cloisters 241 Cluniac order 240 Clytemnestra 99 Coatlicue (deity) 225, 225 Cocteau, Jean 541 Cofer, Judith Ortiz 611 coffers 131, 131 coffins: Ghanaian *566*, 567 Tutankhamen's 52, *53* Colbert, Jean-Baptiste 387, 388, 390 Cold War 578 Cole, Thomas 445-46, 446 Coleridge, Samuel Taylor 450, 456 collages 500, 500, 536, 536, 538, 538-39 collages 500, 500, 536, 536, 538, 538–39 Cologne 253, 336 Colombia 572, 573 colonnades 77, 78, 366, 366–67, 367 color(s) 5, 6, 6, 478 "broken" 479, 479 Color Field abstraction 582, 583 Colosseum, Rome 114, 127, 129, 129, Columbus, Christopher 220, 349 Columbus, Christopher 220, 349 column figures, Gothic 269, 269–70 columns 78, 78 engaged 121 comedy 101, 124, 397 comitatus 236, 237 Commodus, Emperor 126 Communism 460–61, 551 Chinese 506, 511, 512 Russian 528–29, 531, 550, 576, 612 complementary colors 6, 478 composite order 121 composite order 121 composition (of artworks) 4, 5 Conceptual Art 589, 595-96 concertos 374-75 concrete, Roman 121, 129 Confucius/Confucianism 204–6, 207, 208, 209, 210–11 Connery, Sean 549 Conques: Sainte-Foy 246, 249 conquistadores 228 Constable, John 443-44, 444 Constantine I, Emperor 126, 136, 146, 153, 156, 166 Head 135, 135–36 Constantinople 126, 168, 177, 293 Mosque of Sultan Sulayman 182, 182–83, 183
see also Hagia Sophia
content (of artworks) 3, 4
contrapposto pose 93, 94, 95, 298, 319
conventions (definition) 4 Coolidge, Calvin 540 Coolidge, Calvin 540
Copernicus, Nicholas 349–50
Copland, Aaron 540, 559
Copley, John Singleton 423–24, 424
Corday, Charlotte 421
Córdoba (Cordova) 180, 181, 181, 187, 552
Corelli, Arcangelo 374
Corinth 74, 84
pottery 74, 74, 75, 77

Corinthian order 87, 87, 88, 107, 107, 121, 122, 122
Cormont, Renaud de 263
Cormont, Thomas de 263
Cornaro family chapel 368, 368, 369 Corneille, Pierre 39 Corsica 118 Cortés, Hernán 228, 293, 349, 393 Cortona, Domenico da 356, 356 Cosquer cave, nr Marseille 14 Costner, Kevin 549 counterpoint 392 Counter-Reformation 364, 364-65, 370 Courbet, Gustave 462, 462–63, 463, 465, 470–71, 477, 494 courtly love 177, 252–53 covenant 146–47 Coysevox, Antoine 389, 389 craftsmanship 4 Cranach, Lucas 347 Cranmer, Thomas 345 Crassus, Marcus Licinius 119 creation stories 11, 24, 146, 149 creeds: Islamic 179 Nicene 153 crepidoma/crepis 77–78, 78 Crete: Minoan culture 58, 59–64, 65, 77 criticism, art 2-3, 411 cromlechs 18 Cromwell, Oliver 395 Cromwell, Thomas 345 Cross pages 235, 235 Crusades, the 176, 245, 246, 259 Crystal Palace, London 469, 469 Cuba 572, 576, 578, 611 Cubism 479, 489, 497–500, 501, 529, 529, 539 Cufic writing 183 Cultural Revolution, Chinese 512 culture (definition) 14 cunciform writing 19, 20, 31, 35 Cunningham, Merce 594, 595, 595 Cupid/Eros (deity) 68, 120 Cuzco, Peru 227 cybernetic sculpture 610, 610 Cycladic culture 58, 50 Cycladic culture 58-59 cynicism 415 Cyril, St. 522, 522, 523 Cyrus II, of Persia 29 Dacians 133, 134 Dada movement 537-38, 539, 541 Daguerre, Louis-Jacques-Mandé 465 daguerreotypes 465 Daisen-in monastery, Kyoto 516, 516 Dalí, Salvador 542, 542 Damascus 187 D'Amato, Senator Alphonse 346 Danaë 68 dance 2 Egyptian 50 modern 543, 559, 595, 595 Renaissance 306–7, 309 see also ballet Danicl, Book of 149, 151
Däniken, Erich von 229
Dante Alighieri 161, 162, 262, 277–79, 284, 291, 292, 293, 309
Daphne 68 Darius, King of Persia 31, 85 "Dark Ages" 234 Darwin, Charles 470, 472–73 Dasas 190 Daumier, Honoré 460, 460 David I, I, 104, 148, 149, 176, 297, 318, 318, 368–69 David, Jacques-Louis 402, 402, 417, 417, 420, 420–21, 421, 438, 442 Dawkins, Richard 470 "daykeepers" 224 Dead Sea Scrolls 150, 150 death camps, Nazi 577, 579 deathmasks, Roman 122-23

Debussy, Claude 484, 485, 528

Decalogue (Ten Commandments) 147–48

Decadents 486

Decameron (Boccaccio) 284, 285, 291 Decebalus, prince of Dacia 134 Decius, Emperor 153 Declaration of Independence, American 114, 404, 416 Declaration of the Rights of Man and Citizen 404, 416, 418, 419 deconstruction 602 Defoe, Daniel 414, 427 Degas, Edgar 477, 481, 481–82, 483 de Haviland, Olivia 549, 549 Deir-el-Medina 47, 47–48 Delscis +12 de Kooning, Willem 216, 581, 581–82 Delscroix, Eugène 436, 441, 441–42, 443, 443, 455, 458–60, 459, 461, 494 Delhi 188, 199 della Porta, Giacomo 366 demes 84, 85 Demeter/Ceres (deity) 67, 120 de Mille, Agnes 559 democracy 84, 85 Democritus 81, 102, 124 Demuth, Charles 547, 547 Denis, Maurice 495–96 Denis, Maurice 495–96 dénouement (definition) 9 Deogarh, temple at 190 Depression, the 554, 555 Derain, André 495 Derrida, Jacques 602 dervishes 179–80, 186, 186, 431 Descartes, René 394, 394-95, 396, Dessau, Germany 584, 584 De Stijl movement 539-40, 555 detective stories 450
Detroit 549, 549, 559, 589
dharma 196, 198
dhikr 187 Diaghilev, Sergei 503, 528, 540, 549 dialogue (definition) 9 Diana/Artemis (deity) 120 Dias, Bartolomeu 349 Diáz, Porfirio 570 Dickens, Charles 472 Dickinson, Emily 185, 453-54 diction (definition) 8 Diderot, Denis 375, 405, 405, 411, 420 Diocletian, Emperor 126, 127 Dionysos/Bacchus (deity) 69–70, 98, 99, 101, 120 mystery cult 138, *138* diptychs 158, *158* Dipylon vases 71, 71 disciplines (definition) 4 disease 231, 472, see also plague Disney film company 549 dissonance 10 dissonance 10

Divine Comedy (Dante) 161, 162, 277–79, 284, 291, 292, 309

Divine Consort 21, 21

Doges' Palace, Venice 323, 323 dome construction: Baroque 390 Byzantine 171, 172, 173, 173 Byzantine 171, 172, 173, 173 Mycenaean 65, 66 Renaissance 298, 299, 309 Roman 130, 130–31 Dome of the Rock, Jerusalem 176, 176 Domenico di Michelino 278 Donatello 295–98, 296, 297, 301, 308 Donne, John 185, 397–98, 453 Dorians 67, 70 Doric order 78–79, 87, 87, 88, 89, 89, 90, 121 Doryphoros 94-95, 95 Dostoevsky, Fyodor 524, 526 Doyle, Sir Arthur Conan 450 Draco 84 drama. Elizabethan 359-60, 361 French 397 Greek 84, 92, 98–101 Japanese 513, 518–19 medieval mystery plays 240 modern 588–89 and music 361, 598–99 naturalist 485 Nigerian 368

realist 485, 588 Roman 124 Russian 527 Russian 327 see also Beijing opera; Shakespeare Dreaming, the 613 Dresden Codex 349 Dreyfus Affair 486 Dreyfus Affair 486 drip paintings 581 Droysen, Johann Gustav 106 du Barry, Madame 410, 420 Duccio 255, 281–82, 282 Duchamp, Marcel 538, 538, 544, 547 Dufay, Guillaume 307, 308, 309 Du Fu 209–10 Dürer, Albrecht 343, 349, 351, 351-53. Dutch painting see Netherlands Dyck, Anthony van 382, 384 Eakins, Thomas 468, 468 Eastern Orthodox Church 167, 168, 522-23 Ecclesiastes 149, 150 echinus 87, 87 Edgeworth, Maria 465 Edinburgh Review 452 Edison, Thomas Alva 503 Edward the Confessor 244 Edward III, of England 256 Edwards, Blake 11 Egypt, ancient 29, 32, 34–35, 73, 84, 106 architecture 37-40, 44, 45-48, 54 dance 50 hieroglyphics 35, 35-36, 36, 44-45 literature 53-55 Middle Kingdom 35, 43-44 music 50 New Kingdom 35, 45–55 Old Kingdom 35, 37–43, 53 religion 36–37, 146, 160 sculpture 34–35, 37, 40–42, 43, 44, 48, 51–52 tomb painting 43, 48–50 Eiffel, Gustave 469–70 Eiffel Tower 485, 486 Einstein, Albert 487, 595 Eisenstein, Sergei 530–31, 531 el-Amarna, Tell 50 Elamites 28 Eleanor of Aquitaine 245, 252, 253 Eliot, George 472 Eliot, T. S. 279, 450, 503, 547–48 Elizabeth I, of England 345, 345, 356, 357, 357 Elizabeth of Shrewsbury 355 Elizabethan drama 359-60, 361 Ellington, Duke 560-61, 561 Ellison, Ralph 557 El Salvador 222 emaki-mano 214 Emerson, Ralph Waldo 216, 449 emotions 10–11, 436, 447, 448, 454 Empiricus, Sextus 111 enamel work 251, 251–52, 252 Engels, Friedrich 460–61, 472, 528 England see Britain engravings 352, 352, 353 Enki (deity) 20, 24 Enkidu 24 Enlightenment 403, 403, 415, 418, 419
Enlil (deity) 20
entablature 77, 78
environmental art 596, 596 ephemeral arts 9 epic poetry 8, 11 Greek 81, see Homer Indian 192–93 medieval 236–37, 238 mock 414 Roman 72, 132, 142 Sumerian 23–24 Epictetus 141 Epicureanism 81, 111 Epicurus 111, 124 Epidauros: amphitheater 98, 99 Epistles 161

equestrian statues 134, 134-35

equites (equestrians) 119

Erasmus, Desiderius 345-46, 347, 353, 353 ere ibeji dolls 569, 569 Erechtheion see Acropolis Erechtheus, King 92, 92, 93 Eros/Cupid (deity) 68, 120 Eros/Cupid (detty) 68, 120 Este family 325 Esterházy, Prince 428 etchings 379, 379 Ethelbert, king of Kent 234 ethics and morality 104, 105, 147–48, 192; see Bible; Quran; religions etiological stories 149 Etruscan civilization 114-17, 118, 129 Eugene IV, Pope 308 Eumenes II, King 107, 108, 109 Euphrates River 19 Euphronios 76, 77 Euripides 92, 99, 101, 293 Europa 59, 68 Europe 232, 243–44, 254, 256, 280, 350, 362, 400, 474, 534, 536, 551, 574, 576, 612 European Union 578, 578-79 Euxitheos 76, 77 evangelists 146 Evans, Sir Arthur 58, 59-60 Eve 64, 146, 149, 162, 163, 341 evolution, theories of 470, 472–73 Exekias 57, 75, 75 existentialism 579, 588, 589, 594 exploration, world 349, 395 exposition (definition) 9 expressionism see abstract expressionism, German Expressionism Eyck, Hubert van 338, 338–39, 339 Eyck, Jan van 338, 338–39, 339, 340, 341, 344 eye, the 393-94, 394 Ezekiel, prophet 148 Ezra, book of 149, 150 faience 64 Fairbanks, Douglas 549 fakirs 179 Fallingwater, Bear Run 586, 587, 588 Farm Security Administration (FSA) 540, 554, 555 Fascism 548, 550–53 Fascism 546, 530–53 Faulkner, William 540, 557 58 Fauvism 479, 495–97, 501 feminists 64, 536, 580, 598, 602–5, 609 Ferdinand and Isabella 274, 321 Ferdinand VII, of Spain 436, 438 Fertile Crescent 12, 19 fètes galantes 407, 408, 409 feudalism 237, 240 Ficino, Marsilio 293–94, 308 fiction 8, 9 Fiedler, Arthur 598 Fielding, Henry 427 Fifield, Lisa 601, 607, 607 films 11, 219, 530-31, 549, 549 fin de siècle 485-94 Fioravanti, Aristotele 522, 524 Firdawait, Aristotele 122, 124 Firdawsi 185, 185 Fitzgerald, Edward 185 Fitzgerald, Ella 560 Fitzgerald, F. Scott 547 Flamboyant Gothic style 265–66 Flaubert, Gustave 443, 471 Flavian, Emperor 125 Flémalle, Master of see Campin, Robert Flemish music 325–26 Flemish music 323–20 Flemish painting 336–43, 354–55, 375; see also Rubens Flemish tapestry 274–75, 275 Flood, the 24, 146, 147, 149 Florence 1, 234, 278, 281, 282, 285, 290, 290–92, 291, 307–8, 310, 328 Baptistery 294–95, 295 Brancacci Chapel frescoes 301, 301–2 Cathedral 268, 268-69, 291, 298,

299, 308, 309

Laurentian Library 333, 333 Palazzo Medici-Riccardi 300, 300-1, Palazzo Vecchio 313, 313-14 Platonic Academy 293, 305 San Marco monastery 304-5, 305, Santa Croce chapels 291, 317 Santa Maria Novella 302, 302–3 flying buttresses 258, 259, 260, 260, 266 Flynn, Errol 549, 549 Fokine, Michel 528 Forbidden City see Beijing Ford, Edsel B. 559 Ford, Henry 479 form (of artworks) 3, 4, 5 Fortuna Virilis, Temple of 121, 121 Forum, Roman 128, 128–29 Fragonard, Jean-Honoré 410, 410, 420 France 244, 256, 402, 461, 463, 579, see also Paris Academy see French Academy architecture 238, 246–48, 257–66, 356, 388–89, 407, 425–26, 586 Declaration of the Rights of Man and Citizen 404, 416, 418, 419 Directory 419 Channels 231=32 Estates General 416–17 Industrial Revolution 460 July Monarchy 458 literature and drama 238, 252-53, 286-87, 358-59, 396-97, 415, 470-72 music 11, 279, 287, 308, 309, 455, 477, 484, 485, 528 Napoleonic Code 419 National Assembly 416, 417–18, 418
National Workshops 461, 463
painting 272, 375, 386–88, 407–14,
417, 419, 420–21, 436, 439–43,
458–60, 461–65, 476–82, 487–90,
491, 495–97, 499–500
philosophes 403, 405, 411, 449 philosophy 394-95, 403, 415, 449, 602 photography 465 prochistoric art 14–16 Revolution see French Revolution sculpture 249–51, 269–72, 424–25, 447–48, 491–92 World War II 576, 577, 577 Francis, St., of Assisi 277, 277, 280 Francis I, Saltcellar of 332, 332 Francis Ferdinand, Archduke 536 Franciscan order 276, 277, 333 Franco, General Francisco 552–53 Frankenthaler, Helen 583, 583 Franklin, Benjamin 414, 424 Franzen, Cola 186 Frederick I (Barbarossa) 246 Frederick III, of Saxony 347 French Academy 387-88, 409, 411, 420, 421, 494 French Revolution 402, 404, 416-17, 418-19 escoes: early Christian 158–59, 159 Latin American 559, 559, 569, 570 medieval 277, 284, 284 Minoan 62, 62–63 Renaissance 301–3, 304–5, 312–13, 314, 316, 317, 319–21, 328–30 Freud, Sigmund 437, 486, 487, 526, Friedan, Betty 615 Friedrich, Caspar David 436, 436, 452 friezes 78, 78, 87, 87, 88 Frisius, Gemma 351 Fronde rebellions 390 FSA see Farm Security Administration fugues 392 Fuji, Mount 505, 514, 514 Functionalist architecture 493 Futurism 479, 500–1 Gaea/Gaia (deity) 67, 69 Gainsborough, Thomas 413, 413–14

Gaius Caesar 134 Galileo Galilei 394, 396, 397 Gama, Vasco da 349 Gandharan art 109, 109 Gandhi, Mahatma 193, 201 Ganges River 190, 197 García Márquez, Gabriel 573 gardens: American 433, 433 English 432, 433 Japanese 515–16, 526 Versailles 432, 432 gargoyles 258, 271, 271–72 Garrett, Lesley 430 garths 241 Gaud (administrator) 566 Gaud (administrator) 566
Gaudí, Antoní 493–94, 494
Gauguin, Paul 491, 491, 494, 495
Gautama, Siddhartha see Buddha
Gaurier, Théophile 438
Geffroy, Gustave 479
Gehry, Frank 597, 597–98 gelede masks, Yoruba 566, 566–67, 568 Genesis 24, 146, 147, 148, 149, 163 Geneva 348 Genghis Khan 506 Genji, Tale of (Murasaki) 213–14, 516, 518 genre painting 354–55 genres (definition) 4 Gentileschi, Artemisia 372, 372 geoglyphs 229 Geometric period (Greece) 67, 70 73 George III, of England 423 Géricault, Théodore 439-40, 440, 441, 442, 458 441, 442, 458
German Expressionism 501–3
Germany 257, 276, 336, 612
architecture 237–38, 584–85
Berlin Wall 584, 612, 615
Industrial Revolution 460
literature 452–53, 456, 534, 536, 537
medieval art 234
music 253, 375, 391–93, 430–32,
453, 454, 455, 456, 457–58
Naziem 529, 550, 551–52, 552, 571 Nazism 529, 550, 551–52, 552, 571, 572, 577, 579 painting and printmaking 351–54, 436, 479, 501, 538–39 philosophy 419, 449, 457, 460–61, 472, 487 World War I 528, 529, 533, 534, World War II 529, 533, 576, 577, Gershwin, George 560, 560, 598 Ghana 565, 566, 567 ghazal 185 Ghent 336, 338 Ghent Altarpiece 338, 338-39, 339, 341, 344 ghettos 333, 379 Ghibellines 278, 290 Ghiberti, Lorenzo 294-95, 295, 298, Ghirlandaio, Domenico del 317 gigantomachy 108, 109 Gilbert, William 348 Gilgamesh, king of Sumer 19 Gilgamesh, Epic of 23-24 Gillespie, Dizzy 606 Gillman, Charlotte Perkins 484 Ginsberg, Allen 453, 598 Giorgione 324, 324, 357, 464 Giotto 268, 268–69, 282, 283, 284, 284, 291, 292, 317 Gislebertus 250, 251 Giverny 479, 479, 482 Great Pyramids 39, 39–40 Great Sphinx 40, 40–41 Glass, Philip 201 Glastonbury 345 Globe Playhouse, London 359 60, 360 "Glorious Revolution" 395 Gnosticism 162 Godwin, William 418 Goethe, Johann Wolfgang von 452–53, 455, 456

Gogh, Vincent van 482, 482, 490, 490, 494, 495 Golden Section 89-90 Gonzaga, the (Dukes of Mantua) 374, 380 Francesco 326, 327 Gordon, Lyall 548 Gospel books 235-36, 241, 241-43, 242 Gospel music 558 Gospels 151, 152, 160–61 Gothic style 257, 285 architecture 7, 7, 257–69 enamel work 252, 252 manuscript illumination 272, 272, sculpture 269-72 stained glass 259, 264, 265, 272–74, 273, 275 tapestries 274-75, 275 Gothic Revival architecture 448-49 Goths 166, 258 Gouges, Olympe de 418 Goya, Francisco 437, 437-39, 439, 463 graffiti 141, 605 Graham, Martha 543, 543, 559 grammar (definition) 8 Granada, Spain see Alhambra Palace Grant, Ulysses S. 447 Great Fire of London (1666) 390, 414 Great Menhir, Brittany 18 Great Scrpent Mound, Ohio 231, Great Wall of China 202, 207-8 Greco, El (Domenikos Theotokopoulos) 331, 331 Greece, ancient 56, 67, 82
Archaic period 67, 74–81
architecture 75, 77–79, 85–90, 93, 99, 107–9 Classical period 2, 67, 82, 84–105 colonies 73 drama 84, 92, 98-101 Geometric period 67, 70–73 Hellenistic period 84, 105–11, 314 literature 69, 81, see also Homer music 81, 91, 104-5 Orientalizing period 67, 73–74 philosophy 81, 84, 101–4, 111 religion 67–70 sculpture 71–72, 73, 75, 79–81, 90–92, 93–97, 101, 102, 105, 109-11, 314 vase painting 57, 70–71, 71, 74, 74–76, 75–77, 97, 97–98 Greek cross 174 Gregorian chant 243, 253, 279 Gregorian chant 245, 255, 279
Gregory the Great, Pope 234, 243
Gregory XV, Pope 365
Gropius, Walter 584, 584–85
Gruatemala 270, 272–23, 223, 224
Gudea of Lagash: statues 22, 22
Guelphs 278, 290
Guernica 3, 3, 552–53, 553
Guerrilla Girls 602, 603
Guergebiem Museum, New York Guggenheim Museum, New York 588, Guicioli, Contessa Teresa 452 Guido d'Arezzo 243 guilds, medieval 240, 290, 336 Guinevere 253 Guo Si 211 Guo Xi 210–11, 211 Gupta empire (India) 197, 199 cave paintings 198, 198 sculpture 197, 197–98, 198 Gutai Art Association 583 Gutenberg, Johann 293, 309 Habsburg dynasty 343–44 Hades/Pluto (deity) 67, 120 hadith 178 Hadrian, Emperor 107, 125, 130, 136 Hagesandros 110, 110 Hagia Sophia 166, 167, 171, 172, 173,

. 173, 177 Haida, the 229, 230, 230 haiku 517

hajj 179

Hals, Frans 376, 376-77, 463 Hammurabi, Assyrian king 25 Code of 25, 25–26, 31 Han dynasty 202, 208–9 Handel, George Frederick 365, 391–92 391–92 Hangzhou, China 212 Hannibal 118 happenings 594, 596 Harappa 190 Harding, Warren G. 540 Hardouin-Mansart, Jules 389, 389, 390 Hardwick Hall, Derbyshire 356, 356 - 57harem paintings 443
Harlem Renaissance 540
harmonic structure 11
harmony (definition) 10
Harold of Wessex 244, 244 harpsichords 361, 393, 393, 455 Harvey, Sir William 350-51 Hathaway, Anne 359 Hathor (deity) 34, 36 Hatshepsut, Queen 45–46, 52 temple of 45, 45, 46 Haussmann, Georges Eugène 476 Havel, Ambroise 266 Havel, Vaclav 612 Hawkins, Gerald 229 Hawthorne, Nathaniel 349, 472 Hayden, Colonel Ferdinand V. 447 Haydn, Franz Joseph 428-29, 454 Hebrews 146–48, see Judaism Hector 72, 73 Hegel, Georg Wilhelm 419 Hegira 177 Heian period (Japan) 213–14, 215 Heine, Heinrich 456, 459 Helen of Troy 65 Helladic culture see Mycenaean culture Hellenistic period see Greece, ancient Helms, Senator Jesse 346 Hemingway, Ernest 527, 537, 540, 547, 552 henges 18 Henry II, of England 245, 252 Henry II, of France 292 Henry IV, of France 257, 292, 382 Henry VII, of England: chapel of 266, 267 Henry VIII, of England 344, 344-45, 353–54, 356 Hepburn, Audrey 549 Hephaistos/Vulcan (deity) 68, 120 Hera/Juno (deity) 67, 68, 69, 77, 120 Herakleitos 81 Herakles/Hercules 69, 109, 314 Herculaneum 126, 137, 420 Hercules see Herakles Herder, Johann Gottfried 453 Hermes/Mercury (deity) 68, 120 Herod, King 176 Herodotus 11, 29, 37, 85, 114, 293 Hesiod 69 Hestia (deity) 67 Hideyoshi, shogun 515 hieroglyphics, Egyptian 35, 35–36, 36, Hijrah 177 Hijuelos, Oscar 611 Hillipetos, Oscar 611 Hikari, Oe 519 Hilda, Abbess 237 Hildegard of Bingen 253 Himeji Castle, Japan 515, 515 Hinduism 190–91, 194, 197, 199 caste system 191, 199 literature 191–93, 200 music 201 sculpture 190, 200, 200 temples 199–200, 200 Hirohito, Emperor 576, 577 Hiroshige Ando 482 Hiroshima, bombing of 577 historians, Greek 85, 87, 96 history 9, 11 Hitler, Adolf 333, 470, 551–52, 553, 576, 577, 584, 585 Hobbes, Thomas 396, 396, 403, 449 Hodges, C. Walter 360 Hogarth, William 411-12, 412, 415

Hokusai Katsushika 505, 514, 514 Holbein, Hans, the Younger 344, 353, 353 - 54Holland see Netherlands, the "Holmes, Sherlock" 450 Holy Roman Empire 237–43, 254, 290, 400 Homer: *Iliad* and *Odyssey* 8, 24, 58, 64-65, 70, 72-73, 77, 84, 98, 104, 107, 293, 441, 548
Homer, Winslow 466, 468, 468 bomo sapiens 14 homosexuality 486 Honduras 220, 222 Hong Kong 510 Honorius, Emperor 166 Hooch, Pieter de 375–76, 376 Hoover, Herbert 540 Hopi, the 230 Hopper, Edward 555-56, 556 Horace (Quintus Horatius Flaccus) 120, 142, 310 Horta, Victor 493, 493 Horus (Ra) (deity) 40, 41, 44, 45 Horyu-ji, Japan 213, 213 Houdon, Jean-Antoine 424-25, 425 Houses of Parliament, London 448, 448-49 Hsieh Ho 610 Hsi-wen 511 huacas 226 Hubble Space Telescope 397 hubris 68 Hugo, Victor 249, 455, 456, 457 humanism 292-94, 308, 309, 314, 345-46, 358 rational humanism 403–4 Hundred Years' War 254, 256, 280 Huns 197 Hydra 69 Hydra 69 Hyksos, the 45 hymns 161–62, 314–15, 453 chant 10, 161, 243, 253, 279–80 "Hymn to the Sun" 53–54 Lutheran 346, 392-93 iambic pentameter 359 Ibn Sa'id 186

Ibsen, Henrik 485, 527, 588 Ibsen, Henrik 485, 527, 588 iconoclasm 168, 174, 183, 344–45, 346 iconography 5, 177, 275, 338, 341 iconophiles 173–74 iconostases 523, 525 icons 168, 175, 175, 177 Russian 522–23, 523, 525 Ictinus see Iktinos idée fixe 455 ideograms 19 Iktinos 7, 88, 89 Iliad see Homer imagines (deathmasks) 122-23 Imhotep 38, 38 Impressionism 479 music 484, 485 painting 476–83, 494, 513 Inca culture 227, 227–28, 228, 569 Incarnation 161 India 106, 109, 190 architecture 189, 196, 196, 199, 199-200 Gandharan art 109, 109 Gupta era 197-98 Mauryan period 193, 195–96 Mauryan period 193, 195–96 religions see Buddhism; Hinduism; Islam; Jainism sculpture 109, 109, 190, 195–96, 197–98, 200 Vedic period 190 Indus River 106, 177, 190 Industrial Revolution 404-5, 460 Ingres, Jean-Auguste-Dominique 419, 442, 442–43 Innocent VIII, Pope 315 insulae 127 International Style architecture 584–86 Internet 612 Ionic order 87, 87-88, 90, 93, 121 Irish literature 536, 547, 548, 589 Irish manuscript illumination 234,

235-36, 236

Isaac 146, 149, 176 Isabella, Queen see Ferdinand Isaiah, prophet 148, 150 Ishtar Gate, Babylon 28, 29, 29 Isidorus of Miletus see Hagia Sophia Isis (deity) 36, 160 Islamic (Muslim) civilization 166, 177, 178, 179 architecture 167, 168, 177, 181-84 archtecture 161, 168, 171, 181–84 ceramics and miniatures 184, 186, in India 197, 199 literature 184–86, 274 music 177, 186–87 philosophy 180 religion 11, 151, 177–80 sculpture 249 in Spain 165, 177, 180, 181, 181, 187, 183, 184, 237, 274 Israel (patriarch) see Jacob Israel/Israelites 144, 146, 148, 589 Istanbul see Constantinople; Hagia Sophia Italy 234, 288, 290, 548, 550–51 architecture 168, 248–49, 268–69, 298–301, 321–22, 333, 365–68, 369-70 Byzantine art 168, 170, 173-75 humanism 292–94, 309 literature 284–85, 291, 309–10, 326–28, see also Dante music 243, 306–7, 326, 374–75, 456-57 painting 281–84, 301–8, 310–14, 315–16, 319–21, 323–25, 328–31, 370-74, 500-1 science 394, 396, 397 sculpture 281, 294–98, 317–19, 332–33, 367–69 World War II 577 see also Etruscan civilization; Florence; Roman Republic and Empire; Rome Ivan III, Grand Prince 524 Ivan IV, Tsar ("the Terrible") 522, 525

Izanagi and Isanami (deities) 212 Jacob 146, 148, 149 Jaguar gods and kings 223–24 Jainism 190, 191, 193 jamb figures, Gothic 269, 269-70 James I, of England 150 James II, of England 190 James II, of England 395 Jami 184, 184 Japan 212, 214, 504, 512, 516, 577, 578, 579 architecture 213, 217, 514–15 Ashikaga period 216–17 Buddhism 197, see Zen Buddhism gardens 515–16, 526 Heian period 213-14, 215 Kamakura period 215-16 literature 213–14, 516–18 music 517, 519 painting 214, 215, 512–13, 583 painting 214, 217, 312–15, 363 religion see Zen Buddhism; Shinto sculpture 213, 213, 545 tea ceremony 217, 217 theater 513, 518–19 woodblock prints 471, 482, 483, 513-14 World War II 576-77 Jataka 198, 199 jazz 10, 560-61, 568 Jean de Jandun, Master 265 Jeanne-Claude 596, 596 Jefferson, Thomas 327, 416, 424, 426–27, 427, 433, 433, 447 jen 205 Jeremiah, prophet 148 Jerome, St. 150 Jerusalem 148, 176, 176, 246 Jesuits 217, 365, 393, 608 Jesus Christ 151–52, 158, 159–60, 161, 162, 165, 176 Jesus the Good Shepherd 156, 156–57 jewelry: Celto-Germanic 234 Egyptian 44–45 Jewett, Sarah Orne 484 Jews 146, 274, 333, 379

ghettos 333, 379 Vazi genocide 552, 577, 579 Russian 533 see Judaism see Judaism
Job, Book of 149, 150
John, St.: Gospel 151, 160–61, 235
John the Baptist 151, 265
John of the Cross, St. 365, 439
John, king of England 245
John II, of France 256 Johnson, Dr Samuel 414, 432 Jones, John Paul 424 Jonson, Ben 359 Joplin, Scott 560 Joshua 148 Josquin des Près 314–15, 325–26 Jove see Jupiter Joyce, James 527, 547, 548 Juan Carlos, king of Spain 553 Judaea 151, 152 Judah 148 Judaism 146–51, 161, 177 Judd, Donald *594*, 595 Juko, Murata 217 Julia (Caesar's daughter) 119 Julian, Emperor 15. Julian Choir (*Cappella Giulia*) 315, 326 Julius II, Pope 314, 314, 315, 315, 316, 319, 321, 325, 327, 333, 343, 344, 365 Jullienne, Jean de 408 July Monarchy (France) 458 Jun'ichiro, Tanizaki 518 Juno/Hera (deity) 67, 68, 69, 77, 120 Jupiter/Zeus (deity) 120, see Zeus Justinian, Emperor 164, 166, 168, 169, 170, 171 Jutes 166, 234 Juvenal 114, 127

ka 36, 37, 41, 43 Ka 36, 37, 41, 43 Ka-Aper (statue) 42, 42 Kabuki theater 513, 518–19 Kahlo, Frida 570, 571, 571–72 Kali (deity) 191 Kallikrates 7, 89, 89, 93 Kamakura period (Japan) 215–16 Kandariya Mahadeo temple 200, 200 Kandinsky, Vassily 501, *502*, 503, 529 Kant, Immanuel 449 Kant, Immanuel 449
Kaprow, Allan 594
karma 191, 192
Karsavina, Tamara 528
Katsura Palace gardens 217, 217
Katsushika, Hokusai see Hokusai
Kauffmann, Angelica 421–22, 422
Kazuo, Shiraga 583 Keats, John 451-52, 456, 458 Kekrops 93 Kennedy, John F. 576, 593 Kent, William 425, 425, 433 Kenzaburo, Oe 516 Kepler, Johannes 394 Kerouac, Jack 598 keys, musical 11 keystone (definition) 7 Khajuraho, India 200, 200 Khajuraho, India 200, 200 Khamerernebty, Queen see Mycerinus Khrushchev, Nikita 530, 531–32, 533 Kierkegaard, Søren 579 Kiev 522, 523, 533 Kingston, Maxine Hong 610 Kinkakuji, Kyoto 514–15, 515 Kinsey Report 590 Kiowa, the 611 kivas 230, 230 Klosterneuberg Abbey 252, 252 Knossos 58, 60, 60–63, 61, 62, 63 Kofun period 212 Kojiki 212 Kojiki 212 Komar, Käthe 536, 536 Komar, Chris 595 Kooning see de Kooning korai 79, 80, 80–81 Koran see Quran Korea 197, 212, 512, 555 kouroi 79–80, 80 Kovich, Robert 595

kraters 71, 71, 76, 77 Kremlin churches, Moscow 523, 524, 524-25 Krishna 191, 192 Krisnna 191, 192 Kritios Boy 94, 94 Kritzky, Gene 470 Kroc, Ray 576, 590, 590 Kronos 67, 69 Kshatriyas 191, 193 Kublai Khan 506 Kun opera 511 Kuniyaki II 482 Kwakiutl, the 229 Kwei, Kane *566*, *567* Kyoto 217, *217*, *512*, *514–15*, *515*, 516, 516 labor camps, Russian 531, 532 La Cruz, Sor Juana Inés de 393 Laguna, the 611 lais (lays) 252 Lake Shore Drive Apartment Houses, Chicago 585, 585 Lakshmi (deity) 190, 191 Lam, Wilfredo 572, 572 La Madeleine, Paris 425–26, 426 Lancelot 253 Lander, Colonel Frederick 447 Lange, Dorothea 554, 554 Langland, William: Piers Ploughman 162 languages 8 African 565 Akkadian 24 Arabic 184, 185, 186 Aramaic 150 English 150, 234, 245 Greek 100 Latin 167, 284 Occitan 252 Sanskrit 190, 191 Tuscan 284, 285 and structuralism 602 see also writing lantern construction 298 Laocoön 109, 110 Laocoön and His Sons 110, 110-11, 314, 368 Laozi 206, 207 Lapith and centaur metope 90, 90 Lapitin and centaur metope 90, 90
Lascaux: cave paintings 14–15, 15
Latin America 562, 569
literature 393, 572–73
music 572, 573
painting 569–72
see also Mexico La Venta: heads 220, 220 law codes: Greek 84, 86 Hammurabi 25, 25-26, 31 Napoleonic 419 Lawrence, David Herbert 536 Lawrence, Jacob 556–57, 558 Le Brun, Charles 388, 388, 389, 389, Le Corbusier (Charles Édouard Jeanneret) 585, 585-86, 586 Leda 68 Leeuwenhoek, Anton van 393-94 Legalism 208 Leibniz, Gottfried Wilhelm 404, 415 leitmotifs 458 lekythoi 97, 97–98 Lenin, Vladimir Ilyich 528–29, 530, 531, 532 Le Nôtre, André 389, 432 Le Notre, André 389, 432 Leo III, Pope 237 Leo X, Pope 292, 315, 321, 325, 343, 344, 347, 364 Leonardo da Vinci 310–14, 311, 312, 313, 316, 318, 319, 324, 327, 328, 380, 538 Leonides 85 Léonin 279-80 Lepidus 120 Le Tuc d'Audoubert: bison 15, 15-16 Le Vau, Louis 388, 388, 389, 389, 432 Leviticus 147, 148 Levy Oinochoe 74, 74 LeWitt, Sol 595-96, 596

Leyster, Judith 377, 377 li 205 Liang Kai 210 Li Bai (Li Po) 209, 210, 210 libraries 106, 107, 180 Bibliothèque Nationale 257 Laurentian 333, 333 Vatican 314, 314 Lichtenstein, Roy 593, 593 Lieder 454, 455, 456, 538 Life magazine 555 Limbourg brothers 256, 256–57, 280, 336, 355 Limoges: enamel 251, 251, 252 Saint-Martial 246 Saint-Martial 246 Lin, Maya Ling 608–9, 609 Lincoln, Abraham 447, 466 Lindau Gospels 241, 241–42 Lindbergh, Charles 540 Lindisfarne Gospels 235, 235 line (definition) 5 Linear A and Linear B scripts 58 linear perspective 5, 177, 296 Linnaeus, Carolus 405 Lippi, Fra Filippo 305 Lisbon earthquake (1755) 415 Lissitzky, El 529–30, 520, 532, 532 Liszt. Franz 455 literature 8-9 African 568 Akkadian 24 American 398, 450, 453–54, 472, 484, 537, 547, 548–49, 557–58, 598, 609–11 Baroque 396-99 Beat 598 British 236-37, 397-99, 414-15, 427-28, 450-52, 472, 536, 548, see also Shakespeare Carolingian 238 Chinese 207, 209–10, 510–11 Egyptian 53–55 feminist 609, 615 French 238, 252–53, 286–87, 358-59, 415, 470-72 German 452-53, 456, 534, 536, 537 Greek 69, 81, see also Homer Indian 198-99 Indian 198–99 Irish 536, 547, 548, 589 Islamic 184–86, 2/4 Italian 284–85, 291, 309–10, 326–28, see also Dante Japanese 213-14, 516-18 Latin American 393, 572-73 modernist 547-49 naturalist 484 realist 284-85, 470-72, 527 realist 284–83, 470–72, 527 Renaissance 326–28 Roman 54–55, 114, 120–21, 124, 127, 142–43 Romantic 450–54, 456 Russian 526–27, 532–33 Spanish 185–86, 399 Sumerian 23-24, 27 Symbolist 484–85 liturgical music 10, 162 Liu Lang 210 Livia 124, 132, 132, 134 Locke, John 396, 403, 405 logic 103-4 Loire Valley 356, 356 London 414 Chiswick House 425, 425, 426, 433 Crystal Palace 469, 469 Globe Playhouse 359-60, 360 Great Fire 390, 414 Houses of Parliament 448, 448-49 St. Paul's 389-91, 391 Westminster Abbey 266, 267, 268 long galleries 356 Long, Richard 613, 615 looms 404, 404 Lorenz, Konrad 470 Lorrain see Claude Lorrain Los Angeles: mural 606-7, 607 lost-wax casting 200, 226 Lott, Willy 444 Louis VII, of France 245 Louis IX (Saint), of France 256, 265

Louis XII, of France 326 Louis XIII, of France 382, 442, 442 Louis XIV, of France 257, 364, 375 387-88, 389, 402, 402, 405, 407, 416 Louis XV, of France 407, 408, 409, 410, 416 Louis XVI, of France 402, 416, 417, 418, 426 Louis Napoleon Bonaparte 461 Louis-Philippe, of France 458, 459 Louisiana Purchase 447 Louisville Flood 555, 555 Louvre, Paris 256, 256–57, 257, 388, 388 89, 407, 417, 418, 421 love poetry see lyric and love poetry Loyola, St. Ignatius 331, 365, 373–74, 374 Lucretius 124 Ludwig II, king of Bavaria 458 Luke, St.: Gospel 160, 235 Luther, Martin 163, 346–48, 347, 349, 353, 364, 393 Luxor 46, 46–47, 47 Luzarches, Robert de 263 lyric and love poetry: Chinese 207 Egyptian 53-55 Islamic (Spanish) 185-86, 274 Persian 185 Roman 142 Romantic 451 Lysippos 96-97, 97 MacArthur, General Douglas 578 McDonald's 576, 589, 590, 590 Macedonia 84, 105–6, 118, 536 McEvilley, Thomas 612 Machaut, Guillaume de 287 Machiavelli, Niccolò 327–28 Machu Picchu, Peru 219, 228, 228 Maderno, Carlo 322, 323, 365–66, 366 Madrid 553 madrigals 287, 357-58 Magellan, Ferdinand 349 Maghreb, the 564, 565 magic realism 573 Magicians of the Earth 612-13, 613, 615 Magna Carta 245–46 Mahabharata, The 192–93 Mahadeviyakka 200 Mahavira 193 Mahayana Buddhism 197 Mahler, Gustav 454 Malevich, Kazimir 529, 529, 532 Mallarmé, Stéphane 484, 485, 491 Mallia 60 Mandela, Nelson 565 mandorla 249 Manet, Édouard 439, 463–65, 464, 468, 471, 472, 477, 477, 482, 494 Manet, Eugène 477, 480 Manetho of Sebennytos 35 Manicheism 162 Mann, Thomas 536 Mannerism 328, 369 architecture 333 painting 328–31, 365 sculpture 332 Mantua: dukes of 326, 327, 374, 380 Sant'Andrea 299, *300* manuscript illumination 235 Carolingian 241–43 Irish 234, 235-36, 236 Islamic 186 medieval 256–57, 272, 280, 336 Mao Zedong 511, 512 Mapplethorpe, Robert 346 Marat, Jean-Paul 421, 421 Marathon, battle of 85, 96

Marcel, Étienne 256

Marduk 106 ziggurat of 28, 29

Margaret, of Austria 326

Margarita, Infanta of Spain 384

Marcus Aurelius, Emperor 125, 126

Marie Antoinette 402, 402, 407, 411, 416, 418, 419, 421 Marie de Champagne 252 Marie de France 252–53 Marinetti, Filippo 500 Marius, Gaius 118 Mark, St.: Gospel 160, 235 Mark Antony 120 marketing 602 Marlowe, Christopher 359 Mars/Ares (deity) 67, 120 Marshall Plan 577–78, 584 Martin, Jean-Hubert 612, 615 martyrs, Christian 152 Marx, Karl 460–61, 472, 528 Mary see Virgin Mary Mary I, of England 345 Mary of Hungary 343, 344 Masaccio 301, 301–3, 302, 304, 306, 311, 317 masks: African 566, 566-67, 567, 572 Mycenaean 66, 66, 67 Roman 122-23 mass (definition) 5 mastabas 38 materialists, Greek 81, 111 mathematics and geometry 81, 103. 105, 222, 309, 351 Mather, Cotton 349 Matisse, Henri 495, 495–97, 496, 499, 528 Matthew, St.: Gospel 152, 160, 235 Mau, Augustus 137 Maupassant, Guy de 485 Maurice of Sully, Bishop 259 Mauryan perlod (India) 193, 195–96 Maxentius, Emperor 136 Maximian, Emperor 126 Maximilian I, Holy Roman Emperor 327, 353 maya 192 Mayan civilization 220, 222–24, 223, 224, 349, 569 224, 349, 569
Mazarin, Cardinal 390
Mecca 177, 179, 181
Medici, the 290–91, 291, 308, 319, 327, 328, 336
Catherine de' 292
Cosimo de' 291–92, 293, 300, 301, 332 332 Giovanni di Bicci de' 291 Giuliano de' 328 Lorenzo de' (the Magnificent) 292, 292, 293, 294, 305, 306–7, 311, 317 Lorenzo di Pierfrancesco de' 305 Lorenzo, Duke of Urbino 328 Maria (Marie) de' 292, 364, 382 Piero de' 292 medicine 280, 350-51, 393-94, 472 Medina 17 medium (definition) 4 Medusa 69 megaliths 18 Meiji era (Japan) 512, 517–18 melody (definition) 10 Melozzo da Forlì 314 Melville, Herman 349, 450, 472 Ménec Lines (menhirs) 18 Menes, King see Narmer menhirs 18 Mentuhotep II, of Thebes 43 Mercury/Hermes (deity) 120 Mesa Verde, Colorado 230, 230, 447 Mesoamerica 218, 220–25 Mesolithic period 16, 17 Mesopotamia 19-29, 146 Messiah, the 151 metaphor 100, 185, 225, 361, 573 metaphior 100, 185, 225, 361, 573 metaphysical poetry 453, see Donne Methodius, St. 522, 522, 523 metopes 87, 87, 90, 90 Mexica, the 224–25 Mexico 569, 570 architecture 302 architecture 393 literature 393 muralists 557, 559, 570–71 Olmec culture 220 Palenque 223, 223-24

Mexico - continued Teotihuacán 220-22, 221, 224 Toltec culture 224 see also Aztecs; Mayan civilization Michelangelo Buonarroti 1, 1, 314, 315, 316–19, 318, 319, 321, 321, 322, 322–23, 326, 328, 328, 330, 333, 333, 351, 365, 368
Michelozzo di Bartolommeo 300, micro-organisms 472 microscopes 393 Mies van der Rohe, Ludwig 585, 585 mihrab 181 Milan 234, 290 Cathedral 268, 269 dukes of 310, 311, 325 Edict of 136, 153 Santa Maria delle Grazie 312, 312 - 13military bands, Turkish 431 *mille-fleurs* tapestries 275, 275 Miltiades 85 Milton, John 72, 161, 346, 349, 398-99 Minamoto Yoritomo 215 Minerva/Athena (deity) 120, see Athena Ming dynasty 506-8 miniature painting, Persian 184 minimalism 589, 591, 594–96 Minoan culture 58, 59–64, 65, 77 Minotaur, myth of the 62 minuet 428 Miró, Joan 541-42, 542 Mithras, cult of 160 Mnesikles 83, 88, 88, 93 mobiles 544, 544–45 Moche culture 226, 226-27, 229 Modernism 476, 527, 545-50 modes, Greek 105 Mohammad V 184 Mohenjo-Daro 190 Moissac cathedral 249 Molière 397 Momaday, N. Scott 611 Momoyama era (Japan) 514, 515 monasticism and monasteries 238, monasticism and monasteries 238, 240–43, 253, 276, 344–45, 356 Mondrian, Piet 539, 539–40, 540, 555 Monet, Claude 7, 477, 478, 478–79, 479, 480, 482, 485, 494, 501 Mongols 187, 190, 506, 525 Monk's Mound, Illinois 231 monoliths 18 monophony 243 monotheism 146, 177 Monroe, Marilyn 592, 593 montage 531 Montaigne, Michel de 332, 358-59 Monte Cassino 238, 240 Montefeltro, Federico da, Duke of Urbino 303, *304*, 326–27 Monteverdi, Claudio 374, 456 Montezuma Ilhuicamina 225 Montezuma II 228, 293 Monticello, Charlottesville, Virginia 426–27, 427, 433, 433 Montreuil, Pierre de 264 Moore, Henry 543–44, 544 morality see ethics and morality Moran, Thomas 447, 447 More, Sir Thomas 346 Morgan, Richard 230 Morisot, Berthe 477, 480–81, 481, 495 Morley, Thomas 287, 358, 361 Morocco 443, 552 Morrison, Toni 610–11 mosaics Byzantine 170, 170-71, 171, 173, 174, 174–75, 175 early Christian 145, 156, 156 Mosan enamel 252, 252 Moscow 522, 524, 524–26, 525, 526, 529, 555, 590 Moses 147, 148 mosques 168, 176, 176, 179, 180, 181–83, 181, 182, 183 motets 308, 309, 326 Motna, Erna 613, 614, 615 moundbuilders, American 230-31, 231

movies see films Mozart, Leopold 429 Mozart, Maria Anna 429 Mozart, Maria Anna 429
Mozart, Wolfgang Amadeus 428,
429-30, 430, 431, 454, 456-57
mudras 197-98, 198, 200
muezzins 179, 181
Muhammad, Prophet 177, 178, 181
Muhammad of Ghur 199 Mumma, Gordon 595 Mumma, Gordon 595 mummification, Egyptian 36–37 Mumtaz Mahal 199 Munch, Edvard 5–6, 6 Mundy, Peter 375 murals see frescoes; wall paintings Murasaki Shikibu: *Tale of Genji* 213–14, 516, 518 Muromachi period (Japan) 512-13, Muses 98 music 2, 9-11 African 567–68 American 558–61, 590–91, 598–99 Andalusian 287 Andausian 287
Baroque 365, 374–75, 391–93, 455
British 287, 357–58, 361, 391–92
Chinese 207, 511, 512
Classical 428–32, 454 early Christian 161-62 Egyptian 50 Egyptan 50 Flemish 325–26 French 11, 279, 287, 308, 309, 455, 477, 484, 485, 528 German 253, 375, 391–93, 430–32, 453, 454, 455, 456, 457–58 Greek 81, 91, 104–5 Impressionist 484, 485 Indian 201, 201 Islamic 177, 186–87 Japanese 517, 519 jazz 10, 560–61, 568 Latin American 572, 573 liturgical 10, 162 medieval 243, 253, 279–80, 287 minimalist 590–91 Renaissance 306–7, 308–9, 314–15, 325-26 Romantic 452, 454, 454-58 Russian 498, 503, 527-28, 533, 549-50 Sufi 186 twentieth-century 503, 549–50, 558–61, 572, 573, 590–91, 598–99 musical instruments 10, 454 guitars 572 harpsichords 361, 393, 393, 455 lyres 23, 23, 24, 50, 361 pianos 454, 455 sitars 201, 201 sixteenth-century 361, 361 musical theater 10 Muslims see Islamic civilization Musset, Alfred de 456 Mussolini, Benito 548, 550–51, 552 Mussorgsky, Modest 527, 528 muwashshah 186 Muybridge, Eadweard 466, 467, 468 Mycenae 58, 64, 65, 65–66, 67 Mycenaean culture 58, 64–67, 70 Mycerinus, pharaoh: Mycerinus and Khamerernebty 41-42, Pyramid 39, 39-40 mystery plays 240 mystics/mysticism Indian 200 Sufi 179–80 myths 8, 24, 27, 602

Naram-Sin, Akkadian king 24 stele 25, 25, 26 Narmer, king of Egypt 34, 36 Palette of Narmer 34, 34–35 narrative/narration 9, 295 narthex 153 Nasirid dynasty 183 Nasser, President Gamal 37 Native Americans 11, 220, 229-31 literature 611 netrature 011 painting 2, 607–8 "natural law" 114 naturalism 280, 281–84, 471–72, 484–85, 503 nature, portrayal of: Chinese 211 Japanese 514 realist 461 Renaissance 303, 304, 351 Romantic 438, 443-47, 449-50, 451, 452 Navajo, the 2 naves 153 Nazcas 228 Nazca lines 229, 229 Nazis 529, 550, 551-52, 571, 572, 577, Neanderthals, the 14 Nebuchadnezzar II, of Babylon 29, 148, 176 Nefertiti, Queen 51, 51–52, 52 "negative capability" 451–52 Nehemiah, Book of 149, 150 Neo-Babylon 29 Neo-Confucianism 210-11 Neo-Plasticism 539 Neoclassicism 403, 436 architecture 425-27 gardens 433 painting 419-24 Painting 717–27 sculpture 424–25, 447 Neolithic period 16, 17–18 Neoplatonism 162, 293–94, 298, 305, 306, 307, 316, 318, 321 Neptune/Poseidon (deity) 67, 92, 93, 120 Neri, St. Philip 365, 371 Nero, Emperor 125, 127, 129, 153 Nerva, Emperor 125 Netherlands, the 336, 375
painting 341–42, 375–80, 539–40,
see also Gogh, Vincent van
science 393–94
neumes 243 Nevelson, Louise 591–92, 592 "New Deal" 554, 581 New Testament 28, 151–52, 159–61 New York 148, 538, 545, 571 Guggenheim Museum 588, 588 Statue of Liberty 469, 469–70 New York City Ballet 528 New York Philharmonic Orchestra 598 New York Philiarmonic Orch Newton, Sir Isaac 6, 405 Nicene Creed 153 Nicholas II, Tsar 528, 530 Nicholas V, Pope 314, 315 Nicholas of Ely 266, 266 Nicholas of Verdun 252, 252 Nietzsche, Friedrich 487 Nigeria 565, 568; see also Yoruba Nijinsky, Vaslav 528 Nike of Samothrace 110, 110 Nikias 76, 76 Nile, River 35, 36, 37, 43, 47 Nîmes: Maison Carrée 426 Pont du Gard 113, 122, 122, 129 Nineveh 26, 28, 28 Ninhursag (deity) 20, 24 nirvana 194 Nixon, Richard M. 576

Notre-Dame, Amiens see Amiens Notre-Dame, Chartres see Chartres Notre-Dame, Paris 256, 259–60, 260, 263, 270–71, 271 School 276, 279–80 Notre-Dame, Reims see Reims Notre-Dame-du-Haut, Ronchamp 586, 586 Nouilles, Viscount of 417 novels 8, 213–14, 397, 427–28, 452, 470–72, 516–17, 526–27, 557–58, 568, 573, 610–11 numerology 262, 321 Nuremberg 336 "Laws" 552 Nureyev, Rudolf 528

Oba heads 565, 565-66 obelisk 367 Obregón, Alvaro 570 obscenity 346 Occitan 252 Ockham, William of 276-77 O'Connor, Flannery 558 Octavian see Augustus, Emperor oculus 130, 131 odes 142 Odessa, Russia 530-31 Odo of Metz 237-38, 238 Odo of Metz 237–38, 238
Odoacer, king of the Goths 166
Odysseus 70, 72, 73
Odyssey see Homer
Oedipus 100–1
Offenbach, Jacques 477
Ohio Valley 230, 231, 231 oil painting: Flemish 336 Flemsh 336 Venetian 323–24 oinochoe 74, 74 O'Keeffe, Georgia 6, 535, 546, 546–47, 603 Okosun, Sonny 568 Old Testament see Bible, Hebrew Oldenburg, Claes 593, 593–94 Olduvai Gorge 14 Olivares, Gaspar de Guzmán, Count of 384 Olmec culture 220, 220 olpe 74, 74 Olson, Charles 594 Olympic Games 96, 104-5 Olympus, Mount 68 ome 328 opera 10, 374, 391, 429–30, 430, 454, 456–57, 457, 458, 511–12 opisthodomos 89 Opium War 509, 510 oral literature 8 Oratorians 365, 371 oratories 365 oratories 391–92 orchestras 429, 454 orders, Greek architectural 78–79, 87, 87–88, 89, 90, 93, 107, 121, 122

organum 279
Orientalism 443
Orientalism 443
Orientalism period (Greece) 67,
73–74
Orléans, Philippe, duc d' 407
Orozco, José Clemente 571
Oseberg burial ship 234–35, 235
Osiris (deity) 36, 48
Ottomans 177, 431
Ouranos (deity) 67, 69
"Outcastes" 191
Ovid 142–43, 310, 373
Oxford University 276
Pacal, king of Palengue 223–24, 22

Orestes 99

Pacal, king of Palenque 223–24, 224 Padua: Arena Chapel frescoes 284, 284 Paestum: Temple of Hera I 77, 78, 78, 79 Page, Steven 430

Paine, Thomas 414, 418
painting (see also wall paintings):
Aboriginal 612–13, 615
abstract expressionist 580–82, 583
American see United States
Baroque 365, 370–74, 375–88

British see Britain Byzantine 175, 177 Chinese 210–11, 506–8 Color Field 582–83 Cubist 489, 497–500 Cycladic 59 Dada 537–38 De Stijl 539–40 Dutch see Netherlands Egyptian 43, 48-50 Fauvist 495-97 feminist 602-5 Flemish 336–43, 354–55, 375, see also Rubens French see France Futurist 501 German see Germany Greek and Hellenistic see vase painting Impressionist 476-83, 494, 513 Islamic 184 Islamic 184 Italian 281–84, 328–31, 370–74, 500–1, see also Renaissance below Japanese 214, 512–13, 583 Latin American 569–72 Mannerist 328-31, 365 Mexican 559, 570-71 Minoan 62-63 Neoclassical 419-24 Post-Impressionist 487-91, 494 prehistoric 14–15, 17–18 realist 304, 339, 458–60, 461–5, 466, 468 406, 468 Regionalist (USA) 555–57 Renaissance 301–7, 310–14, 315–16, 319–21, 323–25, 343–44 Rococo 407–14 Roman 126, 137-40 Romantic 436-47 Russian 501-3, 522-23, 529-30, 532 Spanish see Spain Suprematist 529 Surrealist 540–42, 553 Pakistan 106, 199 Palace Style ceramics 63, 63-64 Palazzo Farnese, Rome 373, 373 Palazzo Medici-Riccardi, Florence 300, 300–1, 317 Palenque, Mexico 223, 223–24 Paleolithic period 14–16, 16 Palestrina, Giovanni da 326, 365 Pallava dynasty 199 Palmer, Samuel 450 Pan Athenaic Festival/Games 76, 76, 86, 91, 96 Pancatantra 198-99 Pandora 68 Pantheon, Rome 130, 130-31, 390 papacy 308, 314–15, 315, 323, 343, 347, 364, 365, 366, 368, 394 and the Medici 291, 292 see also Julius II; Leo X papyrus scrolls 48 parables 152
Paris 256–57, 405, 461, 476, 480, 485, 486, 612
Arc de Triomphe 448, 448
Eiffel 'lower 485, 486
Hôtel de Soubise 406, 407
La Madeleine 425–26, 426
Louvre 256, 256–57, 257, 388, 388–89, 407, 417, 418, 421
Notre-Dame 256, 259–60, 260, 263, 270–71, 271
Notre-Dame School 276, 279–80
Pompidou Center 384 parables 152 Pompidou Center 584 Saint-Denis 259, 259 Sainte-Chapelle 256, 264, 265, 274, salons 407 University 276, 380
Parker, Charlie ("Bird") 606
Parmigianino 328, 330, 330, 332
Parthenon see Acropolis
Pasternak, Boris 532 Pasteur, Louis 472 patriarchs, Hebrew 146-48 patricians 118 Paul, St. 152, 157, 160, 161, 163, 345 Paul II, Pope *315*

Paul V, Pope 323, 365, 394 Pax Romana 124-25, 126, 132 Paxton, Joseph 469, 469 Pearl Harbor 577 pediments 78, 78 Pei, I. M. 257 Peloponnesian War 70, 87, 88, 101 pendentives *172*, 173 percussion instruments 10, 361 Pergamon 106, 107, 109 Altar of Zeus 108, 109–10 Perikles 86-87 peripteral 121 peristyle 78, 78, 89 Pérotin 279–80 Perrault, Charles 388, 388 Perry, Commodore Matthew 482, 504, Persephone/Proserpina (deity) 120 Persepolis 30, 30–31, 31, 195 Perseus 68–69 Persia/Persians 29-31, 45, 70, 73, 85, 86, 106 poetry 184, 184–85, 185 sculpture 29–30, 195 silk trade 169 perspective 4, 5 perspective 4, 3
atmospheric 5, 302, 339
linear 5, 177, 296, 296
Peru 225–26, 569, 570
Inca culture 227, 227–28, 228, 569
Moche culture 226–27, 228, 229 Nazcas 228, 229
Perugino 314, 315
Pétain, Marshal Henri 576
Peter, St. 153, 157
Peter the Great, Tsar 523–24, 527 Petipa, Marius 528 Petrarch (Francesco Petrarca) 285, 292-93, 294, 309-10, 323 Petronius 143 Petrucci, Ottaviano de' 309 Phaistos 60, 63 pharaohs, Egyptian 35, 39–40, 45 Phidias 86, 88, 89, 90 Phidippides 85, 96 Philip II (Philip Augustus), of France 245, 256, 257 Philip II, of Macedonia 105, 106 Philip II, of Spain 343, 344, 375, 384 Philip IV, of Spain 364, 375, 380, 382, 383, 384 Philip the Bold, duke of Burgundy 336 Philip the Good, duke of Burgundy 336, 338 Philippi, battle of 120 Philips, Thomas 452 philosophes 403, 405, 411, 419 philosophies and philosophers 11 aesthetics 3, 11 American 449-50 Baroque 394–96 British 276–77, 395–96 Christian 162–63, 275–77 deconstruction 602 Epicureanism 81, 111 existentialism 579, 588, 589, 594 French 394–95, 403, 415, 449, 602 German 419, 449, 457, 490–61, 472, Greek 81, 84, 101-4, 111 Islamic 180 Italian humanist 293–94 Roman 140–47 and Romanticism 449-50 Scholasticism 275–77 Stoicism 111, 114, 140–42 stoicisiii 111, 114, 140–42 structuralism 602 Phoenicia 58, 73, 118 photography 377, 465, 465–66, 466, 467, 482, 545–46, 554–55, 604, 604 Piano, Renzo 584 pianos 454, 455 picaresque literature 399 Picasso, Pablo 3, 3, 489, 495, 497, 497, 498, 499, 500, 500, 503, 528, 536, 536, 540, 541, 545, 553, 553, 572,

Pickford, Mary 549 Pico della Mirandola, Giovanni 294 pictograms/pictographs 19, 35, 36 Piero della Francesco 303, 303-4, 304, 313 Piers Ploughman (Langland) 162 pietà 318, 319 pietas 142 Pilate, Pontius 152 pilgrimage churches 246-49 Pill, the 590 pinnacles 258 Pisa: Cathedral group 248, 248–49, 280, 281, 281
Pisano, Andrea 269
Pisano, Bonanno 249 Pisano, Giovanni 281, 281 Pisano, Nicola 280, 281 Pisistratos 84 Pissarro, Camille 477 pitch, musical 10 pitboi 61, 63, 63 Pius II, Pope 291, 315 Pizan, Christine de 286, 286–87 Pizarro, Francisco 228 plague 126, 234, 280, 336 plainchant see chant Platina 314, *314* Plato 01, 90, 102, 102=3, 104, 103, 107, 162, 180, 207, 262, 293, 316, 345 see also Neoplatonism Plautus 124 Platitus 148
Pliny the Elder 96, 138, 433
plot (definition) 9
Plotinus 162, 293, 294 Plutarch 292 Pluto/Hades (deity) 120 Poe, Edgar Allan 472 poetry see epic poctry; lyric and love poetry Pointillism 490, 491 Poissy-sur-Seine 585, 585–86 Poitiers 252, 256, 271 Poland 349–50, 455, 456, 461, 534, Foliati 347–30, 433, 431, 431, 431, 576, 576, 577, 578
Pollock, Jackson 580, 581, 583, 596
Polo, Marco 212, 349 Polydoros of Rhodes 110, 110 Pompeii 126, 137–38, 138, 139–40, 140, 141, 420 Pompey (Gnaeus Pompeius Magnus) 119–20, 128 Pompidou Center, Paris 584 Pont du Gard 113, 122, 122, 129 Pontormo, Jacopo 328 Pop Art 591–94 pop culture 589–94 pop music 10, 11 Pope, Alexander 403, 414, 415, 433 portrait busts and statuary: Greek 101, 102, 105

Roman 122–23, 123, 131–32, 132, 135, 135–36

Portugal 276, 349, 509

Poseidon/Neptune (deity) 67, 92, 93, 135–36 120 Posnik (architect) 522, 525, 526 post and lintel system 7, 18, 37–38 posters, Russian 532, 532 Post-Impressionism 479, 487–91, 494 poststructuralism 602 potlatches 230 Prottery and ceramics 16
British (18th-century) 404
Greek 70–71, 74, 75–77, 97–98 Islamic 184, 184 Minoan 61, 63, 63–64 Moche 226, 226–27 Mycenaean 67

Sèvres 409 Pound, Ezra 210, 540, 547, 548

Poussin, Nicolas 375, 386–87, 387, 388, 407, 419, 420 poussinistes 388, 407, 419, 494 Pozzo, Fra Andrea 373-74, 374 Praxiteles 95, 95-96 precursor portal 269 predestination 163 Priam, King 72, 73 Prierias (theologian) 347 primary colors 6, 6, 478 Princip, Gavrilo 536 printing 293, 309, 347 prints see engravings; etchings;
Japanese woodblock prints Procopius 169 program music 454 55 Prokofiev, Serge 528 Prometheus 68 pronaos 89 propaganda art 532 Prophet, The see Muhammad prophets, Israelite 148 Propylaia see Acropolis proscenium arch 396 prose (definition) 8 Proserpina/Persephone (deity) 120 protagonists (definition) 9 Protagoras 84, 102 Protestantism 344-45, 346 Psalms 149, 150 pseudo-peripteral 121 psychiatry and psychoanalysis 437, 487, see Freud, Sigmund Ptolemies 84, 106
Ptolemy the Great 176
Ptolemy V 36
Ptolemy (astronomer) 18/, 190, 350, 398n p'u 207 Puebla, Mexico 393, 393 Pueblo Benito 230 Pugin, Augustus Welby Northmore 448, 448–49 Punic Wars 118 puppet theater, Japanese 518 Puritans 349 Pushkin, Alexander 527 pylons 47 pyramids: Egyptian 38-40, 54, 54 Louvre (glass) 25' Mesoamerican 221 Moche (Peru) 226, 226 Pyrrho 111 Pythagoras 81, 102, 105, 187 "Q" (Quelle) Gospel 160 gasidah 185 Qianlong, Emperor 510 Qin dynasty 207–8, 208 Qing dynasty 506, 508 Qiu Ying 507, 507–8 quadrivium 276 Quetzalcoatl, temple of 221 Qumran 150 Quran 151, 177–78, 179, 184, 187 Quwwat ul-Islam mosque, Delhi 199 Ra (Horus) (deity) 40, 41, 41, 45

Ra (Horus) (deity) 40, 41, 44, 45
Rabia al-Adawiyya 180
Racine, Jean 397
ragas 201
ragtime 560
Raimondi, Marcantonio 463
Ramaldo (architect) 249
Rama 192
Ramayana, Tbe 192
Ramayana, Tbe 192
Ramesses II, pharaoh 47
temple 48, 49, 54
Raphael 314, 315, 315–16, 316, 316–17, 317, 322, 327, 328
rasas 201
rational humanism 403–4
Rauschenberg, Robert 591, 591, 594, 595
Ravel, Maurice 11, 528
Ravena, Italy 166; see San Vitale rawi 184

realism 438 literature 284–85, 470–72, 526, 527 "magic" 573 painting 304, 339, 439, 458-60, 461–65, 466, 468 recitative 374 Redemption 161 red-figure vases 76, 76–77 reed instruments 10 refectories 241 Reformation 253, 345-49, 350 Regionalist painting 555-57 register system, Egyptian 34, 49 Reiche, Maria 229 Reims 287 Notre-Dame 270, 270, 274, 280 reincarnation 194 Relativity, Theory of 487 relics and reliquaries 11, 246, 251, 251, 256, 260, 262, 265 relief sculpture: Assyrian 26–28 Egyptian 34, 43, 48–49, 51 Greek 90–92 Italian 281, 294-96 Persian 31 Romanesque 249-51 religions 11 Aegean cultures 59, 64 Egyptian 36-37 Greek 67-70 Roman 120 Shinto 212, 215, 512, 518 Sumerian 19–20 Taoism 204, 206–7, 209, 210 Zoroastrianism 31, 162 see Buddhism; Christianity; Hinduism; Islam; Judaism; temples; Zen Buddhism religious literature 8 reliquaries see relics Remarque, Erich Maria 536 Rembrandt van Rijn 377–79, *378*, *379* Renaissance 290, 298 architecture 298–301, 321–22 Northern Europe 355–56 explorers 349 humanism 292–94, 308, 309, 314 Northern Europe 345-46, 358 painting 301–7, 310–14, 315–16, 319–21, 323–25, 343–44 Northern Europe 336–43, 351–55 sculpture 294–98, 317–19 renga 516 Renoir, Picrrc-Auguste 477, 480, 480 repoussé work 242 responsorial singing 161 Revelation (Apocalypse) 28, 160, 161 revolutions 461 American 404, 416 French 402, 404, 416–17, 418–19 "Glorious" 395 Industrial 404-5, 460 Russian 520, 522, 528, 529, 530 Scientific 405 Reynolds, Sir Joshua 412-13, 413, 414, 422 Rhea 67 rhetoric 102 Rich, Adrienne 609 Richard I, of England 245, 246 Richards, M. C. 594 Richardson, Samuel 427 Richelieu, Duc de 390, 407 Richey, Carrie 604 Richthofen, Wolfram von 552-53 Rigaud, Hyacinthe 402, 402, 407 Rihaku see Li Bai Rikyu 217 rising action (definition) 9 ritornello 375 Rivera, Diego 559, 559, 571, 571 Robert, Hubert 54, 54 Robespierre, Maximilien de 418 Robie House, Chicago 586, 587 Robin, Pierre 265, 265–66 Robin Hood 549, 549 Robinson, Sugar Ray 606 Rococo style 403, 406, 407-14, 420 Rodin, Auguste 491-92, 492

Rodrigues, Joao 217 Rogers, Richard 584 Roland, Song of 238 Roman Catholic Church 11, 167, Counter-Reformation 364, 364-65, Index of Prohibited Books 345, 350 Scholasticism 275-76 Scholasticism 273–76 see also papacy; Vatican Roman Republic and Empire 84, 112, 118–20, 119, 124–26, 125, 166 architecture 114, 121–22, 127, 128–31, 136 and Christianity 121, 127, 151, 152-53, 168 Greek legacy 114, 120-21 Greek (egacy 114, 120–21 literature and drama 54–55, 114, 120–21, 124, 127, 142–43 painting 126, 137–40 philosophy 140–42 religion and cults 120, 160 sculpture 122–23, 131–37 silk trade 169 see also Rome romances 253 Romanesque era 243–46 architecture 7, 7, 11, 246–49, 258 decorative arts 251–52 sculpture 249-51 Romano, Giulio 328 Romanticism 432, 436, 438 architecture 448–49 literature 450–54, 456 music 452, 454, 454–58 painting 436–47 philosophy 449–50 sculpture 447-48 Rome 28, 84, 114, 117, 125, 126, 127, 166, 314, 343 Arch of Constantine 136, 136-37, 137, 157 Baths of Caracalla 131, 131 catacombs 158–59, *159* Circus Maximus 127 Colosseum 114, 127, 129, *129*, 130 Forum 128, 128–29 Palazzo Farnese 373, 373 Pantheon 130, 130-31, 390 San Carlo alle Quattro Fontane 369-70, 370, 407 San Luigi dei Francesi 370, 371 Santa Costanza 145, 154, 154, 155, 156, 156 Santa Maria della Vittoria 368, 369, 369 Santa Maria Maggiore 154, 154 Tempietto 321, 321–22 Temple of Fortuna Virilis 121, 121 Temple of Vesta 121-22, 122 Trajan's Column 133, 133-34 see also St. Peter's; Sistine Chapel Rommel, General Erwin 5 Romulus and Remus 117, 117, 118 Ronchamp, France 586, 586 rondos 428, 431 Roosevelt, Franklin Delano *540*, 554 rose windows 259 Rosetta Stone 36, 36 Rosso Fiorentino 328 Rothenberg, Susan 604–5, 605 Rothko, Mark 582, 582 Rouault, Georges 495 Rouen: Saint-Maclou 265, 265-66 Rousseau, Jean-Jacques 403, 449 Royal Academy, London 412, 422, 443, 444 Ruan Ji 210 Ruba'iyat of Omar Khayyam, The 185 rubénistes 388, 407, 419, 494 Rubens, Peter Paul 313, 313, 324–25, 375, 380, 382, 383, 384, 388, 407 Rublev, Andrei 525 Rude, François 448, 448 Rumi, Jalaloddin 180 Ruskin, John 448 Russia/Soviet Union 520, 522, 528–29, 530, 531, 550, 552, 612 architecture 524-26 Cold War 578

literature and drama 526-27, 532-33 Moscow 522, 524, 524–26, 525, 526, 529, 555, 590 music 498, 503, 527–28, 533, painting 501-3, 522-23, 529-30, religion 522–23 Revolution 520, 522, 528, 529, 530 St. Petersburg 523, 523–24, 528, 532 World War II 576, 577 Russo-Japanese War 512, 516 Rutherford, Ernest 487 Ruz, Alberto 223 Saar, Betye 605, 605 Saburo, Murakami 583 sacramentaries 241 sacrifice, human (Aztec) 225 Said, Edward 443 Saikaku Ihara 516-17 St. Basil's Cathedral, Moscow 525-26, St. Bavon Cathedral, Ghent: Ghent Altarpiece 338, 338-339, 339, 341, St. Catherine, monastery of (Mount Sinai) 168 Saint-Denis, nr Paris 259, 259 Sainte-Chapelle, Paris 256, 264, 265, 274, 275 Sainte-Foy, Conques 246, 249 Sainte-Madeleine, Vézelay 248, 248, 250, 250-51 St. Gall, Switzerland 240-41, 241 St. James of Compostela 246, 248 Saint Lazare, Autun 249, 250, 251 St. Louis, Missouri: Wainwright Building 492–93, 493
Saint-Maclou, Rouen 265, 265–66
St. Marks, Venice 173, 173–75, 174, 175, 323 Saint-Martial, Limoges 246 Saint-Martin, Tours 246 St. Paul's, London 389-91, 391 St. Peter's, Rome 153, 153-54, 315, 321, 322, 322–23, 326, 365–67, 366, 367 322, 322–23, 326, 303–07, 300, 30 Baldacchino 367, 367–68 St. Petersburg 523, 523–24, 528, 532 Saint-Pierre, Poitiers 271 Saint-Riquier, Abbeville 238, 239 Saint-Sernin, Toulouse 246, 246–47, 247, 258 Sakyamuni see Buddha Salamis, battle of 85 Salisbury Cathedral, England 266, 266 Salomon, Johann Peter 429 Salon des Refusés 463 salons, Parisian 407 Samothrace 110 samsara 193 Samuel, Book of 149 samurai 215, 217, 512 San Carlo alle Quattro Fontane, Rome 369–70, 370, 407 San Luigi dei Francesi, Rome 370, 371 San Marco, Venice see St. Mark's San Marco monastery, Florence 340-5, 305, 307 San Vitale, Ravenna 168, 169, 170, 170–71, 171 Sanchi: Great Stupa 189, 196, 196 sancta camisia 260, 262 Sand, George 455, 461, 462, 486 sand painting 2, 612–13, 613 Sanskrit 190, 191 Sant' Andrea, Mantua 299, 300 Santa Costanza, Rome 145, 154, 154, 155, 156, 156 Santa Croce chapels, Florence 291, 317 Santa Maria delle Grazie, Milan 312, 312-13

Santa Maria della Vittoria, Rome 368,

Santa Maria Maggiore, Rome 154, 154

Santa Maria in Vallicella, Rome 371

film 530-31

language 522

Santa Maria Novella, Florence: fresco 302, 302-3 Santana, Manuel 568 Santi, Giovanni 315 Santi Pietro e Marcellino, Rome 158, 159 Santiago de Compostela 246, 248 Sant' Ignazio, Rome 373–74, *374* Sappho 81 Saggara 38, 38, 43 Sarajevo, Bosnia 536 sarcophagi: Etruscan 116, 116–17 Mayan 223–24, 224 Sarcophagus of Junius Bassus 157, 157–58 Sardinia 118 Sardinia 118
Sargon I, Akkadian king 24
Sarnath capital 195, 195–96
Sartre, Jean-Paul 579, 580, 588
Satie, Eric 540
satire 114, 143, 414–15, 452
satori 216 Saul, King 148 Savonarola, Girolamo 307–8, 310 Savoye House, Poissy-sur-Seine 585, 585-86 sawm 179 Saxons 166, 234 scat singing 560 Schiller, Friedrich 453 Schliemann, Heinrich 58, 66 Schoenberg, Arnold 550 Scholasticism 275–77 Schopenhauer, Arthur 457 Schubert, Franz 452, 453, 454, 455, 456 Schumann, Robert 454 Schwitters, Kurt 538, 538-39 science and technology 350–51, 393–94, 404, 405, 473, 486–87 see also astronomy Scotland 276, 349, 404 Scotus, Duns 276 Scraper, The 96–97, 97 Scully, Vincent 77 sculpture (see also bronze work; relief sculpture) abstract 542-45 African 565-67 Assyrian 26 Baroque 367–69 British 543–44 cybernetic 610 Ćycladic 58-59 carly Christian 156-58 Egyptian 34–35, 37, 40–42, 43, 44, 48, 51–52 Etruscan 117 feminist 603-4 French 249-51, 269-72, 424-25, 447-48, 491-92 Gothic 269–72 Greek 71–72, 73, 75, 79–81, 90–92, 93–97, 109–11, 314 Gupta 197-98 Italian 281, 294–98, 317–19, 332–33, 367–69 Mannerist 332 Mauryan 195-96 Mesoamerican 220, 225 minimalist 594-96 Minoan 64 Neoclassical 424-25, 447 Paleolithic 15–16 Persian 29–30, 195 Renaissance 294–98, 317–19 Roman 122–23, 131–37 Romantic 447-48 Sumerian 21-23 Sebastian, St. 152 secondary colors 6, 6, 478 secular art (definition) 4 Seleucids 84, 106 Seneca, Lucius Annaeus 141, 310 Senwosret II, pectoral of 44, 44–45 Serbia 536 Serrano, Andreas 346 Sesshu 512–13, *513*, 515 setting (definition) 9

Seurat, Georges 7, 489, 489-90, 491, "Seven Sages of the Bamboo Grove" 210 Seven Years' War 403 Severini, Gino 501, 501 Seville 552 Sèvres Porcelain Manufactory 409 sexuality 486, 590 Sforza, the 325 Battista 303, 304, 313 Ludovico, Dukc of Milan 310, 311 sfumato 312 Shah Jahan 199 shahadah 179 Shakespeare, William 161, 310, 341, 346, 359, 359, 360, 360, 414, 457 and music 361 shamans 224 Shamash (deity) 26 Shang dynasty 204, 204 Shankar, Ravi 201, 201 shape (definition) 5 shastras 199 Shelley, Percy Bysshe 54 Shen Zhou 506–7, 507, 510 Shenzong, Emperor 211 Sherman, Cindy 604, 604 shih 209 oni ites 1// Shinhuangdi, Qin emperor 208, 208 Shinto 212, 215, 512, 518 Shiva (deity) 191 Shiva Nataraja 200, 200 shoguns 215, 217, 512 shopping malls 576, 589–90 Shostakovich, Dmitri 530, 533 Shozo, Shimamato 583 Shrewsbury, Elizabeth of 356 Shrewsbury, Elizabeth of 356 Shudras 191 Sicily 73, 118 Sidney, Philip 310 Siena 281–82, 296, 296 sign (definition) 5 "sign"/"signifier"/"signified" 602 Silk Road 169, 190, 202, 209 Silko, Leslie Marmon 611 Sinai, Mount 147, 168 Sinan 182, 182, 183 Siqueiros, David Alfaro 563, 571, 571 Sisley, Alfred 477
Sister, Alfred 477
Sistine Chapel, Rome 314, 316–17, 319, 320, 321, 328, 328, 330
siture 201, 201 site-specific art 596, 596 Six Dynasties (China) 209, 210 Sixtus IV, Pope 314, 314, 315, 325 Sixtus V, Pope 133 Skepticism 111 slavery/slave trade 127, 445, 445, 565, 568 smallpox 231 Smith, Adam 404–5 Smith, Jaune Quick-to-See 608, 608 Smithson, Harriet 455 Smohalla 231 Smythson, Robert 356, 356 Snake Goddess (Minoan) 64, 64 Soami 516 social contract 396 Socrates 81, 101, 101–2, 103 Soku, Kagaku 516 Solesmes Abbey 253 soliloquies 359 Solomon 148, 176 Solomon, Carl 598 Solon 84, 86 Solzhenitsyn, Alexander 532-33 sonata form 428 sonata form 428 Song dynasty 210–11, 212 Song of Roland 238 Song of Songs 149, 150, 185 songs 287, 326, 559 Lieder 454, 455, 456, 538 Nahuatl 225 see also hymns sonnets, Petrarchan 310 Sophia, Princess of Russia 524 Sophists 102 Sophocles 84, 99, 100-1, 293

Sousa, John Philip 598 South America see Latin America Soviet Department of Fine Arts 529 Soviet Department of File Soviet Union see Russia Soyinka, Wole 568 space travel 530, 576, 589 Spain 276, 375, 436 architecture 493–94 Civil War 3, 3, 552–53 Islamic culture 165, 177, 180, 181, 181, 183, 184, 185–86, 187, 237, 274 literature 185–86, 399 and New Mexico 141 painting 375, 384, 437–39, 463, 541–42, 572, see also Picasso and South America 226, 228, 231, 293, 349, 393 Sparta/Spartans 70, 77, 84, 85, 87 Spear-Bearer 94–95, 95, 132 Spenser, Edmund 310 Sphinx, the 40, 40–41 Spinario 314 stabiles 544 stained glass, Gothic 259, 264, 265, 272–74, 273, 275 Stalin, Joseph 529, 530, 531, 532, 533 Standard, Inlaid (from Ur) 22, 22-23 standing stones 18 Statue of Liberty 469, 469–70 steam engines 404 Stein, Gertrude 495, 497, 497 Stein, Leo 495 Steinbeck, John 540, 554 stelai 25, 25–26 Stephen, St. 152 Stevens, Wallace 453 Stevenson, Robert Louis 450 Stieglitz, Alfred 545, 546, 546, 547 stoas 86 stoas 86 Stoicism 111, 114, 140–42 Stone, Merlin: *When God Was a Woman* 64 stone heads (Olmec) 220, 220 Stonehenge 13, 18, 18, 229 Stravinksy, Igor 498, 503, 549–50 stream of consciousness 548 Strindberg, August 486 stringed instruments 10, 361 structuralism 602 structuralism 602 stupas 189, 195, 196, 196 style (definition) 4 stylobates 78, 78 Suetonlus 128 Sufis 179–80, 185, 186, 431 Suger, Abbot 259, 259, 269 Sui dynasty 209 Sulla, Lucius Cornelius 119, 128 Sullivan, Louis 492-93, 493 "Sumer Is Icumen In" 287 Sumerians 12, 19-24, 20, 27, 146 beer 31 writing 35 "superman" (Nietzsche) 487 Suprematism 529, 529 Surrealism 540–42, 553, 581, 591 Sutton Hoo burial ship 233, 234, 234, Suzuki, Teitaro 216 Swift, Jonathan 403, 414–15, 449 swing music 560-61 Switzerland 240-41, 344, 348, 353, 537, 528, 538 syllogism 103-4 Symbolists 483–84, 485, 491, 495 symbols/symbolism 5, 9, see also iconography symphonies 401, 428, 429, 431–32, 454, 455, 457 syncopation 287, 560 syntax (definition) 8 Taiwan 508, 510, 512, 610 Taj Mahal, Agra 199, 199 Takayoshi 214, 215 Talbot, William Henry Fox 465

Tale of Genji 213–14, 215, 516, 518 Talenti, Francesco 269 Tang dynasty 209–10 Taoism 204, 206–7, 209, 210

tapestries 274-75, 275, 409 Tarquinia, tombs at 116, 116 Tarquinius Superbus, Etruscan king Taxila 109 Taylor, Edward 349 Tchaikovsky, Peter 527–28, 599 te 205, 206 tea ceremony, Japanese 217, 217 technology see science and technology Teerling, Levina Bening 357 teleology 104 teleology 104 telescopes 394, 397 television 491, 579 tempera 175, 175, 282, 283, 336 Tempietto, Rome 321, 321–22 Egyptian 37, 45-47, 48, 54 Egyptail 37, 43–47, 46, 34 Etruscan 115 Greek and Hellenistic 75, 77–79, 89–93, 107, 109, 115 Hindu 190, 199–200 Japanese 213, 514–15 Jerusalem 148, 176 Mesoamerican 221 Roman 121-22, 128-29, 130-31 Sumerian 20, 21 tempo, musical 10, 11 tenebrism 370–71 Tenochtitlán, Mexico 225, 293, 293 tenor 279 Teotihuacán, Mexico 220-22, 221, 224 Terence 124
Teresa of Avila, St. 331, 365, 368, 369 "terracotta army", Qin 208, 208 tertiary colors 6, 6 tetrarchy 126 Tetzel (monk) 347 Texcoco, Lake 224-25 textiles/embroidery 224, 244, 244, 274–75, 275 looms 404, 404 texture (definition) 5 musical 10 Thales 102 theater see drama Thebes, Egypt 43, 45–46, 51, 52 tomb of Nebamun 50, 50 Thebes, Greece 100, 105, 106 theme and variations 428 themes (definition) 9 Themistocles 85 Theodora, Empress 166, 170, 171, 171 Theodosius I, Empcror 96, 153 theology 11 Theophanes the Greek 525 Thera 58, 59, 59 Thermopylai, battle of 85 Thespis 98 Thirty Years' War 364 tholoi 65, 66 Thomas, Gospel of 162 Thomson, Sir Joseph John 479, 487 Thoreau, Henry David 216, 449–50 Thousand and One Nights, The 186, 199 Thucydides 87, 292 Thutmose III, pharaoh 45 Thutmosis (sculptor) 51 Tiananmen Square, Beijing 506, 509, 510, 511 Tiberius, Emperor 134 Tigris, River 19 Tikal, Guatomala 222 23, 223 timbre (definition) 10 Tintern Abbey 345 Tintoretto, Jacopo 325, *325* Titans 67, 68, 69, 109 Titian (Tiziano Vecelli) 59, 324, 324, 331, 343, 344, 344, 357, 382, 383, 384, 464, 465 Tito, Quispe 569, 570 Tiy, Queen of Egypt 52, 53 Tlingit, the 229 togas 123 Toklas, Alice B. 497 Tokugawa shogunate 512, 513 Tokyo 512, 513, 583 Toledo 331, *331*

Tolstoy, Leo 526-27 Toltecs 220, 224 tombs: burial ships 234, 234–35, 235
Chinese 204, 204, 205, 208, 208
Christian catacombs 158–59, 159
Egyptian 38, 43, 43, 44, 50, 50, 52, 53, see also pyramids
Etruscan 115, 115–17, 116 Indian 199 Jewish 147 Mycenaean 65, 65–66 see also sarcophagi; Westminster Abbey tone (definition) 10 Toqué (administrator) 566 Torah 147 Toreador Fresco 62, 62-63 Toru, Takemitsu 516, 517 totem poles, Haida 230, 230 Toulouse: Saint-Sernin 246, 246–47, 247, 258 Toulouse-Lautrec, Henri de 486 Tournai 337 Tours 17 Saint-Martin 246 tragedy: Greek 98, 99, 100-1 Trajan, Emperor 125, 133, 134 Trajan's Column, Rome *133*, 133–34 Transcendentalism 449, 453–54 transept 153 travertine 129 trench warfare (World War I) 536–37 Trent, Council of 324, 345, 364-65 triforium 258, 263 triglyphs 87, 87 triptychs 337, 337-38, 341-43 trivium 276 Trojan War see Troy Trollope, Anthony 472 trompe l'oeil 374 Trotsky, Leon 529 troubadours 252–53, 274 Troy/Trojan War 58, 64–65, 67, 72, 73, 75, 77, 101, 109, 142 Truman, President Harry S. 576, 577 trumeau 249 Tudor, David 594 tufa 115-16, 129 Tula, Mexico 224
Turks/Turkey 177, 431, 441, 442, 452, 536 military bands 431 Turner, Joseph Mallord William 325, 436, 444–45, 445, 452 Tuscan order 115, 121 Tutankhamen, tomb of 52, 53 twelve-tone scale 550 Tyndale, William 150 tyrants, Greek 74–75, 84 Tzara, Tristan 537, 537, 540 ukivo-e 513 Umayyad dynasty 177, 180, 187 Unicorn Tapestry 274–75, 275 United Nations 148, 600 United States 349, 403, 404, 576,

576–79, 589–90 architecture 426–27, 492–93, 586–88, 597–98 Constitution 404, 419 dance 543, 559, 595 Declaration of Independence 114, Great Depression 554, 555 Industrial Revolution 460 Hiterature 398, 450, 453–54, 472, 484, 537, 547, 548–49, 557–58, 598, 609–11 music 558–61, 590–91, 598–99 National Parks 447 National Parks 447
"New Deal" 554, 581
painting 346, 422–24, 445–47, 466, 468, 482–83, 546–47, 555–56, 580–83, 603, 604–5, 606–7
philosophy 449–50

United States - continued photography 447, 466, 545–46, 554–55 Pop Art 591-94 sculpture 424-25, 469-70, 544-45 World War II and after 576, 576-79 see also African Americans; American Civil War; New York unities, dramatic 397 universities 276, 280, 341 "Untouchables" 191 Upanishads, The 192 Ur, Iraq 146 beer 31 Inlaid Standard 22, 22–23 lyre 23, 23, 24 ziggurat of King Urnammu 20, 20–21 Urban II, Pope 246 Urban VIII, Pope 364, 368, 394 Urbino, dukes of 315 Federico da Montefeltro 303-4, 304, 326-27 Lorenzo 328 Urnammu, King: ziggurat 20, 20–21 Ursula, St. 253 Uruguay 569 Uruk, Iraq 19, 21, 21, 23 Utamaro Kitagawa 513–14, 514 Uthman, caliph 178 Vaishyas 191 Valley of the Kings (Thebes) 45 Vallon-Pont-d'Arc: cave paintings 14-15 Valmiki 192 Valtorta Gorge: wall paintings 17, 17–18 value (definition) 5 Vandals 166 van Dyck see Dyck, Anthony van van Eyck see Eyck, Jan van van Gogh see Gogh, Vincent van vanishing point 5, 5, 296, 296 Vasari, Giorgio 292, 301, 306, 311, 313, 316, 317, 321, 333, 333, 338 vase painting: Greek and Hellenistic 57, 70–71, 71, 74, 74–76, 75–77, 97, 97–98 Minoan 63, 63–64 Mycenaean 67, 67 Vasily III, Grand Prince 522 Vatican 314, 314-15, 316, 317, 344 Stanza della Segnatura 316, 317 see also St. Peter's wall paintings/murals: vaulting 7 barrel (tunnel) 7, 7, 247, 247 cross (groin) 7, 7, 248, 248

fan 266, 267 pendant 266, 267 ribbed 7, 258, 258, 259, 259 Vauxcelles, Louis 495, 499–500 Vedas 190, 191–92 Vedic period (India) 190 Velázquez, Diego 375, 384, 385, 437–38, 463, 572 Venice 166, 234, 290, 331, 333, 349 Doges' Palace 323, 323 music 374-75 painting 323-35 St. Mark's 173, 173-75, 174, 175, Venturi, Robert 597 Venus/Aphrodite (deity) 120, see Aphrodite Veracruz, Mexico 220, 231 Verdi, Giuseppe 454, 457 Verlaine, Paul 485 Vermeer, Jan 377, 379-80, 380, 381, Verrocchio, Andrea del 311 Versailles, Palace of 389, 389, 390, 407, 418, 432, 432 Vertue, Robert and William 266, Vesalius, Andreas 350 Vesta, temples of (Rome) 121-22, 122, 128 Vesuvius, eruption of 126, 137, 138 Vézelay: Sainte-Madeleine 248, 248, 250, 250-51 vibrations, musical (definition) 10 vibrato (definition) 10 Viennese composers 428, 429, 430, 431, 550 Vietnam War 598, 602, 611 Veterans' Memorial 608–9, 609 Vigée-Lebrun, Marie-Louise-Elisabeth 410, 410-11 Vignon, Pierre-Alexandre 426, 426 Viid, Ioos 338 Villa-Lobos, Heitor 572, 573 Virgil 72, 132, 142, 292, 310, 517 Virgin Mary 162, 262, 270–71, 338 sancta camisia 260, 262 Virgin of Vladimir 523, 523, 525 Virginia State Capitol 42 Visconti, Gian Galeazzo 269 Vishnu (deity) 190, 191, 192 Visigoths 166, 274 Vitebsk, Russia 529 Vitruvius 115, 115, 138, 299, 353, 388 Vivaldi, Antonio 374-75, 455 Vlaminck, Maurice de 495 Vogel, Susan 567 Voltaire (François Marie Arouet) 403, 415, 419, 449 voussoirs 7, 181 Vulcan/Hephaistos (deity) 68, 120 wahi 217 Wagner, Richard 454, 457, 457–58, 477 Wainwright Building, St. Louis 492–93, 493 Waley, Arthur 210

Egyptian 43, 48-50 Etruscan 116 Gupta (Ajanta caves) 197, 198 Jewish 147 medieval 235 Mexican 570–71 prehistoric 14–15, 17–18 Roman 137-40 see also frescoes; graffiti Walla Walla Valley (USA) 231 Wanderers, the (artists) 532 Warhol, Andy 592, 592-93 Warka see Uruk Warner Brothers 549, 549 Warrior Vase (Mycenae) 67, 67

American 556, 606-7

Cycladic 59

World War I 502, 512, 528, 529, 534, 536–37, 549, 550, 557
World War II 512, 516, 529, 530, 533, 545, 548, 552, 553, 555, 565, 576–77, 579, 589
World Wide Web 612 American Civil 447, 465-66, 466, Austrian Succession 403 Hundred Years' 254, 256, 280 Korean 555 "little" (guerillas) 436, 438 Opium 509, 510 Worms, Diet of 345 Wounded Knee, battle of 607 Russo-Japanese 512, 516 Seven Years' 403 WPA see Works Progress Administration Wren, Sir Christopher 389–90, 391 Wright, Frank Lloyd 575, 584, 586, 587, 588, 588, 597 Sino-Japanese 516 Spanish Civil 3, 3, 552–53 Thirty Years' 364 Vietnam 598, 602, 608-9, 611 see also World War I and II writing 8, 35 Washington, George 424-25, 425 Chinese 204, 212 Watergate hearings 576 Watkins, C. E. 447 Cufic 183 Cunci 185 Greek 36, 58, 73 hieroglyphics 35, 35–36, 36, 44–45 ideograms 19 Linear A and B 58 Watt, James 404 Watteau, Jean-Antoine 407-8, 408, Wedgwood, Josiah 404, 404 Weelkes, Thomas 287, 357-58 Mesoamerican 220, 222, 224, 225 wen 205, 206 Wu Li 506 Wen-Ying Tsai 610, 610 Wu school 507 West, Benjamin 422-23, 423 wu-wei 206-7 Wu Zhen 506, 506 Westminster Abbey, London 266, 267, 268 Wycliffe, John 150 westworks 238 Wetherill, Richard 230 wyrd 236 Whistler, James Abbott McNeill 483, Xerxes I, of Persia 31, 85 Yahweh 146, 149 yakshis 196 white-ground vases 97, 97-98 Whitman, Dr. Marcus 231 Whitman, Walt 449, 453, 454 Yamato clan 212 Wilde, Oscar 486 Willendorf, Woman of 16, 16 William the Conqueror 244, 244-45 William and Mary, of Orange 395-William IX, Duke of Aquitaine 252 Williams, Cootie 561 Williams, William Carlos 453, 547, yi 205

548 Wilson, Edward O. 470 Wilson, Woodrow 540

women:

Winged Victory see Nike of Samothrace

actresses 397, 511 artists 2, 372, 377, 410–11, 421–22, 461, 477, 480–81, 482–83, 546–47, 571–72, 583, 591–92, 603–5, 606–7, 613

603–5, 606–7, 613 photographers 554, 555 rights 418, 540 writers 252, 286–87, 398, 427–28, 433, 452, 453–54, 461, 472, 484, 536, 548, 558, 580, 603, 609–11 Yoruba "mothers" 566–67 see also feminists; Hildegard of Bingen

woodblock prints, Japanese *471*, 482, 483, 513–14 woodcuts 352, *352*

Woodhouse, Richard 451 woodwind instruments 10, 361 Woolf, Virginia 359, 536, 548, 603

word painting, Renaissance 308 Wordsworth, William 345, 449, 451,

Works Progress Administration (WPA) 540, 554, 556, 557

453, 456

Wittenberg 336, 346-48

Wollstonecraft, Mary 418

Yax Moch Xoc, Mayan ruler 222 Yeats, William Butler 536 Yellow River Valley 204 Yellowstone Park 447, 447 Yevtushenko, Evgeny 533 yi 205 Yi of Zheng, Marquis 204 yin and yang 207, 207 Yongle, Emperor 508 Yoruba 565, 566, 566–67, 569, 569 Yosemite Park 447 Yoshimasa, Ashikaga ruler 217 Yoshimitsu, shogun 514 Yuan dynasty 506 Yucatán peninsula 222 Yuendumu sand painting 612-13, 613, 615 Yungang caves 209, 209

zakat 179 Zakro 60 Zapotecs 220 Zarathustra/Zoroaster 31 Zen Buddhism 212, 215-16, 217, 512, 513, 516, 583 Zentis, Jerome de 393 Zeus/Jupiter/Jove (deity) 59, 67, 68, 69, 109, 120, 160 Zhou dynasty 204-7, 205 Zhu Jan 203, 210, 211 Zhu Yuanzhang 506 ziggurats 20, 20–21, 28, 29 Zola, Émile *471*, 471–72, 486 Zoroastrianism 31, 162 Zoser, Stepped Pyramid of 38, 38–39 Zuni, the 230 Zürich 537 Zwingli, Ulrich 344